Include SASE post card for notification by art director or editor that submission arrived safely

Mail first class; include SASE or IRC coupon for return of photos

No response: send follow-up letter

Send thank you note when sale is made

Keep track of sales made and payments due

For more detailed instructions, read the "Business of Freelancing" section

1987 Photographer's Market

*Distributed in Canada by Prentice-Hall of
Canada Ltd., 1870 Birchmount Road,
Scarborough, Ontario M1P 2J7.*

*Managing Editor, Market Books Department:
Constance J. Achabal*

Photographer's Market. *Copyright © 1986
by Writer's Digest Books. Published by
F&W Publications, 9933 Alliance Road,
Cincinnati, Ohio 45242. Printed and bound
in the United States of America. All rights
reserved. No part of this book may be
reproduced in any manner whatsoever
without written permission from the
publisher, except by reviewers who may
quote brief passages to be printed
in a magazine or newspaper.*

*International Standard Serial Number
0147-247X
International Standard Book Number
0-89879-245-2*

1987
Photographer's Market

Where to Sell
Your Photographs

Edited by
Connie Eidenier

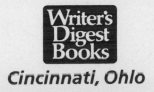

Writer's
Digest
Books

Cincinnati, Ohio

Contents

Appendix

From the Editor

To succeed in the photography marketplace you must be more than an artist. You must be able to market yourself—and your work—to reach the photo buyer. The 1987 *Photographer's Market* will get you started with 2,500 market listings from which to choose. Six hundred of these listings are brand new, and are marked with an asterisk for your convenience. There is something here for every type of interest, such as advertising and public relations agencies, audiovisual firms, galleries, book and magazine publishers, record companies and stock photo agencies, to name a few. This year the Audiovisual section has been expanded and split from Advertising and Public Relations to assist you in easier identification of a new and growing market.

Each listing contains the correct contact person and address at which he can be reached, plus descriptions of photo subject needs, preferred methods of contact, and rates of pay. Pay special attention to the Tips section in each listing; the information offered can give you an important "sales edge" over another photographer.

The heart of *Photographer's Market* is the listings this edition contains—but we offer more to the photographer who is new at the marketing game. The first major article, written by veteran photographer's representative, Maria Piscopo, gives "how-to" advice on marketing yourself through advertising, public relations and personal contact techniques. This step-by-step guide tells you how to keep your name out there in front of the buying public, and how to do it without blowing your budget. In addition, an informative sidebar by *The Perfect Portfolio* (Amphoto Books) author, Henrietta Brackman, highlights the type of material every portfolio should include. Read both pieces to assist your photography marketing efforts!

A second article, in question and answer format, concerns the subject of copyright. Timothy S. Jensen, Esq., director of Legal Services for Volunteer Lawyers for the Arts, explains what a copyright is and how it protects you, the photographer. He also provides an explanation of what constitutes an invasion of privacy, another area with which photographers must be familiar.

As in previous *Photographer's Markets*, you also will gain some excellent marketing advice from our twelve Close-up interviewees. They include freelance photographers Lisl Dennis (Consumer Publications), Margaret McCarthy (Galleries), Cliff Hollenbeck (Advertising/Public Relations) and Jim West (Book Publishers). These four personalities share their views of the marketplace and how to succeed in it, and have sent samples of their own work for you to study. The remaining eight Close-ups are buyers from markets in the book, and each offers a detailed explanation of what he looks for in a good photographer. To further "educate" you, we also have included photo samples from past *Photographer's Market* readers who submitted work to PM markets, and made a sale! They share with you the techniques that work for them.

In the Services & Opportunities section are found contest and workshop listings. While these aren't the same types of markets found in the rest of the book, they shouldn't be overlooked. The financial rewards and/or publicity gained through entering a contest can be a boost to any photographer's career. In addition, every photographer can benefit, at some point in his career, by enrolling in a workshop course to study an aspect of photography he finds particularly interesting. The many fine schools represented in this edition offer a range of subjects.

The successful freelancer also needs to develop good business skills as well as marketing abilities. The Appendix is a completely revised "Business of Freelancing" segment that provides important information on income taxes, recordkeeping, insurance needs, and business-

related areas that include photo filing, packaging and mailing submissions, and writing an appropriate cover letter, query and resume. Finally, a glossary will provide definitions commonly found in the listings.

With all this information, you should have no trouble making initial contacts and incorporating good marketing techniques into your sales efforts. Two things you will need, that this book can't supply, are determination and follow through. Maintain contact with your potential clients—even if they can't use your work initially, they may purchase a photograph(s) from you at a future date. Good luck. I'll be watching for your photo submissions for the 1988 *Photographer's Market*—from your 1987 sales!

Connie Eidenier

Using Photographer's Market

The listings in this book are more than names and addresses. Included is information on who to contact, what kind of photos the listee needs, how he utilizes photographers, and payment method and rate(s). Here are some tips to help you interpret these listings.

How To Read a Market Listing

• The asterisk (*) in front of a listing means that listing is new to this edition.

• The name and title of the person you should contact are given in most listings. If not, address your work to the title listed after "Contact:".

• Established dates are listed only if they are 1985 or 1986. This is to indicate the firm or publication is new and possibly more open to freelance photographers.

• Be aware that reporting time and payment rates may vary from the listing in this directory. This may happen if a change in management occurs after our publication date and new policies are established.

• The number or percentage of jobs assigned to freelance photographers or the number of photos bought gives you an idea of the size of the market.

• Editorial descriptions and client lists appear in listings to help you slant your photography toward that specific business.

• Label each submission you send to a potential buyer with your name and address; tell whether you want your work returned; and enclose all transparencies in slide sheets for easy mailing and review.

• If a market does not return unsolicited material, we have specified such. It is always professionally wise whenever corresponding, to include a self-addressed, stamped envelope (SASE) for a reply. If you are expecting the return of material, especially slides or a portfolio, be sure that sufficient postage and proper packaging are included. If you live in the United States and are soliciting foreign listings, purchase International Reply Coupons (IRC) at your local post office to cover your postage.

• When a market states that it requires model releases for identifiable people, get them. A photo may meet a photo editor's needs exactly, but if he doesn't have model releases the photo is useless to him. Even if a market states that model releases are optional or preferred, it's always a good idea to have them in hand when you submit photos.

• Markets that accept simultaneous submissions or previously published work (especially in publications) state it in their listings. Otherwise they do not accept these submissions.

• If a listing requests samples, we have tried to specify what types of samples it prefers. If the listing states it will keep material on file for possible future assignments, make sure your material easily fits the average 8½x11" file.

• If a listing instructs you to query, please query. Do not send samples unless that is what they want you to do. Some listings tell you to query and then list what type of samples they prefer. This does *not* mean to send samples. It is simply added information so that when you have further contact with them, you will have an idea of what type of samples to submit if they do ask to see them.

• Note what rights the listing prefers to purchase. If several types of rights are listed, it usually means the firm will negotiate. But not always. Be certain you and the photo buyer understand exactly what rights you are selling.

• Many firms work on assignment only. Do not expect them to buy the photos you send as samples. When your photos fill a current need, they will contact you.

• The abbreviations "ms" and "mss" stand for "manuscript" and "manuscripts" respectively. Some listees may prefer photo submissions to be accompanied by an "ms."

A Very Important Note

● *The markets listed in this book are those which are actively seeking new freelance contributors. Those companies not interested in hearing from new photographers are not included. If a particular magazine or other market is missing, it is probably not listed for that reaason, or because 1) it has gone out of business; 2) it did not respond to our questionnaire requesting listing information; 3) it did not verify its listing from last year's edition; 4) it has failed to respond adequately to photographers' complaints against it; or 5) it requested that its listing be deleted.*

● *Market listings new to this edition are marked with an asterisk. These new markets are often the most receptive to new freelance talent.*

● *Although every buyer is given the opportunity to update his listing information prior to publication, the photography marketplace changes constantly throughout the year and between editions. Therefore it is possible that some of the market information will be out of date by the time you make use of it.*

● *Market listings are published free of charge to photography buyers and are not advertisements. While every measure is taken to ensure that the listing information is as accurate as possible, we cannot guarantee or endorse any listing.*

● Photographer's Market *reserves the right to exclude any listing which does not meet its requirements.*

Make Your Advertising and PR Pay Off— in Clients

by Maria Piscopo

Let's start with the assumption that you are selling your photography as a business—to make a profit. Whether full- or part-time, this "profit" orientation may be difficult to achieve at first, but it is essential to the successful marketing of your photography. It is what distinguishes between the hobbyist and the true professional.

Before we discuss the most cost-effective and efficient "tools" to sell your work, let's start with how to write a marketing plan or "map" to help you accomplish your goals.

What's your specialty?

First, you must define the area or areas of photography you want to work in. In the broadest sense, there is consumer photography (weddings and portraits) and commercial photography (just about everything else). Should you select commercial work, you could choose between people photography and product photography. If you select product photography, then you can choose among such areas as advertising, corporate/industrial or still life work. Most importantly, do what you love to do! Success and prosperity will follow accordingly. This means, of course, you must try every kind of photography to select the areas in which you will be successful. This selection process is critical for two important reasons. One, most buyers of photography use the "specialty" method to hire photographers. When a company with chrome products needs photography for its brochure, it will hire the person who specializes in this area before it hires the person who does "everything." Second, you can't find what you are looking for if you don't know where to look! If you specialize in "chrome product" photography, it will be very easy to find clients with "chrome products" compared to the search for clients who buy "everything."

Business/marketing skills

Next, list your strengths and weaknesses in business and marketing. Look at areas such as job procedures, the portfolio, selling skills, brochures, company logo, follow-up techniques and equipment. (You will get lots of other ideas from the rest of this article.) Evaluate each and write down the areas that need the most work.

Now, set goals to correct the above weak areas and to strengthen the strong areas. All of this must be done in writing to ensure the accomplishment of your goals. For example, if you have noted above that your portfolio is weak in "chrome products," then as your goal you will write, "Improve quantity and quality of samples of chrome products in portfolio."

The plan you are writing now starts to fall into place as you write this next section. For each goal written above, write down all of the steps you will take to accomplish the goal and the time in which you expect this to happen. These are the strategies required for goals to become reality. To continue our example from above, for the portfolio you will write, "Shoot one chrome product per month for the next six months." At the end of six months, you have achieved your goal!

This step-by-step planning process can be used to put the following ideas for promotion in-

Maria Piscopo, after eight years as a photographer's rep, started, in 1985, a consulting business, Creative Services Consultant. She specializes in marketing and training reps for photographers, and presents seminars on "How to Be Your Own Best Rep" as well as producing a cassette tape series on the same topic. In addition, she writes for national photo magazines.

to action. You must write down each step, give yourself deadlines and do the work! Only then will you achieve the success you desire.

Before we discuss basic marketing principles to help you write your marketing plan, let's look at your professional image. We are in a visual industry and everything that follows will depend on your ability to set yourself apart from your competition. The easiest way to do this is to have a distinctive and identifiable logo design. This logo must then appear on *everything* that has your name on it such as your business cards, letterhead, shipping labels, ads and press releases. Inconsistency in this area will weaken the effectiveness of your promotion and cost you a great deal in lost business. If you do not have a logo design, then make this your first priority and build your promotion around it.

There are three basic principles of marketing you can apply to achieve cost-effective and successful promotion of your photography. These areas are *advertising, public relations and personal selling*. Before we describe each one, it is important to understand how closely they can work together and how poorly they work alone. Imagine an umbrella made of these three sections. This umbrella is your overall marketing strategy. One-third or even two-thirds of an umbrella will not work for you as well as the whole umbrella.

Advertising

Advertising is called a "nonpersonal" form of marketing because it is designed to reach large quantities of people, but not on a one-to-one basis. It generally will take the form of display ads, directory listings and direct mail. Let's look at each area in detail. Look back at step one of your marketing plan. What kind of photography do you specialize in? The answer to this question will determine where to most effectively place your display advertising. If you photograph weddings, your photography can be promoted through ads in the Yellow Pages and other consumer publications. If you work in advertising product photography, you need to advertise in the publications most likely to be read by buyers in that market. Because display ads are the most expensive promotion tool, you need to ask two questions before you spend any marketing dollars in this area. What percentage of people reading this publication is likely to buy the kind of photography I do? What have been the results for photographers who have advertised in the publication? Other factors to be considered are: geographic coverage (local, regional or national), circulation and distribution, and the prestige of the publication.

An often overlooked area of advertising is *free listings* many publications offer to photographers. Again, you must know what you are selling before you can determine who you are selling to, which in turn determines where you advertise! As a commercial photographer selling to advertising agencies or corporations, there are dozens of local, regional (e.g., *The Workbook* in Los Angeles and *The Creative Directory* in Chicago) and national (e.g., *Black Book* and *Art Director's Index*) directories that offer these free listings. Each area has some kind of promotional book. When in doubt, call your potential client at his business to see what directories he relies on to hire needed photographers.

Because these listings do not include any visual reference to the kind of work you do, use the listing format to your maximum advantage to "stand out" from the crowd. For example, Joan Smith Photography could be listed as Joan Smith Food Photography instead. Some books even let you add a "specialty" line to describe what you do. DON'T list "commercial photography" as a specialty in a book that lists all commercial photographers—be creative—pretend you are a buyer looking for a photographer. What would catch your eye and make you call? When in doubt about the suitability of a publication—or whether they offer free listings—don't hesitate to call and get the information. Good research done here will definitely pay later on.

Direct mail advertising

Direct mail is another form of advertising very popular with photographers. There are four important factors that determine the success of direct mail. If all of these factors are not

present, you will not have as cost-effective and successful a promotional tool as you could have—you may even be wasting the money you spend.

First, the mailing list must be current and include the name of the contact or buyer for the firm you wish to work with. In fact, the firm is not the client at all—the true client is the art director, marketing director or other decision maker who hires the photographer or buys the photos. Without a personal contact, your direct mail will be less effective.

The mailing list must be made up of people who buy the kind of photography you shoot—back to step one of your marketing plan! To use the "umbrella" concept of marketing and to tie in your advertising with your direct mail, try to get a mailing list from the publications you advertise in. First a buyer sees your ad, then gets your brochure in the mail. Before long, this kind of repeated exposure will result in jobs!

Some kind of follow-up is essential to the success of your direct mail. Here again, the marketing umbrella applies. Once a prospective client sees your ad and receives your brochure, you will find him much more open to talking with you about the photography he needs. Just imagine, no more "cold calls!" The objective of repeated exposure through advertising, free listings and direct mail is to have the buyer develop a familiarity with your services *before* you personally call. Some kind of active response mechanism (such as a coupon or reply card) could take the place of follow-up calls, but will not be as effective as a personal call.

And last, a regular schedule of mailings is very important to build needed exposure to the people in your target market. Just as with display advertising, "one-shot" mailings do not work as well as a regular schedule of mailings that are planned around your other ad and press release efforts. Don't forget about the visual impression you must make! A buyer will need to see your logo, company name and any other visual message you want to communicate six to sixteen times before he recognizes just who you are and what you do.

Public relations

Public relations is an excellent form of promotion for photographers—primarily because it is very inexpensive compared to advertising and direct mail. Public relations should never work by itself, but best functions in conjunction with the other nonpersonal marketing communications such as advertising and direct mail. The most common tool of public relations is the press release. The press release is a standardized form of communicating some "newsworthy" item to the editors of publications read by the people in your target market. It is no coincidence that these are the *very same* publications you may be advertising in. In addition to these "trade" publications, don't forget your local newspaper. Almost everyone reads a daily paper and because the goal of public relations is repeated exposure of your name and firm, some of this more "general" exposure couldn't hurt. To again use the example of your marketing umbrella, a prospective client may see your ad, receive your direct mail promotion, read about you in the paper and receive your phone call—that's four exposures or contacts you have made by doing your marketing homework! You now have four times the chance of finding work with this client.

Here are some examples of "newsworthy" items that could generate a press release:
- You relocate your studio;
- add personnel to your staff;
- celebrate the anniversary of your firm;
- begin a big, important job;
- successfully complete a big, important job;
- win an award for your photography;
- expand with additional services for clients, or
- participate in community or industry groups.

(See the *sample press release* and note how some of these items are used.)

Sample Press Release

IMMEDIATE RELEASE

For information:

February 1, 1987

Maria Piscopo
714-556-8133

COSTA MESA. Jack Boyd, Costa Mesa-based architectural photographer, celebrates the beginning of his tenth year in business providing exterior and interior design photography to the building industry. Specializing in architectural photography for business development, awards programs and brochures, Jack's latest assignment was the photography of "Saks Fifth Avenue," Palm Springs Fashion Plaza, for Hambrecht Terrell International in New York. As an Industry Foundation member of the American Society of Interior Designers (ASID), Jack will be donating photography services to the organization's very worthwhile community service project, United Cerebral Palsy Association's Infant Program Facility.

Participation in community or industry groups leads to a second important area of public relations that could be the KEY to cost-effective promotion. Every industry has professional associations or organizations; photographers have groups like Professional Photographers of America and American Society of Magazine Photographers. Membership in these groups is important for the development of good business practices and educational opportunities. These are "peer" groups and often provide an indirect source of job leads—as well as discounts on advertising and other marketing tools. Your target market *has its own group* that can provide a fertile ground for your marketing efforts. Memberships in these "client" or industry groups offer the following benefits to photographers:

- Personal contact at meetings with potential clients;
- advertising (very inexpensive) in their newsletters;
- free listings in their membership directories;
- publication of press releases in their newsletters;
- opportunities to participate in community or industry groups;
- exposure to your target market.

Even though this "networking" can take the form of personal contacts, it is important to remember you are NOT SELLING ANYTHING. You are simply increasing the number of contacts with your target market, their awareness of your services and your chances of getting work. Other areas to look at for additional publicity include participating in trade shows, entering award competitions, writing articles and giving seminars. Most of these will generate additional press releases as well as provide their own public relations benefits.

Personal selling

You can probably see by now how much more effective (and painless) your selling efforts can be by supplementing them with advertising and public relations techniques. Again, once a buyer has been exposed to who you are and what you do, he no longer is a "cold call." Phone

calls and portfolio presentations have been the most traditional method of marketing photography. Let's talk about how to make that time more effective.

First of all, it would be a mistake to consider the portfolio presentation as the first step. The most successful approach to selling your photography includes six separate steps.

1. Prospecting is the search for prospective clients—made easier if you know what you are looking for (back to defining your specialty!). Should you decide your target market will be book publishers, galleries or magazines, refer to publications such as *Photographer's Market*. If you have done your homework and have found a trade organization, its membership directory could be your starting point. Should you decide your area is advertising photography, look beyond the easy-to-find listings of agencies to search out the listings of the clients the agencies represent (ad agencies also are listed in *Photographer's Market*). You will be much more effective selling food photography to an ad agency that has food accounts.

2. Qualifying the prospect is simply a matter of determining the name of the person who has the authority and responsibility to purchase photography. Remember that the client is the contact, not the company. It is very common for any given corporation to have more than one buyer. Check by title—agencies have art directors, corporations have marketing and public relations directors. This is a critical step; you want to be sure you will be approaching the correct person and avoid a lot of wasted time and energy. The end result could be one company with three prospective buyers!

3. Approaching the prospective client is the next step—you only have one chance for a first impression, so make it a good one. You may decide to send several direct mail promotions before calling; be sure this prospect will be the correct person to receive your advertising and public relations messages. Once you decide to approach the prospective client, it is important to establish a personal relationship. In the end, people buy photography from people they feel they know and it is for this reason you want to begin by meeting face-to-face and showing samples of your work. YOU are just as important to selling your photography as your portfolio.

If the client is based in another city, be prepared to send a "traveling" portfolio. A traveling portfolio is not your regular portfolio, but one that is compact in size and scope. You want more than one, depending on how many queries you're handling. A traveling portfolio can take three forms: it can be slide trays, small color prints (8x10 or smaller) or it can be a video cassette of your work.

4. The portfolio presentation will be time most productively spent if you have done all your homework and can fulfill the criteria to these questions. Does this person buy the kind of photography I am selling? Will this person get to know who I am and what I do? It is important, during the presentation, to talk about who you are, what you do and how this relates to the prospective client. Be sure your presentation leaves a very clear visual impression of the work that you do—showing "everything" you do will only confuse the buyer. Someone can like your work (ever hear "nice portfolio" and wonder why you never got called back?) but never consider working with you because you don't shoot what he needs. This means showing 10 to 15 photographs that display your expertise at photographing what he wants. In the end, what you do as a photographer is much less important then what your client needs. (See sidebar at end of article.)

5. Closing the presentation is very simple to do, but is the single most overlooked facet of selling photography. Closing is as simple as coming to some kind of agreement with the client as to what happens next. You could ask about any upcoming jobs to bid on. You could agree to get together again in two months to show an updated portfolio. Whatever you do, don't leave until you have come to some kind of conclusion. Sometimes it might be as specific as a job to bid on or as vague as an agreement to meet again in two months.

If you have sent a "traveling" portfolio, your closing presentation will be handled via telephone. This phone call is critical, and should contain the same questions that would be asked in a person-to-person presentation. This step will increase the number of jobs you get from

portfolio presentations because it provides for the next step—follow-up.

6. Follow-up is how portfolio presentations turn into jobs. Studies have shown that most work for a successful photographer comes after the sixth contact with a client. Remember, these people don't know who you are until they have heard from you or seen your name six times! By effectively closing the presentation (and getting information) you will have something important to say when you call back. ALWAYS DO WHAT YOU SAY YOU WILL DO. If you have promised to call back in two weeks, do it! Most photographers don't do enough follow-up and lose the momentum built up from advertising, public relations and selling. If you don't have the time for a phone call, then drop a note in the mail. It is your job to keep in touch and turn prospects into clients, it is not the client's responsibility.

Don't forget about current and past clients! It is a lot easier and cheaper to keep clients than to find new ones. Take responsibility—good follow-up habits will ensure your success. No marketing will ensure a lack of success; good marketing will increase your chances for success.

Portfolio Presentations:
Start Strong, End Strong

In arranging your portfolio try the trick the old vaudeville actors used so effectively: Start your act strong and end with a blast that will leave your audience wanting more. Clients, like everyone else, react to first impressions. If they are impressed by the first few pictures you show, they are apt to be predisposed to react favorably to what follows. And do you remember the old saying, "Always leave them laughing"? With your portfolio, it's a case of "always leave them impressed."

● **Sensational openers.** *Show half a dozen or so of your real "show stoppers." In this way you immediately tell your client that your portfolio is worth paying attention to, and you set the tone for what follows.*

It is a good idea to use opening shots that all belong to the same subject and which are a part of a major subject area in which you want to generate business. If you don't have enough smashing images on one such subject, however, you can always use half a dozen different subjects, providing that each is a real stopper and that they all work well together.

● **The middle.** *It's all right to drop down a little in impact after your strong opening, but be sure to pick up the power again in the middle with some of your strongest pictures, so that you don't lose your audience's interest.*

● **Powerful ending.** *Try to end with half a dozen of your most powerful pictures to leave a lasting impression. These last few images should be as moving and memorable as any you can find.*

You have several choices for your ending. One is to do a reprise of your strongest subject, perhaps using some of the pictures that were too numerous to be used in their earlier grouping. I realize that this means repeating a subject and some people object to this. If I do it, I try to select those images that reveal a different angle of the subject. For a rough example, daytime scenes to begin with, night scenes later. Another way is to show, again, a miscellany. The third is to end with a new subject untouched earlier in the portfolio—but only if it is very strong.

● **Better safe than sorry.** *Beginning photographers, especially, may lack a sufficient number of outstanding images to use this formula. If you lack stoppers, try using just plain good pictures on a "safe" or universally usable subject. Think of one type of picture that most of your clients are currently using. For instance, in my experience, most clients—whether advertising, corporate or editorial—use what I call testimonial type or "talking" pictures of people looking into the camera and saying something. These are head or torso photographs of people expressing an emotion or opinion, and this is always a safe group to use to start your portfolio. An example of this type of picture would be an individual saying, "I'm glad I bought XYX insurance before my house burned down."*

by Henrietta Brackman
A reprint from The Perfect Portfolio (AMPHOTO)

The Markets

Advertising and Public Relations Firms

Advertising agencies and PR firms offer the freelance photographer a host of creative challenges and opportunities at a lucrative rate of pay. Photographers interested in this specialization must remember that it is a very competitive field, especially in major metropolitan areas. The art directors reviewing portfolios look for the person with a unique approach to his art, a photographic style attained through memorable composition or technical presentation of a product. And it is important to show a conscientious and versatile attitude; these qualities could well land you the assignment when you're involved in a close decision with competing photographers.

Photographers shooting for advertising agencies work in studios and on location, and use black and white as well as color images in a variety of formats. Some advertising agencies and public relations firms also have a need for photographers skilled in the use of film and videotape. For such jobs the photographer will work closely with an art director so the client's product is presented in the most appropriate manner. A willingness to follow directions is important, though many art directors also appreciate a photographer who understands a product well enough to make valuable suggestions regarding its treatment in the photograph.

The listings in this section specify the types of work most advertising agencies and PR firms handle for their clients. Prior to an interview, it is important to scale down your portfolio so it shows only the best quality images that reflect the type of merchandise, products or people being featured in a particular promotion. When shooting for an ad agency, it also is important to get model releases from the subjects. Unlike most editorial use, the law does not guarantee a photographer's protection if an unwilling subject appears in a photograph used for commercial gain.

Ad agencies and PR firms pay by hourly, day or job rates. Pay scales vary from firm to firm, and often are based on how the photos will be used, the client's budget, type of film used and whether the shoot will be held in-studio or on location, the latter to incur additional expenses. Typical uses for advertising photos include billboards, point-of-purchase (P-O-P) displays, brochures, direct mail promotions, newspapers, radio and TV, and consumer and trade magazine ads. The American Society of Magazine Photographers (ASMP) suggests a fee of at least $3,000 for a two-page color ad used in a national magazine. If you are just starting in promotional work, it won't be at this pay level, but do check local companies and query regarding any ad or PR needs. Local ad and PR jobs will build your portfolio and help you compete with more established photographers for higher paying upcoming assignments. The listings in this section run state by state for easier reference, and because many ad agencies and PR firms prefer to hire local freelancers for assignments.

Public relations firms differ from ad agencies only to the extent that the people or products aren't marketed quite as overtly. This partly is explained by the media targeted most frequently by PR professionals—newspapers and magazines. There is a "grey" area between the "sales" approach of advertising and the journalism/documentary approach used in editorial

publications. PR firms' clients vary as much as ad agencies'. They may serve health organizations, fashion firms, or financial or government agencies. Good PR photography skills can be developed through newspaper photography training to gain experience shooting under a variety of conditions and to cultivate a sense of "news." Here again, a good attitude is important because the photographer will be working with a PR director and his client. Quality work and an open mind will increase your chances of being called for the next job that comes up.

Alabama

BARNEY & PATRICK ADVERTISING INC., 306 St. Francis St., Mobile AL 36601. (205)433-0401. Ad agency. Associate Creative Director: George Yurcisin. Senior Art Director: Barbara Spafford. Clients: industrial, financial, medical, food service, shipping.
Needs: Works with 5-10 freelance photographers/year. Uses photographers for billboards, consumer magazines, trade magazines, direct mail, brochures, posters and newspapers. Also works with freelance filmmakers to produce "TV spots—videotape and 35mm."
Specs: Uses 8x10 and 11x14 glossy b&w prints, 35mm, 2¼x2¼, 4x5 and 8x10 transparencies; 35mm film and videotape.
First Contact & Terms: Arrange a personal interview to show portfolio or query with samples. Does not return unsolicited material. Reports in 2 weeks. Payment "varies according to budget." Pays on acceptance. Buys all rights. Model release required.
Tips: Prefers to see "slides and prints of top quality work, on time and within budget."

J.H. LEWIS ADVERTISING, INC., 105 N. Jackson St., Drawer 3202, Mobile AL 36652. (205)438-2507. Senior Vice President/Creative Director: Larry Norris. Ad agency. Uses billboards, consumer and trade magazines, direct mail, foreign media, newspapers, P-O-P displays, radio and TV. Serves industrial, entertainment, financial, agricultural, medical and consumer clients. Commissions 25 photographers/year. Pays/job. Buys all rights. Model release preferred. Arrange a personal interview to show portfolio; submit portfolio for review; or send material, "preferably slides we can keep on file," by mail for consideration. SASE. Reports in 1 week.
B&W: Uses contact sheet and glossy 8x10 prints.
Color: Uses 8x10 prints and 4x5 transparencies.
Film: Produces 16mm documentaries. Pays royalties.

Arizona

CHARLES DUFF ADVERTISING AGENCY, a division of Farnam Companies, Inc., Box 34820, Phoenix AZ 85067-4820. (602)285-1660. Inhouse ad agency. Creative Director: Trish Spencer. Clients: animal health products, primarily for horses and dogs; some cattle. Client list provided on request with SASE.
Needs: Works with 2-3 freelance photographers/month. Uses photographers for direct mail, catalogs, consumer magazines, P-O-P displays, posters, AV presentations, trade magazines, and brochures. Subject matter includes horses, dogs, cats, farm scenes, ranch scenes, cowboys, cattle and horse shows. Occasionally works with freelance filmmakers to produce educational horse health films and demonstrations of product use.
Specs: Uses 8x10 glossy b&w and color prints; 35mm, 2¼x2¼ and 4x5 transparencies; 16mm and 35mm film and videotape. "Would prefer 4x5 transparencies but can accept any size."
First Contact & Terms: Arrange a personal interview to show portfolio; query with samples; send unsolicited photos by mail for consideration; provide resume, business card, brochure, flyer or tearsheets to be kept on file for possible future assignments. Works with freelance photographers on assignment basis only. SASE. Reports in 1 month. Pays $25-75/b&w photo; $50-400/color photo. Pays on publication or receipt of invoice. Buys one-time rights. Model release required. Credit line given whenever possible.
Tips: "Send me a number of good, reasonably priced for one-time use photos of dogs, horses or farm scenes. Better yet, send me good quality dupes I can keep on file for rush use. When the dupes are in the file and I see them regularly, the ones I like stick in my mind and I find myself planning ways to use them. We are looking for original, dramatic work. We especially like to see horses, dogs, cats and cattle captured in artistic scenes or poses. All shots should show off quality animals with good conformation. We rarely use shots if people are shown and prefer animals in natural settings or in barns/stalls."

JOANNE RALSTON & ASSOCIATES, INC., 3003 N. Central, Phoenix AZ 85012. (602)264-2930. Vice President: Gail Dudley. PR firm. Clients: financial, real estate developers/homebuilders,

industrial, electronics, political, architectural and sports.

Needs: Works with 3-4 freelance photographers/month on assignment only basis. Provide flyer, rate sheets and business card to be kept on file for possible future assignments. Uses freelancers for consumer and trade magazines, newspapers and TV.

First Contact & Terms: Call for personal appointment to show portfolio. Prefers to see tearsheets, 8x10 or larger prints and most important b&w contact sheets of assignment samples in a portfolio. Freelancers selected according to needs, cost, quality and ability to meet deadlines. Negotiates payment based on client's budget, amount of creativity required from photographer, where the work will appear, complexity of assignment, and photographer's previous experience/reputation. "We try to work within ASMP rate structure where possible." Pays within 30 days of completed assignment.

Tips: "When interviewing a new photographer we like to see samples of work done on other assignments—including contact sheets of representative b&w assignments."

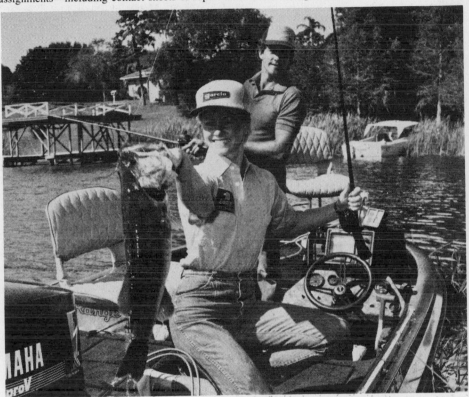

This photo was shot for a client by Walker Agency President Mike Walker. It was used in a newspaper publicity effort, on a magazine cover and in a multimedia show. "It was designed to show product name in a successful situation," explains Walker. Walker works with marine industry and outdoor recreation clients.

***WALKER AGENCY**, Suite 170, 2040 E. Bell, Phoenix AZ 85022. (602)992-5799. Ad agency, PR firm. President: Mike Walker. Clients: banking, marine industry and outdoor recreation products, e.g., Yamaha Outboards, Shimano Tackle. Client list free with SASE.

Needs: Works with 2 photographers/month. Uses photographers for consumer magazines, trade magazines, posters and newspapers. Subjects include outdoor recreation scenes: fishing, camping, etc. "We also publish a newspaper supplement 'Escape to the Outdoors' which goes to 11,000 papers."

Specs: Uses 8x10 glossy b&w print borders; 35mm, 2¼x2¼, 4x5 and 8x10 transparencies.

First Contact & Terms: Query with resume of credits; query with list of stock photo subjects; provide resume, business card, brochure, flyer or tearsheets to be kept on file for possible future assignments. Reports in 1 week. Pay rates vary with job. Pays on receipt of invoice. Buys all rights, or negotiates. Model releases required.

Tips: In portfolio/samples, prefers to see a completely propped scene. There is now more opportunity for photographers with the Ad/PR industry.

Arkansas

BEDELL INC., 521 N. 6th St., Box 1028, Fort Smith AR 72902. (501)782-8261. Ad agency. Production Manager: Jean Woods. Traffic Manager: Janie Lewis. Clients: industrial, finance, retail, services.
Needs: Works with 3 freelance photographers/month. Uses photographers for billboards, direct mail, catalogs, newspapers, consumer magazines, P-O-P displays, posters, AV presentations, trade magazines, brochures and signage. Also works with freelance filmmakers to produce training or inductory films.
Specs: Use "depends on each job and the needs for that job."
First Contact and Terms: Arrange a personal interview to show portfolio; provide resume, business card, brochure, flyer or tearsheets to be kept on file for possible future assignments. Works with freelance photographers on assignment basis only. Does not return unsolicited material. Reports in 2 weeks. Payment "depends on requirements of job." Pays on acceptance. Buys all rights. Model release required. Credit line given depending on job.

BLACKWOOD, MARTIN, AND ASSOCIATES, 31 East Center, Box 1968, Fayetteville AR 72702. (501)442-9803. Ad agency. Creative Director: Gary Weidner. Clients: food, financial, medical, insurance, some retail. Client list provided on request.
Needs: Works with 3 freelance photographers/month. Uses photographers for direct mail, catalogs, consumer magazines, P-O-P displays, trade magazines and brochures. Subject matter includes "food shots—fried foods, industrial."
Specs: Uses 8x10 high contrast b&w prints; 35mm, 4x5 and 8x10 transparencies.
First Contact & Terms: Arrange a personal interview to show portfolio; query with samples; provide resume, business card, brochure, flyer or tearsheets to be kept on file for possible future assignments. Works with freelance photographers on assignment basis only. Does not return unsolicited material. Reports in 1 month. Payment depends on budget—"whatever the market will bear." Buys all rights. Model release preferred.
Tips: Prefers to see "good, professional work, b&w and color" in a portfolio of samples. "Be willing to travel and willing to work within our budget. We are using less b&w photography because of newspaper reproduction in our area. We're using a lot of color for printing."

FRAZIER IRBY SNYDER, INC., 1901 Broadway, Box 6369, Little Rock AR 72216. (501)372-4350. Ad agency. Senior Vice President/Creative Director: Pat Snyder. Clients: industrial, fashion, finance, entertainment.
Needs: Works with 3 freelance photographers/month. Uses photographers for consumer and trade magazines, direct mail, P-O-P displays, brochures, catalogs, posters and newspapers. Also works with freelance filmmakers to produce TV commercials and training films. "We have our own inhouse production company named Ricky Recordo Productions with complete 16mm equipment."
Specs: Uses 8x10 b&w prints; 2¼x2¼ and 4x5 transparencies; 16mm film and videotape.
First Contact & Terms: Query with list of stock photo subjects; provide resume, business card, brochure, flyer or tearsheets to be kept on file for possible future assignments. Works with freelance photographers on assignment basis only. Does not return unsolicited material. Reports in 3 weeks. Pays $35-75/hour; $200-500/day. Pays on acceptance. Buys all rights. Model release required. Credit line "sometimes given, if requested."
Tips: "Prefers to see samples of best work. Have good work and creative input."

MANGAN RAINS GINNAVEN HOLCOMB, Suite 911, 320 West Capitol, Little Rock AR 72201. (501)376-0321. Contact: Steve Mangan. Ad agency. Uses all media. Clients: recreation, financial, consumer and real estate. Buys 300 photos annually. Works with 10 freelance photographers/month on assignment only basis. Provide flyer, business card and brochure to be kept on file for possible future assignments.
Specs: Uses 8x10 glossy b&w and color prints or transparencies; contact sheet OK. Also uses film. Uses b&w photos for newspaper and direct mail.
Payment/Terms: Pays per hour, day, job and per photo; $1,500/day, $100-500/b&w prints. Negotiates payment based on client's budget, amount of creativity required from photographer and where the work will appear. Buys all rights. Model release required.
Making Contact: Submit samples of work by mail or write for an appointment. Reports in 3 days. SASE.

 The asterisk before a listing indicates that the listing is new in this edition. New markets are often the most receptive to freelance contributions.

California

BAFETTI COMMUNICATIONS, Suite 304, 1333 Camino Del Rio S., San Diego CA 92108. (619)297-5390. Ad agency and PR firm. President: Ron Bafetti. Clients: industrial, finance, technical, consumer, electronics, personalities.
Needs: Works with 1-3 photographers/month. Uses photographers for billboards, consumer and trade magazines, direct mail, P-O-P displays, brochures, catalogs, posters, newspapers, AV presentations. Subject matter "varies widely."
Specs: Uses 8x10 b&w glossy, "some matte" prints, 35mm, 2¼x2¼, 4x5 and 8x10 transparencies. "Varies widely—we will direct photographer to what we need."
First Contact & Terms: Arrange a personal interview to show portfolio; query with samples; provide resume, business card, flyer or tearsheets to be kept on file for possible future assignments. Works with freelancers on assignment basis only. SASE. Reports in 2 weeks. Pays $30-75/hour; $200-300/day; $100-500 or more/job; "will negotiate fair price on project basis. Payment made to photographer when we are paid by client." Buys all rights, but allows the photographer to retain the negatives. Model release preferred; captions optional. Credit line given "whenever possible."
Tips: Prefers to see "evidence that the person *really* is a photographer. The market is flooded with *rank* amateurs. *Call me*, I love photography/photographers and *will* look at a portfolio if time permits. We also refer business to worthy freelancers. You might note that 'prima donnas' are not going to make any points in this business. We use *only* working photographers—people who can deliver what we need. We look for the photographer's ability to do a good start to finish job. We really enjoy working with those who have the ability to take initiative for creative lighting and can make a hum-drum project look 'socko.' Photographers must be able to work within our budget. Many of our clients have restricted ability to buy photography."

***BENNETT, ALEON, AND ASSOCIATES**, Suite 212, 13455 Ventura Blvd., Sherman Oaks CA 91423. (818)990-8070. President: Aleon Bennett. Clients: finance, industrial.
Needs: Works with varied number of freelance photographers/month. Uses photographers for trade magazines and newspapers.
Specs: Uses b&w prints.
First Contact & Terms: Query with resume of credits. Does not return unsolicited material. Pays per photo. Pays on acceptance. Buys all rights. Model release required; captions preferred.

RALPH BING ADVERTISING, 16109 Selva Dr., San Diego CA 92128. Production Manager: Ralph Bing. Ad agency. Serves industrial (specializing in ferrous and nonferrous metals, warehousing, stamping, and smelting); and consumer (automotive, political, building and real estate development, food and restaurant) clients. Commissions 1-2 freelance photographers/month on assignment only basis. Provide flyer to be kept on file for possible future assignments. Buys 50-60 photos/year. Pays $10-250/photo; $10-50/hour; $75-250/day; $10-250/project. Pays within 30 days of receipt of invoice and delivery of prints. Buys all rights. Model release required. Arrange personal interview to show portfolio; does not view unsolicited material.
B&W: Uses 5x7 prints.
Color: Uses 5x7 prints and 35mm transparencies.
Film: Occasionally produces film for AV presentations and TV commercials. Does not pay royalties.
Tips: "Portfolio should be conveniently sized to be presented on desk or, possibly, lap."

CORTANI BROWN RIGOLI, 2073 Landing Dr., Mountain View CA 94043. Ad agency. Creative Director: Clay Pamphilon. Clients: industrial.
Needs: Works with 1-4 photographers/month. Uses photographers for trade magazines, direct mail, posters, data sheets, annual reports, newsletters. Subjects include still life, special effects, people, locations.
Specs: Uses 35mm, 4x5 and 8x10 transparencies.
First Contact & Terms: Send unsolicited photos by mail for consideration; provide resume, business card, brochure, flyer or tearsheets to be kept on file for possible future assignments. Does not return unsolicited material. Pays/job. Pays on 30 days of invoice. Buys all rights. Model release preferred.

CUNDALL/WHITEHEAD/ADVERTISING INC., 3000 Bridgeway, Sausalito CA 94965. (415)332-3625. Partner: Alan Cundall. Ad agency. Uses all media except foreign. Serves general consumer and trade clients. Rights vary. Works with 1 freelance photographer/month on assignment only basis. Provide resume, business card and brochure to be kept on file for future assignments. Pays on a per-photo basis; negotiates payment based on client's budget, amount of creativity required and where work will appear. Send samples. "Don't send anything unless it's a brochure of your work or company. We keep a file of talent—we then contact photographers as jobs come up."

***DATELINE COMMUNICATIONS**, #300, 1255 Lincoln Blvd., Santa Monica CA 90401. (213)393-9494. PR firm and video production. President: Frank Widder. Clients: high tech, financial, military.
Needs: Works with 3-4 freelance photographers/year. Uses photographers for catalogs, news releases, production stills. Subjects include: product shots, application photos.
Specs: Uses 8x10 b&w prints and 35mm transparencies.
First Contact & Terms: Query with samples; provide resume, business card, brochure, flyer or tearsheets to be kept on file for possible future assignments. Works with freelance photographers on an assignment basis only. SASE. Reports in 2 weeks. Pays $75-600/job. Pays on receipt of invoice. Buys all rights. Model release preferred. Credit line given if requested.

***DELANEY ADVERTISING**, 321 N. Van Ness Ave., Fresno CA 93701. (209)485-2821. President: Pat Delaney. Clients: food, agriculture (manuf. processors), industrial and retail. Client list with SASE.
Needs: Works with 2 freelance photographers/month. Uses freelance photographers for billboards, consumer and trade magazines, direct mail, P-O-P displays, catalogs, posters, and newspapers. Subjects include: food, product photos, outdoor, architectural.
Specs: Uses custom size, glossy b&w and color prints; 2¼x2¼, 4x5 transparencies.
First Contact & Terms: Arrange a personal interview to show portfolio; query with list of stock photo subjects and samples; submit portfolio for review; provide resume, business card, brochure, flyer or tearsheets to be kept on file for possible future assignments. Works with freelance photographers on assignment basis only. Does not return unsolicited material. "Do not submit photos." Pay negotiated. Pays on receipt of invoice. Buys all rights. Model release preferred. Credit line "occasionally" given.
Tips: Send printed samples for file—need to know price range for client budgeting.

DIMENSIONAL DESIGN, 11046 McCormick, North Hollywood CA 91601. (213)877-5694. President: Wayne Hallowell. Ad agency. Clients: corporations, manufacturers, entertainment.
Needs: Works with 80-95 freelance photographers/year. Uses photographers for brochures, catalogs, posters, AV presentations, newsletters, annual reports. Subject matter covers "all areas." Also works with freelance filmmakers to produce movie titles and training films; "all types dependent on requirement or effects desired by projects."
Specs: Uses 8x10 b&w and color prints; 35mm, 4x5 and 8x10 transparencies.
First Contact & Terms: Arrange a personal interview to show portfolio or submit portfolio for review; provide resume, business card and samples to be kept on file for possible future assignments. SASE. Reports in 2 weeks. Pays ASMP rates per hour or job; approximately $250/color photo, $75/b&w photo. AV presentations $25-50/slide. Buys all rights or one-time rights. Model release and captions preferred. Credit line sometimes given.
Tips: "Know our needs, be professional and understand the message of our client."

DIMON & ASSOCIATES, Box 6489, Burbank CA 91510. (818)845-3748. Ad agency. Creative Director: Jerry Michaud. Clients: healthcare, industrial, finance, insurance, people.
return unsolicited material. Pays $400-800/day. Pays on receipt of invoice. Buys all rights. Model release required. Credit line sometimes given.
Specs: Uses 2¼x2¼, 4x5 transparencies.
First Contact & Terms: Query with samples; provide resume, business card, brochure, flyer or tearsheets to be kept on file for possible future assignments. Works with local freelancers only. Does not return unsolicited material. Pays $400-800/day. Pays on receipt of invoice. Buys all rights. Model release required. Credit line sometimes given.

ESTEY-HOOVER, INC., Suite 225, 3300 Irvine Ave., Newport Beach CA 92660. (714)756-8501. Creative Director: Art Silver. Ad agency. Clients: real estate, consumer, financial, industrial firms.
Needs: Works with freelance photographers on assignment only basis. Uses freelancers for brochures, catalogs, posters, newspapers, AV presentations and annual reports.
First Contact & Terms: Local freelancers *only*. Query with samples; follow up with call for appointment. Payment is by the project; negotiates according to client's budget.

THE FILM GROUP COMPANY, (formerly The Pomeroy Company), 813 N. Cordova St., Burbank CA 91505. President/Creative Director: Chip Miller. Ad agency. Clients: entertainment, motion picture, TV, music.
Needs: Works with 3 freelance photographers/month. Provide business card, resume, references, samples or tearsheets to be kept on file for possible future assignments. Uses freelancers for trade magazines, displays, TV, brochures/flyers, posters and one sheets.
First Contact & Terms: Call for appointment to show portfolio. Negotiates payment based on client's budget.

Tips: Wants to see minimum of 12 pieces expressing range of tabletop, studio, location, style and model-oriented work. Include samples of work published or planned.

***FRANSON & ASSOCIATES, INC.**, 2674 N. 1st St., San Jose CA 95134. (408)946-1400. PR firm. Production Manager: Hollie Straub. Clients: high technology.
Needs: Works with 2-4 freelance photographers/month. Uses freelance photographers for trade magazines, newspapers, press photos. Subjects include: application photography.
Specs: Uses 5x7, 8x10 glossy b&w prints; 35mm, 2¼x2¼, 4x5 transparencies.
First Contact & Terms: Query with resume of credits; send unsolicited photos by mail for consideration; query with samples; provide resume, business card, brochure, flyer or tearsheets to be kept on file for possible future assignments. Works with freelance photographers on assignment basis only. Does not return unsolicited material. Reports in 3 weeks. Pay negotiated. Pays within 30 days. Buys all rights. Model release required. Credit line given "when possible."
Tips: Prefers to see people, product, application. Out of area freelancers are needed when an assignment comes up out of town.

BERNARD HODES ADVERTISING, 16027 Ventura Blvd., Encino CA 91436. (818)501-4613. Ad agency. Production Manager: Barbara Larson. Produces "recruitment advertising for all types of clients."
Needs: Works with 1 freelance photographer/month. Uses photographers for billboards, trade magazines, direct mail, P-O-P displays, brochures, catalogs, posters, newspapers, AV presentations, and internal promotion. Also works with freelance filmmakers to produce TV commercials, training films (mostly stills).
Specs: "Entirely depends on end product. As with all printing, the size, printing method and media determine camera and film. Have used primarily 35mm, 2¼, 4x5; both b&w and color."
First Contact & Terms: Query with samples "to be followed by personal interview if interested." Does not return unsolicited material. Reporting time "depends upon jobs in house. I try to arrange appointments within 3 weeks-1 month." Payment "depends upon established budget and subject." Pays on acceptance for assignments; on publication per photo. Buys all rights. Model release required.
Tips: Prefers to see "samples from a wide variety of subjects. No fashion. People-oriented location shots. Nonproduct. Photos of people and/or objects telling a story—a message. Eye-catching." Photographers should have "flexible day and ½ day rates. Must work fast. Ability to get a full day's (or ½) work from a model or models. Excellent sense of lighting. Awareness of the photographic problems with newspaper reproduction."

DEKE HOULGATE ENTERPRISES, Box 7000-371, Redondo Beach CA 90277. (213)540-5001. PR firm. Contact: Deke Houlgate. Clients: industrial, automotive, sports. Client list free with SASE.
Needs: Works with 1-3 freelance photographers/month. Uses photographers for consumer and trade magazines, direct mail, brochures, posters, newspapers, and AV presentations. Works with freelance filmmakers to produce videotape/film newsclips for news and sports TV feature coverage. Occasionally works with producers of barter and free TV 30-60 minute features.
Specs: Uses 8x10 b&w ("mostly") glossy prints; 35mm and 2¼x2¼ color transparencies, 16mm and ¾" (news) and 1" or 2" (feature) videotape.
First Contact & Terms: Query with list of stock photo subjects. SASE. Reporting time "depends on situation—as soon as client concurs, but early enough not to inconvenience photographer." Pay "variable but conforming to standard the photographer states. We don't ordinarily haggle, but we buy only what the client can afford." Payment by client, "immediately." Buys all rights. Model release and captions required. Credit line "usually not given, but not a hard and fast rule."
Tips: Prefers to see "photographer's grasp of story-telling with a photo; ability to take direction; ideas he/she can illustrate; understanding of the needs of editors. Take an outstanding photograph and submit, relating to one of our clients. If it's a good buy, we buy. If we buy, we strongly consider making assignments for otherwise unknown freelancers. Our company would rather service a photograph than a story, depending on quality. We'd rather pass on a photo than service a mediocre one. With cost-price squeeze, more PR firms will adopt this attitude."

IC COMMUNICATIONS, INC., Suite 6A, 318 W. Katella, Orange CA 92667-4755. (714)639-5558. President: Jerry Pangloum. Vice President, Production: Don Ranson. Clients: industrial, commercial, design. Uses photographers for multimedia productions.
Needs: Subjects include people and product; "move fast and shoot quantity with quality."
Specs: Uses 35mm transparencies.
First Contact & Terms: Arrange a personal interview to show portfolio; provide resume, business card, self-promotion piece or tearsheets to be kept on file for possible future assignments. Works with freelancers by assignment only. Reports in 1 month. Pay individually negotiated. Pays by arrangement. Buys all rights.

IMAHARA & KEEP ADVERTISING & PUBLIC RELATIONS, 1263 Oakmead Parkway, Sunnyvale CA 94086. (408)735-7600. Ad agency. Creative Director: Peter Keep. Clients: industrial/high tech.
Needs: Works with 3 freelance photographers/month. Uses photographers for trade magazines, direct mail, brochures, catalogs, posters, and newspapers. Subject matter "industrial and high tech." Rarely works with freelance filmmakers.
Specs: Uses 11x14 or 16x20 b&w or color repro grade prints; 2¼x2¼ or 4x5 transparencies.
First Contact & Terms: Arrange a personal interview to show portfolio; query with samples. Works with local freelancers only. Reports in 2 weeks. Pays $750-1,500/day. Pays on publication. Buys all rights. Model release required.

***THE JONES AGENCY**, 303 N. Indian Ave., Palm Springs CA 92262. (619)325-1437. Ad agency. Art Director: John B. Thompson. Clients: retail, fashion, finance, hotels.
Needs: Works with 3-5 freelance photographers/month. Uses freelance photographers for consumer magazines, posters, newspapers, hotel brochures, interior design ads. Subjects include product, hotels, PR, interior design.
Specs: Uses 8x10 glossy b&w prints; 35mm, 2¼x2¼, 4x5, 8x10 transparencies.
First Contact & Terms: Arrange a personal interview to show portfolio; provide resume, business card, brochure, flyer or tearsheets to be kept on file for possible future assignments. Works with freelance photographers on assignment basis only. SASE. Reports in 2 weeks. Pay negotiated. Pays on receipt of invoice. Buys all rights. Model release required. Credit line "depends on job."
Tips: Prefers to see professional capabilities.

LOTT ADVERTISING AGENCY, Box 710, Santa Monica CA 90400. (213)397-4217. Ad agency. President: Davis Lott. Clients: industrial.
Needs: Works with "perhaps 1 freelance photographer every 3 months." Uses photographers for trade magazines, direct mail, brochures, catalogs and newspapers. Subjects include: trade items and products.
Specs: Uses 4x5 glossy b&w prints.
First Contact & Terms: Provide resume, business card, brochure, flyer or tearsheets to be kept on file for possible future assignments. Works with local freelancers only. Does not return unsolicited material—"don't send any." Reports in 1 month. Pays/photo. Pays on publication. Model release and captions required. Credit line given.

***MCKENZIE, KING & GORDON**, 1800 N. Argyle Ave., Hollywood CA 90028. (213)466-3421. Ad agency. President: Marie McKenzie. Clients: industrial, retail, brokers, film.
Needs: Uses freelance photographers for consumer and trade magazines, direct mail, catalogs and newspapers. Subjects depends—"some have been pictures of people for magazine covers, others for collateral material."
Specs: Uses b&w and color prints; 35mm, 2¼x2¼, 4x5, 8x10 transparencies.
First Contact & Terms: Arrange a personal interview to show portfolio; provide resume, business card, brochure, flyer or tearsheets to be kept on file for possible future assignments. Works with freelance photographers on assignment basis only. Does not return unsolicited material. "Will return upon request." Pay negotiated. Pays "usually 10 days from receipt of invoice—no later than 30 days." Buys all rights; "we request negatives on completion of job." Model release required; captions preferred. Credit lines given "if client approves."
Tips: Prefers to see a variety—people, industrial, product, landscape, some fashion. "Bring in portfolio and leave some samples which best describe your capabilities."

***MCMULLEN DESIGN & MARKETING**, 15305 Normandie Ave., Gardena CA 90247. (213)515-1701. Creative Director: Christopher R. Hawley.
Needs: Uses freelance photographers for consumer and trade magazines, P-O-P displays, catalogs, and posters.
Specs: Uses 8x10 matte b&w prints; 35mm, 2¼x2¼, 4x5 transparencies.
First Contact & Terms: Arrange a personal interview to show portfolio; query with resume of credits; provide resume, business card, brochure, flyer or tearsheets to be kept on file for possible future assignments. Works with local freelancers only. Does not return unsolicited material. Reports 1 month. Pays $750-1,500/day or pays by the job. Pays 30 days from receipt of invoice. Buys all rights. Model release required.
Tips: Prefers to see industrial, automotive, sports. "Show good quality technical work, be a problem solver, no prima-donna's."

MEALER & EMERSON, 3186-C Airway Ave., Costa Mesa CA 92626. (714)957-1314 or (213)693-0968. Contact: Will Johnson. Clients: Variety. Client list free with SASE.

Needs: Works with 8-10 freelance photographers/month. Uses photographers for billboards, consumer and trade magazines, direct mail, P-O-P displays, catalogs, posters and newspapers.
Specs: Uses b&w and color prints, and 35mm, 2¼x2¼, 4x5 and 8x10 transparencies.
First Contact & Terms: Arrange a personal interview to show portfolio; submit portfolio for review; provide resume, business card, brochure, flyer or tearsheets to be kept on file for possible future assignments. Works with freelance photographers on an assignment basis only. Does not return unsolicited material. Pays $800-2,000/day and by job. Pays on receipt on invoice. Buys all rights. Model release required.

***JO ANN MILLER, LTD.**, 342 N. Rodeo Dr., Beverly Hills CA 90210. (213)271-3000. Ad agency, PR firm, marketing. President: Jo Ann Miller. Clients: fashion, beauty, health, fitness, service industries. Client list with SASE.
Needs: Works with 3 freelance photographers/month. Uses photographers for billboards, consumer and trade magazines, direct mail, P-O-P displays, catalogs, posters, signage, newspapers, "depending on clients needs."
Specs: Various specifications depending on clients needs.
First Contact & Terms: Query with samples; submit portfolio for review; provide resume, business card, brochure, flyer or tearsheets to be kept on file for possible future assignments. Works with freelance photographers on assignment basis only. Reports in 1 month. "Each client has a pre-determined budget for his job." Pays on acceptance. Rights determined before job. Model release required. Credit line sometimes given.
Tips: Prefers to see creativity and excellence in the beauty, fashion, health, fitness and service industries. Send samples of work.

***NORTON-WOOD PR SERVICES**, 1430 Tropical Ave., Pasadena CA 91107. (818)351-9216. PR firm. Partner-owner: Nat Wood. Clients: industrial.
Needs: Works with 1 freelance photographer/month. Uses freelance photographers for trade magazines, catalogs and brochures.
Specs: Uses 8x10 glossy prints; 35mm, 4x5 transparencies.
First Contact & Terms: Query with resume of credits, query with list of stock photo subjects. Works with local freelancers only. Reports in 2 weeks. Pays $50/hour; $500-750/day; $10/b&w photo. Pays on receipt of invoice. Buys all rights. Captions required. Credit line sometimes given.
Tips: Prefers to see industrial products, in-plant shots, personnel, machinery in use. Be available for western states assignments primarily. Use other than 35mm equipment.

***THE PHILLIPS GROUP**, Suite 500, 280 S. Beverly Dr., Beverly Hills CA 90212. (213)278-3801. Partner: Ron Rieder. Clients: industrial, finance.
Needs: Works with 2-3 freelance photographers/month. Uses photographers for consumer and trade magazines, newspapers, publicity. Subjects include publicity of people, products, events, etc.
Specs: Uses 5x7, 8x10 glossy b&w and color prints.
First Contact & Terms: Arrange a personal interview to show portfolio, query with resume of credits; provide resume, business card, brochure, flyer or tearsheets to be kept on file for possible future assignments. Works with freelance photographers on an assignment basis only. SASE. Reports in 1 week. Pay depends on job, client, etc. Pays within "30 days." Buys all rights. Model release required; captions preferred.

PRAXIS CREATIVE PUBLIC RELATIONS, 1105 Rossmoor Tower, #1, Laguna Hills CA 92653. (714)855-6846. Contact: Pearce Davies. PR firm. Clients: realty (hold broker's license), travel agency, retail shopping, construction, etc. "Some are nonprofit. In general, any individual or firm with a public relations problem."
Needs: Works with freelance photographers on assignment only basis. Provide business card and brochures to be kept on file for possible future assignments. Uses freelancers for trade magazines, direct mail, newspapers and TV.
First Contact & Terms: Send resume. "We find advertisements or business cards which detail specialties helpful. If assignment is out-of-town (many are), we try to engage nearby photographers (we have lists). For aerial, underwater or theatrical shots, we know specialists in these fields. In other words, we call on whom we consider the best people for the specific job." Negotiates payment based on client's budget and amount of creativity required from photographer.

PAUL PURDOM & CO., 1845 Magnolia Ave., Burlingame CA 94010. (415)692-8770. President: Paul Purdom. PR firm. Handles clients in finance, industry, architecture, high-tech. Photos used in brochures, newsletters, annual reports, PR releases, AV presentations, sales literature, consumer and trade magazines. Client list available. Provide business card, brochure and samples to be kept on file for

possible future assignments. Buys 500 photos/year. Works with 100-200 freelance photographers/year. Negotiates payment based on client's budget, amount of creativity required from photographer, and photographer's previous experience/reputation. Pays $50-150/hour; $50 minimum/job; and $100-1,200/day. Buys all rights. Model release preferred. Arrange a personal interview to show portfolio or send material by mail for consideration. SASE. Reports in 3 weeks. "Most interested in technical material."
B&W: Uses 8x10 glossy prints; contact sheet and negatives OK.
Color: Uses transparencies.
Film: 16mm television newsfilms; videotape.
Tips: Prefers to see "high technology shots—like computer rooms—done in a creative, clear manner showing a degree of intelligence that goes beyond holding and pointing a camera."

THE RUSS REID CO., 6th Floor, 2 N. Lake Ave., Pasadena CA 91101. (818)449-6100. Art Director: Daniel Billefort. Ad agency. Clients: religious and cause-related organizations; client list provided upon request.
Needs: Works with "very few" freelance photographers on assignment only basis. Uses photographers for trade magazines, direct mail, brochures, posters and newspapers.
First Contact & Terms: Local photographers only. Arrange interview to show portfolio. Negotiates payment according to client's budget; "whether by the hour, project or day depends on job."

ROGERS & COWAN, INC., Suite 400, 10,000 Santa Monica Blvd., Los Angeles CA 90067. (213)201-8800. Contact: Account Executive. PR firm. Clients: entertainment.
Needs: Works with qualified freelance photographers on assignment only basis. Uses photographers for billboards, consumer and trade magazines, direct mail, posters, newspapers, AV presentations, news releases.
First Contact & Terms: Local freelancers only. Phone for appointment. Payment "depends on the job."

SARVER & WITZERMAN ADVERTISING, 3289 Industry, Long Beach CA 90806. (213)597-8040. Ad agency. President: Joe Witzerman. Clients: industrial and financial. Client list free with SASE.
Needs: Works with 3 freelance photographers/month. Uses photographers for billboards, consumer and trade magazines, direct mail, P-O-P displays, brochures, catalogs, posters, and newspapers. Subject needs: "from food to trucks." Works with freelance filmmakers to produce TV commercials.
Specs: Uses 8x10 to 16x20 b&w glossy prints; 35mm and 4x5 transparencies; 16mm film and videotape.
First Contact & Terms: Arrange a personal interview to show portfolio; send unsolicited material by mail for consideration. Works with freelance photographers on assignment basis only. SASE. Reports in 2 weeks. Pays $500-1,000/day. Pays on completion. Buys all rights. Model release required. Credit line given "when requested."

SAWYER CAMERA & INSTRUMENT CO., 1208 Isabel St., Burbank CA 91506. (818)843-1781. Clients: ad agencies, video producers, movie studios.
Needs: Works with 20-25 photographers/month. Uses photographers for multimedia productions, videotapes. Subjects include commercials, educational material and movies.
Specs: Uses VHS, Beta, U-matic ¾" videotape.
First Contact & Terms: Provide resume, business card, self-promotion piece or tearsheets to be kept on file for possible future assignments. Works with freelancers by assignment only. SASE. Reports in 2 weeks. Pays/job. Pays on acceptance. Buys all rights. Captions preferred. Credit lines given.

J. STOKES & ASSOCIATES, Suite 450, 1850 Mt. Diablo Blvd., Walnut Creek CA 94596. (415)933-1624. Contact: Creative Director. Ad agency. Clients: industrial, financial, agricultural and some consumer firms; client list provided upon request.
Needs: Works with 6 freelance photographers/year on assignment only basis. Uses photographers for trade magazines, direct mail, P-O-P displays, brochures, catalogs, posters, signage, newspapers and AV presentations.
First Contact & Terms: Local freelancers only. Arrange interview to show portfolio. Payment is by the project or by the hour; negotiates according to client's budget.

RON TANSKY ADVERTISING CO., Suite 111, 14852 Ventura Blvd., Sherman Oaks CA 91403. (818)990-9370. Ad agency and PR firm. Art Director: Mrs. Shawn Kelly. Serves all types of clients.
Needs: Works with 2 freelance photographers/month. Uses photographers for billboards, consumer and trade magazines, direct mail, P-O-P displays, brochures, catalogs, signage, newspapers and AV presentations. Subjects include "mostly product—but some without product as well." Works with

freelance filmmakers to produce TV commercials.
Specs: Uses b&w or color prints; 2¼x2¼ and 4x5 transparencies; 16mm and videotape film.
First Contact & Terms: Query with resume of credits; provide resume, business card, brochure, flyer or tearsheets to be kept on file for possible future assignments. SASE. Payment "depends on subject and client's budget." Pays in 30 days. Buys all rights. Model release required.
Tips: Prefers to see "product photos, originality of position and lighting" in a portfolio. Photographers should provide "rate structure and ideas of how they would handle product shots."

***TRAVELODGE INTERNATIONAL, INC.**, 1973 Friendship Dr., El Cajon CA 92090. (619)448-1884. Ad agency, corporate headquarters. Art Director: Tom Okerlund. Clients: hotel and motel. Client list with SASE.
Needs: Works with 1-4 freelance photographers/month. Uses freelance photographers for consumer and trade magazines, P-O-P displays, catalogs, posters, newspapers. Subjects include models, exteriors, interiors of hotels.
Specs: "All sizes for print purposes."
First Contact & Terms: Arrange a personal interview to show portfolio; send unsolicited photos by mail for consideration; provide resume, business card, brochure, flyer or tearsheets to be kept on file for possible future assignments. Works with freelance photographers on assignment basis only. SASE. Reports in 1 week. Pays/job. Pays on receipt of invoice, "within 10 days." Buys all rights. Model release required. Credit line given if desired.
Tips: Prefers to see composition, lighting and special effects.

ZHIVAGO ADVERTISING, 417 Tasso St., Palo Alto CA 94301. (415)328-7830. Ad agency and PR firm. Partner: Kristin Zhivago. Serves industrial and high-tech clients.
Needs: Uses photographers for consumer and trade magazines, direct mail, P-O-P displays, brochures, catalogs, posters, newspapers, AV presentations. Subjects include "electronic products; people using electronic products."
Specs: Uses 8x10 b&w or color glossy prints; 4x5 transparencies.
First Contact & Terms: Arrange a personal interview to show portfolio. Query with samples. Works with local freelance photographers on assignment basis only. Does not return unsolicited material. Pays $50-250/hour; $350-2,500/day. Pays in 30 days. Buys one-time rights. Model release preferred. Credit line rarely given.
Tips: Prefers to see "equipment shots; business-like people scenes" in a portfolio. "First show portfolio, then keep checking back by phone on a regular basis."

Los Angeles

BBDO/WEST, 10960 Wilshire Blvd., Los Angeles CA 90024. (213)479-3979. Contact: Creative Secretary. Ad agency. Uses billboards, consumer magazines, newspapers, P-O-P displays, radio, TV and trade magazines. Serves package goods, computer, automotive, newspaper, stereo components, restaurant, shipping, grocery, bank, real estate, food, beverage and religious clients. Deals with photographers in all areas. Provide brochure or flyer to be kept on file for possible future assignments.
Payment & Terms: Negotiable.
Making Contact: Drop off portfolio for review.
Specs: Uses b&w photos, color transparencies and film.

BEAR ADVERTISING, 1424 N. Highland, Los Angeles CA 90028. (213)466-6464. Vice President: Bruce Bear. Ad agency. Uses consumer magazines, direct mail, foreign media, P-O-P displays and trade magazines. Serves sporting goods, fast foods and industrial clients. Works with 4 freelance photographers/month on assignment only basis. Provide business card and tearsheets to be kept on file for possible future assignments.
Payment & Terms: Pays $150-250/b&w photo; $200-350/color photo. Pays 30 days after billing to client. Buys all rights.
Making Contact: Call to arrange interview to show portfolio. Prefers to see samples of sporting goods, fishing equipment, outdoor scenes, product shots with rustic atmosphere of guns, rifles, fishing reels, lures, camping equipment, etc. SASE. Reports in 1 week.
Specs: Uses b&w and color photos.

CHIAT/DAY, 517 S. Olive St., Los Angeles CA 90013. (213)622-7454. President/Creative Art Director: Lee Clow. Advertising agency. Uses billboards, consumer magazines, direct mail, newspapers, P-O-P displays, radio, TV and trade magazines. Serves audio/video equipment,

motorcycle, automotive, home loan, personal computer, and sportswear clients. Deals with 6 photographers/year.
Payment & Terms: Negotiable.
Making Contact: Send samples, then call to arrange interview to show portfolio.
Specs: Uses b&w and color photos.

COLE & WEBER, (formerly Rogers, Weiss/Cole & Weber), Suite 902, 2029 Century Park E., Los Angeles CA 90067. (213)879-7979. Art Directors: Hugh Callahan, Jim Miller, Mike Rose. Ad agency. Clients: consumer.
Needs: Uses 2-3 freelance photographers/month. Uses freelancers for billboards, P-O-P displays, consumer and trade magazines, stationery design, direct mail, TV, brochures/flyers and newspapers.
First Contact & Terms: Call for personal appointment to show portfolio. Negotiates payment based on client's budget.
Tips: "We would like to see something good that shows the freelancer's style. B&w, color transparencies and 8x10 negatives OK."

EVANS/WEINBERG ADVERTISING, 5757 Wilshire Blvd., Los Angeles CA 90036. (213)653-2300. Art Director: Dorothy Allard. Ad agency. Client list provided upon request.
Needs: Uses photographers for billboards, consumer and trade magazines, direct mail, P-O-P displays, brochures, catalogs, posters, signage, newspapers and AV presentations.
First Contact & Terms: Local freelancers only. Arrange interview to show portfolio. Payment varies according to job.

GUMPERTZ, BENTLEY, FRIED, 5900 Wilshire Blvd., Los Angeles CA 90036. (213)931-6301. Art Director: Susan Ichiyama. Executive Art Director: Steve Hollingsworth. Creative Director: Bob Porter. Ad agency. Uses billboards, consumer and trade magazines, newspapers, P-O-P displays, radio and TV, bank, visitors bureau, beer, health care, laundry products, beverages and food clients. Deals with 6-10 photographers/year.
Payment & Terms: Negotiable.
Making Contact: Call to arrange interview to show portfolio.
Specs: Uses b&w and color photos. Will consider director reels (see Penny Webber, Producer).

HCM, 3333 Wilshire Blvd., Los Angeles CA 90010. (213)386-8600. Vice President/Art Services Manager: Joseph Apablaza. Ad agency. Serves clients in air freight, research, manufacturing and food, car stereo equipment, banking.
Needs: Works with 2 freelance photographers/month. Uses photographers for collateral material and consumer and trade magazines.
First Contact & Terms: Call for appointment to show portfolio. Selection based on portfolio review. Negotiates payment based on client's budget and where work will appear.
Tips: No fashion or cars.

NW AYER, INC., 888 S. Figueroa St., Los Angeles CA 90017. (213)486-7400. Executive Art Director: Bob Bowen. Senior Art Director: Lionel Banks. Ad agency.
Needs: Works with freelance photographers on assignment only basis. Uses photographers for billboards, consumer magazines, direct mail, brochures, flyers, newspapers, P-O-P displays, TV, trade magazines and AV.
First Contact & Terms: Call for personal appointment to show portfolio. Pays 30 days after receipt of approved invoice in N.Y. office.
Tips: Wants to see "quality not quantity."

STERN-WALTERS/EARLE LUDGIN, 9911 W. Pico Blvd., Los Angeles CA 90035. (213)277-7550. Art Director: Greg Clarke. Ad agency. Serves clients in a variety of industries.
First Contact & Terms: Call or write and request personal interview to show portfolio and/or resume. "Pays whatever is the going rate for a particular job."
Tips: "No more than 25-30 examples—after that it's boring. Send along anything of quality that shows what you can do."

San Francisco

CHIAT/DAY, 77 Maiden Ln., San Francisco CA 94108. (415)445-3000. Contact: Art Director. Ad agency. Clients: packaged goods, consumer goods, computers, foods, corporate.

Needs: Works with freelance photographers on assignment only basis. Uses photographers for billboards, consumer and trade magazines, brochures, posters and newspapers.
First Contact & Terms: Phone one of the art directors to set up appointment for a showing with all art directors—"as many as are able will attend showing." Payment negotiated on client's budget and how soon the work is needed.

***FISCHER ASSOCIATES/FKQ, INC.**, 55 Francisco St., San Francisco CA 94133. (415)391-2694. Ad agency. Director-Radio & TV Production, Director-Print Production: Bob Zygarlicki. Clients: industrial, retail, commodities, fashion active-wear. Client list provided on request with SASE.
Needs: Works with 3-4 freelance photographers/month. Uses freelance photographers for trade magazines, direct mail, P-O-P displays, newspapers. Subjects include high-tech configurations, commodities, fashion, active-wear clothing.
Specs: Uses b&w prints; $2^{1}/_{4}$x$2^{1}/_{4}$, 4x5 transparencies.
First Contact & Terms: Arrange a personal interview to show portfolio. Works with freelance photographers on an assignment basis only. SASE. Reports in 1 month or "as specific applicable projects become real." Pays $500-1,500/day; $500-1,000/job. Pays on receipt of invoice "within an agreed upon time format." Rights varies with usage need of clients and budget. Model release required.
Tips: Prefers to see full campaign and production understanding of photographer's sampled work.

HOEFER-AMIDEI ASSOCIATES, PUBLIC RELATIONS, 426 Pacific Ave., San Francisco CA 94133. (415)788-1333. Director of Creative Services: Marc Reed. PR firm. Photos used in publicity, brochures, etc. Works with 1-7 freelance photographers/month on assignment basis only. Provide business card, flyer and brochure of sample work to be kept on file for possible future assignments. Pays $100 minimum/job; negotiates payment based on client's budget, amount of creativity required from photographer and photographer's previous experience/reputation. Call to arrange an appointment. Does not return unsolicited material.
Tips: "Keep in touch *by phone* every month."

KETCHUM ADVERTISING, INC., 55 Union St., San Francisco CA 94111. (415)781-9480. Vice President, Associate Creative Director: Dave Sanchez. Ad agency.
Needs: Occasionally works with freelance photographers for consumer and trade print ads. Also works on TV.
First Contact & Terms: Call for appointment to show portfolio. Negotiates payment based on client's budget, amount of creativity required and where work will appear.
Tips: Wants to see whatever illustrates freelancer's style. Include transparencies or prints. "Limited opportunity to review portfolios."

PINNE GARVIN HERBERS & HOCK, INC., 200 Vallejo St., San Francisco CA 94111. (415)956-4210. Creative Director: Robert Pinne. Art Directors: Pierre Jacot, Victor Elsey, Linda Clark, Marsha Sessa, Floyd Yost. Ad agency. Uses all media including radio and TV. Serves clients in electronics, finance, banking, software and hardware and transportation. Buys all rights. Call to arrange an appointment or submit portfolio by mail if out of town. Reports in 5 days. SASE.
Color: Uses transparencies and prints; contact sheet OK. "Do not send originals unsolicited." Model release required.
Tips: "Out of town talent should not send original material unless requested." Photographers should "be realistic as to whether his/her style would be applicable to our client list. If so, call for an appointment. It's a waste of both our time for me to say, 'that's beautiful work, but we can't use that type.'"

***SOLEM/LOEB & ASSOCIATES**, 5th Floor, 545 Mission St., San Francisco CA 94105. Ad agency, PR firm. Art Director: Pam Levinson. Clients: political, retail, fashion, industrial, public service, insurance, law, public utility, communications, development, medical and publishing.
Needs: Works with 2-3 photographers/month. Uses photographers for billboards, consumer magazines, trade magazines, direct mail, P-O-P displays, catalogs, posters, newspapers and slide shows. Subjects include: people and table-top shots in studio situations.
Specs: Uses various size b&w, color prints; 35mm, $2^{1}/_{4}$x$2^{1}/_{4}$, 4x5 and 8x10 transparencies. Arrange a personal interview to show portfolio; query with list of stock photo subjects; provide business card, brochure, flyer or tearsheets to be kept on file for possible future assignments. Works with freelance photographers on an assignment basis only. Does not return unsolicited material. Pay rates based on budget, job and expertise. Pays on receipt of invoice. Buys all rights; one-time rights; negotiates rights also. Models release required. Credit line seldom given.
Tips: "Be negotiable, quick and good, come in when we need someone."

***EDGAR S. SPIZEL ADVERTISING AND PUBLIC RELATIONS**, 1782 Pacific Ave., San Francisco CA 94109. (415)474-5735. Ad agency and PR firm. President: Edgar S. Spizel. Clients: retail, finance, hotels, developers.
Needs: Works with 2 freelance photographers/month. Uses photographers for consumer and trade magazines, direct mail, P-O-P displays, posters, signage, newspapers. Subjects include people, buildings, hotels, apartments, interiors.
Specs: Uses 8x10 glossy b&w and color prints, 35mm, 2¼x2¼, and 4x5 transparencies.
First Contact & Terms: Send unsolicited photos by mail for consideration; provide resume, business card, brochure, flyer or tearsheets to be kept on file for possible future assignments. Works with freelance photographers on an assignment basis only. Does not return unsolicited material. Pays by the hour, day, or job. Pays on acceptance. Buys all rights. Model release required. Credit line sometimes given.

UNDERCOVER GRAPHICS, Suite A, 1169 Howard St., San Francisco CA 94103. (415)626-0500. Creative Director: L.A. Paul. Ad agency. Uses billboards, consumer and trade magazines, P-O-P displays, radio and TV. Serves clients in entertainment (film, TV, radio and music), publishing and recreation. Buys 20-30 photos/year. Local freelancers preferred. Provide brochure, flyer and tearsheets to be kept on file for possible future assignments. Pays $100-1,500/job or on a per-photo basis. Pays on acceptance. Rights purchased vary with job. Model release required. Query with resume of credits; will view unsolicited material. SASE. Reports in 1 month. Does not pay royalties.
B&W: Uses 8x10 prints; contact sheet OK. Pays $25-500/photo.
Color: Uses 8x10 prints, 35mm and 4x5 transparencies; contact sheet OK. Pays $25-500/photo.
Film: Produces 16mm TV commercials and documentaries. Also produces ½" and ¾" video and film-to-video and video-to-film transfers. Assignments include creative consultation and/or technical production.
Tips: "The stylistic and technical trends that we are seeing are bold colors; hazy pastels; sharp, slashing images and severe juxtapositions of subject matter."

Colorado

BULLOCH & HAGGARD ADVERTISING INC., 226 E. Monument, Colorado Springs CO 80903. (303)635-7576. Ad agency. Art Director: Linda Blough. Clients: industrial, real estate, finance, high-tech.
Needs: Works with 2 freelance photographers/month. Uses photographers for consumer and trade magazines, direct mail, brochures, catalogs, newspapers, and AV presentations. Subjects include studio setups, location, some stock material. Also works with freelance filmmakers to produce commercials.
Specs: Uses b&w prints; 35mm, 2¼x2¼, 4x5 and 8x10 transparencies; 16mm and 35mm film and videotape.
First Contact & Terms: Arrange a personal interview to show portfolio; query with list of stock photo subjects. Provide resume, business card, brochure, flyer or tearsheets to be kept on file for possible future assignments. Works with freelance photographers on assignment basis only. Does not return unsolicited material. Reports in 2 weeks. Pays $35-50/hour; $350-500/day. Pays 30 days after billing. Buys all rights or one-time rights. Model release required. Credit line "not usually given."
Tips: Prefers to see "professional (commercial only) work" in a portfolio. "We have little need for portraits and/or photojournalism. Photographers should be able to complete an assignment with minimal supervision. Our photographers solve problems for us. They need to understand deadlines and budgets, and should be able to take an assignment and add their creative input."

EVANS & BARTHOLOMEW, INC., 2128 15th St., Denver CO 80202. (303)534-2343. Creative Director: Betty Londergan. Ad agency. Annual billing: over $10,000,000. Clients: consumer, food, health care, public service, institutions and financial.
Needs: Works with 6 freelance photographers/month. Uses photographers for consumer and trade magazines, brochures/flyers, production companies and newspapers.
First Contact & Terms: Call for appointment to show portfolio. Negotiates payment based on client's budget and where work will appear.

FOX, SWEENEY & TRUE, 707 Sherman, Denver CO 80203. (303)837-0510. Creative Director: Fran Scannell. Art Director: Mary Ellen Hester. Ad agency. Serves clients in industry, finance and food.
Needs: Works with 2-3 freelance photographers/month. Uses photographers for P-O-P displays, consumer and trade magazines, brochures/flyers and newspapers. Provide business card, brochure and flyer to be kept on file for possible future assignments.

First Contact & Terms: Call for appointment to show portfolio. Negotiates payment based on nature of job. Pays in 30 days.
Tips: Prefers to see samples of best work; b&w, color transparencies and 8x10 negatives. "Be patient."

***PERCEPTION** + , Suite 105, 100 E. St. Vrain, Colorado Springs CO 80903. (303)471-0111. PR firm and marketing communications. Account Executive: Ms. Marty Banks. Clients: industrial, corporate, government, institutional, trade/associations, real estate, arts, retail.
Needs: Works with 2-3 freelance photographers/month. Uses photographers for trade magazines, AV catalogs and newspapers. Subjects include portraits, on-site/location (buildings, landscape), product.
Specs: Uses b&w and color prints/transparencies in various sizes/ finishes.
First Contact & Terms: Query with resume of credits, query with list of stock photo subjects, query with samples; provide resume, business card, brochure, flyer or tearsheets to be kept on file for possible future assignments. Works with freelance photographers on an assignment basis only. Does not return unsolicited material. Reports "as need arises, maybe 1 week, 1 month, 1 year. Pay negotiable, depending on job requirements". Pays "usually net: 30 days from invoice but is negotiable." Rights acquired "negotiable" per job requirement and client's budget/wishes. Model release required; captions preferred. Credit line negotiable, per job requirements and client's budget/wishes.
Tips: "Send resume, client list, specialities, roles or other policies; date submission so we know how current it is if we file for future references. Trends are imaginative, expressive work enhanced by new technology."

Florida

AURELIO & FRIENDS, INC., 11110 SW 128th Ave., Miami FL 33186. (305)385-0723. President: Aurelio Sica. Vice President: Nancy Sica. Ad agency. Uses billboards, consumer and trade magazines, direct mail, newspapers, radio and TV. Serves clients in retail stores, shopping centers, developers, manufacturers, resorts, entertainment and fashion. Commissions 10-12 photographers/year. Payment depends on assignment. Buys all rights. Model release required. Query with samples. SASE. Reports in 2 weeks.
Specs: Uses b&w prints and 35mm and 2¼x2¼ color transparencies.

CATALOG PUBLISHING GROUP, (formerly Educational Dealer Group), Box 1025, Orange City FL 32763. (904)775-4336. President: Ed Rancourt. Ad agency/publisher. Clients: educational distributors and teacher stores.
Needs: Works with 1 freelance photographer/month. Uses photographers for catalogs and brochures. Subjects include "children in various school settings; photos of educational products."
Specs: Uses any size color prints and 35mm transparencies.
First Contact & Terms: Query with list of stock photo subjects; provide resume, business card, brochure, flyer or tearsheets to be kept on file for possible future assignments. Works with freelance photographers on assignment basis only. Does not return unsolicited material. Reports in 2 weeks. Pays negotiable rate per job or per b&w photo. Pays on acceptance. Buys all rights. Credit line "sometimes" given.

COLEE & CO., 515 N. Flagler Dr., West Palm Beach FL 33401. (305)832-6019. Ad agency. Art Director: Wendy Maus. Clients: industrial, finance, residential.
Needs: Works with 2-3 photographers/month. Uses photographers for trade magazines, newspapers, brochures. Subjects include residential, pertaining to client.
Specs: Uses b&w and color prints; 35mm, 2¼x2¼, and 4x5 transparencies.
First Contact & Terms: Arrange a personal interview to show portfolio; submit portfolio for review; provide resume, business card, brochure, flyer or tearsheets to be kept on file for possible future assignments. Works with local freelance photographers on an assignment basis only. Pays $50-100/hour and $250-1,000/day. Pays on receipt of invoice. Buys all rights. Model release required.

***WM. COOK ADVERTISING**, 1700 Am. Heritage Life Bldg., Jacksonville FL 32202. (904)353-3911. Ad agency. Studio Manager/Art Buyer: Mary Lane. Clients: industrial, retail, fashion, finance.
Needs: Works with 4-5 freelance photographers/month. Uses photographers for consumer and trade magazines, direct mail, P-O-P displays, and newspapers. Subjects vary: food, location—real estate and industrial, table top or model in studio.
Specs: Uses 8x10 matte b&w prints; 35mm, 2¼x2¼, 4x5 transparencies.
First Contact & Terms: Arrange a personal interview to show portfolio; query with samples; submit

portfolio for review. Works with freelance photographers on assignment basis only. Does not return unsolicited material. Reports in 2 weeks. Pays $200-2,000/day. Pays on receipt of invoice. Buys all rights "when possible." Model release required. Credit line given "only usually on public service type jobs when work is done free or for a nominal fee."

Tips: Prefers to see a mixture of table top and locations—limited number of pieces—only the best—judgment will be on worst pieces. "Contact us with a letter, with a follow up phone call and/or color reproductions of work."

CREATIVE RESOURCES, INC., 2000 S. Dixie Highway, Miami FL 33133. (305)856-3474. General Manager: Mac Seligman. PR firm. Handles clients in travel (hotels, airlines). Photos used in PR releases. Works with 1-2 freelance photographers/month on assignment only basis. Provide resume to be kept on file for possible future assignments. Buys 10-20 photos/year. Pays $50 minimum/hour or $100 minimum/day. Negotiates payment based on client's budget. For assignments involving travel, pays $60-200/day plus expenses. Pays on acceptance. Buys all rights. Model release preferred. Query with resume of credits. No unsolicited material. SASE. Reports in 2 weeks. Most interested in activity shots in locations near clients.
B&W: Uses 8x10 glossy prints; contact sheet OK.
Color: Uses 35mm or 2¼x2¼ transparencies and prints.

GROUP TWO ADVERTISING, INC./FLORIDA, Suite 300, 2691 E. Oakland Park Blvd., Fort Lauderdale FL 33306. (305)563-3390. Art Directors: David Johnson and Renaldo Hernandez. Ad agency. Uses billboards, consumer and trade magazines, direct mail, foreign media, newspapers, P-O-P displays, radio, and TV — "anything that is appropriate to a specific client." Serves clients in finance, food service, real estate, automotives, retail and entertainment. Works with 1 freelance photographer/month on assignment only basis. Provide business card, brochure, flyer and samples or portfolio to be kept on file for future assignments. Pays $40 minimum/3 hours, $300 minimum/day (7 hours); negotiates payment based on amount of creativity required from photographer and photographer's previous experience/reputation. Local freelancers preferred. Buys all rights. Model release required. Arrange personal interview to show portfolio or query with samples or list of stock photo subjects. Prefers to see samples of real estate, "lifestyle" i.e. Southern Florida—beaches, water, skylines, activities, sports and people. SASE.
B&W: Prefers contact sheet; uses glossy or semigloss prints, depending on assignment and subject.
Color: Uses prints and transparencies; size depends on assignment and subject.

HILL & KNOWLTON, Suite 1511, 201 E. Kennedy Blvd., Tampa FL 33602. Vice President: Bill Gray. PR firm. Uses consumer and trade magazines, direct mail and newspapers. Serves general clients. Deals with 20 photographers/year.
Specs: Uses b&w photos and color transparencies. Works with filmmakers on industrial and business films.
Payment & Terms: Pays by hour and day. Buys all rights. Model release required.
Making Contact: Query with resume of credits. SASE. Reports in 2 weeks.

***NEWMAN, BLITZ & MCCONNELL**, Suite 304, 735 NE 125th St., N. Miami FL 33161. (305)893-2800. Ad agency. Art Director: Bruce Fitzgerald. Clients: industrial, retail, finance, service. Client list with SASE.
Needs: Works with 3 freelance photographers/month. Uses freelance photographers for billboards, consumer and trade magazines, direct mail, P-O-P displays, catalogs, posters, signage, newspapers. Subjects include: products, people, scenics.
Specs: Uses 8x10 and color prints, 35mm, 2¼x2¼ transparencies.
First Contact & Terms: Arrange a personal interview to show portfolio; provide resume, business card, brochure, flyer or tearsheets to be kept on file for possible future assignments. Works with freelance photographers on an assignment basis only. Does not return unsolicited material. Reports in 3 weeks. Pays $50-80/hour; $200-600/day; $50-80/job; $50/b&w photo; $80/color print. Pays on publication. Buys all rights and one-time rights. Model release preferred. Credit line sometimes given.

SUSAN NEUMAN, INC., Suite 25K, 555 NE 15th St., Miami FL 33132. (305)372-9966. PR firm. President: Susan Neuman.
Needs: Uses photographers for brochures, newspapers, signage.
Specs: Uses 8x10 glossy prints; 35mm, 2¼x2¼, and 4x5 transparencies.
First Contact & Terms: Arrange a personal interview to show portfolio. Works with freelance photographers on assignment only basis. Does not return unsolicited material. Payment varies. Pays on publication. Buys all rights. Model release required; captions preferred. Credit line "sometimes" given.

PRUITT, HUMPHRESS, POWERS & MUNROE ADVERTISING AGENCY, INC., 516 N. Adams St., Tallahassee FL 32301. (904)222-1212. Creative Director: G.B. Powers. Ad agency. Clients: industrial, consumer.
Needs: Works with 3-4 freelance photographers/month. Uses freelancers for consumer and trade magazines, direct mail, newspapers, P-O-P displays.
First Contact & Terms: Request personal interview or send portfolio for review. Pays 30 days after production.
Tips: Would like to see "photos of past agency work in clean, businesslike fashion including written explanations."

ROBINSONS, INC., 2808 N. Orange Ave., Orlando FL 32854. (305)898-2808. Ad agency. Senior Vice President/Creative Director: Norman Sandhaus. Clients: hotels, resorts, boards of tourism.
Needs: Works with 3 freelance photographers/month. Uses photographers for consumer and trade magazines, direct mail, brochures, posters, AV presentations. Subjects include hotel/resort interiors and exteriors with models.
Specs: Uses 35mm, 2¼x2¼ and 4x5 transparencies.
First Contact & Terms: Query with samples; provide resume, business card, brochure, flyer or tearsheets to be kept on file for possible future assignments. Does not return unsolicited material. Reports in 2 weeks. Pays $650 minimum/day. Pays on acceptance. Buys all rights. Model release required.
Tips: Prefers to see "use of interior lighting and use of models. Show examples of similar work."

BRUCE RUBIN ASSOCIATES, INC., Suite 203, 2655 Le Jeune Rd., Miami FL 33134. (305)448-7450. Contact: Bruce Rubin or Kim Foster. PR firm. Handles clients in finance, travel, education and electronics. Photos used in brochures, newsletters, newspapers, AV presentations, posters, annual reports, PR releases, magazines and advertisements. Gives 200-250 assignments/year. Fees negotiable depending on client's budget. Buys all rights. Model release required. Arrange a personal interview to show portfolio. Local freelancers preferred. No unsolicited material; does not return unsolicited material. Reports in 2 weeks.
B&W: Uses 8x10 glossy prints; contact sheet OK.
Color: Uses transparencies and glossy prints.
Film: Infrequently produces 7-10 minute shorts for clients; TV spots also. Assignment only.
Tips: Obtain agency photography assignment form.

***TULLY-MENARD, INC. ADVERTISING AND PUBLIC RELATIONS**, 2207 S. Dale Mabry, Tampa FL 33629. (813)253-0447. Senior Art Director: Barry Wallace. Clients: retail, fashion.
Needs: Works with 2 freelance photographers/month. Uses photographers for P-O-P displays, posters, and newspapers. Subjects include: fashion, product, possible food.
Specs: Uses b&w prints; 2¼x2¼, 4x5 transparencies.
First Contact & Terms: Provide resume, business card, brochure, flyer or tearsheets to be kept on file for possible future assignments. Works with freelance photographers on an assignment basis only. Does not return unsolicited material. Reports "as assignments arise. We have no set policy for payment—usually a per assignment basis; photographers are allowed to set their own pricing on a bid basis." Pays on receipt of invoice. Buys all rights. Model release preferred.
Tips: Prefers to see effective use of dramatic angle and lighting. "Some of our clients tend to request previously used photographers but from time to time we are allowed to seek out new talent and patience wins the race—we may not use someone on first query. In fashion, photography trends are constantly changing so it's hard to lock into a particular trend."

Georgia

ADAMSON & COMPANY, (formerly Adamson Public Relations & Promotions), 6280 Highway 42, Rex GA 30273. (404)968-1675. Owner: Sylvia Adamson. PR firm. Clients: profit and nonprofit organizations.
Needs: Uses photographers for direct mail, newspapers, posters, audiovisual presentations, trade magazines, brochures. Subject matter and style "depends on client's needs."
Specs: Uses b&w 8x10 glossy prints; or color slides.
First Contact & Terms: Query with resume and list of stock photo subjects; provide resume, brochure, flyer or tearsheets to be kept on file for possible future assignments. SASE. Reports in 3 weeks. Payment "depends on client and job assignment." Pays on acceptance. Model release and captions preferred. Credit line given.
Tips: "We prefer first contact be made by mail."

"The photographer, Michael St. John was selected for his strong fashion background and effective use of lighting and angles," explains Tully-Menard, Inc. Senior Art Director Barry L. Wallace. The photo, taken for Colony Shops of Florida (a client), also shows St. John's eye for detail and his good design sense.

ADVANCE ADVERTISING & PUBLIC RELATIONS, 816 Cotton Ln., Augusta GA 30901. (404)724-7003. Ad agency. President: Connie Vance. Clients: automotive, industrial, manufacturing, residential.
Needs: Works with "possibly one freelance photographer every two or three months." Uses photographers for consumer and trade magazines, catalogs, posters, and AV presentations. Subject matter: "product and location shots." Also works with freelance filmmakers to produce TV commercials on videotape.
Specs: Uses glossy b&w and color prints; 35mm, 2¼x2¼ and 4x5 transparencies; videotape and film. "Specifications vary according to the job."
First Contact & Terms: Provide resume, business card, brochure, flyer or tearsheets to be kept on file for possible future assignments. Works with freelance photographers on assignment basis only. Does not return unsolicited material. Reports in 1 month. Rates vary from job to job. Pays on publication. Buys all rights. Model release preferred.
Tips: Prefers to see "samples of finished work—the actual ad, for example, not the photography alone. Send us materials to keep on file and quote favorably when rate is requested."

D'ARCY-MASIUS BENTON AND BOWLES, (formerly D'Arcy-Macmanus & Masius, Inc.), Suite 1901, 400 Colony Sq., Atlanta GA 30361. (404)892-8722. Art Director: B.A. Albert. Ad agency. Clients: dairy products, real estate, sports equipment, clocks, banks, petroleum, theatre.
Needs: Works with 20 freelance photographers/month. Uses all media.
First Contact & Terms: Arrange interview to show portfolio. Negotiates payment according to client's budget.

FAHLGREN, SWINK AND NUCIFORA, Suite 1000, 2839 Paces Ferry Rd., Atlanta GA 30339. (404)434-2424. Ad agency. Clients: consumer goods, hi-tech, business-to-business. Client list free with SASE.
Needs: Works with 4 photographers/month. Uses photographers for billboards, consumer magazines, trade magazines, direct mail, catalogs, newspapers.
Specs: Uses 7x10 b&w and color prints; 35mm, 2¼x2¼, 4x5 and 8x10 transparencies.
First Contact & Terms: Arrange a personal interview to show portfolio; query with resume of credits; submit portfolio for review; provide resume, business card, brochure, flyer or tearsheets to be kept on file for possible future assignments. Does not return unsolicited material. Reports in 2 weeks. Pays/day or /job. Pays on receipt of invoice. Buys all rights. Model release required.

FLETCHER/MAYO/ASSOCIATES, INC., Suite 710, Five Piedmont Center, Atlanta GA 30305. (404)261-0831. Art Directors: Mark Eden, Joe Erni, John Wieschhaus. Ad agency. Clients: primarily agricultural, industrial, consumer, fashion.
Needs: Works with "many" freelance photographers/month, usually on assignment only basis. Specializes in location photography. Most studio work done locally. Occasionally buys stock photos. Uses all media.
First Contact & Terms: Arrange interview to show portfolio. Pays/day. Purchases all rights.

HAYNES ADVERTISING, 90 5th St., Macon GA 31201. (912)742-5266. Ad agency. Contact: Philip Haynes.
Needs: Works with 1-2 freelance photographers/month. Uses photographers for direct mail, brochures and newspapers. Subjects include: products and people scenes.
Specs: Uses b&w and color prints; 35mm and 2¼x2¼ transparencies and videotape.
First Contact & Terms: Arrange a personal interview to show portfolio. Does not return unsolicited material. Pays $25 minimum/job. Pays on publication. Buys all rights. Model release required.

SMITH MCNEAL ADVERTISING, 368 Ponce de Leon Ave., Atlanta GA 30308. (404)892-3716. Sr. Art Director: Darryl Elliott. Ad agency. Clients: industrial, retail, food.
Needs: Works with one photographer/month. Uses photographers for billboards, consumer magazines, trade magazines, direct mail, P-O-P displays, annual reports, catalogs, posters, newspapers. Subject matter includes food and product.
Specs: Uses 8½x11 glossy b&w prints and 2¼x2¼ and 4x5 transparencies.
First Contact & Terms: Send unsolicited photos by mail for consideration; query with samples; provide resume, business card, brochure, flyer or tearsheets to be kept on file for possible future assignments. Works with local freelancers only. SASE. Pays $250-1,000/job, depending on complexity, props, number of models, etc. Pays within 90 days. Buys all rights. Model release required.
Tips: "Be persistent, it's often difficult, if not impossible to reach me. I like a casual, laid back photographer who is willing to go the extra mile in delivering excellent shots. *Be on budget.*"

J. WALTER THOMPSON USA, 2828 Tower Place, 3340 Peachtree Rd. NE, Atlanta GA 30026. (404)266-2828. Art Directors: Anne Shaver, Bill Tomassi, Mark Ashley, Clem Bedwell, David Harner, Carey Morgan, John Boone. Ad agency. Clients: industrial and financial.
Needs: Works with 4-6 studios or photographers/month. Uses photographers for billboards, consumer and trade magazines, direct mail and newspapers. Uses experienced professional photographers only.
First Contact & Terms: Send resume and samples. SASE. Reports in 2 weeks. Payment negotiable by photo, day or project.

TUCKER WAYNE & CO., Suite 2700, 230 Peachtree St. NW, Atlanta GA 30043. (404)521-7600. Contact: Business Manager/Creative. Ad agency. Serves a variety of clients including packaged products, food, utilities, transportation, agriculture and pesticide manufacturing.
Needs: Uses photographers for consumer and trade magazines, TV and newspapers.
First Contact & Terms: Call for appointment to show portfolio. Negotiates payment based on many factors such as where work will appear, travel requirements, budget, etc.

Idaho

***BITTON ADVERTISING AGENCY**, 1387 Cambridge, Idaho Falls ID 83401. (208)523-7300. Ad agency. "We publish a magazine and a newspaper of flyfishing." Owner: Dennis Bitton. Clients: retail, light industrial, agricultural, recreational lodges, etc.
Needs: Works with 1-2 freelance photographers/month. Uses photographers for trade magazines, direct mail, catalogs and newspapers. Subjects include flyfishing pictures.
First Contact & Terms: Send unsolicited photos by mail for consideration. SASE. Reports in 2 weeks. Pays $25-150/b&w photo, $35-175/color photo. Pays on publication. Buys one-time rights. Model release and captions preferred. Credit line given.
Tips: Prefers to see "anything to do with flyfishing." Send in pictures with SASE and deadline for their return.

***CIPRA ADVERTISING**, 314 E. Curling Dr., Boise ID 83702. (208)344-7770. Ad agency. President: Ed Gellert. Clients: industrial, retail, finance. Client list with SASE.
Needs: Works with 1 freelance photographer/month. Uses freelance photographers for consumer and trade magazines, direct mail, posters and newspapers.
Specs: Uses all b&w and color prints, 35mm, 2¼x2¼, 4x5, 8x10 transparencies.

First Contact & Terms: Send unsolicited photos by mail for consideration; provide resume, business card, brochure, flyer or tearsheets to be kept on file for possible future assignments. Does not return unsolicited material. Reports in 1 week. Pays/job. Pays on acceptance. Buys all rights.

DAVIES & ROURKE ADVERTISING, 1602 Franklin St., Box 767, Boise ID 83701. VP Creative Director: Bob Peterson. Ad agency. Uses billboards, direct mail, newspapers, P-O-P displays, radio, TV and trade magazines. Serves clients in utilities, industrial products, wood products, finance and fast food. Pays $15 minimum/job. Buys all rights. Model release required. Query with resume of credits "listing basic day rate if possible" or query with samples (preferably printed samples, not returnable). Reports in 1 month.
B&W: Prefers contact sheet; print size and finish depends on job.
Color: Uses prints and transparencies; size and finish depends on job.
Film: Produces 16mm TV commercials and presentation films. Does not pay royalties.

Illinois

AMERICAN ADVERTISING, 850 N. Grove, Elgin IL 60120. (312)741-2400. Manager: Karl Novak. Ad agency. Uses freelance photographers for consumer and trade magazines, direct mail, newspapers and P-O-P displays. Serves clients in publishing and nonprofit foundations. Works with 2-3 freelance photographers/month on assignment only basis. Provide resume, flyer, business card and brochure to be kept on file for possible future assignments. Buys 100 photos/year. Local freelancers preferred. Interested in stock photos of families, groups of children, schools and teachers. Negotiates payment based on client's budget and amount of creativity required from photographer. Pays on production. Buys all rights. Model release required. Query with resume of credits. Does not return unsolicited material. Reports in 3 weeks.
B&W: Prefers contact sheet; print size depends on project. Pays $100-150 minimum/photo.
Color: Prefers 2¼x2¼ or 4x5 transparencies: 35mm semigloss prints OK. Pays $100-400/photo.

***THE BASINGER COMPANY**, 1620 Central St., Evanston IL 60201. (312)475-3525. Ad agency. Vice President: Basinger. Clients: industrial, finance.
Needs: Uses photographers for consumer and trade magazines, direct mail and P-O-P displays. Subject matter diverse—table top, location, figures.
Specs: Uses b&w and color prints and 35mm, 2¼x2¼, 4x5 and 8x10 transparencies.
First Contact & Terms: Arrange a personal interview to show portfolio; provide resume, business card, brochure, flyer or tearsheets to be kept on file for possible future assignments. Works with local freelance photographers on assignment basis only. Does not return unsolicited material. Pays on receipt of invoice. Buys all rights. Model release required.

BRAGAW PUBLIC RELATIONS SERVICES, Suite 312, 800 E. Northwest Highway, Palatine IL 60067. (312)934-5580. Contact: Richard S. Bragaw. PR firm. Clients: professional service firms, high tech entrepreneurs.
Needs: Works with 1 freelance photographer/month. Uses photographers for trade magazines, direct mail, brochures, newspapers, newsletters/news releases. Subject matter "products and people."
Specs: Uses 3x5, 5x7 and 8x10 glossy prints.
First Contact & Terms: Provide resume, business card, brochure, flyer or tearsheets to be kept on file for possible future assignments. Works with freelance photographers on assignment basis only. SASE. Pays $25-75/hour; $200-500/day. Pays on receipt of invoice. Buys all rights. Model release preferred. Credit line "possible."
Tips: "Execute an assignment well, at reasonable cost, with speedy delivery. Would like to use more photography."

JOHN CROWE ADVERTISING AGENCY, 1104 S. 2nd St., Springfield IL 62704. (217)528-1076. President: Bryan J. Crowe. Ad agency. Uses billboards, consumer and trade magazines, direct mail, newspapers, radio and TV. Serves clients in industry, commerce, aviation, banking, state and federal government, retail stores, publishing and institutes. Works with 1 freelance photographer/month on assignment only basis. Provide letter of inquiry, flyer, brochure and tearsheet to be kept on file for future assignments. Pays $50 minimum/job or $18 minimum/hour. Negotiates payment based on client's budget. Buys all rights. Model release required. Send material by mail for consideration. SASE. Reports in 2 weeks.
B&W: Uses glossy 8x10 prints.
Color: Uses glossy 8x10 prints and 2¼x2¼ transparencies.

ELVING JOHNSON ADVERTISING, INC., 7800 West College Dr., Palos Heights IL 60463. (312)361-2850. President: Elving Johnson. Art Director: Mike McNicholas. Ad agency and PR firm. Uses billboards, consumer and trade magazines, direct mail, newspapers, P-O-P displays, brochures, collateral material. Serves clients in heavy machinery and construction materials. Buys 200 photos/year. Pays $15-350/job or on a per-photo basis. Negotiates payment based on client's budget and amount of creativity required from photographer. Call to arrange an appointment and present portfolio in person; deals with local freelancers only. Reports in 1 week. SASE.
B&W: Uses 8x10 or 11x14 glossy prints. Pays $15-150.
Color: Uses any size transparency or 8x10 and 11x14 glossy prints. Pays $30-400.

***JRB ADVERTISING**, 18 N. Center, Bensenville IL 60106. (312)766-7340. Ad agency. Creative Director: Al Trungale. Clients: industrial, retail, finance.
Needs: Works with 3 freelance photographers/month. Uses photographers for billboards, ads, for both trade and consumer magazines, direct mail, P-O-P displays, catalogs and posters. Subjects vary "from A to Z."
Specs: Uses 8x10 b&w prints, 35mm, 2¼x2¼, 4x5, 8x10 transparencies.
First Contact & Terms: Query with resume of credits and samples; provide resume, business card, brochure, flyer or tearsheets to be kept on file for possible future assignments. Works with local freelancers only. Does not return unsolicited material. Reports in 2 weeks. Pays/job. Pays on publication. Buys all rights. Model release required.
Tips: Prefers to see standard shots and creative shots. "Call or send printed samples."

WALTER P. LUEDKE AND ASSOCIATES, The Sweden House, 4615 E. State St., Rockford IL 61108. (815)398-4207. Contact: W. P. Luedke. Ad agency. Uses all media including technical manuals and bulletins. Serves clients in heavy machinery, RV vehicles, electronics, women's fashions and building supplies. Needs photos dealing with all kinds of recreation. Buys 10-20 annually. Buys all rights, but may reassign to photographer. Pays per hour, per photo, or $50-500/job. Submit material by mail for consideration or submit portfolio. "We have occasions to find a photographer in a far away city for special location shots." Reports in 1 week. SASE.
B&W: Send 5x7 or 8x10 glossy prints. Model release required. Pays $5-50.
Color: Send 35mm slides, 4x5 transparencies or contact proof sheet. Model release required. Pays $10-75. "We have had the need for specified scenes and needed reliable on-location (or nearby) sources."
Tips: "Although we don't have photo requirements that often we would be happy to hear from photographers. We like good, reliable sources for stock photos and good sources for unusual recreational, travel, pleasant scene shots." Advises beginners to "forget price—satisfy first."

MACE ADVERTISING AGENCY, INC., Northwest Bank Bldg., Suite 2-2, 4516 N. Sterling Ave., Peoria IL 61614. (309)685-5505. Art Director: Dan Scharfenberg. Ad agency. Clients: industrial, finance. Works with 1 photographer/month. Uses photographers for billboards, trade magazines, direct mail, newspapers. Subjects include portrait, architectural, and medical.
Specs: Uses 8x10 b&w prints and 35mm transparencies.
First Contact & Terms: Arrange a personal interview to show portfolio; query with samples; provide resume, business card, brochure, flyer or tearsheets to be kept on file for possible future assignments. Works with local freelancers only. Does not return unsolicited material. Reports in 3 weeks. Pays on receipt of invoice. Buys all rights. Model release preferred.

ARTHUR MERIWETHER, INC., 1529 Brook Dr., Downers Grove IL 60515. Producer: John King. Clients: corporations, ad agencies, associations.
Needs: Works with 3 photographers/month. Uses photographers for films, videotapes, PR photos. Subjects include documentation for PR releases, scientific photography.
Specs: Uses b&w negatives; 35mm, 2¼x2¼ and 4x5 transparencies; 16mm film; U-matic ¾" videotape.
First Contact & Terms: Provide resume, business card, self-promotion piece or tearsheets to be kept on file for possible future assignments. Works with freelancers by assignment only; interested in stock photos/footage. Does not return unsolicited material. Payment individually negotiated. Pays within 30 days. Buys all rights. Model release required. Credit line sometimes given.

Chicago

RONALD A. BERNSTEIN ASSOCIATES, INC., Chicago Place, 310 W. Chicago Ave., Chicago IL 60610. (312)440-3700. Art Director: Joe Gura. Ad agency. Uses consumer and trade magazines, direct

mail, foreign media. Serves clients in sporting goods, home products, real estate, motivation and video products. Commissions 20 photographers/year. Local freelancers preferred. Pays $200-600/job. Usually buys all rights. Model release required. Arrange personal interview to show portfolio.
B&W: Uses prints.
Color: Uses prints and transparencies.

ROBERT E. BORDEN & ASSOCIATES, 6301 N. Sheridan Rd., Chicago IL 60660. Contact: Robert E. Borden. PR and some advertising. Clients: savings & loans, misc. manufacturing, hospitals, real estate and development firms, air conditioning-heating designers/installers, nonprofit organizations.
Needs: Works with varying number of freelance photographers on assignment only basis. Provide resume, brochure and business card to be kept on file for possible future assignments. Negotiates payment based on client's budget, freelancer's hourly rate and commission arrangements.

***BRITT & BRITT CREATIVE SERVICES**, (formerly Associated Media Services Corp., Inc.), 2645 W. Greenleaf, Chicago IL 60645. (312)761-3808. Ad agency. Creative Director: Kaye Britt. Clients: retail, industrial, financial, cosmetic.
Needs: Works with 1 freelance photographer/month. Uses photographers for consumer and trade magazines, direct mail, P-O-P displays, brochures, newspapers, and TV. Subjects include model and produce photography. Also works with freelance filmmakers to produce TV commercials.
Specs: Uses 5x7 and 8x10 b&w or color glossy prints; 4x5 and 8x10 transparencies; 16mm film and videotape.
First Contact & Terms: Arrange a personal interview to show portfolio (if local). Provide resume, business card, brochure, flyer or tearsheets to be kept on file for possible future assignments. Works with freelance photographers on assignment basis only. SASE. Reports immediately in person or on phone. Pays $20-100/hour; $75-500/day; $25-1,000/job; $10/b&w photo; $25/color photo. Pays 30 days after acceptance. Buys all rights. Model release required. Credit line given "in some cases."
Tips: "Be flexible to do 'bread & butter' work without offense—and capable of creativity as necessary."

E.H. BROWN ADVERTISING AGENCY, 20 N. Wacker Dr., Chicago IL 60606. (312)372-9494. Art Director: Arnold Pirsoul. Ad agency. Clients: primarily industrial, financial and consumer products.
Needs: Works with 3 photographers/month. Uses photographers for consumer and trade magazines.
First Contact & Terms: Call for appointment to show portfolio. Pays by day or bid basis.
Tips: Does not want to see table-top, food products or high fashion photography.

BURRELL COMMUNICATIONS GROUP, 20 N. Michigan Ave., Chicago IL 60602. (312)443-8600. Art Directors: Raymond Scheller, Cortrell Harris, Tony Gregory, Michelle McKinney, Abbey Onikoyi, Mel Nickerson, Neil Thomas, Lewis Williams, Ronald McCray, Larry Green. Ad agency. Clients: soft drink, fast foods, beer and liquor, automotive, dental products and cosmetics manufacturers.
Needs: Uses freelance photographers for billboards, P-O-P displays, consumer magazines, still photography for TV, brochures/flyers and newspapers.
First Contact & Terms: Call art director for appointment to show portfolio. Negotiates payment based on "national going rate," client's budget, amount of creativity required, where work will appear and artist's previous experience/reputation.

***DANIEL J. EDELMAN, INC.**,211 E. Ontario St., Chicago IL 60611. (312)280-7000. PR firm. Clients: industrial, fashion, finance, consumer products, real estate, toiletries, medical, high tech—"we handle the full spectrum of public relations areas in all types of industries."
Needs: Number of freelancers used per month "varies according to public relations programs underway but it could run approximately 3-5." Uses photographers for consumer magazines, trade magazines, brochures, newspapers and AV presentations. Subjects include: products, on-site shots for case histories, special events such as groundbreaking, etc.
First Contact and Terms: Arrange a personal interview to show portfolio; provide resume, business card, flyer or tearsheets to be kept on file for possible future assignments. Works with freelancers on an assignment basis only. SASE. Reporting time "depends on the assignment. Freelancer charges are negotiated based on the type and length of assignment." Pays $35-100/hour; $300-1,000/day; $75 minimum/job (including film, processing); $4-8/b&w photo; $8.50-13/color photo. Pays on acceptance. Buys all rights. Model release required.
Tips: Best way to break in is a "personal interview to discuss the assignment, the freelancer's qualifications, etc. Drop off a portfolio rather than just a resume or one brochure. If you blow the first job, offer a reshoot. *Counsel* your client on photo feasibility."

***GARFIELD-LINN & COMPANY**, 875 N. Michigan Ave., Chicago IL 60611. (312)943-1900. Contact: Art Director or Creative Director. Ad agency. Clients: Serves a "wide variety" of accounts; client list provided upon request.
Needs: Number of freelance photographers used varies. Works on assignment only basis. Uses photographers for billboards, consumer and trade magazines, direct mail, brochures, catalogs and posters.
First Contact & Terms: Arrange interview to show portfolio and query with samples. Payment is by the project; negotiates according to client's budget.

HBM/CREAMER, 400 N. Michigan Ave., Chicago IL 60611. (312)337-8070. Art Directors: Pat King, Chris Williams, Karen Frost, Mike Fusello, Orville Sheldon, Tom Grosspietsch, Nobuko Nagaoka, Carl Hofmann. Photos used in advertising, press releases, and sales literature; billboards, consumer and trade magazines, direct mail, foreign media, newspapers, radio and TV. Serves industrial, automotive, consumer, high tech and industry clients. Submit model release with photo. Payment is negotiable. Query with resume of credits and photos. Reports in 2 weeks. SASE.
B&W: Uses 5x7 glossy prints; send contact sheet.
Color: Uses 35mm transparencies or 5x7 glossy prints; contact sheet OK.

HILL AND KNOWLTON, INC., One Illinois Center, 111 E. Wacker Dr., Chicago IL 60601. (312)565-1200. Contact: Jacqueline Kohn, Lynne Strode. PR firm. Clients: manufacturing, consumer products, medical and pharmaceutical, public utilities.
Needs: Works with 6 freelance photographers/month. Uses photographers for corporate collateral, executive portraits, slide programs, multimedia presentations, etc.
First Contact & Terms: Call Jacqueline Kohn or Lynne Strode for appointment to show portfolio. Negotiates payment based on client's budget and photographer's previous experience/reputation.

BERNARD HODES ADVERTISING, Suite 1300, 205 W. Wacker Dr., Chicago IL 60606. (312)222-5800. Production Manager: Joni Watanabee. Art Director: Susan Emerick. Ad agency.
First Contact & Terms: Call for personal appointment to show portfolio. Pays $150-300/b&w photo; $200-500/color photo; $300-500/hour; $500-1,500/day; or $800-1,500/job.
Tips: There seems to be a trend in advertising photography toward "more close-up shots than before, with natural-looking light, more collage and manipulated images." Will accept b&w and color photos. Uses stock photos mostly. Needs photos of people doing their jobs. "Send letter, business card and sample. We'll call you."

INTERAND CORPORATION, 3200 W. Peterson Ave., Chicago IL 60659. (312)478-1700. Director of Corporate Communications: Linda T. Phillips. Clients: Fortune 500 companies.
Needs: Works with 2-3 photographers/year. Uses photographers for product photos for brochures, industrial, in-house portrait. Subjects include building, manufacturing, product, portraits.
Specs: Uses 5x7 and 8x10 glossy or matte b&w prints; 5x7 and 8x10 glossy color prints; 35mm, 2¼x2¼ and 4x5 transparencies; U-matic ¾" videotape.
First Contact & Terms: Provide resume, business card, self-promotion piece or tearsheets to be kept on file for possible future assignments. Works with local freelancers on assignment basis only. Reports in 2 weeks. Pays on acceptance. Buys all rights. Model release required.

MANDABACH & SIMMS, 20 N. Wacker, Chicago IL 60606. (312)236-5333. Sr. Vice President/Creative: Burt Bentkover. Ad agency. Uses all media except foreign. Serves clients in food service, graphic arts, finance, real estate. Needs photos of food, equipment and people. Buys 15 photos/year. Pays $75 minimum/job. Query; call to arrange an appointment. Reports in 1 month. SASE.
Specs: Uses 35mm, 2¼x2¼ or 8x10 transparencies.
Tips: "Check our client list and submit relative samples when requested."

MARKETING SUPPORT, INC., 303 E. Wacker Dr., Chicago IL 60601. (312)565-0044. Ad agency. Executive Art Director: Robert Becker. Clients: manufactured products—industrial and consumer.
Needs: Works with 3-4 freelance photographers/month. Uses photographers for consumer and trade magazines, direct mail, P-O-P displays, brochures, catalogs, posters, and AV presentations. Subject matter: "products, pets and people." Also works with freelance filmmakers to produce "some commercials and sales meeting slide shows."
First Contact & Terms: Arrange a personal interview to show portfolio; provide resume, business card, brochure, flyer or tearsheets to be kept on file for possible future assignments. Works with local freelance photographers on assignment basis only. Does not return unsolicited material. Pays $100 300/b&w photo; $125 3,500/color photo; or $125 5,000/job. Pays 60 days after acceptance. Buys all rights. Model release required.

MARSTRAT, INC., Subsidiary of U.S.G. Corp., 101 S. Wacker Dr., Chicago IL 60606. (312)321-5826. Ad agency. Vice President/Executive Art Director: Edwin R. Wentz. Clients: industrial. Client list provided on request.
Needs: Works with 2-4 freelance photographers/month. Uses photographers for consumer and trade magazines, P-O-P displays, brochures, posters, and newspapers. Subjects include: "locations, industrial, studio, tabletop—from fashion to nuts and bolts, done in a quality approach."
Specs: "Whatever it takes to do assignment to its best advantage."
First Contact & Terms: Arrange a personal interview to show portfolio; query with samples; provide resume, business card, brochure, flyer or tearsheets to be kept on file for possible future assignments. Works with freelance photographers on assignment basis only. Does not return unsolicited material. Pays $150-1,500/b&w photo; $350-2,500/color photo; and $650-2,500/day; $150-2,200/job; "also depends on caliber of talent and what the assignment is." Pays on acceptance. Buys all rights. Model release and captions required. Credit line "sometimes" given.

MULTIVISION INTERNATIONAL INC., 340 W. Huron, Chicago IL 60610. (312)337-2010. Creative Director: Michael Knab. PR and AV firm. Clients: "all types."
Needs: Works with 3 freelance photographers/month. Uses photographers for direct mail, posters, AV presentations, trade magazines, brochures, signage, internal communications. Subject matter "varies a great deal—especially looking for 'people' photographers. We will use freelance directors occasionally, and always freelance cinematographers for commercial and corporate image films."
Specs: Uses color prints; 35mm, 2¼x2¼, 4x5 and 8x10 transparencies; 16mm and 35mm film and videotape.
First Contact & Terms: Query with samples, list of stock photo subjects or submit portfolio for review; provide resume, brochure, flyer or tearsheets to be kept on file for possible future assignments. Works with freelance photographers on assignment basis only. SASE. Reports in 2 weeks. Pays $500-1,000/day; or per photo for stock color photos. Pays upon hiring. Buys one-time rights. Model release required. Credit line given "in some cases."
Tips: Prefers to see a "range of assignments in a photographer's portfolio or samples. Like to see out-takes if feasible on recent jobs."

O.M.A.R. INC., 5525 N. Broadway, Chicago IL 60640. (312)271-2720. Creative Director: Paul Sierra. Ad agency. Clients: consumer, food, TV, utilities.
Needs: Number of freelance photographers used varies. Works on assignment basis only. Uses photographers for consumer magazines, posters, newspapers and TV.
First Contact & Terms: Local freelancers only. Query with resume of credits and samples, then follow up by phone. Payment is by the project; negotiates according to client's budget, but generally $150-500/b&w photo; $500-750/color photo; $150-250/hour; or $750-1,000/day.
Tips: "More women should go into photography."

PUBLIC COMMUNICATIONS, INC., 35 E. Wacker Dr., Chicago IL 60601. (312)558-1770. Chairman: Jim Strenski. PR firm. Clients: marketing, financial, corporate, nonprofit, institutional public relations.
Needs: Works with 10-12 freelance photographers/year. Uses photographers for annual reports, brochures, newsletters and exhibits. Also does extensive on-site case history photography for clients around the US and Canada. Provide resume and brochure to be kept on file for possible future assignments.
First Contact & Terms: Call for appointment to show portfolio. Negotiates payment based on client's budget. Pays within 30 days of invoice receipt. Does not return unsolicited material. Reports in 2 weeks.

PULSE COMMUNICATIONS, 2445 North Sayre Ave., Chicago, IL 60635. (312)622-7066. Creative Director: Frank G. Konrath. Ad Agency.
Needs: Works with 5-15 freelance photographers/year. Uses photographers for brochures, audiovisual, presentations, annual reports. Also uses freelance filmmakers.
First Contact & Terms: Provide resume, business card, brochure, flyer or tearsheets to be kept on file for possible future assignments. Does not return unsolicited material. Reports in one month. Pays $100/job. Buys one-time or all rights, depending on job. Model release and captions required. Credit line negotiated.
Tips: "I'm looking for someone to do the kind of quality and style that they show me in their book, on assignment."

RUDER FINN & ROTMAN, INC., 444 N. Michigan Ave., Chicago IL 60611. (312)644-8600. Executive Vice President: Richard Rotman. PR firm. Handles accounts for corporations, trade and professional associations, institutions and other organizations. Photos used in publicity, AV

presentations, annual stockholder reports, brochures, books, feature articles, and industrial ads. Uses industrial photos to illustrate case histories; commercial photos for ads; and consumer photos—food, fashion, personal care products. Works with 4-8 freelance photographers/month nationally on assignment only basis. Provide resume, flyer, business card, tearsheets and brochure to be kept on file for possible future assignments. Buys over 100 photos/year. Present model release on acceptance of photo. Pays $25 minimum/hour, or $200 minimum/day. Negotiates payment based on client's budget and photographer's previous experience/reputation. Query with resume of credits or call to arrange an appointment. Prefers to see publicity photos in a portfolio. Will not view unsolicited material.

SANDER ALLEN ADVERTISING, INC., Suite 1020, 230 N. Michigan Ave., Chicago IL 60601. (312)444-1771. Art Directors: Larry Marder and Scott Burns. Ad agency. Clients: mostly industrial.
Needs: Works with 2-3 freelance photographers/month. Uses photographers for P-O-P displays, consumer and trade magazines, direct mail, brochures/flyers and newspapers.
First Contact & Terms: Call for appointment to show portfolio. Negotiates payment based on client's budget and where work will appear.
Tips: Likes to see a broad range. B&w, color transparencies and color prints.

STONE & ADLER, INC., 1 South Wacker Dr., Chicago IL 60606. (312)346-6100. Creative Director: David Moore. Ad agency. Clients: consumer, business to business, retail, industry, travel, etc.
Needs: Works with 5-8 freelance photographers/month. Uses photographers for direct mail, brochures, consumer and trade print, sales promotion and TV.
First Contact & Terms: Call for appointment to show portfolio. Negotiates payment based on client's budget and the job.
Tips: B&w, color transparencies and printed samples; show style.

***MORTON B. STONE ASSOCIATES**, 1165 N. Clark St., Chicago IL 60611. (312)664-9780. PR firm. Associate Editor: Naomi Schreier. Clients: medical and pharmaceutical.
Needs: Uses freelance photographers for consumer magazines. Subject matter includes medical tech, food, exercise shots.
Specs: Uses glossy b&w and color prints, 35mm, 8x10 b&w transparencies.
First Contact & Terms: Provide resume, business card, brochure, flyer or tearsheets to be kept on file for possible future assignments. Works with freelance photographers on an assignment basis only. SASE. Reports in 1 month. Pays $40 150/photo. Pays on acceptance or receipt of invoice. Model release required. Credit line given.

***DAVID H. STREMMEL & CO.**, 20 N. Wacker Dr., Chicago IL 60606. (312)726-4450. Ad agency and PR firm. President: David Stremmel. Clients: industrial.
Needs: Works with 3-4 freelance photographers/month. Uses photographers for trade magazines, brochures, catalogs. Subject matter: "in-plant scenes, machinery photos, table-top, some in-office scenes." Also works with freelance filmmakers to produce sales films.
Specs: Uses 4x5 and 8x10 b&w glossy prints; 35mm, 2¼x2¼, and 8x10 transparencies; Super 8mm film and videotape.
First Contact & Terms: Provide resume, business card, brochure, flyer or tearsheets to be kept on file for possible future assignments. Works with freelance photographers on assignment basis only. Does not return unsolicited material. Reports in 1 week. Pay negotiable. Buys all rights or one-time rights. Model release required.
Tips: Artists should "know manufacturing processes: set up and shoot quickly with minimum disruption." Business-to-business advertising is using a great deal of video.

DON TENNANT COMPANY, 500 N. Michigan Ave., Chicago IL 60611. (312)644-4600. Senior Art Director: Larry Moon. Ad agency. Clients: all consumer firms; client list provided upon request.
First Contact & Terms: Works primarily with local freelancers, but considers others. Query with resume of credits. Payment is by the project; negotiates according to client's budget. "Occasionally works with freelance photographers on assignment basis only."

THE JOHN VOLK COMPANY, 676 N. St. Clair, Chicago IL 60611. (312)787-7117. Ad agency. Creative Director: Tom Wright. Art Director: Caroline Adrian. Clients: agricultural. Free client list on request.
Needs: Works with 2-3 freelance photographers/month. Uses photographers for trade magazines, direct mail, P-O-P displays, brochures, posters, newspapers and AV presentations. Subjects include: "farm related products—tractors, chemicals."
Specs: Uses 35mm and 2¼x2¼ transparencies.
First Contact & Terms: Arrange a personal interview to show portfolio; provide resume, business

card, brochure, flyer or tearsheets to be kept on file for possible future assignments. Works with freelance photographers on assignment basis only. Does not return unsolicited material. Pays $500-1,500/job. Rights purchased "depend on price and arrangement." Model release required.
Tips: "I would like to see examples of problem solving—something that would show that the photographer did more than just record what was there. I work with people who are always willing to shoot 'one more shot'. Farm ads are becoming more sophisticated and the quality of the photography is on a par with consumer ads. I'd like to see some new approaches to large equipment shooting (tractors, combines). I also like to shoot with people who add something to the photo, not just record what was there."

Indiana

CALDWELL-VAN RIPER, 1314 N. Meridian, Indianapolis IN 46202. (317)632-6501. Executive Creative Director: Jeffrey Leiendecker. Creative Director: Joe Whitman. Associate Creative Director: John Bugg. Ad agency. Uses billboards, consumer and trade magazines, direct mail, foreign media, newspapers, P-O-P displays, radio and TV. Serves all types of clients. Works with 2-5 freelance photographers/month on assignment only basis. Provide brochure or samples to be kept on file for future assignments.
Specs: Uses b&w photos and color transparencies. Uses filmmakers for TV spots, corporate films and documentary films.
Payment & Terms: Pays $200-2,000/ hour, day and job. Negotiates payment based on client's budget. Model release required. Buys all rights.
Making Contact: Arrange a personal interview to show portfolio or submit portfolio for review. SASE. Prefers local freelancers. Reports in 1 week.

HANDLEY & MILLER, INC., 1712 N. Meridian, Indianapolis IN 46202. (317)927-5500. Art Director/Vice President: Irvin Showalter. Ad agency. Clients: health care, industrial and food products.
Needs: Works with 2 freelance photographers/month. Uses photographers for P-O-P displays, consumer and trade magazines and newspapers.
First Contact & Terms: Call for appointment to show portfolio. Pays standard day rate.
Tips: Likes to see variety unless photographer has one speciality. Especially needs specialists in food photography. "Currently using more people shots."

KELLER CRESCENT COMPANY, 1100 E. Louisiana, Evansville IN 47701. (812)426-7551 or (812)464-2461. Manager Still Photography: Cal Barrett. Ad agency, PR and AV firm. Uses billboards, consumer and trade magazines, direct mail, newspapers, P-O-P displays, radio and TV. Serves industrial, consumer, finance, food, auto parts, dairy products clients. Works with 2-3 freelance photographers/month on assignment only basis. Provide business card, tearsheets and brochure to be kept on file for possible future assignments.
Specs: Uses 8x10 b&w prints and 35mm, 4x5 and 8x10 color.
Payment & Terms: Pays $200-2,500/job; negotiates payment based on client's budget, amount of creativity required from photographer and photographer's previous experience/reputation. Buys all rights. Model release required.
Making Contact: Query with resume of credits; list of stock photo subjects; send material by mail for consideration. Prefers to see printed samples, transparencies and prints. Does not return unsolicited material.

***R. MALCOLM AND ASSOCIATES, INC.**, Box 304, Evansville IN 47702. (812)426-9645. Ad agency. President: Robert Glascook. Clients: industrial.
Needs: Uses photographers for consumer and trade magazines, direct mail, P-O-P displays, catalogs and data sheets—bulletins. Subjects include industrial installations and furniture stores.
Specs: Uses 8x10 glossy or matte b&w and color prints; 35mm, 2¼x2¼ transparencies.
First Contact & Terms: Provide resume, business card, brochure, flyer or tearsheets to be kept on file for possible future assignments. Works with freelance photographers on assignment basis only. Does not return unsolicited material. Pay negotiated. Pays on acceptance and receipt of invoice. Buys all rights. Model release required.
Tips: "List your name and type of work you do best. We will probably be using more outside photographers."

Iowa

***CMF&Z ADVERTISING INC.**, 4211 Signal Ridge Rd. NE, Cedar Rapids IA 52401. (319)395-6500. Ad agency. Executive Art Director: Bui Fritz. Clients: industrial, agricultural and consumer.

Needs: Works with 2-10 freelance photographers, "depending on the month." Uses photographers for billboards, consumer magazines, trade magazines, P-O-P displays, posters and newspapers. Subjects include agriculture.
Specs: No restrictions on specifications, "depends on job."
First Contact & Terms: Query with list of stock photo subjects, query with samples, submit portfolio for review. Works with freelance photographers on an assignment basis only. SASE. Reports in 2 weeks. Pay "depends on job, client, talent etc." Pays on receipt of invoice. Buys all rights. Model release required.
Tips: "Make an appointment or send samples. A good deal of experience necessary."

EBEL ADVERTISING AGENCY,770 Orpheum Bldg., Sioux City IA 51101. (712)277-3343. Ad agency. President: Elmer Ebel. Clients: financial, retail, industrial.
Needs: Works with a freelance photographer on an as needed basis. Uses photographers for brochures and AV presentations. Subjects include: products.
First Contact & Terms: Model release required.

LA GRAVE KLIPFEL CLARKSON ADVERTISING, INC., 1707 High St., Des Moines IA 50309. (515)283-2297. President: Ron Klipfel. Ad agency. Clients: medical health services, financial, industrial and retail; client list provided upon request.
Needs: Works with 2 freelance photographers/month on assignment basis only. Uses photographers for all media.
First Contact & Terms: Phone first then follow with mailed information. Negotiates payment by the project and on freelancer's previous experience.

*****MOHAWK ADVERTISING**, 1307 6th St. SW, Mason City IA 50401. (515)423-1354. Ad agency. Vice President/Executive Art Director: Phillip Means. Clients: agricultural, industrial, business to business, consumer.
Needs: Works with 4 freelance photographers/month. Uses freelance photographers for consumer and trade magazines, direct mail, and catalogs.
Specs: Uses b&w prints; 2¼x2¼ and 4x5 transparencies.
First Contact & Terms: Query with samples; provide resume, business card, brochure, flyer or tearsheets to be kept on file for possible future assignments. Works with freelance photographers on assignment basis only. Does not return unsolicited material. Reports in 1 week. Pay per job negotiated. Pays on receipt of invoice. Buys all rights and one-time rights. Model release preferred. Credit line sometimes given.

Kansas

MARKETAIDE, INC., Box 500, Salina KS 67402. (913)825-7161. Production Manager: Dennis Katzenmier. Ad agency. Uses all media. Serves industrial, retail, financial, agribusiness and manufacturing clients. Needs photos of banks, agricultural equipment, agricultural dealers, custom applicators and general agricultural subjects. Buys all rights. "We generally work on a day rate ranging from $200-1,000/day." Pays within 30 days of invoice. Call to arrange an appointment. Provide resume and tearsheets to be kept on file for possible future assignments. Reports in 3 weeks. SASE.
Tips: Photographers should have "a good range of equipment and lighting, good light equipment portability, high quality darkroom work for b&w, a wide range of subjects in portfolio with examples of processing capabilities." Prefers to see "set-up shots, lighting, people, heavy equipment, interiors, industrial and manufacturing" in a portfolio. Prefers to see "8x10 minimum size on prints, or 35mm transparencies, preferably unretouched" as samples.

PATON & ASSOCIATES, Box 7350, Leawood KS 66207. (913)491-4000. Contact: N.E. (Pat) Paton, Jr. Ad agency. Clients: medical, financial, home furnishing, professional associations, vacation resorts.
Needs: Works with freelance photographers on assignment only basis. Uses freelancers for billboards, consumer and trade magazines, direct mail, newspapers, P-O-P displays and TV.
First Contact & Terms: Call for personal appointment to show portfolio. Negotiates payment based on amount of creativity required from photographer.

STEPHAN ADVERTISING AGENCY, INC., 247 N. Market, Wichita KS 67202. (316)265-0021. Art Director: Jack Billinger. Ad agency. Uses billboards, consumer and trade magazines, direct mail, newspapers, P-O-P displays, radio and TV. Serves clients in retail, industry, finance and fashion. Works with approximately 5 freelance photographers/month on assignment only basis. Provide business card, tearsheets, brochure and rates (hourly, day, etc.).

Specs: Uses b&w and color prints and color transparencies. Also does a lot of videotape and film production. "Filmmakers should contact Gini Johnson."
Payment & Terms: Negotiates payment based on client's budget and where the work will appear. Buys all rights. Model release required, captions preferred.
Making Contact: Arrange a personal interview to show portfolio or query with list of stock photo subjects. Prefers to see samples of product (food, industrial, people, fashion). SASE. Prefers local freelancers. Reports in 1 month.
Tips: "Have solid experience in working with agencies and art directors. Be very comfortable in working with models—both professional and nonprofessional types, i.e., employees of our clients, etc."

TRAVIS/WALZ & ASSOCIATES, 8417 Sante Fe Dr., Overland Park KS 66212. (913)341-5022. Ad agency. Vice President/Creative Director: Gary R. Otteson. Clients: financial, utilities, insurance, consumer products, political, associations.
Needs: Works with 4-5 freelance photographers/month. Uses photographers for billboards, consumer and trade magazines, direct mail, P-O-P displays, brochures, catalogs, posters, newspapers, AV presentations. Subjects include location and product shots. Also uses freelance filmmakers to produce TV commercials.
First Contact & Terms: Arrange a personal interview to show portfolio. Works with local freelancers primarily. SASE. Payment by the job; "depends on the individual job budget." Pays on completion of job. Buys all rights or negotiates rights by contract. Model release required.
Tips: Prefers to see "entire range of photographic capabilities" in a portfolio. Photographers should "show us in person their work, including published work."

Kentucky

MCCANN-ERICKSON, 1469 S. 4th St., Louisville KY 40208. (502)636-0441. Creative Director: Todd Hoon. Ad agency. Serves clients in health care, retailing, manufacturing and transportation.
Needs: Uses mostly local freelance photographers. Works with out-of-town freelance photographers on assignment only basis. Uses photographers for all printed media and TV.
First Contact & Terms: Call for appointment to show portfolio or make contact through artist's rep. Negotiates payment based on project. Rights individually negotiated.

Louisiana

BAUERLEIN, INC., 615 Baronne, New Orleans LA 70113. (504)522-5461. Senior Art Director: Phillip Collier. Ad agency. Serves clients in finance, food, transportation.
Needs: Works with 3-4 photographers/month. Uses freelancers for consumer and trade magazines, brochures/flyers and newspapers.
First Contact & Terms: Call an art director and arrange for appointment to show portfolio (wants to see variety) or send resume and follow up with a call to an art director. Be able to provide samples to be kept on file for possible future assignments.

HERBERT S. BENJAMIN ASSOCIATES, 2736 Florida St., Box 2151, Baton Rouge LA 70821. (504)387-0611. Creative Director: Gus Wales. Ad agency. Clients: diversified including dairy, financial and industrial, heavy in food and beverage, some fashion and some jewelry.
Needs: Works with 10 freelance photographers/year. Uses photographers for industrial trade and business journals, TV, newspapers, magazines and brochures/flyers. Provide business card to be kept on file for possible future assignments.
First Contact & Terms: Send samples, then call for appointment to show portfolio. Negotiates payment based on photographer's rate sheet, client's budget and amount of creativity required. Payment generally is $500-1,200/day; or $150-5,000/job.
Tips: Prefers to see color but also uses b&w prints; prefers to see product (beauty), architectural and industrial shots.

CARTER ADVERTISING, INC., 800 American Tower, Shreveport LA 71101. (318)227-1920. Ad agency. Creative Director: Fair Hyams. Serves a broad range of clients.
Needs: Works with 3-4 freelance photographers/month. Uses photographers for consumer and trade magazines, billboards, brochures, newspapers, and AV presentations. "No specific style or subject matter. It will vary as per the specifications of the job." Also works with freelance filmmakers to produce TV commercials.

Specs: Uses 35mm and large format still-photography and videotape.
First Contact & Terms: Provide resume, business card, brochure, flyer or tearsheets to be kept on file for possible future assignments. Works with freelance photographers on assignment basis only. SASE. Reports in 1 week. Payment "depends upon the job—we prefer paying by the job." Pays in 30 days. Model release preferred. Credit line "not given unless previously negotiated."
Tips: In a portfolio, prefers to see "creativity, originality, attention to detail. *Special* attention to lighting. Show high quality work done on other jobs—we are concerned with *quality*, not *quantity*."

DUKE UNLIMITED, Suite 205, Concourse Place, 1940 Interstate 10 Service Rd., Kenner LA 70065. (504)464-1891. Ad agency/PR firm. Art Director: Anne Esposite. Clients: hospitals, industrial, hotel, restaurant, financial, real estate development.
Needs: Works with 1-2 freelance photographers/month. Uses photographers for billboards, consumer and trade magazines, P-O-P displays, brochures, catalogs, signage, newspapers and AV presentations. Subjects include: people, industrial, housing, food. Also works with freelance filmmakers to produce TV commercials.
Specs: Uses 8x10 glossy b&w and color prints; 35mm and 2¼x2¼ and 4x5 transparencies; 16mm and 35mm film and videotape.
First Contact & Terms: Arrange a personal interview to show portfolio or send unsolicited photos by mail for consideration; provide resume, business card, brochure, flyer or tearsheets to be kept on file for possible future assignments. Works with freelance photographers on individual assignment, hourly or daily. SASE. Reports in 2 weeks. Pays/job. Pays on publication. Buys all rights. Model release required.
Tips: Prefers to see "a neat, concise package including a list of credits and resume. If possible, a basic price sheet. It is important that it all be in one neat package." Looks for work that will reproduce well and photographers who do consistently good work. Ability and desire to work with art director. Ability to light so that work looks uniform (especially when several shots will be used together in a brochure or ad).

RICHARD SACKETT EXECUTIVE CONSULTANTS, Suite 404, 8600 Pontchartrain Blvd., New Orleans LA 70124. (504)282-2568. Ad agency. Art Director: Shawn Nevyen. Clients: industrial, optical, retail, real estate, hotel, shopping center management, marine. Client list free with SASE.
Needs: Works with 3 photographers/month. Uses photographers for billboards, consumer and trade magazines, direct mail, P-O-P displays, posters, newspapers. Subject matter includes merchandise, places, scenery of the city, scenery of the sites of construction, mood photos.
Specs: Uses 35mm, 4x5 and 8x10 transparencies.
First Contact & Terms: Arrange a personal interview to show portfolio; send unsolicited photos by mail for consideration. Works with freelance photographers on an assignment basis only. SASE. Reports in 1 week. Pays $600-1,000/day and $3,000-40,000/job. Pays on publication or on receipt of invoice. Buys all rights. Model release required. Credit line given when appropriate.

Maryland

EISNER & ASSOCIATES, INC., 12 W. Madison St., Baltimore MD 21201. (301)685-3390. Senior Art Director: Steve Parks. Ad agency. Uses billboards, consumer and trade magazines, direct mail, newspapers, P-O-P displays, radio and TV. Serves clients in fashion, food, entertainment, real estate, health, recreation and finance. Works with 3-4 freelance photographers/month on assignment only basis. Provide brochure to be kept on file for possible future assignments.
Specs: Uses b&w photos and color transparencies. Also uses 35mm, 16mm film and videotape for 30 second commercials.
Payment & Terms: Negotiates payment based on client's budget and where the work will appear. Buys all rights or negotiates rights. Model release preferred.
Making Contact: Arrange for a personal interview to show portfolio. Prefers to see samples of experimental work (either still life or people-oriented photos) and tearsheets in a portfolio. SASE. Prefers local freelancers. Reports in 1 week.

HOTTMAN EDWARDS ADVERTISING, 1003 N. Calvert St., Baltimore MD 21202. (301)385-1443. Senior Art Director: Mike Hohner. Ad agency. Clients: industrial, financial, food and real estate firms; client list provided upon request.
Needs: Works with 6-8 freelance photographers/year on assignment only basis. Uses photographers for all media.
First Contact & Terms: Arrange interview to show portfolio; prefers phone call initially. Payment is by the project; negotiates according to client's budget.

MEDIA MATERIALS, INC., 2936 Remington Ave., Baltimore MD 21211-2891. (301)235-1700. Marketing Production Manager: C.M. Szczech. Clients: elementary and secondary educators, administrators.

Needs: Works with 2 photographers/year. Uses photographers for catalogs and print brochures. Subjects include product photography (books, cassette tapes, computer accessories); subject photography (students, teachers, etc.).

Specs: Uses 5x7 glossy b&w prints and 4x5 transparencies.

First Contact & Terms: Provide resume, business card, self-promotion piece or tearsheets to be kept on file for possible future assignments. Works with local freelancers only; interested in stock photos/footage. SASE. Reports in 2 weeks. All jobs are bid individually. Pays within 30 days of receiving completed prints, transparencies, etc. Buys all rights. Model release required.

SHECTER & LEVIN ADVERTISING/PUBLIC RELATIONS, 2205 N. Charles St., Baltimore MD 21218. (301)889-4464. Ad agency and PR firm. Production Manager: V. Lindler. Clients: "varied—no fashion." Client list provided on request.

Needs: Works with freelance photographers. Uses photographers for consumer magazines, direct mail, posters, and newspapers. Subject needs varied. Also works with freelance filmmakers to produce TV commercials.

First Contact and Terms: Provide resume, business card, brochure, flyer or tearsheets to be kept on file for possible future assignments. Prefers to work with local freelance photographers. Does not return unsolicited material. Pay varies. Pays on publication. Buys one-time rights. Model release required. Credit line given "if demanded."

THOMPSON RECRUITMENT ADVERTISING, 1111 N. Charles St., Baltimore MD 21201. (301)385-0800. Ad agency. Associate Creative Director: Karen Kerski. Clients: industrial, finance, computer—all recruitment.

Needs: Works with 1-2 freelance photographers every six months. Uses photographers for consumer and trade magazines, brochures, catalogs, posters, newspapers, and AV presentations. Subjects include people.

Specs: Flexible.

First Contact & Terms: Provide resume, business card, brochure, flyer or tearsheets to be kept on file for possible future assignments. Works with freelance photographers on assignment basis only. SASE. Reports in 3 weeks to 1 month. Payment varies with budget. Pays as soon as possible. Buys all rights. Model release required.

Tips: Prefers to see "people shots" in portfolio. Photographer should demonstrate "flexibility and the ability to work within our budget."

VAN SANT, DUGDALE & COMPANY, INC., The World Trade Center, Baltimore MD 21202. (301)539-5400. Creative Director: J. Stanley Paulus. Ad agency. Clients: corporations, consumer products and services, associations and industrial firms; "very wide range" of accounts; client list provided upon request.

Needs: Works on assignment only basis. Negotiates with photographers on each assignment based on the individual job and requirements. Uses photographers for consumer and trade magazines, brochures, catalogs, newspapers and AV presentations.

First Contact & Terms: Local freelancers only. Query with resume and follow up with personal appointment. Payment negotiated depending upon job.

Tips: "The freelancer should make a showing of his/her work to all our art directors and continue to keep us reminded of his/her work from time to time. Interviews and personal appointments not necessary."

Massachusetts

ALLIED ADVERTISING AGENCY, INC., 800 Statler Bldg., Boston MA 02116. (617)482-4100. Ad agency. Production Manager: Dave Drabkin.

Needs: Works with 6 freelance photographers/month. Uses photographers for billboards, consumer and trade magazines, direct mail, P-O-P displays, brochures, catalogs, posters, signage, newspapers, AV presentations, packaging, and press releases. Subject needs "too varied to list one particular type. About 70% industrial, 25% consumer/retail, 5% PR." Also works with freelance filmmakers to produce TV commercials, industrial films, P-O-P film loops.

Specs: Uses 8x10 RC and glossy b&w prints; 4x5, 8x10 color transparencies for studio work; 16mm, 35mm and videotape film.

First Contact & Terms: Arrange a personal interview to show portfolio. Works with freelance photographers on assignment basis only. Pays $60-150/hour, $600-3,000/day or $100-2,500/photo. Pays on acceptance. Buys all rights. Model release required. Credit line "usually not" given.
Tips: In a portfolio, prefers to see "cross section of types of photography that the photographer feels he/she handles most easily. Photographers are matched by their strong points to each assignment. Keep agency updated as to new projects."

ARNOLD & COMPANY, Park Sq. Bldg., Boston MA 02116. (617)357-1900. Executive Creative Director: Wilson Siebert. Art Director: Len Karkavsok. Ad agency. Clients: fast food, financial and computer firms.
Needs: Works with 6-8 freelance photographers/month. Uses photographers for all media.
First Contact & Terms: Arrange interview to show portfolio; query with "good" samples. Negotiates payment according to client's budget and where work will appear.
Tips: "Don't show a lot of work in your portfolio—only your best."

BLACK & MUSEN, INC., Box 465, East Longmeadow MA 01028-0465. (413)567-0361. Ad agency. Art Director: Victor Brisebois. Clients: industrial, fishing, hunting, greeting cards, stationery, sports, fashion (men's and women's).
Needs: Works with 3-4 photographers/month. Uses photographers for consumer and trade magazines, direct mail, catalogs, newspapers, and literature. Subject matter includes boys, girls, teenagers, sports, industrial, product, fishing, hunting and fashion.
Specs: Uses b&w prints; 35mm, $2^1/4$x$2^1/4$, 4x5 and 8x10 transparencies.
First Contact & Terms: Arrange a personal interview to show portfolio; provide resume, business card, brochure, flyer or tearsheets to be kept on file for possible future assignments. Works with freelance photographers on an assignment basis only. Does not return unsolicited material. Reports in 3 weeks. Pays $35-90/hour; $400-750/day; $100-500/job; and $50-300/photo. Buys all rights. Model release required. Credit line negotiable.

ELBERT ADVERTISING AGENCY, INC., Box 8150, Zero Walpole St., Norwood MA 02062-9109. (617)769-7666. Production Manager: Gary Taitz. Ad agency. Uses all media. Serves clients in fashion and industry. Needs photos of food, fashion and industry; and candid photos. Buys up to 600 photos/year. Pays $25 minimum/hour. Call to arrange an appointment or submit portfolio. Reports in 1 week. SASE.
B&W: Uses 8x10 semigloss prints; contact sheet OK.
Color: Uses prints and 35mm or $2^1/4$x$2^1/4$, 4x5 and 11x14 transparencies.

FRANKLIN ADVERTISING, 88 Needham St., Newton MA 02161. (617)244-8368. Art Director: Donna Knauer. Contact: Debbie Campbell. Ad agency. Clients: mostly industrial, some consumer firms (fashion catalog and furniture).
Needs: Works with 1-2 freelance photographers/month. Uses photographers for consumer and trade magazines, direct mail, brochures, catalogs and newspapers.
First Contact & Terms: Arrange interview to show portfolio. Payment is by the hour or by the project.

HBM/CREAMER, 1 Beacon St., Boston MA 02108. (617)723-7770. Contact: Anne Blevins. Ad agency. Clients: consumer, financial and high tech. Client list provided upon request.
Needs: Works with freelance photographers on assignment basis.
First Contact & Terms: Send sample and follow up with phone call to art buyer. Payment is usually based on type of work involved.

RAYMOND KOWAL & WICKS, One Broadway, Cambridge MA 02142. (617)354-0900. PR firm. Public Relations Associate: B. Gillis. Clients: industrial, business-to-business and consumer.
Needs: Uses 3-5 freelance photographers/month. Uses photographers for newspapers, trade magazines and brochures. Subject matter and style "varies widely depending on assignment from clients."
Specs: Uses primarily b&w prints; 35mm, $2^1/4$x$2^1/4$ and 4x5 transparencies.
First Contact & Terms: "We work with freelancers on an assignment basis only." Reports in 3 weeks. Payment varies "according to nature of job and needs of clients." Pays 45 days from invoice. "Net 30 days is our standard policy for rights. We like to have access to the negatives should future shots/prints be needed." Model release and captions required. Credit line "usually not" given.
Tips: "Drop us a note with some type of work sample. Do not telephone—anyone can telephone; good work is your best 'in.' We like to see product shots (in studio & on location—trade show, for instance), headshots (business), group shots, black & white and color shots, as well as tearsheets and high-tech product shots if available."

MILLER COMMUNICATIONS, INC., 607 Boylston, Copley Sq., Boston MA 02116. (617)536-0470. Production Manager: Maureen O'Rourke. PR firm. Handles high technology/computer accounts, computer communication. Photos used in press kits, consumer and trade magazines. Commissions 10 photographers/year. Pays $75 minimum/half day. Buys all rights. Model release preferred. Most interested in editorial type: photographs, head shots, creative product shots, user shots, equipment, and press conference coverage.
B&W: Uses contact sheet.
Color: Uses 2¼x2¼ transparencies or contact sheet and negatives.
Tips: "Select a product the agency is representing and make up a portfolio showing this particular product from the simplest photography to the most sophisticated image-builder. Photographers we need must be thinkers, philosophers, not impulsive types who take 600 slides from which we can select 1 or 2 good pictures."

PELLAND ADVERTISING ASSOCIATES, Box 878, Springfield MA 01101. (413)737-1474. Ad agency. Contact: Peter Pelland. Clients: recreation, sports and leisure industries (e.g., ski resorts, family campgrounds, fitness clubs, amusement parks and country inns.)
Needs: Works with 2-4 freelance photographers/month. Uses photographers primarily for brochures. Subject matter is "resorts at assigned locations throughout the United States. Stock material used only occasionally."
Spec: Uses 35mm or larger transparencies. Prefers Kodachrome.
First Contact & Terms: Submit resume with appropriate samples and SASE, for potential personal interview—prerequisite to assignment. Works with freelance photographers on assignment basis only. SASE. Reports in less than 1 month. Pays $250/day; or $250/job. "The typical job requires 1 day of photography. Limited expenses are also paid for travel and lodging. Film and processing will be provided or expenses reimbursed." Pays within 30 days of receipt of completed work with invoice. Buys specific rights; additional rights may be negotiated. Model release required. Credit line given "occasionally, if appropriate to the product."
Tips: "Excel technically and compositionally, have a good working rapport with the public, and try to understand the specific marketing challenges of our clients—and transform all of that into quality photographs. We look for portfolios that include properly composed and exposed Kodachrome originals representing a cross-section of appropriate discipline: landscapes, sport, architecture, candids, interiors, food. N. color prints, portraits, or wedding albums. Above all, you must be thoroughly professional in attitude and appearance if you are to, even briefly, represent yourself as a member of our team."

WINARD ADVERTISING AGENCY, INC., 343 Pecks Rd., Pittsfield MA 01201. (413)445-5657. Ad agency. President: Bill Winslow. Uses billboards, consumer and trade magazines, direct mail, foreign media, newspapers, P-O-P displays and radio. Serves clients in industry, finance, manufacturing (wallpaper, coffee pots, sewing threads, trucks, paper), and housing developments. Works with 1 freelance photographer/month on assignment only basis. Provide resume and samples to be kept on file for possible future assignments. Pays $50 minimum/hour; $225 minimum/day; negotiates payment based on client's budget. Pays on acceptance. Buys all rights. Model release and captions preferred. Arrange personal interview to show portfolio. Prefers to see samples of studio merchandise shots and on location industrial shots (plants, machinery, etc.) in a portfolio. Will view unsolicited material. Local freelancers preferred. SASE. Reports in 2 weeks.
B&W: Uses 8x10 and 11x14 matte prints.
Color: Uses 8x10 matte prints and 35mm or 4x5 transparencies.

Michigan

CORPORATE COMMUNICATIONS, INC.,2950 E. Jefferson Ave., Detroit MI 48207. (313)259-3585. Ad and PR agency. Production Manager: Patrick Longe. Clients: healthcare, consumer products, industrial.
Needs: Works with 1-5 freelance photographers/month. Uses photographers for direct mail, catalogs, AV presentations, trade magazines and brochures. Subjects include clients' products. Also works with freelance filmmakers to produce videotapes for training and sales promotion.
Specs: Uses b&w and color prints; 35mm and 2¼x2¼ and 4x5 transparencies; 16mm and 35mm films and videotapes.
First Contact & Terms: Provide resume, business card, brochure, flyer or tearsheets to be kept on file for possible future assignments. Works with freelance photographers on assignment basis only. Does not return unsolicited material. Pays $40-100/hour; $250-600/day. Pays on acceptance. Buys all rights. Model release required; captions preferred.

Tips: Prefers to see an "all-around capability" in a photographer's samples. Photographer should also supply "clear, well-written materials."

CREATIVE HOUSE ADVERTISING, INC., Suite 200, 24472 Northwestern Hwy., Southfield MI 48075. (313)353-3344. Sr. Vice President/Executive Creative Director: Robert G. Washburn. Ad agency. Uses billboards, consumer and trade magazines, direct mail, newspapers, P-O-P displays, radio and TV. Serves clients in retailing, industry, finance, commercial products. Works with 2-3 freelance photographers/month on assignment only basis.
Needs: Uses b&w and color prints and transparencies. Also produces TV commercials (35mm and 16mm film) and demo film to industry. Does not pay royalties.
First Contact & Terms: Provide resume, business card, brochure, flyer and anything to indicate the type and quality of photos to be kept on file for future assignments. Pays $50-70/hour or $500-800/day; negotiates payment based on client's budget and photographer's previous experience/reputation. Pays in 1-4 months, depending on the job. Buys all rights. Model release required. Arrange personal interview to show portfolio; query with resume of credits, samples, or list of stock photo subjects; submit portfolio for review ("Include your specialty and show your range of versatility"); or send material by mail for consideration. Local freelancers preferred. SASE. Reports in 2 weeks.

DALLAS C. DORT AND CO., 815 Citizen's Bank Bldg., Flint MI 48502. (313)238-4677. President/Creative Director: Dallas C. Dort. Ad agency. Uses all media except foreign. Serves food, health care, retail and travel clients. Works with freelance photographers on assignment basis only approximately 10 times/year.
B&W: Uses prints; specifications per assignment.
Color: Uses prints and film; specifications per assignment.
First Contact & Terms: Send resume and samples to be kept on file for possible future assignments. Buys all rights. "We outline the job to the photographer, he quotes on the job and it is billed accordingly." Submit portfolio. SASE. Reports in 2 weeks.

***THE GAINOR COMPANY, INC.**, 404 Penobscot Building, Detroit MI 48226. (313)963-9441. PR firm. President: Paul E. Gainor. Clients: industrial, communication, utilities, manufacturing, companies.
Needs: Works with 2 freelance photographers/month. Uses photographers for direct mail and newspapers. Subjects include head shots, illustrations for news releases.
Specs: Uses 8x10 b&w glossy and 35mm transparencies.
First Contact & Terms: Arrange a personal interview to show portfolio. Works with freelance photographers on an assignment basis only. SASE. Pays according to fee schedule submitted. Pays when client pays. Buys all rights and one-time rights.
Tips: Prefers to see a PR/photo, journalistic style in samples submitted.

T.S. JENKINS & ASSOCIATES, Suite 200, 400 N. Saginaw, Flint MI 48502. (313)235-5654. Ad agency. Art Director: Jack LeSage. Clients: industrial, retail, financial, cultural, education. Client list free with SASE. Works with 2 photographers/month. Uses photographers for billboards, consumer and trade magazines, direct mail, P-O-P displays, catalogs, posters, signage and newspapers. Subject matter varies.
Specs: Uses 8x10 contact sheets, and 35mm, 2¼x2¼ and 4x5 transparencies.
First Contact & Terms: Arrange a personal interview to show portfolio; provide resume, business card, brochure, flyer or tearsheets to be kept on file for possible future assignments. Works with local freelance photographers on an assignment basis only. Reports in 3 weeks. Payment based on photographer's fee. Buys all rights. Model release required. Credit line given.

***MISAMORE ADVERTISING & PUBLIC RELATIONS**, 506 Waters Bldg., Grand Rapids MI 49503. (616)458-1458. Ad agency. Art Director: George Rozinski. Clients: industrial, business to business. Client list free with SASE.
Needs: Works with 4-5 freelance photographers/month. Uses photographers for trade magazines, direct mail, P-O-P displays, catalogs, posters, AV presentations, case history articles. Subjects include products, illustrative, facilities, etc.
Specs: Uses all sizes b&w and color prints; 35mm, 2¼x2¼, 4x5, 8x10 transparencies, "all depending on situation."
First Contact & Terms: Query with resume of credits and samples; provide resume, business card, brochure, flyer or tearsheets to be kept on file for possible future assignments. Works with freelance photographers on an assignment basis only. Does not return unsolicited material. Reports in 1 week. Pays $50-200/hour; $300-1,500/day; $150/b&w photo; $600/color photo. Pays within 30 days. Buys all rights. Model release required.

Tips: Prefers to see industrial, products. "Please send letter, credentials, and samples printed if available."

PHOTO COMMUNICATION SERVICES, INC., 6410 Knapp, Ada MI 49301. (616)676-1499. Commercial/Illustrative and AV firm. President: Michael Jackson. Clients: commercial/industrial, fashion, food, general, human interest.
Needs: Works with variable number of freelance photographers/month. Uses photographers for catalogs, P-O-P displays, AV presentations, trade magazines and brochures. Photographers used for a "large variety of subjects." Sometimes works with freelance filmmakers.
Specs: Uses 8x10 gloss and semigloss b&w and color prints (or larger); 35mm, 2¼x2¼, 4x5 and 8x10 transparencies; 16mm film and videotapes.
First Contact & Terms: Query with resume of credits, samples or list of stock photo subjects. Works with freelance photographers on assignment basis only. SASE. Reports in 1 month. Pays by "private" agreement (project-oriented). Pays 30 days from acceptance. Buys all rights or one-time rights. Model release required. Credit line given "whenever possible."
Tips: "If we are interested we will send guidelines. We also have a library of stock photography and can be reached on the (SOURCE BBH782) and (PhotoNet PHO1289) or MCI mail (ID 247-7996) via your computer or Western Union Easylink (62909611)."

This photo was used for a poster series for Florist's Transworld Delivery Association. The series consisted of four posters, each designed to sell specific holiday bouquets in specific holiday periods. Photographer Dennis Wiand, Midcoast Studios, was assigned the promotional series by Jim Parker, Ross Roy art director. "We worked together on previous FTD projects— Dennis' understanding of the requirements of the client, as well as use of specialized strobe equipment, were a big assist on this appointment." The individual shot paid around $4,000.

***ROSS ROY, INC.**, 2751 E. Jefferson, Detroit MI 48207. (313)568-6000. Ad agency. Creative Coordinator: Sheila O'Donnell. Clients: Chrysler, K-Mart, FTD, Ameritech, La-Z-Boy, state of Michigan.
Needs: Uses freelance photographers for billboards, consumer and trade magazines, P-O-P displays, catalogs, posters, and newspapers. Subjects include retail, corporate, fashion, automotive, product.
Specs: Uses 8x10, 11x14 matte b&w prints; 35mm, 2¼x2¼, 4x5, 8x10 "all formats" transparencies.
First Contact & Terms: Arrange a personal interview to show portfolio; provide resume, business card, brochure, flyer or tearsheets to be kept on file for possible future assignments. Works with freelance photographers on assignment only. Does not return unsolicited material. Pays $250-1,500/b&w photo; $300-2,500/color photo; $750-2,000/day. Pays on receipt of invoice. Buys all rights. Model release required.
Tips: Prefers to see lighting, design and a sense of style and individuality. Contact Sheila O'Donnell for list of art directors; contact art directors individually for interview, or send tearsheets, flyers, etc. if out-of-town. "We use photography extensively, but tend to use mostly local for advertising; out-of-town (location) for automotive. Be persistent in calling to set up the initial contact, but don't be pesky. Work looks best as a combination of laminated tearsheets and mounted transparencies."

Minnesota

***JOHN BORDEN ADVERTISING AGENCY**, #2, 2010 Marshill, St. Paul MN 55104. (612)644-3443.
Ad agency. Owner: John Borden. Clients: commercial, food, ice cubes, retail, industrial.
Needs: Works with 2 freelance photographers/month. Uses freelance photographers for consumer and
trade magazines, direct mail and posters. Subjects include ice cubes, ice cubes in use (and with models).
Specs: Uses 8x10 b&w and color prints; 4x5 transparencies.
First Contact & Terms: Query with samples; provide business card to be kept on file for possible
future assignments. Works with freelance photographers on assignment only. SASE. Reports in 3
weeks. Pay varies. Pays on publication. Buys all rights. Model release required; captions preferred.
Credit line sometimes given.

BUTWIN & ASSOCIATES ADVERTISING, INC., Suite 202, 3601 Park Center Blvd., Minneapolis
MN 55416. (612)929-8525. Ad agency. President: Ron Butwin. Clients: industrial, retail, corporate.
Needs: Works with 1-2 freelance photographers/month. Uses photographers for billboards, direct
mail, catalogs, newspapers, consumer magazines, P-O-P displays, posters, AV presentations, trade
magazines, brochures and signage. Uses "a wide variety" of subjects and styles. Also works with
freelance filmmakers to produce TV commercials and training films.
Specs: Uses all sizes b&w or color prints; 35mm and 2¼x2¼, 4x5 and 8x10 transparencies; 16mm film
and videotape.
First Contact & Terms: Provide resume, business card, brochure, flyer or tearsheets to be kept on file
for possible future assignments. "We work with local freelancers only." Does not return unsolicited
material. Buys all rights. Model release required. Credit line sometimes given.

CARMICHAEL-LYNCH, INC., 100 E. 22nd St., Minneapolis MN 55404. (612)871-8300. Ad agency.
Creative Art Directors: Dan Krumwiede, Dick Wilson and Ron Sackett. Art Buyer: Larry Haataja.
Clients: recreational vehicles, food, finance, wide variety. Client list provided on request.
Needs: Uses "maybe 8" freelance photographers/month. Uses photographers for billboards,
consumer and trade magazines, direct mail, P-O-P displays, brochures, posters, newspapers, and other
media as needs arise. Also works with freelance filmmakers to produce TV commercials.
Specs: Uses b&w and color prints; 35mm, 2¼x2¼, 4x5 and 8x10 transparencies; 16mm and 35mm
film and videotape.
First Contact & Terms: Provide resume, business card, brochure, flyer or tearsheets to be kept on file
for possible future assignments; submit portfolio for review; arrange a personal interview to show
portfolio; works with freelance photographers on assignment basis only. Reports in 1 week. Pay
depends on contract; $400-2,500/day, $200-2,500/job. Pays on acceptance. Buys all rights or one-time
rights, "depending on agreement." Model release required.
Tips: "Be close at hand (Minneapolis, Detroit, Chicago). In a portfolio, we prefer to see the
photographer's most creative work—not necessarily ads. Show only your most technically, artistically
satisfying work."

***THE COMMUNICATIONS GROUP**, 227 Shelard Plaza S., Minneapolis MN 55426. (612)544-2115.
Ad agency. Senior Art Director: Chuck Abrams. Clients: industrial, retail. Client list free with SASE.
Needs: Works with 1-2 freelance photographers/month. Uses photographers for billboards, consumer
and trade magazines, direct mail, P-O-P displays, posters and newspapers. Subjects include product and
models.
Specs: Uses 8x10 matte b&w and color prints; 2¼x2¼, 4x5, 8x10 transparencies.
First Contact & Terms: Arrange a personal interview to show portfolio. Does not return unsolicited
material. Reports in 2 weeks. Pay "depends on job." Pays on receipt of invoice. Buys all rights. Model
release required.
Tips: Prefers to see good lighting, drama, creativity. "Be persistent."

FABER SHERVEY ADVERTISING, 160 W. 79th, Minneapolis MN 55420. President: Paul Shervey. Ad
agency. Clients: industrial, agricultural, consumer accounts. Photos used in advertising, sales literature
and brochures. Buys 40-50 annually. Submit model release with photo. Submit material by mail on
request for consideration. Prefers to see industrial, agricultural and on-location machinery. SASE.
Provide resume, brochure, and tearsheets to be kept on file for possible future assignments.
B&W: Uses 8x10 glossy prints; send contact sheet. Pays $60-400.
Color: Send 2¼x2¼ transparencies or contact sheet. Pays $60-500.

STU GANG & ASSOCIATES INC., Mears Park Place, 120 On The Courtyard, St. Paul MN 55101.
(612)224-4324. Director/Creative Communications: Dean Anderson. Ad agency and PR firm. Photos

used in brochures, newspapers, annual reports, catalogs, PR releases and magazines. Works with 2-3 freelance photographers/month on assignment only basis. Provide resume, tearsheets and samples to be kept on file for future assignments. Pays $25-75/hour; negotiates payment based on client's budget and the amount of creativity required from photographer. Buys all rights. Model release preferred. Photos purchased on assignment only. SASE. Reports in 1 week. "All freelance photos are based on our specific assignments only. Jobs may involve anything from steel construction to a bank promotion."
B&W: Uses 8x10 glossy prints; contact sheet OK.
Color: Uses 8x10 glossy prints and 2¼x2¼ and 4x5 transparencies; contact sheet OK.
Film: 16mm for TV commercials and educational and corporate films. Filmmaker might be assigned anything from a 30-second television spot to a half-hour lip-sync sound film.
Tips: "Currently, we have five photographers we consistently work with, but we're not locked in."

GREY ADVERTISING, Midwest Plaza Bldg. E., Minneapolis MN 55402. (612)341-2701. Executive Vice President/Creative Director: Don Moravick. Associate Creative Director: Ron Newman. Ad agency. Annual billing: $23 million. Clients: retailers, manufacturers, TV, airline, financial institutions and health organizations.
Needs: Works with 3-10 freelance photographers/month. Uses freelancers for billboards, consumer and trade magazines, brochures/flyers, newspapers, P-O-P displays, catalogs, direct mail and TV.
First Contact & Terms: Call or write requesting appointment to show portfolio. Selection based on reputation and references. "We don't buy a lot of out-of-town freelance photos." Negotiates payment based on client's budget.
Tips: Wants to see best work; prefers color transparencies but will look at b&w, color prints and samples of published work. "Show us specific assignments that demonstrate problem solving ability and understanding of clients' needs or present photos done as self-promotion that demonstrate creativity, skill. Develop a style or area of specialization that will give you a unique niche; it helps people remember you in a business crowded with talent."

MARTIN-WILLIAMS ADVERTISING INC., 10 S. 5th St., Minneapolis MN 55402. (612)340-0800. Ad agency. Production Coordinator: Lyle Studt. Clients: industrial, retail, finance, agricultural, business-to-business, food. Client list free with SASE.
Needs: Works with 6-12 photographers/month. Uses photographers for billboards, consumer and trade magazines, direct mail, catalogs, posters and newspapers. Subject matter varies.
Specs: Uses 8x10 and larger b&w and color prints, 35mm, 2¼x2¼, 4x5 and 8x10 transparencies.
First Contact & Terms: Arrange a personal interview to show portfolio; provide resume, business card, flyer or tearsheets to be kept on file for possible future assignments. Works with freelance photographers on an assignment basis only. SASE. Reports in 2 weeks. Payment individually negotiated. Pays $400-1,500/b&w photo; $500-2,000/color photo; $900-1,300/day. Pays on receipt of invoice. Buys one-time rights. Model release required.
Tips: Looks for "everything—no fashion. High quality work."

***RAINBOLT & BROWN, INC.**, +415m 430 1st Ave. N., Minneapolis MN 55401. (612)339-1535. PR firm. President: Rob Brown. Clients: industrial, retail, fashion, architectural. Client list provided with SASE.
Needs: Works with "1 freelance photographer for almost everything we do." Uses freelance photographers for consumer and trade magazines, direct mail, posters and newspapers. Subjects include photograph events, e.g., ribbon-cuttings, galas, executives, committees.
Specs: "Varies depending on usage."
First Contact & Terms: Arrange a personal interview to show portfolio. Works with local freelancers only. Does not return unsolicited material. Reports in 2 weeks depending on job. Pays by the job "depending on our client." Pays when billed to client—usually 30 days.
Tips: Prefers to see photographers's crowd shots, business executives, buildings, etc. The ability to know what are appropriate shots at an event. Schedule a meeting to show portfolio including above.

RUHR/PARAGON INC., (formerly Chuck Ruhr Advertising, Inc.), 1221 Nicollet Mall, Minneapolis MN 55403. (612)332-4565. Creative Directors: Doug Lew and Bob Phacker. Ad agency. Clients: consumer and industrial firms; client list provided upon request.
Needs: Works with 6-8 freelance photographers/year on assignment only basis. Uses photographers for all media.
First Contact & Terms: Send printed mail—in, small index form. Negotiates payment according to client's budget; then the amount of creativity, where work will appear and previous experience are taken into consideration.

VANGUARD ASSOCIATES, INC., Suite 485, 15 S. 9th St., Minneapolis MN 55402. (612)338-5386. Contact: Creative Director. Ad agency. Clients: government, consumer, fashion, food.

Needs: Uses photographers for billboards, consumer and trade magazines, direct mail, P-O-P displays, brochures, posters, newspapers, multimedia campaigns and AV presentations. Payment is by the project; negotiates according to client's budget.

Mississippi

MARIS, WEST, & BAKER ADVERTISING, 5120 Galaxie Dr., Jackson MS 39211. (601)362-6306. Ad agency. Executive Art Director: Jimmy Johnson. Clients: financial, food, life insurance.
Needs: Uses photographers for billboards, consumer and trade magazines, direct mail, P-O-P displays, brochures, catalogs, posters, newspapers and AV presentations. Subjects include: food, table tops, outside. Also uses freelance filmmakers for TV commercials and training films.
Specs: Uses 11x14 b&w prints; 4x5 and 8x10 transparencies; 16mm and 35mm film and videotape.
First Contact & Terms: Submit portfolio for review. Works with freelance photographers on assignment basis only. SASE. Reports in 2 weeks. Pays per hour or per day—"depends on type of photography." Payment on 30 to 60 day billing. Buys all rights. Model release required. Credit line given only if "entered in competition."
Tips: Prefers to see "good samples of food, table tops, outside, exhibiting good lighting techniques, composition and color. Be able to provide good service, excellent product at competitive price. Have positive attitude and be willing to experiment. We are always looking for excellent work and are conditioning most of our clients to want and pay for the same. Be available and punctual on getting back materials. Also be able to work under pressure a few times."

Missouri

***FRANK BLOCK ASSOCIATES**, Chase Park Plaza, St. Louis MO 63108. (314)367-9600. Art Director: Ray Muskopf. Ad agency. Clients: primarily industrial firms; client list provided upon request.
Needs: Works with 4 freelance photographers/month on assignment only basis. Uses photographers for billboards, consumer and trade magazines, direct mail, brochures, catalogs, posters, signage, newspapers, TV and AV presentations.
First Contact & Terms: Arrange interview to show portfolio. Negotiates payment by the project and on freelancer's ability.

AARON D. CUSHMAN AND ASSOCIATES, INC., Suite 900, 7777 Bonhomme, St. Louis MO 63105. (314)725-6400. Contact: Thomas L. Amberg. PR, marketing and sales promotion firm. Clients: real estate, manufacturing, travel and tourism, telecommunications, consumer products, corporate counseling.
Needs: Works with 3-5 freelance photographers/month. Uses photographers for news releases, special events photography, and various printed pieces. More news than art oriented.
First Contact & Terms: Call for appointment to show portfolio. Pays $50-100 b&w/photo; $50-250 color/photo; $50-100/hour; $350-750/day.
Tips: "We are using increasing amounts of architecturally oriented and health care-related stills."

EVERETT, BRANDT & BERNAUER, INC., 314 W. 24 Hwy., Independence MO 64050. (816)836-1000. Contact: James A. Everett. Ad agency. Clients: construction, finance, auto dealership, agribusiness, insurance accounts. Photos used in brochures, newsletters, annual reports, PR releases, AV presentations, sales literature, consumer and trade magazines. Usually works with 1-2 freelance photographers/month on assignment only basis. Provide resume and business card to be kept on file for possible future assignments. Buys 100 photos/year. Pays $35/b&w photo; $50/color photo; $50/hour; $200-400/day. Negotiates payment based on client's budget and amount of creativity required from photographer. Buys all rights. Model release required. Arrange a personal interview to show portfolio. Local freelancers preferred. SASE. Reports in 1 week.
B&W: Uses 5x7 prints.
Color: Uses prints and transparencies.
Tips: "We anticipate increased use of freelance photographers, but, frankly, we have a good working relationship with three local photographers and would rarely go outside of their expertise unless work load or other factors change the picture."

FLETCHER/MAYO, (formerly Barickman Advertising), 427 W. 12th St., Kansas City MO 64105. (816)421-1000. Contact: Art Directors. Ad agency. Uses all media except foreign. Serves industrial,

retail and consumer organizations, and producers of hard goods, soft goods and food. Provide brochure to be kept on file for possible future assignments. Pays $35-800/job. Pays on production. Call to arrange an appointment or submit portfolio showing unique and competent lighting and variety (agriculture, food, people); solicits photos by assignment only. SASE.
B&W: Uses 5x7, 8x10 or 11x14 prints.
Color: Uses transparencies or prints, will vary with need.

GEORGE JOHNSON ADVERTISING, 763 New Ballas Rd. S., St. Louis MO 63141. (314)569-3440. President: George Johnson. Ad agency. Uses all media except foreign. Clients: real estate, financial and social agencies. Works with 2 freelance photographers/month on assignment only basis.
First Contact and Terms: Provide resume and flyer to be kept on file for possible future assignments. Buys 25 photos/year. Pays $10-50/hour; negotiates payment based on client's budget and amount of creativity required. Pays in 60 days. Prefers to see working prints of typical assignments and tearsheets (application). Submit material by mail for consideration.

FLETCHER MAYO ASSOCIATES, John Glenn Rd., St. Joseph MO 64505. (816)233-8261. Ad agency. Vice President/Creative Director: Jim Gampper. Clients: industrial, agricultural, consumer and trade.
Needs: Works with 2-12 freelance photographers/month. Provide business card and brochure to be kept on file for possible future assignments. Uses freelancers for billboards, consumer and trade magazines, direct mail, newspapers, P-O-P displays and TV.
First Contact & Terms: "Write and request personal interview to show portfolio or send portfolio for review including actual photos that might be suited for our clients." Does not return unsolicited material. Reports in 2 weeks. Negotiates payment based on client's budget, photographer's previous experience/reputation and amount of creativity required.

MILLIKEN PUBLISHING COMPANY, 1100 Research Blvd., St. Louis MO 63132. (314)991-4220. Managing Editor: Carol Washburne. Clients: teachers.
Needs: Works with very few photographers. Uses photographers for slide sets. Photos are needed now and then for covers. Needs vary widely from shots of children to landscapes, folkdance, other countries, monuments, etc.
Specs: Uses 8x10 glossy color prints, and 35mm and 4x5 transparencies.
First Contact & Terms: Arrange a personal interview to show portfolio; query with stock photo list; provide resume, business card, self-promotion piece or tearsheets to be kept on file for possible future assignments. Works with local freelancers. SASE. Reports in 1 month. Pays on acceptance. Buys all rights. Captions preferred; model release required. Credit line given.

***SHOSS AND ASSOCIATES, INC.**, Suite 259, 1750 S. Brentwood Blvd., St. Louis MO 63144. (314)961-7620. "We are a business to business advertising agency." Production Manager: Jean Schonyers.
Needs: Works with 6 freelance photographers/month. Uses photographers for trade magazines, direct mail, brochures, and catalogs. Subjects include in-studio product photography; on location photography with models.
Specs: Uses 8x10 b&w or color prints; 2¼x2¼ and 4x5 transparencies.
First Contact & Terms: Arrange a personal interview to show portfolio. Provide resume, business card, brochure, flyer or tearsheets to be kept on file for possible future assignments. Works with freelance photographers on assignment basis only. Does not return unsolicited material. Reports in 2 weeks. Pays $50-250/hour; $100-800/day; $50-3,000/job; $25-30/b&w photo; $50-100/color photo (estimated only). "Our jobs are numerous—rates vary by job." Pays on acceptance. Buys all rights. "All photos become property of our clients." Model release required.
Tips: Prefers to see "b&w product shots—print or printed piece; 4-color product shots and 4-color shots for use in printed collateral material taken on location, i.e., manufacturing" in a portfolio. "We are using quality-oriented photographers that are cost-competitive."

SMITH & YEHLE, INC., 3217 Broadway, Kansas City MO 64111. (816)842-4900. Creative Director: Mike Gettino. Art Directors: Bill Ost, Myra Colbert. Ad agency. Clients: consumer, industrial, financial, retail and utility clients.
Needs: Works with 6-10 photographers/year. Uses photographers for billboards, newspapers, P-O-P displays, radio, TV.
Specs: Uses b&w photos and color transparencies. Also uses 16 and 35mm videotape for commercial TV and AV use.
Payment & Terms: Pays $100-1,500/b&w photo; $250-3,000/color photo; $50-85/hour; $750-1,500/day; $150/job; and 50% advance, 50% when completed for films. Model release required.

Making Contact: Arrange a personal interview to show portfolio; query with samples or list of stock photo subjects; provide business card and brochure to be kept on file for possible future assignments. SASE. Reports in 2 weeks.
Tips: "We look for clean, graphic shots—lots of b&w for ads, and need quick turnaround on short notice. We will pay well to get quality work. Typically, we use tape for lower budget jobs and/or training aids. We use film for 90% of our commercials. 75% of our clients are using video tape, 25% film, with all editing done on tape, rather than stills for promotional AV use. Know how to light and know composition. Let the action happen naturally in front of your lens. Don't force it. Direct the talent, they're paid to do what *you* want. Also, don't be simply a mechanic. Anyone can own a camera. Instead, be creative. Make suggestions. The people you're working for will love it. Then keep your promises, financially and creatively."

STOLZ ADVERTISING CO., 7701 Forsyth, St. Louis MO 63105. (314)863-0005. Contact: Art Department. Ad agency. Clients: consumer firms; client list provided upon request.
Needs: Works with 2 freelance photographers/month on assignment only basis. Uses photographers for billboards, consumer and trade magazines, direct mail, P-O-P displays, brochures, posters, newspapers and AV presentations.
First Contact & Terms: Works with local artists and out-of-town artists. Arrange interview to show portfolio or query with samples. Negotiates payment according to particular job.

VINYARD & LEE & PARTNERS, INC., 745 Old Frontenac Square, St. Louis MO 63131. (314)993-8080. Art Directors: Bob Chester, Vince Cook. Ad agency. Clients: food, finance, restaurants, retailing, consumer goods, produce, business, industry and manufacturing, health care, hospitals.
First Contact & Terms: Call for personal appointment to show portfolio. Negotiates payment based on client's budget, amount of creativity required from photographer, where work will appear and photographer's experience/reputation. "When there aren't set budgets, we set a price/hour."
Tips: "We like to see what you do best."

Montana

SAGE ADVERTISING, 2027 11th Ave., Box 1142, Helena MT 59624. (406)442-9500. Contact: Production Manager. Ad agency and PR firm. Clients: business, government agencies. Produces filmstrips, slide sets, multimedia kits, sound-slide sets and videotape. Buys 300 photos, 10 filmstrips and slides, and 15 films/year.
Subject Needs: Advertising and promotion in all client areas. Photos used in slide shows, brochures, newspaper ads, magazine ads, TV commercials, filmstrips. Not interested in stock filmstrips. Length: up to 300 slides.
Film: Commercials covering all subjects from travel to sports. Interested in stock footage on wildlife, scenic Central Northwest.
Photos: Uses b&w prints and 2¼x2¼ color transparencies.
Payment & Terms: Pays by the job, $25-1,000; or $15-250/b&w photo, $25-250/transparency. Buys all rights. Model release required.
Making Contact: Query with resume of credits; send material by mail for consideration. SASE. Reports in 3 weeks.

Nebraska

J. GREG SMITH, Burlington on the Mall, Suite 102, 1004 Farnam, Omaha NE 68102. (404)444-1600. Director: Shelly Bartek. Ad agency. Clients: finance, banking institutions, national and state associations, agriculture, insurance retail, travel.
Needs: Works with 10 freelance photographers/year on assignment only basis. Uses photographers for consumer and trade magazines, brochures, catalogs and AV presentations.
First Contact & Terms: Arrange interview to show portfolio. Pays $500/color photo; $60/hour; $800/day; varies/job. Buys all rights. Looks for "people shots (with expression), scenics (well known, bright colors)."

SWANSON, ROLLHEISER, HOLLAND, 1222 P St., Lincoln NE 68508. (402)475-5191. Contact: Brian Boesche. Ad agency. Clients: primarily industrial, financial and agricultural; client list provided on request.

Needs: Works with 50 freelance photographers/year on assignment only basis. Uses photographers for consumer and trade magazines, direct mail, brochures, catalogs, newspapers and AV presentations.
First Contact & Terms: Query first with small brochure or samples along with list of clients freelancer has done work for. Negotiates payment according to client's budget. Rights are negotiable.

Nevada

DAVIDSON ADVERTISING CO., 3940 Mohigan Way, Las Vegas NV 89119. (702)871-7172. President: George Davidson. Full-service advertising agency. Clients: beauty, construction, finance, entertainment, retailing, publishing, travel. Photos used in brochures, newsletters, annual reports, PR releases, AV presentations, sales literature, consumer magazines and trade magazines. Arrange a personal interview to show portfolio, query with samples, or submit portfolio for review; provide resume, brochure and tearsheets to be kept on file for possible future assignments. Gives 150-200 assignments/year. Pays $15-50/b&w photo; $25-100/color photo; $15-50/hour; $100-400/day; $25-1,000 by the project. Pays on production. Buys all rights. Model release required. Local freelancers preferred. SASE. Reports in 3 weeks.
B&W: Uses 8x10 glossy prints; contact sheet and negatives OK.
Color: Uses 8x10 glossy prints and 2¼x2¼ and 4x5 transparencies; contact sheet OK.
Film: Uses 16mm; filmmakers might be assigned location shooting for television commercial or an industrial-type film.
Tips: "On certain assignments when the budget is low and there is time we will give a new photographer a chance at the job."

New Hampshire

EDWARDS & COMPANY, 63 South River Rd., Bedford NH 03102. (603)624-1700. Ad agency. Creative Director: Paul Nelson. Client list provided on request.
Needs: Works with 1-2 freelance photographers/month. Uses photographers for billboards, consumer and trade magazines, direct mail, P-O-P displays, brochures, newspapers. Subject needs "variable, dependent upon client needs." Also works with freelance filmmakers to produce TV spots.
Specs: "Depends entirely upon the individual project."
First Contact & Terms: Arrange a personal interview to show portfolio; query with samples; submit portfolio for review; provide resume, business card, brochure, flyer or tearsheets to be kept on file for possible future assignments. SASE. Reports in 2 weeks. Pays $40-125/hour; $400-1,000 + /day. Pays 30 days after billing. Buys all rights. Model release required. Credit line "not usually" given.
Tips: In a portfolio, prefers to see "loose prints, hopefully also with samples of pieces they appeared in. Contact me for interview with portfolio. I will keep resume, etc. on file and give the opportunity to bid on a job when circumstances arise."

New Jersey

A.N.R. ADVERTISING AGENCY, Building F, 150 River Rd., Montville NJ 07045. (201)299-8000. President: A. Scelba. Ad agency. Clients: industrial. Client list provided on request.
Needs: Works with 4 freelance photographers/month. Uses photographers for direct mail, catalogs, trade magazines and brochures. Subjects include high-tech.
Specs: Uses 4x5 or 8x10 b&w or color prints; 4x5 and 8x10 transparencies.
First Contact & Terms: Provide resume, business card, brochure, flyer or tearsheets to be kept on file for possible future assignments. Pays in 30 days. Buys all rights. Model release required.

***LESLIE AARON ASSOCIATES**, 520 Westfield Ave., Elizabeth NJ 07208. (201)351-4666. Ad agency, PR firm. Production Coordinator: Garret Gega. Clients: industrial, tech.
Needs: Works with 6-10 freelance photographers/month. Uses photographers for trade magazines, direct mail, catalogs, signage, literature and PR. Subjects include: machinery.
Specs: Uses 8x10 b&w prints; 4x5, 8x10 transparencies.
First Contact & Terms: Arrange a personal interview to show portfolio; query with resume of credits; submit portfolio for review; provide resume, business card, brochure, flyer or tearsheets to be kept on file for possible future assignments. Works with freelance photographers on assignment basis only. Does not return unsolicited material. Pays/photo; job. Pays on receipt of invoice. Buys all rights. Model release required.

Tips: Prefers to see industrial, plant photography, studio work, all subjects. "Impress us with talent, experience and offer value."

SOL ABRAMS ASSOCIATES, INC., Box 221, New Milford NJ 07646. (201)262-4111. Contact: Sol Abrams. PR and AV firm. Clients: real estate, food, fashion, retailing, beauty pageant, theatrical entertainment, TV, agricultural, animal and pet, automotive, model agencies, schools, record companies, motion picture firms, governmental and political, publishing and travel.
Needs: Works with varying number of freelance photographers/month as per clients' needs. Uses freelancers for billboards, consumer magazines, trade magazines, direct mail, newspapers, P-O-P displays and TV.
First Contact & Terms: Send resume, contact sheet or prints. Provide resume, letter of inquiry and sample to be kept on file for possible future assignments. Negotiates payment based on client's budget and where work will appear. SASE only. Selection based on "knowledge of freelancers' work. Most of our work is publicity and PR. I need things that are creative. Price is also important factor. I have a winning formula to get most mileage in publicity pictures for clients involving the 3 "B's-beauties, babies and beasts—all human interest."
Tips: "We also work with film and TV video producers and syndicators for theater or broadcast productions. We can represent select photographers, models and theatrical people in very competitive New York market. If using models, use great, super models. We are in New York City market and some of the models good photographers use destroy their work. Although it's a very small phase of our business, we have strong connections with two top men's magazines. In these cases we may be of help to both photographers and models."

ADLER, SCHWARTZ, INC., 140 Sylvan Ave., Englewood Cliffs NJ 07632. (201)461-8450. President: Peter Adler. Ad agency. Uses all media. Clients: automotive, electronic, industrial clients.
Needs: Works with freelance photographers on assignment only basis. Uses photographers for cars, people, fashion, still life.
First Contact & Terms: Provide business card and tearsheets to be kept on file for possible future assignments. Buys all rights, but may reassign to photographer. Negotiates payment based on client's budget, amount of creativity required, where the work will appear and photographer's previous experience and reputation. Payment generally ranges from $250-500/b&w photo; $750-1,500/color photo; or $750-1,500/day. Call to arrange an appointment. "Show samples of your work and printed samples." Reports in 2 weeks.
B&W: Uses semigloss prints. Model release required.
Color: Uses transparencies. Model release required.
Tips: "We are interested in cars (location and studio), still life (studio), location, editorial and illustration shots."

ARDREY INC., Suite 314, 100 Menlo Park, Edison NJ 08837. (201)549-1300. PR firm. Contact: Henry Seiz. Clients: industrial. Client list provided on request.
Needs: Works with 10-15 freelance photographers/month through US. Uses photographers for trade magazines, direct mail, brochures, catalogs, newspapers. Subjects include trade photojournalism.
Specs: Uses 4x5 and 8x10 b&w glossy prints; 35mm, $2\frac{1}{4}x2\frac{1}{4}$ and 4x5 transparencies.
First Contact & Terms: Provide resume, business card, brochure, flyer or tearsheets to be kept on file for possible future assignments. Works with freelance photographers on assignment basis only. SASE. Pays $150-600/day; "travel distance of location work—time and travel considered." Pays 30-45 days after acceptance. Buys all rights and negatives. Model release required.
Tips: Prefers to see "imaginative industrial photojournalism. Identify self, define territory he can cover from home base, define industries he's shot for industrial photojournalism; give relevant references and samples. Regard yourself as a business communication tool. That's how we regard ourselves, as well as photographers and other creative suppliers."

THE BECKERMAN GROUP, 35 Mill St., Bernardsville NJ 07924. (201)766-9238. Ad agency. Production Manager: Ilene Beckerman. Clients: industrial. Client list free with SASE.
Needs: Works with 3 photographers/month. Uses photographers for catalogs, posters, corporate internal organs and brochures. Subject matter includes table top.
Specs: Uses b&w prints and $2\frac{1}{4}x2\frac{1}{4}$ transparencies.
First Contact & Terms: Arrange a personal interview to show portfolio; provide resume, business card, brochure, flyer or tearsheets to be kept on file for possible future assignments. Works with freelance photographers on an assignment basis only. Does not return unsolicited material. Payment individually negotiated; maximum $1,500/day. Pays on receipt of invoice. Buys all rights. Model release required.
Tips: Looks for "the ability to think conceptually and solve a problem in a strong fresh way."

***CHAMPION ADV. AGENCY**, 86 Davison Pl., Englewood NJ 07631. (201)569-0792. Ad agency, sales promotion, direct mail. Creative Director: Jerry Hahn. Clients: jewelry manufacturers.
Needs: Works with 3 freelance photographers/month. Uses photographers for consumer and trade magazines, direct mail, P-O-P displays, catalogs, posters and direct mail. Subjects feature jewelry.
Specs: Uses 4x5, 5x7 and 8x10 glossy or matte b&w and color prints; 4x5, 5x7 and 8x10 transparencies.
First Contact & Terms: Arrange a personal interview to show portfolio; query with resume of credits and list of stock photo subjects; send unsolicited photos by mail for consideration; query with samples; submit portfolio for review; provide resume, business card, brochure, flyer or tearsheets to be kept on file for possible future assignments. Works with freelance photographers on assignment only. SASE. Reports in 1 week. Pay negotiated. Pays 30-60 days. Rights varies. Model release required.
Tips: Call, send samples and explanation of why shot was taken that way . . . purpose.

CUFFARI & CO, INC., 311 Claremont Ave., Montclair NJ 07042. (201)746-8084. Ad agency. Art Director: Nancy Martino. Clients: agriculture, animal health, chemical, industrial, transportation, furniture.
Needs: Works with 2-3 photographers/month. Uses photographers for trade magazines, direct mail, P-O-P displays, catalogs, posters, signage and newspapers. Subject matter includes products, food.
Specs: Uses b&w prints, and 35mm, 2¼x2¼, 4x5 and 8x10 transparencies.
First Contact & Terms: Query with list of stock photo subjects; send unsolicited photos by mail for consideration; query with samples; provide resume, business card, brochure, flyer or tearsheets to be kept on file for possible future assignments. Works with freelance photographers on an assignment basis only. Does not return unsolicited material. Payment individually negotiated. Pays in 30 days. Buys all rights. Model release required.

***CURTIS/MATTHEWS ASSOCIATES**, Box 114, Ship Bottom NJ 08008. (609)492-7124. Ad agency. President: Ron Miller. Clients: industrial, boating. Client list provided on request.
Needs: Works with 1-3 freelance photographers/month. Uses photographers for consumer and trade magazines, brochures, catalogs, AV presentations. Subjects include "in-plant and on-site industrial and marine." Also works with freelance filmmakers to produce industrial movies, AV slide presentations (sales).
Specs: Uses b&w prints; 35mm and 2¼x2¼ transparencies, Super 8mm film; video.
First Contact & Terms: Provide business card and tearsheets to be kept on file for possible future assignments. Works with freelance photographers on assignment only basis. Does not return unsolicited material. Reports in 2-3 weeks, "depends on client's availability." Pays $300-1,000/day; $300-5,000/job; pays "as required—subject to client approval. Need firm quote by job—hourly contingency costs due to on-site problems, weather, etc. considered." Pays on acceptance. Buys one-time and/or all rights. Model release required "if definitely identifiable." Credit line given "in some cases, if agreeable with client."
Tips: "I don't need local photographers—many I've used for years. We would contact photographers appropriate for our specific needs in geographic areas." Looks for the basics first: technical quality, composition, creative approach; then any specialized styling—"Star Wars" graphics, etc. in samples.

DIEGNAN & ASSOCIATES, RD #2, Lebanon NJ 08833. President: N. Diegnan. Ad agency/PR firm. Clients: industrial, consumer. Commissions 15 photographers/year; buys 20 photos/year from each. Local freelancers preferred. Uses billboards, trade magazines, and newspapers. Negotiates payment based on client's budget and amount of creativity required from photographer. Pays by the job. Buys all rights. Model release preferred. Arrange a personal interview to show portfolio. SASE. Reports in 1 week.
B&W: Uses contact sheet or glossy 8x10 prints.
Color: Uses 5x7 or 8x10 prints and 2¼x2¼ transparencies.
Film: Produces all types and sizes of films. Typical assignment would be an annual report. Pays royalties.

GILBERT, WHITNEY & JOHNS, INC., 110 S. Jefferson Rd., Whippany NJ 07981. (201)386-1776. Ad agency and PR firm. Art Directors: Leslie Corigliano, Pete Dillon, Eileen Tobin. Clients: wood finishing products, banking and financial, chemicals. Client list free with SASE.
Needs: Works with 4 photographers/month. Uses photographers for consumer magazines, trade magazines, direct mail, P-O-P displays and newspapers. Subject matter includes horizons, scenics, chemical laboratories.
Specs: Uses 4x5 and 8x10 b&w prints, and 4x5 transparencies.
First Contact & Terms: Arrange a personal interview to show portfolio; query with list of stock photo subjects. Works with freelance photographers on an assignment basis only. Does not return unsolicited material. Pays on acceptance or on receipt of invoice. Buys one-time rights. Model release required.

GRAPHIC WORKSHOP INC., 466 Old Hook Rd., Emerson NJ 07630. (201)967-8500. Sales promotion agency. President: Al Nudelman. Clients: industrial, fashion.
Needs: Works with 6 freelance photographers/year. Uses photographers for direct mail, catalogs, newspapers, consumer magazines, posters, AV presentations, trade magazines and brochures. Subjects include a "full range from men's fashion, women's fashion, tool and die, to AV and computers."
Specs: Uses 8x10 glossy air-dried b&w prints; 35mm and 4x5 transparencies.
First Contact & Terms: Query with list of stock photo subjects; send unsolicited photos by mail for consideration; provide resume, business card, brochure, flyer or tearsheets to be kept on file for possible future assignments. Works with local freelancers only. Does not return unsolicited material. Reports in 2 weeks. Pays by the job. Pays on acceptance. Buys all rights. Model release and captions required. Credit line given "sometimes, if negotiated."
Tips: Prefers to see "slides or finished samples" in a portfolio. "Submit samples—be willing to prove ability."

HEALY, DIXCY AND FORBES ADVERTISING AGENCY, 1129 Bloomfield Ave., West Caldwell NJ 07006. (201)882-9440. Ad agency. Art Director: Glen Floyd. Clients: industrial.
Needs: Works with 1 photographer/month. Uses photographers for trade magazines, direct mail, catalogs and newspapers. Subject matter includes industrial research and development, engineering, production, etc.
Specs: Uses various sizes and finishes b&w and color prints; and 4x5 and 8x10 transparencies.
First Contact & Terms: Query with list of stock photo subjects; send unsolicited photos by mail for consideration; provide resume, business card, brochure, flyer or tearsheets to be kept on file for possible future assignments. Works with local freelancers only. Does not return unsolicited material. Reports in 1 month. Pay varies. Pays on receipt of invoice. Buys all rights. Model release required.
Tips: "We are looking for very creative photographers who can produce a job quickly, with quality and a reasonable price."

J.M. KESSLINGER & ASSOCIATES, 37 Saybrook Pl., Newark NJ 07102. (201)623-0007. President: Joseph Dietz. Ad agency. Clients: variety of industries.
Needs: Works with 3 freelance photographers/month. Uses photographers for consumer and trade magazines, direct mail, brochures/flyers and occasionally newspapers.
First Contact & Terms: Call for appointment to show portfolio (include wide range); provide brochure and flyer to be kept on file for possible future assignments. Pays $35-175/b&w photo; $50-600/color photo; $200-650/day. Pays on acceptance.

***LIS KING PUBLIC RELATIONS**, Box 725, Mahwah NJ 07430. (201)529-1240. PR firm. President: Lis King. Clients: industrial, financial, home furnishings. Client list with SASE.
Needs: Works with 6 freelance photographers/month. Uses photographers for consumer and trade magazines, catalogs, newspapers and TV. Subjects include "beautifully decorated or remodeled homes, but these homes MUST feature the products of clients that we represent."
Specs: Uses b&w prints and 35mm transparencies.
First Contact & Terms: "Query with names of our clients and products we represent." Works with freelance photographers on assignment basis only. SASE. Reports in 1 week. Pay negotiated. Pays on acceptance or receipt of invoice. Model release and captions preferred. Credit line given.
Tips: Prefers to see good interiors. "Be business-like. Do not send photos that we could have no interest in."

ROGER MALER, INC., Box 435, Mt. Arlington NJ 07856. (201)770-1500. Ad agency. President: Roger Maler. Clients: industrial, pharmaceutical.
Needs: Works with 3 freelance photographers/month. Uses photographers for billboards, trade magazines, direct mail, P-O-P displays, brochures, catalogs, newspapers, AV presentations. Also works with freelance filmmakers.
First Contact & Terms: Send resume, business card, brochure, flyer or tearsheets to be kept on file for possible future assignments. Works with freelance photographers on assignment only basis. Does not return unsolicited material. Pay varies. Pays on publication. Model release required. Credit line sometimes given.

***THE PUBLIC RELATIONS, INC.**, Box 683, E. Brunswick NJ 08816. (201)249-4159. PR firm. President: Lee Dennegar. Clients: industrial, packaging, adhesives, machinery. Client list free with SASE.
Needs: Works with 2-3 freelance photographers/month. Uses photographers for consumer and trade magazines, catalogs and newspapers. Subjects include on-the-job shots to support case-history articles.
Specs: Open.

First Contact & Terms: Provide resume, business card, brochure, flyer or tearsheets to be kept on file for possible future assignments. Works with freelance photographers on assignment basis only. SASE. Reports in 1 week. Pays $35-75/hour; $200-500/day; $500/job; $50/b&w photo; $100/color photo. Pays on receipt of invoice. Buys one-time rights. Model release and captions preferred. Credit line usually given.
Tips: Sees use of more color, more "humor."

RFM ASSOCIATES, INC., 35 Atkins Ave., Trenton NJ 08610. (609)586-5214. President: Rodney F. Mortillaro. Ad agency. Uses billboards, consumer and trade magazines, direct mail, foreign media, newspapers, P-O-P displays and radio. Clients: industrial, consumer, retail, fashion, entertainment clients. Commissions 45 photographers/year; buys 120 photos/year. Local freelancers preferred. Pays $25 minimum. Buys all rights. Model release required. Query with resume of credits or samples.
B&W: Uses 5x7 prints.
Color: Uses 5x7 prints and 4x5 transparencies.

***ROYAL COMMUNICATIONS, INC.**, 112 Main Rd., Montville NJ 07045. (201)335-0300. Ad agency. Associate Art Director: Michele C. Deluca. Clients: primarily industrial.
Needs: Works with 2 freelance photographers/month. Uses photographers for trade magazines, P-O-P displays, catalogs, posters, newspapers and trade show displays. Subjects include industrial (on-site and equipment).
Specs: Uses b&w and color prints, 35mm and 2¼x2¼ transparencies.
First Contact & Terms: Query with resume of credits; provide resume, business card, brochure, flyer or tearsheets to be kept on file for possible future assignments. Works with local freelancers "primarily but not always." Does not return unsolicited material. Payment "depends on the particular assignment." Pays on receipt of invoice. Rights purchased again, depends on assignment. Model release usually required.
Tips: "Send business card, brochure or self promo piece which we will keep on file and contact when necessary."

SPOONER & COMPANY, Box 126, Verona NJ 07044. (201)857-0053. President: William B. Spooner III. Ad agency. Uses direct mail and trade magazines. Clients: industry. Works with 1-2 freelance photographers/month on assignment only basis. Provide resume, flyer and scope of operations and territory. Pays/job or /day; negotiates payment based on client's budget, amount of creativity required from photographer and photographer's previous experience/reputation. Buys all rights. Model release preferred. Query with samples. SASE. Reports in 2 weeks.
B&W: Uses semigloss 8x10 prints.
Color: Uses semigloss 8x10 prints and 2¼x2¼ or 4x5 transparencies.
Film: Produces industrial films. Does not pay royalties.

DOUGLAS TURNER, INC., 11 Commerce St., Newark NJ 07102. (201)623-4506. Vice President/Creative Director: Gloria Spolan. Ad agency. Clients: banking institutions, window covering, office equipment, toys, optical, electronics (TV, radios, etc.), security, cosmetics.
Needs: Works on assignment only basis. Uses photographers for consumer and trade media, direct mail, brochures, catalogs, posters and storyboards.
First Contact & Terms: Send in literature first—if interested will contact artist. Payment is by the project; negotiates according to client's budget.

VICTOR VAN DER LINDE CO. ADVERTISING, 381 Broadway, Westwood NJ 07675. (201)664-6830. Vice President: A.K. Kingsley. Contact: Peter Hutchins. Ad agency. Uses consumer and trade magazines, direct mail, newspapers, and P-O-P displays. Serves clients in pharmaceuticals and insurance. Call to arrange an appointment. SASE.

***STEVE WEINBERGER ADVERTISING**, 2 Hudson St., Marlboro NJ 07746. President: S. Weinberger. Clients: industrial.
Needs: Works with 1 freelance photographer/month. Uses photographers for trade magazines, direct mail, and brochures. Subjects include products or in-plant shots.
Specs: Uses b&w and color prints and 2¼x2¼ transparencies—"depends on job."
First Contact & Terms: Arrange a personal interview to show portfolio. Works with freelancers on assignment basis only. Does not return unsolicited material. Pays by the day, job or photo. Pays on acceptance. Buys all rights. Model release required.
Tips: Prefers to see "commercial work, not 'fine art'."

New Mexico

THE COMPETITIVE EDGE, Box 3500, Albuquerque NM 87190. (505)761-3000. Ad agency. Art Director: Daryl Bates. Clients: automotive.
Needs: Works with an occasional freelance photographer. Uses photographers for consumer and trade magazines, direct mail, P-O-P displays, brochures, newspapers, TV and AV presentations.
Specs: Uses 8x10 glossy b&w prints; 35mm transparencies; 35mm film and videotape.
First Contact & Terms: Query with list of stock photo subjects; provide resume, business card, brochure, flyer or tearsheets to be kept on file for possible future assignments. Does not return unsolicited material. Reports "as soon as possible." Pays $50-1,000/job. Pays on acceptance. Buys all rights. Model release required; captions preferred. Credit line given "where applicable."
Tips: "Please inquire about current possibilities—*no* unsolicited material."

MEDIAWORKS, Suite 1, 6022 Constitution NE, Albuquerque NM 87110. (505)266-7795. President: Marcia Mazria. Ad agency. Clients: retail, industry, politics, government, law. Produces overhead transparencies, slide sets, motion pictures, sound-slide sets, videotape, print ads and brochures. Works with 1-2 freelance photographers/month on assignment only basis. Provide resume, flyer and brochure to be kept on file for possible future assignments. Buys 70 photos and 5-8 films/year.
Subject Needs: Health, business, environment and products. No animals or flowers. Length requirements: 80 slides or 15-20 minutes, or 60 frames, 20 minutes.
Film: Produces ½" and ¾" video for broadcasts.
Photos: Uses b&w or color prints and 35mm transparencies "and a lot of 2¼ transparencies and some 4x5 transparencies."
Payment/Terms: Pays $40-60/hour, $350-500/day, $40-800/job, $40/b&w photo or $40/color photo. Negotiates payment based on client's budget and photographer's previous experience/reputation. Pays on job completion. Buys all rights. Model release required.
Making Contact: Arrange personal interview or query with resume. Prefers to see a variety of subject matter and styles in portfolio. Does not return unsolicited material.

New York

GENE BARTCZAK ASSOCIATES, INC., Box E, N. Bellmore NY 11710 (516)781-6230. PR firm. Clients: high technology industrial. Provide resume and flyer to be kept on file for possible future assignments.
Needs: Works with 2-4 freelance photographers/month on assignment only basis. Uses freelancers for motion pictures and video recordings.
First Contact & Terms: Write and request personal interview to show portfolio; send resume. SASE. Reports in 2 weeks. Selection based on "experience in industrial photography, with samples to prove. Also consider independent inquiries from studios and freelancers." Pays $25/b&w photo; $35/color photo; $25/hour. Pays on acceptance.

WALTER F. CAMERON ADVERTISING, 50 Jericho Turnpike, Jericho, Long Island NY 11753. (516)333-2500. Ad agency. Art Directors: Richard Dvorak, Cathy Vernino. Clients: retail. Client list free with SASE.
Needs: Uses photographers for consumer magazines, trade magazines, catalogs and newspapers. Subject matter varies from time to time; furniture settings, cars, product shots, on-location shots.
Specs: Uses 4x5 or 8x10 b&w and color glossy prints.
First Contact & Terms: Arrange a personal interview to show portfolio; submit portfolio for review; provide resume, business card, brochure, flyer or tearsheets to be kept on file for possible future assignments. Works with freelance photographers on an assignment basis only. Pays per hour or $300-400/day. Pays on receipt of invoice. Buys all rights. Model release required; captions preferred.

CONKLIN, LABS & BEBEE, 109 Twin Oaks Dr., Syracuse NY 13221. (315)437-2591. Ad agency, PR firm, marketing communciations. Senior Art Director: Jeanette Gryga. Art Director: Robert Wonders. Clients: industrial, fashion, finance.
Needs: Works with 4-6 freelance photographers/month. Uses photographers for billboards, consumer and trade magazines, P-O-P displays, catalogs and newspapers. Subject matter includes industrial, location and/or studio.
Specs: Uses 4x5 transparencies.
First Contact & Terms: Arrange a personal interview to show portfolio; query with resume of credits;

provide resume, business card, brochure, flyer or tearsheets to be kept on file for possible future assignments. Works with freelance photographers on an assignment basis only. Does not return unsolicited material. Reports in 3 weeks. Pay individually negotiated. Pays on receipt of invoice. Buys all rights. Model release required; captions preferred. Credit line sometimes given.
Tips: "We review your work and will call if we think a particular job is applicable to your talents. Our photos are not decorative. They must serve the purpose of conveying a message."

***DATA DIRECTIONS, INC.**, Box 912, Port Washington NY 11050. (516)883-9590. Publishers. Editor: Hank Boerner. Clients: corporate subscribers.
Needs: Works with "2-3 depending on need" freelance photographers/month. Uses photographers for business publications. Subjects include illustrative, buildings, properties, business scenes, executives.
Specs: Uses b&w prints.
First Contact & Terms: Query with resume of credits and list of stock photo subjects; provide resume, business card, brochure, flyer or tearsheets to be kept on file for possible future assignments. Does not return unsolicited material. Reports in 1 week. Pay varies. Pays on acceptance. Buys all rights. Model release required "if not editorial." Captions required. Credit line given.
Tips: "Write and let us know availability. We have Florida focus."

DE PALMA & HOGAN ADVERTISING, 3 Barker Ave., White Plains NY 10601. (914)997-2400. Ad agency. Art Director: Art Glazer. Clients: food, drug, publishing. Client list free with SASE.
Needs: Works with 4 photographers/month. Uses photographers for consumer and trade magazines, direct mail, newspapers and TV.
Specs: Uses b&w and color prints, and 35mm, 2¼x2¼, 4x5 and 8x10 transparencies.
First Contact & Terms: Arrange a personal interview to show portfolio; query with resume of credits or a list of stock photo subjects; provide resume, business card, brochure, flyer or tearsheets to be kept on file for possible future assignments. Pays $500-1,500/color photo. Pays on receipt of invoice. Buys all rights. Model release required; captions preferred.

***ALAN G. EISEN PUBLIC RELATIONS CO., INC.**, 1188 Round Swamp Rd., Old Bethpage NY 11804. (516)752-1008. PR firm. President: Alan G. Eisen. Clients: consumer products and services.
Needs: Works with 1-2 photographers/month. Uses photographers for consumer and trade magazines, catalogs and newspapers. Subjects include: people with products.
Specs: Uses 5x7 matte b&w prints; 4x5 transparencies.
First Contact & Terms: Query with resume of credits; provide resume, business card, brochure, flyer or tearsheets to be kept on file for possible future assignments. Works with freelance photographers on assignment basis only. SASE. Reports back when photos needed. Payment rates per b&w and color photos are negotiable. Buys all rights. Model release required.
Tips: Trends include more natural people and settings for consumer photography, and more eye-catching glitz in trade photography.

THE FURMAN ADVERTISING CO., INC., 155-161 Fisher Ave., Box 128, Eastchester NY 10709. (914)779-9188/9189. Ad agency. President: Roy L. Furman. Vice President: Murray Furman. Clients: automotive/industrial.
Needs: Works with 1-2 freelance photographers/month. Uses photographers for consumer and trade magazines, direct mail, brochures, catalogs. Subjects include "automotive aftermarket, hard parts, service facilities, wholesale and retail outlets."
Specs: Uses 11x14 b&w and color Type C and Cibachrome prints; 35mm and 4x5 transparencies.
First Contact & Terms: Provide resume, business card, brochure, flyer or tearsheets to be kept on file for possible future assignments. Works with freelance photographers on assignment basis only. SASE. Pays "as budget from client dictates." Pays on acceptance. Buys all rights. Model release required.
Tips: Prefers to see "any subject relating to automotive aftermarket" in a portfolio.

ABBOT GEER PUBLIC RELATIONS, 445 Bedford Rd., Box 57, Armonk NY 10504. (914)273-8736. PR firm. President: Abbot M. Geer. Clients: recreational and commercial marine industry, boat, engine and accessory/materials manufacturers. Client list free with SASE.
Needs: Works with 2-3 freelance photographers/month. Uses photographers for consumer and trade magazines, brochures, newspapers. Subject matter "power and sail boats in action; construction shots, engine close-ups, etc." Occasionally works with freelance filmmakers to produce industrial films, videotapes demonstrating boat performance or construction techniques.
Specs: Uses 8x10 glossy b&w prints; 35mm or 2¼x2¼ transparencies; 16mm and videotape film.
First Contact & Terms: Provide resume, business card, brochure, flyer or tearsheets to be kept on file for possible future assignments. Works with freelance photographers on assignment basis only. SASE. Reports in 2 weeks. Pays on acceptance. Buys all rights.

***HAROLD IMBER PR-ADVERTISING**, 60 Thorn Ave., Mt. Kisco NY 10549. (914)241-0939. Ad agency, PR firm. President: Harold Imber. Clients: architecture, design, engineering, home furnishings, contract.
Needs: Works with 1-2 freelance photographers/month. Uses photographers for consumer and trade magazines, direct mail, P-O-P displays, catalogs, newspapers. Subjects include: installation, aerial products.
Specs: Uses 5x7, 8x10 glossy or matte b&w and color prints; 2¼x2¼, 4x5, 8x10 transparencies.
First Contact & Terms: Query with resume of credits; provide resume, business card, brochure, flyer or tearsheets to be kept on file for possible future assignments. Does not return unsolicited material. Reports "as needed for specific projects." Pay negotiated per day, job and photo. Pays on receipt of invoice. Buys all rights. Model release required. Credit line "depends on project."

***KOPF & ISAACSON**, 35 Pine Lawn Rd., Melville NY 11747. Ad agency. Art Director: Evelyn Rysdyk and Art Zimmermann. Clients: industrial (high tech, telephones, computers, software, etc.).
Needs: Works with 6 freelance photographers/month. Uses photographers for billboards, consumer and trade magazines, catalogs, posters, newspapers. Subjects include: still life with products.
Specs: Uses 35mm, 4x5 transparencies.
First Contact & Terms: Send unsolicited photos by mail for consideration; query with samples; provide resume, business card, brochure, flyer or tearsheets to be kept on file for possible future assignments. Works with freelance photographers on assignment only. Does not return unsolicited material. Reports in 3-4 weeks. Pays $150-4,000/job. Pays on receipt of invoice. Buys all rights. Model release required.
Tips: Prefers to see creative still life work.

***S.R. KUNIS & COMPANY, INC.**, 250-07 87 Dr., Bellerose NY 11426. (718)343-5568. Ad agency, PR firm. President: Solomon Kunis. Clients: industrial.
Needs: Uses photographers for trade magazines and catalogs. Subjects include: printing equipment and video systems.
Specs: Uses color prints; 2¼x2¼ and 4x5 transparencies.
First Contact & Terms: Query with resume of credits. Works with freelance photographers on an assignment basis only. Does not return unsolicited material. Reports in 2 weeks. Pays on receipt of invoice. Buys all rights. Model release preferred. Credit line sometimes given.

S.R. LEON COMPANY, INC., 111 Great Neck Rd., Great Neck NY 10021. (516)487-0500. Creative Director: Max Firetog. Ad agency. Clients: food, retailing, construction materials, cosmetics, drugs. Provide business card and "any material that indicates the photographer's creative ability" to be kept on file for possible future assignments.
Needs: Works with 3-4 freelance photographers/month. Uses photographers for consumer and trade magazines, TV, brochures/flyers and newspapers.
First Contact & Terms: Call for appointment to show portfolio. Reports in 2 weeks. Pays $75-1,000/ b&w photo; $150-3,000/color photo; $650-2,500/day.

MCANDREW ADVERTISING CO., 2125 St. Raymonds Ave., Bronx NY 10462. (212)892-8660. Ad agency. Contact: Robert McAndrew. Clients: industrial.
Needs: Works with 1 freelance photographer/month. Uses photographers for trade magazines, direct mail, brochures, catalogs, newspapers. Subjects include industrial products.
Specs: Uses 8x10 glossy b&w or color prints; 4x5 or 8x10 transparencies.
First Contact & Terms: Provide resume, business card, brochure, flyer or tearsheets to be kept on file for possible future assignments. Works with local freelancers only. Pays $500-700/day; $35 minimum/ job; $45-100/b&w photo; $85-200/color photo. Pays in 30 days. Buys all rights; exclusive product rights. Model release required.
Tips: Photographers should "let me know how close they are, and what their prices are. We look for photographers who have experience in industrial photography."

***MCCUE ADVERTISING & PR INC.**, 407 Press Bldg., 19 Chenango St., Binghamton NY 13901. (607)723-9226. Ad agency and PR firm. President: Donna McCue. Clients: industrial, retail, all types.
Needs: Works with 5 freelance photographers/month. Uses photographers for consumer and trade magazines, direct mail, P-O-P displays, catalogs, signage and newspapers.
Specs: Uses 8x10 prints; 35mm, 4x5 transparencies.
First Contact & Terms: Provide resume, business card, brochure, flyer or tearsheets to be kept on file for possible future assignments. Does not return unsolicited material. Reports when assignment comes up. Pay negotiated. Pays on receipt of invoice. Buys all rights. Model release required. Credit line sometimes given.

LLOYD MANSFIELD CO., 237 Main St., Buffalo NY 14203. (716)854-2762. Ad agency. Executive Art Director: Marti Cattoni. Clients: industrial and consumer.
Needs: Works with 2 freelance photographers/month. Uses photographers for direct mail, catalogs, newspapers, consumer magazines, P-O-P displays, posters, AV presentations, trade magazines and brochures. Needs product, situation and location photos. Also works with freelance filmmakers for TV commercials and training films.
Specs: Uses 11x14 b&w and color prints; 35mm, 2¼x2¼, 4x5 and 8x10 transparencies; 16mm film and videotape.
First Contact & Terms: Arrange a personal interview to show portfolio or query with resume of credits. Works with freelance photographers on assignment basis only. Does not return unsolicited material. Reports in 2 weeks. Pays $50-150/hour; $450-1,100/day and $35/b&w and $500/color photo. Pays 1 month after acceptance. Buys all rights. Model release required.
Tips: In a portfolio, prefers to see 35mm slides in carousel, or books with 11x14 or 8x10 prints.

ORGANIZATION MANAGEMENT, 7 Heather Lane, Gloversville NY 12078. (518)725-9714. President: Bill Dunkinson. Ad agency and PR firm. Clients: construction, credit and collections, entertainment, finance, government, publishing and travel accounts. Photos used in brochures, newsletters, annual reports, PR releases, sales literature, consumer and trade magazines. Works with freelance photographers on assignment only basis. Buys 200 photos/year. Pays on a per-job basis. Negotiates payment based client's budget, amount of creativity required, where work will appear and photographer's previous experience/reputation. Credit line sometimes given. Arrange a personal interview to show portfolio. No unsolicited material. Local freelancers preferred. SASE. Reports in 2 weeks.
B&W: Uses 5x7 and 8x10 glossy, matte and semigloss prints.
Film: Freelance filmmakers may query for assignment.

PRO/CREATIVES, 25 W. Burda Pl., Spring Valley NY 10977. President: David Rapp. Ad agency. Uses all media except billboards and foreign. Clients: package goods, fashion, men's entertainment and leisure magazines, sports and entertainment. Negotiates payment based on client's budget. Submit material by mail for consideration. Reports in 2 weeks. SASE.
B&W: Send any size prints.
Color: Send 35mm transparencies or any size prints.

RICHARD—LEWIS CORP., 455 Central Park Ave., Scarsdale NY 10583. (914)723-3020. President: Dick Byer. Ad agency. Uses direct mail, trade magazines and P-O-P displays. Clients: industry. Local freelancers preferred. Pays $25/job minimum or on a per-photo basis. Buys all rights. Model release required. Arrange a personal interview to show portfolio or query with list of stock photo subjects. SASE.
B&W: Uses glossy 8x10 prints. Pays $25/photo minimum.

RONAN, HOWARD, ASSOCIATES, INC., 11 Buena Vista Ave., Spring Valley NY 10977-3040. (914)356-6668. Contact: Muriel Brown. Ad agency and PR firm. Uses direct mail, foreign media, newspapers and trade magazines. Serves clients in slides, filmstrips, motion picture services, video support equipment, portable power units, motion picture cameras, electronic components, pet supplies. Works with 1-2 freelance photographers/month on assignment only basis. Buys 50-100 photos/year. Pays per photo, $25-40/hour in photographer's studio or $250-400/"shoot" on location plus travel expenses. Negotiates payment based on client's budget. Query first with resume of credits.
B&W: Uses glossy prints. Model release required.
Color: Uses transparencies and paper prints. Model release required. Pays $100-500.
Tips: *Extra sharp details on products* are always the assignment. "Photographers must have new, or rebuilt to 'new' performance-ability cameras, high-powered (not the average strobe) strobes and other lights for location shooting, a full range of lenses including lenses suitable for macro, and must understand how to shoot color under fluorescents without going green. Be able to shoot client executives and have them show up with good 'head and shoulders' detail when reproduced in printed media."

TIFFEN MANUFACTURING, 90 Oser Ave., Hauppauge NY 11788. (516)273-2500. Public Relations: Stan Wallace.
Needs: Works with photographers as need arises. Uses photographers for slide sets and still photographs. Subjects include still photographs which utilize effects and color correction also, product shots.
Specs: Uses 4x5 and 8x10 color transparencies, and b&w and color prints.
First Contact & Terms: Arrange a personal interview to show portfolio; provide resume, business card, self-promotion piece or tearsheets to be kept on file for possible future assignments. SASE. Reports in 2 weeks. Pay depends on type of assignment. Payment would be discussed before giving assignments. Credit line sometimes given.
Tips: "Find out what the client is looking for and know how to shoot."

WALLACK & WALLACK ADVERTISING INC., 33 Great Neck Rd., Great Neck NY 11021. (516)487-3974. Art Director: John Napolitano. Clients: fashion, industrial.
Needs: Works with 5-6 freelance photographers/year. Uses photographers for direct mail, catalogs, P-O-P displays, posters, trade magazines and brochures. Subject needs "very clean, graphic look. B&w important."
Specs: Uses 2¼x2¼, 8x10 transparencies; b&w prints-11x14.
First Contact & Terms: Provide resume, business card, brochure, flyer or tearsheets to be kept on file for possible future assignments. Works with freelancers on an assignment basis only. SASE. Pays $750-2,000/day; $100-400/job or $100-250/color photo. Pays on acceptance. Buys all rights. Written release required.
Tips: Prefers to see "what the photographer wants to shoot—his specialty, not a little of everything" in a portfolio.

WINTERKORN AND LILLAS, Hiram Sibley Bldg., 311 Alexander at East Ave., Rochester NY 14604. (716)454-1010. Contact: Art Director. Ad agency. Clients: consumer packaged goods, industrial firms.
Needs: Works with 25 freelance photographers/year on assignment only basis. Uses photographers for trade magazines, direct mail, P-O-P displays, brochures, posters, AV presentations and sales promotion literature.
First Contact & Terms: Query with samples to be kept on file. Payment negotiable.

WOLFF ASSOCIATES, 250 East Ave., Rochester NY 14604. (716)546-8390. Ad agency. Vice President/Visuals: Terry Mutzel. Clients: industrial, fashion.
Needs: Works with 3-4 freelance photographers/month. Uses photographers for billboards, consumer magazines, direct mail, P-O-P displays, brochures, catalogs, posters, newspapers, AV presentations. Also works with freelance filmmakers to produce TV commercials.
First Contact & Terms: Provide resume, business card, brochure, flyer or tearsheets to be kept on file for possible future assignments. Does not return unsolicited material. Pays $400-3,000/day.

New York City

ADVERTISING TO WOMEN, INC., 777 3rd Ave., New York NY 10017, (212)688-4675. Contact: Art Buyer. Ad agency. Clients: women's products, fashion, beauty—client list provided upon request.
Needs: Works on assignment basis only. Uses photographers for trade magazines, direct mail, P-O-P displays, posters, signage and newspapers.
First Contact & Terms: Call to arrange a personal interview to show portfolio. Negotiates payment by the day according to client's budget.

J.S. ALDEN PUBLIC RELATIONS, INC., 535 5th Ave., New York NY 10017. (212)867-6400. Public Relations Director: Jack H. Casper. PR firm. Photos used in newspapers, trade publications and general media. Clients: chemicals, health care, manufacturing. Pays $24 minimum/hour. Model release required. "Write first; describe your area of specialization and general abilities; access to models; props; studio; area/event/people coverage; equipment used; time and fee information; agency/commercial experience; and location and availability." SASE. Reports in 1 month or less. Most interested in product publicity by assignment; event/area coverage by assignment; portraits for publicity use; occasional use of models/props.
B&W: Uses glossy prints.
Color: Uses glossy prints and transparencies; contact sheet and negatives OK.
Film: Gives assignments to filmmakers for industrial and commercial films.

ALTSCHILLER, REITZFELD, SOLIN, 1700 Broadway, New York NY 10019. (212)586-1400. Contact Vice President of Operations: Florence Jesmajian. Call for names of Art Directors. Ad agency. Clients: fashion, cosmetic, publishing, paper products, food and drug products accounts.
Needs: Uses photographers for fashion magazines and TV, some P-O-P displays. Uses very few stills (prints).
First Contact & Terms: Arrange interview to show portfolio, or drop off portfolio for review. Payment negotiable.

ANITA HELEN BROOKS ASSOCIATES, 155 E. 55th St., New York NY 10022. Contact: Anita Helen Brooks. PR firm. Clients: beauty, entertainment, fashion, food, publishing, travel, society, art, politics, exhibits, charity events. Photos used in PR releases, AV presentations, consumer magazines and trade magazines. Works with freelance photographers on assignment only basis. Provide resume and

brochure to be kept on file for possible future assignments. Buys "several hundred" photos/year. Pays $50 minimum/job; negotiates payment based on client's budget. Credit line given. Model release preferred. Query with resume of credits. No unsolicited material; does not return unsolicited material. Most interested in fashion shots, society, entertainment and literary celebrity/personality shots.
B&W: Uses 8x10 glossy prints; contact sheet OK. (B&w preferred.)
Color: Uses 8x10 glossy prints; contact sheet OK.

***CREATIVE MEDIA AGENCY**, 969 First Ave., New York NY 10022. (212)472-0100. Ad agency. Creative Director: Arthur Krieger. Clients: fashion, small business, limousine. Client list with SASE.
Needs: Works with 2 freelance photographers/month. Uses photographers for consumer magazines, catalogs and newspapers. Subjects include: female sexuality.
Specs: Uses 8x10 b&w and color prints; 35mm, 8x10 transparencies.
First Contact & Terms: Send unsolicited photos by mail for consideration; provide resume, business card, brochure, flyer or tearsheets to be kept on file for possible future assignments. Works with local freelancers only. SASE. Reports in 2 weeks. Pay negotiated. Pays on publication. Buys all rights. Model release required.

CUNNINGHAM & WALSH INC., 260 Madison Ave., New York NY 10016. (212)683-4900. Art Buyer and Studio Manager: Harry Samalot. Ad agency.
First Contact & Terms: Call for appointment to show portfolio (print work and actual jobs done) or leave portfolios, Tuesday, Wednesday and Thursday only.

JODY DONOHUE ASSOCIATES, INC., 32 E. 57th St., New York NY 10022. (212)688-8653. PR firm. Clients: fashion, beauty.
Needs: Uses freelancers for direct mail and P-O-P displays.
First Contact & Terms: Call for personal appointment to show portfolio. Selection based on "interview, review of portfolio, and strength in a particular area (i.e., still life, children, etc.)." Negotiates payment based on client's budget, amount of creativity required from photographer and where the work will appear. Pays freelancers on receipt of clients' payment.
Tips: Wants to see "recent work and that which has been used (printed piece, etc.)."

***DOYLE, DANE BERNBACH, INC.,**, 437 Madison Ave., New York NY 10022. (212)415-2000. Contact: Jill Weber. Ad agency. Serves wide variety of clients.
First Contact & Terms: Arrange interview to show portfolio. Works on assignment basis only. Payment depends on job.
Tips: "We are always looking for new talent in various specialties, but must be of the highest quality and dependability. Freelancers must make appointments to show work to the art buyers."

RICHARD FALK ASSOCIATES, 1472 Broadway, New York NY 10036. (212)221-0043. President: Richard Falk. PR firm. Clients: industrial, entertainment. Provide business card and flyer to be kept on file for possible future assignments.
Needs: Works with about 4 freelance photographers/month. Uses photographers for newspapers and TV.
First Contact & Terms: Send resume. Selection of freelancers based on "short letters or flyers, chance visits, promo pieces and contact at events." Also hires by contract. Does not return unsolicited material. Reports in 1 week. Pays $10-50/b&w photo; $50 minimum/hour; $100 minimum/day. Buys one-time rights.

FOOTE, CONE & BELDING COMMUNICATIONS, INC., 101 Park Ave., New York NY 10178. (212)907-1000. Art Buyers: Barbara Sabatino, Irene Jacobusky. Ad agency. Clients: food, travel, industrial, communication, financial and consumer products.
Needs: Works with 5-10 freelance photographers/month. Uses freelancers for billboards, consumer and trade magazines, direct mail, newspapers, P-O-P displays and TV.
First Contact & Terms: Send portfolio for review. Selection of photographers based on "personal knowledge, files and mailers left after portfolios are screened." Negotiates payment based on client's budget and where the work will appear.
Tips: "Be flexible with prices; keep to the estimate; send receipts for expenses. Be innovative." Wants to see "10-15 chromes of experimental and/or job related work. Tearsheets if they're good."

***FOUR WINDS TRAVEL, INC.**, 175 Fifth Ave., New York NY 10010. (212)777-0260. Corporate (tour operator). Production Assistant: Ann Pepe. Clients: travel. Client list with SASE.
Needs: Works with various freelance photographers/month. Uses photographs for direct mail, catalogs and tour brochures. Subjects include: travel.

Specs: Open.
First Contact & Terms: Query with list of stock photo subjects. SASE. Report time "depends on current projects." Pay negotiated. Pays on publication. Model release and captions preferred.
Tips: "Let us know areas you have photographed or plan to visit."

GAYNOR FALCONE & ASSOCIATES, 133 E. 58th, New York NY 10022. (212)688-6900. Senior Art Director: John Cenatiempo. Ad agency. Clients: various. Client list provided upon request.
Needs: Works on assignment basis only. Uses photographers for billboards, consumer and trade magazines, direct mail, P-O-P displays, brochures, catalogs, posters, signage, newspapers and AV presentations.
First Contact & Terms: Query with samples. Negotiates payment according to client's budget and where work will appear. Usually pays by the day or half-day.

PETE GLASHEEN ADVERTISING, INC., 300 E. 34th St., New York NY 10016. (212)889-3188. Vice President: Carol Glasheen. Ad agency. Uses photographers for consumer and trade magazines, direct mail, foreign media, newspapers, P-O-P displays, radio and TV. Serves cosmetic, health food, toy, art supply, office supply, executive toy, packaged goods and consumer and trade magazine clients. Works with 7 freelance photographers/month on assignment basis only. Provide business card to be kept on file for future assignments.
Specs: Uses b&w and color 5x7 and 8x10 prints. Also uses ½" VHS videotape.
Payment/Terms: Pays by job; negotiates payment based on client's budget, amount of creativity required from photographer and where the work will appear. Buys all rights. Model release required.
Making Contact: Send photos and proposal or resume. SASE. Agency will contact.

THE GRAPHIC EXPERIENCE INC., 341 Madison Ave., New York NY 10017. (212)867-0806. Production Manager: John Marinello. Ad agency. Uses consumer and trade magazines, direct mail, newspapers and P-O-P displays. Clients: fashion, hard goods, soft goods and catalogs (fashion/gifts). Buys 600-1,200 photos/year. Pays $100-1,500/day; negotiates payment based on client's budget. Buys all rights. Model release required. Arrange a personal interview to show portfolio or submit portfolio for review. Provide resume, flyer and tearsheets to be kept on file for future assignments. SASE. Reports in 2 weeks.

***GREENE & CLAIRE INC.**, 10 West 33rd St., New York NY 10001. (212)695-5800. Ad agency. Art Director: Clyde Gilliam. Clients: industrial, fashion, other. Client list free with SASE.
Needs: Works with 2-3 freelance photographers/month. Uses photographers for consumer and trade magazines, direct mail, P-O-P displays, catalogs, posters and newspapers.
Specs: Uses b&w and color prints; 35mm, 2¼x2¼, 4x5, 8x10 transparencies.
First Contact & Terms: Provide resume, business card, brochure, flyer or tearsheets to be kept on file for possible future assignments. Works with freelance photographers on assignment basis only. Does not return unsolicited material. Pays per day or job. Pays on acceptance and receipt of invoice. Buys all rights or one-time rights. Model release required.

HCM, 866 3rd Ave., New York NY 10022. (212)752-6500. Associate Creative Director: Joe Mackenna. Ad agency. Clients: automotive, aerospace (military and commercial aircraft, sophisticated electronics) copiers, packaged goods, chemicals, telephone systems, business services (accounting, claim adjusting, insurance) commercial interiors, retail banking, pharmaceuticals, publishing firms.
Needs: "As general agency we are looking for all types of photography, consumer, business-to-business and corporate." Works with 10-100 freelance photographers/year. Photographers are retained for studio, still life and location work, primarily illustrative with some specific situations.
First Contact & Terms: Arrange interview to show portfolio. Pays $500-1,500/b&w photo; $750-2,500/color photo; or $600-6,500/job. "The agency's intent is to purchase as many rights as possible for the budget with the intent to own the work outright for the client with no limitations. Purchase orders should state clearly all intended uses and limits of the rights we wish to purchase in the event we are purchasing less than a buy-out. Rarely do we give photographers a credit line, but consideration will be made case by case."
Tips: Prefers to see only outstanding examples of work, critically edited by the photographer or his representative. "We like to see new 'points of view' of subjects."

JIM JOHNSTON ADVERTISING, INC., 551 5th Ave., New York NY 10017. (212)490-2121. Art Director: Bob Pendleton. Creative Directors: Doug Johnston and Jim Johnston. Ad agency. Uses consumer and trade magazines, direct mail, foreign media, newspapers, TV and radio. Serves clients in publishing and broadcasting, financial services, fashion, travel and high technology. Buys 25-50 photos/year. Local freelancers preferred. Pays $150-2,000/b&w or color photo; $20-250/hour; $150-2,000/day; $150-

5,000/job. Buys all rights. Model release required. Query with resume of credits; query with samples or list of stock photo subjects; or submit portfolio for review. SASE. Reports in 2 weeks.
B&W: Uses 8x10 or larger matte prints; contact sheet OK.
Color: Uses 8x10 or larger glossy prints and 2¼x2¼ or larger transparencies.
Film: Produces 16mm and 35mm documentary and sales film. Does not pay royalties.
Tips: Looks for "finish—the ability to execute someone else's idea *flawlessly*—an overwhelming number of photographers make glaring mistakes in critical areas like focus, lighting, cleanliness, etc. Also the ability to *compose* elements interestingly and the ability to *edit* a portfolio to leave out ugly work! Drop off a portfolio or send a promotional sample. 'Please do not send reps'."

JORDAN/CASE & MCGRATH, 445 Park Ave., New York NY 10022. (212)906-3600. Studio Manager: Jim Griffin. "There's a separate TV department which views TV reels." Ad agency. Uses all media. Clients include insurance companies, makers of cough medicine, frozen foods, liquor and wine, hosiery manufacturers, commercial banks, theatre, facial cleanser and food products. Needs still lifes and product photos. Buys 25-50 annually. Pays on a per-job or a per-photo basis. Call to arrange an appointment.
B&W: Uses contact sheets for selection, then double-weight glossy or matte prints. Will determine specifications at time of assignment. Pays $100 minimum.
Color: Uses transparencies. Will determine specifications at time of assignment. Pays $100 minimum.

***CHRISTOPHER LARDAS ADVERTISING**, Box 1440, New York NY 10101. (212)688-5199. Ad agency. President: Christopher Lardas. Clients: industrial, consumer packaging.
Needs: Works with 1 freelance photographer/month. Uses photographers for trade magazines, direct mail, P-O-P displays, catalogs, newspapers. Subjects include: paper products, safety equipment, confectionery packages.
Specs: Uses 8x10 and larger glossy b&w and color prints; 35mm, 4x5, 8x10 transparencies.
First Contact & Terms: Send unsolicited photos by mail for consideration; provide resume, business card, brochure, flyer or tearsheets to be kept on file for possible future assignments. Works with local freelancers on assignment only. Does not return unsolicited material. Reports in 2 weeks. Pays/job; photo. Photographers submit flat fee first. Pays on receipt of invoice. Buys all rights. Model release required.
Tips: Mail flyer or tearsheets.

LAUNEY, HACHMANN & HARRIS, 292 Madison Ave., New York NY 10017. (212)679-1702. Contact: Hank Hachmann. Ad agency. Clients: textiles, clothing and manufacturing.
Needs: Works with 5-7 freelance photographers/month. Provide business card and printed samples to be kept on file for possible future assignments. Uses freelancers for billboards, consumer and trade magazines, direct mail, newspapers, P-O-P displays and TV.
First Contact & Terms: Call for personal appointment to show portfolio. "When an assignment comes up I will either select a photographer I know whose style is suited for the job or I will review portfolios of other freelancers I am interested in using." Negotiates payment based on client's budget, amount of creativity required from photographer, where work will appear and previous experience/reputation. Set fee/job $400-1,200.
Tips: Wants to see "15-20 samples" of work.

AL PAUL LEFTON COMPANY INC., 71 Vanderbilt Ave., New York NY 10017. (212)867-5100. Director of Graphics: Dick Page. Ad agency. Serves clients in manufacturing, publishing, automobiles, education and a variety of other fields.
First Contact & Terms: Call for personal appointment to show portfolio. Negotiates payment based on client's budget, amount of creativity required from photographer, where work will appear and previous experience/reputation. "We prefer to find out how much a freelancer will charge for a job and then determine whether or not we will hire him."
Tips: "Would like to see whatever they do best. We use just about all types of work."

LEVINE, HUNTLEY, SCHMIDT & BEAVER, 250 Park Ave., New York NY 10017. (212)557-0900. Creative Director: Allan Beaver. Ad agency. Serves clients in food, publishing, liquor, fabrics and fragrances.
Needs: Works with 5-10 freelance photographers/month. Uses photographers for billboards, occasionally P-O-P displays, consumer and trade magazines, direct mail, TV, brochures/flyers and newspapers.
First Contact & Terms: Call for appointment to show portfolio or mail preliminary samples of work (include use of design and lighting). Negotiates payment based on client's budget, amount of creativity required and where work will appear.

***LYONS/GRAPHICS, INC.**, 299 Madison Ave., New York NY 10017. (212)953-9089. Ad agency. President: Patrick Lyons. Clients: trade/optical-fashion.

Needs: Works with 1 freelance photographer/month. Uses photographers for trade magazines, direct mail, P-O-P displays, catalogs and posters. Subjects include models wearing optical frames or product shots.
Specs: Uses 35mm and 4x5 transparencies.
First Contact & Terms: Provide resume, business card, brochure, flyer or tearsheets to be kept on file for possible future assignments. Works with freelance photographers on assignment basis only. Does not return unsolicited material. Reports in 2 weeks if interested. Pays $50-2,000/job. "Payment by client— within 45 days." Buys all rights. Model release required. Credit line sometimes given.
Tips: Have specific experience, quote firm price and turn-around time.

MCCAFFREY AND MCCALL, INC., 575 Lexington Ave., New York NY 10022. (212)421-7500. Art Buyer/Stylist Assistant: Barbara Bonschick. Senior Buyer: Ellen Cervone. Ad agency. Serves clients in airlines, broadcasting, banking, oil, automobiles, liquor, retailing, jewelry and other industries.
Needs: Works with 5-10 freelance photographers/month. Uses photographers for newspapers and magazines.
First Contact & Terms: Send for list of Art Directors and then contact individual director for appointment. Negotiates pay based on estimates from freelancer.

MEKLER/ANSELL ASSOCIATES, INC., 275 Madison Ave., New York NY 10016. (212)685-7850. President: Leonard Ansell. PR firm. Clients: marketing-oriented consumer, industrial public relations accounts. Photos used in news and feature publicity assignments. Buys "a selected few" annually. Present model release on acceptance of photo. Photographers seen by appointment only. Payment "by advance individual agreement."
B&W: Uses 5x7 glossy prints for people and 8x10 glossy prints for scenes, products, etc.; send contact sheet.
Color: Uses 35mm transparencies and prints; send contact sheet for prints.

MORRIS COMMUNICATIONS CORP., (MOR/COM), 124 E. 40th St., New York NY 10016. (212)883-8828. President: Ben Morris. Ad agency. Uses consumer and trade magazines, direct mail, newspapers, P-O-P displays and packaging. Clients: industry, mail order, book publishing, mass transit. Subject needs vary. Provide resume, business card, brochure and flyer to be kept on file for possible future assignments. Buys second (reprint) rights, or all rights, but may reassign to photographer. Query first with resume of credits; works with local freelancers only. Reports in 1 month. SASE.
B&W: Uses 8x10 glossy prints. Model release required. Pays $50-125.
Color: Uses 2¼x2¼ transparencies and 5x7 or 8x10 glossy prints. Model release required. Pays $75-150.
Tips: "We are a very small shop—3 or 4 people. We buy only on an assignment need and then prefer working with the photographer. On rare occasion we seek outside work and would welcome hearing on the above basis."

RUTH MORRISON ASSOCIATES, 509 Madison Ave., New York NY 10022. (212)838-9221. Contact: Melissa Ritter. PR firm. Uses newspapers, P-O-P displays and trade magazines. Serves clients in home furnishings, food, travel and general areas. Commissions 4-5 photographers/year. Pays $25 and up/hour. Model release required. Submit portfolio for review. SASE. Reports in 1 month.
B&W: Uses 8x10 prints.
Color: Uses transparencies.

***MORROW LEWIS & KELLEY INC.,** 25 Central Park W., New York NY 10023. (212)245-7646. Ad agency. Creative Director: Carol Lewis. Clients: consumer products (packaged goods). Client list free with SASE.
Needs: Works with 2-3 freelance photographers/month. Uses photographers for newspapers, consumer magazines, P-O-P displays, posters, trade magazines and brochures. Subject matter is "generally food"; photos are "primarily still life." Seldom works with freelance filmmakers to produce TV commercials.
Specs: Specifications for prints, transparencies and film vary.
First Contact & Terms: Arrange a personal interview to show portfolio; provide resume, business card, brochure, flyer or tearsheets to be kept on file for possible future assignments. SASE. Buys all

rights. Model release required. Credit line "generally not" given.

Tips: Prefers to see photographer's "printed pieces and 4x5's or 8x10's—preferably not carousels."

MOSS & COMPANY, INC., 49 W. 38th St., New York NY 10018. (212)575-0808. Art Director: Georgia Macris. Serves clients in consumer products, manufacturing, utilities and entertainment. Annual billing: $6,000,000.

Needs: Works with 2-3 freelance photographers/month. Uses photographers for billboards, consumer and trade magazines, direct mail, TV, brochures/flyers and newspapers.

First Contact & Terms: Call for appointment to show portfolio. Negotiates payment based on client's budget: $300-1,500/job; $400/b&w photo; $1,500/color photo. Prefers to see samples of still life and people.

Tips: "Photographer must be technically perfect with regard to shooting still life and people. *Then talent!*"

MUIR, CORNELIUS MOORE, INC., 19th Floor, 750 3rd Ave., New York NY 10017. (212)687-4055. Chief Creative Director: Richard Moore. Ad agency/design firm. Clients: banking, manufacturing, systems, computers, communications, other industries. Commissions photographers for specific assignments. Query first with resume of credits.

Tips: "Send promotional material or drop off portfolio to Virginia Martin, Creative Resources Administrator. We need good corporate photographers."

MULLER, JORDAN, WEISS, INC., 666 5th Ave., New York NY 10103. (212)399-2700. Creative Director: Jerry Coleman. Ad agency. Clients: fashion, agricultural, industrial/corporate, plastics, food firms, window and ceiling products.

Needs: Works with 15 freelance photographers/year on assignment only basis. Uses photographers for consumer and trade magazines, direct mail, P-O-P displays, brochures, posters, newspapers and AV presentations.

First Contact & Terms: Phone for appointment. Pays $300/b&w photo; $500/color photo; $300-2,500/day.

***NEWMARKS ADVERTISING AGENCY**, 255 W. 26 St., New York NY 10001. (212)620-7600. Ad agency. Creative Director: Al Wasserman. Clients: industrial, finance, business to business, real estate, health.

Needs: Uses photographers for consumer and trade magazines, direct mail, catalogs, posters and newspapers. Subjects include fitness and sports.

Specs: Uses 8x10 glossy b&w prints; 35mm, 2¼x2¼, 4x5, 8x10 transparencies.

First Contact & Terms: Query with samples; provide resume, business card, brochure, flyer or tearsheets to be kept on file for possible future assignments. Works with freelance photographers on assignment only. Does not return unsolicited material. Reports in 1 week. Pays $500-1,500/day. Pays on acceptance and receipt of invoice. Buys all rights. Model release required; captions preferred. Credit line sometimes given.

Tips: Send nonreturnable samples such as Xerox prints or shots.

OGILVY & MATHER, INC., 2 E. 48th St., New York NY 10017. (212)907-3400. Contact: Mary Mahon for list of creative directors. Ad agency. Clients: cosmetics, food, clothing, tourism and pharmaceuticals; telephone company.

First Contact & Terms: Contact Ellen Johnson, Art Buying Department, for creative directors and individual requirements and needs.

PARK PLACE GROUP, INC., 157 E. 57th St., New York NY 10022. (212)838-6024. Ad agency. President, Creative Director: Bette Klegon. Clients: fashion, publishing, architectural design, cosmetics and fragrances, financial and retail stores.

Needs: Works with 1-5 freelance photographers/month. Uses photographers for consumer magazines, trade magazines, direct mail, brochures and posters. Subjects include: fashion and still life. Also works with freelance filmmakers to produce TV commercials and training films.

Specs: Uses 35mm, 2¼x2¼, 4x5 and 8x10 transparencies; Super 8mm and 16mm film.

First Contact & Terms: Submit portfolio for review; provide resume, business card, brochure, flyer or tearsheets to be kept on file for possible future assignments. Works with freelance photographers on assignment basis only. Does not return unsolicited material. Payment "depends on budget allocations and work involved." Pays on acceptance. Model release required.

Tips: Prefers men's and women's fashion in b&w and color; color still lifes.

***RANKO INTERNATIONAL**, 390 5th Ave., New York City NY 10018. (212)736-2790. Vice President: Elise Krentzel. Clients: Fashion, industrial and commercial filmmakers, banks, department stores. Client list provided with SASE.

Needs: Works with "maybe 1 freelance photographer in 2 months." Uses freelance photographers for press, b&w photos. Subjects include product shots, location shots of interior space.
Specs: Uses 8x10 b&w and color prints, and 8x10 transparencies.
First Contact & Terms: Query with resume of credits or unsolicited photos by mail for consideration. Works with local freelancers only. Does not return unsolicited material. Reports in 1 month. Pays $150-700/day and $150-1,500/job. Pays "when client pays us." Buys one-time rights. Model release preferred.

RAPP & COLLINS, 475 Park Ave. S., New York NY 10016. (212)725-8100. Ad agency. AV Producer/ Art Buyer: Liza Hertzi. Serves all types of clients; specializes in direct response and direct marketing.
Needs: Works with 2-3 freelance photographers/month. Uses photographers for consumer and trade magazines, direct mail, brochures, catalogs, newspapers, AV presentations. Subject matter varies.
Specs: "Varies upon individual client requirements."
First Contact & Terms: Provide brochure, flyer or tearsheets at interview to be kept on file for possible future assignments. "Too many photographers call for personal interview—no time to see all." Pay "depends on particular jobs and budget." Rights purchased vary. Model release required.
Tips: "In a portfolio, we would like to see how a photographer thinks. Be unique, reasonably priced and be patient. It is important that the photographer's work shows a good sense of color, proportion and lighting techniques. It is also important that they show creativity, something that will differentiate them from the rest. We are always interested in new and exciting talent. We tend to use freelancers upon recommendations. New uses for photography include converting photographs to mezotints and using high contrast color xeroxes of photographs to abstract colors."

RICHARD H. ROFFMAN ASSOCIATES, Suite 6A, 697 West End Ave., New York NY 10025. (212)749-3647. Contact: Vice President. PR firm. Clients: all types of accounts, "everything from A to Z." Free client list available with SASE. Photos used in public relations, publicity and promotion. Works with about 3 freelance photographers/month on assignment only basis.
First Contact & Terms: Provide resume, flyer, business card and brochure to be kept on file for possible future assignments. Buys about 40 photos annually. Negotiates payment based on client's budget, amount of creativity required, where work will appear and photographer's previous experience/reputation. Pays $10-20/hour; $50-100/day; $50-100/job; $35/b&w photo; $85/color photo. Pays on delivery. Submit model release with photo.
Tips: "Nothing should be sent except a business card or general sales presentation or brochure. Nothing should be sent that requires sending back, as we unfortunately don't have the staff or time. We have assignments from time to time for freelancers but when we do then we seek out the photographers."

PETER ROTHHOLZ ASSOCIATES, INC., 380 Lexington Ave., New York NY 10168. (212)687-6565. Contact: Peter Rothholz. PR firm. Clients: pharmaceuticals (health and beauty), government, travel. Photos used in brochures, newsletters, PR releases, AV presentations and sales literature. Works with 2 freelance photographers/year, each with approximately 8 assignments. Provide letter of inquiry to be kept on file for possible future assignments. Negotiates payment based on client's budget. Credit line given on request. Buys one-time rights. Model release preferred. Query with resume of credits or list of stock photo subjects. Local freelancers preferred. SASE. Reports in 2 weeks.
B&W: Uses 8x10 glossy prints; contact sheet OK.
Tips: "We use mostly standard publicity shots and have some 'regulars' we deal with. If one of those is unavailable we might begin with someone new—and he/she will then become a regular."

JACK SCHECTERSON ASSOCIATES, INC., 6 E. 39th St., New York NY 10016. (212)889-3950. Ad agency. President: Jack Schecterson. Clients: industrial, consumer.
Needs: Uses photographers for consumer and trade magazines, packaging, product, design, direct mail, P-O-P displays, brochures, catalogs, etc..
Specs: Uses b&w or color prints; 35mm, 2¼x2¼, 4x5 and 8x10 transparencies.
First Contact & Terms: Arrange a personal interview to show portfolio; provide resume, business card, brochure, flyer or tearsheets to be kept on file for possible future assignments. Works with freelancers on assignment only basis. Reporting time "subject to job time requirements." Buys all rights. Model release and captions required.

SPENCER PRODUCTIONS, INC., 234 5th Ave., New York NY 10001. General Manager: Bruce Spencer. PR firm. Clients: business, industry. Produces motion pictures and videotape. Works with 1-2 freelance photographers/month on assignment only basis. Provide resume and letter of inquiry to be kept on file for possible future assignments. Buys 2-6 films/year. Pays $5-15/hour; $500-5,000/job; negotiates payment based on client's budget. Pays a royalty of 5-10%. Pays on acceptance. Buys all

rights. Model release required. Query with resume of credits. "Be brief and pertinent!" SASE. Reports in 3 weeks.

Subject Needs: Satirical approach to business and industry problems. Freelance photos used on special projects. Length: "Films vary—from a 1-minute commercial to a 90-minute feature."

Film: 16mm color commercials, documentaries and features.

Tips: "Almost all of our talent was unknown in the field when hired by us. For a sample of our satirical philosophy, see paperback edition of *Don't Get Mad . . . Get Even* (W.W. Norton), by Alan Abel which we promoted, or *How to Thrive on Rejection* (Dembner Books, Inc.)."

LEE EDWARD STERN COMMUNICATIONS, 27th Floor, 500 Fifth Ave., New York NY 10119. (212)689-2376. PR firm; also provides editorial services. Clients: industrial, financial. Client list free with SASE.

Needs: Works with 1-2 freelance photographers/year. Uses photographers for brochures, annual reports, news coverage. Subject needs vary—people, plants, equipment, destination shots. Also works with freelance filmmakers to produce TV news clips, industrial films.

First Contact & Terms: Provide resume, business card, brochure, flyer or tearsheets to be kept on file for possible future assignments. Works with freelancers on assignment only basis. Pays $350 minimum/day. Pays after receiving client payment. Rights purchased vary. Model release required. Credit line sometimes given.

SUDLER & HENNESSEY, 1633 Broadway, New York NY 10019. (212)265-8000. Creative Director: Ernie Smith. Ad agency. Clients: medical and pharmaceutical.

Needs: Uses photographers for trade shows, booths, conventions, large displays, P-O-P displays, direct mail, brochures/flyers and medical photography.

First Contact & Terms: Call or submit portfolio to Art Coordinators. Negotiates payment based on going rate and client's budget. Pays $250-1,200/b&w photo; $750-3,000/color photo. Buys one-time rights and exclusive product rights.

Tips: "Although our clients are in the medical and pharmaceutical field we don't want to see test tubes or lab shots; we prefer more general photos. Largest and oldest agency in medical field. Ask for a list of art directors and make individual appointments. If not seen, leave your book (well organized and not too heavy), and it will be circulated by the art coordinator."

***THE TARRAGANO COMPANY**, 230 Park Ave., New York City NY 10169. (212)972-1250. PR firm. President: Morris Tarragano. Clients: industrial, consumer products.

Needs: Uses photographers for consumer and trade magazines. Subjects include product shots.

Specs: Uses b&w and color 8x10 prints and 35mm transparencies.

First Contact & Terms: Provide resume, business card, brochure, flyer or tearsheets to be kept on file for possible future assignments. Works with freelance photographers on assignment basis only. Does not return unsolicited material. Pays on receipt of invoice. Model release required.

TELE-PRESS ASSOCIATES, INC., 342 E. 79th St., New York NY 10021. (212)744-2202. President: Alan Macnow. PR firm. Uses brochures, annual reports, PR releases, AV presentations, consumer and trade magazines. Serves beauty, fashion, finance and government clients. Works with 3 freelance photographers/month on assignment only basis. Provide resume, business card and brochure to be kept on file for possible future assignments.

Specs: Uses 8x10 glossy b&w prints; 35mm, 2¼x2¼, 4x5 or 8x10 color transparencies. Works with freelance filmmakers in production of 16mm documentary, industrial and educational films.

Payment & Terms: Pays $100 minimum/job; negotiates payment based on client's budget. Buys all rights. Model release and captions required.

Making Contact: Query with resume of credits or list of stock photo subjects. SASE. Reports in 2 weeks.

VAN BRUNT AND COMPANY, ADVERTISING MARKETING, INC., 300 E. 42nd St., New York NY 10017. (212)949-1300. Contact: Lisa Salay, Art Director. Ad agency. Clients: general consumer firms; client list provided upon request.

Needs: Works on assignment basis only. Uses photographers for consumer and trade magazines, direct mail, P-O-P displays, brochures, catalogs, posters, newspapers and AV presentations.

First Contact & Terms: Arrange interview to show portfolio. Payment is by the project; negotiates according to client's budget.

WARING & LAROSA, INC., 555 Madison Ave., New York NY 10022. (212)755-0700. Contact: Art Directors. Ad agency. Serves clients in food, cosmetics and a variety of other industries.

Needs: Works with 25 freelance photographers/year. Uses photographers for billboards, P-O-P dis-

plays, consumer magazines, TV and newspapers.
First Contact & Terms: Call art directors for appointment to show portfolio. Negotiates payment based on client's budget.

WARNER BICKING & FENWICK, 866 UN Plaza, New York NY 10017. (212)759-7900. Ad agency. Art Director: Dick Grider. Clients: industrial and consumer. Client list provided on request.
Needs: Works with 1-2 freelance photographers/month; "varies, however." Uses photographers for consumer and trade magazines, brochures.
Specs: Uses 4x5 transparencies; varies.
First Contact & Terms: Send unsolicited photos by mail for consideration. Does not return unsolicited material.
Tips: "Send samples of work by mail. There is not enough time to see people."

MORTON DENNIS WAX & ASSOCIATES, 1560 Broadway, New York NY 10031. (212)302-5360. PR firm. Clients: entertainment, industry, health.
Needs: Works with varying number of freelance photographers on 2-3 jobs/month. Uses freelancers for consumer and trade magazines, newspapers and P-O-P displays.
First Contact & Terms: Write and request personal interview to show portfolio. "We select and use freelancers on a per project basis based on specific requirements of clients. Each project is unique." Negotiates payment based on client's budget, amount of creativity required from photographer and previous experience/reputation.

ROSLYN WILLETT ASSOCIATES, INC., 441 West End Ave., New York NY 10024. (212)787-6060. President: R. Willett. PR firm. Clients: industrial, food accounts. Photos used in magazine articles and brochures. Works with 3-4 freelance photographers/month on assignment only basis.
First Contact & Terms: Provide resume, flyer, brochure and list of types of clients and resume of credits; do not send unsolicited material. Submit model release with photo. Pays $300 minimum/day. Negotiates payment based on client's budget, photographer's previous experience/reputation and reasonable time rates (photos are mostly on location).
Tips: "We always need good photographers out of town. Prefers 2¼x2¼ and larger sizes. 35mm only for color transparencies. Natural light."

***WENDI WINTERS PUBLIC RELATIONS**, #701, 920 Broadway, New York NY 10010. (212)475-6589. Ad agency, PR firm. President/Owner: Wendi Winters. Clients: fashion.
Needs: Works with 1-2 freelance photographers/month. Uses photographers for press kits to all media/some ads. Subjects include: fashion.
Specs: Uses 8x10 matte b&w prints; 35mm, 2¼x2¼ transparencies.
First Contact & Terms: Submit portfolio for review; provide resume, business card, brochure, flyer or tearsheets to be kept on file for possible future assignments. Works with local freelancers only. SASE. Reports in 2 weeks. Pays $400-3,000/job. Pays 30 days of receipt of invoice. Buys all rights. Model release required. Credit line given on ads, others negotiated.
Tips: Prefers to see great fashion b&w—understanding of press kit photography. Some color, women, men, kids, stills of accessories. "Have some understanding of the fashion industry and basis of styling, access to good studio and darkroom, good presentation skills."

North Carolina

BOB BOEBERITZ DESIGN, 247 Charlotte St., Asheville NC 28801. (704)258-0316. Graphic Design Studio. Owner: Bob Boeberitz. Clients: ad agencies, real estate developers, retail, computer software, recording artists, mail-order firms, industrial, restaurants, hotels.
Needs: Works with 1 freelance photographer every 2 or 3 months. Uses photographers for consumer and trade magazines, direct mail, brochures, catalogs, posters. Subjects include studio product shots; some location.
Specs: Uses 8x10 b&w glossy prints; 4x5 transparencies, 35mm slides.
First Contact & Terms: Provide resume, business card, brochure, flyer or tearsheets to be kept on file for possible future assignments. Does not return unsolicited material. Reports "when there is a need." Pays $75-150/b&w photo; $75-300/color photo; $50-100/hour; $200-500/job. Payment made on a per-job basis. Buys all rights. Model release preferred.
Tips: Prefers to see "studio capabilities, both b&w and color, creativity" in a portfolio. "Have a unique capability (i.e., studio big enough to drive a bus into) and the ability to turn around a job fast and efficiently. I usually don't have the time to do something twice. Also, stay in budget. No surprises."

CLELAND, WARD, SMITH & ASSOCIATES, Suite 520, Tobacco Square Bldg., 836 Oak St., Winston-Salem NC 27101. (919)723-5551. Ad agency. Production Manager: James K. Ward. Clients: primarily industrial, business-to-business.
Needs: Uses photographers for trade magazines, direct mail, brochures and catalogs. Subjects include: "product shots or location shots of plants, offices, workers and production flow; also technical equipment detail shots."
Specs: Uses 8x10 b&w and color prints and transparencies.
First Contact & Terms: Arrange a personal interview to show portfolio. Works with freelance photographers on assignment basis only. Does not return unsolicited material. Pays/job. Pays on acceptance. Buys all rights. Model release required.
Tips: Prefers to see "innovation—not just execution."

GARNER & ASSOCIATES, INC., Suite 350, 3721 Latrobe Dr., Charlotte NC 28211. (704)365-3455. Art Director: Aecon Stewart. Ad agency. Serves wide range of accounts; client list provided upon request.
Needs: Works with 1-2 freelance photographers/month on assignment only basis. Uses photographers for all media.
First Contact & Terms: Send printed samples or phone for appointment. Payment is by the project or day rate; negotiates according to client's budget. Negotiates photo rights.

LEWIS ADVERTISING, INC., 2309 Sunset Ave., Box Drawer L , Rocky Mount NC 27801. (919)443-5131. Art Director: Scott Brandt. Ad agency. Uses billboards, consumer and trade magazines, direct mail, newspapers, P-O-P displays, product packaging, radio and TV. Serves clients in restaurants, finance and other industries. Deals with a minimum of 6 photographers/year.
Specs: Uses 8x10 and 11x14 glossy b&w prints, and 8x10 color transparencies.
Payment & Terms: Pays $500/day, $150/b&w photo, also by job and hour. Buys all and one-time rights. Model release required.
Making Contact: Arrange a personal interview to show portfolio or query with samples. SASE. Reports in 2 weeks.

SSF ADVERTISING, Drawer 1708, Hickory NC 28603. (704)328-5618. Ad agency. President: Paul F. Fogleman. Clients: industrial, finance, consumer.
Needs: Works with 2-3 freelance photographers/month. Uses photographers for billboards, consumer and trade magazines, direct mail, P-O-P displays, brochures, catalogs, posters, newspapers, AV presentations. Subject needs vary. Also works with freelance filmmakers to produce TV spots, films.
Specs: Uses b&w or color prints; 35mm, 2¼x2¼ and 4x5 transparencies; 8mm, Super 8mm, 16mm and videotape film.
First Contact & Terms: Query with samples. Works with freelance photographers on assignment basis only. Does not return unsolicited material. Reports back "as need dictates." Payment varies by day, job or per photo. Pays on acceptance. Buys all rights. Model release required.
Tips: Prefers to see "specialties and variety" in a portfolio.

Ohio

BARON ADVERTISING, INC., 645 Hanna Bldg., Cleveland OH 44115. (216)621-6800. Ad agency. President: Selma Baron. Clients are "diverse."
Needs: Uses 20-25 freelance photographers/month. Uses photographers for direct mail, catalogs, newspapers, consumer magazines, P-O-P displays, posters, AV presentations, trade magazines, brochures and signage. Subject matter "diverse." Also works with freelance filmmakers.
First Contact & Terms: Query with list of stock photo subjects; provide resume, business card, brochure, flyer or tearsheets to be kept on file for possible future assignments. Works with freelance photographers on assignment basis only. Does not return unsolicited material. Payment "depends on the photographer." Payment made "when job is finished." Buys all rights. Model release required.
Tips: Prefers to see "food and equipment" photos in the photographer's samples. "Samples not to be returned other than regional photographers."

BRAND PUBLIC RELATIONS, 1600 Keith Bldg., Cleveland OH 44115. (216)696-4555. Division of ad firm. Director of Public Relations: Brian D. Bloom. Clients: industrial, medical, consumer, agri-business, associations.
Needs: Works with 1 freelance photographer every 2 months. Uses photographers for trade magazines, feature story photos at varied sites. Subjects include "publicity photos of client's product in use for

feature story." Occasionally works with freelance filmmaker or videographer to produce public service announcements or special projects.

Specs: Uses 5x7 and 8x10 b&w or color glossy prints; 35mm, 2¼x2¼ and 4x5 transparencies; 16mm, 35mm and videotape film.

First Contact & Terms: Provide resume, business card, brochure, rate schedule, flyer or tearsheets to be kept on file for possible future assignments. Works with freelance photographers on assignment basis only. Does not return unsolicited material. "No response if unsolicited." Pays $50-700/job or negotiable with project quote. Pays on acceptance. Buys all rights including negatives. Model release required; captions preferred.

Tips: "Submit resume, rates and any description of publicity photo experience."

***BYER & BOWMAN ADVERTISING AGENCY**, 66 S. Sixth St., Columbus OH 43215. (614)221-7751. Ad agency. Art Director: Teri Myers. Clients: industrial, retail, finance.

Needs: Works with 2-3 freelance photographers/month. Uses photographers for trade magazines, direct mail, P-O-P displays and newspapers. Subjects include food/machinery.

Specs: Uses 4x5 transparencies.

First Contact & Terms: Arrange a personal interview to show portfolio; provide resume, business card, brochure, flyer or tearsheets to be kept on file for possible future assignments. Works with freelance photographers on an assignment basis only. Does not return unsolicited material. Reports in 2 weeks. Pays per job-depends on job. Pays on receipt of invoice. Buys all rights. Model release required.

FAHLGREN & FERRISS, INC., Suite 901, One Seagate, Toledo OH 43604. (419)247-5200. Art Director: Cathy Rennels. Ad agency. Clients: industrial and financial.

Needs: Works with 8 freelance photographers/month. Uses photographers for P-O-P displays, consumer and trade magazines, direct mail, brochures/flyers and newspapers.

First Contact & Terms: Call for appointment to show portfolio or make contact through photographer's representative. Negotiates payment based on client's budget, amount of creativity required and where work will appear.

GRISWOLD INC., 55 Public Sq., Cleveland OH 44113. (216)696-3400. Executive Art Director: Tom Gilday. Ad agency. Clients: Consumer and industrial firms; client list provided upon request. Provide brochure to be kept on file for possible future assignments.

Needs: Works with freelance photographers on assignment only basis. Uses photographers for billboards, consumer and trade magazines, direct mail, P-O-P displays, brochures, catalogs, posters, newspapers and AV presentations.

First Contact & Terms: Works primarily with local freelancers but occasionally uses others. Arrange interview to show portfolio. Payment is by the day or by the project; negotiates according to client's budget. Pays on production.

HAYES PUBLISHING CO., INC., 6304 Hamilton Ave., Cincinnati OH 45224. (513)681-7559. Office Manager: Marge Lammers. AV publisher. Clients: school, civic and right-to-life groups. Produces filmstrips and slide-cassette sets. Subjects include "miscellaneous baby, child and adult scenes." Needs photos of prenatal development of the human body and shots relating to abortion. Buys all rights. Contact by mail first. Reports in 2 weeks. SASE.

B&W: Contact by mail about specifications and needs first.

Color: Uses 35mm transparencies or 35mm negatives with 5x7 glossy prints. Captions and model release required. Pays $50 minimum.

Tips: "We are always looking for excellent, thoroughly documented and authenticated photographs of early developing babies and of any and all types of abortions."

JACKSON/RIDEY & COMPANY, INC., 424 East 4th St., Cincinnati OH 45202. (513)621-8440. Production Director: Mark Schlachter. Advertising agency. Uses brochures, newsletters, annual reports, PR releases, AV presentations, sales literature, consumer and trade magazines. Serves fashion, food, finance, travel and industrial clients. Assigns 50-75 jobs/year.

Specs: Uses 8x10 b&w and color prints; 2¼x2¼ or 4x5 color transparencies. Works with freelance filmmakers on 16-35mm industrial and occasional production of stock for TV commercials.

Payment & Terms: Pays $20-75/hour, $20 minimum/job; $600/day maximum. Buys all rights. Model release required.

Making Contact: Arrange a personal interview with Production Director Mark S. Schlachter to show portfolio or query with samples. SASE. Prefers local freelancers. Reports in 2 weeks.

Tips: "We want to see that a photographer can take direction and work to specifications. We are more concerned with getting what we want than what a photographer thinks we should have. We want to see good commercial and editorial work—b&w or color. The photographer should leave his artsy stuff at home. Seems to be a trend toward the use of large prints—30x40" and bigger."

JONES, ANASTASI, CORBETT, LENNON ADVERTISING, INC., (formerly Corbett Advertising), 40 S. 3rd St., Columbus OH 43215. (614)221-2395. Art Director: Anne Buckley. Ad agency. Clients: hospitals, insurance, colleges, restaurants and industrial.
Needs: Works on assignment basis only. Uses photographers for billboards, consumer and trade magazines, brochures, posters, newspapers and AV presentations.
First Contact & Terms: Arrange interview to show portfolio. Payment is by the hour, by the day, and by the project; negotiates according to client's budget.

LANG, FISHER & STASHOWER, 1010 Euclid Ave., Cleveland OH 44115. (216)771-0300. Executive Art Director: Larry Pillot. Ad agency. Clients: consumer firms.
Needs: Works with 5 freelance photographers/year on assignment only basis. Uses photographers for all media.
First Contact & Terms: Local freelancers primarily. Query with resume of credits and samples. Payment is by the project; negotiates according to client's budget, amount of creativity required, where work will appear and freelancer's previous experience.

***LOHRE & ASSOCIATES INC.**, 1420 E. McMillan St., Cincinnati OH 45206. (513)961-1174. Ad agency. President: Charles R. Lohre. Clients: industrial.
Needs: Works with 1 photographer/month. Uses photographers for trade magazines, direct mail, catalogs and prints. Subjects include: machine-industrial themes and various eye-catchers.
Specs: Uses 8x10 glossy b&w and color prints; 4x5 transparencies.
First Contact & Terms: Query with resume of credits; provide resume, business card, brochure, flyer or tearsheets to be kept on file for possible future assignments. Works with local freelancers only. SASE. Reports in 1 week. Pays $60/b&w photo; $250/color photo; $60/hour; $275/day. Pays on publication. Buys all rights.
Tips: Prefers to see eye-catching and thought provoking images/non-human. Need someone to take photos 35mm on short notice in Cincinnati plants.

McKINNEY/GREAT LAKES, 1166 Hanna Bldg., Cleveland OH 44115. (216)621-0648. Art Directors: Doug Pasek, Harry Bush. A full-service ad agency. Clients: consumer, business-to-business.
Needs: Uses freelancers for people, product photography.
First Contact & Terms: Call for appointment to show portfolio. Negotiates payment based on photographer's fees.
Tips: Likes to see dramatic compositional and design elements. Primarily uses local photographers.

MANDABACH & SIMMS/OHIO, INC., 1277 Lexington Ave., Mansfield OH 44907. (419)756-7771. Art Director: Charles Bowen. Ad agency. Clients: industrial, trade, food, consumer-oriented products.
Needs: Works with 2-3 freelance photographers/month. Uses photographers for trade magazines, direct mail, P-O-P displays, brochures, catalogs, posters, newspapers. "We occasionally purchase stock."
Specs: Uses 4x5 to 16x20 medium matte prints; 35mm, 4x5 and 8x10 transparencies.
First Contact & Terms: Arrange a personal interview to show portfolio. Works with freelance photographers on assignment basis only. Does not return unsolicited material. Pays on acceptance. Buys all rights. Model release required.
Tips: "Proximity is relatively important."

MARK ADVERTISING AGENCY, INC., 1600 5th St., Sandusky OH 44870. (419)626-9000. President: Joseph Wesnitzer. Ad agency. Media includes consumer and trade magazines, direct mail and newspapers. Serves clients in industry. Submit portfolio. Cannot return unsolicited material.
B&W: Uses 8x10 glossy prints.
Color: Uses 35mm, 2¼x2¼ and 4x5 transparencies. Also uses 8x10 glossy prints.

NATIONWIDE ADVERTISING, INC., Euclid Ave. at E. 12th St., Cleveland OH 44115. (216)579-0300. Contact: Creative Director. Ad agency. "This is a recruitment agency which is utilized by a wide variety of clientele, really indiscriminate."
Needs: Works with "very few freelancers but this could change." Uses freelancers for billboards, consumer and trade magazines, newspapers and TV.
First Contact & Terms: Send samples, but "does not want actual portfolio." Selects freelancers "by how easily accessible they are and the characteristics of their work." Negotiates payment based on client's budget. Does not return unsolicited material.

NORTHLICH, STOLLEY, INC., 200 W. 4th St., Cincinnati OH 45202. Creative Director: Cliff Schwandner. Ad agency. Clients: financial, industrial, food service, package goods, durables; client list provided on request.

Needs: Works with 5-6 freelance photographers/month on assignment only basis. Uses photographers for consumer and trade magazines, direct mail, P-O-P displays, brochures, posters, signage, newspapers and AV presentations.
First Contact & Terms: Query with list of stock photo subjects; provide brochure, flyer and tearsheets to be kept on file for possible future assignments. Does not return unsolicited material. Reports in 1 week. Negotiates payment according to client's budget; $500-3,000/ b&w photo; $400-6,000/color photo. Pays on production. Buys exclusive rights; all rights.

THE PARKER ADVERTISING COMPANY, 3077 S. Kettering Blvd., Dayton OH 45439. (513)293-3300. Art Director: Sazro Mahambrey. Ad agency. Clients: industrial.
Needs: Works with 3-4 freelance photographers/year. Uses photographers for trade magazines, direct mail, brochures, catalogs, posters and AV presentations.
First Contact & Terms: Send name, address and samples to be kept on file. Not returnable.

***TRL PRODUCTIONS**, 15655 Brookpark Rd., Cleveland OH 44142. Ad agency. President: Linda Meglin. Clients: industrial. Client list with SASE.
Needs: Works with 6 freelance photographers/month. Uses photographers for trade magazines, direct mail, catalogs/brochures. Subjects include products, location shots, plant shots.
Specs: Uses color prints; 2¼x2¼ and 4x5 transparencies.
First Contact & Terms: Query with resume of credits and list of stock photo subjects; send unsolicited photos by mail for consideration; query with samples; submit portfolio for review; provide resume, business card, brochure, flyer or tearsheets to be kept on file for possible future assignments, "then I'll call to arrange interview." Works with freelance photographers on assignment basis only. SASE. Reports in 3 weeks. Pays "whatever is rate of photographer—must be in our budget limitations." Pays 30 days after receipt of invoice or other established time frame. Buys all rights. Model release and captions preferred. Credit line given if desired.
Tips: Prefers to see industrial and special effects. "Send me resume and brochure (or whatever). I'll call. Don't call, I'll call you."

WYSE ADVERTISING, 24 Public Square, Cleveland OH 44113. (216)696-2424. Art Director: Tom Smith. Ad agency. Uses billboards, consumer and trade magazines, direct mail, newspapers, P-O-P displays, radio and TV. Serves clients in a variety of industries. Deals with 20 photographers/year.
Specs: Uses b&w photos and color transparencies. Works with freelance filmmakers in production of TV commercials.
Payment/Terms: Pays by hour, day and job. Buys all rights. Model release required.
Making Contact: Arrange a personal interview to show portfolio.

Oklahoma

ADSOCIATES, INC., 3727 NW 63 St., Oklahoma City OK 73116. (405)840-1881. Creative Director: Bob Stafford. Ad agency. Clients: 50% industrial, 50% consumer firms; client list provided upon request.
Needs: Works with 6 freelance photographers/month on assignment only basis. Uses photographers for all media.
First Contact & Terms: Query with resume of credits and samples. Payment is by the project; negotiates according to client's budget.

DPR COMPANY, 6161 N. May, Oklahoma City OK 73112. (405)848-6407. Owner: B. Carl Gadd. Industrial PR firm. Photos used in brochures and press releases. Buys 35-100 photos/year. Pays $50 minimum/hour, $400 minimum/day. Pays on production. Photos solicited by assignment only; query with resume of credits or call to arrange an appointment; provide business card and flyer to be kept on file for possible future assignments. Reports in 1 week. Does not return unsolicited material.
Film: Produces all types of film. Buys all rights.
B&W: Uses 5x7 glossy prints.
Color: Uses any size transparencies and prints.
Tips: "All material should be dated and the location noted. Videotape is now 80% of my product needs."

JORDAN ASSOCIATES ADVERTISING & COMMUNICATIONS, 1000 W. Wilshire, Box 14005, Oklahoma City OK 73113. (405)840-3201. Director of Photography: John Williamson. Ad agency. Uses billboards, consumer and trade magazines, direct mail, foreign media, newspapers, P-O-P

displays, radio and TV, annual report and public relations. Clients: banking, manufacturing, food, clothing. Generally works with 2-3 freelance photographers/month on assignment only basis.
Specs: Uses b&w prints and color transparencies. Works with freelance filmmakers in production of 16mm industrial and videotape, TV spots; short films in 35mm.
Payment & Terms: Pays $25-55 minimum/hour for b&w, $200-400 minimum/day for b&w or color (plus materials). Negotiates payment based on client's budget and where the work will appear. Buys all rights. Model release required.
Making Contact: Arrange a personal interview to show portfolio (prefers to see a complete assortment of work in a portfolio); provide flyer and business card to be kept on file for possible future assignments. SASE. Reports in 2 weeks.

Oregon

HUGH DWIGHT ADVERTISING, 4905 SW Griffith Dr., Beaverton OR 97005. (503)646-1384. Ad agency. Production Manager: Pamela K. Medley. Clients: industrial, outdoor sports equipment, lumber, motor yachts, binoculars.
Needs: Works with 3-4 freelance photographers/month. Uses photographers for trade magazines, P-O-P displays, brochures, catalogs, posters, AV presentations, news releases, product shots, ads. Subjects include: "product shots (in-studio); feature photos (with accompanying manuscript) on wood products, preferably made from Roseburg Forest Products materials."
Specs: Uses 35mm, 2¼x2¼ and 4x5 transparencies.
First Contact & Terms: Arrange a personal interview to show portfolio; query with samples or send unsolicited photos by mail for consideration; provide resume, business card, brochure, flyer or tearsheets to be kept on file for possible future assignments. SASE. Reports in 3 weeks. Payment "depends on the work; we're flexible." Pays on acceptance with ad and public relation shots; on publication with feature photos and articles. Buys one-time rights with features. Model release and captions required. Credit line given on catalogs and magazines only.
Tips: Prefers to see tearsheets and prints. "Show a range of photos, from sharp studio photos (well lighted) to outdoor hunting shots, from traditional 'mug' shots to shots of men working outdoors, from nuts and bolts to yachts at sea. Show capabilities of working with different lighting (indoor, outdoor, available, etc.). We like photographers who have assistants who can re-arrange and help in setups. For some of our clients, we look for a photographer who can do studio work quickly, efficiently. We look for people who can work artistically without constant art direction, but also someone able to work within the limits of the clients' expectations. Need location photographers able to use a wide range of lighting and spacing limitations."

RYAN/RYAN SOUTHWICK ADVERTISING & PUBLIC RELATIONS, Suite 400, Century Tower Bldg., 1201 SW 12th, Portland OR 97201. (503)227-5547. Art Directors: Leslie Herzfeld and Jerry Ketel. Ad agency and PR firm. Uses billboards, direct mail, foreign media, newspapers, promotions, P-O-P displays, radio, TV, trade and consumer magazines, brochures, annual reports and slide/tape presentations. Serves industrial, corporate, retail and financial clients. Deals with 5-10 photographers/year. Provide business card, brochure, and flyer to be kept on file for possible future assignments.
Specs: Uses 8x10 glossy b&w photos, RC prints for retouching and 35mm and 4x5 transparencies. Also uses freelance filmmakers in production on 16mm and tape industrial, training films and commercial production.
Payment & Terms: Pays $25 minimum/hour. "All projects quoted in advance." Buys all rights. Model release required.
Making Contact: Send material by mail for consideration. SASE. Prefers local freelancers. Reports in 2 weeks.
Tips: Prefers to see "industrial, financial, business, promotional, humorous, special effects and product shots" in a portfolio. Prefers to see "prints, tearsheets to support transparencies" as samples. "I like to know the format used and why—also what equipment, studios, etc. are available. Keep in touch, show us new projects. Send us sample post cards of mailings; we keep 'em on file and it really helps in selecting photographers!"

Pennsylvania

TED BARKUS COMPANY, INC., Suite 100, 1512 Spruce St., Philadelphia PA 19102. (215)545-0616. Ad agency and PR firm. Executive Vice President: Allen E. Barkus. Clients: industrial, finance,

appliances, home furnishings, publishers, fashion.
Needs: Uses 1 freelance photographer/month. Uses photographers for direct mail, catalogs, newspapers, consumer magazines, P-O-P displays, posters, AV presentations, trade magazines and brochures. Subjects include "products, office scenes, etc." Uses freelance filmmakers to produce TV commercials and AV films.
Specs: Uses 4x5 and 8x10 b&w and color prints; 35mm transparencies; videotape.
First Contact & Terms: Arrange a personal interview to show portfolio. Works with local and New York freelancers only. SASE. Reports in 3 weeks. Payment varies. Pays on acceptance. Buys all rights. Model release required. Credit line sometimes given.

BILL BYRON PRODUCTIONS, 1727 Elm St., Bethlehem PA 18017. (215)865-1083. Producer: Bill Byron. Clients: recording artists.
Needs: Works with 1-6 photographers/year. Uses photographers for album covers and promo. Subjects vary according to projects.
Specs: Uses 8x10 matte b&w prints, 8x10 color prints; 4x5 transparencies; VHS, and U-matic ¾ videotape.
First Contact & Terms: Provide resume, business card, self-promotion piece or tearsheets to be kept on file for possible future assignments. Works with local freelancers on assignment basis only. Reports in 1 month. Pay varies according to contract with artist. Pays on acceptance, royalties by sale. Buys one-time rights. Model release required. Credit line given.

JERRYEND COMMUNICATIONS INC., RD #2, Box 356H, Birdsboro PA 19508. (215)689-9118. PR firm. Vice President: Jerry End. Clients: industrial, automotive aftermarket, financial, heavy equipment.
Needs: Works with 2 freelance photographers/month. Uses photographers for consumer and trade magazines, catalogs, newspapers, AV presentations. Subjects include case histories/product applications. Also works with freelance filmmakers to produce training films, etc.
Specs: Uses 8x10 b&w repro-quality prints and color negatives.
First Contact & Terms: Provide resume, business card, brochure, flyer or tearsheets to be kept on file for possible future assignments. Works with freelance photographers on assignment basis only. SASE. Reports in 1 week. Pays "by estimate for project." Pays on receipt of photos. Buys all rights. Model release required; captions preferred.

***LESKO INC.**, 625 Stanwix St., Pittsburgh PA 15222. (412)566-1680. Art Director: George Lesko. Ad agency. Uses all media. Serves clients in education, housewares, legal associations, building industry, retailing and steel processing. Subject of photo "depends on assignment." Buys 50 annually. Payment is negotiable depending on time and subject. Call to arrange an appointment.
B&W: Uses 8x10 or prints to size.
Color: Uses transparencies. Uses prints to size.

HAWBAKER COMMUNICATIONS, INC., (formerly Thompson/Matelan & Hawbaker, Inc.), Gateway Towers, Suite 318, 1 Oliver Plaza, Pittsburgh PA 15222. (412)261-6519. Head Art Director: Ron Larson. Ad agency. Uses direct mail, newspapers, trade magazines, radio and TV. Serves primarily industrial clients. Commissions 10 photographers/year. Buys all rights. Model release required. Query with resume of credits. SASE. Reports in 2 weeks.
B&W: Uses 8x10 glossy prints; contact sheet and negatives OK.
Color: Uses 8x10 glossy prints, 35mm and 4x5 transparencies.

HOWARD MILLER ASSOCIATION, INC., 103 S. Duke St., Lancaster PA 17602. (717)291-1130. Graphic Designer: Dan Hoover. Clients: industrial, 90%; other, 10%.
Needs: Works with 1-2 photographers/month. Uses photographers for trade magazines, direct mail, posters, corporate and product brochures. Subject matter is quite variable, from studio product and "beauty" shots to industrial location shots.
Specs: Uses 8x10 glossy b&w prints; others depending on job.
First Contact & Terms: Query with resume of credits, query with samples; provide resume, business card, flyer or tearsheets to be kept on file for possible future assignments. Works with freelance photographers on an assignment basis only. Does not return unsolicited material. Reports in 3 weeks. Pays $300-1,000/day. Pays on receipt of invoice, net 30 days. Buys all rights. Model release required.
Tips: "We want to see portfolio *after* submission of a few samples/tearsheets—any subject OK/industrial preferred. Most important is evidence of creativity."

PERCEPTIVE MARKETERS AGENCY, LTD., Suite 903, 1920 Chestnut St., Philadelphia PA 19103. (215)665-8736. Ad agency. Art Director: Marci Mansfield Fickes. Clients retail furniture, contract

furniture, commuter airline, lighting distribution companies, nonprofit organizatons for the arts, publishing houses. Client list free with SASE.
Needs: Buys 100 freelance photographs and makes 10-15 assignments/year. Uses photographers for consumer and trade magazines, direct mail, catalogs, posters, newspapers. Subjects include product, people, industrial (on location). No fashion.
Specs: Uses 8x10 b&w prints and 35mm, $2\frac{1}{4}$x$2\frac{1}{4}$, 4x5 and 8x10 transparencies.
First Contact & Terms: Query with resume of credits and list of stock photo subjects; send unsolicited photos by mail for consideration; provide resume, business card, brochure, flyer or tearsheets to be kept on file for possible future assignments. Works with local freelance photographers on an assignment basis only. Reports after contract. Pay individually negotiated. Pays on receipt of invoice. Buys all rights. Model release required. Credit line negotiable, depending on photo's use.

RICHARDSON MYERS & DONOFRIO, 10 Penn Center, Philadelphia PA 19037. (215)545-0200. Ad agency. Contact: Art Director. Client list provided on request.
Needs: Uses photographers for billboards, consumer and trade magazines, direct mail, brochures, catalogs, posters, newspapers. Subjects include fashion, agriculture, chemicals. Also works with freelance filmmakers to produce TV commercials.
First Contact & Terms: Query with resume of credits or samples; arrange a personal interview to show portfolio; query with list of stock photo subjects. Provide resume, business card, brochure, flyer or tearsheets to be kept on file for possible future assignments. Works with freelance photographers on assignment basis only. Pays by the job. Buys rights "agreed upon per job." Model release required. Credit line sometimes given.
Tips: "Show portfolio—contact and update from time to time."

***SILBERMAN WHITEBROW DOLAN**, 5 Penn Center, Philadelphia PA 19103. (215)665-1202. Ad agency. Senior Art Director: Rick DeDonato. Clients: health care, toys, cheese/foods, music, sporting equipment (fishing reels and rods). Client list with SASE.
Needs: Works with 2-3 freelance photographers/month. Uses photographers for billboards, consumer and trade magazines, direct mail, P-O-P displays, catalogs, posters, signage, newspapers. Subjects include people/still life.
Specs: Open.
First Contact & Terms: Arrange a personal interview to show portfolio. Works with freelance photographers on assignment basis only. Does not return unsolicited material. Reports "right away." Pays $500-3,500/job. Pays "within 30 days of agency getting paid from client." Buys all rights. Model release required.
Tips: Prefers to see what he/she feels they do best. Set up interview. Be polite, prompt and willing to work hard.

SPIRO & ASSOCIATES, 100 S. Broad St., Philadelphia PA 19110. (215)923-5400. Ad agency. Vice President/Creative Director: H. Robert Lesnick. Executive Art Director: Jack Bythrow. Offers a "complete range of services" to all types of clients. Client list available on request.
Needs: Works with 10-20 freelance photographers/month. Uses photographers for billboards, consumer and trade magazines, direct mail, P-O-P displays, brochures, posters, newspapers, AV presentations. Subjects include travel shots utilizing people. Also works with freelance filmmakers to produce TV.
Specs: Uses varied b&w and color prints; 35mm, $2\frac{1}{4}$x$2\frac{1}{4}$, 4x5 and 8x10 transparencies.
First Contact & Terms: Arrange a personal interview to show portfolio; submit portfolio for review; provide resume, business card, brochure, flyer or tearsheets to be kept on file for possible future assignments. Works with local freelancers on assignment basis only. "Prefer not to" return unsolicited material. Pays by the day, job, or photo; payment varies. Pays on acceptance. Buys all rights. Model release required.
Tips: Prefers to see photos "utilizing people doing things, enjoying life. Show us samples first, we will wait for appropriate time."

South Carolina

BRADHAM-HAMILTON ADVERTISING, Box 729, Charleston SC 29402. (803)884-6445. Ad agency. Contact: Michael Schumpert. Clients: industrial, fashion, finance, insurance, real estate, tourism, hotel, beverage, etc.
Needs: Works with 3-4 freelance photographers/month. Uses photographers for billboards, direct mail, newspapers, consumer magazines, P-O-P displays, posters, AV presentations, trade magazines and brochures. Subjects: all types.

Specs: Uses 8x10 b&w and color glossy prints; 35mm or 2¼x2¼ transparencies.
First Contact & Terms: Query with samples or submit portfolio for review; provide resume, business card, brochure, flyer or tearsheets to be kept on file for possible future assignments. Works with freelance photographers on assignment basis only. Pays according to budget and relative value of job and by quotation, generally $25-150/b&w photo; $50-400/color photo; $100/hour; or $750/day. SASE. Reports in 1 week. Pays on acceptance. Buys all rights or one-time rights. Model release required.
Tips: "Show us your best and keep us updated on any of your particular interesting new work."

BROWER, LOWE & HALL ADVERTISING, INC., 215 W Stone Ave., Box 3357, Greenville SC 29602. (803)242-5350. Vice President/Art Director: Tom Hall. Ad agency. Uses billboards, consumer and trade magazines, direct mail, newspapers, P-O-P displays, radio and TV. Clients: finance and industry. Commissions 6 photographers/year; buys 50 photos/year. Buys all rights. Model release required. Arrange personal interview to show portfolio or query with list of stock photo subjects; will view unsolicited material. SASE. Reports in 2 weeks.
B&W: Uses 8x10 semigloss prints.
Color: Uses 8x10 semigloss prints and 2¼x2¼ transparencies.
Film: Produces 16mm industrial films and filmstrips. Does not pay royalties.

***LESLIE ADVERTISING AGENCY**, 874 S. Pleasantburg Dr., Greenville SC 29607. (803)271-8340. Ad agency. Art Director: Jim Reel. Clients: industrial, retail, finance, food, resort.
Needs: Works with 1-2 freelance photographers/month. Uses photographers for consumer and trade magazines and newspapers.
Specs: Varied.
First Contact & Terms: Query with resume of credits, list of stock photo subjects and samples; submit portfolio for review "only on request"; provide resume, business card, brochure, flyer or tearsheets to be kept on file for possible future assignments. Occasionally works with freelance photographers on assignment basis only. SASE. Reports ASAP. Pay "depends on quality of photo and usage." Pays on receipt of invoice. Buys all rights or one-time rights. Model release preferred.
Tips: Prefers to see good lighting and composition skills, good taste, clean work.

SHOREY AND WALTER, INC., 1617 E. North St., Greenville SC 29607. (803)242-5407. Art Director: Alan Edwards. Ad agency. Uses all media. Clients: textiles, industrials, hosiery, packaging, sporting goods, treated wood products, finance, pharmaceuticals. Needs fashion, nature, architectural and special effects photos; table-top product shots; etc. Negotiates payment based on client's budget, amount of creativity required from photographer and photographer's previous experience/reputation. Call to arrange an appointment. No original art or photos; will not return material. Provide flyer, business card and brochure to be kept on file for possible future assignments.

Tennessee

BRUMFIELD-GALLAGHER, 3401 W. End Ave., Nashville TN 37203. (615)385-1380. Creative Director: Chuck Creasy. Senior Art Director: Kathy Benson. Clients: industrial, finance, real estate, package goods and service.
Needs: Works with 6 freelance photographers/month. Uses photographers for direct mail, catalogs, newspapers, consumer and trade magazines, P-O-P displays, posters, AV presentations and brochures. Subjects include people for banks, products, books. Also works with freelance filmmakers for corporate films and finance spots.
Specs: Uses 8x10 b&w or color prints; 35mm, 2¼x2¼, 4x5 transparencies and 16mm film or videotape.
First Contact & Terms: Arrange a personal interview to show portfolio. Works with freelance photographers on assignment basis only. Does not return unsolicited material. Reports in 2 weeks. Pays $50-150/hour; $35-1,500/day and $200 minimum/job. Pays on acceptance. Buys all rights. Model release required.

CARDEN & CHERRY ADVERTISING AGENCY, 1220 McGavock St., Nashville TN 37203. (615)255-6694. Ad agency. Associate Creative Director: Glenn Petack. Clients: TV stations, dairies, savings and loans, car dealers (40%), industrial (40%), all others (20%).
Needs: Works with 2 freelance photographers/month. Uses photographers for direct mail, trade magazines and brochures. Subject needs vary.
Specs: Uses 8x10 b&w prints; 35mm and 4x5 transparencies and 16mm film.
First Contact & Terms: Provide resume, business card, brochure, flyer or tearsheets to be kept on file for possible future assignments. Works with local freelancers. Does not return unsolicited material.

Close-up

Cliff Hollenbeck
Freelance Photographer
Seattle, Washington

It was six years in the U.S. Navy, three of which were
spent in Southeast Asia and Vietnam, that Cliff Hollenbeck
credits with helping to prepare him for a career as a
freelance photographer. "The Navy acquainted me with
travel, foreign languages and, of course, war. All of this
helped give me some of the independence necessary to be a freelancer." In addition to
his military service is a background in journalism, marketing and business; an education
Hollenbeck's father, a photojournalist himself, felt was important for such a career.

Hollenbeck began his photography career through work on daily newspapers in Fairbanks
and Anchorage, Alaska. And he recommends such a background for other aspiring free-
lancers. "Working for a small daily or weekly newspaper means shooting every type of as-
signment and subject. It generally means doing your own darkroom work, page layout, fea-
ture writing and idea development. Small newspaper photographers shoot thousands of sub-
jects in a single month, moving fast and looking for new ways to cover repetitive subjects."

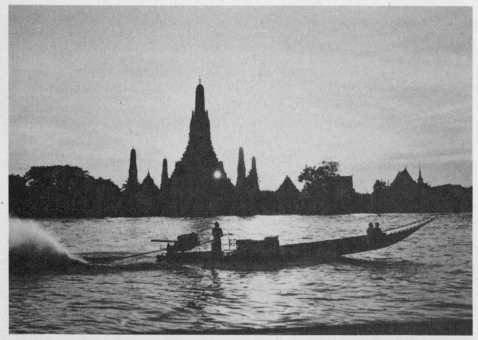

*The photo of the speed boat in front of the Temple of the Dawn, Bangkok, Thailand, was
taken for Thai International Airlines. At right, is a promotional scene shot in Puerto Vallar-
ta, Mexico.*

After a few years in hard news, Hollenbeck realized he was shooting and selling mostly political figures and disaster-coverage shots, "liars and diers" as he calls them. Moving on to advertising and public relations photography work for an airline, Hollenbeck realized that it paid "more per day than I made a week in the news business." It was during this period that Hollenbeck, and his wife and business partner, Nancy, decided travel photography was for them.

Hollenbeck recounts, "I literally sat down and made a list of the organizations, publishers and agencies that utilized advertising and editorial travel photography. I put them into three basic markets: top paying, good paying and little or no payment. I broke these down by location: New York, California, Northwest region, Alaska, Hawaii and miscellaneous." The most important part at the beginning was getting his work in front of the right person, Hollenbeck says. This required phone calls, letters, researching publications and compiling and maintaining a portfolio of his best quality color prints. "I still believe my research and personal contact with the photo markets are just as important as the quality of my photography," he emphasizes.

Important in advertising photography is finding out who *the* photo buyer is. "Beginning photographers should study the process of using photography in an advertising campaign. Learn who all the players are, what their jobs involve and where decisions are made," Hollenbeck advises. "These people, positions and decisions change from job to job, agency to agency and client to client," he says. "There usually are one or two people who actually buy the photos."

Seattle-based Hollenbeck's specialization in travel photography for clients such as Mexicana Airlines, Alaska Airlines and Westin Hotels sounds glamorous but, he points out, the realities of such a job mean he is constantly planning locations, times and schedules for shooting, and getting people, props and equipment to the right place at the right time.

The bottom line to succeed in photography, Hollenbeck says, is self promotion. It is an absolute necessity. This can be accomplished by sending out flyers and correspondence to promote your best work, and when there is more money to be spent, progressing to advertising or major color sheets, posters, national sales calls and trips. And, "always target the people who buy photos."

Reports in 3 weeks. Pays $40-120/hour; $300-1,000/day. Pays on acceptance. Buys all rights. Model release preferred.

MADDEN & GOODWIN, 4301 Hillsboro Rd., Nashville TN 37215. (615)292-4431. Creative Director/Art Division: John Madden or John Fussell. Ad agency. Clients: retail, fashion, finance, etc.
Needs: Works with 2-4 photographers/month. Uses photographers for billboards, consumer magazines, trade magazines, direct mail, P-O-P displays, catalogs, posters, signage and newspapers. Subject matter varies.
First Contact & Terms: Arrange a personal interview to show portfolio; query with samples or submit portfolio for review. Works with freelance photographers on an assignment basis only. Does not return unsolicited material. Reports in 2 weeks. Payment negotiable individually. Pays on receipt of invoice. Buys variable rights. Model release required.

DALLAS NELSON ASSOCIATES, Suite 223, 3387 Poplar, Memphis TN 38111 (901)324-9148. Ad agency. Contact: Dallas Nelson. Clients: industrial, farm, retail.
Needs: Works with 1 freelance photographer/month. Uses photographers for trade magazines, direct mail, brochures, catalogs, newspapers and AV presentations. Also works with freelance filmmakers.
Specs: Uses 8x10 glossy b&w and color prints; 35mm and 2¼x2¼ transparencies; 16mm film and videotape.
First Contact & Terms: Provide resume, business card, brochure, flyer or tearsheets to be kept on file for possible future assignments. Works with freelance photographers on assignment basis only. Does not return unsolicited material. Pays/job. Pays at the end of month. Buys all rights. Model release required; captions preferred.
Tips: Prefers to see samples "similar to assignment."

ROSE, CANUP & WYATT, Suite 205, 640 N. Bldg., Greenway Dr., Knoxville TN 37918. (615)588-5768. Ad agency. Creative Director: Ken Canup. Clients: industrial, retail and general service.
Needs: Works with 4-5 freelance photographers/month. Uses photographers for direct mail, catalogs, newspapers, consumer and trade magazines, AV presentations and brochures. Subjects include "studio photography of products; location photography."
Specs: Uses 8x10 color glossy prints; 35mm, 2¼x2¼ and 4x5 transparencies and videotape.
First Contact & Terms: Provide resume, business card, brochure, flyer or tearsheets to be kept on file for possible future assignments. Works with local and regional freelancers. SASE. Reports in 2 weeks. Payment depends on budget. Pays on publication. Rights purchased depend on situation demands. Model release and captions preferred.
Tips: Prefers to see "studio set-ups and product photography" in a portfolio. "Just show continued interest on a continued basis. There seems to be a lot of freelancers out there."

Texas

ALAMO AD CENTER, INC., 217 Arden Grove, San Antonio TX 78215. (512)225-6294. Ad agency, PR and AV firm. Art Director: Elias San Miguel. Clients: industrial, fashion, finance.
Needs: Uses 3 freelance photographers/month. Uses photographers for billboards, direct mail, catalogs, newspapers, consumer magazines, P-O-P displays, trade magazines and brochures. Subject matter varies. Uses freelance filmmakers to produce TV commercials.
First Contact & Terms: Provide resume, business card, brochure, flyer or tearsheets to be kept on file for possible future assignments. Works with freelance photographers on assignment basis only. Does not return unsolicited material. Reporting time varies. Pays $25-75/hour; $50-200/day; payment by job varies. Pays on acceptance. Buys all rights. Model release required.

JOE BUSER & ASSOCIATES, #400, 2800 Texas Ave., Bryan TX 77802. (409)775-0400. Ad agency. Director/Acct. Services: Lee Leschper. Clients: manufacturing, industrial, financial, automotive. Client list provided on request.
Needs: Uses 3-4 freelance photographers/month. Uses photographers for newspapers, AV presentations, trade magazines and brochures.
Specs: Uses b&w and color prints; 35mm and 120 transparencies.
First Contact & Terms: Query with list of stock photo subjects; provide resume, business card, brochure, flyer or tearsheets to be kept on file for possible future assignments. Works with freelance photographers on assignment basis only. Returns unsolicited material with SASE. Reports in 2 weeks. Pays maximum $50/hour and by the job. Pays on acceptance. Buys all rights or one-time rights. Model release required; captions preferred. Credit line given "only in lieu of payment."

DORSEY ADVERTISING AGENCY/GENERAL BUSINESS MAGAZINE, Box 270942, Dallas TX 75227-0942. (214)288-8900. Ad agency and PR firm. President: Lon Dorsey. Clients: all types.
Needs: Works with varied amount of freelance photographers/month. Uses photographers for billboards, direct mail, catalogs, newspapers, consumer and trade magazines, P-O-P displays, posters, AV presentations and brochures. Subjects include business.
Specs: Uses 4x5 color glossy prints and 4x5 transparencies.
First Contact & Terms: Query with SASE; reports "as we are able to get to them." Works with local freelancers only. SASE. Pays $5-35-b&w/photo; $10-35/color photo; $10-100/hour; $120-1,200/day; complete job negotiated. Pays per agreement. Pays on acceptance or publication. Buys all rights "with exceptions." Model release and captions required. Credit line given "in some cases." Send $2 for guidelines and open market information regarding present photographic needs. Publication is now preparing a brochure which will include the works of photographers from all over the United States, including Canada and the Islands. It will be sent to corporations, ad agencies, and others. Photographers interested in being included in the publication which will be entitled, "Freelance Photographers of America", should write: Freelance Photographer's Publication, c/o Dorsey Advertising Public Relations; General Business Magazine Division; Box 270942, Dallas, Texas 75227-0942. Included shoud be two 8x10 black/white glossies and insertion fee of $100, a business card if available, a resume, complete address info, school background, current photographic specialties, and any other pertinent information including clientele, and other business accounts, collegiate background, etc.
Tips: Looks for professionalism and experience. "Send letters with printed samples and SASE's. Our company now receives a $3 editing fee because of the very high volume of work sent to us. A good percentage of the freelance work is used, however screening time is at its highest in seven years. Materials should be complete and concise."

DYKEMAN ASSOCIATES, INC., 4205 Herschel, Dallas TX 75219. (214)528-2991. Contact: Alice Dykeman or Carolyn Whetzel. PR firm. Clients: health, finance, real estate, arts and leisure. Photos used in brochures, AV presentations, catalogs, news releases and magazines. Gives 100 assignments/year. Model release required. Arrange a personal interview to show portfolio. Photos purchased on assignment only. Provide business card and tearsheets to be kept on file for possible future assignments. Some interest in stock photos: industrial, construction, nature, recreation, architectural. Negotiates payment based on client's budget and photographer's previous experience/reputation. Does not return unsolicited material. "Whatever is needed to help tell the story in brochures, news releases or documentation of an event."
B&W: Uses glossy prints; contact sheet OK.
Color: Uses prints and transparencies.
Film: 35mm transparencies for AV presentations; 16mm and videotape for educational, training or fundraising films.
Tips: "In Dallas, we build a good group of photographers that we like working with, but for out-of-town assignments it's a little more difficult to find someone we know will perform right, follow through on time and can be easy to work with." Finds most out-of-town photographers by references of PR firms in other cities.

***FELLERS LACY GADDIS**, 2203 Saratoga, Austin TX 78741. (512)445-3492. Ad agency, PR firm, advertising marketing and PR. Art Director: Lee Collison. Clients: health care, banking, business to business, high tech, community building. Client list free with SASE.
Needs: Works with 8-10 freelance photographers/month. Uses freelance photographers for consumer magazines, catalogs, posters and newspapers.
Specs: Uses 8x10 b&w prints, 2¹/₄x2¹/₄, 4x5 transparencies; "changes from job to job."
First Contact & Terms: Arrange a personal interview to show portfolio or submit portfolio for review. Works with freelance photographers on assignment basis only. SASE. Reports in 3 weeks. Pays $100/hour; $1,000/day; job negotiable. Pays 30 days after invoice. Buys all rights. Model release required.
Tips: Prefers to see good use of color and simple clean design. "Come by and show portfolio, give price list. We prefer not to seek out trends."

GOODMAN & ASSOCIATES, 601 Penn Ave., Fort Worth TX 76102. (817)332-2261. Production Manager: Janet Lumpee. Ad agency. Clients: financial, fashion, industrial, manufacturing and straight PR accounts.
Needs: Works with freelance photographers on assignment only basis. Uses photographers for billboards, consumer and trade magazines, direct mail, P-O-P displays, brochures, catalogs, posters, signage and AV presentations.
First Contact & Terms: Local freelancers only. Arrange interview to show portfolio. Payment is by the project, by the hour or by the day; negotiates according to client's budget.

***GULF STATE ADVERTISING AGENCY**, 3410 W. Dallas, Houston TX 77019-3892. Art Director: Karen Gregory. Ad agency. Clients: financial, retail, commercial, real estate development, restaurant and industrial firms; client list provided upon request.
Needs: Works on assignment basis only. Uses photographers for consumer and trade magazines, brochures and newspapers.
First Contact & Terms: Local freelancers only. Arrange interview to show portfolio. Payment is by the project; negotiates according to client's budget and where work will appear.

HEPWORTH ADVERTISING CO., 3403 McKinney Ave., Dallas TX 75204. (214)526-7785. Manager: S.W. Hepworth. Ad agency. Uses all media except P-O-P displays. Clients: industrial, consumer and financial. Pays $350 minimum/job; negotiates payment based on client's budget and photographer's previous experience/reputation. Submit portfolio by mail; solicits photos by assignment only. SASE.
Color: Uses transparencies or prints.
Tips: "For best relations with the supplier, we prefer to seek out a photographer in the area of the job location."

HILL AND KNOWLTON, INC., 1500 One Dallas Centre, Dallas TX 75201. (214)979-0090. Contact: Production Coordinator. PR firm. Clients: corporations.
Needs: Works with 2 freelance photographers/month.
First Contact & Terms: Call for appointment to show portfolio. Negotiates payment based on client's budget. Works on buy-out basis only.

***LEVENSON & HILL**, Box 619507, Dallas/Fort Worth Airport TX 75261. (214)556-0944. Ad agency. Art Director: Timothy K. Mantz. Clients: retail and fashion.
Needs: Works with 2 photographers/month. Uses photographers for consumer and trade magazines, and newspapers.
Specs: Uses 4x5 and 8x10 transparencies.
First Contact & Terms: Send unsolicited photos by mail for consideration; provide resume, business card, brochure, flyer or tearsheets to be kept on file for possible future assignments. Works with freelance photographers on an assignment basis only. Does not return unsolicited material. Pays $500-3,500/day; rates depend on usage and budget. Pays on receipt of invoice. Rights purchased with photos vary. Model release preferred. Credit lines may be given.
Tips: Prefers to see "fashion, dramatic lighting and new clean looks in samples submitted. Send brochures and tearsheets, call in a few weeks. We tend to shoot a lot at one time then have a lot of dead time."

MCCANN-ERICKSON WORLDWIDE, INC., Briar Hollow Bldg., 520 S. Post Oak Rd., Houston TX 77027. (713)965-0303. Contact: The Art Directors. Ad agency. Clients: all types including industrial, fashion, financial, entertainment.
Needs: Works with 15 freelance photographers/month. Uses photographers in all media.
First Contact & Terms: Call for appointment to show portfolio. Selection based on portfolio review. Negotiates payment based on client's budget and where work will appear.
Tips: Should be based on photographer's preferences. Especially interested in transparencies.

***TED ROGGEN ADVERTISING AND PUBLIC RELATIONS**, Suite 217, 1770 St. James Place, Houston TX 77056. (713)626-5010. Contact: Ted Roggen. Ad agency and PR firm. Handles clients in construction, entertainment, food, finance, publishing, and travel. Photos used in billboards, direct mail, radio, TV, P-O-P displays, brochures, annual reports, PR releases, sales literature and trade magazines. Buys 1,000-1,800 photos/year; gives 200-400 assignments/year. Pays $25-35/b&w photo; $50-275/color photo. Pays on acceptance. Model release required; captions preferred. Arrange a personal interview to show portfolio or query with samples. "Contact me personally." Local freelancers preferred. SASE. Reports in 2 weeks. Provide resume to be kept on file for possible future assignments.
B&W: Uses 5x7 glossy or matte prints; contact sheet OK.
Color: Uses 4x5 transparencies and 5x7 prints.

SANDERS, WINGO, GALVIN & MORTON ADVERTISING, Arthur Centre, Suite 100, 4171 N. Mesa, El Paso TX 79902. (915)533-9583. Creative Director: Roy Morton. Ad agency. Uses billboards, consumer and trade magazines, direct mail, foreign media, newspapers, P-O-P displays, radio and TV. Clients: retailing and finance. Free client list. Deals with 5 photographers/year.
Specs: Uses b&w photos and color transparencies. Works with freelance filmmakers in production of slide presentations and TV commercials.
Payment & Terms: Pays $25-200/hour, $250-3,000/day, negotiates pay on photos. Buys all rights. Model release required.

Making Contact: Query with samples, list of stock photo subjects; send material by mail for consideration; or submit portfolio for review. SASE. Reports in 1 week.

STAR ADVERTISING AGENCY, Box 66625, Houston TX 77266. (713)977-5366. Ad agency. President: Jim Saye. Clients: industrial.
Needs: Works with 3 freelance photographers/month. Uses photographers for trade magazines, direct mail, P-O-P displays, brochures, catalogs, posters, newspapers and AV presentations. Subjects include: oil field shots, automotive parts. Also works with freelance filmmakers to produce training films.
Specs: Uses 8x10 glossy b&w and color prints; 2¼x2¼ transparencies and 16mm film.
First Contact & Terms: Query with resume of credits; provide resume, business card, brochure, flyer or tearsheets to be kept on file for possible future assignments. Works with local freelancers primarily on assignment basis. SASE. Reports in 1 week. Pays $80 maximum/hour and $700 maximum/day. Pays 30 days from receipt of invoice. Buys all rights. Model release required. Credit line given "sometimes—not on ads or brochures."
Tips: Prefers to see "product shots—*not* 'sunsets' and 'blue skies'. Have a professional, reliable attitude, good credits and reasonable prices."

***TAYLOR BROWN & BARNHILL**, #264, 4544 Post Oak Pl., Houston TX 77027. (713)877-1220. Ad agency. Associated Producer: Cindy Weddle. Clients: retail, fashion, finance, etc.
Needs: Works with varied number of freelance photographers/month. Uses photographers for consumer and trade magazines, P-O-P displays, posters, signage and newspapers.
Specs: Uses 8x10 glossy color prints; 35mm, 8x10 transparencies.
First Contact & Terms: Send unsolicited photos by mail for consideration; provide resume, business card, brochure, flyer or tearsheets to be kept on file for possible future assignments. Works with freelance photographers on assignment basis only. Returns unsolicited material sometimes. Report time varies. Pays per day. Pays on contract. Buys all rights. Model release required.
Tips: Send samples and salary requirements.

ZACHRY ASSOCIATES, INC., 709 North 2nd, Box 1739, Abilene TX 79604. (915)677-1342. Art Director: T. Rigsby. Clients: industrial, institutional, religious service.
Needs: Works with 2 photographers/month. Uses photographers for slide sets, videotapes and print. Subjects include industrial location, product, model groups.
Specs: Uses 5x7, 8x10 b&w prints, 8x10 color prints; 35mm, 2¼x2¼ transparencies; VHS videotape.
First Contact & Terms: Query with samples and stock photo list; provide resume, business card, self-promotion piece or tearsheets to be kept on file for possible future assignments. Works with freelancers by assignment only; interested in stock photos/footage. SASE. Reports as requested. Pay negotiable. Pays on acceptance. Buys one-time and all rights. Model release required. Credit line usually given.

Utah

EVANS/SALT LAKE, 110 Social Hall Ave., Salt Lake City UT 84111. (801)364-7452. Ad agency. Art Director: Michael Cullis. Clients: industrial, finance.
Needs: Works with 2-3 photographers/month. Uses photographers for billboards, consumer and trade magazines, direct mail, P-O-P displays, posters and newspapers. Subject matter includes scenic and people.
Specs: Uses color prints and 35mm, 2¼x2¼ and 4x5 transparencies.
First Contact & Terms: Query with list of stock photo subjects; submit portfolio for review; provide resume, business card, brochure, flyer or tearsheets to be kept on file for possible future assignments. Works with freelance photographers on an assignment basis only. SASE. Reports in 1-2 weeks. Payment negotiated individually. Pays on receipt of invoice. Buys one-time rights. Model release required; captions preferred. Credit live given when possible.

FOTHERINGHAM & ASSOCIATES, 139 East S. Temple, Salt Lake UT 84111. (801)521-2903. Ad agency. Art Directors: Glade Christensen and Randy Stroman. Clients: industrial, financial, development, resort, retail, commercial, automotive, high tech.
Needs: Works with 6 photographers/month. Uses photographers for trade magazines, direct mail, P-O-P displays, catalogs and newspapers. Purchases all subjects.
Specs: Uses 8x10 b&w and color prints; 35mm, 2¼x2¼ and 4x5 transparencies.
First Contact & Terms: Arrange a personal interview to show portfolio; query with samples; provide resume, business card, brochure, flyer or tearsheets to be kept on file for possible future assignments.

Works with freelance photographers on an assignment basis only. Does not return unsolicited material. Reports in 2 weeks. Payment negotiated individually. Pays on receipt of invoice. Buys all rights or one-time rights. Model release required. Credit line sometimes given.

Tips: "We're growing, therefore our photography needs are growing."

Virginia

***DAN ADVERTISING AGENCY, INC.**, 408 West Bute St., Norfolk VA 23510, (804)625-2518. Art Director: Ron Pohling. Ad agency. Uses billboards, consumer and trade magazines, direct mail, foreign media, newspapers, P-O-P displays, radio and TV. Serves clients in industry, fashion, finance, entertainment, travel and tourism. Deals with 20-25 photographers/year.
Specs: Uses b&w photos and color transparencies.
Payment & Terms: Pays by job. Buys all rights. Model release required.
Making Contact: Arrange a personal interview to show portfolio. SASE. Reports in 1 week.

HOUCK & HARRISON ADVERTISING, Box 12487, Roanoke VA 24026. Senior Vice President: Jerry Conrad. Ad agency. Uses billboards, consumer and trade magazines, direct mail, foreign media, newspapers, P-O-P displays, radio, and TV. Clients: home furnishings, travel industry, men's and women's fashions, computer software programs, fast foods, health insurance, banking, industry, consumer products. Works with 5-6 freelance photographers/month on assignment only basis. Provide flyer, tearsheets and brochure to be kept on file for possible future assignments. Buys 200-300 photos/year. Pays $60-250/hour or $50-2,000/job. Negotiates payment based on client's budget and amount of creativity required from photographer. Pays on acceptance. Buys all rights. Model release required. Arrange personal interview to show portfolio. Prefers to see wide range of samples in portfolio. "Phone or write beforehand—don't make a cold call!" Will view unsolicited material. SASE. Reports in 2 weeks.
B&W: Uses 8x10 or larger prints.
Color: Uses 35mm to 8x10 transparencies.
Film: Produces 16mm, 35mm and videotape TV commercials and industrial films.

Washington

COMMUNICATION NORTHWEST INC., 111 W. Harrison St., Seattle WA 98119. (206)285-7070. Contact: Office Manager Personnel. PR firm. Photos, primarily industrial, used in publicity, slide shows and brochures. Works with 2-4 freelance photographers/month on assignment only basis. Provide business card, brochure and list of rates to be kept on file for future assignments. Payment "depends on client situation. Each job is different." Deals with local freelancers only. Call to arrange an appointment.

EHRIG & ASSOCIATES, 4th and Vine Bldg., Seattle WA 98121. (206)623-6666. Creative Directors: Vicki Brems, Jack Higgins, Gregory J. Erickson. Art Directors: Renae Lovre, Tom Scherer, David Dijulio, Betty Kamifuji. Ad agency. Uses billboards, consumer and trade magazines, direct mail, newspapers, P-O-P displays, radio and TV. Clients: industry, broadcasting, computers, major league baseball, finance, tourism, travel, real estate, package goods. Commissions 50 photographers/year; buys 300 photos/year. Rights purchased vary. Model release required. Arrange personal interview to show portfolio. "Show us something better than anybody else is doing." SASE.
B&W: Uses prints; contact sheet OK.
Color: Uses prints and transparencies; contact sheet OK.
Film: Produces 16mm and 35mm 30- or 60-second commercials.

Wisconsin

***CRAMER KRASSELT CO.**, 733 N. Van Buren St., Milwaukee WI 53202. (414)276-3500. Ad agency. Associate Creative Director: Dave Hofmann. Clients: consumer, business to business.
Needs: Works with 4-5 freelance photographers/month. Uses photographers for billboards, consumer and trade magazines, direct mail, P-O-P displays, catalogs, posters, and newspapers. Subjects include product, people, location.
Specs: Open.

First Contact & Terms: Query with samples; submit portfolio for review; provide resume, business card, brochure, flyer or tearsheets to be kept on file for possible future assignments. Works with freelance photographers on assignment basis only. Reports "ASAP." Pays "market price." Pays on receipt of invoice. Buys all rights. Model release required.
Tips: Query with samples.

HOFFMAN YORK AND COMPTON, INC., 330 E. Kilbourn Ave., Milwaukee WI 53202. (414)289-9700. Vice President/Associate Director: Ken Butts. Clients: machinery, food service, appliances, consumer.
Needs: Works with many freelance photographers/year. Uses photographers for most print media. Provide brochure, flyer and samples to be kept on file for possible future assignments.
First Contact & Terms: Call for appointment to show portfolio. "We pay standard rates."

***MCDONALD DAVIS & ASSOCIATES**, 250 W. Coventry Ct., Glendale WI 53217. (414)228-1990. Ad agency, PR firm, marketing consultants, all phases. Senior Art Director: Steve Kerlin. Clients: health care; "we are major leaders in this throughout the country." Client list free with SASE.
Needs: Works with 10 photographers/month; staff of 4 art directors. Uses freelance directors for billboards, consumer and trade magazines, direct mail, P-O-P displays, catalogs, posters, signage and newspapers. Subjects include healthcare, medical.
Specs: Uses 16x20 glossy b&w and color prints; 2¼x2¼ transparencies.
First Contact & Terms: Arrange a personal interview to show portfolio; query with list of stock photo subjects; submit portfolio for review; provide resume, business card, brochure, flyer or tearsheets to be kept on file for possible future assignments. Works with local freelance photographers on assignment basis only. SASE. Reports in 3 weeks. Pays $600-1,200/day; per photo, depends on usage. Pays on receipt of invoice. Buys all rights. Model release required.
Tips: Prefers to see medical, in color and b&w.

Canada

***EVANS ADVERTISING AGENCY INC.**, Suite 10, 2395 Cawthra Rd., Mississauga, Ontario Canada L5A-2W8. (416)848-1818. Ad agency. President: Robert Evans. Clients: industrial, fashion.
Needs: Works with 3-5 freelance photographers/month. Uses photographers for consumer and trade magazines, direct mail, catalogs and newspapers. Subject matter varies.
First Contact & Terms: Provide resume, business card, brochure, flyer or tearsheets to be kept on file for possible future assignments. Works with freelance photographers on assignment basis only. SASE. Reports in 2 weeks. Pays per job. Pays on receipt of invoice. Buys all rights. Model release required.
Tips: Prefers to see variety, adaptability, technique.

***WARNE MARKETING & COMMUNICATIONS**, Suite 810, 111 Avenue Rd., Toronto, Ontario, Canada M5R 3MI. (416)927-0881. Ad agency. President: Keith Warne. Clients: industrial. Client list free with SASE.
Needs: Works with 5 photographers/month. Uses photographers for trade magazines, direct mail, P-O-P displays, catalogs and posters. Subjects include: in-plant photography, studio set-ups and product shots.
Specs: Uses 8x10 glossy b&w and color prints; 2¼x2¼ transparencies.
First Contact & Terms: Send letter citing related experience plus 2 or 3 samples. Works with freelance photographers on an assignment basis only. Does not return unsolicited material. Reports in 2 weeks. Pays $150-175/hour and $1,000-1,250/day. Pays on receipt of invoice. Buys all rights. Model release required.
Tips: In portfolio/samples, prefers to see industrial subjects and creative styles. Send letter and 3 samples, and wait for trial assignment.

Audiovisual, Film and Video Firms

The audiovisual, film and video industries have permeated almost every area of the market-place. Uses range from advertising and public relations purposes, to entertainment, to documentary and educational orientations. Many independent firms can handle a range of clients who require slide sets, multimedia productions, videotapes, films or filmstrips. For this reason freelance photographers must be well versed in a variety of audiovisual equipment. AV photographers must cope with changing technology in the AV field due to rapid advances in computers, lasers, fiber-optics and disc technologies. Still photographers already are used to working with lighting and camera angles, and so transfer these abilities nicely to AV work, but an AV camera person has to take into account the "movement" of the story line. Such movement might not be as literal as that serving film and video, but a slide set or multimedia presentation does move from image to image, sound to sound, and idea to idea. Many firms also need photographers who can add "audio" through writing abilities.

The increased use of video in particular is making many photographers take a look at the possible advantages of moving into this area of specialization. Though the major markets currently are on the East and West coasts, many corporations across the U.S. are using video for documentary and promotional purposes, and studio photographers are finding a viable market in producing wedding videos. With the popularity of VCR's, a new market is evolving as companies move into at-home educational and "game" videos, the latter previously reserved for video arcades.

Photographers wishing to gain experience on video equipment can either purchase state-of-the-art equipment at reasonable prices, or rent it through a local camera store. The key is to become familiar (and comfortable) with video cameras by giving yourself some "hands-on" time to shoot sample videotape. If you should need outside advice, most camera stores can refer you to someone who is expert enough to guide you. It also would be worth your time to look into a comprehensive course offered through a community program or school. By becoming technically familiar with video equipment, you will be free to channel your mental and emotional energies toward the creative aspects of taping.

The listings in this section, entered state by state for easy reference, list the film specifications for each firm and information on how the photographer is used. Pay-wise, the scale can be fairly lucrative for the experienced camera person. Some firms request photographers to submit a pay scale from which the job fee can be negotiated or they may pay based on a set range per day or per job. Prior to negotiating your fee, make a point to price out the services charged by other photographers in your region. If you are just breaking into the field, you may have to start at a slightly lower rate, but awareness of general rates will prevent you from underselling yourself too much.

In addition to assignment work, many firms also specify in the Tips section whether they are interested in stock photos/footage. As in advertising usage, photographers should tune in to the possible need for model releases in case the subject matter is used in a commercial product.

Alabama

***SPOTTSWOOD VIDEO/FILM STUDIO**, 2520 Old Shell Rd., Mobile AL 36607. (205)478-9387. Co-Owner: M. W. Spottswood. Clients: business, industry and government agencies.
Needs: Uses freelance photographers for films, videotapes.

Specs: Uses 16mm, 35mm film; U-matic ¾", 1" videotape.
First Contact & Terms: "We just need the name and location of good photographers—we only use 2 or 3 a year, but when we need them we need them badly and quickly." Works with freelancers by assignment only; interested in stock photos/footage. Pay negotiable. Pays "25-35% up front and balance on acceptance." Buys all rights. Credit line sometimes given.

Arizona

PAUL S. KARR PRODUCTIONS, Utah Division, 1024 N. 250 East, Orem UT 84057. (801)226-8209. Vice President: Michael Karr. Film & tape firm. Clients: industrial, business, education. Works with freelance filmmakers by assignment only.
Needs: Uses filmmakers for motion pictures. "You must be an experienced filmmaker with your own location equipment, and understand editing and negative cutting to be considered for any assignment. We produce industrial films for training, marketing, public relations and government contracts. We do high-speed photo instrumentation. We also produce business promotional tapes, recruiting tapes and instructional and entertainment tapes for VCR and cable."
Specs: Produces 16mm films and videotapes. Provides production services, including inhouse 16mm processing, printing and sound transfers, scoring and mixing and video production, post production, and film to tape services.
First Contact & Terms: Query with resume of credits and advise if sample reel is available. Pays/job; negotiates payment based on client's budget and photographer's ability to handle the work. Pays on production. Buys all rights. Model release required.

California

***AIRLINE FILM & TV PROMOTIONS**, 13246 Weidner, Pacoima CA 91331. (818)899-1151. President: Byron Schmidt. Clients: major film companies.
Needs: Works with 4-5 freelance photographers/month. Uses freelance photographers for films, videotapes. Subjects include publicity and advertising.
Specs: "Specifications vary with each production." Uses 8x10 color prints; 35mm transparencies; VHS videotape.
First Contact & Terms: Provide resume, business card, self-promotion piece or tearsheets to be kept on file for possible future assignments. Works with freelancers by assignment only. Does not return unsolicited material. Payment varies per assignment and production. Pays on acceptance. Buys all rights. Model release required. Credit line sometimes given.
Tips: Send a brochure, business card, experience.

AMVID COMMUNICATION SERVICES, INC., Box 577, Manhattan Beach CA 90266. (213)545-6691. President: James R. Spencer. AV firm. Clients: hospital, restaurant, corporation.
Needs: Buys about 500 photos and 20 filmstrips/year from freelance photographers. Uses photographers for slide sets, filmstrips and videotape. Subjects include employee training and orientation.
Specs: Requires 35mm for filmstrips. Produces videotape, 16mm (educational) and 35mm slides (industrial). Uses color transparencies.
First Contact & Terms: Arrange a personal interview to show portfolio; provide resume, calling card and brochure to be kept on file for future assignments. Pays $300-600/day or by the job; pays 50% to start; 50% upon acceptance. Buys all rights. Model release required.

***BARR FILMS**, 3490 E. Foot Hill, Pasadena CA 91107. (213)681-6978. Vice President, Product Development: George Holland. Clients: public schools, libraries, colleges, businesses.
Needs: Works with various number of freelance photographers/month. Uses photographers for films. Subjects include everything in short formats, except advertising.

 The asterisk before a listing indicates that the listing is new in this edition. New markets are often the most receptive to freelance contributions.

Specs: Uses 16mm film.
First Contact & Terms: Arrange a personal interview to show portfolio. Works with freelancers by assignment only. SASE. Pays "advance plus royalty on most films." Pays "during pre-agreed stages of production." Buys all rights. Credit line given.
Tips: Looks for ability to teach in an interesting fashion or dramatize a story on limited budget.

***BIRNS & SAWYER, INC.**, 1026 N. Highland Ave., Hollywood CA 90038. (213)466-8211. President: Marvin Stern. Clients: motion picture industry.
Needs: Works with 200 freelance photographers/month. Uses freelance photographers for films. Subjects include "all kinds."
Specs: Uses b&w and color prints; transparencies; 16mm, 35mm film; Betacam, U-matic ¾", "C" videotape.
First Contact & Terms: Query with resume; provide resume, business card, self-promotion piece or tearsheets to be kept on file for possible future assignments. Interested in stock photos/footage. Does not return unsolicited material. Buys all rights. Model release and captions preferred.

DOCUMENTARY FILMS, Box 97, Aptos CA 95003. (408)688-4380. Producer: M.T. Hollingsworth. AV firm. Serves clients in schools, colleges, universities, foreign governments and service organizations. Produces motion pictures.
Subject Needs: Language arts, nature, marine science, physical education, anthropology, dance and special education. Uses freelance photos *in series* for consideration as possible film treatments. No individual photos designed for magazine illustrations. Film length requirements: 10, 15 and 20 minutes. Prefers 16mm color prints and camera originals.
Film: Produces 16mm ECO originals, color work print, color internegative and release prints. Interested in stock footage. Pays royalties by mutual agreement depending on production stage at which film is submitted.
Photos: Uses 5x7 and 8x10 color prints and 2¼x2¼, 4x5 transparencies.
Payment/Terms: Pays by mutual agreement. "Royalties if a photographic series or essay is used as the basis for a film treatment. If the concepts are good, and the resulting film successful, the royalties will pay much more than single use rates." Buys all rights. Model release and captions required.
Making Contact: Send material by mail for consideration. "On first submission, send prints, NOT ORIGINALS, unless requested." SASE. Reports in 2 weeks. Catalog available for $1.
Tips: "For photos: Have a definite film treatment in mind. Use photos to illustrate content, sequence, continuity, locations and personalities. For films: have a specific market in mind. Send enough footage to show continuity, significant high points of action and content, personalities. Film should be clearly identified head and tails. Any accompanying sound samples should be in cassettes or 5 inch reel-to-reel at 3¾ ips clearly identified including proposed background music."

EXPANDING IMAGES, A-143, 14252 Culver Dr., Irvine CA 92714. (714)720-0864. President: Robert Denison. Clients: commercial, industrial.
Needs: Works with 2 freelance photographers/month. Uses photographers for multimedia productions, films and videotapes. Subjects vary.
Specs: Uses 35mm transparencies; 35mm film; VHS and U-matic ¾" videotape.
First Contact & Terms: Provide resume, business card, self-promotion piece or tearsheets to be kept on file for possible future assignments. Works with local freelancers on assignment basis only; interested in stock photos/footage. Does not return unsolicited material. Reports in 2 weeks. Pays $350-1,200/day. Pays on acceptance. Buys all rights. Captions and model releases required. Credit line given.

LE DUC VIDEO, #A 2002-21st. St., Santa Monica CA 90404. (213)450-8275. Production/Coordinator: Wally Cronin. Clients: cable, home video market, corporate/industrial, and music videos.
Needs: Works with 3-10 freelance photographers/month. Uses freelance photographers for slide sets, multimedia productions, videotapes, prints. Subjects vary.
Specs: "Video must be/meet broadcast specs." Uses 8x10 and horizontal matte-finish b&w and color prints; 35mm, 2¼x2¼ transparencies; super 8, 16mm, 35mm film; U-matic ¾, 1", and Betacam videotape.
First Contact & Terms: Provide resume, business card, self-promotion piece or tearsheets to be kept on file for possible future assignments. Works with freelancers by assignment only. SASE. Reports in 1 month. Pays $25-up/b&w photo; $35-up/color photo; $20-up/hour; $100-up/day; per job negotiated. Pays on acceptance. Buys one-time rights, all rights; "all rights for specific product." Model release required. Credit line given.
Tips: Have good work to show, have it organized and limited to 5 minutes in length. Have credits and references that can be verified. Looks for "both technical quality and the ability to deal with people, since most of our work involves either talking heads or people in action."

LODESTAR PRODUCTIONS, 1330 Monument St., Pacific Palisades CA 90272. (213)454-0234. President: Dr. Edward D. Hurley. AV firm. Clients: business, nonprofit, educational.
Needs: Uses photographers for AV presentations.
First Contact & Terms: Provide resume, business card, brochure, flyer or tearsheets to be kept on file for possible future assignments. Works with local freelancers on assignment only. Does not return unsolicited material. Reports as soon as possible. Payment negotiable. Buys all rights or one-time rights. Model release required. Credit line sometimes given.
Tips: "Don't phone, but do send data."

ED MARZOLA AND ASSOCIATES, #300, 5555 Melrose Bldg. B-173, Hollywood CA 90038-3197. (213)468-5497. President: Ed Marzola. Clients: agencies and TV stations.
Needs: Works with 2-3 photographers/month. Uses photographers for films, videotapes. Subjects include live action.
Specs: Uses 4x5 and 8x10 b&w prints; 4x5 and 8x10 color prints; 35mm, 2¼x2¼ and 4x5 transparencies; U-matic ¾", 1" and 2" videotapes.
First Contact & Terms: Provide resume, business card, self-promotion piece or tearsheets to be kept on file for possible future assignments. Works with freelancers by assignment only. SASE. Reports in 1 week. Pay individually negotiated. Pays on acceptance. Buys all rights. Credit line given.
Tips: "Be creative, cooperative, deliver as promised and stay with your quote."

***WARREN MILLER PRODUCTIONS, INC.**, 505 Pier Ave., Box 536, Hermosa Beach CA 90254. (213)376-2494. Production Manager: Don Brolin. Motion picture production house. Buys 5 films/year.
Subject Needs: Outdoor cinematography of all sports. Also travel, documentary, promotional, educational and indoor studio filming. "We do everything from TV commercials to industrial films to feature length sports films."
Film: Does 16mm film production. "We purchase exceptional sport footage not available to us."
Payment & Terms: Pays $150-300/day. Also pays by the job. Pays bimonthly. Buys all rights. Model release required.
Making Contact: Filmmakers may query with resume of credits. "We are only interested in motion picture oriented individuals who have practical experience in the production of 16mm motion pictures."
Tips: Looks for technical mastering of the craft and equipment—decisive shot selection. "Make a hot sample reel and be able to work for low $'s."

PACIFIC COAST PRODUCTIONS, 629 Terminal Way #7, Costa Mesa CA 92627. (714)645-1640. Production Manager: Deb Stoetzel. Clients: insurance, businesses with the need of slides/shows.
Needs: Works with 1-2 photographers/month. Uses photographers for slide sets, multimedia productions. Subjects include sound track engineers.
Specs: Uses 35mm transparencies.
First Contact & Terms: Provide resume, business card, self-promotion piece or tearsheets to be kept on file for possible future assignments. Works with freelancers by assignment only. SASE. Reports in 2 weeks. Pay open to budget. Pays on acceptance. Buys all rights.

PENROSE PRODUCTIONS, Suite 204, 1690 Woodside Rd., Redwood City CA 94061. (415)361-8273. President: James R. Penrose. Clients: corporate, resort.
Needs: Works with 5-6 freelance photographers/month. Uses photographers for slide sets, multimedia productions, videotapes. Subjects include corporate training, sales promotion and entertainment.
Specs: Uses U-matic ¾" videotape.
First Contact & Terms: Submit portfolio by mail; provide resume, business card, self-promotion piece or tearsheets to be kept on file for possible future assignments. Works with freelancers by assignment only; interested in stock photos/footage. Reports in 1 month. Pays $20-90/hour; $150-500/day. Pays on acceptance. Buys all rights. Model release required. Credit line sometimes given.

PHOTOCOM PRODUCTIONS, Box 3135, Pismo Beach CA 93449. (805)481-6550. President: Steven C. LaMarine. AV Firm. Clients: schools, businesses.
Needs: Works with 6 freelance photographers/year. "All subject matter is vocationally oriented, including career awareness and technical how-to's for trades." Subjects include vocational training in automotive, agriculture, machine trades, welding, etc.
Specs: Uses 35mm transparencies; VHS videotape OK for samples; U-matic ¾" videotape needed for production.
First Contact & Terms: Query with samples and resume. Works with freelancers by assignment only; interested in stock photo/footage. SASE. Reports in 2 weeks. Pays $20-100/color photo. Pays on publication. Buys one-time rights and all AV rights when series is purchased. Captions and model release preferred. Credit line given.

Tips: Sample photos must illustrate ability to portray people in work situations, as well as how to clearly illustrate a procedure that can be duplicated by students. "Highest priority is given to photographers who can write their own scripts with our help and advice. We have diversified our client listing to include businesses needing PR and training productions on slide or video."

BILL RASE PRODUCTIONS, INC., 955 Venture Court, Sacramento CA 95825. (916)929-9181. Manager/Owner: Bill Rase. AV firm. Clients: industry, business, government, publishing and education. Produces filmstrips, slide sets, multimedia kits, motion pictures, sound-slide sets, videotape, mass cassette, reel duplication and video. Buys 100-300 filmstrips/year. Photo and film purchases vary. Payment depends on job. Pays 30 days after acceptance. Buys one-time rights and exclusive rights; varies. Model release required. Query with samples and resume of credits. Freelancers within 100 miles only. SASE. Reports "according to the type of project. Sometimes it takes a couple of months to get the proper bid info."
Subject Needs: "Script recording for educational clients is our largest need, followed by industrial training, state and government work, motivational, etc." Freelance photos used in filmstrips and slides; sometimes motion pictures. No nudes. Color only for filmstrips and slides. Vertical format for TV cutoff only.
Film: 16mm sound for TV public service announcements, commercials, and industrial films. Some 35mm motion picture work for theater trailers. "We then reduce to Super 8 or video if needed." Uses stock footage of hard-to-find scenes, landmarks in other cities, shots from the 1920s to 1950s, etc. "We buy out the footage—so much for so much."
Color: Uses 8x10 prints and 35mm transparencies.
Tips: "Video footage of the popular areas of this country and others is becoming more and more useful. Have price list, equipment list and a few slide samples in a folder or package available to send or leave."

***TAMARA SCOTT PRODUCTIONS**, 19062 Two Bar Rd., Boulder Creek CA 95006. (408)338-9683.
Needs: Uses freelance photographers for filmstrips, slide sets, multimedia productions, films, videotapes.
First Contact & Terms: Submit portfolio by mail; query with samples, resume and photo stock list; provide resume, business card, self-promotion piece or tearsheets to be kept on file for possible future assignments. Works with freelancers by assignment only; interested in stock photos/footage. Does not return unsolicited material. Reports "as needed." Pays $25-75/hour, $25/b&w photo; $25/color photo; $200-up/day. Pays on client payment. Buys one-time rights, exclusive product rights or all rights. Model release required. Credit line given.
Tips: Looks for special effects and business portraiture. "Submit samples to keep on file."

TRITRONICS INC. (TTI), 733 N. Victory Blvd., Burbank CA 91502. (818)843-2288. General Manager: Robert A. Sofia. Clients: corporate and broadcast video program producers.
Needs: Works with 3 photographers/month. Uses photographers for videotapes.
Specs: Uses U-matic ¾" and Betacam.
First Contact & Terms: Query with resume. Works with freelancers by assignment only. Reports in 1 week. Pays $150-300/job. Pays on acceptance. Buys all rights. Credit lines given with application.

VIDEO IMAGERY, 204 Calle De Anza, San Clemente CA 92672. (714)492-5082. General Manager: Bob Fisher. Clients: industrial-manufacturing.
Needs: Works with 2 photographers/month. Uses photographers for videotapes. Subjects include training in the manufacturing concept, in light and heavy industrial.
Specs: Uses VHS, U-matic ¾" videotape.
First Contact & Terms: Query with resume. Works with freelancers by assignment only. Reports in 3 weeks. Buys all rights. Captions and model release required. Credit line given if requested.

VIDEO RESOURCES, Box 18642, Irvine CA 92713. (714)261-7266. Producer: Brad Hagen. Clients: industrial, electronics.
Needs: Works with 2 photographers/month. Uses photographers for slide sets, films and videotapes. Subjects include action, interior, exterior (including underwater, aerial).
Specs: Uses 16mm, 35mm film, U-matic ¾", 1" Betacam videotape.
First Contact & Terms: Submit portfolio by mail; provide resume, business card, self-promotion piece or tearsheets to be kept on file for possible future assignments. Works with local and national freelancers. Works with freelancers by assignment only. SASE. Reports in 1 month. Pays by day or job. Pays net 10-30 days. Buys one-time and all rights. Model release preferred. Credit line sometimes given.

VOCATIONAL EDUCATION PRODUCTIONS, California Polytechnic State University, San Luis Obispo CA 93407. Contact: Jay Holm. AV firm. Serves clients in vocational-agricultural high schools,

junior colleges and universities offering agricultural education. Produces 20-50 filmstrips and slide sets. Buys stock photos. Provide resume and sample dupe slides to be kept on file for reference. Buys one-time rights to stock shots; all rights to assignments. Query with list of stock photo subjects.
Subject Needs: "We cover all areas of agriculture. We never have any use for b&w materials. We would like sources for stock video footage."
Color: Uses 35mm transparencies. Pays $35 minimum/transparency. Assignments are negotiated.
Tips: "We don't mind paying for quality, so show us your best."

WARNER EDUCATIONAL PRODUCTIONS, Box 8791, Fountain Valley CA 92708. (714)968-3776. Operations Manager: Philip Warner. AV firm. Serves clients in education. Produces filmstrips and multimedia kits. Buys 20 filmstrips/year. Provide business card, brochure and flyer to be kept on file for possible future assignments. Price negotiated for complete filmstrips; pays 12-17.5% royalty. Pays on acceptance. Buys all rights, but may reassign to photographer after use. Model release preferred. Arrange a personal interview to show portfolio. "We want to see only a written synopsis of the proposed unit of work. If we are interested in the topic we will arrange an interview to discuss the specifics. *We are interested only in complete units suitable for production.*" SASE. Reports in 2 weeks. Free catalog.
Subject Needs: "We produce only art craft and art oriented career teaching units. Each filmstrip is a complete unit which teaches the viewer how to do the specific art or craft or career. We are *only* interested in collections of photos which could provide a complete teaching unit. We seldom need individual photos or small groups." Length: 60-140 frames/filmstrip. Color only.
Color: Uses 35mm transparencies.
Tips; "We are now interested in videotape material."

WEST COAST PROJECTIONS, INC., Suite 300, 533 F St., San Diego CA 92101. (619)544-0550. Director of Photography: Nakamoto. Clients: industrial, high-tech, real estate.
Needs: Uses photographers for slide shows, multimedia productions, films and videotapes. Subjects vary.
Specs: Uses 35mm, 2¼x2¼ transparencies, VHS, Beta, U-matic ¾" videotape.
First Contact & Terms: Arrange a personal interview to show portfolio. Works with freelancers by assignment only; interested in stock photos/footage. SASE. Reports in 1 month.

Los Angeles

BOSUSTOW VIDEO, 2207 Colby Ave., W. Los Angeles CA 90064-1504. (213)478-0821. Director: Tee Bosustow. Clients: broadcast, promotional, industrial, institutional, corporate, home video.
Needs: Uses photographers for videotapes. Subjects include documentary, news, interviews and informational.
Specs: Uses U-matic ¾" videotape and Betacam.
First Contact & Terms: "Please, no phone calls. We'll contact you from resume and sample reel, when job comes up." Works with local freelancers usually—limited out-of-town and out-of-country. Reports when job comes up. Pays $450-1,250/day. Payment based on payment schedule of client. Buys all rights. Credit line given.
Tips: "Use only videographers with documentary style experience; some production experience is nice; owning own gear is preferable. One-page resume only. List your best documentary and production experience, your rate, the gear you own and any awards. Short demo tapes are helpful, if you don't need them back."

CATZEL, THOMAS AND ASSOCIATES, INC., 2207 Colby Ave., Los Angeles CA 90064. (213)473-7500. Office Manager: Amanda Foulger. Clients: industrial, commercial, music video.
Needs: Works with 5 photographers/month. Uses photographers for slide sets, multimedia productions, films and videotapes. Subjects include people, places, equipment, etc.
Specs: Uses 35mm transparencies; 16mm and 35mm film; VHS and U-matic ¾" videotape.
First Contact & Terms: Provide resume, business card, self-promotion piece or tearsheets to be kept on file for possible future assignments. Works with freelancers by assignment only; interested in stock photos/footage. SASE. Reports in 2 weeks. Pay individually negotiated. Payment made upon payment by client. Buys variable rights. Model release required. Credit line sometimes given.
Tips: "Send in resume and/or drop off book or sample of work."

CRANIUM PRODUCTIONS, Suite 24, 1531 Fuller Ave., Los Angeles CA 90046. (213)874-6976. Director: Graham Dent. Clients: record companies.
Needs: Works with 1 photographer/month. Uses photographers for films, videotapes. Subjects include rock videos shot on film, mostly conceptual.

Close-up

David Catzel, Kit Thomas
Catzel, Thomas and Associates, Inc.
Los Angeles, California

David Catzel Kit Thomas

By not limiting themselves to specialized productions, David Catzel and Kit Thomas can enjoy running the creative gamut from producing industrial films to music videos to corporate multi-image presentations to video press kits. And the list gets longer with each unique project they take on—such as their interest in expanding the company's entertainment division to include educational "rainy-day" children's videos.

Catzel's business and marketing background, combined with experience at a Hollywood-based design firm, has given him a good foundation for the documentaries, commercials, large scale multimedia events, industrials and music videos he has created during the past 10 years. He has garnered several industry awards; in 1984 he won the Association of Visual Communicators (AVC) Silver Cindy Award for specialized treatment in a corporate film he produced.

Thomas, the other half of the team, has accumulated 18-years experience at ABC Television, Disney Studios and Quantum Leap Films. While at Quantum Leap, Thomas supervised the production of a number of award-winning multimedia presentations and films, one of which was "Genocide," winner of the 1981 Academy Award for Best Feature-length Documentary. He has produced literally dozens of business films, audiovisual productions and videotapes in recent years and this year won two AVC Gold Cindys for his work.

Catzel, Thomas and Associates, formed in 1982, boasts a list of clients that includes American Medical International, Atlantic Ritchfield, Datsun, McDonnell Douglas, Pacific Bell, Revell Toys, TRW, Xerox Corporation, and Yamaha. According to Catzel, 65 percent of their business comes from corporate/industrial clients, with the remaining 35 percent composed of entertainment projects that have included working with such personalities as Robert Guillame (Benson), John Denver and Diana Ross.

A recent, and unique, example of projects undertaken by Catzel, Thomas and Associates, is an "Eyes on Earth from Space" presentation that was viewed at the Pacific Design Center, Los Angeles. This "art event" provides various perspectives via photography, beginning with a view of earth from the GOES 4 weather satellite, 22,000 miles above our planet; to a Landsat satellite orbiting 600 miles overhead; to high altitude aerial photography and overhead stationary photography (photographing Los Angeles); and finally closing in on the eyes of a little boy.

With such diversity, Catzel and Thomas rely on freelance designers and photographers to add the right flavor to these projects. It is important, they feel, to match the best specialized photographer to each type of client, whether it be a cosmetics company or auto manufacturer. Of course, knowledge about working with multi-image equipment and formats is necessary, Catzel stresses. Though experienced photographers are wanted, Catzel hasn't forgotten those trying to get a start in the industry. "We try out new photographers on lower-budget projects involving two to three projector shows," he says. (Some typical past productions have incorporated 12 to 50 projector presentations.)

According to Catzel, there is currently a trend toward film/video projects over multi-image shows. "In the early days of our company, 60 to 70 percent of our work included multi-image production. Now 60 to 70 percent of what we take on is strictly film or video. Slide shows still are used for corporate speaker support or large audience situations where the impact of a non-standard screen format is desired. We are also producing slide shows designed specifically for transfer to videotape, usually in a 6 projector format."

How can aspiring photographers pick up AV skills? "Become familiar with the medium, work as a production assistant for a production company, or shoot demo slide shows and, when they're good enough, hire a rep to take them around," Catzel suggests. This is a competitive market "however, freelancers showing the right portfolio at the right time get the jobs." Many freelancers, he explains, find out which AV companies are bidding on a particular job and orient their portfolios to reflect that subject. When the winning AV company is awarded the bid, the freelancer is then best positioned for the assignment.

Catzel and Thomas feel that on smaller productions, a combination of photography and writing skills (for scripting purposes) can give the freelancer a better shot at a job. "Check with local businesses, like a hospital, to see if they could use a slide show," Catzel suggests as one way to gain some practical experience.

Executive Producers David Catzel and Kit Thomas worked with John Denver (behind camera) on his first music video featuring his song, "Don't Close Your Eyes Tonight." Pictured at the far right is David Hogan, director.

Specs: Uses 16mm and 35mm film.
First Contact & Terms: Query with resume. Works with freelancers by assignment only. SASE. Reports in 2 weeks. Pays $100-400/day. Buys all rights. Credit line given whenever possible.

***HARMONY GOLD**, 8831 Sunset Blvd., Los Angeles CA 90069. (213)652-8720. Director of Creative Services: Richard Firth. Clients: television production and distribution.
Needs: Works with 2-3 freelance photographers/month. Uses freelance photographers for slide sets, videotapes, brochures/posters/one-sheets. Subjects are per assignment; depends on project.
Specs: Uses 8x10 glossy b&w prints; 35mm, 2¼x2¼, 4x5 transparencies; 16mm, 35mm film; U-matic ¾", 1" videotape.
First Contact & Terms: Provide resume, business card, self-promotion piece or tearsheets to be kept on file for possible future assignments. Works with local freelancers only. SASE. Reports in 2 weeks. Pays still photographers $50-100/hour; $150-325/day; video per assignment; $10-100/b&w photo; $15-100/color photo. Pays on acceptance. Buys all rights. Captions preferred; model release required. Credit line given when possible.
Tips: Approach with an eye to future work. Projects come up constantly but not all require photo work. "We look for ability to capture the essence of the scene or production—to help us tell the story. Experiment with converting from single frames of a scene to a flow of action—still photos in motion."

USC DAVIDSON CONFERENCE CENTER, University Park, Los Angeles CA 90089-0871. (213)743-5219. Executive Director: Mr. Philip R. Rapa. Clients: outside companies such as IBM, ARCO, NBC, MONY, etc.
Needs: Uses photographers for slide sets, multimedia productions and videotapes. Subjects depend on conference, clients.
Specs: Uses 8x10 high gloss b&w and color prints; 8x10 transparencies; 16mm film; VHS, Beta, U-matic ¾" videotape.
First Contact & Terms: Provide portfolio, query with samples and resume. Works with freelancers by assignment only. Reports in 3 weeks. Pay varies. Pays on publication. Buys all rights. Credit line depends on assignment.

***MYRIAD PRODUCTIONS**, Suite 402, 1314 N. Hayworth Ave., Los Angeles CA 90046. (213)851-1400. President: Ed Harris. Primarily involved with sports productions and events. Photographers used for portraits, live-action and studio shots, special effects photos, advertising illustrations, brochures, TV and film graphics, and theatrical and production stills. Works with freelance photographers on assignment only basis. Provide brochure, resume and samples to be kept on file for possible future assignments. Payment varies with assignment. Credit line sometimes given. Buys all rights. Send material by mail for consideration. Does not return unsolicited material. Reporting time "depends on urgency of job or production."
B&W: Uses 8x10 glossy prints.
Color: Uses 8x10 prints and 2x2 transparencies.
Tips: "We look for an imaginative photographer, one who captures the subtle nuances within his work. The photographer is as much a part of the creative process as the artist or scene being shot. Working with us depends almost entirely on the photographer's skill and creative sensitivity with the subject being shot. All materials submitted will be placed on file and not returned, pending future assignments. Photographers should not send us their only prints, transparencies, etc. for this reason."

San Francisco

***ARNOLD & ASSOCIATES PRODUCTIONS, INC.**, 2159 Powell St., San Francisco CA 94133. (415)989-3490. President: John Arnold. Clients: Fortune 500.
Needs: Works with 40 freelance photographers/month. Uses photographers for multimedia productions. Subjects include: national trade shows, permanent exhibits, national TV commercials.
Specs: Uses 35mm transparencies; 35mm film; U-matic ¾", 1" videotape.
First Contact & Terms: Query with resume. Works with freelancers by assignment only. Does not return unsolicited material. Reports in 2 weeks. Pays $300-1,200/day. Pays net 20 days. Buys all rights. Model release and captions required.
Tips: "We produce top-quality, award winning productions working with top professionals able to provide highest quality work." Wants to see dramatic lighting, creative composition and sense of style in photos submitted.

HEAPING TEASPOON ANIMATION, 4002 19th St., San Francisco CA 94114. (415)626-1893. Art Director: Chuck Eyler. Clients: commercial, industrial.
Needs: Uses photographers for films and as reference for design work. Subjects, jobs and needs vary.
Specs: Uses b&w and color prints.

First Contact & Terms: Query with stock photo list; provide resume, business card, self-promotion piece or tearsheets to be kept on file for possible future assignments. Works with freelancers by assignment only. SASE. Reports in 2 weeks. Pays $10-100/b&w or color photo. Pays on acceptance. Rights vary on project and use. Credit line sometimes given.

OUROBOROS COMMUNICATIONS, (formerly *Pointer Productions*), Box 624, San Francisco CA 94101. Director Creative Affairs: H. Willard Phelan. AV firm. Serves cable TV, small businesses and various independent producers. Produces motion pictures and videotape. Buys 100 photos and 10-20 films/year.
Subject Needs: Material varies from industrial and promotional films to educational and dramatic applications. Photos used in motion pictures and video. Also looking for candid celebrity photos.
Film: 16mm. Interested in stock footage.
Photos: Uses b&w and color 5x7 glossy prints and 35mm transparencies.
Payment & Terms: Pays by the job, on production; $15 minimum/color photo, $10 minimum/b&w photo, $5 minimum/hour. Credit line given. Rights negotiated. Model release required "except as allowed by law; news shots, for example".
Making Contact: Send material by mail for consideration. "Submitted work *must* be accompanied by SASE—unsolicited work will otherwise be disposed of." Reports in 3 weeks.
Tips: "We encourage submissions of almost any type of photograph due to our diverse output. We don't want the photographer's style to smother his subject. Well-crafted, thoughtful work is what we like. A small percentage of 'walk-in' photography is used, so be patient."

***VARITEL VIDEO**, 350 Townsend St., San Francisco CA 94107. (415)495-3328. Sales Manager: Michele Acosta. Clients: advertising agencies.
Needs: Works with 10 freelance photographers/month. Uses freelance photographers for filmstrips, slide sets, videotapes. Also works with freelance filmmakers for CD Rom, Paint Box.
Specs: Uses color prints; 35mm transparencies; 16mm, 35mm film; VHS, Beta, U-matic ¾" videotape.
First Contact & Terms: Provide resume, business card, self-promotion piece or tearsheets to be kept on file for possible future assignments. Does not return unsolicited material. Reports in 1 week. Pays $50-100/hour; $200-500/day. Pays on acceptance. Rights vary.
Tips: Apply by resume and examples of work to either Michele Acosta or Larry Kenworthy.

VIDEO VISION, 130 Frederick, San Francisco CA 94117. (415)626-5354. Executive Producer: Scott Wiseman. Clients: ad agencies, industry, independent producers.
Needs: Works with 7 photographers/month. Uses photographers for videotapes. Subjects vary with clients.
Specs: Uses 8x10 matte color prints; VHS, U-matic ¾", 1" videotape.
First Contact & Terms: Submit resume. Works with freelancers by assignment only. SASE. Reports in 3 weeks. Pay varies. Pays on publication. Buys one-time and all rights. Captions preferred; model release required.

Colorado

CIMARRON PRODUCTIONS, Suite 215, 6875 E. Evans, Denver CO 80224. (303)753-0988. President: Don Cohen. Clients: corporate, ad agencies, government.
Needs: Works with 1 photographer/month. Uses photographers for slide sets, multimedia productions and videotapes. Subjects include general assignment, specialty.
Specs: Uses 35mm, 2¼x2¼ and 4x5 transparencies; VHS, Beta and U-matic ¾" videotapes.
First Contact & Terms: Arrange a personal interview to show portfolio; query with stock photo list; provide resume, business card, self-promotion piece or tearsheets to be kept on file for possible future assignments. Works with local freelancers by assignment only; interested in stock photos/footage. Does not return unsolicited material. Reports in 2 weeks. Pays $50-200/color photo; $20-40/hour; $160-480/day. Pays within 30 days. Buys all rights. Model release required. Credit line given whenever possible.

CINE/DESIGN FILMS, 255 Washington St., Denver CO 80203. (303)777-4222. Producers: Jon Husband. AV firm. Serves a wide variety of clients. Works with 6-10 freelance photographers/month. Provide resume, letter of inquiry and published examples to be kept on file for future assignments.
Film: Uses 16mm and 35mm film. Works with freelancers by assignment only; interested in stock photos/footage.

Payment & Terms: Pays by the job. Negotiates payment based on client's budget and photographer's previous experience/reputation. Pays on acceptance. Model release preferred. Buys one-time rights.
Making Contact: Arrange personal interview or query with resume. SASE. Reports in 2 weeks.

FRIEDENTAG PHOTOGRAPHICS, 356 Grape St., Denver CO 80220. (303)333-7096. Manager: Harvey Friedentag. AV firm. Serves clients in business, industry, government, trade, union organizations. Produces slide sets, motion pictures and videotape. Works with 5-10 freelance photographers/month on assignment only basis. Provide flyer, business card and brochure and nonreturnable samples to show to clients. Buys 1,000 photos and 25 films/year.
Subject Needs: Business, training, public relations and industrial plants showing people and equipment or products in use. Uses freelance photos in color slide sets, motion pictures and printed material. No posed looks. Length requirement: 3-30 minutes.
Film: Produces mostly 16mm Ektachrome and some 16mm b&w; ¾" and Beta videotape. Interested in stock footage on business, industry, education, recreation and unusual information.
Photos: Uses 8x10 glossy b&w prints; 8x10 glossy color prints and transparencies; and 35mm or 2¼x2¼ or 4x5 color transparencies.
Payment & Terms: Pays $200/day for still; $300/day for motion picture plus expenses, or $25/b&w photo or $50/color photo. Pays on acceptance. Buys rights as required by clients. Model release required.
Making Contact: Send material by mail for consideration. SASE. Reports in 3 weeks.
Tips: "More imagination needed, be different and above all, technical quality is a must. There are more opportunities now than ever, especially new people. We are looking to strengthen our file of talent across the nation."

TRANSTAR PRODUCTIONS, INC., Suite 170, 750 West Hampden, Englewood CO 80110. (303)761-0595. Contact: Doug Hanes or Tony Wilson. Motion picture and video tape production. Serves clients in business and industry. Produces 16mm films, multiprojector slide shows, sound tracks, and video tapes. Also offering slide-to-film and slide-to-video transfers.
Subject Needs: Looking for freelance photographers, writers, and film production personnel experienced in a variety of film and video areas.
Payment & Terms: Pays by the job, or per day. Pays negotiable rates; 50% of expenses up front; balance upon delivery of approved product.
Making Contact: Send resume and/or material before phone contact. Previous sales experience very helpful. "Know the business of film production."

Connecticut

AETNA LIFE & CASUALTY, Corporate Communications, 151 Farmington Ave., Hartford CT 06156. Attention: Corporate Communications, DA 14, Robert Cooke. (203)273-1982. Contact: Administrator, photographic operations. Inhouse AV facility. Produces overhead transparencies and multi image presentations. Subjects include safety and business, photojournalism, employees and businesses, business situations, architectural photos of company property. Extensive use of freelance photographers for inhouse magazine and newspaper photography. Provide portfolio or mailer to be kept on file for possible future assignments. Buys all rights, but may reassign to photographer. Negotiates payment based on project. Query first with resume of credits. Reports in 2 weeks. SASE.
Needs: Extensive use of still photography, b&w and color, for inhouse publications.
B&W: Assignments require contact sheet with negatives. Model release required.
Color: Send transparencies or contact sheet. Model release required.
Tips: "Prefers freelancers from outside of Hartford area."

BRAY STUDIOS INC., 19 Ketchum St., Westport CT 06880. (203)226-3777. Assistant President: Paul Bray. AV firm. Produces filmstrips, slide sets, multimedia kits, motion pictures, sound-slide sets, videotape. Buys 2-8 filmstrips and 10-25 films/year.
Subject Needs: Vary depending on client, e.g. detailed electronic display on traffic control to industrial psychology to a product demonstration.
Film: Produces 16mm, 35mm, video.
Payment & Terms: Pays/job or hour. Pays on production. Buys all rights or according to client needs. Model release required.
Making Contact: Query with resume of credits, or send resume and then telephone. SASE. Provide resume and business card to be kept on file for possible future assignments.
Tips: "Let us know what area you have worked in, with whom, and what equipment used."

CURRENT AFFAIRS, 346 Ethan Allen Hwy., Ridgefield CT 06877. (203)431-0421. Vice President: Sharon Burke. Clients: educational, corporate.
Needs: Uses photographers for filmstrips, multimedia productions and videotapes.
Specs: Uses 35mm transparencies; VHS videotape.
First Contact & Terms: Provide resume, business card, self-promotion piece or tearsheets to be kept on file for possible future assignments. Works with local freelancers by assignment only; interested in stock photos/footage. Reports in 1 month. Pay individually negotiated. Buys one-time and all rights. Captions and model release required. Credit line sometimes given.

EDUCATIONAL DIMENSIONS GROUP, Box 126, Stamford CT 06904. (203)327-4612. Visual Editor: Marguerite Mead. Clients: educational market—schools and libraries nationwide. Uses photographers for filmstrips, slide sets, videotapes.
Needs: Subjects include travel, science, current affairs, language arts (staged dramatizations), careers, etc.
Specs: Uses 35mm, 2¼x2¼ and 4x5 transparencies; VHS videotape.
First Contact & Terms: Arrange a personal interview to show portfolio; provide resume, business card, self-promotion piece or tearsheets to be kept on file for possible future assignments. Works with freelancers by assignment only; interested in stock photos/footage. Pay individually negotiated. Pays on acceptance. Buys one-time rights (for stock), and all rights. Model release required. Credit line given.

GUYMARK STUDIOS, 3019 Dixwell Ave., Box 5037, Hamden CT 06518. (203)248-9323. President: A. Guarino. Offers complete production and technical service for film, video and sound communications. Clients include advertising agencies, financial and educational institutions, and industrial and commercial firms. Produces 16mm and 35mm films, filmstrips and multimedia kits. Pays $125/day. Call to arrange an appointment.
Film: 16mm and 35mm documentary, industrial, TV location, studio camera work, commercial and educational films. Sample assignments include "anything from local factory shooting to extensive around the world travel/location shooting."
B&W: Uses negatives with 8x10 matte prints.
Color: Uses 35mm and 2¼x2¼ transparencies, or negatives with 8x10 glossy or matte prints.

JACOBY/STORM PRODUCTIONS, INC., 22 Crescent Rd., Westport CT 06880. (203)227-2220. President: Doris Storm. Vice President: Frank Jacoby. AV firm. Clients include industry and educational institutions. Produces filmstrips, motion pictures and videotapes. Needs occasional photos of people (all ages and ethnic mixtures), urban/suburban life, school/classroom situations, and scenery. Buys one-time rights. Pays $150-300/day or on a per-job or per-photo basis. Call to arrange an appointment or query with resume of credits. SASE.
Film: 16mm documentary, industrial and educational films in color and b&w. Possible assignments include only freelance crew assignments: assistant cameraman, gaffers, sound, editing, etc.
Color: Uses 35mm transparencies. Pays according to number used.
Tips: "We suggest that you design your portfolio to suit potential client—in our case, emphasize photojournalism techniques in 35mm color slides."

***PRAXIS MEDIA, INC.**, 18 Marshall St., South Norwalk CT 06854. (203)866-6666. Production Coordinator: Barbara Alfano. Serves corporate/industrial clients.
Needs: Works with 3-4 freelance photographers/month. Uses photographers for slide sets, multimedia productions, videotapes. Subjects include corporate primarily, some entertainment/music.
Specs: "We have our own in-house video production company."
First Contact & Terms: Provide resume, business card, self-promotion piece or tearsheets to be kept on file for possible future assignments. Works with local freelancers only; works with freelancers by assignment only. SASE. Reports in 2-3 weeks. Pays $750-1,000/day. Pays via 45 day payment policy. Buys all rights.
Tips: "Follow up on calls—we normally hire local photographers/videographers."

SAVE THE CHILDREN, Communications Center, 54 Wilton Rd., Westport CT 06880. (203)226-7272. Director: Joseph M. Loya. Nonprofit organization. Produces slide presentations, 16mm film, videotapes, publications, and displays. Subjects and photo needs relate to children in poverty areas both in the US and overseas, as well as "examples of self-help and development projects, sponsored by Save the Children." Works with 0-5 freelance photographers/month on assignment only basis. Provide letter of inquiry, flyer and tearsheets to be kept on file for possible future assignments. Buys 25-200 photos and 3,000-4,000 feet of film annually. Buys all rights, but may reassign to photographer. Pays $75-300 minimum/day; negotiates payment based on client's budget and photographer's previous experience/reputation. Pays on receipt of materials. Query first with resume of credits. Reports in 1 month. SASE.

Film: 16mm color sound used as documentaries, fundraising films, public service films and TV commercials. Possible assignments include filming 1,500-2,500' of a Save the Children project on location, which will be submitted to Save the Children for processing and editing. "When catastrophe or natural disaster strike a country in which we have programs, footage is needed immediately," but only on assignment. Model release required for US subjects.

B&W: Send contact sheet or negatives. Uses 5x7 glossy prints. Captions and model release required for US subjects.

Color: Send 35mm transparencies. Captions and model release required for US subjects.

Tips: "We need to communicate, as powerfully as possible, the desperate needs of the poor (have-not) people of the world—especially the children."

WESTON WOODS STUDIOS, 389 Newtown Turnpike, Weston CT 06883. (203)226-3355. Executive Producer: Judy Duris. AV firm and motion picture and distribution company. Clients: educational, TV.

Needs: Works with approximately 1 freelance photographer/month—"varies, depending on projects in production." Uses photographers for direct mail, catalogs, brochures and motion picture production. Subjects include product, candids, promotional for Weston Woods films, children's literature. Also works with freelance filmmakers to produce "films for children based on outstanding children's books."

First Contact & Terms: Query with samples or sample reel; provide resume, business card, brochure, flyer or tearsheets to be kept on file for possible future assignments. Works with local freelancers on an assignment basis only. SASE. Pays $35/roll for candids; "scale" per day. Pays on acceptance. Buys all rights. Model release required. Credit line given "when practical."

Tips: Prefers to see "sample motion picture reel for cinematography; portfolio for stills. Contact us with sample reel or portfolio, then arrange interview."

Delaware

KEN-DEL PRODUCTIONS, INC., 111 Valley Rd., Wilmington DE 19804-1397. (302)655-7488. President: H. Edwin Kennedy. AV firm. Produces slides, videos, filmstrips, motion pictures and overheads. Serves an industrial, educational and commercial market. Submit material by mail for consideration. Reports in 3 weeks. SASE.

Film: Produces documentary, industrial, educational and product sales films in 35mm, 16mm, Super 8mm and ¾" U-matic, ½" VHS and Betamax. Model release required.

Color: Uses 2¼x2¼ or 4x5 and occasionally 35mm transparencies, motion picture footage or videotape. No originals.

District of Columbia

***COMMUNICATION CORP., INC.**, 711 4th St. NW, Washington DC 20001. (202)638-6550. Director of Multimedia: Gerry Drake. Clients: corporations, federal agencies, schools, industrial and broadcasting.

Needs: Buys about 2,000 photos/year. Uses photographers for multi image slide shows, filmstrips, slide sets, multimedia kits and videotape. Subjects include promotion, exhibits, employee training, visitor and orientation centers.

Specs: Produces 16mm documentary, industrial and educational films, multi image shows.

First Contact & Terms: Arrange a personal interview to show portfolio (slides only) or query with resume of credits. Pays $10-20/hour. Payment made on acceptance, production and upon completion of job. Rights purchased depends on client's needs. Model release preferred.

SCREENSCOPE, INC., 4330 Yuma St. NW, Washington DC 20016. (202)364-0055. President: Marilyn Weiner. Motion picture and AV firm. Clients: education, government, business.

Needs: Produces filmstrips, motion pictures and sound-slide sets. Works with 1-2 freelance photographers/month (predominately in motion pictures) on assignment only basis. Documentary; industrial; educational (science, geography, nature); public service and sales training. Photos used in filmstrips and slide presentations.

Specs: Produces 16mm color sound film. Interested in stock geographical footage for educational purposes, particularly foreign countries. Sometimes pays royalties, depending on film. Uses 8x10 glossy b&w prints and 35mm and 2¼x2¼ color transparencies.

First Contact & Terms: Query with resume of credits; provide resume, flyer, tearsheets and brochure

to be kept on file for possible future assignments. SASE. Reports in 2 weeks. Pays by the job. Pays on production. Negotiates payment based on client's budget. Buys one-time rights. Model release required.

WORLDWIDE TELEVISION NEWS (WTN), (formerly Upitn Corp.), Suite 200, 1705 DeSales St. NW, Washington DC 20036. (202)835-0750. Bureau Manager, Washington: Paul C. Sisco. AV firm. "We basically supply TV news on tape, for TV networks and stations. At this time, most of our business is with foreign nets and stations." Produces motion pictures and videotape. Works with 6 freelance photographers/month on assignment only basis. Provide business card to be kept on file for possible future assignments. Buys dozens of "news stories per year, especially sports."
Subject Needs: Generally hard news material, sometimes of documentary nature, sports.
Video: Generally hard news.
Payment & Terms: Pays $100 minimum/job. Pays on receipt of material; nothing on speculation. Video rates about $350/half day, $650/full day or so. Negotiates payment based on amount of creativity required from photographer. Buys all rights. Dupe sheets for film required.
Making Contact: Send name, phone number, equipment available and rates with material by mail for consideration. Fast news material generally sent counter-to-air shipment; slower material by air freight. SASE. Reports in 2 weeks.

Florida

FLORIDA PRODUCTION CENTER, 150 Riverside Ave., Jacksonville FL 32202. (904)354-7000. Vice President: Lou DiGiusto. AV firm. Clients: business, industrial, federal agencies, educational.
Needs: Uses photographers for filmstrips, slide sets, multimedia kits, motion pictures and videotape.
First Contact & Terms: Query with resume of credits; provide resume, calling card, brochure/flyer and tearsheet to be kept on file for future assignments. Pays by the job "depending on project." Buys all rights. Model release required.

***FLORIDA VIDCOM, INC.**, 3685 N. Federal Hgwy., Pompano Beach FL 33064. (305)943-5590. President: Joseph M. Carey. Clients: business, industrial, commercial, ad agencies.
Needs: Works with 1 freelance photographer/month. Uses photographers for multimedia productions, videotapes. Subjects: various.
Specs: Uses 35mm transparencies; U-matic ¾" and Betacam videotape.
First Contact & Terms: Provide resume, business card, self-promotion piece or tearsheets to be kept on file for possible future assignments. Buys all rights. Model release required. Credit line given.
Tips: Call for appointment; bring sample of work.

INDIANER MULTI MEDIA, 16201 SW 95th Ave., Miami FL 33157. (305)235-6132; (800)327-7888. Production Supervisor: Paul Simon.
Needs: Works with 3 photographers/month. Uses photographers for filmstrips, slide sets, multimedia productions, films and videotapes. All subjects.
Specs: Uses b&w and color prints; 35mm and 4x5 transparencies; 16mm and 35mm film; VHS, U-matic ¾" and 1", 2" videotapes.
First Contact & Terms: Submit portfolio by mail; provide resume, business card, self-promotion piece or tearsheets to be kept on file for possible future assignments. Interested in stock photos/footage. Reports in 2 weeks. Pays based on quality. Pays on acceptance. Buys one-time and all rights. Captions preferred; model release required. Credit line given.

HACK SWAIN PRODUCTIONS, INC., 1185 Cattlemen Rd., Sarasota FL 33582. (813)371-2360. President: Tony Swain. Clients: corporate, educational.
Needs: "We have our own staff. Use freelance occasionally for special photo needs." Uses photographers for filmstrips, slide sets, multimedia productions, films and videotapes.
Specs: Uses 35mm and 2¼x2¼ transparencies; 16mm film; VHS, 1", U-matic ¾ videotapes.
First Contact & Terms: Query with stock photo list. Interested in stock photos/footage. SASE. Reporting time varies with complexity of project. Payment individually negotiated. Pays sometimes on acceptance; sometimes on completion of project. Buys all rights. Model release required. Credit line given whenever practical.
Tips: "We usually do our own photography, but seek freelance help for hard to find or hard to recreate historical photo materials. We like to have on file sources for such materials."

***KRYPTON CORP.**, Suite J, 2601 N. Ocean Ave., Singer Island FL 33404. (305)842-1558. Vice President: R. Levine. Clients: various.

Needs: Works with 8-10 freelance photographers/month. Uses freelance photographers for filmstrips, films. Subjects vary.
Specs: Uses 8x10 b&w and color prints; 35mm transparencies; 16mm, 35mm film; Beta, U-matic ¾" videotape.
First Contact & Terms: Submit portfolio by mail. Interested in stock photos/footage. SASE. Reports in 3 weeks. Pay negotiated. Pays on publication. Buys all rights. Captions preferred; model release required. Credit line given.

TEL—AIR INTERESTS, INC., 1755 NE 149th St., Miami FL 33181. (305)944-3268. Contact: Sara Noll. AV firm. Serves clients in business, industry and government. Produces filmstrips, slide sets, multimedia kits, motion pictures, sound-slide sets and videotape. Buys 10 filmstrips and 50 films/year. Pays $100 minimum/job. Pays on production. Buys all rights. Model release required, captions preferred. Arrange a personal interview to show portfolio or submit portfolio for review. SASE. Reports in 1 month.
Film: Documentary, industrial and educational film.
B&W: Uses prints.
Color: Uses 8x10 matte prints and 35mm transparencies.

Georgia

COMPRO PRODUCTIONS, Suite 114, 2080 Peachtree Industrial Court, Atlanta GA 30341. (404)455-1943. Director/Producer: Nels A. Anderson. Film/video producer. Industrial clients and ad agencies.
Needs: Works with variable number of freelance photographers each year. Uses photographers for AV presentations and brochures.
Specs: Uses b&w prints; 35mm transparencies; 16mm and 35mm film and videotape.
First Contact & Terms: Query with resume of credits; provide resume, business card, brochure, flyer or tearsheets to be kept on file for possible future assignments. Does not return unsolicited material. Reports in 2 weeks. Pays $250-500/day. Pays on acceptance. Buys all rights or one-time rights. Model release required.

***CORPORATE MEDIA COMMUNICATIONS, INC.**, 1530 Cooledge Rd., Tucker (Atlanta) GA 30085. (404)491-6300. Clients: all kinds, mostly large business.
Needs: Works with 6 freelance photographers/month. Uses photographers for filmstrips, slide sets, multimedia productions, videotapes, print. Subjects include studio, location, candid.
Specs: Uses 35mm, 2¼x2¼, 4x5, 8x10 transparencies and U-matic ¾", 1" video tape.
First Contact & Terms: Arrange a personal interview to show portfolio. Works with freelancers by assignment only; interested in stock photos/footage. SASE. Reports in 1 week. Payment open. Pays net 30 days after assignment. Buys all rights or stock can be one time. Model release preferred. Credit line given if possible.
Tips: "Do good work, be professional and dress professionally." To get in the field, "start taking videotapes. Learn by doing."

***4TH STREET PRODUCTIONS**, #20 Fourth St., NW, Atlanta GA 30308. (404)873-2020. Business/Production Manager: Glen Vanderbeek. Clients: national/regional/local advertising agencies and major corporations.
Needs: Works with "at least 50" freelance photographers/month, "including all freelancers for film/video." Uses freelance photographers for films, videotapes, location production stills for film/videotape productions; also the use of freelance grips, gaffers, stylists, assistant camera, dp's, producers et al. Subjects include all subjects/styles for commercials and corporate presentations.
Specs: Uses all sizes b&w prints; 35mm transparencies; 16mm, 35mm film. "Our videotape presentations are mastered on 1 inch videotape."
First Contact & Terms: Provide resume, business card, self-promotion piece or tearsheets to be kept on file for possible future assignments, "¾" cassette videotape if their works apply to film/videotape projects." Works with local freelancers by assignment only. SASE. Reports in 3 weeks. Pays by day or job, "depends on expertise level." Pays net 30 days. Buys "per project specification."
Tips: Be enthusiastic, and flexible on rate depending on project. If moving into film/video with little experience, be willing to take a lower position for experience.

PAUL FRENCH & PARTNERS, INC., Rt. 5, Gabbettville Rd., LaGrange GA 30240. (404)882-5581. Contact: Gene Byrd. AV and video firm. Clients: industrial, corporate.
Needs: Works with freelance photographers on assignment only basis. Uses photographers for

filmstrips, slide sets, multimedia. Subjects include: industrial marketing, employee training and orientation, public and community relations.
Specs: Uses 35mm and 4x5 color transparencies.
First Contact & Terms: Query with resume of credits; provide resume to be kept on file for possible future assignments. Pays $75-150 minimum/hour; $600-1,200/day; $150 up/job, plus travel and expenses. Payment on acceptance. Buys all rights, but may reassign to photographer after use.
Tips: "We buy photojournalism . . . journalistic treatments of our clients' subjects. Portfolio: industrial process, people at work, interior furnishings product, fashion. We seldom buy single photos."

Hawaii

PACIFIC PRODUCTIONS, Box 2881, Honolulu HI 96802. (808)531-1560. Manager: Robert Ebert. Clients: various, including educational.
Needs: Works with 6 photographers/month. Uses photographers for slide sets, multimedia productions, films and videotapes.
Specs: Uses 8x10 b&w and color prints; 35mm, 2¼x2¼, 4x5 transparencies; 16mm, 35mm film; VHS, Beta, U-matic ¾", 1" videotape.
First Contact & Terms: Query with samples and stock photo list; provide resume, business card, self-promotion piece or tearsheets to be kept on file for possible future assignments. Works with freelancers by assignments only; interested in stock photos/footage. SASE. Reports in 2 weeks. Pay varies with job. Pays on acceptance. Buys one-time rights. Captions and model release required.
Tips: Query first.

Illinois

GOLDSHOLL DESIGN AND FILMING, 420 Frontage Rd., Northfield IL 60093. (312)446-8300. President of Design: Bob Lavin. Vice President of Design: John Rieben. AV firm. Serves clients in industry and advertising agencies. Produces filmstrips, slide sets, multimedia kits, corporate brochures, merchandising material, and motion pictures. Works with 2-3 freelance photographers/month on assignment only basis. Provide letter of inquiry and brochure to be kept on file for future assignments. Buys 100 photos, 5 filmstrips and 25 films/year.
Subject Needs: Anything. No industrial equipment. Length requirement: 30 seconds to 30 minutes.
Film: Uses 16 and 35mm industrial, educational, TV, documentaries and animation. Interested in stock footage.
Photos: Uses contact sheet or 35mm, 2¼x2¼, 4x5 or 8x10 color transparencies.
Payment/Terms: Pays by the job or by the hour; negotiates payment based on client's budget, amount of creativity required from photographer, photographer's previous experience/reputation. Pays in 30 days. Buys all rights. Model release required.
Making Contact: Query with resume. SASE. Reports in 1 week.

***IMPERIAL INTERNATIONAL LEARNING CORP.**, 329 E. Court, Box 548, Kankakee IL 60901. (815)933-7735. Director, Product Development: Patsy Gunnels. Clients: educational market (early childhood, K-12).
Needs: Works with 1-2 freelance photographers/month. Uses photographers for multimedia productions and videotapes. Subjects include: product shots and video taped educational programs.
Specs: Uses 5x7 glossy b&w prints, various sizes glossy color prints; 35mm color transparencies; 35mm film; VHS, Beta and U-matic ¾" videotape.
First Contact & Terms: Provide resume, business card, self-promotion piece or tearsheets to be kept on file for possible future assignments. Works with freelancers by assignment only; interested in stock photos/footage. SASE. Reports in 2 weeks. Pays by the job or by royalty. Pays on acceptance and by royalty. Buys all rights and exclusive rights in intended market. Captions preferred; model release required. Credit line sometimes given.
Tips: There is an increasing interest in educational use of videotape and computer graphics and computer-enhanced illustrations. Get linked up with a video production house—use their *expensive* equipment.

MOTIVATION MEDIA, INC., 1245 Milwaukee Ave., Glenview IL 60025. (312)297-4740. Vice President, Production Operations: Paul Snyder. Manager/Creative Graphics Division: Perry Anderson. AV firm. Clients: manufacturers of consumer and capital goods, business associations, service industries. Produces filmstrips, multimedia/multiscreen productions, sound slide shows, video productions, 16mm film. Subjects include new product announcements, sales promotion, and sales

training programs and public relations programs—"all on a variety of products and services." Uses "a very wide variety" of photos obtained through assignment only. Provide resume to be kept on file for possible future assignments. Pays $350-600/day, or per job "as negotiated." Query first with resume of credits. Reports in 1 week. SASE.

Film: Produces 16mm and videotape industrials. Possible assignments include serving as producer, responsible for all phases of production; serving as director, involved in studio and location photography and supervises editing; serving as film editor with "creative and conforming" duties; and serving as cinematographer.

Color: Uses 35mm, 2¼x2¼, 4x5 transparencies and 8x10.

Tips: "All freelancers must show evidence of professional experience. Still photographers should have examples of product and location photography in their portfolios. Contact Stan Kotecki, director of still photography, for appointment to show portfolio."

TRANSLIGHT MEDIA ASSOCIATES, INC., 931 W. Liberty Dr., Wheaton IL 60187. (312)690-7780. President: James B. Cudney. Contact: John M. Lorimer. AV film. Clients: industrial, religious, advertising, communications.

Needs: Works with 2-5 freelance photographers/month. Occasionally buys stock. Uses photographs for AV presentations. Sometimes works with freelance filmmakers to produce "mostly documentary or educational films."

Specs: Uses 35mm, 2¼x2¼ and 4x5 transparencies; 16mm film and videotape.

First Contact & Terms: Arrange a personal interview to show portfolio. Works with freelancers on assignment basis only. SASE. Reports in 2 weeks. Pays $25-75/hour; $200-600/day. Pays 30 days from receipt of invoice. Buys one-time rights. Model release preferred. Credit line given "depending on use."

Tips: Prefers to see photographer's "area of specialty or expertise and more event and on-location photography rather than set shots. Know how photography should be shot for AV presentations. Be able to figure out what is required by the show and shoot it right."

UNIVERSAL TRAINING SYSTEMS CO., 255 Revere Dr., Northbrook IL 60062. (312)498-9700. Vice President/Executive Producer: Richard Thorne. AV producers. Serves financial institutions, electronics manufacturers, producers of farm equipment, food processors, sales organizations, data processing firms, etc. Produces filmstrips, sound slide sets, multimedia kits, 16mm and videotape. Subjects include training, product education, personnel motivation, etc. Needs documentary and location photos. Works with freelance photographers on assignment only basis. Provide resume, business card and brochure to be kept on file for possible future assignments. Produces 20-25 films and videotapes annually. Buys "the right to use pix in one film or publication (for as long as the film or publication is used by clients). Exclusivity is not required. The right to sell pix to others is always the seller's prerogative." Pays per job or on a per-photo basis. Negotiates payment based on client's budget. Query with resume of credits. Reports in 2 weeks. SASE.

Film: 16mm documentary, industrial and sales training films. "We handle all casting and direction. We hire crews, photographers, etc." Model release required.

B&W: Uses 8x10 prints. Model release required.

Color: Uses transparencies or prints. Model release required.

Tips: Prefers to see "work of which the photographer is especially proud plus work which the photographer feels represents capability under pressure." There is a "massive move to video training, especially in the area of interactive video."

***VIDEO I-D, INC.**, 105 Muller Rd., Washington IL 61571. (309)444-4323. President: Sam B. Wagner. Clients: health, education, industry, cable, broadcast.

Needs: Works with 5 freelance phtographers/month. Uses freelance photographers for slide sets, multimedia productions, films, videotapes. Subjects "vary from commercial to industrial—always high quality."

Specs: Uses 35mm transparencies; 16mm film; U-matic ¾", 1" videotape.

First Contact & Terms: Provide resume, business card, self-promotion piece or tearsheets to be kept on file for possible future assignments; "also send video sample reel." Works with freelancers by assignment only, "somewhat" interested in stock photos/footage. SASE. Reports in 3 weeks. Pays $8-25/hour; $65-175/day. Pays on acceptance. Buys one-time rights and all rights. Model release required. Credit line sometimes given.

Tips: Sample reel—indicate goal for specific pieces. "Show good lighting and visualization skills. Be willing to learn."

Chicago

***AGS & R COMMUNICATIONS**, 425 N. Michigan, Chicago IL 60015. (312)836-4500. Vice President: Gary J. Ballenger. Clients: advertising, Fortune 1000, 500-corporate and industrial companies.

Needs: Works with "possibly 1" freelance photographer/month depending on work load. Uses photographers for original slide and multimedia productions. Subjects include: portrait, table top, talent, 35mm pin registered photo sequences and 4x5 and 8x10 color transparencies, and product shots.
Specs: Uses 5x7 and 8x10 b&w and color prints; 35mm, 2¼x2¼, 4x5 or 8x10 transparencies; 16mm or 35mm film; VHS, Beta, U-matic ¾", 1" videotape.
First Contact & Terms: Provide resume, business card, self-promotion piece or tearsheets to be kept on file for possible future assignments. "Do not call, please." Works with freelancers by assignment only; interested in stock photos/footage. SASE. Reports in 1-2 weeks. Pays 30 days after completion from invoice. Pay negotiated. Model release required. Credit line sometimes given.
Tips: "You must have good people skills—dependable—and have strong photographer skills in slide market."

BETZER PRODUCTIONS, INC., 450 E. Ohio St., Chicago IL 60611. (312)664-3257. President: Joseph G. Betzer. AV firm. Produces motion pictures, slide films, videotapes and multimedia kits.
Needs: Subjects vary with client's desires.
First Contact & Terms: Pays per hour, per photo, or per job, "depending on the person involved and the assignment." Query first with resume of credits; "send nothing until asked."
Film: Uses 35mm, 16mm, and all sizes of videotape, "depending on client's desires." Does not pay royalties.

CINE-MARK, Division of Krebs Productions, Inc., Suite 2026, 303 E. Ohio St., Chicago IL 60611. (312)337-3303. President: Clyde L. Krebs. AV firm. Clients: industrial, travel, museums. Client list provided on request.
Needs: Works with 3-7 freelance photographers/month. Uses photographers for AV presentations. Subject matter "varies according to client need." Also works with freelance filmmakers to produce "corporate communications: marketing, training, travelogues and museum exhibits."
Specs: Uses 8x10 and 4x5 color prints; 35mm, 2¼x2¼, 4x5 and 8x10 transparencies; 16mm film and videotape.
First Contact & Terms: Provide resume, business card, brochure, flyer or tearsheets to be kept on file for possible future assignments. Works with freelance photographers on assignment basis only. Does not return unsolicited material. Payment varies. Pays on completion of film. Buys all rights. Model release required. Credit line given "seldom on photos, but in film credits."

CLEARVUE, INC., 5711 N. Milwaukee Ave., Chicago IL 60646. (312)775-9433. President: W. O. McDermed. Editor: Joe Vest.
Needs: Works with 4-5 photographers/year. Uses photographers for filmstrips.
Specs: Uses 35mm transparencies.
First Contact & Terms: Query with resume. Works with freelancers by assignment only. SASE. Reports in 3 weeks. Pays/job. Pays on acceptance. Buys all rights. Captions required.

***THE CREATIVE ESTABLISHMENT**, 1421 N. Wells, Chicago IL 60610. (312)943-6700. Graphics Production Manager: Sharon H. Jarosz. Clients: Fortune 500 and other major U.S. corporations.
Needs: Works with 2 freelance photographers/month. Uses freelance photographers for filmstrips, slide sets, videotapes. Subjects include "people, location, emotion, 'flavor' can be all variety."
Specs: Uses 35mm, 2¼x2¼, 4x5, 8x10 transparencies.
First Contact & Terms: Arrange a personal interview to show portfolio; provide resume, business card, self-promotion piece or tearsheets to be kept on file for possible future assignments. Works with freelancers by assignment only, interested in stock photos/footage. Does not return unsolicited material. Reports in 2 weeks. Pay negotiated. Pays on 15th and 30th of month. Usually buys one-time rights. Model release required.

***CYBERN FILM SYSTEMS, INC.**, 7257 West Touhy Ave., Chicago IL 60648. (312)774-2550. Principal: Charles Probst. Clients: technical service training—automotive.
Needs: Works with 1-2 freelance photographers/month. Uses photographers for filmstrips, slide sets, videotapes. Subjects include automotive underhood.
Specs: Uses color negatives; 35mm or 645 transparencies; VHS videotape.
First Contact & Terms: Query with samples. Works with local freelancers only. SASE. Reports in 2 weeks. Pays per job contract. Pays on acceptance. Buys all rights.

SOCIETY FOR VISUAL EDUCATION, INC., 1345 W. Diversey Pkwy., Chicago IL 60614. (312)525-1500. Graphic Arts Manager: Cathy Mijou. Clients: all work for SVE products and services, no outside clients.
Needs: Uses photographers for filmstrips, multimedia productions and slide sets. Subjects varies—for

education market—preschool to Jr.-Sr. High, every subject area (Math, Geography, etc.).
Specs: Uses b&w and color prints and 35mm transparencies and film.
First Contact & Terms: Query with samples; provide resume, business card, self-promotion piece or tearsheets to be kept on file for possible future assignments. Samples should be non-returnable—will be kept on file. Works with freelancers by assignment only, interested in stock photos/footage. Returns material for review if requested with SASE, would prefer to keep as file samples. Reports if interested in using materials submitted. Pay varies according to scope and requirements of project. Pay specified at time of contract. Buys all rights.
Tips: "You should know about the company—products produced and markets sold to. We always look for technical expertise, composition, etc."

G.W. VAN LEER & ASSOCIATES INTERNATIONAL, 1850 N. Fremont, Chicago IL 60614. (312)751-2926. President: G.W. Van Leer. AV firm. Serves schools, manufacturers, associations, stores, mail order catalog houses. Produces filmstrips, motion pictures, multimedia kits, overhead transparencies, slide and sound-slide sets, nature photobooks and videotapes. Makes 3 freelance assignments/year; purchases 300 illustrations/year. "We are looking for complete photo stories on wildflowers in full color." Query with resume and samples. Reports in 3 weeks. SASE.

Indiana

***BALL COMMUNICATIONS**, 1101 N. Fulton Ave., Evansville IN 47710. (812)428-2300. Contact: Director/Audio-Visuals. Clients: medical, industrial, pharmaceutical.
Needs: Works with "few" freelance photographers/month. Uses freelance photographers for slide sets, multimedia productions, videotapes.
Specs: Uses 35mm transparencies; 35mm film; U-matic ¾" and 1" videotape.
First Contact & Terms: Provide resume, business card, self-promotion piece or tearsheets to be kept on file for possible future assignments. Interested in stock photos/footage. Does not return unsolicited material. Pay varies. Pays "30 days from receipt of invoice." Buys one-time rights and all rights, "depends on job." Model release preferred.
Tips: "Send samples of work that can be kept in our files for reference to style, etc. Shoot subject in a series of photos, preferably in register to simulate motion/animation."

OMNI COMMUNICATIONS, Suite 207, 101 E. Carmel Dr., Carmel IN 46032-2669. (317)844-6664. Senior President: Winston Long. AV firm. Clients: industrial, corporate, educational.
Needs: Works with 6-12 freelance photographers/month. Uses photographers for AV presentations. Subject matter varies. Also works with freelance filmmakers to produce training films and commercials.
Specs: Uses b&w and color prints; 35mm transparencies; 16mm and 35mm film and videotape.
First Contact & Terms: Provide resume, business card, brochure, flyer or tearsheets to be kept on file for possible future assignments. Works with freelance photographers on assignment basis only. Does not return unsolicited material. Payment varies. Pays on acceptance. Buys all rights. Model release required. Credit line given "sometimes, as specified in production agreement with client."

***PHOTO ONE CORPORATION**, 4011 S. Wayne Ave., Fort Wayne IN 46807. (219)744-4248. Customer Service: Dennis L. Jeffrey. Clients: commercial and retail.
Needs: Uses photographers for slides sets, mural and photo decor. Subjects include "all."
Specs: Uses 35mm, 2¼x2¼, 4x5, 8x10 transparencies.
First Contact & Terms: Submit portfolio by mail; query with samples, resume and stock photo list. Interested in stock photos/footage. SASE. Reports in 2 weeks. Pays $5-500/b&w photo; $20-1,000 up/color photo; also per bid. Pays on publication. Buys one-time rights, exclusive rights and all rights. Model release required.

PRODUCERS INTERNATIONAL CORPORATION, 3921 N. Meridian St., Indianapolis IN 46208. (317)924-5163. Art Director: Gary Degler. Communications company. Serves businesses, TV, schools, special education. Produces slide sets, motion pictures and videotape. Works with freelance photographers on assignment only basis. Buys 50-300 photos/year.
Subject Needs: Employee motivation, training, travel promotion. Photos used in slide shows or films. Length: 10-30 minutes.
Film: Produces 16mm, 35mm short subjects; business, corporate image, motivational. Interested in stock footage (travel, aerial).
Photos: Uses 35mm, 2¼x2¼ and 4x5 color transparencies.

Payment & Terms: Negotiates payment based on client's budget. Pays within 30 days of acceptance. Buys all rights. Model release and captions required.
Making Contact: Query with resume of credits. "Do not send unsolicited material." Prefers to see 2x2 and 2¼x2¼ slides and 35mm in a portfolio. SASE. Reports as soon as possible. Free catalog available on request.
Tips: "Examples of film/slide/scripts of successful things you have done are most effective in demonstrating your qualifications."

***JIM WILSON, INC.**, 9441 Aronson Dr., Indianapolis IN 46240. (317)844-6418. President: Jim Wilson. Clients: industrial and broadcast.
Needs: Works with 3 freelance photographers/month. Uses photographers for videotapes. Subjects include live sports events.
Specs: Uses 1" videotape.
First Contact & Terms: Query with resume. Works with freelancers by assignment only. Does not return unsolicited material. Pays $100-250/job. Pays "when work is completed." Buys all rights. Credit line given.

Kansas

MARSHFILM, INC., Box 8082, Shawnee Mission KS 66208. (816)523-1059. President: Joan K. Marsh. AV firm. Markets to education, libraries, health organizations, clinics. Produces filmstrips and computer software. Works with freelance photographers on assignment only basis.
Subject Needs: Educational, health and guidance subjects for elementary and junior high school. No porn. Length: 50 frames, 15 minutes/filmstrip. Uses 35mm original transparencies, color only, horizontal format.
Film: Stock footage of animals, nature, etc. used occasionally.
First Contact & Terms: Provide price list to be kept on file for possible future assignments. Buys 400 photos for 12-16 filmstrips/year; prefers local talent. Negotiates payment based on Marsh's budget. Pays on acceptance. Model release required for minors. Query with list of stock photo subjects. Does not return unsolicited material. Free catalog.

Louisiana

***GATEWAY PRODUCTIONS, INC.**, 3011 Magazine St., New Orleans LA 70115. (504)891-2600. President/Vice President: William Manschot or Ruth Young. "We produce audiovisual materials of a regional nature for schools and libraries, concentrating on the states of La., Miss., Ala., Ark., Ga., and Texas, though we are interested in other states depending on the nature of the material. Content areas include general urban scenes, identifiable cities, skylines, local industry, nature material such as wildlife, scenics, plant life, and local topography-material that could be included in programs on social studies/geography."
Needs: Works with "very few so far" freelance photographers/month. Uses photographers for filmstrips, slide sets. Subjects include location photography of general interest within the context of the above subject areas.
Specs: Uses 5x7 or larger color prints and 35mm transparencies.
First Contact & Terms: Query with stock photo list. Interested in stock photos/footage. SASE. Reports in 3 weeks. Pays $100-300/day and $75-500/job. Also pays "for stock shots, depending on the percentage and number of shots on a royalty basis for sets sold or buy-out." Pays 25% upon agreement and 75% upon receipt of acceptable material. Buys all rights. Captions required. Credit line given "only in cases where a substantial percentage of the total visual material is provided by the freelancer either on assignment or from stock photos."
Tips: "We would be receptive to proposals from individuals who may own existing sequences of slides on a single topic, with the school market as a potential audience, or to individuals who have good libraries of regional material. We are looking for subject matter of interest to schools in the social studies and geography area."

***PANORAMIC TEACHING AIDS**, 1810 Rapides Ave., Box 2032, Alexandria LA 71301. (800)443-0606. President: R. Hilton McCrory. Clients: school market, offices, home.
Needs: Works with various freelance photographers/month. Uses photographers for filmstrips, slide sets, videotapes and print.
Specs: Uses 4x5-8x10 satin and glossy-finish color prints; 35mm transparencies; 35mm film; VHS videotape.

First Contact & Terms: Query with samples, resume and stock photo list. Works with freelancers by assignment only; interested in stock photos/footage. SASE. Reports in 1 month. Pay depends on subject needed. Pays on acceptance or royalty. Buys one-time rights or royalty. Credit line given.

Maine

***EXPANDED VIDEO INC.**, 7 Fox Court, Portland ME 04101. (207)773-7005. Senior Producer/Director: Edward R. Miles. Clients: "all types from industrial to educational broadcast. We also *provide* video footage to other producers—specializes in environmental footage—inland, mountains and ocean/coastal."
Needs: Works with 4-6 freelance photographers/month. Uses photographers for "wide variety" of subjects via slide sets and videotapes.
Specs: Uses 35mm transparencies; 16mm film; U-matic ¾", and 1" C videotape.
First Contact & Terms: Provide resume, business card, self-promotion piece or tearsheets to be kept on file for possible future assignments. Interested in stock photos/footage. Does not return unsolicited material. Reports in 3 weeks. Pay "depends on job, budget and quality of shots." Pays on publication. Buys all rights. Model release required. Credit line given when possible.
Tips: "Info on style and subject matter helpful—rates and other pertinent info at start helps us decide who to use."

VIDEO WORKSHOP, 495 Forest Ave., Portland ME 04101. (207)774-7798. Director: Everett K. Foster. AV firm. Serves clients in business, industry and nonprofit organizations. Produces slide sets, multimedia kits, motion pictures, video films and sound-slide sets. Works with freelance photographers on assignment only basis. Provide resume and tearsheets to be kept on file for possible future assignments. Prefers to see industrial-related shots both in b&w and color. Buys 2 filmstrips and 8 video films/year.
Subject Needs: Employee training, public relations and scenic Maine. Uses freelance photos in slide shows. Length requirements: 140 slides, running time of 12 minutes.
Film: Produces 16mm and video films. Interested in stock footage of period Maine.
Photos: Uses 8x10 b&w and color prints and 35mm, 2¼x2¼ and 4x5 transparencies.
Payment & Terms: Pays $100-300/job. Pays $5-25 for b&w photo; $5-25 for color photo. Negotiates payment based on client's budget. Pays on production. Buys all rights. Model release required.
Making Contact: Query with resume. SASE. Reports in 1 week.
Tips: "I hire talent by the job. A freelancer should be available and have resume in my file."

Maryland

SAMUEL R. BLATE ASSOCIATES, 10331 Watkins Mill Dr., Gaithersburg MD 20879-2935. (301)840-2248. AV and stock photo firm. President: Samuel R. Blate. Clients: business/professional, US government, some private. SASE.
Needs: Works with 1-2 freelance photographers/month. Uses photographers for billboards, direct mail, catalogs, consumer and trade magazines, posters, audiovisual presentations, brochures and signage. Subject "varies too much to say."
Specs: Uses 8x10 b&w glossy prints; 35mm, 2¼x2¼ and 4x5 transparencies.
First Contact & Terms: Query with list of stock photo subjects; provide resume, business card, brochure, flyer, tearsheets or sample 35mm slide duplicates to be kept on file for possible future assignments. "Also send a categorical list of images available for stock use; we'll contact you as requirements dictate. We work with freelancers on an assignment basis only." SASE. Reports in 3 weeks. Pays $50-1,500/b&w or color stock photos; $45/hour and $360/day. Pays on acceptance. "We try for one-time rights except when the client makes other demands, in which case we attempt a negotiated upward assignment." Model release and captions required. Credit line given "whenever possible."
Tips: "Submit work that shows technical and aesthetic excellence. We are slowly expanding our use of freelancers as conditions warrant."

***A. S. CSAKY COMMUNICATIONS**, 420 Legato Terrace, Silver Spring MD 20901. (301)681-3333; 681-3390. Owner/Creative Director: A.S. Csaky. Clients commercial and industrial and individual on special assignment, advertising/promotion, direct mail, books (jackets and interiors). Magazines, brochures, newsletters, annual reports, TV news graphics, record albums.
Needs: Works with 1-10 freelance photographers/month. Uses freelance photographers for slide sets, multimedia productions, films, videotapes, publications of all sorts: Advertisements, brochures, annual reports. Subjects vary from architectural building lobbies, people, singers, computer parts, product

photos, news events, nudes, scenics, aircraft, travel, tunnel building, stitching machines, advertising subjects. From product photos to news to nudes. Varies on a project by project basis.

Specs: Uses 8x10 glossy b&w prints and 8x10, 11x14 color prints; 35mm, 2¼x2¼, 4x5, 8x10 transparencies; 16mm, 35mm film; VHS and U-matic ¾" videotape.

First Contact & Terms: Query with samples; query with stock photo list; provide resume, business card, self-promotion piece or tearsheets to be kept on file for possible future assignments. Works with freelancers by assignment only; interested in stock photos/footage. SASE. Reports in 2 weeks. Pays $25-350/b&w photo: $25-500/color print; $40-150/hour; $250-600/day; $100-1,500-3,000/job, negotiated. Pays on acceptance or on publication; "deposit and progress payments." Buys one-time rights or all rights. Captions preferred; model release required. Credit line given "as much as possible."

Tips: "Send sample of best work, don't inundate us. Impress us with your progress as a photographer and how you can help us meet our goals. Study film technique, screen film after film, and then make your own, mistakes and all."

Massachusetts

FILM I, 990 Washington St., Dedham MA 02026. (617)329-3470. Account Executives: Robert Gilmore, Dale Sherman. AV firm. Serves clients in schools and business. Produces filmstrips, slide sets, multimedia kits, motion pictures, sound-slide sets and videotape. Produces programs for inhouse presentations and commercial spots for TV. Works with 3-10 freelance photographers/month on assignment only basis. Provide resume, flyer and tearsheets to be kept on file for possible future assignments.

Film: Produces 35mm slides, super slides and 4x5; 16mm and Super 8 movies.

Photos: Uses 8x10 prints and 35mm transparencies.

***FIRE PREVENTION THROUGH FILMS, INC.**, Box 11, Newton Highlands MA 02161. (617)965-4444. Manager: Julian Olansky. Clients: anyone who has the need for fire prevention and general safety audiovisual aids.

Needs: Works with 3-4 freelance photographers/year. Uses freelance photographers for films. Subjects include fire prevention and general safety.

Specs: Uses 16mm film; may use VHS, Beta, U-matic ¾" videotape.

First Contact & Terms: Query with resume; provide resume, business card, self-promotion piece or tearsheets to be kept on file for possible future assignments. Works with freelancers by assignment only and interested in stock photos/footage. SASE. Reports in 1 month or "as soon as possible." Pay negotiated. Buys all rights. Model release and captions preferred. Credit line given.

Tips: Looks for any good ideas of presenting the subject of fire prevention and general safety to the public. "There is always a need for good training aids in the broad field of fire prevention and general safety."

***GREEN MOUNTAIN POST FILMS**, Box 229, Turners Falls MA 01376. (413)863-4754. Associate Producer: Charles Light. Clients: varied.

Needs: Uses photographers for "films, videotapes, and in our bulletin and film productions as stills." Subjects include documentary films and some sponsored material.

Specs: Uses b&w and color prints; 16mm film; VHS, Beta and U-matic ¾" videotape.

First Contact & Terms: Query with stock photo list. Works with freelancers by assignment only; interested in stock photos/footage. Does not return unsolicited material. Pay rates vary by use. Pays on publication. Buys all rights, preferably, "but this varies." Credit line or end credits on film given.

***TR PRODUCTIONS**, 1031 Commonwealth Ave., Boston MA 02215. (617)783-0200. Executive Vice President: Ross P. Benjamin. Clients: industrial, commercial, educational.

Needs: Works with 1-2 freelance photographers/month. Uses photographers for slide sets and multimedia productions. Subjects include: people shots, manufacturing/sales, facilities.

Specs: Uses 35mm transparencies.

First Contact & Terms: Provide resume, business card, self-promotion piece or tearsheets to be kept on file for possible future assignments. Works with local freelancers by assignment only; interested in stock photos/footage. Does not return unsolicited material. Reports "when needed." Pays $300-1,000/day. Pays "14 days after acceptance." Buys all rights.

Michigan

***LIGHT PRODUCTIONS**, 1915 Webster, Birmingham MI 48008. (313)642-3502. Producer: Terry Luke. Clients: mostly corporations, businesses, institutions, magazines.

These stills are excerpted from "The Secret Agent," a film about the consequences of exposure to dioxin, a chemical found in agent orange. Green Mountain Post Films produces documentary films about "energy, the environment and the planet." "The Secret Agent" was produced by Daniel Keller and Jacki Ochs, directed by Jacki Ochs. Associate Producer: Charles Light.

Needs: Works with 2-3 freelance photographers/month. Uses freelance photographers for slide sets, multimedia productions, videotapes. Subjects include city people in activities, business activities, industrial, landscapes, travel sites and activities, models (glamour and nude).

Specs: Uses 8x10 b&w prints, 5x7 and 8x10 glossy color prints; VHS, U-matic ¾" videotape.

First Contact & Terms: Query with resume; query with stock photo list; provide resume, business card, self-promotion piece or tearsheets to be kept on file for possible future assignments. Works with freelancers by assignment only; interested in stock photos/footage. Does not return unsolicited material. Reports in 2 weeks. "Pay varies according to usage." Pays on publication. Buys one-time rights and all rights. Model release and captions preferred. Credit line sometimes given.

Tips: "Call first." Looks for creativity, light, viewpoint, general use shots, unique viewpoint.

Missouri

MARITZ COMMUNICATIONS CO., 1315 North Highway Dr., Fenton MO 63026. (314)225-6000. General Manager/Photo Services: Jack Lee. AV firm. Clients: business, industrial.
Needs: Uses photographers for filmstrips, slide sets, multimedia kits, motion pictures and videotape. Subjects include employee training, business meeting environment, automotive training, product photography, 35mm location shooting both in-plant and outdoors.
Specs: "Some travel involved, normally 2-3 day shoots. All color. Shoot a variety of filmstrips." Produces 35mm for industrial and educational filmstrips and multimedia shows. Uses 4x5 and 8x10 color transparencies.
First Contact & Terms: Arrange a personal interview to show portfolio (product photo, 35mm location and in-plant work photos in color). Works on assignment only. Provide resume and calling card to be kept on file for future assignments. Pays $150-200/day. Payment made by agreement (30 days). Buys all rights. Model release required.

***PREMIER FILM AND RECORDING**, 3033 Locust, St. Louis MO 63103. (314)531-3555. Secretary/Treasurer: Grace Dalzell. Clients: all areas of human endeavor.
Needs: Works with various number of freelance photographers/month. Uses photographers for filmstrips, slide sets, multimedia productions, films, videotapes, "nearly 100% of our freelance photographers are St. Louisan residents." Subjects include religious, industrial, TV, training, educational.
Specs: Uses any size color prints; 35mm transparencies; reduction prints super 8, 16mm, 35mm film; VHS, Beta, U-matic ¾" videotapes.
First Contact & Terms: Provide resume, business card, self-promotion piece or tearsheets to be kept on file for possible future assignments, "include letter with name, address and phone number." Works with freelancers by assignment only. SASE. Reports "ASAP." Pays per job, negotiable. Pays on acceptance. Buys all rights. Credit line sometimes given.
Tips: Looks for clean traditional work with efficiency in product. Trade magazines, and practice, practice, practice—study, study, study.

Montana

VIDEO INTERNATIONAL PUBLISHERS, INC., 118 Sixth St. S., Great Falls MT 59405. (406)727-7133. Administrative Director: Penny L. Adkins (Ms.). Clients: industrial, educational, retail, broadcast.
Needs: Works with 3-15 photographers/month. Uses photographers for films, videotapes. Subjects include television commercials, educational/informational programs, AU video is shot "film-style" (lit for film, etc.).
Specs: Uses U-matic ¾", prefers 1" C-format.
First Contact & Terms: Provide resume, business card, self-promotion piece or tearsheets to be kept on file for possible future assignments. Works with freelancers by assignment only; interested in stock photos/footage. SASE. Reports in 1 month. Pays upon completion of final edit. Buys all rights. Model release required. Credit line given.
Tips: "Send the best copy of your work on ¾" cassette. Describe your involvement with each piece of video shown."

Nebraska

SIGHT & SOUND, INC., 6969 Grover, Omaha NE 68106. (402)393-0999. President/Owner: L.M. Bradley. Clients: medical, financial, business, government, agricultural.
Needs: Works with 2 photographers/month. Uses photographers for filmstrips, multimedia productions and videotapes. Subjects include promotional, motivational, instructive.
Specs: Uses 2½x2¼ transparencies, U-matic ¾" videotape.
First Contact & Terms: Provide resume, business card, self-promotion piece or tearsheets to be kept on file for possible future assignments. Works with local freelancers only; interested in stock photos/footage. Reports as need arises. Buys all rights.

New Jersey

***AM CORP VIDEO PRODUCTIONS**, 326 High St., Burlington NJ 08046. (609)871-3636 or 387-3636. Owner: E. Burro. Clients: mostly industrial. A Wedding Department (VHS) is under consideration.

Needs: Uses freelance photographers for videotapes. Works with 2-4 freelance photographers/month. Subjects: on location, free style video coverage.

Specs: Uses VHS, Beta, U-matic ¾" videotape.

First Contact & Terms: Provide resume, business card, self-promotion piece or tearsheets to be kept on file for possible future assignments. Works with freelancers by assignment only. Does not return unsolicited material. Pays $5-10/hour; $50-100/day. Pays on completion of assignment. Buys all rights. Credit line given "when we deem appropriate."

Tips: Looks for point of view, visual interpretation of subject, technical ability of photographer. "Rethink the process of image-making. Big difference is in visual storytelling."

CABSCOTT BROADCAST PRODUCTIONS, INC., 517 7th Ave., Lindenwold NJ 08021. (609)346-3400. AV firm. President: Larry Scott. Clients: broadcast, industrial, consumer. Client list provided on request.

Needs: Works with 2 freelance photographers/month. Uses photographers for broadcast, commercials and promotional materials. Subject matter varies. Also works with freelance filmmakers to produce TV commercials, training and sales films, etc.

Specs: Uses up to 11x14 b&w glossy prints; 35mm transparencies; 16mm, 35mm and videotape/film.

First Contact & Terms: Provide resume, business card, brochure, flyer or tearsheets to be kept on file for possible future assignments. Works with freelance photographers on assignment basis only. Does not return unsolicited material. Reports in 1 month. Pays $50 minimum/job. Pays on acceptance. Buys all rights. Model release required.

CREATIVE PRODUCTIONS, INC., 200 Main St., Orange NJ 07050. (201)676-4422. Contact: William E. Griffing. AV producer. Clients: industry, advertising, pharmaceuticals, business. Produces film, video, slide presentations, multimedia, multiscreen programs and training programs. Works with freelance photographers on assignment only basis. Provide resume and letter of inquiry to be kept on file for future assignments.

Subject Needs: Subjects include sales promotion, sales training, industrial and medical topics. No typical school portfolios that contain mostly artistic or journalistic subject matter. Must be 3:4 horizontal ratio for film, video and filmstrips: and 2:3 horizontal ratio for slides.

Specs: Uses b&w and color prints, transparencies. Produces 16mm industrial, training, medical and sales promotion films. Possible assignments include shooting "almost anything that comes along: industrial sites, hospitals, etc." Interested in stock footage.

Payment & Terms: Negotiates payment based on photographer's previous experience/reputation and client's budget. Pays on acceptance. Buys all rights. Model release required.

Making Contact: Query first with resume of credits and rates. SASE. Reports in 1 week.

Tips: "We would use freelancers out-of-state for part of a production when it isn't feasible for us to travel, or locally to supplement our people on overload basis."

HFAV AUDIOVISUAL, INC., 375 Sylvan Ave., Englewood Cliffs NJ 07632. (201)567-8585. AV firm. President: Bob Hess. Clients: industrial.

Needs: Works with 1-2 freelance photographers/month. Uses photographers for trade magazines, P-O-P displays, brochures, catalogs, newspapers, AV presentations. Subjects include industrial and product photography.

Specs: Uses 8x10 b&w and color prints; 35mm, 2¼x2¼, 4x5 transparencies; videotape.

First Contact & Terms: Arrange a personal interview to show portfolio. Works with freelance photographers on assignment only basis. Reports in 2 weeks. Pays $350-650/day. Pays 30 days after acceptance. Buys all rights. Model release required. Credit line sometimes given.

Tips: "Photographer must be creative and dress properly. Computer slides incorporated with photography to make a final slide" are increasingly used in advertising photography. Looks for industrial, plant, people in action, some product.

IMAGE INNOVATIONS, INC., 14 Buttonwood Dr., Somerset NJ 08873. (201)246-2622. President: Mark A. Else. AV firm. Clients: schools, publishers, business, industry, government.

Needs: Uses photographers for videotapes, multi-image and slide-sound.

Specs: Produces 35mm slides and video.

First Contact & Terms: Query with resume of credits. Works on assignment only. Provide resume and

tearsheets to be kept on file for future assignments. Pays $200-500/day; $100 minimum/job. Payment 30 days after billing. Buys all rights. Model release required; captions not necessary. Work with talent only in New York metropolitan area.

INTERNATIONAL MEDIA SERVICES, INC., 718 Sherman Ave., Plainfield NJ 07060. (201)756-4060. AV firm/independant film and tape production company/media consulting firm. President/General Manager: Stuart Allen. Clients: industrial, advertising, print, fashion, broadcast and CATV.
Needs: Works with 0-25 freelance photographers/month; "depending on production inhouse at the time." Uses photographers for billboards, direct mail, catalogs, newspapers, consumer magazines, P-O-P displays, posters, AV presentations, trade magazines, brochures, film and tape. Subjects range "from scenics to studio shots and assignments"—varies with production requirements. Also works with freelance filmmakers to produce documentaries, commercials, training films.
Specs: Uses 8x10 glossy or matted b&w and color prints; 35mm, 2¼x2¼ and 8x10 transparencies; 16mm, 35mm film and ¾-1" videotape.
First Contact & Terms: Provide resume, business card, brochure, flyer or tearsheets to be kept on file for possible future assignments; query with resume of credits; query with list of stock photo subjects; arrange a personal interview to show portfolio. SASE. Reporting time "depends on situation and requirements. We are not responsible for unsolicited material and do not recommend sending same. Negotiated rates based on type of work and job requirements." Usually about $100-750/day, $25-2,500/job. Rights negotiable, generally purchase all rights. Model release required; captions preferred. Credit line given.
Tips: "Wants to see a brief book containing the best work of the photographer, representative of the type of assignment sought. Tearsheets are preferred but must have either the original or a copy of the original photo used, or applicable photo credit. Send resume and sample for active resource file. Maintain periodic contact and update file."

JANUARY PRODUCTIONS, 249 Goffle Rd., Hawthorne NJ 07507. (201)423-4666. President: Allan W. Peller. AV firm. Clients: school and public libraries; eventual audience will be primary, elementary and intermediate-grade school students. Produces filmstrips. Subjects are concerned with elementary education: science, social studies, math, conceptual development. Buys all rights. Call to arrange an appointment or query with resume of credits. SASE.
Color: Uses 35mm transparencies.

★STEPHEN MAYNARD MEDIA SERVICES, 50 Foxwood Court, Bedminster NJ 07921. (201)234-1009. Producer: Stephen Maynard. Clients: corporate/industrial.
Needs: Works with 1-4 freelance photographers/month. Uses freelance photographers for multimedia productions, films, videotapes. Subjects include corporate/industrial.
Specs: Uses 35mm transparencies; 16mm, 35mm film; VHS, Beta, U-matic ¾" and 1" videotape.
First Contact & Terms: Submit portfolio by mail; provide resume, business card, self-promotion piece or tearsheets to be kept on file for possible future assignments. Works with freelancers by assignment only; interested in stock photos/footage. SASE. Reports in 1 month. Pay negotiated. Pays on publication. Buys all rights. Credit line given "if client does not object."
Tips: Looks for "work in line with my next project; speed and quality."

★R.J. MARTIN CO., INC., 321 Commercial Ave., Palisades Park NJ 07650. (201)592-0952. Manager: Kurt von Seekamm. Clients: Fortune 500.
Needs: Works with 2-4 freelance photographers/month. Uses photographers for multimedia productions, videotapes. Subjects are various.
Specs: Uses 35mm, 2¼x2¼, 4x5, 8x10 transparencies; ½" Betacam and 1" videotape.
First Contact & Terms: Submit portfolio by mail; provide resume, business card, self-promotion piece or tearsheets to be kept on file for possible future assignments. Works with freelancers by assignment only. Does not return unsolicited material. Reports in 2 weeks. Pays/day or /job. Pays by purchase order 30 days after work completed. Buys all rights. Model release required. Credit line given "when applicable."
Tips: "Be specific about your best work (what areas), be flexible to budget on project—represent our company when on business."

OPTASONICS PRODUCTIONS, 186 8th St., Cresskill NJ 07626. (201)871-0068. AV firm. President/Producer: Jim Brown. Clients: all types. Send for brochure of clients.
Needs: Uses photographers for direct mail, catalogs, AV presentations, brochures. Subject matter "varies with the project."
Specs: "Specifications are dependent by the job."

First Contact & Terms: Query with resume of credits, samples or with list of stock photo subjects; provide resume, business card, brochure, flyer or tearsheets to be kept on file for possible future assignments. Works with local freelance photographers on assignment basis only. Does not return unsolicited material. Reports "when need for services arises." Payment: Negotiable. Buys all rights but "will do otherwise if project warrants." Model release required. Credit line given "if our client doesn't object."

POP INTERNATIONAL CORP., (also known as American Mind Productions/Pop International Corp.), Box 527, Closter NJ 07624-0527. President: Arnold DePasquale. Producers Film and Videotape: Peter De Caro, Dr. G. Thomas Smith. AV firm and feature entertainment corporation. Clients: airlines, advertising agencies, public relations firms, marketing groups. Pop International Productions also produces 'inhouse' public service media campaigns for regional sponsors. Produces motion pictures and videotape. Works with 1-3 freelance photographers/month on assignment only basis. Provide resume and business card to be kept on file for possible future assignments. Buys 30-50 photos and 1-2 films/year.
Subject Needs: "Pop International Productions is contracted directly by client or by agencies and also produces campaign, educational, promotional and sales projects (film/tape/multimedia) on speculation with its own capital and resources for sale to regional sponsors."
Film: Produces "everything from 30 second TV spots using 5 stills to 9 minute shorts using 50 stills, stock and live-action film; or feature films/TV shows using title graphics." Interested in historical material only—sports and political. Pop International Corp also finances and produces feature films in the 35mm format for world distribution, and consequently contracts 'unit photographers' from union locals.
Photos: Uses 8x10 glossy b&w and 2¼x2¼ color transparencies.
Payment & Terms: "When using union photographers for feature projects we negotiate according to union regulations and scale. When using photographers on nonfeature productions such as promotional, educational or charitable multimedia or videotape projects we pay $35-200/day; $250-1,100/project; we negotiate payment based on client's budget and where work will appear. Refers to payment made by Pop International Corp. for shooting only if Pop International staff assumes all darkroom developing and printing"; or $15-50/photo. When payment is made "depends on whether assigned by agency/client or directly solicited by Pop International Productions." Buys all rights. Model release required.
Making Contact: Query with resume of credits, often assigned by agencies and clients. Prefers to see action events which in one look explains all. Does not want to see artistic panoramas, portraits or scenics. Does not return unsolicited material. Reports in 3 weeks.
Tips: "We consider two types of work. For publicity purposes we like work to reflect interesting action where as much "Who What When Where & Why" is illustrated. For nonentertainment productions we like work that reflects impeccable quality and supports the mood, atmosphere, emotion and theme of the project that will incorporate those photos. Forward material, preferably an illustrated brochure, with business card or like, and then follow up every 6 months or so by mail or phone, as projects arise quickly and are swiftly staffed by contract." Prefers to see photos that were published in the various formats or as they appear in films, filmstrips or videotapes. SASE.

WREN ASSOCIATES, INC., 208 Bunn Dr., Princeton NJ 08540. (609)924-8085. Production Manager: Debbie Schnur. Clients: corporate.
Needs: Works with 2 photographers/month. Uses photographers for slide sets, multimedia productions and videotapes. Subjects include mostly industrial settings and subjects.
Specs: Uses 35mm, 4x5 transparencies; U-matic ¾" videotape.
First Contact & Terms: Arrange a personal interview to show portfolio. Works with freelancers by assignment only. SASE. Freelancer should call. Pays up to $1,000/day. Pays within 45 days. Buys one-time and all rights. Model release required.
Tips: "We are interested in the ability to deal with the special demands of industrials: high volume of shots, filtering for available lighting, etc. I look for shots taken in a setting in which our company would find itself. I also look for clarity and composition. Please be prepared with examples of industrials. In the absence of these, bring examples of indoor shots for which filtering was required. Contact me for an interview."

New York

DON BOSCO MULTIMEDIA, 475 North Ave., Box T, New Rochelle NY 10802. (914)576-0122. Vice President: Rev. James L. Chiosso. Clients: schools, parishes, religious institutions.
Needs: Uses photographers for filmstrips, slide sets, films, videotapes. Subjects include realistic, spiritual.

Specs: Uses 35mm and 4x5 transparencies, super 8 and 16mm film, VHS, Beta and U-matic ¾" videotapes.
First Contact & Terms: Submit portfolio by mail; query with stock photo list; provide resume, business card, self-promotion piece or tearsheets to be kept on file for possible future assignments. Works with freelancers by assignment only; interested in stock photos/footage. SASE. Reports in 3 weeks. Pay depends on assignment. Pays on publication. Buys one-time rights. Credit line given.

EDUCATIONAL IMAGES LTD., Box 3456, West Side Station, Elmira NY 14905. (607)732-1090. Executive Director: Dr. Charles R. Belinky. AV publisher. Clients: educational market, particularly grades 6-12 and college; also serves public libraries, parks and nature centers. Produces filmstrips, slide sets, and multimedia kits. Subjects include a heavy emphasis on natural history, ecology, anthropology, conservation, life sciences, but are interested in other subjects as well, especially chemistry, physics, astronomy, math. "We are happy to consider any good color photo series on any topic that tells a coherent story. We need pictures and text." Works with 12 freelance photographers/month. Buys 200-400 photos/year; film is "open." Buys all rights, but may reassign to photographer. Pays $150 minimum/job, or on a per-photo basis. Query with resume of credits; submit material by mail for consideration. Prefers to see 35mm or larger color transparencies and outline of associated written text in a portfolio. Reports in 1 month maximum. SASE.
Film: "At this time we are not producing films. We are looking for material and are interested in converting *good* footage to filmstrips and/or slide sets." Query first.
Color: Buys any size transparencies, but 35mm preferred. Will consider buying photo collections, any subjects, to expand files. Will also look at prints, "if transparencies are available." Captions required; prefers model release. Pays $15 minimum if only a few pictures used.
Tips: "Write for our catalog. Write first with a small sample. We want complete or nearly complete AV programs—not isolated pictures usually. Be reliable. Follow up commitments on time and provide only sharp, well-exposed, well-composed pictures. Send by registered mail."

NATIONAL TEACHING AIDS, INC., 1845 Highland Ave., New Hyde Park NY 11040. (516)326-2555. President: A. Becker. AV firm. Clients: schools. Produces filmstrips. Uses science subjects; needs photomicrographs. Buys 20-100 photos/year. Call to arrange an appointment; prefers local freelancers. Does not return unsolicited material.
Color: Uses 35mm transparencies. Pays $25 minimum.

TECHNICAL EDUCATIONAL CONSULTANTS, Suite 2010, 76 N. Broadway, Hicksville NY 11801. (516)681-1773. Vice President. Arnold Kleinstein. Clients: Fortune 500 Companies.
Needs: Uses photographers for videotapes. Require people also to design screens for Computer Based Training.
First Contact & Terms: Provide resume, business card, self-promotion piece or tearsheets to be kept on file for possible future assignments. Works with local freelancers on assignment basis only. Reports in 2 weeks. Buys all rights.

VISUAL HORIZONS, 180 Metro Park, Rochester NY 14623. (716)424-5300. AV firm. President: Stanley Feingold. Clients: industrial.
Needs: Works with 2 freelance photographers/month. Uses photographers for AV presentations. Also works with freelance filmmakers to produce training films.
Specs: Uses 35mm transparencies and videotape film.
First Contact & Terms: Provide resume, business card, brochure, flyer or tearsheets to be kept on file for possible future assignments. Works with freelance photographers on assignment basis only. Pays on publication. Buys all rights. Model release and captions required.

ZELMAN STUDIOS, LTD., 623 Cortelyou Rd., Brooklyn NY 11218. (718)941-5500. General Manager: Jerry Krone. AV firm. Clients: industrial, education, publishing, business.
Needs: Works with freelance photographers on assignment only basis. Buys 100 photos/year. Uses photographers for slide sets, filmstrips, motion pictures and videotape. Subjects include people to machines.
Specs: Produces Super 8, 16, 35mm documentary, educational and industrial films. Uses 8x10 color prints; 35mm transparencies; pays $50-100/color photo.
First Contact & Terms: Query with samples; send material by mail for consideration; submit portfolio for review; provide resume, samples and calling card to be kept on file for possible future assignments. Pays $250-800/job. Payment made on acceptance. Buys all rights. Model release required; captions preferred.
Portfolio Tips: Likes to see informal poses of all ages of people; interiors—artificial and available light scenes.

New York City

A.V. MEDIA CRAFTSMAN, INC., Suite 600, 110 E. 23rd St., New York NY 10010. (212)228-6644. President: Carolyn Clark: AV firm. Clients: corporation, internal communications, public relations, publishing, ad agency.
Needs: Local artists only. Uses photographers for filmstrips, transparencies, slide shows, multimedia kits, location and studio setting. Subjects include training experience and education.
Specs: Requires extensive employee training shows which should be evident in portfolio. Others need not apply. Produces industrial 35mm filmstrip and slide shows; 35mm filmstrips for educational markets and 16mm animation. Uses 35mm color transparencies.
First Contact & Terms: Arrange a personal interview to show portfolio; provide resume, brochure/flyer and samples to be kept on file for future assignments. Pays $350-500/day; $250-750/day for educational filmstrips; payment made on agreed terms. Buys all rights. Model release required.
Tips: Prefers to see samples illustrating various lighting conditions (factory, office, supermarket), ability to conceptualize, people working in corporations and active school children. When you call, refer to Photographer's Market.

BACHNER PRODUCTIONS, INC., 360 First Ave., New York NY 10010. (212)673-2946. President: A. Bachner. Production company. Uses filmstrips, motion pictures and videotape. Works with 2 freelance photographers/month on assignment only basis. Provide resume, letter of inquiry and brochure to be kept on file for possible future assignments. Buys 10-20 photos/year. Pays on a per-job basis; negotiates payment based on client's budget and where the work will appear. Pays on acceptance of work. Buys one-time rights or all rights, but may reassign to photographer after use. Model release required. Query with resume of credits. Solicits photos/films by assignment only. Does not return unsolicited material. Reports in 1 month.
Subject Needs: Commercials, documentaries, and sales training films. Interested in stock photos of room interiors, exteriors without people or animals. Freelance photos used as backgrounds for titles or animation stand work. Do not send portfolio unless requested. Length: 30 seconds-30 minutes/film.
Film: 16mm, 35mm, videotape. No 8mm. Filmmaker might be assigned to produce stills for animation or titling. Needs for stock footage vary.

BOARD OF JEWISH EDUCATION, INC., 426 W. 58th St., New York NY 10019. (212)245-8200. Director, Multimedia Services and Materials Development: Yaakov Reshef. AV firm. Clients: Jewish schools, community centers, youth groups and other Jewish organizations. Produces filmstrips, multimedia kits and some films; usually does not buy material from freelance filmmakers. Subjects and photo needs include "all areas of Jewish life and tradition, and Israel." Works with 1-2 freelance photographers/month. Negotiates payment based on client's budget. Buys 100-250 photos/year. Buys first rights. Submit material by mail for consideration or submit portfolio. SASE.
B&W: Send 8x10 glossy prints. Captions required. Pays $35 minimum.
Color: Send transparencies. Captions required. Pays $35 and up.

RAUL DA SILVA & OTHER FILMMAKERS, 137 E. 38th, New York NY 10016. (212)696-1657. Creative Director: Raul da Silva. AV firm. Clients: business and industrial, institutional, educational and entertainment.
Needs: Works on assignment only. Buys 1-3 filmstrips, 2-4 films/year, 2-4 videotapes; mixed AV photography for screen and print. Uses photographers for filmstrips, slide sets, multimedia kits, motion pictures and videotape. Subjects include sales promotion, public relations, internal and external corporate communications, educational and entertainment media.
Specs: Requires both location and studio light and set-up. Produces every phase of AV/film/tape—in every medium. No Super 8 work. Prefers 8x10 b&w glossies and all formats and sizes color transparencies.
First Contact & Terms: Query with resume of credits. Does not return unsolicited material. Reports in 3 weeks. Provide resume to be kept on file for possible future assignments. Pays $300-1,000/job. Pays on acceptance. Buys all rights, but may reassign to photographer after use. Model release required.
Tips: "We work with professionals only. People without commitment and dedication are a dime a dozen. List references with resume, include phone number and address."

DARINO FILMS, 222 Park Ave. S., New York NY 10003. (212)228-4024. Creative Director: Ed Darino. AV firm. Clients: industrial, communications and educational.
Needs: Works with freelance photographers on assignment only basis. Buys 5-10 films/year. Uses photographers for computerized animation, motion pictures and videotape. Subjects include 16mm animated films for children, documentaries, features, graphic animation for TV and corporation identification.

First Contact & Terms: Query with list of stock photo subjects; do not send unsolicited materials. Provide calling card, brochure and flyer to be kept on file for possible future assignments. Pays minimum union rates/hour; basics/job. Payment on publication. Buys educational/TV rights. Model release required.

DISCOVERY PRODUCTIONS, 315 Central Park W 8E., New York NY 10025. (212)752-7575. Proprietor: David Epstein. PR/AV firm. Serves educational and social action agencies. Produces 16mm and 35mm films. Works with up to 2 freelance photographers/month on assignment only basis. Provide resume to be kept on file for possible future assignments. Buys 2 films annually. Pays on use and 30 days. Buys all rights, but may reassign to filmmaker. Query first with resume of credits.
Film: 16mm and 35mm documentary, educational and industrial films. Possible assignments include research, writing, camera work or editing. "We would collaborate on a production of an attractive and practical idea." Model release required. Pays 25-60% royalty.

MARK DRUCK PRODUCTIONS, 300 E. 40th St., New York NY 10016. (212)682-5980. President/Production Director: Mark Druck. AV firm. Clients: corporations, advertisers, etc. Produces 16mm and 35mm films, videotape and filmstrips. Pays on a per-job, per-day or per-week basis. Submit resume of credits. Reports in 1 week. SASE.
Film: 16mm and 35mm educational, industrial, sales and public relations films. Possible assignments include research and on-location filming.

***FV SOUND LTD.**, 17 E. 45th St., New York NY 10017. (212)697-8980. Studio Manager: Lea Marie Braak. Clients: advertising agencies, production companies.
Needs: Works with 30 freelance photographers/month. Subjects include industrial, multimedia productions, videotapes, and sound track for slide shows.
First Contact & Terms: Provide resume, business card, self-promotion piece or tearsheets to be kept on file for possible future assignments. Works with freelancers by assignment only. Does not return unsolicited material. Reports in 1 week.

GRAPHIC MEDIA INC., 12 W. 27th St., New York NY 10001. (212)696-0880. AV firm. Contact: Scott Nicol. Clients: all types. SASE.
Needs: Uses photographers for AV presentations. Subject matter "varied."
Specs: Uses 35mm transparencies.
First Contact & Terms: Arrange a personal interview to show portfolio; query with resume of credits. Does not return unsolicited material. Pays $400-1,000/day. Buys all rights. Model release required.

DON LANE PICTURES, INC., 35 W. 45th St., New York NY 10036. (212)840-6355. Producer/Directors: John Armstrong and Don Lane. Industrial clients.
Needs: Buys 10-1,000 photos, 1-5 filmstrips and 5-15 films/year. Uses photographers for filmstrips, slide sets, 16mm documentary style industrial films and videotape. Subjects include agriculture, medicine and industrial chemicals.
First Contact & Terms: Arrange a personal interview to show portfolio. Provide calling card and tearsheets to be kept on file for possible future assignments. Pays $150-500/day. Payment on acceptance. Buys all rights, but may reassign to photographer after use. Model release required.
Tips: Wants to see "location work; preferably available light; 'documentary' style. Include information on nature and purpose of assignment, technical problems solved, etc."

WILLIAM V. LEVINE ASSOCIATES, INC., 31 E. 28th St., New York NY 10016. (212)683-7177. Contact: Art Director. AV firm. Clients: business, industry. Produces filmstrips, slide sets, multimedia presentations and motion pictures. Negotiates payment based on client's budget, amount of creativity required, where work will appear and previous experience/reputation. Pays on production. Model release and captions preferred. Query with list of stock photo subjects; provide resume and business card to be kept on file for possible future assignments. Local freelancers only. Does not return unsolicited material. Reports in 3 weeks.
Subject Needs: Freelance material used in multimedia presentations on selected business-related subjects. Frequent use of travel and scenic subjects keyed to specific locations.
Film: Produces 16mm industrial movies.
B&W: Uses 8x10 prints.
Color: Uses 2¼x2¼ transparencies or 8x10 prints.
Tips: "Our company produces multi-image slide presentations. Within a given module literally hundreds of slides may be utilized on the screen. Traditional costing is not applicable in this medium. We will also consider outright purchase of slide libraries on given subjects."

MARSDEN, 30 E. 33 St., New York NY 10016. (212)725-9220. Vice President/Creative Director: Stephen Flores. Clients: corporate, nonprofit, Fortune 500.
Needs: Works with 2-3 photographers/month. Uses photographers for filmstrips, slide sets, multimedia productions, films and videotapes. Subjects include industrial technical, office, faces, scenics, special effects, etc.
Specs: Uses 35mm, 2¼x2¼, 4x5 and 8x10 transparencies; 16mm film; U-matic ¾", 1" and 2" videotapes.
First Contact & Terms: Query with samples or a stock photo list; provide resume, business card, self-promotion piece or tearsheets to be kept on file for possible future assignments. Works with local freelancers only; interested in stock photos/footage. "We call when we have a need—no response is made on unsolicited material." Pays $25-1,000/color photo; $150-600/day. Pays on acceptance. Buys one-time rights. Model release preferred. Credit line rarely given.

MEDICAL MULTIMEDIA CORP., 211 E. 43rd St., New York NY 10017. (212)986-0180. President: Stanley R. Waine. AV firm. Clients: doctors, technicians, nurses, educators, lay persons. Produces multimedia kits, videotape programs, slide-cassette sets and filmstrips. Subjects include educational programs dealing with medical hardware and software, as well as programs in the medical and health fields. Uses photos of machinery, people, x-rays, and medical scans. Buys 400-500 photos/year. Buys all rights, but may reassign to photographer. Pays $250-325/day. Call to arrange an appointment; deals by assignment only.
B&W: Uses prints up to 11x14. Model release required.
Color: Uses 35mm transparencies. Model release required.
Tips: "We don't want any samples sent as we're not in the market for buying any."

MRC FILMS, 71 W. 23rd St., New York NY 10010. (212)989-1754. Executive Producer: Larry Mollot. AV firm. Serves clients in industry, government and television. Produces multimedia kits, motion pictures, sound-slide sets and videotape. Produces 6 sound-slide sets, 10 films and 40 video programs/year.
Subject Needs: Employee training; science; technical; motivational; orientation; and public relations.
Film: Produces 16mm color sound motion pictures. "We are more interested in cinematographers than in still photographers, but we do use both."
Payment & Terms: Pays $300-2,000/job. Pays on completion and acceptance. Buys all rights, since all work is done on assignment. Model release required.
Making Contact: Query with resume of credits, background information and description of equipment owned. Cannot return unsolicited material. Reports in 3 weeks.

PRIMALUX VIDEO, 30 W. 26 St., New York, NY 10010. (212)206-1402. Production Coordinator: Barbara Stumacher. Clients: broadcasters, ad agencies, Fortune 500 companies.
Needs: Works with 2-3 photographers/month. Uses photographers for videotapes. Subjects include commercials.
Specs: Uses U-matic ¾" and Betacam.
First Contact & Terms: Provide resume, business card, self-promotion piece or tearsheets to be kept on file for possible future assignments. Works with freelancers by assignment only. SASE. Reports in 1 month. Pay individually negotiated. Pays in 30 days.

RICHTER PRODUCTIONS, INC., 330 W. 42 St., New York NY 10036. (212)947-1395. President: Robert Richter. AV firm. Serves TV networks, local TV stations, government and private agencies. Produces 16mm and 35mm films. Subjects include the environment, science, international affairs, education, natural history, public health, economics, family life and politics. Works with 2 freelance photographers/month on assignment only basis. Provide resume to be kept on file for possible future assignments. Buys simultaneous rights. Pays $250 minimum/day. Negotiates payment based on client's budget, amount of creativity required from photographer, where the work will appear and photographer's previous experience/reputation. Query first with resume of credits. SASE.
Film: 16mm documentaries; some 35mm. Sample assignments include working with sync-sound filming. Model release required.
Tips: "We are primarily interested in talented cameramen and editors with top track records and credentials."

TALCO PRODUCTIONS, 279 E. 44th St., New York NY 10017. (212)697-4015. President: Alan Lawrence. Vice President: Peter Yung. PR and AV firm. Clients: business and nonprofit organizations. Produces motion pictures and videotape. Works with freelance photographers on assignment only basis. Provide resume, flyer or brochure to be kept on file for possible future assignments. Prefers to see general work or "sample applicable to a specific project we are working on." Buys "a few"

photos/year; does subcontract short sequences at distant locations. Pays/job; negotiates payment based on client's budget and where the work will appear. Pays on acceptance. Buys all rights. Model release required. Query with resume of credits only—don't send samples. "We will ask for specifics when an assignment calls for particular experience or talents." Returns unsolicited material if SASE included. Reports in 3 weeks.

Film: 16mm-35mm film and cassette, all professional videotape formats; documentaries, industrials, public relations. Filmmaker might be assigned "second unit or pick-up shots."

Tips: Filmmaker "must be experienced—union member is preferred. We do not frequently use freelancers except outside the New York City area when it is less expensive than sending a crew."

TULCHIN STUDIOS, 240 East 45th St., New York NY 10017. (212)986-8270. Director of Operations: Susannah Eaton-Ryan. Clients: advertising agencies.

Needs: Subjects as required by production needs.

Specs: Uses 35mm, 2¹/₄x2¹/₄, 4x5 and 8x10 transparencies; VHS, 1" videotape.

First Contact & Terms: Provide resume, business card, self-promotion piece or tearsheets to be kept on file for possible future assignments. Works with freelancers only; interested in stock photos/footage. SASE. Reports in 3 weeks. Pays on publication. Buys all rights.

Tips: "Baiscally we use chromes or slides as background plates in TV production. We pay a license fee commersurate with usage."

***VIDEOGRAPHY PRODUCTIONS**, 353 E. 76 St., New York NY 10021. (212)570-6888. President: Dick Fisher. Serves broadcast, industrial clients.

Needs: Works with 2-4 freelance photographers/month. Uses freelance photographers for films, videotapes. Subjects include film/video only.

Specs: Uses 16mm, 35mm film; 1" videotape.

First Contact & Terms: Provide resume, business card, self-promotion piece or tearsheets to be kept on file for possible future assignments. Works with local freelancers only. Does not return unsolicited material. Pays $100-300/day. Pays on publication. Buys all rights.

WINDSOR TOTAL VIDEO, 565 Fifth Ave., New York, NY 10017. (212)725-8080. Contact: Robert Marmiroli. Works with 100 freelance photographers/month. Uses photographers for videotapes, inhouse promotion, videodisc. Clients: film and videotape industry, broadcast, agency, medical, educational, business, industry.Subjects vary—most often in training or generic high-tech.

First Contact & Terms: Query with samples; provide resume, business card, self-promotion piece or tearsheets to be kept on file for possible future assignments. Works with freelancers by assignment only. Does not return unsolicited material. Reports in 1 month. Pays 30 days after receipt of invoice. Buys all rights. Model release preferred.

North Carolina

***WALTER J. KLEIN COMPANY, LTD.**, 6311 Carmel Rd., Box 2087, Charlotte NC 28211-2087. (704)542-1403. Production Manager: Ms. Terry Losardo. Clients: industry, government, organizations.

Needs: Uses photographers for films. Subjects include mostly structured, tightly scripted educational and consumer films. Needs multiple capability directors, cinematographers, and recording technicians.

Specs: Uses 16mm motion pictures.

First Contact & Terms: Arrange a personal interview to show portfolio; submit portfolio by mail; query with samples and resume. "All approaches welcome." Works with freelancers by assignment only. SASE. Reports in 1 week. "We negotiate pay based on capabilities." Pays on completion of work or weekly. Buys all rights. Credit line given if requested.

Tips: "Be adaptable and able to change duties as needed on the job. Be a good teamworker. Deliver excellence. We rarely need narrow specialists. Give us gorgeous reels to look at, with your name in credits to prove your participation. We will pay top prices for top work."

***PCA TELEPRODUCTIONS**, 801 Crestdale Ave., Matthews NC 28105. (704)847-8011. Producer/Director: Vern Stafford. Clients: agencies, corporate, industrial.

Needs: Works with 1 freelance photographer/month. Uses photographers for videotapes. Subjects include: people, places, products.

Specs: Uses U-matic ¾" and 1" videotape.

First Contact & Terms: Provide resume, business card, self-promotion piece or tearsheets to be kept on file for possible future assignments. Works "mostly" with local freelancers; interested in stock photos/footage. SASE. Reports in 1 month. Payment negotiated. Pays on publication or "30 day

cycle." Buys all rights. Model release and captions required.
Tips: Looks for competency in freelance photographers.

Ohio

ALLIANCE PICTURES CORP., 7877 State Rd., Cincinnati OH 45230. (513)474-5818. Contact: John Gunselman or Don Regensburger. AV firm. Serves clients in advertising, media and entertainment. Produces motion pictures. Provide resume and business card to be kept on file for possible future assignments.
Subject Needs: Commercials to theatrical feature films. Length varies from 30 seconds for a TV spot to 100 minutes for theatrical feature picture. Format varies/production.
Film: Produces entertainment, promotional and special purpose films. 70mm, 35mm and 16mm ECN. Pays royalties "only if necessary."
Photos: Uses 8x10 b&w prints and 4x5 or 8x10 color transparencies.
Payment & Terms: Pays/job. Pays on signed agreement for a specific production. Usually buys world rights forever. Model release required.
Making Contact: Call or write. SASE. Reports in 2 weeks, "if we request its submission."

BRIGHT LIGHT PRODUCTIONS, 420 Plum St., Cincinnati OH 45202. (513)721-2574. President: Linda Spalazzi. Film and videotape firm. Clients: national, regional and local companies in the governmental, educational, industrial and commercial categories. Produces 16mm and 35mm films and videotape. Works with freelance photographers on assignment only basis. Provide resume, flyer and brochure to be kept on file for possible future assignments. Pays $100 minimum/day for grip; negotiates payment based on photographer's previous experience/reputation and day rate (10 hrs). Pays on completion of job and within 30 days. Call to arrange an appointment or query with resume of credits. Wants to see sample reels or samples of still work.
Film: 16mm and 35mm documentary, industrial, educational and commercial films. Produces Super 8, reduced from 16mm or 35mm, but doesn't shoot Super 8 or 8mm. Sample assignments include camera assistant, gaffer or grip.

***CREATIVE TALENT MANAGEMENT**, 595 E. Broad St., Columbus OH 43215. (614)224-7827. Talent Developer: Linda Fair. Clients: talent and advertising agencies; production companies.
Needs: Works with 2-3 freelance photographers/month. Uses photographers for slide sets, videotapes. Subjects include models and actors.
Specs: Uses 5x7 and 11x14 b&w prints; 35mm transparencies; and U-matic ¾" videotape.
First Contact & Terms: Query with samples or resume. Works with freelancers by assignment only. SASE. Reports in 2-3 weeks. Payment varies. Pays on acceptance. Buys all rights. Credit line given.
Tips: "Be concise, to the point and have good promotional package. We like to see well lit subjects with good faces."

GERDING PRODUCTIONS, INC., 2306 Park Ave., Cincinnati OH 45206. (513)861-2555. President: Jeff Kraemer. AV producer. Clients: ad agencies, TV networks, business, and industry. Produces multimedia kits, motion pictures and videotape. Works with 1 freelance photographer/month on assignment only basis. Provide resume to be kept on file for future assignments. Buys 25 photos/year.
Subject Needs: Industrial and TV. Uses freelance photos within films and programs.
Film: Produces 16 and 35mm movies for TV, industry, education and commerce. Interested in stock footage.
Photos: Prefers 8x10 prints; 4x5 or 8x10 transparencies.
Payment & Terms: Pays/job or /hour; negotiates payment based on client's budget. Buys all rights. Model release required.
Making Contact: Send material by mail for consideration. SASE. Reports in 2 weeks.

***HARDING PRODUCTIONS**, 4782 Unity Line Rd., New Waterford OH 44445. (216)457-7352. Owner: William R. Harding. Clients: industrial and corporate accounts, television commercials.
Needs: Works with 5 freelance photographers/month. Uses photographers for videotapes, audio and lighting, plus writing. Also looking for new ideas for the home VCR market, possibly "how-to data."
First Contact & Terms: Arrange a personal interview to show portfolio; provide resume, business card, self-promotion piece or tearsheets to be kept on file for possible future assignments. Works with freelancers by assignment only. SASE. Reports in 2 weeks. Payment "very dependent on needs and skills"; $3.50-10/hour and $50-300/day. Pay is "negotiated at time of hiring." Buys all rights. Credit line given.
Tips: "Call first and we will set up an appointment to see your work. We are interested only in self

starters who are motivated to get into this business and are willing to do what it takes to make it. Be prepared to show work you have actually done and not work of a crew you just happened to be on. If on a crew, tell us what you did yourself. Video is starting to dominate the industrial and corporate field. Clients are finding more and more ways to use it."

***THE IMAGE PRODUCERS, INC.**, 3119 Market St., Youngstown OH 44507. (216)783-0572. Vice President Operations: Mark Munroe. Clients: commercial, corporate, industrial.
Needs: Works with 0-3 freelance photographers/month. Uses freelance photographers for slide sets and videotapes.
Specs: "Varies per project."
First Contact & Terms: Query with resume. Works with freelancers by assignment only. SASE. Reports in 2 weeks. Pays $150-300/day. Pays net 30 days. Model release required.

Pennsylvania

ANIMATION ARTS ASSOCIATES, 1100 E. Hector St., Conshohocken PA 19428. (215)563-2520. President: Harry E. Ziegler, Jr. AV firm. Clients: industry, business, pharmaceutical firms, government, publishing, advertising. Produces filmstrips, slide sets, multimedia kits, motion pictures and sound-slide sets. Works with 4 freelance photographers/month on assignment only basis. Provide resume to be kept on file for possible future assignments. Buys 100 photos, 25 filmstrips and 35 films/year. Pays $150-350/day; negotiates payment based on client's budget. Pays 30 days after invoice. Buys all rights. Model release and captions required. Query with resume of credits in 16mm film production. Local freelancers only. Does not return unsolicited material. Reports "only when we have a requirement."
Subject Needs: Location photography for training, sales promotion and documentary, mostly 16mm film. Photos used in slides also. Length: 80 frames/slides; 40-180 frames/filmstrips; 30 seconds-30 minutes/16mm film.
Specs: Uses 35mm, 2¼x2¼, 4x5 and 8x10 transparencies; 16mm and 35mm film; VHS, U-matic ¾" videotape.

DON BISHOP COMMUNICATIONS, 1142 E. Market St., York PA 17403. (717)846-3856. Producer: Don Bishop. Clients: business, industry, associations.
Needs: Works with 6 photographers/month. Uses photographers for slide sets, multimedia productions, films, videotapes.
Specs: Uses 35mm and 4x5 transparencies; 16mm film; U-matic ¾" videotape.
First Contact & Terms: Query with resume. Works with freelancers by assignment only. Reports in 3 weeks. Pays $250-900/day. Pays on acceptance. Buys one-time rights and all rights. Captions preferred; model release required. Credit line sometimes given.

BRODY VIDEO, INC., 1400 Mill Creek Rd., Gladwyne PA 19053. (215)649-6200. Contact: Louis Brody. Clients: commercial, industrial, record companies.
Needs: Works with 1-2 photographers/month. Uses photographers for films and videotapes.
Specs: Uses 16mm and 35mm film, U-matic ¾" and 1" videotapes.
First Contact & Terms: Submit portfolio by mail. Works with local freelancers only. SASE. Reports if SASE is enclosed. Payment determined upon hire. Rights vary. Credit line given where applicable.
Tips: "We use people who fit our needs. We are involved in several phases of video and film production. Music videos are in. Commercials shot on 35mm are great and industrial work pays the bills."

BULLFROG FILMS, Oley PA 19547. (215)779-8226. President: John Abrahall. AV firm. Clients: churches, schools, colleges, public libraries, adult groups. Produces and distributes 16mm films, filmstrips and video cassettes. Subjects and photo needs cover "nutrition, agriculture, energy, appropriate technology (helping people to 'live lightly' on the earth)." Works with freelance photographers on assignment only basis. Provide flyer to be kept on file for possible future assignments. Buys 5 filmstrips and 15 films annually. Pays royalties for all materials: "25% of the gross receipts on sales and rentals, payable quarterly." Submit material by mail for consideration. Reports in 1 month. SASE.
Film: Completed 16mm films on nutrition, agriculture, energy and environmental issues, gardening and "appropriate technology" only.
Color: Send 35mm transparencies "or any transparency stock suitable for reproduction in quantity." Completed filmstrips only.
Tips: "We are looking for films/filmstrips that have some specific education content in the subject areas mentioned. Practical instructions for the average person are preferred. Ten to 20 minutes is the best length."

KENNEDY/LEE, INC., RD 12, York PA 17406. (717)757-4666. AV firm. President: Don Kennedy. Clients: "primarily industrial. Some home furnishings, beer, bread, et. al." Client list free with SASE.
Needs: Works with "almost no freelance photographers in Mid-Atlantic area. We do buy photography/cinematography a few times per year from freelancers in other parts of the country." Uses photographers for AV presentations. Subjects include "industrial scenes, interior and exterior . . . and 'travelogue' shots representing a specific area of the country. We work with photographers, cinematographers, camerapersons for jobs including image films, product introduction, training, orientation, recruiting, TV spots, et al."
Specs: Uses 35mm, 2¼x2¼, 4x5 or 8x10 (rarely) transparencies; 16mm, 35mm film; ½ ¾ and 1" videotape.
First Contact & Terms: Provide resume, business card, brochure, flyer or tearsheets to be kept on file for possible future assignments. Works with freelance photographers on assignment basis only. Does not return unsolicited material. "Please do not submit anything on spec." Pays $50 first hour; $150 for half-day; $250 for one-person day; $350 for a two-person day. Pays on acceptance. Buys all rights. Model release required.
Tips: "Studio tabletops not needed. Prefers industrial interiors and exteriors; travelogue shots of freelancers, geographic area; also information on camera and lighting equipment available for stills, motion picture, and videotape. We'd like information and samples we can keep on file. Do not go to great expense. After initial contact, 16mm or videotape samples will be returned."

***MAX SELZER PRODUCTIONS**, 401 N. Broad St., Philadelphia PA 19108. (215)922-4230. Director of Operations: Jeffrey S. Fischer. Clients: industrial, advertising, commercial, corporation, etc.
Needs: Works with 2 freelance photographers/month. Uses photographers for slide sets, multimedia productions and studio photography. Subjects include production and studio.
Specs: Query first.
First Contact & Terms: Arrange a personal interview to show portfolio. Works with local freelance photographers on assignment basis only. Reports in 2 weeks. Pays on "10th of the month." Buys all rights. Model release required.

***RON SMILEY VISUAL PRODUCTIONS, INC. (RSVP)**, 1728 Cherry St., Philadelphia PA 19103. (215)561-RSVP or (609)452-RSVP. Manager: John Gooch. Clients: broadcast, corporate, industrial.
Needs: Works with 2-4 freelance photographers/month. Uses freelance photographers for films and videotapes. Subjects include EFP/ENG.
Specs: Uses Beta, U-matic ¾" and 1" videotape.
First Contact & Terms: Arrange a personal interview to show portfolio. Works with local freelancers only. Does not return unsolicited material. Pays $125-275/day. Pays net: 30 days. Buys all rights.
Tips: Show a tape that includes hand held, lighting, motion techniques, and high- and low-budget productions.

South Carolina

***SOUTH CAROLINA FILM OFFICE**, State Development Board, Box 927, Columbia SC 29202. (803)758-3091. Manager: Elease A. Goodwin. Clients: motion picture and television producers.
Needs: Works with 8 freelance photographers/month. Uses photographers to recruit feature films/TV productions. Subjects include: location photos for feature films, TV projects, and national commercials.
Specs: Uses 3x5 color prints; 35mm transparencies; 35mm film; VHS, U-matic ¾" videotape.
First Contact & Terms: Submit portfolio by mail; provide resume, business card, self-promotion piece or tearsheets to be kept on file for possible future assignments. Works with local freelancers by assignment only. Does not return unsolicited material. Pays/yearly contract. Pays upon completion of assignment. Buys all rights.
Tips: "Experience working in the film/video industry is essential. Ability needed to identify and photograph suitable structures or settings to work as a movie location."

Texas

ADAMS & ADAMS FILMS, Box 5755, Austin TX 78763. (512)477-8846. Contact: Marjorie V. Adams. Clients: schools, libraries, industry, museums and nature centers, government agencies, public and commercial television and others.
Needs: "Contact producer to find good products on continuous basis. Distributes nationally and to some foreign markets. We need movies on almost any subject; our main requirement is *quality*."
Specs: Uses 16mm film and videotape up to ½ hour long.

First Contact & Terms: Query with resume and description of film or video subject. Returns materials only when insurance forms included. Reports in 1 month. Royalty percentage paid on each sale. Pays made quarterly or according to individual contract. Buys all rights if possible.
Tips: "We like to work with film and video producers *before* final edit if possible to assure producer best marketability of his production. Also, will offer ideas for productions to qualified producers." Looks for original ideas or approaches; style and pace, professional *quality*, and integrity and accuracy—above all, emotional impact.

ARGUS COMMUNICATIONS, (Division of DLM, Inc.), One DLM Park, Allen TX 75002. Photo Editors: Linda Marie, Laura Sammarzo. Clients: education, religion, publishing.
Needs: Uses photographers for videotapes. Subjects include: documentaries, talk shows, entertainment.
Specs: Uses color prints; and 35mm, 2¼x2¼, 4x5 and 8x10 transparencies; 16mm film; and VHS and U-matic ¾" videotape.
First Contact & Terms: Submit portfolio by mail; query with samples; query with resume; query with stock photo list; provide resume, business card, self-promotion piece or tearsheets to be kept on file for possible future assignments. Works with freelancers by assignment only; interested in stock photos/footage. SASE. Pays on acceptance. Rights purchased depend on job. Captions preferred; model release required. Credit line given.

***CREATIVE COMMUNICATIONS GROUP**, 2636 Walnut Hill, Dallas TX 75229. (214)358-4461. Production Manager: Chuck Gideon. Clients: business and industry.
Needs: Works with 10-15 freelance photographers/month. Uses freelance photographers for slide sets, multimedia productions, films, videotapes, collateral. Subjects include people, work, lifestyle, scenic, industrial—*all* location.
Specs: Uses 35mm, 2¼x2¼, 4x5 transparencies; 16mm, 35mm film, and 1" C type, "M" format videotape.
First Contact & Terms: Submit portfolio by mail; provide resume, business card, self-promotion piece or tearsheets to be kept on file for possible future assignments. Works with local freelancers by assignment only; interested in stock photos/footage. SASE. Reports in 2 weeks. Pays $25-75/hour; $250-500/job. "Buy-out only." Pays on acceptance. Buys all rights. Identification and model release preferred.

***EDUCATIONAL FILMSTRIPS**, 1401 19th St., Huntsville TX 77340. (409)295-5767. CEO: George H. Russell. Clients: Jr. high through college (education only).
Needs: Subjects include various educational topics. Uses freelance photographers for filmstrips.
Specs: Uses 35mm transparencies.
First Contact & Terms: Submit camera-ready 35mm slides in carousel tray with script. SASE. Reports in 1 month. Pays per filmstrip, royalty or purchase. Pays on acceptance or December of each year. Royalty. Rights purchased varies. Captions preferred. Credit line given.
Tips: Visit local schools and ask to see most popular recent 35mm filmstrips.

***CARL RAGSDALE ASSOC., INC.**, 4725 Stillbrooke, Houston TX 77035. (713)729-6530. President: Carl Ragsdale. Clients: industrial and documentary film users.
Needs: Uses photographers for multimedia productions, films, still photography for brochures. Subjects include: industrial subjects—with live sound—interiors and exteriors.
Specs: Uses 35mm, 2¼x2¼, 4x5 transparencies; 16mm, 35mm film.
First Contact & Terms: Provide resume to be kept on file for possible future assignments. "Please do not call—send resume by mail." Works with freelancers by assignment only. Does not return unsolicited material. Pay negotiated/job. Pays upon delivery of film. Buys all rights.
Tips: "Do not call. We refer to our freelance file of resumes when looking for personnel. Swing from film to video is major change—most companies are now hiring in-house personnel to operate video equipment."

TEXAS PACIFIC FILM VIDEO, INC., 501 N. I35, Austin TX 78702. (512)478-8585. Production Manager: Tamara Carlile. Clients: ad agencies, music companies.
Needs: Works with 2-3 photographers/month. Uses photographers for slide sets, multimedia productions, films, videotapes and production stills. Subjects include commercials, music videos, feature films.
Specs: Uses various b&w and color prints; 35mm transparencies; 16mm and 35mm film; U-matic ¾", 1" videotape Betacam.
First Contact & Terms: Query with samples. Works with freelancers by assignment only. SASE. Reports if interested. Pays by day or job. Pays on payment from client. Buys one-time rights. Model release preferred. Credit line given depending on project.

Utah

CHARLES ELMS PRODUCTIONS, INC., 1260 South 350 West, Bountiful UT 84010. (801)298-2727. Production Manager: Charles D. Elms. AV firm. Clients: industry, government, associations, education. Produces filmstrips, overhead transparencies, slide sets, multimedia kits, motion pictures, and sound-slide sets. Buys 40 filmstrips and 8 films/year.
Film: Interested in stock footage.
Photos: Uses b&w contact sheet or 35mm color transparencies.
Payment & Terms: Pays by the job. Pays on production. Buys all rights. Model release and captions required.
Making Contact: Query with resume. SASE. Guidelines available.

PAUL S. KARR PRODUCTIONS, UTAH DIVISION, 1024 N. 250 East, Orem UT 84057. (801)226-8209. Vice President & Manager: Michael Karr. Clients: education, business, industry, TV-spot and theatrical spot advertising. Provides inhouse production services of sound recording, looping, printing & processing, high-speed photo instrumentation as well as production capabilities in 35mm and 16mm.
Subject Needs: Same as Arizona office but additionally interested in motivational human interest material—film stories that would lead people to a better way of life, build better character, improve situations, strengthen families.
First & Terms: Query with resume of credits and advise if sample reel is available. Pays by the job, negotiates payment based on client's budget and ability to handle the work. Pays on production. Buys all rights. Model release required.

Virginia

THE MEDIA EXCHANGE, INC., 217 S. Payne St., Alexandria VA 22314. (703)548-7039. President: Tom D'Onofrio. AV firm. Produces filmstrips, slide sets, multimedia kits, motion pictures, sound-slide sets, videotape and print. Works with freelance photographers on assignment only basis. Provide resume.
Photos: 35mm transparencies and special effects work.
Payment & Terms: Negotiates payment based on client's budget. Model release required depending on the job.
Making Contact: Query with resume. SASE. Reports in 1 month.

Canada

***CRAWLEY FILMS LTD.**, 19 Fairmont Ave., Ottawa, Ontario Canada K1Y 1X4. (613)728-3513. Personnel Manager: Cathy Morriscey. Clients: government, private industry, corporate, international.
Needs: Works with 3-5 freelance photographers/month. Uses photographers for films. Subjects include: animation camera, live action (varied subjects).
Specs: Uses 16mm and 35mm film.
First Contact & Terms: Provide resume, business card, self-promotion piece or tearsheets to be kept on file for possible future assignments. Works with freelancers by assignment only. Does not return unsolicited material. Reports in 1 month. Pay negotiated. Pays on acceptance. Buys all rights. Credit line given.

DYNACOM COMMUNICATIONS INTERNATIONAL, Snowdon Station, Box 702, Montreal, Quebec, Canada H3X 3X8. Director: David P. Leonard. AV firm. Clients: business, industry, government, educational and health institutions for training, exhibits, presentations and related communications projects. Produces slide sets, multimedia kits, motion pictures, sound-slide sets, videotape, and multiscreen, split-screen and mixed-media presentations. Fees are negotiated on a per-project basis. Buys all rights, but may reassign to photographer after use. Model release required; captions preferred. Send material by mail for consideration. Solicits photos/films by assignment only. Provide resume, flyer, business card, tearsheets, letter of inquiry and brochure to be kept on file for possible future assignments. Does not return unsolicited material. Reports only when interested.
Subject Needs: Employee training and development, motivation, and management communications presentations. Photos used in slide sets, films, videotapes, and multiscreen mixed-media presentations. No cliche imagery. 35mm only for slides.
Specs: Uses 5x7, 8x10 b&w or color photos; 35mm transparencies; Super 8, 16mm film.

The subject matter for book publishers varies as much as the number of publishing houses. Some companies specialize in a class of books, such as textbooks where the photo needs are as wide as the academic subject matter covered. Other publishing companies run the gamut from fashion topics to cookbooks to sports. It is for this reason that photographers interested in marketing to book publishers should research the photographic subject matter that would most likely be purchased. The listings in this section detail such needs, as well as the film specs each company prefers.

Photographs for books are used for covers, dust jackets, and text illustrations. A good cover photograph many times catches the eye of a consumer who would not otherwise have noticed the book in its bookstore bin surrounded by the covers of competing publications. For textbooks, encyclopedias and "how-to" publications, the photograph is more than an aesthetic enhancement, it is a needed vehicle to further educate the book's reader. To a lesser degree, photography is used in promotional brochures and newsletters to advertise an upcoming book.

It is recommended that photographers query the editor or art director first. Submitting an attractive, typed stock photo list with your query will give the potential purchaser a chance to see how closely your stock subjects match up to current or near-future needs. Not all photos are purchased as stock; some specialized books require the illustrations to be specially photographed via assignment. Either way, the editor or art director (the listings specify the correct contact) needs to have a feel for your talents and abilities as a photographer. You may wish to send some samples of your work to verify your credibility. Be sure to send tearsheets or duplicates you won't need back because many companies do not return samples. Also, be prepared to wait for a few months before you receive any reply; books require a long lead time compared to periodicals, and the exact photo needs may not be known until the book's copy is firm. The good news is that when a response does come through, it may be for a dozen or more prints, rather than the one or two a monthly magazine would purchase. Some of the most obvious shots also will be needed, such as photos you may have taken of the neighborhood children at play. These usually are purchased by religious publishing companies, or in subject books on child development, for instance.

Also of interest to book publishing companies are book proposals incorporating photos and text. If your abilities as a photographer don't extend to written creations, you may want to team up with a qualified writer. Through such a partnership you can present to an editor a query or book proposal about sailing, hunting, French cooking, ceramics or any other subject area that interests you (and your writer). Prior to submitting a sample chapter and photos, though, it will be wise to do some market research. Research a bookstore's stock to see what topics currently are selling and how they could be enhanced with a fresh approach or interesting twist. Publishing companies should also be able to share some predictions about what they foresee as potentially salable material.

When reviewing the listings in this section, pay attention to the tips offered by the editor/art director describing the photos they wish to review. Many of these hints could provide the edge that gives you a sale. And be selective about the technical quality of each photograph. Publishers want good, clear, sharp pictures; the technical aspects of a photograph can be as striking as a unique subject or use of composition. Pay scales vary from good to fairly lucrative depending on the size of the company and its needs. Many of the companies listed also buy photos on a one-time basis, which means those popular subjects you've submitted can continue to remain in the marketplace for additional sales.

A.D. BOOK CO., 10 E. 39th St., New York NY 10036. (212)889-6500. Art Director: Carla Block. Publishes books on advertising, design, photography and illustration. Photos used for promotional materials and dust jackets. Buys 10-25 photos annually; gives 5 freelance assignments annually.
Subject Needs: Most interested in advertising and design photos. Model release and captions required.
Specs: Uses 8x10 b&w and color prints and transparencies.
Payment & Terms: Pays $100/b&w photo and $200/color photo. Buys book rights. Simultaneous submissions OK.
Making Contact: Arrange a personal interview to show portfolio. Prefers to see advertising and design samples. Provide letter of inquiry to be kept on file for possible future assignments. SASE. Reports in 3 weeks.

ADDISON-WESLEY PUBLISHING COMPANY, 6 Jacob Way, Reading MA 01867. (617)944-3700. Contact: Art Director. Publishes college textbooks. Photos used for text illustration, promotional materials, book covers and dust jackets.
Subject Needs: Science, math, computer, business photos.
Specs: B&w prints and color transparencies.
Payment & Terms: Credit line given on copyright or photo credit page. Buys one-time rights. Simultaneous submissions OK "as long as they are not in same market."
Making Contact: Query with list of stock photo subjects; provide resume, business card, brochure, flyer or tearsheets to be kept on file for possible future assignments. Interested in stock photos. SASE. Reports in 1 week.

AGLOW PUBLICATIONS, (A ministry of Women's Aglow Fellowship, International), Box I, Lynnwood WA 98046-1557. (206)775-7282. Art Director: Kathy Boice. Publishes Christian publications, Bible studies, books, booklets, magazine. Photos used for magazine. Buys 10 freelance photos annually, and gives 10 freelance assignments annually.
Subject Needs: Nature scenes, special effects, "portraits and special effects are specifically assigned."
Specs: Uses 35mm, 2¼x2¼ and 4x5 transparencies.
Payment & Terms: Pays $80-250/color photo; and $80/job. Credit line given. Buys one-time rights. Simultaneous submissions and previously published work OK.
Making Contact: Query with list of stock photo subjects; interested in stock photos. SASE. Reports in 1 month.
Tips: "Call and inquire about our needs."

ALCHEMY BOOKS, 717 Market St., San Francisco CA 94103. (415)777-2197. General Editor: Graham Philips. Publishes fiction, nonfiction, outdoors, politics and language books. Photos used for text illustration, promotional materials, book covers and dust jackets. Buys 10-25 photos annually; gives 0-10 freelance assignments annually.
Subject Needs: Model release preferred.
Specs: Uses 3x5, 5x8 or 8x10 glossy b&w prints.
Payment & Terms: Pays $5 minimum/b&w photo; $10 minimum/color photo; $10 minimum/job; "dependent on project, subject, style or complexity, etc." Credit line given "in most cases." Buys book rights. "We do not wish to receive unsolicited material that must be returned. We will keep all samples on file for future reference."
Making Contact: Provide resume, business card, brochure, flyer or tearsheets to be kept on file for possible future assignments; interested in stock photos. Does not return unsolicited material. "We do not report on queries."
Tips: "We prefer samples that we may keep on file (photocopies are fine); lists of stock photos and/or subjects available are also appreciated."

AMPHOTO, AMERICAN PHOTOGRAPHIC BOOK PUBLISHING CO., 1515 Broadway, New York NY 10036. (212)764-7300. Senior Editor: Marisa Bulzone. Publishes instructional and how-to books on photography. Photos usually provided by the author of the book. Query with resume of credits and book idea, or submit material by mail for consideration. Pays on royalty basis. Rights purchased vary. Submit model release with photos. Reports in 1 month. SASE. Simultaneous submissions and previously published work OK.

 The asterisk before a listing indicates that the listing is new in this edition. New markets are often the most receptive to freelance contributions.

Tips: "Submit focused, tight book ideas in form of a detailed outline, a sample chapter, and sample photos. Be able to tell a story in photos and be aware of the market."

AND BOOKS, 702 S. Michigan, South Bend IN 46618. (219)232-3134. Senior Editor/Visuals: Emil Krause. Publishes nonfiction, adult and general. Photos used for text illustration and book covers. Buys 5-10 photos annually; gives 2-5 freelance assignments annually.
Subject Needs: Vary. Model release required; captions preferred.
Specs: Open.
Payment & Terms: Varies. Credit line given. Buys all rights. Simultaneous submissions and previously published work OK.
Making Contact: Provide resume, business card, brochure, flyer or tearsheets to be kept on file for possible future assignments. Interested in stock photos. SASE. Reports in 1 month.

ARCsoft PUBLISHERS, Box 132, Woodsboro MD 21798. (301)845-8856. President: Anthony R. Curtis. Publishes "books in personal computing and electronics trade paperbacks, space science, and journalism." Photos used for book covers. Buys 10 photos annually; gives 10 freelance assignments annually.
Subject Needs: Personal-computer/human interaction action shots and electronics and space science close-up. Captions required.
Specs: Uses 35mm, 2¼x2¼ and 4x5 slides.
Payment & Terms: Payment per color photo or by the job varies. Credit line given. Buys one-time rights and book rights. Simultaneous submissions and previously published work OK.
Making Contact: Query with resume of credits, samples or with list of stock photo subjects; provide resume, business card, brochure, flyer, tearsheets to be kept on file for possible future assignments. SASE. Reports in 1 month.
Tips: "Send query and limit lists or samples to subjects in which we have an interest."

ART DIRECTORS BOOK CO., 10 E. 39th St., New York NY 10016. (212)889-6500. Art Director: Carla Block. Publishes advertising art, design, photography. Photos used for dust jackets. Buys 10 photos annually.
Subject Needs: Advertising. Model release and captions required.
Payment & Terms: Pays $200 minimum/b&w photo; $500 minimum/color photo. Buys one-time rights. Simultaneous submissions OK.
Making Contact: Submit portfolio for review. Solicits photos by assignment only. SASE. Reports in 1 month.

ASSOCIATED BOOK PUBLISHERS, Box 5657, Scottsdale AZ 85261. (602)837-9388. Editor: Ivan Kapetanovic. Publishes adult trade, juvenile, travel and cookbooks. Photos used for promotional materials, book covers and dust jackets. Buys 24 photos/year.
Specs: Uses 8x10 glossy b&w and color prints and 4x5 and 8x10 color transparencies.
Payment & Terms: Pays $10-30/b&w photo and $50-150/color photo. Credit line and rights negotiable.
Making Contact: Send material by mail for consideration. SASE. Solicits photos by assignment only. Reports in 2 weeks.

AUGSBURG PUBLISHING HOUSE, Publication Development Office, Box 1209, Minneapolis MN 55440. (612)330-3300. Editorial Design Service: Karen Loewen. Publishes Protestant/Lutheran books (mostly adult trade), religious education materials, audiovisual resources and periodicals. Photos used for text illustration, book covers, periodical covers and church bulletins. Buys 120 color photos and 1,000 b&w photos annually; gives very few freelance assignments annually.
Subject Needs: People of all ages, variety of races, activities, moods and unposed, Color: nature, seasonal, church year and mood.
Specs: Uses 8x10 glossy or semiglossy b&w, 35mm color transparencies and 2¼x2¼ color transparencies.
Payment & Terms: Pays $20-75/b&w photo; $40-125/color photo and occasional assignments (fee negotiated). Credit line nearly always given. Buys one-time rights. Simultaneous submissions and previously published work OK.
Making Contact: Send material by mail for consideration. "We are interested in stock photos." Provide tearsheets to be kept on file for possible future assignments. SASE. Reports in 6-8 weeks. Guidelines free with SASE.

AVON BOOKS, 1790 Broadway, New York NY 10019. (212)399-1372. Art Director: Matt Tepper. Publishes books on adult and juvenile, fiction and non-fiction in mass market and soft cover trade. Pho-

Photographer Dale D. Gehman of Eureka, Illinois, sold this photo twice to Augsburg Publishing House and once to Nazarene Publishing House for a total of $70. "I submitted it unsolicited for consideration," using business stationery and including a business card, he explains. "This photo has a lot of symbolic meaning. I feel different editors will have different meanings and uses for it."

tos used for book covers. Gives several assignments monthly.

Subject Needs: Most interested in photos of single women, couples (man & woman) in color. Model release required.

Specs: Uses 35mm, 4x5 and 8x10 color transparencies.

Payment & Terms: Pays $300-800/job. No simultaneous submissions.

Making Contact: Query with samples and list of stock photo subjects; or make an appointment to show portfolio on Thursdays; provide business card, flyer, brochure and tearsheets to be kept on file for possible future assignments. SASE.

AZTEX CORPORATION, Box 50046, Tucson AZ 85703. (602)882-4656. Contact: Elaine Jordan. Publishes adult trade, nonfiction. Photos used for text illustration, book covers and dust jackets.

Subject Needs: Transportation, how-to, historical, futuristic detail. "Most photos are provided by authors—we acquire very few." Model release and captions required.

Specs: Open.

Payment & Terms: Payment negotiated individually. Buys all rights.

Making Contact: Query with list of stock photo subjects. Does not return unsolicited material. "We keep queries on file; and contact the photographer only if and when we receive photos with potential for immediate use."

Tips: "We expect the author who submits the ms to acquire all photos, arrange payment and acquire all releases. Occasionally we commission or purchase cover photo."

BALLANTINE/DELREY/FAWCETT BOOKS, 201 E. 50th St., New York NY 10022. (212)572-2251. Art Director: Don Munnson. Publishes fiction, science fiction and general nonfiction. Photos used for book covers on assignment only. Buys all rights. "Freelancers must have 5 years mass-market experience."

BANTAM BOOKS, 666 5th Ave., New York NY 10103. (212)765-6500. Photo Researcher: Ms. Toby Greenberg. Publishes a wide range of books. Photos used for book covers. Buys 30 photos annually.

Subject Needs: Many scenics, children, romantic couples. Model release required.

Specs: Uses 35mm, 4x5 and 8x10 transparencies.

Payment & Terms: Pays per job or $400-700/color photo. Credit line given. Buys book rights. Simultaneous submissions and previously published work OK.

Making Contact: Submit portfolio or samples for review; interested in stock photos. SASE. Reporting time depends on monthly schedule.

Tips: Prefers to see "a selection of photographer's best work in all the categories in which photographer works." Portfolio should be "professional—concise and easy to handle. Work around client's schedule—be flexible! We publish a great number of romance novels, some of which incorporate photography; also nonfiction, how-to, and cookbooks."

***WILLIAM L. BAUHAN, PUBLISHER**, Old County Rd., Dublin NH 03444. (603)563-8020. Editor: W.L. Bauhan. Publishes New England non-fiction. Photos used for book covers, dust jackets. Buys 10 freelance photos annually.
Specs: Uses 8x10 glossy b&w prints.
Payment & Terms: Credit line given. Buys one-time rights. Simultaneous submissions and previously published work OK.
Making Contact: Query with resume of credits. Deals with local freelancers on assignment only. SASE. Reports in 1 month.

***BEAUTIFUL AMERICA PUBLISHING COMPANY**, 9725 SW Commerce Circle, Wilsonville OR 97374. (503)682-0173. Librarian: Beverly A. Paul. Publishes nature-scenic-pictorial-history. Photos used for text illustration, pictorial. Buys 100-150 freelance photos annually, and gives 10 freelance assignments annually.
Subject Needs: Nature, scenic. Model release and captions required.
Specs: Uses 35mm, 2¼x2¼, 4x5, 8x10 color transparencies.
Payment & Terms: Pays $50-100/color photo. Credit line given. Buys one-time rights. Simultaneous submissions and previously published work OK.
Making Contact: Provide resume, business card, brochure, flyer or tearsheets to be kept on file for possible future assignments. "Do NOT send unsolicited photos!!" Interested in stock photos. Reports in 1 month.

***THE BENJAMIN COMPANY, INC.**, One Westchester Plaza, Elmsford NY 10523. (914)592-8088. Sr. Vice President: R. Mowry Mann. Publishes nonfiction only; many cookbooks. Photos used for text illustration, book covers, dust jackets. Gives 5-20 assignments annually.
Specs: Uses 4x5 transparencies.
Payment & Terms: Pay negotiated by job, number of photos, length, location, client. Credit line given on copyright page. Buys book rights.
Making Contact: Provide resume, business card, brochure, flyer or tearsheets to be kept on file for possible future assignments.
Tips: "We absolutely require food photography experience. Studio must have kitchen and a good prop collection. I'm interested in knowing photographers with this capability in various cities, for potential assignment when we have a client who wants to use someone local. Any photographer with extensive food photography experience is of interest to us."

***BENNETT & MCKNIGHT PUBLISHING**, Division of Glencoe/Macmillan, 809 W. Detweiller, Peoria Il. 61615. (309)691-4454. Director of Art/Design/Production: Donna M. Faull. Specializes in vocational education textbooks and related materials, industrial arts, home economics and career education. Uses candid, staged, cover quality photos.

This photo ran with a special feature titled "Please Eat the Centerpiece" in Food for Today, a home economics textbook. "It was taken by a local photographer," explains Donna M. Faull, art/design/production director of Bennett & McKnight Publishing, "whose portfolio included food photography. The photo was part of a large assignment of food photography. Many photographs were taken on schedule and all were of the highest quality."

Specs: Uses more color versus black & white photography.
Payment & Terms: Pays $30 minimum/b&w photo; $40 minimum/color photo; $15 minimum/hour; and $200/day. Buys all rights, some exclusive rights.
Making Contact: Send samples, resume. No drop-ins.

***BISON BOOKS**, 17 Sherwood Place, Greenwich CT 06830. (203)661-9551. Photo Editor: Mary R. Raho. Publishes promotional books—archeology, military science, travel history, movie books, television, art, sports. Photos used for text illustration and dust jackets. Buys 1,500 freelance photos annually.
Subject Needs: Needs nature scenes. Needs action sports shots. Captions preferred.
Specs: Uses 4x5 or 8x10 glossy b&w and color prints; 35mm, 2¼x2¼, 4x5 and 8x10 transparencies.
Payment & Terms: Pays $10-50/b&w photo; $50-100/color photo. Credit line given in back of book. Simultaneous submissions and previously published work OK.
Making Contact & Terms: Query with samples; query with list of stock photo subjects; provide business card, brochure, flyer or tearsheets to be kept on file for possible future assignments. Interested in stock photos. SASE. Report time "varies" 1 to 3 months.

***BONUS BOOKS, INC.**, 160 E. Illinois St., Chicago IL 60611. (312)467-0580. Associate Editor: Ellen Slezak. Estab. 1985. Publishes adult trade: sports, consumer, self-help, how-to, biography. Photos used for text illustration and book covers. Buys 100 freelance photos annually; gives 5 assignments annually.
Subject Needs: Model release and captions required.
Specs: Uses 8x10 matte b&w and color prints, and 35mm transparencies. Credit line given if requested. Buys book rights.
Making Contact: Query with resume of credits; query with samples; provide resume, business card, brochure, flyer or tearsheets to be kept on file for possible future assignments. Solicits photos by assignment only. Does not return unsolicited material. Reports in one month.
Tips: Don't call. Send written query.

BOSTON PUBLISHING COMPANY, INC., 314 Dartmouth St., Boston MA 02116. Senior Picture Editor: Julie Fischer. "Our major project at this time is a 15-volume book series on American wars. Each volume will be illustrated with as many as 150 illustrations—photographs, paintings, memorabilia, and militaria. We use stock agencies and independent photographers, and museums as sources. We mainly need photos for World War I, World War II, and Korea. We have adequate Vietnam resources already." Captions required.
Specs: Uses 8x10 b&w prints and 35mm, 2¼x2¼ or 4x5 slides. Simultaneous submissions and previously published work OK.
Payment & Terms: Pays $70-450/b&w photo; $125-500/color photo. Buys one-time rights.
Making Contact: Query with list of stock photo subjects. SASE. Reports in 1 month.

***BRANDEN PUBLISHING CO.**, 17 Station St., Box 843, Brookline Village MA 02147. (617)734-2045. Contact: Editor. Publishes general trade. Photos used for text illustration, book covers.
Subject Needs: Portraits. Model release and captions required.
Specs: Uses 4x5 glossy b&w and color prints.
Payment & Terms: Pay negotiated. Credit line given. Buys all rights. Simultaneous submissions OK.
Making Contact: Query only with SASE. Deals with local freelancers only. Reports in 1 week.

BRIDGE PUBLICATIONS, INC., 1414 N. Catalina St., Los Angeles CA 90027. (213)661-0478. Art Director: Eugenia May-Monit. Publishes adult trade: self help and fiction (including science fiction). Photos used for promotional materials, book covers, dust jackets, trade shows, P.O.P. displays. Buys 10-30 freelance photos annually, and gives 10 or more freelance assignments annually.
Subject Needs: Outdoor sports, family, special effects (galaxies and outerspace), some nature scenes, executives with computers, etc. Model release required.
Specs: Uses 8x10 matte b&w prints and 35mm and 4x5 transparencies.
Payment & Terms: Payment negotiated individually. Buys all rights, "depending upon agreement."
Making Contact: Arrange a personal interview to show portfolio; query with samples; send unsolicited photos by mail for consideration; or submit portfolio for review; provide resume, business card, brochure, flyer or tearsheets to be kept on file for possible future assignments "be sure to include prices and fees." Deals with local freelancers only. SASE. Reports in 3 weeks.
Tips: "Do not send any more than 10 photos or transparencies. Be professional regarding deadlines, quality and prices. Do not be extravagant."

***BROOKS/COLE PUBLISHING COMPANY**, 555 Abrego St., Monterey CA 93940. (408)373-0728, ext. 27. Photo Editor: Judy Blamer. Publishes college textbooks only—political science, child development, social psychology, family, marriages, chemistry, computers, criminal justice, etc. Photos used for text illustration, book covers, dust jackets.

Subject Needs: Model release preferred.
Specs: Uses glossy b&w prints, 8x10 transparencies. Credit line given. Buys one-time rights.
Making Contact: Query with list of stock photo subjects; submit portfolio for review; provide resume, business card, brochure, flyer or tearsheets to be kept on file for possible future assignments. Interested in stock photos. SASE. Reports in 2-3 weeks.

Photographer Donna Ann Jernigan of Charlotte, North Carolina, sold this photo to William C. Brown Co. Publishers twice—the first time for $80 and the second time for $110. "I had been sending photos to WCB and they were familiar with my work. When my editor called and asked for a 'drug half-way house' photo for a health textbook, I found two agencies in my local phone book. The government one said 'no,' but the private agency was cooperative. Although they needed to protect the privacy of their patients, six staff members showed me how they worked. Your own community has tremendous resources—look around and ask. They might just say yes!"

WILLIAM C. BROWN CO. PUBLISHERS, 2460 Kerper Blvd., Dubuque IA 52001. (319)588-1451. Vice President and Director, Production and Design: David A. Corona. Manager of Design: Marilyn Phelps. Manager, Photo Research: Faye Schilling. Publishes college textbooks for most disciplines (music, business, computer and data processing, education, natural sciences, psychology, sociology, physical education, health, biology, zoology, art). Photos used for book jackets and text illustration. Buys 6,000 b&w and color photos annually. Provide business card, brochure or stock list to be kept on file for possible future use. Submit material by mail for consideration. Pays up to $80/b&w photo; up to $125/color photo. Buys English language rights. Reports in 1-2 months. SASE. Previously published work OK. Direct material to Photo Research. Pays on acceptance.
B&W: Send 8x10 glossy or matte prints.
Color: Send transparencies.
Jacket: Send glossy or matte b&w prints or color transparencies. Payment negotiable.

BUSINESS PUBLICATIONS INC., Suite 390, 1700 Alma Rd., Plano TX 75075. (214)422-4389. Art Director: Patti Holland. Publishes business, marketing, accounting, business law, finance, and business communication textbooks. Photos used for text illustration and book covers.
Subject Needs: Portraits and candid type shots of people at work. Also product type shots from data communication and computer areas.
Specs: Uses 5x7 and larger b&w prints and 2¼x2¼ transparencies.
Payment & Terms: Payment negotiated individually. Credit line given. Buys one-time rights. Simultaneous submissions and previously published work OK.
Making Contact: Query with samples, or list of stock photo subjects; provide resume, business card, brochure, flyer or tearsheets to be kept on file for possible future assignments; interested in stock photos. SASE. Reports in 1 month.
Tips: "We are using an increasing number of photos inside with text, and fewer used photos as covers."

***CHRONICLE GUIDANCE PUBLICATIONS, INC.**, Aurora Street Extension, Box 1190, Moravia NY 13118. (315)497-0330. Photo Editor: Karen A. Macier. Publishes occupational monographs of four, six, or eight pages in length. Photos used for text illustration. Buys 100-155 freelance photos annually and gives 10-15 assignments annually.
Subject Needs: People on the job. Model release preferred.
Specs: Uses 8x10 glossy b&w prints.
Payment & Terms: Pays $50-150/b&w photo. Credit line given. Buys one-time rights. Simultaneous submissions and previously published work OK.
Making Contact: Provide resume, business card, brochure, flyer or tearsheets to be kept on file for possible future assignments. Interested in stock photos. SASE. Reports in 2 weeks. Photo guidelines free with SASE.
Tips: "Have a well rounded sample of occupational photographs. We are looking for the unusual but at the same time we want a photo that gives a feeling of what the job under discussion is all about. We are using more photography than ever, quality is the key however."

M.M. COLE PUBLISHING COMPANY, 919 N. Michigan Ave., Chicago IL 60611. (312)787-0804. Contact: Mike L. Stern. Handles educational records and books. Photographers used for album covers, books, advertising and brochures. Gives 50 assignments/year. Negotiates payment. Credit line given. Buys all rights. Query with resume of credits. Does not return unsolicited material.
Specs: Uses 60% b&w prints; 40% color prints.

***COMPUTER SCIENCE PRESS, INC.**, 1803 Research Blvd., Rockville MD 20850. (301)251-9050. Production Manager: Ilene Hammer. Publishes computer books, textbooks. Photos used for text illustration, book covers.
Subject Needs: Computers. Model release and captions preferred.
Payment & Terms: Buys all rights.
Making Contact: Interested in stock photos. Does not return unsolicited material.

CONCORDIA PUBLISHING HOUSE, 3558 S. Jefferson, St. Louis MO 63118. (314)664-7000, ext. 358. "All our publications are strictly religious (Lutheran) in nature." Photos used for text illustration, promotional materials, book covers and dust jackets.
Subject Needs: Nature and people interacting. Model release required; captions preferred.
Specs: Uses 8x10 b&w and color prints; 4x5 transparencies.
Payment & Terms: "Determined by publication budget. Credit line given. Buys one-time rights; "bulletins constitute 3 year license for stock and 1 year license for every Sunday." Simultaneous submissions OK.
Making Contact: Send unsolicited photos by mail for consideration. Interested in stock photos. SASE. Reports in 3-6 months.

***CPI**, 223 E. 48th St., New York NY 10017. (212)753-3800. Vice President: Sherry Olan. Publishes textbooks. Photos used for text illustrations. Buys 500 freelance photos annually and gives 30 freelance assignments annually.
Subject Needs: Children, families, science/nature. Model release required; captions preferred.
Specs: Uses 35mm transparencies.
Payment & Terms: Pay negotiated. Credit line given "usually on acknowledgement page." Rights vary. Simultaneous submissions and previously published work OK "if we know what other book uses are permissioned."
Making Contact: Query with list of stock photo subjects; provide resume, business card, brochure, flyer or tearsheets to be kept on file for possible future assignments. Solicits photos by assignment; interested in stock photos. SASE. Reports in 1 month.

CRAFTSMAN BOOK COMPANY, 6058 Corte Del Cedro, Carlsbad CA 92008. (619)438-7828. Art Director: Bill Grote. Publishes construction books. Photos used for text illustration, promotional materials, and book covers. Buys 60 freelance photos annually, and gives 10 freelance assignments annually.
Subject Needs: Photos of construction contractors at work, and carpenters at work. Model release required.
Specs: Uses 5x7 b&w prints and 35mm transparencies.
Payment & Terms: Pays $25/b&w photo; and $100/color photo. Buys all rights. Simultaneous submissions and previously published work OK.
Making Contact: Query with samples; provide resume, business card, brochure, flyer or tearsheets to be kept on file for possible future assignments; interested in stock photos. SASE. Reports in 2 weeks.
Tips: "We especially need shots of construction workers on rooftops with lots of sky visible."

THE CROSSING PRESS, Box 640, Trumansburg NY 14885. (607)387-6217. Publishers: Elaine and John Gill. Publishes fiction, feminist fiction, calendars and postcards. Photos used for book covers, calendars and postcards. Buys 10-20 photos/year; gives 2-5 freelance assignments/year.
Subject Needs: "Portraits of famous men and women for our postcard series." Model release required.
Specs: Uses 5x8 b&w glossy prints.
Payment & Terms: Pays $50-100/b&w photo. Credit line given. Simultaneous submissions and previously published work OK.
Making Contact: Query with samples or list of stock photo subjects. Solicits photos by assignment only. SASE. Reports in 3 weeks.

DELTA DESIGN GROUP, INC., 518 Central Ave., Box 112, Greenville MS 38702. (601)335-6148. President: Noel Workman. Publishes cookbooks and magazines dealing with dentistry, gardening, libraries, inland water transportation, shipbuilding (offshore and towboats), travel and southern agriculture. Photos used for text illustration, promotional materials and slide presentations. Buys 25 photos/year; gives 10 assignments/year. Pays $25 minimum/job. Credit line given, except for photos used in ads. Rights negotiable. Model release required; captions preferred. Query with samples or list of stock photo subjects or send material by mail for consideration. SASE. Simultaneous submissions and previously published work OK. Reports in 1 week.
Subject Needs: Southern agriculture; all aspects of life and labor on the lower Mississippi River; Southern historical (old photos or new photos of old subjects); recreation (boating, water skiing, fishing, canoeing, camping).
Tips: "Wide selections of a given subject often deliver a shot that we will buy, rather than just one landscape, one portrait, one product shot, etc."

***DHARMART DESIGNS**, 2425 Hillside Ave., Berkeley CA 94704. (415)548-5407. Director of Sales: Rima Tamar. Photos used for book covers, calendars, cards. Buys various amounts photos annually.
Subject Needs: Nature, animals, cosmos, abstract.
Specs: Uses color prints; no special requirements.
Payment & Terms: Pay negotiated. Credit line given. Rights negotiated. Simultaneous submissions and previously published work OK.
Making Contact: Query with samples, send unsolicited photos by mail for consideration. Interested in stock photos. SASE. Reports in 3 weeks.

THE DONNING CO./PUBLISHERS, INC., 5659 Virginia Beach Blvd., Norfolk VA 23502. (804)461-8090. Editorial Director: Robert S. Friedman. Publishes "pictorial histories of American cities, counties and states, coffee table volumes, carefully researched with fully descriptive photo captions and complementary narrative text, 300-350 photos/book." Query first with resume of credits and outline/synopsis for proposed book. Buys first rights or second (reprint) rights. Pays standard royalty contract.

Permission from sources of nonoriginal work required. Reports in 2 months. SASE. Simultaneous submissions and previously published work OK. Free author guidelines.

Tips: Suggests that "photographers work with an author to research the history of an area and provide a suitable photographic collection with accompanying ms. In some cases the photographer is also the author."

DORCHESTER PUBLISHING CO., INC., Suite 900, 6 E. 39th St., New York NY 10016. (212)725-8811. Editorial Director: Jane Thornton. Publishes mass market paperbacks—chiefly fiction. Photos used for book covers. Buys 24 photos/year. "All our cover art is freelance, though most of it involves painting. We do 120 titles per year."

Subject Needs: "Attractive, sexy ladies; soft-focus, romantic shots of women, still life relating to subject of the book." Model release required.

Specs: Uses 35mm transparencies.

Payment & Terms: Pays $75-500/color photo; negotiates pay by the hour and job. No credit line "as a rule." Buys all rights.

Making Contact: Query with resume of credits, samples. "If we are interested in photographer's work, we will set up a personal appointment to see portfolio." SASE. Reports in 1 month.

DOUBLEDAY AND COMPANY, INC., 245 Park Ave., New York NY 10167. Photo Research Editor: Stefani Arzonetti. Publishes all types of books. Photos used for text illustration, promotional materials, book covers and dust jackets. Buys approximately 200 photos annually; 15-20% supplied by freelancers.

Subject Needs: "Depends on the subject of the book, the deadline and the art director—usually geared around sound lighting, color, well-composed frames." Model release required.

Specs: Uses 8x10 glossy b&w and color prints; 35mm and 4x5 transparencies.

Payment & Terms: Pays $50-500/b&w photo, $50-1,000/color photo. Credit line given. Usually purchases one-time rights, but may vary according to use of photo. Simultaneous submissions and previously published work OK.

Making Contact: Query with resume of credits, samples or with list of stock photos subjects; provide resume, business card, brochure, flyer or tearsheets to be kept on file for possible future assignments. Solicits photos from local freelancers on assignment only; interested in stock photos. Pays "as soon as possible."

Tips: "Charge less than any stock photo house in New York to beat the competition. Make your work worth our search by showing us unique photos of obscure topics."

EASTVIEW EDITIONS INC., Box 783, Westfield NJ 07091. (201)964-9485. Contact: Manager. "Will consider collection of photos depending on subject matter. Eastview publishes or distributes arts internationally—fine arts, architecture, design, music, dance, antiques, hobbies, nature and history." Photos wanted for publication as books.

Payment & Terms: Pays royalties on books sold. At present requires some financial commitment or support.

Making Contact: Query with samples. SASE. Reports in 6 weeks. Free photo guidelines and book catalog on request.

Tips: "No samples that must be returned. Send only 'second generation' materials."

EMC PUBLISHING, 300 York Ave., St. Paul MN 55101. (612)771-1555. Editor: Eileen C. Slater. Publishes educational textbooks. Photos used for text illustration and book covers. Buys 10-15 photos annually; gives 1 freelance assignment annually.

Subject Needs: Vary. Model release required.

Specs: Uses 5x7 glossy b&w prints; 4x5 transparencies.

Payment & Terms: Payment varies. Credit line given. Rights purchased varies.

Making Contact: Query with resume of credits; provide resume, business card, brochure, flyer or tearsheets to be kept on file for possible future assignments. Solicits photos by assignment only; interested in stock photos. Does not return unsolicited material. Reports in 2 weeks.

***ENSLOW PUBLISHERS**, Box 777, Hillside NJ 07205. Vice President: Patricia Culleton. Photos used for text illustration, promotional materials, book covers, dust jackets. Buys 25 freelance photos annually and gives 2-3 assignments annually.

Subject Needs: Science and social issues.

Specs: Uses b&w prints.

Payment & Terms: Pay negotiated. Credit line given. Buys book rights. Simultaneous submissions OK.

Making Contact: "Send a few b&w photocopies of prints for us to keep for reference." Does not return unsolicited material.

FOCAL PRESS, 80 Montvale Ave., Stoneham MA 02180. (617)438-8464. General Manager and Editor: Arlyn Powell. Publishes 20 photo titles average/year.
Subject Needs: "Generally speaking, we are interested in practical rather than aesthetic or artistic books on photography.
Payment & Terms: Authors of text paid by royalty; photographers paid by outright purchase.
Making Contact: Submit outline/synopsis and sample chapters. Provide resume and tearsheet to be kept on file for possible future assignments. SASE. Simultaneous and photocopied submissions OK. Reports in 4-6 weeks. Free catalog. We publish at all levels, from amateur to advanced professional. As a rule we do not publish books *of* photographs but how-to books with photos that demonstrate technique." Free catalog.
Recent Titles: *Nikon/Nikkormat Way* by Keppler; *The Life of a Photograph* by Lawrence Keefe and Dennis Inch; *Starting Your Own Photography Business* by Ted Schwarz.

GARDEN WAY PUBLISHING, Schoolhouse Rd., Pownal VT 05261. (802)823-5811. Contact: Martha Storey, Production Dept. Publishes adult trade books on gardening, country living, alternate energy, raising livestock, cooking, and nutrition. Has added line of business books. Nearly all "how-to" books showing specific skills and processes. Photos used for text illustration, promotional materials and book covers. Buys 50-75 photos/year, or makes 6-8 assignments/year. Provide resume, business card and tearsheets to be kept on file for possible future assignments. Notifies photographer if future assignments can be expected.
Subject Needs: Country living, gardening; "how-to" photos. "Generally we seek specific photos for specific book projects, which we solicit; or we assign a local freelancer. Do not want art photos or urban scenes." Model release and captions preferred.
Specs: Uses 5x7 and 8x10 glossy and semigloss b&w and color prints, 4x5 and 35mm color transparencies. For jacket/cover uses glossy or semigloss b&w prints (contact sheet OK), and 35mm or 4x5 color transparencies.
Payment & Terms: Pays by the job or $10-50/photo depending on assignment. For jacket/cover photos pays $10-100/photo. Credit line usually given. Buys book rights. Previously published work OK.
Making Contact: Query with samples or arrange a personal interview to show portfolio. Prefers to see in a portfolio a dozen or more photos, published work; general samples, especially book photos; and 'how-to' photos. SASE. Reports in 3 weeks.
Tips: "The best thing would be a broad familiarity with Garden Way books, which are largely 'how-to' books. Versatility and an interest in country living plus quality work would count most."

GLENCOE PUBLISHING CO., 17337 Ventura Blvd., Encino CA 91316. Photo Editor: Leslie Andalman. Publishes elementary and high school, religious education, home economics and vocational-technical textbooks. Photos used for text illustration and book covers. Buys 500 photos annually; gives occasional freelance assignments.
Subject Needs: People—children at play, school, Catholic church; interrelationships with parents, friends, teachers; and Catholic church rituals; people in different kinds of business, office automation, new technology. US only. Model release preferred.
Specs: Uses 8x10 glossy b&w prints and 35mm slides.
Payment & Terms: Pays $35-50/b&w photo, $50-100/color photo and $50-300/cover color photo. Credit line given. Buys one-time rights. Simultaneous submissions and previously published work OK.
Making Contact: Query with list of stock photo subjects and SASE; interested in stock photos. Reports as soon as possible—"sometimes there are delays. We will keep your subject list of material available in stock to be kept on file for possible future assignments."
Tips: "Send us a good subject list, be negotiable as to price (book budgets are sometimes low). Show us your best work and be patient. We look for very contemporary, upbeat, spontaneous unposed shots, and a good ethnic mix represented by the models."

DAVID R. GODINE, PUBLISHER, Horticultural Hall, 300 Massachusetts Ave., Boston MA 02115. (617)536-0761. President: David R. Godine. Publishes 2-3 photo titles/year. Authors paid by royalty. Query first; submit outline/synopsis and sample chapters; or submit sample photos. In portfolio, prefers to see "as representative of book project proposed as possible. We publish scholarly books and monographs almost exclusively; we never use freelance photographers." SASE. Simultaneous submissions OK. Free catalog.
Recent Titles: *Urban Romantic* by George Tice; *Second Sight* by Sally Mann; *Photographs* by Joyce Tenneson.

GOLDEN WEST BOOKS, Box 80250, San Marino CA 91108. (213)283-3446. Photography Director: Harlan Hiney. Publishes books on transportation, history, and sports. Photos used in books. Buys "very few" annually. Query first with a resume of credits. Buys first rights. Reports in 1 week. SASE. Previously published work OK.
B&W: Uses 8x10 glossy prints. Pays $8-10.

***GOSPEL LIGHT PUBLICATIONS**, 7300 Knoll Dr., Ventura CA 93003. (805)644-9721, ext. 156. Manager/Creative Services: Barbara LeVan. Publishes adult, childrens, youth paperback and hardback—Christian topics. Photos used for promotional materials, book covers, dust jackets. Buys 10-20 freelance photos annually, and gives 0-3 assignments annually.
Subject Needs: People shots, (world) location shots, some scenery, some special effects. Model release required.
Specs: Varies.
Payment & Terms: Pays $100-200/b&w photo; $350-500/color photo; $50/hour. Credit line given. Rights purchased varies. Simultaneous submissions OK.
Making Contact: Provide business card, brochure, flyer or tearsheets to be kept on file for possible future assignments. Interested in stock photos. SASE. Reports in 2 weeks.
Tips: Prefers to see b/w and color photos. Send tearsheets/samples. Follow up with phone call. Do *great* work, undercut B1G stock companies. "We're looking for more creativity—intense colors, innovative craftspeople."

GRAPHIC ARTS CENTER PUBLISHING COMPANY, Box 10306, Portland OR 97210. (503)226-2402. Editorial Director: Douglas A. Pfeiffer. Publishes adult trade photographic essay books. Photos used for photo essays. Gives 5 freelance assignments annually.
Subject Needs: Landscape, nature, people, historic architecture, other topics pertinent to the essay. Captions preferred.
Specs: Uses 35mm, 2¼x2¼ and 4x5 (35mm as Kodachrome 64 or 25) slides.
Payment & Terms: Pays by royalty—amount varies based on project; minimum, but advances against royalty are given. Credit line given. Buys book rights. Simultaneous submissions OK.
Making Contact: "Photographers must be previously published in book form, and have a minimum of five years full-time professional experience to be considered for assignment."
Tips: "Prepare an original idea as a book proposal. Full color essays are expensive to publish, so select topics with strong market potential. We see color essays as being popular compared to b&w in most cases."

H. P. BOOKS, Box 5367, Tucson AZ 85703. Publisher: Rick Bailey. Publishes 5 photo titles average/year. Publishes books on photography; how-to and camera manuals related to 35mm SLR photography; and lab work.
Specs: Uses 8½x11 format, 160 pages, liberal use of color; requires 200-400 illustrations. Pays royalty on entire book.
Making Contacts: Query first. SASE. Contracts entire book, not photos only. Accepts simultaneous or photocopied submissions. Reports in 4 weeks. Free catalog.
Recent Titles: *Pro Techniques of People Photography*, and *Pro Techniques of Glamour Photography*, both by Gary Bernstein; *Basic Guide to Close-Up Photography*; and *How to Use Electronic Flash*.
Tips: "Learn to write."

HAYDEN BOOK COMPANY, 10 Mulholland Dr., Hasbrouck Heights NJ 07604. Art Director: Jim Bernard. Publishes textbooks, how-to's, and tutorials—all dealing with computers. Photos used for text illustration, promotional materials, book covers, dust jackets and software. Buys 25-50 or more freelance photos annually.
Subject Needs: Computers in business, schools, home, computers in general, robotics, special effects, and computer generated art. Captions preferred.
Specs: Uses any size b&w and color prints, and 35mm, 2¼x2¼ and 4x5 transparencies.
Payment & Terms: Payment negotiated individually. Buys book rights. Simultaneous submissions OK.
Making Contact: Provide resume, business card, brochure, flyer or tearsheets to be kept on file for possible future assignments; interested in stock photos. SASE. Reports in 3-4 weeks "unless rush requested."

D.C. HEATH AND CO., (Div. Raytheon), 125 Spring St., Lexington MA 02173. (617)862-6650. Art Director, School Division: Bob Boxtford. Publishes language arts, reading, math, science, social studies, and foreign language textbooks for elementary and high school; separate division publishes college texts. Buys hundreds photos/year, mostly from stock, but some on assignment. "Furnish us with a list of available subject matter in stock." May also call to arrange an appointment or submit material by mail for consideration. Usually buys one-time North American rights. Pays on a per-job or a per-photo basis. "Varies by project from minimum up to ASMP rates—generally similar to other textbook publishers." Reports in 1 month. SASE. Previously published photos OK, "but we want to know if it was used in a directly competitive book."
B&W: Uses any size glossy, matte, or semigloss prints; contact sheet OK.

Color: Uses any size transparency.
Covers: Mostly done on assignment. Prefers 2¼x2¼ or 4x5 color transparencies.
Tips: "For initial contact the list of a photographer's available subject matter is actually more important than seeing pictures; when we need that subject we'll request a selection of photos. Textbook illustration requirements are usually quite specific. We know you can't describe every picture, but stock lists of general categories such as 'children' don't give us much clue as to what you have."

HEMISPHERE PUBLISHING CORPORATION, Suite 1110, 79 Madison Ave., New York NY 10016. (212)725-1999. Promotion/Production Manager: Suzan T. Mohamed. Publishes technical and medical trade and textbooks, i.e., engineering (all aspects) and social and life sciences. Photos used for promotional materials. Buys 100 freelance photos/year, and gives approximately 25 freelance assignments annually.
Subject Needs: Book photography (groups and/or singles).
Specs: Uses 5x7 to 8x10 silhouetted b&w prints.
Payment & Terms: Pays $25-35/5x7 print (single photo rate), $75/8x10 print (group rate), or as arranged. Buys exclusive product rights.
Making Contact: Arrange a personal interview by mail to show portfolio; provide resume, business card, brochure, flyer or tearsheets of work applicable to publishing needs to be kept on file for possible future assignments. Solicits photos by assignment only.
Tips: "We look for book shots; standard positions and/or creativity of layout, special effects—all in b&w. Many of the shots we use have become standardized (i.e., position) for clarification of need, such as catalog work."

HOLT, RINEHART AND WINSTON, 383-385 Madison Ave., New York NY 10017. (212)872-1931. Creative Director: David Libby. "Our department is the School department and publishes all textbooks for kindergarten to grade 12." Photos used for text illustration, promotional materials and book covers. Buys 5,000 photos annually.
Subject Needs: Photos to illustrate mathematics; the sciences—life, earth and physical; chemistry; and the humanities, as well as stories for reading and language arts. Model release and captions required.
Specs: Uses any size glossy b&w and color transparencies.
Payment & Terms: Rates of payment are "within reason—negotiable." Credit line given. Buys one-time and other rights. Simultaneous submissions OK.
Making Contact: "We reserve Thursdays at 11 a.m. for photographers to come in and show pictures." Otherwise, query with resume of credits, stock photo list or samples. Interested in stock photos. Does not return unsolicited material. Reports "as soon as project allows."
Tips: "We use all types of photos, from portraits to setups to scenics. We like to see slides displayed in sheets or by carousel projector. Send a letter and printed flyer with a sample of work and a list of subjects in stock and then call to set up an appointment to show pictures to our staff."

HORIZON PRESS PUBLISHERS LTD., 156 Fifth Ave., New York NY 10010. Managing Editor: Rose Hass. Publishes books on photography, architecture, literary criticism, music (adult trade) and fiction. Photos used for text illustration and book covers.
Subject Needs: "Depends on books we are publishing."
Payment & Terms: Negotiates payment. Credit line given.
Making Contact: Query with resume of credits or with list of stock photo subjects. Does not return unsolicited material. Reports in 3 months.

CARL HUNGNESS PUBLISHING, Box 24308, Speedway IN 46224. (317)638-1466. Publishes books and magazines on USA open cockpit auto racing. Photos used for text illustration, promotional materials, book covers and dust jackets. Buys 500 + photos annually and gives 5-10 freelance assignments annually.
Subject Needs: Interested in "auto racing cars and people photos; we do not buy single car pan photos of cars going by." Model release optional; captions required (photos are not considered without captions).
Specs: Uses 5x7 or 8x10 b&w; and 5x7 or 8x10 color prints.
Payment & Terms: Pays $3-25/b&w photo; $6-75/color photo. Gives credit line at least 95% of the time. Buys all rights, but may reassign rights to photographer after publication. Simultaneous submissions and previously published work OK.
Making Contact: Query with samples. Works with freelance photographers on assignment only. Provide business card and letter of inquiry to be kept on file for possible future assignments. SASE. Reports in 2 weeks.
Tips: "Our biggest gripe is photos submitted without ID's on back or photographer's name. Send your best; look at our publications to get better ideas."

***IGNATIUS PRESS**, 2515 McAllister, San Francisco CA 94118. Production Editor: Carolyn Lemon. Publishes children and adult books. Catholic theology and devotional books (popular and scholarly). Buys 100 + photos/year.
Subject Needs: Photos of the Pope, priests and religions, sacraments, stained glass. Religious subjects and symbols. Families, parents and children. Catholic churches.
Specs: Uses various size b&w and color, glossy-finish prints.
Payment & Terms: Credit lines given, usually in separate section. Buys all rights.
Making Contact: Provide resume, business card, brochure, flyer or tearsheets to be kept on file for possible future assignments; we will make contact if interested. Send a few samples. Does not return unsolicited material. We will contact photographer only if interested.

ILLUMINATI, Box 67E07, Los Angeles CA 90067. President: P. Schneidre. Publishes books of art and literature. Photos are used for text illustrations, book covers, dust jackets or subject matter.
Subject Needs: Art photos.
Specs: Uses b&w prints only.
Payment & Terms: Payment negotiated. Credit line given. Buys one-time rights.
Making Contact: Query with nonreturnable samples only. Reports in 2 weeks if SASE is provided. Provide samples to be kept on file for possible future use.
Tips: "We don't assign; we only use already existing but unpublished work."

***JAMESTOWN PUBLISHERS**, Box 9168, Providence RI 02940. Courier Delivery: 544 Douglas Ave., Providence RI 02908. (401)351-1915. Production Supervisor: Diane Noiseux. Publishes reading development textbooks; "we need photos to illustrate covers, text material; usually a wide range of photo to matter." Photos used for text illustrations, book covers. Buys 20-40 photographs annually, and gives 5 assignments annually.
Subject Needs: "We use a wide variety of photos: biographical subjects, illustrative photos for covers, historical photos, nature, science, etc."
Specs: Uses 8x10 glossy b&w prints and 35mm transparencies.
Payment & Terms: Pay negotiated. Credit line given. Buys one-time rights. Previously published work OK.
Making Contact: Query with list of stock photo subjects; provide resume, business card, brochure, flyer or tearsheets to be kept on file for possible future assignments. Interested in stock photos. Does not return unsolicited material. Reports in 1 month.

THE KRANTZ COMPANY PUBLISHERS, 2210 N. Burling, Chicago IL 60614. (312)975-9800. Publishes adult trade, how-to, and art. Photos used for text illustration, promotional materials, book covers, and dust jackets. Buys 300-500 photos annually; gives 1-2 freelance assignments annually.
Subject Needs: Needs all types of subjects. Model release required; captions preferred.
Specs: Uses b&w prints and 35mm, 2¼x2¼, 4x5 and 8x10 transparencies.
Payment & Terms: Credit line given. Buys one-time or book rights. Simultaneous submissions OK.
Making Contact: Provide resume, business card, brochure, flyer or tearsheets to be kept on file for possible future assignments. Deals with local freelancers on assignment only. "We are interested in stock photos. SASE. Reports in 1 month."

LEBHAR-FRIEDMAN, 425 Park Ave., New York NY 10022. (212)371-9400. Senior Art Director: Milton Berwin. Publishes trade books, magazines and advertising supplements for the entire retailing industry. Photos used for text illustration, book covers, and ad supplements. Pays $250/day and on a per-photo basis. Buys all rights. Model release required. Send material by mail for consideration. SASE. Reports in 2 weeks.
Subject Needs: In-store location and related subject matter.
B&W: Uses 8x10 prints. Pays $50-100/photo or less, according to size and use.
Color: Uses transparencies. Pays $150-300/photo.
Covers: Uses b&w prints and 2¼x2¼ color transparencies. Pays $50-300/photo.

LITTLE, BROWN & CO., 34 Beacon St., Boston MA 02106. (617)227-0730. Contact: Art Department. Publishes adult trade. Photos used for book covers and dust jackets. Buys 20 photos annually; gives 5 freelance assignments annually.
Subject Needs: Model release required.
Payment and Terms: Credit line given. Buys one-time rights.
Making Contact: Query or arrange a personal portfolio viewing; provide resume, business card, brochure, flyer or tearsheets to be kept on file for possible future assignments; interested in stock photos. SASE. Reporting time varies.

THE LITTLE HOUSE PRESS, INC., Editorial Office: Suite II, 5724 W. Diverscy Ave., Chicago IL 60639. (312)745-6404. Senior Editor: Gene Lovitz. Estab. 1984. Publishes adult trade nonfiction, selected fiction, Americana, politics, business, guide books, institutional and regional histories. Photos used for pictorial books.
Subject Needs: "We are only interested in collections of photographs that are in manuscript form, (i.e., pictorial biographies of notables; nudes; Americana pictorial histories; architecture; sports, animals, etc. *Not interested in porno nudes; only nudes in art form* (Adam & Eve; in nature; and even sexy cheesecake; *good taste*)."
Specs: Uses 8x10 b&w and color glossy prints and 2½x2¼ and 4x5 transparencies (prefer 4x5 transparencies but will work with decent 35mm or 2¼).
Payment & Terms: "We pay standard royalties of around 10%." $25-200/b&w photo; $50-500/color photo. Credit line given. Buys book rights; "depends upon the agreement with the author."
Making Contact: "Query with samples only if sent SASE—must include postage and mailer." Reports in approximately 6 weeks.
Tips: Submissions should consist of "*only photographs to be used in a pictorial book* (showing subject handling and text samples). We want to know if a book will be 50% photography, 60%, 90%, etc. Use a copyright stamp in light blue ink of the photographer's name and address on the backside of each photo print, or labeled on transparency sleeves; use rubber cement, recaption labels; orient text with photographs as closely as possible. Photography will more and more be used for dust jackets and paperback covers in preference to art work; to illustrate books; more pictorial books. *Some mysteries, and even novels, will use photographs of models for fictional characters to illustrate the book inside*. Hardcover books are published under the Little House Press imprint; paperbacks under the Elephant Walk imprint."

***THE LITURGICAL PRESS**, St. John's Abbey, Collegeville MN 56321. (612)363-2213. Promotions Manager: Ann Blattner. Publishes adult trade, religious books. Photos used for text illustration, book covers, Sunday bulletins/audiovisual. Buys 50 photos/year; gives 5 freelance assignments/year.
Subject Needs: Model release preferred.
Specs: Uses b&w prints; 35mm or 2¼x2¼ transparencies.
Payment & Terms: Pays $35/b&w photo; $50-100/color photo. Credit lines given. Buys one-time rights. Simultaneous submissions and previously published work OK.
Making Contact: Query with list of stock photo subjects; provide resume, business card, brochure, flyer or tearsheets to be kept on file for future assignments. Interested in stock photos. SASE. Reports in 1 month.

LIVRES COMMONER'S BOOKS, 432 Rideau St., Ottawa, Ontario, Canada K1N 5Z1. (613)233-4997. Manager: Glenn Cheriton. Publishes adult trade, poetry and fiction. Recent titles include: *Stepfamilies: Making Yours a Success* and *Ottawa in Postcards*. Photos used for text illustration and book covers. Buys 8-12 photos/year. Provide business card to be kept on file for possible future assignments. Credit line given. Buys one-time rights. Model release preferred. Send material by mail for consideration. SASE. Simultaneous submissions and previously published work OK. Reports in 1 month. Free photo guidelines and catalog with SASE.
B&W: Uses 8x10 glossy prints. Pays $10-100/photo.
Color: Uses 35mm transparencies. Pays $20-200/photo.
Jacket/Cover: Uses glossy b&w prints and color transparencies. Pays $10-200/photo.

LLEWELLYN PUBLICATIONS, Box 64383, St. Paul MN 55164. (612)291-1970. Editor: Terry Buske. Publishes consumer books (mostly trade paperback) with astrology and new age subjects, geared toward a young, high tech minded audience, and book catalogs. Buys 2-3 freelance photos annually.
Subject Needs: Science/fantasy, space photos, special effects. Accepts photos with or without accompanying ms.
Payment & Terms: Pays $300-500/color cover photo. Pays on publication. Credit line given. Buys one-time rights.
Making Contact: Query with samples; provide resume, business card, brochure, flyer or tearsheets to be kept on file for possible future assignments. SASE. Reports in 3 weeks.

MACMILLAN PUBLISHING INC., School Division, 866 Third Ave., New York NY 10022. (212)876-6680. Contact: Selma Pundyk. Publishes textbooks. Photos used for text illustration and book covers. Buys freelance photos annually, and gives freelance assignments annually.
Subject Needs: Varying according to projects in production. Captions and complete labeling is essential.
Specs: Open.
Payment & Terms: Pays $75-150/b&w photo, $150-300/color photo, and negotiates rates/job. Buys one-time rights; other terms may be possible.

Close-up

Jim West
Freelance Photographer
Detroit, Michigan

Detroit-based freelancer Jim West learned photography out of necessity—but now is "sold" on photography as a freelance career. Initially this editor (since 1979) of a grass roots labor union newsletter used his photos to pictorially support articles he was writing. "We had an 'idiot-proof' camera around the office that had one pre-set shutter speed. It was so slow that people were often a blur if they were walking. But I got some good pictures with it. Since I enjoyed photography (and purchased a new camera), I decided to see if I could make some money with it. . ."

The majority of his work, West explains, involves selling stock photos rather than doing assignment work. The key in marketing stock, he says, is to have good material to present to the

West shoots a lot of labor and social-issues photos. Above is the Vietnam Veterans Memorial in Washington, D.C.

editor. The next step, which is harder, is getting the editor to look at it when he needs it. This is accomplished, West says, by building up relationships with various editors, so that when they need material they're likely to call. A lot of time also is spent writing for photo guidelines, studying the publications and sending out stacks of photos, he adds. West did discover one other technique that boosted his sales—development of a stock photo list. "This is an enormous job. I put it off for a long time...but once I did it, it paid off almost immediately with $1,000 in sales to one publisher that I wouldn't have made otherwise."

West's advice to photographers breaking into the freelance market is to specialize. Pick topics that interest you, he suggests, and that you know something about. Become an expert in those areas and develop a comprehensive stock file of them. West suggests using *Photographer's Market* and other market guides to research the publications in each area, then start contacting editors. "Whether your thing is preventing nuclear wars or studying flower arrangement, your aim should be to become the photographer whom publications' editors call on for photos of these subjects. Specializing also allows you to work on topics you like—and what's better than having a job you enjoy?"

What about the inevitable rejection? Don't start at the top, where the newcomer is virtually guaranteed rejection, West advises. The beginner should spend most of his time working on markets where there is a good chance of success. This will earn a little money and some tearsheets. When some measure of success is attained, he says, then go for the higher paying markets. It's necessary to spend a majority of one's time marketing, at least at the beginning. "There are very few photographers who have buyers lining up outside their door each morning."

West, whose work credits range from the United Auto Workers and American Federation of Teachers to Glencoe Publishing House, Simon & Schuster and Harcourt, Brace Jovanovich, says regular contributors to publishing houses usually receive subject lists that either offer very specific photo needs or at least general themes to aid the photographer. And unlike the trend in the magazine industry, book publishers don't require model releases unless photo usage centers on controversial topics such as alcoholism or child abuse. What kinds of rights do book publishers buy? "Usually one-time rights, which cover use of a photo through that edition." If revised or foreign language editions are printed, the photographer is paid again, he explains. "If rights other than one-time rights are purchased, your rates should be adjusted accordingly. And though specific rates vary from publisher to publisher, they generally are better than magazine rates," he says.

West advises photographers to become an expert photographer in those areas that interest them. This photo was taken in Malcolm X Park, also in Washington, D.C.

Making Contact: Arrange a personal interview to show portfolio; query with samples; send unsolicited photos by mail for consideration; or submit portfolio for review; provide resume, business card, brochure, flyer or tearsheets to be kept on file for possible future assignments. Reporting time varies.

MCDOUGALL, LITTELL, Box 1667, Evanston IL 60204. (312)869-2300. Picture Researchers: Katherine Nolan and Sally Merar. Textbooks. Photos used for text illustration and book covers.
Subject Needs: Needs photos of "children, elementary-high; news events, fine art photos." Model release preferred.
Specs: Uses 4x5 transparencies.
Payment & Terms: Pays $65-125/b&w photo; $125-200/color photo; follows ASMP rates. Credit line given. Buys one-time rights. Simultaneous submissions OK.
Making Contact: Query with samples and list of stock photo subjects. Interested in stock photos. SASE. Reports in 1 month.

MEADOWBROOK INC., 18318 Minnetonka Blvd., Deephaven MN 55391. (612)473-5400. Art Director: Nancy MacLean. Publishes books on "infant and child care, pre-natal, post-natal care, infant health care—tips and how-to's; juvenile mysteries series—ages 6-13; travel tips; emergency first aid—how-to's; board books on baby animals and their mothers. Photos used for text illustration, promotional materials, book covers and 'illustration reference.' All photography purchased out-of-house."
Subject Needs: "Nature scenes—recreational camping; points of interest—international and national scenes; baby/infant—developmental; parenting scenes; baby animals and their mothers." Model release required.
Specs: Uses 8x10 glossy b&w and color prints; 35mm, 2¼x2¼, 4x5 and 8x10 transparencies.
Payment & Terms: Pays $45-100/hour. Credit line given on credit/copyright page. Buys one-time rights, book rights, all rights; "depends upon use of photograph." Simultaneous submissions and previously published work OK.
Making Contact: Query with samples or with list of stock photo subjects; send unsolicited photos by mail for consideration; submit portfolio for review; provide resume, business card, brochure, flyer or tearsheets to be kept on file for possible future assignments. Solicits photos by assignment only; interested in stock photos. SASE. Reports in 3 weeks.
Tips: Prefers to see "excellent composition and highest quality reproduction" in a photographer's portfolio or samples. "Send materials that can be kept in our files. Many projects arise from an urgent request that does not allow time for a specific talent search."

MERRILL PUBLISHING COMPANY, 1300 Alum Creek Dr., Box 508, Columbus OH 43216. (614)890-1111. Photo Editor: Terry Tietz. Publishes college textbooks with emphasis in education, special ed., computer science, business, marketing, psychology, management and personnel, geography, geology, physics. Photos used for text illustration, promotional materials and book covers. Buys 1,000 text photos, 100 cover photos and assigns 5-10 freelance assignments annually.
Subject Needs: Professionally lit cover quality color and b&w photos of lively and unique general education activities; special ed. students being mainstreamed; use of computers in education, business and home. Model release required.
Specs: 8x10 glossy b&w prints with minimum ¼" border 35mm or larger transpariencies.
Payment & Terms: Competitive textbook prices paid on publicaton. Credit line given. Buys one-time limited exclusive rights. Previously published work not in college textbooks acceptable.
Making Contact: Inquire by calling at 1-800-848-1567 or sending a list of stock photo subjects, business card, brochure, flyer or tearsheets. "Do not send unsolicited photos." Interested in stock photos only after inquiry and authorization to submit material with SASE and phone number. Averages 1-3 months return time for rejected or considered work; 3-6 months return time for published work.
Tips: Prefers to receive duplicate slides or extra prints and contact sheets to hold until needed. "The more of your work we have in our files, the more likely we will select you for publication."

MILADY PUBLISHING CORPORATION, 3839 White Plains Rd., Bronx NY 10467. (212)881-3000. Creative Director-Cosmetology: Mary Healy. Publishes textbooks for vocational education in areas of cosmetology, business education, personal development, fashion. Photos used for text illustration and trade magazine illustration.
Subject Needs: Hair styling, business education, manicuring, aesthetics, and modeling. Model release and captions preferred.
Specs: B&w glossy prints.
Payment & Terms: Payment negotiated individually. Credit line given. Rights purchased varies per usage. Simultaneous submissions and previously published work OK.
Making Contact: Provide resume, business card, brochure, flyer or tearsheets to be kept on file for possible future assignments. Solicits photos by assignment only. SASE. Reports in 2 weeks.

MODERN CURRICULUM PRESS, 13900 Prospect Rd., Cleveland OH 44136. Assistant Production Manager: Vicki Lewis. Publishes educational workbooks and textbooks for K-6th grade. Photos used for text illustration and book covers. Buys approximately 300 photos annually.
Subject Needs: All subject matters of interest to children. Model release required.
Specs: Uses 3x5 transparencies, 8x10 b&w photos and slides.
Payment & Terms: Payment depends on usuage. Credit line given. Buys one-time rights. Simultaneous submissions and previously published work OK.
Making Contact: Provide resume, business card, brochure, flyer or tearsheets to be kept on file for possible future assignments. Solicits photos by assignment only; interested in stock photos.
Tips: "It is best to send a resume listing desired fees for various types of photographs, b&w and color, for slides and transparencies along with a general listing of types of photos available from stock."

***MODERN HANDCRAFT, INC.**, 4251 Pennsylvania Ave., Kansas City MO 64111. (816)531-5730. Editors: The Workbasket—Roma Rice, Workbench—Jay Hedden, Flower and Garden—Rachel Snyder. Subjects for the following include: Flower and Garden—general gardening and related topics; Workbasket—knitting, crochet, sewing; Workbench—woodworking and home improvement. Buys "several hundred" freelance photos annually.
Subject Needs: Model release required.
Specs: Uses b&w and color prints; 35mm, 2¼x2¼, 4x5 transparencies.
Payment & Terms: Pay negotiated. Credit line given. Buys "one time and at least incidental additional uses—generally wants all rights."
Making Contact: Query with list of stock photo subjects, send unsolicited photos by mail for consideration. Interested in stock photos. SASE. Reports in 2 weeks.

MORGAN & MORGAN, INC., 145 Palisade St., Dobbs Ferry NY 10522. (914)693-0023. President: Douglas O. Morgan. Publishes 10 photo titles average/year. Authors paid by royalty or by outright purchase. Submit outline/synopsis and sample chapters or submit sample photos. SASE. Reports in 2 months. Free catalog. Recently published William Crawford, *The Keepers of Light* and *The Morgan & Morgan Darkroom Book*, both technical books; *Martha Graham: Sixteen Dances in Photographs* by Barbara Morgan and *Rising Goddess* by Cynthia MacAdams, both fine art photography books. Standard reference books include: *Photo-Lab-Index* which is kept current with supplements four times per year; *Compact Photo-Lab-Index*.

***MOTOR BOOKS INTERNATIONAL**, 729 Prospect Ave., Osceola WI 54020. (715)294-3345. Publisher: Tim Parker. Publishes trade and specialist and how-to, automotive, aerospace, hobby. Photos used for text illustration, book covers, dust jackets. Buys 30 freelance photos annually, and gives 6 assignments annually.
Subject Needs: Model release and captions preferred.
Specs: Any size prints or transparencies.
Payment & Terms: Pay negotiated. Credit line given. Rights negotiable. Simultaneous submissions and previously published work OK.
Making Contact: Solicits photos by assignment only, interested in stock photos. SASE. Reports in 2 weeks.

MUSIC SALES CORP., 24 E. 22 St., New York NY 10010. (212)254-2100. Contact: Daniel Earley. Publishes instructional music books, song collections, and books on music. Recent titles include: *The Complete Keyboard Player*. Photos used for text illustration and book jackets. Buys 200 photos annually. Query first with resume of credits; provide business card, brochure, flyer or tearsheet to be kept on file for possible future assignments. Buys one-time rights. Present model release on acceptance of photo. Reports in 2 months. SASE. Simultaneous submissions and previously published work OK.
B&W: Uses 8x10 glossy prints. Captions required. Pays $25-50.
Color: Uses 35mm, 2x2 or 5x7 transparencies. Captions required. Pays $25-75.
Jacket: Uses 8x10 glossy b&w prints or 35mm, 2x2, 5x7 color transparencies. Captions required. Pays $50-150.
Tips: "We keep photos on permanent file for possible future use. We need rock, jazz, classical—on stage and impromptu shots. Please send us an inventory list of available stock photos of musicians. We rarely send photographers on assignment and buy mostly from material on hand."

THE NAIAD PRESS, INC., Box 10543, Tallahassee FL 32302. (904)539-9322. Editor: Barbara Grier. "We are the oldest and largest of the lesbian and lesbian/feminist publishing houses. We publish trade and mass-market size paperback books, fiction, poetry, autobiography, biography, mysteries, adventure, self-help, sexuality, history, etc." Photos used for text illustration and book covers. Buys 6-20 photos annually.

Subject Needs: Inquire. Model release required.
Specs: Uses 5x7 glossy b&w prints.
Payment & Terms: Credit line given. Buys all rights. Previously published work OK.
Making Contact: "Drop a note outlining work area." SASE. Reports in 3 weeks.
Tips: "We are interested in submissions from lesbian photographers particularly, and lesbian feminist photographers even more so. Very interested in having a location file of photographers for assigning author pictures (i.e., where the photographer is asked to photograph a local author for publicity purposes)."

NATIONAL GEOGRAPHIC SOCIETY, 17th and M Streets NW, Washington DC 20036. Book Service, Illustrations Editor: Linda B. Meyerriecks. Publishes 2 large format adult books/year. Special Publications, Director: Donald J Crump. Publishes 4 adult and 8 children's book/year, and *World* magazine. Photos used for text illustration, promotional materials, book covers and dust jackets. Photos purchased and freelance assignments given annually vary.
Subject Needs: "High quality—all subjects except advertising." Captions required.
Specs: Uses 35mm, 2¼x2¼, 4x5 and 8x10 transparencies.
Payment & Terms: Pays $75-200/b&w page; $100-200/color page and payment per job varies. Credit line given. Buys one-time rights.
Making Contact: Arrange a personal interview to show portfolio; query with samples or with list of stock photo subjects; provide resume, business card, brochure, flyer or tearsheets to be kept on file for possible future assignments. Interested in stock photos. SASE. Reports in 3 weeks.
Tips: "Prefers to see a portfolio for review—40-60 transparencies; half showing ability to handle different situations, the rest giving in-depth approach to one subject. Keep working at story ideas and stock file."

NATURE TRAILS PRESS, 933 Calle Loro, Palm Springs CA 92262. (619)323-9420. Vice President: Jim Cornett. Publishes nature and outdoor books. Photos used for text illustration and book covers.
Subject Needs: Wildlife, nature scenes, outdoor recreation.
Specs: Uses 5x7 and 8x10 b&w glossy prints; 35mm and 2¼x2¼ transparencies.
Payment & Terms: Pays $7.50-50/b&w photo; $10-75/color photo. Credit line given. Buys one-time rights. Simultaneous submissions and previously published work OK.
Making Contact: Query with list of stock photo subjects. SASE. Reports in 1 month.

NELSON-HALL PUBLISHERS, 111 N. Canal St., Chicago IL 60606. Editor: Steven Ferrara. Publishes educational books for libraries and colleges. Heavy emphasis in social sciences. Photos used for text illustration, promotional materials, book covers and dust jackets. Model release required; captions preferred.
Payment & Terms: Pays $25 minimum/b&w photo; $50 minimum/color photo. Gives credit line. Buys all rights. Previously published work OK.
Making Contact: Query with resume of credits and list of stock photo subjects. Provide resume, flyer and business card to be kept on file for possible future assignments. Does not return unsolicited material.

NEWBURY HOUSE PUBLISHERS INC., 54 Warehouse Lane, Rowley MA 01969. (617)492-0670. Editorial Director: Janice Miller. Publishes reference and textbooks in language learning, language teaching, language science and English as a second or foreign language. Photos used for text illustration. Commissions 3 photographers/year. Provide resume, flyer, tearsheet and brochure to be kept on file for possible future assignments. Credit line given. Buys all rights. Model release preferred. Query with list of stock photo subjects. Does not return unsolicited material.
Subject Needs: Cultural and classroom photos of the US and foreign countries plus special photos for particular texts.
B&W: Uses 5x7 and 8x10 glossy and semigloss prints. Pays $5-20/photo.
Color: Uses 5x7 and 8x10 glossy and semigloss prints. Pays $10-35/photo.
Tips: "Send us one sheet giving name, address, phone, availability, and generalizations about or range of pricing photos."

NITECH RESEARCH CORPORATION, Box 638, Warrington PA 18976. President: Dr. William White, Jr. Publishes adult books on the Bible and ancient world and scientific and laboratory photography. Photos used for text illustration, book covers and dust jackets. Buys 500-1,200 photos annually.
Subject Needs: "Expert 35mm transparencies of ancient sites in Greece, Turkey, Lebanon, Israel, Egypt, Jordan, Syria, particularly ancient inscriptions, texts, papyri, scrolls, etc, also high grade laboratory and engineering. Photomicrography and photomacrography. We want precise focus, detailed formats, true colors, more scientifically acceptable qualities, less soft focus, and no false colors." Captions required.
Specs: Uses 35mm, 2¼x2¼ and 4x5 slides.

Payment & Terms: Pays $35-100/b&w photo; $35-250/color photo. Credit line given. Buys one-time and all rights, book rights or all rights, but may reassign to the photographer after publication. Simultaneous submissions and previously published work OK.
Making Contact: Query with list of stock photo subjects or send unsolicited photos by mail for consideration. SASE. Reports in 1 month.
Tips: "We continually seek new material using more advanced photographic techniques and material. Our two biggest problems are with poor composition and inappropriate captions. In our geographical shots we need detailed captions. We still can use shots with good architectural technique and lab experience. See our publication: KODAK WORKSHOP SERIES CLOSE-UP PHOTOGRAPHY, or our monthly column in SHUTTERBUG ADS."

NORTHWOODS PRESS, Box 88, Thomaston ME 04861. (207)354-6550. Owner: Robert Olmstad. Publishes "all types of books except porn and evangelical." Photos used for promotional materials, book covers, and dust jackets. Buys 8-10 photos annually.
Subject Needs: Model release required if identifiable.
Specs: Uses 3x5 to 8x10 glossy b&w prints.
Payment & Terms: Pays $5-25/b&w photo; by the job negotiable. Credit line given. Buys one-time or book rights. Previously published work OK.
Making Contact: Query with list of stock photo subjects. Send unsolicited photos by mail for consideration. SASE. Reports in 1 week.

ORTHO BOOKS, 575 Market St., San Francisco CA 94105. (415)894-3215. Contact: Photographic Department. Publishes how-to, cooking, and horticulture/gardening books.
Subject Needs: "Well lit subjects displaying great depth of field on Kodachrome transparencies that are technically perfect." Model release and exact captions required. Genus, species, variety captions required for horticultural subjects.
Specs: Uses 35mm, 2^1/4x2^1/4, 4x5 and 8x10 transparencies—Kodachrome *only*.
Payment & Terms: Rates negotiable by ASE. Credit line given at the front of the book rather than on each photo. Buys book rights or all rights. Previously published work OK.
Making Contact: Arrange a personal interview to show portfolio; provide resume, business card, brochure, flyer or tearsheets to be kept on file for possible future assignments; interested in stock photos. SASE. Reports in 6 months—send only dupes.
Tips: "We look for technical excellence, strong use of light and composition and organization."

***OXFORD UNIVERSITY PRESS**, 200 Madison Ave., New York NY 10016. (212)679-7300, ext. 305. Photo Researcher: Karen Lundeen. Publishes adult trade and academic textbooks. Photos used for text illustration, promotional materials, book covers, dust jackets.
Subject Needs: Portraits, historical photo, art and architecture, miscellaneous.
Specs: Uses 8x10 glossy b&w prints; 4x5 transparencies.
Payment & Terms: Pays $350/b&w photo; $400/color photo. Credit line given. Buys one-time rights. Previously published work OK.
Making Contact: Query with list of stock photo subjects; provide resume, business card, brochure, flyer or tearsheets to be kept on file for possible future assignments. Solicits photos by assignment only; interested in stock photos. Does not return unsolicited material.

PANTHEON BOOKS, 201 E. 50th St., New York NY 10022. Publishes books both on and of photography; 3 photo titles average/year.
Subject Needs: "Text often as important as photographs. Subject matter should be socially relevant." Publishes books only by photographers who have exhibited widely.
Payment & Terms: Authors paid by royalty of 6-10% on retail price. Offers advances; average advance is $1,500-5,000.
Making Contact: Query first. SASE. Simultaneous and photocopied submissions OK. Reports in 1-6 months. Free catalog with SASE; 7x10 envelope, 50¢ postage. Publishes books both on and of photography.
Recent Titles: *Annie Leibovitz Photographs*, *All Under Heaven*, *London in the Thirties*; *Cindy Sherman*; Parthen Photo Library (classics).

PEANUT BUTTER PUBLISHING, Suite 401, 911 Western Ave., Seattle WA 98104. (206)628-6200. Publisher: Elliott Wolf. Publishes cookbooks (primarily gourmet); restaurant guides; assorted adult trade books. Photos used for promotional materials and book covers. Buys 24-36 photos/year; gives 0-5 freelance assignments/year.
Subject Needs: "We are primarily interested in shots displaying a variety of foods in an appealing table or buffet setting. Good depth of field and harmonious color are important. We are also interested in cityscapes that capture one or another of a city's more pleasant aspects. No models."

Specs: Uses 2¼x2¼ or 4x5 slides.
Payment & Terms: Pays $50-150/color photo. Credit line given. Buys one-time rights. Simultaneous submissions and previously published work OK.
Making Contact: Arrange a personal interview to show portfolio; query with samples or send unsolicited photos by mail for consideration. Interested in stock photos. SASE. Reports in 2 weeks.
Tips: "We need to see photos—samples or stocks—that meet our needs."

PELICAN PUBLISHING CO., INC., 1101 Monroe St., Gretna LA 70053. (504)368-1175. Production Director: Sam Bububin. Publishes general trade books. Photos used for book jackets. Query first with resume of credits. Buys all rights. Present model release on acceptance of photo. Pays $30-125/job. Reports in 6 weeks. Previously published photos OK. Photos purchased with accompanying ms.
Jacket: Uses glossy b&w prints or color "as specified." Captions required.

POCKET BOOKS, 1230 Avenue of the Americas, New York NY 10020. (212)246-2121. Art Director: Bruce Hall. Publishes mass market and trade paperbacks. Photos used for book covers.
Payment & Terms: Pays $500-1,500/b&w photo; $1,000-2,500/color photo. Buys one-time rights. Model release required.
Making Contact: Submit portfolio for review; provide tearsheets to be kept on file for possible future assignments; also interested in stock photos. SASE. Previously published work OK. Reports in 3 weeks.

***PRINCETON BOOK CO. PRESS**, Box 109, Princeton NJ 08590. (609)737-8177. President: Charles Woodford. Publishes professional and college texts. Photos used for text illustration, book covers. Buys 20 freelance photos annually.
Subject Needs: Dance. Model release required; captions preferred.
Specs: Uses b&w prints. Credit line given. Buys book rights.
Making Contact: Query with list of stock photo subjects. Interested in stock photos. Does not return unsolicited material.

RANDOM HOUSE, College Division, 201 East 50th St., New York NY 10022. Manager, Photo Research: Katherine T. Bendo.
Needs: Uses photographers for college textbooks. Subjects include editorial, reportage, news, special effects, natural history, science, micrography—all college subjects.
Specs: Uses 8x10 repro quality b&w prints; color transparencies or repro-quality dupes.
First Contact & Terms: Provide resume, business card, self-promotion piece or tearsheets to be kept on file for possible future assignment. Do not send unsolicited photos. Interested in stock photos. Pay varies. Pays on acceptance after sizes are determined. Buys one-time rights. Captions and model releases preferred. Credit line given.

REGENTS PUBLISHING COMPANY, INC., 2 Park Ave., New York NY 10016. (212)889-2780. Photo Editor: Robert Sietsema. Publishes language texts, primarily English as a second language. Photos used for text illustration and book covers. Buys over 200 photos annually; gives 20 freelance assignments annually.
Subject Needs: Model release usually not required.
Payment & Terms: Pays $50-100/b&w photo; $75-250/color photo. Credit line given. Buys one-time rights. Simultaneous submissions and previously published work OK.
Making Contact: Arrange personal interview to show portfolio, Wednesday afternoons only; interested in stock photos, anything related to communications with people (different races). Photos taken in Spanish-speaking countries often needed. Does not return unsolicited material. Reports in "one month if specific project is in production." Submissions of photocopies of photos encouraged.

RESOURCE PUBLICATIONS, INC., Suite 290, 160 E. Virginia St., San Jose CA 95112. Publisher: William Burns. Publishes religious books. Photos used for text illustration and promotional materials. Buys 6 photos/year. Pays $15-35/hour. Credit line given. Buys all rights, but may reassign rights to photographer after publication. Model release required. Send material by mail for consideration. SASE. Reports in 6 weeks.
Subject Needs: Photos of music groups at worship; unique church architecture or interior design; and dramatic readings, processions, or any part of a ritual ceremony. Also photos of families celebrating the seasons or celebrating religious feasts together. No nature photos, still life, nudes. "All photos must be of interest to families or professional leaders of worship."
B&W: Uses 8x10 prints. Pays $5-25/photo.
Color: Uses 8x10 prints. Pays $5-25/photo.
Jacket/Cover: Uses b&w prints and color transparencies. Pays $5-25/photo.

RODALE PRESS INC., 33 E. Minor St., Emmaus PA 18049. (215)967-5171. Director of Photography: Thomas L. Gettings. Publishes gardening, bicycling, build-it, shelter, health, cookbooks and farming books and magazines. Photos used for text illustration, promotional materials, book covers, dust jackets and advertising. Gives 50 freelance assignments annually.
Subject Needs: Needs gardening, bicycling, build-it, shelter, health, cookbook and farming photos. Model release required; captions preferred.
Specs: Uses b&w negatives.
Payment & Terms: Payment "varies from $25 in smallest publication to $600 for a color book cover." Buys all rights and multi-use rights. Simultaneous submissions OK.
Making Contact: Arrange a personal interview to show portfolio; submit portfolio for review. Solicits photos by assignment. Interested in stock photos. SASE. Reports in 1 month.
Tips: "Know what Rodale publishes. Read and study any material published by a potential client before arriving for an interview. I am seeing 'more color' in photography for books."

WILLIAM H. SADLIER, INC., 11 Park Place, New York NY 10007. (212)227-2120. Director of Photo Research, Sadlier/Oxford Editorial: Mary Ellen Donnelly. Publishes religious education materials for all ages; academic textbooks, kindergarten-adult. Photos used for text illustration, promotional materials, book covers, filmstrips and posters. Buys 500 photos annually; gives freelance assignments annually.
Subject Needs: Jr. & Sr. high school students interactng with families, friends, members of the opposite sex (all ethnic groups); nature; worship; and technical. Model release required.
Specs: Uses glossy 8x10 b&w prints; 35mm and 2¼x2¼ transparencies.
Payment & Terms: Pays $25-100/b&w photo; $50-350/color photo. "Assignments are negotiated individually." Credit line given. Buys one-time rights, book rights or all rights. Simultaneous submissions OK.
Making Contact: Query with list of stock photo subjects; provide resume, business card, brochure, flyer or tearsheets to be kept on file for possible future assignments; interested in stock photos. SASE. Reports in 1 month.
Tips: Looks for "only superior quality photos with good interaction. No product labels or logos visible. Interior and exterior shots from various economic levels and representation of all parts of the US."

***HAROLD SHAW PUBLISHERS**, Box 567, Wheaton IL 60189. (312)665-6700. General Manager: Stephen Board. Publishes literary, religious. Photos used for book covers, dust jackets. Buys 5-10 freelance photos annually, and gives 3 assignments annually.
Subject Needs: Nature, special effects.
Specs: Uses b&w and color prints; 35mm, 2¼x2¼ transparencies.
Payment & Terms: Pays $50-100/b&w photo; $50-150/color photo; $50-150/job. Credit line given. Buys one-time rights. Simultaneous submissions and previously published work OK.
Making Contact: Query with list of stock photo subjects; provide resume, business card, brochure, flyer or tearsheets to be kept on file for possible future assignments. SASE. Reports in 3 weeks.

***SINAUEU ASSOCIATES, INC.**, North Main St., Sunderland MA 01375. (413)665-3722. Production Manager/Art Director: Joseph J. Vesely. Publishes biology and psychology textbooks. Photos used for text illustration, and book covers. Buys 100 freelance photos annually.
Subject Needs: Nature scenes, biological studies (natural, laboratory, EM's). Model release required; captions preferred.
Specs: Uses 5x7, 8x10 glossy (preferred) b&w and color prints, 35mm, 2¼x2¼, 4x5, 8x10 (any size) transparencies.
Payment & Terms: Pays $50-100/b&w photo; $50-200/color photo. Credit line given if requested. Buys book rights. Previously published work OK.
Making Contact: Provide resume, business card, brochure, flyer or tearsheets to be kept on file for possible future assignments. Solicits photos by assignment; interested in stock photos. SASE. Reports in 1 week.

SIMON & SCHUSTER, 1230 6th Ave., New York NY 10020. (212)245-6400. Art Director: Lisa Hollander. Publishes adult how-to and juvenile non-fiction. Photos used for book covers and dust jackets. Buys 30 photos/year; gives varied number of freelance assignments/year.
Subject Needs: Uses all subjects. Model release required.
Specs: Varies with job.
Payment & Terms: Pays $500 maximum/b&w photo; $700 maximum/color photo. Credit line given on back covers. Buys one-time rights. Simultaneous submissions and previously published work OK.
Making Contact: Query with samples or with list of stock photo subjects; provide resume, business card, brochure, flyer or tearsheets to be kept on file for possible future assignments. Solicits photos by assignment only; interested in stock photos. Does not return unsolicited material. Reporting time varies.

GIBBS M. SMITH, INC./PEREGRINE SMITH BOOKS, (formerly Peregrine Smith Books), 1877 E. Gentile St., Box 667, Layton UT 84041. (801)554-9800. Editor: Buckley C. Jeppson. Publishes 4 photo titles average/year.
Subject Needs: Prefers architecture, pop culture and nature shots. Needs architectural photography to complement written studies and serious thematic photo essays or studies of 30-100 b&w photos.
Payment & Terms: Authors paid by royalty of 10-15%. Pays negotiable rates.
Making Contact: Query first; submit outline/synopsis and sample chapters; or submit sample photos and resume. SASE. Simultaneous and photocopied submissions OK. Reports in 3 months maximum. Catalog 60¢.
Recent Titles: *Edward Weston on Photography* edited by Peter C. Bunnell; *Edward Western Omnibus*, edited by Beaumont Newhall; *In Plain Sight: The Photographs of Beaumont Newhall, The Visionary Pinhole* by Lauren Smith.
Tips: "Gibbs M. Smith, Inc./Peregrine Smith Books is now actively seeking books of photographs as well as books about photography. Collections of photographers and evocative photo essays are also very welcome. We are seeking someone who can send a vision—something new, striking, innovative, radical. We want "grass roots" rather than fussy "high fashion.""

SOUTH-WESTERN PUBLISHING COMPANY, 5101 Madison Rd., Cincinnati OH 45227. Assistant Director of Photographic Services: Paula Hickey. Clients: South-Western publishes texts for the high school and college market, as well as some vocational materials.
Needs: Works with 15-20 stock photographers/month. Uses photographers for textbook publishing. Subjects include occupational shots, human relations, work environment, high-tech, particularly in the field of computer technology.
Specs: Uses 8x10 b&w prints and 35mm, 2¼x2¼, 4x5 and 8x10 color transparencies.
First Contact & Terms: Provide business card, self-promotion piece or tearsheets to be kept on file for possible future assignments. Interested in stock photos. No response unless or until images are needed. Pay negotiated by use. Buys one-time rights usually. Model release preferred. Credit line given.

STANDARD EDUCATIONAL CORP., 200 W. Monroe St., Chicago IL 60606. (312)346-7440. Picture Editor: Irene L. Ferguson. Publishes the New Standard Encyclopedia. Photos used for text illustration. Buys about 200 photos/year. Credit line given. Buys one-time rights. Model release preferred; captions required. Query with list of stock photo subjects. SASE. Do not send unsolicited photos. Simultaneous submissions and previously published work OK. Reports in 1 month. To see style/themes used look at encyclopedias in library.
Subject Needs: Major cities and countries, points of interest, agricultural and industrial scenes, plants and animals. Photos are used to illustrate specific articles in encyclopedia—the subject range is from A-Z.
B&W: Uses 8x10 glossy prints; contact sheet OK. Pays $75-100/photo.
Color: Uses transparencies. Pays $100-200/photo.

***STANDARD PUBLISHING**, 8121 Hamilton Ave., Cincinnati OH 45231. (513)931-4050. Editor: Mildred Mast. Publishes adult trade books, journals, religious curriculum for all ages, children's books. Photos used for text illustration, book covers. Buys 300 freelance photos annually.
Subject Needs: Pictures of human interest—people of all ages, individuals and small groups involved in activities and family situations. People should have a natural appearance, not an artificial, posed, "too perfect" look. Pictures with a definite Christian connotation, such as a church, cross, a still life composed of a Bible, communion cup and bread, grapes, wheat, candle, lamp, etc., and other inspirational scenes and symbols. Pictures of landscapes, seascapes, and natural forms or elements. Model release required.
Specs: Uses 8x10 glossy b&w prints, color transparencies.
Payment & Terms: Pays variable rates/color cover photo, $15-25/b&w photo. Credit line usually given. Buys one-time rights or book rights. Simultaneous submissions and previously published work OK "if known where."
Making Contact: Query with samples and with list of stock photo subjects. Interested in stock photos. SASE. Reports in 1 month.

***STAR PUBLISHING COMPANY**, 940 Emmett, Belmont CA 94002. (415)591-3505. Managing Editor: Stuart Hoffman. Publishes textbooks, regional history, professional reference books. Photos used for text illustration, promotional materials, book covers. Buys 50-60 freelance photos annually, and gives 1 assignment annually.
Subject Needs: Biological illustrations, micro-photography. Model release and captions required.
Specs: Uses 5x7 minimum b&w and color prints, 35mm transparencies.
Payment & Terms: Pays $50/b&w photo; $100/color photo; covers by arrangements. Credit line giv-

Standard Publishing purchased this photo from Port Huron, Michigan, photographer Dennis MacDonald as a cover photo for "Look Out." They paid $150 for one-time use. "Three were purchased immediately; two black and white photos for $25 each and the one color (cover) photo for $150. Simple moods and themes are always the best and easiest to sell. This one was a setup designed to have universal appeal—relationship between mother and child."

en. Buys book rights or all rights. Previously published submissions OK.

Making Contact: Query with samples and list of stock photo subjects; provide resume, business card, brochure, flyer or tearsheets to be kept on file for possible future assignments. Interested in stock photos. SASE. Reports in 1 month.

Tips: Smaller publishers are often overlooked by photographers and are most likely to require freelance services!

STECK-VAUGHN COMPANY, Box 2028, Austin TX 78768. (512)343-8227, ext. 358. Photo Editor: Kurt E. Johnson. Publishes elementary, secondary, special education, and adult education textbooks and workbooks in all academic subject areas. Photos used for text illustration. Buys 1000 + photos/year; gives 6-10 freelance assignments/year.

Subject Needs: Children and adults in every facet of living; geographic, social, and political coverage of specific states. Also a need for photos showing handicapped individuals leading productive lives—show in various occupations. Model release required and captions preferred.

Specs: Uses 8x10 b&w and color glossies and 35mm, 2¼x2¼ and 4x5 transparencies.

Payment & Terms: Pays $25-50/b&w photo; $45-150/color photo and payment by job negotiable. Credit line given. Buys one-time rights. Simultaneous submission and previously published work OK.

Making Contact: Query with list of stock photo subjects. SASE. Reports in 1 month.

STEIN & DAY/PUBLISHERS, Scarborough House, Briarcliff Manor NY 10510. (914)762-2151. Art Director: Candice Lichty. Publishes adult trade fiction and nonfiction—war-related, hard and trade paperback and mass market paperbacks. Photos used for book covers and dust jackets. Buys 10-12 freelance photos annually and gives 1 freelance assignment annually.,

Subject Needs: Photos for types of books listed above. Model release required.

Specs: Uses 8x10 b&w glossies; 4x5 and 3x3 color transparencies. Prefers prints.

Payment & Terms: Pays $250-500 (if rare, old or celebrity)/b&w photo; $500-800/color photo. Credit line given. Buys one-time rights or all rights. Simultaneous submissions or previously published work OK.

Making Contact: Query with samples and list of stock photo subjects. Prefers to see samples of published and experimental work and some contact shees. Provide resume, brochure or tearsheets to be kept on file for possible future assignments. SASE.

Tips: "We use photo retouchers and airbrush photographers, often combining photos into montage format. Usually looking for a subject related to the book title I require. Send cover letter and samples of previously printed work or contact sheet of best photos. Subject matter may vary since we publish 100 or so titles per year."

STONE WALL PRESS, 1241 30th St. NW, Washington DC 20007. President: H. Wheelwright. Publishes national outdoor books and nonfiction. Photos used for text illustration, book covers and dust jackets. Buys all rights. Model release required. Query with samples. Interested in stock photos. SASE. Simultaneous submissions OK. Reports in 2 weeks.

Subject Needs: Outdoor shots dealing with specific subjects.

SYMMES SYSTEMS, Box 8101, Atlanta GA 30306. Photography Director: Ed Symmes. Publishes books about bonsai, the art of growing miniature plants. Needs pictures relating to bonsai; adding titles on other Japanese Arts—Netsuke, Ikebana, Scholar's desk, scrolls, etc." Photos used for text illustration and for book jackets. Query first with resume of credits; provide tearsheets, brochure and dupe slides to be kept on file for possible future assignments. Notifies photographer if future assignments can be expected. Buys first rights or all rights. Present model release on acceptance of photo. Reports in 2 weeks. SASE. Simultaneous submissions and previously published work OK.

B&W: Send negatives with 8x10 glossy prints. Captions required; include location and species of subject. Pays $10 minimum.

Color: Send transparencies. Captions required; include location and species of subject. Pays $25 minimum to several hundred depending on usage.

Jacket: Send negatives with glossy prints for b&w, transparencies for color. Captions required; include location and species of subject. Pays $25 minimum.

Tips: "We're looking for super sharp images with uncluttered backgrounds."

***T.F.H. PUBLICATIONS, INC.**, 211 West Sylvania Ave., Neptune City NJ 07753. (201)988-8400. Managing Editor: Neal Pronek. Publishes "strictly pet books." Photos used for text illustration, promotional materials, book covers, catalogs, and ads. Buys "over 1,000" freelance photos annually, and gives "over 100" assignments annually.

Subject Needs: Strictly animals—pets. Model release required.

Specs: Uses 35mm transparencies. "We prefer transparencies."

Payment & Terms: Pays $10/b&w and color photos. Credit line given. Buys non-exclusive rights. Simultaneous submissions OK.

Making Contact: Query with resume of credits and samples. Deals with local freelancers only; interested in stock photos. SASE. Reports in 3-4 weeks.

Tips: Prefers to see sharp; clear, plain backgrounds; good action shots. "Basically we need straight forward animals (pet only) photos of strictly the pet without busy backgrounds and foregrounds. We're using more and more photographs in our books."

THORNDIKE PRESS, Box 159, Thorndike ME 04986. (207)948-2962. Senior Editor: Tim Loeb. Publishes adult trade, outdoors/nature, how-to, humor, and material of New England regional interest. Photos used for text illustration, book covers and dust jackets. Buys 200 photos annually; gives no freelance assignments annually.

Subject Needs: "Types of photos depend on the particular project." Model release required; captions preferred.

Specs: Uses 5x7 or larger b&w matte prints and 35mm, 2¼x2¼ and 4x5 transparencies.

Payment & Terms: Pays $25-35/b&w photo and $75-150/color photo. Credit line given. Buys one-time rights. Simultaneous and previously published submissions OK.

Making Contact: Query with non returnable samples of work. SASE. Reports in 1 month.

TYNDALE HOUSE PUBLISHERS, 336 Gundersen Dr., Wheaton IL 60189. (312)668-8300. Art Director: Tim Botts. Publishes books "on a wide variety of subjects from a Christian perspective." Photos used for book jackets and text illustration and for a magazine, *The Christian Reader*. Buys 250 photos annually. Submit photos by mail for consideration. Prefers to see originals or high quality dupes "from which we can select and hold for further consideration. Resumes and lists of subjects are not very helpful. We do not have time to send out guidelines, but we will reply to any photos sent with SASE." Buys one-time rights. Previously published work OK in non-competitive books. Direct material to Tim Botts, Production Department.

B&W: Send 8x10 glossy prints. Average page: $35-50.

Jacket: Send 8x10 glossy prints for b&w, transparencies for color. Average pay: $150-200. Uses nature, people, especially the family and groups of mixed ages and backgrounds. Special effects are sometimes useful.
Tips: "We have found it difficult to find candid pictures of people in various relationships such as working, helping, eating, and playing together. The best photos for our use usually tell a story. Send only your very best work. We are looking only for unique, fresh images."

UNIVELT, INC., Box 28130, San Diego CA 92128. (619)746-4005. Manager: H. Jacobs. Publishes technical books on astronautics. Photos used for text illustration and dust jackets.
Subject Needs: Uses astronautics; most interested in artists' concept of space. Model release preferred; captions required.
Specs: Uses 6x9 or 6x4½ b&w photos.
Payment & Terms: Pays $25 minimum/b&w photo. Credit line given, if desired. Buys one-time rights. Simultaneous submissions and previously published work OK.
Making Contact: Query with resume of credits; interested in stock photos; provide business card and letter of inquiry to be kept on file for possible future assignments. SASE. Reports in 1 month.

VEND-O-BOOKS/VEND-O-PRESS, Box 3736, Ventura CA 93006. (805)642-2355. Managing Editor: Dr. Bill Busche. Publishes how to and humor books. Photos used for promotional materials, book covers and dust jackets. Buys 50-100 freelance photos annually, and gives 5 freelance assignments annually.
Subject Needs: People, special effects, landscapes, seascapes, and sports events. Model release required; captions preferred.
Specs: Uses 4x5, 5x7, 8x10 negatives, b&w and color; and 4x5 transparencies.
Payment & Terms: Pays $25-200/b&w negative or transparency; $75-450/color negative or transparency. Credit line usually given. Buys one-time rights or all rights. Simultaneous submissions and previously published work OK.
Making Contact: Query with samples or with list of stock photo subjects; interested in stock photos. SASE. Reports in 3 weeks. Photo guidelines free with SASE.
Tips: "We are going back to larger negatives and transparencies for better quality. Contact sheets help with ideas of what you like and feel about your work."

VICTIMOLOGY, INC., 2333 N. Vernon St., Arlington VA 22207. (703)528-8872. Photography Director: Sherry Icenhower. Publishes books about victimology focusing on the victims not only of crime but also of occupational and environmental hazards. Recent titles include: *Spouse Abuse, Child Abuse,, Fear of Crime* and *Self-defense*. Photos used for text illustration. Buys 20-30 photos/year. Query with a resume of credits or submit material by mail for consideration. Buys all rights, but may reassign to photographer after publication. Submit model release with photo. Reports in 6 weeks. SASE. Simultaneous submissions and previously published work OK.
B&W: Send contact sheet or 8x10 glossy prints. Captions required. Payment depending on subject matter and use.
Color: Send 35mm transparencies, contact sheet or 5x7 or 8x10 glossy prints. "We will look at color photos only if part of an essay with text." Captions required. Pays $30 minimum.
Jacket: Send contact sheet or glossy prints for b&w; contact sheet, glossy prints or 35mm transparencies for color. Captions required. Pays $100-150 minimum.

WALKER & COMPANY, 720 5th Avenue, New York NY 10019. (212)265-3632. Art Director: Laurie McBurnette. Publishes mysteries, young adult romances, westerns, educational, paperback mass-market British mysteries—mostly library sales. Photos used for text illustration and dust jackets. Buys 50 freelance photos annually; gives 150 freelance assignments annually.
Subject Needs: "B&w suitable for cover photo of 3-color dust cover of hard-cover mystery (cloak and dagger genre); murder mysteries." Model release preferred; captions required.
Specs: Uses b&w and color matte or glossy prints; 35mm transparencies.
Payment & Terms: Pays $350-400 minimum/color cover photo; $150/b&w photo; $100-500/color photo; $7-15/hour; $500/job. Credit line given, "usually on back flap. Walker and Company reserves first publication rights, including book club. Payment in 30-60 days."
Making Contact: Provide resume, business card, brochure, flyer or tearsheets to be kept on file for possible future assignments. Solicits photos by assignment only. SASE. Reports "when job applies."
Tips: "Along with mystery cover photos, there is a rare instance where a photo for an education book is needed and has not been provided by the authors—usually depicting young children in an activity situation with adult supervision. Photographers should provide clear, crisp reproductions for the mystery jackets. And keep in mind that type placement will be a factor when a layout cannot be provided."

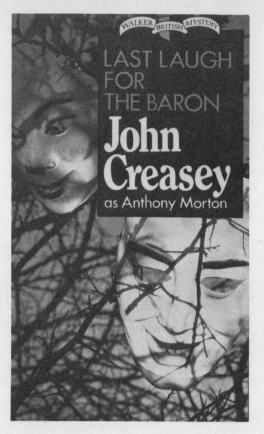

This photo was used by Laurie Mc-Barnette, art director, as the cover picture for a Walker & Company paperback mystery book. McBarnette was attracted to the photographer's work because of his eye for the macabre and good use of available light. "He takes what could be a typical jacket shot and creates something unusual and different . . . something that makes the buyer look and think about how the image was created and what was in the photographer's mind when the shot was set up." She first learned of the photographer, Arthur Tress, when he sent samples of his posters to her office. She paid $300 for North American serial rights.

***WALLACE-HOMESTEAD BOOK CO.**, 580 Waters Edge, Lombard IL 60148. (312)953-1100. Contact: General Manager. Publishes adult trade, antiques, collectibles, quilting. Photos used for promotional materials, book covers, dust jackets.
Subject Needs: Antiques, collectibles, quilting. Model release required; captions preferred.
Specs: Uses 5x7 b&w prints; 35mm transparencies. Credit line sometimes given. Simultaneous submissions and previously published work OK.
Making Contact: Provide resume, business card, brochure, flyer or tearsheets to be kept on file for possible future assignments. Solicits photos by assignment only, interested in stock photos. Does not return unsolicited material.

JOHN WILEY & SONS, INC., 605 3rd Ave., New York NY 10158. (212)850-6731. Photo Research Manager: Stella Kupferberg. Publishes college texts in all fields. Photos used for text illustration. Buys 4,000/year.
Subject Needs: Uses b&w and color photos for use in textbooks in psychology, business, computer science, biology, chemistry, geography, geology, and foreign languages. No posed advertising-type shots. Captions required.
Specs: Uses 8x10 glossy and semigloss b&w prints and 35mm color transparencies.
Payment & Terms: Pays $50-90/b&w print and $75-125/color transparency. Credit line given. Buys one-time rights. Simultaneous submissions and previously published work OK.
Making Contact: Query with list of stock photo subjects. SASE. Reports in 1 month. "We return all photos securely wrapped between double cardboard by registered mail."
Tips: "Initial contact should spell out the material photographer specializes in, rather than a general inquiry about our photo needs."

WILSHIRE BOOK CO., 12015 Sherman Rd., North Hollywood CA 91605. (213)875-1711. President: Melvin Powers. Publishes books on self-development, horse instruction, inspiration and nonfiction.

Photos used for covers. Buys 50 annually. Call to arrange an appointment. Buys second (reprint) rights. Present model release on acceptance of photo. Reports in 1 week. SASE. Simultaneous submissions and previously published work OK.
Jacket: Uses color prints, 35mm and 2¼x2¼ color transparencies. Pays $100 minimum.
Tips: Particularly needs photos of couples and horse photos of all kinds. Always needs photos of women and men suitable for book covers. "Just call with your material. Our door is always open."

WISCONSIN TRAILS BOOKS, Box 5650, Madison WI 53705. (608)231-2444. Production Manager: Nancy Mead. Publishes adult nonfiction, guide books and photo essays. Photos used for text illustration and book covers. Buys "many" photos and gives "many" freelance assignments annually.
Subject Needs: Wisconsin nature and historic scenes and activities. Location information for captions preferred.
Specs: Uses 5x7 or 8x10 b&w prints and any size transparencies.
Payment & Terms: Pays $10-20/b&w photo; $50-150/color photo; payment by the job varies. Credit line given. Buys one-time rights. Simultaneous submissions and previously published work OK.
Making Contact: Query with samples or list of stock photo subjects, or send unsolicited photos by mail for consideration. SASE. Reports in 1 month. Provide resume to be kept on file for possible future assignments. Photo guidelines free on request with SASE.
Tips: "See our products and know the types of photos we use." Also see listing under Consumer Magazines.

WRITER'S DIGEST BOOKS, 9933 Alliance Rd., Cincinnati OH 45242. (513)984-0717. Contact: Art Director. Publishes books about writing, art, and photography. Also publishes *Writer's Digest* magazine. Photos used for book jackets and inside illustrations. Query first with samples. Prefers to see 20-25 b&w photos and/or tearsheets. Provide resume, flyer, business card and brochure to be kept on file for future assignments. Buys first North American rights. Pays $25 minimum/job or on a per-photo basis. Reports in 2 weeks. SASE. Simultaneous submissions and previously published work OK.
Tips: "Study our books before submitting anything. We rely heavily on local photographers."

ZONDERVAN PUBLISHING HOUSE, 1415 Lake Dr., Grand Rapids MI 49506. (616)698-6900. Art Director: Art Jacobs. Publishes religious and conservative books. Photos used for book jackets and covers. Submit material by mail for consideration. Prefers 2¼x2¼ or 4x5 transparencies in a portfolio. Provide flyer, brochure or samples that can be kept on file for possible future assignments. Present model release on acceptance of photo. SASE. Simultaneous submissions OK. Pays $75-400/color photo; worked out on a per project basis.
Color: Send transparencies, negatives, prints or negatives with prints.
Jacket: Send color transparencies. Buys all rights.

Businesses and Organizations

This section should fill the need for photographers who crave variety. The listings here range from for-profit corporations to public service institutions to small industry manufacturers to theater and dance groups. Even though the span of business needs varies, the resulting uses of photography are the same—sales, publicity and public information. Photographers here are needed to take executive portraits, cover special events or promote particular products. The work, generally, will appear in a variety of newspapers and magazines, annual reports, brochures and PR releases.

The variety of businesses and organizations make interesting reading but, prior to querying, be sure to study the listings for specific instructions about subject needs and how the photographer is used. You will most likely be working on assignment, since the needs tend to be specific, and you may deal with personnel ranging from company presidents to PR directors or managers. The key is to present a business-like impression. This includes sending representative samples of your work; tearsheets, business card, resume, etc., so when an assignment comes up, your material can "speak" for itself. Once the assignment is offered, be sure to deliver on time and keep your mind open to any instructions or approaches your "employer" may have regarding the photographing of his product or people.

Since companies want photographers with varying levels of experience, you may want to start "small" just to get some job credits under your belt. Keep in mind that many businesses and organizations will want to work with local people. Within your own town, you can broaden your horizons by querying companies who have publications or public relations departments, but not necessarily a full time photographer on staff. Such companies or organizations could include local hospitals; theater, dance or music groups; small businesses oriented toward publicizing themselves; a local Red Cross or other charity agency; or city council or government organizations. It may not bring in a large pay check at first, but conscientious work combined with photographic talents, will help with your PR as you work your way up to larger, more lucrative companies.

Such experience also will be helpful to you in learning to overcome bad lighting, lack of space or other obstacles that could hinder top-notch results for your clients. Businesses and organizations that require you to shoot action through sports assignments or a theater performance, may want to know if you have experience working with tricky lighting, such as the "greenish" lighting at sports arenas or changing lighting in the theater. A background in newspaper or editorial photography can provide a good background to develop quick reflexes needed on assignments of this nature.

Though many pay scales are listed, some figures are arrived at through negotiation and are based on the photographer's prior experience. Be sure to research comparable pay scales similar businesses have paid other photographers so that in negotiating you don't throw out a figure too low to pay your expenses nor too high to keep you out of the running. Some businesses will have a set range within which they have to work, knowing this beforehand can be helpful to negotiations.

THE ADVERTISING COUNCIL, INC., 25th Floor, 825 3rd Ave., New York NY 10022. (212)758-0400. Director of Public Affairs: Pan Freeman. A nonprofit association chartered by the advertising profession to produce public service advertising campaigns in the public interest. Photos used in brochures,

slide presentations, annual reports, news releases and regular publications. Buys a limited number of freelance photos/year; gives 2-4 freelance assignments/year. Pays $40-60/hour or $150-250/day. Send resume of capabilities and resources. Provide resume, brochure and cover letter to be kept on file for possible future assignments. No unsolicited samples. Reports in 2 weeks. SASE.
B&W: Uses 8x10 or 4x5 glossy prints.
Color: Uses 35mm transparencies or prints.
Tips: "If the photographer looks for any local stories about the Advertising Council and its public service campaigns in his community, we would be interested in pix. Also pix of billboards with Advertising Council public service ads."

ALFA-LAVAL, INC., 2115 Linwood Ave., Box 1316, Fort Lee NJ 07024. (201)592-7800. Manager, Marketing Communications: Rosemarie Eosi. Manufactures industrial centrifuges, heat exchangers and process systems. Gives 6-10 assignments/year. Photos used in brochures, audiovisual presentations, PR releases and for file reference.
Subject Needs: Installation photos of equipment.
Specs: Uses 8x10 b&w and color prints; 35mm and 2¼x2¼ slides; b&w contact sheet; b&w or color negatives OK.
Payment & Terms: Pays $40-75/hour and $50 minimum/job. Buys all rights. Model release required; captions preferred.
Making Contact: Arrange a personal interview to show portfolio. Provide business card and flyer to be kept on file for possible future assignments. Makes assignments in response to correspondence. SASE. Reports in 2 weeks. In a portfolio prefers to see "photos of large equipment in industrial environment. Alfa-Laval has installations throughout the US. Our equipment and locations are not glamorous. They are difficult to light. Our assignments generally do not require more than a ½-day shoot."

ALLRIGHT AUTO PARKS, INC., Suite 1200, Concorde Tower, 1919 Smith St., Houston TX 77002. (713)222-2505. National Director of Public Relations: H. M. Sinclair. Company operates in 77 cities in the US and Canada. Uses photos of parking facilities, openings, before and after shots, unusual parking situations, and Allright facilities. Photos used in brochures, newsletters, newspapers, audiovisual presentations and catalogs. Pays $25 minimum/hour or on a per-photo basis. Buys all rights. Model release preferred. Arrange a personal interview to show portfolio; provide resume, brochure, flyer and tearsheets to be kept on file for future assignments. Does not notify photographer if future assignments can be expected. SASE. Reports in 2 weeks.
B&W: Uses 8x10 glossy prints.
Color: Uses 35mm transparencies or 8x10 glossy prints.
Tips: "We hire local photographers in our individual operating cities through the local manager, or directly by phone with photographers listed at national headquarters, or by prints, etc. sent in with prices from local cities to national headquarters or through local city headquarters."

*****AMATEUR SOFTBALL ASSOCIATION**, 2801 NE 50th St., Oklahoma City OK 73111. (405)424-5266. Director: Bill Plummer, III. Promotion of amateur softball. Buys 3-4 photos year; gives 2-3 assignments annually. Photos used in newsletter, newspapers.
Subject Needs: Subjects include action sports shots.
Specs: Uses 8½x11 prints.
Payment & Terms: Pays $20/b&w photo; $50/color photo. Credit line given. Buys all rights. Model release preferred; captions required. SASE. Reports in 2 weeks.
Tips: Contact ASA National office first before doing any work.

AMERICAN ANIMAL HOSPITAL ASSOCIATION, Box 15899, Denver CO 80215-0899. Director of Communications and Information: Marilyn Bergquist. Editor of Journals: Dr. Jill Frucci. Provides "veterinary continuing education, pet health information to consumers and sets standards for animal hospitals." Buys 10 freelance photos/year. Photos used in newsletters, annual reports, AV presentations, and PR releases.
Subject Needs: "Publicity shots (our meetings); people and pet photos (dogs & cats primarily—some birds); veterinarians with pets in clinical settings (no surgeries, please)." Uses 5x7 or 8x10 b&w and color glossy prints; and 35mm, 2¼x2¼ transparencies.
Payment & Terms: Pays $400-800/day; "all other rates should be negotiated." Credit line given if requested, but not on publicity shots. Prefers to purchase all rights, but will negotiate depending on usage." Model release preferred.
Making Contact: Provide resume, business card, brochure, flyer or tearsheets to be kept on file for possible future assignments. SASE. Reports in 1 month.

*****AMERICAN DENTAL HYGIENISTS' ASSOCIATION**, 444 N. Michigan Ave., Chicago IL 60611. (312)440-8900. Art Director: Mary Kushmir. Provides monthly journal. Buys 8 photos/year; gives 6 as-

signments/year. Photos used in posters and magazines.

Subject Needs: Photos of dental hygienists; young, professional women; children with good smiles; older citizens.

Specs: Uses 35mm, 2¼x2¼, 4x5 transparencies; b&w and color contact sheets.

Payment & Terms: Pays $200/b&w photo; $350/color photo. Credit line given. Buys one-time rights. Model release preferred.

Making Contact: Query with resume of credits and with samples. Solicits photos by assignment only. Does not return unsolicited material. Reports in 1 week.

Tips: Prefers to see clarity; quality; good graphic potential. "Work closely with a dental professional when shooting a technical shot. Members of our association are extremely particular about the popular depiction of dental hygienists."

AMERICAN FUND FOR ALTERNATIVES TO ANIMAL RESEARCH, Suite 16-G, 175 W. 12th St., New York NY 10011. (212)989-8073. Contact: Dr. E. Thurston. Finances research to develop research methods which will not need live animals. Also informs the public of this and about current methods of experimentation. Needs b&w or color photos of laboratory animal experimentation and animal use connected with fashions (trapping) and cosmetics (tests on animals). Uses photography for reports, advertising and publications. Buys 10 + freelance photos/year; gives 5 + freelance assignments/year. Pays $5 minimum/b&w photo, $5 or more/color photo; $30 minimum/job. Credit line given. Rights purchased are arranged with photographer. Model release preferred. Arrange a personal interview to show portfolio, query with samples and list of stock photo subjects. Provide brochure and flyer to be kept on file for possible future assignments. Notifies photographer if future assignments can be expected. SASE. Reports in 2 weeks.

B&W: Uses 5x7 b&w prints.

Film: Interested in 16mm educational films.

***AMERICAN HOCKEY MAGAZINE/AMATEUR HOCKEY ASSOCIATION OF U.S.**, 2997 Broadmoor Valley Rd., Colorado Springs CO 80906. (303)576-4990. Managing Editor/PR Director: Mike Schroeder. Provides national governing body for amateur hockey. Photos used in brochures and magazines.

Subject Needs: Hockey related action; human interest (hockey).

Specs: Uses 5x7 glossy b&w prints, 35mm transparencies.

Payment & Terms: Pays $25/b&w photo; $25/color photo; $200/job. Credit line given. Buys one-time rights or all rights, "usually one-time; may be limited all." Captions preferred.

Making Contact: Query with resume of credits, samples and list of stock photo subjects; provide resume, business card, brochure, flyer or tearsheets to be kept on file for possible future assignments. Solicits photos by assignment only. SASE. Reports in 3 weeks.

Tips: Prefers to see functional hockey action. "A person who can shoot *good* hockey action impresses me. Query me first by telephone. Send samples, if query is a go. Don't bother if you can't shoot good hockey action."

AMERICAN MUSEUM OF NATURAL HISTORY LIBRARY, PHOTOGRAPHIC COLLECTION, Library Services Department, Central Park West, 79th St., New York NY 10024. (212)873-1300, ext. 346 and 347. Assistant Librarian for Reference Services: Linda Reichert. Provides services for advertisers, authors, film & TV producers, general public, government agencies, picture researchers, publishers, scholars, students and teachers. Photos used for brochures, newsletters, posters, newspapers, audiovisual presentations, annual reports, catalogs, magazines, PR releases, books and exhibits.

Payment & Terms: No payment. Credit line given. Model releases and captions required.

Making Contact: Arrange personal interview to show portfolio and query with resume of credits and samples. Reports in 1-2 weeks. "We accept only donations with full rights (non-exclusive) to use; we offer visibility through credits. Please document well."

AMERICAN NATIONAL RED CROSS, Photographic Section, 18th & E Sts. NW, Washington DC 20006. (202)639-3560. Photographic Coordinator: Stephen Anderson. Photos used to illustrate annual reports, articles, slide shows, ads, brochures and news releases. Submit model release with photo. Submit material by mail for consideration. Pays $15-100/b&w photo; $15-100/color photo; payment negotiable, depending on job requirments. SASE. Reports within 2 weeks. "In case of disaster photos, call collect.".

B&W: Send contact sheet or 8x10 glossy prints. Pays $15-100.

Color: Send 35mm transparencies. Pays $15-100. Pays $30 + /hour; $150 + /day; varies per job.

Tips: "Although we have photographers on staff, we do need freelancers occasionally. We would be interested in developing a pool of Washington, DC area photographers from which to draw talent for our overflow assignments. Contact us for an appointment for a portfolio review. We are always interested in

looking at work depicting Red Cross activities, particularly during disasters. If a photographer thinks he or she has something we can use from a disaster, we need to see it immediately. Generic disaster photos, unless of extraordinary quality, are of little use to us. I want to see what you do best. Whether it is portraits, products, or basic PR photography, the technical end must be flawless. A portfolio should contain the types of work that sell to industry; I get tired of, and am not impressed by somebody's college level "art" photography, which is irrelevent. Take the time to find out what kind of work the Red Cross does, and include in the portfolio photographs that show you understand our mission and that you can help to support our work with your photographs."

***AMERICAN POWER BOAT ASSOCIATION**, 17640 E. Nine Mile Rd., Box 377, East Detroit MI 48021. (313)773-9700. Marketing Coordinator: Ms. Hilary Spittle. Sanctioning body for US power boat racing; monthly magazine. Buys 300-400 photos/year; gives 15 assignments/year to writer/photographers. Photos used in brochures, audiovisual presentations, magazines, PR releases, programs.
Subject Needs: Power boat racing—action and candid.
Specs: Uses 5x7 and up b&w prints and b&w contact sheets.
Payment & Terms: Payment varies. Credit line given. Buys all rights. Captions preferred; I.D. required.
Making Contact: Send unsolicited photos by mail for consideration; provide resume, business card, brochure, flyer or tearsheets to be kept on file for possible future assignments. SASE. Reports in 2 weeks.
Tips: Prefers to see selection of shots of power boats in action or pit shots, candids, etc., (all ID'd).

AMERICAN SOCIETY FOR THE PREVENTION OF CRUELTY TO ANIMALS (ASPCA), 441 E. 92nd St., New York NY 10028. (212)876-7700. Head of Publications: Jill Schensul. Publishes quarterly newsletter, pamphlets, booklets and posters. Photos used in brochures, newsletters, posters, newspapers and annual report. Needs photos of animals. Buys 25 freelance photos and gives 5 freelance assignments/year. Pays $35-50/b&w photo; $50-75/color photo; $100-200/day; $200 maximum/job. Buys one-time rights. Credit line given. Model release and captions preferred. Prefers samples of animal-related photos in a portfolio. Provide brochure and resume to be kept on file for possible future assignments. SASE. Reports in 3 weeks. Notifies photographer if future assignments can be expected.

ARIZONA THEATRE COMPANY, Box 1631, Tucson AZ 85702. (602)884-8210. Communications Director: Gary Bacal. "We produce professional theater, performing full seasons in Tucson and Phoenix, and touring the state." Photos used in brochures, newsletters, posters, newspapers, audiovisual presentations, magazines, and PR releases.
Subject Needs: "We purchase all our photo needs from freelance photographers—either for one-time assignments or on an annual contract."
Specs: Uses 8x10 b&w prints, 35mm transparencies, contact sheets, and possibly negatives. Uses freelance videographers to produce tapes of production rehearsals for promotional purposes.
Payment & Terms: Payment negotiated individually. Credit line given. Rights purchased are negotiable. Model release and captions (names, dates, ID's) required.
Making Contact: Query with samples; provide resume, business card, brochure, flyer or tearsheets to be kept on file for possible future assignments. SASE.
Tips: "Be relaxed and flexible! We are seeing an increased need for color."

ASSOCIATION FOR RETARDED CITIZENS OF THE UNITED STATES, National Headquarters, 2501 Avenue J, Arlington TX 76006. (817)640-0204. Director of Communications Department: Liz Moore. "Largest non-profit organization of 160,000 members working for better services and opportunities for this nation's 6.5 million citizens with mental retardation." Gives 3 assignments/year. Photos used in brochures, newsletters, newspapers, annual reports, PR releases and magazines.
Specs: Uses 5x7 glossy prints; contact sheet and negatives OK.
Payment & Terms: Pays $3.50-25/b&w photo; $30 maximum/hour including return of contact sheets, excluding film. Pays $300 maximum/job or day. Credit line given. Buys all rights. Model release and captions required. Does not pay royalties.
Making Contact: Query with samples or stock photo series; provide resume, business card, brochure, flyer or tearsheets to be kept on file for possible future assignments. SASE. Reports in 3 weeks.
Tips: "We are desperately in need of new photos for our morgue file. Because we're a nonprofit association, we cannot afford to pay 'going rates'. However, photographers can enjoy tax breaks if they're astute about those matters. Educational settings ideal. We particularly need more photographs of people who are mentally retarded who are living, working and playing in community settings (as opposed to institutional). Knowledge of mental retardation and ability to erase stereotypes are most valuable. The photographer needs to be motivated to help our cause."

BAKER STREET PRODUCTIONS LTD., 502 Range St., Box 3610, Mankato MN 56001. (507)625-2482. Contact: Karyne Jacobsen. A book and catalog production service. Buys 500 photos/year; gives 2 freelance assignments/year. Photos used in brochures, catalogs, and juvenile books.
Subject Needs: Wildlife.
Specs: Uses b&w and color prints and 35mm transparencies.
Payment & Terms: Pays $65/b&w photo, $85/color photo. Credit line given. Buys reproduction rights for life-time of book. Model release required; captions preferred.
Making Contact: Send list of stock photo subjects; provide resume, business card, brochure, flyer or tearsheets to be kept on file for possible future assignments; interested in stock photos.

LAWRENCE BENDER & ASSOCIATES, 512 Hamilton Ave., Palo Alto CA 94301. (415)327-3821. Contact: L. Bender. Graphic design firm. Buys numerous photos/year; gives numerous assignments/year. Photos used in brochures and annual reports.
Subject Needs: A variety of photo needs and subjects.
Specs: Uses b&w prints and 35mm, 2¼x2¼ and 4x5 transparencies.
Payment & Terms: Payment negotiated individually. Buys one-time rights. Model release required.
Making Contact: Arrange a personal interview to show portfolio, query with resume of credits, with samples, or with list of stock photo subjects; provide resume, business card, brochure, flyer or tearsheets to be kept on file for possible future assignments. Interested in stock photos. SASE.
Tips: "Call for appointment after sending promotional material."

THE BERKSHIRE PUBLIC THEATRE, 30 Union St., Box 860, Pittsfield MA 01202. (413)445-4631. Managing Director: Iris Bessell. "We provide year round productions of plays, musicals, cabarets and children's theater in our 284-seat theatre." Buys contact sheets/30 freelance photos/year; gives 3 assignments/year. Photos used in brochures, newsletters, posters, PR releases, and lobby displays.
Subject Needs: "We are looking for dramatic production shots that capture the essence of the particular piece of work we are exploring."
Specs: Uses 5x7 glossy or studio b&w prints, b&w contact sheets and negatives. "We are interested in video but to date have only recorded our productions on videotape, and have not solicited freelance videography."
Payment & Terms: Credit line given. Buys all rights—"we often reprint photos for promos and list credits."
Making Contact: Query with resume of credits; provide resume, business card, brochure, flyer or tearsheets to be kept on file for possible future assignments. Solicits photos by assignment only. SASE. Reports in 1 month or sooner.
Tips: "We are a small but growing regional repertory theater in the Berkshires. Our capital is often limited and *strictly* budgeted. Patience and understanding goes a long way. We look for compelling photos that 'jump out' at us—photos that evoke a visceral response are theatrically 'trendy'—and work. We look for clear, clean, focused prints. The ability to capture an actor's fleeting emotion. The quality of translating this to a solid print." Send SASE, samples, resumé and refer to enclosed listing for more specifics.

BIKECENTENNIAL, Box 8308, Missoula MT 59807. (406)721-1776. Editor: Daniel D'Ambrosio. A service organization for touring bicyclists; publishes maps of bicycle routes nationwide, runs a trips program, produces a magazine. Buys very few photos/year; gives very few assignments/year. Uses photos in brochures, posters, catalogs, magazines and PR releases.
Subject Needs: Bicycle touring.
Specs: Uses 5x7 and 8x10 glossy b&w prints.
Payment & Terms: Pays $5-15/b&w photo. Credit line given. Buys one-time rights. Model release and captions preferred.
Making Contact: Query with samples. SASE. Reports in 2 weeks.
Tips: "We normally only buy photos that accompany a manuscript."

BRINE INC., 47 Summer St., Milford MA 01757. (617)478-3250. President: Peter Brine. Manufactures soccer and lacrosse equipment. Buys 10-15 photos/year; gives 8 assignments/year. Photos used in brochures, posters, catalogs and magazines.
Subject Needs: Soccer action photos using Brine balls.
Specs: Uses 35mm and 4x5 transparencies.
Payment & Terms: Pays $5-200 depending on quality. Credit line given. Buys all rights. Model release preferred.
Making Contact: Call to discuss needs. SASE. Reports in 2 weeks.

CALIFORNIA REDWOOD ASSOCIATION, Suite 3100, 591 Redwood Hgwy., Mill Valley CA 94941. (415)381-1304. Contact: Charlene Draheim. "We publish a variety of literature, run color ad-

Sausalito, California-based photographer Peter Christiansen shot this photo for the California Redwood Association. It was commissioned for national consumer magazine and newspaper publicity use. The objective, says Publicity Manager Charlene Draheim, is to show use of this product (redwood) for the do-it-yourself market. The photograph has appeared in major newspapers across the country.

vertisements and constantly use photos for magazine and newspaper publicity. We use new, well-designed redwood applications—residential, commercial, exteriors, interiors and especially good remodels and outdoor decks, fences, shelters. Color of wood must look fresh and natural." Gives 40 assignments/year. "We can review scout shots and commission a job or pick up existing photos on a per piece basis. Payment based on previous use and other factors." Credit line given whenever possible. Usually buys all but national advertising rights. Model release required. Send query material by mail for consideration for assignment or send finished speculation shots for possible purchase. Prefers photographers with architectural specialization. Reports in 1 month. Simultaneous submissions and previously published work OK if other uses are made very clear.

B&W: Uses 8x10 prints; contact sheet OK.

Color: Uses 4x5 and 2¼x2¼ transparencies, contact sheet OK.

Tips: "We like to see any new redwood projects showing outstanding design and use of redwood. We don't have a staff photographer and work only with freelancers. We do, however, tend to use people who are specialized in architectural photography. New photo uses might include color shots chosen with an eye for TV usage (commercial or editorial). We generally look for justified lines, true color quality, ability to judge style and design and tasteful props."

CAMPBELL SOUP COMPANY, Campbell Place, Camden NJ 08101. (609)342-4800. Director of Public Relations: Scott Rombach. Uses photos in brochures, audiovisual presentations, catalogs and annual reports. No photography purchased from freelancers except on specific assignment.

Making Contact: Provide resume, brochure and tearsheets to be kept on file for future assignments. Notifies photographer if future assignments can be expected. "Most requirements are handled by staff photographers. We will take initiative in contacting photographer in limited instances in which a freelance assignment is under consideration. Wants photographers with verifiable credentials." SASE. Reports in 1-2 weeks.

CAROLINA BIOLOGICAL SUPPLY COMPANY, 2700 York Rd., Burlington NC 27215. (919)584-0381. Audiovisual Development: Roger Phillips. Stock Photo Manager: Cathy Dollins. Produces educational materials in the biological, earth science, chemistry, physics and computer fields. Gives 10 or less assignments/year. Buys 50 or less freelance photos annually. Photos used in text illustration, promotional materials and filmstrips.
Subject Needs: Nature scenes, natural history, geological, etc. for use on specific projects, or to add to their extensive stock photo library.
Specs: Uses 3x5 and 8x10 glossy color prints and 35mm and 2¼x2¼ transparencies.
Payment & Terms: Pays $30-125/color photo. Will also work on royalty basis. Pays within 30 days of acceptance. Credit line given. Buys one-time rights. Model release required; captions preferred.
Making Contact: Query with resume of credits, samples or with list of stock photo subjects; or send unsolicited photos by mail for consideration. SASE. Reports in 1 month.
Tips: "As the oldest and largest supplier of biological materials in the USA, we are contacted by authors in the sciences who need photographs. We encourage photographers to send us material for review, whether they have 1 photo or 1,000. The chances of a science author requesting a photo from us are excellent. Label transparencies with genus and species if applicable. Send for review an assortment from all categories."

CHILD AND FAMILY SERVICES OF NEW HAMPSHIRE, 99 Hanover St., Box 448, Manchester NH 03105. (603)668-1920. Contact: Director of Public Relations. Statewide social service agency providing counseling to children and families. Uses photos of children, teenagers and families; "pictures depicting our services, such as an unwed mother, teenager on drugs or emotionally upset, couples and/or families—possibly indicating stress or conflict." Photos used in brochures, newspapers, posters, annual reports, PR releases, and displays and exhibits. Buys 3-4 photos/year; gives 1-2 assignments/year. Pays $10 minimum/hour and on a per-photo basis. Credit line given on request. Buys all rights. Model release required. Send material by mail for consideration. Stock photos OK. Provide business card and tearsheets to be kept on file for future assignments. Notifies photographer if future assignments can be expected. SASE. Reports in 1 month.
B&W: Uses 5x7 glossy prints. Pays $10-50/photo.
Color: Uses 5x7 glossy prints. Pays $10-50/photo.
Tips: "Submit a few copies of applicable photos in which we might be interested rather than just a letter or form telling us what you have done or can do."

CHRIST HOSPITAL, 176 Palisade Ave., Jersey City NJ 07306. (201)795-8200. Contact: Public Information Coordinator. Needs hospital-related candid photos and portraits. Photos used in brochures, newsletters, newspapers, quarterly magazine, annual reports and exhibits. Buys all rights. Query, then call to arrange a personal interview to show portfolio. Prefers to see b&w PR shots and creative mood shots in a portfolio. Include tight, crisp newspaper-style shots and any innovative work (color xerox, special lens/filter shots) etc., presented in an organized fashion. Gives assignments to any freelancer who can provide on-location shots. Negotiates payment. Provide flyer and price list to be kept on file for possible future assignments. Usually notifies photographer if future assignments can be expected. SASE. Reports in 1 month.
Specs: Uses 8x10 glossy or matte prints. Size varies for exhibits. Contact sheet OK.

CLYNER'S OF BUCKS COUNTY, 141 Canal St., Nashua NH 03061. (603)882-2180. Contact: Catalog Director. Produces direct mail gift and apparel catalog. Buys 900-1,000 freelance photos/year; places 4 assignments/year. Photos used in catalog.
Subject Needs: Hard and soft goods, and fashion.
Specs: Uses 4x5 and 8x10 transparencies.
Payment & Terms: Payment negotiated individually. Buys all rights. Model release required.
Making Contact: Provide resume, business card, brochure, flyer or tearsheets to be kept on file for possible future assignments. Deals with local freelancers only. SASE. Reports in 1 month.

***COLBY COLLEGE**, Waterville ME 04901. (207)872-3218. Director of Publications: Bonnie Bishop. Provides publications for student recruitment, alumni and friends of the college. Buys 36-48 photos/year; gives 3 major color assignments/year. "We have an inhouse photographer for b&w work." Photos used in books, brochures, newsletters, posters, annual reports, catalogs, calendars, and magazines.
Subject Needs: Scenics of campus and/or Maine and shots of students.
Specs: Uses 5x7 or 8x10 b&w prints; prefers 2¼x2¼ and 4x5 transparencies, crisp 35mm may be OK; b&w contact sheets; b&w negatives. Uses freelance filmmakers to produce student recruitment and educational videos.
Payment & Terms: Payment negotiated. Credit line given if requested. Buys all rights. Model release and captions preferred.

Making Contact: Arrange a personal interview to show portfolio, or provide resume, business card, brochure, flyer or tearsheets to be kept on file for possible future assignments. Deals with local freelancers mostly. Does not return unsolicited material.
Tips: Needs "scenics, student shots, and 'educational' situations." Will work with photographer to set up shots and provide student models. "College publications are getting more professional than they used to be. They are a good starting place for young, talented photographers."

COMMUNITY AND GOVERNMENT AFFAIRS, San Diego Unified Port District, Box 488, San Diego CA 92112. (619)291-3900. Director of Community and Government Affairs: William Dick. Government agency. Photos used in brochures, annual reports, PR releases, audiovisual presentations, sales literature and trade magazines. Infrequently uses freelance photography. Pays $25-50/hour; $200-300/day; and also on a per-photo basis. Credit line given. Buys one-time rights or other depending on photo and usage. Model release and captions required. Arrange a personal interview to show portfolio, query with resume of credits, or query with list of stock photo subjects. No unsolicited material. Local freelancers preferred. SASE. Reports in 1 week. Most interested in unusual photos of maritime or commercial aviation scenes in and around San Diego Bay; also scenic and aerial of San Diego Bay and shots of recreational activities with people ("model releases in this case are absolutely required.") No "pictures without captions or 'junk' pictures sent in the hope they'll be bought."
B&W: Uses 8x10 prints; contact sheet OK. Pays $5-25/photo.
Color: Uses 35mm transparencies.
Film: Interested in stock footage of appropriate subject matter.

***GREG COPELAND INC.**, 10-14 Courtland St., Paterson NJ 07503. (201)279-6166. President: Greg Copeland. Provides art to galleries and visual display. Gives 25 assignments/year. Photos used in posters and original photography.
Subject Needs: Exciting images.
Specs: Uses color prints; 4x5 and 8x10 contact sheets; negatives.
Payment & Terms: Pays 5% royalty. Model release required.
Making Contact: Send unsolicited photos by mail for consideration, submit portfolio for review. Open to solicitations from anywhere. SASE. Reports in 1 month.

***COVENANT COLLEGE**, Scenic Hgwy., Lookout Mountain TN 37350. (404)820-1560, ext. 139. Director of Public Relations: Linda Elmore. Provides all in-house and out-house materials for departments at the college, especially Admission, Development, Annual Support and PR, etc. Photos used in brochures, newsletters, posters, newspapers, audiovisual presentations, annual reports, catalogs, magazines, and PR releases. Buys $600 worth of photos annually; gives 1-2 major assignments/year and 10-20 small jobs/year.
Subject Needs: The college, the faculty, administrators, students, etc. Interested in developing high quality, low budget slide presentation and/or video for admissions-recruitment.
Specs: Uses 4x5, 5x7 and 8x10 b&w and color prints; b&w contact sheets; b&w and color negatives.
Payment & Terms: Payment negotiated per photo, hour, job. $250/day. Credit line negotiable. Buys all rights.
Making Contact: Provide resume, business card, brochure, flyer or tearsheets to be kept on file for possible future assignments. Deals with local freelancers only.
Tips: "Soft sell us, please."

CUSTOM STUDIOS, 1337 W. Devon, Chicago IL 60660. (312)761-1150. President: Gary Wing. Manufacturers custom imprinted products such as T-shirts, jackets, caps, custom printed cups, key tags, ashtrays. Buys 10 freelance photos/year; gives 10 freelance assignments/year. Photos used in brochures, posters, newspapers, catalogs, and magazines.
Subject Needs: Product shots and models wearing custom imprinted products.
Specs: Uses 4x5 to 8x10 matte or glossy b&w and color prints and b&w and color contact sheets.
Payment & Terms: Pays $20/b&w photo, $25/color photo; $20-30/hour. Credit line given. Buys all rights. Model release required.
Making Contact: Send unsolicited photos by mail for consideration; provide resume, business card, brochure, flyer or tearsheets to be kept on file for possible future assignments. "We are open to solicitations from anywhere, but prefer to deal with local freelancers." Does not return unsolicited material. Reports in 3 weeks.

DAYCO CORPORATION, 333 W. 1st St., Dayton OH 45402. (513)226-5927. Public Relations Director: Bill Piecuch. Manufacturer and distributor of highly engineered original equipment and component and replacement parts for a variety of machinery. Uses photos of inplant operations, personnel on the job and products in application. Photos used in newsletters, newspapers, PR releases, annual and quarterly

reports and magazines. Buys 100 freelance photos/year. Pays $250 maximum/day for b&w; $300 maximum/day for color. Buys all rights. Model release required. Query with resume of credits or samples. Prefers to see "industrial photos directly related to our products that exhibit the photographer's ability in that area." Buys photos by assignment only. Provide "past work done for us to be kept on file for possible future assignments." Does not notify photographer if future assignments can be expected. SASE. Reports in 2 weeks-2 months.

B&W: Uses 8x10 glossy prints; contact sheet and negatives OK.

Color: Uses transparencies and 8x10 matte prints.

Tips: "There is a good chance of Dayco using freelancers. An outstanding photo purchased in the past year showed an individual looking through a piece of plastic tubing. The contrast, centering, content and facial expression impressed me. We want to see shots that would show an unusual product application. I'm seeing good photography used in editorial (product publicity) replacing some advertising budget money. The reason is simple: Well-placed, creative product publicity costs less for the dollars invested. It will never replace advertising—and any product publicity person worth his salt will agree—but it does give marketing another excellent shot at potential buyers. Know our company. Ask for our annual report or product listings before you contact us. We don't have time to educate or converse on an individual basis."

DAYTON BALLET, 140 N. Main St., Dayton OH 45402. (513)222-3661. Public Relations/Marketing Director: Cynthia Baka. Schedules 4-5 ballet programs yearly. Gives 4-5 freelance assignments/year. Photos used in brochures and posters.

Subject Needs: "Shots of our dance works."

Specs: Uses b&w and color contact sheets; or transparencies.

Payment & Terms: Pays $6 maximum/b&w photo; $3 maximum/slide. Credit line given. Buys all rights.

Making Contact: Query with resume of credits; provide resume, business card, brochure, flyer or tearsheets to be kept on file for possible future assignments. SASE. "Call us for reports on queries."

Tips: "Make an appointment to come and shoot a dress rehearsal (no fee) and submit your contact sheets. We'll order from contact. If you're good, we'll invite you to shoot in the future and negotiate a fee. We're still looking for a photographer in our region who can capture fast movement in a low-light theater situation."

DENMAR ENGINEERING & CONTROL SYSTEMS, INC., 2309 State St., West Office, Saginaw MI 48602. (517)799-8208. Advertising: Chester A. Retlewski. Produces newspaper vending machines. Photos used in brochures, audiovisual presentations, magazines and PR releases. Needs photos on new product lines. Buys 20-30 freelance photos annually; gives 150 freelance assignments annually. Pays $20-50/b&w photo, $50/color, $18-25/hour and $175-500/job. Credit line given. Buys all rights. Model release preferred. Submit portfolio for review; provide resume to be kept on file for possible future assignments. Notifies photographer if future assignments can be expected. SASE. Reports in 1 month.

Film: Interested in 16mm industrial films. Pays 10% minimum royalty.

***DREXEL UNIVERSITY**, 32nd & Chestnut St., Philadelphia PA 19104. (215)895-2613. Director, Public Relations: Philip Terranova. Provides publications for both internal and external use, as well as press releases. Buys 250+ photos/year; gives 60+ assignments/year. Photos used in brochures, newsletters, posters, newspapers, annual reports, and PR releases.

Subject Needs: Events on campus, portraits, building shots.

Specs: Uses 8x10 glossy b&w prints and b&w contact sheets.

Payment & Terms: Pays $25-50/hour; $150-250/day. Credit line given. Buys all rights. Model release required.

Making Contact: Arrange a personal interview to show portfolio. Deals with local freelancers only and solicits photos by assignment only. Does not return unsolicited material.

***EQUIBANK**, Two Oliver Plaza, Pittsburgh PA 15222. Contact: Manager of Communications. Photos used in brochures, newsletters, newspapers, audiovisual presentations, posters, annual reports, PR releases, and magazines. Gives 6 assignments/year. Payment per job is "open." Credit line given occasionally. Buys all rights. Model release required. Query with samples or submit portfolio for review. Local freelancers preferred.

B&W: Uses 8x10 glossy prints.

Color: Uses 8x10 glossy prints.

Film: Uses all types. Does not pay royalties.

***FELLOWSHIP OF CHRISTIAN ATHLETES**, 8701 Leeds Rd., Kansas City MO 64129. Editor, Sharing the Victory: Skip Stogsdill. Provides year-round outreach to athletes and coaches. Buys 6-8 photos/year. Photos used in magazines.

Subject Needs: Close-up and thoughtful or dramatic sports related shots.
Specs: Uses b&w and color prints, 35mm transparencies, b&w contact sheets.
Payment & Terms: Pays $35 + /b&w photo; $50 + /color photo. Credit line given. Buys one-time rights. Model release preferred.
Making Contact & Terms: Query with samples. SASE. Reports in 1 week. "Best to study sample copy first. Send $1 plus 9x12" SASE."

FIELD PUBLICATIONS, (formerly *Xerox Field*), 245 Long Hill Rd., Middletown CT 06457. (203)638-2557. Senior Photo Librarian: MaryEllen Renn. Publishes periodicals for children ages 4-13. Gives 25-30 freelance assignments annually "varies according to needs." Photos used in newspapers and catalogs.
Subject Needs: News and feature materials appropriate for children/youth audience.
Specs: Uses 8x10 b&w and color glossies; 35mm, 2¼x2¼, 4x5 and 8x10 transparencies and b&w contact sheets.
Payment & Terms: Payment varies. Credit line given. Buys one-time rights. Model release preferred; captions required.
Making Contact: Query with samples or list of stock photo subjects; send unsolicited photos by mail for consideration; provide resume, business card, brochure, flyer or tearsheets to be kept on file for possible future assignments. Reports in 1 month.
Tips: In portfolio prefers to see "black and white photos and color transparencies related to news features appropriate for children/youth audience."

***FRIENDS UNIVERSITY**, 2100 University Ave., Wichita KS 67213. (316)261-5810. Director/PR: Paula Smith. Provides education at a four-year private Christian liberal-arts college. Buys 4-10 photos/year; 4-10 assignments/year. Photos used in brochures, newspapers, magazines and quarterly magazine.
Subject Needs: Subjects include: athletic action shots, formal "portrait"-type photos and composed cover shots.
Specs: Uses 4x5 or 8x10 glossy b&w or color prints. Uses freelance filmmakers to produce educational or promotional material via video tape or multi-media.
Payment & Terms: Pays $5/b&w 4x5 print to maximum $100/8x10 color photo. Photographers credited in front of magazine. Buys all rights.
Making Contact: Query with sample. Open to solicitations from anywhere. SASE. Reports in month.
Tips: In samples, looks for clear, good contrast and creative composition. Has noticed use of more 4 color, more professional photography.

GARY PLASTIC PACKAGING CORP., 530 Old Post Rd., No. 3, Greenwich CT 06830. (203)629-1480. Director, Marketing: Marilyn Hellinger. Manufacturers of custom injection molding; thermoforming; and stock rigid plastic packaging. Buys 10 freelance photos/year; gives 10 assignments/year. Photos used in brochures, catalogs and flyers.
Subject Needs: Product photography.
Specs: Uses 8x10 b&w and color prints; 2¼x2¼ slides; and b&w or color negatives.
Payment & Terms: Pays by the job and the number of photographs required. Buys all rights. Model release required.
Making Contact: Query with resume of credits or with samples. Follow-up with a call to set up an appointment to show portfolio. Prefers to see b&w and color product photography. Deals with local freelancers only. Solicits photos by assignment only. Provide resume to be kept on file for possible future assignments. Notifies photographer if future assignments can be expected. Does not return unsolicited material. Reports in 2 weeks.
Tips: The photographer "has to be willing to work with our designers."

GEORGIA-PACIFIC CORP., 133 Peachtree NE, Altantic GA 30303. Chief Photographer: Steve Dinberg. Produces timber, chemicals, plywood, lumber, gypsum, pulp and paper. Photos/film used for print media publicity, TV documentaries, news film clips, catalogs and sales promotion literature. Solicits photos by assignment only. Provide resume, business card, brochure, flyer, tearsheets and nationwide itineraries to be kept on file for possible future assignments. Does not notify photographer if future assignments can be expected. Submit portfolio on request only. Payment determined from contract or purchase order.
Film: Video and stills. Does not pay royalties.
Tips: "Send samples (not portfolio) to be circulated."

***GOOD SAMARITAN HOSPITAL, PUBLIC AFFAIRS DEPARTMENT**, 2222 Philadelphia Dr., Dayton OH 45406. (513)278-2612, ext. 5225. Photojournalist: Vince Maietta. "We are a not-for-profit, 570-

bed acute care hospital." Buys various numbers freelance photos/year; various number assignments/year. Photos used in brochures, newsletters, posters, newspapers, audiovisual presentations, annual reports, catalogs, magazines, PR releases.

Subject Needs: "Usually health care related, and specifically activities at Good Samaritan. Occasionally we have the need for other types of photographs."

Specs: Uses 8x10 glossy b&w and color prints; 35mm, 2¼x2¼, 4x5, 8x10 transparencies, b&w and color contact sheets, b&w and color negatives.

Payment & Terms: Pays $25/b&w photo; $35/color photo; $30-60/hour plus materials and mileage; day/job negotiated; individual prints/slides negotiated. Credit line given. Buys all rights. Model release required.

Making Contact: Arrange a personal interview to show portfolio; query with resume of credits, samples and list of stock photo subjects; send unsolicited photos by mail for consideration; submit portfolio for review; provide resume, business card, brochure, flyer or tearsheets to be kept on file for possible future assignments. Solicits photos by assignment only; interested in stock photos. SASE. Reports in 2 weeks.

Tips: Prefer to see "primarily health-care related scenes, but often our needs go beyond the obvious. Sometimes we will use anything that applies to our needs—home life, car races, festivals, you name it. Show a portfolio primarily of interaction between people first, concept photography second, product photography third."

***HADASSAH MAGAZINE**, 50 West 58th St., New York NY 10019. (212)355-7900. Photo Editor: Pearl Weisinger. Magazine about Zionism and world Jewish concerns. Buys 50-75 photos/year. Photos used in magazines.

Subject Needs: Israel and Jewish topics.

Specs: Uses 5x7 glossy b&w prints, 35mm transparencies.

Payment & Terms: Pays $50/b&w photo; $75/color photo. Credit line given. Buys one-time rights. Captions preferred.

Making Contact: Query with samples. SASE. Reports in 1 month.

Tips: Prefers to see interesting, fresh approaches to photographing Isreal and Jewish life in general. "The larger the sample, the better the chances we'll like something. However, please note that we mainly deal with established freelance contacts."

***HAMPDEN-SYDNEY COLLEGE**, Box 637, Hampden-Sydney VA 23943-0637. (804)223-4382. Director of Publications: Richard McClintock. Provides 4-year Liberal Arts College. Buys 200 photos/year; gives 6 assignments/year. Photos used in brochures, newsletters, newspapers, audiovisual presentations, magazines, PR releases, and admissions marketing materials.

Subject Needs: Campus Life.

Specs: Uses b&w and color prints; 35mm and 2¼x2¼ transparencies; b&w contact sheets.

Payment & Terms: Pays $1.50-15/b&w photo; $25-30/color photo; $250-1,000/job. Credit line given. Buys all rights "but can be arranged with photographer." Model release required; captions preferred.

Making Contact: Query with samples, business card, brochure, flyer or tearsheet to be kept on file for possible future assignments. Usually deals with local freelancers only. SASE. Reports in 2 weeks.

HARPER & ASSOCIATES, INC., #101, 2285 116th Ave. NE, Bellevue WA 98004. (206)462-0405. Office Manager: Kelley Wood. Design studio/ad agency. Buys 100-200 freelance photos/year; gives 50-100 freelance assignments/year. Photos used in brochures, newsletters, posters, audiovisual presentations, annual reports, and catalogs.

Subject Needs: People and/or products.

Specs: Open. Uses freelance filmmakers when clients' needs dictate.

Payment & Terms: Payment depends on use based on ASMP rates. Credit line "sometimes" given. Rights purchased depends on use of photo. Model release required.

Making Contact: Query with samples; interested in stock photos. SASE. Reports generally in 2 weeks, depending on work load.

Tips: "We like to see creative solutions to mundane situations. We're using more dramatic shots these days. Show us your best work and don't bug us too much."

HIMARK ENTERPRISES, INC., 155 Commerce Dr., Hauppauge NY 11787. (516)273-3300. Contact: Advertising/Catalog Coordinator: Sharon Fling. Manufactures giftware and housewares. Buys "hundreds" of freelance photos/year.

Subject Needs: Products.

Specs: Uses 5x7 and 8x10 b&w and color prints; b&w and color contact sheets and b&w and color negatives.

Payment: Payment is based on competitive finding. Buys all rights.
Making Contact: Query with samples. Deals with local freelancers only. Provide business card to be kept on file for possible future assignments. Notifies photographer if future assignments can be expected. SASE. Reports in 1 week.

HUDSON COUNTY DIVISION OF CULTURAL AND HERITAGE AFFAIRS, County Administration Building, 114 Clifton Place, Jersey City NJ 07304. (201)659-5062. Director: Celeste Oranchak. Needs photos of its project (usually public events). Photos used in brochures and reports. Gives 6-12 assignments/year. Provide resume to be kept on file for possible future assignments. "We prefer to employ residents of New Jersey, particularly residents of Hudson County. Each photographer is employed for a minimum of 1 day. Fees are negotiated directly with the photographer and the Director of this division." Query with samples. Prefers to see non-returnable b&w 8x10 or 5x7 shots of indoor/outdoor events and some portraits. SASE. Reports "within the week."
B&W: Uses 8x10 prints.

IDAHO DEPARTMENT OF PARKS & RECREATION, Statehouse Mail, Boise ID 83720. (208)334-2154. Information Chief: Rick Just. Uses photos of Idaho park and recreation activities and events. Photos used in brochures, newsletters, audiovisual presentations, research studies and reports. "We are producing more and more slide programs and others in the tourism industry seem to be doing the same." No payment. Credit line given whenever possible. Query with list of stock photo subjects, send material by mail for consideration, or telephone. SASE. Reports in 2 weeks.
B&W: Uses 8x10 glossy prints; negatives OK.
Color: Uses transparencies.
Tips: "We simply do not have a budget for buying or assigning photographs. We do offer a credit line for a picture used. We need transparencies (35mm) or b&w glossies of activities in state parks, and scenics in and near the state parks. We need stock photos of outdoor recreation activities, urban, rural, wilderness, etc., from throughout Idaho. We're looking for photos that convey life or movement—people having fun. Transparencies are used in slide presentations (credit not always possible) and for display prints and article illustrations. We need horizontal shots (even of vertical objects and scenes) particularly. Duplicates are preferred over originals."

***ILLINOIS BENEDICTINE COLLEGE**, 5700 College Rd., Lisle IL 60532. Director of Communication: Gerry Czerak. Provides higher education and athletics. Buys 150-200 photos/year; gives 12-15 assignments/year. Photos used in brochures, audiovisual presentations, catalogs, magazines, and PR releases.
Subject Needs: On-campus activity; symbolic stock photos of educational activity by adults. College sports—classrooms and campus activities—special events.
Specs: Uses 5x7 glossy b&w prints; 35mm transparencies; b&w contact sheets; b&w negatives.
Payment & Terms: Pays $5/b&w photo, $30-50/hour. Credit line given in magazine only. Buys one-time rights or all rights. Model release preferred, required for ads; captions preferred.
Making Contact: Query with resume of credits, query with list of stock photo subjects. Deals with local freelancers only; interested in stock photos. Does not return unsolicited material. Reports in 3 weeks.
Tips: Prefer available-light candids when possible.

INDUSTRIAL FABRICS ASSOCIATION INTERNATIONAL, Suite 450, 345 Cedar Building, St. Paul MN 55101. (612)222-2508. Contact: Director of Publications. Publishes *Window Fashions Magazine*, a design and merchandising publication for window treatment retailers; *Industrial Fabric Products Review*, a trade publication for manufacturers of fabric products (tents, awnings, hot air balloons, etc.); and *Geotechnical Fabrics Report*, a trade bimonthly for engineers and specifiers of ground fabrics; *Marine Textiles*, a trade bimonthly for marine fabricators. Buys 30 photos/year; gives 15-20 assignments/year. Photos used in brochures and magazines.
Subject Needs: Photos of "commercial and residential interiors; photos of presidents, employees in their workplaces; fabric products/applications (from sails to camping tents, sport dome covers to soft luggage)."
Specs: Uses 5x7 glossy b&w prints; 35mm, 2¼x2¼, 4x5 and 8x10 transparencies; b&w contact sheets.
Payment & Terms: Pays $25/b&w photo; $35/color photo; $30-75/hour; $200-300/day; $100-300/job. Credit line given. Buys one-time rights.
Making Contact: Query with list of stock photo subjects; send photos by mail for consideration; or submit portfolio for review. Solicits photos by assignment only. Interested in stock photos. SASE. Reports in 2 weeks.
Tips: "Request review copies of our publications."

INNOVATIVE DESIGN & GRAPHICS, Suite 252, 708 Church St., Evanston IL 60201. Art Director: Maret Thorpe. Photos used in magazines, newsletters, and catalogs.

Subject Needs: Product shots, people shots, and topical shots for magazines.

Specs: Uses 8x10 glossy b&w prints, 35mm, 2¼x2¼, and 4x5 transparencies, b&w contact sheets, and b&w negatives.

Payment & Terms: Payment per job negotiated individually. Credit line given. Buys one-time rights or all rights. Model release required; captions preferred.

Making Contact: Provide resume, business card, brochure, flyer or tearsheets to be kept on file for possible future assignments. Solicits photos by assignment only. Interested in stock photos. SASE. "Reports when applicable assignment is available."

Tips: "We look for crisp photos to illustrate ideas, clear photos of products and products in use, and relaxed photos of business people at work. We prefer that freelancers submit work produced on larger-format equipment. Never call."

INTERNATIONAL RESEARCH & EDUCATION (IRE), 21098 IRE Control Center, Eagan MN 55121. IP Director: George Franklin, Jr. IRE conducts in-depth research probes, surveys, and studies to improve the decision support process. Company conducts market research, taste testing, brand image/usage studies, premium testing, and design and development of product/service marketing campaigns. Buys 75-110 photos/year; gives 50-60 assignments/year. Photos used in brochures, newsletters, posters, audiovisual presentations, annual reports, catalogs, PR releases, and as support material for specific project/survey/reports.

Subject Needs: "Subjects and topics cover a vast spectrum of possibilities and needs."

Specs: Uses prints (15% b&w, 85% color), transparencies and negatives. Uses freelance filmmakers to produce promotional pieces for 16mm or videotape.

Payment & Terms: Pays on a bid, per job basis. Credit line given. Buys all rights. Model release required.

Making Contact: Provide resume, business card, brochure, flyer or tearsheets to be kept on file for possible future assignments; "materials sent are put on optic disk for options to pursue by project managers responsible for a program or job." Solicits photos by assignment only. Does not return unsolicited material. Reports when a job is available.

Tips: "We look for creativity, innovation, and ability to relate to the given job and carry-out the mission accordingly."

AL KAHN GROUP, 221 W. 82 St., #PH-N, New York NY 10024. President: Al Kahn. Produces corporate I.D., brochures, annual reports and advertising. Buys 100 photos/year; gives 20 assignments/year. Photos used in brochures, posters, annual reports, and magazines.

Subject Needs: Conceptual designs.

Specs: Uses prints, transparencies, contact sheets and negatives.

Payment & Terms: Pays $500-3,000/b&w photo; $500-3,000/job. Credit line given. Buys one-time rights. Model release required.

How to Contact: Query with samples, send unsolicited photos by mail for consideration, or submit portfolio for review. SASE. Reports when project is assigned.

***KOEN PHOTOGRAPHY**, 2222 Broadway, Lubbock TX 79401. (806)762-8755. Owner: Don Burnett. Clients: University yearbooks.

Needs: Works with 4 freelance photographers/month. Uses photographers for university photos.

First Contact & Terms: Query with samples. Works with freelancers by assignment only. Does not return unsolicited material. Reports back on photos as needed. Pays by day rates; based on experience. Buys all rights.

LA CROSSE AREA CONVENTION & VISITOR BUREAU, Box 1895, Riverside Park, La Crosse WI 54602-1895. (608)782-2366. Administrative Assistant: Mary Waldsmith. Provides "promotional brochures, trade show and convention planning, full service for meetings and conventions." Buys 8 + photos/year; gives "several" assignments/year "through conventions. Conventions also buy photos." Photos used in brochures, newspapers, audiovisual presentations and magazines.

Subject Needs: "Scenic photos of area; points of interest to tourists, etc."

Specs: Uses 5x7 glossy b&w prints and color slides.

Payment & Terms: Payment depends on size/scope of project. Credit line given "where possible." Buys all rights. Model release required; captions preferred.

Making Contact: Provide resume, business card, brochure, flyer or tearsheets to be kept on file for possible future assignments. Deals with local freelancers only. Solicits photos by assignment only. Does not return unsolicited material. Reports in 3 weeks.

***LAMBUTH COLLEGE**, Lambuth Blvd., Jackson TN 38301. (901)427-1500. Director of Information: Sue Ann Tanzer Roberts. Provides brochures and viewbook, annual report. Buys 450 photos/year; gives

4-5 assignments/year. Photos used in catalogs, PR releases, brochures, newsletters, and newspapers, audiovisual presentations, annual reports.
Subject Needs: Special events.
Specs: Uses 8x10 glossy b&w and color prints; 35mm transparencies; b&w and color contact sheets.
Payment & Terms: Pays $4/b&w photo; $7/color photo; $45/hour. Credit line sometimes given. Buys all rights. Model release and captions required.
Making Contact: Arrange a personal interview to show portfolio; query with resume of credits; query with samples; query with list of stock photo subjects; send unsolicited photos by mail for consideration; submit portfolio for review; provide resume, business card, brochure, flyer or tearsheets to be kept on file for possible future assignments. Solicits photos by assignment only. Interested in stock photos. SASE. Reports quarterly.

LONG BEACH SYMPHONY ASSOCIATION, Suite 510, 117 E. 8th St., Long Beach CA 90813. (213)436-3203. Uses photos of musicians, concerts, audiences and special events. Photos used in brochures, newsletters, newspapers, posters, PR releases and magazines. Gives 1-20 assignments/year. Payment negotiated. Credit line given. Buys all rights. Query with samples. Buys photos by assignment only. SASE. Reports in 1 month.
B&W: Uses 5x7 or 8x10 glossy prints.
Color: Uses prints or slides.
Film: "We have not yet begun to explore this area, but we would be interested in queries from filmmakers."
Tips: "We are very interested in working with freelancers who have experience in performance photography and special event/social occasions."

***LORENCO INTERNATIONAL**, Box 1055, Danville IL 61832. Planning Manager: Loren Harrison. Provides lingerie and hosiery, romantic novels, books and magazines. Buys 100 photos/year; gives 12 assignments/year. Photos used in brochures, newsletters, audiovisual presentations, catalogs, magazines, books.
Subject Needs: Lingerie and hosiery, romantic "natural action."
Specs: Uses 4x5 color prints; 4x5 transparencies; color contact sheets, b&w and color negatives. Uses freelance filmmakers for 16mm promotional film.
Payment & Terms: Pays $75/b&w photo; $100/color photo; $29-100/hour; $150-600/day; $200-1,200/job. Buys one-time rights or all rights. Model release preferred.
Making Contact: Send unsolicited photos by mail for consideration. Interested in stock photos. Does not return unsolicited material. Reports in 1 month.
Tips: "Don't get disheartened, try again. Don't give up."

ROB MACINTOSH COMMUNICATIONS, INC., 93 Massachusetts Ave., Boston MA 02115. Creative Services Director: Jamie Scott. Buys 50 photos/year; gives 24 assignments/year. Photos used in brochures, posters, audiovisual presentations, annual reports, catalogs, magazines, and PR releases.
Subject Needs: "We need photos of people."
Specs: Uses 8x10 glossy b&w prints, 35mm, 2¼x2¼, 4x5 and 8x10 transparencies, b&w contact sheet and negatives.
Payment & Terms: Pays $200-1,800/day; per job rate varies. Use of credit line depends on job and client. Buys one-time rights. Model release required.
Making Contact: Provide resume, business card, brochure, flyer or tearsheets to be kept on file for possible future assignments; interested in stock photos. SASE.
Tips: "There is an increasing demand on the photographer to reach beyond the expected and come up with technical solutions that challenge the viewer."

***MANHATTAN COLLEGE**, Manhattan College Parkway, Riverdale NY 10471. (212)920-0231. Director of College Relations: Lydia Arena. Handles in-house and outside publicity for the college. Photos used in brochures and newsletters.
Subject Needs: Pictures of events.
Specs: Uses b&w prints, contact sheets and negatives; and 35mm transparencies.
Payment & Terms: Pays by the hour; rates negotiable. Buys all rights.
Making Contact: Query with resume of credits; arrange a personal interview to show portfolio. Deals with local freelancers only. SASE. Reports ASAP.

***MARYCREST COLLEGE**, 1607 W. 12th St., Davenport IA 52804. (319)326-9253. Contact: PR Director. Photos used in brochures, posters and catalogs.
Subject Needs: Students, classes.
Specs: Uses b&w and color prints; "any" contact sheets; b&w and color negatives.

Payment & Terms: Payment negotiated. Credit line negotiable. Buys one-time rights or all rights, depending on photo usage. Captions preferred.

Making Contact: Call with queries; will discuss needs. Deals with local freelancers only. Reports on queries depending on needs.

Tips: In samples, wants to see teacher helping students, students at work in classroom. "I'd like to see some new and exciting ways to depict classrooms. Show me education pictures."

MENLO COLLEGE, 1000 El Camino Real, Atherton CA 94025. (415)323-6141. Public Information Officer: Penny Hill. Small, independent college. Uses photos of general campus life in brochures, newsletters, posters, direct-mail pieces and catalogs. Buys 150-200 photos/year; gives 4-5 assignments/year. Local freelancers only. Pays competitive local rates; buys all rights. Mail samples and business card, then call to arrange personal interview to show portfolio. Prefers to see photos of people doing things in work or school environment as sample. Notifies photographer if future assignments can be expected. Will not return unsolicited material.

B&W: Uses 8x10 glossy prints; contact sheets required.

Color: Uses 35mm and larger transparencies; negotiates rights.

Tips: "Our opportunities are for local freelancers with a strong photojournalistic style. Our freelancers must excel as 'people' photographers."

***METHODIST COLLEGE**, 5400 Ramsey St., Fayetteville NC 28301. (919)488-7110, ext. 246. Director of Public Information and Publications: Al Robinson. Buys 500 photos annually; gives 25-50 assignments/year. Photos used in brochures, newsletters, posters, newspapers, audiovisual presentations, annual reports, catalogs, magazines, PR releases, recruitment literature ($100,000 package) every 2 years.

Subject Needs: College events, student life, athletics, visitors, fine arts perfomance.

Specs: Uses 5x7 b&w and color prints; 35mm transparencies; b&w and color contact sheets; b&w and color negatives.

Payment & Terms: Pay negotiated. Credit line given. Buys all rights. Model release required.

Making Contact: Arrange a personal interview to show portfolio; send unsolicited photos by mail for consideration; provide resume, business card, brochure, flyer or tearsheets to be kept on file for possible future assignments. Solicits photos by assignment only. SASE. Reports in 3 weeks.

Tips: Prefers to see photos with pzazz, punch—pics that really are *eye-catching and vibrant!* "We are just now getting into this area; limited budget—we can give you a good outlet if you are a beginner."

THE MINNESOTA OPERA, Suite 20, 400 Sibley St., St. Paul MN 55101. (612)221-0122. Public Relations: Kathy Davis. Produces three opera productions, one new works festival and a Broadway musical revival each year. Buys 30 photos/year; gives 5 assignments/year. Photos used in brochures, posters, and PR releases/publicity.

Subject Needs: Operatic productions.

Specs: Uses 5x7 glossy b&w prints and 35mm slides.

Payment & Terms: Pays $3-5/b&w photo; $6-10/color photo; $15-25/hour; $150-300/job. Credit line given. Model release preferred; captions required.

Making Contact: Send unsolicited photos by mail for consideration; provide resume, business card, brochure, flyer or tearsheets to be kept on file for possible future assignments. Deals with local freelancers only. Does not return unsolicited material. Reporting time depends on needs.

Tips: "We look for photography which dynamically conveys theatrical/dramatic quality of opera with clear, crisp active pictures. Photographers should have experience photographing theater and have a good sense of dramatic timing."

***MOUNT VERNON NAZARENE COLLEGE "COMMUNICATOR"**, Martinsburg Rd., Mount Vernon OH 43050. (614)397-1244, ext. 222. Assistant Director of College Relations: Jan Hendrickx. The "Communicator" manufactures a college publication. Photos used in brochures, newsletters, posters, newspapers, audiovisual presentations, catalogs, magazines, PR releases and media guides for athletic teams.

Subject Needs: Subjects include: "looking at any photos relating to college. Our cover shots vary from issue to issue."

Specs: Uses 5x7 glossy b&w prints; b&w negatives; 35mm transparencies.

Payment & Terms: Pays by the job. Captions preferred.

Making Contact: Provide resume, business card, brochure, flyer or tearsheets to be kept on file for possible future assignments. Solicits photos by assignment only. SASE. Reports in 1 month.

Tips: "Be creative, we are looking for ways to give our publication an unique look—especially on the cover."

Close-up

Kathy Davis
Marketing and Public Relations Director
The Minnesota Opera
St. Paul, Minnesota

Theatrical photography, says Kathy Davis, marketing and public relations director of The Minnesota Opera, "affords photographers opportunity to catch moments of artistic brilliance, be it the singers, the sets, the costumes or the lighting." Davis, who began her career as assistant marketer/ PR coordinator for Central City Opera (Colorado) and continued on as marketing/PR director of the Virginia Opera, is familiar with the problems and successes photographers have shooting theater productions. The challenge, she explains, lies in the continually changing light levels.

What qualities do photographers need for this type of work? The ability to shoot quickly, Davis cites. In fast-paced works, like Mozart, one needs to shoot very fast to get a solid cross-section of photos representative of the opera. "I look for a photographer who is experienced

The Minnesota Opera/St. Paul Chamber Orchestra production of "Where The Wild Things Are" presented a challenge to the photographer in terms of capturing each scene's mood under varying lighting.

in shooting indoors, under diverse lighting; for someone who shows flair and accuracy in capturing the best parts of a show; and for someone who shoots dynamically sharp black and white photos, which we use most often." In addition to technical skills, there is a certain diplomacy and sensitivity needed when working around the artists, she adds. This means staying quiet during rehearsals and being as unobtrusive as possible when shooting.

Davis suggests that photographers interested in developing the appropriate skills for theater photography shoot alongside another, more experienced, photographer. Recently, she says, a photographer skilled in shooting outdoors requested permission to take photos of a Minnesota Opera production. "He got several helpful hints from our experienced photographer, then practiced during a dress rehearsal. After two 3-hour sessions, he had really begun to shoot according to the varying light levels." Also helpful, Davis says, is to read a synopsis of the opera or play you're interested in photographing to provide an orientation. Listening to a record or broadcast also would be helpful, she suggests.

One of the more memorable productions that stands out in Davis' mind, photographically speaking, is the September/October 1985 production of "Where the Wild Things Are," an American premiere based on the children's book by Maurice Sendak. "The creatures, sets and lighting were a visual extravaganza, and our photographer had a 'hey-day'," Davis recounts. "His photos had to capture the detail of the creatures and sets plus the beauty of the lighting...and they did. They were not only clear and crisp, but also a full, true reflection of the opera." The photos were reproduced by *Time* magazine, *USA Today* and the *Chicago Tribune*, she says.

According to Davis, there is a market for photographers entering this particular field. "There is an abundance of opportunity for theatrical photographers. Newspapers and magazines depend on good, crisp, dynamic photos to accompany stories and reviews. A visual is always of help in getting a story placed!"

MSD AGVET, Division of Merck and Co. Inc., Box 2000, Rahway NJ 07060. (201)574-4000. Manager, Marketing Communications: Gerald J. Granozio. Manufacturers agricultural and veterinary products. Buys 20-75 freelance photos/year. Photos used in brochures, posters, audiovisual presentations and advertisements.
Subject Needs: Agricultural—crops, livestock and farm scenes.
Specs: Uses 35mm, 2¼x2¼, 5x5 and 8x10 slides.
Payment/Terms: Pays $150-200/b&w; $200-400/color photo. Buys one-time rights. Model release required; captions preferred.
Making Contact: Query with samples or with a list of stock photo subjects; interested in stock photos; provide brochure and flyer to be kept on file for possible future assignments. Notifies photographer if future assignments can be expected. SASE. Reports in 2 weeks.

THE NATIONAL ASSOCIATION FOR CREATIVE CHILDREN & ADULTS, 8080 Springvalley Dr., Cincinnati OH 45236. Editor: Ann S. Isaacs. Ball State University, Muncie IN 47306. Photos used for brochures, newsletters, magazines and books. Needs photos on people (portraits and persons engaged in creative activities). Credit line given. Model release required and captions preferred. Query with samples. SASE. Pays only in copies of *The Creative Child and Adult* quarterly and other publications.

NATIONAL ASSOCIATION OF EVANGELICALS, Box 28, Wheaton IL 60189. (312)665-0500. Executive Editor: Don Brown. Produces a magazine centered on news events of a religious nature. Buys 25 photos/year. Photos used in brochures, posters, and magazines.
Subject Needs: Leaders in the evangelical community addressing or involved in some current issue or newsworthy event; people involved in marches, prayer vigils, and protests that have a religious/political slant.
Specs: Uses 5x7 glossy b&w prints.
Payment & Terms: Pays $40/b&w photo. Credit line given. Buys one-time rights. Model release required; captions preferred.
Making Contact: Query with samples or list of stock photo subjects; provide resume, business card,

brochure, flyer or tearsheets to be kept on file for possible future assignments; interested in stock photos. SASE. Reports in 3 weeks.

Tips: "We prefer photos that have a news or photojournalistic feel. We are looking for the *best* in b&w."

NATIONAL ASSOCIATION OF LEGAL SECRETARIES, Suite 550, 2250 E. 73rd St., Tulsa OK 74136. (918)493-3540. Publications Director: Tammy Hailey. Publishes "an association magazine—for providing continuing legal education along with association news." Buys 6 photos/year; gives 6 assignments/year. Photos used in magazine.
Subject Needs: Needs legal, secretarial photos.
Specs: Uses b&w prints and 35mm transparencies. Uses freelance filmmakers to produce educational and promotional slideshows.
Payment & Terms: Pays $20-100/job. Credit line given. Rights purchased vary with photos.
Making Contact: Query with list of stock photo subjects. Deals with local freelancers only. Interested in stock photos. Does not return unsolicited material. Reports in 1 week.

***NATIONAL BLACK CHILD DEVELOPMENT INSTITUTE**, 1463 Rhode Island, Ave., NW, Washington DC 20005. (202)387-1281. Deputy Director: Vicki D. Pinkston. Buys photos/year. Photos used in brochures, newsletters, newspapers, annual reports and annual calendar.
Subject Needs: Subjects include: candid, action photos of black children and youth.
Specs: Uses 5x7 or 8x10 glossy b&w prints and b&w contact sheets.
Payment & Terms: Pays $25/cover photo and $15/inside b&w photo. Credit line given. Buys one-time rights. Model release required.
Making Contact: Query with samples; send unsolicited photos by mail for consideration. Interested in stock photos. SASE. Reports in 1 month.
Tips: "Candid, action photographs of one black child or youth or a small group of children or youths. Most photographs selected are used in annual calendar and are placed beside an appropriate poem selected by organization, therefore, photograph should communicate a message in an indirect way. Obtain sample of publications published by organization to see the type of photographs selected."

***NATIONAL DUCKPIN BOWLING CONGRESS**, Fairview Ave., Baltimore-Linthicum MD 21090-1466. (301)636-2695. Executive Director: Manuel S. Whitman. "We are a national organization of people who enjoy the game of Duckpin bowling. We provide a wide-range of services to our members." Buys "a few photos," as needed/year; gives 2 assignments/year. Photos used in brochures, newsletters, posters, and newspapers.
Subject Needs: Pictures of people enjoying the game of Duckpin bowling.
Specs: Specifications vary from job to job.
Payment & Terms: "We pay freelance photographers on an individual job basis." Credit line given. Buys all rights. Model release and captions preferred.
Making Contact: Provide resume, business card, brochure, flyer or tearsheets to be kept on file for possible future assignments. "We don't want freelance photographers contacting us—we maintain a file and will contact them when needed." Interested in stock photos. Does not return unsolicited material. Reports in 3 weeks.

NATIONAL FUND FOR MEDICAL EDUCATION, 999 Asylum Ave., Hartford CT 06105. (203)278-5070. Development and Publications Manager: Marla J. Driscoll. Buys 6-10 freelance photos annually. Photos used in newsletters, annual reports and special reports.
Subject Needs: Medical students in educational settings.
Specs: B&w contact sheet.
Payments & Terms: Payment negotiable. Works on assignment only basis. Credit line given. Model release necessary.
Making Contact: Query with list of stock photo subjects or send unsolicited photos by mail for consideration. SASE. Reports in 1 month.

NATIONAL HOT DOG & SAUSAGE COUNCIL, Suite 1100, 1211 W. 22nd St., Oak Brook IL 60521. (312)986-6224. Executive Secretary: Fran Altman. Photos used in newsletters and PR releases.
Subject Needs: "We purchase specialized topics: prefer photos of current head of state, US President, etc. eating a hot dog. Would consider other famous persons of current interest, movie stars, etc. eating a hot dog."
Specs: B&w prints.
Payment & Terms: Pays $100/b&w photo. Credit line given. Buys all rights. Captions preferred.
Making Contact: Query before sending photo.

***NATIONAL SAFETY COUNCIL**, 444 N. Michigan Ave., Chicago IL 60611. (312)527-4800. Editor: Roy Fisher. Clients: business, industrial and consumer.

Needs: Uses photographs for magazines and books. Subjects include aspects of home and traffic safety, health problems and solutions.
Specs: Uses 8x10 glossy b&w and color prints; 35mm and 2¼x2¼ transparencies.
First Contact & Terms: Provide resume, business card, self-promotion piece or tearsheets to be kept on file for possible future assignments. Works with local freelancers by assignment; interested in stock photos. SASE. Reports in 1 month. Pay negotiated. Pays on acceptance. Buys one-time rights or all rights "varies with project or subject." Model release required. Credit line given if requested.
Tips: "Images should be technically excellent and be bold and dramatic in composition and lighting. No mundane, routine images, please." In general, look for technical excellence and ability to compose and create drama visually from mundane situations.

***NEW HAMPSHIRE COLLEGE**, 2500 N. River Rd., Manchester NH 03104. (603)668-2211 ext. 380, 385. Assistant Director of Public Relations: Clifford Gallo. Provides education through news release, alumni newspapers and marketing pieces for the college. Buys various photos/year; gives various assignments/year. Photos used in brochures, newsletters, newspapers, catalogs, PR releases and viewbooks.
Subject Needs: College and student life, athletics.
Specs: Uses 5x7 glossy b&w prints; 35mm transparencies; b&w contact sheets.
Payment & Terms: Credit line given in most cases. Buys all rights.
Making Contact: Provide resume, business card, brochure, flyer or tearsheets to be kept on file for possible future assignments. Deals with local freelancers only and solicits photos by assignment only. Does not return unsolicited material. Reports in 1 month.

OHIO BALLET, 354 E. Market St., Akron OH 44325. (216)375-7900. Contact: Marketing Director. Uses photos of performances and rehearsals and shots of backstage and studio as well as posed business shots. Photos used in brochures, newsletters, newspapers, audiovisual presentations, posters, catalogs, PR releases, magazines, and also for public display and in advertising. Buys 80 photos/year. Credit line given. Pays $2-8/b&w and color photo; negotiable per hour. Buys all rights. Model release required. Query with samples; prefers samples of dance performances. Usually deals with local freelancers. No material returned. Reports in 3 weeks.
B&W: Uses 8x10 glossy prints; contact sheet OK.
Color: Uses 35mm transparencies.

***OPTOMETRIC EXTENSION PROGRAM FOUNDATION**, 2912 S. Daimler, Santa Ana CA 92705. Publications Director: Freda Wyant. Provides continuing education for optometrists (journals, booklets), consumer education (pamphlets, slide shows). Buys 2-6 photos/year; gives 1-2 assignments/year. Photos used in brochures, newsletters, posters, audiovisual presentations, catalogs, PR releases.
Subject Needs: People performing visual tasks.
Specs: Uses b&w prints, b&w and color contact sheets.
Payment & Terms: Pay negotiated. Buys all rights.
Making Contact: Provide resume, business card, brochure, flyer or tearsheets to be kept on file for possible future asignments. Solicits photos by assignment only. SASE. Reports in 1 month.
Tips: Know a little about stress-relieving lenses and the symptoms associated with visual stress.

***ORLANDO PRODUCTS CO.**, 6309 Elinore Ave., Baltimore MD 21206. (301)254-0121. President: Sam Orlando. Buys 6 photos/year; gives 6 assignments/year. Photos used for brochures, catalogs, PR releases.
Subject Needs: New products.
Specs: Uses color prints, transparencies, color negatives. Works with freelance filmmakers.
Payment & Terms: Pay negotiated.
Making Contact: Provide resume, business card, brochure, flyer or tearsheets to be kept on file for possible future assignments. Deals with local freelancers only. SASE. Reports in 2 weeks.

***PACIFIC NORTHWEST DESIGN & DISPLAY LTD.**, 331-1830 Fern St., Victoria, British Columbia, Canada V8R 4K3. (604)595-4217. President: Brock R. Bailey. Industrial Art Director: Richard A. Skene. Clients include Expo '86 and Expo '88, Province of British Columbia Local & International Corporations, Retail, Tourism, Transportation. Works with freelance/professional photographers. Uses photos for newspapers, magazines, posters, direct mail, brochures, advertising, audiovisual, display units, post cards.
Specs: Uses 11x14 standard or larger matte-finish b&w prints; 35mm, 2¼x2¼, 4x5 or 8x10 color transparencies.
Payment & Terms: All rates are set by this agency; pays for work requested upon agency acceptance. Buys all rights unless otherwise agreed upon in writing. Model release required.

Making Contact: Send us a sample of your work on 35mm color slides for files with resume and client list (these will not be returned).
Tips: "Full range of work, including male/female nudes, commercial products."

PALM SPRINGS CONVENTION AND VISITORS BUREAU, Airport Park Plaza, Suite 315, 255 N. El Cielo Rd., Palm Springs CA 92262. (619)327-8411. News Bureau Manager: Gary Sherwin. "We are the tourism promotion entity of the city." Buys 50 freelance photos/year; gives 20 assignments/year. Photos used in brochures, posters, newspapers, audiovisual presentations, magazines and PR releases.
Subject Needs: "Those of tourism interest . . . specifically in the City of Palm Springs."
Specs: Uses 8x10 b&w prints; 35mm slides; b&w contact sheet and negatives OK. "We buy only transparencies in color and 35mm."
Payment & Terms: Pays $25/b&w photo; $40-75/hour. Buys all rights—"all exposures from the job. On assignment, we provide film and processing. We own all exposures." Model release and captions required.
Making Contact: Query with resume of credits or list of stock photo subjects. Provide resume, business card, brochure, flyer, and tearsheets to be kept on file for possible future assignments. Notifies photographer if future assignments can be expected. SASE. Reports in 2 weeks.
Tips: "We will discuss only photographs of Palm Springs, California. No generic materials will be considered."

***PEPPERDINE UNIVERSITY**, 24255 Pacific Coast Hwy., Malibu CA 90265. (213)456-4181. Director: Frederick Mollner. Creative Director: Leah Van Vranken. Provides student recruitment, fund raising and student support publications. Gives 6-10 assignments/year. Photos used in brochures, newsletters, posters, annual reports, catalogs, and magazines.
Subject Needs: On-campus shots, students and buildings; theme photos for annual report; editorial for magazine and waves.
Specs: Uses 8x10 glossy b&w prints.
Payment & Terms: Pays $350-800/day; per photo is negotiable. Credit line given only in magazine and annual report. Buys all rights.
Making Contact: Arrange a personal interview to show portfolio; query with list of stock photo subjects; provide resume, business card, brochure, flyer or tearsheets to be kept on file for possible future assignments. Deals with local freelancers only; interested in stock photos. SASE. Reports in 1 week.
Tips: Prefers to see good candid people shots, b&w and color; interesting angles and lighting on building photos. "We are looking for beginning photographers (usually) with obvious talent and poetential, but with reasonable prices."

PGA OF AMERICA, 100 Ave. of Champions, Palm Beach Gardens FL 33418. (305)626-3600. Editor/Advertising Sales Director: W.A. Burbaum. Services 13,000 golf club professionals and apprentices nationwide. Photos used for brochures, posters, annual reports and monthly feature magazine.
Subject Needs: Special needs include golf scenery, good color action of amateurs as well as tour stars. Buys 50 freelance photos and gives 15 freelance assignments annually.
Payment & Terms: Pays $25 minimum/b&w photo; $50-200/color photo; and $300-375/day. Credit line negotiable. Buys one-time rights. Model release preferred.
Making Contact: Arrange personal interview to show portfolio and query with list of stock photo subjects. Prefers to see 35mm slides in the portfolio. Provide tearsheets to be kept on file for possible future assignments. Notifies photographer if future assignments can be expected. SASE. Reports in 2 weeks.
Tips: Prefers to see cover/gee whiz, good (inside) golf action, photo essay approach.

***PHI DELTA KAPPA**, 8th & Union Sts., Box 789, Bloomington IN 47402. Design Director: Kristin Herzog. Provides Phi Delta Kappan magazine and supporting materials. Buys 10 photos/year; gives 3 assignments/year. Photos used in magazines, flyers, and subscription cards.
Subject Needs: Teachers, classroom, high school students. Model release required.
Specs: Uses 8x10 b&w prints, b&w contact sheets.
Payment & Terms: Pays $25/b&w photo; $10/hour; $100/job. Credit line given. Buys one-time rights. Model release "absolutely" required.
Making Contact: Query with list of stock photo subjects; provide photocopies, brochure or flyer to be kept on file for possible future assignments. Interested in stock photos. SASE. Reports in 3 weeks.
Tips: "Don't start arguing about rights before you understand the assignment and how your photos will be used. I'm finding that most new photographers have read lots about protecting their rights and very little about how to work with an art director."

***PORTLAND-THE UNIVERSITY OF PORTLAND MAGAZINE**, 5000 N. Willamette Blvd., Portland OR 97203. (503)283-7202. Editor: John A Soisson. Manufactures a quarterly, 36 page magazine. Buys

Carl R. Pope Jr., an Indianapolis, Indiana, photographer, sold this photograph to Phi Delta Kappa, Inc. for use in their magazine. It appeared with an article titled "Women in Education." Pope also has sold it to another magazine and to an area health organization for use in their annual report. Phi Delta Kappan Photo Editor Kristin Herzog bought the photo from Pope's stock supply. "I chose it because it did a good job of capturing moods."

20 photos/year; gives 5 assignments/year. Photos used in magazines.
Subject Needs: Subjects include: people.
Specs: Uses 8x10 glossy b&w prints; b&w contact sheets; 35mm and 2¼x2¼ transparencies.
Payment & Terms: Pays $50-75/hour. Credit line given. Buys one-time rights. Model release preferred.
Making Contact: Query with resume of credits; query with list of stock photo subjects. Solicits photos by assignment only; interested in stock photos. SASE. Reports in 2 weeks.
Tips: "Our needs are fairly specific. Tell me how you can help me. We want strong, creative photos. Fewer mugs and 'grip and grins'. More interpretive photos. University magazines are a growing market for first rate photography. Our needs are not extensive. A good promotional brochure gives me someone to contact in various areas on various subjects."

POSEY SCHOOL OF DANCE, INC., Box 254, Northport NY 11768. (516)757-2700. President: Elsa Posey. Sponsors a school of dance, and a regional dance company. Buys 6-10 photos/year; gives 3 assignments/year. Photos used in brochures and newspapers.
Subject Needs: Dancers dancing and at rest.
Specs: Uses 8x10 glossy b&w prints.
Payment & Terms: Payment negotiated individually. Credit line given if requested. Buys one-time rights. Model release required.
Making Contact: "Call us." Solicits photos by assignment only. Interested in stock photos. SASE. Reports in 1 week.

PULPDENT CORPORATION, 75 Boylston St., Brookline MN 02146. Advertising Manager: Jane Hart Berk. Manufacturers dental supplies. Buys 10-25 photos/year; gives 10 assignments/year. Photos used in brochures, catalogs, magazines, and PR releases.
Subject Needs: Product photos.
Specs: Uses 5x7 glossy b&w prints, b&w contact sheets, and b&w negatives.
Payment & Terms: Pays $25-150/b&w photo; $40-250/color photo; $675/day; payment negotiated individually. Credit line given "if appropriate." Buys exclusive product rights. Model release required.
Making Contact: Query with samples; provide resume, business card, brochure, flyer or tearsheets to

be kept on file for possible future assignments. Deals with local freelancers only. SASE. Reports in 3 weeks.

THE QUARASAN GROUP, INC., Suite 7, 1845 Oak St., Northfield IL 60093. (312)446-4777. Project Manager: Fran Simon. "A complete book publishing service including design of interiors and covers to complete production stages, art and photo procurement." Buys 250-300 photos/year; gives 10-15 assignments/year. Photos used in brochures and books.
Subject Needs: "Most products we produce are educational in nature. The subject matter can vary. For textbook work, male-female/ethnic/handicapped/minorities balances must be maintained in the photos we select to insure an accurate representation."
Specs: Prefers 8x10 b&w prints, 35mm, 2¼x2¼, 4x5, or 8x10 transparencies, or b&w contact sheets.
Payment & Terms: Fee paid is based on final use size. Pays $60-135/b&w photo; $100-200/color photo. Credit line given, but may not always appear on page. Buys exclusive use rights or other rights determined by publisher. Model release required.
Making Contact: Query with list of stock photo subjects or nonreturnable samples (photocopies OK); provide resume, business card, brochure, flyer or tearsheets to be kept on file for possible future assignments; interested in stock photos. Does not return unsolicited material. "We contact once work/project requires photos."
Tips: "Learn the industry. Analyze the books on the market to understand *why* those photos were chosen. Be organized and professional and meet the agreed upon schedules and deadlines. We are always looking for experienced photo researchers local to the Chicago area."

RECO INTERNATIONAL CORP., 138-150 Haven Ave., Port Washington NY 11050. (516)767-2400. President: Heio W. Reich. Manufactures gourmet kitchen accessories, collectors plates and lithographs. Buys 20-60 photos/year; gives 30-50 assignments/year. Photos used in brochures, newsletters, posters, newspapers, catalogs, magazines and PR releases.
Subject Needs: Product shots.
Specs: Uses 5x7 b&w and color prints and color negatives.
Payment & Terms: Payment determined by agreement. Buys all rights. Model release required. Query with resume of credits; provide resume, business card and flyer to be kept on file for possible future assignments. Does not return unsolicited material. Reports when needed.

RECREATIONAL EQUIPMENT, INC., Box C-88126, Seattle WA 98188. (206)575-4480. Contact: Sue Brockmann. Retailer of muscle-powered sporting goods. Buys varied amount of photos/year. Photos used for catalogs. Sample copy free with SASE.
Subject Needs: "We need mountain sports, scenics and outdoor shots for use as catalog covers."
Specs: Uses transparencies.
Payment & Terms: Buys one-time rights. Model release required.
Making Contact: Query with samples; provide resume, business card, brochure, flyer or tearsheets to be kept on file for possible future assignments. SASE. Reports in 4 weeks.
Tips: "Scenics with people doing muscle-powered sports are our main need."

RECREATION WORLD SERVICES, INC., Drawer 17148, Pensacola FL 32522. (904)478-4372. Executive Vice President: Ken Stephens. Serves publishers and membership service organizations. Buys 5-10 photos/year; gives 2-5 assignments/year. Photos used in brochures, newsletters, newspapers, magazines, PR releases.
Subject Needs: Recreation type.
Specs: Uses 3x4 prints. Buys all rights. Model release required; captions preferred.
Making Contact: Send unsolicited photos by mail for consideration; provide resume, business card, brochure, flyer or tearsheets to be kept on file for possible future assignments. SASE. Reports in 2 weeks.

REPERTORY DANCE THEATRE, Box 8088, Salt Lake City UT 84108. (801)581-6702. General Manager: Douglas C. Sonntag. Uses photos of dance company for promotion. Photos used in brochures, newspapers, posters, PR releases and magazines. Buys all rights. Local freelancers only. Arrange a personal interview to show portfolio. Prefers to see dance or movement photos. Queries by mail OK; SASE. Reports in 2 weeks.
B&W: Uses 8x10 glossy prints; contact sheet OK. Payment is negotiable.

***RIPON COLLEGE MAGAZINE**, Box 248, Ripon WI 54971. (414)748-8115. Director of College Relations: Andrew G. Miller. Provides higher education. Gives 10 assignments/year. Photos used in brochures, newsletters, posters, newspapers, audiovisual presentation, annual reports, magazines, and PR releases.

Subject Needs: Formal and informal portraits of our alumni, on-location shots, architecture.
Payment & Terms: Pay negotiated by job. Buys all rights. Model release preferred.
Making Contact: Provide resume, business card, brochure, flyer or tearsheets to be kept on file for possible future assignments. Solicits photos by assignment only. SASE. Reports in 1 month.

***ROLLER SKATING RINK OPERATORS ASSOCIATION**, Box 81846, Lincoln NE 68501. (402)489-8811. Director of Communications: Nance Kirk. Provides roller skating business magazine, plus posters and brochures promoting recreational roller skating. Buys 6 photos/year; gives 2 assignments/year. Photos used in brochures, posters, and magazines.
Subject Needs: Indoor recreational rollerskaters, especially families enjoying skating together.
Specs: "No set specs—negotiated per assignment."
Payment & Terms: Pay negotiated. Credit line given. Rights negotiated per photo or project. Model release required; captions preferred.
Making Contact: Query with samples; provide resume, business card, brochure, flyer or tearsheets to be kept on file for possible future assignments. Interested in stock photos. SASE. Reports in 1 month.
Tips: Prefers to see well-lighted, exciting action of roller skaters at an indoor skating center—35mm color—vertical—and 8x10 b&w glossies, horizontal or vertical. "If shooting samples on spec, give us a call for more information about specific needs."

***ROSARY COLLEGE**, 7900 West Division St., River Forest IL 60305. Publications Manager: John Easton. Photos used in recruiting and fund-raising brochures, newsletters, posters, audiovisual presentations, annual reports, and magazines.
Subject Needs: Campus events.
Specs: Uses 8x10 b&w prints and color transparencies.
Payment & Terms: Pays $4-20/b&w photo; $20-35/hour; $400/day. Credit line sometimes given. Buys all rights. Model release preferred.
Making Contact: Provide resume, business card, brochure, flyer or tearsheets to be kept on file for possible future assignments. Does not return unsolicited material.
Tips: Prefers "imaginative treatments of standard situations. Sharp, clear photos with a broad range of tones. Ability to produce good shots under adverse lighting conditions."

RSVP MARKETING, Suite 5, 450 Plain St., Marshfield MA 02050. President: Edward C. Hicks. Direct marketing consultant/agency. Buys 100-200 photos/year; gives 5-10 assignments/year. Photos used in brochures, catalogs, and magazines.
Subject Needs: Industrial equipment, travel/tourism topics, and fund raising events.
Specs: Uses 2x2 and 4x6 b&w and color prints, and transparencies.
Payment & Terms: Payment per photo and per job negotiated individually. Buys all rights. Model release preferred.
Making Contact: Query with list of stock photo subjects; provide resume, business card, brochure, flyer or tearsheets to be kept on file for possible future assignments. Solicits photos by assignment only. Interested in stock photos. SASE. Reports when needs and relevant jobs dictate.
Tips: "We look for photos of industrial and office products, high tech formats, and fashion."

SAINT VINCENT COLLEGE, Rt. 30, Latrobe PA 15650. (412)539-9761. Director of Publications: Don Orlando. Uses photos of students/faculty in campus setting. Photos used in brochures, newsletters, posters, annual reports and catalogs. Buys 50 photos/year. Credit line given. Buys all rights. Send material by mail for consideration. SASE. Reports in 1 month.
B&W: Uses 5x7 prints; contact sheet OK. Pays $10-50/photo.
Color: Uses 5x7 prints and 35mm transparencies; contact sheet OK. Pays $5 minimum/photo.
Tips: Impressed with technical excellence first, then the photographer's interpretative ability.

***LOUISE SALLINGER ACADEMY OF FASHION**, 101 Jessie St., San Francisco CA 94105. (415)974-6666. President: Esther Herschelle. Provides fashion design school. Gives 1-2 assignments/year. Photos used in catalogs, and annual fashion show.
Subject Needs: Runway models in a fashion show, and students in the classroom.
Specs: Works with freelance fimmmakers. "We need a video done every year of the fashion show, for both promotional and educational purposes."
Payment & Terms: "Terms are quite low, we are a very small, non-profit school." Credit line given.
Making Contact: Arrange a personal interview to show portfolio. Deals with local freelancers only. SASE. Reports in 1 month.
Tips: Prefers to see fashion show photos, brochure-type classroom or office photos.

***SAN FRANCISCO CONSERVATORY OF MUSIC**, 1201 Ortega St., San Francisco CA 94122. (415)564-8086. Publications Editor: Susan Shepard. Provides publications about the conservatory pro-

grams, concerts and musicians. Buys 25 photos/year; gives 10 15 assignments/year. Photos used in brochures, posters, newspapers, annual reports, catalogs, magazines, PR releases.
Subject Needs: Musical—musicians.
Specs: Uses 5x7 b&w prints.
Payment & Terms: Payment varies by photographer. Credit line given "most of the time." Buys one-time rights. Deals with local freelancers only.
Tips: Prefers to see in-performance shots, and studio shots of musicians. "Contact us only if you are experienced in photographing performing musicians."

SAN FRANCISCO OPERA CENTER, War Memorial Opera House, San Francisco CA 94102. (415)861-4008. Business Manager: Russ Walton. Produces live performances of opera productions of both local San Francisco area performances and national touring companies. Buys 2-3 photos/year; gives 1 assignment/year. Photos used in brochures, newspapers, annual reports, PR releases and production file reference/singer resume photos.
Subject Needs: Production and performance shots, and artist/performer shots.
Specs: Uses 8x10 standard finish b&w prints, and b&w negatives.
Payment & Terms: Pays $10-20/hour. Credit line given. Buys all rights.
Making Contact: Query with resume of credits; provide resume, business card, brochure, flyer or tearsheets to be kept on file for possible future assignments. SASE. Reports in 2 weeks.
Tips: "We need live performance shots and action shots of individuals; scenery also. Photographers should have previous experience in shooting live performances and be familiar with the opera product. Once good photographers are located, we contract them regularly for various production/social/public events."

SAN JOSE STATE UNIVERSITY, Athletic Department, San Jose CA 95192. (408)277-3296. Sports Information Director: Lawrence Fan. Uses sports action photos. Photos used in brochures, newspapers and posters. Buys 50 photos/year; gives 5-10 assignments/year. Credit line given. Buys all rights. Arrange a personal interview to show portfolio. SASE. Reports in 2 weeks.
B&W: Uses 8x10 glossy prints; contact sheet OK. Pays $2 minimum/photo.
Color: Uses 35mm transparencies. Pays $3 minimum/photo.

***SCHWINN BICYCLE CO.**, 217 N. Jefferson St., Chicago IL 60606. Manager/Marketing Communications: Paul Chess. Products include bicycles. Photos used in brochures, newsletters, posters, audiovisual presentations, catalogs, magazines, and PR releases.
Subject Needs: Subjects include Schwinn bicycles in use.
Specs: "Depends on final use."
Payment & Terms: Pay negotiated. Credit line given if requested. Buys all rights. Model release and captions required.
Making Contact: Send unsolicited photos by mail for consideration. Interested in stock photos, "from time to time." Reports ASAP."

THE SOCIETY OF AMERICAN FLORISTS, 1601 Duke St., Alexandria VA 22314. (703)836-8700. Communications Director: Drew Gruenburg. National trade association representing growers, wholesalers and retailers of flowers and plants. Gives 1-2 assignments/year. Photos used in magazines.
Subject Needs: Needs photos of personalities, greenhouses, inside wholesalers, flower shops and conventions.
Specs: Uses b&w and color contact sheets.
Payment & Terms: Rates negotiable. Credit line given. Model release required; captions preferred.
Making Contact: Query with samples; provide resume, business card, brochure, flyer or tearsheets to be kept on file for possible future assignments; interested in stock photos. SASE. Reports in 1 week.

SOHO REPERTORY THEATRE, 80 Varick St., New York NY 10013. (212)925-2588. Artistic Directors: Jerry Engelbach and Marlene Swartz. An off off Broadway theatre. Buys 50 photos/year; gives 6

66 *Know our company. Ask for our annual report or product listings before you contact us. We don't have time to educate or converse on an individual basis.* **99**

—Bill Piecuch, Dayco Corp.

assignments/year. Photos used in brochures, newspapers, and press releases.
Subject Needs: "Photos of our theatrical productions; particularly close-ups and action shots."
Specs: Uses 8x10 b&w prints and b&w contact sheets.
Payment & Terms: Pays $100-350/job. Credit line given. Buys non-exclusive perpetual use rights.
Making Contact: Query with resume of credits or samples; provide resume, business card, brochure, flyer or tearsheets to be kept on file for possible future assignments. SASE. Reports in 1 month.
Tips: "Practice shooting candids in theatres—catch the rising moments at their peak. Also, ability to do salable, publishable publicity photos."

SOUTHSIDE HOSPITAL, E. Main St., Bay Shore NY 11706. (516)666-1630. Vice President: John Mariner. Uses publicity photos of people, medical equipment, etc. Photos used in brochures, newsletters, newspapers, audiovisual presentations, posters, annual reports and PR releases. Gives 50 assignments/year. Buys all rights. Model release required; captions preferred. Arrange a personal interview to show portfolio or send material by mail for consideration. Assignment only. Provide resume and price sheet to be kept on file for possible future assignments. Notifies photographer if future assignments can be expected. SASE. Reports in 2 weeks.
B&W: Uses 5x7 glossy prints; contact sheet OK.

STATE HISTORICAL SOCIETY OF WISCONSIN, 816 State St., Madison WI 53706. (608)262-9606. Publication Information Officer: Robert Granflaten. Needs photos of the society's six outdoor museums. Buys all rights, but may reassign to photographer after use. Model release and captions preferred. Query with resume of credits. Send no unsolicited material.
B&W: Uses 8x10 b&w glossies.
Color: Uses 8x10 color glossies and 35mm or larger color transparencies.

***STOLLER PUBLICATIONS, LTD.**, Suite 709, 8306 Wilshire Blvd., Beverly Hills CA 90211. (213)653-7491. President: Jeff Stoller. Provides calendars, greeting cards, posters, prints and novelties. Photos used in brochures, posters, catalogs, PR releases, calendars, and greeting cards.
Subject Needs: Subject matter includes nature, sealife, teddy bears, cats, girls, hunks (male), etc. Credit line given. Model release required.
Making Contact: Query with resume of credits and list of stock photo subjects; provide resume, business card, brochure, flyer or tearsheets to be kept on file for possible future assignments. SASE. Reports in 3 weeks.

***THE TALBOTS**, 175 Beal St., Hingham MA 02110. Photo/Production Coordinator: Lisa Bourdon. Manages the photo production of 20+ women's classic clothing catalogs per year. Hires location and studio fashion photographers. No stock photos.
Subject Needs: Subjects include fashion location photography.
Specs: Uses 35mm (location), 2¼x2¼ (usually), 4x5 (studio), 8x10 transparencies.
Payment & Terms: Buys all rights.
Making Contact: Query with resume of credits; photographer's book, business card, brochure, flyer or tearsheets to be kept on file for possible future assignments. Does not return unsolicited material.

***THIEL COLLEGE**, 75 College Ave., Greenville PA 16125. (412)588-7700, ext. 203. Director of Media Services: Ian Scott Forbes. Provides education-undergraduate and community programs. Buys 25-35 photos/year; gives 2-3 assignments/year. Photos used in brochures, newsletters, newspapers, audiovisual presentations, annual reports, catalogs, magazines, and PR releases.
Subject Needs: "Basically we have an occasional need for photography depending on the job we want done." Cover quality-4-Color publications.
Specs: Uses 35mm transparencies.
Payment & Terms: Payment negotiated. Credit line given depending on usage. Buys all rights.
Making Contact: Query with resume of credits. Solicits photos by assignment. Reports back depending on needs.

***TOPS NEWS**, c/o TOPS Club, Inc., Box 07360, Milwaukee WI 53207. Editor: Gail Schemberger. TOPS is a nonprofit, noncommercial self-help weight-control organization. Photos used in membership magazine.
Subject Needs: "Subject matter to be illustrated varies greatly."
Specs: Uses 2¼x2¼ transparencies.
Payment & Terms: Pays $150/color photo. Buys one-time rights.
Making Contact: Query with list of stock photo subjects; provide resume, business card, brochure, flyer or tearsheets to be kept on file for possible future assignments. Interested in stock photos. SASE. Reports in 1 month.

TREASURE CRAFT, (formerly Treasure Craft/Pottery Craft), 2320 N. Alameda, Compton CA 90222. President: Bruce Levin. Manufactures earthenware and stoneware housewares and gift items. Buys 30 freelance photos/year; gives 30 assignments/year. Photos used in catalogs and magazines.
Specs: Uses 5x7 and 8x10 b&w and color prints.
Payment & Terms: Pays $85-100/color photo. Buys all rights. Query with samples. Solicits photos by assignment only. Provide business card and flyer to be kept on file for possible future assignments. SASE. Reports in 3 weeks.

T-SHIRT GALLERY LTD., 154 E. 64, New York NY 10021. (212)838-1212. President: Finn. Manufactures clothing and printed fashions. Buys 30 photos/year; gives 20 assignments/year. Photos used in brochures, newspapers, magazines and PR releases.
Subject Needs: Models in T-shirts.
Specs: Uses b&w and color prints and 8x10 transparencies.
Payment & Terms: Payment negotiable on a per photo basis. Buys all rights. Model release preferred.
Making Contact: Query with samples or send unsolicited photos by mail for consideration. SASE. Reports in 3 weeks.

***UNION FOR EXPERIMENTING COLLEGES & UNIVERSITIES**, Suite 1010, 632 Vine St., Cincinnati OH 45202. (513)621-6444. Director, Institutional Relations: Kelly Butler. Community Relations Coordinator: Pat Garry. Provides alternative higher education, baccalaureate and doctoral programs. Photos used in brochures, newsletters, posters, newspapers, audiovisual presentations, annual reports, catalogs and PR releases.
Subject Needs: "Members of our UECU community involved in their activities."
Specs: Uses 5x7 glossy b&w and color prints; b&w and color contact sheets; b&w and color negatives. Uses freelance filmmakers.
Payment & Terms: Credit line given. Model release preferred; required in some cases.
Making Contact: Arrange a personal interview to show portfolio. SASE. Reports in 3 weeks.
Tips: Prefers "good closeups and action shots of our alums/faculty, etc. We are a national, and even international, organization with about 1,000 current students nationally, and 2,500 alumni/ae.

UNITED AUTO WORKERS (UAW), 8000 E. Jefferson, Detroit MI 48214. (313)926-5291. Editor: David Elsila. Trade union representing 1.2 million workers in auto, aerospace, and agricultural-implement industries. Publishes *Solidarity* magazine. Photos used for brochures, newsletters, posters, magazines and calendars. Needs photos of workers at their place of work and social issues for magazine story illustrations. Buys 85 freelance photos and gives 12-18 freelance assignments/year. Pays $25/b&w photo; $150/half-day; or $250/day. Credit line given. Buys one-time rights. Model releases and captions preferred. Arrange a personal interview to show portfolio, query with samples and send material by mail for consideration. Uses stock photos. Provide resume and tearsheets to be kept on file for possible future assignments. Notifies photographer if future assignments can be expected. SASE. Reports in 2 weeks.
B&W: Uses 8x10 prints; contact sheets OK.
Film: Uses 16mm educational films.
Tips: In portfolio, prefers to see b&w workplace shots; prefers to see published photos as samples.

UNITED CEREBRAL PALSY ASSOCIATIONS, INC., 66 E. 34th St., New York NY 10016. (212)481-6345. Publications Director: Mark Fadiman. Uses photos of children and adults with disabilities in normal situations. Photos, which must be taken at UCP affiliate-sponsored events, used in brochures, newsletters, newspapers, posters, annual reports, PR releases and magazines. Gives 6 assignments/year. Pay varies. Credit line given if stipulated in advance. Model release and captions required. Query with samples or send material by mail for consideration. "Don't phone." SASE. Reports in 3 weeks.
B&W: Uses 5x7 or 8x10 prints.
Tips: "Work by photographers who themselves have physical disabilities is particularly invited. Contact a local UCP affiliate and make your presence known—work at reasonable prices. We also publish *Social and Health Review*, a quarterly magazine. B&w and color photos. Assignments only."

***UNITED STATES PROFESSIONAL TENNIS ASSOCIATION**, Box 7077, Wesley Chapel FL 34249. (813)973-3777. Public Relations: Desiree du Toit. Profesional trade association for tennis instructors. "We produce a monthly member magazine in which we use tennis-related photographs." Photos used in brochures, newsletters, audiovisual presentations, and magazines.
Subject Needs: Tennis-related.
Specs: Uses b&w and color prints, b&w and color negatives.
Payment & Terms: Pay negotiable. Credit line given. Buys all rights. Model release preferred.
Making Contact: Query with samples. Does not return unsolicited material. Reports in 2-3 weeks.
Tips: Prefers to see any tennis-related photos, preferably playing.

UNITED STATES STUDENT ASSOCIATION, Suite 403, 1012 14th St. NW, Washington DC 20005. (202)775-8943. President: Tom Swan. Legislative Director: Kathy Ozer. Publishes student affairs information. Uses photos in promotional materials, newsletters, newspapers, for text illustration and book covers. Buys 5 photos/year. Pays $5-40/job. Credit line given if requested. Buys all rights, but may reassign to photographer. Captions preferred. Query with samples, send material by mail for consideration or call. SASE. Simultaneous submissions and previously published work OK. Reports in 1 month.
Subject Needs: People (students) on university and college campuses; student activists; classroom shots. "Experimental photography is fine. Conference photography also needed—speakers, forums, groups." No nature shots, shots of buildings or posed shots.
B&W: Uses 5x7 prints; contact sheet OK.
Tips: "Contact us in late February and July for conference photography needed. We need photos of student activities such as Women's Centers at work; Minority Students' activities; college registration scramble; admissions officers; administration types; any clever arrangement or experiment disclosing campus life or activities."

UNIVERSITY OF NEW HAVEN, 300 Orange Ave., West Haven CT 06516. (203)932-7243. News Bureau Director: Noel Tomas. Uses University of New Haven campus photos. Photos used in brochures, newsletters, newspapers, annual reports, catalogs, and PR releases. Pays $2-9/b&w photo; $10-25/color photo; $10/20/hour; $100-200/day; payment negotiable on a per-photo basis. Buys one-time rights. Credit line often negotiable. Query with resume "and one sample for our files. We'll contact to arrange a personal interview to show portfolio." Local freelancers preferred. SASE. "Can't be responsible for lost materials." Reports in 1 week.
B&W: Uses 5x7 glossy prints; contact sheet OK.
Color: Mostly 35mm transparencies.
Tips: Looks for good people portraits, candids, interaction, news quality. Good prints b&w and color quality. Good slide color, sharp focus. Overall good versatility in mixed situations. "Contact us for appointment to show portfolio. Be reasonable on costs (we're a non-profit institution). Be a resident in local area available for assignment."

***UNIVERSITY OF REDLANDS**, 1200 E. Colton Ave., Redlands CA 92373-0999. (714)793-2121, ext. 4670. Director of Public Information: Miriam Lowenkron. News Bureau Manager: Nina Serrano. Publications Assistant: Renata Parrino. Four-year, private, non-sectarian liberal arts university, offering a bachelor's degree in some 25 areas and limited master's programs. Buys "hundreds" photos/year; gives 50-75 assignments/year. Photos used in brochures, newsletters, posters, annual reports, catalogs, magazines, PR releases, ads, and photo displays.
Subject Needs: On-campus scenic shots, classroom and individual student shots; "grip-and-grin" pix of donors presenting checks, receiving plaques, etc.; action shots for sports and academic events, etc.
Specs: Uses 5x7, 8x10 matte or glossy b&w prints; 35mm, 4x5 transparencies; b&w contact sheets; b&w and color negatives.
Payment & Terms: Pays $3-10/b&w photo; $20/hour; $500-900/day. Credit line sometimes given. Buys all rights; "willing to negotiate so photographer holds copyright but we hold unlimited, lifetime access."
Making Contact: Arrange a personal interview to show portfolio; query with samples; submit portfolio for review; provide resume, business card, brochure, flyer or tearsheets to be kept on file for possible future assignments. "As we are somewhat 'off the beaten path' geographically, we prefer to use local vendors." SASE. Reports in 1 week, usually.
Tips: "We are looking for a sensitive eye and well developed aesthetic sense. Pensive student photos are quite different from fashion photography, for example. Don't bother if you don't have the *patience* to work with college students and "absent-minded" professors and academic administrators. Most colleges have pretty poor b&w photography in most of their publications. We have strived to correct this and our publications have won many national awards in the last five years."

***USYRU (United States Yacht Racing Union)**, Box 209, Newport RI 02840. (401)849-5200. Communications Director: Mimi Dyer. Provides newsmagazine, brochures for 20,000 + members; services offered are yacht racing related. Buys 10-12 cover shots/b&w photos/year; gives various assignments/year. Photos used in brochures and magazines.
Subject Needs: Sailors/sailing shots with people discernible, having fun, intense or profile shots of particular personalities.
Specs: Uses 5x7 b&w prints; 35mm transparencies; b&w contact sheets; b&w and cover negatives.
Payment & Terms: Pay negotiated, "sometimes an honorarium." Credit line given. Rights purchased "can be arranged with photographer—he may use it in any additional way." Model release preferred; captions required (mainly identification of event, etc.)
Making Contact: Send unsolicited photos by mail for consideration; provide resume, business card,

brochure, flyer or tearsheets to be kept on file for possible future assignments; send photos only if familiar with what would be needed. SASE. Reports in 2 weeks.

Tips: Prefers to see USYRU events. "Think of exposure to 20,000 plus sailors. Bear with us as we have only just made the transition from newsletter to newsmagazine and are establishing policies, etc."

***UNIVERSITY OF TAMPA**, 401 W. Kennedy, Tampa FL 33606. (813)253-3333, ext. 274. Director of Communications: Karl Funds. Provides student recruitment brochures. Buys 400-800 photos/year; gives 30-50 assignments/year. Photos used for brochures, newsletters, audiovisual presentations, and catalogs.

Subject Needs: Local freelancers given specific assignments.

Payment & Terms: Pays $35-100/hour. Negotiates/photos. Buys all rights.

Making Contact: Arrange a personal interview to show portfolio. Solicits photos by assignment only. SASE. Reports in 2 weeks.

Tips: "Be timely with contact sheets and prints."

***VAC-U-MAX**, 37 Rutgers St., Belleville NJ 07109. Director of Marketing: John Andrew. Provides pneumatic conveying systems for dry powders, pellets, granules etc. in pharmaceutical, chemical, food processing, plastics plants, etc. Air operated industrial vacuum cleaners. Anticipates 10-12 freelance assignments/year. Photos used for brochures, audiovisual presentations, catalogs, magazines, PR releases.

Subject Needs: "We will be looking for photos of installations of our products."

Specs: Uses b&w prints; 35mm, 2¼x2¼ transparencies; b&w negatives.

Payment & Terms: Pay negotiated. Buys all rights. Model release and captions preferred.

Making Contact: Query with resume of credits, send unsolicited photos by mail for consideration. SASE. Reports in 2 weeks.

Tips: "We are interested in photographer's capability in photographing industrial equipment in an operating environment. We prefer that he bring installations to our attention which he knows he will be permitted to photograph."

WALTER VAN ENCK DESIGN LIMITED, 3830 N. Marshfield, Chicago IL 60613. President: Walter Van Enck. Produces corporate communications materials (primarily print). Buys 25 photos/year; gives 10 assignments/year. Photos used in brochures, newsletters, posters, audiovisual presentations, annual reports and catalogs.

Subject Needs: Corporate service related activities and product and architectural shots.

Specs: Uses 8x10 glossy and matte b&w prints, 2¼x2¼ and 4x5 transparencies, and b&w contact sheets.

Payment & Terms: Pays $600-1,500/day. Credit line seldom given. Model release required.

Making Contact: Arrange a personal interview to show portfolio or query with samples; provide resume, business card, brochure, flyer or tearsheets to be kept on file for possible future assignments. Deals with local freelancers only. Interested in stock photos. SASE. "Queries not often reported on—only filed."

Tips: "We look for straight corporate (conservative) shots with a little twist of color or light, and ultra high quality b&w printing. Try to keep your name and personality on the tip of our minds."

WEST JERSEY HEALTH SYSTEM, Mt. Ephraim and Atlantic Ave., Camden NJ 08104. (609)342-4676. Assistant Vice President: James Durkan. Uses b&w of hospital event coverage, feature shots of employees and photo essays on hospital services. Assigns 35mm color slides for audiovisual shows and photo layouts. Photos are used in brochures, audiovisual presentations, posters, annual reports and PR releases. Gives 50 assignments/year; buys 500 photos/year. Pays $25 minimum/hour and $100 minimum/day; maximum negotiable. Pays also on a $5/photo basis for b&w. Buys one-time rights or all rights. Model release required from patients; captions required. Query with list of stock photo subjects or submit portfolio for review. "No walk-ins, please. Call or write first." Assignment only. Provide business card and price list to be kept on file for possible future assignments. SASE. Reports in 2 weeks.

B&W: Uses 8x10 glossy or semigloss prints; contact sheet OK. Pays $5 minimum/photo, $1.75/reprint of the same exposure.

Color: Uses 35mm transparencies.

WESTERN WOOD PRODUCTS ASSOCIATION, 1500 Yeon Bldg., Portland OR 97204. (503)224-3930. Manager of Product Publicity: Mike O'Brieu. Uses photos of new homes or remodeling using softwood lumber products; commercial buildings, outdoor living structures or amenities. Photos used in brochures, newspapers and magazines. Buys 20 photos/year; gives 5 assignments/year. Pays a daily rate or on a per-photo basis. Fee is sometimes split with architect, builder, or editor. Credit line given. Buys all rights. Model release required. Query with samples or send material by mail for consideration. Wants

experienced professionals only. Provide brochure to be kept on file for possible future assignments. Notifies photographer if future assignments can be expected. SASE. Reports in 2 weeks.
B&W: Uses 8x10 glossy prints. Pays $35 minimum/photo.
Color: Uses 4x5 transparencies. 2¼x2¼ transparencies OK. Pays $50 minimum/photo.
Tips: Needs photos that will "quickly capture an editor's attention, not only as to subject matter but also photographically."

***WOODEN CANOE HERITAGE ASSOCIATION, LTD.**, Box 5634, Madison WI 53705. Editor: Jill Dean. Buys 12 photos/year. Photos used in magazines and booklets.
Subject Needs: Historic and contemporary images of wooden canoes in use, under construction, under restoration, and as elements in waterscapes. "Wooden canoes" include birchbark, dugout, wood-and-canvas, wood strip, Ashcroft, lapstrake, double cedar, and other canoes wherein wood constitutes the primary structure of, as opposed to decoration on, the canoe.
Specs: Uses b&w prints and b&w contact sheets.
Payment & Terms: Pays $25/b&w photo. Credit line given. Buys one-time rights. Model release and captions preferred.
Making Contact: Send unsolicited photos by mail for consideration. SASE. Reports in 1 month.
Tips: "We need good, clear black-and-white prints showing wooden canoes crisply and with sensitivity to the heritage of this craft. We find it easy to get loads of 35mm color slides, but hard to get good, clear, handsome black-and-white prints."

***WORCESTER POLYTECHNIC INSTITUTE**, 100 Institute Rd., Worcester MA 01609. Director of Publications: Kenneth McDonnell. Provides educators, all promotional, recruiting, fund raising printed materials. Buys 30 photos/year; gives "6 each" assignments/year. Photos used in brochures, newsletters, posters, audiovisual presentations, annual reports, catalogs, magazines, and PR releases.
Subject Needs: On-campus, comprehensive and specific views of all elements of the college experience. Relations with industry, alumni.
Specs: Uses 5x7 (minimum) glossy b&w prints; 35mm, 2¼x2¼, 4x5 transparencies; b&w contact sheets. Uses freelance filmmakers to produce occasional, promotional and educational video, 16mm format and 35mm transparencies.
Payment & Terms: Pays $500/day. Credit line given. Buys one-time rights or all rights; negotiable. Captions preferred.
Making Contact: Arrange a personal interview to show portfolio; query with list of stock photo subjects; send unsolicited photos by mail for consideration; provide resume, business card, brochure, flyer or tearsheets to be kept on file for possible future assignments. "No phone calls." Open to solicitations from anywhere. Interested in stock photos. SASE. Reports in 2 weeks.

WORLD WILDLIFE FUND-US, 1255 23rd St. NW, Washington DC 20037. (202)387-0800. Photo Librarian: Sally Russell. "WWF-US, a private international conservation organization, is dedicated to saving endangered wildlife and habitats around the world and to protecting the biological diversity upon which human well-being depends." Photos used in brochures, newsletters, posters, audiovisual presentations, annual reports, PR releases, and WWF Calendar. The calendar is the only publication for which photos are regularly purchased. Uses photos of endangered or threatened animals and plants around the world. Write to Holly Denton for calendar guidelines.
Subject Needs: Coverage of WWF projects worldwide, and endangered plants, animals, and habitat types around the world.
Specs: Uses 5x7 or 8x10 glossy b&w prints and 35mm transparencies. Rarely works with freelance filmmakers. "We are interested in photos of key WWF projects. *We rarely purchase material*. If the location being visited is of interest or coverage of unusual species is anticipated, we would discuss providing stock and processing."
Payment & Terms: Pays $25/b&w photo used in publications and $25/color photo used in slide shows. Credit line given. Buys non-exclusive rights. Prefers donation for on-going use in WWF publications and audiovisuals as needed. Captions required.
Making Contact: Query for list of WWF projects. Follow up with list of photo subjects and/or locations that appear to be of interest to WWF. Send credentials on request. Reports in 1 month.
Tips: "We look for close-ups of wildlife and plants worldwide, candids of conservationists working in the field, and scenics worldwide. We need photographers who are already traveling to WWF project areas; we prefer experience in nature photography. Write us to request a current list of WWF projects. Contact us again if you are planning a trip; we will advise on valuable locations. Call us for advice on valuable locations."

***YOUNG CALVINIST FEDERATION—INSIGHT MAGAZINE**, Box 7259, Grand Rapids MI 49510. (616)241-5616. Managing Editor: Martha Kalk. Provides a monthly magazine for senior high school

young people. Buys 100 photos/year. Photos also used in brochures, newsletters and posters.
Subject Needs: Senior high school age teens—at school, at work, group shots/individuals, couples, involved in activities—sports, volunteer work, hobbies, music, varying radial/ethnic backgrounds— white, black, Hispanic, Asian.
Specs: Uses 8x10 glossy/b&w prints.
Payment & Terms: Pays $25/b&w photo. Photographers given credit in upfront "Credits" listing. Model release preferred.
Making Contact: Send unsolicited photos by mail for consideration. SASE. Reports in 2 months.
Tips: Interested in photos of 1980's kids—please don't send *dated* material. Include terms or "stipulations" for use with initial submission. A real need for *contemporary* photos—can't use *dated* material.

***YOUNG CALVINIST FEDERATION—TEAM MAGAZINE**, 1333 Alger St. SE, Box 7259. Grand Rapids MI 49510. (616)241-5616. Program Manager/Editor: Dale Dieleman. *Team* magazine is a quarterly digest for volunteer church youth leaders. It promotes shared leadership for holistic ministry with high school young people. Buys 25-30 photos/year. Photos used in magazines, *books—"we also produce 1-2 books annually for youth leaders*, an additional 5-25 pix."
Subject Needs: High school young people in groups and as individuals in informal settings—on the street, in the country, at retreats, at school, having fun; racial variety; discussing in two's, three's, small groups; studying the Bible, praying, dating, doing service projects, interacting with children, adults, the elderly.
Specs: Uses 5x7 or 8x10 b&w glossy prints.
Payment & Terms: Pays $20-30/photo. Credit line given. Buys one-time rights.
Making Contact: Query with samples, query with list of stock photo subjects, send unsolicited photos by mail for consideration. SASE. *"We like to keep those packages that* have potential on file for 6-8 weeks. Others (with no potential) returned immediately."
Tips: "Ask us for our Contributor's Guidelines and a sample issue of the magazine, *Team*. We appreciate a SASE for return."

***YOUNG CALVINIST FEDERATION—YOUNG ADULT MINISTRIES**, Box 7259, Grand Rapids MI 49510. (616)241-5616. Editor: Steve G. Geurink. Provides a general interest magazine for young adults of the Christian Reformed, Reformed Church in America and Presbyterian Churches. Buys 40 photos/ annually. Photos used in brochures, magazines.
Subject Needs: Subjects include young adults in the work-a-day world, in service projects; Christian symbolism.
Specs: Uses 8x10 glossy b&w prints.
Payment & Terms: Pays $15-25/photo. Credit line given. Buys one-time rights. Model release required.
Making Contact: Query with samples. Interested in stock photos. SASE. Reports in 1 month.

Nothing can be more flattering to a photographer's ego than to enjoy his own exhibition—or an exhibition shared with fellow photographers. More and more galleries are becoming oriented to presenting photographic art in addition to painted media. Though the public is becoming accustomed to viewing photography from a fine-arts standpoint, and in purchasing it for home decor, the subject matter found tasteful will vary from state to state and gallery to gallery.

Some galleries' patrons prefer more classical landscape and still life images, others go for more experimental themes. Since many galleries are commercial, that is, they exist to make a profit, it will be wise when soliciting them to understand what type of material they prefer. Also be aware of what costs you may incur versus costs they will carry for you.

Such costs include promoting your shows; matting or framing prints; installation or handling costs; and reception food, drink and/or music. Be sure these costs, and who is handling them, are made clear up front by getting such terms in writing. Commercial galleries also help with sales, and commissions range from 20 percent to 50 percent. Many photographers who exhibit through galleries establish a price for their photo that represents their needs, and the gallery tacks its profit margin onto that. Some of these galleries require a photographer to be fairly well established; others exist for the sole purpose of "presenting" new talent to the public. Newer photographers, who haven't had the experience of previous shows and therefore have no real name recognition, should consider going through some nonprofit galleries for their first shows.

Some nonprofit galleries will sell work at whatever price the photographer wants, while taking little or no commission. Other nonprofit organizations don't offer works for sale, they are strictly opportunities to get your work out before the viewing public. In the latter case, sales to interested parties can be worked out privately. In addition to nonprofit galleries are a selection of alternative exhibition areas that can be found in government buildings, business lobbies, schools and libraries, and at local art fairs.

If you are submitting to an out-of-town gallery, you probably want to send a query letter and biographical data first. Most galleries, however, will want to see samples of your work before a commitment for an exhibition is made. And before you send your priceless collection through the mail, make sure it is packaged securely to avoid any damage in shipping, and be sure the gallery is ready to receive it both from the standpoint of interest, and in knowing the package is coming so they can watch for it. Many galleries listed here also specify that they will review transparencies. In this case, mailing will be a bit easier than it would be were you to ship off large format prints for examination. For local galleries, you may find it wiser to schedule an interview at some point, as a means to further explain your work and goals, and to further establish your interest and credibility.

Finally, be sure to show only work which you feel can stand up under public scrutiny, work you feel proud to show as representative of your talents or of a particular phase of your photography career. Decide what statement it is that you want to make. This will make presenting your show to a gallery director easier, and will help you to explain the theme for promotional purposes.

ADAMS MEMORIAL GALLERY, (formerly Access to the Arts Inc.), 600 Central Ave., Dunkirk NY 14048. Gallery Manager: Kay Collins. Interested in b&w and color photography of all types. All works must be insured and ready to be put on exhibit upon date of exhibit. Presents 1-2 shows/year. Shows last

1 month. "Arrangements set up with artist." Photographer's presence at opening preferred. Receives 25% sponsor commission. General price range: $250-800. Will review transparencies. Interested in framed, mounted and matted work only. Send material by mail for consideration. SASE. Accepts work from photographers living and working within a radius of 300 miles from Dunkirk, NY.

THE AFTERIMAGE PHOTOGRAPH GALLERY, The Quadrangle 250, 2800 Routh St., Dallas TX 75201. (214)871-9140. Owner: Ben Breard. Interested in any subject matter. Photographer should "have many years of experience and a history of publication and museum and gallery display; although if one's work is strong enough, these requirements may be negated." Open to exhibiting work of newer photographer; "but that work is usually difficult to sell." Prefers Cibachrome "or other fade-resistant process" for color and "archival quality" for b&w. Sponsors openings; "an opening usually lasts 2 hours, and we only do 2 or 3 a year." Receives 50% sales commission (photographer sets price), or buys photos outright. Price range: $20-10,000. Query first with resume of credits and biographical data or call to arrange an appointment. SASE. Reports in 2 days-2 months. Unframed work only.
Tips: "Work enough years to build up a sufficient inventory of, say, 20-30 prints, and make a quality presentation. Landscapes are currently selling best. The economy in Dallas just keeps getting better and better—aiding sales."

AMERICAN SOCIETY OF ARTISTS, INC., Box 1326, Palatine IL 60078. (312)991-4748 or (312)751-2500. Membership Chairman: Helen Del Valle. "Our members range from internationally known artists to unknown artists—quality of work is the important factor. We have shows throughout the year which accept photographic art." Only members may exhibit. Price range: "varies." Send SASE for membership information and application. Reports in 2 weeks. Framed mounted or matted work only. Accepted members may participate in lecture and demonstration service. Member Publication: *ASA Artisan*.

***ANAKOTA ARTS**, 516 7th St., Rapid City SD 57701. (605)348-1890. President: Anna Marie Thatcher. Estab. 1983. Interested in large (over 24"x30") for corporate and office spaces. "We must like the work." Presents 1 show every 2 years. Shows last 4 weeks. Sponsors openings. Photographer's presence at opening preferred but optional. Photographer's presence during the show is preferred. Photography sold in gallery on limited basis. Receives 40% commission. General price range: $25-500. Will review transparencies. Interested in framed or unframed work, mounted or unmounted work, unmatted work only. Requires exclusive presentation within metropolitan area. Arrange a personal interview to show portfolio; query with samples, send material by mail for consideration, submit portfolio for review. SASE. Reports in 1-2 months.
Tips: Don't come to show without an appointment, know what you want, have information ready—be prepared! "Photography is still lagging behind other visual arts in sales—particularly in our area."

ANDERSON GALLERY, Virginia Commonwealth University, 907½ W. Franklin St., Richmond VA 23284. (804)257-1522. Contact: Director. Interested in historical and contemporary photography. Sponsors openings. Presents 3-4 shows/year. Shows last 1 month. Photographer's presence at opening and during show preferred. Receives 20% sales commission. Will review transparencies. SASE. Reports in 1 month. Mounted and matted work only.

ANDOVER GALLERY, 68 Park St., Andover MA 01810. (617)475-7468. Director: Howard Yezerski. Interested in any photography of high quality. Presents 4-6 shows/year. Shows last 4-5 weeks. Sponsors openings; announcements, refreshments. Photographers's presence at opening is preferred. Photography sold in gallery. Receives 40-50% commission. General price range: $200-1,500. Will review transparencies. Interested in framed or unframed, mounted or unmounted, matted or unmatted work. Requires exclusive representation within metropolitan area. Arrange a personal interview to show portfolio; query with resume of credits or with samples; send material by mail for consideration. SASE. Reports in 1 week.
Tips: "If the work is exciting we are extremely receptive. Get in touch with us."

ARMORY ART GALLERY, Virginia Polytechnic Institute and State University, Blacksburg VA 24061. (703)961-5547. Gallery Director: Robert Graham. Interested in all types of photography. Sponsors openings. Very receptive to exhibiting the work of newer photographers. Presents 1 show/year. Show lasts 3 weeks. Photography sold only during exhibition. Receives 15% commission, which is donated to the department's Educational Fund. Query with resume of credits. Will review transparencies. SASE. Reports in 1 month. Size: "Limits established by size of gallery."
Tips: "At the present time, the gallery budget is very limited, and we are unable to pay high rental fees for exhibitions."

***ART RESEARCH CENTER (ALTERNATIVE ARTISTS) Not-For-Profit SPACE CORP.**, 3rd Floor, Lucas Place, 323 W. 8th St., Kansas City MO 64105. (816)561-2006. Coordinator: Thomas Michael

Roswell Angier/Archive Pictures

This photo, by Roswell Angier of Cambridge, Massachusetts, was exhibited at the Andover Gallery for one month. "The photograph," explains Angier, "is part of a book project documenting Gallup, New Mexico. It was reproduced as part of a portfolio published in Photo (France). Archive Pictures (New York) also markets the photo, which has been used in stock sales to textbook publishers." Howard Yezerski, gallery director, liked the photo for its "universality. She looks like the prototype waitress, he explains. There is a quality of weariness about her . . . the photo caught the essence of all people who do that type of job."

Stephens. Interested in structural and experimental photography and other aspects of "apparative" (art by machine/apparatus) art-computerzied photo-mechanical. The photographer should have an interest in and understanding of this procedure/methodology. Presents 2-5 shows/year. Shows last 4-8 weeks. Sponsors openings; invitations, media press releases, public receptions, lectures, symposia. Photography sold in gallery. Receives "20-40% commission in case of published multiples. General price range: $50-1,500/print; less for published multiples usually. Will review transparencies. Interested in framed or unframed work, mounted or unmounted work, matted or unmatted work. Size restrictions: "3½x4¾", prints matted to 5x7" minimum; 36x?" rolled/laminated, maximum." Query with resume of credits and samples; send material by mail for consideration; submit portfolio for review or submit slides and resumes. SASE. Reports in 2-4 weeks.

Tips: "Study history and theories of modern experimental photography—ask specific questions about structural art."

***ARTBANQUE**, 1608 Harmon Pl., Minneapolis MN 55403. (612)333-1821. Director: Richard Halonen. Estab. 1982. Interested in straight, humorous, technical, abstractions, unique presentation. Photographer must have 10 years experience. Presents 1 show/year. Shows last 4 weeks. Sponsors openings; split costs equally with artist for announcements, postage and entertainment costs. Photographer's presence at opening required. Photographer's presence during the show is preferred. Photography sold in gallery. Receives 50% commission. Buys photography outright. General price range: $500. Will review transparencies. Interested in framed or unframed work, mounted or unmounted work, matted or

unmatted work. Requires exclusive representation within metropolitan area. Send material by mail for consideration and slides, biography, resume. SASE. Reports in 1 month.
Tips: The photography gallery market is smaller than that of painting/paints etc., but is rapidly gaining attention as a serious art medium.

***ARTEMISIA GALLERY**, 341 W. Superior, Chicago IL 60610. (312)751-2016. Director, Search Committee: Maureen Warren. Interested in fine art—straight or manipulated, b&w or color—no restrictions on subject matter. The photographer must submit 6-10 slides, plus resume and SASE. Acceptance for exhibition based very strongly on the quality of the art; much less on credentials. Presents 3-4 shows/year. Shows last 4 weeks. Sponsors openings; provides cash bar: soda, beer, wine, liquor. Photographer's presence at opening preferred. Photography sold in gallery. "We are a non-profit gallery." General price range: $200-1,000. Will review transparencies. Interested in framed or unframed work, mounted or unmounted work, matted or unmatted work. Send material by mail for consideration or submit portfolio for review. "Prints can be sent or dropped off." SASE.
Tips: "We see *a lot* of work in all fine art media, and we weed out most of it very quickly. What will get attention is work that is innovative, creative, stylistically sophisticated."

A.R.T.S. RESOURCES, (formerly Gallery Imago), 619 Post St., San Francisco CA 94109. (415)775-0707. Director: Will Stone. The photographer must submit 8-10 slides of available works, resume, SASE and review fee of $45; refunded if work is not accepted. Presents 8 shows/year. Shows last 3-4 weeks. Receives 25% commission. General price range: $200-500. Will review transparencies. Framed work only. Requires exclusive representation in area. Pieces limited to 40x60 size. Send material by mail for consideration; submit portfolio for review. SASE. Reports in 4-6 weeks.

ASCHERMAN GALLERY/CLEVELAND PHOTOGRAPHIC WORKSHOP, Suite 4, 1846 Coventry Village, Cleveland Heights OH 44118. (216)321-0054. Director: Herbert Ascherman, Jr. Sponsored by Cleveland Photographic Workshop. Subject matter: all forms of photographic art and production. "Membership is not necessary. A prospective photographer must show a portfolio of 40-60 slides or prints for consideration. We prefer to see distinctive work—a signature in the print, work that could only be done by one person, not repetitive or replicative of others." Very receptive to exhibiting work of newer photographers, "they are our primary interest." Presents 10 shows/year. Shows last about 5 weeks. "Openings are held for most shows. Photographers are expected to contribute toward expenses of publicity if poster desired." Photographer's presence at show "always good to publicize, but not necessary." Receives 25-40% commission, depending on the artist. Sometimes buys photography outright. Price range. $100-1,500. "Photos in the $100-300 range sell best." Will review transparencies. Matted work only for show.
Tips: "Be as professional in your presentation as possible: identify slides with name, title, etc.; matte, mount, box prints. We are a midwest firm and people here respond to competent, conservative images better than experimental or trendy work. Traditional landscapes, mood or emotional images (few people pictures) and more studies currently sell best at our gallery."

THE BALTIMORE MUSEUM OF ART, Art Museum Dr., Baltimore MD 21218. (301)396-6330. Contact: Department of Prints, Drawings and Photographs. Interested in work of quality and originality; no student work. Arrange a personal interview to show portfolio or query with resume of credits. SASE. Reports in 2 weeks-1 month. Unframed and matted work only.

BC SPACE, 235 Forest Ave., Laguna Beach CA 92651. (714)497-1880. Contact: Jerry Burchfield or Mark Chamberlain. Interested only in contemporary photography. Presents 8 solo or group shows per year; 6 weeks normal duration. General price range: $150-3,000; gallery commission 40%. Collaborates with artists on special events, openings, etc. For initial contact submit slides and resume. Follow up by arranging personal portfolio review. SASE. Responds "as soon as possible—hopefully within a month, but show scheduling occurs several times a year. Please be patient."
Tips: "Keep in touch—show new work periodically. If we can't give a show right away, don't despair, it may fit another format later. The shows have a rhythm of their own which takes time. Salability of the work is important, but not the prime consideration. We are more interested in fresh, innovative work."

***BERGSTROM-MAHLER MUSEUM**, 165 N. Park Ave., Neenah WI 54956. Contact: Alex Vance. Interested in all types of photography. Presents 2 shows/year. Shows last 6-8 weeks. Receives 15% commission. Price range: $150-200. Submit vitae and 4 slides by mail for consideration. Will review transparencies. SASE. Reports in 2 weeks. "Exceptionally large pieces cannot be hung."

MONA BERMAN GALLERY, 168 York St., New Haven CT 06510. (203)562-4720. Director: Mona Berman. Subject matter varies. The work must be archival. Number of shows varies each year. Shows

last 4 weeks. Sponsors openings. Photographer's presence at opening is preferred. Receives 50% commission. General price range: $200-1,000. Will review transparencies. "Interested in seeing slides for initial review; then if still interested will look at any format." Requires exclusive representation within metropolitan area. Send slides, resume, credits and price list. Reports in 2 weeks.
Tips: "Good slide portfolio is important. We understand that many photographers are hesitant to do this, but since many presentations are made through slides, we need to know that the work can be well represented by these."

JESSE BESSER MUSEUM, 491 Johnson St., Alpena MI 49707. (517)356-2202. Contact: Director. Chief of Resources: Robert Haltiner. Interested in a variety of photos suitable for showing in general museum. Presents 1 show/year. Shows last 6-8 weeks. Receives 20% sales commission. Price range: $10-1,000. "However, being a museum, emphasis is not placed on sales, per se." Submit samples to museum exhibits committee. Framed work only. Will review transparencies. SASE. Reports in 2 weeks. "All work for exhibit must be framed and ready for hanging."

***BLUE SKY GALLERY/OREGON CENTER OF PHOTOGRAHIC ARTS**, 117 NW 5th Ave., Portland OR 97209. (503)225-0210. Co-Director: Christopher Rauschenberg. Interested in "all photography of high quality. We emphasize work in a contemporary/non-traditional vein." Presents 9 shows, with 2 photographers presented/year. Shows last 27 days. Sponsors shows with standard reception fare. Photographer's presence at opening preferred. Photography sold in gallery. Receives 34% commission. General price range: $100-450. Will review transparencies, "It is encouraged." Interested in unframed work only, mounted or unmounted work, matted or unmatted work. Submit portfolio for review and send slides through mail. SASE. Reports in 1 month.
Tips: Present quality slides.

BREA CIVIC CULTURAL CENTER GALLERY, Number One Civic Center Circle, Brea CA 92621. (714)990-7713. Gallery Cordinator: Marie Sofi. Sponsored by City of Brea. Presents 2 juried all media shows/year and a photography show on the average of once every 2 years. Walk-in entries only. Shows last 6 weeks. Sponsors openings. Photographer's presence at opening and show preferred. Receives 30% sales commission. Framed work only, ready to hang.

***BROMFIELD GALLERY**, 36 Newbury St., Boston MA 02116. (617)262-7782. Director: Beth Ann Gersten. Interested in all types, styles and subject matter. Photographer must go through review process through slides or prints. Presents 3-6 shows/year. Shows last 4 weeks. Sponsors openings. "Cost is split by participants. Photographer's presence at opening preferred. Photography sold in gallery. Receives 30% commission. General price range: $150-800. Will review transparencies. Interested in framed or unframed work, mounted or unmounted work, matted or unmatted work. Send or deliver slides or prints, resume and support information. SASE. Reports "anywhere from 1 week to a month."

***CALIFORNIA MUSEUM OF PHOTOGRAPHY**, University of California, Riverside CA 92521 (714)787-4787. Curator: Edward Earle. The photographer must have the "highest quality work." Presents 12-16 shows/year. Shows last 6-8 weeks. Sponsors openings; inclusion in museum calendar, reception. Photographer's presence at opening preferred. Occasionally buys photography outright. Will review transparencies. Interested in unframed work only, mounted or unmounted work, matted or unmatted work. Query with resume of credits. SASE. Reports in 90 days.
Tips: "This museum attempts to balance exhibitions among historical, technology, contemporary, etc. We can show only a small percent of what we see in a year."

***CAMBRIDGE MULTICULTURAL ARTS CENTER GALLERY**, 41 Second St., Cambridge MA 02141. (617)577-1400. Gallery Director: Janet Lane. Estab. 1985. Interested in documentary photography as it relates to cultural/geographic groups, also non-commercial (fine art) photography. The photographer must be willing to participate in a group show, share costs of printed announcements and reception costs. Presents 4-5 shows/year. Shows last 5-6 weeks. Photographer's presence at opening preferred. "Appropriate if there is a gallery talk, does *not* have to serve as gallery attendant." Photography sold in gallery. Receives 25% commission. General price range: $175-300. Will review transparencies. Interested in slides. Arrange a personal interview to show portfolio; query with resume of credits and sample slides. SASE. Reports when jury review panel meets—4-6 months.
Tips: Work demonstrating ethnographic cultural elements will receive highest interest. Smaller works, works under $200 are being considered by new collectors, as interest and appreciation for artwork increases.

***THE CAMERA OBSCURA GALLERY**, 1307 Bannock St., Denver CO 80204. (303)623-4059. Director: Hal Gould. Shows last 6 weeks. Sponsors openings. Photographer's presence at opening preferred.

Photography sold in gallery. Receives 40-50% commission. Buys photography outright. General price range: $200-25,000. Will review transparencies. Interested in mounted or unmounted work, matted or unmatted work. Requires exclusive representation within metropolitan area. Arrange a personal interview to show portfolio. SASE. Reports in 2 weeks.

THE CANTON ART INSTITUTE, 1001 Market Ave., Canton OH 44702. (216)453-7666. Associate Director: M.J. Albacete. "We are interested in exhibiting all types of quality photography, preferably using photography as an art medium, but we will also examine portfolios of other types of photography work as well: architecture, etc. The photographer must send preliminary letter of desire to exhibit; send samples of work (upon our request); have enough work to form an exhibition; complete *Artist's Form* detailing professional and academic background, and provide photographs for press usage." Presents 2-5 shows/year. Shows last 6 weeks. Sponsors openings; minor exhibits (shown in photo salon), only news announcement. Major exhibits (in galleries), postcard or other type mailer, public reception. Photography sold in gallery. Receives 20% commission. Occasionally buys photography outright. General price range: $300 or more. Interested in exhibition-ready work. No size limits. Query with samples. SASE. Reports in 2 weeks.
Tips: "Submit letter of inquiry first, with samples of photos; we look for photo exhibitions which are unique, not necessarily by 'top' names. Anyone inquiring should have some exhibition experience, and have sufficient materials; also, price lists, insurance lists, description of work, artist's background, etc. Most photographers and artists do little to aid galleries and museums in promoting their works—no good publicity photos, confusing explanations about their work, etc. We attempt to give photographers—new and old—a good gallery exhibit when we feel their work merits such. While sales are not our main concern, the exhibition experience and the publicity can help promote new talents. If the photographer is really serious about his profession, he should design a press-kit type of package so that people like me can study his work, learn about his background, and get a pretty good picture of his work. This is generally the first knowledge we have of any particular artist, and if a bad impression is made, even for the best photographer, he gets no exhibition. How else are we to know? We have a basic form which we send to potential exhibitors requesting all the information needed for an exhibition, a copy of which will be sent on request. Also, I am writing an article, 'Artists, Get Your Act Together If You Plan to Take it on the Road,' showing artists how to prepare self-promoting kits for potential sponsors, gallery exhibitors, etc. Copy of article and form sent for $1 and SASE."

***CARLSON GALLERY-UNIV. OF BRIDGEPORT**, Bernhard Ctr., U of B , Bridgeport CT 06601. (203)576-4402. Director: Roger Baldwin. Interested in contemporary fine-arts photography. Photographer must be of regional or national standing. Presents 3 (on the average) shows/year. Shows last 4 weeks. Sponsors openings, provides refreshments. "We also provide announcements, press material, etc." Photographer's presence at opening preferred. Photography sold in gallery. General price range: varies-average around $500. Will review transparencies. Interested in framed or matted work only. Send material by mail for consideration. "Submissions by mail to include: sheet of 20 slides, resume, statement, SASE." Reporting time: yearly decisions made in February-March. Submissions held until the April after they're sent.
Tips: "We emphasize innovative fine-arts photography (but occasionally show photojournalistic and photodocumentary work as well). We produce thematic group shows as well as one-person shows. There are quite a few opportunities for a photographer, but there is also a pool of photographic talent proportionately larger than that of other media."

CATSKILL CENTER FOR PHOTOGRAPHY, 59A Tinker St., Woodstock NY 12498. (914)679-9957. Exhibitions Director: Kathleen Kenyon. Interested in all fine arts photography. No commercial or hobby. Presents 10 shows/year. Shows last 4 weeks. Sponsors openings. Receives 33 1/3% sales commission. Price range: $75-1,000. Photographs should not be 30"x40" unless by invitation. Send material by mail for consideration. SASE. Reports in 1 month.
Tips: "Visit us first—set up an appointment, or write us a brief letter, enclose resume, statement on the work, 20 slides, SASE. We are closed Wednesdays and Thursdays. We sell more contemporary photography than historical."

C.E.P.A. (CENTER FOR EXPLORATORY & PERCEPTUAL ART), 4th Floor, 700 Main St., Buffalo NY 14202. (716)856-2717. Director: Gary Nickard. "C.E.P.A. is a not-for-profit organization whose *raison d'etre* is the advancement of photography which engages contemporary issues within the visual arts. C.E.P.A.'s varied programs explore aesthetic and intellectual issues within the camera arts of still photography, photo-installation, video, film and multimedia performance. An artist must meet the aesthetic standards of the director and also must produce work that conforms to the aesthetic mission stated above. C.E.P.A. provides a venue of innovative work as well as original visions by known and unknown artists that break new ground in the photo-related arts." Presents 8 major exhibitions of four artists per

show a year with six satellite and 12 public transit exhibits. Shows last 4-6 weeks. Sponsors openings; provides postcard announcement and curator's statement in the C.E.P.A. Newsletter. Cash Bar at reception. Photography sold in gallery. Receives 10% commission. General price range: $250-5,000. Will review transparencies. Requires submission of a representative slide portfolio, a resume and a statement of intent or explanation of the work proposed for exhibition. Interested in seeing slides only. Considers any size, shape, form, or permutation of any camera art. Send material by mail for consideration. SASE. Reports in 1 month.

CITY OF LOS ANGELES PHOTOGRAPHY CENTERS, 412 S. Parkview St., Los Angeles CA 90057. (213)383-7342. Director: Glenna Boltuch. Interested in all types of photography. Presents 12 shows/year. Exhibits last 4 weeks. Offers rental darkrooms, studio space, outings, lectures, classes, monthly newsletter, juried competitions, a photo library, photographer's slide registry, and free use of models for shooting sessions. Arrange a personal interview to show portfolio or "send up to 20 slides with resume for us to keep on file. Send SASE if you want them returned." Reports in 1 month. Mounted work only. Gallery retains 20% of sold photographs.
Tips: "We are interested in seeing professional photography which explores a multitude of techniques and styles, while expanding the notion of the art of photography. We have been extremely receptive to exhibiting the work of newer, lesser-known photographers. We are interested in seeing series of works that are unique, and work together as a body of work, that have a message or explore a technical area that is unique, that expand the art of photography in some way."

COLORFAX LABORATORIES, Design & Exhibits Office, 11961 Tech Rd., Silver Spring MD 20904. (301)622-1500. Advertising Director: Glenn Barber. Interested in photography on any subject for galleries in Washington DC, Maryland and Virginia. The sale of prints is optional and handled directly by the photographer. *Colorfax* takes no commission. Price range: $25-500. Call to arrange an appointment.

CONTEMPORARY ART WORKSHOP, 542 W. Grant Place, Chicago IL 60614. (312)472-4004. Administrative Director: Lynn Kearney. "We encourage artists with professional background or art school." Fine art photography only. Presents 1-2 shows/year. Shows last 3½ weeks. Photographer's presence at opening required. Receives 33% sales commission. Price range: $100-300. Query with resume of credits and samples. SASE. Reports in 1 month. Framed, mounted and matted work only.
Tips: "We're not a big selling place; we're more for exposure. We are a nonprofit gallery primarily showing painting, graphics and sculpture but have been showing 1 to 2 photo shows a year. We prefer beginning careerists from the Midwest. We also have one studio with darkroom for rental at moderate cost. Send slides and SASE for studio consideration."

***THE CONTEMPORARY ARTS CENTER**, (non-profit institution), 115 E. Fifth St., Cincinnati OH 45202. (513)721-0390. Curator: Sarah Rogers-Lafferty. Interested in avant garde, innovative photography. Photographer must be selected by the curator and approved by the board. Presents 1-3 shows/year. Exhibits last 6 weeks. Sponsors openings; provides printed invitations, music, refreshments, cash bar. Photographer's presence at opening preferred. Photography sometimes sold in gallery. Receives 10% commission. General price range: $200-500. Will review transparencies. Interested in matted work only. Send query with resume and slides of work. SASE. Reports in 1 month.

CREATIVE PHOTOGRAPHY GALLERY, University of Dayton, Dayton OH 45469. (513)229-2230. Director: Sean Wilkinson. Interested in "all areas of creative photography." Photographers with exhibition experience are preferred. Submit 20 slides of work (including dimensions) with resume of credits and SASE in February. Decision is in March, material returned by end of month.
Tips: "Ours is the only gallery in this area that continually and exclusively features photography. A large number of people see the work because of its location adjacent to an active university photography facility. We want to see work that is unified by a particular individual quality of vision. This could be traditional or not, it simply must be good. Don't apply for shows unless you feel you have a mature, well thought out statement to make through your work."

***DART GALLERY**, 212 W. Superior, Chicago IL 60610. (312)787-6366. Directors: Rebecca Donelson, Andree Stone. Interested in documentary and documentary of performances. Directors must be enchanted with photographer's work. Presents 1-2 shows/year. Shows last 4-5 weeks. Sponsors openings; announcements, cocktail party. Photography sold in gallery. Commission "depends on situation." Will review transparencies. Requires exclusive presentation in metropolitan area. Any size photography acceptable. Send material by mail for consideration. SASE. Reports in 3 weeks.

DINNERMAN GALLERY, (formerly The Photography Gallery), 7825 Fay, La Jolla CA 92037. (619)459-1800. Director: Jill Moon. Shows contemporary fine art photography. "Prints must be of ar-

chival quality and the artist must have a track record of pursuing a career as a fine art photographer." Presents 6 shows/year. Shows last 6-7 weeks. Receives 50% commission. General price range: $400-2,000. Will review transparencies. Interested in unframed work only. Requires exclusive representation within metropolitan area. Query with resume of credits or submit portfolio for review. SASE. Reports in 1 month.

DUNEDIN FINE ARTS & CULTURAL CENTER, 1143 Michigan Blvd., Dunedin FL 33528. (813)733-4446. Executive Director: Carla Crook. "All work would be considered. This is a family-oriented art center and as such, consideration is given to the subject matter." Present resume and a set of slides or small portfolio along with proposal for show if it is a group of individuals. Presents variable number shows/year. Shows last 1 month. Sponsors opening. Photographer's presence at opening is preferred. "I like to have a talk by the artist either following the reception or on a Sunday afternoon. Scheduling is flexible and this is not required. All work in the gallery is for sale unless the artist chooses not to sell." Receives 30% commission. General price range: varies. "I like to see work as the artist presents it for gallery showing." No restrictions unless they get to be billboard size. Send material by mail for consideration; personal interview granted to everyone. SASE. Reports in 1 week.
Tips: "I am interested in the serious artists who present themselves and their work in a professional manner."

EATON/SHOEN GALLERY, 315 Sutter St., San Francisco CA 94108. (415)788-3476. Director: Timothy A. Eaton. Interested in modern and contemporary. Photographers "must meet a standard of excellence which can only be determined by gallery staff." Presents 3-4 shows/year. Shows last 4 weeks. General price range: $200-800. Will review transparencies only with SASE. Reports in 1 month.
Tips: "Present thorough, complete and detailed resume in correct form. We are seeing a trend toward the use of travel photography, which currently sells best at our gallery."

ETHERTON GALLERY, 424 E. 6th St., Tucson AZ 85705. (602)624-7370. Director: Terry Etherton. Interested in contemporary photography with emphasis on artists in Western and Southwestern US. Photographer must "have a high-quality, consistent body of work—be a working artist/photographer—no 'hobbyists' or weekend photographers." Presents 8-9 shows/year. Shows last 5 weeks. Sponsors openings; provides wine and refreshments, publicity, etc. Photographer's presence at opening and during show preferred. Receives 50% commission. Occasionally buys photography outright. General price range: $100-1,000 + . Will review transparencies. Interested in matted or unmatted unframed work. Arrange a personal interview to show portfolio or send material by mail for consideration. SASE. Reports in 3 weeks.
Tips: "You must be fully committed to photography as a way of life. I'm not interested in 'hobbyists' or weekend amateurs. You should be familiar with photo art world and with my gallery and the work I show. Do not show more than 20 prints for consideration—show only the best of your work—no fillers. Have work sent or delivered so that it is presentable and professional."

EVANSTON ART CENTER, 2603 Sheridan Rd., Evanston IL 60201. (312)475-5300. Executive Director: MaryBeth Murphy. Interested in fine art photography. Photographer is subject to exhibition committee approval. Presents 9 shows/year. Shows last 6 weeks. Sponsors openings; provides opening reception. Photographer's presence at opening is preferred. Receives 35% commission. Will review transparencies. Interested in matted work only. Requires exclusive area representation during exhibition. Send material by mail for consideration. SASE. Reports in up to 3 months.

FOCAL POINT GALLERY, 321 City Island Ave., New York NY 10464. (212)885-1403. Photographer/Director: Ron Terner. Subject matter open. Presents 9 shows/year. Shows last 4 weeks. Photographer's presence at opening preferred. Receives 30% sales commission. Price range: $75-250. Arrange a personal interview to show portfolio. Cannot return unsolicited material. "Since it is a personal interview, one will be given an answer right away."
Tips: "The gallery is geared towards exposure—letting the public know what contemporary artists are doing—and is not concerned with whether it will sell. If the photographer is only interested in selling, this is not the gallery for him/her, but if the artist is concerned with people seeing the work and gaining feedback, this is the place."

THE FOTO-TEK DARKROOM, 428 E. 1st Ave., Denver CO 80203. (303)777-9382. Gallery Director: Jim Johnson. "Very open to exhibiting work of newer photographers if the work meets our standards." Interested in "everything." Gallery capacity is 40-55 prints; exhibits changed every month. Receives 33⅓% sales commission; sometimes buys outright; the artist sets the retail price. Price range: $50-800. Call to arrange an appointment, or send unmounted samples and include SASE. Mounted and unframed work only. Size: 16x20 maximum.

Tips: "We are primarily concerned with the visual & technical level of the photographs, rather than subject matter."

THE FRIENDS OF PHOTOGRAPHY, Box 500, Sunset Center, San Carlos at 9th, Carmel CA 93921. (408)624-6330. Executive Director: James Alinder. Executive Associate: David Featherstone. Interested in all types of photography, especially significant and challenging contemporary and historical imagery. No restrictions. Sponsors openings; "a preview and reception for the artist is held for each exhibition." Presents 9-10 shows/year. Shows last 4-6 weeks. Receives no commission, "but members receive 10% discount." Price range: $75-1,000. Arrange a personal interview to show portfolio or submit portfolio for review. Call ahead for appointment. Will review transparencies, "but preferably not." Matting or mounting not necessary for review. For exhibition, work is hung as presented. SASE. "Portfolios are reviewed all year."
Tips: "Photographers should recognize that only a few exhibitions each year are selected from unsolicited portfolios. *The Friends of Photography* publishes a newsletter which serves as the announcement for each exhibition. We also sponsor two grants; The Fergson Grant and the Ruttenberg Award. Interested persons should send SASE in February of each year for Grant Guidelines and due dates. Traditional black and white creative photography is most popular with buyers. We are receptive to exceptional creative photography by lesser-known photographers, but generally we don't exhibit photographers until they have had other exhibits. Call to make an appointment for a portfolio review. A large group (30 or more) of coherent work is necessary. Most photographers who have shown here have produced over 50 photographs in the particular group being exhibited."

JEFFREY FULLER FINE ART, The Studio, Lehman Lane, Philadelphia PA 19144. (215)848-2266. Owner/Director: Jeffrey Fuller. "Submit one sheet of slides of current work with a curriculum vitae and a self-addressed stamped envelope for their return." Presents 6 shows/year. Shows last 5 weeks. Sponsors openings; handles all arrangements. Photographer's presence at opening is preferred. Photography sold in gallery. Receives variable commission. Buys vintage photography outright. General price range: $250 and up. Will review transparencies. Interested in seeing slides first. Requires exclusive representation within metropolitan area. No size limitations. SASE. Reports in 1 month.

***GALLERY OF ART UNIVERSITY OF NORTHERN IOWA**, Cedar Falls IA 50614-0362. (319)273-2077. Director: Daniel E. Stetson. Interested in all styles of high-quality contemporary art and photojournalistic works. "The photographer must meet a standard of artistic quality, and we do review credentials." Presents average of 4 shows/year. Shows last 4-8 weeks. Sponsors openings, provides reception for the public. Photographer's presence at opening preferred. Photography sold in gallery. Receives 33% commission. Buys photography outright "within budget, for photographic collection." General price range: varies $50-1,500. Will review transparencies. Interested in framed or unframed work, mounted or unmounted work, matted or unmatted work; for review, have *limited* framing for exhibitions. Arrange a personal interview to show portfolio; query with resume of credits; query with samples; send material by mail for consideration; submit portfolio for review. SASE. Report time varies.
Tips: Advice to interested photographers: "Patience—we schedule over long term."

***GALLERY TWO NINE ONE**, One Rhodes Center North, Atlanta GA 30309. (404)874-9718. Director: Kevin Brown. Estab. 1982. Interested in contemporary fine art photography. "No documentary, historic or 'press' photos. Presents 10 shows/year. Shows last 6 weeks. Sponsors openings; provides press, bar, food, "the whole bit." Photographer's presence at opening preferred. Photography sold in gallery. Receives 40-50% commission. General price range: $200-2,000. Work is priced on the basis of the artist's critical and professional reputation, market rates and also the originality and uniqueness of the work. Will review transparencies. Requires exclusive representation within metropolitan area. Query with resume of credits; include slides. SASE. Reports in 1 month.
Tips: Be direct and orderly in presentation, also realistic. "We are very receptive to new young artists, but do not feel that beginner status is any excuse for sloppiness, lateness or carelessness. Get it together, then show me. Take a cold hard look at your work. Is it derivative, or imitative, can you stand behind it, what is it really worth to you?"

***FAY GOLD GALLERY**, 3221 Cains Hill Place NW, Atlanta GA 30305. (404)233-3843. Owner/Director: Fay Gold. Interested in surreal, nudes, allegorical, landscape (20th century). The photographer must be inventive, speak a new language, something not seen before of quality, historical importance or corporate oriented material. Presents 12 shows/year. Shows last 4 weeks. Sponsors openings, provides invitation, mailing, press releases to all media, serves wine, contacts all private corporate collectors. Photographer's presence at opening preferred. Photography sold in gallery. Receives 50% commission. Buys photography outright. General price range: $200-1,500. Will review transparencies. Interested in unframed work, mounted work and matted work only. Generally requires exclusive representation with-

in metropolitan area. Arrange a personal interview to show portfolio. "Call to make an appointment—work is seen 3rd Monday of each month." SASE. Reports in 1 month.
Tips: Make an appointment as stated above or send slides and resume. Trends are toward more surreal figurative, work for collectors; landscapes for corporate collections.

LENORE GRAY GALLERY, INC., 15 Meeting St., Providence RI 02903. President/Director: Lenore Gray. Interests include contemporary, innovative photography. Requires professionalism. Presents various numbers/year. Shows last 4 weeks. Photographer's presence at opening is preferred. General price range: $200 and up. Will review transparencies. Interested in unframed work only (mounted or unmounted, matted or unmatted). Requires exclusive representation within metropolitan area. Arrange a personal interview to show portfolio or send material by mail for consideration.

THE HALSTED GALLERY, 560 N. Woodward, Birmingham MI 48011. (313)644-8284. Contact: Thomas Halsted. Interested in 19th and 20th century photographs and out-of-print photography books. Sponsors openings. Presents 3 shows/year. Shows last 6-8 weeks. Receives 40% sales commission or buys outright. General price range: $300-10,000. Call to arrange a personal interview to show portfolio only. Prefers to see 10-15 prints overmatted. Send no slides or samples. Unframed work only. Requires exclusive representation.

***HARVEST RESTAURANT**, 44 Brattle St., Cambridge MA 02138. (617)547-8111. Assistant Manager: Linda Pellagrini. Interested in current, somewhat abstract, *color images*, new techniques with photography (i.e. colored pencil, oil paint on image) *not* b&w, not figurative generally (i.e., people, portraits). The artist must hang/take down work. Presents 12 shows/year. Shows last 4-6 weeks. Sponsors openings occasionally; provides wine, cheese, paté; artist generally arranges publicity. Photographer's presence at opening is required. Photographer's presence during the show preferred. Photography occasionally sold in gallery. Receives 20% commission. General price range: $250-350. Will review transparencies. Interested in framed or unframed work, mounted work only, matted work only. Query with samples, send material by mail for consideration. Will return material submitted. Reports in 2 weeks.

***G. RAY HAWKINS GALLERY**, 7224 Melrose, Los Angeles CA 90046. (213)550-1504. Contact: David Fahey. Interested in all types of fine art photography. Conducts 1 photo auction/year. "Primarily vintage & established artists." Wants photographers with minimum of 10 years in fine art photography and with work represented in at least 5 museum collections and shown in at least 10 major galleries or museums. Presents 4-6 shows/year. Shows last 4-7 weeks. Photographer's presence during shows preferred. Receives 40-50% sales commission or buys outright. Price range $1000-70,000. Query with non-returnable resume of credits, include statement regarding work for permanent files. Will review transparencies (dupe slides).
Tips: "Be patient. Produce innovative, fresh and new work. Understand origins of your specific media."

IMAGES, IMAGES, IMAGES, 328 West Fourth St., Cincinnati OH 45202. (513)241-8124. Director: Nancy Koehler. Interested in quality photographs in all mediums. No commercial work or travel photography. Documentary photographs which speak to social issues will be considered. Must have a portfolio of work which contains a strong thematic series dealing with a subject or art concern. Presents 7 shows/year. Shows last 6 weeks. Sponsors openings, evening open hours; invitation (no food or beverage). Photographer's presence at opening is preferred. Receives 40% commission. Rarely buys photographs. Will review transparencies. Interested in mounted and matted work only. Arrange a personal interview to show portfolio or send material for consideration. SASE. Reports in 1 month.

IMPRIMATUR, LTD., 415 1st Ave. N., Minneapolis MN 55401. (612)333-9174. Director: Christopher A. Frommer. Subjects include all types and styles, with a strong emphasis on alternative and non-silver process. Presents 8-10 shows/year. Shows last 5-6 weeks. Sponsors openings. Photographer's presence at opening is preferred; photographers' presence during show is preferred. Photography sold in gallery. Receives 50% commission. General price range: $400-4,000. Will review transparencies. Requires exclusive representation within metropolitan area. Submit portfolio for review. SASE. Reports in 1 month.

INTERNATIONAL CENTER OF PHOTOGRAPHY, 1130 5th Ave., New York NY 10128. (212)860-1777. Contact: Department of Exhibitions. "Before you submit a portfolio of photographs, please first write ICP and briefly describe the work and your background in photography. Appointments may be arranged by phone."

INTERNATIONAL MUSEUM OF PHOTOGRAPHY AT GEORGE EASTMAN HOUSE, 900 East Ave., Rochester NY 14607. Curator, 20th Century: Marianne Fulton. "We are a museum housing one of

the finest and largest collections of photographs. The photographic collection consists of over 500,000 photographs spanning the entire history of photography, and represents the work of some 8,000 photographers.'' Interested in photography on any subject; but "primarily interested in either personal or documentary photography." May buy photos outright, but photos are not put up for sale. Submit prints or slides by mail for consideration. SASE. Reports in 4-8 weeks. Interested in seeing unframed work only.

IRIS PHOTOGRAPHICS, 15 W. Walnut St., Asheville NC 28801. (704)254-6103. Owners: Ralph and Brigid Burns. "Emphasis has been on non-traditional but the gallery exhibits a broad range of types and styles. We are looking for a body of work which is cohesive or thematic and expresses a personal style or viewpoint." The photographer must present approximately 10 exhibition quality prints (these do not need to be matted or mounted). Presents 4 shows/year. Shows last 5 weeks. Sponsor openings, cost usually the photographer's expense but gallery does contribute. Receives 35-50% commission. General price range: $125-300. Will review transparencies. For exhibitions work must be matte to professional standards; framing optional. Requires exclusive 1 year contract pertaining to exhibited work only. "We provide standard size glass only. Other sizes can be exhibited but photographer must provide glass." Query with samples or submit portfolio for review. SASE. Reports in 2 weeks by mail; "if portfolio is submitted in person, we ask to keep it overnight."
Tips: "Interested in working with photographers who have a cohesive idea or statement to make with their show. Good idea to submit written proposal for show as well."

JANAPA PHOTOGRAPHY GALLERY LTD., 402 E. 12th St., New York NY 10009-4020. (212)777-1277. Director: Stanley Simon. Interested in contemporary, fine-art, avant-garde, photojournalism and art photography. Photographers must be professional. Presents 8-10 shows/year, both group and one-person. Shows last 3-4 weeks. Sponsors openings; provides press and public mailing list, local listing, and advertising at photographer's expense. "We charge a fee of $250/person, one person show or proportionate amount for group shows." Photographer's presence at opening and show preferred. Receives 50% commission. Will buy some photography outright in future. General price range: $150-250/b&w; $250-350/color for 16x20 prints. Will review transparencies. Interested in matted work only. Requires exclusive area representation "if possible." Arrange a personal interview to show portfolio or query with resume of credits. SASE. Reports in 2 weeks.
Tips: "We only accept exceptional work in both composition and originality, including technical concepts. We lean toward innovative and technical work." There is a strong trend toward "technical styles—multi-imaging, abstracts, hand coloring on prints, infra-red toning in colors, and panoramics."

JEB GALLERY, INC., 295 Albany St., Fall River MA 02720. (617)673-8010. Contact: Ronald Caplain or Claire Caplain. All contemporary photographers are represented. Color is accepted. Photographer receives 40% commission, with prices ranging from $300-5,000. No slides. Requires exclusive representation in New England. "Portfolios of photographers are reviewed by appointment."

K&L CUSTOM PHOTOGRAPHIC, (formerly Berkey K&L Gallery of Photographic Art), 222 E. 44th St., New York NY 10017. (212)661-5600. Director: Jim Vazoulas. Interested in fine art color photography. Commission received varies. Price range: $100-3,000. Call first, then submit portfolio. Will review transparencies. SASE. Reports in 1-2 weeks.
Tips: "Submit pleasing photos about pleasant objects. Corporate executives are not interested in spending company funds on depressing topics. Cheerful, lovely scenics and activities are admired. The gallery direction has changed from exhibit art to commercial art. Experimental, abstracted, overly-impressionistic concepts are not for our clients. We seek the photographer who can shoot reality yet lift it above the mundane so it has appeal. There is a greater demand for wall-size murals and cityscapes and landscapes."

***KENT STATE UNIVERSITY SCHOOL OF ART GALLERY**, KSU, 201 Art Building, Kent OH 44240. (216)672-7853. Director: Fred T. Smith. Interested in all types, styles and subject matter of photography. Photographer must present quality work. Presents 1 show/year. Exhibits last 3 weeks. Sponsors openings; provides cheese, crackers, vegetables, dip, wine and non-alcoholic punch. Photographer's presence at opening preferred. Photography can be sold in gallery. Receives 20% commission. Buys photography outright. Will review transparencies. Send material by mail for consideration. SASE. Reports usually in 1 month, but it depends on time submitted.

***ROBERT KLEIN GALLERY**, 355 Boylston St., Boston MA 02116. (617)262-2278. Contact: Robert Klein. Estab. 1981. Interested in museum quality, fine 10¢ and 20¢ art photos. Presents 8 shows/year. Shows last 6 weeks. Sponsors openings; provides book signing, reception, radio, TV, newspaper coverage. Photographer's presence at opening preferred. Photographer's presence during show is preferred. Photography sold in gallery. Recieves 50% commission. Buys photography outright. General price

range: $300-15,000. Will review transparencies. Interested in matted or unmatted work. Arrange a personal interview to show portfolio, submit portfolio for review. SASE. Reports in 1 week.
Tips: Be aware of what is happening in world of revolutionary-trends—be flexible, able to accept criticism. Be organized, dependable.

PETER J. KONDOS ART GALLERIES, 700 N. Water St., Milwaukee WI 53202. (414)271-9600. Owner: Peter J. Kondos. Interested in photos of women, seascapes and landscapes. Sponsors openings; "arrangements for each opening are individualized." Receives a negotiable sales commission or buys photos outright. Price range: $8 and up. Submit material by mail for consideration. SASE. Size: standard framing sizes. Requires exclusive representation in area.
Tips: Subject matter should be well-defined and of general human interest. "Emphasis is on precise detail."

***LEE GALLERY**, 119 Charles St., Boston MA 02114. (617)395-8913. Director: Mack Lee. Interested in 19th, 20th century and contemporary photography. Shows last 4-6 weeks. Photography sold in gallery. Receives 50% commission. Buys photography outright. General price range: "$100 to several thousand." Interested in unframed work only, unmounted work only, matted or unmatted work. Shows are limited to 16x20 prints and smaller. Call for appointment only. Report time varies.
Tips: Have a portfolio with a least 20 very strong photographs. Prints must be signed, dated and numbered in limited editions.

***LEHIGH UNIVERSITY ART GALLERIES**, Chandler-Ulmann, #17, Bethlehem PA 18015. (215)861-3615. Director/Curator: Richard Viera. Interests: open (fine art preferable). The photographer should "preferably be an established professional." Presents 5-8 shows/year. Shows last 4-6 weeks. Sponsors openings. Photographer's presence at opening preferred. Photographer's presence during the show preferred. Will review transparencies. Arrange a personal interview to show portfolio. SASE. Reports in 1 month.
Tips: Don't send more than 20 (top) slides.

JANET LEHR PHOTOGRAPHS, INC., Box 617, New York NY 10028. (212)288-1802. Contact: Janet Lehr. We offer "fine photographs both 19th and 20th century. For the contemporary photographer needing public exhibition I offer minimal resources. Work is shown by appointment only." Presents 8 shows/year. Shows last 6 weeks. Receives 40% commission or buys outright. General price range: $350-15,000. Send a letter of introduction with resume; do not arrive without an appointment. Will review transparencies, but prints preferred. SASE. Reports in 2 weeks.

LIGHT, 724 Fifth Ave., New York NY 10019. (212)582-6552. Contact: Director. Interested in "photographs which extend our dialogue with contemporary history." Sponsors openings. Presents 15-20 shows/year. Shows last 6 weeks. Photographer's presence at opening and during show preferred. Receives 40-50% sales commission. Price range: $250-25,000. Contact for appointment to arrange to leave portfolio for at least 3 days. Will review transparencies. SASE. Unframed work only. Prefers exclusive representation.
Tips: "Send transparencies and if we feel it is work in which we may have interest we will request a portfolio be dropped off. No comments are offered unless we would like to exhibit. Include as much biographical data as possible with the transparencies."

LONGAN GALLERY, 104 N. Broadway, Billings MT 59101. (406)259-3440. Owner: Fred Longan. Subjects include classic 19th & 20th century images, 19th century images of the Northern Plains. "We do not have regular exhibits." Buys photography outright. General price-range: matte works are $75-2,500. "Most works in $500-2,500 range." Does not return unsolicited material. "If I am interested, I'll contact the artist. I am a poor bet for unsolicited work."
Tips: "Do well; grow old; then contact me. I don't mean to be facetious, but I buy no work of unestablished artists. If I were to change that policy I would represent artists living in this region: the Northern plains states Alberta, Saskatchewan, possibly British Columbia."

MARI GALLERIES OF WESTCHESTER, LTD., 133 E. Prospect Ave., Mamaroneck NY 10543. (914)698-0008. Owners/Directors: Carla Reuben and Claire Kaufman. Interested in all types of photography. Photographer should have a comprehensive selection of framed photographs ready to hang. Presents 4-6 shows/year. Shows last 4-5 weeks. Sponsors openings. "Five to six artists are featured per show. Each artist sends flyers to their own people, plus gallery sends mailing list of its own. Press is invited. Refreshments and jazz band are provided by gallery on opening day." Photographer's presence at opening is preferred. Receives 40% sponsor commission. General price range: open. Will review transparencies. Interested in framed or unframed; mounted or unmounted; matted or unmatted work. Re-

Close-up

Margaret McCarthy
Freelance Photographer
New York City

S.B. Klausner

Margaret McCarthy, a professional editorial and assignment photographer, is also a pro when it comes to getting her work exhibited at galleries. She has had shows at New York City's Janapa Gallery, by the Bronx Museum and at the Overseas Press Club, plus others throughout New York and in Connecticut, New Hampshire and Massachusetts.

According to McCarthy, "An exhibit still remains one major way to show a group of photographs together and make a statement often not possible with (publishing) a single image." Another benefit of pursuing gallery exhibits as part of a photographer's career growth is that the artist has control over his work—not the editor. And, says McCarthy, "an exhibit is an impressive vehicle for a photographer's work; it shows the photographer's best work to its best advantage."

A 1975 graduate of the School of Visual Arts in New York City, she didn't consciously decide to specialize in gallery exhibiting. "After my first one-person show, offers for other exhibits followed. It was a question of following up on the opportunities." That first show, "Color Photographs of the Irish Landscape," (Overseas Press Club—1982) is still one of her

favorite exhibits. "The level of energy I invested in it amazes me. It was a joy to see everything come together . . . the large, beautiful prints; 300 people at the opening reception; the notices and reviews; the contacts and opportunities that resulted."

There are some key points photographers should address prior to soliciting galleries. McCarthy suggests newcomers "test the water" by participating in group shows and juried exhibits. For those aspiring to one-person shows, she first advises "have a strong concept of what the exhibit should be about, and a strong body of work to back up the concept." Also, photographers should be inventive about the places they approach for an exhibit. "Don't limit yourself to galleries." She suggests investigating alternative exhibition spaces, such as bank lobbies, government buildings and businesses that have a subject tie-in such as airlines, tourist boards, and embassies or consulates for travel-oriented photography.

What do prospective exhibitors need to be aware of when dealing with galleries? "Good communications are the basis of a good working relationship with your gallery or exhibition-space personnel," McCarthy says. "A photographer should be business-like and professional enough to know what things need to be put in writing to prevent misunderstandings." Some key items include specifying whether the gallery is the exclusive agent for selling the work exhibited and whether this is limited to a geographic area or period of time; and incorporation of a consignment list that itemizes the works to be covered by the agreement, and specifies the title, media, size and retail price of each photo. In addition, discussions of copyright (and reproduction rights), commissions, exhibit dates and costs, and promotional activities should be held. "A successful exhibit requires not only good pictures, but also good planning, coordination among all involved and good promotion," McCarthy says.

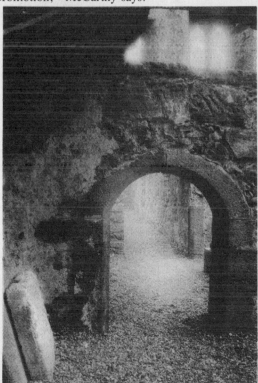

McCarthy is the author of Exhibiting Your Photography: A Manual, *distributed by The Professional's Library. Sample photos she has exhibited include "Lake & Peat Turf, West of Ireland" (left), and "Ross Abbey" (right).*

quires exclusive area representation. Arrange a personal interview to show portfolio; send material by mail for consideration or submit portfolio for review. SASE. Reports in 2 weeks.

Tips: "The aim of *MARI Galleries* is to act as a showcase for talented artists. Presenting good to excellent art to be viewed by the public is of prime importance for the survival of art in this country. Unfortunately, government support falls short of the requirements for this maintenance. We therefore try, in our small way, to nurture artists through exhibitions supported by informative publicity. *MARI* presents a spectrum of contemporary work in varied media. Our old barn acts as a perfect backdrop."

MARLBOROUGH GALLERY, INC., 40 West 57th St., New York NY 10019. (212)541-4900. Vice President: Jack Lognaz. Presents 2-4 shows/year. Shows last 4 weeks. Photography sold in gallery. Receives 40-50% commission. General price range: $700-7,000. Will review transparencies with SASE. Usually requires exclusive representation. Submit portfolio overnight, by appointment. SASE. Reports in 2 weeks.

Tips: "We work only with 'blue chip' photographers—i.e., Brassai, Berenice Abbott, Irving Penn, Bill Brandt and occasionally with outstanding younger contemporary photographers, usually in group exhibitions."

MATTINGLY BAKER, 3004 McKinney, Dallas TX 75204. (214)526-0031. Assistant Director: Debbie Nance. Interested in abstract/figurative photography. Send slides and biography to be reviewed; "we then prefer to contact the artist personally." Presents 10 shows/year. Shows last 1 month-6 weeks. Sponsors openings; arrangements negotiable. Photographer's presence at opening preferred. Rarely buys photos outright; usually taken on consignment; general price range: retail price is between $300-2,000. Photographer receives 50% commission. Will review transparencies. Interested in framed and unframed, mounted or unmounted, matted or unmatted work. Requires exclusive representation within Texas. Send material by mail only for consideration. SASE required for return of slides. Reports in 3-4 weeks.

Tips: "We represent several artists who work with silver prints, and hand colored. Be thorough in sending info on yourself—and precise. Send quality slides so we are getting a good idea of what your work really looks like."

MIDTOWN Y PHOTOGRAPHY GALLERY, 344 E. 14th St., New York NY 10003. (212)674-7200. Director: Michael Spano. Interested in all types of photography. Sponsors openings. Presents 9 or 10 shows/year. Shows last 4 weeks. "During the year we have 2- or 3-person shows." Photographer's presence at opening preferred. Receives no commission. Price range: $100-250 (average). Arrange a personal interview to show portfolio; "call for an appointment. Carefully edit work before coming and have a concept for a show." Will review transparencies; prints preferred. SASE. Reports in 1 month. Unframed work only. Size: 8x10 to 30x40 prints.

Tips: "We do not show work that has already been seen in this area. We prefer to exhibit photographers living in the metropolitan area but we have shown others. We try to have an exhibition or two each year dealing with New York City."

THE MILL GALLERY, Ballard Mill Center for the Arts, S. William St., Malone NY 12953. (518)483-0909. Curator: Nancy Child. Interested in photojournalism, color, fine b&w images and new techniques. Presents 2 shows/year. Shows last 6 weeks. Sponsors openings. "We print invitations, mail them, send press releases, and offer wine and cheese, and sometimes music." Photographer's presence at opening preferred. Receives 30% sponsor commission. General price range: $100 (depends on matting). Will review transparencies. Interested in framed work only. Query with resume of credits or samples. SASE. Reports in 2 weeks.

Tips: "We are a unique complex of craft, studio and small business spaces—the hub of cultural activity in Northern New York. Any artistic input and interest is welcomed. Photography in the past decade has become an acceptable art form. Our area is very responsive to this."

***MONTEREY PENINSULA MUSEUM OF ART**, 559 Pacific St., Monterey CA 93940. (408)372-5477. Director: Jo Farb Hernandez. Interested in all subjects. Presents 2-4 shows/year. Shows last 5-8 weeks. Sponsors openings. Buys photography outright. Will review transparencies. Work must be framed to be displayed; review can be by slides, transparencies, unframed or unmatted. Send material by mail for consideration. SASE. Reports in 1 month.

MUSEUM OF NEW MEXICO, Box 2087, Santa Fe NM 87503. (505)827-4455. Associate Director of Museum of Fine Arts: David Turner. Curator of Photographs: Steven A. Yates. Emphasis on photography in New Mexico and the Southwest. Sponsors openings. Presents 1-2 shows/year. Shows last 2-3 months. Contact Curator of Photographs.

MUSKEGON MUSEUM OF ART, 296 W. Webster, Muskegon MI 49440. (616)722-2600. Curator of Collections/Exhibitions: Henry Matthews. Interested in creative photography of the highest quality.

Prefers established photographers with past exhibition experience. Presents 1-2 shows/year. Shows last 1-2 months. Sales agreement arranged on an individual basis. Query with resume and samples. Will review transparencies. SASE.

NEIKRUG PHOTOGRAPHICA LTD., 224 E. 68th St., New York NY 10021. (212)288-7741. Owner/ Director: Marjorie Neikrug. Interested in "photography which has a unique way of seeing the contemporary world. Special needs include photographic art for our annual Rated X exhibit." Sponsors openings "in cooperation with the photographer." Photographer's presence preferred. Receives 40% sales commission. Price range: $100-$5,000. Call to arrange an appointment or submit portfolio in person. SASE. Size: 11x14, 16x20 or 20x30. Requires exclusive representation in area.
Tips: "We are looking for meaningful and beautiful images—images with substance and feeling! Edit work carefully; have neat presentation. We view portfolios once a month. They should be left on the assigned Wednesday between 1-5 pm and picked up the next day between 1-5 pm."

***NEW GALLERY OF THE EDUCATIONAL ALLIANCE**, 197 E. Broadway, New York NY 10002. (212)475-4595. Contact: Director. Interested in all types of photography. No nudes, frontal or otherwise, or erotica. Presents about 6 shows/year. Shows last 3 weeks. Photographer's presence at opening required. Receives 25% sales commission. Price range: $25-100. Arrange a personal interview to show portfolio and resume. Will review transparencies. B&w should be 8x10. Does not return unsolicited material. Dry mounted and matted work only.

NEW ORLEANS MUSEUM OF ART, Box 19123, City Park, New Orleans LA 70179. (504)488-2631. Curator of Photography: Nancy Barrett. Interested in all types of photography. Presents shows continuously. Shows last 1-3 months. Buys photography outright. No longer have NEA grant for purchase of contemporary American work. Query with resume of credits only. SASE. Reports in 1-3 months.

***NEW STRUCTURES GALLERY, (PRIVATE)**, 820 East 48th St., Kansas City MO 64110. (816)561-2006. Director: T. Michael Stephens. Interested in contemporary *experimental* photography: structural photography, "generative" photography in b&w and color. Presents "continuous representative selections throughout year." Sponsors openings, invitations, announcements in media, refreshments, slide screenings. Photography sold in gallery. Receives 33⅓% commission. General price range: $50-600/ print (framed & matted). Interested in framed or unframed, mounted or unmounted work, matted or unmatted work. Size restrictions: 5x7" or 3½x4¾" (matted) minimum; 30"-40" (mounted), maximum. Arrange a personal interview to show portfolio, query with resume of credits, query with samples, send material by mail for consideration, submit portfolio for review or submit slides and resume. SASE. Reports in 2 weeks.
Tips: "Do homework on 20th country experimental photography: 291, Man Ray, Lazlo Moholy-Nagy, Alexander Redchenko, Kertesz. There is more interest in unmanipulated, straight experimental photography and its extension into holograms, video."

NIKON HOUSE, 620 5th Ave., New York NY 10020. (212)586-3907. Interested in "creative photography, especally 35mm, that expresses an idea or attitude. We're interested in many subjects, just as long as they are visually stimulating and done tastefully. Our gallery shows all types of work. We prefer photographers with gallery experience. We'll see 'emerging' newcomers and established pros." Photographer must pay for printing, matting, mounting and frames; "Nikon pays for press releases, invitations, posters, etc." Presents 12 shows/year in the gallery. Shows last one calendar month. Photographer's presence at opening required and during show preferred. Photography is not sold in gallery, but will give out the photographer's phone number and/or address. Arrange a personal interview to show portfolio or query with resume of credits. Will review transparencies but prints preferred. "We're booked up 1 year in advance." For submission of works call: Strear, David, and Mitchell Inc., 575 Madison Ave., New York NY 10022. (212)605-0325.

NORMANDALE GALLERY, 9700 France Ave. S., Bloomington MN 55431. (612)830-9300, ext. 338. Director of College Center: Gael Cywinski. Interested in all types of photography, both traditional and experimental. Sponsors openings. Presents 6 shows of photography/year. Shows last 8 weeks. Photographer's presence at opening preferred. Buys photos outright. Price range: $25 and up. Submit portfolio or slides for review. Will review transparencies. SASE. Reports in 2 weeks. Photographer should frame, mount and matte his/her work for exhibition if accepted.

OPEN SPACE GALLERY, 510 Fort St., Victoria, British Columbia V8W 1E6 Canada. (604)383-8833. Director: Jeanne Celon. Interested in photographs as fine art in an experimental context, as well as interdisciplinary works involving the photograph. No traditional documentary, scenics, sunsets or the like. Sponsors openings. Presents 5 shows/year. Shows last 3-5 weeks. Pays the C.A.R.F.A.C. fees. Price range: $100-250. Query with transparencies of work. SASE. Reports in 6 weeks.

OPTICA-A CENTRE FOR CONTEMPORARY ART, 3981 Blvd. St.-Laucent, #501, Montreal, Quebec, Canada H2W 1Y5. (514)287-1574. Contact: Administrator. Coordinators: Dominque Guillauman, Jacques Doyan. "There is no limit in subject matter and exhibitions; only a portion of our program is photography." Sponsors openings. Presents 15 shows/year. Shows last 1 month. "10 shows last 1 month, where 5 shows last 1 evening." Artist's presence at opening preferred. Does not buy. "We have jury by slides every 4 months. Photographers are asked to submit 15 slides, a CV, and a short letter describing their work. We are funded by the Provincial Federal and Municipal Governments." Prefers to review transparencies. SASE. "We will consider unframed and unmatted works as well."

ORLANDO GALLERY, 14553 Ventura Blvd., Sherman Oaks CA 91403. (818)789-6012. Director: Philip Orlando. Interested in photography demonstrating "inventiveness" on any subject. Sponsors openings. Open to work of newer photographers. Shows last 3 weeks. Receives 50% sales commission. Price range: $350-1,800. Submit portfolio. SASE. Framed work only. Requires exclusive representation in area.

THE PHOTO GALLERY AT PORTLAND SCHOOL OF ART, 619 Congress St., Portland ME 04101. (207)775-3052. Head, Photo Department: John Eide. Requires work that has been matted and ready to hang. Presents 7 + shows/year. Shows last 4 weeks. Photography could be sold in gallery. General price range: $100-500. Will review transparencies. Interested in unmounted work only. Submit portfolio for review. SASE. Reporting time varies.

PHOTOGRAPHIC INVESTMENTS GALLERY, Box 8101, Atlanta GA 30306. (404)876-7260. Contact: Ed Symmes. Interested in "19th century vintage images and 20th century images of technical and visual excellence. All work must be framed, delivered and picked up at gallery." Presents 10-12 shows/year. Shows last 1 month. Photographer's presence at opening preferred. Receives 50% commission. Sometimes buys 19th century photography outright; rarely 20th century. General price range: $75-2,000. Will review transparencies. "Will look at anything, hang only framed work." Arrange a personal interview to show portfolio; query with samples or submit portfolio for review. SASE. Reports in 1 month "or sooner."
Tips: "Prefers working with artists in person who can appear at openings. Would like to encourage regional artists, but not exclusively."

***PHOTOGRAPHIC RESOURCE CENTER**, 602 Commonwealth Ave., Boston MA 02215. (617)353-0700. Exhibitions Coordinator: Anita Douthat. Estab. 1985. Interested in contemporary and historical photography and mixed-media work incorporating photography. "The photographer must meet our high quality requirements." Presents 6-7 group thematic exhibitions in the David and Sandra Bakalar Gallery and 8-10 one and two-person shows in the Natalie G. Klebenov Gallery/year. Shows last 4-6 weeks. Sponsors openings; "we have receptions with refreshments for the Bakalar Gallery shows. Will review transparencies. Interested in matted or unmatted work. Query with samples or send material by mail for consideration. SASE. Reports in 2-3 months "depending upon frequency of programming committee meetings."

PHOTOGRAPHICS UNLIMITED GALLERY, 17 W. 17th St., New York NY 10010. (212)255-9678. Contact: Pat O'Brien. Interested in "competent, progressive women photographers." Presents 9 shows/year. Shows last 1 month. Photographer's presence during show required. Receives 20% commission. General price range: $250-500. Will review dupe transparencies only with SASE. Interested in unframed, mounted and matted work. 20x24 size limit. Query with resume of credits. SASE. "We are booked through 1986."

PHOTOGRAPHY AT OREGON GALLERY, University of Oregon Museum of Art, Eugene OR 97403. (503)344-5010. Contact: Susie Morrill, Chairperson. "We are interested in all approaches to the photographic medium in which both technical virtuosity and serious intent on the part of the artist are displayed." Presents 10 shows/year. Shows last 1 month. "Review to be held in May for individual shows in the following year." Receives 30% sales commission. Submit portfolio for review in early May. Will review transparencies or copy slides with 1 print example. Send resume and letter of interest. No portfolios returned without prepaid postage.
Tips: "There seems to be a stylistic return to straight imagery. Our clients are interested in seeing first-rate photography. They rarely buy, except at our annual auction of donated photographs."

***THE PHOTOGRAPHY GALLERY**, 97 Spring St., Portland ME 04101. (207)775-3052. Director: John Eidg. Interested in all types, styles and subject matter. Presents 7 shows/year. Shows last 4 weeks. Photography sold in gallery. Will review transparencies. Send material by mail for consideration. SASE. Reports in 1 month.

PHOTOWORKS, INC., 204 N. Mulberry St., Richmond VA 23220. (804)359-5855. President: David L. Everette. Interested in "fine arts, mainly, but open to journalism, etc." Sponsors openings only for local and Virginia artists in all areas of photography. General price range: $100-400. Will review transparencies. Interested in framed or unframed work. Requires exclusive area representation. Send material by mail for consideration. SASE. Reports in 2 weeks.

PLAINS ART MUSEUM, 521 Main Ave., Moorhead MN 56560. (218)236-7171. Director: James O'Rourke. Sponsors openings. Presents 5-7 shows/year. Shows last 4-8 weeks. Photographer's presence at opening expected. Receives 33⅓% sales commission or buys outright. Price range: $30-4,000. Arrange personal interview to show portfolio. Will review transparencies. SASE. Reports in 1 month. Framed, mounted and matted work only. Permanent collection of regional and international photographers including Andre Kertesz, Edward S. Curtis, Edward Weston, Edward Curtis, Charles Harbutt and Todd Strand. Color and b&w catalogs created to accompany various exhibitions.

POSITIVE PHOTOGRAPHICS GALLERY, 84 Summer St., Boston MA 02174. (617)646-6080. Partner: James Rohan. Subjects include all types; good commercial, fashion and architectural photography is as welcome as art photography. Presents 8-10 shows/year. Shows last 4-6 weeks. Will review transparencies. Interested in framed or unframed work, mounted work only and matted or unmatted work. Arrange a personal interview to show portfolio.
Tips: "Work must be competent technically as well as artistically. Gallery complements our main business which is custom photographic printing, so your work should meet our technical standards."

PRAKAPAS GALLERY, 19 E. 71st St., New York NY 10021. (212)737-6066. Director: Eugene J. Prakapas. "Primary interest is Modernism. But, we are interested in any work that is of genuinely outstanding quality—not just good or accomplished, but remarkable—as I say, genuinely outstanding." Presents 0-8 exhibits/year. Shows last 6 weeks. Photography sold in gallery, commission received "depends entirely upon the situation." Buys photography outright. General price range: $3500-40,00. Will review transparencies, "but only if we request them—i.e., if prior arrangements are made." Requires exclusive representation in area. Query with resume of credits. "We are not interested in seeing unsolicited material."
Tips: Opportunties offered photographers by galleries in general are "excellent, better than ever before."

THE PRINT CLUB, 1614 Latimer St., Philadelphia PA 19103. (215)735-6090. Interested in the work of student nonprofessionals, professionals, all persons. Does some photography shows. Receives 40% sales commission. General price range: $100-1,000. Prefers unframed work. Sponsors annual competition each fall. Write for prospectus. Over $8,000 in prizes, including possible museum purchase.
Tips: "We prefer high quality experimental work, though we do show some vintage photographs."

PROJECT ART CENTER, 141 Huron Ave., Cambridge MA 02138. (617)491-0187. Photo Gallery Director: Karl Baden. Interested in all types of photography. Artists' major expenses, including openings, paid for by gallery. Presents 13 shows/year. Shows last 25 days. Receives 40% commission. General price range: $100-1,000. Arrange a personal interview to show portfolio or submit slides for review. SASE. Reports in 6-8 weeks. Unframed work only.

***REAL ART WAYS**, 94 Allyn St., Hartford CT 06103. (203)525-5521. Curator: Patricia Reville. Interested in avant-garde-experimental, styles. Presents 6 shows/year. Shows last 4 weeks. Sponsors openings; provides refreshments from 6 pm to 8 pm. Will review slides. Interested in framed or unframed work, matted or unmatted work. Send material by mail for consideration, slides/resume/clippings. SASE. Reports in 1 month.

REFLECTIONS, 199 River St., Leland MI 49654. (616)256-7120. Contact: Richard Braund. Interested in all type and subjects from nature to nude. Presents 3 shows/year. Shows last 2 months. Receives 45% sponsor commission. General price range: $5-100. Will review transparencies. Interested in framed or unframed; mounted or unmounted; matted or unmatted work. Requires exclusive area representation. No works larger than 20x30. Query with samples; send material by mail for consideration or submit portfolio for review. SASE. Reports in 3-4 weeks.

RIDER COLLEGE STUDENT CENTER GALLERY, 2083 Lawrenceville Rd., Lawrenceville NJ 08648-3099. (609)896-5326. Director of Cultural Programs: Sarah-Ann Harnick. Group or one-person shows; photographers "need to fill 150 running feet of wall space." Sponsors 2-hour opening at beginning of show; photographers must be present at opening. Price range: $50-150. Receives 33% sales commission. Submit material by mail for consideration. SASE. Framed work only.

RINHART GALLERIES, INC., Upper Grey, Colebrook CT 06021. (203)379-9773. President: George R. Rinhart. Interested in 19th and 20th century photographs. Presents 4-6 shows/year. Shows last approximately 1 month. Sponsors openings; provides drinks, hor d'oeuvres, music, etc. Photographer's presence at opening is preferred. Receives 40% commission. Buys photography outright. General price range: $50-25,000. Will review transparencies. Interested in unframed work. Requires exclusive area representation. Query with resume of credits. Does not return unsolicited material. Reports in 1 month. Sees photographers by appointment only.

C.E. RYND PHOTOGRAPHY ARTS, (formerly Equivalents Gallery), Box 4028, Seattle WA 98104. (206)325-3283. Director: Charles Rynd. "Primarily interested in 20th century photography with an emphasis on the contemporary. I represent a wide range of styles and subject matter." Private dealer, marketing to a clientele of corporate, museum and private collectors. Also acting as exclusive national agent for a selected number of artists. Receives 40-50% commission. Buys photographs outright. General price range: $150-2,000. Will review transparencies. Interested in unframed work and matted work only. Generally requires exclusive representation within metropolitan area. Submit portfolio for review. SASE. Reports in 1 month.

***SAN FRANCISCO CAMERAWORK, INC.**, 70 12th St., San Francisco CA 94103. (415)621-1001. Director: Marnie Gillett. Center for photography related visual arts. Sponsors openings during the first week of each show on a weekend evening. Presents 20 shows/year at 2 galleries. Shows last 6 weeks. Photographer's presence at opening preferred. Receives 30% donation. General price range: minimum $100. Portfolios reviewed on a continuing basis, by slide submission. Slides may be sent to the exhibition committee. Include resume and SASE. Interested primarily in solid bodies of consistent work, from 20-30 slides.
Tips: "Camerawork is a nonprofit gallery, operated by a board of working artists, writers and educators. We are supported by donations, grants and contributions from members. Membership applications are available upon request. We do not discourage any photographer from presenting work for consideration."

SANDER GALLERY INC., 51 Greene St., New York NY 10013. (212)219-2200. President: Gerd Sander. Vice-President: Christine Sander. Interested in Vintage European photography (as well as contemporary European and American). No photojournalism or commercial advertising type of photography. Work shown by appointment only.

***SANDFORD GALLERY**, Clarion University, Clarion PA 16214. (814)226-2412 or 226-2282. Director: Dr. Charles Marlin. Estab. 1982. Interested in contemporary straight and mixed media. "We require a contract covering delivery dates and documentation." Presents 2 shows/year. Shows last 4 weeks. Sponsors openings; "we print and mail the announcements and provide refreshments and hospitality." Photography sold in gallery. Buys photography outright. General price range: $200-1,500. Will review transparencies. Interested in framed or unframed work, mounted or unmounted work, matted work only. Query with resume of credits. SASE. Reports in 3 weeks.

***SANTA BARBARA MUSEUM OF ART**, 1130 State St., Santa Barbara CA 93101. (805)963-4364. Contact Curator of Photography: Timothy Hearsum. Interested in "a variety of photographic approaches: historical, art photography, documentary, color photography, whatever is happening in contemporary photography as well as curated historical shows. Photographer should have an exhibition record appropriate to museum quality exhibition. Openings are usually in conjunction with other exhibitions opening at the museum. The average length of a reception is 2 hours." Receives 10% sales commission, but photos are usually not put up for sale. Buys outright for the collection. Submit slides by mail for consideration. SASE.

DONNA SCHNEIER FINE ARTS., 10 East 22nd St., New York NY 10010. (212)505-7787. President: Donna Schneier. Interested in vintage photographs. Receives sales commission or buys outright. General price range: $100-10,000.

MARTIN SCHWEIG STUDIO/GALLERY, 4658 Maryland Ave., St. Louis MO 63108. (314)361-3000. Gallery Director: Martin Schweig. Interested in all types of photography. Shows last 6 weeks. Receives 40% sales commission. General price range: $100-1,000. Submit portfolio for review. Will review transparencies. SASE. Reports in 3-4 weeks. Finished work must be professionally mounted and ready to display. Mounting and framing must be decided with gallery.

SCHWEINFURTH MEMORIAL ART CENTER, 205 Genesee St., Box 916, Auburn NY 13021. (315)255-1553. Director: Heather Tunis. Interested in black and white, color, other toned or manipula-

ted images, primarily realism; artistic, personal vision, travelogue, photodocumentation. Relevance to the region, outstanding quality, confirmed reputation are all significant, however not necessarily inter-related, criteria. "We require quality, professionalism, appropriately mounted and framed images, la-bels and biographical information." Presents an average of 4 shows/year. Shows last 6-8 weeks. Spon-sors openings; provides wine and cheese or seasonally appropriate refreshments. Dependent upon other exhibitions, music and/or thematic environment is provided. Photographer's presence at opening is pre-ferred. Photography is sold "discretely; we are not a sales gallery per se. We are primarily an exhibition site." Receives 25% commission. General price range: $50-250. Will review transparencies. Interested in seeing slides or unframed, unmounted protected prints; interested in exhibiting matted, framed im-ages only. Requires exclusive representation within 50-mile radius. "We do not seek large format pho-tography per se." Send resume and slides or sample prints for review. SASE. Reports in 1 month to 6 weeks.

Tips: "Work should be professional, beyond amateur, not too experimental but rather expressive of the photographer's vision and control of media. By virtue of location, size and typical audience, work should be of relevance to exhibition in small, northeastern city."

***SCOTTSDALE CENTER FOR THE ARTS**, 7383 Scottsdale Mau, Scottsdale AZ 85251. (602)994-2315. Assistant Exhibits Coordinator: Tom Finke. Interested in all fine art styles. Photographer must have good work. Presents 3-4 shows/year. Shows last 3-6 weeks. Sponsors openings; refreshments, no-host bar, sometimes music. Photography sold in gallery. Receives 25% commission. Occasionally buys photography outright. General price range: $125-1,000. Will review transparencies. Interested in framed or unframed work, mounted or unmounted work, matted or unmatted work. Arrange a personal interview to show portfolio; send material by mail for consideration. SASE. Reports 1 month or depends upon review panel deadline.

Tips: Prefers well-done photos, both technically and visually. Trends in the exhibition of photographic art and among the buying public include: more contemporary work that is moderately priced.

SEA CLIFF PHOTOGRAPH CO., 310 Sea Cliff Ave., Sea Cliff NY 11579. (516)671-6070. Coordina-tors: Don Mistretta, Diann Mistretta. Interested in serious vintage and contemporary works. Are ex-panding to include other media. "The images must stand on their own either separately or in a cohesive grouping." Presents 25 shows/year. Shows last 4-8 weeks. Sponsors openings; provides press coverage; opening reception and framing facilities. Photographer's presence at opening preferred. Receives 40% commission. Occasionally buys photography outright. General price range: $100-500. Will review transparencies. Interested in unframed work only. Arrange a personal interview to show portfolio or query with resume of credits. Does not return unsolicited material. Reports in 2 weeks.

Tips: "Come to us with specific ideas and be willing to explore alternative avenues of thought. All forms of photographic imagery are acceptable. The buying public is looking for good contemporary and fine vintage photography."

THE SILVER IMAGE GALLERY, 310 Occidental Ave. S., Seattle WA 98104. (206)623-8116. Director: Dan Fear. Interested in contemporary fine art photography. Receives 40-50% sales commission; buys work by the "masters" and early photographs outright. General price range: $125-up. Submit slides and resume by mail for consideration, or submit portfolio. No more than 20 prints or 40 slides. SASE. "Re-turns slides, no comments."

Tips: "The main goal of the gallery is to sell fine photographic prints. The Silver Image Gallery is one of the oldest in the country. Communication is very important. Photographers should also be interested in working closely with the gallery. They need to know the gallery before a good working relationship can be formed. We are interested in fine art photography posters that might be included in our mail order photography poster catalog. For catalog send $2. If you have a poster for consideration, send sample. Special interests include nudes and hand colored photographs."

SIOUX CITY ART CENTER, 513 Nebraska St., Sioux City IA 51101. (712)279-6272. Contemporary expressive photography (color/b&w); altered/alternative; conceptual; generative. No student work (ex-cept advanced graduate). Send slides, resume first. SASE.

Tips: "The graphics gallery contains 107 running feet of display space. Send 25-40 *good quality* slides, resume, SASE for return of materials, and letter of introduction."

SOL DEL RIO, 1020 Townsend, San Antonio TX 78209. (512)828-5555. Director: Dorothy Katz. Inter-ested in photography on any subject. Open to work of newer photographers. Sponsors openings. Shows last 3 weeks. Receives 40% sales commission. General price range: $85-200. Query first with resume of credits and examples of work. SASE. Requires exclusive representation in area.

Tips: "Landscapes, and object shots currently sell best at our gallery."

***SOMERSTOWN GALLERY**, Box 379, Somers NY 10589. (914)277-3461. Photography Curator: Howard Goodman. Interested in straight, unmanipulated, and antique processes. The photographer must be "committed to creativity, not sales." Presents 2-4 shows/year. Shows last 4 weeks. Sponsors openings; provides mailings and printing and publicity; food and staff. Photographer's presence at opening preferred. Photography sold in gallery. Buys photography outright. General price range: $75-1,500. Will review transparencies. Interested in framed or unframed work, mounted or unmounted work, matted or unmatted work. All work must be archivally processed and presented. Submit portfolio for review. SASE. Reports in 3 weeks.
Tips: "Edit. Edit. Edit. Don't show everything. We aren't interested in what you did in the past unless it's as high quality as present work."

SOUTHERN LIGHT, Box 447, Amarillo TX 79178. (806)376-5111. Director: Robert Hirsch. Sponsored by Amarillo College. "Very open to work of newer photographers. We don't believe that the only good artist is a dead artist." Presents 12-18 shows/year. Shows last 3-4 weeks. Receives 10% sales commission. General price range: $100 and up. "We are now showing video art (prefer ¾"). Looking for features and shorts for gallery and to air on twice a week film program on college cable station. Include detailed statement for TV consideration. Include resume, statement and postage in all cases." For still works, will review transparencies. Prefers to see portfolio of 20-40 pieces. Wants to see unmounted work for preview; matted work for shows.
Tips: "We are open to anything since we don't rely on sales to stay open. We want to show work that is on the cutting edge. People photographs currently sell best at our gallery."

SUSAN SPIRITUS GALLERY, INC., 522 Old Newport Blvd., Newport Beach CA 92663. (714)631-6405. Owner: Susan Spiritus. Interested in contemporary art photography archivally processed. Line art photo books, and posters. Very open to work of newer photographers. Sponsors several person exhibitions/month with gallery reception. Has group shows; sponsored symposium on photography. Receives 50% sales commission. General price range: $150-10,000. Prefers to see slides and resume, then set up appointment. SASE. Unframed work mounted on 100% rag board only. No size limits, but must conform to stock size frames for exhibitions.
Tips: "Landscapes (color or black and white), currently sell best. The economy most definitely has affected the amount of photographs sold. We exhibit on a regular basis. We are Orange County's leading gallery for photographic art."

SUNPRINT CAFE & GALLERY, 638 State St., Madison WI 53703. (608)255-1555. Directors: Rena Gelman, Linda Derrickson. Interested in all types of photography. Sponsors openings. Receives 40% sales commission. General price range: $50 and up. Submit a 10-piece mounted portfolio; include name, address, and price of each print. Mounted or matted work only. "We need 1 month to view each portfolio and expect a follow-up phone call from the photographer. We prefer the mount boards to be a standard 11x14 or 16x20, for we put all photos behind glass; also framed photos of any size."
Tips: "We have a small cafe inside the gallery which allows people to sit and view the work in a relaxed atmosphere. We have 2 showrooms for the exhibits which hang approximately 6 weeks."

THOMAS COLLEGE ART GALLERY, W. River Rd., Waterville ME 04901. (207)873-0771. Financial Consultant: Ford A. Grant. Presents 5 shows/year. Shows last 1 month. Interested in seeing framed or unframed; mounted work only; matted or unmatted. Query with resume of credits. SASE. Reports in 2 weeks.

TIDEPOOL GALLERY, 22762 Pacific Coast Hwy., Malibu CA 90265. (213)456-2551. Partner: Jan Greenberg. Interested in "any photography related to the ocean—sea life, shore birds, etc." Sponsors openings; "we have 2 shows every year, with a reception for the artists. The shows last 1 month to 6 weeks." Photographer must be present for opening. Artist receives 60% sales commission. General price range: $25-1,500. Call to arrange an appointment or submit material by mail for consideration. SASE. Dry mounted work only. "The work must be able to be hung, and protected by being framed or in acetate sleeves." Size: "nothing smaller than 1' square or larger than 3' long or wide." Requires exclusive representation in area "for a certain period of time when we are sponsoring a show."
Tips: "Keep the price as low as possible."

T.M. GALLERY, Thomas Moore College, Crestview Hills KY 41017. (606)344-3419. Gallery Director: Barbara Raul. Presents 6 shows/year. Shows last 3-4 weeks. Sponsors openings; refreshments, publicity provided. Photographer's presence at opening is preferred. Infrequently buys outright. Will review transparencies. Interested in framed work only. Submit portfolio for review. Reports in 1 month.

TONGASS HISTORICAL MUSEUM, 629 Dock St., Ketchikan AK 99901. (907)225-5600. Secretary: Karla Sunderland. Accepts photographs relevant to southeastern Alaska and depicting Alaskan life-

styles and scenery only. "It is imperative that we review materials prior to purchase or exhibit." Presents at least 2 shows/year. Shows last 4 weeks. Provides publicity only. Receives 40-50% commission. Buys photography outright. General price range: $3-20. Will review transparencies. Unmounted or matted work only. Requires exclusive representation within metropolitan area. "We require that photographs be reasonably priced for sale to a heavy influx of tourists during the summer tourist season." Send material by mail for consideration; submit portfolio for review. SASE. Reports in 1 week.

TOUCHSTONE GALLERY, 2130 P St. NW, Washington DC 20037. (202)223-6683. Director: Luba Dreyer. Interested in fine arts photography. Photographer "must be juried in and pay the membership fee. We are an artists' cooperative." Presents one feature show per artist; plus group shows each year. Shows last 3 weeks. Photographer's presence at opening preferred. Receives 35% sponsor commission. General price range: $90-400. Submit portfolio consisting of current work plus transparencies for review at time of jurying, once a month; must be picked up next day. Reports "one day after jurying."
Tips: "We offer more exposure than sales."

BERTHA URDANG, 23 E. 74th St., New York NY 10021. (212)288-7004. The only requirement is that a photographer submit very good, innovative work. Presents 8 shows/year. Shows last 1 month. "The artist pays for a simple invitation which the gallery mails; the gallery pays for the opening reception." Receives 50% commission. Seldom buys photography outright. General price range: $250-1,500. Will review transparencies. Matted work only. Arrange a personal interview by phone to show portfolio. "I do not want to see material without a prior interview."
Tips: "The photographer should come here again and again, anonymously, and get the feel of what this gallery is about. If he/she feels an affinity, we'll talk."

VISION GALLERY INC., 1151 Mission St., San Francisco CA 94103. (415)621-2107. President: Joseph G. Folberg. Interested in contemporary and vintage 19th century. Presents 8 shows/year. Shows last 4-6 weeks. Sponsors openings. Photographer's presence at opening is preferred. Receives 50% sales commission. Buys photography outright. General price range: $200-15,000. Interested in mounted work only. Does not return unsolicited material. Arrange a personal interview to show portfolio. Reports immediately.

VISUAL STUDIES WORKSHOP GALLERY, 31 Prince St., Rochester NY 14607. (716)442-8676. Assistant Curator: Karen Chase. Interested in "contemporary mid-career and emerging artists working in photography, video, and artists' books; new approaches to the interpretation of historical photographs. Theme exhibitions such as 'Text/Picture: Notes,' 'Visual Mapping and Cataloguing,' and exhibitions which draw parallels between picture-making media." No requirements except high quality. Presents 15-20 shows/year. Shows last 4-8 weeks. Sponsors openings; provides lectures, refreshments. Photographer's presence at opening preferred. Receives 40% commission. Rarely buys photography outright. General price range: $150-500. Prefers to review transparencies. Send material by mail for consideration. SASE. Submissions are reviewed twice yearly—spring and fall. "We prefer slides which we can keep and refer to as needed."
Tips: "It is important that the photographer be familiar with the overall programs of the Visual Studies Workshop. We represent mostly younger, emerging photographers whose work we see as being significant in our time. Therefore, I feel that most of our clients buy the work they do because they are responding to the qualities of the image itself."

VOLCANO ART CENTER, Box 189, Volcano HI 96785. (808)967-7511 or 967-7676. Executive Director: Marsha A. Erickson. Gallery Manager: Margot Griffith. Interested in "b&w, and good Cibachrome prints. Preferably, work should reflect an artist's relationship with Hawaii, its landscapes, peoples, cultures, etc. All work is juried by director and gallery manager." Presents up to 12 shows/year. Shows last 3 weeks. Sponsors openings. "Sunday afternoon openings are usual. Invitations go to a mailing list of 1,600, Hawaii and West Coast press coverage is provided and refreshments served." Photographer's presence at opening preferred. Receives 40% sponsor commission. Will review transparencies or unmounted prints. Work must be presented ready for hanging. Send material for consideration or submit portfolio for review. SASE. Reports in 3 weeks.

WARD-NASSE GALLERY, 178 Prince St., New York NY 10012. (212)925-6951. Interested in photography on any subject. Open to work of newer photographers. Photographer must be voted in by other members. Price range varies. "Artist determines prices with guidance from Director if desired. No commission. We are a non-profit organization." Query about memberships, call to arrange an appointment, and submit name and address and ask to be notified about voting schedules. SASE. Photographs should be signed and in a numbered edition. Prints must be in plastic pages.
Tips: "Individual artist maintains binders containing biographical information, press clippings, slides, etc. These are easily accessible to the visitor who wants to focus on a particular mode or artist's work."

RICK WESTER PHOTOGRAPHIC, 465 Broadway, Hastings-on-Hudson NY 10706. (914)478-0277. President: Rick Wester. Handling 20th century photography and specializing in contemporary work.

THE WITKIN GALLERY, INC., 415 W. Broadway, New York NY 10012. (212)925-5510. Contact: Edmund Yankov, Assistant Director. Interested in photography on any subject. "We will also be showing some work in the other media: drawing, litho, painting—while still specializing in photography." Will not accept unsolicited portfolios. Query first with resume of credits. "Portfolios are viewed only after written application *and* recommendation from a gallery, museum, or other photographer known to us." Buys photography outright. Price range: $10-14,000.

DANIEL WOLF, INC., 30 W. 57th St., New York NY 10019. (212)586-8432. Contact: John Froats. Interested in 19th century to contemporary photography. Sponsors openings. Presents 10 shows/year. Photographer's presence at opening required. Receives 50% of selling price. Price range: $200-10,000. "We look at work once every 3 months; photographer must drop off work and pick up the following day. Call for viewing date."

WOMEN'S ART REGISTRY OF MN (WARM), 414 1st Ave. N., Minneapolis MN 55401. (612)332-5672. Exhibition Coordinator: Jody Williams. Interested in photography by women—limited to women living in MN, midwest and New York City—reviews all styles and contents. Must be an associate member of WARM. $20 annual fee. Out of state artists must apply to invitational program. Presents 2-3 shows/year. Shows last 1 month. Sponsors openings; refreshments, and provides publicity. Photographer's presence at opening is preferred. Receives 15% commission. General price range: $50-300. Will review transparencies. Interested in slides submitted during competition. Request invitational space or juried show application form. Reports in 1-2 months after application deadline.

THE WOODSTOCK GALLERY AND DESIGN CENTER, Woodstock East, Woodstock VT 05091. (802)457-1900. Gallery Director: Jon Gilbert Fox. Interested in landscape, abstract, seasonal, experimental—black-and-white, color, hand-made. Photographer must submit portfolio and resume to the gallery director for consideration. All work selected should be archivally mounted and matted, preferably framed. Presents 2 photography exhibits only/year, 6-10 with other media/year. Shows last 1 month. Sponsors openings; shares expenses. Photographer's presence at opening is preferred. Receives 40% commission. Occasionally buys outright. General price range: $100-1,500. Will review transparencies. Interested in framed or unframed work. Generally requires exclusive representation in metropolitan area. Unless they are to be labeled and priced accordingly, color photographs should be Cibachrome or Dye Transfer prints. Arrange a personal interview to show portfolio; query with samples; send material by mail for consideration or submit portfolio for review. Reporting time varies "according to how busy we are at the time."
Tips: "The best sellers are regional and collectible (good investments) and medium to low price ranges. We tend not to give one-man shows to first time exhibitors at the gallery, but try out the waters with a sampling of a photographer's work first. Photographer's work carried and displayed in gallery at all times."

***WORKS/SAN JOSE**, Box 90294 (66 S. 1st St.), San Jose CA 95109. (408)295-8378. Contact: Artist Selection Committee. Interested in avant-garde, alternative processes. The photographer may be represented by a commercial gallery but should not require/expect sales. Presents 2-5 shows/year. Shows last 1 month. Sponsors openings: food, beverage, ambiance. Photographer's presence at opening during show preferred. "We are non-profit, non-commercial." Receives 10% commission. Will review transparencies. Interested in mounted work only and framed or unframed work, and matted or unmatted work. "The bigger the better," for work shown in gallery. Query with slides and other pertinent info. SASE. Report time "varies, but usually within one month."
Tips: "Be pleasant, flexible, intelligent, willing to show in an experimental space."

CHARLES A. WUSTUM MUSEUM OF FINE ARTS, 2519 Northwestern Ave., Racine WI 53404. (414)636-9177. Director: Bruce W. Pepich. "Interested in all fine art photography. It's regularly displayed in our Art Sales and Rental Gallery and the Main Exhibition Galleries. We sponsor a biennial exhibit of Wisconsin Photographers. The biennial show is limited to residents of Wisconsin; the sales and rental gallery is limited to residents of the Midwest. There is no limit to applicants for solo, or group exhibitions, but they must apply in January of each year. Presents an average of 3 shows/year. Shows last 4-6 weeks. Sponsors openings. "We provide refreshments and 50 copies of the reception invitation to the exhibitor." Photographer's presence at opening preferred. Receives 30% commission from exhibitions, 40% from sales and rental gallery. General price range: $125-350. Will review transparencies. Interested in framed or unframed work. "Must be framed unless it's a 3-D piece. Sale prices for sales and rental gallery have a $1,000 ceiling." Query with resume of credits or send material by mail for consideration. SASE.

Newspapers and Newsletters

The newspapers and newsletters in this section range from general readership to special-interest publications. Though the subject matter used from newspaper to newspaper will vary, almost all of them use black and white prints, with the occasional exception of a Sunday supplement or a larger circulation tabloid. News photography, or photojournalism, is one of the most visible photography specializations—especially photos picked up by the wire services. Events captured on film shape the world's historical perception of a news event, such as the flag raising at Iwo Jima.

Many of the photos that appear in metropolitan dailies and large news magazines are taken by staff photographers, yet these markets are still open for the freelance photographer who wants to work as a stringer. Staff photographers may already be out on assignment, and an editor needs to have on call a photographer capable of good news coverage.

How does a good photojournalist get action news photos? News stories must be pursued to be captured. This involves investing some of your time to follow local political, civic and social action groups for any possible news leads. Watch for scheduled events, and monitor the newspaper, TV and radio for any unique angles they could provide, or information that would help you anticipate tomorrow's news. Many reporters also use police scanners to get up-to-date information. It may be wise to check first with your local police to see if permission is required before purchasing a scanner. If you ever find yourself to be the only photographer at the scene of a breaking news event, shoot as much film as possible and from a wide variety of angles. Rush this to the local news editor, explain the story angle to him, and chances are he will be willing to negotiate for its use. You also will have made that important step to proving yourself a good photojournalist.

Whenever you sell a news package to an editor, try to retain resale rights to your photos. The news event may be prominent enough to generate sales to other newspapers or news magazines.

Newsletters, like newspapers, provide current news for readers, though the news in this case will be more narrow, such as to members of a particular profession. Since newsletters do focus on more specialized news, it will be wise to study the material each covers to see how your strengths and interests could be used toward generating a photo essay or photo/text package. Many editors will provide a sample copy of their publication or photo guidelines (with SASE) for review.

***ALLIED PUBLISHING**, 430 Haywood Rd., Asheville NC 28006. (704)253-7175. Editor: Ralph Roberts. Publishes *North Carolina Veterans News* and *Sagebrush Journal*. Monthly newspapers. Emphasizes veterans, cowboys, books and western movies. Readers are age 30-up, interested in western movies or veterans. Circ. combined: 15,000. Sample copy $2.50 each.
Photo Needs: Uses 30-40 photos/issue; 50% supplied by freelance photographers. Needs photos of western stars as they are today, western conventions, veterans, etc. Special needs include western conventions. Model releases and captions preferred.
Making Contact & Terms: Query with list of stock photo subjects or send any size b&w glossy print by mail for consideration. SASE. Reports in 1 month. Pay negotiated. Pays on publication. Credit line given. Buys one-time rights. Simultaneous submissions and previously published work OK.
Tips: Prefers to see "good, sharp, clear b&w photos, especially western stars as they are now, at conventions."

THE AMERICAN SHOTGUNNER, Box 3351, Reno NV 89505. (702)826-3825. Managing Editor: Sue Bernard. Monthly; 88 pages. Circ: 124,000. Buys 25 photos annually. Emphasizes hunting techniques, tournament shooting, new products for hunting and gun collecting. For educated sportsmen and affluent gun owners.
Subject Needs: Nature; product shot (high-grade modern shotguns or accessories); animal and wildlife (ducks, geese, dogs and hunting subjects); and special effects/experimental. Would also like interesting photos of celebrity hunters afield. Special needs include high-quality studio shots for potential covers. Captions required.
Specs: Uses 8x10 glossy b&w prints and prefers 2¼x2¼ or larger color transparencies. Uses color covers; originals only.
Payment/Terms: Pays $10-40/b&w print, $15-200/color transparency and $50-200/cover. Credit line given. Pays on publication, sometimes on acceptance. Buys all rights. Submit model release with photo.
Making Contact: Send photos for consideration. SASE. Reports in 2 weeks. Free sample copy. Provide resume and business card to be kept on file for possible future assignments.
Tips: Photos must be of superior quality. No posed dead game shots. "Most photos are purchased with stories. We need how-to-build-it or how-to-do-it photo narratives. Send only your very best work. We remember quality or the lack of it and associate it to names we have used or reviewed. If we reject your work three times, we probably won't even look at additional submissions."

AMERICAN SPORTS NETWORK, Box 6100, Rosemead CA 91770. (818)572-4727. President: Louis Zwick. Publishes four newspapers covering "general collegiate, amateur and professional sports; i.e., football, baseball, basketball, track and field, wrestling, boxing, hockey, powerlifting and bodybuilding, etc." Circ. 50,000-755,000. Sample copy and photo guidelines free with SASE.
Photo Needs: Uses about 10-85 photos/issue in various publications; 90% supplied by freelancers. Needs "sport action, hard-hitting contact, emotion-filled, b&w glossy 8x10s and 4x5 transparencies. Have special bodybuilder annual calendar, collegiate and professional football pre- and postseason editions." Model release and captions preferred.
Making Contact & Terms: Send 8x10 b&w glossy prints and 4x5 transparencies by mail for consideration; provide resume, business card, brochure, flyer or tearsheets to be kept on file for possible future assignments. SASE. Reports in 1 week. Pays $1,000/color cover photo; $250/inside b&w photo; negotiates rates by the job and hour. Pays on publication. Buys first North American serial rights. Simultaneous and previously published submissions OK.

***ANCHORAGE DAILY NEWS**, 200 Potter Dr., Anchorage AK 99502. (907)786-4347. Editor: Howard Weaver. Photo Editor: Richard Murphy. Daily newspaper. Emphasizes all Alaskan subjects. Readers are Alaskans. Circ. 60,000. Sample copy free with SASE.
Photo Needs: Uses 10-50 photos/issue; 5% supplied by freelance photographers. Needs photos of all subjects, primarily news. Model release and captions required.
Making Contact & Terms: Contact photo editor with specific ideas. SASE. Reports in 1-3 weeks. Pays "by photo, prices vary with subject." Pays on acceptance. Credit line given. Buys one-time rights. Simultaneous submissions OK.
Tips: "We, like most daily newspapers, are primarily interested in timely topics, but at times will use dated material."

ATV NEWS, Box 1030, Long Beach CA 90801. (213)595-4753. Publisher: Skip Johnson. Senior Editor: Jack Mangus. Editor: Matt Hilgenberg. Biweekly tabloid. Circ. 88,000. Emphasizes all terrain vehicle views and recreation for ATV racers and recreationists nationwide. Needs photos of ATV racing to accompany written race reports; prefers more than one vehicle to appear in photo. Wants no dated material. Buys 1,000 photos/year. Buys all rights, but may reassign to photographer after publication. Send photos or contact sheet for consideration or call for appointment. "Payment on 15th of the month for issues cover-dated the previous month." Reports in 3 weeks. SASE. Free photo guidelines.
B&W: Send contact sheet, negatives, or prints (5x7 or 8x10, glossy or matte). Captions required. Pays $10 minimum.
Color: Send transparencies. Captions required. Pays $50 minimum.
Cover: Send contact sheet, prints or negatives for b&w; transparencies for color. Captions required. Pay negotiable.
Tips: Prefers sharp action photos utilizing good contrast. Study publication before submitting "to see what it's all about." Primary coverage area is the United States.

***BAJA TIMES**, Box 755, San Ysidro CA 92073. (706)612-1244. Publisher: Hugo Torres. General Manager: Carlos Chabert. Editorial Consultant: John W. Utley. Monthly. Circ. 50,000. Emphasizes Baja California travel and history. Readers are travelers to Baja California, Mexico, and Baja aficionados from all over US and Canada. Free sample copy with SASE (legal size).

Photo Needs: Uses about 12 photos/issue; most supplied by freelance photographers. Needs current travel, scenic, wildlife, historic, women, children, fishing, Baja fashions and beach photos. Photos purchased with or without accompanying ms. Special needs include: History of cities in Baja California and resorts, Baja shopping, sports, and general recreation. Model release and captions preferred.
Making Contact & Terms: Send by mail for consideration b&w prints, or query with list of stock photo to subjects. Now using full color photos for front cover. Will consider outstanding Baja California, Mexico subjects. Will review color prints, but must have transparencies for publication. Reports in 4 weeks. Pays $5-20/b&w photo; $25-60/color photo. Buys one-time rights.
Tips: "We need sharp photography with good definition. Photo essays are welcome."

BANJO NEWSLETTER INC., Box 364, Greensboro MD 21639. (301)482-6278. Editor: Hub Nitchie. Monthly. Emphasizes 5-string banjo information. Readers include musicians, teachers. Circ. 8,000.
Photo Needs: Uses 3-8 photos/issue; very few supplied by freelance photographers. Needs musical instruments, cases, well known banjo players, band, PR shots. Model release preferred.
Making Contact & Terms: Query with samples, usually writers provide photos from banjo manufacturers or musicians. Reports in 1 month. Pays $40-50/b&w cover photo, $10-15/b&w inside photo. Pays on publication. Credit line given. Buys one-time rights. Simultaneous submissions and previously published work OK with permission from publisher.

BASKETBALL WEEKLY, 17820 E. Warren Ave., Detroit MI 48224. (313)881-9554. Managing Editor: Matt Marsom. Published 20 times/year. Circ. 40,000. Emphasizes complete national coverage of pro, college and prep basketball. Freelancers supply 50% of the photos. Pays on publication. Buys all rights. Simultaneous submissions OK. Send photos. SASE. Reports in 2 weeks. Free sample copy.
Subject Needs: Close facials and good game action. "We don't necessarily want different photos, just good ones which we attempt to play prominently. Since we are not daily, we are very interested in receiving a package of photos which we will pay for one photo at a time when and if used. Will return unused photos only if requested. No elbows and armpits with a black background."
B&W: Uses 8x10 and 5x7 prints. Pays $10 per photo used.
Cover: Uses b&w covers only.

BOSTON GLOBE MAGAZINE, *Boston Globe*, Boston MA 02107. Editor: Ms. Ande Zellman. Weekly tabloid. Circ. 817,000. For general audiences. Buys 150 photos annually. Buys first serial rights. Pays on publication. "All photographs are assigned to accompany specific stories in the magazines." Write for an appointment to show portfolio of work to designer, Ronn Campisi. Query *before* sending material.
B&W: Uses glossy prints; send contact sheet. Captions required. Payment negotiable.
Color: Uses transparencies. Captions required. Query first. Payment negotiable.
Cover: Uses color transparencies. Captions required. Query first. Payment negotiable.

BOSTON PHOENIX, 100 Massachusetts Ave., Boston MA 02115. (617)536-5390. Design Director: Cleo Leontis. Associate Design Director: Steve Vornbusch. Weekly tabloid. Circ. 150,000. Emphasizes "local news, arts and lifestyle." Especially needs freelance photographers on assignment only basis. Buys 20-35 photos/issue. Credit line given. Pays on publication. Buys one-time rights. Query first to arrange personal interview to show portfolio. SASE. Previously published work OK. Reports in 4 weeks.
Subject Needs: "All photos are assigned in any and all categories depending on the needs of special supplements which are published as part of our regular news/arts editions." Model release required.
B&W: Uses 8x10 matte prints. Pays $40 for first photo; $25 for each additional photo.

BUSINESS INSURANCE, 740 N. Rush, Chicago IL 60611. (312)649-5398. Editor: Kathryn J. McIntyre. Emphasizes commercial insurance for the commercial buyer of property/casualty and group insurance plans. Weekly. Circ. 47,000. Free photo guidelines.
Photo Needs: Uses up to 20 photos/issue, 2 supplied by freelance photographers. Works on assignment. Provide letter of inquiry and samples. Needs "photos of big property losses, i.e., fires, explosions." Model release required if it's not a news event. Captions required.
Making Contact & Terms: Make query with resume of photo credits to Holly Seguine, graphics editor at (312)649-5277. SASE. Reports in 2 weeks. Pays on publication $10-20/b&w photo; or pays $10 minimum/hour, $100 minimum/job, or lump sum for text/photo package. Credit line given. Buys all rights on a work-for-hire basis.

 The asterisk before a listing indicates that the listing is new in this edition. New markets are often the most receptive to freelance contributions.

CAPPER'S WEEKLY, 616 Jefferson, Topeka KS 66607. (913)295-1108. Editor: Dorothy Harvey. Bimonthly tabloid. Emphasizes human-interest subjects. Readers are "mostly Midwesterners in small towns and on rural routes." Circ. 400,000. Sample copy 55¢.
Photo Needs: Uses about 20-25 photos/issue, "one or two" supplied by freelance photographers. Needs "35mm color slides of human-interest activities, nature (scenic), etc., in bright primary colors." Captions preferred.
Making Contact & Terms: Query with samples; send 35mm transparencies by mail for consideration. SASE. Reporting time varies. Pays $25/color page/photo. Pays per photo $10-15 b&w; $25 color. Pays on acceptance. Credit line given. Buys one-time rights.
Tips: Artists should study publication before submitting photos. "We are not a photography magazine—many beautiful scenes are eliminated because they are too 'artistic' or lacking human interest."

CHICAGO READER, 11 E. Illinois, Chicago IL 60611. (312)828-0350. Art Director: Bob McCamant. Weekly tabloid. Circ. 120,000. For young adults in Chicago's lakefront communities interested in things to do in Chicago and feature stories on city life. Buys 10 photos/issue. "We will examine, in person, the portfolios of *local* Chicago photographers for possible inclusion on our assignment list. We rarely accept unassigned photos."

COLORADO SPORTSTYLES MAGAZINE, (formerly *Colorado Sports Monthly*), Box 3519, Evergreen CO 80439. (303)670-3700. Editor: R. Erdmann. Monthly tabloid. Circ. 25,000. Emphasizes "individual participation sports within Colorado—skiing, running, racquet sports, bicycling, etc. Readers are young, active, fitness conscious." Sample copy free with SASE.
Photo Needs: Uses about 20 photos/issue; 10-15 supplied by freelance photographers. Needs sports photos in the above subject areas. Model release preferred; captions required.
Making Contact & Terms: Query with samples. Provide resume, business card, brochure, flyer or tearsheets to be kept on file for possible future assignments. SASE. Reports in 1 month. Pays by the job. Pays 30 days after publication. Credit line given. Buys one-time rights. Simultaneous submissions and previously published work OK.
Tips: "Focus on people as they're involved in the sport."

COLUMBUS-DAYTON-CINCINNATI-TOLEDO BUSINESS JOURNALS, 666 High St., Worthington OH 43085. (614)888-6800. Publisher: Paul Parshall. Editor: Wynn Hollingshead. Monthly tabloids. Combined circ. 45,000. Emphasizes business. Readers' average income: $43,000 + . Sample copy free with SASE and postage.
Photo Needs: Uses about 20 photos/issue. Needs photos covering business, government and high-tech. Captions required.
Making Contact & Terms: Send b&w prints by mail for consideration. SASE. Reports in 2 weeks. No payment. Credit line given. Buys one-time rights. Simultaneous submissions OK.

CYCLE NEWS, Box 498, Long Beach CA 90801. (213)427-7433. Publisher: Sharon Clayton. Editor: John Ulrich. Weekly tabloid. Circ. 88,000. Emphasizes motorcycle news for enthusiasts and covers nationwide races. Needs photos of motorcycle racing to accompany written race reports; prefers more than one bike to appear in photo. Wants current material. Buys 1,000 photos/year. Buys all rights, but may reassign to photographer after publication. Send photos or contact sheet for consideration or call for appointment. "Payment on 15th of the month for issues cover-dated the previous month." Reports in 3 weeks. SASE.
B&W: Send contact sheet, negatives (preferred for best reproduction) or prints (5x7 or 8x10, glossy or matte). Captions required. Pays $10 minimum.
Color: Send transparencies. Captions required. Pays $50 minimum.
Cover: Send contact sheet, prints or negatives for b&w; transparencies for color. Captions required. Pay negotiable.
Tips: Prefers sharp action photos utilizing good contrast. Study publication before submitting "to see what it's all about." Primary coverage area is nationwide.

CYCLING U.S.A., U.S. Cycling Federation, 1750 E. Boulder St., Colorado Springs CO 80909. Editor: Diane Fritschner. Emphasizes bicycle racing for active bicycle racers. Circ. 20,000. Sample copy free with SASE.
Photo Needs: Uses about 10 photos/issue; 100% supplied by freelance photographers. Needs action racing shots, profile shoots or competitors. Captions required.
Making Contact & Terms: Query with samples. Send 5x6 or 8x10 b&w prints by mail for consideration; submit photos on speculation. SASE. Reports in 3 weeks. Pays $175/color cover photo; $25 minimum/b&w inside photo, depending on size; 10¢/word. Pays on publication. Credit line given. Buys one-time rights "unless other arrangements have been made."

Tips: "Study European and American bicycle racing publications. Initially, it's a tough sport to shoot, but if a photographer gets the hang of it, he'll get his stuff published regularly."

DAILY TIMES, Box 370, Rawlins WY 82301. (307)324-3411. Editor-in-Chief: Chuck Bowlus. Daily. Circ. 5,000. Emphasizes general news.
Photo Needs: Uses about 12-15 photos/issue; 2-3 supplied by freelance photographers. Needs "everything—stress on news photos." Photos purchased with accompanying ms only. Model release preferred.
Making Contact & Terms: Query with samples. Provide resume and tearsheets to be kept on file for possible future assignments. "We do not pay for photos." Credit line given.

DOLLARS & SENSE, 325 Pennsylvania Ave., Washington DC 20003. (202)543-1300. Editor-in-Chief: Tom G. Palmer. 10 times/year. Circ. 140,000. Emphasizes taxpayer-related issues. Readers are people interested in reducing taxes and government spending. Free sample copy with SASE.
Photo Needs: Uses about 3 photos/issue. Needs "pictures that coincide thematically with subject matter of the articles."
Making Contact & Terms: Query with list of stock photo subjects. SASE. Reports in 3 weeks. Pays $25-50/b&w cover photo; $15-30/b&w inside cover photo. Pays on publication. Credit line given. Buys one-time rights. Simultaneous submissions and/or previously published work OK.

ECM NEWSLETTERS, Suite F57, 8520 Sweetwater, Houston TX 77037. (713)591-6015; (800)231-0440. Editor: Deborah Jackson. Monthly. Circ. 2,000,000. Emphasizes real estate. "Newsletters are sent out to homeowners by real estate agents." Sample copy and photo guidelines free with SASE.
Photo Needs: Uses about 3-6 photos/issue; 1-3 supplied by freelance photographers. "We use color photos to illustrate various articles—our needs range from pets to home improvement, travel, current events, landmarks, famous persons and food. We feature a recipe in each issue which must be accompanied by a color photo." Model release required.
Making Contact & Terms: Query with list of stock photo subjects. Send any size color glossy prints or transparencies by mail for consideration. SASE. Reports in 1 month. Pays $25/color cover photo; $25/color inside photo. Pays on acceptance. Buys all rights "but nonexclusive." Simultaneous submissions and previously published work OK.
Tips: "We look for clear, sharp photos, free of detracting shadows."

EXCHANGE & COMMISSARY NEWS, Box 1500, Westbury NY 11590. (516)334-3030. Senior Editor: Bob Moran. Monthly tabloid. Emphasizes "military retailing: grocery and mass merchandising stores." Readers are buyers and managers.
Photo Needs: Uses about 40-50 photos/issue. Needs "store shots." Captions preferred.
Making Contact & Terms: Send b&w prints; 35mm or 4x5 transparencies; b&w contact sheets by mail for consideration. SASE. Reports in 2 weeks. Payment varies. Pays on acceptance. Credit line given. Buys all rights.

FISHING AND HUNTING NEWS, 511 Eastlake Ave. E., Box C-19000, Seattle WA 98109. (206)624-3845. Managing Editor: Vence Malernee. Weekly tabloid. Circ. 133,000. Buys 300 or more photos/year. Emphasizes how-to material, fishing and hunting locations and new products. For hunters and fishermen.
Subject Needs: Wildlife—fish/game with successful fishermen and hunters. Captions required.
Specs: Uses 5x7 or 8x10 glossy b&w prints or negatives for inside photos. Uses color covers and some inside color photos—glossy 5x7 or 8x10 color prints, 35mm, 2¼x2¼ or 4x5 color transparencies. When submitting 8x10 color prints, negative must also be sent.
Payment & Terms: Pays $5-15 minimum/b&w print, $50-100 minimum/cover and $10-20 editorial color photos. Credit line given. Pays on acceptance. Buys all rights, but may reassign to photographer after publication. Submit model release with photo.
Making Contact: Send samples of work for consideration. SASE. Reports in 2 weeks. Free sample copy and photo guidelines.
Tips: Looking for fresh, timely approaches to fishing and hunting subjects. Query for details of special issues and topics. "We need newsy photos with a fresh approach. Looking for near-deadline photos from Oregon, California, Utah, Idaho, Wyoming, Montana, Colorado, Texas, Alaska and Washington (sportsmen with fish or game)."

FLORIDA GROWER AND RANCHER, 723 E. Colonial Dr., Orlando FL 32803. (305)894-6522. Editor: Frank Abrahamson. Monthly. Emphasizes commercial agriculture in Florida. Readers are "professional farmers, growers and ranchers in the state of Florida." Sample copy free with SASE and $1 postage. Photo guidelines free with SASE.

Photo Needs: Uses about 20-25 photos/issue; "few, at present" supplied by freelance photographers. Needs photos of "Florida growers and ranchers in action in their day-to-day jobs. Prefer modern farm scenes, action, of specific farm which can be identified." Model release preferred; captions required.
Making Contact & Terms: Query with list of stock photo subjects. Provide resume, business card, brochure, flyer or tearsheets to be kept on file for possible future assignments. SASE. Reports in 3 weeks. Pays $50/color cover photo; $5-10/b&w inside photo. Pays by the line plus photo for text/photo package. Pays on publication. Credit line given if required. Buys all rights "but we usually allow resale or use anywhere outside the state of Florida." Simultaneous submissions and previously published work OK.
Tips: "Query first—photography usually tied in with writing assignment."

GAY COMMUNITY NEWS, 5th Floor, 167 Tremont St., Boston MA 02111. (617)426-4469. Managing Editor: Gordon Gottlieb. Design Director: Ina Cohen. Weekly. Circ. 15,000. Emphasizes "gay rights, liberation, feminism. *Gay Community News* is the primary news source for anyone concerned with what is being done to and by lesbians and gay men everywhere in this country." Sample copy $1.
Photo Needs: Uses 5 photos/issue, all supplied by freelance photographers. Needs "primarily news photos of events of interest to gay people e.g., b&w photos of demonstrations, gay news events, prominent gay people, etc." Model release and captions preferred.
Making Contact & Terms: Arrange a personal interview to show portfolio. SASE. Reports in 1 week. "We can pay only for materials, up to $5/photo. Our photographers, writers and illustrators are all volunteers." Pays on publication. Credit line given. Buys one-time rights.

GAY NEWS, 254 S. 11st St., Philadelphia PA 19107. (215)625-8501. Weekly tabloid. Circ. 15,000. Assistant to Publisher: Tony Lombardo. Emphasizes news and features of interest to Philadelphia's lesbian and gay community. Readers are gay people who are variously politically involved or socially aspiring. Sample copy 75¢.
Photo Needs: Uses about 5-8 photos/issue. Needs illustrations for features on wide variety of topics that are gay-related. Photos purchased with accompanying ms only. Model release required; captions preferred.
Making Contact & Terms: Provide resume, business card, brochure, flyer or tearsheets to be kept on file for possible future assignments. SASE. Reports in 3 weeks. Pays $25/b&w cover photo and $5/b&w inside photo. Pays on publication. Credit line given. Buys first North American serial rights. Previously published work OK.

GIFTED CHILDREN MONTHLY, Box 115, Sewell NJ 08080. (609)582-0277. Managing Editor: Robert Baum. Monthly. Circ. 45,000. Emphasizes "gifted education; preschool children up to age 14—grade level 9." Readers are "primarily parents; some teachers, schools, libraries." Sample copy free with 9x12 SASE and 56¢ postage.
Photo Needs: Uses about 1-2 photos/issue; none at present supplied by freelance photographers but "would consider both assignments and speculation." Needs photos of children's projects and activities. Model release required; captions preferred. "Persons must be identified."
Making Contact & Terms: Send b&w glossy prints, contact sheet by mail for consideration. SASE. Reports in 2 weeks or as soon as possible. Pays $10-25/b&w photo. Pays on publication. Buys one-time rights.
Tips: Looks for "action, contrast, good range of grays. Study us and our particular audience."

GLOBE, 5401 NW Broken Sound Blvd., Boca Raton FL 33431. (305)997-7733. Photo Editor: Ron Hanes. Weekly tabloid. Circ. 2,000,000. "For everyone in the family. *Globe* readers are the same people you meet on the street, and in supermarket lines—average, hard-working Americans who prefer easily digested tabloid news." Needs human interest photos, celebrity photos, humorous animal photos, anything unusual or offbeat. Buys all photos from freelancers. Buys first serial rights. Send photos or contact sheet for consideration. Pays on acceptance. Reports in 1 week. SASE. Previously published work OK.
B&W: Send contact sheet or 8x10 glossy prints. Captions required. Pays "by arrangement."
Color: Color for covers and inside spreads. Send good quality of any subject shots.
Tips: Advises beginners to look for the unusual, offbeat shots.

GRIT, 208 W. 3rd St., Williamsport PA 17701. Editor: Naomi L. Woolever. Photo Editor: Joanne Decker. Weekly tabloid. Circ. 600,000. Emphasizes "people-oriented material which is helpful, inspiring and uplifting. When presenting articles about places and things, it does so through the experiences of people. Readership is small-town and rural America." Photos purchased with or without accompanying ms. Buys "hundreds" of photos/year. Buys one-time rights, first serial rights or second serial (reprint) rights. Send material by mail for consideration. SASE. Previously published work OK. Pays on accept-

ance. Reports in 2-3 weeks. Sample copy $1, photo guidelines free with SASE.

Subject Needs: Needs on a regular basis "photos of all subjects, provided they have up-beat themes that are so good they surprise us. Human interest, sports, animals, celebrities. Get action into shot, implied or otherwise, whenever possible. Make certain pictures are well composed, properly exposed and pin sharp. All color transparencies for the cover are square in format. We use 35mm and up." Captions required. "Single b&w photos that stand alone must be accompanied by 50-100 words of meaningful caption information." Model release preferred. "No cheesecake. No pictures that cannot be shown to any member of the family. No pictures that are out of focus or grossly over/or under-exposed. No ribbon-cutting, check-passing, hand-shaking pictures."

B&W: Uses 8x10 glossy prints. "Because we print on newsprint, we need crisp, sharp b&w with white whites, black blacks and all the middle gray tones. Use fill-in flash where needed. We also want good composition." Pays $35/photo; $15/photo for second rights. Pays $25/photo for pix accompanying mss, $10 for reprint rights on pix accompanying mss.

Color: Uses transparencies for cover only. "Remember that *Grit* publishes on newsprint and therefore requires sharp, bright, contrasting colors for best reproduction. Avoid sending shots of people whose faces are in shadows; no soft focus." Pays $100/front cover color.

Accompanying Mss: Pays 12¢/word, first rights; 6¢/word for second or reprint rights. Free writer's guidelines for SASE.

Tips: "Good major-holiday subjects seldom come to us from freelancers. For example, Easter, 4th of July, Christmas or New Year. Using newsprint we need crisp b&w. Avoid shadows on people's faces—when photo requires action make sure action is *in* photo."

GROUP, Box 481, Loveland CO 80539. (303)669-3836. Editor: Gary Richardson. Eight times/year. Circ. 70,000. For leaders of high-school-age Christian youth groups. Emphasizes youth ministry activities, concerns and problems. Photos purchased with or without accompanying ms. Buys 10 photos/issue. Pays $30-200 for text/photo package; pays also on a per-photo basis. Credit line given. Pays on publication. Buys one-time rights. Send material by mail for consideration or call for appointment. SASE. Simultaneous submissions and previously published work OK. Reports in 2 weeks. Sample copy $1. Photo guidelines free with SASE.

Subject Needs: Sport (young people in all kinds of sports); human interest (young people); adults and adults with young people; humorous; photo essay/photo feature (youth group projects and activities).

B&W: Uses 8x10 prints. Pays $20-50/photo.

Color: Uses 35mm or 2¼x2¼ color transparencies. Pays $40-150/photo.

Cover: Uses 35mm or 2¼x2¼ color transparencies. Vertical format required. Pays $100 minimum/color photo.

Accompanying Mss: Seeks how-to feature articles on activities or projects involving high school students or Christian youth groups. Pays $75 minimum/ms. Writer's guidelines free with SASE.

Tips: "Make sure photos look contemporary, not dated, and relate to, or are appropriate for, Christian teenagers and adults."

GUARDIAN NEWSWEEKLY, 33 W. 17th St., New York NY 10011. (212)691-0404. Photo Editor: Jeff Jones. Weekly newspaper. Emphasizes "progressive politics and national and international news; focuses on Third World and on women's movement, disarmament, labor, economy, environment, grassroots community groups." Readers are "activists, students, labor; we have subscribers around the world." Circ. 30,000. Sample copy for SASE and 90¢ postage.

Photo Needs: Uses 25-35 photos/issue; "at least 50%" supplied by freelance photographers. Needs "news photos—local, international and national. Includes mugs of figures in the news, local rallies, features; most to accompany stories." Captions preferred.

Making Contact & Terms: Prefers query with 2 samples or list of stock photo subjects. Send any size b&w glossy prints by mail for consideration. SASE. Reports in 1 month "or sooner." Pays $15/b&w inside photo. Pays on publication. Credit line given. Buys one-time rights. Simultaneous and previously published submissions OK.

Tips: Prefers to see "good quality, good sense of political side of subject *and* human interest aspect" in samples. "We pay low rates, but our photos are often requested by other publications for reprinting and they will pay photographer too. We feature photos on cover and in centerfold."

GUN WEEK, Box 488, Station C, Buffalo NY 14209. (716)885-6408. Editor: Joseph P. Tartaro. Weekly newspaper. Circ. 30,000. Emphasizes gun-related hobbies—sports, collecting and news. For people interested in firearms. Credit line given. Buys first North American serial rights. Model release required. Send contact sheet or photos for consideration. Pays on publication. Reports in 6 weeks. SASE. Simultaneous submissions OK. Sample copy and editorial guidelines $1.

Subject Needs: Needs nature, sports, photo essay/photo feature, human interest, product shots, sport news and wildlife on a regular basis. Needs photos of firearms, antique firearms, shooters taking aim at

targets, hunters in the field; news photos related to firearms, legislation, competitions and gun shows. Captions required.
B&W: Send contact sheet or 5x7 or 8x10 glossy prints. Pays $5 minimum/photo and caption.
Color: Send 35mm transparencies. Pays $10 minimum/photo and caption.
Tips: "*Gun Week* is based on a newspaper format, and therefore space is limited. We have a lead time of two weeks, making our publication timely. News material is considered on this basis." Send for publication schedule. Submit seasonal material 6 weeks in advance.

HICALL, Church School Literature Department, 1445 Boonville Ave., Springfield MO 65802. (417)862-2781. Editor: Jennifer J. Eller. Association publication for the general council of the Assemblies of God. Thirteen weekly, 8-page issues published quarterly. Readers are primarily high school students (but also junior high). Circ. 120,000. Sample copy and photo guidelines free with SASE.
Photo Needs: Uses 2-3 photos/issue; 75% supplied by freelance photographers. Needs photos of teens in various moods (joy, loneliness, prayer, surprise). Some scenics used, also nature close-ups; high school settings and activities. Reviews photos with or without accompanying ms.
Making Contact & Terms: Query with list of stock photo subjects, send 8x10 glossy b&w prints, 35mm, 2¼x2¼, and 4x5 transparencies by mail for consideration. SASE. Pays $30/b&w cover photo; $40/color cover photo; $25/b&w inside photo; and $30/color inside photo. Pays on acceptance. Credit line given. Buys one-time rights. Simultaneous submissions and previously published work OK.

THE HONOLULU ADVERTISER, Box 3110, Honolulu HI 96802. (808)525-8000. Editor-in-Chief: George Chaplin. Photo Editor: Allan Miller. Daily newspaper. Circ. 90,000 daily; 100,000 Sunday. Emphasizes local news, features and sports for general newspaper audiences. Needs human interest, local spot news, sports, general feature and scenic photos. Buys 120/year. Credit line given. Buys all rights, but may reassign to photographer after publication. Send photos for consideration. Provide resume, calling card and brochure to be kept on file for possible future assignments. Pays on publication. Reports in 1 week. SASE. Simultaneous submissions OK.
B&W: Send 8x10 glossy prints. Pays $20 minimum.
Cover: Send 8x10 glossy prints. Pays $25 minimum.
Tips: "Local human interest feature art is what we're looking for in freelance photos that we buy. We're primarily interested in people pictures: people working, playing, etc." Wants no posed or group shots, ribbon cutting, award presentations, other ceremonial "stock" photos and "no cheesecake."

***HOTEL & MOTEL MANAGEMENT**, 7500 Old Oak Blvd., Cleveland OH 44130. (216)243-8100. Editor: Michael DeLuca. Photo Editor: Robert Nozar. Trade. Published every 3 weeks. Newspaper tabloid. Emphasizes hotel industry. Readers are hotel chain executives, owners, managers and developers of lodging facilities. Circ. 41,000.
Photo Needs: Uses 40 photos/issue; 3-5 supplied by freelance photographers. Needs newsy, travel, scenic. Special needs include city-scapes, skylines. Captions required.
Making Contact & Terms: Query with resume of credits and samples; provide resume, business card, brochure, flyer or tearsheets to be kept on file for possible future assignments. Does not return unsolicited material. Reports in 2 weeks. Pays $200-500/text/photo package. Pays on acceptance. Credit line given. Buys one-time rights. Previously published work OK.

***HOUSEWARES Harcourt Brace Jovanovich Publications**, 7500 Old Oak Blvd., Cleveland OH 44130. (216)243-8100. Editor: Jeff Adair. Trade. Biweekly newspaper, tabloid size on glossy stock. Emphasizes the housewares retail business. Readers are merchandise managers of housewares and electric housewares; buyers; and chain store top management personnel who are involved in buying and selling housewares products. Circ. 13,500. Sample copy $2/issue.
Photo Needs: Uses "10 photos, not counting new products"/issue; 0-2 supplied by freelance photographers. Needs retail display photos of houseware products. Model release required. "We rarely use models; prefer static display shots."
Making Contact & Terms: Provide resume, business card, brochure, flyer or tearsheets to be kept on file for possible future assignments. Does not return unsolicited material. Pay negotiated. Pays on acceptance. Credit line given. Buys all rights.

HUNGRY HORSE NEWS, Box 189, Columbia Falls MT 59912. Editor-in-Chief: Brian Kennedy. Weekly. Circ. 7,500. Emphasizes local news; wildlife and scenic areas. Readers are "local residents and many others across the country."
Photo Needs: Uses about 20 photos/issue; 1 supplied by freelance photographers. Needs animal, wildlife and local scenic shots. Photos purchased with or without accompanying ms. Captions required.
Making Contact & Terms: Send by mail for consideration 8x10 color or b&w prints; or submit portfolio for review. Provide resume, business card, flyer and tearsheets to be kept on file for possible future

assignments. Payment is negotiable. Pays on publication. Credit line given. Buys one-time rights. Simultaneous submissions and/or previously published work OK.

ILLINOIS ENTERTAINER, Box 356, Mt. Prospect IL 60056. (312)298-9333. Editor: Guy Arnston. Monthly. Circ. 80,000. Emphasizes music and entertainment, including film and leisure activities. **Photo Needs:** Uses about 80 photos/issue; 50 supplied by freelance photographers. Needs "concert photography, band and entertainment, portrait, still life—b&w and color." Special needs include festivals during the summer.
Making Contact & Terms: Query with samples and list of entertainers' photos available. Provide samples to be kept on file for possible future assignments. Does not return unsolicited material. Reports ASAP. Pays $100-125/color cover photo and $15-25/b&w inside photo. Pays on publication. Credit line given. Buys one-time rights. Previously published work OK.
Tips: Prefers to see "live concert, portrait, still life, architecture; looking for action or dynamic lighting instead of line 'em up and shoot 'em."

InfoAAU, AAU House, 3400 W. 86th St., Indianapolis IN 46268. (317)872-2900. Editor: Mike Bowyer. Monthly newsletter. Circ. 5,000 est. Emphasizes amateur sports. For members of the Amateur Athletic Union of the United States. Buys one-time rights. Model release required. Send photos for consideration. Pays on publication. Reports in 2-3 weeks. SASE. Free sample copy. "We have national championships across the US. Right now I'm looking to make contacts with photographers in all parts of the country. Send resume and tearsheets for possible future assignments."
Subject Needs: Celebrity/personality; head shot; and sport. Must deal with AAU sports: basketball, baton twirling, bobsledding, boxing, diving, gymnastics, handball, horseshoe pitching, judo, karate, luge, powerlifting, physique, swimming, synchronized swimming, taekwondo, volleyball, water polo, weightlifting, wrestling, trampoline and tumbling. Also photos dealing with the AAU Junior Olympics "and all matters pertaining to Olympic development in AAU sports." Captions and identifications required.
B&W: Send 8½x11 glossy prints. Pays $5-25.
Color: Send transparencies. Pays $10-25.
Tips: Request AAU National Championship and International Competition schedules.

INFOWORLD MAGAZINE, Suite C-200, 1060 Marsh Rd., Menlo Park CA 94025. (415)328-4602. Editor-in-Chief: Jonathan Sacks. Circ. 140,000. Weekly magazine emphasizing computer systems. Readers are owners of all types of computers. Sample copy $1.75.
Photo Needs: Uses about 20 photos/issue; 4-8 supplied by freelance photographers. Model release required.
Making Contact & Terms: Query with samples. SASE. Does not return unsolicited material. Payment negotiable. Pays on publication. Credit line given.

INSIDE RUNNING, 9514 Bristlebrook, Houston TX 77083. (713)498-3208. Publisher/Editor: Joanne Schmidt. Monthly tabloid. Circ. 25,000. Emphasizes running and jogging. Readers are Texas runners and joggers of all abilities. Sample copy $1.25.
Photo Needs: Uses about 20 photos/issue; 10 supplied by freelance photographers. Needs photos of "races, especially outside of Houston area; scenic places to run; how-to (accompanying articles by coaches)." Special needs include "top race coverage; running camps (summer); variety of Texas running terrain." Captions preferred.
Making Contact & Terms: Query with list of stock photo subjects. Send 5x7 b&w or color glossy prints by mail for consideration. SASE. Reports in 1 month. Pays $25/b&w cover photo, $35/color cover photo; $10/b&w inside photo. Pays on publication. Credit line given. Rights—"negotiable." Simultaneous submissions and previously published work OK.
Tips: Prefers to see "human interest and compostion" in photos. "Look for the unusual. Race photos tend to look the same." Wants "clear photos with people near front; too often photographers are too far away when they shoot and subjects are a dot on the landscape."

INTERNATIONAL LIVING, 824 E. Baltimore St., Baltimore MD 21202. (301)234-0515. Editor: Bruce Totaro. Monthly. Circ. 40,000. Emphasizes "international lifestyles, travel." Readers are "well-to-do Americans between 30 and 75; many retired, almost all travelers for business and pleasure; many with second homes outside the U.S." Sample copy $3.50.
Photo Needs: Uses about 6 photos/issue; 50% supplied by freelance photographers. Needs photos of "travel destinations, but no obvious tourists. We like photos which capture the local spirit." Captions required.
Making Contact & Terms: Query with list of stock photo subjects. Provide resume, business card, brochure, flyer or tearsheets to be kept on file for possible future assignments. SASE. Reports in 1

month. Pays $10-75 "varies"/b&w inside photo. Pays on acceptance. Credit line given. Buys one-time rights. Previously published work OK.
Tips: "Contact *International Living* if you are planning a trip outside U.S. Send us 'pictures with a story'—no obvious tourists, please. We're interested in slice of life, against readily identifiable backgrounds."

JAZZ TIMES, 8055 13th St., Silver Spring MD 20910. (301)588-4114. Editor: Mike Joyce. Monthly tabloid. Emphasizes jazz. Readers are jazz fans, record consumers, music industry. Circ. 50,000. Sample copy $1.
Photo Needs: Uses about 18 photos/issue; all supplied by freelance photographers. Needs performance shots, portrait shots of jazz musicians. Captions preferred.
Making Contact & Terms: Send 5x7 b&w prints by mail for consideration. SASE. "If possible, we keep photos on file till we can use them." Pays $25/b&w cover photo; $10/b&w inside photo. Pays $25/color photo. Pays on publication. Credit line given. Buys one-time or reprint rights.
Tips: "Send whatever photos you can spare. We keep them on file until we can use them. Name and address should be on back."

JEWISH EXPONENT, 226 S. 16th St., Philadelphia PA 19102. (215)893-5740. Managing Editor: Al Erlick. Weekly newspaper. Circ. 70,000. Emphasizes news of impact to the Jewish community. Buys 15 photos/issue. Photos purchased with or without accompanying mss. Pays $15-50/hour; $10-100/job; or on a per photo basis. Credit line given. Pays on publication. Buys one-time rights, all rights, first serial rights or first North American serial rights. Rights are open to agreement. Query with resume of credits or arrange a personal interview. "Telephone or mail inquiries first are essential. Do not send original material on speculation." Provide resume, calling card, letter of inquiry, samples, brochure, flyer and tearsheets. SASE. Model release required, "where the event covered is not in the public domain." Reports in 1 week. Free sample copy.
Subject Needs: Wants on a regular basis news and feature photos of a cultural, heritage, historic, news and human interest nature involving Jews and Jewish issues. Query as to photographic needs for upcoming year. No art photos. Captions are required.
B&W: Uses 8x10 glossy prints. Pays $10-35/print.
Color: Uses 35mm or 4x5 transparencies. Pays $10-75/print or transparency.
Cover: Uses b&w and color covers. Pays $10-75/photo.
Tips: "Photographers should keep in mind the special requirements of high-speed newspaper presses. High contrast photographs probably provide better reproduction under new sprint and ink conditions."

JEWISH TELEGRAPH, Telegraph House, 11 Park Hill, Bury Old Rd., Prestwich, Manchester, England. Editor: Paul Harris. Weekly newspaper. Circ. 11,500. For a family audience. Needs photos with Jewish interest. Buys simultaneous rights. Submit model release with photo. Send photos for consideration. Pays on publication. Reports in 1 week. SAE and International Reply Coupons. Simultaneous submissions and previously published work OK. Free sample copy and photo guidelines.
B&W: Send 5x7 glossy prints. Captions required. Pays $5/photo minimum.

***JEWS FOR JESUS NEWSLETTER**, 60 Haight, San Francisco CA 94102. Contact: Editor. Circ. 170,000. Emphasizes evangelical Christian work among Jews. Readers are ministers and lay leaders.
Photo Needs: Uses about 5-6 photos/issue; "any or all" are supplied by freelance photographers. Needs photos pertaining to "Judaica—Jewish life, synagogues, city scenes involving Jews or Jews for Jesus." Photos purchased with or without accompanying ms. Model release required.
Making Contact & Terms: Send by mail for consideration 3¼x3¼ b&w or color prints (minimum size 3¼x3¼). SASE. Reports in 6 weeks. Pays $25-75/photo (inside) or $100-300 for text/photo package. Pays on acceptance. Credit line "negotiable—not usually." Buys one-time rights. Simultaneous submissions and/or previously published work OK.
Tips: Would like to see photos of a person at prayer or a synagogue building, in a portfolio.

***THE LIQUOR REPORTER**, 101 Milwaukee Blvd. S., Pacific WA 98047. (206)833-9642. Editor: Robert Smith. Monthly. Circ. 11,500. Estab. 1982. Emphasizes "alcoholic beverages; regulation by government and liquor board; social gambling legalized in Washington state and state lottery." Readers are operators of 1,600 taverns; 4,600 restaurants; 3,600 grocers, beer and wine wholesalers; state liquor store employees, spirits representatives and suppliers. Sample copy free with SASE.
Photo Needs: Uses about 10-15 photos/issue; "none at this time" supplied by freelance photographers. Needs "photos at wine and beer tastings; photos on location of products being marketed; photos of retailers at work; photos outside Puget Sound area of state, especially Eastern Washington. Looking for people who can shoot good cover art." Model release and captions required.
Making Contact & Terms: Query with list of stock photo subjects. Provide resume, business card,

brochure, flyer or tearsheets to be kept on file for possible future assignments. SASE. Reports in one month "or sooner." Pays $25 or more/b&w cover photo; $5-25/b&w inside photo. Pays on publication. Credit line given. Buys one-time rights. Simultaneous submissions (in separate markets) and previously published work OK.
Tips: "Talk to us first; we need photos, particularly those taken outside the Seattle-Tacoma area, but also in that area. We will need more as we grow." Also publishes *Tavern Tap Talk* for restaurants and taverns, and *Washington Foodservice News*, both second sections to main publication.

LOCUS, The Newspaper of the Science Fiction Field, Box 13305, Oakland CA 94661. Editor: C.N. Brown. Monthly newsletter. Circ. 8,000. Emphasizes science fiction events. Readers are "mostly professionals." Sample copy $2.50.
Photo Needs: Uses about 80 photos/issue, some in color; 10 supplied by freelance photographers. Needs photos of science fiction conventions and author photos. Photos purchased with accompanying ms only. Captions required.
Making Contact & Terms: Send 5x7 glossy b&w prints or smaller color by mail for consideration. SASE. Reports in 3 weeks. Pays $10-25/b&w inside photo; payment for text/photo package varies. Pays on publication. Credit line given. Buys one-time rights.

LOS ANGELES READER, 2nd Floor, 8471 Melrose Ave., Los Angeles CA 90069. (213)655-8810. Editor: Dan Barton. Art Director: Miriam King. Weekly newspaper. Emphasizes entertainment. Readers are "hip, affluent, well-educated young adults in Los Angeles." Circ. 82,000. Sample copy free with SASE and $1. Photo guidelines free with SASE.
Photo Needs: Uses about 10 photos/issue; all by freelance photographers. Needs "Los Angeles or Southern California subject matter only." Model release and captions required.
Making Contact & Terms: Submit portfolio for review. SASE. Reports in 1 month. Pays $60/b&w cover photo, $200/color cover photo, $30/b&w inside photo. Pays on publication. Credit line given. Buys one-time rights.
Tips: Prefers to see "(1) technical competence in photography; (2) good eye; (3) ability to work under pressure."

LYNCHBURG NEWS & DAILY ADVANCE, Box 10129, Lynchburg VA 24506. (804)237-2941. Executive Editor: W.C. Cline. Chief Photographer: Aubrey Wiley. Daily. Circ. 42,100. Two daily newspapers. Sample copy 75¢.
Photo Needs: Uses about 15 photos/issue; currently none are supplied by freelance photographers. Needs "animals, people features, lifestyles; general and spot news; sports." Photos purchased with accompanying ms only.
Making Contact & Terms: Query with samples. SASE. Reports in 2 weeks. Credit line given.
Tips: "Do not give up! Keep trying."

MAINE SPORTSMAN, Box 365, Augusta ME 04330. Editor: Harry Vanderweide. Monthly tabloid. Circ. 23,000. Emphasizes outdoor recreation in Maine. Photos are purchased with accompanying ms. Credit line given. Pays on publication. Not copyrighted. "Read our publication and submit b&w prints that might fit in." SASE. Simultaneous submissions and previously published work OK. Reports in 1-2 weeks.
Photo Needs: Uses 40-50 photos/issue; all supplied by freelance photographers. Needs animal, how-to, human interest, nature, photo essay/photo feature, sport and wildlife. Wants on a regular basis dramatic, single subject b&w cover shots. Does not want photos of dead fish or game. Captions required. Pays $50/b&w cover photo; $10/b&w inside photo. Buys one-time rights.
Accompanying Mss: Needs articles about outdoor activities in Maine. Pays $30-100/ms.

THE MANITOBA TEACHER, 191 Harcourt St., Winnipeg, Manitoba, Canada R3J 3H2. (204)888-7961. Editor: Mrs. Miep van Raalte. Readers are "teachers and others in education in and outside Manitoba." Magazine is issued 4 times/year (October, December, March and June). Circ. 16,900. Free sample copy. Provide resume and samples of work to be kept on file for possible future assignments.
Photo Needs: Uses about 8 photos/issue (including cover material). Interested in classroom and other scenes related to teachers and education in Manitoba. Model release required "depending on type of photo;" captions required.
Making Contact & Terms: Send by mail for consideration actual 5x7 or 8x10 b&w photos; or submit portfolio by mail for review. SASE. Reports in 1 month. Pays $5/inside photo. Credit line given upon request. No simultaneous submissions or previously published work.
Tips: Prefers to see photos relevant to teachers in public schools and to education in Manitoba, e.g., "classroom experiences, educational events, other scenes dealing with education."

MICHIANA MAGAZINE, 227 W. Colfax, South Bend IN 46626. (219)233-3434. Editor: Bill Sonneborn. Weekly. Circ. 130,000. General interest Sunday magazine section. Sample copy free with SASE.
Photo Needs: Uses about 12 photos/issue; 6 supplied by freelance writer-photographers. Needs "scenic and wildlife photos in Indiana and Michigan." Photos purchased with accompanying ms only. Model release preferred; captions required.
Making Contact & Terms: Query with samples. SASE. Reports in 3 weeks. Pays on publication. Credit line given. Buys one-time rights. Simultaneous submissions and previously published work OK.

MICHIGAN, The Magazine of The Detroit News, 615 W. Lafayette, Detroit MI 48231. (313)222-2620. Editor: Lisa K. Velders. Sunday weekly magazine. Circ. 860,000. "We want stories on any subject of interest to the residents of our state. We're looking for the offbeat, the unusual, especially in people or profiles. Please, no changing leaves." Readers are "mix of blue and white-collar; local (Detroit) and regional (statewide)."
Photo Needs: Uses 10-20 photos/issue; 5-10 supplied by freelance photographers. "We need ideas more than photos. Local needs for assigned stories are well filled by a competitive freelance market. We need interesting people or places beyond the Detroit area." Prefers photos with mss. Model release and captions required.
Making Contact & Terms: If local, arrange interview; if out-of-state, send samples with SASE. Reports in 1 month. Pays $350/color cover photo; $100/b&w and $150/color page. Pays on publication. Credit line given. Buys one-time rights.
Tips: Prefers to see "a certain level of technical competence" in a photographer's portfolio or samples. "Find something, or someone, interesting that we don't know about and team up with a good writer. Complete packages, especially from out-of-state, sell well."

MILKWEED CHRONICLE, Hennepin Center for the Arts, Room 508, 528 Hennepin Ave., Minneapolis MN 55403. Send mail to: Box 24303, Minneapolis MN 55424. (612)332-3192. Editor-in-Chief: Emilie Buchwald. Art Director: Randall W. Scholes. Magazine published 3 times/year. Circ. 5,000. Emphasizes "poetry and graphics and the relationship therein." Readers are interested in "poetry, design and art and in between." Sample copy $4; one free to published artists with discount for further issues.
Photo Needs: Uses about 15 photos/issue; all are supplied by freelance photographers. Interested in poetic form, experimental, textural with meaning, varied subjects but always able to refer to the "Life Mystery." Photos purchased with or without accompanying ms.
Making Contact & Terms: Send by mail for consideration b&w glossy prints or query with samples. SASE. Reports in 3 months—"we are working to speed process though." Provide tearsheets and examples with address to be kept on file for possible future assignments. Pays $50/b&w cover photo; $10-30/b&w inside photo. "On assignment pieces we help pay for processing." Pays on publication. Credit line given. Buys one-time rights. Simultaneous submissions and/or previously published work OK.
Tips: Prefers to see a wide range of subjects; quality, diversity and vision. "Look over our themes, and don't be scared by the titles—we are just covering a large area; think what may be a subtext."

NATIONAL ENQUIRER, Lantana FL 33464. (305)586-1111. Contact: Photo Editor. Weekly tabloid. Circ. 4,512,689. Emphasizes celebrity, investigative and human interest stories. For people of all ages. Needs color and b&w photos: humorous and offbeat animal pictures, unusual action sequences, good human interest shots and celebrity situations. Buys first North American rights. Present model release on acceptance of photo. Query with resume of credits or send photos for consideration. Pays on publication. Returns rejected material; reports on acceptances in 2 weeks. SASE.
B&W: Send contact sheet or any size prints or transparencies. Short captions required. Pays $50-$190.
Color: "If it's a color shot of a celebrity, we'll pay $200 for the first photo," and more if it's in a sequence. For a noncelebrity color shot, pay is $160 for the first photo.
Cover: Pays up to $1,440.
Tips: "If you have anything amusing or that you think would be of interest to our readers, please send it in. We're happy to take a look. If we can't use your photos, we'll return them to you immediately. If you have any questions, call us."

NATIONAL NEWS BUREAU, (formerly *ElectriCity*), 2019 Chancellor St., Philadelphia PA 19103. (215)569-0700. Editor: Andrea Diehl. Weekly syndication packet. Circ. 1,000 member publications. Emphasizes entertainment. Readers are "youth-oriented, 17-45 years old." Sample copy $1.
Photo Needs: Uses about 20 photos/issue; 15 supplied by freelance photographers. Captions required.
Making Contact & Terms: Arrange a personal interview to show portfolio; query with samples; submit portfolio for review. Send 8x10 b&w prints, b&w contact sheet by mail for consideration. SASE. Reports in 1 week. Pays $50 minimum/job. Pays on publication. Credit line given. Buys all rights.

NATIONAL VIETNAM VETERANS REVIEW, Box 35812, Fayetteville NC 28303-0812. (919)484-2343. Editor: Chuck Allen. Monthly tabloid. Circ. 15,000-20,000. Emphasizes Indochina, Southeast

Asia, primarily the Vietnam War period. Readers are "29-60 years of age, Vietnam era veterans, veterans hospitals, organizations and families." Sample copy and photo guidelines free with SASE.
Photo Needs: Uses about 20-25 ("we need more!") photos/issue; all supplied by freelance photographers. Needs historical, individual, military equipment and action photos. Special needs include "strong combat, emotional, unique, good general subject photos that tell the 'whole story in one shot'." Captions preferred.
Making Contact & Terms: Send 5x7 or 8x10 b&w glossy prints by mail for consideration. SASE. Reports in 1 month. "So far photos have been contributed and photographers paid by subscription. If *real good* we'll negotiate." Pays on publication. Credit line given. Simultaneous submissions and previously published work OK.
Tips: "You're probably a Nam vet or Vietnam era veteran with a story to tell. Stories with photo get first billing. Good action shot receives cover position. News photos are always in demand, such as Vietnam marchers in Washington, etc."

THE NEVADAN, Box 70, Las Vegas NV 89101. (702)385-4241. Editor: A.D. Hopkins. Sunday supplement tabloid. Circ. 90,000. Emphasizes history, life-styles, arts, personality. "All photos must be accompanied by story." Credit line given. Provide business card to be kept on file for possible future assignments. Pays on publication. Buys first or second serial (reprint) rights. Previously published work OK. Send photos or query. SASE. Reports in 3 weeks. Free sample copy.
Subject Needs: "There has to be enough for a layout of two pages with supporting text, but pictures can be the main part of the article. Mostly copies of old photos and photos of present places and living people who were involved in area history. Remember we must have a regional angle, but that includes the entire state of Nevada, southern Utah, northern Arizona and desert counties of California. No celebrity stuff; no Polaroid or Instamatic photos; and nothing without a regional angle. No photo essays without a supporting story, although stories may be short." Captions are required.
B&W: Uses 5x7 or 8x10 prints. Pays $10/print plus $100 for supporting text.
Cover: Uses 35mm or larger (uses a lot of 120mm) transparencies. Pays $15 for color.
Accompanying Mss: "We use a lot of Nevada history: A good deal of it is oral history based on still-living people who participated in early events in Nevada; photos are usually copies of photos they own or photos of those people as they are today, usually both. Stories are sometimes based on diaries of now deceased people, or on historical research done for term papers, etc. Strong photo text packages on regional experiences, i.e. chariot racing, desert racing, helicopter skiing, ranch work, small-town Nevada characters, IMPORTANT artists, etc."
Tips: "Read the writer's guideline. Believe us when we tell you we won't buy photo essays without accompanying mss. Lack of good accompanying photos is now the main reason we reject mss."

NEW ENGLAND ENTERTAINMENT DIGEST, Box 735, Marshfield MA 02050. (617)837-0583. Editor/Publisher: Paul J. Reale. Bimonthly. Circ. 17,000. Emphasizes entertainment. Readers are theatergoers, theater owners, performers, singers, musicians, moviemakers, production companies, film/video producers, theatrical suppliers, dancers. Free sample with SASE.
Photo Needs: Uses about 23-33 photos/issue. Needs photos of New England entertainment. Photos purchased with accompanying ms only. Department needs: centerfold, featuring a performer or group. Captions required.
Making Contact & Terms: Send by mail for consideration b&w prints. SASE. Reports in 1 month. Pays $2.50/b&w cover photo. Pays on publication. Credit line given. Buys one-time rights. Simultaneous submissions and previously published work OK.

NEW ENGLAND SENIOR CITIZEN/SENIOR AMERICAN NEWS, 470 Boston Post Rd., Weston MA 02193. Editor: Ira Alterman. Monthly newspaper. Circ. 60,000. For men and women ages 60 and over who are interested in travel, finances, retirement life-styles, special legislation and nostalgia. Photos purchased with or without accompanying ms. Buys 1-3 photos/issue. Credit line given, if requested. Pays on publication. Buys first serial rights. Send material by mail for consideration. SASE. Simultaneous submissions and previously published work OK. Reports in 4-6 months.
Subject Needs: Animal, celebrity/personality, documentary, fashion/beauty, glamour, head shot, how-to, human interest, humorous, nature, photo essay/photo feature, scenic, sport, still life, travel and wildlife. Needs anything of interest to people over 60. Model release required; captions preferred.
B&W: Uses 5x7 and 8x10 glossy prints; contact sheet OK. Pays $5 minimum/photo.
Cover: Uses b&w glossy prints. Vertical or square format preferred. Pays $20 minimum/photo.
Accompanying Mss: Pays 25¢/inch.

***THE NEW MEXICAN**, 202 E. Marcy St., Santa Fe NM 87501. (305)983-3303. Photo Editor: Michael Heller. Association publication of Gannett. Daily newspaper. Readers are tri-cultural (Hispanic, Indian, Anglo). Circ. 17,000. Sample copy 35¢.

Photo Needs: Uses 15-20 photos/issue; "few, if any" supplied by freelance photographers. Needs photos of local news, features, sports.
Making Contact & Terms: Call and make arrangements. Does not return unsolicited material. Reports ASAP. Pays on publication. Credit line given. Buys one-time rights. Simultaneous submissions OK.
Tips: Prefers to see maximum of 40 35mm slides, should be mix of hard news, sports, self-generated features.

NORTHWEST MAGAZINE/THE OREGONIAN, 1320 SW Broadway, Portland OR 97201. (503)221-8235. Graphics Coordinator: Kevin Murphy. Sunday magazine of daily newspaper. Emphasizes stories and photo essays of Pacific Northwest interest. "Estimated readership of 1,000,000 is affluent, educated, upscale." Sample copy and photo guidelines available.
Photo Needs: Uses about 12-15 photos/issue; 4-6 supplied by freelance photographers. Needs photos "depicting issues and trends (as identified in stories), travel, scenics, interiors, fashion. Thematic photo essays particularly encouraged." Model release and captions preferred.
Making Contact & Terms: Arrange a personal interview to show portfolio. Does not return unsolicited material. Reports in 2 weeks. Pays $150/page rate or $150/half day "assignment rate." Pays on acceptance. Credit line given. Buys one-time rights. All work accepted "on spec." Previously published work OK "but first-time rights in Pacific Northwest preferred."
Tips: Prefers to see "examples of color, showing range of style (portraits, editorial, landscape, interiors)."

NUMISMATIC NEWS, 700 E. State St., Iola WI 54990. (715)445-2214. Editor: David C. Harper. Weekly tabloid. Circ. 39,000. Emphasizes news and features on coin collecting. Photos purchased only on assignment. Buys 50-75 photos/year. Pays $40 minimum/job or on a per-photo basis. Credit line given. Pays on publication. Buys all rights, but may reassign to photographer after publication. Phone or write for consideration. SASE.
Subject Needs: Spot news (must relate to coinage or paper money production or the activities of coin collectors). No photos of individual coins unless the coin is a new issue. Captions required.
B&W: Uses 5x7 prints. Pays $3-25/photo.
Cover: Uses b&w and color prints. Format varies. Pays $5 minimum/b&w photo and $25 minimum/color photo.
Accompanying Mss: Needs "documented articles relating to issues of coinage, medals, paper money, etc., or designers of same." Pays $30-100/ms.
Tips: "Devise new techniques for covering coin conventions and depicting the relationship between collectors and their coins."

OBSERVER NEWSPAPERS, 2262 Centre Ave., Bellmore NY 11710. (516)679-9888 or 679-9889. Editor-in-Chief: Jackson B. Pokress. Weekly newspaper. Circ. 50,000. Emphasizes general news with special emphasis on all sports. "We cover all New York metropolitan sports on a daily basis: Mets, Yanks, Jets, Giants & Islanders; Rangers and Knicks on weekly basis. We feature articles and human interest stories on sports personalities." Readers are teens to senior citizens; serving all areas of Long Island. Photo guidelines with SASE.
Photo Needs: Uses about 25-30 photos/issue; "some" are supplied by freelance photographers. Needs photos on general news, sports and political leaders. Photos purchased with or without accompanying ms. Model release and captions required.
Making Contact & Terms: Send by mail for consideration 8x10 b&w prints, b&w contact sheet or negatives; arrange a personal interview to show portfolio or query with samples. SASE. Reports in 2 weeks. Provide business card and tearsheets to be kept on file for possible future assignments. Pays $10/inside b&w photo. Pays on publication. Credit line given. Buys one-time rights or all rights. Simultaneous submissions OK.
Tips: Prefers to see "sampling of work—news, spot news, sports, features and sidebars. Photos should show thought and planning, must be sharp and clear, good print quality. Wherever possible photographer should pre-plan photo shoot. Do not shoot the same thing as everyone else. Make your shot different. Photos should not be cluttered."

***OHIO MOTORIST**, Box 6150, Cleveland OH 44101. Contact: Editor. Emphasizes automobile and other travel, highway safety and automobile-related legislation. Tabloid published 12 times/year. Circ. 310,000. Emphasizes automotive subjects and travel (domestic and foreign). Readers are members of AAA-Ohio Motorists Association. Sample copy free with SASE.
Photo Needs: Uses 25 photos/issue; 5 supplied by freelance photographers. Needs scenics for cover use. Photos purchased with or without accompanying ms. Captions required.
Making Contact & Terms: Send 8x10 glossy prints or 35mm transparencies by mail for consider-

ation. SASE. Reports in 2 weeks. Pays $20-50/b&w photo; $100-150/color cover photo; $100-350/ complete package. Pays on acceptance. Credit line given. Buys one-time rights. Previously published work OK.

OK MAGAZINE, Sunday Magazine of Tulsa World, Box 1770, Tulsa OK 74102. (918)581-8345. Editor: Terrell Lester. Weekly newspaper magazine. Circ. 240,000. Emphasizes general interest, people, trends, medicine, sports, entertainment and interior design. Readers are "mostly adult, middle income." Sample copy available.
Photo Needs: Uses about 10-12 photos/issue; 1-2 supplied by freelance photographers. "We accept unsolicited travel photos as well as photo layouts of regional interest." Model release and captions preferred.
Making Contact & Terms: Query with samples or list of stock photo subjects; send 8x10 b&w prints, 35mm or 2¼x2¼ b&w or color transparencies or good color prints by mail for consideration. SASE. Reports in 3 weeks. Pays $75/color cover photo; $30/b&w inside photo, $40/color inside photo. Pays on publication. Credit line given. Previously published work OK.
Tips: Send "timely photos early enough that we can use them—we work a month, at least, in advance of publication."

OLD CARS NEWSPAPER, 700 E. State St., Iola WI 54990. (715)445-2214. Editor: John Gunnell. Weekly tabloid. Circ. 85,500. "*Old Cars* is edited to give owners of collector cars (produced prior to 1970) information—both of a news and of a historical nature—about their cars and hobby." Photos used with or without accompanying mss, or on assignment. Uses 35 photos/issue. Credit line given. Buys all rights, but may reassign to photographer after publication. Send material by mail for consideration. Provide calling card and samples to be kept on file for future assignments. SASE. Reports in 2 weeks. Sample copy 50¢.
Subject Needs: Documentary, fine art, how-to (restore autos), human interest ("seldom—no 'I did it myself' restoration stories"); humorous, photo essay/photo feature and spot news (of occasional wrecks involving collector cars). Wants on a regular basis photos of old cars along with information. "No photos of Uncle Joe with the Model A Ford he built in his spare time." Captions preferred.
B&W: Uses 5x7 glossy prints.
Color: Note—color photos will be printed in b&w. Uses 5x7 glossy prints.
Accompanying Mss: Brief news items on car shows, especially national club meets. Occasionally covers "swap meets."

ON TRACK, Unit M, 17165 Newhope St., Fountain Valley CA 92708. (714)966-1131. Editor: John Phillips. Bimonthly magazine. Emphasizes auto racing. Readers are auto racing enthusiasts. Sample copy $1.50. Photo guidelines free with SASE.
Photo Needs: Uses about 120 photos/issue; all supplied by freelance photographers. Needs photos of auto racing action and drivers. Special needs filled by assignment. Captions, dates, locality required.
Making Contact & Terms: Send 5x7 or 8x10 glossy b&w prints with borders; 35mm transparencies by mail for consideration. SASE. Reports in 1 month. Pays $75/color cover photo; $10/b&w inside photo. Pays on publication. Credit line given. Buys first North American serial rights. "Address photo submissions to the attention of Anne Peyton, Art Director."
Tips: "Our photos are moving toward action rather than static can shots. We're also seeing more creative photographs." Looks for "photos that tell the story of an auto race; photos that compliment our writers' styles; photos that add a human element to a mechanical subject. Try to shoot important events during a race—not just race cars going by. Look for relationships between drivers and cars and try to find excitement—it's harder than it seems."

PARADE, 750 3rd Ave., New York NY 10017. (212)573-7000. Editor: Walter Anderson. Director of Design: Ira Yoffe. Photo Editor: Brent Petersen. Weekly newspaper magazine. Circ. 31,000,000. Emphasizes news-related features concerning celebrities, education, medicine and lifestyles. For general audiences. Needs photos of personalities and current events. Buys 30 photos/issue. Buys first rights. Query first with resume of credits. Pays on publication. Reports in 2 weeks. SASE. Previously published work OK.
B&W: Pays $75 minimum/inside photo.
Cover: Uses transparencies. Captions required. Pays $500-750.
Tips: "We are looking for a good photojournalistic style."

PARENTS' CHOICE, A REVIEW OF CHILDREN'S MEDIA, Box 185, Wabon MA 02168. (617)332-1298. Editor-in-Chief: Diana H. Green. Emphasizes children's media. Readers are parents, teachers, librarians and professionals who work with parents. Sample copy $1.50.
Photo Needs: Uses photos occasionally. Needs "photos of parents and children; children's TV, books,

movies, etc. and children participating in these media." Column Needs: Parents' Essay, Opinion, Profile uses photos of the author and the subject of interview. Model release not required; captions required.
Making Contact & Terms: Send sample photos. Arrange personal interview to show portfolio. Provide brochure, flyer and samples to be kept on file for future assignments. SASE. Pays on publication $20/photo. Credit line given.

PC WEEK, 800 Boylston St., Boston MA 02199. (617)375-4000. Photo Editor: Ann Rahimi-Assa. Art Director: Thea Shapiro. Weekly tabloid. Emphasizes IBM PC's. Readers are IBM PC and PC compatible users. Estab. 1984. Sample copy available.
Photo Needs: Uses about 15-30 photos/issue; ¼ supplied by freelance photographers. Needs photos of "business, PC's and users, and hires photographers to cover companies who are large volume users of PC's." Model release preferred.
Making Contact & Terms: Arrange a personal interview to show portfolio; provide resume, business card, brochure, flyer or tearsheets to be kept on file for possible future assignments. Does not return unsolicited material. Reports in 2 weeks. Payment varies. Pays according to ASMP suggested rates; pays on publication. Credit line given. Buys one-time rights.
Tips: Looks for "good candid, journalistic photography. Clear shots of computer products. Photographs should be crisp."

THE PRODUCE NEWS, 2185 Lemoine Ave., Fort Lee NJ 07024. (201)592-9100. Editor: Gordan Hochberg. Weekly tabloid. Circ. 6,000. For people involved with the fresh fruit and vegetable industry: growers, shippers, packagers, brokers, wholesalers and retailers. Needs feature photos of fresh fruit and vegetable shipping, packaging, growing, display, etc. Buys 5-10 annually. Buys feature stories with photos. Send photos for consideration. Pays on publication. Reports in 45 days. SASE. Free sample copy and photo guidelines.
B&W: Send 4x5 or larger glossy prints. Captions required.

RADIO & TELEVISION PROMOTION NEWSLETTER, Drawer 50108, Lighthouse Point FL 33064. (305)426-4881. Publisher: William N. Udell. Monthly newsletter emphasizing radio, TV and cable. Circ. 600. Readers are owners, managers, and program director of stations. Sample copy free with SASE.
Photo Needs: Uses about 6 photos/issue; 1 supplied by freelance photographers. Needs photos of "special, unusual promotional programs of radio and TV stations—different."
Making Contact & Terms: Send 4x5 or smaller b&w/color prints by mail for consideration, or "call and say you *got* something." SASE. Reports in 2 weeks. Pays $5-10/b&w inside. Pays on acceptance. Credit line given "if desired." Buys one-time plus reprint rights. Simultaneous submissions and previously published work OK.

ROLLING STONE, 745 5th Ave., New York NY 10151. Photo editor: Laurie Kratochvil. Associate Photo Editor: Stephanie Allen. Emphasizes all forms of entertainment (music, movies, politics, news events).
Photo Needs: "All our photographers are freelance." Provide brochure, calling card, flyer, samples and tearsheet to be kept on file for future assignments. Needs famous personalities and rock groups in b&w and color. No editorial repertoire. SASE. Reports immediately. Pays $150-300/day.
Tips: "Drop off portfolio at front desk any Wednesday between 10 am and noon. Pickup same day between 4 pm and 6 pm or next day. Leave a card with sample of work to keep on file so we'll have it to remember."

SAILBOARD NEWS, Box 159, Fair Haven VT 05743. (802)265-8153. Editor: Mark Gabriel. Monthly magazine. Circ. 19,000. Emphasizes boardsailing retailing. Readers are trade and competitors in boardsailing. Sample copy free with SASE and 71¢ postage. Photo guidelines free with SASE.
Photo Needs: Uses about 25 photos/issue; 15 supplied by freelance photographers. Photos purchased with accompanying ms only. Captions required.
Making Contact & Terms: Send b&w prints; 35mm, 2¼x2¼, 4x5 or 8x10 transparencies; or b&w contact sheet by mail for consideration. SASE. Reports in 2 weeks. Pays $35/b&w cover photo, $70/color cover photo; $10/b&w inside photo, $20/color inside photo; $100-300 for text/photo package. Pays 30 days after publication. Credit line given. Buys one-time rights. Simultaneous submissions and previously published work OK.

SERVICE REPORTER, Box 745, Wheeling IL 60090. (312)537-6460. Editorial Director: Ed Schwenn. Monthly tabloid. Emphasizes heating, air conditioning, ventilating and refrigeration. Circ. 45,000. Sample copy $4.
Photo Needs: Uses about 12 photos/issue; no more than one supplied by freelance photographers, oth-

Close-up

Brent Petersen
Photo Editor
Parade
New York City

The world of photojournalism is not a new one to Brent
Petersen, photo editor of *Parade* magazine. "I entered the
field about the same time I started to drive," he laughs. At
the age of 16, Petersen landed a job on the Laramie (Wyo-
ming) *Daily Boomerang* where he gained hands-on experi-
ence in photographic coverage of news events. And when he enrolled in Brigham Young
University (Provo, Utah) to continue studies in photography/journalism, he stayed active
in the market by working as a stringer for AP. Through this position he covered such well-
known events as the Gary Gilmore case in 1976 and the Argentina World Cup Soccer match in
1978.

Petersen, who joined *Parade* in 1979, knows what he likes to see in portfolios. "Photos
that communicate feelings and move me emotionally through presentation of a subject" stand
the best chance of being published. "Of course, the technical side must be up to par, other-
wise it detracts from the photograph's ability to communicate," he cautions. Each issue of
Parade, published weekly, has its editorial schedule set two to three months in advance.
"Our needs are specific—we work on an assignment basis, so send queries," Petersen sug-
gests. "I don't recommend sending unsolicited photos . . . they tend to come in one door and
go out the other."

Since competition is tight when it comes to being published in *Parade*, Petersen offers ad-
vice to new photojournalists on how to improve their skills—and chances. Get experience
through shooting assignments, he says. Work on a daily newspaper can provide this. And the
wider the range of coverage, the better. "It's generally not wise (for photographers) to spe-
cialize in the beginning. The tendency to specialize comes only after years of experience."
First find out what interests you the most, he recommends, then concentrate on that.

Parade features news across the United States and in many other countries, so a photogra-
pher's assignment isn't necessarily based on locality versus accessibility to a news story. "We
look for photographers who can meet the needs of a story, who have the right blending of
skills and talent." When these needs are met, Petersen says, it won't matter whether the pho-
tographer is California-based and the story is in Florida—he will be sent there.

Petersen recalls a particular photo assignment that exemplifies a photographer's encoun-
ters on the job. An issue of *Parade* was to feature an offer from Trailways, Inc. to transport
penniless runaway children back home free of charge. Petersen didn't want to rely on stock
photos to illustrate the feature—he wanted a live case study. The *Parade* photographer as-
signed to the story spent six days in a Miami halfway house before a runaway boy turned up
who qualified for Trailways' offer. "Shelly Katz (the photographer) got a great series of pho-
tos, including shots of a reunion with the boy's family," Petersen recalls. Katz, who rode
with the boy, also had taken painstaking notes in order to fill in the more intimate details of the
story. It turned out to be a great feature, Petersen says.

The moral of this story is not that the photographer also has to be a writer. But, Petersen
points out, "the photojournalist IS a reporter and must have a reporter's instincts, otherwise
he could miss the whole story. A photojournalist is really a reporter with a camera."

ers manufacturer-supplied. Needs photos pertaining to the field of heating, air conditioning, ventilating and refrigeration. Special needs include cover photos of interiors and exteriors of plants. Model release and captions required.
Making Contact & Terms: Query with list of stock photo subjects; query on needs of publication. SASE. Reports in 2 weeks. Pays $50-100/color cover photo; $10/b&w and $25/color inside photo. Pays on publication. Credit line given. Buys one-time rights.

SKYDIVING, Box 1520, De Land FL 32721. (904)736-9779. Editor: Michael Truffer. Readers are "sport parachutists worldwide, dealers and equipment manufacturers." Monthly newspaper. Circ. 7,400. Sample copy $2; photo guidelines for SASE.
Photo Needs: Uses 12-15 photos/issue; 8-10 supplied by freelance photographers. Selects photos from wire service, photographers who are skydivers and freelancers. Interested in anything related to skydiving—news or any dramatic illustration of an aspect of parachuting. Model release required; captions not required.
Making Contact & Terms: Send by mail for consideration actual 5x7 or 8x10 b&w photos. SASE. Reports in 2 weeks. Pays on publication minimum $25 for b&w photo. Credit line given. Buys one-time rights. Simultaneous submissions (if so indicated) and previously published (indicate where and when) work OK.

SOCCER AMERICA, Box 23704, Oakland CA 94623. (415)549-1414. Editor-in-Chief: Lynn Berling. Managing Editor: Paul Kennedy. Weekly magazine. Circ. 12,000. Emphasizes soccer news for the knowledgeable soccer fan. "Although we're a small publication, we are growing at a very fast rate. We cover the pros, the international scene, the amateurs, the colleges, women's soccer, etc." Photos purchased with or without accompanying ms or on assignment. Buys 10 photos/issue. Credit line given. Pays on publication. Buys one-time rights. Query with samples. SASE. Previously published work OK, "but we must be informed that it has been previously published." Reports in 1 month. Sample copy and photo guidelines for $1.
Subject Needs: Sport. "We are interested in soccer shots of all types: action, human interest, etc. Our only requirement is that they go with our news format." Captions required.
B&W: Uses 8x10 glossy prints. Pays $12.50 minimum/photo.
Cover: Uses b&w glossy prints. Pays $25 minimum/photo.
Accompanying Mss: "We are only rarely interested in how-to's. We are interested in news features that pertain to soccer, particularly anything that involves investigative reporting or in-depth (must be 'meaty') personality pieces." Pays 50¢/inch to $100/ms. Free writer's guidelines. SASE required.
Tips: "Our minimum rates are low, but if we get quality material on subjects that are useful to us we use a lot of material and we pay better rates. Our editorial format is similar to *Sporting News*, so newsworthy photos are of particular interest to us. If a soccer news event is coming up in your area, query us."

THE SOUTHEASTERN LOG, Box 7900, Ketchikan AK 99901. (907)225-3157. Editor: Nikki Murray Jones. Monthly tabloid. Circ. 26,000. Emphasizes general interests of southeast Alaskans, including fishing (commercial and sport), general outdoors, native and contemporary arts, etc. For residents of southeastern Alaska and former residents and relatives living in mainland US. Buys 15 photos/issue. Not copyrighted. Query with resume of credits or send photos for consideration. Pays on publication. Reports in 3 weeks. SASE. Free sample copy and photo guidelines.
Subject Needs: General news and feature photos about southeastern Alaska "that show the character of this island region and its residents." Animal, fine art, head shot, how-to, human interest, humorous, nature, photo essay/photo feature, spot news, travel and wildlife. "Photos used most are those accompanying copy and showing the people, fishing, timber, marine and air transportation 'flavor' of the southeast."
B&W: Send 5x7 or 8x10 glossy prints. Captions required. Pays $10.
Cover: Send color slides. Captions required. Shots must be taken within the past 18 months and related to the copy accepted for the same issue. Pays $25 and up.
Tips: "We need sharp, uncluttered photos that convey the story in a single glance. The best submission is a package of both story and photos, but photo essays are used if cutlines and visual images contain sufficient information to relate the message."

SOUTHERN MOTORACING, Box 500, Winston-Salem NC 27102. (919)723-5227. Associate Editor: Greer Smith. Editor/Publisher: Hank Schoolfield. Biweekly tabloid. Emphasizes autoracing. Readers are fans of auto racing. Circ. 18,000-19,000. Sample copy 50¢.
Photo Needs: Uses about 10-15 photos/issue; some supplied by freelance photographers. Needs "news photos on the subject of Southeastern auto racing." Captions required.
Making Contact & Terms: Query with samples; send 5x7 or larger matte or glossy b&w prints; b&w negatives by mail for consideration. SASE. Reports in 1 month. Pays $25-50/b&w cover photo; $5-25/

b&w inside photo; $50-100/page. Pays on publication. Credit line given. Buys first North American serial rights. Simultaneous submissions OK.

Tips: "We're looking primarily for *news* pictures, and staff produces many of them—with about 25% coming from freelancers through long-standing relationships. However, we're receptive to good photos from new sources, and we do use some of those. Good quality professional pictures only, please!"

THE SPORTING NEWS, 1212 N. Lindberg Blvd., St. Louis MO 63132. (314)997-7111. Contact: Rich Pilling. Weekly tabloid. Emphasizes major league and minor league baseball, pro and college football, pro and college basketball, pro hockey and major sporting events in other sports. Readers are 18-80 years old, 75% male, sports fanatics. Circ. 700,000. Sample copy $1.95. Photo guidelines free with SASE.

Photo Needs: Uses about 25 b&w photos/issue; 2-4 color photos for cover; all supplied by freelance photographers. Needs photos of athletes, posed or in action, involved in all sports covered by the magazine. Captions required.

Making Contact & Terms: Send 8x10 b&w glossy prints by mail for consideration. "35mm transparencies by special request." SASE. Pays $250/main color photo, $150/smaller color; $50/b&w inside photo; $350/day for assignments. Pays on publication. Credit line given for covers only. Buys one-time rights on covers; all rights on b&w photos.

Tips: "Once accepted, call for tips on upcoming needs."

***THE STATE JOURNAL-REGISTER**, One Copley Plaza, Springfield IL 62705. (217)788-1475. Editor: Edward H. Armstrong. Photo Editor: Barry J. Locher. Daily newspaper. Emphasizes agriculture/politics/human interest features. Readers are largely state government employees and rural dwellers. Circ. 70,000. Sample copy free with SASE.

Photo Needs: Uses 7 photos/issue; "very few" supplied by freelance photographers. "We have a great need for travel, home and design, and science photographs." Reviews photos with accompanying ms only. Captions required.

Making Contact & Terms: Provide resume, business card, brochure, flyer or tearsheets to be kept on file for possible future assignments. SASE. Reports in 1 week. Pays/job. Pays on acceptance. Credit line given. Buys one-time rights. Simultaneous submissions and previously published work OK.

Tips: Prefers to see 11x14 b&w prints/color transparencies.

SUBURBAN NEWS PUBLICATIONS, 919 Old W. Henderson Rd., Box 2092, Columbus OH 43220. (614)451-1212. News Editor: Martin Rozenman. Weekly. Includes: Tri-Village News, Northland News, Booster, Upper Arlington News, N.W. Columbus News, Westerville News, Worthington Suburbia News, Dublin News, Bexley News, Whitehall News and News East. Combined Circ: 150,000 + . "We are weekly, community suburban newspapers."

Photo Needs: Uses about 30 photos/issue. "Features involving people in the community, sports, arts."

Making Contact & Terms: Does not buy nonlocal, nonassigned photos. Make appointment; provide resume and portfolio to establish background. Stringer work is available, particularly in sports. Compensation $10 an assignment. Credit line given. Film and developing supplied.

SUNDAY WOMAN PLUS, 235 E. 45th St., New York NY 10017. (212)682-5600. Editor: Merry Clark. Weekly. "We are a Sunday supplement in a tabloid format—similar to *Parade* and *USA Weekend* with a general newspaper audience." Circ. 4,000,000. Sample copy free with 9x12 SASE.

Photo Needs: Uses about 10 photos/issue; 1-2 supplied by freelance photographers. Needs "*celebrity color* for covers, b&w of notables." Model release preferred.

Making Contact & Terms: Query with samples; "please *don't* call." SASE. Reports in 1 week. Payment varies—"no price structure." Pays on acceptance. Credit line given. Buys one-time rights. Previously published submissions OK.

SUNSHINE MAGAZINE, 101 N. New River Dr. E., Box 14430, Ft. Lauderdale FL 33302. (305)761-4017. Editor: John Parkyn. Art Director: Kent H. Barton. "*Sunshine* is a Sunday newspaper magazine emphasizing articles of interest to readers in the Broward and Palm Beach Counties region of South Florida. Readers are "the 600,000 readers of the Sunday edition of the *Fort Lauderdale News & Sun-Sentinel*." Sample copy and photo guidelines free with SASE.

Photo Needs: Uses about 12-20 photos/issue; 30% supplied by freelance photographers. Needs "all kinds of photos relevant to the interests of a South Florida readership." Photos purchased with accompanying ms. Model release and captions preferred.

Making Contact & Terms: Query with samples; provide resume, business card, brochure, flyer or tearsheets to be kept on file for possible future assignments. SASE. Reports in 1 month. "All rates negotiable; the following are as a guide only." Pays $200-300/color cover photo; $50/b&w and $75/color in-

The Sacramento, California-based writing/photography team work of Phyllis and Louis Zauner, netted them $350 from King Features Syndicate for one-time and reprint rights for publication in Sunday Woman."The photo's subjects," Louis Zauner explains, "are 75-year-old women. It was important to show them in an alert position, on the job, and in their setting on the lake."

side photo; $150/color page; $250-1,000 for text/photo package. Pays on acceptance. Credit line given. Buys one-time rights. Simultaneous and previously published submissions OK.

THE TIMES-PICAYUNE/THE STATES-ITEM, 3800 Howard Ave., New Orleans LA 70140. (504)826-3279, 826-3420/21. Editor: Charles A. Ferguson. Executive Photo Editor: Jim Pitts. Photo Editor: Robert W. Hart. Daily newspaper. Circ. 280,000. For general audiences. Needs "feature photos with South Louisiana/South Mississippi flavor." Spot news photos should be from the New Orleans area only. Wants no photos of familiar local gimmicks, tricks, scenes or photos lacking people. Send photos for consideration. All work with freelance photographers on assignment only basis. Pays on publication. Reports in 2 weeks. SASE. Simultaneous submissions OK "as long as it's not in the same circulation area."
B&W: Send 8x10 glossy or matte prints. Captions required. Pays $25-30.
Color: Send transparencies, but rarely uses. Captions required. Pays $25 minimum.
Tips: "We would like creative, perceptive feature photos. Use a different slant. Submit seasonal material 2 weeks in advance."

***THE TOWNSHIPS SUN**, Box 28, Lennoxville, Quebec, Canada J1M 1Z3. Editor: Bernard Epps. Monthly magazine, tabloid format. Circ. 3,000. "Aimed at the rural English-speaking people of Quebec. Emphasizes local history, agriculture, organic gardening, country living, ecology, wild life and survival, economically and politically." Buys 0-10 photos/issue.
Subject Needs: Animal, photo essay/photo feature, scenic, how-to, human interest, humorous, nature, still life and wildlife. "Quebec subjects only please. No nudes, urban scenes or glamour or fashion shots." Captions preferred.
Specs: Uses 5x7 b&w matte prints. Uses b&w cover only; vertical format required.
Payment & Terms: Pays $35-50/text and photo package, $2.50-5/b&w, and $5-10/cover. Credit line given. Pays 2-4 weeks after publication. Buys one-time rights. Simultaneous submissions and previously published work OK.
Making Contact: Send material by mail for consideration. Usually works with freelance photographers on assignment only basis. Provide letter of inquiry, samples and tearsheets to be kept on file for future assignments. SASE. Reports in 2-4 weeks. Sample copy $1.50.

***UPSTATE MAGAZINE, Gannet Rochester Newspapers**, 55 Exchange St., Rochester NY 14614. (716)232-7100. Editor: Dan Olmstead. Photo Editor: David Perdew. Weekly Sunday (newspaper) magazine. Circ. 240,000. Emphasizes stories, photo layouts of interest to upstate New York and greater Rochester readers. Sample copy free with SASE.

Photo Needs: Uses about 10 photos/issue; varied amount supplied by freelance photographers. Needs "wildlife, travel, specific photo story ideas; study the magazine for examples." Special needs include seasonal upstate material. Model release and captions required.
Making Contact & Terms: Send b&w prints and 35mm transparencies by mail for consideration. SASE. Reports in 1 month. Payment per cover and inside photo open. Pays on publication. Credit line given. Buys one-time rights.

***USA WEEKEND**, (formerly *Family Weekly*), Box 500 W, Washington DC 20044. (703)276-4534. Editor: Marcia Bullard. Director of Photography: Dixie D. Vereen. Weekly weekend supplement. Magazine. Emphasizes celebrities. Circ. 13,600,000. Estab. '85.
Photo Needs: Uses 20 photos/issue; 98% supplied by freelance photographers. Needs celebrity photos. "We review photos only for purpose of finding qualified photographers." Captions required.
Making Contact & Terms: Submit portfolio for review; provide resume, business card, brochure, flyer or tearsheets to be kept on file for possible future assignments. Reports in 2 weeks. Pays $200-300/job. Pays by assignment. Credit line given.
Tips: Prefers to see well lit portraits, etc., extremely high quality with imagination.

VELO-NEWS, Box 1257, Brattleboro VT 05301. (802)254-2305. Editor: Barbara George. Published 18 times/year; tabloid. Circ. 15,000. Emphasizes national and international bicycle racing news for competitors, coaches and fans. Photos purchased with or without accompanying ms. Buys 3-10 photos/issue. Credit line given. Pays on publication. Buys one-time rights. Send samples of work by mail or, "if immediate newsworthy event, contact by phone." Provide brochure, flyer, letter of inquiry, samples or tearsheets to be kept on file for future assignments. SASE. Simultaneous submissions and previously published work OK. Reports in 2 weeks. Free sample copy.
Subject Needs: Bicycle racing and nationally important bicycle races. Not interested in bicycle touring. Captions preferred.
B&W: Uses glossy prints. Pays $15-20/photo.
Cover: Uses glossy prints. Vertical format required. Pays $45 minimum/photo.
Accompanying Mss: News and features on bicycle racing. Query first. Pays $10-75/ms.
Tips: "Get photos to us immediately after the event, but be sure it's an event we're interested in."

THE WASHINGTON BLADE, Suite 315, 930 F St. NW, Washington DC 20004. (202)347-2038. Managing Editor: Lisa M. Keen. Weekly tabloid. Circ. 20,000. For and about the Gay community. Readers are gay men and lesbians; moderate to upper level income; primarily Washington, DC metropolitan area. Sample copy $1.
Photo Needs: Uses about 6-7 photos/issue; only out-of-town photos are supplied by freelance photographers. Needs "Gay related news, sports, entertainment events, profiles of Gay people in news, sports, entertainment, other fields." Photos purchased with or without accompanying ms. Model release and captions preferred.
Making Contact & Terms: Query with resume of credits. SASE. Reports in 1 month. Provide resume, business card and tearsheets to be kept on file for possible future assignments. Pays $25/photo inside. Pays within 45 days of publication. Credit line given. Buys all rights when on assignment, otherwise one-time rights. Simultaneous submissions and/or previously published work OK.

WDS FORUM, 9933 Alliance Rd., Cincinnati OH 45242. (513)984-0717. Editor: Kirk Polking. Bimonthly newsletter. Circ. 11,000. For students of Writer's Digest School; emphasizes writing techniques and marketing, student and faculty activities and interviews with freelance writers. Photos purchased with accompanying ms. Buys 1-2 photos/issue. Credit line given. Pays on acceptance. Buys one-time rights. Send material by mail for consideration. SASE. Simultaneous submissions and previously published work OK. Reports in 3 weeks. Sample copy 50¢.
Subject Needs: Celebrity/personality of well-known writers. No photos without related text of interest/help to writing students. Model release preferred; captions required.
B&W: Uses 8x10 glossy prints for inside or cover photos. Pays $15/photo.
Accompanying Mss: Interviews with well-known writers on how they write and market their work; technical problems they overcame; people, places and events that inspired them, etc. 500-1,000 words. Pays $10-25/ms.
Tips: "Get a sample if you are interested in working with our publication."

WEEKLY WORLD NEWS, 600 S. East Coast Ave., Lantana FL 33462. (305)586-0201. Editor: Joe West. Photo Editor: Linda McKune. Weekly national tabloid sold in supermarkets. Circ. 1,000,000.
Photo Needs: Uses 75-100 photos/issue; 40-50% supplied by freelancer photographers. Needs "celebrity candids; human interest including children; the bizarre and the unusual; occult." Model release and captions preferred.

Making Contact & Terms: Query with list of stock photo subjects or send 5x7 or 8x10 b&w glossy prints by mail for consideration. Provide resume, business card, brochure, flyer or tearsheets to be kept on file for possible future assignments. SASE. Pays $100/b&w cover; $50-100/b&w inside; minimum $100 plus mileage by the job. Pays on publication. Buys one-time rights.

WESLEYAN CHRISTIAN ADVOCATE, Box 54455, Atlanta GA 30308. (404)659-0002. Editor: William M. Holt. Weekly tabloid. Emphasizes religion. Readers are members of United Methodist Church. Circ. 31,000. Sample copy $1.
Photo Needs: Uses about 10 photos/issue; 1 supplied by freelance photographers. Needs religious themes of a seasonal nature. Captions preferred.
Making Contact & Terms: Query with samples; list of stock photo subjects; send 8x10 b&w prints by mail for consideration. SASE. Reports in 2 weeks. Pays $15/b&w cover photo. Pays on acceptance. Credit line given. Buys one-time rights. Simultaneous submissions OK.

WESTART, Box 6868, Auburn CA 95604. (916)885-0969. Editor-in-Chief: Martha Garcia. Emphasizes art for practicing artists, artists/craftsmen, students of art and art patrons, collectors and teachers. Circ. 7,500. Free sample copy and photo guidelines.
Photo Needs: Uses 20 photos/issue, 10 supplied by freelance photographers. "We will publish photos if they are in a current exhibition, where the public may view the exhibition. The photos must be b&w. We treat them as an art medium. Therefore, we purchase freelance articles accompanied by photos." Wants mss on exhibitions and artists in the western states. Model release not required; captions required.
Making Contact & Terms: Send by mail for consideration 5x7 or 8x10 b&w prints. SASE. Reports in 2 weeks. Payment is included with total purchase price of ms. Pays $25 on publication. Buys one-time rights. Simultaneous and previously published submissions OK.

WESTERN FLYER, Box 98786, Tacoma WA 98498-0786. (206)588-1743. Editor: Bruce Williams. Biweekly tabloid. Circ. 25,000. General aviation newspaper for private pilots, homebuilders, and owner-flown business aviation. Readers are pilots, experimental aircraft builders. Sample copy $2; photo guidelines free with SASE (57¢ postage).
Photo Needs: Uses about 25-30 photos/issue; 40-50% supplied by freelance photographers. Needs photos of aircraft, destinations, aviation equipment. Photos purchased with accompanying ms only. Complete captions required for each photo.
Making Contact & Terms: Query with samples; "news photos may be sent unsolicited." Send b&w prints, color prints, contact sheets, negatives by mail for consideration. "Query first on slides." SASE. Reports in 2 weeks. Pays $10-25/b&w inside photo; $15-50/color photo; up to $3/column inch plus $10/photo used for text/photo package. Credit line given. Buys one-time rights.
Tips: "Learn something about aviation subjects—we don't need or use pictures of air show teams flying maneuvers, airplanes flying overhead, people patting their airplanes affectionately, etc."

THE WESTERN PRODUCER, Box 2500, Saskatoon, Saskatchewan, Canada S7K 2C4. (306)665-3500. Editor and Publisher: R.H.D. Phillips. News Editor: Mike Gillgannon. Weekly newspaper. Circ. 140,000. Emphasizes agriculture and rural living in western Canada. Photos purchased with or without accompanying ms. Buys 0-10 photos/issue. Pays $50-250 for text/photo package. Credit line given. Pays on acceptance. Buys one-time rights. Send material by mail for consideration. SASE. Previously published work OK. Reports in 2 weeks. Free photo guidelines.
Subject Needs: Livestock, nature, human interest, scenic, rural, agriculture, day-to-day rural life and small communities. Captions required.
B&W: Uses 5x7 glossy prints. Pays $15 minimum/photo.
Color: Pays $35 minimum/photo.
Accompanying Mss: Seeks mss on agriculture, rural western Canada, history, fiction and contemporary life in rural western Canada. Pays $50-200/ms.
Tips: "Don't waste postage on abandoned, derelict farm building or sunset photos. We want modern scenes with life in them—people or animals, preferably both. Farm kids are always a good bet."

WISCONSIN, The Milwaukee Journal Magazine, Box 661, Milwaukee WI 53201. (414)224-2341. Editor: Beth Slocum. Weekly magazine. General-interest Sunday magazine focusing on the places and people of Wisconsin or of interest to Wisconsinites. Circ. 530,000. Free sample copy with SASE.
Photo Needs: Uses about 12 photos/issue; 1 supplied by freelance photographers. Needs "human-interest, wildlife, travel, adventure, still life and scenic photos, etc." Model release and captions required.
Making Contact & Terms: Query with samples. SASE. Reports in 3 months. Pays $125/color cover photo; $25-50/b&w inside photo, $75/color inside photo. Pays on publication. Buys one-time rights, "preferably first-time rights."

Paper Products

"Paper Products" covers a wide range of material including calendars, wall murals, post cards, greeting cards, puzzles and playing cards. The subject matter varies according to the needs of each particular company . . . and according to current market trends. These listings mention the particular product or products manufactured by each company and their current photographic needs—from a variety of sports shots to swimsuit photos to landscape scenes to a host of special effects images. The key to sales success is to submit photography that is very clean and sharp. Since a transparency (most companies tend to use color over b&w due to public buying trends) may possibly be enlarged to poster size or a large calendar format, a clear image with no defects is imperative. Insignificant marks, when enlarged in the printing process, turn into distracting shapes marring the overall impact of the photo itself.

If needs call for poster-size prints, the listings' specifications will require an ability to work with medium ($2\frac{1}{4}$x$2\frac{1}{4}$) or large format (4x5 or 8x10) transparencies. Familiarity with such cameras may prove a boost to your sales efforts in this section.

One attraction to this type of market is its pay scale, though the money gleaned from sales to these companies won't necessarily come in overnight. Check each listing carefully to become acquainted with the method of payment. Some will buy photographs outright, which means you will be paid upfront. Other companies pay on a royalty basis; this means you don't see your money until the product is out there selling in the marketplace. Such a waiting period can pay off in the long run if the product is successful, but it may be a two-year wait from the time the product is developed until it is produced. In that case you would be advised to market photos to other businesses and publications in order to supplement your income during the waiting period. Rights purchased with some photographs are exclusive product rights, which means you can sell the photo to a magazine or other nonpaper products company. All rights are purchased frequently, too. If you give up all rights to your shots, be sure the price you are paid reflects the value you feel the photo would have brought in the marketplace.

Most initial contacts with paper products companies will be in the form of a query sent with quality samples to give an idea of your photographic abilities. Since some companies handle a multitude of products and subjects, it might be wise to also include a stock subject list. This will be helpful to generating future sales even if the current needs don't reflect the type of images you have to offer. In addition to studying the needs of each company in the Subject Needs section, go down to your local card shop to see what trends are appearing on note cards, post cards, greeting cards and stationery. Your photography might have to be modified slightly to keep pace with trends in subjects, color use or any special effects creeping into the market.

For those a bit more enterprising, consider making your own post cards in the dark room. Since the marketing end of the procedure might be a little foreign to some, a good option would be to call on local gift shops and stationery stores to sell on consignment, or sell at an art fair. On a consignment basis, you get paid when the product sells. Many major photography magazines run ads from interested paper products firms; check near the back of each issue. Potential clients for post cards also can be found in hotels and motels, restaurants, resorts and camps.

A.F.B. MANUFACTURING & SALES CORP., #2, 1230 Gateway Rd., Box 12665, Lake Park FL 33403. (305)848-8721. President: Al Brooks. Specializes in brochures/bulletins. Buys 3 photos/year. **Subject Needs:** Needs subjects of animals, flowers or themes. Special needs include birds (1 inch negatives). No scenics.

Specs: Uses negatives.
Payment & Terms: Pays by the job. Pays on acceptance. Buys all rights, but may reassign to photographer after use. Model release and captions required.
Making Contact: Arrange a personal interview to show portfolio or send unsolicited photos by mail for consideration. Interested in stock photos. SASE. Reports in 1 month. Simultaneous submissions and previously published work OK.
Tips: "Negatives must be able to produce a transfer or decal."

***ABBEY PRESS**, Plant #1, Hill Dr., St. Meinrad IN 47577. (812)357-8011. Creative Art Director: JoAnne Calucchia. Specializes in greeting cards, framing prints, wall decor, calendars, post cards, and posters. Buys 30-50 photos/year.
Subject Needs: Nature, sun shots, sky, sea, some florals, couples, silhouetted subjects, Christian shots, seasonal, some set-ups (Valentines, Irish, Easter . . .). No un-Christian shots: nudes, fashion . . .
Specs: Uses 35mm, 2¼x2¼, 4x5, 8x10 transparencies.
Payment & Terms: Pays $200-300/color photo. Pays on acceptance of product, invoice will be required. Credit line given where possible. Buys exclusive product rights.
Making Contact: Send unsolicited photos by mail for consideration; provide resume, business card, brochure, flyer or tearsheets to be kept on file for possible future assignments. "Do not phone!" Interested in stock photos. Send seasonal material 3-6 months in advance. SASE. Reports in 3 weeks. Simultaneous submissions OK. Photo guidelines free with SASE.

***ABERTURA, INC.**, Suite 406, 535 Cordova Rd., Santa Fe NM 87501. (505)983-5803. Picture Editor: C.L. Phillips. Estab. 1980. Specializes in greeting cards, calendars and post cards. "We are a stock photograph agency basically, but have moved into publishing."
Subject Needs: "For our calendar and notecards and post cards we use primarily humorous and nature or seasonal images—of absolutely superior quality. For our stock photograph files, we will look at all kinds of images as long as they are superior in color, focus and composition." Write for a list of needed images.
Specs: Uses 5x7, 8x10 glossy b&w prints; 35mm, 2¼x2¼, 4x5 transparencies; b&w contact sheets.
Payment & Terms: Pays $50-1,700/b&w photo; $50-3,000/color photo; $55/hour; $400-600/day; negotiable/job. "This is on each item marketed (note cards, post cards, calendar images etc.) when we bear full production costs and distribution costs." Pays on publication. Credit line sometimes given. Buys one-time (for stock photos) or exclusive product rights (for cards, calendars). Model release and captions required.
Making Contact: Query with list of stock photo subjects; provide resume, business card, brochure, flyer or tearsheets to be kept on file for possible future assignments. Interested in stock photos. Submit seasonal material 1 year in advance. SASE. Reports in 3 weeks. Simultaneous submissions OK. Photo guidelines free with SASE.
Tips: Prefers to see 20 slides and/or b&w prints that best represent the subject matter and quality he/she is capable of. Only the *best* photography will do: most dramatic composition; the most superior lighting (either dramatic or subtle); the finest film and the most arresting composition will do. "We are looking for 'specialists'—photographers who do one thing, or one kind of photography exceptionally well. We need a first rate wildlife photographer; an underwater photographer; a sports photographer. And of course, the photography must be *superior* and of *exceptional* quality! Send only the best work you are capable of. Send 100 transparencies to start with (include return postage) and then if encouraged send additional material every 2-3 months but send non-dated or new material. Everything must be fully captioned and stamped with your name and copyright symbol. Write for our guidelines sheet."

***ADVANCED GRAPHICS**, 99 S. Buchanan Circle, Pacheco CA 94553. (415)827-4600. Photo Editor: Stephen Henderson. Provides posters, note cards, greeting cards, post cards. Buys 100-200 photos/year; gives 10-15 assignments/year. Photos used in posters, catalogs.
Subject Needs: Subject matter includes wildlife and scenic, plus exotic sports cars.
Specs: Uses 35mm, 2¼x2¼, 4x5, 8x10 transparencies. "Bigger is better."
Payment & Terms: Pays $50-500/color photo. Credit line given. Buys one-time rights.
Making Contact: Send unsolicited photos by mail for consideration; submit portfolio for review. Interested in stock photos. SASE. Reports in 3 weeks.
Tips: Prefers to see wildlife, ducks, deer, geese, grist mills. "Review our catalog, call for samples, submit, submit, submit. Looking for that 'something new & hot'."

***ALFA DECOR-DIV. OF ALFA COLOR LAB INC.**, 535 W. 135th St., Gardena CA 90248. (213)532-2532. Art Director: Chi-Chi Juaneza. Clients: interior designers, interior decorators, builders.
Needs: Works with about 100 freelance photographers/month. Uses freelance photographers for photographic art for wall decor. Subjects include scenics, landscapes, seascapes, boats, airplanes, animals, abstracts, any artistic photograph.

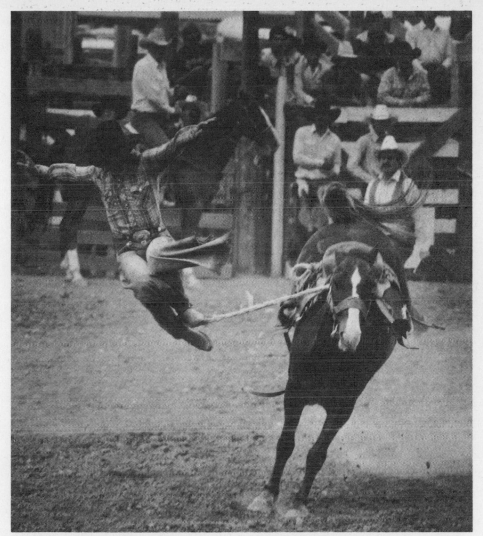

C.L. Phillips, picture editor at Abertura, Inc., published this photo and others in a special calendar "A Fresh Look at the Rodeo Cowboy." The photographer, Barbara Van Cleve, who was raised on a ranch, says, "The images of the rodeo cowboy grew out of a photographic project to illustrate the similarities between rodeo and ballet. The male part in a ballet is very dynamic, as is the cowboy's role at a rodeo. We have such a macho image of cowboys, the ballet lends another perspective." Abertura also wants to use Van Cleve's work for their series of photographic note cards.

Specs: Uses 35mm, 2¹/₄x2¹/₄, 4x5 transparencies; prefers 35mm Kodachrome.

First Contact & Terms: Query with samples. Interested in stock photos. SASE. Reports in 2 weeks. Pays "10% of the finished, framed product price paid by ultimate user." Pays "upon payment to Alfa Decor. We do not require exclusive rights." Captions and model release preferred. Credit line given if requested.

Tips: "Color composition is center of interest; would it be enjoyed by all if displayed in large format (30x40 or larger) in public place? Photographic art for decorative purpose is a fast growing field. It will prove to be a huge market in the next 5-10 years."

THE AMERICAN POSTCARD COMPANY, INC., 285 Lafayette St., New York NY 10012. (212)966-3673. Art Director: George Williams. Specializes in novelty post cards. Buys 500 photos/year; 50%

purchased from freelance photographers. Photo guidelines free with SASE, only.

Subject Needs: Humorous type, Christmas, birthday, Halloween, Easter, Valentines Day, unusual animal situations, erotic. No traditional post card material, i.e., no scenic, landscapes or florals.

Specs: Uses any size b&w or color prints; 35mm, 2¼x2¼, or 4x5 color transparencies; b&w and color contact sheet.

Payment & Terms: Payments made on royalty basis paid quarterly; some outright purchases made at $50-75/photo. Credit line given. Buys one-time rights. Model release required.

Making Contact: Query with samples or with list of stock photo subjects; send unsolicited photos; submit portfolio for review. Interested in stock photos. SASE. Reports in 6 weeks. Simultaneous submissions and previously published work OK. "We take no responsibility for loss or damage of submissions." Photo guidelines free on request with SASE.

Tips: "We look for unique, outrageous, and off-beat humor in our selections."

ARGONAUT PRESS, RR1, #142, Fairfield IA 52556. (515)472-4668. Editor: John Koppa. Specializes in post cards. Buys 40+ freelance photos/year.

Subject Needs: Scenes and events showing various cultural situations and behavior of odd people. Contemporary art shots. "Street Art" and "Off-the-Wall" Americana images.

Specs: Uses 8x10 or smaller glossy b&w and color prints; and 35mm and 2¼x2¼ transparencies.

Payment & Terms: Pays $30/b&w photo; $60/color photo, plus royalty of $60 per each 6,000 cards printed. Pays on acceptance for photo; royalty paid at time of printing. Credit line given. Buys exclusive rights (for post card use only). Model release required.

Making Contact: Query with samples or send unsolicited photos by mail for consideration. Interested in stock photos. SASE. Simultaneous submissions and previously published work OK. SASE. Guideline sheet available.

ARGUS COMMUNICATIONS, 1 DLM Park, Box 9000, Allen TX 75002. (214)248-6300, ext. 283. Photo Editors: Laura Sammarco, Linda Marie. Specializes in greeting cards, calendars, post cards, posters, stationery, filmstrips, books, educational materials. Buys "thousands" of freelance photos/year.

Subject Needs: "Varied—humorous, animals, inspirational, people relationships (must have releases), spectacular scenics (also illustration)." No animals in captivity (zoo) or family snapshots. "This year we're looking for front shots of animals with good eye contact, and soft focus couples."

Specs: Uses 35mm, 2¼x2¼, 4x5, 5x7 and 8x10 transparencies.

Payment & Terms: Depends on purchase; pays ASMP rates. Pays on publication. Credit line given. Normally buys one-time rights. Model release required; captions preferred.

Making Contact: Query with resume of credits; provide resume, business card, brochure, flyer or tearsheets to be kept on file for possible future assignments. Interested in stock photos. Submit seasonal material 8 months-1 year in advance. SASE. Reports in 2 months. Previously published work OK. Photo guidelines free on request.

Tips: "In a portfolio we look for vibrant color, crisp focus, depth of field, good lighting, highlights and back lighting."

ARPEL GRAPHICS, Box 21522, Santa Barbara CA 93121. (805)965-1551. President: Patrick O'Dowd. Specializes in greeting cards, calendars, post cards, posters, framing prints, stationery, books, puzzles. Buys 150 freelance photos/year.

Subject Needs: "Product lines are developed by artist not by subject, so coverage is very broad with most all genre of photography included." Uses 35mm, 2¼x2¼, 4x5 and 8x10 transparencies. Royalty and other payments negotiated by artist. Credit line given. Buys exclusive product rights. Model release and captions required.

Making Contact: Arrange a personal interview to show portfolio; query with resume of credits; provide resume, business card, brochure, flyer or tearsheets to be kept on file for possible future assignments. "SASE required for reply." Solicits photos by assignment. Reports in 1 month. Previously published work OK.

Tips: "Photographers interested in submitting work for review by *Arpel* should study the existing line carefully. We generally look for artists who have already established themselves in their field and have solid archives of work to draw upon. In order to more fully do each artist justice, we usually work with a limited number of artists in each genre of photography." Return postage and mailer must be provided with all work sent to *Arpel Graphics* for review.

ART SOURCE, Unit 10, 70 Gibson Dr., Markham, Ontario L3R 4C2 Canada. (416)475-8181. President: Lou Fenninger. Specializes in greeting cards, posters, stationery, wall decor. Buys 100-150 photos/year.

Subject Needs: Artistic nature.

Specs: Uses b&w and color prints, 35mm, 2¼x2¼, 4x5 and 8x10 transparencies; b&w and color contact sheets.
Payment & Terms: Pay individually negotiated. Pays on publication and on royalty as per sales. Credit line given. "We buy exclusive product rights for our products only." Model release required.
Making Contact: Query with samples; send unsolicited photos by mail for consideration; submit portfolio for review; provide resume, business card, brochure, flyer or tearsheets to be kept on file for possible future assignments. Interested in stock photos. Submit seasonal material any time. SASE. Reports in 1 month. Simultaneous submissions and previously published work OK.

CAROLYN BEAN PUBLISHING, LTD., 120 Second St., San Francisco CA 94105. (415)957-9574. Art Director: Tom Drew. Specializes in greeting cards and stationery. Buys 10-25 photos/year for the Sierra Club Notecard and Christmas card series only.
Subject Needs: "Our line is diverse."
Specs: Uses 35mm, 2¼x2¼, 4x5, etc., transparencies.
Payment & Terms: Up to $200/color photo. Credit line given. Buys one-time rights; anticipates marketing broader product lines for Sierra Club and may want to option other limited rights. Model release required.
Making Contact: Submit by mail. Interested in stock photos. Prefers to see dramatic wilderness and wildlife photographs "of customary Sierra Club quality." Provide business card and tearsheets to be kept on file for possible future assignments. Submit seasonal material 1 year in advance; all-year-round review. Publishes Christmas series December; everyday series January and May. SASE. Reports in 1 month. Simultaneous submissions and previously published work OK.
Tips: "Send only your best—don't use fillers."

BEAUTYWAY, Box 340, Flagstaff AZ 86002. (602)779-3651. President: Kenneth Schneider. Specializes in post cards, greeting cards, calendars, and posters. Buys 300-400 freelance photos/year (fee pay and joint venture). Joint Venture, a program within *Beautyway*, "allows the photographer to invest in his own images and to work more closely with the company in overall development of his photography." Through this program photographers can work on developing new lines for the company's postcard, note card and calendar products.
Subject Needs: Nationwide landscapes, animals, flowers, sports, marine life. All photos must have a dramatic value, strong color and contrast. Animals shots should focus on eyes, young animals and interaction. Rarely people's faces or people's bodies, except in sports, scale, or powerful mood shots.
Specs: Uses 35mm, 2¼x2¼, 4x5 and 8x10 transparencies.
Payment & Terms: Fee payment—pays $100 on the first printing of cards, $5 per 1,000 on reprinting, following publication. Joint Venture—photographers underwrite printing and receive royalty of 40% on gross sales. Model release required; captions preferred, and titles required.
Making Contact: Query with samples. Interested in stock photos "according to our assortment priorities." SASE. First report averages 2 weeks, second report variable. Previously published work OK. "Good publication record for photo is a plus, except where directly competitive." Photo guidelines free with SASE.
Tips: When reviewing samples, prefers to see landscapes, shots of animals and flowers, water and air sports, skiing, marine life and shells.

***BOKMON DONG COMMUNICATIONS**, Box 17504, Seattle WA 98107. Photo Editor: Jean Haner. Specializes in greeting cards.
Subject Needs: "The subject matter is not as important as the treatment. We are looking for a strong, original image that creates a mood and evokes positive feelings. It is essential that the photograph be unusual, sophisticated and innovative in style. A good balance of foreground and background interest, strong color, composition, and lighting are important. Avoid cliches; no pictures of people. Send $1 and first class stamp for sample card."
Specs: Uses any size transparencies.
Payment & Terms: Payment is negotiable; depends on purchase. Pays on publication. Credit line given. Buys greeting card rights. Model release and captions required.
Making Contact: Send SASE for photographer's guidelines. Interested in stock photos. Submit seasonal material 8-12 months in advance. Reports in 2 weeks on queries; 1 month on photos. Simultaneous and previously published submissions OK "but not if submitted, published or sold to another card publisher."
Tips: "The photographer must remember the function of a greeting card—to communicate positive feelings from one person to another. The image must create a mood and have strong visual impact. The kinds of photographs we are looking for are ones that: the photographer can recall without having to look through their files; people remember them by; are hanging on their walls."

Close-up

Kenneth Schneider
President, Beautyway
Flagstaff, Arizona

Beautyway, a Navajo word that means "on the trail of beauty," is a good representation of what Kenneth Schneider looks for in the world of photography. The Utah-born, ranch-raised company president explains that he started Beautyway, a paper products company, in 1979 "out of love for the great Colorado Plateau; a sense of the human potential of environment; and experience in editing, printing and publishing."

Photo subjects most often used by Schneider include national park scenes, and animal, marine, floral and sports shots. When reviewing submissions, he looks for a dramatic or unique appeal in the photographic expression. Each photo used, he explains, has to stand on its own artistically. "The photo which runs on a post card is crucial to that item's sale, unlike an editorial photograph that doesn't necessarily take away the sales appeal of the whole publication. I look at photos from two different perspectives, one being the artistic orientation and the other the public interest in the subject." People buy photos of places they have visited or recognize, Schneider explains, so a striking photo of Yosemite Valley probably will sell much better than a similar image of lesser known landscapes. And, says Schneider, "it must sell 10,000 times" to get a good return on investment.

The qualities Schneider feels photographers need to compete in this industry are described in two words, discipline and experimentation. Out of these traits comes imaginative growth, he says. "Photographers need to align their photography to what people want, and what the market demands," Schneider explains. "But they also must find ways to tickle the wants. Both a photographic and a business strategy are imperative for the photographer to succeed."

Trends are occurring within the industry that, according to Schneider, include a diversification of outdoor photography, such as undersea, skiing and air sports as well as a specialization in landscape photography. Schneider personally wants to see more cityscapes and airscapes. "It would also be good if portfolios appeared in classes of images, such as patterns, textures, or even in colors and highlights, macro and micro forms."

If photographers have a social responsibility beyond their own acclaim or profit, Schneider says, "it is certainly to teach people to see and to acquire habits of perceiving all that is distinctive and significant around them, both natural and man-built."

***BRIGHT PRODUCTS INC.**, 907 4th St. SE, Roanoke VA 24013. (703)982-1300. Assistant Graphics Manager: Luke Foster. Specializes in posters, stationery, gift wrap, wall decor, memo boards, note pads, coasters and paper products. Buys 20-30 photos/year.
Subject Needs: Informative, nature, useful, humorous and seasonal.
Specs: Uses 4x6 glossy b&w and color prints, contact sheets and negatives and 4x5 transparencies.
Payment & Terms: Pays $10-15/hour; 10% royalty on sales. Pays through weekly salary. Credit line occasionally given. Buys exclusive product rights.
Making Contact: Submit portfolio for review; provide resume, business card, brochure, flyer or tearsheets to be kept on file for possible future assignments. Deals with local freelancers only; interested in stock photos. Submit seasonal material 3 months in advance. Does not return unsolicited material. Report in 3 weeks. Previously published work OK.

***THE COLORTYPE COMPANY**, 1640 Market St., Corona CA 91720. (714)734-7410. Marketing Director: Mike Gribble. Specializes in greeting cards, wall decor, and stationery. Buys 75 photos/year.
Subject Needs: Humorous, inspirational, and unusual shots of people. No flowers.
Specs: Uses transparencies.
Payment & Terms: Pays $100/color photo; 3% royalties. Pays on acceptance. Buys one-time and all rights, depending on photo usage. Model release required.
Making Contact: Query with samples or send unsolicited photos by mail for consideration. Seasonal material should be submitted 9 months in advance. SASE. Reports in 2 weeks. Simultaneous submissions OK.

DAVIS-BLUE ARTWORK INC., 3820 Hoke St., Culver City CA 90230. (213)202-1550. Art Director: Robert Blue. Specializes in greeting cards, calendars, post cards, posters, limited edition silkscreening.
Subject Needs: Floral; nature; and animals. Pays according to contract agreement. Model release and captions required.
Making Contact: Arrange a personal interview to show portfolio; query with samples; query with list of stock photo subjects; send unsolicited photos by mail for consideration. Deals with local freelancers only; interested in stock photos. SASE. Reports in 3 weeks.

DICKENS COMPANY, 59-47 Fresh Meadow Lane, Flushing NY 11365. (718)357-5700. Art Director: David Podwal. Specializes in musical greeting cards. Buys 50 freelance photos/year.
Subject Needs: "Valentines' Day, nature, humorous, Christmas."
Specs: Whatever is suitable for photographer or artist.
Payment & Terms: Pays/job. Pays on acceptance. Credit line given. Model release and captions preferred.
Making Contact: "Phone us." Deals with local freelancers only. Submit seasonal material 6 months in advance. SASE. Reports in 3 weeks. Simultaneous submissions and previously published work OK.

***DOT CORP.**, 318 E. 7th St., Auburn IN 46706. (219)925-1700. Art Director: Steven R. Nelson. Specializes in calendars. Buys 150-200 photos/year.
Subject Needs: People/relationships, scenics/outdoors.
Specs: Uses 35mm, 2¼x2¼, 4x5, 8x10 transparencies.
Payment & Terms: Pays $150/color cover photo. Pays on acceptance. Credit line sometimes given. Buys one-time rights.
Making Contact: Send unsolicited photos by mail for consideration. Interested in stock photos. Send seasonal material August-September each year. SASE. Reports in 1-2 months. Previously published work OK. Photo guidelines free with SASE.

FIXOPHOTOS, D-24, M.I.D.C., Satpur, NASIK-422 007, Nasik India 30181. Partner: H.L. Sanghavi. Specializes in greeting cards, calendars. Buys 80-100 freelance photos/year.
Subject Needs: Nature, wildlife, landscapes, flowers. No religious.
Specs: Uses b&w and color prints.
Payment & Terms: Pays $30/color photo. Pays on acceptance. Credit line given. Buys one-time rights. Captions preferred.
Making Contact: Query with samples. Interested in stock photos. Submit seasonal material any time, but preferably before April. SASE. Reports in 1 month. Previously published work OK.

FLASHCARDS, INC., 781 W. Oakland Park Blvd., Fort Lauderdale FL 33311. (305)563-9666. Photo Researcher: Micklos Huggins. Specializes in post cards and notecards. Buys 500 photos/year.
Subject Needs: Humorous, human interest, animals in humorous situations, nostalgic looks, Christmas material, valentines, children in interesting, humorous situations. No traditional post card material; no florals, nudes, scenic or art. "If the photo needs explaining, it's probably not for us."
Specs: Uses any size b&w prints, transparencies and b&w contact sheets.
Payment & Terms: Pays $100 for exclusive product rights. Pays on publication. Credit line given. Buys exclusive product rights. Model release required.
Making Contact: Query with samples; send photos by mail for consideration; or provide resume, business card, brochure, flyer or tearsheets to be kept on file for possible future assignments. SASE. Interested in stock photos. Submit seasonal material 8 months in advance. Reports in 3 weeks. Simultaneous and previously published submissions OK. Photo guidelines free with SASE.

FREEDOM GREETINGS, 1619 Hanford St., Levittown PA 19057. (215)945-3300. Vice President: Jay Levitt. Specializes in greeting cards. Buys 200 freelance photos/year.
Subject Needs: General greeting card type photography of scenics, etc., and black ethnic people.
Specs: Uses larger than 5x7 color prints; 35mm and 2¼x2¼ transparencies.

Payment & Terms: Payment negotiable. Pays on acceptance. Credit line given. Model release required. "Looking for exclusive rights, only."
Making Contact: Query with samples. Submit seasonal material 1½ years in advance. SASE. Reports in 1 month. Simultaneous submissions OK. Photo guidelines free on request.
Tips: "Keep pictures bright—no 'soft touch' approaches."

***GEORGI PUBLISHERS**, #3W, 35 W. 38th St., New York NY 10018. (212)730-0518. Vice President, Marketing: Ingrid Risop. Specializes in calendars.
Subject Needs: Art, nature.
Specs: Uses 8x10 b&w and color prints, and 8x10 transparencies.
Payment & Terms: Pay negotiated. Pays on acceptance. Credit line given. Buys one-time rights. Model release and captions preferred.
Making Contact: Query with list of stock photo subjects. SASE. Reports in 1 month.

C.R.GIBSON, Knight St., Norwalk CT 06856. (203)847-4543. Photo Coordinator: Marilyn Schoenleber. Specializes in stationery, gift wrap, and gift books and albums. Buys 30 photos/year. Pays on acceptance. Credit line given if space allows. Buys all rights. Model release required. "Query and ask about our present needs." Send check to cover mailing, postage and insurance. Simultaneous submissions and previously published work OK, "but not if published by or sold to another company within this industry." Reports in 6 weeks.
Subject Needs: Still life, nature, florals. No abstracts, nudes, "art" photography or b&w.
Color: Uses transparencies. Pays $100/photo.

One-time rights were purchased with this photograph by East Lansing, Michigan, resident, Melva J. Baxter. "Golden Turtle Press purchased the photo originally for their 'Flowers' calendar. For an additional fee the photo was made into a greeting card," explains Baxter. She was paid $400 for the picture. The photo, she says, conveys "the beauty of nature and the 'new birth'—the coming of spring."

GOLDEN TURTLE PRESS, 1619 Shattuck Ave., Berkeley CA 94709. (415)548-2314. Production Manager/Art Director: Robert Young. Specializes in calendars and greeting cards. Buys up to 200 or more photos/year.

Subject Needs: Scenic rainbows, Himalayan mountains, other.
Specs: Uses *original* 35mm, 2¼x2¼, 4x5 and larger transparencies.
Payment & Terms: Pays $400/photo for interior calendar use; $ 500/cover; $ 250 introduction; $ 225 plus reprint fee for cards. Payment due upon publication. Credit line given. Buys one-time rights for calendars. Model release required.
Making Contact: Write for guidelines, issued once a year in the spring; send # 10 SASE, Attn: Photo Editor. Late requests will be held until next guideline issued. No questionnaires or forms to fill out, please. No liability assumed for unsolicited materials, they will be returned un-reviewed.
Tips: "Please submit your best work. We look for images that are unique in their quality of light, color or contrast, or present unusual and/or striking composition. Sharpness a must in all submissions, all transparencies will be viewed using a 8x magnifier. We consider ourselves as calendar and card specialists who produce some of the highest quality pieces on the market."

***GOOD CARDS**, 1159 Topaz Ave., San Jose CA 95117. (408)241-6404. Director: Henny De Groot. Estab. 1984. Specializes in greeting cards, and post cards.
Subject Needs: Humorous, nature.
Specs: Uses any prints, contact sheets and negatives.
Payment & Terms: Open. Pays on publication. Credit line given. Buys all rights. Model release required; captions preferred.
Making Contact: Provide resume, business card, brochure, examples, flyer or tearsheets to be kept on file for possible future assignments. SASE. Reports in 2 weeks. Simultaneous submissions OK.
Tips: Prefers to see samples suitable for postcards.

GRAND RAPIDS CALENDAR CO., 906 S. Division Ave., Grand Rapids MI 49507. Photo Buyer: Rob Van Sledright. Specializes in retail druggist calendars. Buys 10-12 photos/year. Pays on acceptance. Model release required. Submit material January through June. SASE. Simultaneous submissions and previously published work OK. Free photo guidelines; SASE.
Subject Needs: Used for drug store calendars. Baby shots, family health, medical dental (doctor-patient situations), pharmacist-customer situations, vacationing shots, family holiday scenes, winter play activities, senior citizen, beauty aids and cosmetics. No brand name of any drug or product may show.
B&W: Uses 5x7 and 8x10 glossy prints. Pays $10-20/photo.

GRAPHIC IMAGE PUBLICATIONS, Box 6417, Alexandria VA 22306. Photo Editor: John Hunter. Specializes in greeting cards, calendars, posters; also publishes how-to and travel. Buys 150-250 photos/year.
Subject Needs: Nature scenes for calendar shots; tasteful location or studio female shots (nude, seminude) for calendar and poster shots. Greeting cards have similar needs (scenics). For posters, tasteful seminudes, studio or location, with a "glamour" look (product illustration). "We are always looking for a new model to promote in the poster market."
Specs: Uses b&w and color prints; 35mm and 2¼x2¼ transparencies, and b&w and color contact sheets.
Payment & Terms: Pays $15-35/b&w photo, $35 and up/color photo; commissions $10-75/hour; but job rates "depend on subject and experience—query." Credit line given. Buys all rights, or pays royalty, but may reassign to photographer after use. Model release and identification required. "Finders fee paid for a salable model when used, if photographer not used."
Making Contact: Query with resume of credits or send unsolicited photos by mail for consideration; provide resume, business card, brochure, flyer or tearsheets to be kept on file for possible future assignments. SASE. Reports in 12 weeks. Simultaneous submissions and previously published work OK. Photo guidelines $1 on request. *No phone calls, please.*
Tips: Prefers to see "clean, well-composed transparency samples. Can be artsy but must be mood-impacting and original. Be creative, have a flair for your own style, submit some examples and we'll evaluate from there." If query for modeling jobs, submit sample photograph, SASE, and $1 for modeling info.

H.W.H. CREATIVE PRODUCTIONS, INC., 87-53 167 St., Jamaica NY 11432. (212)297-2208. Contact: President. Specializes in greeting cards, calendars, post cards, brochures/bulletins and magazines. Buys 20 photos/year.
Subject Needs: Science, energy, environmental, humorous, human interest, art, seasonal, city, high tech, serialized photo studies.
Specs: Uses 8x10 semi-matte color and b&w prints; 35mm, 2¼x2¼ and 4x5 transparencies.
Payment & Terms: Pays $15/b&w, $30/color photo; $35-100/job. Pays on publication or completion of job. Credit line "sometimes" given. Buys all rights, but may reassign to photographer after use. Model release required; captions preferred.

Making Contact: Arrange a personal interview to show portfolio or query with list of stock photo subjects; send unsolicited photos by mail for consideration. Interested in stock photos. Provide resume and brochure to be kept on file for possible future assignments. Submit seasonal material 6 months in advance. SASE. Reports in 3 weeks. Simultaneous submissions and previously published work OK.

***THE HAMILTON GROUP**, 9550 Regency Square Blvd., Jacksonville FL 32211. (904)723-6027. Senior Design and Production Director: Deborah M. Levine. Specializes in collectibles. Buys 250 photos from photographers—commissioned shots.
Subject Needs: Subjects include nature, scenics, abstract, product shots (majority).
Specs: Uses b&w prints and color transparencies.
Payment & Terms: Pay varies/b&w photo; $500/color photo; $50-3,000/job. Pays on acceptance. Credit line given. Buys one-time rights and exclusive product rights. Model release and captions preferred.
Making Contact: Provide resume, business card, brochure, flyer or tearsheets to be kept on file for possible future assignments. Deals mostly with local freelancers and solicits photos by assignments only. Interested in stock photos. SASE. Reports in 2-3 weeks.

***HOT SHOTS, INC.**, 4026 Melrose Ave., Roanoke VA 24017. (703)362-2361 or 989-2881. Poster producers and distributors. President or Vice President: Peter Ostaseski or Bill Jones. Clients: retail and wholesale.
Needs: Works with 1-2 freelance photographers/month. Uses freelance photographers for direct mail and posters. Subjects include automobiles and attractive women. The women are generally partially or completely unclothed.
Specs: Uses color prints, and 2¼x2¼ and 4x5 transparencies.
First Contact & Terms: Send unsolicited photos by mail for consideration; provide resume, business card, brochure, flyer or tearsheets to be kept on file for possible future assignments. Works with freelance photographers on assignment basis only. SASE. Reports in 1 month. Pays $100-750/job. Photos negotiated. Pays on acceptance. Buys all rights. Model release required; captions preferred. Credit line given.
Tips: Prefers to see incredible sexy photographs of cars and girls. "Send an unsolicited sample, (35mm slide, 2¼ transparency or print of typical piece of work along the lines of the posters we produce, or a copy of a poster that the photographer has produced. We will continue to increase our use of photographs or photographers as the demand for our product increases."

INTERCONTINENTAL GREETINGS, LTD., 176 Madison Ave., New York NY 10016. (212)683-5830. Contact: Robin Lipner, Creative Marketing. Specializes in greeting cards, calendars, post cards, posters, stationery and gift wrap.
Subject Needs: "Seasonal holidays, concepts. Not interested in ordinary florals, landscapes, nature; no 35mm unless extraordinary!"
Specs: Uses 4x5 transparencies.
Payment: Pays 20% royalties. Payment on sale to publisher. Credit line "generally not given." Buys exclusive product rights. Model release preferred.
Making Contact: Query with sample and list of stock photo subjects; send unsolicited photos by mail for consideration; provide resume, business card, brochure, flyer or tearsheets to be kept on file for possible future assignments. "We deal with local freelancers." SASE. Reports in 1-3 weeks. Previously published work OK.
Tips: Prefers to see "new commercial concepts" in a photographer's samples—"can be almost any subject matter suitable for the above mentioned products. We look for good design, technical quality and a different viewpoint on familiar subjects. Come in and see us."

JOLI GREETING CARD CO., 2520 W. Irving Park Rd., Chicago IL 60618. (312)588-3770. President: Joel Weil. Specializes in greeting cards and stationery. Buys variable number of photos/year.
Subject Needs: Humorous, seasonal.
Payment & Terms: Pays 30 days from acceptance of merchandise. Payment varies. Credit line optional. Buys all rights or exclusive product rights. Model release required; captions preferred.
Making Contact: Query with samples. Interested in stock photos. Submit seasonal material as soon as possible. SASE. Reports in 1 month. Simultaneous submissions OK.
Tips: "Subject must be humorous."

ARTHUR A. KAPLAN CO., INC., 460 West 34th St., New York NY 10001. (212)947-8989. President: Arthur Kaplan. Specializes in posters, wall decor, and fine prints and posters for framing. Buys the rights to 50-100 freelance photos/year.
Subject Needs: Flowers, scenes, animals, ballet, autos, still life, oriental motif, and musical instruments.

Specs: Uses any size color prints; 35mm, 2¼x2¼, 4x5 and 8x10 transparencies. Will accept b&w.
Payment & Terms: Royalty 5-10% on sales. Pays on publication. Credit line given if requested. Buys all rights, exclusive product rights. Model release required; captions preferred.
Making Contact: Send unsolicited photos or transparencies by mail for consideration. Interested in stock photos. Reports in 1-2 weeks. Simultaneous submissions and previously published work OK.
Tips: Looking for unique shots—strong color—excellent lighting; hand colored effect would be of much interest.

LANDMARK GENERAL CORP., Suite 227, 475 Gate Five Rd., Box 1100, Sausalito CA 94966. (415)331-6400. Contact: Photo Department. Specializes in greeting cards, calendars and posters. Buys 5,000 photos/year.
Subject Needs: Animals, scenic, cities, fish, food, men, women, sports, collectibles, nature, art and teddy bears.
Specs: Any format. Transparencies only.
Payment & Terms: Pays 5% royalty for full calendars; $100-300/individual photo according to sales. Payment time varies. Credit line given. Buys one-time rights and exclusive product rights. Model release and captions required.
Making Contact: Request photo guidelines with SASE. Interested in stock photos. Submit seasonal material 1 year in advance for calendars, 6 months in advance for cards. SASE. Reports in 2-6 weeks. Previously published work OK.

MAGIC MOMENTS GREETING CARDS PUBLISHING CO., 31 Seabro Ave., Amitville NY 11701. (516)842-9292. Vice President: David Braunstein. Specializes in greeting cards. Buys 500 photos/year.
Subject Needs: All greeting card subjects.
Specs: Uses 35mm, 2¼x2¼, 4x5, 8x10 transparencies.
Payment & Terms: Pays $25-35/color photo. Pays on acceptance. Buys all rights, greeting cards only. Model release required.
Making Contact: Query with samples. Deals with local freelancers only. Submit seasonal material 1 year in advance. SASE. Reports in 1 month.

MAINE LINE COMPANY, Box 418, Rockport ME 04856. (207)236-8536. Art Director: Elizabeth Stanley. Greeting cards and post cards. "Our readers are 90% women who are sophisticated, have college degrees, and good senses of humor."
Subject Needs: "Humorous, nontraditional, nonconservative photos of any kind; photos for occasions—birthday. We do not publish greeting cards for children; no pretty scenics or sentimental pictures. Also need photos of exotic, humorous, out-of-the way locales, with 50s look."
Specs: Prefers prints, and 35mm slides, 2¼x2¼, 4x5 transparencies. "We will look at any size b&w or color print; may wish to have negatives for production."
Payment & Terms: "Payment varies and is individually discussed with each photographer." Pays on publication; "sometimes partially on acceptance." Credit line given. Buys exclusive product rights. Model release required. "Photographer must warrant that he/she has rights to sell to us for reproduction."
Making Contact: Query with samples; send photos by mail for consideration; submit portfolio for review; or provide resume, business card, brochure, flyer or tearsheets to be kept on file for possible future assignments. Interested in stock photos. Christmas material should be submitted 12 months in advance; Valentines Day, 9 months. SASE. Reports in 1 month. Previously published submissions OK "but not if it is previously published as a greeting card. Ad or editorial OK." Photo guidelines free with SASE.
Tips: In a portfolio or samples, prefers to see "the best of what's on hand—images that would be available to us for reproduction. Submit photos that can bear humorous messages, and that have good technical quality. Check us out first to see if your submissions are appropriate. Please, no family album photos!"

MARK I INC., 1733-1755 Irving Park Rd., Chicago IL 60613. (312)281-1111. Art Director: Kevin Lahvic. Specializes in greeting cards. Buys 500 photos/year; almost all supplied by freelance photographers. Pays on acceptance. Buys exclusive world-wide rights on stationery products. Model release required. Send material by mail for consideration. Submit seasonal material 3-6 months in advance. SASE. Previously published work OK. Reports in 6 weeks. Free photo guidelines with SASE only.
Subject Needs: Pictures of children or animals in humorous situations.
B&W: Uses 8x10 glossy prints. Pays $100-200/photo (humorous baby photos only).
Color: Will accept any size transparency as long as subject is vertical format. Pays $100-150/photo.

MIDWEST ART PUBLISHERS, 1123 Washington Ave., St. Louis MO 63101. (314)241-1404. Sales Manager: Karen Strobach. Specializes in calendars, pad and pen sets, photo albums and pocket calendars.

Subject Needs: Mixed: scenic, animals and floral.
Specs: Uses color prints or transparencies.
Payment & Terms: Pays per photo or by the job. Buys all rights. Model release required.
Making Contact: Query with samples; provide resume and brochure to be kept on file for possible future assignments. SASE. Returns unsolicited material "if self-addressed, stamped return envelope provided." Simultaneous submissions and previously published work OK.

NATURESCAPES, INC., 24 Mill St., Box 90, Newport RI 02840. (401)847-7464. General Manager: Thayer Tanton. Specializes in photographic wall murals (7'x9' to 14'x9').
Subject Needs: Nature photographs (landscapes); city skylines; famous neighborhoods; underwater.
Specs: Uses 4x5, 5x7 and 8x10 transparencies. No 35mm or b&w without prior approval. "Technical perfection, zero to infinity focus, foreground detail to reinforce viewers presence (but not overwhelming when enlarged) are a must."
Payment & Terms: Usually on a royalty basis; negotiable.
Making Contact: Send unsolicited transparencies or prints with cover letter and contents list; send certified, return receipt mail. SASE with same. Reports in 3-4 weeks.
Tips: "We deal with a group of the finest naturalist/photographers in the country on a regular basis. To break into our limited market you must present a top quality professional presentation. Send only your absolute best efforts as we use only 'first choices.' In evaluating your own submissions, imagine the image blown up to wall size and hanging in a home or office; is it interesting enough that the viewer would not become bored with it after seeing it every day for a year? We look at thousands of submissions a year so limit yours to a small number of bests rather than a large number of possibles. Quality is much more important than quantity!"

***THOMAS NELSON PUBLISHERS**, Box 141000, Nashville TN 37214-1000. (615)889-9000. Vice President/Marketing: Robert Schwalb. Specializes in greeting cards, calendars, posters, gift wrap, books. Buys 5,000 + photos/year.
Subject Needs: "Religious, nature." No nudes, explicit nature.
Specs: Uses 8x10 matte b&w prints; 4x5 transparencies; b&w contact sheets.
Payment & Terms: Pays $25/job. Negotiable. Pays on publication. Credit line given if requested. Buys one-time rights and all rights. Model release required.
Making Contact: Arrange a personal interview to show portfolio; query with samples; submit portfolio for review. Interested in stock photos. SASE. Reports in 1 month. Simultaneous submissions and previously published work OK.
Tips: "We are looking for nature and religious photos."

PAPERCRAFT CORP., Papercraft Park, Pittsburgh PA 15238. (412)362-8000. Art Director/Product Manager: Dan O'Donnell. Needs photographs from professional artists. Specializes in Christmas wraps, packaging and promotion. Pays $75-125/hour; $500-850/day. Submissions accepted year-round. Buys all rights. Reports in 4 weeks. SASE. Free catalog and photo guidelines.
Tips: Include prices with all submissions. Looks for Christmas sentiments, brilliant color, proper lighting in portfolios submitted.

PARAMOUNT CARDS, INC., Box 1225, Pawtucket RI 02862. (401)726-0800. Photo Director: Keith Carey. Specializes in greeting cards. Buys approximately 700 photos annually. Pays on acceptance, usually $100-225/color photo. Buys exclusive world greeting card—all time rights. Model release required. Send material by mail for consideration. Prefers to see scenes, florals, still lifes, some animals. Submit Christmas and fall seasonal material January 1-May 1; valentine material June 1-August 1; Easter material June 1-October 1; and Mother's Day, Father's Day and Graduation October 1-December 15. SASE. Simultaneous submissions OK. Reports in 2-4 weeks. Free photo guidelines.
Subject Needs: People ("black or white, single or couples, in age groups of 20s, 40s or 60s, in love, friendship or general situations"); animals (cats, dogs, horses); humorous (wild and domestic animals); scenic (landscapes and seascapes in all four seasons); sport (fishing, golf, etc.); and still life (suitable for all occasions in greeting cards). No farm animals (pigs, cows, chickens, etc.), desert or tropical scenes or family get-togethers (e.g., birthday parties). Sharp or soft focus.
Color: Uses transparencies; prefers colorful, vertical transparencies with light title area at the top. Pays $100-225/photo.
Tips: "Send small submissions (20-40 transparencies) of only the best that are suitable for greeting cards. We are looking for all kinds of work. Mainly needing simple, graphic and clean fresh photos. Don't try to send a large quantity, but a few of your very best."

***LEE PASSARELLA**, Lawrenceville NJ 08648. (609)896-2800. Specializes in china (Lenox) and crystal. Buys 500-750 photos/year.

Subject Needs: China and crystal/design settings. No portraits.
Specs: Uses 8x10 b&w and color prints; 35mm, 2¼x2¼, 4x5, 8x10 transparencies.
Payment & Terms: Pay negotiated. Pays on acceptance. Buys all rights. Model release required.
Making Contact: Provide resume, business card, brochure, flyer or tearsheets to be kept on file for possible future assignments. Deals with local freelancers only. Submit seasonal material 6 months in advance. Does not return unsolicited material. Reports "when interested."
Tips: "We look for photographers familiar with shooting china and crystal."

PEMBERTON & OAKES, Department PM, 133 E. Carrillo St., Santa Barbara CA 93101. (805)963-1371. Photo Researcher: Patricia Kendall. Specializes in limited edition collector's porcelain plates. Buys 10-15 photos/year.
Subject Needs: "Interested only in photos of kids, kids and pets, babies, kittens and Nutcracker ballet."
Specs: Uses any size or finish color or black & white prints, and any size transparencies.
Payments & Terms: Pays $1,000 minimum/color or b&w photo. Payment on acceptance. Buys "limited exclusive rights to be determined at time of purchase; all rights, if possible."
Making Contact: Send unsolicited photos by mail for consideration. Interested in stock photos. Reports in 3 weeks. Simultaneous submissions and previously published work OK. Photo guidelines free on request.
Tips: "We are adding new artists and will acquire more photos. Submit a good selection and keep us in mind when shooting new material."

PHOTO/CHRONICLES, LTD., 500 West End Ave., New York NY 10024. (212)595-8498. President: David W. Deitch. Specializes in post cards. Buys 60-75 photos/year.
Specs: Uses b&w prints, size irrelevant. Must be excellent quality.
Payment & Terms: Pays royalty on wholesale price times size of press run. Pays on publication. Credit line given. Buys exclusive product rights. Model release and captions required.
Making Contact: Call to arrange a personal interview; send photocopies. Not interested in stock photos. SASE. Reports in 2 weeks.

PRODUCT CENTRE-S.W. INC., THE TEXAS POST CARD CO., Box 708, Plano TX 75074. (214)423-0411. Art Director: Susan Hudson. Specializes in greeting cards, calendars, post cards, posters, melamine trays and coasters. Buys approximately 150 freelance photos/year.
Subject Needs: Texas towns, Texas scenics, Oklahoma towns/scenics, regional (Southwest) scenics, humorous, inspirational, nature (including animals), staged studio shots—model and/or products. No hardcore nudity.
Specs: Uses "C" print 8x10 or smaller color glossy prints; 35mm, 2¼x2¼, 4x5 and 8x10 transparencies.
Payment & Terms: Pays up to $100/photo. Pays on acceptance of printing proof. Buys all rights. Model release required.
Making Contact: Arrange a personal interview to show portfolio, or may send insured samples with return postage/insurance. Submit seasonal material 1 year in advance. SASE. Reports usually 6-8 weeks, depending on season.

***P.S. GREETINGS, INC. D/B/A FANTUS PAPER PRODUCTS**, 4459 West Division St., Chicago IL 60651. (312)384-0234. Vice President: Rudy Schwarz. Specializes in greeting cards, gift wrap, and note cards. Buys 50-100 photos/year.
Subject Needs: Everyday—photo floral, photo pets, photo fruits, photo anniversary, photo scenery, photo religious. Christmas—photo: winter scenes, religious, candles, bells, ornaments, etc.
Specs: Uses 4x5 b&w and color prints; 35mm or 2¼x2¼ transparencies.
Payment & Terms: "Our rates are very competitive, (depending on size, subject matter, etc.)" Pays on acceptance. "Our company is willing to work with all freelance artists for a suitable arrangement for all." Buys exclusive product rights.
Making Contact: Query with resume of credits, samples and list of stock photo subjects; send unsolicited photos by mail for consideration; submit portfolio for review; provide resume, business card, brochure, flyer or tearsheets to be kept on file for possible future assignments. "We prefer seeing photo submittals before an interview is scheduled." Solicits photos by assignment; interested in stock photos. Submit Christmas and Easter material only 1 year in advance. SASE. Reports in 3-4 weeks. Simultaneous submissions and previously published work OK to veiw style of artist. Photo guidelines free with SASE.
Tips: Prefers to see everyday and Christmas greeting card photos.

QUADRIGA ART, INC., 11 E. 26th St., New York NY 10010. (212)685-0751. President: Thomas B. Schulhof. Specializes in greeting cards, calendars, post cards, posters and stationery. Buys 400-500

photos/year; all supplied by freelance photographers.
Subject Needs: Religious, all-occasion, Christmas, Easter, seasonal, florals, sunsets. No buildings or sports.
Specs: Uses color prints; 4x5 or 8x10 transparencies. Prefers Ektachrome, and transparencies submitted in sets of 4 to 6.
Payment & Terms: Payment varies. Pays on acceptance.
Making Contact: Arrange a personal interview to show portfolio; query with samples; send photos by mail for consideration, or submit portfolio for review. Interested in stock photos. Submit seasonal material 1 year in advance. SASE. Reports in 1 week. Simultaneous submissions OK.
Tips: "We prefer shots that focus on a singular subject, rather than a subject hidden in a busy backdrop."

ROCKSHOTS, INC., 632 Broadway, New York NY 10012. Art Director: Tolin Greene. Specializes in greeting cards. Buys 20 photos/year.
Subject Needs: Sexy, outrageous, satirical, ironical, humorous photos.
Specs: Uses b&w and color prints; 35mm, 2¼x2¼ and 4x5 slides. "Do not send originals!"
Payment & Terms: Pays $150/b&w, $200/color photo; $300-500/job. Pays on acceptance. Credit line given. Buys all rights. Model release required.
Making Contact: Interested in stock photos. Provide flyer and tearsheets to be kept on file for possible future assignments. Submit seasonal material 6 months in advance. SASE. Reports in 8-10 weeks. Simultaneous submissions and previously published work OK.
Tips: Prefers to see "greeting card themes, especially birthday, Christmas, Valentine's Day."

SACKBUT PRESS, 2513 E. Webster, Milwaukee WI 53211. Editor-in-Chief: Angela Peckenpaugh. Poem notecards.
Photo Needs: Uses 1 photo/card; all supplied by freelance photographers. Needs art photos, specific illustrations.
Making Contact & Terms: Query with samples. SASE. Reports in 1 month. Pays $10/photo. Credit line given. Buys all rights. Simultaneous submissions OK.
Tips: "Ask for exact subjects needed; we *never* use stock photos."

***SANPIPER PUBLISHING**, Box 5143, Stateline NV 89449. (916)544-3506. Publisher: Annette Schoonover. Estab. 1984. Specializes in calendars. Buys 25-50 photos/year.
Subject Needs: River rafting, canoeing, kayaking white water as well as calm water. Action as well as mood shots depicting river life.
Specs: Uses 35mm and 2¼x2¼ transparencies. "Please package slides properly."
Payment & Terms: Pays $100/color photo. Pays on publication. Credit line given. Buys exclusive product rights. Model release and captions required.
Making Contact: Query with samples. Deals with freelancers only. Submit seasonal material 1 year in advance. SASE. Reports "when final shots are selected prior to calendar production." Photo guidelines free with SASE.
Tips: Prefers to see "clear, crisp, well-composed shots. Try fast shutter speeds, unusual angles, subjects. Best light on the river is mornings and late afternoon. No trick shots, double exposures or other concocted surrealism. Be honest."

SCAFA-TORNABENE PBG. CO., 100 Snake Hill Rd., West Nyack NY 10994. (914)358-7600. Vice President: Claire Scafa. Specializes in inspirationals, religious, contemporary florals, dramatic wildlife, nostalgia, children of yesteryear.
Specs: Uses camera ready prints, 35mm, 2¼x2¼, 4x5 and 8x10 transparencies.
Payment & Terms: Royalty negotiated individually. Pays on acceptance. Credit line sometimes given. Buys all rights. Model release required.
Making Contact: Query with samples. Deals with local freelancers only. SASE. Reports in 2 weeks. Simultaneous submissions and previously published work OK.

***SIERRA CLUB BOOKS**, 730 Polk St., San Francisco CA 94109-7813. Contact: Calendar Editor. Specializes in nature calendars. Buys 143 photos annually. Send for free photo guidelines (mailed in May of every year), then submit material by mail for consideration. "We accept submissions *only* in June and July of each year for calendars covering the year after the following" (i.e. photos for the 1986 calendar will be reviewed in the summer of 1984). Buys exclusive calendar rights for the year covered by each calendar. Reports in 6-10 weeks. Simultaneous submissions OK.
Subject Needs: Needs photos of wildlife, natural history, scenery, hiking, etc. Captions required. Calendars: nature/scenic; wildlife; "Trail" (people in the outdoors); engagement (nature and wildlife). No animals in zoos; no people engaged in outdoor recreation with machines.

Color: Send transparencies. Pays $150-400.
Tips: "We're using international, as opposed to strictly North American, subjects in some of the calendars. We get lots of good scenics but not as many good wildlife shots or shots appropriate for the 'Trail' calendar (can include human subjects in activities such as climbing, canoeing, hiking, cross country skiing, etc.). *Be selective.* Don't submit more than 100 transparencies. Follow the guidelines in the spec sheet. Send only work of the highest quality/reproducibility. We're looking for strong images and seasonal appropriateness." Pays on publication.

SORMANI CALENDARS, 613 Waverly Ave., Mamaroneck NY 10543. Vice President: Donald H. Heithaus. Specializes in calendars. Buys 50 freelance photos/year.
Subject Needs: Scenics of the USA.
Specs: Uses 4x5 and 8x10 transparencies.
Payment & Terms: Pays $100 minimum/color photo. Pays on publication. Buys one-time rights. Model release preferred.
Making Contact: Query with samples or send unsolicited photos by mail for consideration. SASE. Reports in 2 weeks. Simultaneous submissions and previously published work OK.
Tips: Prefers to see "scenic pictures of the USA . . . lots of color and distance."

***SWEET STOP INC.**, Box 149, Staten Island NY 10304. (218)447-8400. President: G. Feldman. Specializes in candy novelties. Buys 6-8 photos annually.
Subject Needs: Seasonal, candy, teddy bears, etc.
Specs: Uses 4x5 glossy b&w prints, b&w negatives.
Payment & Terms: Open. Pays on acceptance. Credit line given. Buys all rights. Model release preferred.
Making Contact: Send unsolicited photos by mail for consideration, submit portfolio for review. Interested in stock photos. Submit seasonal material 6 months in advance. SASE. Reports in 3-4 weeks. Simultaneous submissions and previously published work OK.

***TRADE ASSOCIATES GROUP**, 1476 Merchandise Mart, Chicago IL 60654. (312)337-0878. Product Manager: Lucia Johnson. Specializes in calendars, post cards, posters, gift wrap, catalogs, mailers, ads, magazines.
Subject Needs: "Seasonal and non-housewares, specialty candles."
Specs: Uses 35mm and 4x5 transparencies.
Payment & Terms: Pays $80/color photo. Pays net 30 days. Credit line often given. Buys all and exclusive product rights.
Making Contact: Query with samples; provide resume, business card, brochure, flyer or tearsheets to be kept on file for possible future assignments. Deals with local freelancers only and solicits photos by assignments only. Submit seasonal material 1 year in advance. Reports "at time of project." Simultaneous submissions and previously published work OK.

THE UNSPEAKABLE VISIONS OF THE INDIVIDUAL, Box 439, California PA 15419. Copublishers: Arthur and Kit Knight. Specializes in books and post cards. Buys 50 + photos/year. Buys first serial rights. Send material by mail for consideration. "Work not accompanied by SASE is destroyed." Simultaneous submissions and previously published work OK. Reports in 2 months. Sample copy available for $3.50 and SASE.
Subject Needs: "We are only interested in work pertaining to Beat writers so know who they are, and, generally, as much about them as possible. Representative writers we're interested in seeing photos of include Allen Ginsberg, William S. Burroughs, Gary Snyder, Gregory Corso, Lawrence Ferlinghetti, Philip Whalen, Peter Orlovsky, etc. Representative photographers we've published work by include Fred W. McDarrah, Richard Avedon, Jill Krementz and Larry Keenan, Jr."
B&W: Uses 8x10 glossy prints. Pays $10 maximum.

***VAGABOND CREATIONS, INC.**, 2560 Lance Dr., Dayton OH 45409. (513)298-1124. President: George F. Stanley, Jr. Specializes in greeting cards. Buys 2 photos/year.
Subject Needs: General Christmas scene . . non-religious.
Specs: Uses 35mm transparencies.
Payment & Terms: Pays $100/color photo. Pays on acceptance. Buys all rights.
Making Contact: Query with list of stock photo subjects. Interested in stock photos. Submit seasonal material 9 months in advance. SASE. Reports in 1 week. Simultaneous submissions OK.

WARNER PRESS, INC., 1200 E. 5th St., Anderson IN 46012. Contact: Millie Corzine. Specializes in weekly church bulletins. Buys 100 photos/year. Submit material by mail for consideration; submit only November 1-15. Buys all rights. Present model release on acceptance of photo. Reports when selections are finalized.

Subject Needs: Needs photos for 2 bulletin series; one is of "conventional type"; the other is "meditative, reflective, life- or people-centered. May be 'soft touch.' More 'oblique' than the conventional, lending itself to meditation or worship thoughts contributive to the Sunday church service."
Color: Uses transparencies (any size 35mm-8x10). Pays $100-150.
Tips: "Send only a few (10-20) transparencies at one time. Identify *each* transparency with a number and your name and address. Avoid sending 'trite' travel or tourist snapshots. Don't send ordinary scenes and flowers. Concentrate on *verticals*—many horizontals eliminate themselves. Do not resubmit rejections. If we couldn't use it the first time, we probably can't use it later!"

WILDERNESS STUDIO, INC., 874 Broadway, New York NY 10003. (212)228-0866. Picture Editor: Danielle Sheppard. Specializes in greeting cards, posters. Buys 1-5 freelance photos/year.
Subject Needs: Fine photography, major cities, cats.
Payment & Terms: Payment negotiated individually. Credit line given. Buys exclusive product rights.
Making Contact: Query with resume and tearsheet or other printed material. "Absolutely no original unsolicited material returned."
Tips: "We are a small venture, essentially an expanded self-publication enterprise. We use almost no outside work."

WISCONSIN TRAILS MAGAZINE., Box 5650, Madison WI 53705. (608)231-2444. Production Manager: Nancy Mead. Bimonthly magazine. Specializes in calendars portraying seasonal scenics, some books and activities from Wisconsin. Needs photos of nature, landscapes, wildlife and Wisconsin activities. Buys 20/issue of magazine. Submit material by mail for consideration or submit portfolio. Makes selections in January; "we should have photos by December." Buys one-time rights. Reports in 4 weeks. Simultaneous submissions OK "if we are informed, and if there's not a competitive market among them." Previously published work OK.
Color: Send 4x5, 35mm, and 2¼x2¼ transparencies. Captions required. Pays $150.
Tips: "Be sure to inform us how you want materials returned and include proper postage. Scenes must be horizontal to fit 8½x11 format. Submit only Wisconsin scenes."

***WOESTEMEYER PRESS, INC.**, 3826 W. Clay, Houston TX 77019. (713)520-7070. President: Marjorie Woestemeyer. Estab. 1982. Specializes in calendars and post cards.
Subject Needs: Advertising material.
Specs: Uses b&w and color prints; 4x5 transparencies; b&w and color contact sheets; b&w and color negatives. Pays on acceptance. Credit line sometimes given. Buys all rights. Model release required.
Making Contact: Query with resume of credits and samples; submit portfolio for review; provide resume, business card, brochure, flyer or tearsheets to be kept on file for possible future assignments. Solicits photos by assignments only. Submit seasonal material 8 months in advance. Does not return unsolicited material. Reports in 2 weeks.

Publications

The four categories comprising the Publications section—Association, Company, Consumer and Trade—offer more than 1,000 opportunities for editorial photographers. While there are many more periodicals published in the U.S. and Canada, the listings presented here represent the needs of publications *actively* seeking freelance photographers. There are a variety of subjects needed by editors and photo editors which range from general interest to specialized material.

Prior to sending any photo submissions, be sure to study the listings carefully to see exactly what each magazine needs, and what film format serves its needs. It would also be wise to purchase a back issue of the magazine(s) you are most interested in querying, or send away for a sample copy. Many magazines will gladly provide a sample of their publication either free with a SASE or for a nominal fee. In addition, many publications have their own set of writer's and photographer's guidelines, which can provide accurate detailed information on what types of subjects they use most, and how to query them. Many libraries subscribe to association, consumer and trade journals, so check there also for any hard-to-find specialty publications not carried at the local bookstore.

Once you are familiar with the markets you wish to query, send a letter describing the photos you have sent; include pertinent information about where they were taken, what is happening and to whom. This serves as information from which the "cutline" or photograph's explanation can be written. Remember to include your name, address, phone number and copyright notice. Also, check the listing for publications requiring a SASE if you wish to have your samples returned. If the listing states that they do not return unsolicited material, then send tearsheets, prints and duplicate transparencies for them to keep on file. If an interest is expressed in purchasing your photography, the original transparency(ies) can then be mailed.

If you have good writing skills, or can team up with a competent writer, you will greatly increase your chances of making a sale. Since editors are charged with the responsibility of generating new and exciting articles, a well thought-out piece presented clearly in your query letter may interest the editor. The combination of copy and photography also pays better in a market where selling photos alone tends to be a highly competitive experience. Watch for any publications that might require model releases for identifiable people in the photographs. The law, generally, protects the editorial market from legal reprisals, but many publications require model releases just to be on the safe side.

For newcomers to this market, there are two words of advice—be persistent. This is a competitive area, and if you don't already have a lot of published photos, it won't be wise to start at the top. Search out some of the smaller special interest publications that cover areas in which you are familiar or have an interest. They might not pay quite as lucratively as the major market publications, but they could build a nice portfolio for you that will enable you to go on to the larger markets.

Magazine buyers purchase photography on assignment and through stock. Currently, more photography is being purchased through photographer's stock because it is more economically feasible for the editor or photo editor to pay for an existing photo(s). Some story outlines will be specific enough, on occasion, that a magazine will justify the extra expense of an assignment for the photographer.

It is in your best interest to develop a working rapport with the editors of your favorite publications. They will be much more likely to call the photographer who understands their needs and has come through for them in the past. Such rapport takes time and persistence to maintain via regular contact, but it pays off in the long run.

These magazines represent a host of organizations that range from law groups, boat associations and fitness groups to left-handed people, hunters and religious groups. The goals of such publications are to provide their members with news about the groups' activities. Most of these publications are not available to the general public. For this reason it is recommended that you send for a review copy of any interesting publications. Your chances of working with the editors will greatly increase when they realize you understand their needs and the interests of their members.

For these types of publications, a combination of writing and photography skills will come in handy. Some of these organizations have branch offices across the U.S., so take the time to get involved locally. It might land you a job when the local director decides photos are needed for their publications or for area publicity. The same advice applies to any national or local chapters of organizations that may not be listed here. Making yourself known could pay off in additional income. If you're not sure what organizations exist in your area, check the local Yellow Pages.

Association publications aren't much different editorially from consumer magazines. They come in all sizes and formats, and range from black and white to four-color printing. The only discernible difference is that the readers share a common bond in interest regarding a hobby, profession, membership, or concern about social or political issues.

AAA MICHIGAN LIVING, 17000 Executive Plaza Dr., Dearborn MI 48126. (313)336-1211. Editor: Len Barnes. Managing Editor: Jo-Anne Harman. Monthly magazine. Circ. 870,000. Emphasizes auto use, as well as travel in Michigan, US and Canada. "We rarely buy photos without accompanying ms. We maintain a file on stock photos and subjects photographers have available." Buys 100-200 photos/year. Credit line given. Pays on publication for photos, on acceptance for mss. Buys one-time rights. Query with list of stock photo subjects. SASE. Simultaneous submissions and previously published work OK. Reports in 6 weeks. Free sample copy and photo guidelines.
Photo Needs: Scenic and travel. Captions required.
B&W: Uses 8x10 glossy prints. Pay is included in total purchase price with ms.
Color: Uses 35mm, 2¼x2¼ or 4x5 transparencies. Pays $50-200/photo.
Cover: Uses 35mm, 4x5 or 8x10 color transparencies. Vertical format preferred. Pays up to $350.
Accompanying Mss: Seeks mss about travel in Michigan, US and Canada. Pays $150-300/ms.

AEROBICS & FITNESS, The Journal of the Aerobics and Fitness Association of America, Suite 802, 15250 Ventura Blvd., Sherman Oaks CA 91403. (818)905-0040. Editor: Peg Angsten. Art Director: Sherie Stark. Publication of the Aerobics and Fitness Association of America. Bimonthly trade. Emphasizes exercise, fitness, health, sports nutrition, aerobic sports. Readers are fitness enthusiasts and professionals, 75% college educated, 66% female, majority between 20-45. Circ. 30,000. Sample copy $1.05.
Photo Needs: Uses about 20-40 photos/issue; most supplied by freelance photographers. Needs action photography of runners, aerobic classes, especially high drama for cover: swimmers, bicyclists, aerobic dancers, runners, etc. Special needs include food choices, male and female exercises, dos and don'ts. Model release required.
Making Contact & Terms: Query with samples or with list of stock photo subjects, send b&w prints, 35mm, 2¼x2¼ transparencies, b&w contact sheets by mail for consideration. SASE. Reports in 2 weeks. Pays $200/color cover, $35/inside b&w photo, $50-100 for text/photo package. Pays on publication. Credit line given. Buys first North American serial rights. Simultaneous submissions and previously published work OK.

AIR FORCE MAGAZINE, 1501 Lee Hgwy., Arlington VA 22209-1198. (703)247-5800. Editor: John Correll. Photo Editor: Guy Aceto. Publication of the Air Force Association. Monthly. Emphasizes aero-

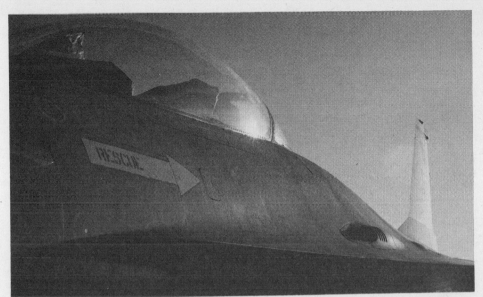

Freelance photographer, Bill Gregerson-Morash of Seattle, Washington, submitted this un-solicited photo to Air Force Magazine. "The photo was tucked away until the right mo-ment," says Guy Aceto, art director. "The piece is an advertising promotion 'mini-poster' sent to advertisers reminding them of an important special issue." The photographer was paid $100 for one-time use of the photo.

space technology, high technology, weapons systems, Air Force. Readers are manufacturers and re-tired, active duty and foreign members of the Air Force. Circ. 235,000. Free sample copy for SASE.
Photo Needs: Uses about 30-45 photos/issue; 3-5 supplied by freelance photographers. Needs photos of specific aircraft, special effects, space. Photos purchased with accompanying ms only. Special needs include composite special effects, high-tech. Captions preferred.
Making Contact & Terms: Query with samples; provide resume, business card, brochure, flyer or tearsheets to be kept on file for possible future assignments. SASE. Reports in 2 weeks. Pays $50-500 color photo or by hour. Pays on publication. Credit line given. Buys all rights. Simultaneous submis-sions OK.
Tips: Looks for Air to Air shots! Knowledge of Air Force terminology important not 'just' pretty air-plane pictures.

***ALCALDE MAGAZINE**, Box 7278, Austin TX 78713. (512)476-6271. Editor: Ernestine Wheelock. Publication of the University of Texas Ex-Students' Association. Bimonthly magazine. Emphasizes University Alumni. Readers are graduates, former students, and friends who pay dues in the UT Ex-Stu-dents' Association. Circ. 48,000. Sample copy free with SASE.
Photo Needs: Uses 65 photos/issue; 2-3 supplied by freelance photographers. Needs UT campus shots, professors, students, buildings, city of Austin, UT sports. Will review photos with accompanying ms only. Model release preferred; captions required.
Making Contact: Query with list of stock photo subjects; send unsolicited photos by mail for consider-ation. Send 5x7 or 8x10 glossy b&w and color prints; 35mm, 2¼x2¼ or 4x5 transparencies by mail for consideration. SASE. Reports in 1 month. Pays $100/color cover photo; $25/b&w and color inside pho-to. Pays on publication. Credit line given. Buys one-time rights. Simultaneous submissions and previ-ously published work OK.

AMERICAN ATHEIST, Box 2117, Austin TX 78768. (512)458-1244. Editor: Robin Murray-O'Hair. Published by American Atheist Press. Monthly magazine. Circ. 60,000. "The *American Atheist* con-centrates on atheist thought and history but also deals with First Amendment issues. Many articles ap-pear concerning the lifestyle of atheists as well as their civil rights and special concerns. Our audience consists exclusively of atheists, agnostics, rationalists, materialists, etc." Sample copy and photo guidelines free with SASE.
Photo Needs: "We only use photos for special events and for seasonal covers. The covers only are sup-

plied by freelancers. We usually need only four such covers a year. We need nature shots seasonally for our cover to celebrate the equinoxes and solstices; photos dealing with pagan celebrations of the solstices and equinoxes, such as Stonehenge.''
Making Contact & Terms: Query with samples. Pays $100/cover. Pays on publication. Credit line given. Buys one-time rights. Simultaneous and previously published submissions OK.

AMERICAN BIRDS, 950 3rd Ave., New York NY 10022. (212)546-9193. Editor: Susan Roney-Drennan. Assistant Editor: Fred Baumgarpen. Publication of National Audubon Society. Published 5 times/year. Circ. 15,000. ''Our major areas of interest are the changing distribution, population, migration, and rare occurrence of the avifauna of North and South America, including Middle America and the West Indies. Readers are 'bird people only'. Of our 29,000 readers, 11% are professional ornithologists, or zoologists, 79% serious amateurs, the rest novices.'' Sample copy $3; photo guidelines free with SASE.
Photo Needs: Uses one cover-quality shot, vertical format, color/issue. This most often supplied by freelance photographer. Also very interested in excellent b&w photos for inside use. Birds can be flying or perched, singly or in flocks, in any wild American habitat; picture essays on bird behavior. Avoid zoo or back-yard shots. ''Since we never know our needs too far in advance, best to send representative sampling.''
Making Contact & Terms: Query with samples; send any size glossy prints, transparencies, contact sheet or negatives by mail for consideration; provide resume, business card, brochure, flyer or tearsheets to be kept on file for possible future assignments. SASE. Reports in 1 month. Pays up to $100/color cover photo; $10-25/inside b&w photo. Pays on publication. Credit line given.

AMERICAN CRAFT, 401 Park Ave. S., New York NY 10016. (212)696-0710. Editor: Lois Moran. Senior Editor: Pat Dandignac. Bimonthly magazine of the American Craft Council. Circ. 40,000. Emphasizes contemporary creative work in clay, fiber, metal, glass, wood, etc. and discusses the technology, materials and ideas of the artists who do the work. Pays on publication. Buys one-time rights. Arrange a personal interview to show portfolio. SASE. Previously published work OK. Reports in 1 month. Free sample copy.
Photo Needs: Visual art. Shots of crafts; clay, metal, fiber, etc. Captions required.
B&W: Uses 8x10 glossy prints. Pays according to size of reproduction; $40 minimum.
Color: Uses 4x5 transparencies and 35mm film. Pays according to size of reproduction; $40 minimum.
Cover: Uses 4x5 color transparencies. Vertical format preferred. Pays $175-300.

AMERICAN FORESTS MAGAZINE, 1319 18th St., NW, Washington DC 20036. Editor: Bill Rooney. Publication for the American Forestry Association. Emphasizes use and enjoyment of forests and natural resources. Readers are ''laymen (rather than professional foresters) who are landowners (10 acres or more), mostly suburban to rural rather than urban.'' Monthly. Circ. 40,000. Sample copy and free photo guidelines with magazine-size envelope and 95¢ postage.
Photo Needs: Uses about 40 photos/issue, 35 of which are supplied by freelance photographers (most supplied by article authors). Needs woods scenics, wildlife and forestry shots. Model release and captions preferred.
Making Contact & Terms: Query with resume of credits. SASE. Reports in 4-6 weeks. Pays on acceptance $150-200/color cover photo; $25-40/b&w inside; $40-75/color inside; $250-400 for text/photo package. Credit line given. Buys one-time rights.

AMERICAN HOCKEY MAGAZINE, 2997 Broadmoor Valley Rd., Colorado Springs CO 80906. (303)576-4990. Managing Editor: Mike Schroeder. Publication of the Amateur Hockey Association of the US. Published 7 times/year. Circ. 35,000. Emphasizes ice hockey, including rinks and arenas, coaching tips, referee's information, Americans playing professional ice hockey, youth hockey, college hockey plus other features. Readers are hockey players, coaches, referees, parents and fans. Sample copy $2.
Photo Needs: Uses about 25-30 photos/issue; 100% supplied by freelance photographers. Needs photos of hockey action, plus special-request photos. Captions preferred.
Specs: B&w or color transparencies only.
Making Contact & Terms: Query with samples; ''telephone calls also acceptable.'' Does not return unsolicited material. Reports in 2 weeks. Pays $50-200 for text/photo package, and approximately $25 for each photo (contact the editor for specifics). Pays on publication. Credit line given. Buys all rights;

 The asterisk before a listing indicates that the listing is new in this edition. New markets are often the most receptive to freelance contributions.

"agreements can be arranged." Simultaneous submissions OK.
Tips: "We look for good action photos (color and/or b&w)."

AMERICAN HUNTER, 1600 Rhode Island Ave. NW, Washington DC 20036. (202)828-6230. Editor: Tom Fulgham. Monthly magazine. Circ. 1,400,000.
Photo Needs: Uses wildlife shots and hunting action scenes. Captions preferred.
Specs: Uses 8x10 glossy b&w prints and 35mm color transparencies. (Uses 35mm color transparencies for cover.) Vertical format required for cover.
Accompanying Mss: Photos purchased with or without accompanying mss. Seeks general hunting stories on North American game. Free writer's guidelines.
Payment & Terms: Pays $25/b&w print; $40-275/color transparency; $275/color cover photo; $200-450 for text/photo package. Credit line given. Pays on publication for photos. Buys one-time rights.
Making Contact: Send material by mail for consideration. SASE. Reports in 2 weeks. Free sample copy and photo guidelines.

AMERICAN LIBRARIES, 50 E. Huron St., Chicago IL 60611. (312)944-6780. Assistant Managing Editor: Edith McCormick. Publication of the American Library Association. Magazine published 11 times/year. Emphasizes libraries and librarians. Readers are "chiefly the members of the American Library Association but also subscribing institutions who are not members." Circ. 40,000-45,000. Sample copy free with SASE. Photo guidelines free with SASE.
Photo Needs: Uses about 5-20 photos/issue; 1-3 supplied by freelance photographers. "Prefer vertical shots. Need sparkling, well-lit color transparencies of beautiful library exteriors—35mm and larger. Dramatic views; can be charming old-fashioned structure with character and grace or striking modern building. Library should be *inviting*. Added color enrichment helpful: colorful foliage, flowers, people engaged in some activity natural to the photo are examples." Special needs include "*color* photos of upbeat library happenings and events—must be unusual or of interest to sophisticated group of librarian-readers."
Making Contact & Terms: "Supply possible cover photos of library exterior—as many views as possible of same subject." Send transparencies and contact sheet by mail for consideration. SASE. Reports in 2-6 weeks. Pays $100-150/cover photo; $200-300/color cover photo; $50-75/b&w inside photo; $75-100/color inside photo; and $100-450/text/photo package. Credit line always given. Buys first North American serial rights.

AMERICAN MOTORCYCLIST, Box 141, Westerville OH 43081. (614)891-2425. Executive Editor: Greg Harrison. Associate Editors: Bill Wood, John Van Barriger. Monthly magazine. Circ. 130,000. For "enthusiastic motorcyclists, investing considerable time in road riding or competition sides of the sport." Publication of the American Motorcyclist Association. "We are interested in people involved in, and events dealing with, all aspects of motorcycling." Buys 10-20 photos/issue. Buys all rights. Mail query required. Provide letter of inquiry and samples to be kept on file for possible future assignments. Credit line given. Pays on publication. Reports in 3 weeks. SASE. Sample copy and photo guidelines for $1.50.
Photo Needs: Travel, technical, sport, humorous, photo essay/photo feature, celebrity/personality.
B&W: Send 5x7 or 8x10 semigloss prints. Captions preferred. Pays $15-40.
Color: Send transparencies. Captions preferred. Pays $20-60.
Text/Photo Package: Photo rates as described above; pays $3.50/column inch minimum for story.
Cover: Send color transparencies. "The cover shot is tied in with the main story or theme of that issue and generally needs to be with accompanying ms." Pays $100 minimum.
Tips: "Work to be returned *must* include SASE. Show us experience in motorcycling photography and suggest your ability to meet our editorial needs and complement our philosophy."

AMERICAN TRAVELER, 60 E. 42nd St., New York NY 10165. (212)682-3710. Art Director: Phyllis Busell. Emphasizes travel for members of September Days Club which includes people 55 and older whose common interest is travel. Quarterly. Circ. 450,000.
Photo Needs: Buys 15-20 photos/issue; all provided by freelance photographers. Works with professional photographers on an ongoing basis. Choose from those who have carried out assignment well in past. Use photos to accompany ms primarily. Interested in dramatic generic cover shots. "I'd like to review brochures and tearsheets so that freelancers could be contacted when needs arise. We feature four cities of areas of US per issue. Need area photos at those times." Wants on a regular basis travel photos. "Always looking for good covers (vertical)." Model and informational captions required.
Specs: Kodachrome preferred.
Making Contact & Terms: Do not send unsolicited photos or slides. Upon request, send by mail the actual color prints or 35mm, 2¼x2¼, 4x5 or 8x10 color transparencies. Query with stock list. Reports in 3 weeks. Pays $200 for each inside page, and $500 minimum/color cover photo. Pays on publication.

Credit line given. Buys one-time rights. Previously published work OK.

Tips: "We like to review brochures and tearsheets so freelancers can be contacted when needs arise. We're talking with freelancers new to the company all the time."

AN GAEL, c/o Irish Arts Center, 553 W. 51st St., New York NY 10019. (212)757-3318. Director: Abby Karp. Publication of the Irish Arts Center. Quarterly. Circ. 6,000. Emphasizes traditional Irish culture: poetry, fiction, book reviews, biography, interviews, etc., as well as the Irish in America and in Ireland. Readers are middle class, working class and college educated.

Photo Needs: Uses about 10-12 photos/issue; all supplied by freelance photographers. Needs photos of people, scenery, well-known musicians and artists, anonymous and famous people—*all* Irish or relating to Irish subject matter in general. Special needs include cover or other photos; may relate to the Irish in Ireland, in America or in other places. Captions required.

Making Contact & Terms: Query with samples; send 5x7 or 8x10 b&w prints for consideration; a written or phoned description is acceptable. SASE. Reports in 1 month. Pays $20/b&w cover photo; $10/b&w inside photo. Pays on publication. Credit line given. Buys one-time rights. Simultaneous submissions and previously published work sometimes accepted; "each case is given individual consideration."

Tips: "*An Gael* is devoted to the Irish experience in Ireland and in America. Strong photos of immigrants—lumberjacks, railroad workers in USA—as well as all other related material is very much wanted."

ANCHOR NEWS, 75 Maritime Dr., Manitowoc WI 54220. (414)684-0218. Editor: Isacco A. Valli. Publication of the Manitowoc Maritime Museum. Bimonthly magazine. Emphasizes Great Lakes maritime history. Readers include learned and lay readers interested in Great Lakes History. Circ. 1,900. Sample copy $1. Guidelines free with SASE.

Photo Needs: Uses 8-10 photos/issue; infrequently supplied by freelance photographers. Needs historic/nostalgic, personal experience, and general interest articles on Great Lakes maritime topics. How-to and technical pieces and model ships and shipbuilding are OK. Special needs include historic photography or photos that show current historic trends of the Great Lakes. Photos of waterfront development, bulk carriers, sailors, recreational boating etc. Model release and captions required.

Making Contact & Terms: Query with samples, send 4x5 or 8x10 glossy b&w prints by mail for consideration. SASE. Reports in 1 month. Pays in copies only on publication. Credit line given. Buys first North American serial rights. Simultaneous submissions and previously published work OK.

Tips: "Besides historic photographs I see a growing interest in underwater archaeology, especially on the Great Lakes, and underwater exploration—also on the Great Lakes. Sharp, clear photographs are a must. Our publication deals with a wide variety of subjects, however we take a historical slant with our publication. Therefore photos should be related to a historical topic in some respect. Also current trends in Great Lakes shipping. A query is most helpful. This will let the photographer know exactly what we are looking for and will help save a lot of time and wasted effort."

ANGUS JOURNAL, 3201 Frederick Blvd., St. Joseph MO 64501. (816)233-0508. Editor: Jim Cotton. Publication of the American Angus Association. Monthly. Circ. 19,000. Emphasizes purebred Angus cattle. Readers are Angus cattle breeders. Sample copy and photo guidelines free with SASE.

Photo Needs: "Cover shots only" are supplied by freelancers. Needs scenic color shots of angus cattle. Special needs include "cover shots, especially those depicting the four seasons. Autumn scenes especially needed—vertical shots only." Identify as to farm's location.

Making Contact & Terms: Send 8x10 color prints; 35mm, 2¼x2¼, 4x5, or 8x10 transparencies; color contact sheet; color negatives (all vertical shots). Provide resume, business card, brochure, flyer or tearsheets to be kept on file for possible future assignments. SASE. Pays $50-150/color cover photo. Pays on acceptance. Credit line given. Buys all rights; rights purchased are negotiable.

APA MONITOR-AMERICAN PSYCHOLOGICAL ASSOCIATION, 1200 17th St. NW, Washington DC 20036. (202)955-7690. Editor: Jeffrey Mervis. Associate Editor: Kathleen Fisher. Monthly newspaper. Circ. 70,000. Emphasizes "news and features of interest to psychologists and other behavioral scientists and professionals, including legislation and agency action affecting science and health, and major issues facing psychology both as a science and a mental health profession." Photos purchased on assignment. Buys 60-90 photos/year. Pays by the job; $30-50/hour; or $25-40/b&w photo; or $300-400/day. Credit line given. Pays on publication. Buys first serial rights. Arrange a personal interview to show portfolio or query with samples. SASE. Simultaneous submissions and previously published work OK. Sample copy with $3 and 9x12 envelope.

Photo Needs Head shot; feature illustrations; and spot news.

B&W: Uses 5x7 and 8x10 glossy prints; contact sheet OK.

Tips: "Become good at developing ideas for illustrating abstract concepts and innovative approaches to

cliches like meetings and speeches. We look for quality in technical reproduction, and innovative approaches to subjects."

APPALACHIA, Appalachian Mountain Club, 5 Joy St., Boston MA 02108. (617)523-0636. Managing Editor: Diane Welebit. Monthly. Circ. 32,000. Emphasizes "outdoor activities, conservation, environment, especially in the Northeastern USA. We run extensive listings of club outings, workshops, etc." Readers are "interested in outdoor activities and conservation." Sample copy available for $1, SASE and 50¢ postage. Photo guidelines free with SASE.
Photo Needs: Uses about 10 photos/issue; all supplied by freelance photographers. Needs "scenic, wildlife, outdoor activities in the Northeast USA, especially mountains; color slides for covers (prefer vertical); b&w for inside." Model release preferred for inside photos; required for cover photos. Subject description required.
Making Contact & Terms: Arrange a personal interview to show portfolio; query with samples or send unsolicited photos by mail for consideration. Send 8x10 b&w glossy prints, 35mm transparencies by mail for consideration. SASE. Reports in 1 month. No payment. Credit line given. Simultaneous submissions and previously published work (with permission) OK.
Tips: "Think vertical (for covers)."

APPALACHIAN TRAILWAY NEWS, Box 807, Harpers Ferry WV 25425. (304)535-6331. Editor-in-Chief: Judith Jenner. Publication of the Appalachian Trail Conference. Published 5 times/year. Circ. 21,000. Emphasizes the Appalachian Trail. Readers are "Appalachian Trail supporters, volunteers, hikers." Guidelines free with SASE; sample copy $3.
Photo Needs: Uses about 25 photos/issue; 4-5 supplied by freelance photographers. Needs b&w photos relating to Appalachian Trail. Captions preferred.
Making Contact & Terms: Query with list of stock photo subjects. Send 5x7 or larger b&w prints or b&w contact sheet by mail for consideration. Provide resume, business card, brochure, flyer and tearsheets to be kept on file for possible future assignments. SASE. Reports in 1 month. Pays on publication; $15-100/b&w photo. Credit line given. Buys one-time rights. Simultaneous submissions and previously published work OK.
Tips: "We're inundated with Macro shots of flora and fauna but we need pictures of trail users—hikers and maintainers. Since we primarily use b&w we often choose the prints which will reproduce *well*— good, crisp tones—solid blacks and whites."

ASH AT WORK, American Coal Association, Suite 510, 1819 H St., NW, Washington DC 20006. (202)659-2303. Contact: Editor-in-Chief. Bimonthly. Circ. 2,700 + . Emphasizes coal ash production and utilization. Readers are in the electric utility, government, marketing, consulting, construction and civil engineering industries. Free sample copy.
Photo Needs: Uses about 6-7 photos/issue. Needs photos concerning applications of power plant ash. Model release and captions preferred.
Making Contact & Terms: Send 5x7 or 8x10 glossy b&w prints; 2¼x2¼ transparencies or b&w and color negatives by mail for consideration. SASE. Reports in 2 weeks. Negotiates payment. Pays on publication. Credit line given. Buys all rights. Simultaneous submissions OK.

ATA MAGAZINE, Box 240835, Memphis TN 38124. (901)761-2821. Editor-in-Chief: Milo Dailey. Publication of the American Taekwondo Association℠. Quarterly. Circ. 15,000. Photo guidelines free with SASE.
Photo Needs: Uses 40 + photos/issue; 5 supplied by freelance photographers. Model release and captions required. Query with samples. SASE. Reports in 2 weeks. Pays $25/published page, "to include both word and photo copy." Pays on publication. Credit line given. Buys all rights "unless otherwise agreed." Simultaneous submissions OK.
Tips: Virtually all photos are from people with an "ATA connection" due to subject matter. Photographers need not be members, but *do* need familiarity with ATA. "Major interest in association activities. Look at publication."

AUTO TRIM NEWS, 1623 Grand Ave., Baldwin NY 11510. (516)223-4334. Editor: Nat Danas. Publication of National Association of AutoTrim Shops. Monthly. Circ. 8,000. Emphasizes automobile restoration and restyling. Readers are upholsterers for auto marine trim shops; body shops who are handling cosmetic soft goods for vehicles. Sample copy $1 with SASE; photo guidelines free with SASE.
Photo Needs: Uses about 15 photos/issue; 6-10 supplied by freelance photographers. Needs "how-to photos; photos of new store openings; restyling showcase photos of unusual completed work." Special needs include "restyling ideas for new cars in the after market area; soft goods and chrome add-ons to update Detroit." Captions preferred.
Making Contact & Terms: Provide resume, business card, brochure, flyer or tearsheets to be kept on

file for possible future assignments; submit ideas for photo assignments in local area. Photographer should be in touch with a cooperative shop locally. SASE. Reports in 1 week. Pays $35/b&w cover photo; $75-95/job. Pays on acceptance. Credit line given if desired. Buys all rights. Simultaneous submissions and previously published work OK.

Tips: "First learn the needs of a market or segment of an industry. Then translate it into photographic action so that readers can improve their business."

***BICYCLE USA**, Suite 209, 6707 Whitestone Rd., Baltimore MD 21207. (301)944-3399. Editor: Karen Missavage. Association publication of *Bicycle USA*, the League of American Wheelmen. Published 9 times annually; magazine. Emphasizes bicycles. Readers are bicycle enthusiasts who ride for transportation, recreation, fitness. Circ. 16,000. Sample copy $1.50.

Photo Needs: Uses 10 photos/issue; 5-10 supplied by freelance photographers. Needs photos of people with 10 speed bikes wearing bicycle clothes. High-quality and wearing bicycle helmets if riding. (No racing bikes.) Special needs include some stock location photography: country roads, nice scenery, specific locales. Model release and captions preferred.

Making Contact & Terms: Query with list of stock photo subjects; provide resume, business card, brochure, flyer or tearsheets to be kept on file for possible future assignments. SASE. Reports "immediately—6 months (I'm swamped)." Pays $10/job. "Most payments are in portfolio copies, referrals, and profuse thanks. Low budget operation." Pays on publication. Credit line given. Rights vary. Previously published work OK.

Tips: "Go riding with your local bicycle club, and take pictures of real people riding real bicycles. (And have fun!)"

BIKEREPORT, Box 8308, Missoula MT 59807. (406)721-1776. Managing Editor: Daniel D'Ambrosio. Publication of Bikecentennial, Inc. Bimonthly journal. Circ. 18,000. Emphasizes "bicycle touring. Readers are mostly under 40, active." Sample copy and contributor's guidelines free with SASE.

Photo Needs: Uses about 8 photos/issue; "all photos accompany manuscripts." Model release required.

Making Contact & Terms: Query with resume of credits. SASE. Reports in 3 weeks. Pays $50/b&w cover photo; $5-10/b&w inside photo. Pays on publication. Credit line given. Buys one-time rights.

BOWLING MAGAZINE, 5301 S. 76th St., Greendale WI 53129. (414)421-6400. Editor: Dan Matel. Published by the American Bowling Congress. Emphasizes bowling for readers who are bowlers, bowling fans or media. Published 11 times annually. Circ. 140,000. Free sample copy; photo guidelines for SASE.

Photo Needs: Uses about 20 photos/issue, 1 of which, on the average, is supplied by a freelance photographer. Provide calling card and letter of inquiry to be kept on file for possible future assignments. "In some cases we like to keep photos. Our staff takes almost all photos as they deal mainly with editorial copy published. Rarely do we have a photo page or need freelance photos. No posed action." Model release and captions required.

Making Contact & Terms: Send by mail for consideration actual 5x7 or 8x10 b&w or color photos. SASE. Reports in 2 weeks. Pays on publication $10-15/b&w photo; $15-20/color photo. Credit line given. Buys one-time rights but photos are kept on file after use. No simultaneous submissions or previously published work.

BROTHERHOOD OF MAINTENANCE OF WAY EMPLOYES JOURNAL, 12050 Woodward Ave., Detroit MI 48203. Associate Editor: R.J. Williamson. Monthly magazine. Circ. 120,000. Emphasizes trade unionism and railroad track work. For members of the international railroad maintenance workers' union, "who build, repair and maintain the tracks, buildings and bridges of all railroads in the U.S. and Canada." Needs "strong scenics or seasonals" and photos of maintenance work being performed on railroad tracks, buildings and bridges; large format color transparencies only. Uses average of 10 photos/issue; 1 supplied by freelance photographer. Credit line sometimes given. Not copyrighted. Query first. Pays on acceptance. Reports in 2 weeks. SASE. Simultaneous submissions and previously published work OK. Free sample copy.

Cover: Send 4x5 or larger color transparencies. Photos must be "dynamic and sharp." Uses vertical format. Pays $100-200.

B&W: Pays $10-15/photo for inside use. Captions preferred. Buys one-time rights.

***BUCKEYE FARM NEWS**, 35 E. Chestnut, Columbus OH 43216. (614)225-8758. Editor: Jack Hill. Photo Editor/Art Director: Marty Handley. Association publication of the Ohio Farm Bureau. Monthly magazine. Emphasizes farming. Readers are farmers. Circ. 100,000. Sample copy free with SASE.

Photo Needs: Uses 20 photos/issue; 5 supplied by freelance photographers. Needs photos of scenic farm shots, farm animals, farm equipment, farmers. Reviews photos with accompanying ms only.

Making Contact & Terms: Query with samples. Send b&w contact sheets by mail for consideration. SASE. Reports in 2 weeks. Pays on publication. Credit line given. Buys one-time rights.
Tips: Prefers to see sharp, b&w photos for magazine reproduction in a farm magazine.

BULLETIN OF THE ATOMIC SCIENTISTS, 5801 S. Kenwood Ave., Chicago IL 60637. (312)363-5225. Production Editor: Lisa Grayson. Monthly (except bimonthly in summer, 10 issues/year). Circ. 25,000. Emphasizes science and world affairs. "Our specialty is nuclear politics; we regularly present disarmament proposals and analysis of international defense policies. However, the magazine prints more articles on politics and the effects of technology than it does on bombs. The *Bulletin* is *not* a technical physics journal." Readers are "educated, interested in foreign policy, moderate-to-left politically; high income levels; employed in government, academe or research facilities; about 50% are scientists." Sample copy $2.50.
Photo Needs: Uses about 7-10 photos/issue; "few if any" supplied by freelance photographers. "Our publication is so specialized that we usually must get photos from the insiders in government agencies." Needs photos of "people using alternative technologies in Third World countries, defense workers, or protesters of weapons or environmental policies." Future needs include shots of "Eastern Europe (unusual scenes of people), Soviet Union, Japan, Middle East—for special reports on the regions."
Making Contact & Terms: Provide resume, business card, brochure, flyer or tearsheets to be kept on file for possible future assignments. "Don't send a manuscript or photos without a preliminary query." SASE. Reports in 2-4 weeks. Photographers are paid by the job; amount of payment is negotiable. Pays on publication. Credit line given. Buys one-time rights. Previously published work OK "on occasion."
Tips: "Make sure you examine several issues of any magazine you consider soliciting. This will save you time and money. Editors weary of reviewing photos and art from contributors with no knowledge of the publication. You'll make a better impression if you know what the magazine's about."

THE CALIFORNIA STATE EMPLOYEE, 1108 O St., Sacramento CA 95814. (916)444-8134. Administrator Government Relations and Public Affairs: Nanette Kelley. Publication of the California State Employees Association, Local 1000 of the Service Employees International Union, AFL-CIO. Bimonthly tabloid. Circ. 128,000. Emphasizes "labor union news." Readers are California State civil service and State University employees. Sample copy free for SASE and 54¢ postage.
Photo Needs: Uses about 15 photos/issue, 1 supplied by freelance photographer. Needs "strictly 'concept' photos to accompany staff-written articles on labor issues—salaries, negotiations, women's issues, health and safety, stress, etc."
Making Contact & Terms: Send 8x10 glossy or matte prints by mail for consideration. Provide resume, business card, brochure, flyer or tearsheets to be kept on file for possible future assignments. SASE. Reports in 3 weeks. Pays $25-40/b&w inside photo. Pays on acceptance. Buys first North American serial rights. Simultaneous submissions and previously published work OK.

CATHOLIC FORESTER, 425 W. Shuman Blvd., Naperville IL 60566. (312)983-4920. Editor: Barbara Cunningham. Publication of the Catholic Order of Foresters. Bimonthly. Circ. 155,000. Publication is "Catholic-religious in tone, but not necessarily held to religious subjects." Readers are mostly middle-class people, all Catholic. Sample copy available for SASE and 56¢ postage.
Photo Needs: "We would be interested in any unusual, dynamic shots, not particularly scenic, but animal, wildlife, children or child, unusual occupation, etc., and of course, religious (Catholic). Model release and captions preferred. Picture stories especially welcome."
Making Contact & Terms: Send color prints, 4x5 or 8x10 transparencies by mail for consideration; submit portfolio for review. Reports in 1 month or ASAP. Pay is negotiable. Pays on acceptance. Credit line given. Simultaneous and previously published submissions OK.

CEA ADVISOR, Connecticut Education Association, 21 Oak St., Hartford CT 06106. (203)525-5641. Managing Editor: Michael Lydick. Monthly tabloid. Circ. 30,000. Emphasizes education. Readers are public school teachers. Sample copy free for 75¢ postage.
Photo Needs: Uses about 20 photos/issue; 1 or 2 supplied by freelance photographers. Needs "classroom scenes, students, school buildings." Model release and captions preferred.
Making Contact & Terms: Send b&w contact sheet by mail for consideration. Provide resume, business card, brochure, flyer or tearsheets to be kept on file for possible future assignments. Does not return unsolicited material. Reports in 1 month. Pays $50/b&w cover photo; $25/b&w inside photo. Pays on publication. Credit line given. Buys all rights. Simultaneous submissions and previously published work OK.

CHESS LIFE, 186 Route 9W, New Windsor NY 12550. (914)562-8350. Editor-in-Chief: Larry Parr. Publication of the U.S. Chess Federation. Monthly. Circ. 55,000. *Chess Life* covers news of all major national and international tournaments; historical articles, personality profiles, columns of instruction,

fiction, humor . . . for the devoted fan of chess. Sample copy and photo guidelines free with SASE.
Photo Needs: Uses about 10 photos/issue; 7-8 supplied by freelance photographers. Needs "news photos from events around the country; shots for personality profiles." Special needs include "Chess Review" section. Model release and captions preferred.
Making Contact & Terms: Query with samples. Provide business card and tearsheets to be kept on file for possible future assignments. SASE. Reports in "2-4 weeks, depending on when the deadline crunch occurs." Pays $50-100/b&w or color cover photo; $10-25/b&w inside photo. Pays on publication. Credit line given. Buys one-time rights; "we occasionally purchase all rights for stock mug shots." Simultaneous submissions and previously published work OK.
Tips: Using "more color, and more illustrative photography. The photographer's name and date should appear on the back of all photos. 35mm color transparencies are preferred for cover shots."

CHILDHOOD EDUCATION, Suite 200, 11141 Georgia Ave., Wheaton MD 20902. (301)942-2443. Editor: Lucy Prete Martin. Publication for the Association for Childhood Education International. Bimonthly. Emphasizes the education of children from infancy through early adolescence. Readers include teachers, administrators, day care workers, parents, psychologists, student teachers, etc. Circ. 10,000. Sample copy free with 7x10 SASE and $1 postage; photo guidelines free with SASE.
Photo Needs: Uses 8-10 photos/issue; 2-3 supplied by freelance photographers. Subject matter includes children from 0-14 years in groups or alone, in or out of the classroom, at play, in study groups; boys and girls of all races, and in all cities and countries. Reviews photos with or without accompanying ms. Special needs include photos of minority children; photos of children from different ethnic groups together in one shot; boys and girls together. Model release required.
Making Contact & Terms: Send unsolicited photos by mail for consideration. Uses 8x10 glossy b&w prints. SASE. Reports in 1-4 months. Pay individually negotiated. Pays on publication. Credit line given. Buys one-time rights. No simultaneous submissions or previously published work.
Tips: "Send pictures of unposed children, please."

CHINA PAINTER, 2641 NW 10, Oklahoma City OK 73107. (405)943-3841. Editor: Pauline Salyer. Publication of The World Organization of China Painters. Bimonthly. Emphasizes those interested in hand painted porcelain china. Circ. 8,500.
Photo Needs: Needs designs of anything that can be painted on china—flowers, animals, birds, landscapes, fruit, etc.
Making Contact & Terms: Send no larger than 8½x11 b&w/color prints by mail for consideration. Does not return unsolicited material. Reports in one month. Credit line given.

THE CHOSEN PEOPLE, Box 2000, Orangeburg NY 10962. (914)359-8535. Editor: Jonathan Singer. Publication of the American Board of Missions to the Jews. Monthly. Emphasizes Jewish subjects, Israel. Readers are Christians interested in Israel and the Jewish people. Circ. 85,000. Sample copy free with SASE.
Photo Needs: Uses about 3-4 photos/issue; 3 supplied by freelance photographers. Needs "scenics of Israel, preferably b&w; photos of Jewish customs and traditions." Model release preferred.
Making Contact & Terms: Query with samples or with list of stock photo subjects; send 8½x10 glossy b&w photos by mail for consideration; provide resume, business card, brochure, flyer or tearsheets to be kept on file for possible future assignments. SASE. Reports in 3 weeks. Pays $160/b&w cover photo and $75/b&w inside photo. Pays on acceptance. Credit line given. Buys one-time rights. Simultaneous submissions OK.

CHURCH & STATE, 8120 Fenton St., Silver Spring MD 20910. (301)589-3707. Managing Editor: Joseph L. Conn. Publication of the Americans United for Separation of Church and State. Monthly, except August. Circ. 52,000. Emphasizes "religious liberty, church and state separation." Readers are "interfaith, nondenominational." Sample copy free with SASE.
Photo Needs: Uses about 8-10 photos/issue; 1 supplied by freelance photographers. Needs photos covering "churches and church-related events."
Making Contact & Terms: Query with resume of credits or list of stock photo subjects. Reports in 1 month. Pays $75-150/b&w cover photo; pay negotiable for inside photo; up to $150. Pays on acceptance. Credit line given. Buys one-time rights. Simultaneous submissions and previously published work OK.

CINCINNATI BAR ASSOCIATION REPORT, Suite 400, 26 E. 6th St., Cincinnati OH 45202. (513)381-8213. Director of Public Relations: Nancy L. Valyo. Publication of the Cincinnati Bar Association. Monthly journal. Circ. 3,500. Emphasizes the legal profession. Readers are "attorneys—members of the local bar association." Sample copy free for SASE and 22¢ postage.
Photo Needs: Uses about 5 photos/issue. Needs people and how-to photos. Model release and captions required. Payment varies.

Making Contact & Terms: Provide resume, business card, brochure, flyer or tearsheets to be kept on file for possible future assignments. Pays on publication. Credit line given. Buys all rights.

CIVIL ENGINEERING—ASCE, 345 East 47th St., New York NY 10017-2398. (212)705-7507. Editor: Virginia Fairweather. Publication of the American Society of Civil Engineers. Monthly magazine. *Civil Engineering—ASCE* deals with "design and construction engineering; all topics related to civil engineering." Readers are "practicing engineers, academics, government engineers, consulting engineers." Circ. 95,000.
Photo Needs: Uses 30 photos/issue; a maximum of 2 supplied by freelance photographers. Needs photos of "construction in progress, buildings, bridges, roads, environmental-related, rehabilitation of public works." Special needs include "occasional concept cover or major inside art." Only reviews photos if accompanied by ms. Written release and captions required.
Making Contact & Terms: Arrange a personal interview to show portfolio. Pay varies. Payment is made on publication. Buys one-time rights or all rights, "depending on the negotiation and deal concluded."
Tips: "Consider major construction projects in your area; contact the magazine and query about interest; contact the owners, builders or designers of the project."

CLEARWATERS, New York Water Pollution Control Assoc. Inc., Suite 122, 90 Presidential Plaza, Syracuse NY 13202. (315)422-7811. Editor: Judi Doherty. Quarterly magazine. Circ. 3,500. Publication of the New York Water Pollution Control Association, Inc. "*Clearwaters* deals with design, legislative and operational aspects of water pollution control." Buys 12 photos/year. Pays $12 minimum/hour, or on a per-photo basis. Credit line given. Pays on acceptance. Buys all rights, but may reassign to photographer after publication. Arrange personal interview to show portfolio or query with samples. SASE. Simultaneous submissions OK. Reports in 1 month. Free sample copy and photo guidelines.
Subject Needs: Photo essay/photo feature (on most aspects of water pollution control); and nature ("any good water shots). We particularly want shots from New York state, and are looking for a familiarity with the water pollution control industry." Model release preferred; captions required.
B&W: Uses 8x10 glossy prints. Pays $10 minimum/photo.
Cover: Uses b&w prints. Vertical format preferred. Pays $50 minimum/photo.

COACHING REVIEW, 333 River Rd., Ottawa, Ontario, Canada K1L 8H9. (613)741-0036. Editor: Steve Newman. Publication of the Coaching Association of Canada. Bimonthly. Circ. 12,000. Emphasizes "coaching of all sports." Readers are "60% men, 40% women. Most are actively engaged in the coaching of athletes."
Photo Needs: Uses about 35-50 photos/issue; 20% supplied by freelance photographers. Needs photos of "coaches in action, working with athletes. Prefer well-known coaches; photo profiles on different coaches." Model release and captions preferred.
Making Contact & Terms: Query with samples. Send 2¼x2¼ transparencies, b&w or color contact sheets by mail for consideration. SASE. Reports in 2 weeks. Pays $25-150 per job. Negotiates rights purchased. Simultaneous submissions OK.

COMMUNICATION WORLD, Suite 940, 870 Market St., San Francisco CA 94102. (415)433-3400. Editor: Cliff McGoon. Photo Editor: Gloria Gordon. Publication for the International Association of Business Communicators. Monthly. Emphasizes public relations, international and external communication. Readers include public relations professionals, editors, writers, communication consultants for businesses—small and large corporations, and nonprofit organizations. Circ. 15,000.
Photo Needs: Uses 6-10 photos/issue; 50% supplied by freelance photographers. Needs editorial "illustration" shots of corporate interest, i.e., annual reports, company publications' interest. Special needs include portfolio section featuring excellence in photography, 4-color and b&w—3 pp, center section. "We look for innovative and creative handling of often boring subjects." Model release preferred; captions required.
Making Contact & Terms: Arrange a personal interview to show portfolio; query with samples; send 5x7 b&w/color glossy prints, 35mm, 2¼x2¼, 4x5 or 8x10 transparencies by mail for consideration; submit portfolio; provide resume, business card, brochure, flyer or tearsheets to be kept on file for possible future assignments. SASE. Reports in 1 month. Pays by the job. Pays on publication. Credit line given. Buys one-time rights. Simultaneous submissions and previously published work OK.

***COMPUTER MAGAZINE**, 10662 Los Vaqueros Circle, Los Alamitos CA 90720. (714)821-8380. Editor: Richard Landry. Association publication of IEEE Computer Society. Monthly magazine. Emphasizes computer industry and research. Readers are electrical engineers, technical managers, computer designers, value-added resellers and system integrators. Circ. 90,000.
Photo Needs: Uses 1 cover photo/issue; all supplied by freelance photographers. Needs high-technol-

ogy-oriented images. "We are always looking to establish contacts with photographers who are willing to keep us abreast of their latest projects so that we can call on them if a need develops."

Making Contact & Terms: Query with samples, query with list of stock photo subjects. Send 8x10½ color prints, 35mm transparencies by mail for consideration. SASE. Reports in 1-4 weeks. Pays $300/color cover photo. Pays on publication. Credit line given. Buys one-time rights. Previously published work OK "depends on where published."

Tips: Prefers chips, boards, waters in futuristic settings.

CURRENTS, Voice of the National Organization for River Sports, 314 N. 20th St., Colorado Springs CO 80904. (303)473-2466. Editor: Eric Leaper. Bimonthly magazine. Circ. 10,000. Membership publication of National Organization for River Sports, for canoeists, kayakers and rafters. Emphasizes river conservation and river access, also techniques of river running. Provide tearsheets or photocopies of work to be kept on file for possible future assignments.

Subject Needs: Photo essay/photo feature (on rivers of interest to river runners). Need features on rivers that are in the news because of public works projects, use regulations, Wild and Scenic consideration or access prohibitions. Sport newsphotos of canoeing, kayaking, rafting and other forms of river and flatwater paddling, especially photos of national canoe and kayak races; nature/river subjects, conservation-oriented; travel (river runs of interest to a nationwide membership). Wants on a regular basis close-up action shots of river running and shots of dams in progress, signs prohibiting access. Especially needs for next year shots of rivers that are threatened by dams showing specific stretch to be flooded and dam-builders at work. No "panoramas of river runners taken from up on the bank or the edge of a highway. We must be able to see their faces, front-on shots. We always need photos of the twenty (most) popular whitewater river runs around the U.S." Buys 10 photos/issue. Captions required.

Specs: Uses 5x7 and 8x10 glossy b&w prints. Occasional color prints. Query before submitting color transparencies.

Accompanying Mss: Photos purchased with or without accompanying ms. "We are looking for articles on rivers that are in the news regionally and nationally—for example, rivers endangered by damming; rivers whose access is limited by government decree; rivers being considered for Wild and Scenic status; rivers hosting canoe, kayak or raft races; rivers offering a setting for unusual expeditions and runs; and rivers having an interest beyond the mere fact that they can be paddled. Also articles interviewing experts in the field about river techniques, equipment, and history." Pays $25 minimum. Free writer's and photographer's guidelines with SASE.

Payment & Terms: Pays $15-35/b&w print or color prints or transparencies; $35-100 for text/photo package. Credit line given. Pays on acceptance. Buys one-time rights. Simultaneous submissions and previously published work OK if labeled clearly as such.

Making Contact: Send material or photocopies of work by mail for consideration. "We need to know of photographers in various parts of the country." SASE. Reports "up to" 3 months. Sample copy 75¢; free photo guidelines with SASE.

Tips: "We look for three key elements: (1)*Faces* of the subjects are visible; (2)*Flesh* is visible; (3)*Lighting* is dramatic; catching reflections off the water nicely. Send a few river-related photos, especially 8x10 b&w glossies. We'll reply as to their usefulness to us. *Look* at the publication first! Send *action* photos. Send copies we can keep on file, instead of originals. Read a copy of our publication or carefully study this listing. We're not interested in motorboats, steam boats, etc. Canoe and kayaking only."

DEFENDERS, 1244 19th St. NW, Washington DC 20036. (202)659-9510. Editor: James G. Deane. Membership publication of Defenders of Wildlife. Bimonthly. Circ. 70,000. Emphasizes wildlife and wildlife habitat. Sample copy and photo guidelines free with SASE.

Photo Needs: Uses 35 or more photos/issue; "almost all" from freelance photographers. Caption information required.

Making Contact & Terms: Query with list of stock photo subjects. SASE. Reports ASAP. Pays $40/b&w photo; $60-350/color photo. Pays on publication. Credit line given. Buys one-time rights.

Tips: "*Defenders* focuses heavily on endangered species and destruction of their habitats, wildlife refuges and wildlife management issues, primarily North American, but also some foreign. Images must be sharp. Cover images usually must be vertical, able to take the logo up top, and be arresting and *simple*. Think twice before submitting anything but low speed (preferably Kodachrome) transparencies."

THE DEKALB LITERARY ARTS JOURNAL, 555 N. Indian Creek Dr., Clarkston GA 30021. Editor-in-Chief: Frances Ellis. Quarterly. Circ. 1,000. Publication of Dekalb Community College. Emphasizes literature for students and writers. Sample copy $4.

Photo Needs: Uses about 8-10 photos/issue; all supplied by freelance photographers. Needs "anything of quality." Photos purchased with or without accompanying ms.

Making Contact & Terms: Submit portfolio for review or send by mail for consideration b&w prints or b&w contact sheet. SASE. Reports in 6 months. Pays in contributors copies. Pays on publication. Credit line given. Buys one-time rights. Simultaneous submissions OK.

DENTAL HYGIENE, Suite 3400, 444 N. Michigan, Chicago IL 60611. (312)440-8900. Editor: Judith E. Legg. Art Director: Mary Kushmir. Publication of the American Dental Hygienists' Association. Monthly. Emphasizes dental hygiene and the special concerns of the dental hygienist. Circ. 35,000.
Photo Needs: Uses photos for cover only. Needs photos of dental office; classroom setting; young, attractive, mostly female models. Model release required.
Making Contact & Terms: Arrange a personal interview to show portfolio; query with samples; provide resume, business card, brochure, flyer or tearsheets to be kept on file for possible future assignments. Reports in 1 week. Pays $350/color cover photo. Pays on publication. Credit line given. Buys one-time rights. Simultaneous submissions and previously published work OK.
Tips: "Photos depicting positive image for young working women—particularly the dental hygienist. Good portraits."

DEPAUW ALUMNUS, Charter House, DePauw University, Greencastle IN 46135. (317)658-4626, ext. 241. Editor: Greg Rice. Quarterly magazine. Circ. 28,500. Alumni magazine emphasizing alumni-related events and personalities, interest in university, its programs, future and past.
Subject Needs: Uses celebrity/personality, photo essay/photo feature, head shot, spot news, *all relating to alumni or campus events*. Captions and model release preferred.
Specs: Uses glossy b&w contact sheets and negatives. Cover color slides and negatives; color transparencies, vertical or horizontal wraparound format.
Accompanying Mss: Photos purchased with or without accompanying ms. Seeks alumni related features—but not on speculation. Query first.
Payment & Terms: Pay negotiated. Credit line sometimes given. Pays on publication. Buys one-time rights. Simultaneous submissions and/or previously published work OK.
Making Contact: First contact with resume of credits and basic information only. Works with photographers on assignment basis only. Advise of availability for assignments. Reports in 2 weeks. Free sample copy.
Tips: "Like to see how they handle people (personality) photos. We use these with feature stories on our interesting alumni, but often we can't get the photos ourselves so we assign them to freelancer in vicinity."

DIABETES FORECAST, American Diabetes Association, 1660 Duke St., Alexandria VA 22314. (800)232-3472. Managing Editor: Peter Banks. Publication of American Diabetes Association. Bimonthly. Circ. 170,000. Emphasizes "diabetes—includes food, fitness, profiles, medical pieces." Readers are "diabetics, men-women, aged 20-80. Also has sections for children." Sample copy $3.
Photo Needs: Uses about 3-10 photos/issue; most supplied by freelance photographers. Needs "color slides or b&w glossies, anything diabetes-related. Model release and captions required."
Making Contact & Terms: Arrange a personal interview to show portfolio; query with resume of credits or list of stock photo subjects. Provide resume, business card, brochure, flyer or tearsheets to be kept on file for possible future assignments. Reports in 1 month. Payment varies. Pays on publication. Credit line given. Prefers to buy all rights "but will negotiate."
Tips: "Call first and speak to art director."

***DISCIPLESHIP JOURNAL**, Box 6000, Colorado Springs CO 80934. (303)558-1212, ext. 298. Editor: Susan Maycinik. Art Director: Naomi Ann Trujillo. Publication of The Navigators/Navpress. Bimonthly magazine. Emphasizes Christian living and discipleship. Readers are 25-34 years old; almost 50/50 male-female Christian audience. Circ. 90,000. Sample copy $2.95.
Subject Needs: Uses 2-3 photos/issue; 1 currently supplied by freelance photographer, but would "like to use more freelancers." Needs depend on articles and subject matter. Photos will be used editorially so should be highly conceptual.
Making Contact & Terms: Provide resume, business card, brochure, flyer or tearsheets to be kept on file for possible future assignments. SASE. Reports back if interested. Pay depends on location in magazine and size. Pays on publication. Credit lines given. Buys one-time rights.

THE DOLPHIN LOG, 8440 Santa Monica Blvd., Los Angeles CA 90069. (213)656-4422. Editor: Pamela Stacey. Publication of The Cousteau Society, Inc., a nonprofit organization. Quarterly magazine. Emphasizes "ocean and water-related subject matter for children ages 7 to 15." Circ. 60,000. Sample copy $2. Photo guidelines free with SASE.
Photo Needs: Uses about 22 photos/issue; 8 supplied by freelance photographers. Needs "selections of images of individual creatures or subjects, such as architects and builders of the sea, how sea animals eat, the smallest and largest things in the sea, the different forms of tails in sea animals, children of the sea, resemblances of sea creatures to other things, different vessels of the sea. Also excellent potential cover shots or images which elicit curiosity, humor or interest." Please request photographer's guidelines. Model release required; captions preferred.

Making Contact & Terms: Query with samples, list of stock photos or send duplicate 35mm transparencies or b&w contact sheets by mail for consideration. Send duplicates only. SASE. Reports in 1 month. Pays $100/color cover photo; $25/inside b&w photo, $50/color full or half page photo, $25/color or less than half page photo. Pays on publication. Credit line given. Buys one-time rights and worldwide translation rights. Simultaneous and previously published submissions OK.

Tips: Prefers to see "rich color, sharp focus and interesting action of water-related subjects" in samples. "Assignments are rarely, if ever, made. Stock photos purchased only when an author's sources are insufficient or we have need for a shot which cannot be pulled from our resource files. These are most often hard-to-find creatures of the sea."

DUCKS UNLIMITED, 1 Waterfowl Way at Gilmer Road, Long Grove IL 60647. (312)438-4300. Senior Editor: Niki Barrie. Publication of Ducks Unlimited, Inc. Bimonthly magazine. Emphasizes waterfowl, waterfowl hunting and conservation for "highly affluent, well-educated professionals and executives, primarily under 55 with genuine interest in outdoor activity. Median age: 39; median income: $45,350." Circ. 660,000. Sample copy $1.50. Photo guidelines free with SASE.

Photo Needs: Uses up to 28 photos/issue donated by freelance photographers. Needs waterfowl and hunting photos. Captions preferred.

Making Contact & Terms: Send photos by mail for consideration with the understanding that the magazine does not pay for the use of freelance material. "We prefer transparencies but will accept any format." SASE. Reports in 3 weeks. Credit line given. Requires one-time rights. Simultaneous and previously published submissions OK.

EL PASO MAGAZINE, 10 Civic Center Plaza, El Paso TX 79901. (915)544-7880. Editor: Russell S. Autry. Publication of the Chamber of Commerce. Monthly. "City magazine." Circ. 5,000. Readers are "owners and/or managers of El Paso businesses." Sample copy free with SASE.

Photo Needs: Uses about 10 photos/issue; all supplied by freelance photographers. Needs "photos of El Paso people and scenes." Model release and captions required.

Making Contact & Terms: Arrange a personal interview to show portfolio. Does not return unsolicited material. Reports in 6 weeks. Pays $300/color cover; $10/b&w inside photo, $50/color inside photo. Pays on publication. Credit line given. Buys first North American serial rights. Simultaneous submissions OK.

Tips: "We are actively seeking freelance photographers. Call editor for appointment."

THE ENSIGN, Box 31664, Raleigh NC 27622. (919)821-0892. Editor: Carol Romano. Publication of the United State Power Squadrons. Published monthly. Circ. approx. 50,000. "We serve USPS, an organization of 50,000 male and female boat operators nationwide whose primary interests lie in boating and boating education. All articles in our publication relate to boating." Sample copy for 8x12 SAE and 85¢ postage.

Photo Needs: Uses 40 photos/issue; "none at this time" supplied by freelance photographers. "We look for action boating shot, power and sail boating photos. Most inside photos tend to be b&w's relating to cruises in different areas of the world or shipboard activities; cover shots are color and often more scenic." Special needs include "shots stressing power boating activities." Model release required; captions preferred.

Making Contact & Terms: Send 5x7 or 8x10 b&w glossies or 35mm or 2¼x2¼ color photos by mail for consideration. SASE. Reports in 2 weeks. Pays in copies and certificate of recognition from organization. Acquires one-time rights.

FACETS, 535 N. Dearborn, Chicago IL 60614. (312)645-4470. Editor: Kathleen T. Jordan. Publication of the AMA Auxiliary. Publishes magazine 6 times/year. Emphasizes health/health care. Readers are physicians' spouses. Circ. 80,000. Free sample copy with SASE. Photo guidelines free with SASE.

Photo Needs: Uses about 5-10 photos/issue; 5-10 supplied by freelance photographers. Needs photos of community health projects—health fairs, screenings, etc. "Assigns jobs in areas of country as needed." Model release required.

Making Contact & Terms: Query with samples; provide resume, business card, brochure, flyer or tearsheets to be kept on file for possible future assignments. SASE. Reports in 8 weeks. Pays $300-500 plus expenses/job. Pays on acceptance. Credit line given. Buys first North American serial rights.

Tips: "Color photos to indicate quality or variety of work; particularly interested in treatment of people."

***FELLOWSHIP**, Box 271, Nyack NY 10960. (914)358-4601. Editor: Virginia Baron. Photo Editor: Jody Richards. Association publication of the Fellowship of Reconciliation. Bimonthly magazine, 32 page black & white. Emphasizes peace-making/social justice/non-violent social change. Readers are religious peace fellowships—inter-faith pacifists. Circ. 8,500. Sample copy free with SASE on request.

Photo Needs: Uses 8-10 photos/issue; 90% supplied by freelance photographers. Needs monument photos/civil disobedience shots—demonstrations—middle east; South Africa; prisons; anti-nuclear; children; farm crisis; USSR. Captions required.

Making Contact & Terms: Provide resume, business card, brochure, flyer or tearsheets to be kept on file for possible future assignments. "Call on specs." SASE. Reports in 3 weeks. Pays $25/b&w cover photo; $13.50/b&w inside photo. Pays on publication. Credit line given. Buys one-time rights. Simultaneous submissions and previously published work OK.

Tips: "You must want to make a contribution to peace-movements. Money is simply token; (our authors contribute without tokens)."

***FINANCIAL PLANNING**, Suite 800, Two Concourse Pkwy., Atlanta GA 30328. (404)395-1605. Editor: Robert N. Veres. Photo Editor: Cary L. Purvis. Association of the I.A.F.P. Monthly magazine. Emphasizes financial-services industry. Readers are financial planners, bankers, stockbrokers, insurance agents. Circ. 30,000. Sample copy free with SASE.

Photo Needs: Uses 50-80 photos/issue; 30-50 supplied by freelance photographers. Needs executive/corporate shots, environmental, and set-ups. Model release required; captions preferred.

Making Contact & Terms: Query with samples, submit portfolio for review. Send 35mm or 2¼x2¼ transparencies by mail for consideration. SASE. Reports in 2 weeks. Pays $500/b&w cover photo; $700/color cover photo; $300/job. Pays on acceptance. Credit line given. Buys first North American serial rights plus reprint rights. Simultaneous submissions OK, previously published work OK "must advise when and where previously published."

Tips: Prefers to see composition and clarity.

FLORIDA WILDLIFE, 620 S. Meridian St., Tallahassee FL 32301. (904)488-5563. Editor: John M. Waters Jr. Publication of the Florida Game & Fresh Water Fish Commission. Bimonthly magazine. Emphasizes wildlife, hunting, fishing, conservation. Readers are wildlife lovers, hunters, and fishermen. Circ. 29,000. Sample copy $1.25. Photo guidelines free with SASE.

Photo Needs: Uses about 20-40 photos/issue; 75% supplied by freelance photographers. Needs 35mm color transparencies and b&w glossies of southern fishing and hunting, all wildlife (flora and fauna) of southeastern U.S.A.; how-to; covers and inside illustration. Do not feature products in photographs, where they can be subdued. No alcohol or tobacco. Special needs include hunting and fishing activities in southern scenes; showing ethical and enjoyable use of outdoor resources. Model release required.

Making Contact & Terms: Query with samples, or send "mostly 35mm transparencies, but we use some b&w enlarged prints" by mail for consideration. "Do not send negatives." SASE. Reports in 1 month or longer. Pays $50/back color cover; $100/front color cover; $15-45/b&w or color inside photo. Pays on publication. Credit line given. Buys one-time rights; "other rights are sometimes negotiated." Simultaneous submissions OK "but we prefer originals over duplicates." Previously published work OK but must be mentioned when submitted.

Tips: "Use flat slide mounting pages or individual sleeves. Show us your best."

FLYFISHER, 1387 Cambridge Dr., Idaho Falls ID 83401. (208)523-7300. Editor: Dennis G. Bitton. Quarterly magazine. Circ. 10,000. Emphasizes fly fishing for members of the Federation of Fly Fishers. Uses 100 photos/year, most bought with ms. Pays $50-200 for text/photo package, or on a per-photo basis. Credit line given. Pays on publication. Buys first North American serial rights. Query with resume of credits or samples. "Send us 20-40 slides on spec with due date for returning." SASE. Reports in 1 month. Sample copy $3, available from Federation of Fly Fishers, Box 1088, West Yellowstone MT 59758. Photo guidelines free with SASE.

Subject Needs: How-to (on tying flies, fishing techniques, etc.); photo essay/photo feature; and scenic. No photos of angling unrelated to fly fishing. Captions required.

B&W: Uses 8x10 glossy prints. Pays $15-50/photo.

Color: Uses 35mm, 2¼x2¼ or 4x5 transparencies. Pays $25-100.

Cover: Uses 35mm, 2¼x2¼ or 4x5 color transparencies. Needs scenics. Vertical or square formats required. Pays $100-150.

Accompanying Mss: "Any mss related to fly fishing, its lore and history, fishing techniques, conservation, personalities, fly tying, equipment, etc." Writer's guidelines free with SASE.

***FOOD TECHNOLOGY**, 221 N. LaSalle St., Chicago IL 60601. (312)782-8424. Photo Editor: Curt Mattson. Association publication of the Institute of Food Technologists. Monthly magazine. Emphasizes food science and technology. Readers are food industry professionals, research and development, academic, regulatory. Circ. 22,000. Sample copy free with SASE.

Photo Needs: Uses 6-12 photos/issue; "presently, very few" supplied by freelance photographers. Needs industrial and laboratory shots of food product research, development, production, and packaging. Special needs include supercritical processing, cryogenic processing, irradiation, microwave proc-

essing, quality control instruments, preservatives, genetic engineering, fermentation, enzymes, sensory evaluation, aseptic processing and packaging. Model release and captions preferred.

Making Contact & Terms: Send unsolicited photos by mail for consideration. Send 35mm and 2¹/₄x2¹/₄ transparencies by mail for consideration. SASE. Reports in 1 month. Pays $250/color photo. Pays on publication. Credit line given. Buys one-time rights. Previously published work OK.

Tips: Prefers to see food-styling, high-tech food processing.

FOREIGN SERVICE JOURNAL, 2101 E. St. NW, Washington DC 20037. (202)338-4045. Editor: Stephen R. Dujack. Publication of the American Foreign Service Association. Monthly magazine except August. Emphasizes foreign service issues. Readers are US diplomats. Circ. 10,000. Sample copy $2.

Photo Needs: Uses 7 photos/issue; 0-1 supplied by freelance photographers. Needs news items, political pictures. Model release and captions preferred.

Making Contact & Terms: Provide resume, business card, brochure, flyer or tearsheets to be kept on file for possible future assignments. Does not return unsolicited material. Pays by the job. Pays on publication. Credit line usually given. Buys one-time rights.

FORT WORTH MAGAZINE, 700 Throckmorton St., Fort Worth TX 76102-5073. (817)336-2491. Art Director: Susan Abbenante. Publication of the Chamber of Commerce of Fort Worth. Monthly. Circ. 10,000. Emphasizes community events and people. Readers are chamber members and the community at large. Sample copy $1.58 and 75¢ postage.

Photo Needs: Uses 25 photos/issue; all supplied by freelance photographers. Uses photos "to accompany articles upon specification." Special needs include "up-to-date skyline, aerial and quality-of-life shots." Model release and captions required.

Making Contact & Terms: Provide resume, business card, brochure, flyer or tearsheets to be kept on file for possible future assignments. Does not return unsolicited material. Pays $75/color cover photo; $15/b&w inside photo. Pays on acceptance. Credit line given. Rights purchased are negotiated at time of purchase.

***FOUNDATION NEWS**, 1828 L St. NW, Washington DC 20036. (202)466-6512. Editor: Mr. Arlie Schardt. Association publication of the Council on Foundations (loosely affiliated; not house organ). Bimonthly magazine. Emphasizes grantmaking, grantseeking, nonprofit sector, philanthropy. Readers are philanthropists and nonprofit organizations (of many different interests). Circ. 16,000. Sample copy $5.

Photo Needs: Uses about 25 photos/issue. Needs photos of all subjects.

Making Contact & Terms: Query with resume of credits; provide resume, business card, brochure, flyer or tearsheets to be kept on file for possible future assignments. SASE. Report time varies. Pays on acceptance. Credit line given. Rights purchased varies. Simultaneous submissions and previously published work OK.

4-H LEADER—THE NATIONAL MAGAZINE FOR 4-H, 7100 Connecticut Ave., Chevy Chase MD 20815. Editor: Suzanne Carney Harting. Monthly magazine. Circ. 70,000. For "volunteers of all ages who lead 4H clubs." Emphasizes practical help for the leader and personal development for leader and for club members. Photos "must be genuinely candid, of excellent technical quality and preferably shot 'available light' or in that style; must show young people or adults and young people having fun learning something. How-to photos or drawings must supplement instructional texts. Photos do not necessarily have to include people." Buys 10-12/year. Buys first serial rights or one-time rights. Submit photos by mail for consideration. Works with freelance photographers on assignment only basis. Provide resume, samples, and tearsheets to be kept on file for possible future assignments. Credit line given for cover; not usually for inside magazine. Pays on acceptance. Reports in 1 month. SASE. Free sample copy and editorial guidelines.

Subject Needs: Kids working with animals; nature; human interest; kids and adults working together; still life; special effects/experimental; kids enjoying leisure living activities; teens involved together in appropriate activities.

B&W: Send 5x7 or 8x10 glossy prints or contact sheet. Captions required. Pays $25-100.

Cover: 2¹/₄x2¹/₄ color transparencies. Covers are done on assignment; query first. Captions required. Pays $100-250.

Tips: "Photos are usually purchased with accompanying ms, with no additional payment."

FUSION MAGAZINE, Box 17149, Washington DC 20041-0149. (703)689-2490. Art Director: Alan Yue. Photo Editor: Carlos DeHoyos. Published 6 times/year. Circ. 75,000. Publication of Fusion Energy Foundation. Emphasizes fusion, fission, high technology, aerospace, biophysics, SDI and frontiers of science for lay/technical readers. Sample copy $3.

Photo Needs: Uses about 50 photos/issue; 2-3 supplied by freelance photographers. Needs same categories as listed above. Model release required.

Making Contact & Terms: Query with resume of credits or samples (*not* originals). Reports in 1 month. Provide samples or tearsheets to be kept on file for possible future assignments. Pays $10-100/b&w photo; $100-400/color phots (cover only). Pays on publication. Credit line given. Buys one-time rights and all rights. Simultaneous submissions and previously published work OK.

Tips: Looks for photos that express the magazine's protechnology outlook, "portraits" of scientists, photos of technology abroad. "Query first!"

FUTURE MAGAZINE, Box 7, Tulsa OK 74121-0007. (918)584-2481. Editor: Terry Misfeldt. Photo Editor: Dave Nershi. Publication of the Jaycees. Bimonthly magazine. Emphasizes volunteerism. Readers are men and women 18 to 36. Circ. 270,000. Sample copy $2.

Photo Needs: Uses 6-10 photos/issue; 1 supplied by freelance photographers. Needs of photos varies, primarily people, also meetings. Model release required; captions preferred.

Making Contact & Terms: Query with list of stock photo subjects. SASE. Reports in 3 weeks. Pay varies by assignment. Pays on acceptance. Credit line given. Buys one-time rights. Previously published work OK.

***THE FUTURIST**, 4916 St. Elma Ave., Bethesda MD 20814. (301)656-8274. Editor: Edward Cornish. Photo Editor: Cynthia Wagner. Publication of the World Future Society. Bimonthly magazine. Emphasizes the future. Readers are middle-aged, well educated, more males than females. Circ. 25,000. Sample copy for $3.50.

Subject Needs: Uses 25-50 photos/issue; few supplied by freelancers. Model release and captions preferred.

Making Contact & Terms: Query with resume of credits. SASE. Reports in 1 month. Pay varies. Pays on publication. Credit lines given. Buys one-time rights. Previously published work OK.

GOLD PROSPECTOR MAGAZINE, Box 507, Bonsall CA 92003. (619)728-6620. Editor: Steve Teter. Association publication of the Gold Prospectors Association. Bimonthly. Emphasizes prospecting, gold mines, rocks and minerals. Readers include men age 35-54, middle class, sportsmen, etc. Circ. 100,000. Sample copy $1; photo guidelines free with SASE.

Photos Needs: Uses 12-15 photos/issue; 100% supplied by freelance photographers. Needs prospecting—pictures of gold—historical mines, gold rush, etc. Reviews photos with accompanying ms only. Model release and captions required.

Making Contact & Terms: Send unsolicited photos by mail for consideration; provide resume, business card, brochure, flyer or tearsheets to be kept on file for possible future assignments. Uses any size finish b&w and color prints. SASE. Reports in 3 weeks. Pays $100/color cover, $15-25/b&w inside, $25-50/color, $100-500/text/photo package. Pays on publication. Credit line given. Buys first North American serial rights. Previously published work OK.

GOLF COURSE MANAGEMENT, 1617 St. Andrews Dr., Lawrence KS 66046. (913)841-2240. Director of Communications: Clay Loyd. Publication of the Golf Course Superintendents Association of America. Monthly. Circ. 17,500. Emphasizes "golf course maintenance/management." Readers are "golf course superintendents and managers." Sample copy and photo guidelines free with SASE.

Photo Needs: Uses about 12-18 photos/issue; 1-2 supplied by freelance photographers. Needs "scenic shots of famous golf courses, good composition, unusual holes dramatically portrayed." Model release required; captions preferred.

Making Contact & Terms: Query with samples. Provide business card, brochure, flyer or tearsheets to be kept on file for possible future assignments. SASE. Reports in 3 weeks. Pays $125-250/color cover photo. Pays on acceptance. Credit line given. Buys one-time rights.

Tips: Prefers to see "good color, unusual angles/composition for vertical format cover."

THE GREYHOUND REVIEW, Box 543, Abilene KS 67410. (913)263-4660. Contact: Gary Guccione or Tim Horan. Publication of the National Greyhound Association. Monthly. Circ. 6,000. Emphasizes greyhound racing and breeding. Readers are greyhound owners and breeders. Sample copy with SASE and $2.50 postage.

Photo Needs: Uses about 15 photos/issue; 10 supplied by freelance photographers. Needs "anything pertinent to the greyhound that would be of interest to greyhound owners." Captions required.

Making Contact & Terms: Query with samples; send b&w or color prints and contact sheets by mail for consideration; submit portfolio for review; provide resume, business card, brochure, flyer or tearsheets to be kept on file for possible future assignments. Can return unsolicited material if requested. Report within 1 month. Pays $50/b&w and $100/color cover photo; $10-50/b&w and $25-100/color inside photo. Pays on acceptance. Credit line given. Buys one-time North American rights. Simultaneous and previously published submissions OK.

Tips: "We look for human-interest or action photos involving greyhounds. No muzzles, please, unless the greyhound is actually racing. When submitting photos for our cover, make sure there's plenty of cropping space on all margins around your photo's subject; full bleeds on our cover are preferred."

***HARVARD MAGAZINE**, 7 Ware St., Cambridge MA 02138. (617)495-5746. Managing Editor: Christopher Reed. Photo Editor: Jean Martin. University publication of Harvard University. Bimonthly magazine. Emphasizes Harvard University, Radcliffe College and alumni/alumnae of those schools. Readers are alumni/and alumnae of Harvard University and Radcliffe College. Circ. 115,00 (4 times/ year), 200,000 (2 times/year.
Photo Needs: Uses 60 + photos/issue; ¹/₃-¹/₂ supplied by freelance photographers. Needs photos of the Cambridge area, university area. Captions preferred.
Making Contact & Terms: Provide resume, business card, brochure, flyer or tearsheets to be kept on file for possible future assignments. SASE. Reports in 1 month or longer. Pays $300/b&w cover photo; $300 and expenses/color photo; $50/inside b&w or color photo shot on assignment; $35/b&w or color stock photo. Pays on publication. Credit line given. Buys one-time rights. Simultaneous submissions and previously published work OK.
Tips: "We need a fairly limited range of photos, but are happy to pay for variety within that range."

HISTORIC PRESERVATION, 1785 Massachusetts Ave., NW, Washington DC 20036. (202)673-4084. Editor: Thomas J. Colin. Bimonthly magazine. Circ. 160,000. For a "diversified national readership comprised of members of the National Trust for Historic Preservation and newsstand buyers, interested in preservation of America's heritage, including historic buildings, sites and objects." No obviously posed shots or photos of architecture distorted by use of a wide-angle lens. Mainly works with top-quality freelance photographers on assignment only basis. Provide resume, brochure, flyer, samples, tearsheets or list of credits to be kept on file for possible future assignments. Buys 300 photos annually. Send sample photos for consideration or query. Credit line given. Pays on acceptance. Reports in 2-4 weeks. SASE. No previously published work. Free photo guidelines.
Subject Needs: Historical; architectural; people involved in restoration; unusual history, urban and rural features sought. Photos essays/features. No shots of buildings unless unusually interesting or aesthetic.
B&W: Send 8x10 glossy prints or contact sheets. Pays $25-100/b&w used.
Color: Send transparencies. Pays $50-200.
Cover: See requirements for color.
Tips: "It is helpful to have photographer's itinerary for travel; we need article ideas from Middle America and the West. Freelance photographs are used for their relevance to the subject matter. *HP* wants a wide range of articles dealing with American culture, from urban restoration to rural preservation. The keys are readability and relevance."

HOBIE HOTLINE, Box 1008, Oceanside CA 92054. (619)758-9100. Publisher: Bonnie Hepburn-Jonas. Publication of the World Hobie Class Association. Bimonthly. Circ. 26,000. Emphasizes "Hobie Cat and Alpha sailboard sailing in the U.S. and foreign countries." Readers are "young adults and sailing families, average age 26 to 35. Enthusiastic active group of people who love sailing." Sample magazine $1 and photo guidelines free with SASE.
Photo Needs: Uses about 30-35 photos/issue; 90% supplied by freelance photographers. Needs "action photos of Hobie Cats; action photos of Alpha sailboards; scenics that correspond to location of shoot." Special needs include "mid-America photo essays; lake sailing on a Hobie Cat; wave surfing on a Hobie Cat."
Making Contact & Terms: Send 8x10 b&w glossy prints; 35mm or 2¹/₄x2¹/₄ transparencies or b&w contact sheet by mail for consideration. Prefers Kodachrome. SASE. Reports in 1 month. Pays $200/ color cover photo; $10-60/b&w and $25-100/color inside photo; $35/b&w and $65/color page; and $150-300 for text/photo package. Pays on publication. Credit line given. Buys one-time rights. Simultaneous submissions and previously published work OK.
Tips: "We are looking for sharp, clear, exciting Hobie Cat and Alpha action shots as well as mood shots."

HOME & AWAY MAGAZINE, Box 3535, Omaha NE 68103. (402)390-1000. Editor-in-Chief: Barc Wade. Bimonthly. Circ. 1,750,000. Emphasizes travel (foreign and domestic), automotive, auto safety, consumerism from the viewpoint of auto ownership. Readers are between 45-50 years of age, above average income, broadly traveled and very interested in outdoor recreation and sports. Free sample copy with SASE.
Photo Needs: Uses 20-30 photos/issue; 75% supplied by freelance photographers/travel writers. Needs photos on travel subjects. "Not generally interested in scenics alone; want people in the photos— not posed, but active." Photos purchased with accompanying ms only; "exception usually for cover photo." Captions preferred.

Making Contact & Terms: Query with list of stock photo subjects. SASE. Reports in 2 weeks. Provide resume, brochure, flyer and tearsheets to be kept on file for possible future assignments. Pays an average of $300/color photo (cover); $50/color photo (inside); $250-600 for text/photo package. Pays on acceptance. Credit line given. Buys one-time rights. Simultaneous submissions and/or previously published work OK, as long as not in territory of magazine circulation.

HOOF BEATS, 750 Michigan Ave., Columbus OH 43215. (614)224-2291. Executive Editor: Dean Hoffman. Design/Production Manager: Jenny Gilbert. Publication of the U.S. Trotting Association. Monthly. Circ. 26,000. Emphasizes harness racing. Readers are participants in the sport of harness racing. Sample copy free.
Photo Needs: Uses about 30 photos/issue; about 20% supplied by freelance photographers. Needs "artistic or striking photos that feature harness horses for covers; other photos on specific horses and drivers by assignment only."
Making Contact & Terms: Query with samples. SASE. Reports in 3 weeks. Pays $150 + /color cover photo; freelance assignments negotiable. Pays on publication. Credit line given if requested. Buys one-time rights. Simultaneous submissions OK.
Tips: "We look for photos with unique perspective and that display unusual techniques or use of light. Be sure to shoot pictures of harness horses only, not Thoroughbred or riding horses."

IMPRINT, 555 W. 57th St., New York NY 10019. Managing Editor: B.J. Nerone. Publication of the National Student Nurses' Association. Magazine published 5 times/year. Emphasizes education, health issues and health care for undergraduate students of nursing. Circ. 33,000. Sample copy $5.
Photo Needs: Uses about 10-15 photos/issue; none currently supplied by freelance photographers. Needs photos showing health care, current issues and education. Model release and captions required.
Making Contact & Terms: Query with samples or list of stock photo subjects. SASE. Reports in 3 weeks. Pays $50/b&w inside photo; other rates negotiable. Pays on publication. Credit line given. Simultaneous and previously published submissions OK.

INTERRACIAL BOOKS FOR CHILDREN BULLETIN, 1841 Broadway, New York NY 10023. (212)757-5339. Photo Editor: Ruth Charnes. Published 8 times/year. Circ. 5,000. Publication of Council on Interracial Books for Children. Emphasizes antiracism and antisexism in children's books for librarians, teachers, writers, editors and parents.
Photo Needs: Uses 0-10 photos/issue. Needs photos of "multiracial groups of children, especially in school/library settings, nonsexist portrayals of children, multiracial children with adults, etc." Photos purchased with or without accompanying ms. Model release preferred.
Making Contact & Terms: Query with samples. SASE. Reports in 4 weeks. Provide resume, business card and tearsheets to be kept on file for possible future assignments. Pays $50/b&w cover, $25/b&w inside. Pays on publication. Credit line given. Simultaneous submissions and/or previously published work OK.

THE JOURNAL OF FRESHWATER, 2500 Shadywood Rd., Box 90, Navarre MN 55392. (612)471-7467, (612)471-8407. Editor: Linda Schroeder. Annual magazine. "*The Journal* explores the world of freshwater: how we affect it and how it affects us. *The Journal's* goal is to translate and interpret freshwater issues and their implications for the public, and to instill greater appreciation for the freshwater environment." Buys 20-30 photos/issue. Credit line given. Pays on publication (November). Buys one-time rights or all rights, but may reassign to photographer after publication. Send material by mail for consideration. SASE. Reports in 6 weeks. Sample copy $11; free photo guidelines for SASE.
Photo Needs: All subjects should be very closely water-related. Documentary, fine art, how-to, human interest, still life, nature, photo essay/photo feature, scenic, travel. "No marine or saltwater photos, special effects (must be seen as is in nature) or pollution pictures." Columns needing photos include Freshwater Folio, a section of fine art photos.
B&W: Uses 5x7 or 8x10 glossy or matte prints. Pays $50/photo.
Color: Uses 35mm, 2¼x2¼ or 4x5 transparencies. Pays $50/photo.
Cover: Uses glossy color prints or 35mm, 2¼x2¼, 4x5 or 8x10 color transparencies. Pays $100-125/photo.
Tips: "Our photography needs usually crystallize in the summer. From May to June is the time to send in speculative material."

JOURNAL OF PHYSICAL EDUCATION, RECREATION & DANCE, American Alliance for Health, Physical Education, Recreation & Dance, Reston VA 22091. (703)476-3400. Managing Editor: Frances Rowan. Monthly magazine. Emphasizes "teaching and learning in public school phsycial education, youth sports, youth fitness, dance on elementary, secondary, or college levels (not performances; classes only), recreation for youth, children, families, girls and women's athletics and physical education and

fitness." Circ. 35,000. Sample copy free with SASE. Photo guidelines free with SASE.
Photo Needs: Freelancers supply cover quotes only. Written release and captions preferred. B&w by contract.
Making Contact & Terms: Query with list of stock photo subjects. Buys 5x7 or 8x10 color prints and 35mm transparencies. Returns unsolicited photos with SASE. Reports in 2 weeks. Credit line given. Buys one-time rights. Previously published work OK.

JOURNAL OF SCHOOL HEALTH, Box 708, Kent OH 44240. (216)678-1601. Editor: R. Morgan Pigg, Jr., HSD, MPH. Photo Editor: T.M. Reed. Publication of the American School Health Association. Monthly journal except June/July. Emphasizes school health. Readers include health educators at all academic levels; school nurses, school physicians, counselors, psychologists and nutritionists. Circ. 8,000. Sample copy available.
Photo Needs: Uses cover shots; children; schools. Model release required.
Making Contact & Terms: Query with samples or send unsolicited photos by mail for consideration. Uses color prints. SASE. Reports in 2 weeks. Pays with a contributor's copy only. Credit line given. Previously published work OK.

JOURNAL OF THE SENSES, 814 Robinson Rd., Topanga CA 90290. (213)455-1000. Editor: Ed Lange. Publication of the Elysium Institute. Quarterly. Circ. 20,000. Emphasizes "human potential, body self-appreciation and self-image." Readers are students and educators. Sample copy for SAE and $1 postage. Photo guidelines for SASE.
Photo Needs: Uses about 25 photos/issue; half supplied by freelance photographers. Needs photos of "people: intimate, emotional, joyous." Model release and captions required.
Making Contact & Terms: Query with samples; send b&w contact sheets by mail for consideration. SASE. Reports in 2 weeks. Pays $30/b&w or color cover photo; $20/b&w or color inside photo. Pays on publication. Credit line given. Buys all rights. Previously published work OK.

JOURNAL OF SOIL AND WATER CONSERVATION, 7515 NE Ankeny Rd., Ankeny IA 50021. (515)289-2331. Editor: Max Schnepf. Association publication for the Soil Conservation Society of America. Bimonthly journal. Emphasizes land and water conservation. Readers include a multidisciplinary group of professionals and laymen interested in the wise use of land and water resources. Circ. 13,800. Free sample copy.
Photo Needs: Uses 25-40 photos/issue; 0-2 supplied by freelance photographers. Needs photos illustrating land and water conservation problems and practices used to solve those problems; including items related to agriculture, wildlife, recreation, reclamation, and scenic views. Reviews photos with or without accompanying ms. Model release and captions preferred.
Making Contact & Terms: Send unsolicited photos by mail for consideration. Uses 5x7, 8x10 b&w prints, and 35mm, 2¼x2¼, 4x5 and 8x10 color transparencies; b&w contact sheet. SASE. Reports in 2 weeks. Pays $50/color cover, $10/up inside b&w. Pays on acceptance. Credit line given. Buys one-time rights.

***THE JOURNAL/THE INSTITUTE FOR SOCIOECONOMIC STUDIES**, Airport Rd., White Plains NY 10604. (914)428-7400. Editor: B.A. Rittersporn, Jr. The Journal/The Institute for Socioeconomic Studies. Semiannual journal. Emphasizes economic development, social motivation, poverty, urban regeneration, quality of life of the elderly, all socioeconomic issues. Readers are the nation's outstanding figures in public affairs, business/finance, the universities, labor and the professions. Circ. 17,500. Sample copy free with SASE.
Photo Needs: Uses 12-15 photos/issue; occasionally 1 supplied by freelance photographers. Photos specifically illustrate articles which are on socioeconomic issues mentioned above, or political figures involved in the issues. Captions required.
Making Contact & Terms: Query with list of stock photo subjects; provide resume, business card, brochure, flyer or tearsheets to be kept on file for possible future assignments. Reports in 3 weeks. Pays $50-75/b&w inside photo. Pays on publication. Credit line given. Buys one-time rights. Simultaneous submissions and previously published work OK.
Tips: "If we are provided with a subject list, we will call when we have a specific need to fill."

KIWANIS MAGAZINE, 3636 Woodview Trace, Indianapolis IN 46268. (317)875-8755. Executive Editor: Chuck Jonak. Art Director: Jim Patterson. Published 10 times/year. Circ. 300,000. Emphasizes organizational news, plus major features of interest to business and professional men involved in community service. Send resume of stock photos. Provide brochure, calling card and flyer to be kept on file for future assignments. "We work regularly with local freelancers who make an appointment with Art Director or Production Manager to show portfolio." Buys one-time rights.
B&W: Uses 5x7 or 8x10 glossy prints. Pays $50-500/b&w photo.

Color: Uses 35mm but would rather use 2¼x2¼ and 4x5 transparencies. Pays $50-1,000/color photo.
Accompanying Mss: Pays $250-750/ms with photos. Free sample copy and writer's guidelines.
Tips: "We are a nonprofit organization and subsequently do not have a large budget. But we can offer the photographer a lot of freedom to work *and* worldwide exposure. And perhaps an award or two if the work is good. We are now using more conceptual photos. We also use studio set-up shots. When we assign work, we want to know if a photographer can follow a concept into finished photo without on sight direction."

LACMA PHYSICIAN, Box 3465, Los Angeles CA 90054. (213)483-1581. Managing Editor: Howard Bender. Published 20 times/year—twice a month except January, July, August and December. Circ. 10,500. Emphasizes Los Angeles County Medical Association news and medical issues. Readers are physicians and members of LACMA.
Photo Needs: Uses about 1-20 photos/issue; 1-20 are supplied by freelance photographers. Needs photos of meetings of the association, physician members, association events—mostly internal coverage. Photos purchased with or without accompanying ms. Model release required.
Making Contact & Terms: Arrange a personal interview to show portfolio. Does not return unsolicited material. Pays by hour, day or half day; negotiable. Pays on publication with submission of invoice. Credit line given. Buys one-time rights or first North American serial rights "depending on what is agreed upon."
Tips: Prefers to see "a wide variation, b&w and color of people, meetings, special subjects, etc. A good overall look at what the photographer can do."

LANDSCAPE ARCHITECTURE, 1733 Conn Ave. NW, Washington DC 20009. (202)466-7730. Publication of the American Society of Landscape Architects. Bimonthly magazine. Emphasizes "landscape architecture, urban design, parks and recreation, architecture, sculpture" for professional planners and designers. Circ. 18,000. Sample copy $4; photo guidelines free with SASE.
Photo Needs: Uses about 30-40 photos/issue; 5-15 supplied by freelance photographers. Needs photos of landscape- and architecture-related subjects as described above. Special needs include aerial photography. Model release required, captions preferred.
Making Contact & Terms: Query with samples or list of stock photo subjects; provide resume, business card, brochure, flyer or tearsheets to be kept on file for possible future assignments. SASE. Reporting time varies. Pays $250/color cover photo; $100/b&w inside; $100/color inside ($50/¼ page). Pays on publication. Credit line given. Buys one-time rights. Previously published submissions OK.

LEFTHANDER MAGAZINE, Box 8249, Topeka KS 66608. (913)234-2177. Managing Editor: Suzan Menendez. Publication of Lefthanders International. Emphasizes lefthandedness. "Our readers are lefthanders, mostly women between 25-40 who are college-educated. Mid-high income." Circ. 22,000. Sample copy free with SASE and $2 postage. Guidelines free with SASE.
Photo Needs: Uses about 20 photos/issue; 20% supplied by freelance photographers. Needs "how-to, people, and still life photos—must relate to lefthanded athletes, celebrities." Prefers photos with manuscripts. Model release and photos required.
Making Contact & Terms: Query with samples. SASE. Reports in 3 weeks. Payment varies. Pays on publication. Credit line given. Simultaneous submissions and previously published work OK.

THE LION, 300 22nd St., Oak Brook IL 60570. (312)986-1700. Editor: Robert Kleinfelder. Monthly magazine. Circ. 650,000. For members of the Lions Club and their families. Emphasizes Lions Club service projects. Works with freelance photographers on assignment only basis. Provide resume to be kept on file for possible future assignments. Buys 10 photos/issue. Buys all rights. Submit model release with photo. Query first with resume of credits or story idea. "Generally photos are purchased with ms (300-1,500 words) and used as a photo story. We seldom purchase photos separately." Pays $50-100/ page; $50-400/text/photo package. Pays on acceptance. Reports in 2 weeks. SASE. Free sample copy and photo guidelines.
Photo Needs: Photos of Lions Club service or fundraising projects. "All photos must be as candid as possible, showing an activity in progress. Please, no award presentations, meetings, speeches, etc."
B&W: Uses 5x7 or 8x10 glossy prints. Also accepts color prints and 35mm transparencies. Captions required. Pays $10-25.

THE MAGAZINE FOR CHRISTIAN YOUTH!, Box 801, Nashville TN 37202. (615)749-6463. Editor: Sidney D. Fowler. Publication of The United Methodist Church. Monthly. Emphasizes what it means to be a Christian teenager in the 80's—developing a Christian identity and being faithful. Readers are junior and senior high teenagers (Christian). Circ. estimated 50,000. Estab. 1985. Free sample copy with SASE.

Photo Needs: Uses about 16 photos/issue; 11 supplied by freelance photographers. Needs photos of teenagers. Special needs include "up-to-date pictures of teens in different situations—at school, at home, with parents, friends, doing activities, etc. Need photos of both white and ethnics." Model release required. Query with samples and list of stock photo subjects. Send 8x10 b&w prints, 35mm, 2¼x2¼ and 4x5 transparencies, and b&w contact sheet by mail for consideration. SASE. Reports in 1 month. Pays on acceptance. Credit line given. Buys one-time rights. Simultaneous submissions oK.
Tips: Prefers to see "quality photographs of teenagers in various situations, settings. Should appear realistic, not posed, and should be up-to-date in terms of clothing, trends (break-dancing, use of alcohol, hanging out in malls, etc). Photos of single teens plus some of teens with others. Give us photographs that don't look posed or set-up. Don't give us photos that are blurry and/or have bad compositions. Give us pictures of *today's* teens."

MAINSTREAM—ANNUAL PROTECTION INSTITUTE OF AMERICA, 6130 Freeport Blvd., Sacramento CA 95822. (916)422-1921. Contact: Publications Coordinator. Publication of the Animal Protection Institute of America. Quarterly. Circ. 90,000. Emphasizes "humane education towards and about animal issues and events concerning animal welfare." Readers are "all ages; people most concerned with animals." Sample copy available.
Photo Needs: Uses approximately 30 photos/issue; 15 supplied by freelance photographers. Needs "photos of animals in the most natural settings as possible. No limit as to which species. Photos of particular species of animals may be needed to highlight feature stories for future issues. We need to build our companion animal files. We also need photos of people and animals working together, photos of whales, dolphins, porpoises, endangered species, primates, animal experimentation and in factory farming. API also uses fine animal photos in various publications besides its magazine. Vertical format required for *Mainstream* covers." Model release and captions required.
B&W: Send 5x7 or 8x10 glossy prints.
Color: Send 35mm or 2¼x2¼ transparencies.
Making Contact & Terms: Query with resume and credits, samples or list of stock photo subjects. After query, send photos by mail for consideration. Provide business cards, brochure, flyer or tearsheets to keep on file for possible future assignments. "We welcome all contacts." SASE. Reports in approximately 2 weeks. Pays $150-200/color cover photo; $20/b&w inside photo, $50-150/color inside photo. Depends on each photograph and usage. Pays on publication. Credit line given. Buys one-time or all rights; "if photographer will allow us to reprint with notification." Simultaneous submissions and previously published work OK.
Tips: "We prefer to see animals in natural settings. We need excellent quality photos."

MAP INTERNATIONAL, Box 50, Brunswick GA 31520. (912)265-6010 or (800)225-8550 (interstate toll free). Association publication of MAP International. Bimonthly. Reports on the organization's annual distribution of $20 million in donated medicines and supplies to relief agencies in 80 countries in the developing world as well as work in community health development projects. Sample copy and photo guidelines free with SASE.
Photo Needs: "Specifically, we need photos depicting the health needs of people in the developing countries of Africa, Asia and Latin America, and the work being done to meet those needs. Also use photos of disaster situations like the Columbia volcano of '85, *while situation is current*." Captions required.
Making Contact & Terms: Query with resume of credits; query with samples; query with list of stock photo subjects. Uses b&w 5x7 glossy prints; 35mm transparencies. SASE. Reports in 1 month. Pays $75/b&w cover photo; $25 + /b&w inside photo; payment for color photos individually negotiated. Pays on acceptance. Credit line given. Buys one-time rights. Simultaneous submissions and previously published work OK, "depending on where else they had been submitted or used."
Tips: "Photos should center on people: children, patients receiving medical treatment, doctors, community health workers with the people they are helping, hospitals, health development projects and informal health education settings. The kind of photography that came out of Ethiopia during its crisis is fairly typical of what we use although our interest is much broader than crisis situations and emergency aid alone, and we frequently try to show the hopeful side of what is being done. Care about people. We are a people-developing agency and if a photographer cares about the problems of people in developing nations it will come through in the work."

MATURE YEARS, 201 Eighth Ave. S., Nashville TN 37203. (615)749-6438. Editor: Daisy Warren. Publication of the United Methodist Church. Quarterly magazine. "*Mature Years* is a leisure-time resource for older adults in The United Methodist Church. It contains fiction, articles dealing with health, matters related to aging, poetry, and lesson material." Readers are "adults over fifty-five in The United Methodist Church. The magazine may be used in classroom, home, or nursing and retirement homes." Circ. 100,000. Sample copy free with SASE.

Photo Needs: Uses about 15 photos/issue; many supplied by freelance photographers. Needs "mainly photos showing older adults in various forms of activities. We have problems finding older adults pictured as healthy and happy. We *desperately* need pictures of older adults that are in the ethnic minority."
Making Contact & Terms: Query with list of stock photo subjects. Send 8x10 b&w glossy prints and any transparencies by mail for consideration. SASE. Reports in 1-2 weeks. Pays $65-175/cover photo; $10-45/inside photo. Pays on acceptance. Credit line given on copyright page. Buys one-time rights. Simultaneous submissions and previously published work OK.
Tips: Prefers to see "ethnic minority older adults, older adults who are healthy and happy—pictures portraying the beauty and wonder of God's creation. Remember that all older adults are not sick, destitute, or senile."

THE MAYO ALUMNUS, Harwick 8, Mayo Clinic, Rochester MN 55905. (507)284-4084. Editor: Mary Ellen Landwehr. Quarterly magazine. Circ. 12,000. Alumni journal for Mayo Clinic-trained physicians, scientists and medical educators. Photos purchased with or without accompanying ms or on assignment. Pays $20-75/hour, $20-400/job, $100-500 for text/photo package, or on a per-photo basis. Credit line given. Pays on acceptance. Buys all rights. Query with samples. SASE. Previously published work OK. Free sample copy.
Photo Needs: Human interest or photo essay/photo feature on Mayo-trained physicians, scientists and medical educators, "who are interesting people or who are involved in pertinent medical issues." Cannot use photos of subjects unrelated to Mayo-trained physicians. Captions preferred.
Inside: Uses 8x10 b&w glossy prints, contact sheet or contact sheet with negatives OK. Also uses color transparencies; 35mm or 2¼x2¼.
Cover: Uses 35mm or 2¼x2¼" color transparencies. Horizontal wraparound preferred.
Accompanying Mss: Needs human interest features on Mayo-trained physicians. Pays $100-400/ms.

***METASCIENCE,** Box 32, Kingston RI 02881. (401)294-2414. Art Director/Associate Editor: Robert Adsit. Publication of the MetaScience Foundation. Annually. Circ. 1,500. Emphasizes parapsychology, metaphysics, quantum physics and consciousness, depth psychology, the occult. Readers are academic and educated scientists, medical doctors, psychics and parapsychologists. Sample copy $7.95.
Photo Needs: Uses about 8 photos/issue; 2-4 supplied by freelance photographers. Needs "occasional art photos with psychic themes, photos of people interviewed, bizarre photos of ghosts, UFO's, auras, etc."
Making Contact & Terms: Query with samples; send b&w prints and contact sheets by mail for consideration. SASE. Reports in 1 month. Pays $50/b&w cover photo; $15/b&w inside photo. Pays on acceptance. Credit line given. Buys republication rights. Previously published submissions "considered."
Tips: "See sample copy if interested in working with our publication. Looking for unusual and psychic photos."

***MILITARY COLLECTORS NEWS,** Box 702073, Tulsa OK 74170. (918)743-6048. Editor: Jack Britton. Magazine. Circ. 18,000. For collectors of military medals, badges, insignia. Photos purchased with or without accompanying ms. Buys 72 photos/year. Pays $5-25 for text/photo package or on a per-photo basis. Credit line given. Pays on publication. Buys all rights. Send material by mail for consideration. SASE. Simultaneous submissions and previously published work OK. Reports in 1 month. Sample copy $1.
Photo Needs: Only photos of military items used or worn on uniforms (preferably foreign or old US) or men in uniform. Model release and captions preferred.
B&W: Uses 8x10 or smaller prints. Pays 50¢-$2/photo.
Color: Uses 8x10 or smaller prints. Pays 50¢-$3/photo.
Cover: Uses b&w or color prints. Vertical format preferred.
Accompanying Mss: Needs mss on military collecting. Pays $3-25/ms.

MISSISSIPPI STATE UNIVERSITY ALUMNUS, Box 5328, Mississippi State MS 39762. (601)325-3442. Editor: Linsey H. Wright. Quarterly magazine. Circ. 15,000. Emphasizes articles about Mississippi State graduates and former students. For alumni of Mississippi State University; readers are well educated and affluent. Photos purchased with accompanying ms. "Send us a well-written article that features Mississippi State University or its graduates or former students. We'll help with the editing, but the piece should be interesting to our alumni readers. We welcome articles about MSU grads in interesting occupations. We welcome profiles on prominent Mississippi State alumni in business, politics, medicine, the arts, the sciences, agriculture, public service and sports." Buys 3-4 photos/annually, but welcomes more submissions. Buys one-time rights. Query or send complete ms. Pays on publication. SASE. Reports in 1 month. Simultaneous submissions and previously published work OK. Free sample copy.

B&W: Uses 8x10 prints. Captions required. Pays $50-150, including ms.
Color: Uses 35mm transparencies.
Tips: "Write a story about an interesting MSU alumnus and illustrate it, or get a freelance writer to write the story and split the payment with him for the photos."

MODERN MATURITY, 3200 Carson St., Lakewood CA 90712. Editor: Ian Ledgerwood. Picture Editor: M.J. Wadolny. Bimonthly magazine. Circ. 11,000,000. For people over age 50. Needs "spectacular scenics" and photos dealing with "stories of interest to retired and working people in the following categories: human interest (celebrities in education, science, art, etc., as well as unknowns); practical information on health, finances, fashion, housing, food, etc.; inspiration; Americana; nostalgia; and crafts." Buys 100 photos/year. Buys first North American serial rights. Submit model release with photo. Send photos for consideration. Credit line given. Pays space rates. Reports in 1 month. SASE. Sample copy and free photo guidelines; enclose SASE.
B&W: Send 8x10 glossy prints. Captions required. Pays $75 minimum.
Color: Send transparencies. Captions required. Pays $150 minimum.
Cover: Send color transparencies. "We occasionally use cover shots with people in them." Captions required. Pays $600/inside cover, $750/front cover.

MOMENTUM, National Catholic Educational Association, Suite 100, 1077 30th St. NW, Washington DC 20007. (202)293-5954. Editor: Patricia Feistrizer. Quarterly magazine. Circ. 16,000. For Catholic school administrators and teachers. Needs photos relevant to Catholic elementary and secondary education. Buys one-time rights. Credit line given. Reports in 3 months. Free sample copy.
B&W: Uses 8x10 glossy prints. Pays $7.

THE MORGAN HORSE, Box 1, Westmoreland NY 13490. (315)736-8306. Photo Editor: Carol Misiaszek. Publication of the American Morgan Horse Association. Monthly. Circ. 10,000. Emphasizes Morgan horses. "The audience of *The Morgan Horse* is composed of primarily Morgan owners, breeders and horse enthusiasts in general. Over half of the readers are members of the American Morgan Horse Association." Sample copy $3; photo guidelines free with SASE.
Photo Needs: "The Morgan, being the model of versatility that it is, offers photographers a wide range of possibilities. Whether used for driving, dressage, jumping, trail riding, farming, ranch work, parading, or as a family pleasure horse, the Morgan's real asset is his versatility. Photos submitted should not only reflect the true natural beauty and action of the Morgan, but should also reflect his versatility. We're looking for not only beautiful pictures of Morgans, but also of people enjoying their Morgans. (Sorry, no show ring shots will be accepted.) We also publish a calendar each year in which we like to show the beauty and action of the Morgan horse." Model release required; captions preferred; "The following basic information should accompany each photo: 1) the horse's name and registration number, 2) the owner's name and address, 3) the location where the photo was taken, and 4) a model release. Your name and address should appear on the back of each photo as well. Photos and manuscript packages will also be considered."
Making Contact & Terms: Query with list of stock photo subjects or send 8x10 glossy color prints, 35mm, 2¼x2¼ or 4x5 color transparencies by mail for consideration. SASE. Reports in 1 month "but this may vary." Provide resume and tearsheets to be kept on file for possible future assignments. Pays $50 minimum/color cover and $5/b&w inside photo. Color for calendar and promotion use varies. Pays on publication. Credit line given. Buys one-time rights unless otherwise arranged. Simultaneous and previously published work OK.
Tips: "When you do submit photos, be patient. Sometimes it takes weeks before a decision is made to use or not to use a photo. We are always interested in creative photography. Hope to be hearing from you soon."

MUZZLE BLASTS, Box 67, Friendship IN 47021. (812)667-5131. Editor: Maxine Moss. Publication of The National Muzzle Loading Rifle Association. Monthly. "Our publication relates to the muzzle-loading firearms (rifles, pistol, shotguns), primitive aspects of these firearms and to our heritage as signified within early Americana history." Readers are "a membership audience of shooters of muzzle-loading firearms, hunters, and historians desiring general information of the muzzle-loading era." Circ. 29,000+. Sample copy free. Photo guidelines free upon request. Uses color only.
Photo Needs: Most photos are purchased from writers as part of text/photo packages, but "we will have a need for cover photos depicting the muzzle-loading era. We also use photos of paintings or will be glad to accept cover work in order to promote cover work of photographer. This only upon review of the material presented." Model release preferred; captions required.
Making Contact & Terms: Call to discuss needs. Reports in 2 weeks. "No rate schedule set up at present." Credit line given. Previously published work OK.
Tips: "Past experience in rejecting photos has been due to poor lighting on subject matter. To bring out

the richness of wood, embellished with silver inlay work, a photographer's knowledge of highlighting comes into play. When photographing a group of people, do not pose to face camera other than if it is only suitable with photo captions to identify those in the picture."

***NATIONAL DRAGSTER**, 10639 Riverside Dr., North Hollywood CA 91602. (818)985-6472. Editor: Phil Burgess. Photo Editor: Leslie Lovett. Publication of National Hot Rod Association. Weekly newspaper tabloid. Emphasizes drag racing and auto racing. Readers are members of the NHRA racing circuit. Captions preferred.
Making Contact & Terms: Send 3 ½x5 b&w or color prints by mail for consideration. SASE. Reports in 2 weeks. Pays $75-100/color cover photo; $15/b&w inside photo. Pays on publication. Credit line given. Buys all rights.
Tips: "Don't be tardy in sending good photos to us for consideration. We are weekly and need to see the photos as soon as possible to make a decision on what we run."

THE NATIONAL FUTURE FARMER, 5632 Mount Vernon Hgwy., Box 15160, Alexandria VA 22309. (703)360-3600. Editor-in-Chief: Wilson Carnes. Publication of the Future Farmers of America. Bimonthly. Circ. 475,000. Emphasizes "youth in agriculture, production agriculture and agribusiness topics, former FFA members, general youth interest items for FFA members." Readers are "between ages 14-21, primarily male rural youth." Sample copy free.
Photo Needs: Uses about 30-35 photos/issue; 5-10 supplied by freelance photographers. "Our largest need is creative photos that show FFA members as an illustration; usually the idea is so specific it must be assigned first, but general agriculture shots are used also." Model release and captions preferred.
Making Contact & Terms: Query with samples or list of stock photo subjects. SASE. Reports in 1 month, "sometimes longer." Pays $100/color cover photo; $15/b&w inside photo, $25-35/color inside photo. Pays on acceptance. Credit line given. Buys all rights.
Tips: "Know the organization/magazine inside and out. If you *really* want to be accepted, submit a story idea with illustration. We look for quality."

NATIONAL GARDENING, 180 Flynn Ave., Burlington VT 05401. (802)863-1308. Editor: Katharine Anderson. Publication of the National Gardening Association. Monthly. Circ. 250,000. Emphasizes food gardening. Readers are home and community gardeners. Sample copy for $1 postage. Photo guidelines free with SASE.
Photo Needs: Uses about 50 photos/issue; half supplied by freelance photographers. Needs photos of "food plants and gardens; people gardening; special techniques; how to; specific varieties; unusual gardens and food gardens in different parts of the country. We often need someone to photograph a garden or gardener in various parts of the country for a specific story." Model release required; captions preferred.
Making Contact & Terms: Query with samples or list of stock photo subjects. SASE. Reports in 2 weeks. Pays $100-200/color cover photo; $20-25/b&w and $40/color inside photo. Pays on acceptance. Credit line given. Buys one-time rights.
Tips: "We're becoming more selective all the time, need top quality work. Most photos used are color, though we'd like to have more black and white; for some reason we don't see much b&w that's good. We look for general qualities like clarity, good color balance, good sense of lighting and composition. Also interesting viewpoint, one that makes the photos more than just a record (getting down to ground level in the garden, for instance, instead of shooting everything from a standing position.) Look at the magazine carefully, and at the photos used. We work at making the stories friendly, casual and personal. When we write a story on raising broccoli, we'd love to have photos of people harvesting or eating broccoli, not a formal shot of broccoli on a black background. Send us photos of happy people gardening (they're hard to get)."

***NATIONAL MOTORIST**, One Market Plaza, San Francisco CA 94105. (415)777-4000. Editor: Jane Offers. Association of National Auto Club. Bimonthly magazine. Emphasizes travel-domestic international, transportation, some auto. Readers are auto club members, CA only, affluent. Circ. 200,000. Sample copy free with SASE.
Photo Needs: Uses 16 photos/issue; all supplied by freelance photographers, though some free from travel bureaus. Photos needed depends on features. Covers—seasonal vertical scenics. Model release required; captions preferred.
Making Contact & Terms: Query with resume of credits, samples, and list of stock photo subjects; provide resume, business card, brochure, flyer or tearsheets to be kept on file for possible future assignments. Send 35mm, 2¼x2¼ and 4x5 transparencies by mail for consideration. SASE. Reports in 1 month. Pay negotiated. Pays promptly on publication. Adjacent credit line given. Buys one-time rights.
Tips: Prefers to see sheet of 20 35mm, variety-cover shots, travel. Ask for issue; accept magazine's payment "constrictions," always on lookout for good covers.

THE NATIONAL NOTARY, 23012 Ventura Blvd., Box 4625, Woodland Hills CA 91365-4625. (818)347-2035. Editor: Charles N. Faerber. Bimonthly. Circ. 45,000. "Notaries Public and notarization—goal is to impart knowledge, understanding and unity among Notaries nationwide and internationally. Readers are employed primarily in the following areas: law, government, finance and real estate." Sample copy $5.
Photo Needs: Uses about 20-25 photos/issue; 10 are supplied by non-staff photographers. "Photo subject depends on accompanying story/theme; some product shots used." Unsolicited photos purchased with accompanying ms only. Special needs include "Profile," biography of a specific notary, living anywhere in the United States. "Since photos are used to accompany stories or house ads, they cannot be too abstract or artsy. Notaries, as a group, are conservative, so photos should not tend towards an ultramodern look." Model release required.
Making Contact & Terms: Query with samples. Prefers to see prints as samples. Does not return unsolicited material. Reports in 4-6 weeks. Provide business card, tearsheets, resume or samples to be kept on file for possible future assignments. Pays $25-300 depending on job. Pays on publication. Credit line given "with editor's approval of quality." Buys all rights. Previously published work OK.
Tips: "Since photography is often the art of a story, the photographer must understand the story to be able to produce the most useful photographs."

THE NATIONAL RURAL LETTER CARRIER, 1448 Duke St., Alexandria VA 22314. Managing Editor: RuthAnn Saenger. Weekly magazine. Circ. 65,000. Emphasizes Federal legislation and issues affecting rural letter carriers and the activities of the membership for rural carriers and their spouses and postal management. Photos purchased with accompanying ms. Buys 52 photos/year. Credit line given. Pays on publication. Buys first serial rights. Send material by mail for consideration or query with list of stock photo subjects. SASE. Previously published work OK. Reports in 4 weeks. Sample copy 34¢; photo guidelines free with SASE.
Photo Needs: Animal; wildlife; sport; celebrity/personality; documentary; fine art; human interest; humorous; nature; scenics; photo essay/photo feature; special effects & experimental; still life; spot news; and travel. Needs scenes that combine subjects of the Postal Service and rural America; "submit photos of rural carriers on the route." Especially needs for next year features of the state of Iowa particularly the city of Des Moines. Model release and captions required.
B&W: Uses 8x10 glossy prints. Pays $50/photo.
Color: Uses 8x10 glossy prints. Pays $50/photo.
Cover: Uses b&w or color glossy prints. Vertical format preferred. Pays $50/photo.
Tips: "Please submit sharp and clear photos with interesting and pertinent subject matter. Study the publication to get a feel for the types of rural and postal subject matter that would be of interest to the membership. We receive more photos than we can publish, but we accept beginners' work if it is good."

NATIONAL UTILITY CONTRACTOR, Suite 606, 1235 Jefferson Davis, Arlington VA 22202. (703)486-5555. Director of Communications: Janis L. Hampton. Publication of the National Utility Contractors Association. Monthly. Circ. 12,000. Emphasizes underground construction (sewer, water, electric line, gas line, fiber optic line, etc.), by private construction companies. Readers are presidents and CEOs of private construction companies as well as suppliers, distributors and manufacturers of construction equipment and supplies. Sample copy available.
Photo Needs: Publishes photos "seldom;" "seldom" uses photos supplied by freelancers. Needs "primarily cover shots—4-color 35mm Kodachrome or larger format—of underground construction activity." Model release preferred; captions required.
Making Contact & Terms: Send 35mm, 2¼x2¼, 4x5 or 8x10 transparencies by mail for consideration. SASE. Reports in 1 month. Pays $325/color cover photo; $50/b&w inside photo. Pays on publication. Credit line given. Buys all rights; will negotiate "at photographer's preference." Simultaneous and previously published submissions OK.
Tips: "All photography requirements are keyed to articles by leading industry experts."

THE NATURE CONSERVANCY NEWS, Suite 800, 1800 N. Kent, Arlington VA 22209. (703)841-5377. Photo Editor: Susan Bournique. Publication of The Nature Conservancy. Bimonthly. Emphasizes "nature, rare and endangered flora and fauna, ecosystems in North and South America." Readers are the membership of The Nature Conservancy. Circ. 275,000.
Special Needs: Migrating waterfowl central flyway—Texas, Gulf Coast, Platt and Dakota potholes and Atlantic flyway. The Nature Conservancy welcomes permission to make duplicates of slides submitted to the *News* for use in slide shows only.
Photo Needs: Uses about 17 photos/issue. Captions preferred (location and names of flora and fauna).
Making Contact & Terms: Send stock photo list to be kept on file. Many photographers contribute the use of their slides. Uses color transparencies. Pays $150/color cover photo; $50-100/color inside photo. Pays on publication. Credit line given. Buys one-time rights. Guidelines and want list available.

Tips: "Membership in the Nature Conservancy is only $10/year and the *News* will keep photographers up to date on what the Conservancy is doing in your state. Many of the preserves are open to the public. Occasionally submit updated stock photo lists as to where and what (species) you have added to your collection. We look for rare and endangered species, wetlands and flyways."

ND REC MAGAZINE, Box 727, Mandan ND 58554. Managing Editor: Dennis Hill. Publication of the ND Rural Electric Cooperatives. Monthly. Circ. 75,000. Emphasizes rural electrification and the rural lifestyle. Readers are rural or farm dwellers. Sample copy available.
Photo Needs: Uses about 12 photos/issue; 2-3 supplied by freelance photographers. "We're always looking for attractive scenes of rural North Dakota for our 4-color cover."
Making Contact & Terms: Query with samples; send 35mm transparencies by mail for consideration. SASE. Pays $25/color cover photo; $5/b&w inside photo. Pays on acceptance. Credit line given on cover photos only. Buys one-time rights. Simultaneous and previously published submissions OK.
Tips: "We cover North Dakota only, especially rural lifestyle."

NETWORK, The Paper for Parents, 410 Wilde Lake Village Green, Columbia MD 21044. (301)997-9300. Editor: Chrissie Bamber. Publication of the National Committee for Citizens in Education. Tabloid published 8 times/year. Circ. 6,000. Emphasizes "parent/citizen participation in public school." Readers are "parents, citizens, educators." Sample copy available.
Photo Needs: Uses various number photos/issue. Needs photos of "children (elementary and high school) in school settings or with adults (parents, teachers) shown in helping role." Model release required; captions preferred.
Making Contact & Terms: Query with samples. Send glossy prints, contact sheets or good quality duplicator facsimiles by mail for consideration. SASE. Reports in 2 weeks. Pays $50/b&w cover photo; $25/b&w inside photo. Pays on acceptance. Credit line given. Negotiates rights purchased. Simultaneous submissions and previously published work OK.
Tips: "Photos of school buildings and equipment are more appealing when they include children. Pictures of children should be ethnically diverse."

***THE NEW PHYSICIAN**, 1910 Association Dr., Reston VA 22091. (703)620-6600. Editor: Renie Schapiro. Publication of American Medical Student Association. Published 9 times/year magazine. Emphasizes medicine/health. Readers are medical students, interns, residents, medical educators. Circ. 50,000. Sample copy free with SASE.
Photo Needs: Needs freelance photos for about 6 stories per year. Needs photos usually on health, medical, medical training. Special needs include commission photos to go with story or photo essay on above topic only. Model release and captions required.
Making Contact & Terms: Provide resume, business card, brochure, flyer or tearsheets to be kept on file for possible future assignments. Pay negotiated. Pays 2-4 weeks after acceptance. Buys first North American serial rights.

NJEA REVIEW, 180 W. State St., Box 1211, Trenton NJ 08607. (609)599-4561, ext. 322. Editor: Martha O. DeBlieu. Monthly magazine (September-May). Circ. 120,000. Emphasizes educational issues for teachers and school personnel. Photos purchased with or without accompanying ms and on assignment. Provide resume, brochure, letter of inquiry, prices and samples to be kept on file for possible future assignments. Buys 25 photos/year. Credit line given. Pays on acceptance. Buys all rights, but may reassign to photographer after publication. Contact by mail only. SASE. Previously published work OK. Free sample copy.
Photo Needs: Celebrity (in New Jersey state government or on federal level in education); how-to (classroom shots); human interest (of children and school staff; classroom shots; shots of supportive staff, i.e., secretaries, custodians, bus drivers, cafeteria personnel, aids, etc.); wildlife (environmental education); photo essay/photo feature (of an educational nature); and shots of educational facilities. Model release preferred.
B&W: Uses 5x7 glossy prints. Pays $10-25/photo.
Cover: Uses b&w glossy prints. Pays $25-100/photo.
Accompanying Mss: Seeks mss on education. Pays $50-250/ms. Writer's guidelines free on request.
Tips: "Do not make fun of school staff or children in scene. We prefer a multiethnic approach."

NLADA CORNERSTONE, 1625 K St., N.W., Washington DC 20006. (202)452-0620. Contact: Photo Editor. Bimonthly. Circ. 5,000. Emphasizes legal and public defender services to poor people. Readers are NLADA members—legal aid attorneys and professionals, clients, private attorneys, some news media and general public.
Photo Needs: Uses about 1 photo/issue; "none currently" are supplied by freelance photographers. Needs photos "of poor people, photos of legal aid going to poor people, poor neighborhoods, perhaps

other photos depending on the article." Photos purchased with or without accompanying ms. Special needs include photos for general use, such as an annual report—are needed more than those for the publication. Model release and captions preferred.

Making Contact & Terms: Query with samples or with list of stock photo subjects. Prefers to see b&w samples of magazine work. Does not return unsolicited material. Reports in 1 month. Provide business card, flyer or tearsheets to be kept on file for possible future assignments. Payment negotiable. Pays on acceptance or publication. Credit line given "either on photo or in contents section." Buys all rights. Simultaneous submissions and previously published work OK.

NORTH AMERICAN HUNTER, Box 35557, Minneapolis MN 55435. Editor/Associate Publisher: Mark LaBarbera. Managing Editor: Bill Miller. Publication of North American Hunting Club Inc. Bimonthly. Circ. 100,000. Emphasizes hunting. Readers are all types of hunters with an eye for detail and an appreciation of wildlife. Sample copy $3.
Photo Needs: Uses about 20 photos/issue; 1-2 supplied by freelance photographers; remainder bought as part of ms package. Needs "action wildlife centered in vertical format. North American game, game-birds and waterfowl only." Model release and captions required.
Making Contact & Terms: Send 35mm, 2¼x2¼, 4x5 or 8x10 transparencies by mail for consideration or submit list of photos in your file. SASE. Reports in 1 month. Pays $250/color cover photo; $75-100/b&w photo; $75-250/color photo. "We recently began paying $100 for both b&w and color photos used ½ page or larger inside, since they require equal effort from the photographer"; and $225-325 for text/photo package. "Pays promptly on acceptance." Credit line given.
Tips: "Practically all photos are purchased in conjunction with a manuscript/photo package. We want top quality photos of North American big game that depict a particular behavior pattern that members of the North American Hunting Club might find useful in pursuing that animal. Action shots are especially sought. Get a copy of the magazine and check out the type of photos we are using."

OCAW REPORTER, Box 2812, Denver CO 80201. (303)987-2229. Editor: Rodney Rogers. Publication of the Oil, Chemical & Atomic Workers International Union. Bimonthly. Circ. 120,000. Emphasizes labor union, consumer, political and social topics, as well as job health and safety. Readers are principally blue-collar workers. Free sample copy.
Photo Needs: Uses about 75 photos/issue; 1-2 supplied by freelance photographers. Needs spot news-related photos. Model release and captions required.
Making Contact & Terms: Send 8x10 b&w glossy prints by mail for consideration. SASE. Reports in 1 week. Pays $25/b&w cover photo; $20/b&w inside photo; $35 minimum/hour; $35 minimum/job. Pays on acceptance. Credit line given. Buys one-time rights or all rights; "depends on photo subject and whether photographer was hired for specific assignment." Simultaneous and previously published submissions OK.

OKLAHOMA TODAY, Box 53384, Oklahoma City OK 73152. (405)521-2496. Managing Editor: Kate Lester Jones. Bimonthly magazine. "We are the official publication of the state of Oklahoma, published by the Department of Tourism and Recreation. We cover all aspects of Oklahoma, from history to people profiles, but we emphasize travel and tourism." Readers are "Oklahomans, whether they live in state or are exiles; studies show them to be above average in education and income." Circ. 30,000. Sample copy $2; photo guidelines free with SASE.
Photo Needs: Uses about 50 photos/issue; 90-95% supplied by freelance photographers. Needs photos of "Oklahoma subjects only; the greatest number are used to illustrate a specific story on a person, place or thing in the state. We are also interested in stock scenics of the state." Model release preferred; captions required.
Making Contact & Terms: Query with samples or send 8x10 b&w glossy prints, 35mm, 2¼x2¼, 4x5, 8x10 transparencies or b&w contact sheets by mail for consideration. SASE. Reports in 4-6 weeks. Pays $100-200/color cover photo; $100/color page; $25-100/b&w photo; $50-150/color photo; $50-600/by the job; $250-750 for text/photo package. Payment for text material on acceptance; payment for photos as soon as layout is final and rate can be figured. Buys one-time rights, plus right to reproduce photo in promotions for magazine, without additional payment with credit line. Simultaneous and previously published submissions OK (on occasion).
Tips: "We love to see large-format color transparencies of people and places in Oklahoma; also high-quality b&w prints and original approaches. No color prints. We're small—try us!"

OPERA NEWS, 1865 Broadway, New York NY 10023. (212)582-3285. Associate Editor: Gerald Fitzgerald. Published by the Metropolitan Opera Guild. Biweekly (December-April) and monthly (May-November) magazine. Emphasizes opera performances and personalities for operagoers, members of opera and music professions. Circ. 120,000. Sample copy $2.50.
Photo Needs: Uses about 45 photos/issue; 15 supplied by freelance photographers. Needs photos of

"opera performances, both historical and current; opera singers, conductors and stage directors." Captions preferred.

Making Contact & Terms: Query with samples; provide resume, business card, brochure, flyer or tearsheets to be kept on file for possible future assignments. SASE. Reporting time varies. Payment negotiable. Pays on publication. Credit line given. Buys one-time rights. Simultaneous submissions OK.

PACIFIC DISCOVERY, California Academy of Sciences, Golden Gate Park, San Francisco CA 94118. Photography Editor: Johan Kooy. Quarterly magazine. Circ. 24,000. Journal of nature and culture worldwide, emphasizing natural history for scientists, teachers and nature lovers. Photos purchased with accompanying captions or text only. Buys 150 photos/year; 30-40 photos/issue. Credit line given. Pays on publication. Buys one-time rights. Send material by mail for consideration. SASE. Reports in 2-3 months. Sample copy and photo guidelines free with *large* SASE.

Subject Needs: Wildlife and nature. Captions required. Color and b&w. Uses color transparencies and 8x10 glossy prints. "We also make b&w conversions." Pays $70-200/photo.

Accompanying Mss: Behavior and natural history of animals and plants; ecology; anthropology; geology; paleontology; biogeography; taxonomy; and natural science-related topics. Pays $250-1,000/ms. Free writer's guidelines. "We favor series of photos that tell a story. Photographers will have the best chance if they think in *editorial* terms when they're shooting. Our favorite photographers seek out topics and people (authorities) and then behave as if they were writers: taking notes, interviewing scientists and taking pictures. Their submissions come in with obvious relationships to the subject—photos are very carefully edited into sections highlighting, for example, aspects of the natural history of an animal."

Tips: Read the magazine and spec sheet; "then send photo story and text. On photo stories, queries are useless—what counts is the photos themselves. For us, the chances of freelancing are fine. Although we pay relatively little per shot, we usually buy 5-15 photos at once to go with a story. In captions or text accompanying photos of individual plants or animals include scientific names and be sure they're *accurate*. We are looking for high quality photography. Sharpness of focus and detail and aesthetic merit are often critical determining factors in selection."

PASSAGES NORTH, Wm. Bonifas Fine Arts Center, Escanaba MI 49829. (906)786-3833. Editor: Elinor Benedict. Association publication for the William Bonifas Fine Arts Center (nonprofit). Semiannual tabloid. Emphasizes high-quality fiction and poetry. Readers include those interested in contemporary literature. Circ. 2,000. Sample copy $1.50. General guidelines for all submissions free with SASE.

Photo Needs: Uses 15 photos/most issues; all supplied by freelance photographers. Needs b&w portfolios of work by single photographer as group of related work by more than one (guild, group, school, etc.). Inquire with resume and 1 sample at first. Model release and captions preferred.

Making Contact & Terms: Query with resume of credits; provide resume, business card, brochure, flyer or tearsheets to be kept on file for possible future assignments. SASE. Reports in 1 month. Pays only in case of grants available; pre-arranged commissions. Credit line given. Pays on publication. Buys first North American serial rights.

Tips: "Send for sample issue first for $1.50. We use few photos but still are interested."

PENNSYLVANIA ANGLER, Box 1673, Harrisburg PA 17105-1673. (717)657-4520. Editor: Art Michacls. Monthly. Circ. 60,000. "*Pennsylvania Angler* is the Keystone State's official fishing magazine, published by the Pennsylvania Fish Commission." Readers are "anglers who fish in Pennsylvania waterways." Sample copy and photo guidelines free with 9x12 SASE and 73¢ postage.

Photo Needs: Uses about 25 photos/issue; 60% supplied by freelance photographers. Needs "action fishing and boating shots." Model release preferred; captions required.

Making Contact & Terms: Query with resume of credits, samples or list of stock photo subjects. Send 8x10 glossy b&w prints; 35mm or larger transparencies by mail for consideration. SASE. Reports in 2 weeks. Pays up to $150/color cover photo; $5-75/b&w inside photo, $25 and up/color inside photo; $50-250 for text/photo package. Pays on acceptance. Credit line given. Buys all rights. "After publication, rights can be returned to contributor."

Tips: "Consider a fishing subject that's been worked to death and provide materials with a fresh approach. For instance, take fishing tackle and produce extreme close-ups, or take a photograph from an unusual angle. Crisp, well-focused action shots get prompt attention. Study the magazine before submitting material."

PENNSYLVANIA HERITAGE, Box 1026, Harrisburg PA 17108-1026. (717)787-1396. Editor: Michael O'Malley, III. Published by the Pennsylvania Historical & Museum Commission, The Official State History Agency for the Commonwealth of Pennsylvania. Quarterly magazine. Emphasizes Pennsylvania history and culture. Readers are "varied—generally well-educated with an interest in history,

museums, travel, etc." Circ. 10,000. Sample copy free with SASE and 65¢ postage. Photo guidelines free with SASE.

Photo Needs: Uses approximately 75 photos/issue; "at this time, very few" supplied by freelance photographers. Needs photos of "historic sites, artifacts, travel, scenic views, objects of material culture, etc." Photos purchased with accompanying ms only. "We are generally seeking illustrations for specific manuscripts." Captions required.

Making Contact & Terms: Query with samples and list of stock photo subjects. Provide resume, business card, brochure, flyer or tearsheets to be kept on file for possible future assignments. SASE. Reports in 1 month. Pays $100/color cover photo; $5/b&w inside photo; $25/color inside photo. Pays on acceptance. Credit line given. Buys all rights. Simultaneous submissions OK.

THE PENNSYLVANIA LAWYER, 100 South St., Harrisburg PA 17108. (717)238-6715. Editor: Donald C. Sarvey. Publication of the Pennsylvania Bar Association. Published 7 times/year. Circ. 27,000. Emphasizes "news and features about law and lawyering in Pennsylvania." Readers are "the 25,000 members of the Pennsylvania Bar Association plus allied professionals and members of the Pennsylvania press corps." Sample copy free with SASE.

Photo Needs: Uses about 12 photos/issue; "very few" supplied by freelance photographers. "Mostly we use photos of individuals about whom we are writing or photos from association functions; sometimes photos to illustrate special story subject." Model release and captions preferred.

Making Contact & Terms: Query with resume of credits. Provide resume, business card, brochure, flyer or tearsheets to be kept on file for possible future assignments. SASE. Reports in 2 weeks. Pays up to $200/b&w cover photo; up to $50/b&w inside photo. Pays on acceptance. Credits listed on contents page. Buys one-time rights. Simultaneous submissions and previously published work OK.

PENTECOSTAL EVANGEL, 1445 Boonville, Springfield MO 65802. (417)862-2781. Editor: Richard G. Champion. Managing Editor: Harris Jansen. Weekly magazine. Circ. 290,000. Official organ of the Assemblies of God, a conservative Pentecostal denomination. Emphasizes denomination's activities and inspirational articles for membership. Credit line given. Pays on acceptance. Buys one-time rights; all rights, but may reassign to photographer after publication; simultaneous rights; or second serial (reprint) rights. Send material by mail for consideration. SASE. Simultaneous submissions and previously published work OK if indicated. Reports in 1 month. Free sample copy and photo guidelines.

Photo Needs: Uses 25 photos/issue; 5 supplied by freelance photographers. Human interest (very few children and animals). Also needs seasonal and religious shots. "We are interested in photos that can be used to illustrate articles or concepts developed in articles. We are not interested in merely pretty pictures (flowers and sunsets) or in technically unusual effects or photos." Model release and captions preferred.

B&W: Uses 8x10 glossy prints; "any size providing enlargements can be made." Pays $10-20/photo.

Color: Uses 8x10 prints or 35mm or larger transparencies. Pays $15-50/photo.

Cover: Uses color 2¼x2¼ to 4x5 transparencies. Vertical format preferred. Pays $25-60/color.

Accompanying Mss: Pays 2½-4¢/word. Free writer's guidelines.

Tips: "Writers and photographers must be familiar with the doctrinal views of the Assemblies of God and standards for membership in churches of the denomination. Send seasonal material 6 months to a year in advance—especially color."

THE PENTECOSTAL MESSENGER, Box 850, Joplin MO 64802. (417)624-7050. Editor: Don Allen. Monthly magazine. Circ. 10,000. Official publication of the Pentecostal Church of God. Buys 20-30 photos/year. Credit line given. Pays on publication. Buys second serial rights. Send samples of work for consideration. SASE. Simultaneous submissions and previously published work OK. Reports in 4 weeks. Free sample copy with 9x12 SASE; free photo guidelines with SASE.

Subject Needs: Scenic; nature; still life; human interest; Christmas; Thanksgiving; Bible and other religious groupings (Protestant). No photos of women or girls in shorts, pantsuits or sleeveless dresses. No men with cigarettes, liquor or shorts.

Cover: Uses 8x10 color prints. Pays $10-25/photo; 3½x5 color prints. Vertical format required.

Tips: "We must see the actual print or slides (120 or larger). Do not write on back of picture; tape on name and address. Enclose proper size envelope and adequate postage. We need open or solid space at top (preferably left) of photo for name of magazine. We also print in the foreground often. Several seasonal photos are purchased each year. In selecting photos, we look for good composition, good color and detail. We anticipate the use of *more* photography (and less art) on covers. Most of our cover material comes from stock material purchased from freelance photographers."

***THE PENTECOSTAL TESTIMONY**, 10 Overlea Blvd., Toronto, Ontario, Canada M4H 1A5. (416)425-1010. Editor: R.J. Skinner. Publication of The Pentecostal Assemblies of Canada. Monthly. Circ. 27,000. Emphasizes religion. Readers are church members. Sample copy free with SASE.

Photo Needs: Uses 10 photos/issue; 5 supplied by freelance photographers. Need photos of "people—special days such as holidays."

Making Contact & Terms: Query with list of stock photo subjects. Send 4x6 b&w glossy prints, 35mm transparencies by mail for consideration. SAE and International Reply Coupons. Reports in 1 month. Pays $100/color cover photo; $25/b&w inside photo, $50/color inside photo. Pays on publication. Credit line given. Buys one-time rights. Simultaneous submissions OK.

***PERSONNEL ADMINISTRATOR**, 606 N. Washington St., Alexandria VA 22314. (703)548-3440. Editor: Lynne Chiara. Art Director: Randy Leonard. Association publication of ASPA. Monthly magazine. Emphasizes human resource management. Readers are human resource professionals. Circ. 42,000. Sample copy $5.
Photo Needs: Uses 10-25 photos/issue; 90% supplied by freelance photographers. Needs photos of worklife situation—software use, technology, work environments, human resource or personal situations—issue. Model release and captions preferred.
Making Contact & Terms: Query with samples and list of stock photo subjects; provide resume, business card, brochure, flyer or tearsheets to be kept on file for possible future assignments. Does not return unsolicited material. Reports in 2 weeks. Pays $400/color cover photo. Pays on acceptance. Credit line given. Buys all rights. Previously published work OK.

PHI DELTA KAPPAN, Box 789, Bloomington IN 47402. (812)339-1156. Editor-in-Chief: Dr. Robert Cole, Jr. Photo Editor: Kristin Herzog. Publication of Phi Delta Kappa, Inc. Monthly (September-June). Circ. 140,000. Education magazine. Readers are "higher education administrators, curriculum and counseling specialists, professional staffs, consultants and state and federal education specialists."
Photo Needs: Uses 1-2 b&w photos/issue; "very few supplied by freelancer—we would use more if appropriate photos were submitted." Needs 1) portrait shots of newsmakers in education; 2) news photos of education and related events; 3) thematic shots that symbolically portray current issues: i.e., desegregation, computer learning, 4) teacher/child interaction, classroom scenes." Model release required.
Making Contact & Terms: Query with samples or with list of stock photo subjects. Send 5x7 or 8x10 b&w prints or photocopies by mail for consideration. "We do not use color photos." Provide business card to be kept on file for possible future assignments. SASE. Reports in 3 weeks. Pays $15-35/b&w inside photo. Pays on acceptance. Credit line given. Buys one-time rights. Simultaneous submissions and previously published work OK.
Tips: Prefers to see "good technical quality, good composition; content related to our editorial subject matter and style. *Read* the publication before submitting—most libraries have copies. Do what we ask and do it on time. Get model releases. If I don't have a release I can't run the photo no matter how great it is. Send a list of stock photos and one or two pieces that I can keep on file."

PHOTO MARKETING MAGAZINE, 3000 Picture Place, Jackson MI 49201. (517)788-8100. Editor: Nancy Brent. Publication of Photo Marketing Association International. Monthly. Emphasizes photography. Readers are photo retailers, photo processors and manufacturers who are in the business of marketing photo products. Circ. 15,000. Sample copy free with SASE.
Photo Needs: Uses about 3 photos/issue; 0-1 supplied by freelance photographers. Needs how-to—business for camera store, i.e., how to sell telescopes would use an action shot of salesperson demonstrating features. Model release and captions required.
Making Contact & Terms: Provide resume, business card, brochure, flyer or tearsheets to be kept on file for possible future assignments. Does not return unsolicited material. Reports in 3 weeks. Pays $25-35/b&w inside photo; $25-35/35mm transparencies; $250-650/text/photo package. Pays on acceptance. Credit line given. Buys first North American serial rights. Simultaneous submissions OK.
Tips: "Know my market/needs before submitting, then suggest photos to illustrate upcoming articles in our editorial calendar."

PIONEER PROBE, (formerly *Probe*), 1548 Poplar Ave., Memphis TN 38104. (901)272-2461. Editor: Michael Day. Monthly magazine. Circ. 50,000. For boys ages 12-17 who are members of a mission organization in Southern Baptist churches. Photos purchased with or without accompanying mss. Buys 30 photos/year. Credit line given. Pays on acceptance. Buys one-time rights. Send material for consideration. SASE. Simultaneous submissions and previously published work OK. Reports in 1 month. Free sample copy and photo guidelines with 9x12 SASE and $1.18 postage.
Subject Needs: Celebrity/personality (with Christian testimony) and photo essay/photo feature (teen interest, school, nature/backpacking, sports, religious). No "posed, preachy shots that stretch the point. We like teens in action." Captions required.
B&W: Uses 8x10 glossy prints. Pays $20/photo.
Accompanying Mss: Seeks mss on subjects of interest to teens, sports and the religious activities of teens. Pays 3½¢/word. Free writer's guidelines.
Tips: "We look for action shots, clear focus, good contrast and dramatic lighting. We target 14-15 year-old males. Coed shots welcome."

PLANNING, American Planning Association, 1313 E. 60th St., Chicago IL 60637. (312)955-9100. Monthly magazine. Circ. 25,000. Editor: Sylvia Lewis. Photo Editor: Richard Sessions. "We focus on urban and regional planning, reaching most of the nation's professional planners and others interested in the topic." Photos purchased with accompanying ms and on assignment. Buys 50 photos/year. Credit line given. Pays on publication. Buys all rights. Query with samples. SASE. Previously published work OK. Reports in 1 month. Free sample copy and photo guidelines.
Subject Needs: Photo essay/photo feature (architecture, neighborhoods, historic preservation, agriculture); scenic (mountains, wilderness, rivers, oceans, lakes); housing; and transportation (cars, railroads, trolleys, highways). "No cheesecake; no sentimental shots of dogs, children, etc.; no trick shots with special filters or lenses. High artistic quality is very important." Captions required.
B&W: Uses 8x10 glossy and semigloss prints; contact sheet OK. Pays $35-100/photo.
Cover: Uses 4-color; 35mm or 4x5 transparencies. Pays up to $250/photo (cover only).
Accompanying Mss: "We publish high-quality nonfiction stories on city planning and land use. Ours is an association magazine but not a house organ, and we use the standard journalistic techniques: interviews, anecdotes, quotes. Topics include energy, the environment, housing, transportation, land use, agriculture, neighborhoods, urban affairs." Pays $200 maximum/ms. Writer's guidelines included on photo guidelines sheet.
Tips: "Just let us know you exist. Eventually, we may be able to use your services. Send tearsheets or photocopies of your work, or a little self-promo piece. Subject lists are only minimally useful. How the work looks is of paramount importance."

POLICE TIMES, Voice of Professional Law Enforcement, 1100 NE 125th St., North Miami FL 33161. (305)891-1700. Managing Editor: Gerald Arenberg. Published 8 times/year. Circ. 100,000. Emphasizes "law enforcement and other police-related activities." Readers are "members of the law enforcement community."
Photo Needs: Needs "action photos, b&w preferred. Photos dealing with law enforcement trends and events."
Making Contact & Terms: SASE. Pays $10-25 for each photo used. Pays on acceptance.

THE PRACTICAL REAL ESTATE LAWYER, A11, 4025 Chestnut St., Philadelphia PA 19104. (215)243-1655. Editor: Mark Carroll. Photo Editor: Robert O'Leary. Bimonthly. Emphasizes real estate law. Readers include lawyers. Estab. 1985. Sample copy available.
Photo Needs: Photos of skylines, commercial real estate. Needs pictures of buildings, specifically skyscrapers.
Making Contact & Terms: Query with samples and list of stock photo subjects. Send b&w 8½x10 glossy, matte prints. Reports in 1 week. Payment individually negotiated. Pays within 6 weeks. Credit line given. Buys one-time rights. Simultaneous submissions and previously published work OK.
Tips: "Please query me first, our needs are very limited."

THE PRESBYTERIAN RECORD, 50 Wynford Dr., Don Mills, Ontario, Canada M3C 1J7. (416)441-1111. Production Editor: Mary Visser. Monthly magazine. Circ. 75,771. Emphasizes subjects related to The Presbyterian Church in Canada, ecumenical themes and theological perspectives for church-oriented family audience. Uses 2 photos/issue by freelance photographers.
Subject Needs: Religious themes related to features published. No formal poses, food, nude studies, alcoholic beverages, church buildings, empty churches or sports. Captions are required.
Specs: Uses prints only for reproduction; 8x10, 4x5 glossy b&w prints and 35mm and 2¼x2¼ color transparencies. Usually uses 35mm color transparency for cover or ideally, 8x10 transparency. Vertical format used on cover.
Accompanying Mss: Photos purchased with or without accompanying mss.
Making Contact: Send photos. SASE. Reports in 1 month. Free sample copy and photo guidelines.
Payment & Terms: Pays $5-25/b&w print, $35-50/cover photo and $20-50 for text/photo package. Credit line given. Pays on publication. Simultaneous submissions and previously published work OK.
Tips: "Unusual photographs related to subject needs are welcome."

***PRESERVATION NEWS**, 1785 Massachusetts Ave., Washington DC 20036. (202)673-4075. Editor: Arnold Berke. Monthly newspaper. Emphasizes historic preservation. Readers are homeowners, preservation professionals, architects, planners, etc. Circ. 175,000. Sample copy 50¢.
Subject Needs: Uses 50 photos/issue; 10 supplied by freelance photographers.. Needs buildings, street scenes, people, historical shots. Model release and captions preferred.
Making Contact & Terms: Query with resume of credits, query with samples, query with list of stock photo subjects, send unsolicited photos by mail for consideration. Send 8x10 b&w prints, b&w contact sheet by mail for consideration. SASE. Reports in 1 month. Pays $50/b&w cover and inside photo. Pays on publication. Credit line given. Buys one-time rights. Simultaneous submissions and previously published work OK.

PRINCETON ALUMNI WEEKLY, 41 William St., Princeton NJ 08540. (609)452-4885. Editor-in-Chief: Charles L. Creesy. Photo Editor: Margaret Keenan. Publication of the Princeton Alumni Association. Biweekly. Circ. 51,000. Emphasizes Princeton University and higher education. Readers are alumni, faculty, students, staff and friends of Princeton University. Sample copy $1.

Photo Needs: Uses about 15 photos/issue; 10 supplied by freelance photographers. Needs photos of "people, campus scenes; subjects vary greatly with content of each issue. Show us photos of Princeton." Captions required.

Making Contact & Terms: Arrange a personal interview to show portfolio. Provide brochure to be kept on file for possible future assignments. SASE. Reports in 1 month. Pays $100/b&w and $200/color cover photos; $25/b&w inside photo; $50/color inside photo; $45/hour. Pays on publication. Buys one-time rights. Simultaneous submissions and previously published work OK.

PRINCIPAL MAGAZINE, 1615 Duke St., Alexandria VA 22314-3406. (703)684-3345. Photo Editor: Carolyn Pool. Publication of the National Association of Elementary School Principals. Bimonthly. Emphasizes public education—kindergarten to 8th grade. Readers are mostly principals of elementary and middle schools. Circ. 23,000. Sample copy free with SASE.

Photo Needs: Uses 5-10 photos/issue; all supplied by freelance photographers. Needs photos of school scenes (classrooms, playgrounds, etc.); teaching situations; school principals at work. *No posed groups.* Closeups preferred. Reviews photos with or without accompanying ms. Special needs include seasonal scenes (especially fall and winter); children playing in school setting (indoors or outdoors). Model release preferred; captions required.

Making Contact & Terms: Arrange a personal interview to show portfolio; query with samples and list of stock photo subjects; send unsolicited photos by mail for consideration. Send b&w prints; 35mm and 2¼x2¼ transparencies; b&w and color contact sheet by mail for consideration. SASE. Reports in 1 month. Pays $200/color cover photo; $50/b&w inside photo; $150/day. Pays on publication. Credit line given. Buys one-time rights and all rights. Simultaneous submissions and previously published work OK.

***PROFESSIONAL SANITATION MANAGEMENT**, 1019 Highland Ave., Largo FL 33540. (813)586-5710. Publishing Director: Harold C. Rowe. Publication for the Environmental Management Association. Bimonthly magazine. Emphasizes "Industrial Sanitation Maintenance" involved in the work, product and recreational environments that are utilized by people. Readers are quality/assurance/control, directors of environmental services, physical plant directors, superintendent of buildings/grounds, safety, etc. Circ. 6,500. Sample copy free.

Photo Needs: Uses 6 photos/issue; all supplied by freelance photographers. Photo needs depends on editorial content of each issue. Model release required.

Making Contact & Terms: Query with samples or with list of stock photo subjects. SASE. Reports in 3 weeks. Pay negotiated. Pays on acceptance. Credit line given, "if desired, off photo." Buys all rights. Simultaneous submissions and previously published work OK.

PROVIDER, AMERICAN HEALTH CARE ASSOCIATION JOURNAL, (formerly *American Health Care Association Journal*), 1200 15th St., NW, Washington DC 20005. (202)833-2050. Executive Editor: Sheran Hartwell. Vice President of Communications: Stephen H. Press. Monthly. Circ. 22,000. Emphasizes long term health care. Readers are nursing home administrators, professional staff, organizations, associations, individuals concerned with long term care. Sample copy available.

Photo Needs: Uses about 10-15 photos/issue; 1-3 supplied by freelance photographers. Needs "long term care-related photos (residents, staff training, patient care, quality of life, facility extensions, etc.)." Model release preferred. Payment varies.

Making Contact & Terms: Arrange a personal interview to show portfolio. Does not return unsolicited material. Reports in 2 weeks. Pays on publication. Credit line given. Buys all rights. Simultaneous submissions and previously published work OK.

Tips: Prefers to see "shots which show the 'human element.' "

***PSA JOURNAL**, 2005 Walnut St., Philadelphia PA 19103. (215)563-1663. Editor: Reid Goldsborough. Publication of Photographic Society of America. Monthly magazine. Emphasizes how-to photography. Readers are advanced amateur photographers. Circ. 344,000. Sample copy $2.50. Photo guidelines free with SASE.

Photo Needs: Uses 15-25 photos/issue; 10-20 supplied by freelance photographers. Needs "black and white glossies and color transparencies that accompany how-to articles or photography. The photos should either typify the results you get from using the technique or illustrate the equipment used." Reviews photos with accompanying ms only. Model release preferred; captions required.

Making Contact: Send unsolicited photos by mail for consideration. Send 8x10 glossy b&w prints; 35mm and 2¼x2¼ transparencies by mail for consideration. SASE. Reports in 2 weeks. "Payment in copies and exposure only." Pays on publication. Credit line given. Buys one-time rights.

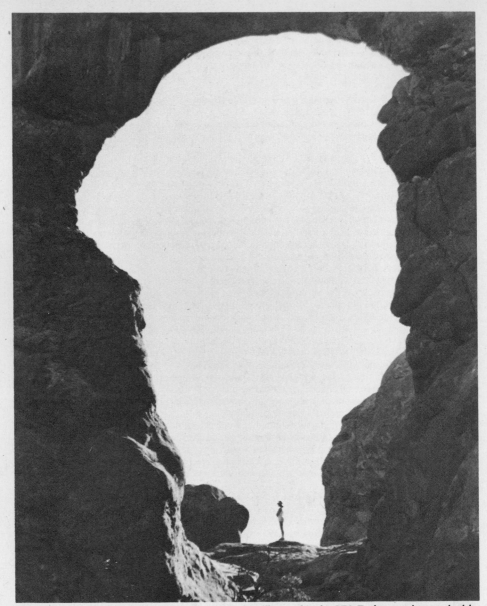

This photo was used both as a cover and inside illustration by PTA Today, and as an inside illustration for alive now! Magazine. One-time rights were purchased each time for a total payment of $135. Photographer Leo A. Meyer of St. Paul, Minnesota, first queried PTA Today, then sent material to fill their printed needs list." I wanted to show the enormity of our world when compared to one individual," he explains.

THE PSYCHIC OBSERVER, Box 55482, Washington DC 20011. (202)723-4578. Publisher: Rev. Henry J. Nagorka. Published by the National Spiritual Science Center. Bimonthly. Emphasizes parapsychology, metaphysics, frontiers of science. Readers are 12 years old and up. Circ. 10,000. Sample copy $2.50.
Photo Needs: Uses about 6-10 photos/issue; all supplied by freelance photographers. "All paranormal, major events, famous individuals in the psychic field." Special needs include "documentation of

psychic events." Model release required; captions preferred.
Making Contact & Terms: Query with samples. SASE. Reports in 1 month. Pays on publication; $25/b&w photo. Credit line given. Buys all rights.
Tips: "We look for documentation and portraiture of events and persons in psychic phenomena, frontiers, or science. Become acquainted with parapsychology."

PTA TODAY, 700 N. Rush St., Chicago IL 60611. Photo Editor: Moosi Raza Rizvi. Published 7 times/year. Circ. 40,000. Emphasizes parent education. Readers are parents living in the U.S.—rural, urban, suburban and exurban. Sample copy $1.
Photo Needs: Uses about 20-25 photos/issue; all are supplied by freelance photographers. Needs "candid, not cutesy, shots of kids of all ages who live in the 1980s—their parents and teachers; anything to do with infancy through adolescence." Model release required "allowing photo to be used at the editor's discretion."
Making Contact & Terms: Send prints (any size or finish) by mail for consideration. SASE. Reports in 2 weeks. Pays $35/b&w inside and $75/b&w cover each time used. Pays on publication. Credit line given on contents page. Buys all rights. Simultaneous submissions and previously published work OK. Every photo should have the name and address of photographer.
Tips: "Our preference is for the dramatic, uncluttered, strong contrast, clean photo. Send SASE for schedule of topics to be covered in upcoming issues. Next year's themes: October—celebrating our public schools; November—building a safer world for children and youth; December-January—helping children grow; February—fit and healthy children; March—parents in education (a parent/teacher/community involvement theme); April—arts and enrichment; May 1986—all kids are special."

REAL ESTATE TODAY, 430 N. Michigan Ave., Chicago IL 60611-4087. (312)329-8277. Editor: Karin L. Nelson. Publication of the National Association of Realtors. Published 9 times/year. Circ. 710,000. Emphasizes "real estate for active practitioners. We cover residential sales, brokerage-management and commercial-investment sales." Readers are "real estate brokers and salespeople, most of whom are members of the Association; approximately 80% are salespeople." Sample copy available on request.
Photo Needs: Uses about 14 photos/issue (plus photos with mss) supplied by freelance photographers. B&w and 4-color. "Subject matter depends entirely upon the articles to be published. Usually, we assign a project to a photographer based upon our immediate needs." Reviews photos with accompanying ms or appropriate press release only. Special needs include photos relating to "energy conservation in housing and commercial buildings, or to rehabbed and adaptive reuse of commercial buildings." Model release and caption information required.
Making Contact & Terms: Query with resume of credits or samples; provide resume, business card, brochure, flyer or tearsheets to be kept on file for possible future assignments. SASE. Reports in 1 month. Pay is negotiable and based on the particular assignment. Pays on "acceptance and submission of invoice." Credit line given "if desired. We prefer to buy all rights, but will negotiate."
Tips: "Contact us with query letter, samples, etc. We maintain a file and will call if our needs and photographer's portfolio match up. Best tip: ask for a copy of our magazine to see if what we do is what you do."

THE RETIRED OFFICER MAGAZINE, 201 N. Washington St., Alexandria VA 22314. (703)549-2311. Associate Editor: Susan H. McFarland. Monthly. Circ. 345,000. Publication represents the interests of retired military officers from the seven uniformed services: history (particulary Vietnam, Korea, and WWII), travel, hobbies, humor, second-career job opportunities, military family lifestyle and current affairs. Readers are officers or warrant officers from the Army, Navy, Air Force, Marine Corps, Coast Guard, Public Health Service and NOAA. Free sample copy and photo guidelines.
Photo Needs: Uses about 24 photos/issue; 1 (the cover) usually supplied by freelance photographers. "We use many *scenics* showing areas across the country. We hope to run more people shots of Americans or of those native to a particular foreign country featured in a particular issue. We're *always* looking for holiday-related (Christmas, Veteran's Day, Fourth of July) shots with a military theme." Model release not needed; prefers captions and credit line on a separate sheet.
Making Contact & Terms: Send original 35mm, 2x2 or 4x5 transparencies by mail for consideration. SASE. Reports in 3 weeks. Pays $125/color cover photo; $20/b&w inside photo; $35/slides or transparencies for inside use (in color). Pays on acceptance. Credit line and complimentary copies given. Buys first serial rights.

RODEO NEWS, INC., Box 587, Pauls Valley OK 73075. (405)238-3310. Associate Editor: G. Del Hollingsworth. Publication of the International Professional Rodeo Association. Monthly (December-January combined-11 issues). Circ. 15,000 + . Emphasizes rodeo. Readers are "rodeo contestants, producers, stock contractors, committees and fans." Sample copy and photo guidelines free.
Photo Needs: Uses about 30-40 photos/issue; 100% supplied by freelance photographers. Needs "ro-

deo action, arena shots and rodeo-related still shots. Must have identifying cutlines." Captions required.
Making Contact & Terms: Send 5x7 or 8x10 b&w or color glossy prints by mail for consideration. SASE. Reports in 2 weeks. Pays negotiable rates. Pays on publication. Credit line given. Buys all rights.

THE ROTARIAN, 1600 Ridge Ave., Evanston IL 60201. (312)328-0100. Editor: Willmon L. White. Photo Editor: Judy Lee. Monthly magazine. Circ. 502,000. For Rotarian business and professional men and their families in 160 countries and geographical regions. "Our greatest need is for the identifying face or landscape, one that says unmistakably, 'This is Japan, or Minnesota, or Brazil, or France, or Sierra Leone,' or any of the other countries and geographical regions this magazine reaches." Buys 10 photo/issue. Buys first-time international rights. Query with resume of credits or send photos for consideration. Pays on acceptance. Reports in 1-2 weeks. SASE. Free sample copy and photo guidelines.
B&W: Uses 8x10 glossy prints; contact sheet OK. Pays $35.
Color: Uses 8x10 glossy prints or transparencies. Pays $75-100.
Cover: Uses color transparencies. Photos are "generally related to the contents of that month's issue."
Tips: "We prefer vertical shots in most cases. The key words for the freelance photographer to keep in mind are *internationality* and *variety*. Study the magazine. Read the kinds of articles we publish. Think how your photographs could illustrate such articles in a dramatic, story-telling way. Key submissions to general interest, art-of-living material." Plans special pre-convention promotion coverage of 1987 Rotary International convention in Munich, West Germany.

ROWING USA, Suite 980, 251 N. Illinois, Indianapolis IN 46204. (317)237-2769. Editor: Peggy O'Neill. Publication of the U.S. Rowing Association. Bimonthly magazine. Emphasizes competitive and recreational rowing. Readers are competitive and recreational rowers, male and female, ages from 12 to 90. Circ. 11,500. Sample copy $3.
Photo Needs: Uses about 20 photos/issue; 15 supplied by freelance photographers. Needs "rowing photos, particularly news photos of large regattas." Captions preferred.
Making Contact & Terms: Query with samples. SASE. Reports in 3 weeks. Pays $100/b&w cover photo and $25/b&w inside photo. Pays on publication. Credit line given. Buys one-time rights. Simultaneous submissions OK.
Tips: Prefers to see "just good rowing photos—no cliches."

***SAFARI MAGAZINE**, Suite 1680, 5151 E. Broadway, Tucson AZ 85711. (602)747-0260. Editor: W.R. Quimby. Publication of Safari Club International. Bimonthly magazine. Emphasizes big game hunting. Readers are international big game hunters. Circ. 13,000. Sample copy $3.50. Photo guidelines free with SASE.
Photo Needs: Uses 50 photos/issue; all supplied by freelance photographers. Needs photos of live big game animals.
Making Contact & Terms: Query with samples. Send b&w prints and 35mm transparencies by mail for consideration. SASE. Reports in 1 month. Pays $150/color cover photo; $35/b&w inside photo; $50-100/color inside photo. Pays on publication. Credit line given. Buys one-time rights.
Tips: Prefers to see live big game animals in natural settings, not zoo shots—must be trophy size.

ST. LAWRENCE, Publication Office, St. Lawrence University, Canton NY 13617. (315)379-5586. Editor: Neal S. Burdick. Publication of St. Lawrence University. Quarterly. Circ. 21,000. Coverage is "limited exclusively to St. Lawrence University, a small, private, highly selective liberal arts college." Readers are "college graduates, many with advanced degrees; and parents of college students." Sample copy $2.
Photo Needs: Uses about 40 photos/issue; few supplied by freelance photographers. Needs "all kinds of photos." Model release preferred; captions required.
Making Contact & Terms: Arrange a personal interview to show portfolio; query with list of stock photo subjects. SASE. Reports in 1 week. Pays $125/color cover photo; $10/b&w inside photo; $15-40/hour. Pays on acceptance. Buys all rights. Simultaneous and previously published submissions OK.

SAM ADVANCED MANAGEMENT JOURNAL, 2331 Victory Pkwy., Cincinnati OH 45206. (513)751-4566. Editor: Dr. M.H. Abdelsamad. Association publication for the Society for Advancement of Management. Quarterly journal. Emphasizes business management. Readers are upper- and middle-level management executives. Circ. 13,000. Sample copy $6.
Photo Needs: Uses 8 photos/issue. Needs photos of business subjects. Reviews photos with accompanying ms only. Model release required.
Making Contact & Terms: SASE. Reports in 1 month. Pays on publication. Credit line given. Simultaneous submissions and previously published work OK.

SAVINGS INSTITUTIONS, 111 E. Wacker Dr., Chicago IL 60601. (312)644-3100. Editor: Mary Nowesnick. Publication of the US League of Savings Insitutions. Monthly. Circ. 30,000. Emphasizes sav-

ings-institution management. Free sample copy.

Photo Needs: Uses about 25 photos/issue; 5 supplied by freelance photographers, 3-5 photos on assignment, 2-3 firm stock. Model release preferred.

Making Contact & Terms: Query with samples; provide resume, business card, brochure, flyer or tearsheets to be kept on file for possible future assignments. SASE. Reports in 1 month. Payment varies. Pays on acceptance. Credit line given "if requested." Rights purchased vary. Previously published submissions OK.

Tips: "We're looking for photos that fit our style. Request a sample of the publication to see this. Good luck. Keep plugging."

SCIENCE AND CHILDREN, 1742 Connecticut Ave. NW, Washington DC 20009. (202)328-5800. Editor: Phyllis R. Marcuccio. Association publication for the National Science Teachers. Published 8 times/year, September-May. Emphasizes science education. Readers include teachers of science in grades K-8. Circ. 17,500. Free sample copy and photo guidelines with SASE.

Photo Needs: Uses 20 photos/issue; 5 supplied by freelance photographers. Needs "children and young adolescents participating in science activities outdoors or indoors; teachers leading such activities." Reviews photos with or without accompanying ms. Photographers must hold model release; captions requested.

Making Contact & Terms: Query with samples and list of stock photo subjects; or send unsolicited photos by mail for consideration. Uses b&w prints, 35mm transparencies, b&w contact sheets. SASE. Pays $75/color cover photo, $35 b&w inside photo. Pays on acceptance. Credit line given. Buys one-time editorial use only.

SCOUTING MAGAZINE, Boy Scouts of America, 1325 Walnut Hill Lane, Irving TX 75062. Photo Editor: Gene Daniels. Bimonthly magazine. Circ. 1,000,000. For adults within the Scouting movement. Needs photos dealing with success and/or personal interest of leaders in Scouting. Wants no "single photos or ideas from individuals unfamiliar with our magazine." Pays $200 per day against space. "No assignments will be considered without a portfolio review by mail or in person." Call to arrange a personal appointment, or query with ideas. Buys first rights only. Pays on acceptance. Reports in 10 working days. SASE. Free photo guidelines.

SEA FRONTIERS/SEA SECRETS, 3979 Rickenbacker Causeway, Virginia Key, Miami FL 33149. (305)361-5786. Editor-in-Chief: Dr. F.G. Walton Smith. Photo Editor: Jean Bradfisch. Bimonthly magazine. Circ. 30,000. For anyone with an interest in any aspect of the sea, the life it contains and its conservation. Buys 80 photos annually. Buys one-time rights. Send photos for consideration. Credit line given. Pays on publication. Reports in 10 weeks. SASE. Sample copy $3; photo guidelines for business-sized SAE with 22¢ postage.

Photo Needs: Animal (marine); nature (marine); photo feature (marine); scenic (marine); wildlife (marine); vessels, structures and geological features; ocean-related subjects only.

B&W: Send 8x10 glossy prints. Captions required. Pays $10 minimum.

Color: Send 35mm or 2¼x2¼ transparencies. Captions required. Pays $15 minimum.

Cover: Send 35mm or 2¼x2¼ color transparencies. Captions required. Uses vertical format. Allow space for insertion of logo. Pays $50 for front cover and $35 for back cover.

***SEATTLE BUSINESS**, 109 W. Mercer, Seattle WA 98119. (206)285-2050. Editor: Tim Healy. Publication of the Greater Seattle Chamber of Commerce. Monthly magazine. Emphasizes business-related news, analysis, tips, columns. Readers are business executives in the greater Seattle area. Circ. 8,600. Sample copy $2.

Photo Needs: Uses 4-7 photos/issue; 0-1 supplied by freelance photographers. Needs photos of business—"most of our stories are directly related to business in Seattle." Model release preferred; captions required.

Making Contact & Terms: Arrange a personal interview to show portfolio; query with resume of credits and list of stock photo subjects. Does not return unsolicited material. Reports in 1 month. Pays $100-200/color cover photo; $15-100/b&w and color inside photo. Pays on publication. Credit line given. Buys one-time rights. Simultaneous submissions and previously published work OK.

Tips: "Business stories can be dry. I look for the ability to illustrate a story in an interesting, unique way. We don't want to run mug shots only."

THE SECRETARY, 301 East Armour Blvd., Kansas City MO 64111-1299. (816)531-7010. Editor: Shirley S. Englund. Association publication of the Professional Secretaries International. Published 9 times/year. Emphasizes secretarial profession-proficiency, continuing education, new products/methods, and equipment related to office administration/communications. Readers include career secretaries, 98% women, in myriad offices, with wide ranging responsibilities. Circ. 50,000. Free sample copy with SASE.

Photo Needs: Uses 6 photos/issue. Needs secretaries (predominately women, but occasionally men could be used) in appropriate and contemporary office settings using varied office equipment or performing varied office tasks. Must be in good taste and portray professionalism of secretaries. Reviews photos with or without accompanying ms. Model release preferred.
Making Contact & Terms: Query with samples or send unsolicited photos by mail for consideration. Uses 3¹/₂x4¹/₂, 8x10 glossy prints, 35mm, 2¹/₄x2¹/₄, 4x5 and 8x10 transparencies. SASE. Reports in 1 month. Pays on publication. Credit line given. Buys first North American serial rights. Simultaneous submissions and previously published work OK.

SIERRA, 730 Polk St., San Francisco CA 94109. Editor/Publisher: James Keough. Magazine published 6 times annually. Circ. 300,000. For members of the Sierra Club, an environmental organization. Emphasizes outdoor activities, enjoyment of the land and the problems of preserving the environment. Pays $250-1,000 for text/photo package. Credit line given. Buys one-time rights. Contact Art and Production Manager, Linda K. Smith, by mail with 20-40 slides/transparencies representative of stock file. Reports in 2-4 weeks. SASE. Editorial and photography guidelines available.
Photo Needs: Animal (wildlife, endangered species, general—no pet shots); nature/scenic (general scenics of wide variety of places, foreign and domestic, wilderness areas, National Parks, forests, monuments, etc., BLM or Forest Service lands, out-of-the-way places; seasonal shots); outdoor recreation (camping, rafting, skiing, climbing, backpacking); documentary (areas of environmental crises, pollution/industrial damage etc.). "No dupes, superimposed photos, urban/commercial style photos, zoos or nightlife. No submissions *strictly* of butterflies, flowers, etc."
B&W: Send 8x10 prints. Captions required. Pays $100 minimum. B&w submissions not encouraged.
Color: Send transparencies. Captions required. Pays $100 minimum; $125/half page, $150/full page, $175/spread.
Cover: Send color transparencies. Verticals. Captions required. Pays $300.

SIGNPOST MAGAZINE, 16812 36th Ave. W., Lynnwood WA 98037. (206)743-3947. Editor: Ann Marshall. Publication of the Washington Trails Association. Monthly. Emphasizes "backpacking, hiking, cross-county skiing, all nonmotorized trail use, outdoor equipment, and minimum-impact camping techniques." Readers are "people active in outdoor activities, primarily backpacking; residents of the Pacific Northwest, mostly Washington. Age group: 18-80, family-oriented, interested in wilderness preservation, trail maintenance." Circ. 3,800. Free sample copy. Photo guidelines free with SASE.
Photo Needs: Uses about 10-15 photos/issue; 30% supplied by freelance photographers. Needs "wilderness/scenic; people involved in hiking, backpacking, canoeing, skiing; wildlife; outdoor equipment photos, all with Pacific Northwest emphasis." Captions required.
Making Contact & Terms: Send 5x7 or 8x10 glossy b&w prints by mail for consideration. SASE. Reports in 1 month. No payment for inside photos. Pays $20/b&w cover photo. Pays on publication. Credit line given. Buys one-time rights. Simultaneous submissions and previously published work OK.
Tips: "We are always looking for photos that meet our cover specifications. We look for prints that are in focus and contrast enough to reproduce well. We look for the ability of the photographer to think like the editor: to compose and crop the shot for the magazine page. And subjectively, we like to feel part of the scene we are viewing. The photographer should be familiar with *Signpost*. He needn't be a subscriber, but he should at least request a sample copy, or should look up back issues in his library. Contributing to *Signpost* won't help pay your bills, but it can help you 'break into print,' and besides, sharing your photos with other backpackers and skiers has its own rewards."

THE SINGLE PARENT, Suite 1000, 7910 Woodmont Ave., Bethesda MD 20814. (301)654-8850. Editor: Donna Duvall. Assistant Editor: Jacqueline Conciatore. Publication of Parents Without Partners, Inc. Published 6 times/year. Circ. 210,000. Emphasizes "issues of concern to single parents, whether widowed, divorced, separated or never-married, and their children, from legal, financial, emotional, how-to, legislative or first-person experience." Readers are "parents mainly between 30-55, US and Canada." Sample copy free with SASE.
Photo Needs: Uses about 6 photos/issue; all supplied by freelance photographers. "We usually make assignments for a particular story. We also buy shots of children or parents and children." Model release and captions required.
Making Contact & Terms: Query with samples. Send 8x10 b&w prints, b&w contact sheets and color slides/photos by mail for consideration. Provide resume, business card, brochure, flyer or tearsheets to be kept on file for possible future assignments. SASE. Reports in 1 month. Pays $75-100/color cover photo; $50/b&w inside photo. Pays on publication. Credit line given. Negotiates rights purchased. Simultaneous submissions OK.

One-time rights to this photo were purchased by Skate magazine from Ted Kirk, Lincoln, Nebraska. Kirk, a staff photographer for the Journal-Star Newspapers in Lincoln, shot this photograph while covering the United States Amateur Roller Skating Championships. The photo was used on the cover of Skate magazine. Kirk wanted "to show a skater in action and at the same time show the grace of the sport."

***SKATE MAGAZINE**, Box 81846, Lincoln NE 68501. (402)489-8811. Senior Editor: Nance Kirk. A competitive roller skating magazine, plus brochures and other promotional pieces. Buys 20 photos/year; gives 4 assignments/year. Photos used in brochures, newsletters, and magazines.
Subject Needs: Athletes in regional and national roller skating competitions.
Specs: "No set specs—negotiated per assignment."
Payment & Terms: Pay negotiated. Credit line given. Rights negotiated per photo or project. Model release required; captions preferred.
Making Contact: Provide resume, business card, brochure, flyer or tearsheets to be kept on file for possible future assignments. Solicits photos by assignment only. SASE. Reports in 1 month.

SNAPDRAGON, Library - Humanities University of Idaho, Moscow ID 83843. (208)885-6584. Editors: Gail Eckwright, Ron McFarland, Tina Foriyes. Photo Editor: Karen Buxton. Publication for the University of Idaho. Semiannual. Emphasizes poetry, short fiction, art and photography of Idaho and the Pacific Northwest. Circ. 200. Sample copy $2; free photo guidelines with SASE.
Photo Needs: Uses about 6 photos/issue; all supplied by freelance photographers. Needs "artistic photography, of any subject matter. Photographs are run galley style and should have a theme. Six or more photographs should be submitted at once. We are interested in photographs depicting the people and places in Idaho and the Northwest."
Making Contact & Terms: Send unsolicited photos by mail for consideration. Uses 8x10, 5½x7 b&w prints. SASE. Reports in 3 weeks. Buys one-time rights. Payment in copies only. Simultaneous submissions OK.

STUDENT LAWYER, 750 N. Lake Shore Dr., Chicago IL 60611. Editor: Lizanne Poppens. Associate Editor: Sarah Hoban. Publication of the American Bar Association. Magazine published 9 times/school year. Emphasizes social and legal issues for law students. Circ. 40,000. Sample copy upon request.
Photo Needs: Uses about 3-5 photos/issue; all supplied by freelance photographers. "All photos are assigned, determined by story's subject matter." Model release and captions required.
Making Contact & Terms: Arrange a personal interview to show portfolio or send samples. SASE. Reports in 3 weeks. Pays $300/color cover photo; $75-200/b&w, $100-250/color inside photo. Pays on publication. Credit line given. Buys one-time rights. Previously published submissions OK.

THE SURGICAL TECHNOLOGIST, 8307 Shaffer Parkway, Littleton CO 80127. (303)978-9010. Editor: Michelle Armstrong. Publication of the Association of Surgical Technologists. Bimonthly. Circ. 11,000. Emphasizes surgery. Readers are "20-60 years old, operating room professionals, well educated in surgical procedures." Sample copy and photo guidelines free with SASE.
Photo Needs: Uses about 2 photos/issue. Needs "surgical, medical, operating room, preop, postop photos." Model release required.
Making Contact & Terms: Query with samples; submit portfolio for review. Send 8½x11 or 5x7 glossy or matte prints; 35mm, 2¼x2¼ or 4x5 transparencies; b&w or color contact sheets; b&w or color negatives by mail for consideration. Provide resume, business card, brochure, flyer or tearsheets to be kept on file for possible future assignments. SASE. Reports in 2 weeks. Pays $50/b&w cover photo, $100/color cover photo; $25/b&w inside photo, $50/color inside photo. Pays on acceptance. Credit line given. Buys all rights. Simultaneous submissions and previously published work OK.

TEEN TIMES, 1910 Association Dr., Reston VA 22091. (703)476-4900. Editor: Deb Olcott Taylor. Publication of Future Homemakers of America. Bimonthly magazine. Emphasizes youth leadership development for home economics students through grade 12. Readers are "325,000 FHA/HERO members—junior and senior high school students and 12,000 adult advisers and supporters." Sample copy for $1 and SASE.
Photo Needs: Uses approximately 10-15 photos/issue; approximately 80% by freelance photographers (20% sent in by members). Needs photos of "FHA/HERO members and chapters in action; FHA/HERO advisers in action. We occasionally need photographers to cover chapter events (almost everywhere in country)." Written release preferred.
Making Contact & Terms: Provide resume, business card, brochure, flyer or tearsheets to be kept on file for possible future assignments. Payment "depends on assignment/location/use, etc." Credit line given. Buys all rights.

THE TENNESSEE BANKER, Tennessee Bankers Association, 21st Floor, Life & Casualty Tower, Nashville TN 37219. (615)244-4871. Managing Editor: Dianne W. Martin. Monthly magazine. Circ. 2,200. Emphasizes Tennessee bankers and banking news. Buys 12 photos/year; 1 photo/issue. Credit line given. Pays on publication. Buys one-time rights. Query by phone or mail query with samples. SASE. Simultaneous submissions and previously published work OK. Reports immediately.
Photo Needs: Tennessee scenics, historical sites, etc. (cannot use "people" scenes) for the cover. Will not use anything that is outside the state of Tennessee.
Cover: Uses 35mm and 4x5 transparencies. Vertical format preferred.

***TENNIS USA**, 3 Park Ave., New York NY 10016. (212)340-9200. Editor: Mary Witherell. Publication of US Tennis Association. Monthly newspaper. Emphasizes tennis. Readers are the entire membership of the USTA, ranging from teenagers to senior citizens; both sexes. Circ. 250,000. Sample copy free with SASE.
Photo Needs: Uses 20-25 photos/issue; ½ supplied by freelance photographers. Needs tennis action black and white, portraits of tennis people, tennis sites, artistic tennis shots, tennis cartoons. "IDs for photos are required."
Making Contact & Terms: Query with samples. SASE. Reports in 1 month. Pays $25/b&w photo. Pays on publication. Credit line given. Buys one-time rights, "if possible, we like to retain certain photos for files for repeat (paid) use."
Tips: Prefers to see the ability to well frame a tennis action b&w shot under various lighting conditions. "Contact your USTA sectional office for a schedule of tournaments in your area."

TEXTILE RENTAL MAGAZINE, Box 1283, Hallandale FL 33009. (305)457-7555. Managing Editor: Nancy Jenkins. Publication of the Textile Rental Services Association of America. Monthly magazine. Emphasizes the "linen supply, industrial and commercial laundering industry." Readers are "heads of companies, general managers of facilities, predominantly male audience; national and international readers." Circ. 6,000.
Photo Needs: Photos "needed on assignment basis only." Model release preferred; captions preferred or required "depending on subject."
Making Contact & Terms: "We contact photographers on an as-needed basis selected from a directory of photographers." Does not return unsolicited material. Pays $250/color cover plus processing; "depends on the job." Pays on acceptance. Credit line given if requested. Buys all rights. Previously published work OK.
Tips: "Meet deadlines; don't charge more than $100-200 for a series of b&w photos that take less than half a day to shoot."

THE TOASTMASTER, 2200 N. Grand Ave., Box 10400, Santa Ana CA 92711. (714)542-6793. Editor: Tamara Nunn. Monthly magazine. Circ. 120,000. Emphasizes self-improvement, especially in the

areas of communication and leadership. Photos purchased on assignment. Buys 1 photo/issue. Pays $25-150 for text/photo package or on a per-photo basis. Credit line given on request. Pays on acceptance. Buys all rights, but may reassign to photographer after publication. Query with list of stock photo subjects. SASE. Simultaneous submissions and previously published work OK. Reports in 3 weeks. Free sample copy.

Photo Needs: Celebrity/personality (to illustrate text); head shot (speaking, listening management and interviewing); how-to ("definitely—on speaking, listening, interviewing and management"); human interest; and humorous (for special issue relating to speaking situations).

B&W: Uses 8x10 glossy prints. Pays $10-50/photo.

Color: Uses 35mm or $2\frac{1}{4}$x$2\frac{1}{4}$ transparencies. Pays $10-50/photo.

Cover: Uses b&w and color glossy prints or 35mm and $2\frac{1}{4}$x$2\frac{1}{4}$ color transparencies. Vertical format required. Pays $35-75/photo.

Accompanying Mss: Seeks educational mss; how-to with plenty of illustrative examples; on the subjects of speaking, listening techniques, time management, leadership, audiovisuals, etc. Length: 1,800-3,000 words. Pays $25-150/ms. Free writer's guidelines.

Tips: "We would rather buy photos with manuscripts."

TODAY'S INSURANCE WOMAN, Box 4410, Tulsa OK 74159. (918)744-5195. Director of Communications: Vicki J. Rex. Publication of the National Association of Insurance Women. Quarterly. Circ. 19,000. Emphasizes women in business and insurance/financial planning. "*TIW* is edited for the woman who is already established in her insurance career and planning to move up. Our average reader is involved in some sort of continuing education program to assist her in her career advancement." Sample copy $2.50.

Photo Needs: Limited use of photography from outside sources. Special needs include photos of "women featured in business settings in capacities other than secretarial and safety subjects." Model release preferred. Query with list of stock photo subjects. SASE. Pays $50/color cover photo; $10-20/b&w and $20-35/color inside photo. Pays on publication. Credit line given. Buys one-time rights. Simultaneous and previously published work OK.

TORSO/JOCK MAGAZINES, #210, 7715 Sunset Blvd., Los Angeles CA 90046. (213)850-5400. Editor: Timothy Neuman. Creative Art Director: Alfonso Sabelli. Association publication for the GPA (Gay Press Association). Monthly. Emphasizes gay male erotica. The readers include average gay male from all walks of life. Sample copy $5; photo guidelines free with SASE.

Photo Needs: Uses 20-30 photos/issue; 30% supplied by freelance photographers. Needs male nudes. Reviews photos with or without accompanying ms. Model release and captions required. Arrange a personal interview to show portfolio, query with samples or send unsolicited photos by mail for consideration, submit portfolio for review. Uses 5x7 glossy b&w or color prints, 35mm transparencies, contact sheets, negatives. SASE. Reports in 1 month. Pays $200-300/job. Pays on publication. Credit line given. Buys first North American serial rights.

Tips: Needs "good lighting, interesting subject matter, etc. Keep the continuity in color throughout your work. Don't get too artsy. Just simple, good photography."

TOUCH, Box 7259, Grand Rapids MI 49510. (616)241-5616. Managing Editor: Carol Smith. Publication of the Calvinettes. Monthly. Circ. 14,000. Emphasizes "girls 7-14 in action. The magazine is a Christian girls' publication geared to the needs and activities of girls in the above age group." Readers are "Christian girls ages 7-14; multiracial." Sample copy and photo guidelines free with 8x10 SASE. "Also available is a theme update listing all the themes of the magazine for six months."

Photo Needs: Uses about 8-10 photos/issue; "most" supplied by freelance photographers. Needs "photos of cross-cultural girls aged 7-14 involved in sports, Christian service and other activities young girls would be participating in." Model release preferred.

Making Contact & Terms: Send 5x7 b&w glossy prints by mail for consideration. SASE. Reports in 1 month. Pays $20-25/b&w photo. Pays on publication. Credit line given. Buys one-time rights. Simultaneous submissions OK.

Tips: "Make the photos simple. We prefer to get a spec sheet rather than photos and we'd really like to be able to hold photos sent to us on speculation until publication. We select those we might use and send others back. Freelancers should write for our biannual theme update and try to get photos to fit the theme of each issue."

***TRANSPORT TOPICS**, 2200 Mill Rd., Alexandria VA 22314. (703)838-1781. Editor: Oliver B. Patton. Publication of American Trucking Associations. Trade. Weekly tabloid (slick paper). Emphasizes trucking. Readers are trucking industry management, anyone interested in transportation. Circ. 33,000. Sample copy free with SASE. Photo guidelines free with SASE.

Photo Needs: Need scenic, generic pictures of trucks in color and b&w. Captions required.

Making Contact & Terms: Query with samples. SASE. Reports in 3 weeks. Pay negotiated. Pays on acceptance. Credit line given if desired. Buys first North American serial rights. Simultaneous submissions OK.

TURKEY CALL, Box 530, Edgefield SC 29824. (803)637-3106. Publisher: National Wild Turkey Federation, Inc. (nonprofit). Editor: Gene Smith. Bimonthly magazine. Circ. 28,000. For members of the National Wild Turkey Federation—people interested in conserving the American wild turkey. Needs photos of "wild turkeys, wild turkey hunting, wild turkey management techniques (planting food, trapping for relocation), wild turkey habitat." Buys 20-30 photos/annually. Copyrighted. Send photos to editor for consideration. Credit line given. Pays on acceptance. Reports in 4 weeks. SASE. Sample copy $2. Free contributor guidelines for SASE.
B&W: Send 8x10 glossy prints. Captions required. Pays $10-20.
Color: Send color transparencies. Uses any format. Requires space for insertion of logo. Pays $25-50/ inside photo; $100/cover.
Tips: Wants no "poorly posed or restaged shots, mounted turkeys representing live birds, domestic turkeys representing wild birds, or typical hunter-with-dead-bird shots."

UNITED EVANGELICAL ACTION, 450 E. Gundersen, Box 28, Wheaton IL 60189. (312)665-0500. Editor: Don Brown. Bimonthly. Circ. 11,000. Emphasizes religious concerns as those concerns relate to current news events. Readers are evangelicals concerned about putting their faith into practice. Free sample copy and photo guidelines with SASE.
Photo Needs: Uses about 5-10 photos/issue; all are supplied by freelance photographers. No travel or scenic photos. "Think 'news.' On the lookout for photos depicting current news events that involve or are of concern to evangelicals. Interested in photos demonstrating current moral/social problems or needs; Christians reaching out to alleviate human suffering; Christians involved in political rallies, marches or prayer vigils; and leading evangelicals addressing current moral/social issues." Photos purchased with or without accompanying ms. Model release required.
Making Contact & Terms: Query with samples, list of stock photo subjects and send by mail 8x10 b&w glossy or matte prints for consideration. Provide brochure, flyer and periodic mailings of shots available to be kept on file for possible future assignments. SASE. Reports in 1 month. Pays $35-125/ b&w photo. Pays on publication. Credit line given. Buys one-time rights.
Tips: "Would like to see 'people' shots with a strong news or current events, or religious orientation. Please no family or children shots. Send a wide variety of samples. This will allow us to see if your work fits our editorial needs."

UTU NEWS, 14600 Detroit Ave., Cleveland OH 44107. (216)228-9400. Editor: Art Hanford. Monthly tabloid. Circ. 165,000. For railroad and bus employees who are members of the United Transportation Union (UTU). Needs news photos of rail and bus accidents, especially if an employee has been killed. "Avoid gory scenes, but try to get people somewhere in the picture." Wants no photos of simple derailments—"there are hundreds of these every week. Nor do we want grade crossing accident shots unless the train is derailed or a crewman injured." Also needs "unusual shots of rail or bus employees at work." Buys 10-30 photos/year. Not copyrighted. Send photos for consideration. Pays on publication. Reports in 1 month. SASE. Simultaneous submissions OK.
B&W: Send 8x10 glossy prints. Caption material required. Pays $10-25. Photographer must supply Social Security number to be paid.
Tips: "Speed is a must with accident photos. The quicker we get the prints, the better chance they have of being used. Please enclose newspaper clippings with accident shots, if possible." Wants no photos of clean-up operations. Rescue shots "OK."

VIRGINIA WILDLIFE, 4010 W. Broad St., Box 11104, Richmond VA 23230. (804)257-1000. Editor: Harry L. Gillam. Monthly magazine. Circ. 55,000. Emphasizes Virginia wildlife, as well as outdoor features in general, fishing, hunting, and conservation for sportsmen and conservationists. Photos purchased with accompanying ms. Buys 2,000 photos/year. Credit line given. Pays on acceptance. Buys one-time rights. Send material by mail for consideration. SASE. Reports (letter of acknowledgement) within 10 days; acceptance or rejection within 45 days of acknowledgement. Free sample copy and photo guidelines.
Subject Needs: Good action shots relating to animals (wildlife indigenous to Virginia); action hunting and fishing shots; photo essay/photo feature; scenic; human interest outdoors; nature; travel; outdoor recreation (especially boating); and wildlife. Photos must relate to Virginia. No "dead game and fish!"
Color: Uses 35mm and 2¼x2¼ transparencies. Pays $15-25/photo.
Cover: Uses 35mm and 2¼x2¼ transparencies. Vertical format required. Pays $125/photo.
Accompanying Mss: Features on wildlife; Virginia travel; first-person outdoors stories. Pays 15¢/ printed word. Free writer's guidelines; included on photo guidelines sheet.

Tips: "We don't have time to talk with every photographer who submits work to us. We discourage phone calls and visits to our office, since we do have a system for processing submissions by mail. Our art director will not see anyone without an appointment. Show only your best work. Name and address must be on each slide. Plant and wildlife species should also be identified on slide mount. We look for outdoor shots (must relate to Virginia); close ups of wildlife."

VITAL CHRISTIANITY, 1200 E. 5th St., Anderson IN 46011. (317)644-7721. Editor-in-Chief: Arlo F. Newell. Managing Editor: Richard L. Willowby. Publication of the Church of God. Published 20 times/year. Circ. 28,000. Emphasizes Christian living. "Our audience tends to affiliate with the Church of God." Sample copy and photo guidelines $1 with SASE.
Photo Needs: Uses about 5 photos/issue; 2 supplied by freelance photographers. Needs photos of "people doing things, family life, some scenic." Special needs include "minorities, people 40-93." Model release preferred.
Making Contact & Terms: Query with samples. Send b&w glossy prints, or 4x5 or 8x10 transparencies by mail for consideration. SASE. Reports in 1 month. Pays $125-150/color cover photo; $25-40/b&w inside photo. Pays on acceptance. Credit given on contents page. Buys one-time rights. Simultaneous submissions and previously published work OK.
Tips: "Send carefully selected material quarterly (not every month), and make sure people photos are up-to-date in dress and hairstyle."

THE WAR CRY, The Salvation Army, 799 Bloomfield Ave., Verona NJ 07044. (201)239-0606. Editor-in-Chief: Lt. Colonel Henry Garicpy. Publication of The Salvation Army. Biweekly. Circ. 280,000. Emphasizes the inspirational. Readers are general public and membership. Sample copy free with SASE.
Photo Needs: Uses about 6 photos/issue. Needs "inspirational, scenic, general illustrative photos."
Making Contact & Terms: Send b&w glossy prints or contact sheets by mail for consideration. SASE. Reports in 2 weeks. Pays $35/b&w photo; up to $150/color photo; payment varies for text/photo package. Pays on acceptance. Credit line given "if requested." Buys one-time rights. Simultaneous submissions and previously published work OK.

WASHINGTON WILDLIFE MAGAZINE, Washington Department of Game, 600 N. Capitol Way, Olympia WA 98504. (206)753-5707. Editor: Janet O'Mara. Quarterly magazine. Emphasizes wildlife and wildlife recreation in Washington state. Readers include hunters, fishermen, nongamers, bird watchers, hikers and photographers. Circ. 13,000. Photo guidelines free with SASE.
Photo Needs: Uses about 7-9 color and 10-15 b&w photos/issue; ½ to ⅔ supplied by freelance photographers. Needs "shots of wildlife that live *in Washington*; occasionally Washington scenics and habitat, wraparound covers, some how-tos." Special needs include "photos to enlarge for wraparound covers." Model release and captions preferred.
Making Contact & Terms: Arrange a personal interview to show portfolio; or query with samples; send no smaller than 5x7 matte or glossy prints, 35mm, 2¼x2¼ or 4x5 transparencies by mail for consideration; provide resume, business card, brochure, flyer or tearsheets to be kept on file for possible future assignments. SASE. Pays in copies of magazine. Credit line given. "We do not purchase rights. We may ask to use photos in our other publications or displays with approval."
Tips: Prefers to see "clarity, sharpness, unusual angles and interesting animal expressions" in photos. "Strive for highlights in wildlife's eyes, good close-up animal portraits, interesting lighting, subjects that appeal to families."

WASTE AGE MAGAZINE, 10th Floor, 1730 Rhode Island Ave. NW, Washington DC 20036. (202)659-4613. Editor: Joseph A. Salimando. Publication of the National Solid Wastes Management Association. Monthly magazine. Emphasizes management of solid wastes. Readers are sanitation departments, refuse haulers, etc. Circ. 30,000.
Photo Needs: Uses about 12-20 photos/issue; 3-5 supplied by freelance photographers. Needs "cover shots in color illustrating main story in magazine; inside shots to go with that story. We need names of artists who can take cover photos of quality in various areas of the country."
Making Contact & Terms: Provide resume, business card, brochure, flyer or tearsheets to be kept on file for possible future assignments. SASE. Reports in 3 weeks. Pays $200/color cover. Pays on acceptance. "Sometimes" gives credit line. Buys all rights.
Tips: "Print up a cheap brochure, resume or similar item describing experience, covers taken, etc., (maybe include a photocopy, offering sample on request) and price range."

THE WATER SKIER, Box 191, Winter Haven FL 33882. (813)324-4341. Editor: Duke Cullimore. Publication of the American Water Ski Association. Bimonthly magazine. Emphasizes water skiing. Readers are members of American Water Ski Association, active, competitive and recreational water skiers. Circ. 18,500. Photo guidelines free with SASE.

Photo Needs: Uses 40-50 photos/issue; "few" supplied by freelance photographers. Photos purchased with accompanying manuscript only except for color used on the cover. Model release and captions required.

Making Contact & Terms: Query with photo story ideas. SASE. Reports in 3 weeks. Pays lump sum for text/photo package. Pays on acceptance. Credit line given. Buys one-time rights.

***WHAT IS MAGAZINE**, Box 6068, Malibu CA 90264. Editor: Sharon Boyd. Publication of Reincarnationists. Quarterly magazine. Emphasizes reincarnation and karma—how to end suffering and attain peace of mind. Readers are people interested in the subject of reincarnation and karma, psychic development, life after death, eastern philosophy. Circ. 24,000. Estab. 1986. SASE for copy.

Photo Needs: Uses 15 photos/issue; most supplied by freelance photographers. Needs surreal photos—"spooky" shots, double image type photos—infering a ghostly presence, etc. Also shots that would be in keeping with Eastern wisdom and tranquility, and leaving much light colored open space for editorial copy to overprint. Model release required.

Making Contact & Terms: Send unsolicited photos by mail for consideration. Send b&w and color prints; 35mm, 2¼x2¼ transparencies by mail for consideration. "We are primarily interested in color for this publication." SASE. Reports in 2 weeks. Pays on publication. Credit line given if desired. Buys one-time rights. Simultaneous submissions and previously published work OK.

WILDERNESS, 1400 Eye St. NW, Washington DC 20005. (202)842-3400. Editor: T.H. Watkins. Quarterly magazine. Circ. 140,000. Membership publication of The Wilderness Society; focuses on wilderness preservation and public land management in the U.S. Buys 100-180 photos/year. Pays on publication. Buys first serial rights. Query first for photo guidelines. SASE (8½x11), sample copy $2.

Subject Needs: "We are concerned especially with unprotected federal lands, so snapshots of a favorite pond in one's backyard or a favorite woods or seashore are of no interest. Photos of people are not used." Captions required.

Specs: Uses 8x10 b&w prints; 4x5 and larger transparencies (no duplicates).

Payment & Terms: Pays $75/b&w photo; $125/full inside page or less; $150/back cover; $250/front cover.

WIRE JOURNAL, 1570 Boston Post Rd., Guilford CT 06437. (203)453-2777. Editor: Arthur Slepian. Monthly. Circ. 13,000. Emphasizes wire industry (worldwide). Readers are members of the Wire Association International and others including industry suppliers, manufacturers, research and development, production engineers, purchasing managers, etc. Free sample copy with SASE.

Photo Needs: Uses about 30 photos/issue; "very few" are supplied by freelance photographers. Needs photos of "wire manufacturing of all descriptions that highlights a production activity or products (finished and in fabrication). Also fiber optics, and plant engineering in wire plants." Photos purchased with or without accompanying ms. Special needs include cover photos (4 special issues) in color. Model release and captions preferred.

Making Contact & Terms: Send by mail for consideration 8x10 b&w glossy prints, 2¼x2¼ or 4x5 slides or b&w contact sheet; query with samples or submit portfolio for review. SASE. Reports in 2 weeks. Provide resume, business card and tearsheets to be kept on file for possible future assignments. Pays $350/color cover photo; $25/b&w inside photo and $250-350 for text/photo package. Pays on publication. Credit line given for cover photos only. Buys all rights.

Tips: Prefers to see "industrial subjects showing range of creativity."

WOODMEN OF THE WORLD, 1700 Farnam St., Omaha NE 68102. (402)342-1890, ext. 302. Editor: Leland A. Larson. Monthly magazine. Circ. 470,000. Official publication for Woodmen of the World Life Insurance Society. Emphasizes American family life. Photos purchased with or without accompanying ms. Buys 25-30 photos/year. Credit line given on request. Pays on acceptance. Buys one-time rights. Send material by mail for consideration. SASE. Previously published work OK. Reports in 1 month. Free sample copy and photo/writer's guidelines.

Subject Needs: Historic; animal; celebrity/personality; fine art; photo essay/photo feature; scenic; special effects & experimental; how-to; human interest; humorous; nature; still life; travel; and wildlife. Model release required; captions preferred.

B&W: Uses 8x10 glossy prints. Pays $10-25/photo.

Color: Uses 35mm, 2¼x2¼ and 4x5 transparencies. Pays $25 minimum/photo.

Cover: Uses b&w glossy prints and 4x5 transparencies. Vertical format preferred. Pays $25-150/photo.

Accompanying Mss: "Material of interest to the average American family." Pays 5¢/printed word.

Tips: "Submit good, sharp pictures that will reproduce well. Our organization has local lodges throughout America. If members of our lodges are in photos, we'll give them more consideration."

WORDS, 1015 N. York Rd., Willow Grove PA 19090. (215)657-3220. Editor/Publisher: Mark Hertzog. Art Director: Nancy A. East. Bimonthly. Circ. 18,000. Emphasizes information/word processing

and personal computer use. Readers are word processing managers, office automation consultants, educators and manufacturers—male and female, ages 20-50. Free sample copy with SASE.

Photo Needs: Uses about 2-4 photos/issue; 1-2 are supplied by freelance photographers. Needs photos of management shots; equipment shots; people and word processing equipment and creative, editorial photos of the industry. Photos purchased with or without accompanying ms. Model release required.

Making Contact & Terms: Arrange a personal interview to show portfolio or query with samples. Reports in 2 weeks. Provide resume, business card or tearsheets to be kept on file for possible future assignments. Pays $50-200/b&w photo; $50-400/color photo; $10-15/hour; or $40-75/day. Pays on publication. Credit line given. Buys all rights.

Tips: "Know the information/word processing field. Prefers to see printed samples and photographer's favorites, as well as clean, neat prints. We are a professional organization that has to work within strict deadlines, and demands quality images. We look for variety (fun pieces, serious, special effects, etc.)."

WYOMING RURAL ELECTRIC NEWS, Suite 101, 340 W. B St., Casper WY 82601. (307)234-6152. Editor: Gale A. Eisenhauer. Publication of Rural Electric. Monthly. Circ. 38,500. "Electricity is the primary topic. We have a broad audience whose only common bond is an electrical line furnished by their rural electric system. Most are rural, some are ranch." Sample copy free with SASE and 54¢ postage.

Photo Needs: Uses about 4 photos/issue; 1 supplied by freelance photographers. Needs "generally scenic or rural photos—wildlife is good, something to do with electricity—ranch and farm life." Model release and captions preferred.

Making Contact & Terms: Query with samples or list of stock photo subjects. SASE. Reports in 1 month. Pays up to $50/color cover photo; $5/b&w inside photo. Pays on publication. Credit line given. Buys one-time rights. Simultaneous submissions and previously published work OK.

Tips: "Keep in mind that we have a basically rural audience with a broad variety of interests."

YOGA JOURNAL, 2054 University Ave., Berkeley CA 94704. (415)841-9200. Editor-in-Chief: Stephan Bodian. Photo Editor: Diane McCarney. Publication of California Yoga Teachers' Association. Bimonthly. Circ. 25,000. Emphasizes yoga.

Photo Needs: Buys about 20 photos/issue; all supplied by freelance photographers. Needs "mostly yoga related photos; some food, scenic." Model release required; captions preferred.

Making Contact & Terms: Arrange a personal interview to show portfolio or query with samples. SASE. Reports in 1 month. Pays $150-250/color cover photo and $15-30/b&w inside photo. Pays on publication. Credit line given. Buys one-time rights. Simultaneous submissions OK.

YOUNG CHILDREN, 1834 Connecticut Ave., NW, Washington DC 20009-5786. (202)232-8777. Editor: Janet Brown McCracken. Bimonthly journal. Circ. 55,000. Emphasizes education, care and development of young children and promotes education of those who work with children. Read by teachers, administrators, social workers, physicians, college students, professors and parents. Photos purchased with or without accompanying ms. Buys 5-10 photos/issue. Credit line given. Pays on publication. Also publishes 8 books/year. Query with samples. SASE. Simultaneous submissions and previously published work OK. SASE. Reports in 2 weeks. Free sample copy and photo guidelines.

Subject Needs: Children (from birth to age 8) unposed, with/without adults. Wants on a regular basis "children engaged in educational activities: art, listening to stories, playing with blocks—typical nursery school activities. Especially needs ethnic photos." No posed, "cute" or stereotyped photos; no "adult interference, sexism, unhealthy food, unsafe situations, old photos, children with workbooks, depressing photos, parties, religious observances." Model release required.

B&W: Uses glossy prints. Pays $15/photo.

Cover: Uses color transparencies. Pays $50/photo.

Accompanying Mss: Professional discussion of early childhood education and child development topics. No pay. Free writer's guidelines.

Tips: "Write for our guidelines and sample issue."

***ZYMURGY,** Box 287, Boulder CO 80306. (303)447-0816. Editor: Charlie Papazian. Publication of the American Homebrewer Association. Quarterly magazine. Emphasizes beer, brewing, homebrewing, breweries. Readers are "persons with a passionate interest in beer." Circ. 7,000. Sample copy $1; photo guidelines with SASE and 37¢ postage.

Photo Needs: Uses 30 photos/issue; 10-25% supplied by freelance photographers. Needs photos of breweries and historical photos. Model release and captions required.

Making Contact & Terms: Send 5x7 b&w glossy prints, 35mm, 2¼x2¼ and 4x5 transparencies or b&w contact sheets by mail for consideration. SASE. Reports in 2 weeks. Pays $100-400/color cover photo; $10-50/job. Pays on publication. Credit line given. Buys one-time rights. Simultaneous and previously published submissions OK.

Company

Company publications are read by a select group who generally share the bond of being employed by the same corporation or business. The readership, in many companies, can range beyond the immediate employees to include stockholders, employees of branch offices, professionals in related industries, or purchasers of the company's product or service who wish to keep up on consumer news.

Some company publications are smaller, newsletter oriented, while many more are slick, professionally produced pieces. In any case, the slant will be a little different from general periodicals—it will be more public-relations oriented. And the publications may very well be produced in an inhouse public relations or corporate communications department rather than a publications department. Publishers of these periodicals want coverage of the company's activities presented in a positive light.

Do a little research here before submitting any photography. Get to know the types of products or services the company deals with, and become familiar with the type of photography they require and how it is used. Also, read through some sample copies of publications produced by the company. Some of the larger companies pay quite well, so it is worth your efforts to do a little research beforehand.

This is also a field where good writing skills can generate an increased chance of making a sale. Your initial research could turn up some story ideas or, as you develop a working relationship with the corporate executives, the executives themselves may suggest particular photojournalism projects.

ABOARD, 777 41 St., Miami Beach FL 33140. (305)673-8577. Editor: Anna Mix. Inflight magazine of Dominicana/Ecuatoriana/Air Panama/Air Paraguay/Lloyd Aero Boliviano/LanChile/TACA/VIASA. Bimonthly. Circ. 100,000. Emphasizes travel destinations for passengers on the eight airlines listed above. Sample copy free with SASE and $1.90 postage; photo guidelines free with SASE.
Photo Needs: Uses about 50-60 photos/issue; 20 supplied by freelance photographers. "Photos *must* be related to the article and submitted along with copy of article for editor's approval. Mostly destinations of the airlines, but also sports, business, health and travel-related photo essays." Model release and captions required.
Making Contact & Terms: Send 5x7 or 8x10 b&w glossy prints; 35mm, 2¼x2¼, 4x5, 8x10 transparencies; or b&w contact sheet by mail for consideration. SASE. Reports in 1 month. Pays $50-150 for text/photo package. Credit line given. Buys simultaneous and reprint rights. Simultaneous submissions and previously published work OK.
Tips: Prefers to see "colorful, crisp, informative shots related to interesting stories."

AMERICAN NURSERYMAN, 111 N. Canal St., Chicago IL 60606. (312)782-5505. Editor: Brian Smucker. A semimonthly publication of the American Nurseryman company. Emphasizes horticulture—the woody ornamental nursery business. Readers include owners and managers of nurseries, garden centers and landscaping companies. Circ. 15,000. Sample copy $3.
Photo Needs: Uses about 50-75 photos/issue; some supplied by freelance photographers. Needs individual plant habits and detail shots, store displays, people shots, created landscapes (residential and commercial property landscaping). Reviews photos with or without accompanying ms. Special needs include photos for business management articles. Captions required.
Making Contact & Terms: Query with list of stock photo subjects; send unsolicited photos by mail for consideration. Uses 5x7 or 8x10 glossy b&w/any size transparencies. SASE. Reports in 3 weeks. Pays $10/color or b&w cover; $10/inside color or b&w photo. Pays on publication. Credit line given if requested. Buys one-time rights. Simultaneous submissions and previously published work OK if not submitted to or published by other national nursery trade magazines.
Tips: "We pay very little, but we believe we're the best, most respected trade magazine in the nursery business."

APPLIED CARDIOLOGY, 1640 5th St., Santa Monica CA 90401. (213)395-0234. Editor: Esther Gross. Photo Editor: Tom Medsger. Company publication of the Medical journal. Bimonthly. Emphasizes cardiology in all its aspects. Not open heart surgery. Readers are cardiologists.
Photo Needs: Uses 2-3 photos/issue; all supplied by freelance photographers. Needs everything relating to the heart and cardiology. Abstracts, stylized treatments for covers. Reviews photos with or without accompanying ms. Model release required; captions preferred.
Making Contact & Terms: Query with resume of credits, samples and list of stock photo subjects. Uses any size color prints, 35mm, 2¼x2¼ transparencies. SASE. Reports in 2 weeks. Pays $400/color cover photo, $100 inside cover photo. Pays on acceptance. Credit line given for cover photo. Buys all rights. Photo is returned to photographer. Brentwood Publishing reserves the right to use photo again in any of its publications.

AUTOMOTIVE GROUP NEWS, 5200 Auto Club Dr., Dearborn MI 48126. (313)593-9600. Editor-in-Chief: Chuck Thomas. Bimonthly. Circ. 20,000. Publication of United Technologies. Emphasizes high-technology electronics and automotive components. Readers are employees, press and executives. Free sample copy with SASE (when available).
Photo Needs: Uses about 16-20 photos/issue; all are supplied by freelance photographers. Photos purchased with or without accompanying ms. Model release and captions preferred.
Making Contact & Terms: Send query with samples. Does not return unsolicited material. Reports in 4-6 weeks. Provide business card and tearsheets to be kept on file for possible future assignments. Payment negotiable. Pays on acceptance. Buys all rights. Simultaneous submissions OK.
Tips: Assigns photos of high-technology products and applications in the auto industry.

CATERPILLAR WORLD, 100 NE Adams ABID, Peoria IL 61629-1470. Editor: Tom Biederbeck. Quarterly magazine. Circ. 75,000. Emphasizes Caterpillar people, products, plants and human interest features with Caterpillar tie-in, for Cat employees, dealers and customers. Photos purchased with accompanying ms or on assignment. Pays on acceptance. Submit portfolio for review or query with samples. "SASE necessary." Reports in 2 weeks.
Subject Needs: Personality and documentary (of anything relating to Caterpillar); photo essay/photo feature (on construction projects, etc.); product shot; and human interest. "We don't want to see Cat products without accompanying texts. Feature the people, then show the product. Please don't send anything that doesn't have a Caterpillar tie." Model release preferred; captions required.
Color: Uses all format transparencies; contact sheet and negatives OK.
Cover: Color contact sheet OK; or color transparencies.
Accompanying Mss: "Anything highlighting Caterpillar people, products, plants or dealers." Free writer's guidelines and sample copy.
Tips: "Please send photos well protected and insured. We have had some lost in transit."

CENTERSCOPE, 1325 N. Highland Ave., Aurora IL 60506. (312)859-2222. Public Relations Director: Sharon Muhlethaler. Publication of Mercy Center for Health Care Services. Quarterly. Circ. 6,500. Emphasizes medical care, technology, wellness.
Photo Needs: Uses about 40 photos/issue; 2 supplied by freelance photographers. Needs photos of people and faces; medical/hospital scenes. Model release required; captions preferred.
Making Contact & Terms: Query with samples. Provide resume, business card, brochure, flyer or tearsheets to be kept on file for possible future assignments. SASE. Reports in 2 weeks. Pays $125-500 per job. Pays on acceptance. Credit line given. Buys all rights.

CONTACT MAGAZINE, 2500 IDS Tower, Minneapolis MN 55474. (612)372-3543. Editor: Marie Davis. Publication of IDS Financial Services, Inc. Quarterly. Circ. 10,000. Emphasizes financial services. Readers are home office employees, registered representatives throughout the country, retirees and others. Sample copy free with SASE.
Photo Needs: Uses about 25 photos/issue; some are supplied by freelance photographers. Needs "photojournalist impressions of people or work. Generally, we do *not* purchase file photos."
Making Contact & Terms: Query with samples. SASE. Reports in 1 month. Pays $10-50 maximum/hour; $50-500/day. Pays on acceptance. Credit line given. Buys all rights.
Tips: Prefers to see "b&w photojournalism" in samples. "Offer good work and pleasant client/photographer working arrangements. Be involved in the whole project, from the concept stage. Know the story you're trying to tell."

 The asterisk before a listing indicates that the listing is new in this edition. New markets are often the most receptive to freelance contributions.

CREDITHRIFTALK, 601 NW 2nd St., Box 59, Evansville IN 47701. (812)464-6638. Editor: Gregory E. Thomas. Monthly magazine. Circ. 4,200. "The publication emphasizes company-related news and feature stories. Employees read *CTT* for in-depth information regarding company events and policy and to gain a better understanding of fellow employees." Photos purchased with or without accompanying ms. Works with freelance photographers on assignment only basis. Provide business card to be kept on file for possible future assignments. Credit line given if requested. Pays on acceptance. Not copyrighted. Query with b&w contact sheet showing business portraits and/or candid people photos. SASE. Simultaneous submissions and previously published work OK. Reports in 2 weeks. Free sample copy and photo guidelines for SASE.

Photo Needs: Uses 30 photos/issue; 20 supplied by freelance photographers. Head shot ("the majority of photos purchased are of this type—subjects include newly promoted managers, and photos are also used for advertising, files, etc."); and photo essay/photo feature (depicting company offices or employees). "I don't want to see photos that don't relate to either our company or the finance industry. *Credithriftalk* is published by Credithrift Financial, which has over 850 consumer finance branches in 31 states coast-to-coast. Also known as General Finance. In California we are known as Morris Plan. Feature subjects have ranged from an employee working as a volunteer probation officer to one coaching a softball team. Any subject will be considered and in some cases I may be able to supply a subject for a photographer who lives near an office. We always need good portrait photographers. Please include your daytime phone number in your query." Pays $10-25/b&w for portraits and office exterior shots; $50-250/job for photo essay assignments.

Accompanying Mss: Feature stories describing employees involved in any activity or interest, and articles of general interest to the finance or credit industry.

CSC WORLD, Computer Sciences Corporation, 2100 E. Grand Ave., El Segundo CA 90245. (213)615-0311. Manager, Employee Publications: Mary Rhodes. Quarterly. Circ. 18,000. Emphasizes computer services. Readers are "professional and high technically oriented individuals." Sample copy free with SASE.

Photo Needs: Uses about 20 photos/issue; 1 supplied by freelance photographers. Needs photos of people at work—special projects (military and space oriented). Photos purchased with accompanying ms only. Captions preferred.

Making Contact & Terms: Query with list of stock photo subjects; send b&w prints, contact sheet, b&w negatives by mail for consideration. Provide resume, business card, brochure, flyer or tearsheets to be kept on file for possible future assignments. SASE. Reports in 1 week. Pay varies. Pays on acceptance. Credit line given. Buys one-time rights. Simultaneous submissions and previously published work OK.

DEPARTURES, Travel Marketing Dept., 3rd Floor, 101 McNabb, Markham, Ontario, Canada L3R 4H8. (416)474-8000. Editor: Dianne Dukowski. Quarterly. Circ. 80,000. Emphasizes travel. Readers are active travellers. Sample copy free with SASE.

Photo Needs: Interested in highest quality photography only. Prefers articles submitted with accompanying photography.

Making Contact & Terms: Query articles with a sample of photography, preferably previously published work that does not need to be returned. Provide list of destinations and subject matter. SASE. Pays $50-200/color inside photo and $350 minimum for text/photo package. Pays on acceptance. Credit line given. Buys one-time rights. Previously published work OK.

Tips: "Deals primarily with Canadian writers/photographers."

DISCOVERY, Allstate Motor Club, 3701 W. Lake Ave., Glenview IL 60025. (312)291-5416. Editor: Elizabeth Brewster. Publication of Allstate Motor Club. Quarterly. Circ. 1,300,000. Emphasizes travel. Readers are members of the Allstate Motor Club. Free sample copy and photo guidelines with large SASE and $1 postage.

Photo Needs: Uses about 40 photos/issue; all supplied by freelance photographers. Needs travel photos—"but not straight travel scenic shots. Should have a specific subject." Model release and captions preferred.

Making Contact & Terms: Query with resume of credits or with samples. SASE. Reports in 2 weeks. Pays ASMP rates. Pays on acceptance. Credit line given. Buys one-time rights. Previously published work OK.

Tips: Portfolio "should be good solid photojournalism—we're not just looking for pretty nature shots or scenics. Be familiar with the magazine you're working with. Be persistent."

ECHELON, (formerly *Skylite*), 12955 Biscayne Blvd., North Miami FL 33181. (305)893-1520. Executive Editor: Chauncey Mabe. Editor: Debra Silver. Publication of Butler Aviation International. Monthly. Circ. 25,000. Emphasizes business and business personalities. Readers are corporate executives and

their families. Sample copy $3; photo guidelines free with SASE.

Photo Needs: Uses about 30-40 photos/issue; 90% supplied by freelance photographers. "The magazine covers a wide spectrum, in addition to business/industry: sports, science, domestic and foreign travel, lifestyle, etc." Photos usually purchased with accompanying ms. Model release and captions preferred.

Making Contact & Terms: Provide resume, business card, brochure, flyer or tearsheets to be kept on file for possible future assignments. SASE. "Sometimes it may take 2-3 months" to report. Pays $150/color cover photo; $50/color inside photo; $50/color page and $300-500 for text/photo package. Pays on publication. Credit line given. Buys one-time rights. Simultaneous submissions OK.

Tips: "Be persistent—it's a very competitive field, but quality will find a market."

***ENDLESS VACATION PUBLICATIONS, INC.**, Box 80260, Indianapolis IN 46280. (317)848-5000. Editor: Helen Wernle. Photo Editors: Pat Prather/Lisa Krassick. Bimonthly magazine. Emphasizes travel features and topics of interest to vacation owners. Ninety-eight percent of readers are vacation owners. Circ. 500,000.

Photo Needs: Uses 76 photos/issue; 20% supplied by freelance photographers. Needs photos of travel, destination shots, people, scenic. Model release preferred.

Making Contact & Terms: Provide resume, business card, brochure, flyer or tearsheets to be kept on file for possible future assignments. Does not return unsolicited material. Reports in 2 weeks. Pays $300/color cover photo; $135-200/color inside photo. Pays on publication. Credit line given. Buys one-time rights. Simultaneous submissions and previously published work OK.

Tips: Prefers to see sharp focus, graphic treatment of travel destinations, as well as typical travel photos.

ESPRIT, #1 Horace Mann Plaza, Mail #E002, Springfield IL 62715. (217)789-2500, ext. 5734. Manager Corporate Photographic Services: David Waugh. Publication of The Horace Mann Companies. Quarterly. Circ. 1,400. Emphasizes the "concerns of our agents' personal lives; what they do when they're not working." Readers are sales agents and their families. Sample copy free with SASE.

Photo Needs: Uses about 4 photos/issue; all supplied by freelance photographers. Needs photos of "agents and their families—for example, the wife of an agent in her daycare school; an agent and his wife who raise Salukis. We write the mss." Captions preferred.

Making Contact & Terms: Provide resume, business card, brochure, flyer or tearsheets to be kept on file for possible future assignments. SASE. Reports "when we need a photographer in his/her area of the country." Pays $25-30/hour; $125 maximum/job. Pays on acceptance. Credit line given. Buys all rights. Simultaneous submissions and previously published work OK.

Tips: "Let us know you're interested in working for us and we'll call you when we need a photographer from your area. We're now using freelance photographers more often than in the past."

THE EXPLORER, Cleveland Museum of Natural History, Wade Oval, University Circle, Cleveland OH 44106. (216)231-4600. Editor-in-Chief: Aaron M. Leash. Emphasizes natural history and science for members of 41 natural history and science museums located all over the country. Quarterly. Circ. 29,000. Free photo guidelines.

Photo Needs: Uses about 40 photos/issue, 30% of which are supplied by freelance photographers. "Most of our color and b&w photos are submitted by mail. Museums which are members of our 41 institution consortium have their own photographic staffs which *contribute* pictures. Our policy is to use only technically excellent, professional quality, sharp photographs with superior storytelling content. This does not rule out amateurs' work—but your pictures have to equal professional quality. Our printing quality is top-notch and done on heavy glossy paper. We want both the editor and the photographer to be proud of the photo(s) printed in *The Explorer*, the only picture magazine publication published solely for a large group of fine natural history and science museums. The magazine runs on a shoestring budget but we take a backseat to no publication in scientific approach to relating words and pictures. *The Explorer* has coast to coast circulation distributed through museum memberships. It now has national magazine status in the eyes of public and educational institution libraries where you may find a copy to study. We wish to see b&w photos of animals (not domesticated), nature subjects, oddities of nature, people engaged in exploring nature and science—everything from butterfly catching, looking through binoculars at birds, collecting insects, underwater photography, weather, big close-ups of unusual species of fauna and flora to subjects *you* specialize in shooting in nature. We are always in the market for vertical color covers and full-page color shots of U.S. animals."

Column Needs: "Photo Essays"—a roundup of briefly stated facts about a nature and science subject illustrated by photos." Informative captions required.

Making Contact & Terms: Send by mail for consideration actual 5x7 or 8x10 b&w and color prints; 35mm, 2¼x2¼, 4x5 or 8x10 color transparencies; or b&w or color contact sheet; query with resume of photo credits or with list of stock photo subjects. SASE. Reports in 3-6 weeks, sooner if possible. Pays on publication with 5 free copies/byline and sometimes a biography or profile of photographer. Credit line given. Buys one-time rights. Simultaneous and previously published work OK.

***FALCON**, Eastern Airlines, Bldg. 16, Rm. 810 (MIALR), Miami International Airport, Miami FL 33148. Editor: Lee C. Bright. Biweekly tabloid. Circ. 43,600. For employees of Eastern Airlines, their families and retirees. Buys 6 photos annually. Buys all rights. Model release not required when subjects are employees; submit model release with photos when subjects are the "traveling public." Notify editors of availability, rates, etc. before attempting assignment. Provide business card and brochure to be kept on file for possible future assignments. Pays on publication. Simultaneous submissions OK.
Subject Needs: Celebrity/personality, head shot, human interest, photo essay/photo feature, scenic, sport, spot news and airport life. Photos depicting "employee participation in business and recreation." No photos without people, obviously posed shots, out of focus photos, poorly printed work, "grain" or "picket profile/fence slats shots of groups."
B&W: Uses 8x10 glossy or semigloss prints "and full color transparencies (slides) since 16 pages of each selection are in 4-color;" prefers contact sheet and negatives for custom processing. Captions required. Pays $20-30/published photo. "We're looking for crisp, well-composed color slides and b&w prints."

***FARM FAMILY AMERICA**, 1999 Shepard Rd., St. Paul MN 55116. (612)690-7200. Editor: George Ashfield. Photo Editor: Julie Hally. Publication of American Cyanamid. Quarterly magazine. Emphasizes travel, sport activities, lifestyle. Readers are high income farmers and farm families. Circ. 300,000. Estab. 1986. Sample copy free with SASE.
Photo Needs: Uses 18 photos/issue; 12-15 supplied by freelance photographers. Needs photos of travel destinations, US and foreign—sporting activities including fishing, hunting, skiing, etc. Reviews photos with accompanying ms only. Model release required; captions preferred.
Making Contact & Terms: Provide resume, business card, brochure, flyer or tearsheets to be kept on file for possible future assignments. SASE. Reports in 1 month. Pays ASMP suggested rates. Pays on acceptance. Credit line given. Buys one-time rights or first North American serial rights.

FORD TIMES, One Illinois Center, Suite 700, 111 E. Wacker Dr., Chicago IL 60601. Editor: Thomas A. Kindre. Monthly. Circ. 1,200,000. General interest: current topics with a magazine featuring slant. Free sample copy and photo guidelines with SASE.
Photo Needs: Uses about 25 photos/issue; most from freelance photographers. Photos purchased with accompanying ms or by assignment. Model release and captions required.
Making Contact & Terms: Query with samples. Prefers to see published works in a printed form and original photography as samples. SASE. Reports in 1 month. Pays $350/b&w or color inside photo, full page or more; $150/b&w or color inside photo, less than page size; $500/cover photo. Pays on publication. Credit line given. Buys one-time rights.
Tips: Prefers to see "a good choice of well-composed, high-impact photos, utilizing both natural and artificial lighting. Go beyond the obvious requirements of an assignment, and come up with the unexpected."

FRANKLIN MINT ALMANAC, Franklin Center PA 19091. (215)459-7016. Publisher/Editor-in-Chief: Barbara Cady. Editor: Samuel H. Young. Photo Editor: Bridget DeSocio. Bimonthly. Circ. 1,200,000. Emphasizes "collecting" for buyers. Free sample copy on request.
Photo Needs: Uses about 40 photos/issue; 35 are supplied by freelance photographers and stock agencies. Photos purchased with or without accompanying ms. Model release and captions required.
Making Contact & Terms: Query with resume of credits. SASE. Reports in 2 weeks. Provide resume and tearsheets to be kept on file for possible future assignments. Negotiates price on length, difficulty and cost of assignment. Pays on publication. Credit line given. Buys world rights. Previously published work OK.
Tips: "We're hard to reach—geographically. Sending tearsheets or 35mm slides is most practical. We want to see that the photographer can handle both people and the items they collect. Have a good eye, be technically proficient and understand what we're looking for. It helps to be in a location not populated with our 'regulars.' "

FRIENDS MAGAZINE, 30400 Van Dyke Ave., Warren MI 48093. (313)575-9400. Editor: Herman Duerr. Publication of Chevrolet. Monthly. Circ. 1,000,000. Emphasizes Chevrolet products and general interest material. Readers are Chevrolet owners. Sample copy free with SASE.
Photo Needs: Uses about 20 photos/issue; 75% supplied by freelance photographers. Needs "action, adventure, people-oriented photos limited to United States." Model release and captions required. All stories and photo essays must "tie-in" Chevrolet or Chevy product.
Making Contact & Terms: Query with resume of credits and query in writing with story outline. SASE. Reports in 2 weeks. Pays $200/color page and $400 minimum for photo package. Pays on acceptance. Credit line given. Rights purchased "to be negotiated."
Tips: "Submit tearsheets of samples along with specific queries in brief outline. Photos are used primar-

ily to support a text, therefore a photographer should team with a top-notch writer, or be able to supply a well-written text."

FRUITION, Box 872-PM, Santa Cruz CA 95061. (408)458-3365. Editor: C.L. Olson. Publication of The Fruition Project. Biannual. Circ. 300. Emphasizes "public access food trees via community and other food tree nurseries; healthful living through natural hygiene. Readers are naturalists, health minded, environmentalists, humanists." Sample copy $2.
Photo Needs: Uses about 4-5 photos/issue; all supplied by freelance photographers. "B&w is what we print; color prints acceptable: food trees and bushes and vines (fruit and nut) in single and multiple settings; good contrast photos of various fruits and nuts and various states of ripening, and the foliage flowers and parts of the plants." Special needs include "photos of the state of Massachusetts' project planting public access food trees; photos of chestnut trees on Corsica (island); photos of Portland, Oregon's Edible City Project; photos of trees in parks and public lands to include government offices." Model release and captions preferred.
Making Contact & Terms: Send unsolicited photos by mail for consideration. SASE. Reports in 2 week. All rates negotiable; prefer trade for subscription; low rates paid; tax deductions available. Pays on either acceptance or publication. Credit line given on request. Negotiates rights purchased. Simultaneous submissions and previously published work OK.
Tips: "Prints with excellent contrast best. Some work paid for in cash."

***GROWTH MAGAZINE**, Georgia-Pacific Corp., 133 Peachtree St. NE, Atlanta GA 30303. Editor: Polly Warren. Publication of Georgia-Pacific Corp. Monthly. Circ. 40,000. Emphasizes items of interest to Georgia-Pacific employees worldwide. Readers are 40,000 Georgia-Pacific employees, plus stockholders, retirees and friends of the company. Sample copy free.
Photo Needs: Uses about 10-15 photos/issue; 10% supplied by freelance photographers. Wants color shots for duotone cover reproduction. Needs "product shots; on-site plant photography; good candid people shots; occasional 'how-to' (standard industrial photojournalism)." Model release and caption required.
Making Contact & Terms: Query with samples. Provide resume, business card, brochure, flyer or tearsheets to be kept on file for possible future assignments. Reports in 3 weeks. Rates vary; ranges around $500/color cover; $150/b&w inside; $300/color inside; $20-50/by the hour. Pays on acceptance. Credit line given. Buys all rights. Terms include purchase of negative.
Tips: Prefers to see "industrial photography showing creative approach to plant, people and operations."

HEALTHPLEX MAGAZINE, 8303 Dodge St., Omaha NE 68114. (402)390-4528. Editor: Gini Goldsmith. Company publication of the Methodist/Childrens' Hospital. Quarterly. Emphasizes health care. Readers include health care consumers. Circ. 35,000. Estab. 1985. Sample copy $1.
Photo Needs: Uses 12-15 photos/issue; most supplied by freelance photographers. Needs health care photos. Reviews photos with or without accompanying ms. Model release required.
Making Contact & Terms: Query with samples. Reports in 3 weeks. Pays $50-300/job. Pays on acceptance. Buys all rights. Previously published work OK.
Tips: "We prefer photos which relate to consumer health-care articles on topics such as heart attacks, breast cancer, Reyes Syndrome, Alzheimer's Disease, etc. Send samples of printed work in subject area. Besides quality photography, we look for unique style or presentation. Send for sample copy of publication to see what has been used in past issues. Do not send subject matter which would not be appropriate to topics in publication."

THE ILLUMINATOR, Box 3727, Spokane WA 99220. (509)482-4577. Publications Coordinator: Steve Blewett. Publication of Washington Water Power. Monthly. Circ. 3,000. Emphasizes company interests. Readers are employees. Sample copy free with SASE.
Photo Needs: Uses about 6-10 photos/issue. Needs mostly photos of "employees involved in a variety of work and hobby areas. Little chance for any but local photographer to supply photos."
Making Contact & Terms: Arrange a personal interview to show portfolio. SASE. Reports in 3 weeks. Pays $25/b&w photo; payment negotiated. Pays on publication. Credit line given. Rights purchased "as dictated by subject matter."
Tips: Prefers to see "range of work, including posterization, etc. I need anyone with ideas and imagination on how to get the best job completed in the least time. Be professional!" Looks for a range of subject matter from people to things, demonstrating the ability to "see" or conceive a communications concept; technical competence.

LEADERSHIP, 465 Gundersen Dr., Carol Stream IL 60188. (312)260-6200. Editor: Terry Muck. Company publication for Christianity Today, Inc. Quarterly. Emphasizes the clergy. Circ. 90,000. Sample copy $5.

Photo Needs: Uses about 12 photos/issue; 100% supplied by freelance photographers, most designed. Reviews photos with accompanying ms only.
Making Contact & Terms: Reviews photos only with ms. Send b&w contact sheet. SASE. Reports in 2 weeks. Payment individually negotiated. Pays on acceptance. Credit line given. Buys first North American serial rights. Simultaneous submissions and previously published work OK; depends on material.

***MICHIGAN MAGAZINE**, The Detroit News, 615 W. Lafayette, Detroit MI 48231. (313)222-2620. Editor: Lisa K. Velders. Photo Editor/Art Director: Michael Walsh. Publication of The Detroit News. Weekly magazine. Michigan-oriented. Readers are middle to upper middle-class Michigan residents. Circ. 860,000. Sample copy free with SASE. Photo guidelines free with SASE.
Photo Needs: Uses 5-10 photos/issue; 1/3 supplied by freelance photographers. Subject matter varies widely. Captions preferred.
Making Contact & Terms: Arrange a personal interview to show portfolio; send 4x5 transparencies, b&w and color contact sheet by mail for consideration; submit portfolio for review; provide resume, business card, brochure, flyer or tearsheets to be kept on file for possible future assignments. SASE. Reports in 3 weeks. Pays $350/color and b&w cover photo; $100/b&w page; $150/color page; text/photo package negotiated. Pays on publication. Credit line given. Buys first North American serial rights. Simultaneous submissions and previously published work OK.

***MMC TODAY**, (formerly *Dimensions of MCC*), 900 S. 8th St., Minneapolis MN 55404. Senior Communications Specialist: David Neuger. Quarterly. Circ. 25,000. Publication of Metropolitan Medical Center. Emphasizes "features about our hospital; health-related news, features and photos." Readers are employees, former students, medical staff members and friends of the hospital.
Photo Needs: Uses about 12-14 photos/issue. Needs "internal and external hospital photos as well as photos which go together with nonhospital articles." Model release required; captions preferred.
Making Contact & Terms: Arrange a personal interview. Does not return unsolicited material. Reports in 3 weeks. Provide resume, business card and tearsheets to be kept on file for possible future assignments. Pay "depends on project." Buys all rights.
Tips: Prefers to see "a sampling of photography work including health-related topics, business and industry."

MOTORLAND MAGAZINE, 150 Van Ness Ave., San Francisco CA 94102. (415)565-2464. Editor: John Holmgren. Photo Editor: Al Davidson. Company publication for the California State Auto Association. Bimonthly. Emphasizes travel. Readers include RVH travelers 40-45 median age. Circ. 1,600,000. Free sample copy and photo guidelines with SASE.
Photo Needs: Uses 35 photos/issue; 30 supplied by freelance photographers. Needs include travel, scenic. Reviews photos with or without accompanying ms. Model release and captions required.
Making Contact & Terms: Arrange a personal interview to show portfolio. SASE. Reports in 3 weeks. Pays $300/color cover photo, $175/inside color photo, $400-600/text/photo package. Pays on acceptance. Credit line given. Buys one-time rights. Previously published work OK.

MUSCULAR DEVELOPMENT MAGAZINE, Box 1707, York PA 17405. (717)767-6481. Editor/Photo Editor: Jan Dellinger. Company publication for the York Barbell Company. Monthly. Emphasizes competitive bodybuilding, powerlifting and general heavy exercise. Readers include the serious weight training public. Circ. 80,000.
Photo Needs: Uses 100+ photos/issue; most supplied by freelance photographers. Needs b&w and color shots from various bodybuilding contests, some of top name bodybuilders training or posing individually, casual shots of some individuals. Reviews photos with or without accompanying ms. Model release preferred; captions required. Query with list of stock photo subjects; send unsolicited photos by mail for consideration. Uses 5x7 glossy b&w prints, 2 1/4x2 1/4 transparencies, b&w or color contact sheet. SASE. Reports in 2 weeks. Pays $250-300/color cover photo, $10-15/inside b&w photo and $30-40/color photo. Pays on publication. Credit line given. Buys all rights. Previously published work OK.

> **66** *Offer good work and pleasant client/photographer working arrangements. Be involved in the whole project, from the concept stage. Know the story you're trying to tell.* **99**
>
> *—Marie Davis, Contact Magazine*

This cover photo by Jim Krantz, an Omaha, Nebraska-based photographer, was shot as part of an assignment. He was selected by Gini Goldsmith, editor of Healthplex Magazine, after she viewed samples from his portfolio. "He has a feel for 'people' shots and a superior sense of design," she explains. Krantz has a "reputation in the community for excellent commercial photography. He also has won several Omaha Federation of Advertising Awards," she says. The entire shoot paid about $2,000.

Spokane, Washington-based free-lancer, J. Craig Sweat shot this photo as part of an assignment series. It was used on the cover of the August 1985 Illuminator, as well as on the cover of a special stockholders' edition of the Illuminator. Both pieces are published by the Washington Water Power Company. The photo "illustrates the close relationship the people pictured had in developing a highly technical electronic system," explains Publications Coordinator Steve Blewett. This photo, plus five others, earned Sweat and an assistant $650.

NEW BODY MAGAZINE, 888 Seventh Ave., New York NY 10106. (212)541-7100. Art Director: Rosanne Guararra. Company publication for the G.C.R. New Body. Published 8 times a year. Emphasizes health and fitness. Readers include men and women 25-45 years old. Circ. 110,000.
Photo Needs: Needs beauty, beach, bodies, workout and exercise photos. Reviews photos with or without accompanying ms. Model release and captions required.
Making Contact & Terms: Arrange a personal interview to show portfolio; submit portfolio for review; provide resume, business card, brochure, flyer or tearsheets to be kept on file for possible future assignments. Does not return unsolicited material. Reports in 2 weeks. Pays by the job. Pays on publication. Credit line given. Buys one-time rights. Previously published work OK.

NEW WORLD OUTLOOK, Rm. 1351, 475 Riverside Dr., New York NY 10115. (212)870-3758/3765. Editor: Arthur J. Moore. Executive Editor: George M. Daniels. Monthly magazine. Circ. 38,000. Features Christian mission and involvement in social concerns and problems around the world. For United Methodist lay persons; not clergy generally. Credit line given. Pays on publication. Buys one-time rights. Send material by mail for consideration; submit portfolio for review or query with samples. SASE. Previously published work OK. Reports in 3 weeks. Sample copy available.
Subject Needs: Query for needs. Captions preferred.
B&W: Uses 8x10 glossy prints. Pays $15 minimum/photo.
Color: Uses 35mm or larger transparencies. Pays $50-100/photo.
Cover: Uses color transparencies. Vertical format required. Pays $100-150/photo.

OZARK MAGAZINE, 5900 Wilshire Blvd., Los Angeles CA 90036. (213)937-5810. Art Director: Carla Schrad. Publication of Ozark Airlines. Monthly magazine. "We chronicle the good life in the Midwest, with emphasis on sports, personalities, lifestyle, food, fashion, etc." Readers are passengers of Ozark Airlines (mostly executives). Circ. 120,000. Sample copy for $2.
Photo Needs: Uses approximately 27 photos/issue; 12 supplied by freelance photographers. Subject needs "depend on the story—wide range." Special needs include "photo essays in association with the Midwest." Captions required.
Making Contact & Terms: Query with samples. Provide resume, business card, brochure, flyer or tearsheets to be kept on file for possible future assignments. Returns unsolicited material with SASE. Pays $350/color cover photo; $125/b&w; $250/color; $150-500/job; $250/text/photo package. Pays on acceptance. Credit line given. Buys one-time rights.
Tips: Prefers to see "graphic, powerful images that show the creative ability of the photographer."

PAGES, 300 N. State St., Chicago IL 60610. (317)674-6441. Editor-in-Chief: Shirley A. Lambert. Monthly. Circ. 3,000. Publication of the Berry Publishing Co. "Call for photo guidelines."
Photo Needs: Uses 1 cover photo/issue; supplied by freelance photographers. Needs "snow scenes suitable for duotone; full color spring flowers; full color autumn leaves and miscellaneous summer photos." Photos purchased with or without accompanying ms.
Making Contact & Terms: Query with list of stock photo subjects. SASE. Reports in 3 weeks. Provide business card or flyer to be kept on file for possible future assignments. Pays $35/b&w or color photo or will consider photographer's asking price. Pays on acceptance. Credit line not generally given, "but might if requested." Buys one-time rights. Simultaneous submissions and previously published work OK.

PERSPECTIVE, Box 1766, Rochester NY 14603. (716)475-9000. Editor: Thomas Bloodgood. Publication of Pennwalt Prescription Division. Quarterly. Circ. 500. Emphasizes pharmaceuticals. Readers are company sales force, managers, executives. Sample copy 50-75¢ with SASE.
Photo Needs: Uses about 20-30 photos/issue; none currently are supplied by freelance photographers. Needs photos of "subjects that deal with pharmaceuticals, research, medicine." Model release required; captions preferred.
Making Contact & Terms: Send 5x7 b&w glossy prints by mail for consideration. SASE. Reports in 3 weeks. Pays $75-150/b&w cover photo. Pays on publication. Credit line given. Buys all rights. Simultaneous submissions OK.

THE PILOT'S LOG, 501 Boylston St., Boston MA 02117. (617)578-2662. Editor: Patrick Crowley. Bimonthly. Circ. 5,000. Publication of New England Mutual Life Insurance Co. Emphasizes selling insurance and related products and services. "*The Pilot's Log* is New England Life's feature magazine for its national sales force of 5,000." Free sample copy with SASE.
Photo Needs: Uses about 6-10 photos/issue; 2-3 are supplied by freelance photographers. Needs photos of "mostly New England Life agents in business settings. Occasionally, we assign a photographer to take photos for illustrative purposes." Photos purchased with or without accompanying ms. Model release required.

Making Contact & Terms: Arrange a personal interview; query with samples or submit portfolio for review. "Absolutely no unsolicited photos." Does not return unsolicited material. Reports in 1 month. Provide brochure, flyer, tearsheets and samples to be kept on file for possible future assignments. Pays $50-100/b&w, $150-250/color cover photo, $100-200 for text/photo package. Pays on acceptance. Buys all rights.
Tips: "We need quality freelancers in almost every major metropolitan area in the country for sporadic photo assignments." Prefers to see b&w candid shots and cover shots for business periodicals.

***PNEUMATIC PACKAGING**, 65 Newport Ave., Quincy MA 02171. (617)328-6100. Editor: Don McKay. Quarterly magazine. Circ. 12,000. Features histories of customer companies that package food, cosmetics, chemicals, drugs and beverages. For customers, prospects and stockholders of Pneumatic Scale. Provide flyer to be kept on file for possible future assignments. Uses 15 photos/issue; 1 supplied by freelance photographers. Pays on acceptance. Buys one-time rights. SASE. Previously published work OK. Reports in 3 weeks. Free sample copy.
Subject Needs: Scenic, sport (action), human interest and nature. Interested in "any eye-catching, unusual photo." Model release and captions required.
Cover: Uses color glossy prints and 4x5 transparencies. Square format preferred. Pays $75-250/color cover photo.
Tips: "Don't send out-of-focus, individual flower, insect and snow track views. Use imagination, creativity and common sense. Be professional."

***POPULAR HOT RODDING**, Box 49659, Los Angeles CA 90049. (213)820-3601. Editor: Cam Benty. Publication of Argus Publishers Corp. Monthly magazine. Emphasizes technical automotive. Readers are male, 18-35, auto enthusiast. Circ. 244,000. Photo guidelines free with SASE.
Photo Needs: Uses 100-200 photos/issue; 40-75 supplied by freelance photographers. Needs photos of automotive feature, auto how-to, auto action. Will review photos with accompanying ms only. Model release and captions required.
Making Contact & Terms: Query with samples. SASE. Reports in 1 month. Pay negotiated. Pays on publication. Credit line given. Buys first North American serial rights.
Tips: For color, send transparencies only. Focus!

QUEST, #1 Horace Mann Plaza, Mail #E002, Springfield IL 62715. (217)789-2500, ext. 5734. Manager Corporate Photographic Services: David Waugh. Publication of The Horace Mann Companies. Quarterly. Circ. 1,400. Emphasizes multiline insurance for sales agents and managers. Sample copy free with SASE.
Photo Needs: Uses about 30 photos/issue; at the present, none are supplied by freelance photographers. Needs photos of "agents at work in our field offices; agents in the schools (our primary market is teachers); other needs as they arise. We supply all the mss." Captions (at least names of subjects) preferred.
Making Contact & Terms: Provide resume, business card, brochure, flyer or tearsheets to be kept on file for possible future assignments. SASE. Reports "as soon as we would need a photographer from his/her area of the country." Pays $25-30/hour; $125 maximum/job. Pays on acceptance. Credit line given. Buys all rights. Simultaneous submissions and previously published work OK.

ROCHESTER TELEPHONE TIELINE, 700 Sibley Tower, Rochester NY 14604. (716)423-7059. Editor: B J Weiss. Bimonthly. Circ. 3,000. Publication of Rochester Telephone Corporation. Emphasizes telephone/telecommunications services. Readers are 4,000 employees in all levels at Rochester Telephone and its subsidiaries, along with several hundred interested outside parties. Free sample copy (limited number/month—send manila envelope with 40¢ postage).
Photo Needs: Uses about 25 photos/issue; "most of them" are supplied by freelance photographers, "but we use primarily local freelancers on a long-term basis." Needs photos on "new applications of telephone technology, interesting gimmick shots (telephone theme), location work being done by our

66 *We're hard to reach—geographically. Sending tearsheets or 35mm slides is most practical. We want to see that the photographer can handle both people and the items they collect. Have a good eye, be technically proficient and understand what we're looking for.* 99

—Bridget De Socio, Franklin Mint Almanac

subsidiaries (Rotelcom Division and RCI) in areas other than Western New York." Photos purchased with accompanying ms. Pays $50-100/photo. Model release preferred "except when they are RTC employees, then not necessary"; captions required.

Making Contact & Terms: Send by mail for consideration slides or b&w contact sheet; or query with resume of credits or with list of stock photo subjects. "We do not use color." SASE. "Queries answered only in affirmative (no response—no work available)." Materials submitted returned in 1 month. Payment negotiated. Pays on acceptance. Credit line given "only in exceptional cases." Rights purchased depends on determination of use. Simultaneous submissions and previously published work OK if *not* previously used by another telephone company.

ROSEBURG WOODSMAN, c/o Hugh Dwight Advertising, Suite 101, 4905 SW Griffith Dr., Beaverton OR 97005. Editor: Shirley P. Rogers. Monthly magazine. Circ. 8,000. Publication of Roseburg Forest Products Co. Emphasizes wood and wood products for customers and others engaged in forest products/building materials industry. Wants on a regular basis interesting uses of wood in construction, industrial applications, homes, etc. "Look for uses of wood. Show us your interests and outlook." Especially needs for next year Christmas-oriented features related to wood. "Will not buy photos that are grainy, lacking in contrast, or badly composed, no matter how well the subject fits our format." Buys 100 or more photos annually. Buys one-time rights, and will reassign to photographer after publication. Submit model release with photo. Query. Provide resume and calling card to be kept on file for possible future assignments. Pays on publication; fee negotiable on assignment. Reports in 1 month. Free sample copy and photo guidelines.

Color: Transparencies preferred; 35mm acceptable. Captions required. Pays $25-50, up to $125 each for unsolicited submissions. Per complete package, pays $175-500.

Cover: Color transparencies or 35mm slides. Captions required. Pays $75-125.

Tips: Prefers to buy package of pix and ms. Background information must accompany photos, but polished copy "not mandatory. We are looking for sharp, clean shots that need little if any cropping. I like to see versatility, imagination, awareness of all elements and sensitive framing. Show samples that indicate interest or experience in field. Actually more interested in combination writer/photographer or team."

THE SENTINEL, Industrial Risk Insurers, 85 Woodland St., Hartford CT 06102. (203)525-2601. Editor: A. Waller. Quarterly magazine. Circ. 54,000. Emphasizes industrial loss prevention for "insureds and all individuals interested in fire protection." Pays on acceptance. Send material by mail for consideration. Previously published work OK. Reports in 2 weeks. Free sample copy and photo guidelines.

Photo Needs: Uses 4-8 photos/issue; 2-3 supplied by freelance photographers. Needs photos of fires, explosions, windstorm damage and other losses at industrial plants. Prefers to see good industrial fires and industrial process shots. No photos that do not pertain to industrial loss prevention (no house fires). Model release preferred. Credit line given. Buys one-time rights.

B&W: Uses glossy prints. Pays $15-35/photo.

Color: Uses glossy prints. Pays $25-100/photo.

Cover: Uses b&w or color glossy prints. Vertical format required. Pays $35-100/photo.

SPERRY NEW HOLLAND NEWS, Sperry New Holland, New Holland PA 17557. (717)354-1121. Editor: Gary Martin. Published 8 times/year. Circ. 400,000. Emphasizes agriculture. Readers are farmers. Sample copy and photo guidelines free with SASE.

Photo Needs: Buys 30 photos/year of scenic agriculture relating to the seasons, harvesting, farm animals, farm management and farm people. Also, photos with one-paragraph story/captions. Model release and captions required. "Large collections viewed and returned quickly."

Making Contact & Terms: "Show us your work." SASE. Reports in 2 weeks. Payment negotiable. Pays on acceptance. Buys first North American serial rights. Previously published work OK.

Tips: Photographers "must see beauty in agriculture and provide meaningful photojournalistic caption material to be successful here. It also helps to team up with a good agricultural writer and query us on a photojournalistic idea."

***SURVEYOR**, 45 Eisenhower Dr., Paramus NJ 07652. (201)368-9100. Editor: Daniel F. Kelly. Publication of American Bureau of Shipping. Quarterly magazine. Emphasizes international maritime industry including offshore oil and gas exploration and production. Readers are about fifty percent international and fifty percent domestic involved with maritime industry and offshore oil and gas. Circ. 9,000.

Photo Needs: Uses 40-50 photos/issue; 10 supplied by freelance photographers. Needs photos of non-cliche 8x10, b&w, action shots of maritime industry, offshore oil and gas—no picture post-card, sunsetting photos ever used. Photos must include three to four line caption. Captions required.

Making Contact & Terms: Query with samples; provide resume, business card, brochure, flyer or tearsheets to be kept on file for possible future assignments. SASE. Reports in 1 week. Pay negotiated. Pays on publication. Credit line given. Buys one-time rights. Previously published work OK.

TOPICS, 34th Floor, 270 Park Ave., New York NY 10017. (212)286-7453. Editor: Nancy Daigler. Publication of Manufacturers Hanover Corporation. Monthly. Emphasizes people, new products and services in banking and finance industry. Readers are 35,000 employees mostly in New York metropolitan area, some overseas distribution.

Photo Needs: Uses about 15-20 photos/issue; 3-5 supplied by freelance photographers. Needs b&w photos of employees in office or on location. "We occasionally need shots of employees in other cities across the U.S. or overseas." Captions preferred.

Making Contact & Terms: Query with samples. Provide resume, business card, brochure, flyer or tearsheets to be kept on file for possible future assignments. Does not return unsolicited material. Reports in 1 month. Pays $150-200/half-day; $300-400/day. Pays on acceptance. Credit line given. Buys all rights; sometimes negotiable depending upon photo use. Previously published work OK.

Tips: Prefers to see "b&w photos of business executives and staff in office and on location. Journalistic flair preferred (i.e., an eye for photo story); sharp, dramatic b&w photos. We don't want typical 'grip-and-grin' photos or dull corporate settings."

TRADEWINDS, Suite 600, 301 Commerce St., Ft. Worth TX 76102. (817)878-8155. Editor: Steve McLinden. Publication of Pier 1 Imports. Bimonthly. Emphasizes "fun of the business" in importing. Readers are 4,000 Pier 1 employees nationwide, mostly young (16-35 age group). Sample copy free with SASE.

Photo Needs: Uses about 30-35 photos/issue; "one or two per issue" are supplied by freelance photographers. Needs "photos of Pier 1 store fronts, employees in freelancer's area (mostly larger metro areas)."

Making Contact & Terms: Send 4x5 glossy b&w prints or b&w contact sheet by mail for consideration. SASE. Reports in 2 weeks. "Will consider most price scales." Pays on acceptance. Buys all rights. Simultaneous submissions and previously published work OK.

TRAILBLAZER MAGAZINE, 15325 SE 30th Place, Bellevue WA 98007. (800)426-5045. Managing Editor: Rudy Yuly. Thousand Trails, Inc. Monthly magazine. Emphasizes the outdoors, destinations, RV travel, leisure time, hobbies and self-improvement. Readers are 55 +, $30,000 a year, who enjoy traveling and camping; active, fairly well educated. Circ. 100,000. Sample copy $1.50 with SASE. "Please send appropriate sized envelope for sample copy." Photo guidelines free with SASE.

Photo Needs: Uses 25-30 photos/issue; 10 supplied by freelance photographers. Needs "photos to accompany articles, photographers who work with writers." Photos purchased with accompanying ms. Model release preferred; captions required.

Making Contact & Terms: Provide resume, business card, brochure, flyer or tearsheets to be kept on file for possible future assignments. SASE. Reports in 1 month. Pays $35/b&w cover photo; $200/color cover photo; $15-35/b&w inside photo and $25-100/color inside photo. Pays on publication. Credit line given. Buys first North American serial rights.

Tips: Looks for "*sharpness* of image, quality of light, camera cropping, professional presentation—*good* b&w prints would be a pleasant surprise! Hook up with a writer—complete, high-quality packages are *very* attractive."

VOLKSWAGEN'S WORLD, Volkswagen of America, 888 W. Big Beaver Rd., Box 3951, Troy MI 48099. (313)362-6000. Editor: Ed Rabinowitz. Quarterly magazine. Circ. 250,000. For owners of Volkswagen (VW) automobiles. Buys 25 photos annually. Buys all rights. Submit model release with photo or present model release on acceptance of photo. Query first with story or photo essay idea. Photos purchased with accompanying ms; "features are usually purchased on a combination words-and-pictures basis." Credit line given. Pays on acceptance, $150-450 for full photo features; $150-450 for text/photo package; and $150 page rate. Reports in 6 weeks. SASE. Previously published work OK. Free sample copy and contributor's guidelines.

Subject Needs: Celebrity/personality, how-to, human interest, humorous, photo essay/photo feature, sport, and travel.

Color: Send transparencies; prefers 35mm but accepts any size. Captions required. Pay is included in total purchase price with ms.

Cover: Submit color transparencies. Uses vertical format. Captions required. Pays $350.

Tips: Needs photos for "Talk About Volkswagen" department which features "offbeat VWs—no commercial 'kit' cars, please." Prefers photos featuring new generation VWs—Golf, Scirocco, Jetta, Vanagon, Camper and Quantum models. Pays $15 minimum.

Consumer

When photographers think of editorial photography, this particular class of magazines comes to mind. Consumer, as opposed to association and company publications, implies the magazines can be purchased on the newsstand or by subscription, without the reader necessarily having to belong to a particular special-interest group or be involved in a particular profession. Consumer magazines, as opposed to association and company publications, are funded through magazine sales and advertising, not association dues or company budgets. There are as many consumer magazines available as there are groups of readers with similar interests.

Many of the publications for which photographers dream of shooting assignments pay well and offer excellent material to add to a portfolio. But, this is an area in which fledgling photographers must be honest with themselves. If you are new at this, you will have to start at a smaller level in order to build your portfolio. Then you can grow and compete on equal ground with the best of photographers. This not only takes years of shooting quality work and establishing editorial contacts, it takes diligent research on each new publication you want to query. Fortunately this highly competitive area offers an equal chance for all who have developed their technical and compositional skills to top-notch standards.

Because there is such a large selection of magazines covering a range of subjects, it should be easy to zero in on your favorite hobbies, sports, travel destinations, or more academic subjects such as health or social issues. If you already subscribe to certain magazines, you may want to start querying their editors first since you are already familiar with their format and usage of photography. Perhaps through reading these publications over a period of time, you have developed some ideas for a good photo essay or text/photo package you could inquire about. It is a good idea, when contacting the magazine for a copy of their photo guidelines—if they provide such an item—to ask for an editorial schedule as well. This will help you channel your areas of interest into each magazine's upcoming needs, and will save both you and the editor wasted time spent shooting and reviewing unwanted photos.

If you are interested in putting together a photo/text package, be sure the quality of both is equally good. It will only hurt your credibility in the eyes of the editor to see work not quite up to par in either area. A well thought-out story proposal will show the editor you have put some time into researching his publication. And even if a similar story was run a year ago, or was just assigned to a freelancer, he will remember your conscientiousness.

Numerous magazines rely on stock photographs. Since the budgets of many publications are a bit tight now, a good stock list of photos will be appreciated by the photo editor who can call you with a needed request. Many stock photos are used to illustrate articles, and a well-organized, well-researched stock photographer will find a steady market through persistence in sending out updated stock photo lists. The bottom line, as far as the editor is concerned, is that you are the photographer who provided a quality photo when it was needed. This kind of PR is good for any photographer's freelancing business.

***ABOARD MAGAZINE,** 777 41st St., Miami Beach FL 33140. (305)673-8577. Editor: Anna Mix. Photo Editor: Alex Sanchez-Abascal. Consumer bimonthly magazine. Emphasizes travel through Central and South America. Readers are mainly Latin American businessmen and American tourists and businessmen. Circ. 100,000. Sample copy free with SASE. Photo guidelines free with SASE.
Photo Needs: Uses 50 photos/issue; 25 supplied by freelance photographers. Needs photos of travel, scenic, and fashion. Special needs include good quality pix of Latin American countries, particularly

Chile, Ecuador, Bolivia, Paraguay, Dominicana, El Salvador, Panama, Venezuela, Republica. Model release and captions preferred.

Making Contact & Terms: Query with samples; submit portfolio for review; provide resume, business card, brochure, flyer or tearsheets to be kept on file for possible future assignments. SASE. Reports in 1 month. Payment varies. Pays on publication. Credit line given. Buys one-time rights. Previously published work OK.

Tips: If photos are accompanied with an article, they have a much better chance of being accepted.

THE ABSOLUTE SOUND, 2 Glen Ave., Sea Cliff NY 11579. (516)676-2830. Editorial Director: Brian Gallant. Quarterly magazine. Emphasizes the "high end of audio—component reviews and record reviews. Readers are audiophiles and doctors. Circ. 15,000-20,000. Sample copy free with SASE and $1.94 postage.

Photo Needs: Uses about 10-20 photos/issue; all supplied by freelance photographers. Needs photos of "people at trade shows in recording industry, artists, audio components." Captions preferred.

Making Contact & Terms: Query with samples. Send unsolicited 4x5 b&w prints; b&w contact sheet; and b&w negatives by mail for consideration. Provide resume, business card, brochure, flyer or tearsheets to be kept on file for possible future assignments. SASE. Reports in 1 month. Pays on publication. Credit line given. Buys one-time rights.

ACCENT, Box 10010, Ogden UT 84409. Editor: Robyn Walker. Monthly magazine. Circ. 89,000. Emphasizes travel—interesting places, foreign and domestic advice to travelers, new ways to travel, money-saving tips, new resorts, innovations and some humor. Stories and photos are usually purchased as a package. "We work 8-12 months in advance, so keep the seasonal angle in mind." Buys 15-20 photos/issue. Sample copy $1 with 9x12 envelope.

Subject Needs: Scenic (color transparencies) for cover usually goes along with lead story. Captions required. "We can't use moody shots."

Specs: Uses color transparencies; 4x5 preferred but will use 35mm. Vertical or square format used on cover.

Accompanying Mss: Seeks mss between 1,000 and 1,200 words.

Payment/Terms: Pays $35/color transparency and $50 minimum/cover; 15¢/printed word. Credit line given. Pays on acceptance. Buys first North American rights.

Making Contact: Query first. Query with list of stock photo subjects. If submitting cover possibilities, "please send us your best pix with a cover letter and SASE." Provide brochure, samples and tearsheet to be kept on file for possible future assignments.

ACCENT ON LIVING, Box 700, Bloomington IL 61702. (309)378-2961. Editor: Betty Garee. Quarterly magazine. Circ. 18,000. Emphasizes successful disabled people who are getting the most out of life in every way and *how* they are accomplishing this. For physically disabled individuals of all ages and socioeconomic levels and professionals. Buys 20-50 photos annually. Buys first-time rights. Query first with ideas, get an OK, and send contact sheet for consideration. Provide letter of inquiry and samples to be kept on file for possible future assignments. Pays on publication. SASE. Reports in 2 weeks. Simultaneous submissions and previously published work OK "if we're notified and we OK it." Sample copy $2. Free photo guidelines; enclose SASE.

Subject Needs: Photos dealing with coping with the problems and situations peculiar to handicapped persons: how-to, new aids and assistive devices, news, documentary, human interest, photo essay/photo feature, humorous and travel. "All must be tied in with physical disability. We want essentially action shots of disabled individuals doing something interesting/unique or with a new device they have developed. Not photos of disabled people shown with a good citizen 'helping' them."

B&W: Send contact sheet. Uses glossy prints. Manuscript required. Pays $5 minimum.

Cover: Cover is usually tied in with the main feature inside. Also use color photos, transparencies preferred. Pays $50-up/cover.

Tips: Needs photos for Accent on People department, "a human interest photo column on disabled individuals who are gainfully employed or doing unusual things." Also uses occasional photo features on disabled persons in specific occupations: art, health, etc. Pays $25-200 for text/photo package. Send for guidelines. "Concentrate on improving photographic skills. Join a local camera club, go to photo seminars, etc. We find that most articles are helped a great deal with *good* photographs—in fact, good photographs will often mean buying a story and passing up another one with very poor or no photographs at all."

ADIRONDACK LIFE, Rt. 86, Box 97, Jay NY 12941. (518)946-2191. Editor: Jeffrey G. Kelly. Bimonthly. Circ. 40,000. Emphasizes the Adirondacks and the north country of New York State. Sample copy $4; photo guidelines free with SASE.

Photo Needs: "We use about 40 photos/issue, most supplied by freelance photographers. All photos

must be taken in the Adirondacks and all shots must be identified as to location and photographer."
Making Contact & Terms: Send one sleeve (20 slides) of samples. Send b&w prints (preferably 8x10) or 35mm color transparencies. SASE. Reports in 1 month. Pays $300/cover photo; $75/full-page color photo; $50/half-page color photo; $25/b&w photo. Pays on publication. Credit line given. Buys first North American serial rights. Simultaneous submissions OK.
Tips: "Send quality work pertaining specifically to the Adirondacks. In addition to technical proficiency, we look for originality and imagination. We avoid using typical shots of sunsets, lakes, reflections, mountains, etc. We are using more photos of people."

AFRICA REPORT, 833 UN Plaza, New York NY 10017. (212)949-5731. Editor: Margaret A. Novicki. Bimonthly magazine. Circ. 12,000. Emphasizes African political, economic and social affairs, especially those significant for US. Readers are Americans with professional or personal interest in Africa. Photos purchased with or without accompanying ms. Buys 20 photos/issue. Provide samples and list of countries/subjects to be kept on file for future assignments. Pays $80-250 for text/photo package or also on a per-photo basis. Credit line given. Pays on publication. Buys one-time rights. SASE. Simultaneous submissions and previously published work OK. Reports in 1 month. Free sample copy.
Subject Needs: Personality, documentary, photo feature, scenic, spot news, human interest, travel, socioeconomic and political. Photos must relate to African affairs. "We will not reply to 'How I Saw My First Lion' or 'Look How Quaint the Natives Are' proposals." Wants on a regular basis photos of economics, sociology, African international affairs, development, conflict and daily life. Captions required.
B&W: Uses 8x10 glossy prints. Pays $15-35/photo.
Cover: Uses b&w glossy prints. Vertical format preferred. Pays $25-75/photo.
Accompanying Mss: "Read the magazine, then query." Pays $50-150/ms. Free writer's guidelines.
Tips: "Read the magazine; live and travel in Africa; and make political, economic and social events humanly interesting."

AFTA-THE ALTERNATIVE MAGAZINE, Suite 2, 153 George St., New Brunswick NJ 08901. (201)828-5467. Editor-in-Chief: Bill-Dale Marcinko. Quarterly. Circ. 25,000. Emphasizes films, rock music, TV, books and political issues. Readers are young (18-30), male, regular consumers of books, records, films and magazines, socially and politically active, 40% gay male, 60% college educated or attending college. Sample copy $3.50.
Photo Needs: Uses 50 photos/issue; 25 supplied by freelance photographers. Needs photos of rock concert performers, film and TV personalities, political demonstrations and events, erotic photography (no pornography); b&w only. No nature or landscape photography. Photos purchased with or without accompanying ms. Column needs: Rock Concerts (section needing photos taken at rock concerts); Issues (section needing photos taken at political demonstrations). "We are expanding our coverage of political demonstrations and international news coverage—any photographs of same would be appreciated. We are also using New-Wave-art photos and surreal, dada and experimental photos."
Making Contact & Terms: Query with samples. Prefers to see b&w prints or published clippings as samples. "Photos should be stark, provoctive and surreal." SASE. Reports in 2 weeks. Pays in contributor's copies only. Pays on publication. Credit line "and also biographies/profiles" given. Buys one-time rights. Simultaneous submissions and previously published work OK.

AIM MAGAZINE, 7308 S. Eberhart Ave., Chicago IL 60619. (312)874-6184. Art Director: Bill Jackson. Quarterly magazine. Emphasizes "material of social significance." Readers are "high school, college students and the general public." Circ. 10,000. Sample copy $3.
Photo Needs: Uses about 15 photos/issue; 4 supplied by freelance photographers. Needs "photos depicting society's deprivation—ghetto shots and ethnic group activities (Indian, Mexican, Hispanic)." Photos purchased with accompanying ms only. Special needs include photos "depicting inequities in our society, economically, educationally." Model release and captions preferred.
Making Contact & Terms: Query with samples. Send 8½x11 b&w prints by mail for consideration. SASE. Reports in 1 month. Pays $10/b&w cover photo; $5/b&w inside photo. Pays on acceptance. Credit line given. Buys one-time rights. Simultaneous submissions OK.
Tips: "Look for incidents of police brutality—activities of organizations such as the KKK, etc."

***ALASKA**, Box 99050, Anchorage AK 99509-9050. Editor: Tom Gresham. Monthly magazine. Circ. 200,000. For residents of, and people interested in, Alaska. "Photos may depict any aspect of 'Life on the Last Frontier'—wildlife, scenics, people doing things they can only do in the North country." Buys 300 photos annually. Buys first rights. Send photos for consideration. Pays on publication. Reports in 3-4 weeks. SASE. Sample copy $2; free photo guidelines.
B&W: Send 8x10 prints, but prefers color submissions. Pays $25 minimum.
Color: Send 35mm, 2¼x2¼ or 4x5 transparencies. Pays $150/2-page spread, $100/full page or $50/half page.

Cover: Send 35mm, 2¼x2¼ or 4x5 color transparencies. Pays $200.
Tips: "Each issue of *Alaska* features an 8-page section of full-page and 2-page color photos—the best received."

ALASKA OUTDOORS MAGAZINE, Box 82222, Fairbanks AK 99708. (907)455-6691. Editor: Chris Batin. Bimonthly. Circ. 70,000. Emphasizes "hunting and fishing in Alaska; sometimes covers other outdoor-oriented activity." Readers are "outdoor oriented, male, interested in Alaska, whether for trip planning or just armchair reading." Sample copy $1; photo guidelines free with SASE.
Photo Needs: Uses about 40 photos/issue; 50% supplied by freelance photographers. Needs outdoor, hunting and fishing action, scenic, wildlife, adventure-type photo essays. Captions required.
Making Contact & Terms: Send 5x7, 8x10 b&w glossy prints; 35mm, 2¼x2¼ transparencies; or b&w contact sheet by mail for consideration. SASE. Reports in 3 weeks. Pays $200/color cover photo; $10-25/b&w inside photo, $25-100/color inside photo; $50-275 for text/photo package. Pays on publication. Credit line given. Buys one-time rights. Previously published work OK.
Tips: "Tell the whole story through photos—from grain of sand subjects to mountain scenics. Capture the 'flavor' of Alaska in each photo."

ALCOHOLISM AND ADDICTION MAGAZINE, 1005 NE 72nd, Seattle WA 98103. (206)527-8999. Art Director: Teri McDarby. Bimonthly. Circ. 35,000. Emphasizes recovery from alcohol or drugs. Readers are treatment professionals and recovering alcoholics and drug addicts. Sample copy for $5 with SASE.
Photo Needs: Uses 40-50 photos/issue; 25% supplied by freelance photographers. Needs "photos showing horror/pain of alcoholism—people; photos showing how good life can be—people." Special needs include "photo illustrations of alcohol-related subjects." Model release required.
Making Contact & Terms: Arrange a personal interview to show portfolio; send 8x10 b&w or color prints; 35mm, 2¼x2¼, 4x5 or 8x10 transparencies; b&w or color contact sheet; or b&w or color negatives by mail for consideration; provide resume, business card, brochure, flyer or tearsheets to be kept on file for possible future assignments. SASE. Pays $200-500/color cover photo; $50-75/color inside photo; $30-50/hour and $100-200/job. Pays 30 days after publication. Buys one-time rights. Simultaneous submissions and previously published work OK.
Tips: Prefers to see concept photos and photo illustrations in a portfolio. "Emphasis must be on the positive if we're to use the photo at all."

ALIVE! for Young Teens, Box 179, St. Louis MO 63166. (314)371-6900. Assistant Editor: Vandora Ellrink. Monthly. Circ. 12,000. "*Alive!* is a church-sponsored magazine for young adolescents (12-16) in several Protestant denominations. We use a wide variety of material that appeals to this audience." Sample copy $1; writer's guidelines and photo guidelines available free with SASE.
Photo Needs: Uses about 5-15 photos/issue; most supplied by freelance photographers. Needs photos of "younger adolescents in a variety of activities. In overall usage we need multi-ethnic variety and male/female balance. A few scenics and animal shots."
Making Contact & Terms: Query with list of stock photo subjects; send b&w glossy prints by mail for consideration. SASE. "We also consider copies of photos we can keep and file for reference." Reports in 1 month. Pays $35/b&w cover photo; $15-25/b&w inside photo; payment for text/photo package varies. Pays on acceptance. Credit line given. Buys one-time rights. Simultaneous submissions and previously published work OK.
Tips: "Don't send photocopies of your work. We can't judge quality from a photocopy."

alive now! MAGAZINE, 1908 Grand Ave., Box 189, Nashville TN 37202. (615)327-2700, ext. 466. Assistant Editor: Pamela J. Crosby. Bimonthly magazine published by The Upper Room. "*alive now!* uses poetry, short prose, photography and contemporary design to present material for personal devotion and reflection. It reflects on a chosen Christian concern in each issue. The readership is composed of primarily college-educated adults." Circ. 80,000. Sample copy free with SASE; photo guidelines available.
Photo Needs: Uses about 25-30 b&w prints/issue; 90% supplied by freelancers. Needs b&w photos of "family, friends, people in positive and negative situations; scenery; celebrations; disappointments; ethnic minority subjects in everyday situations—Native Americans, Hispanics, Asians and blacks." Model release preferred.
Making Contact & Terms: Query with samples; send 8x10 glossy b&w prints by mail for consideration; submit portfolio for review. SASE. Reports in 1 month; "longer to consider photos for more than one issue." Pays $20-30/b&w inside photo; no color photos. Pays on publication. Credit line given. Buys one-time rights. Simultaneous and previously published submissions OK.
Tips: Prefers to see "a variety of photos of people in life situations, presenting positive and negative slants, happy/sad, celebrations/disappointments, etc. Use of racially inclusive photos is preferred."

ALOHA, THE MAGAZINE OF HAWAII, 828 Fort St. Mall, Honolulu HI 96813. (808)523-9871. Editor: Rita Ariyoshi. Emphasizes Hawaii. Readers are "affluent, college-educated people from all over the world who have an interest in Hawaii." Bimonthly. Circ. 85,000. Sample copy $2; photo guidelines for SASE.
Photos: Uses about 50 photos/issue; 40 of which are supplied by freelance photographers. Needs "scenics, travel, people, florals, strictly about Hawaii. We buy primarily from stock. Assignments are rarely given and when they are it is to one of our regular local contributors. Subject matter must be Hawaiian in some way. A regular feature is the photo essay, 'Beautiful Hawaii,' which is a 6-page collection of images illustrating that theme." Model release required if the shot is to be used for a cover; captions required.
Making Contact & Terms: Send by mail for consideration actual 35mm, 2¼x2¼ or 8x10 color transparencies; or arrange personal interview to show portfolio. SASE. Reports in 6-8 weeks. Pays $25/b&w photo; $50/color transparency; $150 for cover shots. Pays on publication. Credit line given. Buys one-time rights. Previously published work OK if other publications are specified.
Tips: Prefers to see "a unique way of looking at things, and of course, sharp, well-lit images."

ALTERNATIVE SOURCES OF ENERGY MAGAZINE, 107 S. Central Ave., Milaca MN 56353. (612)983-6892. Editor: Donald Marier. Bimonthly magazine. Circ. 25,000. Emphasizes independent power production from wind, hydro, PV, and cogeneration. Buys 10 photos/issue. Buys first NA serial rights. Submit model release with photo. Send contact sheet or photos for consideration. Pays on publication. Reports in 4 weeks. SASE. Simultaneous submissions and previously published work OK "if we are so notified." Sample copy $4.50.
B&W or Color: Send contact sheet or 8x10 glossy prints. Captions required. Pays $15/b&w photo; $100/color photo.
Tips: "We prefer to purchase pix with mss rather than alone. Advice: study the magazine; understand the issues."

AMATEUR RADIO, (formerly *73 for Radio Amateurs*), WGE Center, Peterborough NH 03458. (603)924-9261. Publisher: Wayne Green. Executive Editor: Perry Donham. Monthly magazine. Circ. 60,000. Emphasizes amateur (ham) radio for ham radio operators and experimenters. Prefers ms with photo submissions. Buys 1-20 photos/issue. Pays on per-photo basis. Credit line given. Pays on acceptance. Buys all rights. Model release required. Send query with resume of credits. Provide letter of inquiry, resume and samples to be kept on file for possible future assignments. Reports in 4-6 weeks. SASE. Sample copy $2.50 and free photo guidelines.
Subject Needs: Celebrity/personality, documentary, human interest, photo essay/photo feature, travel and staged shots of equipment. Photos must relate to radio. Captions are required.
B&W: Uses 8x10 glossy prints. Pays $10-50.
Color: Uses 8x10 glossy prints or 35mm or 2¼x2¼ transparencies. Pays $50-100.

AMERICAN CAGE-BIRD MAGAZINE, One Glamore Court, Smithtown NY 11787. (516)979-7962. Editor: Arthur Freud. Photo Editor: Anne Frizzell. Monthly. Emphasizes care, breeding and maintenance of pet cage birds. Readers include bird fanciers scattered throughout the United States, Canada and other countries. Circ. 13,000. Sample copy $2.
Photo Needs: Uses about 10 photos/issue; 6 supplied by freelance photographers. Needs sharp, clear black and white photos of budgies, cockatiels, canaries, parrots, toucans and people with such birds. Clever seasonal shots also good (Xmas, etc.). We choose photos which inform and/or entertain. Identification of the bird type or species is crucial." Special needs include Christmas theme, Fourth of July theme, etc. Model release preferred; captions required.
Making Contact & Terms: Send 5x7 glossy b&w prints by mail for consideration. SASE. Reports in 1 week. Pays $15-25/photo. Pays on publication. Credit line given. Buys one-time rights. Previously published work OK.

***AMERICAN DANE MAGAZINE**, 3717 Harney St., Omaha NE 68131. (402)341-5049. Editor-in-Chief: Pamela K. Doray. Monthly magazine. Circ. 11,000. For an audience of "primarily Danish origin, interested in Danish traditions, customs, etc." Wants no scenic photos "unless they are identifiably Danish in origin." Avoid general material. Buys 6 photos annually. Buys all rights, but reassigns to photographer after publication. Send contact sheet or prints for consideration. Pays on publication. Reports in 1-3 weeks. SASE. Previously published work OK. Sample copy $1.
B&W: Send contact sheet or 5x7 glossy or semigloss prints. Pays $10-25.
Cover: Send contact sheet or glossy or semigloss prints for b&w. Pays $25.
Tips: "Must be ethnic in content."

AMERICAN SURVIVAL GUIDE, 2145 West La Palma Ave., Anaheim CA 92801. (714)635-9040. Editorial Director: Bob Clark. Managing Editor: Jim Benson. Monthly. Circ. 96,000. Emphasizes "self-

reliance and survival. People whose chief concern is protection of life and property. Preparedness and how to meet the threats posed in day-to-day living; urban violence, natural disaster, ecological and environmental considerations, economic breakdowns, nuclear conflict. The technology, hardware, weapons, and practice of survival. The magazine is a textbook and a reference." Average reader is "age 34, male, $28,000/year income, spouse provides second income. Is interested in food preservation and storage, weaponry, tactics, techniques, shelter, products, related to preparedness, self-reliance and survival." Photo guidelines free with SASE.

Photo Needs: Uses about 7 photos/article; half supplied by freelance photographers. "Photos must, in all cases, illustrate accompanying text material. How-to and preparedness situational photos." Photos purchased with accompanying ms only. Special photo needs include "disaster, earthquake, chemical spill, wildfire, urban riot and crime scene." Model release and captions required.

Making Contact & Terms: Query with samples or with list of stock photo subjects. SASE. Reports in 1 month. Pays $100 maximum color cover photo, (special rates may apply), $70 maximum/b&w or color or inside photo; $70 maximum/b&w or color page. Pays on publication. Credit line given. Buys first North American serial rights.

Tips: "Learn the survivalist marketplace, philosophy, hardware, attitudes and people."

***AMERICANA MAGAZINE**, 29 W. 38 St., New York NY 10018. (212)398-1550. Picture Editor: Sandra Wilmot. Bimonthly magazine. Circ. 360,000. Emphasizes an interest in American history and how it relates to contemporary living. Photos purchased with or without accompanying mss. Freelancers supply 95% of the photos. Pays by assignment or on a per-photo basis. All payments negotiable. Credit line given. Pays on publication. Buys one-time rights and first North American serial rights. Model release is requested when needed. Send query with resume of credits. "Look at several issues of the magazine and then have story ideas before talking to us." SASE. "Make envelope large enough to hold material sent." Previously published work OK. Reports in 2 months. Sample copy $1 and free photo guidelines.

Subject Needs: Celebrity/personality (outstanding in the field of Americana—curator of White House, head of National Trust, famous painter, etc.); fine art; scenic (US—must relate to specific article); human interest; humorous; photo essay/photo feature (majority of stories); US travel; fashion; museum collections and old photography. Captions are required.

B&W: Uses 8x10 matte prints.

Color: Uses 35mm, 2¼x2¼, 4x5 and 8x10 transparencies.

Cover: Uses color covers only with vertical format.

Accompanying Mss: "*Americana*'s stories should open the door on the past by giving the reader the opportunity to participate in the activity we are covering, be it crafts, collecting, travel or whatever. Travel, crafts, collecting, cooking and people are only a few of the subjects we cover. We often rely on contributors to point out new areas that are suitable for *Americana*. Many of the articles are very service-oriented, including practical advice and how-to information."

Tips: "We rarely accept freelance work that does not relate to a specific story we are doing."

***AMERICAS**, Organization of American States, (OAS), Washington DC 20006. Editor-in Chief: Enrique Purand. Photo Editor: Roberta Okey. Bimonthly magazine in separate English and Spanish language editions. Circ. 125,000. For people with a special interest in Latin America and the Caribbean living in all countries of the New World and in other continents. Needs photos "dealing with the history, culture, arts, society, wildlife, tourism and development of the nations of the Americas. Prefers to see wide variety of subjects of a documentary nature taken in any country of Latin America or the Caribbean. Special need for modern, developed, urban pix." Wants no shots of "picturesque poverty" in Latin America. Buys 175 annually. Not copyrighted "unless specifically requested." Query first with resume of credits. "Photos are not purchased without accompanying manuscript unless specifically solicited." Pays $250-300/text/photo package. Pays on acceptance. Reports in 2 months. SASE. Previously published work OK. Free sample copy and photo guidelines.

B&W: Send 8x10 matte or glossy prints. Captions required. Pays $20.

Color: Send transparencies. Captions required. Pays $25-50.

Cover: Send color transparencies. Captions required. Allow space in upper left hand corner for insertion of logo. Pays $50-75.

ANIMAL KINGDOM, New York Zoological Park, Bronx NY 10460. (212)220-5121. Editor: Eugene J. Walter, Jr. Bimonthly. Emphasizes wildlife conservation, natural history. Readers include mature people (over 12), interested in wildlife and nature. Circ. 152,000. Sample copy available for $2; photo guidelines free with SASE.

Photo Needs: Uses 25 photos/issue; supplied by freelance photographers varies. Needs wildlife photos. Captions required.

Making Contact & Terms: Query with list of stock photo subjects. Does not return unsolicited material. Reports in 1 month. Pays $125-175/b&w cover photo, $150-200/color cover photo, $150/b&w

Americas magazine purchased one-time rights to this photo from photographer Michael Ventura of Bethesda, Maryland. The photograph was reproduced in color. Ventura was paid $25 for use of the photograph, which had been shot on assignment for another magazine but hadn't been published.

page, $150/color page. Other page sizes and approximate rates available; request rate sheet. Pays on publication. Credit line given. Buys one-time rights. Simultaneous submissions OK.

ANN ARBOR OBSERVER, 206 South Main, Ann Arbor MI 48104. (313)769-3175. Editor: Don Hunt. Monthly magazine. Emphasizes "what's going on in Ann Arbor." Readers are 70,000 Ann Arbor adults. Sample copy $1.
Photo Needs: Uses about 20 photos/issue. Needs "mostly photos of buildings and people in Ann Arbor." Model release preferred; captions required.
Making Contact & Terms: Query with resume of credits. SASE. Reports in 2 weeks. Pays $30/b&w inside photo. Pays on publication. Credit line given. Buys all rights.

APPALOOSA RACING RECORD, Box 1709, Norman OK 73070. (405)364-9444. Editor: Emma Hollingsworth. Monthly magazine. Emphasizes "Appaloosa horses—racing, training, and breeding." Readers are owners, breeders, trainers of Appaloosa race horses. Circ. 2,000. Sample copy $3.
Photo Needs: Uses 20 photos/issue; 90% supplied by freelance photographers. Subject needs are "varied. Most photos are done on assignment, by freelancers." Captions required.
Making Contact & Terms: Provide resume, business card, brochure, flyer or tearsheets to be kept on file for possible future assignments. Reports in 2 weeks. Pays $125/color cover photo; $15/b&w inside photo; and $50/color inside photo. Pays on publication. Credit line given. Buys all rights. Previously published work OK.

ARCHERY WORLD, Suite 100, 11812 Wayzata Blvd., Minnetonka MN 55343. (612)545-2662. Editor: Richard Sapp. Bimonthly magazine. "*Archery World* is the oldest and most respected magazine in

print for the hunting archer. It focuses editorially on all aspects of hunting with a bow and arrow in North America. Our 125,000 circulation is primarily male: college-educated, avid bowhunters who participate in their sport year-round and who make an above average income." Circ. 125,000. Free sample copy and photo guidelines with SASE.

Photo Needs: Uses 10-25 photos/issue; "many are from freelancers. We want to see wildlife photos—especially or almost exclusively—those wildlife subjects commonly hunted as big game species in North America. "Special needs include "big game species for cover selections, principally whitetailed deer."

Making Contact & Terms: Send 35mm/2¼x2¼ tranparencies by mail for consideration. SASE. Reports in 2-4 weeks. Pays $200/color cover photo; $25/b&w inside photo; $75 color/inside photo; and $50-250/text/photo package. Pays on publication. Credit line given. Buys one-time rights. Simultaneous submissions and previously published work OK.

ARCHITECTURAL DIGEST, 5900 Wilshire Blvd., Los Angeles CA 90036. Art Director: Thomas Sullivan. For people interested in fine interior design. "We are interested in seeing the work of photographers with background and portfolio of architecture, interiors and/or gardens. We cannot accept tearsheets or prints; only 4x5 or 2¼x2¼ transparencies. We have no staff photographers." Works with freelance photographers on assignment only basis. Provide transparencies. Reports once a month. Pay is based on ASMP guidelines.

Tips: Looks for "crisp and sharp lighting, knowledge of composition with interiors, capability of not losing exterior views out of windows. Keep portfolio limited to your best work and pertaining to (who you are presenting it to). Interiors, architecture, and/or gardens."

ART & CINEMA, Box 1208, Imperial Beach CA 92032. (619)429-5533. Quarterly. Emphasizes art, theater, dance, video, film. Readers are instructors in universities and colleges, and university libraries. Circ. 5,000.

Photo Needs: Needs photographs of art works, of theater, dance and video performances, and of film subjects. Special needs include experimental theatre and contemporary paintings. Model release and captions required.

Making Contact & Terms: Query with resume of credits. Reports in 3 weeks. Pays by job; text/photo package negotiated. Pays on publication. Previously published work OK.

ATLANTIC CITY MAGAZINE, 1637 Atlantic Ave., Atlantic City NJ 08401. (609)348-6886. Editor-in-Chief: Jill Schoenstein. Monthly. Circ. 50,000. Sample copy $2 plus $1 postage.

Photo Needs: Uses 50 photos/issue; all are supplied by freelance photographers. Model release and captions required. Prefers to see b&w and color fashion, product and portraits, sports, theatrical.

Making Contact & Terms: Query with portfolio/samples. Does not return unsolicited material. Reports in 3 weeks. Provide resume and tearsheets to be kept on file for possible future assignments. Payment negotiable; usually $35-50/b&w photo; $50-100/color; $250-450/day; $175-300 for text/photo package. Pays on publication. Credit line given. Buys one-time rights.

Tips: "We promise only exposure, not great fees. We're looking for imagination, composition, sense of design, creative freedom and trust."

ATTAGE, ACCESS 86, DATABASE MONTHLY, 11754 Jowyville Rd., Austin TX 78759. (512)250-1255. Photo Editor: Fred Graber. Emphasizes computer industry. Readers include users. Circ. 30,000.

Photo Needs: Uses 4 photos/issue; all supplied by freelance photographers. Needs product/cover shots. Special needs include digitized, special effects, computer graphics, bloc pix, etc. Model release required.

Making Contat & Terms: Arrange a personal interview to show portfolio; provide resume, business card, brochure, flyer or tearsheets to be kept on file for possible future assignments. Does not return unsolicited material. Reports in 2 weeks. Pays $100-325/color cover photo; $50-200/b&w photo; $20-30/hour. Pays on publication. Credit line given. Buys first North American serial rights. Simultaneous submissions OK.

Tips: Looks for "large format, slides or printed material; photographer must possess good lighting skills. We have never used stock photography. Nine times out of ten, the interior photography plays off the cover theme which translates into one specific assignment."

***AUCTION & SURPLUS**, 6730 San Fernando Rd., Glendale CA 91201. (818)240-5522. Editor: Joseph Haiek. Photo Editor: Mark Arnold. Copy Editors: Gail Madyun, Holly Winslow. Monthly magazine. Circ. 10,000. Emphasizes covering auctions and surplus industry.

Subject Needs: Photos of auctions, auctioneers, military and charitable surplus, and general merchandise (real estate, computers and heavy equipment).

Specs: Uses 8x10 b&w glossy prints.

Payment & Terms: Buys all rights. Submit model release with photo. Pays on publication. Pays $10-25/b&w photo. Captions required.
Making Contact: Submit portfolio. Reports in 1 month. SASE. Simultaneous submissions and previously published work OK. Free sample copy and photo guidelines.

AUDUBON MAGAZINE, 950 3rd Ave., New York NY 10022. Picture Editor: Martha Hill. Bimonthly magazine. Circ. 400,000. Emphasizes wildlife. Photos purchased with or without accompanying mss. Freelancers supply 100% of the photos. Credit line given. Pays on publication. Buys one-time rights. Send photos by mail for consideration. No simultaneous submissions. SASE. Reports in 1 month. Sample copy $3.
Subject Needs: Photo essays of nature subjects, especially wildlife, showing animal behavior, unusual portraits with good lighting and artistic composition. Nature photos should be artistic and dramatic, not the calendar or post card scenic. Query first before sending material; include tearsheets or list previously published credits. Portfolios should be geared to the magazine's subject matter. Must see original transparencies as samples. Also uses some journalistic and human interest photos. No trick shots or set-ups; no soft-focus, filtered or optical effects like those used in some commercial photography. Captions are required.
B&W: Uses 8x10 glossy prints. Pays $100-250, inside.
Color: Uses 35mm, 2¼x2¼ and 4x5 transparencies. Pays $100-250 inside; $600 cover. Plastic sheets only. No prints. No dupes.
Cover: Uses color covers only. Horizontal wraparound format requires subject off-center. Pays $600.
Accompanying Mss: Seeks articles on environmental topics, natural areas or wildlife, predominantly North America.
Tips: "Content and subject matter can be determined by careful study of the magazine itself. We do not want to see submissions on subjects that have recently appeared. We have very high reproduction standards and can therefore only use the best quality photographs. Try photographing less popular subjects—certain areas such as the national parks and the Southwest are overphotographed. Study the magazine and edit carefully if you are interested in working with us. Learn to be very selective about images submitted and don't be afraid to send only one or two pictures."

AUSTIN & SAN ANTONIO HOMES & GARDENS, Box 5950, Austin TX 78763. (512)479-8936. Editors: (Austin) Marsia Hart Reese, (San Antonio) June W. Hayes. Monthly magazines. Emphasizes "homes, gardens, and people of Austin and San Antonio and its environs." Circ. 25,000. Sample copy $1.95 plus $1.05 postage.
Photo Needs: Uses 86 photos/issue; 42 supplied by freelance photographers. Needs photos of "home interiors, architecture, food, restaurants, some travel. Always interested in experienced photographers specializing in interiors, architecture, and food." Model release and captions preferred.
Making Contact & Terms: Arrange a personal interview with art director Jan Heaton to show portfolio; query with resume of credits; provide resume, business card, brochure, flyer or tearsheets to be kept on file for possible future assignments. "Do not call during the week prior to the 10th of the month." Reporting time "depends on schedule." Pays $35-50/b&w photo; $50/-125/color photo; $75-300/job. Pays on acceptance. Credit line given. Buys one-time rights or "depending on use." Simultaneous submissions OK.
Tips: "Usually, we make assignments of subjects that we wish illustrated." In a portfolio prefers to see "color transparencies of interiors, architecture, gardens and landscaping, food; b&w prints of architecture, people."

AUTOBUFF MAGAZINE, Suite 100, 4480 N. Shallowford Rd., Atlanta GA 30338. (404)394-0010. Publisher: D.B. Naef. Monthly. "High-performance (late model), domestic automobiles (Camaros, Firebirds, Chevelles, Mustangs, etc.) that have been modified into street racers. No foreign makes. Topless models are featured (no lower nudity, please) as well as swimwear models. Young, 18- to 26-year-old, well-developed models get our attention." Readers are "young men (18-24) with an above-average interest in high-performance cars and beautiful women." Circ. 200,000. Free sample copy. Photo guidelines free with SASE.
Photo Needs: Uses about 250 photos/issue; 100 supplied by freelance photographers. Needs "high-performance cars (domestic) as car features and/or car features shot with female models." Model release required.
Making Contact & Terms: Query with samples; send b&w prints, 2¼x2¼ transparencies by mail for consideration. SASE. Reports in 3 weeks. Pays $100-500/job, depending on needs, quality, etc. Pays on acceptance. Credit line given. Buys all rights. Simultaneous submissions OK.
Tips: "Read the magazine. Learn the type vehicles and the type models we require."

***AXIOS**, 800 S. Euclid St., Fullerton CA 92632. (714)326-2131. Editor-in-Chief: David J. Gorham. Monthly. Circ. 4,981. Emphasizes Eastern Orthodox Christian religion. Readers are "religious." Sample copy $2.

Photo Needs: Uses 5-10 photos/issue; all supplied by freelance photographers. Needs "photos of churches, clergy, people, events, moods, and trend-setting of Orthodox Christian content! Photos from Greece, Russia, Syria, Yugoslavia, Bulgaria, Rumania and Orthodox in Ireland and England, France wanted!" Model release preferred.

Making Contact & Terms: Query with list of stock photo subjects. Send 8x10 b&w glossy prints by mail for consideration. Provide resume, business card and flyer to be kept on file for possible future assignments. SASE. Reports in 3 weeks. Pays $5-25/b&w cover photo—"if an assignment is given we would pay more—depending on what and where." Pays on acceptance. Credit line given. Buys one-time rights. Simultaneous submissions and previously published work OK.

Tips: "We want those photos which reflect this religion. *Please* look it up and read in the reference books or ask us who we are!"

Daniel E. Wray of Scotia, New York, sold one-time use of this photo to Baby Talk. It appeared (full page) to illustrate the 'fifteen-month old' period. Wray first wrote for photo guidelines, and the editor responded by suggesting he send any transparencies he thought would fit their needs. "It was important that the child fit the developmental stage being written about," Wray says. He was paid $75 for use of the photograph.

BABY TALK, 185 Madison Ave., New York NY 10016. (212)679-4400. Art Director: Doris Manual. Monthly. Circ. 925,000. Emphasizes infants and toddlers. Readers are "pregnant and new parents." Sample copy with SASE and 88¢ postage.

Photo Needs: Uses about 8-10 photos/issue; most are supplied by freelance photographers. Needs photos of "babies, expectant parents, babies with mothers."

Making Contact & Terms: Send transparencies by mail for consideration. SASE. Reports in 3 weeks. Pays $150-200/color cover photo 4 color transparencies; $25/b&w inside photo, $50/color inside photo. Pays on acceptance. Credit line given. Buys one-time rights.

***BACK HOME IN KENTUCKY**, Box 267, Mt. Morris IL 61054. (815)734-4073. Editor: P.S. Cockrel. Consumer bimonthly magazine. Emphasizes the state of Kentucky. Readers are interested in promoting the heritage and future of Kentucky. Circ. 20,000. Sample copy free with SASE.

Photo Needs: Uses 25 photos/issue; all supplied by freelance photographers. Needs photos of scenic, specific places, events. Reviews photos with accompanying ms only. Special needs include holidays in Kentucky—Christmas especially in 1987—The Kentucky Derby sights and sounds. Captions required.

Making Contact & Terms: Send any size, glossy b&w and color prints, 35mm transparencies by mail for consideration. Reports in 2 weeks. Pays $15/text/photo package. Pays on publication. Credit line given. Buys one-time rights. Simultaneous submissions and previously published work OK.

Tips: Have a great story to go with the photo—by self or another.

BASSIN', 15115 S. 76th East Ave., Bixby OK 74008. (918)366-4441. Managing Editor: André Hinds. Publishes 8 times/year. Emphasizes freshwater fishing, especially bass fishing. Readers are predominantly male, adult; nationwide circulation with heavier concentrations in South and Midwest. Circ. 250,000+ subscribers, 30,000+ newsstand sales. Free sample copy. Photo guidelines free.

Photo Needs: Uses about 50-75 photos/issue; "almost all of them" are supplied by freelance photographers. "We need both b&w and color action shots of freshwater fishing; close-ups of fish with lures, tackle, etc., and scenics featuring lakes, streams and fishing activity." Captions preferred.

Making Contact & Terms: Query with samples. SASE. Reports in 6 weeks. Pays $250-300/color cover photo; $25/b&w inside photo; $35-50/color inside photo; $50-100/hour; $400-1,000/day. Pays on acceptance. Credit line given. Buys first North American serial rights. Previously published work OK.

Tips: "We will be using many more color photos in the magazine, as well as freelance b&w. Cover photos should show action—fishermen hauling in a big bass. The same goes for the inside, although we occasionally use more moody photos there (these are kept to a minimum). Send lots of photos and give me a specific deadline in which to send them back. Don't send lists—I can't pick a photo from a grocery list. In the past, we used only photos sent in with stories from freelance writers. However, we would like higher quality stuff. I urge freelance photographers to participate."

BC OUTDOORS, 202-1132 Hamilton St., Vancouver, B.C., Canada V6B 2S2. (604)687-1581. Editor: Henry L. Frew. Emphasizes any outdoor activity that is not an organized sport. "We're interested in family recreation." Readers are "persons interested in any way in the outdoors." Published 10 times/year (January/February, February, March, April, May, June, July, August, September, November/December). Circ. 37,000. Free sample copy and writer's guidelines.
Photo Needs: Uses about 30-35 photos/issue; 99% of which are supplied by freelance photographers. "Fishing (in our territory) is a big need—people in the act of catching, not standing there holding a dead fish. Hunting, canoeing, hiking, camping, snowmobiling, cross-country skiing—any outdoor recreation that's not a competitive sport. Family oriented. By far most photos accompany mss. We are always on lookout for good covers—fishing, wildlife, recreational activities, people in the outdoors—vertical format, primarily of B.C., and Yukon. Photos with mss must, of course, illustrate the story. There should, as far as possible, be something happening. Photos generally dominate lead spread of each story. They are used in everything from double-page bleeds to thumbnails. Column needs basically supplied inhouse." Model release preferred; captions or at least full identification required.
Making Contact & Terms: Send by mail for consideration actual 5x7 or 8x10 b&w prints; 35mm, 2¼x2¼, 4x5 or 8x10 color transparencies; color contact sheet; if color negative send jumbo prints and negatives only on request; or query with list of stock photo subjects. SASE, Canadian stamps. Reports in 4-6 weeks normally. Pays $15/b&w photo; $15 and up/color photo; and $125/cover photo. "Payment for photos when layout finalized so we know what we're using. We try to give 'photos-only' contributors an approximate publication date at time of acceptance. We reach an arrangement with the contributor in such cases (usually involving dupes)." Credit line given. Buys one-time rights inside; with covers "we retain the right for subsequent promotional use." Simultaneous submissions not acceptable if competitor; previously published work OK.

BEND OF THE RIVER ® MAGAZINE, 143 W. Third St., Box 239, Perrysburg OH 43551. (419)874-7534. Co-editors: Christine Alexander and R. Lee Raizk. Monthly magazine. Circ. 3,000. Emphasizes northwestern Ohio history, and Ohio places and personalities. Photos purchased with cutline or accompanying ms. Buys 50 photos/year. Credit line given. Pays on publication. Buys one-time rights. SASE. Previously published work OK. Reports in 1 month. Sample copy $1.
Subject Needs: Historic buildings, memorials, inns, and items about historic renovation and preservation. Captions required.
B&W: Uses 5x7 glossy prints; will accept other print sizes and finishes. Pays $1-3/photo.
Color: Uses 5x7 glossy prints. Pays $1-3/photo.
Cover: Uses b&w or color glossy prints. Vertical format only. Pays $1-3/photo.
Accompanying Mss: Pays $5-10/ms.
Tips: "We are always interested in Toledo area places and people. Ohio pictures are also in demand. Send us something!"

***BETTER NUTRITION**, 6255 Berfield Rd., Atlanta GA 30328. (404)256-9800. Editor: Patti Seikus. Monthly magazine. Emphasizes nutrition, health, fitness, skin care. Readers are health food store consumers. Circ. 590,000. Sample copy $1.
Photo Needs: Uses 25 photos/issue; 16 supplied by freelance photographers. Needs photos of how-to (food preparation, beauty care), action (fitness shots), still life (food, supplements). Model release required; captions preferred.
Making Contact & Terms: Provide resume, business card, flyer or tearsheets to be kept on file for possible future assignments. Does not return unsolicited material. Reports in 2 weeks. Pays $300/color cover photo; $20-25/text/photo package. Pays on publication. Credit line given. Buys all rights.
Tips: Prefers to see b&w shots. Be willing to work for nominal fee in order to establish your portfolio.

BICYCLING, 33 E. Minor St., Emmaus PA 18049. (215)967-5171. Editor and Publisher: James C. McCullagh. Photo Editor: Christie Tito. 6 monthly issues, 3 bimonthly issues. Circ. 250,000. Emphasizes touring, commuting, health, fitness and nutritional information, recreational riding and technical gearing for the beginning to advanced bicyclist. Buys 5-10 photos/issue. Photos purchased with accompanying ms. Credit line given. Pays on publication. Buys all rights. Send material by mail for consideration or query with resume of credits. SASE a must. Reports in 3 months. Sample copy $2; photo guidelines free with SASE.

Subject Needs: Celebrity/personality, documentary, how-to, human interest, photo essay/photo feature, product shot, scenic, special effects and experimental, sport, spot news and travel. "No cheesecakes nor beefcakes." Model release and captions required.
B&W: Uses negatives. Pays $35-75/photo.
Color: Uses 35mm, 2¼x2¼, 4x5 transparencies. Pays $75-150/photo.
Cover: Uses 35mm, 2¼x2¼, 4x5 color transparencies. Vertical format required. Pays $400/photo.
Accompanying Mss: Seeks mss on any aspects of bicycling (nonmotorized); commuting, health, fitness and nutritional information, touring or recreational riding. Pays $25-500/ms. Writer's guidelines on photo guidelines sheet.
Tips: "We prefer photos with ms. Major bicycling events (those that attract 500 or more) are good possibilities for feature coverage in the magazine. Use some racing photos. The freelance photographer should contact us and show examples of his/her work; then, talk directly to the editor for guidance on a particular shoot. For covers: Shoot vertical. The logo and blurbs run on every cover. These are constant; be aware of their location and what that means while shooting. A large single image that creates a simple cover often works best. Riding: While shooting people riding, be aware of the background. Watch out for wires, shadows, or other major distractions. Make sure people are riding in proper positions and on the correct side of the road."

BILLIARDS DIGEST, Suite 1801, 875 N. Michigan Ave., Chicago IL 60611. (312)266-7179. Editor: Michael Panozzo. Bimonthly magazine. Circ. 10,000. Emphasizes billiards and pool for tournament players, room owners, tournament operators, dealers, enthusiasts and beginning players, distributors, etc. Buys 5-10 photos/issue. Pays on publication. Not copyrighted. Send material by mail for consideration. Works with freelance photographers on assignment only basis. Provide resume, tearsheet and samples (photostats of 6 are adequate) to be kept on file for possible future assignments. Credit line given. Reports in 2 weeks. SASE.
Subject Needs: "Unusual, unique photos of billiards players, particularly at major tournaments. Should also stress human emotions, their homelife and outside interests." No stock hunched-over-the-table shot. "We want photos that convey emotion, either actively or passively. Show pool people as human beings." Captions required.
B&W: Uses prints; contact sheet OK. Pays $5-50/photo.
Color: Uses transparencies. Pays $10-50/photo.
Cover: Uses transparencies. Pays $10-50/photo.

BIOLOGY DIGEST, 143 Old Marlton Pike, Medford NJ 08055. (609)654-6500. Editor: Mary Suzanne Hogan. Photo Editor: Dorothy Whitaker. Monthly. Comprehensive abstracts journal covering all the life sciences from anatomy to zoology. Readers include high school and undergraduate college students. Circ. 1,700. Sample copy $12.
Photo Needs: Uses about 20 photos/issue. Photos purchased with descriptive captions only.
Making Contact & Terms: Send 8x10 or 5x7 b&w prints by mail for consideration. SASE. Reports in 1 month. Pays $10-15/b&w cover photo; b&w inside photo. Pays on acceptance. Credit line given. "If photographer desires one-time rights, we will honor that but prefer to have all rights (non-exclusive) so that we may use again."

BIRD TALK, Box 6050, Mission Viejo, CA 92690. (714)240-6001. Editor: Linda W. Lewis. Managing Editor: Karyn New. Monthly magazine. Emphasizes "better care of pet birds through informative and entertaining articles. Birds of interest are: canaries, finches, parrots, parakeets, toucans, macaws, conures, lovebirds, cockatiels, cockatoos, mynahs." Readers are "owners of one pet bird or breeders of many." Estab. 1984. Sample copy $3. Photo guidelines free with SASE.
Photo Needs: Uses 15-20 photos/issue; all by freelance photographers. Needs photos of "any and all pet birds either in portraits or in action—doing anything a bird is able to do." Model release and captions preferred.
Making Contact & Terms: Send 5x7, 8x10 b&w prints; 35mm, 2¼x2¼, 4x5, 8x10 transparencies, or b&w contact sheets by mail for consideration. SASE. Reports in 2 weeks. Pays $15/b&w (partial page) inside photo; $50/color (partial page) inside photo; full pages: $25/b&w, $75/color. Color prints acceptable but will probably be used b&w. Pays on publication. Credit line given. Buys one-time rights.
Tips: Prefers to see "sharp feather focus. Cage bars acceptable, cages and perches must be clean. More black and white photos are used per issue than color. Send us clear shots of a variety of pet birds with cover letter specifying each *species* of bird. We also need a variety of shots of people interacting with their birds."

BIRD WATCHER'S DIGEST, Box 110, Marietta OH 45750. (614)373-5285. Editor-in-Chief: Mary B. Bowers. Bimonthly. Circ. 50,000. Emphasizes birds and bird-watchers. Readers are bird watchers/bird-

ers (backyard and field, veterans and novices). Digest size. Sample copy $2.

Photo Needs: Uses 10-15 photos/issue; all supplied by freelance photographers. Needs photos of "birds; appropriate photos for travel pieces." For the most part, photos are purchased with accompanying ms. Model release preferred.

Making Contact & Terms: Query with list of stock photo subjects. SASE. Reports in 2 months. Pays $10/b&w and $25/color inside. Pays on publication. Credit line given. Buys one-time rights. Previously published work OK.

BLAIR & KETCHUM'S COUNTRY JOURNAL, Box 870, Manchester Center VT 05255. (802)362-1022. Picture Editor: Stephen R. Swinburne. Monthly. Emphasizes country living in rural northern America (snowbelt). Readers are upper middle class, well-educated professionals who chose to live in rural areas or small towns. Circ. 350,000. Sample copy $2.50. Photo guidelines free with SASE.

Photo Needs: Uses about 25-30 photos/issue; most supplied by freelance photographers. Needs photos of "wild animals and birds of the northern states; farm life, people doing things in a rural setting; country humor; sports; chores around the house; vegetable and flower gardening, country summer recreation, harvesting, preparing for winter, etc. Continuing need for color shots of people engaged in all kinds of activities in the country. Activity must be believable for a country setting. Special need for shots of humorous nature for 'This Country Life' page, color only." Model release preferred; captions required.

Making Contact & Terms: Arrange a personal interview to show portfolio; send 8x10 lustre b&w prints; 35mm, 2¼x2¼, 4x5 or 8x10 transparencies by mail for consideration; submit portfolio for review. SASE. Reports in 3 weeks to a month. Pays $275-500/color cover photo; $140-225/b&w page; $140-225/color page. Pays on acceptance. Credit line given. Buys one-time or first North American serial rights.

Tips: "Send only photos that show country life, either as a selection of related shots that tell a story, or individual shots that demonstrate photographer's ability. Please study back issues, and send me only what you think are the best in the bunch."

THE BLOOMSBURY REVIEW, Box 8928, Denver CO 80201. (303)455-0593. Art Director: Chuck McCoy. Editor: Tom Auer. Monthly. Circ. 18,000. Emphasizes book reviews, articles and stories of interest to book readers. Sample copy $2.

Photo Needs: Uses 2-3 photos/issue; all supplied by freelance photographers. Needs photos of people who are featured in articles. Photos purchased with or without accompanying ms. Model release and captions preferred.

Making Contact & Terms: Provide brochure, tearsheets and sample print to be kept on file for possible future assignments, SASE. Reports in 1 month. Payment by the job varies. Pays on publication. Credit line and one-line bio given. Buys one-time rights.

Tips: "Send good photocopies of work to Art Director."

BLUEGRASS UNLIMITED, Box 111, Broad Run VA 22014. (703)361-8992. Editor: Peter V. Kuykendall. Monthly magazine. Circ. 19,500. Emphasizes old-time traditional country music for musicians and devotees of bluegrass, ages from teens through the elderly. Buys 50-75 photos/annually. Buys all rights, but may reassign to photographer after publication. Send photos for consideration or call. Pays on publication. Credit line given. Reports in 2 months. SASE. Previously published work OK. Free sample copy and photo guidelines.

Subject Needs: Celebrity/personality, documentary, head shot, how-to, human interest, humorous, photo essay/photo feature, product shot, spot news and travel.

B&W: Send 5x7 glossy prints. Pays $20-40/printed page of photos.

Color: Send 5x7 glossy prints or transparencies. Pays $30-80/printed page of photos.

Cover: Send 5x7 glossy b&w prints, 5x7 glossy color prints or color transparencies. Pays $100-150.

THE B'NAI B'RITH INTERNATIONAL JEWISH MONTHLY, 1640 Rhode Island Ave. NW, Washington DC 20036. (202)857-6645. Editor: Marc Silver. Monthly magazine. Circ. 200,000. For Jewish family members. Emphasizes religious, cultural and political happenings worldwide. Buys 30 photos annually, usually on assignment only. Occasional photo essays. Buys first serial rights. Send sample photos for consideration. Pays on publication. Reports in 6 weeks. SASE.

B&W: Pays $20-150/photo.

Color: Pays $50-250/photo; $250 by the day.

BOAT PENNSYLVANIA, Box 1673, Harrisburg PA 17105-1673. (717)657-4520. Editor: Art Michaels. Bimonthly magazine. Emphasizes "non-angling boating in Pennsylvania: powerboating, canoeing, kayaking, sailing, rafting, and water skiing." Sample copy and guidelines free with 9x12 SASE and 73¢ postage.

Photo Needs: Uses about 30 photos/issue; 60% supplied by freelance photographers. Model release and captions required.

Making Contact & Terms: Query with resume of credits. Send 35mm, 2¼x2¼ transparencies by mail for consideration. SASE. Reports in 1 week on queries; 3 months on submissions. Pays on acceptance. Credit line given. Buys all rights, but reassigns rights after publication on written request.

Tips: "We are hungry for top-quality materials, but no matter how good a picture is, we insist on a few items. For one thing, all boaters must be wearing PFDs. We feature subjects appropriate to Pennsylvania, so we can't use pictures with foreign backgrounds, palm trees, saltwater settings, and snow-capped mountain ranges. We prefer to show boats registered in Pennsylvania. If this is a problem, try to hide the boat registration completely. Finally, *Boat Pennsylvania* stresses safety, so pictures must show boaters accordingly. For instance, we would not publish a picture of a powerboat under way with people lying on the gunwale or leaning over the side."

BOP, Suite 850, 3500 Olive Ave., Toluca Lake CA 91505. (818)953-7999. Editor: Julie Laufer. Monthly. Emphasizes teenage entertainment; includes music stars, TV and film personalities of interest to the teenage/youth market. Readers are primarily teenage girls, average age 13 years. Circ. 350,000. Sample copy $1.95.

Photo Needs: Uses about 215 photos/issue; 60 supplied by freelance photographers. Needs photos of entertainment personalities. "We're always looking for new and unusual photos of celebrities popular among young people." Model release required; captions preferred.

Making Contact & Terms: Query with samples; send 5x7 or 8x10 b&w, matte or glossy, prints; 35mm or 2¼x2¼ transparencies; b&w contact sheet by mail for consideration. Pays $75 + /color cover photo; $15-25/b&w and $35-50 + /color inside photo; $50 minimum for text/photo package. Pays on publication. Buys all rights. Simultaneous submissions and previously published work OK.

Tips: "Send b&w prints or contact sheets or color transparencies of TV, film and music celebrities popular with young people. Please provide clear, focused photos, preferably never before published in the US."

BOW & ARROW, Box HH, Capistrano Beach CA 92624. Editor: Jack Lewis. Bimonthly magazine. Circ. 98,000. For archers and bowhunters. "We emphasize bowhunting—with technical pieces, how-tos, techniques, bowhunting tips, personality profiles and equipment tests." Photos purchased with accompanying ms; rarely without. "We buy approximately 4 text/photo packages per issue. Most cover shots are freelance." Pays $50-300 for text/photo package or on a per-photo basis for photos without accompanying ms. Credit line given. Pays on acceptance. Buys first rights. Query with samples OK, but prefers to see completed material by mail on speculation. SASE. Reports in 2-3 weeks.

Subject Needs: Animal (for bowhunting stories); celebrity/personality (if the celebrity is involved in archery); head shot ("occasionally used with personality profiles, but we prefer a full-length shot with the person shooting the bow, etc."); how-to (must be step-by-step); human interest; humorous; nature, travel and wildlife (related to bowhunting); photo essay/photo feature; product shot (with equipment tests); scenic (only if related to a story); sport (of tournaments); and spot news. "No snapshots (particularly color snapshots), and no photos of animals that were not hunted by the rules of fair chase. We occasionally use photos for Bow Pourri, which is a roundup of archery-related events, humor, laws and happenings." Captions required.

B&W: Uses 5x7 or 8x10 glossy prints.

Color: Uses 35mm or 2¼x2¼ transparencies.

Cover: Uses 35mm or 2¼x2¼ color transparencies. Vertical format preferred.

Accompanying Mss: Technical pieces, personality profiles, humor, tournament coverage, how-to stories, bowhunting stories (with tips), equipment tests and target technique articles. Writer's guidelines included with photo guidelines.

Tips: "We rarely buy photos without an accompanying manuscript, so send us a good, clean manuscript with good-quality b&w glossies (our use of color is limited)."

BOWHUNTER, 3150 Mallard Cove Lane, Fort Wayne IN 46804. (219)432-5772 or 456-3580. Editor/Publisher: M.R. James. Managing Editor: Wayne Van Zuoll. Bimonthly magazine. Circ. 180,000. Emphasizes bow and arrow hunting. Photos purchased with or without accompanying ms. Buys 50-75 photos/year. Credit line given. Pays on acceptance. Buys one-time publication rights. Send material by mail for consideration or query with samples. SASE. Reports on queries in 1-2 weeks; on material in 4-6 weeks. Sample copy $2. Photo guidelines free with SASE.

Subject Needs: Scenic (showing bowhunting) and wildlife (big and small game of North America). No cute animal shots or poses.

B&W: Uses 5x7 or 8x10 glossy prints. Pays $25-50/photo.

Color: Uses 5x7 and 8x10 glossy prints or 35mm and 2¼x2¼ transparencies. Pays $50-100/photo.

Cover: Uses 35mm and 2¼x2¼ color transparencies. Vertical format preferred. Pays $50-100/photo, "more if photo warrants it."

Accompanying Mss: "We want informative, entertaining bowhunting adventure, how-to and where-to-go articles." Pays $25-250/ms, occasionally more. Writer's guidelines free with SASE.
Tips: "Know bowhunting and/or wildlife and study several copies of our magazine before submitting. We're looking for better quality and we're using more color on inside pages. Get to know our magazine before submitting any material. Most purchased photos are of game animals. Hunting scenes are second. In b&w we look for sharp, realistic light, good contrast, both vertical and horizontal format. Color must be sharp; early, late light is best. We avoid anything that looks staged. Send only your best, and if at all possible let us hold those we indicate interest in. If your work is in our files it will probably be used."

BOWLERS JOURNAL, 875 N. Michigan Ave., Chicago IL 60611. (312)266-7171. Editor: Mort Luby. Managing Editor: Jim Dressel. Monthly magazine. Circ. 22,000. Emphasizes bowling. For people interested in bowling: tournament players, professionals, dealers, etc. Needs "unusual, unique photos of bowlers." Buys 20-30 annually. Not copyrighted. Send contact sheet or photos for consideration. Pays on publication. Reports in 3 weeks. SASE. Simultaneous submissions OK.
B&W: Send contact sheet or 8x10 glossy prints. Captions required. Pays $5-50.
Color: Send transparencies. Captions required. Pays $10-75.
Cover: See requirements for color.
Tips: "Bowling is one of the most challenging areas for photography, so try it at your own risk . . . poor lighting, action, etc."

BOY'S LIFE, Boy Scouts of America, 1325 Walnut Hill Lane, Irving TX 75038-3096. (214)580-2358. Editor: William McMorris. Photo Editor: Gene Daniels. Monthly magazine. Circ. 1,500,000. Emphasizes topics of interest to boys, such as Boy Scouting, sports, stamp and coin collecting, fiction and careers. For boys age 8-17. Wants no single photos or photos with no "story theme." Submit portfolio or query with "strong story outline." Pays on acceptance. Reports in 1 week. SASE. Free photo guidelines.
Color: Send 35mm transparencies. Captions required. Pays $200/day.
Cover: Send 35mm color transparencies. Cover photos must pertain directly to an inside story. Captions required. Pays $500 minimum.
Tips: "All photography is assigned to first-class talent. A properly prepared portfolio is a must." Query before submitting photos.

BREAD, 6401 The Paseo, Kansas City MO 64131. (816)333-7000. Editor: Gary Sivewright. Monthly magazine. Circ. 25,000. Christian leisure reading magazine for junior and senior high school students, published by the department of youth ministries. Church of the Nazarene. Buys 150 photos annually. Free sample copy and photo guidelines with SASE.
Subject Needs: Family scenes involving teens, teens in action, seasonal photos involving teens and all types of photos illustrating relationships among teens. "No obviously posed shots or emphasis on teens involved in negative situations (smoking, drinking, etc.). Prefers photos of teens fully clothed, e.g., no teens in swimwear."
Specs: Uses 8x10 glossy b&w prints inside and color transparencies for cover.
Payment & Terms: Pays $15-25/b&w and $50-125/cover. Buys first rights. Pays on acceptance. Simultaneous submissions and previously published work OK.
Making Contact: Send photos by mail for consideration. Reports in 6-8 weeks. SASE.
Tips: "Make sure photos are *current*—watch clothing styles, etc."

BRIGADE LEADER, Box 150, Wheaton IL 60189. (312)665-0630. Editor: David R. Leigh. Art Director: Lawrence Libby. Quarterly magazine. Circ. 12,000. For Christian men, age 20 and up. Seeks "to make men aware of their leadership responsibilities toward boys in their families, churches, and communities." Buys 2-7 photos/issue. Buys first serial rights. Arrange a personal interview to show portfolio or send photos for consideration. Pays on publication. Reports in 6 weeks. SASE. Simultaneous submissions and previously published work OK. Sample copy $1.50. Photo guidelines available. Include a SASE.
Subject Needs: Photos of men in varied situations (alone, with their sons, with groups of boys or with one boy, with their families or at work), head shot, photo essay/photo feature and scenic.
B&W: Send 8x10 glossy prints. Pays $25.
Cover: Send glossy b&w prints. Pays $50-75.

BRITISH HERITAGE, Historical Times, Inc., 2245 Kohn Rd., Box 8200, Harrisburg PA 17105. (717)657-9555. Editor: Mrs. Gail Huganir. Bimonthly magazine. Emphasizes British history, Commonwealth travel and history. Readers are professional, middle-aged. Circ. 65,000. Sample copy $4, author guidelines available with SASE.
Photo Needs: Uses about 80 photos/issue; 60% supplied by freelance photographers. Needs travel,

scenic and historical photos. Captions required.
Making Contact & Terms: Provide resume, business card, brochure, flyer or tearsheets to be kept on file for possible future assignments. SASE. Reports in 4-6 weeks. Negotiates pay for cover photos. Pays $20/b&w inside photo; $60/color inside photo. Pays on publication. Credit line given. Buys one-time rights.

***CALIFORNIA HORSE REVIEW**, Box 2437, Fair Oaks CA 95628. Editor: Carolee Weber. Monthly. Circ. 9,000. Emphasizes "equines—horses, mules. Readers are horse owners—hobbyists and professionals." Sample copy $1.25; writers' guidelines free with SASE.
Photo Needs: Uses about 30 photos/issue; 20 supplied by freelance writers/photographers. Needs "horse and rider photos primarily." Photos purchased with accompanying ms only; will consider photo stories. Special needs include "photos of events (Western) of interest to horse owners, breeders and trainers." Model release preferred; captions required.
Making Contact & Terms: Query with samples or with list of stock photo subjects. Does not consider unsolicited manuscripts. SASE. Reports in 4 weeks. Pays $25-125 for text/photo package. Pays on publication. Credit line given. Buys one-time rights or first North American serial rights.
Tips: "Learn more about horses—what constitutes good conformation, etc."

CALIFORNIA MAGAZINE, Suite 1800, 11601 Wilshire Blvd., Los Angeles CA 90025. Art Assistant: Rick Kraus. Monthly. Circ. 300,000. Emphasizes California—people, places and events. Readers are national (U.S.—most subscribers in California). Sample copy $2 for current; $3.50 for back issues.
Photo Needs: Uses about 30-50 photos/issue (depends on features); 20% supplied by freelance photographers. Needs photos of people (minor celebrities) and specific events. Model release required; captions preferred.
Making Contact & Terms: Query with list of stock photo subjects; submit portfolio for review; provide resume, business card, brochure, flyer or tearsheets to be kept on file for possible future assignments. SASE. Reports in 2 weeks. Pays approximately $500/b&w cover photo, approximately $800/color cover photo; $150-250/b&w page, $300-400/color page; $600-1,500 for text/photo package (depends on work involved). Pays on publication. Credit line given. Buys one-time rights. Simultaneous submissions OK.
Tips: Prefers to see "tearsheets or photographs with an editorial emphasis" in a portfolio. "If you are interested in working with our publication we suggest you look at our magazine before submitting photos. We have a strict drop-off policy for portfolios. Leave portfolios with receptionist Mon-Wed mornings; portfolios will be ready for pick-up in afternoon."

CALLALOO: A Tri-Annual/Afro-American Journal of Arts and Letters, English Department, University of Kentucky, Lexington KY 40506. Editor-in-Chief: Charles H. Rowell. Managing Editor: Nikki Swingle. Triannual. Circ. 600. Emphasizes "the creative work of black writers, artists and photographers worldwide, as well as scholarly works about these artists." Single issue $7.
Photo Needs: Photos by and about blacks. Model release and captions preferred.
Making Contact & Terms: Send 5x7 b&w prints by mail for consideration. SASE. Reports in 2-3 months. Pays in copies. Credit line given. Buys one-time rights. Simultaneous submissions OK.

CAMPUS LIFE, 465 Gundersen Dr., Carol Stream IL 60188. (312)260-6200. Senior Editors: Gregg Lewis, Jim Long. Photo Editor: Diane Eble. Monthly magazine except May/June and July/August. Circ. 155,000. "*Campus Life* is a magazine for high school and college-age youth. We emphasize balanced living—emotionally, spiritually, physically and mentally." Photos purchased with or without accompanying ms. Buys 20 photos/issue. Credit line given. Pays on publication. Buys one-time rights. SASE. Simultaneous submissions and previously published work OK. Reports in 4-6 weeks. Sample copy $2; photo guidelines for SASE.
Subject Needs: Head shots (of teenagers in a variety of moods); humorous, sport and candid shots of teenagers/college students in a variety of settings. "We want to see multiracial teenagers in different situations, and in every imaginable mood and expression, at work, play, home and school. No travel, how-to, still life, travel scenics, news or product shots. We stay away from anything that looks posed. Shoot for a target audience of 18-year-olds."
B&W: Uses 8x10 glossy prints. Pays $50-75/photo.
Color: Uses 35mm or larger format transparencies. Pays $90-125 minimum/photo.
Cover: Uses 35mm or larger format color transparencies. Pays $250/photo.
Accompanying Mss: Query. Pays $125 minimum/ms. Writer's guidelines for SASE.
Tips: "We try to choose photos that portray a variety of types of teenagers. Our guiding philosophy: that readers will 'see themselves' in the pages of our magazine." Looks for ability to catch teenagers in real-life situations that are well-composed but not posed. Technical quality; communication of an overall mood or emotion, or action. "Look at a few issues to get a feel for what we choose. We're not interested in posed shots. Cover shots are usually tight head shots."

CAMPUS VOICE, 505 Market St., Knoxville TN 37902. (615)521-0600. Editor: Keith Bellows. Senior Art Director: Tim Smith. Photo Researcher: Cheri Sims. Bimonthly magazine distributed during the school year on college campuses. Emphasizes college life, careers, job hunting and consumer articles. Circ. 1.2 Million. Sample copy for $2 and SASE (9x12 envelope).
Photo Needs: Uses about 25 photos/issue both b&w and color to illustrate features in both the Youth and Adult Divisions (e.g. the college experience, the world of business, the world of travel, etc.); 10-15 supplied by freelance photographers. Wants to hear from photographers who can supply photos of students and their activities. Interested in classroom situations, fads, fashions, leisure activities and travel appropriate to college students. Model release and captions required.
Making Contact & Terms: Query with resume of photo credits and tearsheets; or samples along with SASE. Also indicate availability and location for assignments. B&w photography should be submitted as 5x7 glossy prints; color as 35mm, 2¼x2¼ or 4x5 transparencies. All slides sent on speculation will be returned promptly. Payment is commensurate with photographer's experience and extent of assignment. Buys one-time rights.

***CANADIAN YACHTING MAGAZINE**, 7th Floor, Maclean Hunter Bldg., 777 Bay St., Toronto, Ontario, Canada M5W 1A7. Editor: John Morris. Monthly magazine. Circ. 30,000. Emphasizes yachting for Canadians. Photos purchased with or without accompanying ms, or on assignment. Buys 12-20 photos/issue from freelance photographers. Pays on a per-photo basis unless photos accompany ms. Credit line given. Pays on acceptance. Buys first serial rights and promotional rights for cover shots. Send material by mail for consideration. SAE and International Reply Coupons. Repors in 2 months. Free sample copy.
Cover: Uses 35mm, 2¼x2¼ or color transparencies. "Kodachrome preferred. We need very sharp action shots of power and sailing people in color—not 'boat portraits,' but shots of people driving and sailing—for our full-bleed cover. We need Canadian subjects." Vertical format required. Pays $35-200/photo.
Accompanying Mss: Query.
Tips: "We are looking for high quality originals with clear focus and bright resolution—both b&w and color. I'm interested in photography that is technically right, i.e., focus, exposure and basic composition. That's the first step. It is remarkably absent in many boat photographs. Beyond that, the responsibility is on the photographers to be fresh, interpretive, interesting, etc. in their work. I look for distinctive styles in photgraphers."

CANOE, Box 3146, Kirkland WA 98083. (206)827-6363. Managing Editor: George I. Thomas. Associate Editor: Steve Simpson. Bimonthly magazine. Circ. 55,000. Emphasizes a variety of paddle sports as well as how-to material and articles about equipment. For canoe and kayak enthusiasts at all levels of ability. Also publishes calendar and special projects/posters. Photos only occasionally purchased with or without accompanying mss. Thirty photos used/issue: 90% supplied by freelancers. Pays $50-150 on a per-photo basis. Credit line given. Pays on publication. Buys one-time rights, first serial rights and exclusive rights. Model release required "when potential for litigation." Query with resume of credits, submit portfolio for review or send material. "Let me know those areas in which you have particularly strong expertise and/or photofile material. Send best samples only and make sure they relate to the magazine's emphasis and/or focus. (If you don't know what that is, pick up a recent issue first, before sending me unusable material.) We will review dupes for consideration only. Originals *required* for publication. Also, if you have something in the works or extraordinary photo subject matter of interest to our audience, let me know! It would be most helpful to me if those with substantial reserves would supply indexes by subject matter." SASE. Simultaneous submissions and previously published work OK, in noncompeting publications. Reports in 1 month. Free sample copy with 9x12 envelope and postage only.
Subject Needs: Canoeing, kayaking, ocean touring, canoe sailing, fishing when compatible to the main activity, canoe camping and, occasionally, rafting. No photos showing subjects without proper equipment in evidence, such as modem, Type III lifejackets in other than still water; no photos showing disregard for the environment, be it river or land; no photos showing gasoline-powered, multi hp engines; no photos showing unskilled persons taking extraordinary risks to life, etc. Captions are required, unless impractical.
B&W: Uses 5x7 and 8x10 glossy prints.
Color: Uses 35mm, 2¼x2¼ and 4x5 transparencies.
Cover: Uses color transparencies; vertical format preferred. Pays $250. Pays $150/full page b&w or color photos: $100/half to full page photos; $75/quarter to half page photos; $50/quarter or less.
Accompanying Mss: "Editorial coverage strives for balanced representation of all interests in today's paddling activity. Those interests include paddling adventures, both close to home and far away; camping; fishing; flatwater; whitewater; ocean kayaking; racing; poling; sailing; outdoor photography; how-to projects; instruction and historical perspective. Regular columns feature paddling techniques, compe-

tition, conservation topics, safety, interviews, equipment reviews, book/movie reviews, new products and reader letters."

Tips: "We have a highly specialized subject and readers don't want just 'any' photo of the activity; they want something they can identify with, can wallow in over the memories it recalls of trips, feats, cruises gone by. We're particularly interested in photos showing paddlers *faces*; the faces of people having a good time. We're after anything that highlights the paddling activity as a lifestyle and the urge to be 'in' the out-of-doors." All photos should be "as natural as possible with authentic subjects."

***CAPE CODE LIFE MAGAZINE**, Box 222, Osterville MA 02655. (617)428-5706. Editor/Publisher: Brian F. Shortsleeve. Photo Editor: Elizabeth R. Morin. Bimonthly magazine. Emphasizes Cape Cod people, places and concerns. A regional magazine that looks at Cape Cod living. Readers are educated group of middle class and upper-middle class men and women. Age concentration is 40 to 70. Circ. 32,000-34,000. Sample copy available for $3.

Subject Needs: Uses about 55 photos/issue; all supplied by freelancers. Needs scenic photos for the cover and photo spread. "The scenics must be identified as Cape Cod. We also use people quite often in these areas." Reviews photos with accompanying ms only. Model release and photo captions preferred.

Making Contact & Terms: Send unsolicited photos by mail for consideration. Uses 35mm transparencies. SASE. Reports in 2 months. Pays $200/color cover photo; $25-100/photo spread; $20-40/articles and photos; $15-30/b&w photo. Pays on publication. Credit line given. Buys one-time rights.

Tips: "When we look for scenics, the strongest contenders are those that also involve people and familiar landmarks. We are not seeking general post card shots."

THE CAPE ROCK, Southeast Missouri State University, Cape Girardeau MO 63701. (314)651-2156. Editor-in-Chief: Harvey Hecht. Emphasizes poetry and poets for libraries and interested persons. Semiannual. Circ. 1,000. Free photo guidelines.

Photo Needs: Uses about 13 photos/issue; all supplied by freelance photographers. "We like to feature a single photographer each issue. Submit 30 thematically organized 8x10 glossies, or send 5 pictures with plan for complete issue. We favor most a series that conveys a sense of place. Seasons are a consideration too: we have winter and summer issues. Photos must have a sense of place: e.g., an issue featuring Chicago might show buildings or other landmarks, people of the city (no nudes), travel or scenic. No how-to or products. Sample issues and guidelines provide all information a photographer needs to decide whether to submit to us." Model release not required "but photographer is liable"; captions not required "but photographer should indicate where series was shot."

Making Contact & Terms: Send by mail for consideration actual 8x10 b&w photos, query with list of stock photo subjects, or submit portfolio by mail for review. SASE. Reporting time varies. Pays $100 and 10 copies on publication. Credit line given. Buys "all rights, but may release rights to photographer on request." No simultaneous submissions or previously published work.

CAR COLLECTOR, Box 28571, Atlanta GA 30328. (404)998-4603. Editor: Donald R. Peterson. Monthly. Emphasizes collector automobiles. Readers are "people who collect or are otherwise interested in cars more than 15 years old." Sample copy $2. Photo and writers guidelines free with SASE.

Photo Needs: Uses about 50-75 photos/issue; "nearly all" supplied by freelance photographers. Needs photos of "automobiles." *Photos purchased with accompanying ms only*. Captions required.

Making Contact & Terms: Query with samples; send b&w prints; 35mm, 2¼x2¼, 4x5 and/or 8x10 transparencies by mail for consideration. Pays minimum of $50/color cover photo; $5/b&w and $10/color inside photo. Pays on publication. Credit line always given. Buys all rights.

Tips: "*Do not submit photos to us without accompanying story and captions*. No 'fish-eye' or other 'trick lens' photos purchased."

CAR CRAFT, 8490 Sunset Blvd., Los Angeles CA 90069. (213)657-5100. Editor: Jeff Smith. Monthly magazine. Circ. 400,000. Emphasizes how-to's, car features, technical features, racing coverage, etc. "We cater to the high-performance automotive and drag racing fan. People read it to keep abreast of cruising news and to learn how to 'hop up' their cars, what the latest trends in high-performance are, and what the newest cars are like." Buys 6-7 photos/issue. Pays $150-350 for text/photo package, and on a per-photo basis. Credit line given. Pays on publication. Buys all rights. Send material by mail for consideration. SASE. Reports in 3 weeks. Free sample copy and photo guidelines.

Subject Needs: How-to (e.g., how to build portable air compressors; how to swap engines; how to paint and polish your car) and sport (drag racing events). Wants features on street machine enthusiasts. No snapshots, no auto racing other than drag racing (unless there's a tie-in), no back-lit black cars, no color technical how-to shots, no car models older than '49. Hi Riser column uses b&w shots of recognized automotive individuals. Etc. section uses unusual, humorous and spectacular b&w photos, usually of drag racers, car gatherings, etc. Racing Action is a color showcase of spectacular drag racing cars.

B&W: Uses 8x10 glossy prints. Pays $30-150/photo.

Color: Uses 35mm or 2¼x2¼ transparencies. Pays $50-300/photo.
Cover: Uses 35mm or 2¼x2¼ color transparencies. Vertical format preferred. Pays $150-300/photo. Cover shots seldom purchased from freelancers.
Accompanying Mss: Seeks mss detailing technical information, as in swapping engines, installing clutches, adding custom items; featuring drag racing drivers, owners, mechanics; featuring citizens with street machines, etc. Pays $100-300/ms. and $100-700 for a text/photo package.
Tips: "Become involved with the editorial subject matter so you have a specific knowledge of the magazine's market and requirement."

CAR REVIEW MAGAZINE, Dobbs Publication, Inc., Box Drawer 7157, Lakeland FL 33803. (813)646-5743. Editor: Paul Zazarine. Car magazine with emphasis on late 50's, 60's and early 70's factory original muscle cars. Monthly. Circ. 105,000. Free sample copy and photo guidelines.
Photo Needs: Uses about 50 photos/issue supplied by freelance photographers. Needs include celebrities/muscle car owners, photo essay/features, special effects/experimental, human interest, humorous; all with collectible muscle car. Especially needs color photos. No "autos hidden by people or pictures missing part of auto." Model release and captions required.
Making Contact & Terms: Send by mail for consideration actual 5x7 b&w photos, 35mm, 2¼x2¼ or 4x5 color transparencies; query with list of stock photo subjects, resume of credits, or samples; or submit portfolio for review. Provide resume, brochure, calling card, flyer, tearsheet and samples to be kept on file for possible future assignments. SASE. Reports in 1 month. Pays on publication $10 minimum/b&w inside photo; $50/color transparencies for cover and inside. Credit line given. No simultaneous submissions or previously published work.

***CAREERS MAGAZINE**, 1001 Avenue of the Americas, New York NY 10018. (212)354-8877. Editor: Elizabeth Bibb. Published three times per year. Emphasizes careers—college. Readers are high school juniors and seniors. Circ. 600,000. Sample copy available for $2.
Subject Needs: Uses 10 photos/issue; all are supplied by freelance photographers. Needs shots of teens, on-the-job photos, product shots (most are assigned). Model release and captions are required.
Making Contact & Terms: Arrange a personal interview to show portfolio, provide resume, business card, brochure, flyer or tearsheets to be kept on file for possible future assignments. SASE. Reports in 1 month. Pays $200/color cover photo; $100/inside b&w photo; $150-250/inside color photo. Pays 30 days after acceptance. Credit lines given. Buys first North American serial rights.
Tips: In photographer's samples looks for personality shots, good product shots, mix of field and studio work and creative use of b&w. Photographers are advised to "be flexible, keep expenses reasonable."

CAROLINA QUARTERLY, Greenlaw Hall, 066-A, University of North Carolina, Chapel Hill NC 27514. (919)962-0244. Editor: Emily Stockard. Circ. 1,000 and up. Emphasizes "current poetry, short fiction and reviews." Readers are "literary, artistic—primarily, though not exclusively, writers and serious readers." Sample copy $3.
Photo Needs: Uses 1-8 photos/issue; all supplied by freelance photographers. "No set subject matter. Artistic outdoor as well as interior scenes. Attention to form. No photojournalsim, please."
Making Contact & Terms: Send b&w prints by mail for consideration. SASE. Reports in 1-3 months, depending on deadline. Pays on publication. Credit line given. Buys one-time rights.
Tips: Prefers to see "high quality artistic photography. Attention to form, design. Look at a few high quality small literary magazines which use photos. Subject matter is up for grabs."

CARONN PUBLICATIONS, (formerly *The Crib Sheet*), 14109 NE 76th St., Vancouver WA 98662-4950. (206)892-3037. Editor: Karen LaClergue. Monthly. Emphasizes family life, especially for expectant or new parents. Readers include female, 18-36, many new parents. Circ. 5,000. Free sample copy with SASE (2 first class stamps).
Photo Needs: Uses 5-10 photos/issue; all supplied by freelance photographers. Needs cover photos of young child 0-4 years. Some with holiday setting. Many of young children or child and parent(s). Young mother—many different settings, etc. Some-6-9 year olds with activity settings (biking). Would like parents release for cover picture—as well as name/age of child, and parents name and general location. Also interested in interior design, landscape, family, remodeling, projects, etc.
Making Contact & Terms: Send any size, non-matte b&w or color prints by mail for consideration. Will be printed as b&w. SASE. Reports in 1 month. Pays $5/b&w cover; $2.50/b&w inside photo; $7.50/text/photo package. Pays on publication. Credit line given. Buys one-time rights. Simultaneous submissions and previously published work OK.

CAT FANCY, Fancy Publications, Inc., Box 6050, Mission Viejo CA 92690. (714)240-6001. Editor-in-Chief: Linda Lewis. Readers are "men and women of all ages interested in all phases of cat ownership." Monthly. Circ. 170,000. Sample copy $3; photo guidelines for SASE.

Photo Needs: Uses 20-30 photos/issue; 100% freelance supplied. Each issue focuses on a specific purebred. Prefers photos "that show the various physical and mental attributes of the breed. Include both environmental and portrait-type photographs, but in both cases we would prefer that the animals be shown without leashes or collars. We also need good-quality, interesting b&w and color photos of any breed cat for use with feature articles." Model release required.

Making Contact & Terms: Send by mail for consideration actual 8x10 b&w photos, 35mm or 2¼x2¼ color transparencies. SASE. Reports in 6 weeks. Pays $15-25/b&w photo; $50-150/color photo; and $50-300 for text/photo package. Credit line given. Buys first North American serial rights.

Tips: "Nothing but sharp, high contrast shots, please. Send SASE for list of specific photo needs. We are using more color photos and prefer more action shots, fewer portrait shots."

***CATHOLIC DIGEST**, St. Paul's Square, Box 64090, St. Paul MN 55164. (612)647-5323. Editor: Henry Lexau. Photo Editor: Susan Schaefer. Monthly magazine. Emphasizes religion, family life. Readers are mostly Catholic, mature with teenagers or grown children. Circ. 620,000. Sample copy free with SASE.

Photo Needs: Uses 6-9 photos/issue; 2 supplied by freelance photographers. Needs photos of family life, children, teenagers, senior citizens, middle-age, young adults, religious symbols and scenes, food, health, medical. Special needs include Catholic photos of all kinds, holiday/religious feasts. Model release required; captions preferred.

Making Contact & Terms: Send b&w and color prints, contact sheets, negatives or color slides by mail for consideration. SASE. Reports in 3 weeks. Pays on acceptance. Credit line given. Buys one-time rights. Previously published work OK.

CATHOLIC NEAR EAST MAGAZINE, 1011 1st Ave., New York NY 10022. Editor: Michael Healy. Quarterly magazine. Circ. 130,000. Emphasizes "charitable work conducted among poor and refugees in Near East; religious history and culture of Near East; Eastern Rites of the Church (both Catholic and Orthodox)." General readership, mainly Catholic; wide educational range. Buys 40 photos/year. Buys first North American serial rights. Query first. Credit line given. "Credits appear on page 3 with masthead and table of contents." Pays on publication. Reports in 3 weeks; acknowledges receipt of material immediately. SASE. Simultaneous submissions and previously published work OK, "but neither one is preferred. If previously published please tell us when and where." Sample copy and photo guidelines free with SASE.

Subject Needs: "We are interested in shots taken in the Middle East, and we consider a variety of subjects within that general category. Mainly, though, we are oriented toward people pictures, as well as those which show the Christian influence in the Holy Land. We are also interested in good shots of artistic and cultural objects/painting, crafts and of the Eastern Rite Churches/priests/sacraments/etc." No posed shots, pictures showing combat, violence, etc. or "purely political pictures of the area." Payment varies; $25 and up, depending on size, quality, etc.

B&W: Uses 8x10 glossy prints. Captions required.

Color: Uses 35mm or larger transparencies. Captions required.

Cover: Send color negatives or color transparencies. "Generally, we use shots which show our readers what the people and places of the Middle East really look like. In other words, the shot should have a distinctly Eastern look." Captions required.

Tips: "We always need *people* pictures. Additionally, we use shots of the Eastern Rites of the Catholic Church. Finally, we do a story on cities and countries of the Middle East in almost every issue. If the pictures were good enough, we would consider doing a photo story in any of the above categories." Also, "try to put the photos you send into some kind of context for us—briefly, though. We would welcome a ms accompanying photos, if the freelancer has a good deal of knowledge about the area."

CATS MAGAZINE, Box 37, Port Orange FL 32029. Monthly magazine. Circ. 109,000. For cat owners and breeders; most are adult women. Buys 30 photos/year. Buys first serial rights. Send contact sheet or photos for consideration. Pays on publication. Reports in 8-12 weeks. SASE. Free sample copy and photo guidelines. Provide tearsheets to be kept on file for possible future assignments.

Subject Needs: Felines of all types; celebrity/personality (with their cats); fine art (featuring cats); head shot (of cats); how-to (cat-oriented activities); human interest (on cats); humorous (cats); photo essay/photo feature (cats); sport (cat shows); travel (with cats); and wildlife (wild cats). No shots of clothed cats or cats doing tricks.

B&W: Send contact sheet or 5x7 or 8x10 glossy prints. Wants no silk finish. Pays $5-25.

Cover: Send 2¼x2¼ color transparencies. Prefers "shots showing cats in interesting situations." Pays $150. Send to Linda J. Walton, above address.

Tips: "We are always receptive to seasonal themes." If purebred cats are used as subjects, they must be representative specimens of their breed. "Our most frequent causes for rejection: cat image too small; backgrounds cluttered; uninteresting; poor quality purebred cats; dirty pet-type cats; shot wrong shape for cover; colors untrue; exposure incorrect."

CAVALIER, Suite 204, 2355 Salzedo St., Coral Gables FL 33134. (305)443-2378. Editor: Douglas Allen. Photo Editor: Nye Willden. Sexually oriented men's magazine. Readers are 18-35, single males, educated, aware, heterosexual, "affluent, intelligent, interested in current events, ecology, sports, adventure, travel, clothing, good fiction." Monthly. Circ. 250,000. Sample copy $3; photo guidelines for SASE.
Photo Needs: Uses about 100 photos/issue; all of which are supplied by freelance photographers consisting of 5 girl sets, 1 feature set and 5-10 singles, all color. "First priority—we buy picture sets of girls. We also publish photo features of special interest and they are selected for uniqueness and excellence of photography but they must appeal to our male readership . . . everything from travel to sports but not current events (we have a 4 month lead time) and no subjects which have been done over and over in the media." Runs 4-5 picture sets of nudes/issue. Model release required.
Making Contact & Terms: Query first with list of stock photo subjects or with resume of photo credits. "Photographers should contact by mail only, describe your material, and we'll respond with a yes or no for consideration." Provide calling card, tearsheets and samples to be kept on file for possible future assignments. SASE. Reports in 2-3 weeks. Pays on publication $250/color cover photo, $150/b&w photo, $250/color inside photo; $100-350/job and $500-750/nude set. Credit line given. Buys first North American one-time rights. No simultaneous submissions.
Tips: "Study the market. See what is selling. When sending samples, show a rounded sampling, the wider and more varied the better. Include photo studies of nudes if applicable."

***CENTRAL FLORIDA MAGAZINE**, 341 N. Maitland Ave., Maitland FL 32751. (305)628-8850. Editor: Mimi Martin. Photo Editor: Charles Utz. Monthly magazine. Emphasizes central Florida lifestyle—city magazine. Readers are affluent, upper-income, college graduates. Circ. 25,000. Sample copy free with SASE.
Photo Needs: Uses 25-30 photos/issue; 25 supplied by freelance photographers. "All photography is assigned to complement the editorial content of that monthly issue; contact photo editor." Model release required; captions preferred.
Making Contact & Terms: Provide resume, business card, brochure, flyer or tearsheets to be kept on file for possible future assignments. SASE. Reports in 1 week. Pays $350/color cover photo; $25-50/b&w inside photo; $50-100/color inside photo; $250-750/text/photo package. Pays on publication. Credit line given. Buys one-time rights, "exclusive in this market, please." Simultaneous submissions and previously published work OK "only from alternate markets."
Tips: Prefers to see published photo-illustration and journalistic photography. Prove your abilities by showing samples.

CHANGING MEN: Issues in Gender, Sex & Politics, 306 N. Brooks St., Madison WI 53715. Editor: Mike Biernbaum. Triquarterly. Emphasizes men's issues, feminist, male politics, gay issues. Readers are anti-sexist men; feminists, gay, political activists. Circ. 25,000. Sample copy $4.50.
Photo Needs: Uses 6-8 photos/issue; 100% supplied by freelance photographers. Needs art photography, male nude, images of men at work, play, etc.; journalism on gay and male feminist gatherings. Special needs include features on men's issues, Aids relationships with women, men's health, gay issues, antiporn, 3rd world masculinities, etc. Model release preferred.
Making Contact & Terms: Query with list of sample relevant stock photo subjects. Send b&w prints and b&w contact sheets. SASE. Reports in 1 month. Pays $10-50/text/photo package. Pays on publication. Credit line given. Buys one-time rights.
Tips: "Display sensitivity to subject matter; provide political photos showing conscience, strong journalism on gay issues."

CHARLOTTE MAGAZINE, Box 36639, Charlotte NC 28236-6639. (704)375-8034. Managing Editor: Diane Clemens. Editor: David Mildenberg. Emphasizes probing, researched articles on local people and local places. Readers are "upper income group, 30s or early 40s, college degree, homeowners, travelers, men and women with executive-type jobs." Monthly. Circ. 20,000. Sample copy $3; photo guidelines for SASE. Provide tearsheets to be kept on file for possible future assignments.
Photo Needs: Uses about 4 photos/issue, all of which are supplied by freelance photographers. "Freelance photographers are usually sent out on assignments according to editorial content for a specific issue." Sometimes photo essays, which are all regional in nature, are assigned by the editor. Column needs: Travel (worldwide), Town Talk (various short articles of information and trivia), The Arts, Restaurants, Music, Galleries, Theatre, Antiques, etc. Model release and captions required.
Making Contact & Terms: Arrange personal interview to show portfolio, or if sending by mail for consideration, call first (do not call collect). SASE. Reports in 3 weeks. Pays 30 days after publication $10-100/job. Credit line given. Buys one-time rights. Simultaneous and previously published submissions OK.

CHERI PUBLICATIONS, 801 2nd Ave., New York NY 10017. (212)661-7878. Publisher: Brian Riley. Monthly. Emphasizes topics for the male sophisticate. Readers are 18- to 45-year-old, blue-collar men. Circ. 500,000+. Sample copy $3.95. Photo guidelines free with SASE.
Photo Needs: Uses about 325/photos per issue; 50% supplied by freelance photographers. Needs nude glamour layouts. Model release required.
Making Contact & Terms: Arrange a personal interview to show portfolio; query with samples; send 35mm, 2¼x2¼ transparencies by mail for consideration. SASE. Reports in 1 month. Pays $450/color cover photo; $750-1,500/job. Pays on publication. Buys first North American serial rights. Simultaneous submissions OK.
Tips: Photographer should "be familiar with our publication. Have an adequate number of models available."

THE CHESAPEAKE BAY MAGAZINE, 1819 Bay Ridge Ave., Annapolis MD 21403. (301)263-2662. (202)261-1323. Art Director: Ginny Leonard. Monthly. Circ. 20,000. Emphasizes boating—Chesapeake Bay only. Readers are "people who use Bay for recreation." Sample copy available.
Photo Needs: Uses "approximately" 5-20 photos/issue. Needs photos that are "Chesapeake Bay related (must); vertical power boat shots are badly needed (color)." Special needs include "vertical 4-color slides showing boats and people on Bay."
Making Contact & Terms: Query with samples or list of stock photo subjects; send 35mm, 2¼x2¼, 4x5 or 8x10 transparencies by mail for consideration. SASE. Reports in 3 weeks. Pays $150/color cover photo. Pays on publication. Credit line given. Buys one-time rights. Simultaneous submissions OK.
Tips: "We prefer Kodachrome over Ektachrome. Vertical shots of the Chesapeake bay with *power* boats badly needed, but we use all subject matter related to Bay."

CHICKADEE MAGAZINE, 59 Front St. E, Toronto, Ontario, Canada M5E 1B3. (416)364-3333. Editor: Janis Nostbakken. Published 10 times/year. Circ. 75,000-80,000. "This is a natural science magazine for children 4-8 years. Each issue has a careful mix of stories and activities for different age levels. We present animals in their natural habitat." Sample copy with SAE and 64¢ Canadian postage (no American postage).
Photo Needs: Uses about 3-6 photos/issue; 2-4 supplied by freelance photographers. Needs "crisp, bright, close-up shots of animals in their natural habitat." Model release required.
Making Contact & Terms: Query with list of stock photo subjects. SAE (Canadian postage). Reports in 6-8 weeks. Pays $200 Canadian/color cover; $200 Canadian (centerfold); pay negotiable for text/photo package. Pays upon acceptance. Credit line given. Buys "one time rights, nonexclusive, to reproduce in *Owl* and *Chickadee* in Canada and affiliated children's publications in remaining world countries."

CHILD LIFE, Box 567, Indianapolis IN 46206. (317)636-8881. Editor: Steve Charles. Magazine published 8 times/year. For children 7-9. Photos purchased only with accompanying ms. Credit line given. Pays on publication. Buys all rights to editorial material, but usually one-time rights on photographs. Send material by mail for consideration. Query not necessary. SASE. Reports within 10 weeks. Sample copy 75¢; free writer's guidelines with SASE.
Subject Needs: Health, medical and safety articles are always needed "but we are looking for photo stories on any subject which will entertain and inform our readers." Captions and model release required.
B&W: Prefer 8x10 or 5x7 glossy to accompany mss. Pays $10/photo.
Color: Transparencies 35mm or larger. Pays $20/photo. Will consider photo accompanying photo story for cover, pay $50/cover.
Tips: "Address all packages to Editor and mark 'Photo Enclosed.' "

***CHILDREN'S DIGEST**, 1100 Waterway Blvd., Box 567, Indianapolis IN 46206. (317)636-8881. Editor: Elizabeth Rinck. Eight issues/year magazine. Emphasizes children's better health. Readers are children aged 8 to 10 years. Circ. 132,000. Sample copy 75¢.
Photo Needs: Uses 0-10 photos/issue; all supplied by freelance photographers. "We do not purchase individual photographs. We do purchase short photo features (6-8 pictures) or photos that accompany and help illustrate editorial matter." Reviews photos with accompanying ms only. Model release and captions required.
Making Contact & Terms: Send unsolicited manuscript with photos. Send any size, glossy finish b&w and color prints for consideration. SASE. Reports in 1 month. Pays $7/inside b&w and color photo; 6¢/word and $7/photo for text/photo package. Pays on publication. Credit line given. Buys one-time rights.

***CHRISTIAN BOARD OF PUBLICATION**, 2700 Pine, Box 179, St. Louis MO 63166. Director, Product Development: Guin Tuckett. Assistant Director: Alice Stifel. Religious age-level magazines/curric-

ulum; monthly, quarterly and annual. For various age levels (children, youth, adults) engaging in educational and recreational activities. Buys 4-6 or more photos/issue for each publication.

Subject Needs: Uses educational activities, recreation, and some closeups. Does not want posed "pretty" pictures, industrial or fashion models.

Specs: Uses 5x7 and 8x10 glossy b&w. Uses b&w and some color covers; format varied.

Payment/Terms: Pays $15 minimum/b&w print. Credit line given. Pays on publication. Buys one-time rights. Simultaneous submissions and previously published work OK.

Making Contact: Send photos by mail for consideration. SASE. Reports in 4 weeks.

Tips: "Send about 25 samples with return postage; then we can comment."

CHRISTIAN BUSINESS MAGAZINE, Box 64951, Dallas TX 75206-0951. (214)288-8900. Contact: Editor. Monthly. Emphasizes Christians in business, Christian and moral living. Business to Business, Business to Consumer. Readers include Christian communities nationally, Christian retail consumer market, Christian business market, Secular business to Christian consumer. Circ. 10,000. Estab. 1984. Sample copy $3.50 with SASE. Photo guidelines $2.

Photo Needs: Uses 15-20 photos; 80% supplied by freelance photographers. Needs photo-stories on Christian businesspersons (business related), fishing, sports, seminars, conventions, etc. which are Christian business related or perhaps travel, advertisers, inventors, Christian novelists, photographers, and general subjects. Photos purchased with accompanying ms only. Organizational guidelines should be ordered prior to any submissions. "Christian Business will need work from photographers who have a developed understanding of our guidelines and can assist with photography from their local areas or who can travel to on-locale spots to shoot assignments. Must be professional." Model release and captions required.

Making Contact & Terms: Order copy of publication first and include resume of credits, sample of work. Does not return unsolicited photos. Reports in 2-3 weeks. Pays $5-35/b&w photo; $10-35/color photo; $10-100/hour; $120-1,200/day; text/photo package negotiated. "All prices are individually negotiated." Pays on acceptance and publication. Credit line sometimes given. Buys one-time rights, first North American serial rights, all rights. Simultaneous submissions, previously published work OK. "Photographers and photojournalists should be aware of our format. Before trying to get started, send for guideline packet or order copy of publication so that you'll know what CBM is looking for. Then go for it. Persons needed in every state! Remember, clean, wholesome principles will net a job which may have lasting job relationships. CBM does not utilize sex, cigs, perversion. *Christian Business* is looking for the hot shot who can shoot straight and knows how to work well·within the Christian community. Professionalism a must! Follow the rules. Also desparately need 'talent Photographers' to work in their local areas. Must know the Christian community and be professional. Send $14.95 for our complete package including our talent directory and photography contract. Earnings are immediate."

THE CHRISTIAN CENTURY, 407 S. Dearborn St., Chicago IL 60605. (312)427-5380. Editor: James M. Wall. Photo Editor: Dean Peerman. Magazine published 40 times/year. Circ. 35,000. Emphasizes "concerns that arise at the juncture between church and society, or church and culture." Deals with social problems, ethical dilemmas, political issues, international affairs, the arts, and theological and ecclesiastical matters. For college-educated, ecumenically minded, progressive church clergy and laymen. Photos purchased with or without accompanying ms. Buys 50 photos/year. Credit line given. Pays on publication. Buys all rights. Send material by mail for consideration. SASE. Simultaneous submissions OK. Reports in 4 weeks. Free sample copy and photo guidelines for SASE.

Subject Needs: Celebrity/personality (primarily political and religious figures in the news); documentary (conflict and controversy, also constructive projects and cooperative endeavors); scenic (occasional use of seasonal scenes and scenes from foreign countries); spot news; and human interest (children, human rights issues, people "in trouble," and people interacting). Model release and captions preferred.

B&W: Uses 5x7 glossy prints. Pays $15-50/photo.

Cover: Uses glossy b&w prints. Alternates among vertical, square and horizontal formats. Pays $20 minimum/photo.

Accompanying Mss: Seeks articles dealing with ecclesiastical concerns, social problems, political issues and international affairs. Pays $35-100. Free writer's guidelines for SASE.

Tips: Needs sharp, clear photos. "We use photos sparingly, and most of those we use we obtain through an agency with which we have a subscription. Since we use photos primarily to illustrate articles, it is difficult to determine very far in advance or with much specificity just what our needs will be."

CHRISTIAN HERALD, 40 Overlook Dr., Chappaqua NY 10562. (914)769-9000. Art Director: Peter A. Gross. Monthly magazine. Emphasizes "evangelical Christian life as revealed in the Bible." Readers are "evangelical Christian families." Circ. 200,000. Sample copy $2. Photo guidelines free with SASE.

Photo Needs: Uses 10-15 photos/issue; all supplied by freelance photographers. Needs "photos of

Christian performers, authors, and speakers; general scenes of worship and Christian life." Model release and captions preferred.
Making Contact & Terms: Send 8x10 b&w prints, 35mm, 2¼x2¼ transparencies by mail for consideration. SASE. Reports in 1 month. Pays $300/color cover photo; $50-175/b&w inside photo, $75-200/color inside photo and $200-350/text/photo package. Pays on publication. Credit line given. Buys one-time rights. Previously published work OK.

CHRISTIAN SINGLE, 127 Ninth Ave. N, Nashville TN 37234. (615)251-2469. Art Director: Jerry Ross. Monthly magazine. Emphasizes "Christian material which caters to ages 20-45 generally, and emphasizes values and subjects related to the Christian life. Readers are mostly college grads, most are church-members and are single. Enjoy scenics, shots of groups, moods of people, and sports." Circ. 100,000. Sample copy free with SASE.
Photo Needs: Uses 20 photos/issue; 15 supplied by freelance photographers. Needs "scenics and shots of people in all situations, within the age group described."
Making Contact & Terms: Send 8x10 b&w prints or 35mm, 2¼x2¼ transparencies by mail for consideration. Provide resume, business card, brochure, flyer or tearsheets to be kept on file for possible future assignments. SASE. Reports in 2 weeks. Pays $150/color cover photo and $30/b&w inside photo. Pays on publication. Credit line given. Buys one-time rights. Simultaneous submissions and previously published work OK.

CHRISTIAN TALENT SOURCE DIRECTORY/CHRISTIAN BUSINESS SERVICE SOURCE BOOK, Box 270942, Dallas TX 75227-0942. (214)288-8900. Contact: Editor. Association publication for the Christian Models U.S.A. Company publication of the CMUSA News Today Newsletter. Semi-annually. Directories emphasize Christian principles, wholesome photography requirements for models, actors and other talent photography needs nationwide. Talent procurement necessitates photographers who work within our guidelines. Readers include the National Christian communities, both consumer and business. Circ. 2,500-10,000. Sample copy $14.95 for Directory, $3 SASE for newsletter.
Photo Needs: Photo guidelines $3 with SASE or free newsletter or directory order $14.95 p.pd. Uses 75-100 photos/issue; 98% supplied by freelance photographers. "CMUSA requires stationary photographers within their local areas to work with our organization who can see the necessity of Christian principles within our photography; to assist our talent on a nationwide basis. CMUSA needs photographers of above persuasion to contact us immediately. Guidelines. Directory of newsletter must be ordered if person is serious about receiving work from CMUSA in order to know what our format is." Model release required.
Making Contact & Terms: Send query with resume. SASE. Prefer contact prior to receipt of photographer's material. Persons should order guidelines before submissions. Reports in 1 week. Pay rates included in photo guidelines. Pays on acceptance, publication.
Tips: Photographers for this market are badly needed. Immediate income after ordering of directory and guidelines. Minimum pay $50 to $750. $3,000 monthly is possible for right persons. Must know Christian communities. Must be professional. Must be able to follow instructions to the letter. Must have business attitude, be fast worker. Great opportunities now.

***THE CHRONICLE OF THE HORSE**, Box 46, Middleburg VA 22117. (703)687-6341. Editor: John Strassburger. Weekly magazine. Emphasizes horses in sport: hunters, combined training, dressage, polo, steeplechasing, jumpers. Thoroughbred racing, foxhunting, endurance/trail riding. Chronicle readers range from serious competitors and foxhunters to pleasure riders, retired horsemen. No Western style riding. Circ. 21,500. Sample copy $2. Photo guidelines free with SASE.
Photo Needs: Uses 14-20 photos/issue; "majority" supplied by freelance photographers. Photos must relate to horses. Vast majority relate to *accompanying* story; news, personality profile, etc. Rarely use "mood" or single unrelated photos unless of exceptional merit. Special needs: "We cover major horse sporting events, it is best to consult editorial staff about news features." Photos must have complete identification of subjects and location (event, place, etc.).
Making Contact & Terms: Contact the Chronicle with specific event, photo in mind. SASE. Reports in 1 month. Pays $10-15/b&w and color inside photo. Pays on publication. Credit line given. Buys one-time rights, print must be retained by magazine. Simultaneous submissions and previously published work OK.
Tips: "We want black & white 5x7 glossies. We are flexible in some instances. But photo needs to have a reason—champion in action at horse show, winning race horse in current race. We are a news publication."

THE CHURCH HERALD, 1324 Lake Dr. SE, Grand Rapids MI 49506. (616)458-5156. Editor: John Stapert. Photo Editor: Christina Van Eyl. Biweekly magazine. Circ. 54,000. Emphasizes current events, family living, evangelism and spiritual growth, from a Christian viewpoint. For members and

clergy of the Reformed Church. Needs photos of life situations—families, couples, vacations, school; religious, moral and philosophical symbolism; seasonal and holiday themes; nature scenes—all seasons. Buys 2-4 photos/issue. Buys first serial rights, second serial (reprint) rights, first North American serial rights or simultaneous rights. Send photos for consideration. Pays on acceptance. Reports in 2 weeks. SASE. Simultaneous submissions and previously published work OK. Free sample copy.
B&W: Send 8x10 glossy prints. Pays $25-35.
Cover: B&w or color. Pays $50-100.
Tips: Looks for "good photo quality—a lot of what we get is junk photos we can't use—photos that our readers will relate to in a positive way. I want to see interesting photos of good quality which depict real-life situations."

CINCINNATI MAGAZINE, Suite 300, 35 E. 7th St., Cincinnati OH 45202. (513)421-4300. Editor: Laura Pulfer. Art Director: Thomas E. Hawley. Monthly magazine. Circ. 28,000. Emphasizes Cincinnati city life for an upscale audience—average household income $59,000, college educated. Send examples with SASE. Works with freelance photographers on assignment only basis. Provide samples to be kept on file for possible future assignments. Pays $20-600/job; $50-150 for text/photo package. Pays on publication. Buys first serial rights. Reports in 2 weeks. SASE. Simultaneous submissions and previously published work OK.
B&W: Uses 5x7 or 8x10 glossy prints; contact sheet OK. Pays $20/photo.
Color: Uses 35mm, 2¼x2¼, 4x5 or 8x10 transparencies. Pays $50/photo.
Cover: Uses 2¼x2¼ or 4x5 color transparencies. Special instructions given with specific assignments. Pays $200-400.
Tips: Most photography is oriented toward copy. Study the magazine. Address submissions in care of art director. "A good portfolio should have no more than 15-20 samples—a good cross section of techniques and different kinds of lighting situations that the photographer has mastered."

CIRCLE K MAGAZINE, 3636 Woodview Trace, Indianapolis IN 46268. (317)875-8755. Executive Editor: Karen J. Pyle. Published 5 times/year. Circ. 12,000. For community service-oriented college leaders "interested in the concept of voluntary service, societal problems, and college life. They are politically and socially aware and have a wide range of interests." Assigns 5-10 photos/issue. Works with freelance photographers on assignment only basis. Provide calling card, letter of inquiry, resume and samples to be kept on file for possible future assignments.
Subject Needs: General interest, "though we rarely use a nonorganization shot without text. Also, the annual convention (St. Louis, 1987) requires a large number of photos from that area." Captions required, "or include enough information for us to write a caption."
Specs: Uses 8x10 glossy b&w prints or color transparencies. Uses b&w covers only; vertical format required for cover.
Accompanying Mss: Prefers ms with photos. Seeks general interest features aimed at the better than average college student. "Not specific places, people topics."
Payment/Terms: Pays up to $200-250 for text/photo package, or on a per-photo basis—$15 minimum/b&w print and $50 minimum/cover. Credit line given. Pays on acceptance. Previously published work OK if necessary to text.
Making Contact: Send query with resume of credits. SASE. Reports in 3 weeks. Free sample copy.

CITY SPORTS MAGAZINE, Box 3698, San Francisco CA 94119. (415)546-6150. Editor: Dan Tobin. Monthly magazine on newsprint. Emphasizes active sports. Readers are active, healthy, young upscale people. Circ. 200,000. Sample copy $3. Photo guidelines free with SASE.
Photo Needs: Uses 50 photos/issue; all supplied by freelance photographers. Needs photos of participation sports—tennis, skiing (x-c and downhill), swimming, backpacking, cycling, walking, aerobics etc. Model release required.
Making Contact & Terms: Query with list of stock photo subjects. SASE. Reports in 1 month. Pays $150-350/color cover photo; $20-35/b&w inside photo; $50/color inside photo. Pays on publication. Credit line given. Buys one-time rights. Previously published work OK.

COAST MAGAZINE, Drawer 2448, Myrtle Beach SC 29577. (803)449-7121. Editor: Greg Tyler. Emphasizes sports, recreation and entertainment. Readers are "tourists to the Grand Strand of South Carolina." Weekly. Circ. 850,000. Free sample copy and photo guidelines.
Photo Needs: Uses about 10 photos/issue; 2-3 of which are supplied by freelance photographers. "All submitted material is reviewed for possible publication." Makes "occasional use of color for color section. These photos must be easily associated with the Grand Strand of South Carolina such as beach or pool scenes, sports shots, sunsets, etc. B&w photos primarily used in conjunction with feature articles, except for use weekly in 'Beauty and the Beach' page which features swimsuit or playsuit clad females (no nudes)." Model release required; captions not required.

Making Contact & Terms: Send by mail for consideration actual b&w photos, or 35mm or 2¼x2¼ color transparencies. SASE. Reports in 2 weeks; "color may be held longer on occasion." Pays on acceptance $15/b&w photo; $25-50/color transparency. Credit line given for color only. Buys one-time rights. Simultaneous submissions OK "if not in the same market area." Previously published work OK.

COINS MAGAZINE, 700 E. State St., Iola WI 54990. (715)445-2214. Editor: Arlyn G. Sieber. Monthly. Circ. 65,000. Emphasizes coin collecting. Readers are coin, paper money and medal collectors and dealers at all levels. Free sample copy with SASE.
Photo Needs: Uses 100 photos/issue; 5-10 supplied by freelance photographers. Needs photos of coins, paper money, medals, all numismatic collectibles. Photos purchased with or without accompanying ms. Model release required; captions preferred.
Making Contact & Terms: Query with samples. SASE. Reports in 2 weeks. Provide brochure and tearsheets to be kept on file for possible future assignments. Pays $25-200/color cover, $5/b&w inside, $25/color inside. Pays on acceptance. Credit line "not usually" given. Buys all rights. Previously published work OK.

COLONIAL HOMES MAGAZINE, 1700 Broadway, New York NY 10019. (212)247-8720. Art Director: Richard Lewis. Bimonthly. Circ. 600,000. Emphasizes traditional architecture and interior design. Sample copy available.
Photo Needs: All photos supplied by freelance photographers. Needs photos of "American architecture of 18th century or 18th century style—4-color chromes—no people in any shots; some food shots." Special needs include "American food and drink; private homes in Colonial style, historic towns in America." Captions required.
Making Contact & Terms: Submit portfolio for review. Send 4x5 or 8x10 transparencies by mail for consideration. Provide resume, business card, brochure, flyer or tearsheets to be kept on file for possible future assignments. SASE. Reports in 1 month. Pays $500/day. Pays on acceptance. Credit line given. Buys all rights. Previously published work OK.

***COLORADO OUTDOOR JOURNAL**, Box 432, Florence CO 81226. (303)275-3166. Editor: Galen L. Geer. Consumer. Quarterly (bimonthly in 1987). Magazine. Emphasizes outdoor recreation, hunting, fishing, camping, etc. Readers are active sportsmen and women. Circ. 10,000. Estab. 1987. Sample copy $3.50. Photo guidelines free with SASE.
Photo Needs: Uses 15-25 photos/issue; 50% supplied by freelance photographers. Needs photos of wildlife shots, travel and scenic about Colorado. Special needs include big game and small game animals in natural environment. Model release and captions required.
Making Contact & Terms: Query with samples, provide resume, business card, brochure, flyer or tearsheets to be kept on file for possible future assignments. Uses 8x10 glossy b&w and color prints; 35mm and 2¼x2¼ transparencies; b&w and color contact sheets. SASE. Reports in 1 month. Pays $200/color cover photo; $25-50/b&w inside photo; $25-75/inside color photo; $100-300 text/photo package. Pays on acceptance, on publication. Credit line given. Previously published work OK. May offer to buy all if possible to use in promo.
Tips: Limit portfolio to five shots per subject and total of 25 shots total. All photos should be grouped by subject. No phony wildlife shots from zoos or of tame animals. *Wild*life should be wild. Stress the natural side.

COLUMBIA MAGAZINE, Drawer 1670, New Haven CT 06507. (203)772-2130, ext. 263. Photo Editor: John Cummings. Monthly magazine. Circ. 1,370,812. For Catholic families; caters particularly to members of the Knights of Columbus. Features dramatizations of a positive response to current social problems. Buys 18 photos/issue.
Subject Needs: Documentary, photo essay/photo feature, human interest and humorous. Captions required. Model release preferred.
Specs: Uses 8x10 glossy color prints. Uses 4x5 color transparencies for cover. Vertical format required.
Accompanying Mss: Photos purchased with accompanying ms only.
Payment/Terms: Pays up to $1,000 lump sum for text/photo package. Credit line given. Pays on acceptance. Buys all rights.
Making Contact: Query with samples. SASE. Reports in 1 month. Free sample copy and photo guidelines.

COLUMBUS MONTHLY, 171 E. Livingston Ave., Columbus OH 43215. (614)464-4567. Editor: Max S. Brown. Assistant Editor: Laura Messerly. Monthly magazine. Circ. 44,000. Emphasizes local and regional events, including feature articles; personality profiles; investigative reporting; calendar of events; and departments on politics, sports, education, restaurants, movies, books, media, food and drink, shelter and architecture and art. "The magazine is very visual. People read it to be informed and

entertained." Photos purchased with accompanying ms or on assignment. Buys 150 photos/year. Pays $35-200/job, $50-500 for text/photo package, or on a per-photo basis. Credit line given. Pays on acceptance. Buys one-time rights. Arrange personal interview with design director to show portfolio or query with resume of credits. Works with freelance photographers on assignment only basis. Provide calling card, samples and tearsheet to be kept on file for possible future assignments. SASE. Previously published work OK. Reports in 3-4 weeks. Sample copy $2.64.

Subject Needs: Celebrity/personality (of local or regional residents, or big name former residents now living elsewhere); fashion/beauty (local only); fine art (of photography, fine arts or crafts with a regional or local angle); head shot (by assignment); photo essay/photo feature on local topics only; product shot ("for ads, primarily—we rarely use out-of-town freelancers"); scenic (local or regional Ohio setting usually necessary, although one or twice a year a travel story, on spots far from Ohio, is featured); and sport (should accompany an article unless it has a special angle). No special effects or "form art photography." Model release required; captions preferred.

B&W: Uses 8x10 glossy prints; contact sheet OK.

Color: Uses 8x10 glossy prints or 35mm, 2¼x2¼ or 4x5 transparencies; contact sheet OK.

Cover: Uses color prints or 2¼x2¼ or 4x5 color transparencies. Vertical format preferred.

Accompanying Mss: "Any manuscripts dealing with the emphasis of the magazine. Query suggested."

Tips: "Live in the Columbus area. Prior publication experience is not necessary. Call for an appointment."

***COMMODORE MAGAZINE**, 1200 Wilson Dr., West Chester PA 19380. (215)431-9100. Assistant Director: Robert Andersen. Monthly magazine. Emphasizes Commodore specific computers/users. Readers are male 13-35. Circ. 225,000.

Photo Needs: Uses 5-25 photos/issue; all supplied by freelance photographers. Needs photos of futuristic landscapes (stock), people using computers/product shots.

Making Contact & Terms: Query with samples and with list of stock photo subjects; provide resume, business card, brochure, flyer or tearsheets to be kept on file for possible future assignments. Send transparencies by mail for consideration. SASE. Reports in 2 weeks. Pay negotiated. Pays on publication. Credit line given. Buys one-time rights or all rights.

Tips: Prefers to see "what makes this photographer special. How does he 'twist' what he sees to create a style. Always go beyond the call of duty."

***COMMON LIVES/LESBIAN LIVES**, Box 1553, Iowa City IA 52244. (319)353-6265. Contact any staff member. Quarterly. Emphasizes "the lives, ideas, experiences and visions of lesbians." Readers are lesbians. Circ. 2,000. Sample copy $4. Photo guidelines free with SASE.

Photo Needs: Uses about 6 photos/issue; all supplied by freelance photographers. Needs "photos of lesbians in any presentation; photos by lesbians." Special needs include "photos of lesbian family groups, lesbians of color, older or younger lesbians, lesbians at work." Model release and captions required.

Making Contact & Terms: Send any size glossy b&w prints by mail for consideration; "include bio sketch of photographer, personal rather than professional." SASE. Reports in 3 months. Pays in copies of issue work appears in. Pays on publication. Credit line given. "Copyright reverts to photographer; any reprint acknowledges where 1st appeared."

COMMONWEALTH, THE MAGAZINE OF VIRGINIA, 121 College Place, Norfolk VA 23510. (804)625-4800. Art Director: Lucy Alfriend. Monthly magazine. Emphasizes "feature articles and consumer/lifestyle stories specific to Virginia. Readers are upscale; 35-50. Circ. 30,000. Sample copy free with SASE and $1.35 postage.

Photo Needs: Uses about 40 photos/issue; 10 by freelance photographers. "Prefer to assign photos specific to stories." Model release and captions required.

Making Contact & Terms: Arrange a personal interview to show portfolio. Reports within 3 months. Pays $35-60/b&w inside photo and $50-100/color inside photo. Pays on publication. Credit line given. Buys all rights.

Tips: Prefers to see "exceptional portraits and photo illustrations" in a portfolio.

***CONGRESSIONAL QUARTERLY WEEKLY REPORT**, 1414 22nd St. NW, Washington DC 20237. (202)887-8500. Managing Editor: Kathryn Waters Gest. Photo Editor: Martha Angle. Weekly newsmagazine. Emphasizes Congress, especially need pictures of congressmen "in action" both in Washington and their home districts; foreign policy (timely) shots; other federal and state politicians. Readers are mostly in Washington: all congressional offices; trade associations; businesses; lobbyists. Also, gubernatorial offices; school libraries; political scientists. Circ. 12,000. Sample copy free with SASE.

Photo Needs: Uses 20 photos/issue; about half supplied by freelance photographers. In general, the

photos need to be timely "news" photos. "Need photos of subjects currently on the House and Senate floors (e.g., farm pictures when the Farm Bill is moving through Congress; pictures of Contras when Congress is considering aid to Nicaragua, etc." Special photo needs: "This is an election year for many members of Congress. Pictures of them campaigning in their states/districts will be needed. We are also constantly in need of mug shots of congressmen." Model release preferred; captions required.

Making Contact & Terms: Provide resume, business card, brochure, flyer or tearsheets to be kept on file for possible future assignments. SASE. Pays $100-200/b&w cover photo; $50-75/b&w inside photo; $35-50/hour. Payment "depends on whether we commission a photographer or merely buy what he has on hand." Credit line given. Rights negotiable. Simultaneous submissions and previously published work OK.

Tips: Wants to see experience in photojournalism, especially in Washington, D.C.

CONNECTICUT MAGAZINE, Box 6480, Bridgeport CT 06606. (203)576-8978. Art Director: Lori Bruzinski Wendin. Monthly. Circ. 68,000. Emphasizes issues and entertainment in Connecticut. Readers are Connecticut residents, 40-50 years old, married, average income of $55,000. Sample copy $1.95 and postage; photo guidelines free with SASE.

Photo Needs: Uses about 100 photos/issue; all supplied by freelance photographers. Needs photos of Connecticut business, arts, education, interiors, people profiles, restaurants. Model release required.

Making Contact & Terms: Arrange a personal interview to show portfolio; query with samples or list of stock photo subjects; provide resume, business card, brochure, flyer or tearsheets to be kept on file for possible future assignments. SASE. Does not return unsolicited material. Reports in 3 months. Pays $400-800/color cover photo; $50-175/b&w inside photo, $100-300/color inside photo. Pays on publication. Credit line given. Buys one-time rights. Previously published work OK.

CONSERVATIVE DIGEST, Suite 800, National Press Bldg., Washington DC 20045. (202)662-8919. Editor: Mr. Scott Stanley. Photo Editor: Marla Mernin. Monthly magazine. Circ. 30,000. Emphasizes activities and political issues for "New Right" conservatives. Photos purchased with or without accompanying ms, or on assignment. Buys 4 photos/issue. Credit line given. Pays on publication. Buys one-time rights or second serial (reprint) rights. Send material by mail for consideration, query with list of stock photo subjects, or query with samples. SASE. Simultaneous submissions and previously published work OK. Reports in 3 weeks. Sample copy $3.

Subject Needs: Political celebrity/personality, head shot, human interest, humorous and spot news. Model release preferred; captions required.

B&W: Uses 5x7 or 8x10 glossy prints. Pays $15-50/photo.

Cover: Uses 35mm color transparencies. Vertical format preferred. Pays $100-175/photo.

Accompanying Mss: Pays $50-100.

***CONTEMPORARY CHRISTIAN MAGAZINE**, Box 6300, Laguna Hills CA 92654. (714)951-9106. Art Director: Lynn Schrader. Monthly. Emphasizes music profiles of well-known contemporary Christian artists, reviews and current events. Circ. 40,000. Sample copy $1.95 plus postage.

Photo Needs: Uses about 25 photos/issue; 2 or 3 supplied by freelance photographers. Needs photos of Christian concerts and artists. Model release and captions preferred. "Must include date, place, photo credit and phone number on back of photo."

Making Contact & Terms: Query with resume of credits; with sample or with list of stock photo subjects; send 8x10 b&w glossy prints, 35mm transparencies, b&w or color contact sheet by mail for consideration; provide resume, business card, brochure, flyer or tearsheets to be kept on file for possible future assignments. Does not return unsolicited material. Reports "as needed." Pays $100/color cover photo; $20/b&w and $30/color inside photo; $300 maximum/job "or as per discussed." Pays 30 days after publication. Credit line given. Buys one-time rights. Simultaneous submissions ("must be marked where published or submitted") and previously published work OK.

Tips: "We look for dynamic quality and style. Read our magazine. Get a feeling for what we want and need."

DAVID C. COOK PUBLISHING CO., 850 N. Grove, Elgin IL 60120. Director of Design Services: Gregory Clark. Photo Acquisition Coordinator: Cynthia Miller. Publishes books and Sunday school material for pre-school through adult readers. Photos used primarily in Sunday school material for text illustration and covers, particularly in *Sunday Digest* (for adults), *Christian Living* (for senior highs) and *Sprint* (for junior highs). Younger age groups used, but not as much. Buys 200 photos minimum/year; gives 20 assignments/year. Uses more b&w than color photos. Pays $50-250/job or on a per-photo basis. Credit line given. Usually buys one-time rights. Model release preferred.

Subject Needs: Prefers to see Sunday school, church activities, social activities, family shots, people, action, sports. SASE. Previously published work OK. Mostly photos of junior and senior high age youth of all races and ethnic backgrounds, also adults and children under junior high age, and some preschool.

B&W: Uses glossy b&w and semigloss prints. Pays $30-50/photo. 8x10 prints are copied and kept on file for ordering at a later date.

Color: Uses 35mm and larger transparencies; contact sheet OK. Pays $75-200/photo.
Jacket/Cover: Uses glossy b&w prints and 35mm and larger color transparencies. Pays $50-250/photo.
Tips: "Make sure your material is identified as yours. Send material to the attention of Cynthia Miller, photo acquisitions coordinator."

CORVETTE FEVER MAGAZINE, Box 44620, Ft. Washington MD 20744. (301)839-2221. Editor-in-Chief: Patricia Stivers-Bauer. Bimonthly. Circ: 35,000. Emphasizes Corvettes—"their history, restoration, maintenance and the culture that has grown around the Corvette—swap meets, racing, collecting, concourse, restoring, etc." Readers are young (25-45), primarily male but with growing number of women, Corvette owners and enthusiasts looking for anything new and different about their favorite sports car and Corvette events. Sample copy $2; contributor's guidelines free with SASE.
Photo Needs: Uses 30-40 photos/issue; 30-40% supplied by freelance photographers. Needs "photos of Corvettes, especially unusual Corvettes (rare originals or unique customs); must have details of car for accompanying story." Photos purchased with accompanying ms only. Special needs: centerfold Vettemate photo features. Model release and lengthy captions required for Vettemate.
Making Contact & Terms: Query with samples or send by mail 5x7 glossy b&w or color prints; 35mm, 2¹/₄x2¹/₄ or 4x5 transparencies. SASE. Reports in 1 month. Provide resume or brochure and tearsheets to be kept on file for possible future assignments. Pays $150+/color cover; $5-15/b&w inside, $10-20/color inside plus 10¢/word for text/photo package; $175/Vettemate center spread. Pays on publication. Buys first rights and reprint rights.

COUNTRY MAGAZINE, Box 246, Alexandria VA 22313. (703)548-6177. Editor: Jim Scott. Monthly magazine. Emphasizes the "*Mid-Atlantic* region: travel, leisure, lifestyles, people, history, sports, nature, food, gardening, architecture, etc." Readers are 43 median age, 50-50 male/female, affluent, educated, well-read, who travel extensively. Circ. 100,000. Sample copy $2.50. Photo guidelines free with SASE.
Photo Needs: Uses about 30-35 photos/issue; all supplied by freelance photographers. Captions preferred.
Making Contact & Terms: Query with resume of credits. Send 5x7 b&w glossy prints; 35mm, 2¹/₄x2¹/₄, 4x5 or 8x10 transparencies; b&w or color contact sheet; no negatives. Provide resume, business card, brochure, flyer or tearsheets to be kept on file for possible future assignments. SASE. Reports in 5-8 weeks. Pays $300/color cover photo, $50/full page b&w inside photo, and $50/full page color inside photo. Pays on publication. Credit line given. Buys one-time rights.

THE COVENANT COMPANION, 5101 N. Francisco Ave., Chicago IL 60625. Editor: James R. Hawkinson. Managing Editor: Jane K. Swanson-Nystrom. Art Director: David Westerfield. Monthly denominational magazine of The Evangelical Covenant Church of America. Circ. 27,000. Emphasizes "gathering, enlightening and stimulating the people of our church and keeping them in touch with their mission and that of the wider Christian church in the world." Credit line given. Pays within one month following publication. Buys one-time rights. Send photos. SASE. Simultaneous submissions OK. "We need to keep a rotating file of photos for consideration." Sample copy $1.50.
Subject Needs: Mood shots of nature, commerce and industry, home life, church life, church buildings and people. Also uses fine art, scenes, city life, etc.
B&W: Uses 5x7 and 8x10 glossy prints. Pays $15.
Color: Uses prints only. Pays $15.
Cover: Uses b&w prints. Pays $25.

CREEM, Suite 209, 210 S. Woodward, Birmingham MI 48011. (313)642-8833. Photo Editor: Ginny Cartmell. Monthly magazine. Circ. 150,000. Emphasizes rock stars. For people, ages 16-35, interested in rock and roll music. Needs photos of rock stars and other celebrities in the music and entertainment business. Buys 1,200 photos/year. Buys one time use with permission to reuse at a later time. Send photos for consideration. SASE. Simultaneous submissions OK.
B&W: Send 8x10 glossy prints. Pays $35 minimum.
Color: Send transparencies. Pays $50-300.
Cover: Send color transparencies. Allow space at top and left of photo for insertion of logo and blurbs.

***CROSS COUNTRY SKIER**, 135 N. 6th St., Emmaus PA 18102. (215)967-5171. Editor: Virginia Hostetter. Photo Editor: John Hamel. Published October through March. Magazine. Emphasizes the cross country skiing sport. Readers are active, 20-45 years, adventurous. Circ. 55,000. Photo guidelines free with SASE.
Photo Needs: Uses 45 photos/issue; 50% supplied by freelance photographers. "We are looking for unpredictable and spectacular photographs that capture the enthusiasm of people involved in the sport of cross country skiing. All aspects of touring and racing are important to us." Special needs include fami-

lies, couples and lone skiers enjoying the sport. Model release and captions preferred.
Making Contact & Terms: Query with samples. Send 35mm, 2¼x2¼, 4x5 transparencies by mail for consideration. SASE. Reports in 1 week. Pays $400/color cover photo; $75/b&w page; $150/color page. Pays on publication. Credit line given. Photography rights vary according to assignment. Simultaneous submissions OK.

CROSSCURRENTS, 2200 Glastonbury Rd., Westlake Village CA 91361. Editor-in-Chief: Linda Brown Michelson. Photo Editor: Michael Hughes. "This is a literary quarterly that uses a number of photos as accompaniment to our fiction and poetry. We are aimed at an educated audience interested in reviewing a selection of fiction, poetry and graphic arts." Circ. 3,000. Sample copy $5. Free photo guidelines with SASE.
Photo Needs: Uses about 8-11 photos/issue; half supplied by freelance photographers. Needs "work that is technically good: sharp focus, high b&w contrast. We are also eager to see arty, experimental b&w shots." Photos purchased with or without accompanying ms.
Making Contact & Terms: Include SASE with all submissions. Reports in 1 month. Pays $15/b&w cover photo or b&w inside photo; $25/color cover photo. Pays on acceptance. Credit line given. Buys first one-time use.
Tips: "We want the following: b&w submissions—5x7 vertical print, publication quality, glossy, no matte; color submissions—slide plus 5x7 vertical print. Study our publication. We are in greatest need of b&w material."

CRUISING WORLD MAGAZINE, Box 452, Newport RI 02840. (401)847-1588. Photo Editor: Susan Thorpe. Circ. 120,000. Emphasizes sailboat maintenance, sailing instruction and personal experience. For people interested in cruising under sail. Needs "shots of cruising sailboats and their crews anywhere in the world. Shots of ideal cruising scenes. No identifiable racing shots, please." Buys 15 photos/year. Buys all rights, but may reassign to photographer after publication; or first North American serial rights. Credit line given. Pays on publication. Reports in 2 months. Sample copy free for 8½x11 SASE.
B&W: "We rarely accept miscellaneous b&w shots and would rather they not be submitted unless accompanied by a manuscript." Pays $15-75.
Color: Send 35mm transparencies. Pays $50-200.
Cover: Send 35mm Kodachrome transparencies. Photos "must be of a cruising sailboat with strong human interest, and can be located anywhere in the world." Prefers vertical format. Allow space at top of photo for insertion of logo. Pays $500. "Submit original Kodachrome slides; sharp focus works best. *No* duplicates. No Ektachrome. Most of our editorial is supplied by author. We look for good color balance, very sharp focus, the ability to capture sailing, good composition, and action. Always looking for *cover shots.*"

CURRENT CONSUMER & LIFESTUDIES, 3500 Western Ave., Highland Park IL 60035. (312)432-2700. Photo Editor: Barbara A. Bennett. Associate Photo Editor: Kelly Mountain. Monthly magazine published from September to May. Emphasizes consumer education and interpersonal relationships for students in junior and senior high.
Photo Needs: Pays on publication. Buys one-time rights. Credit line given. Model release "preferred." Reports in 2-4 weeks. Simultaneous submissions and previously published work OK. Free sample copy and subject outline with 8x11 SASE.
B&W: Uses 8x10. Payment negotiable.
Tips: "Research our publication; we don't use photos of cute puppies or sunsets. We *do* use photos of teens: mood shots showing a particular emotion like happiness, loneliness, etc. Be patient. Be persistent. Don't let one rejection stop you from sending in another submission. We like to work with *new* photographers."

CURRENT HEALTH 1, 3500 Western Ave., Highland Park IL 60035. (312)432-2700. Photo Editor: Barbara A. Bennett. Associate Photo Editor: Kelly Mountain. Monthly health magazine for 4-6 grade students. List of upcoming article topics and sample copy free with 8x11 SASE. Simultaneous submissions and previously published work OK. Reports in 2-4 weeks. Pays on publication. Credit line given. Buys one-time rights.
Subject Needs: B&w: "Junior high aged children geared to our health themes for inside use." Color: "35mm or larger transparencies geared to our monthly focus article for cover use." Send 8x10 b&w prints or transparencies. Payment negotiable.

CURRENT HEALTH 2, 3500 Western Ave., Highland Park IL 60035. (312)432-2700. Photo Editor: Barbara A. Bennett. Associate Photo Editor: Kelly Mountain. Monthly health magazine for 7-12 grade students. List of upcoming article topics and sample copy free with 8x11 SASE. Simultaneous submissions and previously published work OK. Reports in 2-4 weeks. Pays on publication. Credit line given. Buys one-time rights.

Subject Needs: B&w: teens with emphasis on health themes for inside use. Color: "35mm or larger transparencies geared to our monthly focus article for cover use." Send 8x10 b&w prints or transparencies. Payment negotiable.
Tips: "Study our publication and future article topics. We need sharp, clear photos of teens interacting with friends and family. Don't let one rejection stop you from sending in another submission."

DAILY WORD, Unity School of Christianity, Unity Village MO 64065. (816)524-3550. Editor: Colleen Zuck. Monthly. Emphasizes daily devotional—non-denominational. General audience. Circ. 2,500,000. Free sample copy.
Photo Needs: Uses 3-4 photos/issue; all submitted by freelance photographers. Needs scenic and seasonal photos.
How to Contact: Send 35mm, 2¼x2¼ or 4x5 transparencies by mail for consideration. SASE. Reports in 1 month. Pays $100/color cover photo; $100/inside color photo. Pays on acceptance. Credit line given. Buys one-time rights. Previously published work OK.

***DALLAS LIFE MAGAZINE, DALLAS MORNING NEWS**, Communications Center, Dallas TX 75265. (214)977-8433. Editor: Melissa East. Art Director: Lesley Becker. Weekly magazine. Emphasizes Dallas. Circ. 500,075. Sample copy free with SASE.
Photo Needs: Uses 20 photos/issue; 5% supplied by freelance photographers. Needs photos of fashion, food, personality—"almost all shot by staff." Reviews photos with accompanying ms only. Captions required.
Making Contact & Terms: Query with resume of credits; provide resume, business card, brochure, flyer or tearsheets to be kept on file for possible future assignments. SASE. Reports in 1 month. Pays $50-200/color inside photo. Pays on acceptance. Credit line given. Buys one-time rights.

DANCE MAGAZINE, 33 W. 60th St., New York NY 10023. (212)245-9050. Photo Editor: Deirdre Towers. Monthly magazine. Emphasizes "all facets of the dance world." Readers are 85% female, age 18-24. Circ. 75,000.
Photo Needs: Uses about 60 photos/issue; almost all supplied by freelance photographers. Needs photos of all types of dancers—from ballroom to ballet. Written release required; captions preferred.
Making Contact & Terms: Send 8x10 b&w or color prints; 35mm transparencies by mail for consideration. SASE. Reports in 1 month. Pays up to $285/color cover photo; $15-75/b&w inside photo; $40-100/color inside photo. Pays on publication. Credit line given. Buys one-time rights. Previously published work OK.
Tips: "We look for a photojournalistic approach to the medium—photos that catch the height of a particular performance or reveal the nature of a particular dancer."

DARKROOM PHOTOGRAPHY MAGAZINE, Suite 600, One Hallidie Plaza, San Francisco CA 94102. Editor: Richard Senti. Publishes 8 times/year. Circ. 80,000. Emphasizes darkroom-related photography.
Subject Needs: Any subject if darkroom related. Model release preferred, captions required.
Specs: Uses 8x10 or 11x14 glossy b&w prints and 35mm, 2¼x2¼, 4x5 or 8x10 color transparencies or 8x10 glossy prints. Uses color covers; vertical format required.
Payment/Terms: Pays $50-500/text and photo package, $30-75/b&w photo, $50 minimum/color photo and $400/cover photo; $200/portfolio. Credit line given. Pays on publication. Buys one-time rights.
Making Contact: Query with samples. SASE. Reports in 1 month-6 weeks. Free editorial guide.

DARKROOM & CREATIVE CAMERA TECHNIQUES, Preston Publications, Inc., 7800 Merrimac Ave., Box 48312, Niles IL 60648. (312)965-0566. Publisher: Seaton T. Preston, Jr. Editor: David Alan Jay. Bimonthly magazine focusing on darkroom techniques, creative camera use, photochemistry and photographic experimentation/innovation—particularly in photographic processing, printing and reproduction—plus general user-oriented photography articles aimed at advanced amateurs and professionals. Circ. 37,000. Pays on publication. Credit line given. Buys one-time rights.
Photo Needs: "The best way to publish photographs in *Darkroom Techniques* is to write an article on photo or darkroom techniques and illustrate the article. Except for article-related pictures, we publish few single photographs. The two exceptions are: cover photographs—we are looking for strong poster-like images that will make good newsstand covers; and Professional Portfolio—exceptionally fine planned, professional photographs of an artistic or human nature. Model releases are required where appropriate."
Making Contact & Terms: "To submit for cover or Professional Portfolio, please send a selected number of superior photographs of any subject; however, we do not want to receive more than ten or twenty in any one submission. Prefer color transparencies over color prints. B&w submissions should be 8x10. Color only for covers. Payment up to $300 for covers. Articles pay up to $100/page for text/

photo package." SASE for free photography and writers guidelines. Sample copy $3.
Tips: "We are looking for exceptional photographs with strong, graphically startling images. No run-of-the-mill postcard shots please."

DASH, Box 150, Wheaton IL 60189. (312)665-0630. Managing Editor: David R. Leigh. Art Director: Lawrence Libby. Magazine published 7 times a year. Circ. 25,000. Sample copy $1.50. For Christian boys ages 8-11. Most readers are in a Christian Service Brigade church program. Needs on a regular basis boys 8-11 in family situations, camping, scenery, sports, hobbies and outdoor subjects. Buys 1-2 photos/issue. Buys first serial rights. Arrange a personal interview to show portfolio or send photos for consideration. Pays on publication. Reports in 2-6 weeks. SASE. Simultaneous submissions and previously published work OK. Photo guidelines available for a SASE.
B&W: Send 8x10 glossy prints. Pays $25.
Cover: Send glossy b&w prints. Pays $50-75.

DEER AND DEER HUNTING, Box 1117, Appleton WI 54912. (414)734-0009. Art Director: Jack Brauer. Bimonthly. Distribution 100,000. Emphasizes whitetail deer and deer hunting. Readers are "a cross-section of American deer hunters—bow, gun, camera." Sample copy and photo guidelines free with SASE (9x11 envelope) with $2 postage.
Photo Needs: Uses about 25 photos/issue; 20 supplied by freelance photographers. Needs photos of deer in natural settings. Model release preferred.
Making Contact & Terms: Query with resume of credits and samples. "If we judge your photos as being usable, we like to hold them in our file. It is best to send us duplicates because we may hold the photo for a lengthy period." SASE. Reports in 2 weeks. Pays $350/color cover; $30/b&w inside; $100/color inside. Pays within 10 days of publication. Credit line given. Buys one-time rights. Simultaneous submissions and previously published work OK.
Tips: Prefers to see "adequate selection of b&w 8x10 glossy prints and 35mm color transparencies. Submit a limited number of quality photos rather than a multitude of marginal photos. Have your name on all entries. Cover shots must have room for masthead."

DELAWARE TODAY, Box 4440, Wilmington, DE 19807. Design Director: Ingrid Hansen-Lynch. Monthly magazine. Circ. 17,000. Emphasizes people, places and events in Delaware. Buys 250 photos/year. Credit line given. Pays on the 15th of the month after publication. Buys first North American serial rights. Arrange a personal interview to show portfolio. Works with freelance photographers on assignment only basis. Provide calling card, samples and tearsheet to be kept on file for possible future assignments. SASE. Reports in 2-4 weeks. Free sample copy.
Subject Needs: Fashion/beauty, how-to, human interest, photo essay/photo feature, special effects and experimental, still-life, travel and some news. Model release required.
B&W: Uses 8x10 glossy prints. Pays $100-200/photo story, $25-35/photo.
Cover: Uses 35mm or larger color transparencies. Vertical format preferred. Pays $100/transparency; $50/non-cover color photo.
Tips: Prefers to see "a variety of shots illustrating news stories as well as people and human interest stories" in a portfolio. Photographer "should have a good eye for the usual and work within given deadlines."

DELTA SCENE, Box B-3, D.S.U., Cleveland MS 38733. (601)846-1976. Editor: Curt Lamar. Business Manager: Sherry Van Liew. Quarterly magazine. Circ. 2,000. For "persons wanting more information on the Mississippi Delta region, i.e., folklore, history, Delta personalities." Readers are art oriented. Needs photos of "Delta scenes, unusual signs in the Delta, historical buildings, photo essays accompanied with ms, Delta artists, Delta writers, hunting, fishing, skiing, etc." Buys 1-3 photos annually. Buys first serial rights. Query with resume of credits for photos for specific articles or send photos for consideration. Pays on publication. Reports in 6 weeks. SASE. Simultaneous submissions OK. Sample copy $1.75; free photo guidelines "when available."
B&W: Send negatives or 5x7 glossy prints. Captions required. Pays $5-10.
Color: Send 5x7 glossy prints or transparencies. Captions required. Pays $5-10.
Cover: See requirements for color.
Tips: "Because *Delta Scene* is a regional magazine, it is suggested that only local photographers should apply for assignments."

DERBY, Box 5418, Norman OK 73070. (405)364-9444. Editor: G.D. Hollingsworth. Monthly magazine. Emphasizes owners, breeders, and trainers of Thoroughbred race horses in the central and southwestern states. Circ. 3,000. Sample copy $3.
Photo Needs: Uses about 20 photos/issue; 15 supplied by freelance photographers. Needs photos of horses and people. "Most photos are done on assignment by freelancers." Captions required.

Making Contact & Terms: Provide resume, business card, brochure, flyer or tearsheets to be kept on file for possible future assignments. Reports in 2 weeks. Pays $25/b&w inside photo; $75/color inside photo. Pays on publication. Buys all rights. Previously published work OK.

***DISC SPORTS MAGAZINE**, Box 419, Fair Haven VT 05743. (802)265-3533. Editor: John Houck. 6 times year magazine. Emphasizes disc sports, footbags. Readers are enthusiasts of disc sports and footbags. Circ. 20,000. Sample copy free with SASE. Photo guidelines free with SASE.
Photo Needs: Uses 20 photos/issue; all supplied by freelance photographers. Needs photographers of disc or footbag play. Model release preferred; captions required.
Making Contact & Terms: Query with samples, send 5x7 or 8x10 glossy b&w prints by mail for consideration. SASE. Reports in 1 month. Pays $20/b&w cover photo, $10/b&w inside photo. Pays on publication. Credit line given. Usually buys one-time rights, except if used for covers for house and/or corp. advertising. Simultaneous submissions and previously published work OK.
Tips: Prefers to see quality, good expressions.

THE DISCIPLE, Box 179, St. Louis MO 63166. Editor: James L. Merrell. Monthly magazine. Circ. 57,000. Emphasizes religious news of local churches of the Christian Church (Disciples of Christ), of the national and international agencies of the denomination and of the total church in the world. For a general church audience, largely adult. Buys 25-30 photos annually. Buys simultaneous rights. Works with freelance photographers on assignment. Buys from photo packets sent to editors on approval. Pays on acceptance. Reports in 2 weeks. SASE. Simultaneous submissions and previously published work OK. Sample copy $1.25; free photo guidelines; enclose SASE.
Subject Needs: Persons of all ages in close-ups; symbolic shots; and photographs of people in worship environment—praying, participating in church functions.
B&W: Send 8x10 glossy prints. Captions required. Pays $25-35.
Cover: Send color transparencies. Captions required. Pays $50-75.

DISCOVERIES, 6401 The Paseo, Kansas City MO 64131. (816)333-7000. Editor: Rebecca Schreffler. Weekly Sunday school publication. Circ. 50,000-75,000. Emphasizes Christian principles for children 8-12. Freelancers supply 95% of the photos. Buys 1-2 photos/issue. Pays on acceptance. Model release required. Send photos. SASE. Simultaneous submissions and previously published work OK. Reports in 2-3 weeks. Free sample copy and photo guidelines.
Subject Needs: Children with pets, nature, travel, human interest pictures of interest to 3rd-6th grade children. No nude, fashion, sport or celebrity photos.
B&W: Uses 8x10 glossy prints. Pays $15-30.
Cover: Uses b&w prints; vertical format preferred. Pays $20-30.
Tips: "Subjects must be suitable for a conservative Christian denomination and geared toward 10 to 12 year olds. Children prefer pictures with which they can identify. For children, realistic, uncluttered photos have been the standard for many years and will continue to be so. Photographing children in their natural environment will yield photos that we will buy."

THE DIVER, Box 249, Cobalt CT 06414. (203)342-4730. Publisher/Editor: Bob Taylor. 10 issues/year. Emphasizes springboard and platform diving. Readers are divers, coaches, officials and fans. Circ. 5,000. Sample copy $2 with SASE and 54¢ postage.
Photo Needs: Uses about 25 photos/issue; 1/3 supplied by freelance photographers. Needs action shots, portraits of divers, team shots and anything associated with the sport of diving. Special needs include photo spreads on outstanding divers and tournament coverage. Captions required.
Making Contact & Terms: Send 4x5 or 8x10 b&w glossy prints by mail for consideration; "simply query about prospective projects." SASE. Reports in 4 weeks. Pays $15-25/b&w cover photo; $7-15/b&w inside photo; $35-100 for text/photo package. Pays on publication. Credit line given. Buys one-time rights. Simultaneous submissions and previously published work OK.
Tips: "Study the field, stay busy."

DIVER MAGAZINE, 8051 River Rd., Richmond, British Columbia, Canada V6X 1X8. (604)273-4333. Publisher: Peter Vassilopoulos. Editor: Neil McDaniel. Magazine published 9 times/year. Emphasizes sport scuba diving, ocean science, technology and all activities related to the marine environment. Photos purchased with or without accompanying ms, and on assignment. Buys 20 photos/issue. Credit line given. Pays within 4 weeks of publication. Buys first North American serial rights or second serial rights. Send material by mail for consideration. SAE and International Reply Coupons must be enclosed. Previously published work OK. Reports in 4 weeks. Guidelines available for SAE and International Reply Coupon.
Subject Needs: Animal (underwater plant/animal life); celebrity/personality (for interview stories); documentary (sport, commercial, military, scientific or adventure diving); photo essay/photo feature;

product shot (either static or "in use" type, should be accompanied by product report; scenic; special effects & experimental; sport (all aspects of scuba diving above and below surface); how-to (i.e., building diving related equipment, performing new techniques); humorous; nature; travel (diving worldwide); and wildlife (marine). No sensational photos that portray scuba diving/marine life as unusually dangerous or menacing. Model release preferred; captions required.

B&W: Uses 5x7 and 8x10 glossy prints. Pays $7 minimum/photo.

Color: Uses 35mm transparencies. Pays $15 minimum/photo.

Cover: Uses 35mm transparencies. Vertical format required. Pays $100 minimum/photo.

Accompanying Mss: Articles on dive sites around the world; diving travel features; marine life—habits, habitats, etc.; personal experiences; ocean science/technology; commercial, military, and scientific diving, written in layman's terms. Writer's guidelines for SAE and International Reply Coupon.

Tips: Prefers to see "a variety of work: close-ups, wide angle—some imagination!"

DOG FANCY, Box 6050, Mission Viejo CA 92690. (714)240-6001. Editor-in-Chief: Linda Lewis. Readers are "men and women of all ages interested in all phases of dog ownership." Monthly. Circ. 95,000. Sample copy $3; photo guidelines available with SASE.

Photo Needs: Uses 20-30 photos/issue, all supplied by freelance photographers. Specific breed featured in each issue. Prefers "photographs that show the various physical and mental attributes of the breed. Include both environmental and portrait-type photographs, but in both cases we would prefer that the animals be shown without leashes or collars. We also have a major need for good-quality, interesting b&w photographs of any breed dog or mutts in any and all canine situations (dogs with veterinarians; dogs eating, drinking, playing, swimming, etc.) for use with feature articles." Model release required.

Making Contact & Terms: Send by mail for consideration actual 8x10 b&w photos, 35mm or 2¼x2¼ color transparencies. Reports in 6 weeks. Pays $15-20/b&w photo; $50-150/color photo and $100-300 per text/photo package. Credit line given. Buys first North American serial rights.

Tips: "Nothing but sharp, high contrast shots. Send SASE for list of photography needs. We're looking more and more for good quality photo/text packages, that present an interesting subject both editorially and visually. Bad writing can be fixed, but we can't do a thing with bad photos. Subjects should be in interesting poses or settings with good lighting, good backgrounds and foregrounds, etc. We are very concerned with sharpness and reproducibility; the best shot in the world won't work if it's fuzzy, and it's amazing how many are. Submit a variety of subjects—there's always a chance we'll find something special we like."

DOLLS—The Collector's Magazine, 170 5th Ave., New York NY 10010. (212)989-8700. Editor: Krystyna Poray Goddu. Bimonthly. Circ. 55,000. Estab. 1982. Emphasizes dolls—antique and contemporary. Readers are doll collectors nationwide. Sample copy $2.

Photo Needs: Uses about 75-80 photos/issue; 12 supplied by freelance photographers. Needs photos of dolls to illustrate articles. Photos purchased with accompanying ms only. "We're looking for writers/photographers around the country to be available for assignments and/or submit queries on doll collections, artists, etc."

Making Contact & Terms: Query with samples; provide resume, business card, brochure, flyer or tearsheets to be kept on file for possible future assignments. SASE. Reports in 6-8 weeks. Pays $100-300/job; $150-350 for text/photo package. Pays within 30 days of acceptance. Credit line given. Buys one-time or first North American serial rights ("usually"). Previously published work "sometimes" OK.

Tips: Prefers to see "relevant (i.e., dolls) color transparencies or black and white prints; clear, precise—not 'artsy'—but well-lit, show off doll."

EAGLE, 1115 Broadway, New York NY 10010. (212)807-7100. Contact: Harry Kane. Bimonthly. Circ. 200,000. Emphasizes adventure, military and paramilitary topics for men. Free sample copy; photo guidelines free with SASE.

Photo Needs: Uses about 50 photos/issue; all supplied by freelance photographers. Needs "photos to accompany articles on combat, espionage, personal defense and survival. Cover pictures are very military-oriented. Photo essays with establishing text are used." Photos purchased with or without accompanying ms. Model release required when recognizable people are included; captions required.

Making Contact & Terms: Query with list of stock photo subjects or send by mail for consideration 8x10 b&w glossy prints, any size transparencies or b&w contact sheet. SASE. Reports in 3 weeks. Pays $300/color cover; $25-100/b&w or color inside and $100-300 with accompanying ms. Pays on acceptance. Credit line given. Buys one-time rights. Simultaneous submissions and/or previously published work OK if indicated where and when published.

EARTHTONE, Publication Development, Inc., Box 23383, Portland OR 97223. (503)620-3917. Editor: Pat Jossy. Bimonthly magazine. Emphasizes "general interest (country living, food, folk art); his-

torical/nostalgic; how-to (crafts, home projects, small scale low cost building); humor; interview/profile (on people living this sort of lifestyle); new products (if unusual or revolutionary); animal husbandry; health; energy; organic gardening; recreation; aspects of homesteading, self-sufficient lifestyle, country living." Readers are "people with a back-to-the-land lifestyle as well as urban dwellers interested in becoming more independent and self-sufficient in their current residence; western US readership primarily." Circ. 50,000. Sample copy $2. Photo guidelines free with SASE.
Photo Needs: Uses about 20-30 photos/issue; approximately 30% supplied by freelance photographers. Needs "how-to; interview portrait; new products (if unusual); animal husbandry; energy-related ideas; small-scale, low-cost building ideas; general interest to accompany articles." Photos purchased with accompanying ms only. Model release preferred; captions required.
Making Contact & Terms: Submit 4x5 or 5x7 b&w glossy prints by mail for consideration. SASE. Reports in 1 month. Pays $50-300/text/photo package. Pays on publication. Credit line given. Buys first North American serial rights.
Tips: Submit seasonal/holiday material 6 months in advance; photocopied submissions OK. Prefers to see "clear, top-quality (no fuzzy, out-of-focus) b&w photos to accompany manuscript; 35mm or larger transparencies with manuscript. We're looking for the article or story that stands out (offbeat, unusual, revolutionary, etc.). Include good quality photos with your manuscripts. We're a good market for unpublished writers and photographers as we are less concerned with an impressive resume as with the technical merits of the photo/essay package. We welcome new writers."

EARTHWISE POETRY JOURNAL, Box 680536, Miami FL 33168. (305)688-8558. Editor-in-Chief: Barbara Albury. Photo Editors: Katie Hedges and Susan Holley. Quarterly journal. Circ. over 3,000. Emphasizes poetry. Readers are "literate, cultured, academic, eclectic, writers, artists, etc." Sample copy $4; photo guidelines free with SASE.
Photo Needs: Uses 2-4 photos/issue; all supplied by freelance photographers. Needs photos of poets in their locale. Photos purchased with or without accompanying ms. Special needs: interviews, articles on ecology and wildlife preservation and human interest. Special issues include one on American Indian, one on The Dance & Music. Model release and captions preferred.
Making Contact & Terms: Query with resume of credits or samples; send by mail for consideration 5x7 b&w matte prints, contact sheet or Velox; provide resume and 1-2 5x7 stats to be kept on file for possible future assignments. "We cannot use colored pictures unless halftone repros have been made." SASE. Reports as soon as possible. Pays $5-50/b&w photo. Pays on publication. All rights revert to owner. Original photos returned.

***EASYRIDERS MAGAZINE**, Box 52, Malibu CA 90265. (818)889-8740. Editor: Frank Kaisler. Monthly. Emphasizes "motorcycles (Harley-Davidsons in particular), motorcycle women, bikers having fun." Readers are "adult men—men who own, or desire to own, custom motorcycles. The individualist—a rugged guy who enjoys riding a custom motorcycle and all the good times derived from it." Free sample copy. Photo guidelines free with SASE.
Photo Needs: Uses about 60 photos/issue; "the majority" supplied by freelance photographers. Needs photos of "motorcycle riding (rugged chopper riders), motorcycle women, good times had by bikers, etc." Model release required.
Making Contact & Terms: Send b&w prints, 35mm transparencies by mail for consideration. SASE. Reports in 1 month. Pays 30 days after publication. Credit line given. Buys all rights. All material must be exclusive.
Tips: "Read magazine before making submissions."

EBONY, 820 S. Michigan, Chicago IL 60605. (312)322-9200. Publisher: John H. Johnson. Photo Editor: Basil Phillips. Monthly magazine. Circ. 1,800,000. Emphasizes the arts, personalities, politics, education, sports and cultural trends. For the black American. Needs photo stories of interest to black readers. Buys all rights. Submit model release with photo. Query first with resume of credits to Charles L. Sanders, managing editor. Photo stories are purchased with or without an accompanying ms. Pays on publication. Reports in 3-4 weeks. SASE.
B&W: Prefers negatives and contact prints. Pays $50/photo, $150 minimum with accompanying ms. Pays $150-250/day.
Color: Uses 35mm, 2¼x2¼ or larger transparencies. Pays $75 minimum, $200 with accompanying ms.
Cover: Cover shots are rarely done by freelancers.

***THE ECONOMIST**, 25 St. James's St., London England SW1A 1HG. (010)441-839-7000. Editor: Rupert Pennant-Rea. Photo Editor: Louise Fawkner-Corbett. Weekly magazine. Emphasizes news and comment on international events and business. Readers are businessmen, students, politicians—generally well informed educator market. Circ. 280,000.

Photo Needs: Uses 40-50 photos/issue; 10% supplied by freelance photographers. Needs photos of news and current events, politicians, businessmen. Model release and captions required.
Making Contact & Terms: Arrange a personal interview to show portfolio; query with list of stock photo subjects; provide resume, business card, brochure, flyer or tearsheets to be kept on file for possible future assignments. SASE. Reports in 1 month. Pays $400/color cover photo; $100/b&w inside photo; $75/hour; $300/day. Pays on publication. Buys one-time rights. Simultaneous submissions and previously published work OK. Submissions may also be sent to the NY office: The Economist, 12th Floor, 10 Rockefeller Plaza, New York NY 10020. (212)541-5730. Bureau Manager: Mrs. Muriel Davis.
Tips: Prefers to see well arranged portfolio, recent work, neatly presented—tearsheets etc. Should be properly mounted, even laminated. Have a well presented portfolio, check the publication's requirements and gear presentation toward that, although make selection of other work show range.

***EIDOS MAGAZINE: Erotic Entertainment For Women**, Box 96, Boston MA 02137. (617)333-0612. Editor: Brenda L. Tatelbaum. Quarterly magazine. Emphasizes erotic entertainment for adult men and women notably involved/interested in sexuality issues, alternative sexual lifestyles and the erotic arts. "Our international readership is energetic, well-informed and interested in searching out new information, material and formats for educational/lifestyle/entertainment purposes." Circ. 5,000. Estab. 1983. Sample copy $5. Photo guidelines free with SASE.
Photo Needs: Uses 15-20 photos/issue, all supplied by freelance photographers. Needs explicit photos of human sexuality (non-pornographic) depicting sensual, sensitive, delicate relationships between/among people; also nude studies. B&w is preferred, 5x7 or 8x10; non-commercial techniques preferred. Special needs include "photos of men and/or women are equally marketable: Real people with all their beauty and flaws; older folks, handicapped, too." Model release required, "if model is recognizable".
Making Contact & Terms: Query with samples, send unsolicited photos by mail for consideration. Send 5x7, 8x10 glossy (preferred) b&w prints; b&w contact sheets by mail for consideration. SASE. Reports in 1 month. Pays "contribution copies—byline—any credits, bio desired." Pays on publication. Credit line given. Buys first N.A. serial rights. Simultaneous submissions OK.
Tips: Prefers to see creative erotic content, not typically commercialized depictions of the male and female human form and explicit erotic content perceived as an alternative to mainstream pornography. "Take a chance and send us samples of your work. There is no precedent for the type of material we publish. Order a sample issue and see what others have done and what direction we're heading into. You must feel comfortable with erotica in order to produce high quality erotic photography."

THE ELECTRIC COMPANY MAGAZINE, 1 Lincoln Plaza, New York NY 10023. (212)595-3456. Editor: Randy Hacker. Monthly. Circ. 370,000. Emphasizes "informative, entertaining articles, stories, games and activities that encourage reading for 6-9 year olds."
Photo Needs: Uses about 12 photos/issue; all supplied by freelance photographers. Assigned. Needs vary.
Making Contact & Terms: Submit portfolio for review on Wednesdays and Thursdays. Reports when an assignment is available. Provide flyer to be kept on file for possible future assignments. Pays $200-500 for color cover photo. Pays between acceptance and publication. Credit line given. Rights purchased negotiated by contract with each assignment.

THE ELECTRON, 4781 East 55th St., Willoughby OH 44094. (216)946-9065. Editor: Janice Weaver. Bimonthly tabloid. School publication. Emphasizes electronics. Readers are 75% CIE grads or CIE students. Circ. 65,000. Free sample copy.
Photo Needs: Uses about 35-40 photos/issue; 15-20 supplied by freelance photographeers. Needs photos of how-to technical, people at work, and product usage. Reviews photos with or without accompanying ms. Model release preferred.
Making Contact & Terms: Send 5x7 glossy unsolicited photos by mail for consideration; provide resume, business card, brochure, flyer or tearsheets to be kept on file for possible future assignments. SASE. Reports in 4-6 weeks. Pay negotiated. Pays on publication. Credit line given if desired. Buys all rights.

ELYSIUM GROWTH PRESS, 5436 Fernwood Ave., Los Angeles CA 90027. (213)465-7121. Publisher: Ed Lange. Quarterly. Emphasizes naturism/nudism/alternative lifestyles. Readers are New Aged Human Potential participants. Circ. 20,000. Sample copy varies from $4.95 to $19.95 and 50¢ postage. Photo guidelines free with SASE.
Photo Needs: Uses about 30 photos/issue; 70% supplied by freelance photographers. Needs photos of "outdoor recreational activities—option to do so without clothes." Model release and captions required.
Making Contact & Terms: Query with samples. SASE. Reports in 2 weeks. Pays $100/b&w or color cover photo; $25/b&w or color inside photo; $25/color page and $150-300 with accompanying ms. Pays on acceptance or publication. Credit line given. Buys all rights. Previously published work OK.

Close-up

Lisl Dennis
Freelance Photographer
New York City

Nancy Brown

While a sculpture student in Florence, Italy, Lisl Dennis
learned more than just the classical techniques taught at the
Academy of Fine Arts—she learned something that
changed her career path. By experimenting with photogra-
phy in her free time, Dennis was able to compare photog-
raphy and sculpting, and realized that "photography would keep me out in the world;
art would keep me in a studio in Soho or somewhere."

She didn't take on the world immediately, though; she worked for two years as a photo-
journalist at the *Boston Globe*. It was only after her marriage to *Christian Science Monitor*
staff writer Landt Dennis, that the two of them embarked on a career in travel photography/
writing that has spanned 18 years. For them, getting started took a combination of persistence
in contacting editors for appointments and coming up with salable ideas for these editors.
"You have to meet the needs of editors in an editorial/journalistic sense," Dennis empha-
sizes. This means you must be familiar with the publications you're querying. Many up and
coming people fall flat because they don't know their markets, she says.

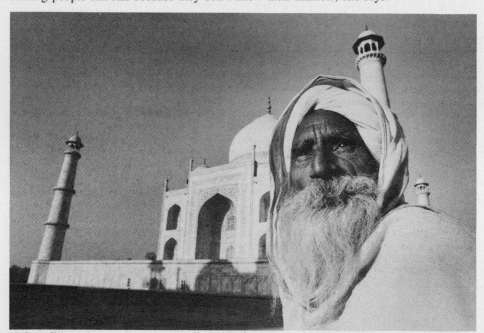

*A lot of thought goes into Dennis' use of lighting, color and composition. Above, a well-
known landmark takes on her distinctive flavor. At right, a unique interpretation of the
Venice Winter Carnival.*

The combination of photography/writing has paid off for Dennis and her husband. Such packages are more marketable, she says, than submitting photos only, but "both must be very good." Bad writing can't be hidden behind good photos, warns the author of *Shooting Portraits on Location* (Amphoto) and *How to Take Better Travel Photos* (HP Books). If a photographer isn't skilled at writing, he should hook up with someone who is. Just what is the market for prospective travel photographers? "There is an increased use of stock photography among magazines and advertising. With tighter magazine budgets, fewer assignments are being doled out."

Despite the tight and competitive market conditions that exist for travel photography, Dennis has carved out an impressive list of credits. This includes magazines such as *Travel & Leisure*, *Travel/Holiday*, *Architectural Digest*, *Town & Country*, *Geo*, *Glamour*, *Islands*, *Popular Photography*, *Modern Photography*, *Petersen's Photographic* and *Outdoor Photography*. The key to outstanding photos for her lies in her particular philosophy of travel photography. "I try to interpret a sense of place, not just record destinations," she explains. This unique approach, she acknowledges, is in direct contrast to the traditional, descriptive photos most travel publications use. Dennis feels that the "aesthetic retardation" of travel photography partly is due to the lack of "visual sophistication" among many editors and art directors who tend to opt for more generic photography.

To achieve any kind of success in such a competitive field, the photographer should be good at marketing. "I would say a photographer has to spend 70 percent of his time marketing and 30 percent shooting," Dennis says. The myth of a photographer sweating bullets and starving, only to later ride a wave of recognition just isn't true. "You have to sweat bullets every day of your life." If you're not out there pushing your name to editors, you will be forgotten, she says, citing the glut of photographers currently in the marketplace.

Due to such tight market conditions, Dennis suggests photographers diversify, as she is doing by branching off into architectural/interior design photography. "If you need to support yourself through photography, it's necessary to develop skills to enter the other commercial photography markets."

She offers an interesting insight about what makes the freelance photography markets so crowded. People from the more expressive baby-boom generation are out there vying for prestigious jobs, she says. "This is an era of communications people," she reflects, citing Simon & Garfunkel's well-known lyrics, "Mama don't take my Kodachrome away . . ."

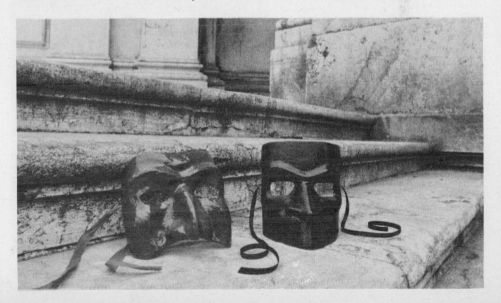

ENVIRONMENT, 4000 Albemarle St., Washington DC 20016. (202)362-6589 or 362-6445. Editor: Jane Scully. Photo Editor: Ann Rickerich. Magazine published 10 times/year. Covers science and science policy from a national, international, and global perspective. "We cover a wide range of environmental topics —acid rain, tropical deforestation, nuclear winter, hazardous waste disposal, worker safety, energy and environmental legislation." Readers include libraries, colleges and universities, and professionals in the field of environmental science. Circ. 12,500. Sample copy $4.
Photo Needs: Uses 15 photos/issue; varying number supplied by freelance photographers. "Our needs vary greatly from issue to issue—but we are always looking for good photos showing man's impact on the environment—powerlines, plants, industrial sites, cities, alternative energy sources, pesticide use, disasters, third world growth, hazardous wastes, pollution." Model release preferred; captions required.
Making Contact & Terms: Query with list of stock photo subjects; send unsolicited photos by mail for consideration; provide resume, business card, brochure, flyer or tearsheets to be kept on file for possible future assignments. Send any size b&w print by mail for consideration. SASE. Reports in 1 month. Pays $35-50/b&w inside photo. Pays on publication. Credit line given. Buys one-time rights. Simultaneous submissions and previously published work OK.

EQUINOX MAGAZINE, 7 Queen Victoria Dr., Camden East, Ontario, Canada K0K 1J0. (613)378-6661. Executive Editor: Frank B. Edwards. Bimonthly. Circ. 162,000. Emphasizes "Canadian subjects of a general 'geographic' and scientific nature." Sample copy $5; photo guidelines free with SAE and International Reply Coupon.
Photo Needs: Uses 80-100 photos/issue; all supplied by freelance photographers. Needs "photo essays of interest to a Canadian readership as well as occasional stock photos required to supplement assignments; wildlife, landscapes, profiles of people and places." Captions required.
Making Contact & Terms: Query with samples; submit portfolio for review. SASE. Reports in 6 weeks. "Most stories are shot on assignment basis—average $1,000 price—we also buy packages at negotiable prices and stock photography at about $200 a page if only one or two shots used." Pays on publication. Credit line given. Buys first North American serial rights.
Tips: Prefers to see "excellence and in-depth coverage of a subject. Stick to Kodachrome/Ektachrome transparencies."

ERIE & CHAUTAUQUA MAGAZINE, Charles H. Strong Bldg., 1250 Tower Lane, Erie PA 16505. (814)452-6070. Editor: Mary J. Brownlie. Twice yearly magazine covering the City of Erie, Erie County, Crawford County, Warren County, Pennsylvania and Chautauqua County, New York, for upscale readers with above average education and income. Circ. 30,000. Sample copy $2.50. Photo guidelines free with SASE.
Photo Needs: Uses about 125 photos/issue; 60-70 supplied by freelance photographers. "Because so much of our content is region-oriented, most of our photography work has to be done on an assignment basis, by photographers who live in the region. May need photos for specific sports: sailing, boating, skiing, ice skating, horseback riding, golf, tennis, etc." Model release and captions required.
Making Contact & Terms: Query with samples or list of stock photo subjects; provide resume, business card, brochure, flyer or tearsheets to be kept on file for possible future assignments. "Photographers living in our coverage area are encouraged to arrange for personal interview to show portfolio." SASE. "All photographic fees are negotiated with photographer, according to type of assignment." Pays $15-25/b&w photo; $15-25 + film/color photo; "occasionally negotiates on a per-job basis. Will not consider an hourly or daily basis." Pays 30 days after publication. Credit line given. Buys all rights on assignments; "will buy one-time or first North American serial rights only on stock photos." Previously published submissions OK.
Tips: "We want to know that the photographer's work has the quality and clarity we are looking for— ours is a quality book with excellent reproduction on coated stock. Most new photographers show us b&w work that does *not* have the clarity and contrasts that will reproduce well; color shots are often fuzzy or faded. We welcome seeing portfolios of any photographers living in our coverage area. Those outside our coverage area would have their best opportunity via stock photos and should let us know what kinds of subjects they've covered."

EUROPE FOR TRAVELERS!, 408 Main St., Nashua NH 03060. (603)888-0633. Publisher: Carol Grasso. Semi-annual. Emphasizes travel in Europe. Readers include upscale professionals, librarians, travel agents. Circ. 5,000. First issue March 1985; 1984 (incorporated). Writers guidelines free with SASE.
Photo Needs: Uses 20 photos/issue; most supplied by freelance photographers. Usually purchased as part of article package. Needs occasional scenic travel photos for use as illustrations. Model release required.
Making Contact & Terms: Send any size glossy b&w or color prints, or 35mm, 2¼x2¼, or 4x5

transparencies by mail for consideration, or query with resume of credits or list of stock photo subjects. SASE. Reports in 1 month. Pays $50/color cover photo; $10 maximum/inside b&w photo, $20 maximum/color photo and $35-100/text/photo package. Pays on publication. Credit line given. Buys one-time rights or first North American serial rights. Previously published work OK.

Tips: "We generally look over the samples, take notes, and return all the photos; when need arises, we recontact the photographer. The more detailed the stock list, the better—our needs are usually quite specific. Looking for beauty or interest that catches the eye and/or the "right photo" to illustrate a particular article. Seasonal-looking covers needed 6 months in advance: in March/April for Fall/Winter issue, in September/October for Spring/Summer issue."

THE EVANGELICAL BEACON, 1515 E. 66th St., Minneapolis MN 55423. (612)866-3343. Editor: George M. Keck. Circ. 40,000. Magazine of the Evangelical Free Church of America. Emphasizes Christian living, evangelism, denominational news; inspiration and information. Uses 2 or 3 photos/issue. Photos purchased with or without accompanying mss. Credit line usually given. Pays on acceptance for photos; on publication for articles. Buys all or one-time rights. Model release preferred. Send material. SASE. Simultaneous submissions and previously published work OK. Reports in 4-8 weeks.

Subject Needs: Human interest: children and adults in various moods and activities; and scenic shots: churches and city scenes. Captions not required, but helpful (especially locations of scenes). No cheesecake.

B&W: Uses 8x10 glossy prints. Pays $10-15.

Cover: Uses glossy color prints; vertical format required. Pays $25 minimum.

Accompanying Mss: Seeks personal testimonies, Christian living, Christian and life issues and concerns, and church outreach ideas.

EVANGELIZING TODAY'S CHILD, Child Evangelism Fellowship Inc., Warrentown MO 63383. (314)456-4321. Editor: Mrs. Elsie Lippy. Bimonthly magazine. Circ. 26,000. Written for people who work with children, ages 5-12, in Sunday schools, Bible clubs and camps. Buys 1-2 photos/issue. Pays on a per-photo basis. Credit line given. Buys one-time rights. Prefers to retain good quality photocopies of selected glossy prints and duplicate slides in morgue for future use. Send material by mail with SASE for consideration. Publication is under no obligation to return materials sent without SASE. Simultaneous submissions and previously published work OK. Free photo guidelines with SASE.

Subject Needs: Children, ages 5-12. Candid shots of various moods and activities. "We use quite a few shots with more than one child and some with an adult. The content emphasis is upon believability and appeal. Religious themes may be especially valuable." No nudes, scenery, fashion/beauty, glamour or still lifes.

B&W: Uses 8x10 glossy prints. Pays $25/photo. Color: uses 35mm or larger transparencies, inside $30-35/photo; cover shots $100.

Tips: Each issue built around a theme (i.e., children's ministries, evangelism & follow-up, Christian education).

EVENT, Douglas College, Box 2503, New Westminster, B.C., Canada V3L 5BZ. (604)520-5400, ext. 3311. Editor: Dale Zierieth. Visuals Editor: Ken Hughes. Magazine published every 6 months. Circ. 1,000. Emphasizes literature and fine art graphics (essays, short stories, plays, reviews, poetry, verse, photographs and drawings). Photos purchased with or without accompanying ms. Buys 20 photos/issue. Pays $5-10/page. ("Normally, one photo appears per page.") Credit line given. Pays on publication. Query, send material by mail for consideration or submit portfolio for review. SAE and International Reply Coupons or Canadian stamps. Simultaneous submissions OK. Reports in 2-4 weeks. Sample copy $3; free photo guidelines or writer's guidelines.

Subject Needs: Animal, celebrity/personality, documentary, fine art, human interest, humorous, nature, nude, photo essay/photo feature, scenic, special effects/experimental, still life, travel and wildlife. Wants any "nonapplied" photography, or photography not intended for conventional commercial purposes. Needs excellent quality. Must be a series. Model release and captions required. "No unoriginal, commonplace or hackneyed work."

B&W: Uses 8x10 prints. Any smooth finish OK.

Color: "No color work unless the photographer agrees to reproduction in b&w and unless work is of a sufficient standard when in b&w."

Cover: Uses b&w prints. Any smooth finish OK. Vertical format preferred.

Tips: "We prefer work that appears as a sequence: thematically, chronologically, stylistically. Individual items will only be selected for publication if such a sequence can be developed. Photos should preferably be composed for vertical, small format (6x9) and in b&w."

THE EVERY OTHER WEEKLY, Suite 301, 222 S. Meramee, Clayton MO 63105. (314)725-3101. Editor: Ed Presberg. Every other week. Circ 50,000. Free sample copy.

Photo Needs: Needs include local celebrity/personality and head shot, photo essay/photo feature, and travel photos. Rarely takes photos only; needs photos with accompanying ms. B&w: $25-500. Color cover: $100/up.
Making Contact & Terms: Send by mail for consideration actual 8x10 b&w glossies. SASE. Pays on publication. Buys one-time rights.

THE EXCEPTIONAL PARENT, 605 Commonwealth Ave., Boston MA 02215. (617)536-8961. Managing Editor: Ellen Herman. Publishes 8 issues/year. Emphasizes disabled children and parents of disabled children. Readers include parents of disabled children and professionals working with disabled children, also some disabled teens. Circ. 35,000. Sample copy $3.
Photo Needs: Uses 30 photos/issue; very few supplied by freelance photographers. Needs pictures of disabled kids and their families, playing, at school, eating, sleeping, etc. Also pictures of mobility devices and other aids for disabled individuals. Model release required.
Making Contact & Terms: Send any size glossy b&w prints by mail for consideration. SASE. Reports in 2 months. Payment negotiated individually; "unfortunately, we cannot afford to pay much of anything." Pays on publication. Buys one-time rights. Simultaneous submissions and previously published work OK.

EXPECTING MAGAZINE, 685 3rd Ave., New York NY 10017. (212)878-8642. Art Director: Ruth M. Kelly. Quarterly. Circ. 1,200,000. Emphasizes pregnancy and birth. Readers are pregnant women 18-40. Sample copy available.
Photo Needs: Uses about 12 photos/issue. Works with freelance photographers on assignment only basis. Provide card to be kept on file for future assignment. Occasionally uses stock color transparencies of women during labor and birth, hospital or doctor visits. Model release required.
Making Contact & Terms: Arrange for drop off to show portfolio; send 35mm, 2¼x2¼, 4x5 or 8x10 transparencies by mail for consideration. SASE. No b&w photos used. "Usually reports immediately." Pays $250/color page. Pays on publication. Credit line given. Buys one-time rights. Simultaneous submissions and previously published work OK.

FACES: The Magazine About People, 20 Grove St., Peterborough NH 03458. (603)924-7209. Editor-in-Chief: Carolyn P. Yoder. Monthly (except July and August) magazine. Emphasizes cultural anthropology for young people ages 8 to 14. Estab. 1984. Sample copy $3.50.
Photo Needs: Uses about 15-20 photos/issue. "Photos (b&w) for text must relate to themes; cover photos (color) should also relate to themes. Send SASE for themes. Model release and captions preferred.
Making Contact & Terms: Query with samples. SASE. Reports in 1 month. Pays $5-10/text photos; approximately $50 for cover photos. Pays on publication. Credit line given.

FACT MAGAZINE, 305 E. 46th St., New York NY 10017. (212)319-6868, ext. 24. Art Director: Christopher Goldsmith. Monthly magazine. Emphasizes "consumer money management and investment." Readers are "consumers interested in money management, with incomes of $50,000 and up." Circ. 107,000.
Photo Needs: Uses about 8 photos/issue; 2 or 3 supplied by freelance photographers. Needs "good photos directly associated with subject matter, often real estate, stocks, funds, bonds, collectibles: gems, coins, etc." Written release and captions preferred "only to identify specific info, i.e., 1957 Cadillac."
Making Contact & Terms: Query with samples. Provide resume, business card, brochure, flyer or tearsheets to be kept on file for possible future assignments. Prefers color transparent material. Pays $400-600/color cover photo; $100-300/color inside photo. Pays on acceptance. Credit line given. Buys one-time rights.

FAMILY COMPUTING, 730 Broadway, New York NY 10003. (212)505-3578. Design Director: Vincent Ceci. Monthly. Emphasizes home computers. Readers are home users, parents and kids. Circ. 375,000. Free sample copy.
Photo Needs: Uses 30 photos/issue; 6 supplied by freelance photographers. Photos purchased with accompanying ms only. Model release required.
Making Contact & Terms: Query with samples; submit portfolio for review. Reports in 1 month. Pays on acceptance. Credit line given. Buys first world rights.

FAMILY MAGAZINE, Box 4993, Walnut Creek CA 94596. (415)284-9093. Editor: Mary Jane Ryan. Monthly except January/July. Emphasizes military families. Readers include women between ages of 18-45 whose husbands are in the military. Circ. 545,000. Sample copy $1.25.
Photo Needs: Uses 10-25 photos/issue; all supplied by freelance photographers. Needs photos related

to travel, families—men, women, children, food. Captions preferred.
Making Contact & Terms: Send any size b&w or color prints or transparencies by mail for consideration. SASE. Reports in 1 month. Pays $135-150/color cover photo; $25/b&w inside photo and $50/color inside photo, or on a per job basis. Pays on publication. Credit line given. Buys first North American serial rights. Simultaneous submissions OK.

FARM & RANCH LIVING, 5400 S. 60th St., Greendale WI 53129. (414)423-0100. Managing Editor: Bob Ottum. Bimonthly. Circ. 270,000. "Concentrates on people and places in agriculture, but not the 'how to increase yields' type. We show farming and ranching as a way of life, rather than a way to make a living." Readers are "farmers and ranchers in all states in a wide range of income." Sample copy for $2; photo guidelines free with SASE.
Photo Needs: Uses about 100-125 photos/issue; all supplied by freelance photographers. Needs "agricultural photos: farms and ranches, farmers and ranchers at work and play. Work one full season ahead—send summer photos in spring, for instance." Special needs include "good-looking seasonal photos of a rural nature."
Making Contact & Terms: Query with samples or list of stock photo subjects; send 35mm, 2¼x2¼ or 4x5 transparencies by mail for consideration. SASE. Reporting time varies; "immediately to a month." Pays $150/color cover photo; $35-50/b&w inside photo, $75-150/color inside photo; $200-400 for text/photo package. Pays on acceptance. Buys one-time rights. Previously published work OK.
Tips: "Looking for brilliant colors in photos of agricultural and rural nature. Also looking for shots of photogenic farms and ranches to feature in series 'Prettiest Place in the Country.' A little imagination goes a long way with us. We like to see an unusual angle or approach now and then, but don't see nearly enough like that."

FARM WOMAN, (formerly *Farm Woman News*), Box 643, Milwaukee WI 53201. (414)423-0100. Managing Editor: Ruth Benedict. Circ. 320,000. Emphasizes rural life and a special quality of living to which rural (farm and ranch) women can relate; at work or play, in sharing problems, etc. Photos purchased with or without accompanying ms. Uses 20-40 photos/issue, color and b&w. Pays $350-600/assignment or on a per-photo basis; $10 80/hour; $100-400/day; $100-400 for text/photo package. Pays on acceptance. Buys one-time rights. Send material by mail for consideration. Provide brochure, calling card, letter of inquiry, price list, resume and samples to be kept on file for possible future assignments. SASE. Previously published work OK. Reports in 6 weeks. Sample copy $2.50 and free photo guidelines.
Subject Needs: "We're always interested in seeing good shots of farm and ranch women (in particular) and farm/rural families (in general) at work and at play." Uses photos of farm animals, children with farm animals, farm and country scenes (both with and without people), and nature. Wants on a regular basis scenic (rural), seasonal, photos of rural women and their families at work on the farm. "We're always happy to consider cover ideas. Covers are seasonal in nature. Additional information on cover needs available. Always need good harvest, planting, livestock photos, too. We try to show the best of agriculture—healthy cattle, bright green fields of soybeans, etc." Captions are required. Work 3-6 months in advance. "No poor quality b&w or color prints, posed photos, etc. In general, if subject guidelines described above are met and quality is good, there should be no problem with sales."
B&W: Uses 8x10 glossy prints. Pays $25-75/photo.
Color: Uses transparencies. Pays $50-225/photo.
Tips: Prefers to see "rural scenics, in various seasons; emphasis on farm women, ranch women and their families. Slides appropriately simple for use with poems or as accents to inspirational, reflective essays, etc."

FARMSTEAD MAGAZINE, Box 111, Freedom ME 04941. (207)382-6200. Publisher: George Frangoulis. Managing Editor: Heidi Bruggar. Magazine, published 6 times a year. Circ. 170,000. Emphasizes home gardening, livestock care, alternative energy, shelter, and country living. Manuscript preferred with photo submissions. Freelancers supply 90% of material. Credit line given. Pays on publication. Submit portfolio for review. SASE. Reports in 3 months. Free sample copy. Provide resume, business card or brochure to be kept on file for possible future assignments.
Subject Needs: Photos of home gardening related subjects such as people in their gardens and close-ups of vegetables, flowers and some domestic farm animals. Captions required.
B&W: Uses 5x7 or 8x10 glossy prints. Pays $10 minimum/5x7 b&w print.
Color: Uses transparencies. Pays $25/transparency.
Cover: Uses transparencies. Pays $50-100/photo.
Accompanying Mss: Seeks mss on gardening, homesteading, care of livestock, construction, insects (beneficial and injurious), etc.
Tips: Prefers to see "country life scenes, vegetables, flowers, wildlife, gardens and people in them, small farm and garden equipment in use and some domestic farm animals as samples. Photographers should be willing to start small and cheap and *work* to build a relationship through time and patience."

FESTIVALS, (formerly *Family Festivals*), Suite 290, 160 E. Virginia St., San Jose CA 95112. (408)286-8505. Art Director: Ben Lizand. Bimonthly. Circ. 14,000. Emphasizes "celebrations of the feasts and seasons of the year in a religious context—at home, parents and children, ethnic, popular and traditional feasts." Readers are "people who want to recover a sense of the sacred in ordinary living." Sample copy $3.

Photo Needs: Uses about 6 photos/year; 2 supplied by freelance photographers. Needs "photos depicting family celebrations; photos showing reverence for a natural or man-made object; photos showing the seasons."

Making Contact & Terms: Query with samples; send 4x5 or 8x10 b&w glossy prints by mail for consideration. SASE. Reports in 1 month. Pays $40/b&w cover photo; $20/b&w inside photo. Pays on publication. Credit line given. Buys one time and first North American serial rights, promotional use rights. Previously published work OK.

***FIELD & STREAM**, 1515 Broadway, New York NY 10036. (212)719-6000. Editor-in-Chief: Duncan Barnes. This is a broad-based service magazine. The editorial content ranges from very basic "how it's done" filler stories that tell in pictures and words how an outdoor technique is accomplished or device is made, to feature articles of penetrating depth about national conservation, game management, and resource management issues; and recreational hunting, fishing, travel, nature and outdoor equipment.

Subject Needs: Photos using action and a variety of subjects and angles in both b&w and color. "We are always looking for cover photographs, in color, which may be vertical or horizontal. Remember: a cover picture must have room at the left for cover lines."

Specs: Uses 8x10 b&w photos; 35mm and 2¼x2¼ color transparencies. Will also consider 4x5 or 8x10 size transparencies, but "majority of color illustrations are made from 35mm or 2¼-inch film."

Payment & Terms: Pays $75 + /per b&w photo, $450/color photo depending on size used on single page; $800/partial color spread; $900/full color spread; $1,000 + /color cover. Buys First World Rights; rights returned after publication. Needs photo information regarding subjects, the area, the nature of the activity and the point the picture makes. Don't attach caption information to color photos.

Making Contact: Submit photos by registered mail. Send slides in 8½x11 plastic sheets, and pack slides and/or prints between cardboard. SASE. Reports in 60 days. Writer's/photographer's guidelines available.

FIGHTING WOMAN NEWS, Box 1459, Grand Central Station, New York NY 10163. (212)228-0900. Editor: Valerie Eads. Photo Editor: Muskat Buckby. Quarterly. Circ. 6,300. Emphasizes women's martial arts. Readers are "adult females actively practicing the martial arts or combative sports." Sample copy $3.50; photo guidelines free with SASE.

Photo Needs: Uses 18 photos/issue; 14 supplied by freelance photographers. Needs "action photos from tournaments and classes/demonstrations; studio sequences illustrating specific techniques, artistic constructions illustrating spiritual values. Please do *not* send piles of snapshots from local tournaments unless there is something important about them, such as illustration of fine technique, etc. Obviously, photos illustrating text have a better chance of being used. We have little space for fillers. We are always short of photos suitable to our magazine." Model release preferred; captions and identification required.

Making Contact & Terms: Query with resume of credits or with samples or send 8x10 glossy b&w prints or b&w contact sheet by mail for consideration; provide resume, business card, brochure, flyer or tearsheets to be kept on file for possible future assignments. SASE. Reports "as soon as possible." Pays $10 plus film cost cover/photo; payment for text/photo package to be negotiated. Pays on publication. Credit line given. Buys one-time rights. Simultaneous submissions and previously published work OK; "however, we insist that we are *told* concerning these matters; we don't want to publish a photo that is in the current issue of another martial arts magazine."

Tips: Prefers to see "technically competent b&w photos of female martial artists in action. No glamour, no models; no cute little kids unless they are also skilled. Don't just go to a tournament and shoot blind. Get someone knowledgeable to caption your photos or at least tell you what you have—or don't have. We are a poor alternative publication chronically short of material, yet we reject 90% of what is sent because the sender obviously never saw the magazine and has no idea what it's about. The cost of buying sample copies is a lot less than postage these days."

***FILM COMMENT**, 140 W. 65th St., New York NY 10023. (212)877-1800. Editor: Harlan Jacobson. Photo Editor: Marlaine Glicksman. Bimonthly magazine, non-profit. Emphasizes film—as a social and cultural medium, as an industry and an art. Readers are filmmakers, critics, academics, anyone interested in film and good writing. Circ. 40,000. Sample copy $2.50. "Photo guidelines depend on article."

Photo Needs: Uses about 75 photos/issue; "usually under 10" supplied by freelance photographers. Needs photos of film stills, archive film stills, portraits.

Making Contact & Terms: Query with samples; provide resume, business card, brochure, flyer or tearsheets to be kept on file for possible future assignments. Send b&w prints; 35mm transparencies;

b&w and color contact sheets by mail for consideration. SASE. Reports in 2 weeks. "We are non-profit. Photos that are stock or already in existence go for $25. If we ask for a shoot, price is arranged." Pays "generally on publication, other arrangements can be made." Credit on back page unless otherwise arranged. Rights purchased depend on photo. Simultaneous submissions and previously published work OK.

***FINE ART PHOTOGRAPHY**, 3015 Woodsdale Blvd., Lincoln NE 68502-5053. (402)421-3172. Editor: John Richard Austin. Photo Editor: Committee. Quarterly magazine. Emphasizes freelance, fine art expression. Readers are freelance photographers. Circ. 2,350. Estab. 1986. Sample copy available, price cover "*TBA.*" Photo guidelines free with SASE.
Photo Needs: Uses 40-50 photos/issue; all supplied by freelance photographers. Model release required; captions preferred.
Making Contact & Terms: Query with samples; query with list of stock photo subjects; provide resume, business card, brochure, flyer or tearsheets to be kept on file for possible future assignments. SASE. Reports in 1 month. Payment varies. Pays on publication. Credit line given. Buys one-time rights. Previously published work OK.
Tips: Prefers to see visual expression.

FINESCALE MODELER, 1027 N. 7th St., Milwaukee WI 53233. (414)272-2060. Editor: Bob Hayden. Photo Editor: Paul Boyer. Bimonthly. Circ. 39,500. Emphasizes "how-to-do-it information for hobbyists who build nonoperating scale models." Readers are "adult and juvenile hobbyists who build nonoperating model aircraft, ships, tanks and military vehicles, cars and figures." Sample copy $2.50; photo guidelines free with SASE.
Photo Needs: Uses more than 50 photos/issue; "anticipates using" 10 supplied by freelance photographers. Needs "in-process how-to photos illustrating a specific modeling technique; photos of full-size aircraft, cars, trucks, tanks and ships." Model release and captions required.
Making Contact & Terms: Provide resume, business card, brochure, flyer or tearsheets to be kept on file for possible future assignments. "Phone calls are OK." Reports in 8 weeks. Pays $25 minimum/color cover photo; $5 minimum/b&w inside photo, $7.50 minimum/color inside photo; $30/b&w page, $45/color page; $50-500 for text/photo package. Pays for photos on publication, for text/photo package on acceptance. Credit line given. Buys one-time rights. "Will sometimes accept previously published work if copyright is clear."
Tips: Looking for "clear b&w glossy 5x7 or 8x10 prints of aircraft, ships, cars, trucks, tanks and sharp color positive transparencies of the same. In addition to photographic talent, must have comprehensive knowledge of objects photographed and provide copious caption material. Freelance photographers should provide a catalog stating subject, date, place, format, conditions of sale and desired credit line before attempting to sell us photos. We're most likely to purchase color photos of outstanding models of all types for our regular feature, FSM Showcase."

FIRST HAND MAGAZINE, MANSCAPE, 310 Cedar Lane, Teaneck NJ 07666. (201)836-9177. Editor: Jack Veasey. Monthly magazine. "*First Hand* deals with all aspects of homosexuality: *Manscape* will lean towards the kinky." Readers are "men, glorious men." Circ. 60,000. Sample copy $3. Photo guidelines free with SASE.
Photo Needs: Uses about 2 photos/issue; 2 supplied by freelance photographers. Needs photos of "sexy men. *No* uncovered groin shots. Cover photo should show face. Back cover can show behind." Written release required.
Making Contact & Terms: Arrange a personal interview to show portfolio; query with samples. Send 35mm, 2¼x2¼, 4x5 transparencies, color contact sheet by mail for consideration. SASE. Reports in 3 weeks. $150/front cover photo; $100/back cover photo. Credit line given. Buys one-time rights. Simultaneous submissions OK.
Tips: "Don't send in photos of people with acne. Don't overload the company with your work. It's better to send 20 slides than 100."

THE FISHERMAN, (Long Island, Metro Edition), Box 1994, Sag Harbor NY 11963. (516)725-4200. Editor: Fred P. Golofaro. Weekly magazine. Circ. 45,000. Emphasizes salt water recreational angling. Photos are purchased with or without accompanying ms. Credit line given. Pays on publication. Buys all rights, but may reassign to photographer after publication. Query with list of stock photo subjects and samples. SASE. Reports in 6-10 weeks. Free photo guidelines.
Subject Needs: Salt water fish from NE coastal region, how-to (salt water fishing), human interest (children with fish) and sport (action fishing). No dead fish photos. Captions required.
B&W: Uses 8x10 or 5x7 glossy prints. Pays $10/photo.
Cover: Uses 8x10 glossy prints. Square or vertical format required. Pays $25/photo.
Accompanying Mss: Marine angling in New York metropolitan area. Pays $100/full feature, $50/short feature. Free writer's guidelines.

FISHING WORLD, 51 Atlantic Ave., Floral Park NY 11001. Editor: Keith Gardner. Bimonthly magazine. Circ. 385,000. Emphasizes techniques, locations and products of both freshwater and saltwater fishing. For men interested in sport fishing. Needs photos of "worldwide angling action." Buys 18-30/annually. Buys first North American serial rights. Send photos for consideration. Photos purchased with accompanying ms; cover photos purchased separately. Pays on acceptance. Reports in 3 weeks. SASE. Free sample copy and photo guidelines.
B&W: Send glossy prints. Captions required. Pays $25-100 for text/photo package under 1,000 words.
Color: Send transparencies. Requires originals. Captions essential. Pays $300 for complete text/photo package.
Cover: Send color transparencies. "Drama is desired rather than tranquility. Fish portraits and tight close-ups of tackle are often used." Requires originals. Captions essential. Pays $250.
Tips: "In general, queries are preferred, though we're very receptive to unsolicited submissions accompanied by smashing photography." Inside photos are primarily color, but b&w is used to supplement these.

***FLOWER AND GARDEN MAGAZINE**, 4251 Pennsylvania Ave., Kansas City MO 64111. Editor: Rachel Snyder. "We use mainly horticultural subjects, which must be accurately identified. No scenics. No wildflowers." Prefers to see "good studies of plants or gardens reflecting superior care; seasonal aspects. People-related. Gather identifications of plants as you photograph them. Such information is important to us. We purchase one-time rights."

FLY FISHERMAN, Historical Times, Inc., Editorial Offices, 2245 Kohn Rd., Box 8200, Harrisburg PA 17105. (717)657-9555. Founding Publisher: Donald D. Zahner. Editor: John Randolph. Emphasizes all types of fly fishing for readers who are "99% male, 79% college educated, 79% married. Average household income is $62,590 and 55% are managers or professionals. 85% keep their copies for future reference and spend 35 days a year fishing." Bimonthly. Circ. 130,000. Sample copy $2.95; photo/writer guidelines for SASE.
Photo Needs: Uses about 45 photos/issue, 70% of which are supplied by freelance photographers. Needs shots of "fly fishing and all related areas—scenics, fish, insects, how-to." Column needs are: Fly Tier's Bench (fly tying sequences); Tackle Bag; and Casting About (specific streams and rivers). Captions required.
Making Contact & Terms: Send by mail for consideration 5x7 or 8x10 b&w prints or 35mm, 2¼x2¼, 4x5 or 8x10 color transparencies. SASE. Reports in 4-6 weeks. Pays on publication $30-75/b&w photo; $40-200/color transparency; $400/color covers; $250 maximum day rate; $35-400 for text/photo package. Credit line given. Buys one-time rights. No simultaneous submissions; previously published work OK.

FOOD & WINE, 1120 Avenue of the Americas, New York NY 10036. (212)382-5600. Art Director: Elizabeth Woodson. Monthly. Circ. 500,000. Emphasizes food and wine. Readers are an "upscale audience who cook, entertain, dine out and travel stylishly."
Photo Needs: Uses about 25-30 photos/issue; mostly studio photography on assignment basis. "We look for editorial reportage specialists who do restaurants, food on location and travel photography." Model release and captions required.
Making Contact & Terms: Drop-off policy to show portfolio, third week of month. Provide tearsheets to be kept on file for possible future assignments. Pays $300-400/color page. Pays on acceptance. Credit line given. Buys one-time world rights.

FOREVER YOUNG, (formerly *Total Fitness*), 15115 S. 76th E. Ave., Bixby OK 74008. (918)366-4441. Managing Editor: André Hinds. Photo Editor: Dana C. Davis. Bimonthly. Circ. 120,000. Emphasizes how to stay and look younger. Readers are males and females 35-55 years old. Sample copy and photo guidelines free with SASE.
Photo Needs: Cover shots—color transparencies of celebrities over 40. Also needs black and white inside photos of the same. Other photos would be on assignment only.
Making Contact & Terms: Query with samples. SASE. Reports in 1 month. Pays $50-150/color cover photo; $25-50/b&w inside photo. Pays on publication. Credit line given. Buys first North American serial rights. Simultaneous submissions OK.

FORTUNE, Time-Life Bldg., New York NY 10020. (212)841-2583. Managing Editor: William Rukeyser. Picture Editor: Alice Rose George. Emphasizes analysis of news in the business world for management personnel. Photos purchased on assignment only. Portfolios seen by appointment.

***FOUR WHEELER MAGAZINE**, 6728 Eton Ave., Canoga Park CA 91303. (818)992-4777. Editor: David Cohen. Photo Editor: Bruce Smith. Consumer. Monthly magazine. Emphasizes four wheel drive

vehicles and enthusiasts. Circ. 205,000. Sample copy free with SASE. Photo guidelines free with SASE.

Photo Needs: Uses 100 color/100 b&w photos/issue; 10% supplied by freelance photographers. Needs how-to, travel/scenic/action (off-road-4x4s only) photos. Reviews photos with accompanying ms only. Model release and captions required.

Making Contact & Terms: Provide resume, business card, brochure, flyer or tearsheets to be kept on file for possible future assignments. Does not return unsolicited material. Reports in 1 month. Pays $10-50/inside b&w photo; $20-100/inside color photo; $100/b&w and color page; $200-600/text/photo package. Pays on publication. Credit line given. Buys all rights.

Tips: "Be creative; accurate exposures; sharp focus; fine grain films; use a variety of focal length."

FRANCE TODAY MAGAZINE, 1051 Divisadero St., San Francisco CA 94115. (415)921-5100. Editor: Anne Prah-Perochon. Biannual. Emphasizes modern-day France. Readers are Americans who travel often to Europe; teachers and students of the French language. Circ. 40,000. Estab. 1984. Sample copy free with SASE.

Photo Needs: Uses 30 photos/issue; 20 supplied by freelance photographers. Needs photos depicting travel, food and wine, products, personalities and holiday activities. Reviews photos with or without accompanying ms. Captions preferred.

Making Contact & Terms: Query with samples; send unsolicited photos by mail for consideration. Send b&w 8x10 prints; 35mm transparencies. SASE. Reports in 1 month. Pays $50/b&w inside photo; $200/color cover photo; and $100/color inside photo. Pays on publication. Credit line given. Buys one-time rights. Simultaneous submissions OK.

FREEWAY, Scripture Press, Box 623, Glen Ellyn IL 60138. Editor: Cindy Atoji. Four-page magazine. Circ. 70,000. For older Christian teens. Photos purchased with or without accompanying ms. Freelancers supply 90% of the photos. Pays on acceptance. Buys one-time rights and simultaneous rights. "Mail portfolio with SASE; we will photocopy prints we're interested in for future ordering." Simultaneous submissions and previously published work OK. Reports in 1 month. Free sample copy and photo guidelines available on request.

Subject Needs: "Photos should include teenage subjects. We need action photos, human relationships, objects, trends and sports." Also uses some religious and mood photos. No fine art; no photos with too-young subjects or outdated styles; no overly posed or obviously gimmicky shots. No scenery.

B&W: Uses 8x10 b&w prints. Pays $20-35.

Accompanying Mss: "*Freeway* emphasizes personal experience articles which demonstrate God working in the lives of older teens and young adults. Most of our readers have an interest in Christian growth."

Tips: "We would like to use a greater percentage of photos in our layouts. Thus, we'd like to see more action photos of teenagers which we can use to illustrate stories and articles (teen personal crisis, self-help, how-to). We'd like to see some creativity and real-life situations. We're overstocked with close-up reflective shots, and teens at school and other typical actions and settings."

FRETS MAGAZINE, 20085 Stevens Creek, Cupertino CA 95014. (408)446-1105. Editor: Phil Hood. Photo Editor: Cachlan Throndson. Emphasizes personality profiles, how-to material and feature stories. Readers are serious musicians devoted to string acoustic music. Monthly. Circ. 69,350. Free sample copy and photo guidelines.

Photo Needs: Uses about 15 photos/issue; most supplied by freelance photographers. Selects photographers "on merits of each piece." Needs include photos of musicians with instruments (playing) and not eating mikes. Group or solo artist shots. Model release not required; include dates, location, and names of people involved; captions required.

Specs: Uses any size, 5x7 or larger, b&w print, glossy; or contact sheet. Needs 35mm color slides for cover.

Making Contact & Terms: Send by mail for consideration actual prints, slides, and/or contact sheet. Query with lists of stock photo subjects. SASE. Reports "after publication of material." Pays on publication $25 minimum for b&w photo full shots, depending on size used; $75, and up/color transparency. Credit line given, "except for mugshots, 'coming next month' ad, and table of contents photos." Buys one-time rights and one-time reprint rights. No simultaneous submissions.

***FRIENDS OF WINE**, 2302 Perkins Place, Silver Spring MD 20910. (301)588-0980. Managing Editor: Kevin Moran. Association publication of Les Amis Du Vin. Bimonthly magazine. Emphasizes wine. Readers are wine lovers and trade members. Circ. 100,000. Sample copy free with SASE. Photo guidelines free with SASE.

Photo Needs: Uses 30 photos/issue; 1-10 supplied by freelance photographers. Needs wine art shots, wine scenery shots. Model release required.

Making Contact & Terms: Provide resume, business card, brochure, flyer or tearsheets to be kept on file for possible future assignments. Does not return unsolicited material. Pay negotiated. Pays on publication. Credit line given. Rights negotiated. Simultaneous submissions and previously published work OK.

FUN IN THE SUN, 5436 Fernwood Ave., Los Angeles CA 90027. (213)465-7121. Publisher: Ed Lange. Quarterly. Emphasizes nudism/naturism/alternative lifestyles. Circ. 5,000. Photo guidelines free with SASE.
Photo Needs: Uses about 50 photos/issue; 20 supplied by freelance photographers. Needs photos of "nudity; fun in sun (nonsexist)." Model release and captions required.
Making Contact & Terms: Query with samples. SASE. Reports in 3 weeks. Pays $50/b&w cover photo; $100/color cover photo; $25/b&w inside photo; $25/color inside photo. Pays on acceptance. Credit line given. Buys one-time or all rights. Previously published work OK.

FUN/WEST, Box 2026, North Hollywood CA 91602. Editor: S. Richard Adlai. Quarterly magazine. Emphasizes living on the West Coast for young, single people; resorts in the US and jet set activities.
Subject Needs: Travel, fashion/beauty, glamour, few nude ("good taste only"), product shot, wine and gourmet food. Captions preferred; model release required.
Specs: Uses 8x10 b&w and color prints. Uses b&w and color covers.
Payment/Terms: Payment negotiable. Credit line given. Pays on publication. Buys all rights. Simultaneous submissions and previously published work OK.
Making Contact: Query only with list of stock photo subjects. Unsolicited materials will be discarded. SASE. Reports in 1 month or more.
Tips: "Exercise good taste at all times. Concentrate on showing the same subjects under different light or style."

FUR-FISH-GAME, 2878 E. Main St., Columbus OH 43209. Editor: Ken Dunwoody. Monthly magazine. Cir. 190,000. Emphasizes hunting, fishing, trapping, camping, conservation and guns in the U.S. For outdoor enthusiasts of all ages. Buys 200 text/photo packages annually, paying $75-150. Also buys photos depicting game animals, birds or fish in their natural environment, or photos which depict the mood of fishing, hunting, camping or trapping. Pays $10-20 for most photos, rights negotiable. Pays on acceptance. Reports in 1 month. SASE. Sample copy $1; photo guidelines free.
Specs: Uses b&w prints. Send 5x7 or 8x10 glossy prints (3x5 sometimes accepted). Caption information required.
Tips: "We need photos that capture the general spirit of fishing, hunting, trapping or camping and can be used to fit a variety of story ideas. We also have a shortage of photos that depict small game and waterfowl."

FUTURIFIC MAGAZINE, Suite 1210, 280 Madison Ave., New York NY 10016. Editor-in-Chief: Mr. Balint Szent-Miklosy. Monthly. Circ. 10,000. Emphasizes future related subjects. Readers range from corporate to religious leaders, government officials all the way to blue collar workers. Sample copy with $2—for postage and handling.
Photo Needs: Uses 10 photos/issue; all supplied by freelance photographers. Needs photos of subjects relating to the future. Photos purchased with or without accompanying ms. Captions preferred.
Making Contact & Terms: Send by mail for consideration b&w prints or contact sheets. Reports in 1 month. Payment negotiable. Pays on publication. Buys one-time rights. Simultaneous submissions and/or previously published work OK.
Tips: "Photographs should illustrate what directions society and the world are heading. Optimistic only."

G&S PUBLICATIONS, 1472 Broadway, New York NY 10036. (212)840-7224. Editor: Will Martin. Publishes two magazines—*Gem* and *Buf*, bimonthly men's sophisticate publications. "Gem features photo sets of models with extra-large size breasts. Although we look for models as pretty as we can get, big breasts take precedence. Buf Pictorial features large women, plumpers and super plumpers. Models should be shown eating in some shots. Models' measurements and food preferences should be included with submissions. Readers are men." Circ. 100,000. Sample copy $3.95; photo guidelines free with SASE. Bimonthly; 12 issues/year—6 of each.
Photo Needs: "We look for a variety of poses, the object being to present attractive, titillating photo spreads for our readers. Poses should be erotic but *not* pornographic. Sets should include full-figure nudes seen from front, side and back. A set requires both color (35mm) and black and white. The b&w photos should be submitted on contact sheets, accompanied by several 8x11 blow-ups to give an idea as to the quality of the photography." Model release required.
Making Contact & Terms: Query with samples; send unsolicited photos by mail for consideration.

SASE. Reports in 1 month. "Payment depends on several factors, whether it is a first rights set or not, how often the model has been used in other publications (or ours) even if it is a first rights set, the quality of the model and the quality of the photography. Generally speaking, for a first rights set with a new model, we pay $400; $450 if the set includes a cover shot. These fees include the ordering of about 6 prints." Pays two weeks after receipt of b&w photos and model release. Credit line given "if requested." Buys first rights and second rights.

GALLERY MAGAZINE, 800 2nd Ave., New York NY 10017. (212)986-9600. Photo Editor: Judy Linden. Monthly. Circ. 550,000. Emphasizes men's interests. Readers are male, collegiate, middle class. Free photo guidelines with SASE.
Photo Needs: Uses 80 photos/issue; 30 supplied by freelance photographers. Needs photos of nude women and celebrities. Model release required.
Making Contact & Terms: Send by mail for consideration at least 80 35mm transparencies. SASE. Reports in 4 weeks. Girl sets: pays $800/up, $500 extra for cover. Buys first North American Serial rights. Also Girl Next Door contest: $50 for published photo, $1,000 monthly winner, $100 to photographer of monthly winner. Send by mail for contest information. Pays on publication. Credit line given.

GAME & FISH PUBLICATIONS, Box 741, Marietta GA 30061. (404)953-9222. Editor: David Morris. Publishes 13 monthly magazines: *Alabama Game & Fish, Arkansas Sportsman, Carolina Game & Fish, Tennessee Sportsman, Texas Sportsman, Florida Game & Fish, Missouri Game, Oklahoma Game & Fish, Virginia-West Virginia Game & Fish.* Circ. 250,000 (total). All emphasize "hunting—white tailed deer and other species; fishing—bass and other species." Readers are hunters/fishermen. Sample copy $2.50; photo guidelines free with SASE.
Photo Needs: Uses approximately 80 photos for all magazines per month; 50% supplied by freelance photographers. Needs photos of live or dead deer; action fishing shots. Model release preferred; captions required.
Making Contact & Terms: Query with samples. Send 8x10 b&w glossy prints; 35mm transparencies by mail for consideration. SASE. Reports in 1 month. Pays $250/color cover photo; $75/color inside photo; $150 minimum for text/photo package. Pays on acceptance. Credit line given. Buys one-time rights. Simultaneous submissions not accepted.
Tips: "Study our publications."

***GAMES MAGAZINE**, 515 Madison Ave., New York NY 10022. (212)421-5984. Editor: Wayne Schmittberger. Photo Editor: Debra Kagan. Monthly magazine. Emphasizes games. Readers are 20-40 years of age. Circ. 600,000.
Photo Needs: Uses 10 photos/issue; all supplied by freelance photographers. Needs various stock shots (all different subjects) studio set ups and still lifes, constructions of puzzles, illusions. Reviews photos with accompanying ms only. Model release preferred.
Making Contact & Terms: Submit portfolio for review. Reports in 2 weeks. Pay varies. Pays on acceptance. Credit line given. Buys all rights. Previously published work OK.
Tips: Prefers to see ideas for departments in the magazine such as "Eyeball Benders," ideas for puzzles or good studio work. "Read the magazine first."

***GAMING INTERNATIONAL**, 219 Covered Bridge Rd., Cherry Hill NJ 08034. (609)345-6848. Editor: Rick Snyder. Photo Editor: Dan Zigler. Quarterly magazine. Emphasizes gaming (casino). Readers are 75% male, $50-60,000 income, 42 years old. Circ. 50,000. Sample copy free with SASE.
Photo Needs: Uses about 15 photos/issue; all supplied by freelance photographers. Needs cover shots (women in general) in gaming scenes. Casino Resorts Features; cover story shots for articles. Special needs include Las Vegas shots; Lake Tahoe shots. Model release required; captions preferred.
Making Contact & Terms: Send unsolicited photos by mail for consideration. Send 4x5 glossy prints and 2¼x2¼ transparencies by mail for consideration. SASE. Reports in 1 month. Pays $500 maximum/color cover photo; $50 maximum/b&w inside photo; $100 maximum/color inside photo. Pays on publication. Credit line given. Buys first N.A. serial rights. Previously published work OK.
Tips: "Be reasonable with costing."

GAMUT, Cleveland State University, Cleveland OH 44115. (216)687-4679. Editor: Louis T. Milic. Triannual journal. General interest. Circ. 1,500. Sample copy $2.50.
Photo Needs: Uses about 25-50 photos/issue; 1-2 at present supplied by freelance photographers. Subject needs "depend on the sort of articles we print. But we also print groups of interesting photographs (portfolios) on any subject." Model release preferred; captions required.
Making Contact & Terms: Query with b&w samples. SASE. Reports in 2 months. Pays in cash and contributor's copies. Range is $25 for a single full-page photo to $125 for a group (portfolio). Pays on publication. Credit line given. Buys first North American serial rights.

GARDEN, New York Botanical Garden, Bronx NY 10458. Photo Editor: Anne Schwartz. Bimonthly magazine. Circ. 30,000. Emphasizes botany, agriculture, horticulture and the environment for members of botanical gardens and arboreta. Readers are largely college graduates and professionals, united by a common interest in plants and the environment. Provide letter of inquiry and samples with SASE, especially related to plants, gardening and the environment, "however, we are adding *very* few new photographers. We call for photos on subjects wanted." Photos purchased with or without accompanying ms. Buys 12 photos/issue. Credit line given. Pays on publication. Buys one-time rights. SASE. Reports in 1 month. Sample copy $3.
Subject Needs: Nature and wildlife (of botanical and environmental interest) and scenic (relating to plants, especially to article subjects). Captions not required, "but plants must be accurately identified."
B&W: Uses 5x7 glossy prints. Pays $35-50/photo.
Color: Uses 35mm or 4x5 transparencies. Pays $40-70/photo.
Cover: Uses 35mm or 4x5 color transparencies. Vertical format preferred. Pays $100-150/photo.
Accompanying Mss: Articles relating to emphasis of the magazine. No photo essays. Length: 1,500-2,500 words. Pays $100-300/ms. Request writer's guidelines separately.
Tips: Looks for "high quality—mastery of the basics—focus, light, composition—plus a unique or original vision. We look for photographers who have a large stock file of unusual plant subjects, well-identified. Also those with many environment-related photos, and with photos of gardens all over the world. Quality is our first criterion, but your chances are better if you have many and unusual plant-related subjects, not just pretty flowers."

GARDEN DESIGN, 1733 Connecticut Ave. NW, Washington DC 20009. (202)466-7730. Quarterly. Emphasizes residential landscape architecture and garden design. Readers are gardeners, home owners, architects, landscape architects, garden designers and garden connoisseurs. Sample copy $5; photo guidelines free with SASE.
Photo Needs: Uses about 80 photos/issue; nearly all supplied by freelance photographers. Needs photos of "indoor-outdoor garden rooms; public and private gardens which exemplify professional quality design; specific horticultural shots, and exhibits the total design intent." Model release and captions preferred.
Making Contact & Terms: Submit proposal with resume and samples. Reports in 2 months or sooner if requested. Pays $250/color cover photo; $100 inside photo over ⅕ p; $150 double page special; $50 ⅕ page or smaller (color *or* b&w.) Credit line given. Buys 2-time reproduction rights. Previously published work OK.
Tips: "Show both detailed and comprehensive views that reveal the design intent and content of a garden, as well as subjective, interpretative views of the garden. A letter and resume are not enough—must see evidence of the quality of your work, in samples or tearsheets."

GENESIS, 770 Lexington Ave., New York NY 10021. (212)486-8430. Editor: J.J. Kelleher. Art Director: Ray Mondesire. Monthly magazine. Circ. 450,000. Emphasizes celebrities, current events, issues and personal relationships. For the young male.
Subject Needs: Celebrity/personality, nude, product shot, sport and humorous. Model release required. "We have a constant need for girl sets."
Specs: Uses 35mm color transparencies. Uses color covers; vertical format required.
Payment/Terms: Pays $500-750/job; girl sets $1,200 and up; and $250-500 extra/cover. Credit line given. Pays within 60 days of acceptance. Buys one-time rights.
Making Contact: Send material by mail for consideration. "Send 'return receipt requested.' " SASE. Reports in 2 weeks. Free sample copy and 6-page photo guidelines for 9x12 SASE.
Tips: "We are looking for photos of exceptionally beautiful and new models only. Quality of work must show experience and expertise in this specialized field. We use photos only; no illustration."

GENT, Suite 204, 2355 Salzedo St., Coral Gables FL 33134. (305)443-2378. Editor: John Fox. Monthly magazine. Circ. 150,000. Showcases full-figure nude models. Credit line given. Pays on publication. Buys one-time rights or second serial (reprint) rights. Send material by mail for consideration. SASE. Previously published work OK. Reports in 2 weeks. Sample copy $5. Photo guidelines free with SASE.
Subject Needs: "Nude models must be extremely large breasted (minimum 38" bust line). Sequence of photos should start with woman clothed, then stripped to brassiere and then on to completely nude. Bikini sequences also recommended. Cover shots only of torso with nipples covered. Chubby models also considered if they are reasonably attractive and measure up to our 'D-Cup' image." Model release required. Buys in sets, not by individual photos.
B&W: Uses 8x10 glossy prints; contact sheet OK. Pays $150 minimum/set.
Color: Uses transparencies. Prefer Kodachrome. Pays $250-400/set.
Cover: Uses color transparencies. Vertical format required. Pays $150/photo.
Accompanying Mss: Seeks mss on travel, adventure, cars, racing, sports and products. Pays $125-175/ms.

GEOMUNDO, 6355 NW 36th St., Virginia Gardens FL 33166. (305)871-6400. Editor-in-Chief: Pedro J. Romanãch. Monthly magazine. Emphasizes geography, history, the natural sciences and art. Readers are well-educated, Spanish-speaking persons in Latin America and the US. Circ. 175,000. Free sample copy and photo guidelines with SASE.
Photo Needs: Uses about 140 photos/issue; 80% supplied by freelance photographers. Needs 35mm (or larger) color slides, very accurately identified, pertaining to geography, history, the natural sciences or art for Hispanic markets only. Model release and captions required.
Making Contact & Terms: Arrange a personal interview to show portfolio; query with resume of credits; query with samples; query with list of stock photo subjects; provide resume, business card, brochure, flyer or tearsheets to be kept on file for possible future assignments. Does not return unsolicited material. Reports in 1 month. Pays on acceptance; "texts are paid for separately about two months before publication." Buys one-time rights or all rights; "depends on subject and quality." Simultaneous submissions and previously published work OK.

***GLIMPSES OF MICRONESIA**, (formerly *Glimpses of Micronesia & the Western Pacific*), Box 8066, Tamuning, Guam 96911. (671)477-3483. Editor-in-Chief: Pedro C. Sanchez. Quarterly magazine. Circ. 10,000. For people who live in the Micronesia area now or who have been there and maintain enough interest to want to keep updated. "Our audience covers all age levels and is best described as well educated and fascinated by our part of the world." Photos purchased with or without accompanying ms. Freelancers supply 90% of the photos. Pays on a per-photo basis. Credit line given. Pays on publication. Buys first serial rights. If in the area, arrange a personal interview. If not, send material for consideration. "When I receive photos through the mail, I always appreciate a written introduction, plus an explanation of what the photographer was doing where and when, and his/her impressions of what was experienced. It often helps the photo come even more alive. Also, I ask that photographers submit transparencies in sleeves rather than loose in boxes, when possible." SASE. Reports in 3 weeks. Sample copy $3.
Subject Needs: Animal/wildlife (any which is found in the area, particularly endangered species); celebrity/personality ("Must be a person who lives here or is somehow connected with the area. Can be a political or government figure or good 'character' shot."); scenic ("Ocean, jungle, mountains, flora, you name it... but it must be from the area."); special effects and experimental ("I have yet to see anything in this vein which was well done and which also related to our area—but I'll certainly consider any that is submitted."); human interest; photo essay/photo feature (anything from flora to island life-style); nature and travel (any destination which is easily reachable from Micronesia). All photos must be from the Micronesia area, except those for travel articles. No obviously posed photos. Captions are not required, "however we do need an explanation of what is shown or where it is."
B&W: Uses 5x7 or 8x10 glossy or matte prints (contact sheet OK). Pays $10 minimum.
Color: Uses 35mm or 2¼x2¼ transparencies. Pays $10 minimum.
Cover: Uses color transparencies; vertical format required. Pays $75-100.
Tips: "In the future, I'll probably be looking for a little more simplicity, a little more depth in subject matter."

GOLDEN YEARS MAGAZINE, Box 537, Melbourne FL 32901. (305)725-4888. Editor-in-Chief: Carol B. Hittner. Monthly magazine. Emphasizes lifestyles. Readers are the over-50 generation—active seniors. Circ. 504,000. Free sample copy with SASE and $1 postage.
Photo Needs: Uses about 12-20 photos/issue; all supplied by freelance photographers. Needs vary, but uses "basically good-looking seniors in active life situations." Model release and captions required.
Making Contact & Terms: Query with samples; query with list of stock photo subjects; send prints, transparencies or contact sheet by mail for consideration; submit portfolio for review. SASE. Pays $10/b&w photo; $25/color slide photo. Pays on publication. Credit line given. Buys one-time rights. Previously published work OK.

GOLF DIGEST, 5520 Park Ave. Box 0395, Trumbell CT 06611. (203)847-5811. Editorial Art Director: Nick DiDio. Monthly magazine. Circ. 1,200,000. Emphasizes golf instruction and features on golf personalities and events. Buys 10-15 photos/issue from freelance photographers. Pays $100 minimum/job and also on a per-photo or per-assignment basis. Credit line given. Pays on publication. Send material by mail for consideration. "The name and address of the photographer must appear on every slide and print submitted." SASE. Simultaneous submissions OK. Reports in 1 month. Free sample copy. Free photo guidelines with SASE.
Subject Needs: Celebrity/personality (nationally known golfers, both men and women, pros and amateurs); fashion/beauty (on assignment); head shot (golfing personalities); photo essay/photo feature (on assignment); product shot (on assignment); scenics (shots of golf resorts and interesting and/or unusual shots of golf courses or holes); and sport (golfing). Model release preferred; captions required. "The captions will not necessarily be used in print, but are required for identification."

B&W: Uses 8x10 glossy prints. No contact sheet. Pays $75-200/photo.
Color: Uses 35mm transparencies. No duplicates. Pays $100-600/photo.
Cover: Uses 35mm color transparencies. Vertical format required. Pays $500 minimum/photo.
Tips: "We are a very favorable market for a freelance photographer who is familiar with the subject. Most of the photos we use are done on specific assignment, but we do encourage photographers to cover golf tournaments on their own with an eye for unusual shots, and to let the magazine select shots to keep on file for future use. We are always interested in seeing good quality color and b&w work." Prefers Kodachrome-64 film; no Ektachrome.

GOLF JOURNAL, Golf House, Far Hills NJ 07931. (201)234-2300. Editor: Robert Sommers. Managing Editor: George Eberl. Art Director: Diane Chrenko. Emphasizes golf for golfers of all ages and both sexes. Readers are "literate, professional, knowledgeable on the subject of golf." Monthly. Circ. 145,000. Free sample copy.
Photo Needs: Uses 20-25 photos/issue, 5-20 supplied by freelance photographers. "We use color photos extensively, but usually on an assignment basis. Our photo coverage includes amateur and professional golfers involved in national or international golf events, and shots of outstanding golf courses and picturesque golf holes. We also use some b&w, often mugshots, to accompany a specific story about an outstanding golfing individual. Much of our freelance photo use revolves around USGA events, many of which we cover. As photo needs arise, we assign photographers to supply specific photo needs. Selection of photographers is based on our experience with them, knowledge of their work and abilities, and, to an extent, their geographical location. An exceptional golf photo would be considered for use if accompanied by supportive information." Column needs are: Great Golf Holes, a regular feature of the magazine, calls for high quality color scenics of outstanding golf holes from courses around the country and abroad. Model release not required; captions required.
Making Contact & Terms: Query Managing Editor George Eberl with resume of photo credits; or call (do not call collect). Works with freelance photographers on assignment only basis. Provide calling card, resume and samples to be kept on file for possible future assignments. SASE. Reports in 2 weeks. Pays on acceptance. Negotiates payment based on quality, reputation of past work with the magazine, color or b&w and numbers of photos. Pays $25 minimum. Credit line given. Rights purchased on a work-for-hire basis. No simultaneous or previously published work.

***GOLFWEEK MAGAZINE**, 226 W. Central Ave., Box 1458, Winter Haven FL 33882. (813)294-5511. Editor: Tom Stine. Bimonthly magazine. Emphasizes golf, golf travel, golf course real estate, golf equipment, golf fashion, golf resorts. Readers are average age 50, average income $40,000 annually, plays 121 rounds of golf per year, travels 21 days a year. Circ. 33,000. Sample copy $1.95 and postage.
Photo Needs: Uses 15-20 photos/issue. Needs photos of golf, golf travel, golf course real estate, golf equipment: clubs, ball, etc., golf fashion, golf resorts.
Making Contact & Terms: Query with samples and with list of stock photo subjects; send 8½x11 b&w prints; 35mm, 2¼x2¼, 4x5, 8x10 transparencies by mail for consideration; submit portfolio for review; provide resume, business card, brochure, flyer or tearsheets to be kept on file for possible future assignments. Does not return unsolicited material. Reports in 2 weeks. Pay negotiated. Pays on publication. Credit line given. Buys one-time rights. Simultaneous submissions and previously published work OK.

GOOD HOUSEKEEPING, 959 8th Ave., New York NY 10019. (212)262-3614. Editor: John Mack Carter. Art Director: Herb Bleiweiss. Monthly magazine. Circ. 5,500,000. Emphasizes food, fashion, beauty, home decorating, current events, personal relationships and celebrities for homemakers. Photos purchased on assignment. Buys 200 photos/issue. Pays $50-400/printed page, or on a per-photo basis. Credit line given. Pays on acceptance. Buys all rights. Drop off portfolio for review or send with SASE. Reports in 2 weeks.
Subject Needs: Submit photo essay/photo feature (complete features on children, animals and subjects interesting to women that tell a story with only a short text block) to the Articles Department. All other photos done on assignment only basis. Model release required; captions preferred.
B&W: Uses 8x10 prints. Pays $50-300/photo.
Color: Uses 35mm transparencies. Pays $150-400/photo.
Cover: Query. Vertical format required. Pays $1,200 maximum/photo.

***GOOD NEWS BROADCASTER**, Box 82808, Lincoln NE 68501. (402)474-4567. Managing Editor: Norman A. Olson. Staff Photographer: Tom Bishop. Monthly magazine. Circ. 150,000. Interdenominational magazine for Christian adults from age 16 on up. Needs photos of adults in a wide variety of everyday situations, at work, at home, etc. Buys 20-25 annually. Buys first serial rights. Query with re-

sume of credits or send contact sheet or photos for consideration. All should be sent to the attention of Norman Olson, managing editor. Pays at time of appearance in magazine. Reports in 5 weeks. SASE required. No simultaneous submissions or previously published work. Free sample copy.
B&W: Send contact sheet or vertical 8x10 glossy or semigloss prints. Pays $20 maximum.
Color: 35mm preferred. Pays $50.
Cover: Send 2¼x2¼ or vertical 35mm color transparencies. Pays $80 maximum.
Tips: Prefers "good shots of people (as individuals); superior scenic photos that don't look calendar-ish. We want *quality* in looks as well as in technical areas. No blurred (out-of-focus) backgrounds. Pictures should be bright, not faded. Avoid clutter. Simplicity a must in cover photos. No shots of women or girls in sloppy jeans, short skirts or less than fully clothed. No men or boys with hair over shirt collar or covering ears, or less than fully clothed. No pictures of people smoking or drinking. I would also suggest getting a subscription to our magazine ($10/year) or at least writing for a sample as a guide to the types of photos we use."

GRAND RAPIDS MAGAZINE, 1040 Trust Bldg., 40 Pearl St., NW, Grand Rapids MI 49503. (616)459-4545. Publisher: John H. Zwarensteyn. Editor: Ron Koehler. Monthly magazine. Emphasizes community-related material; local action and local people. Works with staff photographer almost exclusively, but some freelancers as well. Provide business card to be kept on file for possible future assignments; "only people on file are those we have met and personally reviewed." Pays $15-100/job and on a per-photo basis. Buys one-time rights. Arrange a personal interview to show portfolio, query with resume of credits, send material by mail for consideration, or submit portfolio for review. SASE. Reports in 3 weeks. Model release and captions required.
Subject Needs: Animal, nature, scenic, travel, sport, fashion/beauty, photo essay/photo feature, fine art, documentary, human interest, celebrity/personality, humorous, wildlife, vibrant people shots and special effects/experimental. Wants on a regular basis western Michigan photo essays and travel-photo essays of any area in Michigan. Especially needs for next year color work, but on assignment only.
B&W: Uses 8x10 or 5x7 glossy prints; contact sheet OK. Pays $15-25/photo.
Color: Uses 35mm, 120mm or 4x5 transparencies or 8x10 glossy prints. Pays $15-25/photo.
Cover: Uses 2¼x2¼ and 4x5 color transparencies. Pays $100/photo. Vertical format required.
Tips: "Most photography is by our staff photographer, so freelancers should sell us on the unique nature of what they have to offer."

GRAY'S SPORTING JOURNAL, Box 2549, South Hamilton MA 01982. (617)468-4486. Editor: Ed Gray. Quarterly magazine. Circ. 50,000. Covers strictly hunting, fishing and conservation. For "readers who tend to be experienced outdoorsmen." Needs photos relating to hunting, fishing and wildlife. "We have 4 issues/year. We want no 'hunter or fisherman posed with an idiot grin holding his game.' No snapshots." Buys 150 photos/year. Buys first North American serial rights. Send photos for consideration. Pays on publication. Reports in 6-8 weeks. SASE. Sample copy $6.50; photo guidelines free with SASE.
Color: Send transparencies; Kodachrome 64 preferred. Pays $50 minimum.
Tips: "We like soft, moody, atmospheric shots of hunting and fishing scenes, as well as action. We like to blow our pix up *big* i.e., clarity is a must. Look at the photos we have published. They are absolutely the best guide in terms of subject matter, tone, clarity, etc."

GREAT LAKES FISHERMAN, 1570 Fishinger Rd., Columbus OH 43221. (614)451-9307. Editor: Ottie M. Snyder. Monthly. Circ. 41,000. Emphasizes fishing for anglers in the 8 states bordering the Great Lakes. Sample copy and photo guidelines free with SASE.
Photo Needs: 12 covers/year supplied by freelance photographers. Needs transparencies for covers; 99% used are verticals. No full frame subjects; need free space top and left side for masthead and titles. Fish and fishermen (species common to Great Lakes Region) action preferred. Photos purchased with or without accompanying ms. Model release required for covers; captions preferred.
Making Contact & Terms: Query with tearsheets or send unsolicited photos by mail for consideration. Prefers 35mm transparencies. SASE. Reports in 1 month. Provide tearsheets to be kept on file for possible future assignments. Pays minimum $100/color cover. Pays on acceptance. Credit line given. Buys one-time rights.

GREATER PORTLAND, 142 Fee St., Portland ME 04101. (207)772-2811. Editor: Daniel Weeks. Quarterly magazine. "We use many b&w and selected color photos in each issue. Our layouts are highly visual, with a lot of gutter-jumping. Our readers are 'upscale city magazine readers.' " Circ. 10,000. Sample copy $1 with $1.35 postage.
Photo Needs: Uses about 50 photos/issue; all supplied by freelance photographers. Needs "Portland cityscapes, Casco Bay Island photos—everything must have local appeal. We're always looking for cover transparencies. We have both beautiful process color and b&w signatures, and full-bleed color

covers on an 8½x11 vertical format—a lavish production that makes for good clips." Arrange a personal interview to show portfolio. Query with resume of credits. Send 8x10 b&w or color transparencies by mail for consideration. Submit portfolio for review. Provide resume, business card, brochure, flyer or tearsheets to be kept on file for possible future assignments. "Very open to new talent." SASE. Reports in 2 weeks. Pays $150/color cover photo; all others negotiable. Pays on publication. Credit line given. Buys first North American serial rights. Simultaneous submissions and previously published work (if identified as such) OK.

THE GRENADIER MAGAZINE, 3833 Lake Shore Ave., Oakland CA 94610. (415)763-0928. Senior Editor: S.A. Jefferis-Tibbetts. Bimonthly magazine. Emphasizes "military theory, history, and simulation. Our readers are "military professionals, agents, war gamers, computer programmers." Circ. 5,600. Sample copy free with SASE and $1.25 postage/large envelope. Photo guidelines free with SASE.

Photo Needs: Uses about 12 photos/issue; 1-2 supplied by freelance photographers. Needs photos of "current military hardware, military personnel, and present military development (i.e., The Falklands, Kharg Island, etc.)." Special needs include, "Biannual Reforger Exercises." Captions preferred.

Making Contact & Terms: Send any size b&w prints by mail for consideration. SASE. Reports in 2 weeks. Pays $125/b&w cover photo, $250/color cover photo and $25/b&w inside photo. Pays on publication. Credit line given. Buys all rights. Previously published work OK.

Tips: Prefers to see "crisp detail and technical nuance (e.g., is this a Mark IVHc or Mark IVHf type tank?)."

***GUIDEPOSTS ASSOCIATES, INC.**, 747 3rd Ave., New York NY 10017. (212)754-2225. Art Coordinator: Brooks Gibson. Monthly magazine. Circ. 4,000,000. Emphasizes tested methods for developing courage, strength and positive attitudes through faith in God. Pays by job or on a per-photo basis. Credit line given. Pays on acceptance. Buys one-time rights. Send photos or arrange a personal interview. SASE. Simultaneous submissions OK. Reports in 1 month. Free sample copy and photo guidelines.

Subject Needs: "Photos mostly used are of an editorial reportage nature or stock photos, i.e., scenic landscape, agriculture, people, animals, sports. No lovers, suggestive situations or violence."

Color: Uses 35mm, 2¼x2¼; pays $200-300.

Cover: Uses color transparencies; vertical format required. Pays $500.

***GUITAR WORLD**, 1115 Broadway, New York City NY 10010. (212)807-7100. Editor: Noë Goldwasser. Bimonthly magazine. Emphasizes rock (electric) guitarists. Readers are age 18-30, guitar players and enthusiasts. Circ. 135,000. Sample copy $3.

Photo Needs: Uses 40 photos/issue; 20 supplied by freelance photographers. Needs photos of guitarists with guitar. Model release preferred.

Making Contact & Terms: Send unsolicited photos by mail for consideration; provide resume, business card, brochure, flyer or tearsheets to be kept on file for possible future assignments. Send b&w prints; 35mm, 2¼x2¼, 4x5 transparencies by mail for consideration. SASE. Reports in 2-3 weeks. Pays $300-350/color cover photo; $30/b&w inside photo; $75/color inside photo. Pays on acceptance. Credit line given. Buys one-time rights, sometimes all rights. Previously published work OK.

Tips: "Know the magazine; don't waste our time."

GULF COAST GOLFER, Suite 212, 9182 Old Katy Rd., Houston TX 77055. (713)464-0308. Editor: Bob Gray. Monthly tabloid. Emphasizes golf in the gulf coast area of Texas. Readers are average 50, $60,000+ income, upscale lifestyle and play golf 2-3 times weekly. Circ. 33,000. Estab. 1984. Sample copy free with SASE and 75¢ postage.

Photo Needs: Uses about 20 photos/issue; none supplied by freelance photographers. "Photos are bought only in conjunction with purchase of articles." Photos purchased with accompanying ms only. Model release and captions preferred.

Making Contact & Terms: "Use the telephone." SASE. Reports in 2 weeks. Pays on publication. Credit line given. Buys one-time rights or all rights, if specified.

GULFSHORE LIFE, 3620 Tamiami Trail N., Naples FL 33940. (813)262-6425. Editor: Anita Atherton. Art Director: Alyce Mathias. Monthly magazine. Circ. 18,000. Emphasizes lifestyle along the Southwest Florida Gulfcoast. Readers are affluent, leisure class with outdoor activities such as golf, tennis, boating. Photos purchased with or without accompanying ms. Uses 40-50 photos/issue; 10% supplied by freelance photographers. Pays on a per-photo basis. Credit line given. Pays on publication. Buys one-time rights. Query with resume and samples or send photos by mail for consideration. SASE. Simultaneous submissions or previously published work OK. Reports in 5 weeks. Sample copy $2; photo guidelines free with SASE.

Subject Needs: Wildlife and nature that pertain to the Southwest Florida Gulfshore. "We are strictly regional, and other than travel, feature only things pertaining to this coast." No photos that aren't sharp and dramatic. Model release and captions preferred; photo subjects must be identified.
B&W: Uses 5x7 glossy prints. Pays $10/photo.
Color: Uses 35mm and 2¼x2¼ transparencies. Pays $25/photo.
Cover: Uses color transparencies. Vertical format required. Pays $35 minimum/photo.
Accompanying Mss.: Seeks mss on personalities, community activities, hobbies, boating, travel and nature. Pays 5¢/word. Writer's guidelines free with SASE.
Tips: Prefers to see nature, boating, leisure activities, travel. "Photos *must* be sharp and regionalized to Southwest Florida: Marco Island/Naples/Fort Myers/Sanibel-Captiva. A sample copy is helpful. No color prints are used. Photos with mss stand a better chance unless assigned." SASE required.

GUN WORLD, 34249 Camino Capistruno, Capistrano Beach CA 92624. (714)493-2101. Editor: Jack Lewis. Photo Editor: Dan Grennell. Monthly. Emphasizes firearms, all phases. Readers are middle to upper class, aged 25-60. Circ. 136,000. Sample copy $2; photo guidelines free with SASE.
Photo Needs: Uses 70-80 photos/issue; about 50% (with mss) supplied by freelance photographers. Needs hunting and shooting scenes. Reviews photos with accompanying ms only. Model release preferred; captions required.
Making Contact & Terms: Query with samples; send unsolicited photos by mail for consideration. Send 5x7 minimum glossy b&w prints and 35mm, 2¼x2¼ and 4x5 transparencies. SASE. Reports in 1 month. Pays $100/color cover photo; $5-100/inside b&w photo; $40/color inside cover; $100-350/text/ photo package. Pays on acceptance. Credit line given if requested. Buys one-time rights. Simultaneous submissions OK.

THE HAPPY WANDERER, 7842 N. Lincoln Ave., Skokie IL 60077. (312)676-1900. Photo Editor: Mark Greenfield. Bimonthly magazine. Circ. 210,000. Emphasizes the planning of vacations and leisure-time activities featuring resorts, cruises, adventures, trips, and accommodations all over the world for travelers and travel agents. Buys 80-120 photos/year. Credit line given. Pays on publication. Buys one-time rights. Send material by mail for consideration. Prefers to see color prints or slides. SASE. Previously published work OK. "Rejects are returned immediately."
Subject Needs: Travel, outdoor activities and scenic. Wants on a regular basis photos of people at tourist attractions. "No shots of overdone subjects (e.g., the Eiffel Tower or the Lincoln Memorial), or subjects that could be in any locale (beaches, harbors, aerial city views) with no distinguishing visual features pegging the area. No art photos." Model release preferred; captions required. Pays $40/photo.
Cover: Please inquire before submitting color transparencies. Pays $75 minimum/photo.
Tips: "The more photos a freelancer sends in to me, the more chance he/she has of selling a photo."

HARROWSMITH, 7 Queen Victoria Rd., Camden East, Ontario, Canada K0K 1J0. (613)378-6661. Editor/Publisher: James Lawrence. Magazine published 6 times/year. Circ. 154,000. Emphasizes alternative lifestyles, self-reliance, energy conservation, gardening, solar energy and homesteading. Photos purchased with or without accompanying ms and on assignment. Provide calling card, samples and tearsheet to be kept on file for possible future assignments. Buys 400 photos/year, 50 photos/issue. Pays $50-500/job or $200-1,000 for text/photo package. Credit line given. Pays on acceptance. Buys First North American rights. Query with samples and list of subjects. SASE. Previously published work OK. Reports in 4 weeks. Sample copy $5; free photo guidelines.
Subject Needs: Animal (domestic goats, sheep, horses, etc., on the farm); how-to; nature (plants, trees, mushrooms, etc.); photo essay/photo feature (rural life); scenic (North American rural); and wildlife (Canadian, nothing exotic). "Nothing cute. We get too many unspecific, pretty sunsets, farm scenes and landscapes." Captions preferred.
B&W: Uses 8x10 glossy prints. Contact sheet and negatives OK. Pays $75-250/photo.
Color: Uses 35mm and 2¼x2¼ transparencies and 8x10 glossy prints. Pays $75-300/photo.
Accompanying Mss: Pays $125-1,000/ms. Free writer's guidelines.
Tips: Prefers to see portfolio with credits and tearsheets of published material. Samples should be "preferably subject oriented. There is a much greater chance of success if a submission is made in a photo essay type package."

HEALTH MAGAZINE, 3 Park Ave., 32nd Floor, New York NY 10016. (212)340-9200. Assistant Art Director: Michael Dowdy. Monthly magazine. Emphasizes health, sports and general well-being for women. Readers are women, median age 35, college graduates, both working and homemakers. Circ. 950,000.
Photo Needs: Uses approximately 35 photos/issue. Needs photos of "women in health situations— jogging, sports; some beauty; some generic scenes—family, office situations—all geared towards women." Model release preferred; captions required.

Making Contact & Terms: Submit portfolio for review. Provide resume, business card, brochure, flyer or tearsheets to be kept on file for possible future assignments. Rates given "upon photo submissions." Pays on publication. Credit line given. Buys one-time rights. Simultaneous submissions and previously published work OK.
Tips: In a portfolio, prefers to see "women—health, sports, some fashion, outdoors, food, beauty slots."

THE HERB QUARTERLY, Box 275, Newfane VT 05345. (802)365-4392. Editor: Sallie Ballantine. Readers are "herb enthusiasts interested in herbal aspects of gardening or cooking." Quarterly. Circ. 22,000. Sample copy $5.
Photo Needs: Needs photo essays related to some aspect of herbs. Captions required.
Making Contact & Terms: Query with resume of credits. SASE. Reports in 1 month. Pays on publication $25/essay. Credit line given. Buys first North American serial rights or reprint rights.

HIDEAWAYS GUIDE, Box 1464, Littleton MA 01460. (617)486-8955. Managing Editor: Betsy Thiel. Published 3 times/year. Circ. 5,000 + . Emphasizes "travel, leisure, real estate, vacation homes, yacht/house boat charters, inns, small resorts." Readers are "professional/executive, affluent retirees." Sample copy $10.
Photo Needs: Uses 12-15 photos/issue; half supplied by freelance photographers. Needs "travel, scenic photos, especially horizontal format for covers." Special needs include "spectacular and quaint scenes for covers, snow on mountains, lakes and tropics, etc." Model release and captions preferred.
Making Contact & Terms: Arrange for personal interview to show portfolio; query with samples; send 8x10 b&w glossy prints by mail for consideration. SASE. Reports in 3 weeks. Payment is "negotiable but not more than $100." Pays on publication. Credit line given. Buys one-time rights. Simultaneous submissions and previously published work OK.

HIGH SCHOOL SPORTS, Suite 5450, 30 Rockefeller Plaza, New York NY 10012. (212)765-3300. Editor: Gale Benn. Bimonthly during school year. Emphasizes the efforts and achievements of high school athletes. Readers include teenagers who participate in high school athletics across the United States. Circ. 500,000. Estab. 1985. Sample copy $2; free photo guidelines with SASE.
Photo Needs: Uses 30-35 photos/issue; 100% supplied by freelance photographers. Needs photos of boys and girls participating in high school sports. Photos that accompany feature stories will be assigned. Reviews photos with or without accompanying ms. Color transparencies of outstanding performances for 6-page news roundup. Also, humorous sports photo for full-page. "Photo finish." Captions required.
Making Contact & Terms: Query with samples; send unsolicited photos by mail for consideration; provide resume, business card, brochure, flyer or tearsheets to be kept on file for possible future assignments. Uses 35mm transparencies. SASE. Reports in 1 month. Pays $350/day. Pays on acceptance. Credit line given. Buys one-time rights. Previously published work "in some situations."
Tips: "Prefers samples of color sports action as well as set ups. When possible, we would like to see published feature assignments. We are people-oriented and are not interested in still life or scenics."

***HIGH TECHNOLOGY MAGAZINE**, 38 Commercial Wharf, Boston MA 02110. (617)227-4700. Editor: Robert Haavind. Photo Editor: Sharon Hopwood. Monthly magazine. Emphasizes state of the art technology and business applications. Readers are business and technology managers. Circ. 300,000.
Photo Needs: Uses 55 photos/issue; 50% supplied by freelance photographers. Needs business portraits, manufacturing, general. Model release and captions required.
Making Contact & Terms: Provide resume, business card, brochure, flyer or tearsheets to be kept on file for possible future assignments. Reports "ASAP depending on time available." Pays on acceptance. Credit line given. Buys one-time rights. Previously published work OK.

HIS MAGAZINE, Box 1450, Downers Grove IL 60515. (312)964-5700. Art Director: Kathy Lay Burrows. Monthly October-May magazine. Directed toward Christian students on the secular campus. Readers are Christian students (university). Circ. 30,000. Free sample copy. Photo guidelines free with SASE.
Photo Needs: Uses about 12 photos/issue; 4 supplied by freelance photographers. Needs photos of "students—groups or singles (racially mixed)."
Making Contact & Terms: Arrange a personal interview to show portfolio. Query with samples. SASE. Reports in 1 month. Pays $300/b&w cover photo; $100/color cover photo; $60/color inside photo. Pays on acceptance. Credit line given. Buys one-time rights. Simultaneous submissions and previously published work OK.

***ALFRED HITCHCOCK'S MYSTERY MAGAZINE**, 380 Lexington Ave., New York NY 10017. (212)557-9100. Monthly magazine. Emphasizes short mystery fiction. Readers are mystery readers, all

ages, both sexes. Circ. 200,000. Sample copy $2.50. Photo guidelines free with SASE.
Photo Needs: Uses 1 photo/issue; all supplied by freelance photographers. Needs mysterious photographs that contain a narrative element, should allow for a variety of possible interpretations. No gore; no accidents; no crime scenes. Black and white photos only. Model release required.
Making Contact & Terms: Query with samples, "nonreturnable xeroxes only." Does not return unsolicited material. Reports in 2 months. Pay negotiated. Pays on acceptance. Credit line given. Buys one-time rights.
Tips: Prefers to see non-returnable xeroxes only.

HOME, 140 E. 45th St., New York NY 10017. (212)682-4040. Editor: Olivia Buehl. Monthly. Circ. 700,000. Emphasizes "home remodeling, home building, home improving and interior design with special emphasis on outstanding architecture, good design and attractive decor." Readers are "home owners and others interested in home enhancement." Sample copy free with SASE.
Photo Needs: Uses 50-70 photos/issue; 100% provided by freelancers; "however, 95% are assigned rather than over the transom." Needs "4-color transparencies of residential interiors and exteriors—any subject dealing with the physical home. No lifestyle subjects covered." Model release and captions required.
Making Contact & Terms: Portfolio drop-off 5 days/week; same day pick-up; query with resume and samples; send transparencies ("4x5 and 2 ¼ are preferred") by mail for consideration; provide resume, business card, brochure, flyer or tearsheets to be kept on file for possible future assignments. Payments are in line with ASMP guidelines. "Material submitted on spec paid on publication. Assigned material paid on acceptance." Credit line given. Buys all rights.
Tips: Prefers to see "recent residential work showing a variety of lighting situations and detail shots as well as overall views. We accept only quality material and only use photographers who have the equipment to handle any situation with expertise."

THE HOME SHOP MACHINIST, Box 1810, Traverse City MI 49685. (616)946-3712. Editor: Joe D. Rice. Bimonthly. Circ. 17,000. Emphasizes "machining and metal working." Readers are "amateur machinists, small commercial machine shop operators and school machine shops." Sample copy and photo guidelines free with SASE.
Photo Needs: Uses about 30-40 photos/issue; "most are accompanied by text." Needs photos of "machining operations, how-to-build metal projects." Special needs include "good quality machining operations in b&w."
Making Contact & Terms: Send 4x5 or larger b&w glossy prints by mail for consideration. SASE. Reports in 3 weeks. Pays $40/b&w cover photo; $9/b&w inside photo; $30 minimum for text/photo package ("depends on length"). Pays on publication. Credit line given. Buys one-time rights. Simultaneous submissions OK.
Tips: "Photographer should know about machining techniques or work with a machinist. Subject should be strongly lit for maximum detail clarity."

***HOMESTYLES MAGAZINE**, Suite 190, 6800 France Ave. S., Minneapolis MN 55435. (612)927-6707. Editor: Anne Welsbacher. Photo Editor: Anne Welsbacher/Ed Jackson. Quarterly magazine. Emphasizes new homes and home building. Readers are national; middle-to-upper income. Circ. 100,000. Estab. 1985. Sample copy free with SASE.
Photo Needs: "We want to use freelance photographers as much as possible." Needs "interior and exterior shots of homes that have been built from home plans that we sell; also shots of homes in the process of being built. We need people who can go to locations of potential home subjects and judge them for photo possibilities—people with photo judgment as well as skills." Model release and captions required.
Making Contact & Terms: Query with resume of credits, samples and list of stock photo subjects. Does not return unsolicited material. Reports in 3 weeks. Pays 6 weeks to 2 months after acceptance. Pay range is $50-250; day rates also negotiable. Credit line given. Buys one-time rights.
Tips: Prefers to see strong use of color, interesting but not unusual shots of homes and interiors. Write or call to introduce yourself and send samples.

HORSE & RIDER MAGAZINE, 41919 Moreno Rd., Temecula CA 92390. (714)676-5712. Photo Editor: Laurie Guidero. Monthly consumer magazine. Emphasizes training and care of horses. Circ. 400,000. Sample copy $2.60; free photo guidelines with SASE.
Photo Needs: Uses 45 photos/issue; 40 supplied by freelance photographers. Needs photos of horses, prefer action, verticals, slides or 8x10 prints. Riders should be wearing Western hats and boots. The horse should be the emphasis of the photo; the horse expression is also important. Reviews photos with or without accompanying ms. Captions preferred.
Making Contact & Terms: Send 8x10, matte b&w or color prints; 35mm, 2¼x2¼ transparencies;

b&w contact sheets with ms, b&w negatives with ms by mail for consideration. SASE. Reports in 1 month unless used in magazines. Pays $100/color cover photo, $5-30/inside b&w photo, $5-50/color photo, $50/page, and $25-450/text/photo package. Pays prior to publication. Credit line given. Simultaneous submissions OK. Prefers "western riders with the Marlboro man appearance. Be patient if your material is not published right away."

HORSE ILLUSTRATED, Box 6050, Mission Viejo CA 92690. (714)240-6001. Editor: Jill-Marie Jones. Readers are "primarily young horsewomen who ride and show mostly for pleasure and who are very concerned about the well being of their horses." Circ. 50,000. Sample copy $3; photo guidelines free with SASE.
Photo Needs: Uses 20-30 photos/issue, all supplied by freelance photographers. Specific breed featured every issue. Prefers "photos that show various physical and mental aspects of horses. Include environmental, action and portrait-type photos. Prefer people to be shown only in action shots (riding, grooming, treating, etc.). We like riders—especially those jumping—to be wearing protective headgear. We also need good-quality, interesting b&w photos of any breed for use in feature articles." Model release required.
Making Contact & Terms: Send by mail for consideration actual 8x10 b&w photos or 35mm and 2¹/₄x2¹/₄ color transparencies. Reports in 6 weeks. Pays $10-25/b&w photo; $50-150/color photo and $50-150 per text/photo package. Credit line given. Buys first North American serial rights.
Tips: "Nothing but sharp, high contrast shots. Send SASE for a list of photography needs."

HORSEMAN, THE MAGAZINE OF WESTERN RIDING, 5314 Bingle Rd., Houston TX 77092. (713)688-8811. Editor: Michael Rieke. Monthly magazine. Circ. 144,144. For youth and adult owners of stock-type horses who show, rodeo, breed and ride horses for pleasure or as a business. Needs how-to photos showing training, exhibiting and keeping horses and horse management. Buys 15-30 photos/issue. Buys first serial rights, all rights or first North American serial rights. Query first. Credit line given. Pays on publication. Reports in 1 month. SASE. Free sample copy and photo guidelines.
B&W: Uses 5x7 or 8x10 glossy prints. Captions required. Pays $15.
Color: Uses 35mm and 2¹/₄x2¹/₄ transparencies. Captions required. Pays $30-50/inside photo; $100/cover photo.
Tips: "Photographing horses properly takes considerable technical skill. We use only a few photographers throughout the country and work with them on a personal basis. We want to see photos as part of a complete story effort. We want photo essays, with minimum text, both color and b&w, on Western horsemanship subjects." Wants no photos dealing with results of horse shows.

HORSEPLAY, 11 Park Ave., Box 545, Gaithersburg MD 20877. (301)840-1866. Publisher: John M. Raaf. Editor: Cordelia Doucet. Photo Editor: Cathy Heard. Monthly magazine. Circ. 50,000. Emphasizes horse shows and events and fox hunting. Photos purchased on assignment. Buys 150 photos/year, or 13 photos/issue. Pays $75/job plus $20/b&w photo used; $45/color photo. Credit line given. Pays on publication. Buys all rights, but may reassign to photographer after publication. Send material by mail for consideration. SASE. Reports in 1 month. Sample copy $2.75.
Subject Needs: Animals, humorous, photo essay/photo feature and sport. No western riding shots. Captions preferred.
B&W: Uses 8x10 semigloss prints. Pays $20/photo.
Color: Uses 35mm color transparencies. Pays $45/photo.
Cover: Uses 35mm color transparencies. Vertical format required. Pays $175 minimum/photo.
Accompanying Mss: Photographer's and writer's guidelines free with SASE.
Tips: Needs "clear, uncluttered pix—send only best work. Know the subject matter well. The photographer must have a good understanding of horses and the sports in which they compete. Just because a photo has got a horse in it doesn't make it a good photo of a horse."

HOT BIKE, (formerly *Street Chopper/Hot Bike*), 2145 W. LaPalma, Anaheim CA 92801. (714)635-9040. Editor: Tod Knuth. Monthly magazine. Emphasizes custom and high-performance motorcycles. Readers are motorcycling enthusiasts. Circ. 80,000. Sample copy $2.25. Photo guidelines available.
Photo Needs: Uses about 200 photos/issue; 75 supplied by freelance photographers. Subject needs includes photos of "motorcycle events, tech articles and motorcycle features mostly relating to Harley-Davidson." Written release required; captions preferred.
Making Contact & Terms: Query with samples. Send unsolicited b&w glossy; 35mm or 2¹/₄x2¹/₄ transparencies by mail. Returns unsolicited material with SASE. Pays $20-300/photo. Payment made on publication. Credit line given. Buys all rights.

HOT ROD MAGAZINE, 8490 Sunset Blvd., Los Angeles CA 90069. (213)657-5100. Editor: Leonard Emanuelson. Monthly magazine. Circ. 850,000. For enthusiasts of high performance and personalized

Bob Johnson, a Lancaster, California, freelance photographer, wanted to show "the power of a relatively small cubic-inch cycle, with the rider hanging on as the front wheel lifts the track." The Hot Bike editor who chose this photo explains, "Bob covers a lot of drag races, and knows his 'timing,' thus capturing this exciting moment between success and imminent disaster."

automobiles. Typical subject areas include drag racing, street rods, customs, modified pickups, off-road racing, circle track racing. Will consider b&w and color photo features on individual vehicles; of race or event coverage with information; or b&w photos of technical or how-to subjects accompanied by text. However, best market is for "Roddin at Random" section, which uses single photo and/or short copy on any "newsy" related subject, and "Finish Line," which runs short pieces on a wide variety of vehicular racing or other competition. These sections pay $50-150 per photo or item used. Model release necessary. Buys all rights. Credit line given. Pay on acceptance. Reports in 2 weeks.
B&W: Send 8x10 glossy prints or contact sheets with negs. Pays $50-250.
Color: Send transparencies. Pays $100-500.
Tips: "Look at the magazine before submitting material. Use imagination, bracket shots, allow for cropping, keep backgrounds clean. We generally need very sharp, crisp photos with good detail and plenty of depth of field. Majority of material is staff generated; best sell is out-of-area (non-Southern California) coverage, or items for news/human interest/vertical interest/curiosity columns (i.e., "Roddin' at Random" and "Finish Line"). Again, study the magazine to see what we want."

HOUSE BEAUTIFUL, 1700 Broadway, New York NY 10019. (212)903-5206. Editor: JoAnn Barwick. Managing Editor: Betty Boote. Monthly magazine. Circ. 900,000. Emphasizes design, architecture, building and home improvement. Primarily for home-oriented women. Buys all rights. Present model release on acceptance of photo. Query with resume of credits or send photos for consideration. Pays on publication. Reports in 2 weeks. SASE. Free photo guidelines.
B&W: Send contact sheet. Captions required. Pays $25-150 (based on space rates).
Color: Send transparencies. Captions required. Pays $25-250 (based on space rates).
Tips: "Wants no travel photos. Study the magazine."

HUDSON VALLEY MAGAZINE, Box 425, Woodstock NY 12498. (914)679-5100. Editor-in-Chief: Joanne Michaels. Monthly magazine. Emphasizes *regional* events, history, etc. Readers are upscale in both education and income; age 35-55, homeowners, most married. Circ. 26,750. Sample copy free with SASE and $1.25 postage.
Photo Needs: Uses about 35 photos/issue; all supplied by freelance photographers. Needs photos of "local shops, hotels/inns, caterers/food (we have 2 dining guides each year)." Model release preferred; captions required.
Making Contact & Terms: Query with resume of credits. SASE. Reports in 2 weeks. Pays $5/b&w inside photo and $10/color inside photo. Pays on publication. Credit line given. Buys one-time rights. Simultaneous submissions and previously published work OK.

***HUMAN POTENTIAL**, 2721 Carter Farm Ct., Alexandria VA 22306. (703)780-6063. Photo Editor: Ted Bartek. Bimonthly magazine. Emphasizes human development. Readers are growth-oriented professionals and individuals. Circ. 25,000. Estab. 1983. Sample copy $3.50.
Photo Needs: Uses 3-5 photos/issue; 2-3 supplied by freelance photographers. Needs people, action shots, how-to, humorous, creative. Special needs include body balancing, brain building, intraprenuership. Model release and captions required.
Making Contact & Terms: Query with samples and list of stock photo subjects. Send 8x10 glossy b&w and color prints by mail for consideration. SASE. Reports in 6-8 weeks. Pays $75/b&w cover photo; $15/b&w inside photo. Pays on publication. Credit line given. Buys one-time rights. Simultaneous submissions and previously published work OK.

HUSTLER MAGAZINE/CHIC MAGAZINE, Suite 3800, 2029 Century Park E., Los Angeles CA 90067. (213)556-9200. Contact: Photo Editor. Monthly magazine. Circ. 2,000,000. For the middle-class man, age 18-35.

Photo Needs: "High caliber, imaginative girl-sets in 35mm and 120mm formats. Explicit and erotic pictorial and sequential. Sets must have a range from soft to hard. A model release is a must."
Making Contact & Terms: Submit transparencies in plastic protector sheets. "We will return with a rejection/acceptance reply within 60-90 days." Pays $300/page. "We assume all rights to photos."

IDEALS MAGAZINE, Thomas Nelson Publishers, Nelson Place at Elm Hill Pike, Nashville TN 37214. Editor: Ramona Richards. Magazine published 8 times/year. Emphasizes "seasonal themes—bright flowers and scenics for Thanksgiving, Christmas, Easter and Mother's Day—all thematically related material. Other 4 issues are variable from year to year, but still overall seasonal in appearance." Readers are "mostly college-educated women who live in rural areas, aged 35-70." Circ. 200,000. Sample copy $3.50. Photo guidelines free with SASE.
Photo Needs: Uses about 21 or 22 photos/issue; half supplied by freelance photographers. Needs photos of "bright, colorful flowers, scenics, primarily; subject-related shots depending on issue. We regularly send out a letter listing the photo needs for our upcoming issue." Model release required.
Making Contact & Terms: Query with samples. Send 2¼x2¼, 4x5 or 8x10 transparencies by mail for consideration. SASE. Reports in 1 month. Pays $200-450/color cover photo, $50-100/b&w inside photo, $75-150/single color inside photo and $150-300/double page spread. Pays on publication. Credit line given. Buys one-time rights. Simultaneous submissions OK.
Tips: "Would suggest the photographer purchase several recent issues of *Ideals* magazine and study photos for our requirements. *Ideals'* reputation is based on quality of its color reproduction of photos."

ILLINOIS MAGAZINE, Box 40, Litchfield IL 62056. (217)324-3425. Editor: Peggy Kuethe. Bimonthly. Emphasizes travel, history, current events, points of interest, people—all in Illinois. Readers are people primarily interested in Illinois history, (e.g. genealogists, teachers, students, historians), mostly rural. Circ. 12,000. Sample copy $2.25. Photo guidelines free with SASE.
Photo Needs: Uses about 35-40 photos/issue; 90% supplied by freelance photographers. Needs "cover photos: 35mm vertical photos of Illinois scenes, natural attractions, points of interest, botanical subjects." Model release preferred and captions required.
Making Contact & Terms: Query with list of stock photo subjects; send 35mm transparencies by mail for consideration. SASE. Reports in 1 month. Pays $50/color cover photo; $8/b&w inside photo. Pays on publication. Credit line given. Buys one-time rights. Previously published work OK.
Tips: "Obtain a sample copy to see what we've published in the past—and stick to the standards *already* set—we do *not* deviate."

IN TOUCH, Box 2000, Marion IN 46952. (317)674-3301. Editor: James Watkins. Consumer. Monthly magazine. Emphasizes joy and excitement in a biblical life-style, witnessing, sexual purity and abstinence from all things harmful to the body and soul, without being preachy. Readers are 13-19 year-olds. Circ. 26,000. Sample copy free with SASE. Photo guidelines free with SASE.
Photo Needs: Uses 3 photos/issue; all are supplied by freelance photographers. Needs photos of candid close-up of faces.
First Contact & Terms: Send unsolicited photos by mail for consideration. Uses 8x10 glossy b&w prints. SASE. Reports in 2 weeks. Pays $25/b&w cover photo; $15/b&w inside photo. Pays on acceptance. Credit line given. Buys one-time rights. Simultaneous submissions and previously published work OK.

INDIAN LIFE MAGAZINE, Box 3765, Station B, Winnipeg, Manitoba, Canada R2W 3R6. (204)949-9452. Editor: George McPeek. Bimonthly. Circ. 10,000. Emphasizes North American Indian people. Readers are members of Christian Indian churches spanning more than 30 denominations and missions. Sample copy $1 (Canadian); photo guidelines free with SAE and International Reply Coupon.
Photo Needs: Uses about 5 photos/issue; currently none are supplied by freelance photographers. Needs "anything depicting Indian people in a positive light—monuments; historic sites; day-to-day life; crafts—most anything that covers some aspect of Canadian-U.S. Indian scene." Model release and captions required.
Making Contact & Terms: Query with samples or list of stock photo subjects; send 5x7 or larger b&w or color glossy prints; 35mm, 2¼x2¼, 4x5, 8x10 transparencies or b&w or color contact sheet by mail for consideration. Provide resume, business card, brochure, flyer or tearsheet to be kept on file for possible future assignments. SASE—must have Canadian postage or International Reply Coupon. Reports in 1 month. Pays $10/b&w and $25/color cover photo; $5/b&w and $10/color inside photo; $25-50 for text/photo package. Pays on publication. Credit line given. Buys one-time rights. Simultaneous submissions and previously published work OK.

INDIANAPOLIS 500 YEARBOOK, Box 24308, Speedway IN 46224. (317)638-1466. Editor-in-Chief: Carl Hungness. Annually. Circ. 50,000. Emphasizes auto racing. Readers are auto racing fans. Sample copy $14.95.

Photo Needs: Uses 750 photos/issue; 50% supplied by freelance photographers. Model release and captions required.

Making Contact & Terms: Query with 5x7 b&w/color glossy prints. SASE. Provide brochure, flyer and tearsheets to be kept on file for possible future assignments. Pays $5/b&w inside, $7/color inside. Pays on publication. Credit line given. Buys one-time rights. Simultaneous submissions and previously published work OK.

Tips: Need to submit race photos by June 10 for consideration.

INSIDE DETECTIVE, Official Detective Group, 20th Floor, 460 W. 34th St., New York NY 10001. (212)947-6500. Editor: Rose Mandelsberg. Readers are "police buffs, detective story buffs, law and order advocates." Monthly. Circ. 400,000. Sample copy $1.95; photo guidelines for SASE.

Photo Needs: "Only color covers are bought from freelance photographers. Subjects must be crime, police, detective oriented, man and woman. Action must portray impending disaster of a crime about to happen. *No women in subservient position.* Covert sensuality but no blatant sex." Model release required; captions not required.

Making Contact & Terms: Send by mail for consideration color photos or 35mm, 2¼x2¼ or 4x5 color transparencies. SASE. Reports in 1 month after monthly cover meetings. Pays on publication $200/color photo. No credit line given. Buys all rights. No simultaneous or previously published submissions. Send all chromes to Editor-in-Chief: Art Crockett.

INSIGHT, Box 7259, Grand Rapids MI 49510. (616)241-5616. Art Editor: John Knight. Managing Editor: Martha Kalk. Magazine published 9 times per year. Circ. 15,000. For senior high. "Our readers come from Christian backgrounds and are well exposed to the Christian faith." Needs photos of young people in a variety of activities. No landscapes, sunsets, churches or still lifes. Prefers action shots of youth, young adults, faces, expressions, sports, hobbies, interaction, couples, multiracial subjects in a portfolio. Buys one-time rights. Send photos for consideration. Pays on publication. Reports in 2 months. SASE. Simultaneous submissions and previously published work OK. Free sample copy and editorial guidelines. Request should include a 9x12 SASE.

B&W: Send 8x10 glossy prints. Pays $15-30.

Tips: "We like breezy, fresh stills that say 'youth' and portray an exuberant lifestyle. We're sensitive to ethnic minorities."

INTERNATIONAL GYMNAST, 410 Broadway, Santa Monica CA 90401. (213)451-8768. Publisher: Glenn M. Sundby. Editor: Dwight Normile. Monthly magazine. Circ. 26,000. Primarily for youngsters and teens interested in gymnastics; also for coaches, teachers, athletes, international gymnasts and their associations, schools and libraries. Rights purchased vary. Needs action shots. Send photos for consideration. Credit line given. Buys 10-15 photos/issue. Pays on publication. Reports in 1 month. SASE. Previously published work OK if published outside U.S. Sample copy $1; free editorial guidelines.

B&W: Send 5x7 or 8x10 glossy prints with "loose cropping." Captions required. Pays $3-8.

Color: Send 35mm or 2¼x2¼ transparencies. Captions required. Pays $10-35; pays up to $50 for full color spread or for photos used as posters.

Cover: Captions required. Pays $35.

Tips: "The magazine was born on, and grows on, voluntary writers and photographers. It is not on newsstands, so has a limited readership and therefore limited payments. We do encourage writers/photographers and will pay for *quality* material if need be. Must be gymnastic-oriented and all sources identified."

INTERNATIONAL WILDLIFE, 1412 16th St. NW, Washington DC 20036. (703)790-4000. Editor: John Strohm. Photo Editor: John Nuhn. Bimonthly magazine. Circ. 450,000. For nature and outdoor enthusiasts, "our readers are concerned about Earth's environment, and they appreciate the drama and beauty of the world's diverse wildlife and plant life." Buys 40-50 photos/issue. Buys one-time publication rights. Query with story ideas or send photos for consideration. Invite letters of inquiry and stock lists to be kept on file. Pays on acceptance. Reports in 4 weeks. SASE. Free photo guidelines.

Subject Needs: On an international level: mammals, birds, fish, reptiles, insects (action shots, close-ups, sequence, complete picture stories, unusual, dramatic and humorous single shots); people and how they live (environmental issues, people profiles and adventure stories); flowers; plant life; scenics. Especially needs distinctive, cover-quality photos; b&w stories that use the medium to its fullest and would not be more effective in color; subjects in Canada, South America, Asia, Australia, West Africa, Europe and islands. No pets or "wild" animals that have been domesticated; no garden flowers unless there is a very unusual story line.

B&W: Uses 8x10 glossy prints. Captions required. Pays $255 minimum/single photo.

Color: Uses 35mm (prefer Kodachrome or Fuji 50-100), 2¼x2¼ or 4x5 transparencies. Captions required. Pays $255 minimum/single photo.

Tips: "*International Wildlife* magazine depends heavily on contributions from photographers, both professionals and outstanding amateurs, from around the world. We urge the photographer to think editorially. Although single photos are always needed for covers and inside use, we want the photographer's ideas on 'packaging' photos into a feature that will give the reader a different way of seeing a familiar or not so familiar place, or some aspect of wildlife. Study our last few issues to see how these packages are done. Send quality originals rather than dupes where possible. Also, we prefer to receive photos in protective sheets rather than slide boxes or rubber bands. We cannot accept cash, checks or money orders for payment of postage, so please ensure that the proper amount of stamps are glued to the return envelope." Also publishes *National Wildlife* which has the same needs within the U.S. Direct queries and submissions to the photo editor.

THE IOWAN MAGAZINE, 214 Ninth St., Des Moines IA 50309. (515)282-8220. Editor: Charles W. Roberts. Quarterly magazine. Emphasizes "Iowa—its people, places, events, and history." Readers are over 30, college-educated, middle to upper income. Circ. 23,000. Sample copy $3.75. Photo guidelines free with SASE.
Photo Needs: Uses about 60-70 photos/issue; 80% by freelance photographers on assignment. Needs "Iowa scenics—all seasons." Captions required.
Making Contact & Terms: Send b&w prints; 35mm, 2¼x2¼ or 4x5 transparencies; or b&w contact sheet by mail for consideration. SASE. Reports in 1 month. Pays $50/color cover photo, $45/color inside photo and $150-400/text/photo package. Pays on publication. Credit line given. Buys one-time rights.

THE ITINERARY MAGAZINE, Box 1084, Bayonne NJ 07002-1084. (201)858-3400. Editor: Robert S. Zywicki. Bimonthly. Emphasizes travel for persons with disabilities. Circ. 5,000 + . Free sample copy and photo guidelines with SASE.
Photo Needs: Uses 10-15 photos/issue; 5 supplied by freelance photographers. Needs travel type photos—scenic—famous cities, etc. Especially showing people with disabilities in the photos. Reviews photos with or without accompanying ms. Model release and captions required.
Making Contact & Terms: Query with samples and list of stock photo subjects; send 5x7 and 8x10 glossy b&w prints, b&w contact sheets by mail for consideration; submit portfolio for review; provide resume, business card, brochure, flyer or tearsheets to be kept on file for possible future assignments. SASE. Reports in 1 month. Pays $25-100/job and $100-300/text/photo package. Pays on publication. Credit line given. Buys one-time rights. Simultaneous submissions and previously published work OK.
Tips: Prefers "travel photos with people, especially disabled. Disabled make up 20% of our population. Represent them in your photos showing other people."

***JAGUAR INTERNATIONAL MAGAZINE**, 402 E. Church, Benton IL 62812. (618)439-9595. Editor: Cecilia Kirkpatrick. Monthly magazine. Emphasizes Jaguar cars. Readers are Jaguar owners and dreamers. Circ. 5,100. Estab. 1983. Sample copy $3.
Photo Needs: Uses 1 freelance photo/issue. Needs photos of Jaguar cars. Special needs include cover photos.
Making Contact & Terms: Query with list of stock photo subjects. Send b&w and color prints by mail for consideration. SASE. Reports in 1 month. Pays on acceptance. Credit line given. Simultaneous submissions OK.
Tips: Prefers to see cover and centerfold in color of Jaguar cars of different makes.

JAZZIZ MAGAZINE, Box 8309, Gainesville FL 32605-8309. (904)375-3705. Publisher: Michael Fagien. Bimonthly magazine. Emphasizes "the spectrum of contemporary jazz music." Circ. 45,000. Sample copy $2. Photo guidelines free with SASE.
Photo Needs: Uses about 35 photos/issue; 20 supplied by freelance photographers. Needs photos of "jazz musicians, color and b&w, playing or posed."
Making Contact & Terms: Query with samples and list of stock photo subjects. Send color or b&w prints by mail for consideration. Submit portfolio for review. SASE. Reports in 1 month. Payment by the job negotiable by contact. Pays on publication. Credit line given. Rights purchased negotiable.
Tips: Prefers to see "high quality photos with expression—photos which give the essence of inner feeling of the person phtographed."

JOCK MAGAZINE, #210, 7715 Sunset Blvd., Los Angeles CA 90046. (213)850-5400. Editor: Timothy Neuman. Photo Editor: Alfonso Sabelli. Publication of the GPA. Monthly. Emphasizes gay male. Readers are young to old gay males, aged 18-60. Estab. 1985. Sample copy $5; photo guidelines free with SASE.
Photo Needs: Uses 25 photos/issue; 75% supplied by freelance photographers. Needs nude shots of males. Photographic portfolios of artistically erotic subjects, etc. Reviews photos with or without ac-

companying ms. Model release and captions required.

Making Contact & Terms: Arrange a personal interview to show portfolio; query with samples and list of stock photo subjects; send 8x10 b&w and color glossy prints, 35mm, 2¼x2¼, 4x5 and 8x10 transparencies, b&w and color contact sheet, and negatives by mail for consideration. SASE. Reports in 1 month. Pays $200-400/job. Pays on publication. Credit line given. Buys first North American serial rights. Simultaneous submissions OK.

Tips: "Work should be technically superior and subjects should be attractive. Shoot basic backgrounds with good color usage, etc. Lighting continuity is important."

***JUNIOR SCHOLASTIC**, 730 Broadway, New York NY 10003. (212)505-3000. Editor: Lee Baier. Photo Editor: Deborah Thompson. Biweekly educational school magazine. Emphasizes junior high social studies (grades 6-8): world and national news, US history, geography, how people live around the world. Circ. 725,000. Sample copy free with SASE.

Photo Needs: Uses 20 photos/issue; all supplied by freelance photographers. Needs photos of young people ages 11-14; non-travel photos of life in other countries; US news events. Reviews photos with accompanying ms only. Model release (under 18) and captions required.

Making Contact & Terms: Arrang a personal interview to show portfolio; query with samples; submit portfolio for review. SASE. Reports in 1 month. Pays $200/color cover photo; $75/b&w inside photo; $100/color inside photo. Pays on acceptance. Credit line given. Buys one-time rights. Simultaneous submissions OK.

Tips: Prefers to see young teenagers; in US and foreign countries.

KANSAS, 6th Floor, 503 Kansas Ave., Topeka KS 66603. (913)296-3810. Editor: Andrea Glenn. Quarterly magazine. Circ. 40,000. Emphasizes Kansas scenery, arts, crafts and industry. Photos are purchased with or without accompanying ms or on assignment. Buys 60-80 photos/year. Credit line given. Pays on acceptance. Not copyrighted. Send material by mail for consideration. SASE. Previously published work OK. Reports in 1 month. Free sample copy and photo guidelines. Photos are returned after use.

Subject Needs: Animal, documentary, fine art, human interest, nature, photo essay/photo feature, scenic, sport, travel and wildlife, all from Kansas. No nudes, still life or fashion photos. Transparencies must be identified by location and photographer's name.

Color: Uses 35mm, 2¼x2¼ or 4x5 transparencies. Pays $35 minimum/photo.

Cover: Uses 35mm color transparencies. Vertical and horizontal format required. No black and whites. Pays $50 minimum/photo.

Accompanying Mss: Seeks mss on Kansas subjects. Pays $75 minimum/ms. Free writer's guidelines.

Tips: Kansas-oriented material only. Prefers Kansas photographers.

***KARATE/KUNG FU ILLUSTRATED**, 1813 Victory Pl., Burbank CA 91504. (818)843-4444. Editor: Loren Franck. Monthly magazine. Readers are enthusiasts of marital arts, some fitness. Circ. 100,000. Sample copy free with SASE. Photo guidelines free with SASE.

Photo Needs: Uses 100 + photos/issue; "most supplied by freelance photographers." Needs "dramatic, impactful martial arts shots showing kicks, punches and other moves. Query!!" Special needs include color transparencies of Chinese martial artists for covers. Model release required; captions preferred.

Making Contact & Terms: Query with samples, send 35mm, 4x5 transparencies; b&w contact sheet by mail for consideration. SASE. Reports in 2 weeks. Pays $200/color cover photo; $50/b&w inside photo. Pays on publication. Credit line given. Buys all rights. Simultaneous submissions and previously published work OK.

KEEPIN' TRACK OF VETTES, Box 48, Spring Valley NY 10977. Editor: Shelli Finkel. Monthly magazine. Circ. 30,000 monthly, plus additional 50,000 on newsstands February, June and October. For people interested in Corvette automobiles. Buys all rights. Send contact sheet or photos for consideration. Credit line given. Photos purchased with accompanying ms. Pays on publication. Reports in 6 weeks. Free sample copy and editorial guidelines.

Subject Needs: Needs interesting and different photos of Corvettes and picture essays. Human interest, documentary, celebrity/personality, product shot and humorous.

B&W: Send contact sheet or 5x7 or 8x10 glossy prints. Pays $10-100 for text/photo package.

Color: Send transparencies. Pays $25-150 for text/photo package.

KEYBOARD, 20085 Stevens Creek Blvd., Cupertino CA 95014. (408)446-1105. Editor: Tom Darter. Photo Editor: Bob Doerschuk. Monthly magazine. Circ. 63,000. Emphasizes "biographies and feature articles on keyboard players (pianists, organists, synthesizer players, etc.) and keyboard-related material. It is read primarily by musicians to get background information on their favorite artists, new develop-

ments in the world of keyboard instruments, etc." Photos purchased with or without accompanying ms and infrequently on assignment. Buys 10-15 photos/issue. Pays on a per-photo or per-job basis. Pays expenses on assignment only. Credit line given. Pays on publication. Buys rights to one-time use with option to reprint. Query with list of stock photo subjects. SASE. Send first class to Bob Doerschuk. Simultaneous submissions OK. Reports in 2-4 weeks. Free sample copy and photo guidelines.
Subject Needs: Celebrity/personality (photos of pianists, organists and other keyboard players at their instruments). No "photos showing only the face, unless specifically requested by us; no shots where either the hands on the keyboard or the face are obscured." Captions required for historical shots only.
B&W: Uses 8x10 glossy prints. Pays $35-75/photo.
Color: Uses 35mm color transparencies for cover shots. Vertical format preferred. Leave space on left-hand side of transparencies for cover shots. Pays $250/photo for cover, $50-100 for shots used inside.
Accompanying Mss: Free photographer's and writer's guidelines.
Tips: "Send along a list of artist shots on file. Photos submitted for our files would also be helpful—we'd prefer keeping them on hand, but will return prints if requested. Prefer live shots at concerts or in clubs. Keep us up to date on artists that will be photographed in the near future. Freelancers are vital to *KM*."

KITE LINES, 7106 Campfield Rd., Baltimore MD 21207-4699. (301)484-6287. Publisher-Editor: Valerie Govig. Quarterly. Circ. 8,500. Emphasizes kites and kiteflying exclusively. Readers are international adult kiters. Sample copy $3; photo guidelines free with SASE.
Photo Needs: Uses about 40 photos/issue; "50-80% are unassigned and over-the-transom—but nearly all are from *Kiter*-photographers." Needs photos of "unusual kites in action (no dimestore kites), preferably with people in the scene (not easy with kites). Needs to relate closely to *information* (article or long caption)." Special needs include major kite festivals; important kites and kiters. Captions required. "Identify *kites* as well as people."
Making Contact & Terms: Query with samples or send 2-3 b&w 8x10 uncropped prints or 35mm or larger transparencies by mail for consideration. Provide relevant background information, i.e., knowledge of kites or kite happenings. SASE. Reports in "2 weeks to 2 months (varies with workload, but any obviously unsuitable stuff is returned quickly—in 2 weeks." Pays $0-30 per inside photo; $0-50 for color or cover photo; special jobs on assignment negotiable; generally on basis of expenses paid only. "Important to emphasize that we are not a paying market and usually do not pay for photos. *Sometimes* we pay lab expenses. Also we provide extra copies to contributors. Our limitations arise from our small size and we hope to do better as we grow. Meantime, *Kite Lines* is a quality showcase for good work and helps to build reputations. Also we act as a referral service between paying customers and kite photographers. This helps us feel less stingy! Admit we can do this because we cater to kite buffs, many of whom have cameras, rather than photographers who occasionally shoot kites." Pays on acceptance. Buys one-time rights. Usually buys first world serial rights. Previously published work OK. "There are no real competitors to *Kite Lines*, but we avoid duplicating items in the kite newsletters."
Tips: "Just take a great kite picture, and be patient with our tiny staff."

LAKELAND BOATING, Suite 5704, 505 N. Lakeshore Dr., Chicago IL 60611. (312)644-0126. Editor: Brian Callaghan. Monthly magazine. Circ. 47,000. Covers freshwater pleasure boating focusing on the Great Lakes and major rivers of the Midwest. Photos purchased with or without accompanying ms and on assignment.
Payment & Terms: Pays $35-250 for text/photo package or on a per-photo basis. Credit line given. Pays in the month of publication. Buys one-time rights. Send photo/text packages by mail for consideration or query. SASE. Reports in 4-6 weeks. Sample copy $2.
Subject Needs: "Cruising" (real life experiences motoring or sailing on fresh water); Great Lakes boating action; river boating, houseboating; and people on boats. Cannot use salt water settings.
B&W: Uses 4x5 to 8x10 prints or negatives.
Color: Uses 35mm or 2¼x2¼ transparencies.
Cover: Uses transparencies.
Tips: "Must shoot from a boat—shore shots almost never make it. 'Mood' shots (sunsets, seagulls, rusty buoys, etc.) not needed. We want colorful, lively shots of people enjoying boating. Look carefully at current issues, then query."

***LEAF & LEISURE**, 902 E. 7th St., Austin TX 78702. (512)482-8199. Editor: Marilyn J. Good. Bimonthly magazine. Emphasizes horticulture—Texas only. Readers are age 40 + , flower and vegetable gardeners. Circ. 20,000. Estab. 1984. Sample copy free with SASE.
Photo Needs: Uses 12 photos/issue; all supplied by freelance photographers. Needs photos of garden, plant, landscapes, pools, spas. Model release and captions required.
Making Contact & Terms: Query with resume of credits. SASE. Reports in 2 weeks. Pays/job. Pays on publication. Credit line given. Buys one-time rights. Previously published work OK.

Close-up

John Loengard
Picture Editor
LIFE
New York City

LIFE magazine has a unique twist—photographs are used to tell each story, not just to illustrate them. It is because of this orientation that good freelance photographers are so important to LIFE Picture Editor John Loengard.

What qualities does Loengard look for in the freelancers he uses? The photographer must have a sense of how to make a story interesting versus just presenting good pictures, Loengard cites, and must be able to shape photos of a subject within the editorial framework in which it was assigned. Loengard looks for freelancers who "can say something about humans that can be expressed in a photo. This is the rarest and most interesting thing to us." Many submissions, he explains, include photos that have technically inventive, skilled studio work qualities. "It's one thing to have graphically strong pictures; it's rarer to see graphically strong photos that use good insight in dealing with the subject. Most of our photos utilize this last quality."

If Loengard knows the qualities that make LIFE magazine so interesting, it partly can be explained by his own background. This 1956 Harvard University graduate has freelance experience of his own through work on Harvard's alumni magazine and student newspaper. His first assignment from LIFE came in his senior year, and he continued freelancing for the magazine until he joined its staff in 1961 as a photographer. He became picture editor in the early 70s. LIFE was suspended from weekly publication in 1972 so Loengard put his energies toward biannual LIFE Special Report editions, and was the first picture editor of PEOPLE magazine, until LIFE resumed regular publication in 1978 on a monthly basis.

On that schedule, it's good to maintain a wide sampling of photographers. This is part of the reason Loengard is also receptive to reviewing the work of younger photographers. "Photographers in their 20s can be as good as those in their 60s," he asserts. With older, established freelancers, he sees the benefits of each being able to "refine his abilities to work well with the magazine's style." But, he counters with an additional interest in having "new blood coming along."

What kind of photography background do most freelancers who query LIFE have? "Of the 25-year average age group," Loengard notes, "I find those who either have worked as an assistant to a New York, Chicago or West Coast photographer or those who have had two years experience on a newspaper." And other than newspapers, the editorial market is very tight, he warns. "Only two national magazines, *National Geographic* and SPORTS ILLUSTRATED, have a staff of photographers. It's a very discouraging market." There are editorial photographers who make a comfortable living, Loengard says, but this is a field which tends to offer very little money.

LIFE magazine, 50 years old as of November 1986, represents a symbol for photojournalists:There are 1,500,000 buyers a month who appreciate this photography-oriented medium. This is a magazine, says Loengard, whose photographers physically have to go to the source for their stories. It's not like written news publications whose staff can handle a percentage of their information-gathering via telephone. "We're like the tombstone industry—but we carve things in stone on the spot," he says, referring to photojournalism's ability to carry the memory of a moment.

LET'S LIVE, 444 N. Larchmont Blvd., Los Angeles CA 90004. (213)469-3901. Art Director: John De-Dominic. Monthly. Circ. 125,000. Emphasizes nutrition, health and recreation. Readers are "health-oriented typical family-type Americans seeking advice on food, nutritional supplements, dietary and exercise guidelines, preventive medicine, drugless treatment and latest research findings. Ages: 20-35 and 49-70." Sample copy $1.50; photo guidelines for SASE.
Photo Needs: Uses 9-15 photos/issue, 6 supplied by freelance photographers. Needs "candid life scenes; before-and-after of people; celebrities at work or leisure; glamour close-ups; organic uncooked foods; 'nature' views; sports; human organs (internal only); cross-sections of parts and systems (from color art or models); celebrities who are into nutrition and exercise; travel is OK if connected with food, medical research, triumph over disease, etc.; 'theme' and holiday motifs that tie in with health, health foods, clean living, preferably staged around known celebrity. Emphasis on upbeat, wholesome, healthy subject or environment with strong color values for bold full-page or double-truck layouts." Model release required; captions not required, but preferred when explanatory.
Making Contact & Terms: Send by mail for consideration 5x7 or 4x5 b&w or color prints, 35mm color transparencies, or tearsheets with publication name identified; write or call (do *not* call collect); or query with list of stock photo subjects. Provide calling card, club/association membership credits, flyer, samples and tearsheets to be kept on file for possible future assignments. SASE. Reports in 3-5 weeks. Pays on publication $17.50/b&w photo; $20/color transparency; $50-200 for text/photo package. Credit line given. Buys first North American serial rights. Simultaneous submissions and previously published work OK. .

LIFE, Time-Life Bldg., Rockefeller Center, New York NY 10020. (212)841-4523. Photo Editor: John Loengard. Assistant Photo Editor: Barbara Baker Burrows. Monthly magazine. Circ. 1,400,000. Emphasizes current events, cultural trends, human behavior, nature and the arts, mainly through photojournalism. Readers are of all ages, backgrounds and interests.
Photo Needs: Uses about 100 photos/issue. Prefers to see topical and unusual photos. Must be up-to-the minute and newsworthy. Send photos that could not be duplicated by anyone or anywhere else. Especially needs humorous photos for last page article "Just One More."
Making Contact & Terms: Send material by mail for consideration. SASE. Uses 35mm, 2¼x2¼, 4x5 and 8x10 slides. Pays $500/page; $600/page in color news section; $1,000/cover. Credit line given. Buys one-time rights.
Tips: "Familiarize yourself with the topical nature and format of the magazine before submitting photos and/or proposals."

LIGHT AND LIFE, 901 College Ave., Winona Lake IN 46590. (219)267-7656. Managing Editor: Lyn Cryderman. Monthly magazine. Circ. 46,000. Emphasizes Evangelical Christianity with Wesleyan slant for a cross-section readership. Photos purchased on freelance basis. Buys 5-10 photos/issue. Credit line given. Buys one-time rights. Send material by mail for consideration. Provide letter of inquiry and samples to be kept on file for possible future assignments. SASE, postage or check. Simultaneous submissions and previously published work OK. Reports in 1 month. Sample copy, photo guidelines, and cover directions $1.50.
Subject Needs: Head shot, human interest, children, parent/child, family, couples, scenic, some special effects (symbolic and religious ideas) and unposed pictures of people in different moods at work and play. No nudes, no people with immodest dress, no sexually suggestive shots. Model release required.
B&W: Uses 8x10 glossy or semigloss prints. Pays $15-35/photo.
Cover: Uses color slides. Vertical preferred. Prefers to tie covers in editorially. Pays $25-35/photo.
Tips: "Send seasonal slides for covers four months in advance. Study the magazine, then show us your work. Send us 10-15 prints, then be patient. We are using a little less photography, but what we do use, we are using bolder and bigger. The first thing I look for is quality. If it's a great composition but the quality isn't there, I won't use it. I also look for the unusual: interesting subject, unusual lighting, exceptional composition. Send a variety of work. We use a lot of shots of people in a wide range of ages and situations. We could always use some nice mood shots."

LIGHTS AND SHADOWS, Box 27310, Market Square, Philadelphia PA 19150. (215)224-1400. Editor: R.W. Lambert. Magazine consisting entirely of freelance photography. Buys first rights. Submit material by mail for consideration. Reports in 1 month. SASE. Previously published work OK.
B&W: Send 8x10 glossy prints. Typical payment is $50.
Color: Send 35mm or 2¼x2¼ transparencies. Typical payment is $100.

LIVE STEAM MAGAZINE, Box 629, Traverse City MI 49685. (616)941-7160. Editor-in-Chief: Joe D. Rice. Monthly. Circ. 13,000. Emphasizes "steam-powered models and full-size equipment (i.e., locomotives, cars, boats, stationary engines, etc.)." Readers are "hobbyists—many are building scale models." Sample copy and photo guidelines free with SASE.

Photo Needs: Uses about 80 photos/issue; "most are supplied by the authors of published articles." Needs "how-to-build (steam models), historical locomotives, steamboats, reportage of hobby model steam meets. Unless it's a cover shot (color), we only use photos with ms." Special needs include "strong transparencies of steam locomotives, steamboats, or stationary steam engines."
Making Contact & Terms: Query with samples. Send 3x5 b&w glossy prints by mail for consideration. SASE. Reports in 3 weeks. Pays $40/color cover photo; $8/b&w inside photo; $30/page plus $8/photo; $25 minimum for text/photo package (maximum payment "depends on article length"). Pays on publication—"we pay bimonthly." Credit line given. Buys one-time rights. Simultaneous submissions OK.
Tips: "Be sure that mechanical detail can be seen clearly. Try for maximum depth of field."

THE LOOKOUT, Standard Publishing, 8121 Hamilton Ave., Cincinnati OH 45231. (513)931-4050. Editor: Mark A. Taylor. Weekly magazine. Circ. 150,000. For adults in conservative Christian Sunday schools interested in family, church, Christian values, answers to current issues and interpersonal relationships. Buys 2-5 photos/issue. Buys first serial rights, second serial (reprint) rights or simultaneous rights. Send photos for consideration to Ralph M. Small, publisher. "His office will circulate your work among about two dozen other editors at our company for their consideration." Credit line given if requested. Pays on acceptance. Reports in 2-6 weeks. SASE. Simultaneous submissions and previously published work OK. Sample copy 50¢; free photo guidelines for SASE.
Subject Needs: Head shots (adults in various moods/emotions); human interest (families, scenes in church and Sunday school, groups engrossed in discussion).
B&W: Send contact sheet or 8x10 glossy prints. Pays $10-25.
Color: Send 35mm or 2¼x2¼ transparencies. Pays $25-150.
Cover: Send 35mm or 2¼x2¼ color transparencies. Needs photos of people. Pays $50-150. Vertical shots preferred; but "some horizontals can be cropped for our use."

LOS ANGELES MAGAZINE, 1888 Century Park E., Los Angeles CA 90067. (213)552-1021. Editor: Geoff Miller. Art Director: James Griglak. Editorial Coordinator and Photo Editor: Judith Grout. Monthly magazine. Circ. 160,000. Emphasizes sophisticated southern California personalities and lifestyle, particularly Los Angeles area. Most photos are purchased on assignment, occasionally with accompanying ms. Provide brochure, calling card, flyer, resume and tearsheets to be kept on file for possible future assignments. Buys 45-50 photos/issue. Pays $50 minimum/job. Credit line given. Pays on publication. Buys first serial rights. Submit portfolio for review. SASE. Simultaneous submissions and previously published work OK. Reports in 2 weeks.
Subject Needs: Celebrity/personality, fashion/beauty, human interest, head shot, photo illustration/photo journalism, photo essay/photo feature (occasional), sport (occasional), food/restaurant and travel. Most photos are assigned.
B&W: Send contact sheet or contact sheet and negatives. Pays $50-100/photo.
Color: Uses 4x5, 2¼x2¼ or 35mm transparencies. Pays $50-200/photo.
Cover: All are assigned. Uses 2¼x2¼ color transparencies. Vertical format required. Pays $400/photo.
Accompanying Mss: Pays 10¢/word minimum. Free writer's guidelines.
Tips: To break in, "Bring portfolio showing type of material we assign. Leave it for review during a business day (a.m. or p.m.) to be picked up later. Photographers should mainly be active in L.A. area and be sensitive to different magazine styles and formats."

***LOST TREASURE**, 15115 S. 76th E. Ave., Bixby OK 74008. (918)366-4441. Editor/Art Director: James D. Watts Jr. Monthly magazine. Emphasizes treasure hunting and metal detecting. Readers are people involved in all aspects of the treasure hunting hobby, who actively pursue the search for all kinds of valuables. Circ. 41,000. Sample copy free with 9x12 SASE. Photo guidelines free with SASE.
Photo Needs: Uses 25-50 photos/issue; 90% supplied by freelance photographers. "Needs photos which specifically illustrate a particular story—of actual scene of hunt, items found, historical photos of area, etc. Rarely use serendipitous shots." Reviews photos with accompanying ms only. Captions required.
Making Contact & Terms: Query with samples, send 5x7 glossy b&w prints by mail for consideration. SASE. Reports "usually within 2 months." Pays $5-10/b&w inside photo. Pays on publication. Credit line given "if not author of ms." Buys first North American serial rights.
Tips: "Write a good story and accompany it with sharp, clear photos."

***LOTTERY PLAYER'S MAGAZINE**, 2311 W. Marlton Pike, Cherry Hill NJ 08002. (609)665-7577. Editor: Crys Crystall. Monthly digest "like TV guide." Emphasizes lotteries and recreational gaming. Circ. 200,000. Sample copy free with SASE. Photo guidelines free with SASE.
Photo Needs: Uses 20-50 photos/issue; 10-12 supplied by freelance photographers. Needs photos of

lottery winners at time of check presentation, drawings, etc. Casino winners (slots, table games, special promotions). Captions required.
Making Contact & Terms: Provide resume, business card, flyer or tearsheets to be kept on file for possible future assignments. Reports in 3 weeks. Pays $80-125/color cover photo; $20-35/b&w inside photo. Pays on publication. Credit line given. Simultaneous submissions OK.

***LOUISIANA LIFE MAGAZINE**, Box 308, Metairie LA 70004. (504)456-2220. Editor: Nancy & Tom Marshall. Photo Editor: Tessa Tilden-Smith. Bimonthly magazine. Emphasizes topics of special interest to Louisianians; a people-oriented magazine. Readers are statewide; upper middle class; college educated; urban and rural. Circ. 46,000. Sample copy $4 including postage. Photo guidelines free with SASE.
Photo Needs: Uses 45 photos/issue; all supplied by freelance photographers. Photos are assigned according to stories planned for each issue. Color transparencies are used for features, b&w for columns. Special needs include people, places, events in Louisiana. Identification required.
Making Contact & Terms: Arrange a personal interview to show portfolio; query with resume of credits and with samples; provide resume, business card, brochure, flyer or tearsheets to be kept on file for possible future assignments. Send 8x10 glossy b&w prints; 35mm, 2¼x2¼, 4x5, 8x10 transparencies; b&w contact sheet by mail for consideration. SASE. Reports in 3 weeks. Pays $150/color page. Pays on publication. Credit line given. Buys one-time rights.
Tips: Prefers to see a careful selection of photographer's best work; quality, not quantity. Can send duplicates for review. "Study Louisiana Life to become familiar with our needs."

LOUISVILLE MAGAZINE, One Riverfront Plaza, Suite 604 , Louisville KY 40202. (502)566-5050. Editor: Betty Lou Amster. Managing Editor: Jim Oppel. Monthly magazine. Circ. 20,000. Emphasizes community and business developments for residents of Louisville and vicinity who are involved in community affairs. Buys 12 photos/issue. Buys all rights, but may reassign to photographer after publication. Model release required "if photo presents an apparent legal problem." Submit portfolio. Photos purchased with accompanying ms; "photos are used solely to illustrate accompanying text on stories that we have already assigned." Works with freelance photographers on assignment only basis. Provide calling card, portfolio, resume, samples and tearsheets to be kept on file for possible future assignments. Pays on publication. Reports in 1 week. SASE. Sample copy $1.
Subject Needs: Scenes of Louisville, nature in the park system, University of Louisville athletics, fashion/beauty and photo essay/photo feature on city life. Needs photos of people, places and events in and around the Louisville area.
B&W: Send 8x10 semigloss prints. Captions required. Pays $10-25.
Color: Send transparencies. Captions required. Pays $10-25.
Cover: Send color transparencies. Uses vertical format. Allow space at top and on either side of photo for insertion of logo and cover lines. Captions required. Payment negotiable.
Tips: "All ideas must focus on the Louisville market. A photographer's portfolio, of course, may be broader in scope." Wants no prints larger than 11x14 or smaller than 5x7; 8x10 preferred. Annual Kentucky Derby issue needs material dealing with all aspects of Thoroughbred racing. Deadline for submissions: January 1.

THE LUTHERAN JOURNAL, 7317 Cahill Rd., Edina MN 55435. (612)941-6830. Editor: Rev. Armin U. Deye. Photo Editor: John Leykom. Quarterly magazine. Circ. 136,000. Family magazine for Lutheran Church members, middle aged and older.
Photo Needs: Uses about 6 photos/issue; 1 or 2 of which are supplied by freelance photographers. Needs "scenic—inspirational." Captions not required but invited; location of scenic photos wanted.
Making Contact & Terms: Send by mail for consideration actual b&w or color photos or 35mm, 2¼x2¼ and 4x5 color transparencies. SASE. Pays on acceptance $5/b&w photo; $5-10/color transparency. Credit line given.

THE LUTHERAN STANDARD, 426 S. 5th St., Box 1209, Minneapolis MN 55440.(612)330-3300. Editor: Lowell Almen. Biweekly magazine. Circ. 561,000. Emphasizes news in the world of religion, dealing primarily with the Lutheran church. For families who are members of congregations of the American Lutheran Church.
Photo Needs: Needs photos of persons who are members of minority groups. Also needs photos of families, individual children, groups of children playing, adults (individual and group). Buys 100 photos annually. Buys first serial rights or simultaneous rights. Send photos for consideration. Pays on acceptance or publication. Reports in 4-6 weeks. SASE. Simultaneous submissions and previously published work OK. Free sample copy and photo guidelines.
Making Contact & Terms: Send inquiries to James Lipscomb, Augsburg Publishing House, 426 S. 5th St., Box 1209, Minneapolis MN 55440. Send contact sheet or 8x10 glossy or semigloss b&w prints. Pays $20-45.

Cover: Send glossy or semigloss b&w prints. Pays $30-70.
Tips: No obviously posed shots. Wants photos of "real people doing real things. Find shots that evoke emotion and express feeling."

***MACUSER MAGAZINE**, 11th Floor, 35 West 39th St., New York NY 10018. (212)302-2626. Editor: Steven Bobker. Photo Editor: Lisa Orsini. Monthly magazine. Emphasizes Macintosh computer hardware and software. Readers are middle income professionals. Circ. 200,000. Estab. 1985. Sample copy $3.95.
Photo Needs: Uses 2-6 photos/issue; all supplied by freelance photographers. Needs photos of still life's of computer hardware. Model release required.
Making Contact & Terms: Query with samples, send transparencies by mail for consideration. SASE. Reports in 1 week. Pays $500/b&w and color cover photo; $400/b&w and color inside photo; $400/job; $400/text/photo package. Pays on publication. Credit line given. Buys all rights.
Tips: Prefers to see still life photographs with intriguing lighting techniques or interesting environments. "Have a consistent style throughout your work."

***MAGICAL BLEND MAGAZINE**, Box 11303, San Francisco CA 94101. (415)282-9338. Editor: Michael Peter Langevin. Photo Editor: Jerry Snider. Quarterly magazine. Emphasizes occult, mysticism, new age thought, spiritual, nature. Readers are into alternative lifestyles. Circ. 15,000. Sample copy $4. Photo guidelines free with SASE.
Photo Needs: Uses 20 photos/issue; all supplied by freelance photographers. Needs photos of animal, people, travel, wildlife. Special needs include much more travel. Model release preferred.
Making Contact & Terms: Query with samples, send unsolicited b&w prints; b&w contact sheets by mail for consideration. SASE. Reports in 2 months. Pays/copies. Pays on publication.
Buys one-time rights.
Tips: Prefers to see nature, people, travel. "Get an issue to see what we print first."

MANDATE, 11th Floor, 155 Avenue of the Americas, New York NY 10013. (212)691-7700. Editor-in-Chief: Freeman Gunter. Monthly. Emphasizes male nudes, presented tastefully. Readers are gay men whose ages range from under 20 to 60 and beyond, (median ages 25-40); some women readers who prefer *Mandate* to *Playgirl*. Circ. 100,000. Sample copy $5. Photo guidelines free with SASE.
Photo Needs: Uses about 50 photos/issue; all supplied by freelance photographers. Needs photos of attractive men who look like fashion models, photographed nude in imaginative settings; erections permitted; also, head shots for cover consideration. Model release required.
Making Contact & Terms: Send b&w glossy prints; 35mm transparencies; b&w contact sheet by mail for consideration. SASE. Reports in 1 month. Pays $200/color cover photo; $75/full page color inside photo; and $50/full-page b&w photo. Pays on publication. Credit line given. Buys first North American serial rights.
Tips: "We see a greater demand for a positive attitude from models. Happy, smiling men requested."

MARRIAGE AND FAMILY LIVING MAGAZINE, Abbey Press, St. Meinrad IN 47577. (812)357-8011. Photo Editor: Jo R. Brahm. Monthly magazine. Circ. 40,000. Emphasizes Christian marriage and family enrichment for parents, couples, counselors and priests. Buys 100-120 photos/year. Credit line given. Pays on publication. Buys one-time rights. Query with samples. SASE. Reports in 1-3 months. Free guidelines; sample copy $1.
Subject Needs: Photos of couples, families, teens, or children; candids; and a few scenics. Photos should suggest mood or feeling. No posed, studio-style shots.
B&W: Uses 8x10 glossy prints. Pays $15-35/photo.
Cover: Uses color transparencies or 35mm slides. Pays $150/color cover. Prefers uncluttered field as background.
Tips: "*Marriage* magazine likes to keep its files up-to-date by rotating them every six months to a year. When photos are returned to you, we request a new set of current photos to keep on file for possible use." Also, "be sure to include sufficient return postage, SASE, and label each photo with your name, address and phone number."

MENDOCINO REVIEW, Box 1580, Mendocino CA 95460. (707)964-3831. Editor-in-Chief: Camille Ranker. Direct inquiries to Bob Avery, Art Director. Annually. Circ. 5,000. Emphasizes literature, music and the arts. Circulated throughout the US.
Photo Needs: Uses about 40-50 photos/issue; all supplied by freelance photographers. Needs "general and scenic photos as we do publish poetry and photos are used with each poem to help carry through on the feeling of the poem. Very open!" Model release preferred when indicated; captions preferred.
Making Contact & Terms: Query with samples or with list of stock photo subjects. Send 5x7 b&w matte or glossy prints by mail for consideration. SASE. Reports in 6-8 weeks. Pays with copies; ad ex-

changes considered. Pays on publication. Credit line given. Buys one-time rights only. Simultaneous submissions OK.
Tips: "We use photos to illustrate stories and poetry. Photo essays will be considered as well as sequence photography."

***METAL EDGE**, 355 Lexington Ave., New York NY 10017. (212)391-1400. Editor: Gerri Miller. Bimonthly magazine. Emphasizes heavy metal music. Readers are young fans. Circ. 250,000. Estab. 1985. Sample copy free with large manila SASE.
Photo Needs: Uses 125 photos/issue; 100 supplied by freelance photographers. Needs studio b&w and color, concert shots, and behind-the-scenes (b&w) photos of heavy metal artists.
Making Contact & Terms: Arrange a personal interview to show portfolio, query with samples, and list of stock photo subjects. Reports ASAP. Pays $25/b&w inside photo; varies/color; job. Pays on publication. Buys one-time rights for individual shots. Buys all rights for assigned sessions or coverage. Previously published work OK.
Tips: Prefers to see very clear, exciting concert photos; studio color with vibrancy and life, that capture subject's personality.

MICHIGAN NATURAL RESOURCES MAGAZINE, Box 30034, Lansing MI 48909. (517)373-9267. Editor: Norris McDowell. Photo Editor: Gijsbert van Frankenhuyzen. Bimonthly. Circ. 140,000. Emphasizes natural resources in the Great Lakes region. Readers are "appreciators of the out-of-doors; 15% readership is out of state." Sample copy $2; photo guidelines free with SASE.
Photo Needs: Uses about 40 photos/issue; 25% supplied by freelance photographers. Needs photos of Michigan wildlife, Michigan flora, how-to, travel in Michigan, energy usage (including wind, water, sun, wood). Captions preferred. Query with samples or list of stock photo subjects; send 35mm color transparencies by mail for consideration. SASE. Reports in 1 month. Pays $50-200/color page; $200/job; $400 maximum for text/photo package. Pays on acceptance. Credit line given. Buys one-time rights. Simultaneous submissions and previously published work OK.
Tips: Prefers "Kodachrome 64 or 25, 35mm, *razor sharp in focus!* Send about 40 slides with a list of stock photo topics. Be sure slides are sharp, labeled clearly with subject and photographer's name and address. Send them in plastic slide filing sheets."

MICHIGAN OUT-OF-DOORS, Box 30235, Lansing MI 48909. (517)371-1041. Editor: Kenneth S. Lowe. Monthly magazine. Circ. 110,000. For people interested in "outdoor recreation, especially hunting and fishing; conservation; environmental affairs." Buys first North American serial rights. Credit line given. Send photos for consideration. Reports in 1 month. SASE. Previously published work OK "if so indicated." Sample copy $2; free editorial guidelines.
Subject Needs: Animal; nature; scenic; sport (hunting, fishing and other forms of noncompetitive recreation); and wildlife. Materials must have a Michigan slant.
B&W: Send any size glossy prints. Pays $15 minimum.
Cover: Send 35mm transparencies or 2¼x2¼. Pays $60 for cover photos, $25 for inside color photos.
Tips: Submit seasonal material 6 months in advance.

MICHIGAN SPORTSMAN, Box 2483, Oshkosh WI 54903. (414)231-9338. Editor: Steve Smith. Emphasizes fishing, hunting and related outdoor activities. Sample copy $2 with a SASE; photo guidelines free with SASE.
Photo Needs: Uses 15-20 photos/issue; all supplied by freelance photographers. Reviews photos with or without accompanying ms. Captions preferred.
Making Contact & Terms: Query with list of stock photo subjects; send 5x7 or larger glossy prints, 35mm and 2¼x2¼ transparencies and b&w contact sheet by mail for consideration; submit portfolio for review. SASE. Reports in 3-5 weeks. Pays $300-400/color cover photo, $25-250 b&w inside photo, $50-400/color inside photo. Pays on acceptance. Credit line given. Buys one-time rights. No simultaneous submissions. Previously published work OK.

THE MILEPOST (All-the-North Travel Guide), Box 4-EEE, Anchorage AK 99509. (907)563-5100. Managing Editor: Kris Valencia. Annual paperback. Circ. 75,000. For travelers to and in Alaska. Needs photos of "Alaska and Northwestern Canada travel destinations, attractions and people doing things unique to the North. No sunsets, please." Buys first serial rights. Send photos for consideration. Photo selection begins July, ends in September. Pays on publication. Reports in 4-8 weeks. SASE. Sample copy $12.95; free photo guidelines.
Color: Send 35mm, 2¼x2¼ or 4x5 transparencies (Kodachrome or Extachrome preferred). No duplicate slides. Captions required. Pays $20-45.
Cover: Send 35mm, 2¼x2¼ or 4x5 color transparencies. Captions required. Pays $200 maximum.
Tips: "Don't send color prints. Sharp, properly exposed color transparencies only." Send photos by certified mail with return postage for certified return and "we'll return the same way."

***MINIATURE COLLECTOR**, 170 5th Ave., New York NY 10010. (212)989-8700. Editor: Krystyna Poray Goddu. Managing Editor: Louise Fecher. Bimonthly magazine. Emphasizes miniatures: dollhouses, furnishings, dollhouse dolls. Circ. 30,000. Sample copy $2.
Photo Needs: Uses 40 photos/issue; 15 supplied by freelance photographers. Needs "only high-quality photos of miniatures are used. They should be straightforward and shot against a plain, seamless background. Generally we look for a photo-and-manuscript package, but are always on lookout for good photographers around the country for occasional assignments." Special needs: "We look for photographers to cover miniature shows for our 'Show Stoppers' feature." Captions required.
Making Contact & Terms: Query with samples. SASE. Reports in 1-2 months. Pays $100-150/job; $100-175/text/photo package. Pays within 30 days of acceptance. Credit line given. Buys one-time rights and first N.A. serial rights.
Tips: Prefers to see photos of miniatures or photos that indicate an ability to get in close to tiny objects. "We generally do not use photos without an accompanying article except for our show coverage feature. We cover 4-6 shows in our magazine each year, and need good photographers around the country to shoot on location."

MINNESOTA SPORTSMAN, Box 2266, Oshkosh WI 54903. Editor: Chuck Petrie. Emphasizes fishing, hunting and related outdoor activities. Sample copy $2 with a SASE; photo guidelines free with SASE.
Photo Needs: Uses 15-20 photos/issue; all supplied by freelance photographers. Reviews photos with or without accompanying ms. Captions preferred.
Making Contact & Terms: Query with list of stock photo subjects; send 5x7 or larger glossy prints, 35mm and 2¼x2¼ transparencies and b&w contact sheet by mail for consideration; submit portfolio for review. SASE. Reports in 3-5 weeks. Pays $300-400/color cover photo, $25-250 b&w inside photo, $50-400/color inside photo. Pays on acceptance. Credit line given. Buys one-time rights. No simultaneous submissions. Previously published work OK.

MODERN DRUMMER MAGAZINE, 870 Pompton Ave., Cedar Grove NJ 07009. (201)239-4140. Editor: Ronald Spagnardi. Photo Editor: David Creamer. Magazine published 12 times/year. Buys 200-300 photos annually. For drummers at all levels of ability: students, semiprofessionals and professionals.
Subject Needs: Celebrity/personality, product shots, action photos of professional drummers and photos dealing with "all aspects of the art and the instrument."
Specs: Uses b&w contact sheet, b&w negatives, or 5x7 or 8x10 glossy b&w prints; color transparencies. Uses color covers.
Payment/Terms: Pays $150/cover, $50-100/color, $25-50/b&w photos. Credit line given. Pays on publication. Buys one-time rights. Previously published work OK.
Making Contact: Send photos for consideration. Reports in 3 weeks. SASE. Sample copy $2.50.
Tips: Submit freelance photos with letter. Looking for "clean photos with good composition and imagination. Ask to be put on photo want-list; submit as many requested photos as possible; request assignment after 3 or 4 submissions."

MODERN LITURGY, 160 E. Virginia St., Box 290, San Jose CA 95112. Editor: Kenneth Guentert. Magazine published 9 times annually. Circ. 15,000. For "religious artists, musicians, pastors, educators and planners of religious celebrations," who are interested in "aspects of producing successful worship services." Buys one-time rights. Present model release on acceptance of photo. Query first with resume of credits "or send representative photos that you think are appropriate." Pays on publication. Reports in 6 weeks. SASE. Sample copy $4.
B&W: Uses 8x10 glossy prints. Pays $5-25.
Color: Note: color photos will be reproduced in b&w. Uses 35mm transparencies. Pays $5-25.
Cover: Send 8x10 glossy b&w prints. Pays $5-25.
Tips: "We encourage all artists to develop a small 'piece' along the lines of one of our future themes to be considered as editorial content for a coming issue." Also interested in submissions of slides in groups of 12-30 "for use in constructing a visual story, meditation, talk or discussion on a seasonal, sacramental or topical religious theme. Offer to work with us to develop profiles and showcases of the industries we serve dealing with art, architecture, and the environment for working. Some of the firms that would like to be profiled or showcased need photography help. We have been doing color sections from slides, when the subject matter has been suitable for advertising support."

MODERN PERCUSSIONIST MAGAZINE, 870 Pompton Ave., Cedar Grove NJ 07009. (201)239-4140. Editor: Rick Mattingly. Photo Editor: David Creamer. Quarterly. Emphasizes percussion. Readers include percussionists at all levels, from student to professional. Circ. 15,000. Estab. 1984. Sample copy $2. Photo guidelines with SASE.
Photo Needs: Uses 20-25 photos/issue; 75% supplied by freelance photographers. Needs portraits of

percussionists featured in interviews, along with performance shots featuring instruments. Reviews photos with or without accompanying ms.
Making Contact & Terms: Query with samples or send 5x7, 8x10 matte b&w prints, 35mm, 2¼x2¼ transparencies, b&w contact sheets by mail for consideration. SASE. Reports in 2 weeks. Pays $75-100/color cover photo, $20-40/inside b&w photo and $35-75/color photo. Pays on publication. Credit line given. Buys one-time rights. Previously published work OK.

MODERN PHOTOGRAPHY, ABC Consumer Magazines, Inc., 825 7th Ave., New York NY 10019. (212)265-8360. Publisher/Editorial Director: Herbert Keppler. Editor: Julia Scully. Picture Editor: Howard Millard. Monthly magazine. Circ. 750,000. For the advanced amateur photographer. Pays $100-250/printed page, or on a per-photo basis. Pays on acceptance. Buys one-time rights. Send material for consideration or submit portfolio for review. SASE. Reports in 1 month. Free photo guidelines for SASE.
Subject Needs: "All sorts, since we cover photography from gadgetry to fine art."
B&W: Uses 8x10 prints. Pays $100 minimum/photo.
Color: Uses prints or 35mm, 2¼x2¼, 4x5 or 8x10 transparencies. Pays $100 minimum/photo.
Cover: Uses 35mm, 2¼x2¼, 4x5 or 8x10 color transparencies. Pays $400 minimum/photo.

MOMENT MAGAZINE, Suite 301, 462 Boylston St., Boston MA 02116. Managing Editor: Nechama Katz. Monthly magazine. Circ. 25,000. Emphasizes Jewish affairs and concerns; "includes fiction, poetry, politics, psychology, human interest, community concerns and pleasures." Send brochure, tearsheets, business card or list of stock photos for possible future assignment. Credit line given. Pays on publication. Rights purchased vary. Sample copy $2.50 plus postage and handling.
Subject Needs: Celebrity/personality, documentary, fine art, human interest, humorous, photo essay/photo feature, scenic, still life and travel. All subjects should deal with Jewish life.
B&W: Uses 8x10 glossy prints. Pays $15 minimum/photo.
Tips: "We use very little freelance photography. If you want to get on our list for assignments (which we do fairly infrequently) or for stock orders, send list of what you have, and if you send samples, that helps."

***MONEY MAKER MAGAZINE**, 5705 N. Lincoln Ave., Chicago IL 60659. (312)275-3590. Editor: John Manos. Art Director: Craig Smith. Bimonthly magazine. Emphasizes personal finance and investments. Readers are upper income, 30-65 age, college educated, home owners. Circ. 300,000. Sample copy free with SASE.
Photo Needs: Uses 3-10 photos/issue; 90% supplied by freelance photographers. Needs photos prepared per assignment. Special needs are determined according to article content—most are illustrative (non-literal) photos. Model release preferred; captions required.
Making Contact & Terms: Arrange a personal interview to show portfolio; query with resume of credits, list of stock photo subjects; provide resume, business card, flyer or tearsheets to be kept on file for possible future assignments. SASE. Reports in 1 month. Pays $1,000-5,000/color cover photo; $450/b&w page; $900/color page. Pays on acceptance. Credit line given. Buys first North American serial rights. Simultaneous submissions and previously published work OK.
Tips: "Contact Art Director to show or send samples, tailor material to subject matter—in this case, investment materials—and to illustrative skills, i.e., creativity, sources, facilities."

***MONTANA MAGAZINE**, Box 5630, Helena MT 59604. (406)443-2842. Publisher: Rick Graetz. Editor: Mark O. Thompson. Bimonthly magazine. Circ. 86,000. Emphasizes history, recreation, towns and events of Montana. Buys 8-10 photos/issue. Credit line given. Pays on publication. Buys one-time rights. Send material by mail for consideration. SASE. Simultaneous submissions and previously published work OK. Reports in 6-8 weeks. Sample copy $2; photo guidelines free with SASE.
Subject Needs: Animal, nature (generally not showing development, roads, etc.), scenic, travel (to accompany specific travel articles) and wildlife; "photos showing lesser known places in Montana as well as the national parks." Captions required.
Color: Uses transparencies. Pays $20-50/inside photo.
Cover: Uses 35mm, 2¼x2¼ or 4x5 color transparencies. Pays $75 minimum/photo.

MOTOR BOATING & SAILING MAGAZINE, 224 W. 57th St., New York NY 10019. (212)262-8768. Editor: Peter A. Janssen. Art Director: Erin Kenney. Emphasizes powerboats and large sailboats for those who own boats and participate in boating activities. Monthly magazine. Circ. 145,000. Information on and enjoyment of boating. Photos are purchased on assignment. Buys 30-50 photos/issue. Pay negotiated. Credit line given. Pays on acceptance. Buys one-time rights. Send material by registered mail for consideration. SASE. Reports in 1-3 months. Provide flyer and tearsheets to be kept on file for possible future assignments.

Subject Needs: Power boats; scenic (with power and sail, high performance, recreational boats of all kinds and boat cruising). "Sharp photos a must!" Model release and captions required.
Color: Kodachrome 25 preferred. Kodachrome 64 OK; Ektachrome and Fuji OK.
Cover: Uses 35mm color transparencies. Vertical format preferred.

MOTORCYCLIST, Petersen Publishing Co., 8490 Sunset Blvd., Los Angeles CA 90069. (213)854-2230. Editor: Art Friedman. Monthly magazine. Circ. 250,000. For "totally involved motorcycle enthusiasts." Buys 6-20 photos/issue. "Most are purchased with mss, but if we like a photographer's work, we may give him an assignment or buy photos alone." Provide calling card, letter of inquiry, resume and samples to be kept on file for possible future assignments.
Subject Needs: Scenic, travel, sport, product shot; special effects/experimental and humorous. "We need race coverage of major national events; shots of famous riders; spectacular, funny, etc. photos." Wants no "photos of custom bikes, local races, unhelmeted riders or the guy down the block who just happens to ride a motorcycle." Captions preferred.
Specs: Uses 8x10 glossy b&w prints and 35mm or 2¼x2¼ color transparencies.
Payment/Terms: Pays $25-75/photo. Credit line given. Pays on publication. Buys all rights, but may reassign to photographer after publication. Present model release on acceptance of photo.
Making Contact: Written query preferred; or query with resume of credits or send photos for consideration. Reports in 1 month. SASE. Sample copy $1.50; free photo guidelines.
Tips: Needs photos for columns: Sport, which deals with race reports; and Hotline, which features "interesting competition-related tidbits. We prefer most photos with ms, unless they tie in with one of our columns, a major event or human interest. Also unusual, humorous, bizarre for 'Last Page.' "

MOTORHOME, 29901 Agoura Rd., Agoura CA 91301. (818)991-4980. Editor: Bob Livingston. Managing Editor: Gail Harrington. Monthly. Circ. 130,000. Emphasizes motorhomes and travel. Readers are "motorhome owners with above-average incomes and a strong desire for adventurous travel." Sample copy $1; photo guidelines for SASE.
Photo Needs: Uses 25 photos/issue; 12 from freelancers. Needs "travel-related stories pertaining to motorhome owners with accompanying photos and how-to articles with descriptive photos. We usually buy a strong set of motorhome-related photos with a story. Also we are in the market for cover photos. Scenes should have maximum visual impact, with a motorhome included but not necessarily a dominant element. Following a freelancer's query and subsequent first submission, the quality of his work is then evaluated by our editorial board. If it is accepted and the freelancer indicates a willingness to accept future assignments, we generally contact him when the need arises." Captions required.
Making Contact & Terms: Send by mail for consideration 8x10 (5x7 OK) b&w prints or 35mm or 2¼x2¼ (4x5 or 8x10 OK) slides. Also send standard query letter. SASE. Reports as soon as possible, "but that sometimes means up to one month." Pays on acceptance $200-400 for text/photo package; up to $600 for cover photos. Credit line given if requested. Buys first rights. No simultaneous submissions or previously published work.

MUSCLE MAG INTERNATIONAL, Unit 7, 2 Melanie Dr., Brampton, Ontario, Canada L6T 4K8. (416)457-3030. Editor: Robert Kennedy. Monthly magazine. Circ. 130,000. Emphasizes male and female physical development and fitness. Photos purchased with accompanying ms. Buys 500 photos/year. Credit line given. Pays on acceptance. Buys all rights. Send material by mail for consideration; send $3 for return postage. Reports in 2-4 weeks. Sample copy $3.
Subject Needs: Celebrity/personality, fashion/beauty, glamour, how-to, human interest, humorous, special effects/experimental and spot news. "We require action exercise photos of bodybuilders and fitness enthusiasts training with sweat and strain." Wants on a regular basis "different" pics of top names, bodybuilders or film stars famous for their physique (i.e. Schwarzenegger, The Hulk, etc.). No photos of mediocre bodybuilders. "They have to be among the top 20 in the world or top film stars exercising." Captions preferred.
B&W: Uses 8x10 glossy prints. Query with contact sheet. Pays $10/photo.
Color: Uses 2¼x2¼, 4x5, or 8x10 transparencies. Pays $10-500/photo.
Cover: Uses color 2¼x2¼ or 4x5 transparencies. Vertical format preferred. Pays $100-500/photo.
Accompanying Mss: Pays $85-200/ms. Writer's guidelines $3.

Market conditions are constantly changing! If this is 1988 or later, buy the newest edition of **Photographer's Market** *at your favorite bookstore or order directly from* **Writer's Digest Books.**

N. Y. HABITAT, 928 Broadway, New York NY 10010. (212)505-2030. Managing Editor: Tom Soter. Bimonthly. Emphasizes co-op, condominium and loft living in New York City. Readers are owners and potential owners of lofts, co-ops and condos in New York City. Circ. 10,000. Sample copy $2.50.
Photo Needs: Uses about 10 photos/issue; 75% supplied by freelance photographers. Needs "co-op, condo and loft related photos; photos tied into articles." Model release and captions required.
Making Contact & Terms: Query with resume of credits. SASE. Reports in 3 weeks. Pays in cover photos and cover credit for cover photo; $50-100/b&w photo; $100-300/color photo and $100-300/day. All payments negotiable. Pays on publication. Credit line given. Buys one-time rights.

***NATIONAL EXAMINER**, 5401 NW Broken Sound Blvd., Boca Raton FL 33431. (305)997-7733. Editor: William Burt. Photo Editor: Ken Matthews. Weekly tabloid. Emphasizes general interest. Circ. 1,000,000. Sample copy 55¢.
Photo Needs: Uses 80-100 photos/issue; 90% supplied by freelance photographers. Needs general photos. Model release preferred; captions required.
Making Contact & Terms: Query with samples and list of stock photo subjects, send transparencies by mail for consideration. SASE. Pays $100/b&w cover photo; $50/b&w inside photo; varies page/ hour/job. Pays on acceptance or publication. Buys one-time rights. Previously published work OK.

NATIONAL GEOGRAPHIC, 17th and M Sts. NW, Washington DC 20036. Director of Photography: Rich Clarkson. Monthly magazine. Circ. 11,000,000. For members of the National Geographic Society, a nonprofit scientific and educational organization. Publishes photo series about interesting places, done in a journalistic way. Usually buys first serial rights and option to reprint in National Geographic Society publications. Send photos for consideration only after careful study of magazine. Works with freelance photographers on assignment only basis. Pays on acceptance. Reports in 1 month. SASE. If the color photographs submitted, or others on the same subject taken at the same time, have been published or sold elsewhere before being submitted to *National Geographic* this must be clearly stated. Sample copy $1.25.
Color: Send transparencies; 35mm preferred. Complete, accurate captions required. Pays $300/page of photos, or $100 minimum/photo; $350/day.
Tips: Submission of portfolios without accompanying ideas not advisable. A portfolio should be of no more than 50 photographs and should show the photographer's versatility. Transparencies should be sent registered first class or express mail and should be accompanied by a brief explanatory letter. No return by a given date guaranteed.

NATIONAL GEOGRAPHIC TRAVELER, 17th and M Sts. NW, Washington 20036. Illustrations Director: David R. Bridge. Quarterly, becoming bimonthly March 1987. Emphasizes "travel, primarily in the U.S. and Canada. At least two foreign articles per issue on high interest, low-risk, readily accessible areas. Occasional photographic essay with no text. Approximately 120 pages, 8½"x11", 7-8 articles per issue." Circ. 850,000 + . Estab. 1984. Photo guidelines free with SASE. Sample copy available for $4.85 from Robert Dove, National Geographic Society, Gaithersburg MD 20760.
Photo Needs: Uses approximately 120 photos per issue, all color; 95% assigned to freelance photographers. Occasional needs for travel-related stock. Captions required.
Making Contact & Terms: Provide business card, brochure, flyer or tearsheets to be kept on file for possible future assignments. SASE. Reports in 2 weeks. Pays $100 minimum/b&w and color inside photo; $300/color page. Pays on publication. Credit line given. Buys one-time world rights. Does not piggyback on other assignments or accept articles previously published or commissioned by other magazines.
Tips: "The key is a good story idea well presented in writing after submitting convincing sample of work. Do *not* telephone. Do not ask for appointment unless your work has been seen and you have a good idea to present. We are looking for increased impact, atmosphere and surprise. We want the pictures we use to motivate readers to want to visit places profiled. *Study the magazine!* Don't underestimate the difficulty! Don't overestimate your abilities!"

NATIONAL GEOGRAPHIC WORLD, 17th and M Sts. NW, Washington DC 20036. Editor: Pat Robbins. Associate Editor: Margaret McKelway. Art Director: Ursula Vosseler. Illustrations Editor: Dave Johnson. Monthly magazine. Circ. 1,300,000. Emphasizes natural history and child-oriented human interest stories. "Children age 8 and older read it to learn about other kids their age and to learn about the world around them. We include activities, supersize pullout pages and other special inserts." Buys more than 500 photos/year, at least 50 photos/issue. Credit line given on contents page and on supersize pages. Pays on publication. Buys one-time rights. Send material by mail for consideration or query with story proposals listing photo possibilities. SASE. Simultaneous submissions and previously published work (if not in a recent children's publication) OK. Reports in 4 weeks. Provide business card and stock list to be kept on file. Index available for $4.50 from National Geographic Society, Department 4787, Washington, DC 20036.

Subject Needs: Animal; (children); how-to (for children); science, technology and earth science; human interest (children); humorous; nature; photo essay/photo feature; special effects/experimental; sport (children); and wildlife. No dangerous activities where proper safety equipment is not being used. No travelog without specific focus. Model release preferred; captions with complete ID required. Departments with special photo needs include Kids Did It!, a photo of an outstanding or newsworthy child aged 8-16; What in the World . . . ?, a photo that tricks the eye or is unusual in some way, or a set of 9 close-ups with a theme to be guessed; and Far-Out Facts, a photo illustrating a "gee whiz" statement or out of the ordinary fact that children would not know.
Color: Uses 35mm or 2¼x2¼ or larger transparencies. No color prints, duplicates or motion picture frames. Prefers Kodachrome, Ektachrome or Fujichrome. Pays $75-400/photo.
Cover: Uses 35mm or 2¼x2¼ or larger color transparencies. Vertical format preferred. Pays $400/photo. Must relate to story inside.

***NATIONAL MASTERS NEWS**, Box 2372, Van Nuys CA 91404. (818)785-1895. Editor: Al Sheahen. Photo Editor: Gretchen Snyder. Monthly tabloid. Official world and US publication for Masters (age 35 and over) track and field, long distance running and race walking. Circ. 3,600. Sample copy free.
Photo Needs: Uses 25 photos/issue; all supplied by freelance photographers. Needs photographers of Masters athletes (men and women over age 35) competing in T&F events, LDR races or racewalking competitions. Captions preferred.
Making Contact & Terms: Send any size matte or glossy b&w print by mail for consideration, "may write for sample issue." SASE. Reports in 1 month. Pays $20/b&w cover photo; $7.50/inside b&w photo. Pays on publication. Credit line given. Buys one-time rights. Simultaneous submissions and previously published work OK.

NATIONAL PARKS MAGAZINE,, 1701 18th St. NW, Washington DC 20009. (202)265-2717. Editor: Michele Strutin. Bimonthly magazine. Circ. 50,000. Emphasizes the preservation of national parks and wildlife. Pays on publication. Buys one-time rights. SASE. Simultaneous submissions and previously published work OK. Reports in 1 month. Sample copy $3; free photo guidelines only with SASE.
Subject Needs: Photos of wildlife and people in national parks, scenics, national monuments, national recreation areas, national seashores, threats to park resources and wildlife. "Send sample (40-60 slides) of one or two national park service units to photo editor."
B&W: Uses 8x10 glossy prints. Pays $25-70/photo.
Cover: Pays $200/wraparound color covers. Pays $35-100/4x5 or 35mm color transparencies.
Accompanying Mss: Seeks mss on national parks, wildlife. Pays $200/text and photo package.
Tips: "Photographers should be more specific about areas they have covered that our magazine would be interested in. We are a specalized publication and are not interested in extensive lists on topics we do not cover. Send stock list with example of work if possible."

***NATIONAL RACQUETBALL**, Suite C, 400 Douglas Rd., Dunedin FL 33528. (813)733-5555. Editor: Chuck Leve. Monthly. Circ. 30,000. Emphasizes racquetball. Readers are "racquetball players and court club owners; median age 18-35; college educated and professionals; health-conscious and sports minded." Sample copy free with SASE.
Photo Needs: Uses 30-40 photos/issue; 10 supplied by freelance photographers. Looking for "action shots of racquetball players, head and informal shots of personalities in the racquetball world and shots illustrating principles." Model release required.
Making Contact & Terms: Query with samples; send 3x5 and up b&w glossy or matte prints, 35mm transparencies by mail for consideration; provide resume, business card, brochure, flyer or tearsheets to be kept on file for possible future assignments. SASE. Reports in 3 weeks. Pays $50/color cover photo; $15/b&w inside photo, $25/color inside photo; negotiates payment per job; $50-150 for text/photo package. Pays on publication. Credit line given. Buys all rights. Previously published work OK.

NATIONAL SCENE MAGAZINE, 22 E. 41st St, New York NY 10017. (212)689-1989. Editor: Decker Clark. Monthly magazine. Emphasizes general-interest magazine geared toward a black readership that is upscale, professional, business-oriented, 63% female. Circ. 1,600,000.
Photo Needs: Uses approximately 20 photos/issue; 7 supplied by freelance photographers. Needs how-to and personality photos. Model release and captions preferred.
Making Contact & Terms: Provide resume, business card, brochure, flyer or tearsheets to be kept on file for possible future assignments. SASE. Reports in 2 weeks. Pays $75-100/b&w cover photo, $150-200/color cover photo; $10/b&w inside photo; $20/color inside photo; negotiates pay by the hour and by the job. Pays on publication. Credit line given. Buys all rights.

NATIONAL WILDLIFE, 1412 16th Street NW, Washington DC 20036. (703)790-4000. Editor: John Strohm. Photo Editor: John Nuhn. Bimonthly magazine. Circ. 875,000. For nature and outdoor enthusi-

National Wildlife Photo Editor John Nuhn, purchased this photograph from Dr. Scott Nielsen of Superior, Wisconsin. "Action photos are always popular with our readers," Nuhn explains. "Photographer Scott Nielsen successfully captured this ring-necked duck in mid-lift off by positioning himself at water level and using a fast shutter speed." The photo was submitted as part of a general mailing, Nielsen explains, and also has been used in a calendar, poster and by wildlife groups throughout the U.S. and Canada for slide programs. Nielsen was paid $200 by National Wildlife *for first rights to the photo.*

asts; "our readers are concerned about the environment, and they appreciate the drama and beauty of our diverse wildlife and plant life." Buys 40-50 photos/issue. Buys one-time publication rights. Query with story ideas or send photos for consideration. Invite letters of inquiry and stock lists to be kept on file. Pays on acceptance. Reports in 4 weeks. SASE. Free photo guidelines.

Subject Needs: Mammals, birds, fish, reptiles, insects (action shots, close-ups, sequences, complete picture stories, unusual, dramatic and humorous single shots); people and how they live (environmental issues, people profiles and adventure stories); flowers; plant life; scenics. Especially needs distinctive, cover-quality photos and b&w stories that use the medium to its fullest and would not be more effective in color. No pets or "wild" animals that have been domesticated; no garden flowers unless there is a very unusual story line.

B&W: Send 8x10 glossy prints. Captions required. Pays $255 minimum/single photo.

Color: Send 35mm (prefer Kodachrome or Fuji 50-100), 2¼x2¼ or 4x5 transparencies. Captions required. Pays $255 minimum/single photo.

Tips: "We urge the photographer to think editorially. Although single photos are always needed for covers and inside use, we want the photographer's ideas on 'packaging' photos into a feature that will give the reader a different way of seeing a familiar or not so familiar place, or some aspect of wildlife. Study our last few issues to see how these packages are done. Send quality originals rather than dupes where possible; originals will be given proper care and they may increase chances of acceptance. Captions must be on mounts, backs of prints, or keyed to separate sheet. Do not tape photos to paper or cardboard. We prefer to receive photos in protective sheets rather than slide boxes or rubber bands. Don't send protective photo sheets in binders, attached to cardboard individually, or use any other method which prevents a quick review. Never send glass-mounted slides because of possible breakage in transit. We cannot accept cash, checks or money orders for payment of postage, so please ensure that the proper amount of stamps are glued to the return envelope." Also publishes *International Wildlife*, which has the same needs on a worldwide scope. Direct queries and submissions to the photo editor.

NATURE FRIEND MAGAZINE, 22777 State Rd. 119, Goshen IN 46526. (219)534-2245. Editor/Publisher: Stanley K. Brubaker. Monthly. Emphasizes the operation of God's Creation. Readers include children ages 4 and older of Christian families who hold a literal view of Creation. Circ. 5,000. Sample copy with SASE and 56¢ postage. Photo guidelines $1.
Photo Needs: Uses 6-10 photos/issue; most supplied by freelance photographers. Special needs include sharp Kodachrome, or glossy b&w 8x10's of wildlife up close; birds and animals, including some pets. Photo stories and sequences considered. Hardly any adult scenery such as stilllife, sunsets, etc.—must appeal to *children*. Reviews photos with accompanying ms only. Special needs include "sharp colorful popular bird and mammal photos, as well as reptiles, insects, amphibians, ocean life if high quality. We prefer photographs without dark backgrounds." Model release preferred.
Making Contact & Terms: Send 8x10 glossy b&w prints, 35mm, 2¼x2¼ transparencies, b&w or color contact sheets by mail for consideration. SASE. Pays $35-60/color cover photo, $10-20/b&w inside photo, $15-60/color photo, and $40-150/text/photo package. Pays on publication. Buys one-time rights. Previously published work OK if "we are made aware of other submissions or past use."
Tips: "Send only your very best photos. Sending more slides of inferior quality only hurts your reputation. We receive too many Kodachromes that are not sharp enough, or do not otherwise meet our specifications."

NEVADA MAGAZINE, Capitol Complex, Carson City NV 89710. (702)885-5416. Managing Editor: David E. Moore. Photo Editor: Jim Crandall. Bimonthly magazine. Circ. 75,000. Devoted to promoting tourism in Nevada, particularly for people interested in travel, people, history, events and recreation; age 30-70. Buys 20-30 photos/issue. Credit line given. Buys first North American serial rights. Pays on publication. Reports in 2 months. Send samples of *Nevada* photos. SASE. Sample copy $1.
Subject Needs: Towns and cities, scenics, outdoor recreation, people, events, state parks, tourist attractions, travel, wildlife, ranching, mining, and general Nevada life. Must be Nevada subjects.
B&W: Send 8x10 glossy prints. Must be labeled with name, address, and captions on back of each. Pays $10-75.
Color: Send transparencies. Must be labeled with name, address, and captions on each. Pays $10-75.
Cover: Send color transparencies. Prefers vertical format. Captions required. Pays $50-75.
Tips: "Send the best of your work; edit out marginals. Label each slide or print properly with name, address, and caption on each, not on a separate sheet. Send 35mm slides in 8x10 see-through slide sleeves. Don't send photos of California or Rhode Island."

NEW ALASKAN, Rt. 1, Box 677, Ketchikan AK 99901, (907)247-2490. Editor-in-Chief: Bob Pickrell. Monthly. Circ. 6,000. Emphasizes the Southeastern Alaska life-style, history, politics and general features. Send $1 for sample copy with SASE.
Photo Needs: Uses about 25 photos/issue; 5 supplied by freelance photographers. "All photos must have Southeast Alaska tie-in. Again, we prefer finished mss with accompanying photos concerning lifestyle, history, politics, or first-person adventure stories dealing with Southeast Alaska only." Photos purchased with accompanying ms. Model release and captions preferred.
Making Contact & Terms: Query with samples. SASE. Reports in 3 months. Provide business card and tearsheets to be kept on file for possible future assignments. Pays $25/b&w cover photo; $2.50/b&w inside photo; and text/photo package dependent on number of pictures used and story length. Pays on publication. Credit line given. Buys one-time rights. Simultaneous submissions and/or previously published work OK.

NEW BREED, 30 Amarillo Dr., Nanuet NY 10954. (914)623-9244. Editor-in-Chief: Lt. Colonel Harry Belil. Bimonthly. Circ. 92,000. Emphasizes "military, combat weapons, survival, martial arts, heroism, etc." Readers are "military, persons interested in para-military, law officers." Sample copy $2.50; photo guidelines free with SASE.
Photo Needs: Uses about 120 photos/issue; 75% supplied by freelance photographers. Needs "photo stories, such as conventions, gun clubs, shooting matches." Model release and captions required.
Making Contact & Terms: Query with samples or with list of stock photo subjects. Send 8x10 b&w prints, 35mm, 2¼x2¼ or 4x5 slides or b&w contact sheet by mail for consideration. Provide resume and sample photos to be kept on file for possible future assignments. SASE. Reports in 3 weeks. Pays $35/b&w and $50/color inside photo; $200-500 for text/photo package. Pays on publication. Credit line given. Buys first rights.

NEW CATHOLIC WORLD, 997 Macarthur Blvd., Mahwah NJ 07430. (201)825-7300. Managing Editor: Laurie Felknor. Bimonthly magazine. Circ. 13,000. Buys 5-10 photos/issue. Credit line given. Pays on publication. Buys one-time rights. Send material by mail for consideration. SASE. Simultaneous submissions and previously published work OK. Reports in 1 month.
Subject Needs: Human interest, nature, fine art and still life.
B&W: Uses 8x10 glossy prints. Pays $20/photo.
Tips: Each issue of *New Catholic World* is on a specific theme. Send query as to themes for the 6-issues-per-year.

NEW CLEVELAND WOMAN JOURNAL, 106 E. Bridge St., Berea OH 44107. (216)243-3740. Editor: Jean Linderman. Monthly magazine. Emphasizes "news and features pertaining to working women in the Cleveland/Akron area." Readers are working women, 50% married, average age 35. Circ. 30,000.
Photo Needs: Uses about 10 photos/issue; 2 supplied by freelance photographers. Needs "photo illustrations of subject-careers, travel, finance, etc." Model release preferred; captions required.
Making Contact & Terms: Query with samples. Provide business card and brochure to be kept on file for possible future assignments. SASE. Reports in 1 month. Pays $25/b&w inside photo. Pays on publication. Credit line given. Buys first North American serial rights. Simultaneous submissions OK.

***NEW ENGLAND LIVING**, Box 725, Worchester MA 01613. (617)892-4979. Editor: Anne Marie Rafferty. Bimonthly magazine. Emphasizes lifestyles and travel in the six New England States. Readers are married, professional, median age of 34.3 years, 76% live in New England. Sample copy $2.
Photo Needs: Uses 50 photos/issue; 10% supplied by freelance photographers. Needs scenic photos of New England, travel oriented shots, people enjoying New England activities, museums and New England attractions and sports. Will review photos with accompanying ms only. Special needs include scenic photos (4-C slides) of New England for possible color spreads. Model release and captions required.
Making Contact & Terms: Send 8x10 glossy b&w prints and 35mm transparencies by mail for consideration; provide resume, business card, brochure, flyer or tearsheets to be kept on file for possible future assignment. SASE. Reports in 2 months. Pays $50-100/color cover photo; $10-25/color inside photo; $5-15/b&w page; $50-150/text/photo package. Pays on publication. Credit line given. Buys onetime rights. Simultaneous submissions and previously published work OK.
Tips: Prefers to see slides 4c; send in sample copies of work.

NEW ENGLAND SKIERS' GUIDE, % Ski Racing International, 2 Bentley Ave., Poultney VT 05764. (802)287-9090. Managing Editor: Don Metivier. Annual. Emphasizes skiing—Alpine and cross-country; New England only. Readers include skiers in New England and beyond who ski or are considering so. Circ. 100,000. Sample copy $4; photo guidelines free with SASE.
Photo Needs: Needs include skiing in New England and related activities on snow and apres ski. Reviews photos with or without accompanying ms. Model release preferred; IDs for photos required.
Making Contact & Terms: Query with samples and list of stock photo subjects; send 5x7 and 8x10 b&w prints, 35mm, 2¼x2¼, 4x5, 8x10 transparencies by mail for consideration. SASE. Reports in one month or "depends on how close to production we are—but we will at least acknowledge receipt and serial back to those we aren't considering." Pays $100/b&w or color cover photo, $25-50/b&w or color inside photo. Pays on publication. Credit line given. Buys one-time rights. Previously published work OK.

***THE NEW HOMEOWNER**, 222 Keswick Ave., Glenside PA 19038. (215)572-7508. Editor: Thomas Purdom. Quarterly magazine. Emphasizes new homeowner guide to furnishing and remodeling. Circ. 1.3 million. Estab. 1985. Sample copy free with SASE.
Photo Needs: Uses 50 photos/issue; 20 supplied by freelance photographers. Reviews photos with accompanying ms only. Special needs include marriage preparation, prenatal education. Model release required; captions preferred.
Making Contact & Terms: Query with samples. Send 35mm, 2¼x2¼, 4x5 transparencies by mail for consideration. SASE. Reports in 1 month. Pays on acceptance or publication. Credit line given if requested. Buys one-time rights. Simultaneous submissions OK.

NEW MEXICO MAGAZINE, Joseph Montoya State Building, 1100 St. Francis Dr., Santa Fe NM 87503. Editor: Emily Drabanski. Monthly magazine. Circ. 100,000. For people interested in the Southwest or who have lived in or visited New Mexico.
Photo Needs: Needs New Mexico photos only—landscapes, people, events, architecture, etc. "Most work is done on assignment in relation to a story, but we welcome photo essay suggestions from photographers." Buys 40 photos/issue. Buys one-time rights.
Making contact & Terms: Submit portfolio to Mary Sweitzer. Credit line given. Pays on publication. SASE. Sample copy $1.95; free photo guidelines with SASE.
Color: Send transparencies. Captions required. Pays $30-80.
Cover: Cover photos usually relate to the main feature in the magazine. Pays $100.
Tips: Prefers transparencies submitted in plastic pocketed sheets. Interested in different viewpoints, styles not necessarily obligated to straight scenic. "All material must be taken in New Mexico. Representative work suggested. Transparencies or dupes are best for review and handling purposes."

NEW ORLEANS REVIEW, Loyola University, Box 195, New Orleans LA 70118. (504)865-2152. Editor: John Mosier. Magazine published 4 times/year. Circ. 3,000. Literary journal for anyone interested

in literature, film and art. Buys 20-30 annually. Buys all rights. Submit portfolio for consideration. Pays on publication. Reports in 2 months. SASE. Sample copy $7.
Subject Needs: Everything including special effects/experimental.
B&W: Send 5x7 or 8x10 prints; prefers glossy, but semigloss OK. Each issue includes Portfolio Department, which features 6 or more photos by a single artist.
Cover: Send glossy prints for b&w; glossy prints or transparencies for color. Uses vertical format—8½x11.

***NEW SHELTER**, 33 E. Minor St., Emmaus PA 18049. (215)967-5171. Editor: John Viehman. Photo Editor: Mitch Mandel. Published 9 times/year magazine. Emphasizes contemporary housing and houseowners subjects. Readers are middle and upper middle-class homeowners. Circ. 700,000. Sample copy free with SASE. Photo guidelines free with SASE.
Photo Needs: Uses 60 photos/issue; 50% supplied by freelance photographers. Needs photos of new homes, remodeling projects, solar energy subjects, landscaping and yard projets, room interests, etc. Model release required; captions preferred.
Making Contact & Terms: Query with samples and list of stock photo subjects; submit portfolio for review; provide resume, business card, brochures, flyer or tearsheets to be kept on file for possible future assignments. SASE. Reports in 1 month. Pays $300/color cover photo; $75-200/inside color photo; $75-200/color page; negotiates job; text/photo package. Pays on publication. Credit line given. Rights negotiated. Previously published work OK.

NEW TIMES, 111 W. Monroe #918, Phoenix AZ 85003. (602)271-0040. Editor: Michael Lacey. Photo Editor: Rand Carlson. Weekly. Emphasizes news and arts. Readers are young, professional, affluent and stylish. Circ. 120,000.
Photo Needs: Uses 15 photos/issue; none currently supplied by freelance photographers. Needs odd shots, environmental, cultural, etc. Model release and captions required.
Making Contact & Terms: Query with resume of credits and with list of stock photo subjects; provide resume, business card, brochure, flyer or tearsheets to be kept on file for possible future assignments. Does not return unsolicited material. Reports in 1 month. Pays $150/b&w cover photo, $50-75/b&w inside photo. Pays on publication. Credit line given. Buys one-time rights.

NEW YORK ALIVE, 152 Washington Ave., Albany NY 12210. (518)465-7511. Editor/Photo Editor: Mary Grates Stoll. Bimonthly. Emphasizes the people, places and events of New York State. Readers include young adults to senior citizens, well-educated, fairly affluent, who enjoy reading about life (past and present) in New York State. Circ. 30,000. Sample copy $2.45; photo guidelines free with SASE.
Photo Needs: Uses 40-50 photos/issue; 75% supplied by freelance photographers. Needs scenic (appropriate to season of cover date) and illustrations for specific features. Reviews photos with or without accompanying ms. Model release preferred.
Making Contact & Terms: Query with samples. SASE. Pays $250/color cover photo; $15-30/b&w inside photo; $30-125/color inside photo; $100/halfday; $250/fullday; and $500 maximum/text/photo package. Pays on publication. Credit line given. Buys one-time rights. Previously published work OK.

***NEW YORK MAGAZINE**, 755 Second Ave., New York NY 10017. (212)880-0829. Editor: Edward Kosner. Photography Director: Jordan Schaps. Weekly magazine. Full service city magazine: national and local news, fashion, food, entertaining, lifestyle, design, profiles, etc. Readers are 35-55 years average with $90,000 + average family income. Professional people, family people, concerned with quality of life and social issues affecting them, their families and the community. Circ. 450,000. Sample copy free with SASE.
Photo Needs: Uses about 50 photos/issue. Needs full range: photojournalism, fashion, food, product still lifes, conceptual, and stock (occasionally). Always need great product still life, and studio work. "Model release and captions preferred for professional models; require model release for 'real' people."
Making Contact & Terms: Arrange a personal interview to show portfolio, submit portfolio for review, "as this is a FAST paced weekly, phone appointments are ESSENTIAL, time permitting. Drop offs, by appointment also preferred. *Does not return unsolicited material.* Reports as soon as possible. Pays $1,000/color cover photo; $300/page of color; $125-150/photo spot. Pays on publication and receipt of original invoices. Credit line given. Buys one-time rights, possible minimum to-the-trade in-house advertising.
Tips: "While we love fine aerial photographs of the moors of Scotland, they do not show how a photographer would solve our photographic problems. Anyone who wants to work in *New York Magazine* needs to be conversant with what it does, because no solid magazine is going to alter its format for the artistry of one talented individual."

NIGHTBEAT MAGAZINE, Box 55573, Houston TX 77255. (713)954-1393. Editor: Menda Stewart. Photo Editor: Hank Smith. Monthly slick tabsize. Emphasizes entertainment. Readers are fun loving, relaxed, entertainment seeking people. Circ. 100,000. Free sample copy and photo guidelines with SASE.
Photo Needs: Uses 100 photos/issue; 50% supplied by freelance photographers. Needs entertainers on stage, back stage or relaxed at home or work. Reviews photos with accompanying ms only. Model release and captions required.
Making Contact & Terms: Query with samples, send any b&w prints, 35mm transparencies, b&w or color contact sheet by mail for consideration; provide resume, business card, brochure, flyer or tearsheets to be kept on file for possible future assignments. SASE. Reports in 1 month. Pays $100/color cover photo; $25/b&w inside photo; $50/color inside photo; $18-50/hour; $160-400/day. Pays on publication. Credit line given. Buys all rights. "We give a release after use." Simultaneous submissions and previously published work OK.
Tips: "We plan on using 150% more photos in 1987. More explicit and details more exact. Looks for usual ability with a flare for action—naturally, in focus, sharp, exact and expressing a feeling. Let us make the decision on selection of photos to be used. Send more material—we might buy more than you think!"

NIGHT LIFE MAGAZINE, Box 6372, Moore OK 73153. (405)685-3675. Editor: Vernon L. Gowdy III. Monthly tabloid. Emphasizes music and entertainment. "Readers include people aged 14-30 who love music and entertainment." Circ. 10,000. Estab. 1984. Free sample copy and photo guidelines with SASE.
Photo Needs: Uses 10-12 photos/issue; 4-5 supplied by freelance photographers. Needs concert, entertainment photos. Reviews photos with or without accompanying ms. Model release preferred.
Making Contact & Terms: Send 5x7, 8x10 glossy and semi-glossy b&w prints by mail for consideration. Reports in 3 weeks. Pays $25/b&w cover photo and $10/b&w inside photo. Pays on publication. Credit line given. Buys one-time rights. Previously published work OK.

NIT & WIT, CHICAGO'S ARTS MAGAZINE, Box 627, Geneva IL 60134. (312)232-9496. Editor: Marie Aguirre. Publisher: Harrison McCormick. Bimonthly. Circ. 7,500. Emphasizes visual and performing arts and literature. Readers are 25-40 year old professionals, "interestingly eclectic, very well educated, well traveled and above all, gifted with a global view of life, the arts and the rich cultures which surround us." Sample copy $2.50.
Photo Needs: Uses 25-30 photos/issue; all supplied by freelance photographers. Needs photos of all types. Photos purchased with or without accompanying ms. Model release required, when necessary.
Making Contact & Terms: Arrange interview to show portfolio or send by mail for consideration b&w prints or contact sheet. SASE. Reports in 2-3 weeks. Pays in contributor's copy on publication. Credit line given. Buys one-time rights.
Tips: "Send us samples of what you consider your best."

NORTHEAST OUTDOORS, Box 2180, Waterbury CT 06722-2180. (203)755-0158. Editor: Debbie Nealley. Monthly tabloid. Circ. 14,000. Emphasizes family camping in the Northeast. Photos purchased with accompanying ms. Buys 15 photos/issue with accompanying ms.
Subject Needs: Camping, nature and scenic. Needs shots of camping and recreational vehicles. No noncamping outdoor themes or poor quality prints. Model release and captions preferred.
Accompanying Mss: Photos purchased with accompanying ms only. Seeks mss about camping— how-to or where—in the Northeast (i.e., campground or tourist destinations). Free editorial guidelines.
Specs: Uses 3x5 glossy b&w prints. Uses b&w covers; 8x10 vertical format preferred for covers.
Payment/Terms: Pays $40-80/job or on a per-photo basis—$5-10/b&w print and $50/cover. Credit line given. Pays on publication. Buys one-time rights.
Making Contact: Send material by mail for consideration. SASE. Reports in 2-3 weeks. Free sample copy and editorial guidelines (includes photography).
Tips: "Read and study the magazine. Try to use RVs, travel trailers, tents, camping scenes, especially for cover shots. Go camping in our area (northeastern United States), take b&w verticals of campgrounds and campsites, and let us see a few."

NUCLEAR TIMES, Rm. 512, 298 5th Ave., New York NY 10001. (212)563-5940. Art Director: Bill Rose. Publishes 6 times/year. "We are the newsmagazine for the antinuclear-weapons movement in the US and abroad." Readers are anti-nuclear-weapons-movement people and interested people. Circ. 80,000. Sample copy $1.
Photo Needs: Uses about 10-20 photos/issue; all supplied by freelance photographers. Needs "news photos of antinuclear events, people, places, activities, etc.; weapons photos; anything relating to the antinuclear issue."

Making Contact & Terms: Arrange a personal interview to show portfolio; query with samples; query with list of stock photo subjects; provide resume, business card, brochure, flyer or tearsheets to be kept on file for possible future assignments; call. SASE. Reports in 2 weeks. Pays $25-50/b&w cover photo; $25/b&w inside photo; and by arrangement for text/photo package. Pays on publication. Credit line given. Buys one-time rights. Simultaneous submissions and previously published work OK.
Tips: "We look for material relevant to our magazine—or a photographer showing an interest and talent in news/political photography and portraits. Show your work around. We need photographers who are both talented and interested in the antinuclear movement, since we don't pay large sums."

NUGGET, Suite 204, 2355 Salzedo St., Coral Gables FL 33134. (305)443-2378. Editor: John Fox. Bimonthly magazine. Circ. 150,000. Emphasizes sex and fetishism for men and women of all ages. Uses 100 photos/issue. Credit line given. Pays on publication. Buys one-time rights or second serial (reprint) rights. Submit material (in sets only) for consideration. SASE. Previously published work OK. Reports in 2 weeks. Sample copy $5; photo guidelines free with SASE.
Subject Needs: Interested only in nude sets; single woman, female/female or male/female. All photo sequences should have a fetish theme (sadomasochism, leather, bondage, transvestism, transsexuals, lingerie, infantilism, wrestling—female/female or male/female—women fighting women or women fighting men, amputee models, water sports, etc.). Model release required. Buys in sets, not by individual photos. No Polaroids or amateur photography.
B&W: Uses 8x10 glossy prints; contact sheet OK. Pays $150 minimum/set.
Color: Uses transparencies. Prefer Kodachrome. Pays $200-300/set.
Cover: Uses color transparencies. Vertical format required. Pays $150 minimum/photo.
Accompanying Mss: Seeks mss on sex, fetishism and sex-oriented products. Pays $125-175/ms.

OCEANS, 2001 W. Main St., Stamford CT 06902. Editor: Michael Robbins. Bimonthly magazine. Circ. 40,000. Emphasizes exploration, conservation and life of the sea. For well-educated persons who enjoy science and marine art and are concerned with the environment. Buys 100 photos annually. Buys first serial rights. Credit line given. Pays on acceptance. Reports in 1 month. SASE. $3 sample copy.
Subject Needs: All photos must be marine-related; animal, nature, scenic, sport, wildlife and marine art. "Photos should have a definite theme. No miscellaneous."
B&W: Send contact sheet or 8x10 semigloss prints. Captions required. Pays $25-50.
Color: Send 35mm or 2¼x2¼ transparencies or duplicates. Captions required. Pays $30-100.
Cover: Send 35mm or 2¼x2¼ transparencies. Captions required. Pays $150.
Tips: Prefers ms with photos (pays $100/printed page). Wants transparencies in sleeves.

OFF DUTY AMERICA, Suite C-2, 3303 Harbor Blvd., Costa Mesa CA 92626. Editor: Bruce Thorstad. *Off Duty Pacific*, Box 9869, Hong Kong. Editor: Jim Shaw. *Off Duty Europe*, Eschersheimer Landstr. 69, 6 Frankfurt/M, West Germany. European Editor: J.C. Hixenbaugh. "Off Duty Magazines publish 3 editions, American, Pacific and European, for US military personnel and their families stationed around the world." Combined circ. 708,000. Emphasis is on off duty travel, leisure, military shopping, wining and dining, sports, hobbies, music and getting the most out of military life. Overseas editions lean toward foreign travel and living in foreign cultures. Free sample copy and contributor guidelines.
Photo Needs: "Travel photos to illustrate our articles, especially shots including people who could be our readers depicted in travel locations. Need to hear from professional photographers having access to military personnel or uniforms and who can do set-up shots to illustrate our articles. Amateur models usually OK." Uses 5x7 or similar glossy b&w prints and color transparencies. "Must have at least vertical-format 35mm for cover."
Making Contact & Terms: "Material with special US, Pacific or European slant should be sent to separate addresses above; material common to all editions may be sent to US address and will be forwarded as necessary. Photographers living or traveling in European or Pacific locations should contact Frankfurt or Hong Kong offices above for possible assignments." Pays $25/b&w; $50/color; $100/full-page color; $200/cover. "Usually pays more for assignments." Pays on acceptance. Buys first serial or second serial rights.
Tips: "We need establishing shots with a strong sense of people and place for our travel stories. We are interested in building a file of color and b&w shots showing the U.S. military and their dependents (our only readers) at work and at play. Learn to write, or work closely with a writer who can offer us several article proposals . . . start with the written word and take photos that *illustrate* the story, or—better yet—that tell an essential part of the story that the words alone cannot tell. We often avoid sending a staffer long distances and go instead to a freelancer on the scene. Become a particularly good source for some subject or group of subjects. Then send us a stock list describing what you have. Photographers looking for assignments probably prefer to characterize themselves as all-around shooters. But since we're most often looking for *pre-existing* pictures, we deal a lot with photographers who have established something of a specialty and a reputation for delivering quality."

OFFSHORE, New England's Boating Magazine, Box 148, Waban MA 02168. (617)244-7520. Editor: Herb Gliick. Monthly tabloid. Emphasizes boating in New England for boat owners. Circ. 18,000.
Photo Needs: Uses about 24 photos/issue; 12 supplied by freelance photographers. Needs photos of "boats and New England harbors and waterfronts." Captions preferred.
Making Contact & Terms: Query with samples—contact sheets are sufficient. SASE. Reports in 1 week. Pays $125/color cover; $15/b&w inside photo; $50/page rate; $50-150 for text/photo package. Pays on acceptance. Credit line given. Buys one-time rights "plus the right to use in promotional materials."
Tips: "We prefer interesting rather than pretty subjects."

***OHIO FAMILY MAGAZINE**, Box 183, Yellow Springs OH 45387. (513)767-3421. Editor: Dennis Greehan. Photo Editor: Teri Schoch. Bimonthly magazine. Emphasizes families, healthcare, social service. Readers are mid-income women 18-45 years old. Circ. 30,000. Estab. 1986. Sample copy free with SASE.
Photo Needs: Uses 5-10 photos/issue; all supplied by freelance photographers. Needs photos specific to each issue, family themes. Model release required; captions preferred.
Making Contact & Terms: Provide resume, business card, brochure, flyer or tearsheets to be kept on file for possible future assignments. SASE. Reports in 2 weeks. Pay negotiated. Pays on publication. Credit line given. Buys all rights. Previously published work OK.
Tips: Prefers to see primarily b&w samples.

OHIO FISHERMAN, 1570 Fishinger Rd., Columbus OH 43221. (614)451-5769. Editor: Ottie M. Snyder. Monthly. Circ. 41,000. Emphasizes fishing. Readers are the Buckeye State anglers. Sample copy and photo guidelines free with SASE.
Photo Needs: 12 covers/year supplied by freelance photographers. Needs transparencies for cover; 99% used are verticals with as much free space on top and left side of frame as possible. Fish and fishermen (species should be common to coverage area) action preferred. Photos purchased with or without accompanying ms. Model release preferred; required for covers. Captions preferred.
Making Contact & Terms: Query with tearsheets or send unsolicited photos by mail for consideration. Prefers 35mm transparencies. SASE. Reports in 1 month. Provide tearsheets to be kept on file for possible future assignments. Pays minimum $100/color cover. Pays on publication. Credit line given. Buys one-time rights.

OHIO MAGAZINE, 40 S. 3rd St., Columbus OH 43215. (614)461-5083. Art Inquiries Submissions: Ellen Stein. Monthly magazine. Emphasizes features throughout Ohio for an educated, urban and urbane readership. Pays $150/day plus color film expenses for photojournalism or on a per-photo basis. Credit line given. Pays within 90 days after acceptance. Buys first world rights and permission to reprint in later issues or promotions. Send material by mail for consideration; query with samples; or arrange a personal interview to show portfolio. Work from Ohio only. SASE. Reports in 3 weeks.
Subject Needs: Travel, sports, photo essay/photo feature, celebrity/personality, product show and spot news. Photojournalism and concept-oriented studio photography.
B&W: Uses 8x10 glossy prints; contact sheet mandatory. Pays $50/in-stock shot.
Color: Pays $50-100/35mm, 2¼x2¼ or 4x5 transparencies.
Cover: Uses 35mm, 2¼x2¼ or 4x5 transparencies. Vertical square format preferred. Pays $350 maximum/photo.
Tips: "Send sheets of slides and/or prints with return postage and they will be reviewed. We are leaning more towards well-done documentary photography and less toward studio photography. Dupes for our files are always appreciated—and reviewed on a *regular* basis."

OKLAHOMA LIVING MAGAZINE, Box 75579, Oklahoma City OK 73147. (405)943-4289. Managing Editor: Lu Hollander. Bimonthly. Emphasizes housing industry—homes, apartments, condominiums, plus a city living section with general interest. Readers are a mixed audience—people moving to Oklahoma City, those looking for shelter, general population. Circ. 68,000. Sample copy free with SASE and $2 postage.
Photo Needs: Uses about 100 photos/issue; half supplied by freelance photographers. Needs photos relating to the housing industry—how-to, architectural photo journals, Oklahoma-related photos, interior decorating. "We have a City Living feature every issue, and our needs vary. We need to be familiarized with work so we can determine how individual photographers work can fill our needs. Model release and captions preferred.
Making Contact & Terms: Query with samples; query with list of stock photo subjects; send 5x7 b&w or color glossy prints; 2¼x2¼, 4x5 or 8x10 transparencies; b&w or color contact sheet; b&w or color negatives (with contact sheet) by mail for consideration; provide resume, business card, brochure,

flyer or tearsheets to be kept on file for possible future assignments. SASE. Reports in 1 month. Payment per assignment. Pays on publication. Credit line given. Buys all rights.

OLD WEST, Box 2107, Stillwater OK 74076. Editor: John Joerschke. Quarterly. Circ. 100,000. Emphasizes history of the Old West (1830 to 1910). Readers are people who like to read the history of the West. Sample copy available.
Photo Needs: Uses 100 or more photos/issue; "almost all" supplied by freelance photographers. Needs "mostly Old West historical subjects, some travel, some scenic (ghost towns, old mining camps, historical sites). Prefers to have accompanying ms. Special needs include western wear, cowboys, rodeos, western events.
Making Contact & Terms: Query with samples, b&w only for inside, color covers. SASE. Reports in 1 month. Pays $100-150/color cover photos; $10/b&w inside photos. Pays on acceptance. Credit line given. Buys one-time rights.
Tips: "Looking for transparencies of existing artwork as well as scenics for covers, pictures that tell stories associated with Old West for the inside. Most of our photos are used to illustrate stories and come with manuscripts; however, we will consider other work (scenics, historical sites, old houses)."

ON CABLE, 25 Van Zant St., Norwalk CT 06855. (203)866-6256. Monthly national. Emphasizes cable television: programs, subject, personalities, etc. Readers are cable television subscribers-/magazine available through cable operators. Limited newsstand sales in New York City. Circ. 1.6 million.
Photo Needs: Uses about 47 color photos/issue; number supplied by freelancers varies. Needs photos of celebrity personalities; subjects relating to cable television, news, entertainment, music, movies, etc.; sports; movie/television production. Interested in color photos only; no manuscripts. Captions or identifications required.
Making Contact & Terms: Arrange a personal interview to show portfolio; query with resume of credits, samples and list of stock photo subjects; provide resume, business card, brochure, flyer or tearsheets to be kept on file for possible future assignments. "We are interested in speaking with photographers if they are in the Southeast Connecticut/New York area; seeing nonreturnable examples of photos from photographers." Does not return unsolicited material. "We will not respond except where interested in purchasing rights to reproduce stock photography or to make photo assignments." Pays $300-400/color cover; $100-125/color inside photo ¼ page; $150/color half page; $175/color three-quarter page; $200/color full page; $150/half-day; $300/full day. Pays within 30 days of receipt of bill for assignment work. Credit line given. "We generally buy First North American serial rights; for assignment work purchase rights for period of 6 months then return to photographer. For stock: one-time rights. We prefer work that has not been published and is not currently being considered by another similar-subject magazine. We are interested in photographers who can produce excellent quality work and are flexible in terms of price/use structure."

ON THE LINE, 616 Walnut Ave., Scottdale PA 15683. (412)887-8500. Contact: Editor. Weekly magazine. Circ. 12,000. For junior high students, ages 9-14. Needs photos of children, age 9-14. Buys one-time rights. Send photos for consideration. Pays on acceptance. Reports in 1 month. SASE. Simultaneous submissions and previously published work OK. Free sample copy and editorial guidelines.
B&W: Send 8x10 prints. Pays $10-30.
Tips: "We need quality black & white photos for use on cover. Prefer vertical shots, use some horizontal. We need photos of children, age 9-14 representing a balance of male/female, white/minority/international, urban/country, clothing and hair styles must be contemporary, but not faddish."

1001 HOME IDEAS, 3 Park Ave., New York NY 10016. (212)340-9258. Art Director: R. Thornton. Monthly magazine. Emphasizes interiors, gardening and food. Sample copy free with SASE.
Photo Needs: Uses about 30-40 photos/issue; all supplied by freelance photographers. Needs photos of interiors.
Making Contact & Terms: Arrange a personal interview to show portfolio. Send 2¼x2¼, 4x5 or 8x10 transparencies by mail for consideration. Reports in 3 weeks. Payment varies. Pays on publication. Credit line given. Buys all rights.

ONTARIO OUT OF DOORS, 7th Floor, 777 Bay St., Toronto, Ontario, Canada M5W 1A7. (416)368-3011. Editor: Burton J. Myers. Published 10 times/year. Circ. 55,000. Emphasizes hunting, fishing, camping and conservation. For outdoors enthusiasts. Needs photos of fishing, hunting, camping, boating ("as it relates to fishing and hunting"), wildlife and dogs. Dogs department uses b&w action photos of hunting dogs in the field. Wants no "lifeless shots of large numbers of dead fish or game." Buys 50-75 annually. Buys first North American serial rights. Model release "not required except when featuring children under 18"; when required, present on acceptance of photo. Send photos for consideration. Pays $100-350 for text/photo package. Pays on acceptance. Reports in 6 weeks. SAE and International Reply

Coupons. Previously published work OK. Free sample copy and photo guidelines.
B&W: Send 8x10 glossy prints. Captions required. Pays $25-75.
Color: Uses transparencies to accompany feature articles. Pays $35-100.
Cover: Send color transparencies. "Photos should portray action or life." Uses vertical format. Captions required. Pays $350-500.
Tips: "Examine the magazine closely over a period of six months. Concentrate on taking vertical format pictures. We see a rise in the use of freelance photography to cover submissions by freelance writers. We look for clear, crisp dramatic photos rich with colour of action or life."

OPEN WHEEL MAGAZINE, Box 715, Ipswich MA 01938. (617)356-7030. Editor: Dick Berggren. Bimonthly. Circ. 175,000. Emphasizes sprint car supermodified and midget racing with some Indy coverage. Readers are fans, owners and drivers of race cars and those with business in racing. Photo guidelines free for SASE.
Photo Needs: Uses 100-125 photos/issue supplied by freelance photographers. Needs documentary, portraits, dramatic racing pictures, product photography, special effects, crash. Photos purchased with or without accompanying ms. Model release required for photos not shot in pit, garage or on track; captions required.
Making Contact & Terms: Send by mail for consideration 8x10 b&w or color glossy prints and any size slides. SASE. Reports in 1 week. Pays $20/b&w inside; $35-250/color inside. Pays on publication. Buys all rights.
Tips: "Send the photos. We get dozens of inquiries but not enough pictures. We file everything that comes in and pull 80% of the pictures used each issue from those files. If it's on file, the photographer has a good shot."

***OREGON MAGAZINE**, Suite 404, 208 SW Stark St., Portland OR 97204. (503)223-0304. Art Director: Richard Jester. Emphasizes news, life-styles and personalities of Oregon. Monthly magazine. Circ. 30,000. Query by phone or mail. SASE.
Subject Needs: Animal/wildlife (native to Oregon), celebrity/personality, scenic (no snapshots), sport (Oregon sports figures and teams), human interest, photo essay/photo feature (on assignment only), nature, travel and fashion (on assignment).
Tips: "We buy both color and b&w stock or on an assignment basis. Payment, unless other arrangements are made, is $50-150 per assignment."

ORGANIC GARDENING, 33 E. Minor St., Emmaus PA 18049. (215)967-5171. Art Director: Robert Ayers. Monthly magazine. Circ. 1,400,000. Emphasizes vegetable and flower gardening. Readers are "a diverse group whose main hobby is growing their own healthy food." Sample copy and photo information free with SASE.
Photo Needs: Uses 35-40 photos/issue; 10-15 supplied by freelance photographers. Needs "vegetable close-ups, garden overviews, pictures of gardeners with innovative techniques. We stress gardening *without* harmful chemicals." Special needs include "more photos of gardeners with lots of flowers; landscaping with flowers." Captions required.
Making Contact & Terms: Query with sample or list of stock photo subjects; send 5x7 and 8x10 glossy prints or any size transparencies by mail for consideration. SASE. Reports in 4 weeks. Pays $300-400/color cover photo; $35-55/b&w inside photo; $55-75/color inside photo. Pays on acceptance. Credit line given. Buys all rights.
Tips: "Send us shots of unusual vegetable varieties with all the information you can gather on them."

THE ORIGINAL NEW ENGLAND GUIDE, 2245 Kohn Rd., Box 8200, Harrisburg PA 17105. (717)657-9555. Editor: Kathie Kull. Consulting Editor: Mimi E. B. Steadman. Annual magazine. Circ. 160,000, nationwide and international. For vacationers and visitors to New England. Forty-two percent are New Englanders. Buys 30-45 photos/issue. Buys one-time rights. Credit line given. Pays on publication (early spring). Reports in 3 weeks after receipt. SASE. Previously published work OK. Sample copy $4.50; free photo guidelines. Deadline is October 31 each year. Publication in early spring.
Subject Needs: "We seek photographs that reflect the beauty and appeal of this region's countryside, seacoast, and cities, and entice readers to travel and vacation here. In addition to seeking specific photo subjects to illustrate scheduled articles, we welcome unsolicited submissions, provided they are of professional quality and are accompanied by SASE. We use scenics taken primarily in spring and summer; photos of landmarks and attractions, especially those with historical significance; and photos of groups and individuals participating in action sports (such as hiking, mountain climbing, sailing, canoeing) and special events (auctions, craft shows, fairs, festivals and the like). All photos must convey a distinctly New England atmosphere." Wants no "posed shots, faked shots, shots of commercial property."
B&W: Send contact sheet or 5x7 or 8x10 glossy prints. Identification required. "Make photo locations specific." Pays up to $100.

Color: Send 35mm, 2¼x2¼ or 4x5 transparencies, in plastic pocket sheets. "Please label every slide and print with photographer's name and address." Locations required. Pays up to $300.
Cover: Send 35mm, 2¼x2¼ or 4x5 color transparencies. Locations required. Pays $200-400.
Tips: "Study the magazine—we only use 7 real scenics—one for cover and one to open each of 6-state sections. All the rest of the photos illustrate specific articles, so it's wise to send a list of subjects available so we can pick those that fit with articles being planned. Clarity of photo in transparency, composition, good contrast in b&w, and strong colors in color work are important. Please mark each photo clearly with your name and address and indicate the location in which it was taken." No Polaroids. "We are happy to consider work by amateurs, but please don't just send us all the slides of your New England vacation. Edit first, and send only those of very best quality. You'll save yourself some postage, and save both of us a lot of time. Know what states are and what states *aren't* in New England—we're not going to use a shot of New York or Maryland or New Jersey, or wherever, no matter *how* spectacular it is." Fewer "calendar" scenics; more pictures of *people* enjoying New England's attractions and activities.

"I was observing an album cover shoot in Centennial Park in Nashville," explains photographer Lin Rutherford of Nashville, Tennessee, "when the little boy wandered into the frame. He got as close as possible to the violinist as his curiosity would allow." Rutherford sold this photo to The Other Side *and* Photographer's Forum: The Best of College Photography. *She sent it unsolicited to both magazines; each purchased it for $25.*

THE OTHER SIDE, Box 12236, Philadelphia PA 19144. (215)849-2178. Art Director: Cathleen Boint. Monthly magazine. Circ. 14,000. Emphasizes social justice issues from a Christian perspective. Buys 6 photos/issue. Credit line given. Pays within 4 weeks of acceptance. Buys one-time rights. Send samples or summary of photo stock on file. SASE. Simultaneous submissions and previously published work OK. Reports in 1 month. Sample copy $1.
Subject Needs: Documentary and photo essay/photo feature. "We're interested in photos that relate to current social, economic or political issues, both here and in the Third World."
B&W: Uses 8x10 glossy prints. Pays $15-30/photo.

Cover: Uses color transparencies. Vertical format required. Pays $125-175/photo. Also pays $8-12/hour and $50-90/day.
Tips: Send samples of work; a list of subjects is difficult to judge quality of work by.

OTTAWA MAGAZINE, Suite 2, 340 MacLaren St., Ottawa, Ontario, Canada K2P 0M6. (613)234-7751. Editor-in-Chief: Louis Valenzuela. Art Director: Peter di Gannes. Emphasizes life-styles for sophisticated, middle and upper-income, above-average-educated professionals. Most readers are women. Monthly. Circ. 43,500. Sample copy $1.
Photo Needs: Uses about 30-40 photos/issue; 20-40 are supplied by freelance photographers. Needs photos on travel and life-styles pegged to local interests. Model release and captions required.
Making Contact & Terms: Send material by mail for consideration, arrange personal interview to show portfolio and query with list of stock photo subjects. Prefers creative commercial, product and studio shots; also portraiture (for magazine) in portfolio. Uses 8x10 b&w and color prints; 35mm and 2¼x2¼ slides. SASE. Reports in 30 days. Pays $30-50/b&w photo; $30-150/color photo; $150-250/day; $125 minimum/page; $125-250/job and $200-500 for text/photo package. Credit line given. Payment made on acceptance. Buys first time or second rights or by special arrangement with photographer. Simultaneous and previously published work OK.
Tips: "Contact art director, send work samples or photocopies. No originals. Have a well-rounded portfolio. I look for photos that tell me the photographer went through some sort of thinking. I look for wit or at least a sign that he/she had the good judgement to recognize a good photo and seized the opportunity to take it."

OUR FAMILY, Box 249, Battleford, Saskatchewan, Canada S0M 0E0. Editor/Photo Editor: Albert Lalonde, O.M.I. Monthly magazine. Circ. 14,265. Emphasizes Christian faith as a part of daily living for Roman Catholic families. Photos are purchased with or without accompanying ms. Buys 5-10 photos/issue. Credit line given. Pays on acceptance. Buys one-time rights and simultaneous rights. Send material by mail for consideration or query with samples after consulting photo spec sheet. Provide letter of inquiry, samples and tearsheets to be kept on file for possible future assignments. SAE and International Reply Coupons. (Personal check or money order OK instead of International Reply Coupon.) Simultaneous submissions or previously published work OK. Reports in 4 weeks. Sample copy $2.50. Free photo guidelines with SAE and payment for postage 39¢.
Subject Needs: Head shot (to convey mood); human interest ("people engaged in the various experiences of living"); humorous ("anything that strikes a responsive chord in the viewer"); photo essay/photo feature (human/religious themes); and special effects/experimental (dramatic—to help convey a specific mood). "We are always in need of the following: family (aspects of family life); couples (husband and wife interacting and interrelating or involved in various activities); teenagers (in all aspects of their lives and especially in a school situation); babies and children; any age person involved in service to others; individuals in various moods (depicting the whole gamut of human emotions); religious symbolism; and humor. We especially want people photos, but we do not want the posed photos that make people appear 'plastic', snobbish or elite. In all photos, the simple, common touch is preferred. We are especially in search of humorous photos (human and animal subjects), particularly pictures that involve young children. Stick to the naturally comic, whether it's subtle or obvious." Model release required if editorial topic might embarrass subject; captions required when photos accompany ms.
B&W: Uses 8x10 glossy prints. Pays $25/photo.
Color: Transparencies or 8x10 glossy prints are used on inside pages, but are converted to b&w. Pays $75-100/photo.
Cover: Uses color transparencies for cover. Vertical format preferred. Pays $75-100/photo.
Accompanying Mss: Pays 7-10¢/word for original mss; 4-6¢/word for nonoriginal mss. Free writer's guidelines with SAE and payment for postage 39¢.
Tips: "Send us a sample (20-50 photos) of your work after reviewing our Photo Spec Sheet."

OUTDOOR CANADA, Suite 301, 801 York Mills Rd., Don Mills, Ontario, Canada M3B 1X7. (416)429-5550. Editor: Teddi Brown. Magazine published 8 times annually. Circ. 141,000. Needs Canadian photos of fishing, hunting, hiking, wildlife, cross-country skiing. Action shots. Buys 70-80 annually. Buys first serial rights. Send photos for consideration. Pays on publication. Reports in 3 weeks; "acknowledgement of receipt is sent the same day material is received." SAE and International Reply Coupons for American contributors; SASE for Canadians *must* be sent for return of materials. Free writers' and photographers' guidelines "with SASE or SAE and International Reply Coupons only." No phone calls, please.
B&W: Send 8x10 glossy prints. Pays $10-45.
Color: Send transparencies. Pays $20-150 depending on size used.
Cover: Send color transparencies. Allow undetailed space along left side of photo for insertion of blurb. Pays $250 maximum.

Tips: "Study the magazine and see the type of articles we use and the types of illustration used" and send a number of pictures to facilitate selection.

OUTDOOR LIFE MAGAZINE, 380 Madison Ave., New York NY 10017. (212)687-3000. Art Director: Jim Eckes. Monthly. Circ. 1,500,000. Emphasizes hunting, fishing, shooting, camping and boating. Readers are "outdoorsmen of all ages." Sample copy "not for individual requests." Photo guidelines free with SASE.
Photo Needs: Uses about 50-60 photos/issue; ¾ of total supplied by freelance photographers. Needs photos of "all species of wildlife and fish, especially in action and in natural habitat; how-to and whereto. No color prints—preferably Kodachrome 35mm slides." Captions preferred. No duplicates.
Making Contact & Terms: Send 5x7 or 8x10 b&w glossy prints; 35mm or 2¼x2¼ transparencies; b&w contact sheet by mail for consideration. Pays $35-275/b&w photo, $50-700/color photo depending on size of photos; $800-1,000/cover photo. SASE. Reports in 1 month. Rates are negotiable. Pays on publication. Credit line given. Buys one-time rights. "Multi subjects encouraged."
Tips: "Have name and address clearly printed on each photo to insure return, send in 8x10 plastic sleeves."

OUTSIDE, 1165 N. Clark St., Chicago IL 60610. (312)951-0990. Editor: John Rasmus. Photography Director: Larry Evans. Published 12 times/year. Circ. 240,000. For a young (29 years old), primarily male audience specifically interested in nonmotorized outdoor sports. Buys 50-60 photos/issue. Buys first serial rights. Send photos for consideration. Pays on publication. Reports in 4-6 weeks. SASE. Free photo guidelines.
Subject Needs: Photo essay/photo feature; scenic; wildlife; and photos of people involved in sports such as: backpacking, mountain climbing, skiing, kayaking, canoeing, sailing, river rafting and scuba diving.
Color: Send transparencies. Captions required. Pays $25-200.
Cover: Send color transparencies. Prefers action photos "close enough to show facial expression." Captions required. Pays $450.

OVATION, 320 W. 57 St., New York NY 10019. (212)765-5110. Publisher and Editor: Frederick R. Selch. Emphasizes classical music personalities and events. Monthly. Sample copy $2.79.
Photo Needs: Uses about 40-50 photos/issue; most supplied by publicists and record companies, originally commissioned of freelance photographers. Selects freelancers by reputation, talent and compatibility. "Submit classical music celebrities in nonmusical activities—away from concert hall—doing unusual and newsworthy things." Model release and captions required.
Making Contact & Terms: Send by mail for consideration actual b&w and/or color transparencies. Pays on publication $25/b&w photo. Credit line given. Buys one-time rights. Simultaneous and previously published submissions OK if so indicated.

OVERSEAS!, Kolpingstr 1, 6906 Leimen, West Germany. Editorial Director: Charles Kaufman. Monthly magazine. Circ. 83,000. Emphasizes entertainment and European travel information of interest to the G.I. in Europe. Read by American and Canadian military personnel stationed in Europe, mostly males ages 18-30. Buys 12 cover photos/year. Pays on acceptance. Buys one-time rights for "American and Canadian military communities in Europe." Query or send photos. SAE with International Reply Coupons. Simultaneous submissions OK. Previously published work OK. Reports in 2 weeks. Sample copy for 4 International Reply Coupons.
Subject Needs: "Women! All we want is cover shots of women. Pretty women, active women, clothed women. No nudes. No head shots (prefer full to ¾ body shots). Nothing perverted. No women's fashion-type photos. We prefer the unposed, healthy look. The woman should not look into the camera. Subjects of women we are always in need of: winter-women skiing, sledding, playing in the snow, etc.; summer-women on the beach, in bikinis, on a sail boat, fishing, motorcycling (or standing next to a motorcycle), on a jet ski, wind surf board, anything with a summer-type activity. Also need photos of women in or next to cars, women at a disco, woman with luggage or traveling." Pays $300-400; depending on dollar exchange rates. Will negotiate.
Color: Uses 35mm or larger transparencies. No prints.

OWL, 59 Front St. E., Toronto, Ontario, Canada M5E 1B3. (416)364-3333. Editor: Sylvia S. Funston. Magazine published 10 times/year. Circ. 80,000. Children's natural science magazine for ages 8-12 emphasizing relationships of all natural phenomena. Photos purchased with or without accompanying ms and on assignment. Buys approximately 200 photos/year. Pays $100-600 for text/photo package or on a per-photo or per-job basis. Credit line given. Pays on publication. Buys one time rights, nonexclusive to reproduce in *OWL* and *Chickadee* in Canada and affiliated children's magazines. Send material by mail for consideration. Provide business card and stock photo list. SASE. (Canadian postage, no American

postage.) Previously published work OK. Reports in 6-8 weeks. Sample copy available.
Subject Needs: Animal (not domesticated), documentary, photo feature, how-to (children's activities), nature (from micro to macro) photo puzzles and wildlife. Wants on a regular basis cover shots and centerfold close-ups of animals. No zoo photographs—all animals must be in their natural habitat. No staged photos or mood shots. Model release required; captions preferred.
B&W: Uses 8x10 glossy prints. Pays $10-25/photo.
Color: Uses original transparencies. Pays $40-200/photo.
Cover: Uses color transparencies. Vertical and horizontal formats required. Pays $40 minimum/photo, depending on size.
Accompanying Mss: Fully researched, well-organized presentation of facts on any natural history or science topic of interest to 8- to 12-year-old children. Pays $100 minimum/ms. Free writer's guidelines.
Tips: "Know your craft, know your subject and remember that children love surprises. We need cover shots of children, the appropriate age for our readership; close-ups of animals in their natural habitat that are unusual or humorous. Seasonal material e.g., Halloween, winter, summer, etc. These need to be a vertical format with room at top for logo."

PACIFIC BOATING ALMANAC, Box Q, Ventura CA 93002. (805)644-6043. Editor: Bill Berssen. Circ. 25,000. Emphasizes orientation photos of ports, harbors, marines; particularly aerial photos. For boat owners from Southeastern Alaska to Acapulco, Mexico. "We only buy specially commissioned art and photos." Query. Provide resume to be kept on file for possible future assignments. "No submissions, please."

PAINT HORSE JOURNAL, Box 18519, Fort Worth TX 76118. (817)439-3400. Editor: Bill Shepard. Emphasizes horse subjects—horse owners, trainers and show people. Readers are "people who own, show or simply enjoy knowing about registered paint horses." Monthly. Circ. 11,000. Sample copy $1; photo guidelines for SASE. Provide resume, business card, brochure, flyer and tearsheets to be kept on file for possible future assignments.
Photo Needs: Uses about 50 photos/issue; 3 of which are supplied by freelance photographers. "Most photos will show paint (spotted) horses. Other photos used include prominent paint horse showmen, owners and breeders; notable paint horse shows or other events; overall views of well-known paint horse farms. Most freelance photos used are submitted with freelance articles to illustrate a particular subject. The magazine occasionally buys a cover photo, although most covers are paintings. Freelance photographers would probably need to query before sending photos, because we rarely use photos just for their artistic appeal—they must relate to some article or news item." Model release not required; captions required. Wants on a regular basis paint horses as related to news events, shows and persons. No "posed, handshake and award-winner photos."
Making Contact & Terms: Query with resume of photo credits or state specific idea for using photos. SASE. Reports in 3-6 weeks. Pays on acceptance $7.50 minimum/b&w photo; $10 minimum/color transparency; $50 minimum/color cover photo; $50-250 for text/photo package. Credit line given. Buys first North American serial rights or per individual negotiation.

PALM BEACH LIFE, Box 1176, Palm Beach FL 33480. (305)837-4762. Design Director: Anne Wholf. Monthly magazine. Circ. 23,000. Emphasizes entertainment, gourmet cooking, affluent lifestyle, travel, decorating and the arts. For a general audience. Photos purchased with or without accompanying mss. Freelance photographers supply 20% of the photos. Pays $100-300/job, $200-350 for text/photo package or on a per-photo basis. Credit line given. Pays on publication. Query or make appointment. SASE. Simultaneous submissions OK. "*Palm Beach Life* cannot be responsible for unsolicited material." Reports in 4-6 weeks. Sample copy $3.50.
Subject Needs: Fine art, scenic, human interest and nature. Captions are required.
B&W: Uses any size glossy prints. Pays $10-25.
Color: Uses 35mm, 2¼x2¼ and 4x5 transparencies. Pays $25-50.
Cover: Uses color transparencies; vertical or square format. Payment negotiable.
Tips: "Don't send slides—make an appointment to show work. We have staff photographers, are really only interested in something really exceptional or material from a location that we would find difficult to cover. We are looking for dramatic, graphic covers of subjects relating to Florida or life-style of the affluent."

PARENTS MAGAZINE, 685 3rd Ave., New York NY 10017. (212)878-8700. Editor-in-Chief: Elizabeth Crow. Photo Editor: Dianna J. Caulfield. Emphasizes family relations and the care and raising of children. Readers are families with young children. Monthly. Circ. 1,670,000. Free sample copy and photo guidelines.
Photo Needs: Uses about 60 photos/issue; all supplied by freelance photographers. Needs family and/or children's photos. No landscape or architecture photos. Column needs are: fashion, beauty and food. Model release required. Pays ASMP rates for b&w; color: standard rates-/change yearly.

Making Contact & Terms: Works with freelance photographers on assignment only basis. Provide brochure and calling card to be kept on file for possible future assignments. Arrange for drop off to show portfolio. "Clifford Gardener, Art Director, and Dianna Caulfield, Photo Editor, see photographers by appointment. By looking at portfolios of photographers in whom we are interested we will assign a job." Report time depends on shooting schedule, usually 2-6 weeks. Payment depends on layout size. SASE. Credit line given. Buys one-time rights. No simultaneous submissions; previously published work OK.

PC WORLD, 555 De Haro, San Francisco CA 94107. (415)861-3861. Editor: Harry Miller. Monthly. Circ. 145,000. Emphasizes IBM personal computers and IBM-compatible computers. Readers are affluent, professional.
Photo Needs: Uses 15-25 photos/issue; 50% supplied by freelance photographers. Needs photos of equipment (computers) and photos of people using computers; trade shows. Special needs include "good indoor photos using flash equipment." Model release and captions preferred.
Making Contact & Terms: Provide resume, business card, brochure, flyer or tearsheets to be kept on file for possible future assignment. SASE. Reports in 2 weeks. Pays $100 minimum/b&w and $150 minimum/color inside photo; cover rates vary. Pays on publication. Credit line given. Buys all rights. Simultaneous submissions OK.

***PEACEMAKING FOR CHILDREN**, 2437 N. Grant Blvd., Milwaukee WI 53210. (414)445-9736. Editor: Jacqueline Haessly. Five times yearly; magazine. Emphasizes skills in peace building and conflict resolution; each issue focuses on a specific theme, children—ages 6-14. Circ. 3,000. Sample copy $1.
Photo Needs: All photos supplied by freelance photographers. Needs photos of children playing or working cooperatively; photos related to themes of each issue; featured Peace Heroes. Model release and captions required.
Making Contact & Terms: Query with list of stock photo subjects, send 2½x2½ to 9x12 glossy b&w prints by mail for consideration; provide resume, business card, brochure, flyer or tearsheets to be kept on file for possible future assignments. SASE. Reports in 3 weeks. "We have not yet used photos; we do use graphics and pay in 2 copies of magazine. This may change in fall 86." Pays on publication. Credit line given. Buys one-time rights. Simultaneous submissions and previously published work OK.

PENNSYLVANIA, Box 576, Camp Hill PA 17011. (717)761-6620. Editor: Albert E. Holliday. Quarterly. Emphasizes history, travel and contemporary issues and topics. Readers are 40-60 years old professional and retired; income average is $46,000. Circ. 21,000. Sample copy $2.50; photo guidelines free with SASE.
Photo Needs: Uses about 40 photos/issue; most supplied by freelance photographers. Needs include travel and scenic. Reviews photos with or without accompanying ms. Captions required.
Making Contact & Terms: Query with samples and list of stock photo subjects; send 5x7 and up b&w prints and 35mm and 2¼x2¼ transparencies by mail for consideration. SASE. Reports in 2 weeks. Pays $75-100/color cover photo, $10-25/inside b&w photo, $50-400/text/photo package. Credit line given. Buys one-time rights. Simultaneous submissions and previously published work OK.

PENNSYLVANIA GAME NEWS, Box 1567, Harrisburg PA 17105-1567. (717)787-3745. Editor: Bob Bell. Monthly magazine. Circ. 210,000. Published by the Pennsylvania Game Commission. For people interested in hunting in Pennsylvania. Buys all rights, but may reassign to photographer after publication. Model release preferred. Send photos for consideration. Photos purchased with accompanying ms. Pays on acceptance. Reports in 1 month. SASE. Free sample copy and editorial guidelines.
Subject Needs: Considers photos of "any outdoor subject (Pennsylvania locale), except fishing and boating."
B&W: Send 8x10 glossy prints. Pays $5-20.
Tips: Buys photos without accompanying ms "rarely." Submit seasonal material 6 months in advance.

PENNSYLVANIA OUTDOORS, Box 2483, Oshkosh WI 54903. (414)233-7474. Editor: Steve Smith. Emphasizes fishing, hunting and related outdoor activities. Photo guidelines free with a SASE; sample copy $2 with a SASE.
Photo Needs: Uses 15-20 photos/issue; all supplied by freelance photographers. Reviews photos with or without accompanying ms. Captions required.
Making Contact & Terms: Query with list of stock photo subjects; send 5x7 or larger glossy prints, 35mm and 2¼x2¼ transparencies and b&w contact sheet by mail for consideration; submit portfolio for review. SASE. Reports in 3-5 weeks. Pays $300-400/color cover photo, $25-250 b&w inside photo, $50-400/color inside photo. Pays on acceptance. Credit line given. Buys one-time rights. No simultaneous submissions. Previously published work OK.

THE PENNSYLVANIA SPORTSMAN, Box 5196, Harrisburg PA 17110. Contact: Editor. Eight times a year. Circ. 50,000. Emphasizes field sports—hunting, fishing, camping, boating and conservation in

Pennsylvania. "No ball sports." Photo guidelines free for SASE.
Photo Needs: Uses about 20-25 photos/issue; half supplied by freelance photographers. Needs "wildlife shots, action outdoor photography, how-to photos to illustrate outdoor items." Photos purchased with or without accompanying ms. Model release and captions preferred.
Making Contact & Terms: Send by mail for consideration 5x7 or 8x10 b&w glossy prints or 35mm or 2¼x2¼ slides or query with list of stock photo subjects. SASE. Reports in 6 weeks. Pays $75/slide for cover; $10/b&w or $20/color inside photo. Pays on publication. Credit line given. Buys one-time rights. Previously published work OK.

PENTHOUSE, 2nd Floor, 1965 Broadway, New York NY 10023-5965. (212)496-6100. Art Director: Richard Beleiweiss. Monthly magazine. Circ. 3,500,000. Emphasizes beautiful women, social commentary and humor. For men, age 18-34. Photos purchased with or without accompanying ms and on assignment. Pays on a per-job or per-photo basis. Credit line given. Pays on acceptance. Buys all rights. Send material by mail for consideration. SASE. Reports in 1 month. Photo guidelines free with SASE.
Subject Needs: Nudes and photo essay/photo feature. Model release required. Needs nude pictorials.
Color: Uses 35mm and 2¼x2¼ transparencies.

PERSONAL COMPUTING, 10 Mulholland Dr., Hasbrouck Height NJ 07604. (201)393-6000. Editor: Charles Martin. Art Director: Traci Churchill. Monthly. Circ. 550,000. Business magazine for personal computer users. Readers are "40-year-old business people, heads of household, earning $40,000 and up." Sample copy free with SASE.
Photo Needs: Uses about all photos/issue; all supplied by freelance photographers. Needs "illustrative photos of creative people with product shots. All have a personal computer worked into the shot." Most four-color, some b&w. Photos reviewed only if assigned; may be assigned with articles." Model release required; photo I.D. preferred.
Making Contact & Terms: Provide business card, resume, and tearsheets to be kept on file for possible future assignments. Reports in 1 month. Payment varies. Pays on acceptance. Credit line given. Buys all rights.

PETERSEN'S HUNTING MAGAZINE, Petersen Publishing Co., 8490 Sunset Blvd., Los Angeles CA 90069. (213)854-2222. Editor: Craig Boddington. Monthly magazine. Circ. 275,000. For sport hunters who "hunt everything from big game to birds to varmints." Buys 4-8 color and 10-30 b&w photos/issue. Buys one-time rights. Present model release on acceptance of photo. Send photos for consideration. Pays on publication. Reports in 3-4 weeks. SASE. Free photo guidelines.
Subject Needs: "Good sharp wildlife shots and hunting scenes. No scenic views or unhuntable species."
B&W: Send 8x10 glossy prints. Pays $25.
Color: Send transparencies. Pays $75-250.
Cover: Send color transparencies. Pays $350-500.
Tips: Prefers to see "photos that demonstrate a knowledge of the outdoors, heavy emphasis on game animal shots, hunters and action. Try to strive for realistic photos that reflect nature, the sportsman and the flavor of the hunting environment. Not just simply 'hero' shots where the hunter is perched over the game. Action . . . such as running animals, flying birds, also unusual, dramatic photos of same animals in natural setting." Identify subject of each photo.

PETERSEN'S PHOTOGRAPHIC MAGAZINE, 8490 Sunset Blvd., Los Angeles CA 90069. (213)854-2200. Publisher: Paul Pzimoulis. Editor: Bill Hurter. Monthly magazine. For the beginner and advanced amateur in all phases of still photography. Buys 1,500 annually. Buys all rights, but may reassign to photographer after publication. Send photos for consideration. Pays on publication. "Mss submitted to *Photographic Magazine* are considered 'accepted' upon publication. All material held on a 'tentatively scheduled' basis is subject to change or rejection right up to the time of printing." Reports in 3 weeks. SASE. Free photo guidelines.
Subject Needs: Photos to illustrate how-to articles: animal, documentary, fashion/beauty, fine art, glamour, head shot, human interest, nature, photo essay/photo feature, scenic, special effects and experimental, sport, still life, travel and wildlife. Also prints general artistic photos.
B&W: Send 8x10 glossy or matte prints. Captions required. Pays $25-35/photo, or $60/printed page.
Color: Send 8x10 glossy or matte prints or transparencies. "Color transparencies will not be accepted on the basis of content alone. All color presentations serve an absolute editorial concept. That is, they illustrate a technique, process or how-to article." Captions required. Pays $25/photo or $60/printed page.
Cover: Send 8x10 glossy or matte color prints or color transparencies. Captions required. "As covers are considered part of an editorial presentation, special payment arrangements will be made with the author/photographer."
Tips: Prints should have wide margins; "the margin is used to mark instructions to the printer." Photos

accompanying how-to articles should demonstrate every step, including a shot of materials required and at least one shot of the completed product. "We can edit our pictures if we don't have the space to accommodate them. However, we cannot add pictures if we don't have them on hand."

PHOEBE, The George Mason Review, 4400 University Dr., Fairfax VA 22030. (703)323-2168. Editor-in-Chief: David Canter. Quarterly. Circ. 5,000. Emphasizes literature and the arts. Sample copy $3.
Photo Needs: "We are looking for photographs with a high narrative content, conveyed through the subject matter or form. Our format favors vertical b&w photos, though we occasionally consider color photos for the cover." Photos accepted with or without accompanying ms.
Making Contact & Terms: Send by mail for consideration up to 8½x11 b&w prints. SASE. Reports in 4-6 weeks. Pays in contributor's copies. Pays on publication. Credit line given. Buys first North American serial rights.

PHOENIX HOME/GARDEN, 3136 N. 3rd Ave., Phoenix AZ 85013. (602)234-0840. Editor-in-Chief: Manya Winsted. Monthly. Circ. 32,000. Emphasizes homes, entertainment and gardens, life-style, fashion, travel, fitness and health. Readers are Phoenix-area residents interested in better living. Sample copy $2.
Photo Needs: Uses about 50 photos/issue; all supplied by freelance photographers. Needs photos of still lifes of flowers, food, wine and kitchen equipment. "Location shots of homes and gardens on assignment only." Photos purchased with or without accompanying ms. Model release and very specific identification required.
Making Contact & Terms: Arrange a personal interview to show portfolio, query with samples, list of stock photo subjects and tearsheets. Prefers b&w prints, any size transparencies and b&w contact sheets. SASE. Reports in 1 month. Provide resume and tearsheets to be kept on file for possible future assignments. Pays $25-40/b&w inside and $50-100/color inside for stock photos, by the job or by photographer's day rate. Pays on publication. Credit line given. Buys one-time rights for stock photos; all rights on assignments.
Tips: "The number of editorial pages has diminished as advertising pages increased, so we now use fewer photos."

PHOENIX MAGAZINE, 4707 N. 12th St., Phoenix AZ 85014. (602)248-8900. Editor: Robert J. Early. Monthly magazine. Circ. 40,000. Emphasizes "subjects that are unique to Phoenix: its culture, urban and social achievements and problems, its people and the Arizona way of life. We reach a professional and general audience of well-educated, affluent visitors and long-term residents." Buys 10-35 photos/issue.
Subject Needs: Wide range, all dealing with life in metro Phoenix. Generally related to editorial subject matter. Wants on a regular basis photos to illustrate features, as well as for regular columns on arts, restaurants, etc. No "random shots of Arizona scenery, etc. that can't be linked to specific stories in the magazine." Special issues: *Restaurant Guide*, *Valley "Superguide"* (January); *Desert Gardening Guide*, *Lifestyles* (March); *Summer "Superguide"* (June); *Phoenix Magazine's Book of Lists* (July); *Valley Progress Report* (August). Photos purchased with or without an accompanying ms.
Payment & Terms: B&w: $25-75; color: $50-200; cover: $250-400. Pays within two weeks of publication. Payment for manuscripts includes photos in most cases. Payment negotiable for covers and other photos purchased separately.
Making Contact: Query. Works with freelance photographers on assignment only basis. Provide resume, samples, business card, brochure, flyer and tearsheets to be kept on file for possible future assignments. SASE. Reports in 3-4 weeks.
Tips: "Study the magazine, then show us an impressive portfolio." Looking for pictures which tell a story, which show imagination and which demonstrate technical competence, especially in lighting techniques.

PHOTO COMMUNIQUE, Box 129, Station M, Toronto, Ontario, Canada M6S 4T2. (416)868-1443. Editor/Publisher: Gail Fisher-Taylor. Quarterly. Circ. 11,000. Emphasizes fine art photography for "photographers, critics, curators, art galleries and museums." Sample copy $3.50.
Photo Needs: Uses about 35 photos/issue; "almost all" supplied by freelance photographers. Model release preferred; captions required.
Making Contact & Terms: Send 8x10 b&w/color prints or 35mm or larger format transparencies by mail for consideration. SASE. Reporting time "depends on our schedule." Credit line given. Acquires one-time rights. Simultaneous submissions not accepted.
Tips: Prefers to see "strong, committed work. We are interested in seeing work of dedicated artists whose lives are committed to photography. Do not send us stock lists or brochures since we *never* are able to use them."

PHOTOGRAPHER'S MARKET, 9933 Alliance Rd., Cincinnati OH 45242. Editor: Connie Eidenier. Annual hardbound directory for freelance photographers. Credit line given. Pays on publication. Buys one time and promotional rights. Send material by mail for consideration. SASE. Simultaneous submissions and previously published work OK.

Subject Needs: "We hold all potential photos and make our choice in mid April. We are looking for photos you have sold (but still own the rights to) to buyers listed in *Photographer's Market*. The photos will be used to illustrate to future buyers of the book what can be sold. Captions should explain how the photo was used by the buyer, how you got the assignment or sold the photo, what was paid for the photo, your own self-marketing advice, etc. Reports after April deadline. For the best indication of the types of photos used, look at the photos in the book." Buys 20-50 photos/year.

B&W: Uses 5x7 or 8x10 glossy prints. Pays $25 plus complimentary copy of book for photos previously sold.

Murrysville, Pennsylvania, photographer, Hank Somma, took this photo on assignment for Pittsburgh Magazine. It appeared in the April 1986 issue. "After having shown my portfolio to the art director of Pittsburgh Magazine, I was given an assignment. The directions were as follows: Take a picture of Mrs. Hodges sitting down reading a book (she is the author of several children's books); bring out the character in the person; show her animated and lively and make her look ageless and timeless. After the photograph appeared in the magazine, I received a note from Mrs. Hodges which read in part," . . . The result was the best picture I have had taken in a long time . . .' "

PITTSBURGH MAGAZINE, 4802 5th Ave., Pittsburgh PA 15213. (412)622-1358. Art Director: Michael Maskarinec. Emphasizes culture, feature stories and public broadcasting television schedules. Readers are "city mag style, upwardly mobile." Monthly. Circ. 60,000. Sample copy $2.

Photo Needs: Uses 3 photos/issue, all supplied by freelance photographers. Needs b&w photos to illustrate stories; some color used. Column needs are: dining, sports. Model release and captions required.

Making Contact & Terms: Arrange personal interview to show portfolio. Reports in 2 weeks. Pays $50-100 for a b&w photo used inside; $600 maximum/cover and inside color; $250-400 by the day. Pays on publication. Credit line given. Buys one-time rights. Simultaneous submissions and previously published work OK.

PLANE & PILOT, HOMEBUILT AIRCRAFT, 16200 Ventura Blvd., Encino CA 91436. (818)986-8400. Art Director: J.R. Martinez. Monthly magazine. Emphasizes personal, business and home-built aircraft. Readers are private, business and hobbyist pilots. Circ. 70,000-100,000.

Photo Needs: Uses about 50 photos/issue; 90% supplied by freelance photographers. Needs photos of "production aircraft and homebuilt experimentals." Special needs include "air-to-air, technical, general aviation and special interest" photos. Written release and captions preferred.

Making Contact & Terms: Query with samples. Send 9x7 or 8x10 b&w glossy prints; 35mm transparencies; b&w contact sheets. SASE. Reports in 1 month. Pays $150-200 color cover photo; $25-50/ inside photo; $100-150/color inside photo; $500/job; $250-500/text/photo package. Pays on acceptance. Credit line given. Buys one-time rights. Simultaneous submissions and previously published work OK.
Tips: Prefers to see "a variety of well-shot and composed color transparencies and b&w prints dealing with mechanical subjects (aircraft, auto, etc.)" in samples. "Use good technique, a variety of subjects and learn to write well."

PLEASURE BOATING, 1995 NE 150th St., North Miami FL 33181. (305)945-7403. Managing Editor: Joe Green. Monthly. Circ. 30,000. Emphasizes recreational fishing and boating. Readers are "recreational boaters throughout the South." Free sample copy.
Photo Needs: Uses about 35-40 photos/issue. Needs photos of "people in, on, around boats and water." Model release and captions preferred.
Making Contact & Terms: Query with samples. Provide brochure to be kept on file for possible future assignments. SASE. Reports in 4 weeks. Pays $15-75/b&w photo; $25-200/color photo; $100-300/ color photo/feature illustrations; $250-375/day. Pays month of publication. Credit line given. Buys one-time rights and full rights. Simultaneous submissions OK.
Tips: Prefers 35mm slides, good quality. Prefers verticals, strong colors; people involved in water and/ or boating activity. "Contact editorial department on telephone regarding photos available. Submit in envelope with stiffner for protection. Include SASE."

PODIATRY MANAGEMENT, 401 N. Broad St., Philadelphia PA 14108. (215)925-9744. Editor: Dr. Barry Block. Photo Editor: Bob Gantz. Published 8 times/year. Emphasizes podiatry. Readers include podiatrists. Circ. 11,000. Free sample copy with 9x12 SASE.
Photo Needs: Uses 4 photos/issue; 3 supplied by freelance photographers. Needs cover—office or surgical shots. Reviews photos with accompanying ms only. Model release and captions required.
Making Contact & Terms: Query with resume of credits. SASE. Payment individually negotiated; $100-250. Pays on publication. Buys all rights.

POPULAR CARS MAGAZINE, 2145 W. LaPalma Ave., Anaheim CA 92801. Monthly magazine. Emphasizes "street machines, pro-style street cars, restored 'musclecars', drag race cars, all of the 1955-1986 vintage. Features include drag race coverage, show and event coverage. Technical is all performance oriented." Audience is predominantly male, 18-40 years of age. Circ. approx. 130,000. Send $1 and SASE for contributor's guidelines. Additional $2 for a sample copy. Guidelines cover photo and manuscript needs. Freelance content approximately 25-35%. Average rates: $110 for two-page (1 color, 1 b&w) car feature. $100-300 for feature/technical photo/text package. Pays on publication. Buys all rights. Address all inquiries "Attn Editor."
Tips: Looks for automotive work or features showing familiarity and enthusiasm for high-performance American-made cars. "Read *Popular Cars* for an idea of what we're looking for and send for one of our writer's/photographer's guidelines."

***POPULAR LURES**, 15115 S. 76 E. Ave., Bixby OK 74008. (918)366-4441. Editor/Photo Editor: Andre Hinds. Published 6 times/year magazine. Emphasizes freshwater and saltwater fishing. Readers are weekend anglers. Circ. 50,000. Estab. 1986. Sample copy free. Photo guidelines free.
Photo Needs: Uses 30 photos/issue; all supplied by freelance photographers. Needs photos of fishing action, lures and how-to; for cover "we need close-up of fish jumping in water with lure in its mouth." Captions required; 2 ID's are needed.
Making Contact & Terms: Query with samples. Send 5x7 b&w prints and 35mm transparencies by mail for consideration. Reports in 6 weeks. Pays $300/color cover photo; $25-100/color inside photo; $25/b&w file photo; $175-350 for text/photo package. Pays on acceptance or publication. Credit line given. Buys one-time rights. Simultaneous submissions and previously published work OK.
Tips: Prefers to see good, clear photos. No duplicate or very similar shots. "Look at our covers! This kind of cover treatment will be very big among all outdoor magazines in the coming year. Request a specific date for photos to be returned."

POPULAR PHOTOGRAPHY, 1 Park Ave., New York NY 10016. Editor: Sean Callahan. Executive Editor: Steve Pollock. Picture Editor: Monica R. Cipnic. Monthly magazine. Circ. 865,000. Emphasizes good photography, photographic instructions and product reports for advanced amateur and professional photographers. Buys 50+ photos/issue. "We look for portfolios and single photographs in color and b&w showing highly creative, interesting use of photography. Also, authoritative, well-written and well-illustrated how-to articles on all aspects of amateur photography." Buys first serial rights and promotion rights for the issue in which the photo appears; or all rights if the photos are done on as-

signment, but may reassign to photographer after publication. Present model release on acceptance of photo. Submit portfolio or arrange a personal interview to show portfolio. Pays on publication. Reports in 4 weeks. SASE. Previously published work generally OK "if it has not appeared in another photo magazine or annual." Free photo guidelines.

B&W: Send 8x10 semigloss prints. Captions are appreciated: where and when taken, title and photographer's name; technical data sheets describing the photo must be filled out if the photo is accepted for publication. Pays $150/printed page; but "prices for pictures will vary according to our use of them."

Color: Send 8x10 prints or any size transparencies. Captions required; technical data sheets describing the photo must be filled out. Pays $200/printed page; but "prices for pictures will vary according to our use of them."

Cover: Send color prints or color transparencies. Caption required; technical data sheets describing the photo must be filled out. Pays $500.

Tips: "We see hundreds of thousands of photographs every year; we are interested only in the highest quality work by professionals or amateurs." No trite, cornball or imitative photos. Submissions should be insured.

POPULAR SCIENCE, 380 Madison Ave., New York NY 10017. (212)687-3000. Art Director: W. David Houser. Monthly magazine. Circ. 1,850,000. Emphasizes new developments in science, technology and consumer products. Freelancers provide 25% of photos. Pays on an assignment basis. Credit line given. Pays on acceptance. Buys one-time rights and first North American serial rights. Model release required. Send photos by mail for consideration or arrange a personal interview. SASE. Reports in 1 month.

Subject Needs: Documentary photos related to science, technology and new inventions; product photography. Captions required.

B&W: Uses 8x10 glossy prints; pays $35 minimum.

Color: Uses transparencies. Pay variable.

Cover: Uses color covers; vertical format required.

Tips: "Our major need is for first-class photos of new products and examples of unusual new technologies. A secondary need is for photographers who understand how to take pictures to illustrate an article."

***POWDER MAGAZINE**, Box 1028, Dana Point CA 92629. (714)496-5922. Creative Director: Neil Stebbins. Published September through March. Circ. 100,000. Emphasizes skiing. Sample copy $1; photo guidelines free with SASE.

Photo Needs: Uses 70-80 photos/issue; 90% supplied by freelance photographers. Needs ski action, mountain scenics, skier personality shots. "At present, our only area where we have too few photographers is the East—Vermont, New Hampshire, Maine, New York." Model release preferred.

Making Contact & Terms: Query with samples or call to discuss requirements, deadlines, etc. SASE. Reports in 2 weeks. Pays $500/color cover photo; $200/color page, $50/color minimum. Pays on publication. Credit line given. Buys first North American serial rights. Simultaneous submissions OK.

Tips: "Edit your submissions to reflect an understanding of our readers' level of skiing—expert. Be creative. We *are* a market for experimental photos as well as 'traditional' action shots. Call to discuss our needs and your preferences and abilities."

PRAYING, Box 281, Kansas City MO 64141. (800)821-7926. Editor: Art Winter. Photo Editor: Rich Heffern. Bimonthly. Emphasizes spirituality for everyday living. Readers include mostly Catholic laypeople. Circ. 12,000. Sample copy and photo guidelines free with SASE.

Photo Needs: Uses 12 photos/issue; 80% supplied by freelance photographers. Needs quality photographs which stand on their own as celebrations of people, relationships, ordinary events, work, nature, etc. Reviews photos with or without accompanying ms.

Making Contact & Terms: Query with samples; send 8x10 b&w prints by mail for consideration. SASE. Reports in 2 weeks. Pays $50/b&w cover, $25/b&w inside photo. Pays on publication. Credit line given. Buys one-time rights. Simultaneous submissions and previously published work OK.

Tips: Looking for "good *printing*, composition. We get a lot of really *poor* stuff! Know how to take and print a quality photograph."

***PREMIERE & UPFRONT MAGAZINES**, Box 24649, Nashville TN 37202. (615)329-1973. Editor: Jennifer Harris. *Premiere*: quarterly; *Upfront*: monthly. Magazines. Emphasizes concerts, performing arts. Circ. 100,000. Sample copy free with SASE.

Photo Needs: Uses 10-15 photos/issue; all supplied by freelance photographers. Needs photos related to concerts, performing artists and fine arts. Model release and captions preferred.

Making Contact & Terms: Query with list of stock photo subjects; send color prints and 35mm transparencies by mail for consideration; provide resume, business card, brochure, flyer or tearsheets to be kept on file for possible future assignments. SASE. Reports in 1 month. Pay negotiated. Pays on publication. Credit line given. Buys one-time rights. Previously published work OK.

PRESBYTERIAN SURVEY, 341 Ponce de Leon Ave. NE, Atlanta GA 30365. (404)873-1531. Art Director: Linda Colgrove. Ten issues/year. Circ. 195,000. Emphasizes religion and moral values. Readers are members of the Presbyterian Church. Sample copy $2 with SASE.
Photo Needs: Uses about 35 photos/issue; 10 supplied by freelance photographers. Needs "photos to illustrate the articles, sometimes how-to, scenic, people, countries, churches." Model release and captions preferred.
Making Contact & Terms: Query with samples or list of stock photo subjects; send prints or contact sheet by mail for consideration. SASE. Reports in 8 weeks. Pays $100 maximum/b&w cover photo, $200 maximum/color cover photo, $30 maximum/b&w inside photo; $50 maximum/color inside photo. Pays on acceptance. Credit line given. Buys one-time rights. Simultaneous submissions and previously published work OK.

PRESENT TENSE, 165 E. 56th St., New York NY 10022. (212)751-4000. Editor: Murray Polner. Photo Editor: Ira Teichberg. Quarterly magazine. Circ. 45,000. Emphasizes Jewish life and events in US and throughout the world for well-educated readers. Photos purchased with or without accompanying ms. Buys 100 photos/year, 25/issue. Credit line given. Pays on publication. Buys one-time rights. Arrange personal interview to show portfolio; query with list of stock photo subjects; query with photo essay ideas. Provide business card, letter of inquiry and samples to be kept on file for possible future assignments. SASE. Reports in 1 month.
Subject Needs: "Subjects of Jewish interest only." Prefers photojournalism essays and documentary and human interest photos. Model release and captions required.
B&W: Uses 8x10 glossy prints; contact sheet OK. Negotiates pay.
Cover: Query with b&w contact sheet.

***PREVENTION MAGAZINE**, 33 E. Minor St., Emmaus PA 18049. (215)967-5171, ext. 1709. Editor: Mark Bricklin. Photographer: Angelo M. Caggiano. Monthly magazine. Emphasizes health. Readers are mostly female, 35-50, up scale. Circ. 2,500,000.
Photo Needs: Uses 12-15 photos/issue; 1-3 supplied by freelance photographers. Photo needs very specific to editorial, health, beauty, food. Model release and captions required.
Making Contact & Terms: Provide resume, business card, brochure, flyer or tearsheets to be kept on file for possible future assignments; tearsheets and/or dupes very important. Does not return unsolicited material. Reports in 2 weeks. Pays $75/b&w page; $150/color page. Pays on publication. Credit line given. Buys one-time rights, all rights, and non-exclusive rights.
Tips: Prefers to see ability to do many things very well.

***PREVIEWS MAGAZINE**, Suite 245, 919 Santa Monica Blvd., Santa Monica CA 90401. (213)458-3376. Editor: Jan Loomis. Monthly magazine. *Previews* is a community magazine for West Los Angeles. Readers are affluent, well-educated, average age 39; 50% college educated. Circ. 40,000. Sample copy available for large size envelope and 73¢ postage.
Photo Needs: Uses 15 photos/issue; all supplied by freelance photographers. Needs photos of travel, locally oriented to story. Will review photos with accompanying ms only. Model release required; captions preferred.
Making Contact & Terms: Arrange a personal interview to show portfolio. SASE. Reports in 1 month. Pays $100/b&w cover photo; $35/b&w inside photo. Pays on publication. Credit line given. Buys all rights.
Tips: Prefers to see style, clarity, creativity. "Be organized, meet deadlines, etc."

PRIME TIME SPORTS & FITNESS, Box 6091, Evanston IL 60204. (312)864-8113 or 276-2143. Editor: Dennis A. Dorner. Executive Editor: Nicholas Schmitz. Bimonthly magazine. Emphasizes "recreational sports, and fashion, tennis, bodybuilding, racquetball, swimming, handball, squash, running." Readers are "high-income health club users." Circ. 29,000. Sample copy free with SASE. Photo guidelines free with SASE.
Photo Needs: Uses about 100 photos/issue; 80 supplied by freelance photographers. Needs photos of "sports fashion with description; specific and general fitness photo features such as aerobics, exercises and training tips; any other sport mentioned." Special needs include "photo sequences explaining various training techniques in recreational sports and exercises." Model release required; captions preferred.
Making Contact & Terms: Query with samples and with list of stock photo subjects. Send b&w or color glossy prints by mail for consideration. Submit portfolio for review. "Query by phone as to what you might have first if possible." SASE. Reports in 1-6 weeks. Pays $25-150/text/photo package. Pays on publication. Credit line given. Buys all rights. "We will return rights to photographer after use of photo with permission for us to use elsewhere." Simultaneous submissions and previously published work OK.

Tips: "We are in constant need for aerobic, exercise, sports training pieces, and sports fashion with detailed fashion explanations. Be aware of subject matter. Women in sports can be the best way of breaking into our publication."

PROBLEMS OF COMMUNISM, U.S. Information Agency, Room 402, 301 4th St. SW, Washington DC 20547. (202)485-2230. Editor: Paul A. Smith, Jr. Photo Editor: Wayne Hall. Bimonthly magazine. Circ. 34,000. Emphasizes scholarly, documented articles on politics, economics and sociology of Communist societies and related movements. For scholars, government officials, journalists, business people, opinion-makers—all with higher education. Needs "current photography of Communist societies, leaders and economic activities and of related leftist movements and leaders. We do not want nature shots or travelogues, but good incisive photos on economic and social life and political events. Although the magazine is not copyrighted, it does bear the following statement on the index page: 'Graphics and pictures which carry a credit line are not necessarily owned by *Problems of Communism*, and users bear responsibility for obtaining appropriate permissions.' " Query first with resume of credits, summary of areas visited, dates and types of pix taken. Pays on acceptance. Reports in 1 month. SASE. Simultaneous submissions and previously published work OK. Free sample copy and photo guidelines.
B&W: Uses 8x10 glossy prints. "Captions with accurate information are essential." Pays $45-75.
Color: "We occasionally convert transparencies to b&w when no appropriate b&w is available." Uses 35mm transparencies. Captions required. Pays $45-75.
Cover: Uses 8x10 glossy b&w prints. Also uses 35mm color transparencies, but will be converted to b&w. "The stress is on sharp recent personalities in Communist leaderships, although historical and mood shots are occasionally used." Pays $50-150.
Tips: "Photos are used basically to illustrate scholarly articles on current Communist affairs. Hence, the best way to sell is to let us know what Communist countries you have visited and what Communist or leftist movements or events you have covered."

THE PROGRESSIVE, 409 E. Main St., Madison WI 53703. (608)257-4626. Art Director: Patrick JB Flynn. Monthly. Circ. 50,000. Emphasizes "political and social affairs—international and domestic." Sample copy $1.07 postage.
Photo Needs: Uses about 10 b&w photos/issue; all supplied by freelance photographers and photo agencies. Needs photos of "political people and places (Central America, Middle East, Africa, etc.)." Special photo needs include "Third World societies, and labor activities, antinuke and war resistance." Captions and credit information required.
Making Contact & Terms: Query with samples or with list of stock photo subjects; provide tearsheets to be kept on file for possible future assignments. SASE. Reports in 1 month. Pays $200/b&w cover photo; $25-75/b&w inside photo; $100/b&w full-page. Pays on publication. Credit line given. Buys one-time rights. Simultaneous submissions and previously published work OK.
Tips: "We are open to photo-essay work by creative photographers."

PSYCHIC GUIDE, Box 701, Providence RI 02901. (401)351-4320. Editor: Paul Zuromski. Quarterly. Emphasizes new age, natural living, metaphysical topics. Readers are split male/female interested in personal transformation and growth. Circ. 125,000. Sample copy $3.95.
Photo Needs: Uses 10-15 photos/issue; 5-10 supplied by freelance photographers. Needs inspirationals, natural scenes, paranormal photography; photos that are uplifting, spiritual (not religious) and illustrative of the New Age. Model release and captions required.
Making Contact & Terms: Query with samples, provide resume, business card, brochure, flyer or tearsheets to be kept on file for possible future assignments. SASE. Reports in 1-3 months. Pays $10-200/job. Pays on publication. Credit line given. Buys first North American serial rights. Previously published work OK.

***PUBLISHING CONCEPTS CORP.**, Main St., Luttrell TN 37779. Editor-in-Chief: Boyce E. Phipps. Circ. 60,190. "We publish several publications and work submitted on a freelance basis may be considered for any one." Publications emphasize the unusual, human interest and national interest for general middle- to upper-income readers. Sample copy and photo guidelines free with SASE.
Photo Needs: Uses about 20 photos/issue; 15 supplied by freelance photographers. Needs shots depicting travel, the unusual and scenic. Photos purchased with accompanying ms only. Model release required.
Making Contact & Terms: Query with list of stock photo subjects or send by mail for consideration 8x10 b&w or color prints with b&w or color negatives. SASE. Reports in 1 week. Provide resume and business card or letter to be kept on file for possible future assignments. Pays $100-150/color cover; $10 minimum/b&w inside; $10-100/job. Pays on acceptance. Credit line given "if requested." Buys first North American serial rights. Previously published work OK.

THE QUARTER HORSE JOURNAL, Box 32470, Amarillo TX 79120. (806)376-4811. Editor: Audie Rackley. Monthly magazine. Circ. 77,000. Emphasizes breeding and training of quarter horses. Buys first North American serial rights and occasionally buys all rights. Photos purchased with accompanying ms only. Pays on acceptance. Reports in 2-3 weeks. SASE. Free sample copy and editorial guidelines.
B&W: Uses 5x7 or 8x10 glossy prints. Captions required. Pays $50-250 for text/photo package.
Color: Uses 2¼x2¼, 35mm or 4x5 transparencies and 8x10 glossy prints; "we don't accept color prints on matte paper." Captions required. Pays $50-250 for text/photo package.
Cover: Pays $150 for first publication rights.
Tips: "Materials should be current and appeal or be helpful to both children and adults." No photos of other breeds.

RACING PIGEON PICTORIAL, 19 Doughty St., London, WCIN 2PT England. (01)242-0565. Editorial Assistant: R.W. Osman. Monthly magazine. Circ. 15,000. Emphasizes how-to and scientific pieces concerning racing pigeons. Freelancers supply 20% of photos. Manuscript preferred with photo submissions. Credit line given. Pays on publication. Prefers to buy all rights but will negotiate. Send material by mail for consideration. SASE and International Reply Coupons. Previously published work OK. Reports in 3 weeks. Sample copy $2.
B&W: Uses 8x10 and 11x14 glossy and semigloss prints. Pays $10 and up/photo.
Color: Uses transparencies. Pays $20 and up/photo.
Cover: Uses color covers; square format preferred. Pays $30 and up.
Accompanying Mss: Prefers a ms with photo submissions. Anything connected with racing pigeons considered. Pays $30-120 for text/photo package.

RADIO-ELECTRONICS, 500B Bi-County Blvd., Farmingdale NY 11783. (516)293-3000. Editorial Director: Art Kleiman. Monthly magazine. Circ. 221,000. Consumer publication. Emphasizing practical electronics applications for serious electronics activists and pros. Photos purchased with accompanying ms. Buys 3-4 photos/issue. Pays $25-250/job; $100-350 for text/photo package; or on a per-photo basis. Credit line given on request. Buys all rights, but may reassign other rights after publication. Query with samples. SASE. Reports in 2 weeks. Free sample copy.
Subject Needs: Photo essay/photo feature, spot news and how-to "relating to electronics." Model release required; captions preferred.
B&W: Uses 5x7 glossy prints. Pays $25 minimum/photo, included in total purchase price with ms.
Color: Uses 35mm, 2¼x2¼ or 4x5 transparencies. Pays $25 minimum/photo, included in total purchase price with ms. Color rarely used.
Cover: Uses 35mm, 2¼x2¼, 4x5 or 8x10 color transparencies. Pays $100-350/photo.
Accompanying Mss: Articles relating to electronics, especially features and how-to's. Pays $100-350. Free writer's guidelines.

RANGER RICK, 1412 16th St. NW, Washington DC 20036-2266. Photo Editor: Robert L. Dunne. Monthly magazine. Circ. 700,000. For children interested in the natural world, wildlife, conservation and ecology; age 6-12. Buys 400 photos annually; 90% from freelancers. Credit line given. Buys first serial rights and right to reuse for promotional purposes at half the original price. Submit portfolio of 20-40 photos and a list of available material. Photos purchased with or without accompanying ms, but query first on articles. Pays 3 months before publication. Reports in 2 weeks. SASE. Previously published work OK. Sample copy $1.50; free photo guidelines.
Subject Needs: Wild animals (birds, mammals, insects, reptiles, etc.), humorous (wild animals), pet animals children would keep (no wild creatures), nature (involving children), wildlife (US and foreign), photo essay/photo feature (with captions), celebrity/personality (involved with wildlife—adult or child)

> **66** *We are always eager to see new material. We are assigning in-depth boat text/photo sessions in all parts of the country. Nautical experience a plus. We're looking for photographers with a journalistic approach. Action photos of boats particularly sought. Tone should be candid, fresh.* **99**
>
> —*Tom Bakes, The Small Boat Journal*

and children (age 6-12) doing things involving wild animals, outdoor activities (caving, snowshoeing, backpacking), crafts, recycling and helping the environment. No plants, weather or scenics. No soft focus, grainy, or weak color shots.
B&W: Uses 8x10 prints; prefers matte-dried glossy paper. Pays $60-180.
Color: Uses original transparencies. Pays $180 (half page or less); $480 (2-page spread).
Cover: Uses original color transparencies. Uses vertical format. Allow space in upper left corner or across top for insertion of masthead. Prefers "rich, bright color." Pays $300.
Tips: "Come in close on subjects." Wants no "obvious flash." Mail transparencies inside 20-pocket plastic viewing sheets, backed by cardboard, in a manila envelope. "Don't waste time and postage on fuzzy, poor color shots. Do your own editing (we don't want to see 20 shots of almost the same pose). We pay by reproduction size. We are extending our subject boundaries somewhat beyond strictly nature/wildlife. For example totempoles, hot air ballooning and kids sailing small boats. Check *printed* issues to see our standards of quality which are high. Looking for fresh, colorful, clean images. New approaches to traditional subject matter welcome."

***REASON MAGAZINE**, 2716 Ocean Park Blvd., Santa Monica CA 90405. (805)963-5993. Editor: Marty Zupan. Photo Editor: Laura Main. Monthly magazine. Emphasizes public policy. Readers are well-educated, high income, fairly young—average-mid-30's. Circ. 30,000. Sample copy free with SASE.
Photo needs: Uses 10-12 photos/issue; most supplied by freelance photographers. Needs photos of particular people, places, and cities, etc., businesses, some high-tech products. Model release required; captions preferred.
Making Contact & Terms: Query with samples and list of stock photo subjects; send matte/glossy b&w and color prints by mail for consideration; provide resume, business card, brochure, flyer or tearsheets to be kept on file for possible future assignments. SASE. Reports in 2 weeks. Pays $150-250/b&w cover photo; $250-450/color cover photo; $50-175/b&w inside photo; $100-275/color inside photo; $35-85/hour. Pays on publication. Credit line given. Buys one-time rights. Simultaneous submissions OK.
Tips: Prefers to see shots of people—interesting portraits, etc.; editorial work.

REEVES JOURNAL, Box 30700, Laguna Hills CA 92654. (714)830-0881. Editor: Larry Dill. Monthly. Emphasizes plumbing, heating, and cooling industry in 14 Western states. Readers include primarily plumbing contractors, also wholesalers, manufacturers and government officials. Majority of features and major news stories involve Western industry members. Circ. 22,000. Free sample copy with SASE.
Photo Needs: Uses 20-30 photos/issue; very few supplied by freelance photographers. Needs unusual installations, special projects. Reviews photos with or without accompanying ms. Special needs include news photos concerning the plumbing, heating, cooling industry. Captions required.
Making Contact & Terms: Send 5x7 and 8x10 glossy b&w prints by mail for consideration; telephone queries accepted. SASE. Pays $50-100/color cover photo, $10/b&w inside photo, $15-25/color photo; other payment negotiable. Pays on publication. Credit line given. Buys one-time rights.
Tips: "We are looking for feature material on leading contractors in the West. Find a contractor who is working on an unusual or unique project and let us know about it. We are also always open for 'spot news' photos concerning the industry."

***RENO/TAHOE MAGAZINE**, Box 5400, Reno NV 89513. (702)786-2107. Editor/Photo Editor: Craig Beardsley. Summer issue magazine. Emphasizes tourism in the Reno and Lake Tahoe areas. Readers are tourists. Circ. 50,000. Estab. 1984. Sample copy $2. Photo guidelines free with SASE.
Photo Needs: Uses 5-6 photos/issue; 3-4 supplied by freelance photographers. Needs scenic shots of the Reno or Lake Tahoe areas, both summer and winter.
Making Contact & Terms: Send 35mm, 2¼x2¼, 4x5, 8x10 transparencies by mail for consideration. SASE. Reports "same day!" Pays $150/color cover photo; $50-100/color inside photo. Pays on publication. Credit line given. Buys one-time rights. Simultaneous submissions OK.

REVIEW OF OPTOMETRY, Chilton Way, Radnor PA 19380. (215)964-4376. Editor: Richard L. Guerrein. Photo Editor: Stan Herrin. Monthly. Emphasizes optometry. Readers include 22,000 practicing optometrists nationwide; academicians, students. Circ. 28,000.
Photo Needs: Uses 40 photos/issue; 8-10 supplied by freelance photographers. "Most photos illustrate news stories or features. Ninety-nine percent are solicited. We rarely need unsolicited photos. We will need top-notch freelance news photographers in all parts of the country for specific assignments." Model release preferred; captions required.
Making Contact & Terms: Provide resume, business card, brochure, flyer or tearsheets to be kept on file for possible future assignments, tearsheets and business cards or resumes preferred. Pay varies. Credit line given. Rights purchased vary with each assignment. Simultaneous submissions and previously published work OK.

RELIX MAGAZINE, Box 94, Brooklyn NY 11229. (212)645-0818. Editor: Toni A. Brown. Bimonthly. Circ. 20,000. Emphasizes rock and roll music. Readers are music fans, ages 13-40. Sample copy $2.50.
Photo Needs: Uses about 50 photos/issue; "almost all" supplied by freelance photographers. Needs photos of "music artists—in concert and candid, backstage, etc." Special needs: "Photos of rock groups, especially the Stones, Grateful Dead, Bruce Springsteen, San Francisco-oriented groups, etc."
Making Contact & Terms: Send 5x7 or larger b&w and color prints by mail for consideration. SASE. Reports in 1 month. "We try to report immediately; occasionally we cannot be sure of use." Pays $100-150/b&w or color cover; $50/b&w inside full page. Pays on publication. Credit line given. Buys all rights. Simultaneous submissions and previously published material OK.
Tips: "B&w photos should be printed on grade 4 or higher for best contrast."

RIVER RUNNER MAGAZINE, Box 2047, Vista CA 92025. (619)744-7170. Editor: Mark C. Larson. Bimonthly. Emphasizes whitewater river running. Readers are predominately male, college grads, aged 18-40. Circ. 15,000. Sample copy $2 and photo guidelines free.
Photo Needs: Uses 30 photos/issue; 25 supplied by freelance photographers. Needs shots of canoeing, kayaking, rafting or anything that might be of interest to outdoor enthusiasts. Reviews transparencies with or without accompanying ms.
Making Contact & Terms: Query with samples, with list of stock photo subjects; send b&w prints, 35mm transparencies by mail for consideration. SASE. Reports in 1 month. Pays $100/color cover, $10-25/inside b&w, $15-30/inside color photo, $50 minimum/text/photo package. Pays on publication. Credit line given. Buys first North American serial rights. Simultaneous submissions in nonrelated publications OK.

***ROAD KING MAGAZINE**, 23060 S. Cicero, Richton Park IL 60471. (312)481-9240. Editor: William A. Coop. Photo Editor: Rich Vurva. Quarterly magazine. Emphasizes trucks, truckers and trucking. Readers are over-the-road, long-haul truckers. Circ. 224,000. Sample copy free with SASE.
Photo Needs: Uses 20-25 photos/issue; 10-15 supplied by freelance photographers. Needs photos of trucks, truckstops, and facilities, truckers. "We will need and use freelancers to accompany our reporters gathering stories. Our reporters also take back-up pictures simultaneously." Model release required.
Making Contact & Terms: "Let us know who you are, where you are, if you are available for story assignments and your day rate." SASE. Pays $150-250/text/photo package. Buys all rights.

THE ROANOKER, Box 12567, Roanoke VA 24026. (703)989-6138. Editor: Kurt Rheinheimer. Monthly. Circ. 10,000. Emphasizes Roanoke and western Virginia. Readers are upper income, educated people interested in their community. Sample copy $2.
Photo Needs: Uses about 60 photos/issue; less than 10 are supplied by freelance photographers. Need "travel and scenic photos in western Virginia; color photo essays on life in western Virginia." Model release preferred; captions required.
Making Contact & Terms: Send any size b&w or color glossy prints and transparencies by mail for consideration. SASE. Reports in 1 month. Payment negotiable. Pays on publication. Credit line given. Rights purchased vary. Simultaneous submissions and previously published work OK.

***THE ROBB REPORT—The Magazine for Connoisseurs**, One Acton Place, Acton MA 01720. (617)263-7749. Photo Researcher: Sarah Prince. Monthly. Emphasizes "the good life, e.g., yachting, exotic autos, investments, art, travel, lifestyle and collectibles." The magazine is aimed at the connoisseur who can afford an affluent lifestyle. Circ. 50,000.
Subject Needs: Uses 30-50 photos/issue. Generally uses existing photography; freelance work is assigned once story manuscripts have been reviewed for design treatment.
Specs: Uses 35mm (Kodachrome preferred), 2¼x2¼, 4x5 or 8x10 color transparencies.
Payment & Terms: Pay is individually negotiated prior to assignment. Rates vary depending on whether photography purchased is stock or assigned. Pays on publication. Prefers to buy all rights, but will negotiate. Credit lines given. Captions preferred.
Making Contact: Arrange a personal interview to show portfolio or send promotional mailers to be kept on file for possible future assignments. Photo guidelines are free with a SASE. Reports within 1 month.

ROCHESTER WOMEN MAGAZINE, 771 Ridge Rd., Webster NY 14580. (716)671-1490. Editor: Carolyn Zaroff. Art Director: Chris Anderson. Monthly. Emphasizes women in professions, business, sports, high tech, consumer reports. Readers are upper demographic women aged 22-64. Circ. 20,000.
Photo Needs: Uses 8-12 photos/issue; all supplied by freelance photographers. Needs head shots-profiles; consumer for high tech and homestyles columns. Special needs include fall-spring fashions, women and computers, Christmas gift ideas. Model release and captions required.
Making Contact & Terms: Query with samples. Send 5x7 glossy b&w prints by mail for consider-

ation. Does not return unsolicited material. Pays $40/color cover photo and $5/inside b&w photo. Pays on publication. Credit line given. Buys one-time rights. Simultaneous submissions and previously published work outside of local region OK.

***ROCKBILL MAGAZINE**, 850 7th Ave., New York NY 10019. (212)977-7745. Editor: Robert Edelstein. Photo Editor: Cliff Sloan. Monthly magazine. Emphasizes music, rock and some film stars. Readers are 18-35 year old trendsetting nightlife club-goers. Circ. 500,000. Sample copy free with SASE.
Photo Needs: Uses 25 photos/issue; 20 supplied by freelance photographers. Needs photos of rock stars, studio and performance. Special needs include color only, no b&w. Captions preferred.
Making Contact & Terms: Query with samples and list of stock photo subjects; send unsolicited photos by mail for consideration; submit portfolio for review; provide resume, business card, brochure, flyer or tearsheets to be kept on file for possible future assignments. Send any size, glossy color prints, 35mm, 2¼x2¼, 4x5, 8x10 transparencies; color contact sheet by mail for consideration. SASE. Reports in 2 weeks. Pay negotiable depending on size, placement and rights. Pays on publication. Credit line given. Rights negotiable. Simultaneous submissions and previously published work OK.
Tips: Prefers either candid shots good for gossip column or colorful, clean shots for cover. "I'm a 'facial expression' man but I'm open to all."

RODALE'S NEW SHELTER, 33 E. Minor St., Emmaus PA 18049. Photo Editor: Mitch Mandel. Published 9 times/year. Circ. 700,000. Emphasizes home design, home management and home renovation. Readers are 30-50 year old male, college educated homeowners. Free sample copy and photo guidelines with photo samples and SASE.
Photo Needs: Uses 50-75 photos/issue; ⅓ supplied by freelance photographers. "We need attractive, practical single-family homes, and other residential projects, i.e., kitchens, baths, remodelings, additions, etc. All projects must be unique and well designed. We have ongoing needs for stock photos of greenhouses, solar heating and cooling devices, and other energy-related home improvements." Photos purchased with or without accompanying ms. Model release required; captions preferred "or at least background information for us to caption."
Making Contact & Terms: Query with list of stock photo subjects or send by mail for consideration 8x10 b&w prints; 35mm, 2¼x2¼, 4x5 transparencies or b&w contact sheets. SASE. Reports in 1 month. Provide resume, business card, brochure and flyer to be kept on file for possible future assignments. Pays $300/color cover, $35-100/b&w inside, $75-200/color inside. Pays upon publication. Credit line given. Buys all rights for assignment work, one-time rights for stock purchases. Previously published work OK.
Tips: "We do a lot of contract assignment work, and are constantly looking for top quality photographers across the country. We invite inquiries, which will be handled as they arrive, on a case-by-case basis."

***RODALE'S ORGANIC GARDENING**, 33 E. Minor St., Emmaus PA 18049. (215)967-5171. Editor: Stevie Daniels. Photo Editor: Alison Miksch. Monthly magazine. Emphasizes gardening. Readers are gardeners. Circ. 1.2 million. Sample copy free with SASE. Photo guidelines free with SASE.
Photo Needs: Uses 20 photos/issue; 25% supplied by freelance photographers. Needs photos of vegetable and plant varieties, how-to, ornamentals, fruits. Special needs include cover images of gardens, natural gardening techniques: composting, transplanting, mulching, interplanting, herebaries. Model release and captions required.
Making Contact & Terms: Query with samples and list of stock photo subjects. Reports in 2 weeks. Pays $100/b&w cover photo; $200-400/color cover photo; $50-75/b&w inside photo; $100-150/color inside photo. Pays on acceptance. Credit line given. Buys all rights and non-exclusive rights. Simultaneous submissions OK.
Tips: Read the publication, understand the magazine's photographic needs.

RUNNER'S WORLD, 135 N. 6th St., Emmaus PA 18049. (215)967-5171. Editor: Daivd Bumke. Photo Editor: Margaret Skrovanek. Monthly magazine. Emphasizes running. Readers are median aged: 32, 65% male; median income $37,000, college-ed. Circ. 300,000. Photo guidelines free with SASE.
Photo Needs: Uses 65 photos/issue; 55 supplied by freelance photographers. Needs photos of action, features, photojournalism. Model release and captions preferred.
Making Contact & Terms: Query with samples; send b&w and color prints and 35mm transparencies by mail for consideration; submit portfolio for review; provide resume, business card, brochure, flyer or tearsheets to be kept on file for possible future assignments. SASE. Pays as follows: color—$200/full page, $125/half page, $75/quarter page, $300/spread; b&w—$100/full page, $60/half page, $35/quarter page, $150/spread. Cover shot negotiable. Pays on publication. Credit line given. Photographic rights vary with assignment. Simultaneous submissions and previously published work OK.

Tips: "Become familiar with the publication and send photos in on spec. Also send samples that can be kept in our source file. Show full expanse of expertise—color transparencies that can be kept on file are preferred (dupes are fine). Both action and indoor strobe use if applicable, should be shown."

RUNNING TIMES, Suite 20, 14416 Jefferson Davis Hwgy., Woodbridge VA 22191. (703)643-1646. Editor: Edward Ayres. For runners, racers and others interested in fitness. Monthly. Circ. 41,000.
Photo Needs: Uses 15-20 photos/issue; 75% supplied by freelance photographers. Selection is based on news appeal, technical and artistic qualities. Needs poster style and personality photos, people racing, running (with scenic backgrounds). "Overall aesthetics of picture might be as valuable to us as the running aspect." Department needs: Running Shorts, photos to accompany humor and anecdotes. Model release required only in cases where runner is not in race or public event; captions preferred (but not essential).
Making Contact & Terms: Send by mail for consideration actual b&w 5x7 or 8x10 glossies or 35mm color transparencies. SASE. Reports in 4-8 weeks. Pays on publication $25-60/b&w photo; $30-100/color inside; $200-250/cover. Buys one-time rights. Indicate if simultaneous submission; previously published work OK if so indicated. Sample copy $2; photo guidelines for SASE; mention *Photographer's Market*.
Tips: "We look for unusual angles or perspectives (the head-on finish line shot is a cliché), and for the significant moments in a competition. Photos of races should be submitted ASAP after the event; we often receive excellent photos a month or two after a race, when it's too late for publication."

***RURAL KENTUCKIAN**, Box 32170, Louisville KY 40232. (502)451-2430. Editor: Gary W. Luhr. Monthly magazine. Emphasizes Kentucky. Readers are Kentucky residents who receive electricity from the state's rural electric cooperatives. Circ. 300,000. Sample copy free with SASE.
Photo Needs: Uses 6-10 photos/issue; "nearly all" supplied by freelance photographers. Reviews photos with accompanying ms only. Captions preferred.
Making Contact & Terms: Query with samples and list of stock photo subjects; send unsolicited photos by mail for consideration. Send b&w and color prints, transparencies, and contact sheets by mail for consideration. Reports in 2 weeks. Pays $50/color cover photo; $50-250/text/photo package. Pays on acceptance. Credit line given. Buys one-time rights. Simultaneous submissions OK "if other submissions are outside Kentucky."

***RV'N ON**, 10417 Chandler Blvd., N. Hollywood CA 91601. Editor-in-Chief: Kim Ouimet. Monthly. Circ. 3,500. Official publication of the International Travel and Trailer Club, Inc. Emphasizes recreational vehicles and use. Readers are full- and part-time RVers. Sample copy 95¢.
Photo Needs: Uses at least 4 photos/year; "none at present" supplied by freelance photographers. "We have had no offers." Needs photos of the "outdoors in all seasons, people enjoying camping, wildlife, etc." Photos purchased with or without ms (300 word minimum for ms). Special needs: photos of unusual rigs, etc. Model release and captions required. Query first.
Making Contact & Terms: Query with resume of credits and samples. SASE. Reports in 1 month. Provide resume and tearsheets to be kept on file for possible future assignments. Payment in copies only. Credit line given. Buys one-time rights and some reprints.

SACRAMENTO MAGAZINE, 1021 Second St., Sacramento CA 95814. (916)446-7548. Editor: Nancy Martini. Managing Editor: Ann McCully. Art Director: Chuck Donald. Emphasizes business, government, culture, food, outdoor recreation, and personalities for middle- to upper middle class, urban-oriented Sacramento residents. Monthly magazine. Circ. 32,000. Free sample copy and photo guidelines.
Photo Needs: Uses about 40-50 photos/issue; mostly supplied by freelance photographers. "Photographers are selected on the basis of experience and portfolio strength. No work assigned on speculation or before a portfolio showing. Photographers are used on an assignment only basis. Stock photos used only occasionally. Most assignments are to area photographers and handled by phone. Photographers with studios, mobile lighting and other equipment have an advantage in gaining assignments. Darkroom equipment desirable but not necessary." Needs news photos, essay, avant-garde, still life, landscape, architecture, human interest and sports. All photography must pertain to Sacramento and environs. Captions required.
Making Contact & Terms: Send slides, contact sheets (no negatives) by mail or arrange a personal interview to show portfolio. Also query with resume of photo credits or mail portfolio. SASE. Reports up to 4 weeks. Pays $5-45/hour; pays on acceptance. Average payment is $15-20/hour; all assignments are negotiated to fall within that range. Credit line given on publication. Buys rights on a work-for-hire basis. Will consider simultaneous submissions and previously published work, providing they are not in the Northern California area.

SAIL, 34 Commercial Wharf, Boston MA 02110. (617)241-9500. Editor: Keith Taylor. Monthly magazine. Circ. 185,000. For audience that is "strictly sailors, average age 35, better-than-average education." Needs cover photos of racing or cruising. Buys first North American serial rights. Model release necessary "if model requires it." Send slides for consideration. Pays on publication. Reports in 1 month. SASE. Free sample copy and photo guidelines.
B&W: Send contact sheet or 8x10 prints. Captions required. Pays $50-250/photo.
Color: Send transparencies, Kodachrome preferred. Captions required. Pays $50-200/photo.
Cover: Send color transparencies. Uses vertical and horizontal format. Subject should fill the frame and shots should be "conceptually clear (readers should be able to discern the mood and context immediately; good *Sail* covers are usually but not always action shots)." Covers should portray people and boats acting in close interrelationship. Captions required. Pays $600/photo.
Tips: For photos used inside, "mss and photos usually bought as a package." Inside work not accompanying an article is mostly on commission and is discussed at the time of assignment. "We will return negatives and transparencies via certified mail whenever possible. Return envelope and postage requested."

SAILORS' GAZETTE, Suite 110, 337 22nd Ave. N., St. Petersburg FL 33704. (813)823-9172. Editor: Alice N. Eachus. Monthly. Emphasizes sailing in the Southeastern USA. Readers include sailors—both racing and cruising. Circ. 15,000. Sample copy $2.
Photo Needs: Uses 15 photos/issue; 10 supplied by freelance photographers. Needs sailing—action or personality. Prefers b&w 5x7 glossy lake and ocean gulf sailing shots. Reviews with or without accompanying ms. Model release and captions preferred.
Making Contact & Terms: Query with samples and list of stock photo subjects; send 5x7 glossy b&w prints by mail for consideration. SASE. Reports in 2 weeks. Pays $25/b&w cover photo $10-15/inside b&w photo. Pays on publication. Credit line given. Buys one-time rights. No simultaneous submissions or previously published work. "Must be sailing or we cannot use."

ST. LOUIS MAGAZINE, 612 N. 2nd, Box 88908, St. Louis MO 63188. (314)213-7200. Art Director: Jon Davis. Paid circ. 27,800. Emphasizes life in St. Louis for "those interested in the St. Louis area, recreation issues, lifestyles, etc."
Subject Needs: Celebrity/personality, documentary, fine art, scenic, local color, sport, human interest, travel, fashion/beauty and political. Photos purchased with or without accompanying mss. Freelancers supply 90% of the photos. Pays by assignment or on a per-photo basis.
Making Contact & Terms: Provide calling card, resume and samples to be kept on file for possible future assignments. Credit line given. Pays on publication. Arrange a personal interview or submit portfolio for review. SASE. Reports in 1 month. Sample copy $1.95 and free photo guidelines.
B&W: Uses 8x10 glossy prints. Pays $50-250/photo.
Color: Uses 35mm, 2¼x2¼ and 4x5 transparencies. Pays $100-300/photo.
Cover: Uses color covers only. Vertical format required. Pays $200-600/photo.
Tips: Prefers to see "b&w prints, color photos or transparencies of St. Louis people, events and places, fashion and history. Any printed samples, especially from magazines. Don't be a jack-of-all trades. Any photographer who has an 'I can do it all' portfolio is not as likely to get a general assignment as a specialty photographer."

***SAINT RAPHAEL'S BETTER HEALTH**, 1450 Chapel St., New Haven CT 06511. (203)789-3509. Managing Editor: Kelly Anthony. Bimonthly. Circ. 120,000. Emphasizes health, lifestyles, fitness, medicine. Sample copy $1.25.
Photo Needs: Uses about 40 photos/issue; some supplied by freelance photographers. Needs "cover photos, within health realm and always related to an article; check with editor." Model release required.
Making Contact & Terms: Provide resume, business card, brochure, flyer or tearsheets to be kept on file for possible future assignments. Pays $25-100/b&w photo; $175-350/color photo; $150-350/day. Pays on acceptance. Credit line given. Buys one-time or all rights. Simultaneous submissions and previously published work OK.
Tips: Looks for overall skill in technical areas: lighting, composition, intensity, creativity in capturing the best of the subject.

SALOME: A LITERARY DANCE MAGAZINE, 5548 N. Sawyer, Chicago IL 60625. (312)539-5745. Editor: E. Mihopoulos. Quarterly. Circ. 1,000. Emphasizes dance. Readers are the general public, dance oriented, students, librarians, etc. Sample copy $4 for double issues; photo guidelines free with SASE.
Photo Needs: Uses about 200-250 photos/issue; 80% supplied by freelance photographers. Needs "dance photos—any photo/photo collages relating to dance." Model release preferred; captions required.

This photo was submitted by Alice George, public relations director of the Chicago Repertory Dance Ensemble, to accompany a review that ran in Salome: A Literary Dance Magazine. *"I used the photo," explains Effie Mihopoulos,* Salome *editor, "because of the seemingly different characters portrayed, who all have their own roles to play in the dance. The photo is very precise, clearly defined. For both these reasons, I think it captures the reader's attention."*

Making Contact & Terms: Query with samples or submit portfolio for review or send b&w prints (no larger than 8½x11) by mail for consideration. SASE. Reports in 2 weeks. Pays with one copy of magazine the photo appears in. Pays on publication. Credit line given. Buys first North American serial rights. Previously published work OK, "but please specify date and source of previous publication."
Tips: Looks for "quality of photo's design, subject matter, relation to other photos already accepted in magazine. I am looking for clear, concise, attention-grabbing photos, images that are interesting to look at and are compelling."

SALT WATER SPORTSMAN, 186 Lincoln St., Boston MA 02111. (617)426-4074. Editor: Barry Gibson. Monthly magazine. Circ. 115,000. Emphasizes all phases of salt water sport fishing for the avid beginner-to-professional salt water angler. "Only strictly marine sportfishing magazine in the world." Buys 1-3 photos/issue (including covers) without ms; 20-30 photos/issue with ms. Pays $175-350 for text/photo package. Accepting slides and holding them for 1 year and will pay as used. Pays on acceptance. Buys one-time rights. Send material by mail for consideration or query with samples. SASE. Provide resume and tearsheets to be kept on file for possible future assignments. Reports in 1 month. Free sample copy and photo guidelines.
Subject Needs: Salt water fishing photos. "Think scenery with human interest, mood, fishing action, storytelling close-ups of anglers in action. Make it come alive—and don't bother us with the obviously posed 'dead fish and stupid fisherman' back at the dock. Wants, on a regular basis, cover shots, vertical Kodachrome (or equivalent) original slides depicting salt water fishing action or 'mood.' "
B&W: Uses 8x10 glossy prints. Pay included in total purchase price with ms, or pays $20-200/photo.
Color: Uses 8x10 glossy prints and 35mm or 2¼x2¼ transparencies. Pay included in total purchase price with ms, or pays $20-400/photo.
Cover: Uses 35mm and 2¼x2¼ transparencies. Vertical format required. Pays $400 minimum/photo.
Accompanying Mss: Fact/feature articles dealing with marine sportfishing in the U.S., Canada, Caribbean, Central and South America. Emphasis on how-to. Free writer's guidelines.
Tips: "Prefers to see a selection of fishing action or mood—no scenics, lighthouses, birds, etc.—must

be sport fishing oriented. Be familiar with the magazine and send us the type of things we're looking for. Example: no horizontal cover slides with suggestions it can 'be cropped' etc. Don't send Ektachrome slides. We're using more 'outside' photography—that is, photos not submitted with ms package. Take lots of verticals and experiment with lighting. Most shots we get are too dark.''

***SANTA BARBARA MAGAZINE**, 123 W. Padre, Santa Barbara CA 93105. (805)682-1812. Editor: Annette Burden. Photo Editor: Trish Reynales. Bimonthly magazine. Emphasizes Santa Barbara community and culture. Circ. 11,000. Sample copy $2.95.
Photo Needs: Uses 50-60 photos/issue; 40% supplied by freelance photographers. Needs portrait, environmental, architectural, travel, celebrity, et al. Reviews photos with accompanying ms only. Model release required; captions preferred.
Making Contact & Terms: Provide resume, business card, brochure, flyer or tearsheets to be kept on file for possible for future assignments; "portfolio dropoff Thursdays, pick up Fridays." Does not return unsolicited material. Reports in 4-6 weeks. Payment varies. Pays on acceptance. Credit line given. Buys first North American serial rights.
Tips: Prefers to see strong personal style and excellent technical ability.

SATELLITE DEALER, Box 53, Boise ID 83707. (208)322-2800. Editor: Howard Shippey. Monthly. Emphasizes home satellite television. Readers include retailers of satellite television equipment. Circ. 18,700. Sample copy and photo guidelines free with SASE.
Photo Needs: Uses 20-30 photos/issue; 5-10 supplied by freelance photographers. Needs "scenics that make use of satellite dishes; electronics shots; assignment photos." Reviews photos with or without accompanying manuscript. Model release preferred; captions required.
Making Contact & Terms: Query with samples. SASE. Reports in 1 month. Pays $150-300/color cover photo, $25-75/inside b&w photo, $50-100/inside color photo. Pays on publication. Credit line given. Buys all rights; "if we don't pay for film and developing, we will negotiate first rights." Previously published work OK.
Tips: Prefers to see "a shot that would be beautiful, with or without a dish in it" in a photographer's samples. "Keep shooting, keep writing queries and keep trying."

THE SATURDAY EVENING POST SOCIETY, Benjamin Franklin Literary & Medical Society, 1100 Waterway Blvd., Indianapolis IN 46202. (317)634-1100. Editor: Cory SerVaas, M.D. Photo Editor: Patrick Perry. Magazine published 9 times annually. Circ. 800,000. For family readers interested in travel, food, fiction, personalities, human interest and medical topics—emphasis on health topics. Needs photos of people and travel photos; prefers the photo essay over single submission. Prefers all rights, will buy first U.S. rights. Model release required. Send photos for consideration. Provide business card to be kept on file for possible future assignments. Pays on publication. Reports in 1 month. SASE. Simultaneous submissions and previously published work OK. Sample copy $4; free photo guidelines.
B&W: Send 8x10 glossy prints. Pays $50 minimum/photo or by the hour; pays $150 minimum for text/photo package.
Color: Send 35mm or larger transparencies. Pays $75 minimum; $300/cover photo.

SATURDAY REVIEW, 214 Massachusetts Ave. NE, Washington DC 20002. (202)547-1106. Art Director: Carla Frank. Bimonthly. Circ. 250,000. Emphasizes literature and the arts. Readers are literate and sophisticated. Sample copy $2.50.
Photo Needs: Uses 20 photos/issue; 80-100% supplied by freelance photographers. Needs "documentary photographs of writer/artist illustrating personality and lifestyle, including at least one representative environmental portrait." Model release preferred; captions required.
Making Contact & Terms: Query with samples; provide resume, business card, brochure, flyer or tearsheets to be kept on file for possible future assignments. Does not return unsolicited material. Reports in 1 month. Pays $100-200/color cover photo; $250-500/job. Pays within 30 days of publication. Credit line given. Buys one-time rights.
Tips: Prefers to see "photographer's ability to cover a human subject and show something of that subject's personality and lifestyle. We do *not* want one posed portrait after another. Variety and perserverence are the key. Also must be high in technical quality."

SCIENCE ACTIVITIES, 4000 Albemarle St. NW, Washington DC 20016. (202)362-6445. Managing Editor: Mrs. Dale Saul. Quarterly magazine. Circ. 1,600. Emphasizes classroom activities for science teachers. Reimbursement $5/photo used. Credit line given on request. Pays on publication. Send photos with ms for consideration. SASE. Reports in 3-4 months. Free sample copy and photo guidelines.
Subject Needs: How-to, "Any photos which illustrate classroom science activities. No photos accepted without ms. Write to editor for information on special theme issues planned."

B&W: Uses 5x7 glossy prints.
Color: Can use color prints, but will transfer to b&w. B&w strongly preferred.
Cover: Uses glossy b&w prints.
Accompanying Mss: Description of classroom science activities (such as teaching aids) for grades K through college. Free writer's guidelines.

SCIENCE DIGEST, 888 7th Ave., New York NY 10106. (212)262-6562. Picture Editor: Jodie Boublik. Monthly. Circ. 525,000. Emphasizes science. Readers are laymen age 18 + , college educated. Photo guidelines free with SASE.
Photo Needs: Uses about 60 photos/issue; 50% supplied by freelance photographers. Needs photos of "science: wildlife, archeology, technology, anthropology, astronomy, aerospace, biology, etc." Model release preferred; captions required.
Making Contact & Terms: Query with samples. SASE. Reports in 1 month. Pays $75-350/b&w inside photo; $125-450/color inside photo; $300/day. Pays on publication. Credit line given. Buys all magazine and periodical rights. Simultaneous submissions and previously published work OK.
Tips: "Propose story ideas that you would like to shoot that would be appropriate for the magazine."

SCIENCE 86, 11th Floor, 1333 H. St. NW, Washington DC 20005. (202)326-6767. Editor-in-Chief: Allen L. Hammond. Picture Editor: Barbara Moir. Readers are educated laymen who are interested in science but may not have a technical background. Pubished 10 times/year. Circ. 700,000. Free sample copy (mention *Photographer's Market*).
Photo Needs: Uses 30-40 photos/issue supplied by freelance photographers and agencies. Needs include photographs which explain or illustrate articles. Unsolicited photos should be accompanied by captions or ms. "Our subjects include natural and physical sciences, technology, medicine, astronomy, geology and profiles of scientific figures."
Making Contact & Terms: Send by mail for consideration science-related color transparencies (any size) or prints or clippings. Provide samples to be kept on file for possible future assignments. SASE. Reports in 1 month. Pays on publication $180/color quarter page. Credit line given. Buys one-time rights. No simultaneous submissions. Previously published work OK if so indicated.

SCIENCE OF MIND MAGAZINE, 3251 West Sixth St., Los Angeles CA 90020. (213)388-2181. Editor: John S. Niendorff. Associate Art Director & Photo Editor: Alicia E. Esken. Monthly. Emphasizes science of mind philosophy. Readers include positive thinkers, holistic healing, psychological thinkers. Circ. 100,000. Sample copy and photo guidelines free with SASE.
Photo Needs: Uses 7-10 photos/issue; 4-8 supplied by freelance photographers. Needs scenic nature, sensitive (e.g., baby, baby animals, people situations). Reviews with or without accompanying ms.
Making Contact & Terms: Send 5x7, 8x10 b&w prints, high quality duplicate 35mm transparencies by mail for consideration. SASE. Reports in 3 weeks. Pays $100/color cover photo, $25-60/inside b&w photo, $60-75/inside color photo. Pays on publication. Credit line given. Buys one-time rights unless otherwise specified. Simultaneous submissions and previously published work OK. Send work directly to Alicia E. Esken.
Tips: *1st contact* do not send more than 24 duplicate slides.

SCOPE, Box 1209, Minneapolis MN 55440. (612)330-3300. Contact: Karen Loewen. Monthly magazine. Circ. 310,000. For women of all ages who are interested in everything that touches their home, their careers, their families, their church and community. Needs action photos of family life, children and personal experiences. Buys 50-75 photos annually. Buys first North American serial rights. Model release not required. Send photos or contact sheet for consideration. Pays on acceptance or publication. Reports in 1 month. SASE. Simultaneous submissions and previously published work OK. Guidelines free with SASE.
B&W: Send contact sheet or 8x10 glossy prints. Pays $20-35/photo.
Cover: Send b&w glossy prints or 35mm or 2¼x2¼ color transparencies. Pays $40-100/photo.

SCORE, Canada's Golf Magazine, 287 MacPherson Ave., Toronto, Ontario Canada M4V 1A4. (416)928-2909. Managing Editor: Lisa A. Leighton. Magazine published 7 times/year. Emphasizes golf. "The foundation of the magazine is Canadian golf and golfers, but *Score* features U.S. and international male and female professional golfers, golf personalities and golf travel destinations on a regular basis." Readers are affluent, well-educated, 87% male, 13% female. "Most are members of private or semi-private golf clubs. Majority Canadian, others U.S. and foreign subscribers." Circ. over 170,000 + . Sample copy $2 (Canadian). Photo guidelines free with SAE with IRC.
Photo Needs: Uses between 15 and 20 photos/issue; approximately 85% supplied by freelance photographers. Needs "professional-quality, golf-oriented color and b&w material on prominent male and

female pro golfers on the US PGA and LPGA tours, as well as the European and other international circuits, prominent Canadians, scenics, travel, closeups and full-figure." Model releases (if necessary) and captions required.

Making Contact & Terms: Query with samples and with list of stock photo subjects. Send 8x10 or 5x7 glossy b&w prints and 35mm or 2¼x2¼ transparencies by mail for consideration. Provide resume, business card, brochure, flyer or tearsheets to be kept on file for possible future assignments. SAE with IRC. Reports in 3 weeks. Pays $75-100/color cover photo, $30/b&w inside photo, $50/color inside photo, $40-65/hour, $320-520/day, and $80-2,000/job. Pays on publication. Credit line given. Buys all rights. Simultaneous submissions OK.

Tips: "When approaching *Score* with visual material, it is best to illustrate photographic versatility with a variety of lenses, exposures, subjects and light conditions. Golf is not a high-speed sport, but invariably presents a spectrum of location puzzles: rapidly changing light conditions, weather, positioning, etc. Capabilities should be demonstrated in query photos. Scenic material follows the same rule. Specific golf hole shots are certainly encouraged for travel features, but wide-angle shots are just as important, to 'place' the golf hole or course, especially if it is located close to notable landmarks or particularly stunning scenery. Approaching *Score* is best done with a clear, concise presentation. A picture is absolutely worth a thousand words, and knowing your market and your particular strengths will prevent a mutual waste of time and effort. Sample copies of the magazine are available and any photographer seeking to work with *Score* is encouraged to investigate it prior to querying."

SEA, 1760 Monrovia, Costa Mesa CA 92627. (714)646-0173. Managing Editor: Cathi Douglas. Monthly magazine. Circ. 50,000. Emphasizes "recreational boating in 13 western states (including Alaska), Mexico and British Columbia for owners of recreational power and sail boats." Sample copy and photo guidelines free with SASE.

Photo Needs: Uses about 50 photos/issue; 30 supplied by freelance photographers. Needs "boating-oriented people, activity and scenics shots; shots which include parts or all of a boat are preferred." Special needs include "square or vertical-format shots involving sail or power boats for cover consideration." Photos should have west coast angle. Model release required; captions preferred.

Making Contact & Terms: Query with samples. SASE. Reports in 1 month. Pays $200/color cover photo; $15-25/b&w photo; $50-100/color inside photo; $25-50/hour; $50-250/day; $100-400/complete package. Pays on publication. Credit line given. Buys one-time rights.

Tips: "We look for action shots, interiors, studio shots and general composition; we want clear, crisp color and black and white prints or transparencies and prefer photographers with some knowledge of boating, though that is not a requirement. We buy cruising, profile, studio and action photographs." Send samples of work with a query letter and a resume outlining your photography experience.

SEEK, 8121 Hamilton Ave., Cincinnati OH 45231. (513)931-4050, ext. 365. Publisher: Ralph Small. Editor: Eileen H. Wilmoth. Photo Editor: Mildred Mast. Emphasizes religion/faith. Readers are church people—young and middle-aged adults. Quarterly, in weekly issues; 8 pages per issue; bulletin size. Circ. 60,000.

Photo Needs: Uses about 3 photos/issue; supplied by freelance photographers. Needs photos of people, scenes and objects to illustrate stories and articles on a variety of themes. Must be appropriate to illustrate Christian themes. Model release required.

Making Contact & Terms: Send by mail for consideration actual 8x10 b&w photos or query with list of stock photo subjects. SASE. "Freelance photographers submit assortments of b&w 8x10 photos that are circulated among all our editors who use photos." Reports in 4 weeks. Pays on acceptance $15-25/b&w photo. Credit line given. Buys first North American serial rights. Simultaneous submissions and previously published work OK if so indicated. Free sample copy with SASE.

Tips: "Make sure photos have sharp contrast. We like to receive photos of young or middle-aged adults in a variety of settings."

SELF, 350 Madison Ave., New York NY 10017. (212)880-8834. Editor-in-Chief: Phyllis Starr Wilson. Emphasizes self-improvement and physical and mental well being for women of all ages. Monthly magazine. Circ. 1,091,112.

Photo Needs: Uses up to 200 photos/issue; all supplied by freelancers. Works with photographers on assignment basis only. Provide tearsheets to be kept on file for possible future assignments. Pays $200 day rate. Needs photos emphasizing health, beauty, medicine and psychology relating to women.

***SELF-HELP UPDATE**, Box 38, Malibu CA 90265. (818)889-1575. Editor: Dick Sutphen. Quarterly magazine. Emphasizes metaphysical, psychic development, reincarnation, self-help with tapes. Everyone receiving the magazine has attended a Sutphen Seminar or purchased Valley of the Sun Publishing books or tapes from a line of over 300 titles: Hypnosis/meditation/New Age music/seminars on tape, etc. Circ. 120,000. Sample copy free with SASE (80¢ in stamps).

Photo Needs: "We purchase about 50 photos per year for the magazine and also for cassette album covers. We are especially interested in surrealistic photography which would be used as covers, to illustrate stories and for New Age music cassettes. Even seminar ads often use photos which we purchase from freelancers." Model release required.

Making Contact & Terms: Send b&w and color prints; 35mm, 2¼x2¼ transparencies by mail for consideration. SASE. Reports in 2 weeks. Pays $100/color photo; b&w negotiated. Pays on publication. Credit line given if desired. Buys one-time rights. Simultaneous submissions and previously published work OK.

SHAPE, 21100 Erwin St., Woodland Hills CA 91367. (213)884-6800. Editor: Christine MacIntyre. Photo Editor: Sonya Weiss. Monthly. Circ. 525,000. Emphasizes "women's health and fitness." Readers are "women of all ages."
Photo Needs: Uses about 40-50 photos/issue; all (including stock houses) supplied by freelance photographers on assignment, predominantly from the Los Angeles area. Needs "exercise, food, sports, psychological fitness and photo illustrations." Model release required.
Making Contact & Terms: Arrange a personal interview to show portfolio or send samples. SASE. Pays $25/b&w partial inside photo; $50/color partial inside photo. Pays on publication. Credit line given. Buys all rights (negotiable).

SIGNS OF THE TIMES, 407 Gilbert Ave., Cincinnati OH 45202. (513)421-2050. Editor: Tod Swormstedt. Art Director: Magno Relojo. Monthly plus a 13th "Buyer's Guide." Emphasizes the sign industry. Readers include sign and outdoor companies, graphic designers, architects, sign users. Circ. 17,000. Sample copy free with 8x11 SASE.
Photo Needs: Uses about 100 photos/issue; 2-3 supplied by freelance photographers. Needs sign industry related photos. Reviews with or without accompanying ms. Model release and captions preferred.
Making Contact & Terms: Query with samples. SASE. Reports in 2 weeks. Pay varies. Pays on publication. Credit line given. Buys one-time rights. Simultaneous submissions and previously published work OK.

***SINGLELIFE MILWAUKEE**, 606 W. Wisconsin Ave., Milwaukee WI 53203. (414)271-9700. Art Director: Dawn Kieweg. Bimonthly. Emphasizes recreation and special interests for single adults. Readers are 18- to 70-year-old single adults. Circ. 24,000. Sample copy free with SASE and $1.50 postage.
Photo Needs: Uses about 20 photos/issue; all supplied by freelance photographers. Need photos of skiing, biking, dining, dancing, picnics, sailing— single people, couples or groups of people in recreational settings. Model release and captions required.
Making Contact & Terms: Send b&w or color glossy prints, 2¼x2¼ transparencies, b&w contact sheet by mail for consideration. SASE. Pays $30-100/b&w photo; $40-300/color photo; $50-300/job. Pays on publication. Credit line given. Buys all rights. Previously published work OK.
Tips: "We look for recreational scenes (active and passive) of couples or individuals, in a portfolio. We also are getting very active in fashion photography."

SKI, 380 Madison Ave., New York NY 10017. (212)687-3000. Editor: Dick Needham. Monthly. Circ. 420,000. Emphasizes skiing for skiers.
Photo Needs: All photos supplied by freelance photographers, most assigned. Model release and captions required.
Making Contact & Terms: Send 35mm, 2¼x2¼ or 4x5 transparencies by mail for consideration. SASE. Reports in 1 week. Pays $700/color cover photo; $50-250/b&w inside photo, $75-350/color inside photo; $150/b&w page, $250/color page; $200-600/job; $500-850 for text/photo package. Pays on acceptance. Credit line given. Buys one-time rights.

SKI RACING MAGAZINE, Two Bentley Ave., Poltney VT 05764. (802)287-9090. Editor: Don A. Metivier. News Editor: Hank McKee. Published 20 times/year. Circ. 40,000. Emphasizes ski competition. Readers are "serious skiers, coaches, ski industry, ski press, all interested in photos of skiers in competition." Sample copy free with SASE.
Photo Needs: Uses about 20-25 photos/issue; most supplied by freelance photographers. Needs photos of "skiers in world class or top national competition, action shots, some head and shoulders, some travel shots of ski destinations. There are never enough new skier action photos." Captions required. "If photo is to be used in an ad, model release is required."
Making Contact & Terms: Send any size b&w and color glossy prints by mail for consideration; provide resume, business card, brochure, flyer or tearsheets to be kept on file for possible future assignments. SASE. Reports in 2 weeks. Pays $50/b&w cover photo; $15-50/b&w inside photo; $25-100/color photo. Pays on publication. Credit line given. Buys one-time rights. Simultaneous submissions OK.
Tips: "Take good pictures and people will buy them especially good *action* photos that fill the *entire*

frame. We need someone who can stop a downhill racer going 80 miles an hour through a blind gate at 10 below zero, so we can read the logo on his pants. We are taking all our photos in color print format—Fuji color 100 or 500; we make all our b&w prints from color negative film and keep the color for our annual.''

SKIING MAGAZINE, One Park Ave., New York NY 10016. (212)503-3500. Art Director: Barbara Rietschel. Published monthly (September through March). Circ. 435,000. Emphasizes skiing for Alpine skiers. Photo guidelines free with SASE.
Photo Needs: Uses 75-120 photos/issue; 75% supplied by freelance photographers. Needs photos of ski areas, famous people and competitions. Captions required.
Making Contact & Terms: Query with dupes, not original samples or with list of stock photo subjects; send 8x10 b&w matte or glossy prints, 35mm transparencies or b&w contact sheet by mail for consideration; submit portfolio for review; or provide resume, business card, brochure, flyer or tearsheets to be kept on file for possible future assignments. SASE. Reports in 1 month. Pays $750/color cover photo; $25 minimum/b&w inside photo, $50 minimum/color inside photo; $150/b&w page, $300/color page. Pays on acceptance. Buys one-time rights.
Tips: ''Show work *specifically* suited to *Skiing*—and be familiar with the magazine before submitting.''

SKIN DIVER, 8490 Sunset Blvd., Los Angeles CA 90069. (213)657-5100. Editor/Publisher: Bill Gleason. Executive Editor: Bonnie J. Cardone. Monthly magazine. Circ. 209,676. Emphasizes scuba diving in general, dive travel and equipment. ''The majority of our contributors are divers-turned-writers.'' Photos purchased with accompanying ms only; ''particularly interested in adventure stories.'' Buys 60 photos/year; 85% supplied by freelance photographers. Pays $50-100/published page. Credit line given. Pays on publication. Buys one-time rights. Send material by mail for consideration. SASE. Free sample copy and photo guidelines.
Subject Needs: Adventure; how-to; human interest; humorous (cartoons); wreck diving, game diving, local diving. All photos must be related to underwater subjects. Model release required; captions preferred.
B&W: Uses 5x7 and 8x10 glossy prints.
Color: Uses 35mm and 2¼x2¼ transparencies.
Cover: Uses 35mm color transparencies. Vertical format preferred. Pays $300.
Accompanying Mss: Free writer's guidelines.
Tips: ''Read the magazine; submit only those photos that compare in quality to the ones you see in *Skin Diver*.''

THE SMALL BOAT JOURNAL, Box 400, Bennington VT 05201. (802)447-1561. Editor: Tom Baker. Emphasizes good quality small craft, primarily for recreation, regardless of construction material or origin. ''Generally we mean boats 30' or less in length, but focus is primarily on those less than 23-feet long. Traditional, contemporary and unusual boats are all covered. Bimonthly. Circ. 53,000. Free sample copy and photo guidelines with 9x12 SAE and postage.
Photo Needs: Buys 30-40 photos/issue. Photos must be related to small boats and boat building. ''B&w often purchased with ms, but strong photo essays with full caption information welcome. Color covers should communicate the high excitement inherent in the ownership and use of small boats.'' No cute or humorous photos; scantily clad females; mundane points of view/framing/composition. Model release and captions required.
Specs: B&w film and contacts with 5x7 or 8x10 unmounted glossies; 35mm or larger transparencies for interior color or cover.
Making Contact & Terms: Query with samples. Works with photographers on assignment basis only. Provide resume, business card, brochure and tearsheets to be kept on file for possible future assignments. Prefers to see exterior photos with natural light, in a portfolio. Prefers to see tearsheets as samples. SASE. Pays $10-40/b&w; $50-150/interior color; $150 minimum/cover; $160/day; $100-500 for text/photo package. Pays on acceptance. Credit line given. Reports in 2-4 weeks. Free sample copy and photo guidelines with 9x12 SAE and postage.
Tips: ''We are always eager to see new material. We are assigning in-depth boat text/photo sessions in all parts of the country. Nautical experience a plus. We're looking for photographers with a journalistic approach. Action photos of boats particularly sought. Tone should be candid, fresh.''

SNOWMOBILE MAGAZINE, Suite 100, 11812 Wayzata Blvd., Minnetonka MN 55343. (612)545-2662. Senior Editor: C.J. Ramstad. Published 4 times/year. Emphasizes ''snowmobiles and snowmobiling, people, industry, places.'' Readers are 500,000 owners of two or more registered snowmobiles. Sample copy $2. Photo guidelines free with SASE.
Photo Needs: Uses about 70 photos/issue; 5 or more supplied by freelance photograhers. Needs ''scenic photography of winter, primarily with snowmobiles as primary subject interest—travel slant is need-

ed—people." Special needs include "scenics, great snowmobiling tour places, snowmobiling families and family activities, snowmobiles together with other winter activities." Written release preferred.
Making Contact & Terms: Query with samples. SASE. Reports in 1 month. Pays $250/color cover photo; $25 and up/b&w inside photo; $40 and up/color inside photo. Pays on publication. Credit line negotiable. Buys one-time rights. Simultaneous submissions and previously published work OK.
Tips: "Snowmobiling is a beautiful and scenic sport that most often happens in places and under conditions that make good pictures difficult . . . capture one of these rare moments for us and we'll buy."

SOAP OPERA DIGEST, 254 W. 31st St., New York NY 10001. (212)947-6300. Executive Editor: Meredith Brown. Art Director: Andrea Wagner. Biweekly. Circ. 850,000. Emphasizes daytime and nighttime TV serial drama. Readers are mostly women, all ages.
Photo Needs: Needs photos of people who appear on daytime and nighttime TV programs; special events in which they appear. Uses color and b&w photos.
Making Contact & Terms: Query with resume of credits to the art director. Do not send unsolicited material. Reports in 1 week. Provide business card and promotional material to be kept on file for possible future assignments. Pays $30-100/b&w photo; $60-150/color photo. Pays on publication. Credit line given. Buys all rights.
Tips: "Have photos of the most popular stars and of good quality." Sharp color quality is a must. "I look for something that's unusual in a picture, like a different pose instead of head shots. We are not interested in people who happened to take photos of someone they met."

SOCIETY, Rutgers University, New Brunswick NJ 08903. (201)932-2280. Editor: Irving Louis Horowitz. Bimonthly magazine. Circ. 31,000. For those interested in the understanding and use of the social sciences and new ideas and research findings from sociology, psychology, political science, anthropology and economics. Needs photo essays—"no random submissions." Essays should stress human interaction; photos should be of people interacting, not a single person or natural surroundings. Include an accompanying explanation of photographer's "aesthetic vision." Buys 75-100 photos annually. Buys all rights. Send photos for consideration. Pays on publication. Reports in 3 months. SASE. Free sample copy and photo guidelines.
Subject Needs: Human interest, photo essay and documentary.
B&W: Send 8x10 glossy prints.

SOUTHERN ANGLER'S & HUNTER'S GUIDE, Box 2188, Hot Springs AR 71914. (501)623-8437. Editor: Don J. Fuelsch. Annual magazine. Circ. 50,000. Emphasizes fishing and hunting, "how-to-do-it, when to do it and where to do it in the southern states." Per-photo rates determined by negotiation. Credit line given. Pays on acceptance. Buys all rights. Send photos by mail for consideration. SASE. Simultaneous submissions and previously published work OK. Reports in 30-60 days.
Subject Needs: Live shots of fish and game; shots of different techniques in taking fish and game; scenics of southern fishing waters or hunting areas; and tropical fish, aquatic plants and aquarium scenes (for separate publication). No shots of someone holding up a dead fish or dead squirrel, etc. Captions are required.
B&W: Uses 8x10 glossy prints.
Color: Uses 2¼x2¼ transparencies.
Cover: Uses color covers only. Requires square format.

SPECTRUM STORIES, Box 58367, Lousiville KY 40258. Executive Editor/Publisher: Walter Gammons. Bimonthly. Circ. 15,000. Emphasizes science fiction, fantasy, horror, mystery/suspense stories, articles, interviews/profiles, art and photo portfolios, essays, reviews. Readers well educated, well read, managerial or professional or student, 18-80. Sample copy $4 (postpaid); photo guidelines $1.
Photo Needs: Uses about 12-24 photos/issue; 50% supplied by freelance photograhers. Needs "surrealistic, fantastic, experimental photos; story and article illustrations—portraits of famous people, authors, artists, scientists, etc., featured in magazine." Also needs "special photos for illustrations for articles, stories, features—experimental, artistic, advertising for subscribers, etc." Model release required; captions preferred.
Making Contact & Terms: Query with samples; send 8x10 b&w prints, 35mm, 2¼x2¼, 4x5 or 8x10 transparencies (prefer 2¼x2¼) by mail for consideration or submit portfolio for review. Provide resume, business card, brochure, flyer or tearsheets to be kept on file for possible future assignments. "Send photos with articles, features, etc." SASE. Reports in 1 month. Pays $100 and up/color cover photo; $15-25/b&w inside photo, $25 and up/color inside photo, 1-5¢/word plus extra for photos for text/photo package. Pays on publication. Credit line given. Buys first North American serial and option on first anthology rights.
Tips: "Send photos and/or manuscripts for consideration or to keep on file."

SPIN, 1965 Broadway, New York NY 10023. (212)496-6100, ext. 336. Editor: Bob Guccione, Jr. Photo Editor: George DuBose. Monthly. Emphasizes music, articles of general interest for ages 18-35. Readers are 20-25 age group. Circ. 300,000. Estab. 1985. Sample copy $2.

Photo Needs: Uses 30-50 photos/issue; all supplied by freelance photographers. Needs studio portraits of musicians, celebrities, location portraits of groups, live performance shots, "generally great photos." Reviews photos with or without accompanying ms. Model release required; captions preferred.

Making Contact & Terms: Arrange a personal interview to show portfolio; query with list of stock photo subjects. Uses 8x10 glossy b&w prints, 35mm, 2¼x2¼, 4x5 transparencies, b&w contact sheets, b&w negatives. SASE. Reports in 1 month. Pays $500/b&w or color cover photo, $75-100/inside b&w photo, $50-200/inside color photo; $150/day. Pays on publication. Credit line given. Buys one-time rights. Simultaneous submissions and previously published work OK.

Tips: Prefers to see "good rapport with subjects, good use of lighting and technique. Technique is everything. You must have deep love for music and sensitivity when dealing with people. Don't be aggressive with or intimidated by celebrities."

***SPORT FISHING**, Box 2456, Winter Park FL 32790. (305)628-4802. Photo Editor: Doug DuKane. Monthly magazine. Emphasizes off shore fishing. Readers are upscale boat owners and offshore fishermen. Circ. 70,000. Estab. 1986. Sample copy $2.50. Photo guidelines free with SASE.

Photo Needs: Uses 50 photos/issue; 75% supplied by freelance photographers. Needs photos o off shore fishing—big boats/big fish, travel destinations. Model release and captions preferred.

Making Contact & Terms: Query with samples; send unsolicited photos by mail for consideration; provide resume, business card, brochure, flyer or tearsheets to be kept on file for possible future assignments. Send 35mm, 2¼x2¼ and 4x5 transparencies by mail for consideration. "Kodachrome and slow Fuji are preferred." Reports in 3 weeks. Pays $20-100/b&w page; $30-300/color page. Pays 30 days after publication. Buys one-time rights unless otherwise agreed upon. Simultaneous submissions OK.

Tips: We need razor sharp images. "The best guideline is the magazine itself. Get used to shooting on, in or under water. Most of our needs are found there."

SPORTS AFIELD, 250 W. 55th St., New York NY 10019. (212)262-5700. Art Director: Gary Gretter. For persons of all ages interested in the out-of-doors (hunting and fishing) and related subjects. Write by registered mail. Credit line given.

Subject Needs: Animal, nature, scenic, travel, sports, photo essay/photo feature, documentary, still life and wildlife.

Tips: "We are looking for photographers who can portray the beauty and wonder of the outdoor experience."

SPORTS ILLUSTRATED, Time-Life Bldg., New York NY 10020. (212)841-3131. Picture Editor: Barbara Henckel. A newsweekly of sports; emphasizes sports and recreation through news, analysis and profiles for participants and spectators. Circ. 2,250,000. Almost *everything* is done on assignment; has photographers on staff and on contract. Freelancers may submit portfolio by appointment in person if in the area or by mail; also looking for feature ideas by mail. Reports on portfolios in 2 weeks. SASE. Pays a day rate of $350 against $500/page, $1,000/cover.

Tips: "On first contact with the photographer, we want to see a portfolio only. Portfolios may be varied, not necessarily just sport shots. We like to meet with photographers after the portfolio has been reviewed."

SPORTS PARADE, Box 10010, Ogden UT 84409. Editor: Robyn Walker. Monthly. Circ. 50,000. Covers all sports. Readers are generally business and family oriented. Sample copy $1 plus 9x12 envelope. Free guidelines with SASE.

Photo Needs: Uses 10-12 photos/issue; 90% supplied by freelance photographers. Needs photos of sports personalities. Photos purchased with or without accompanying ms.

Making Contact & Terms: Send photos by mail for consideration. SASE. Provide resume, flyer or tearsheets to be kept on file for possible future assignments. Pays $50/color cover, $35/color inside. Pays on acceptance. Credit line given. "We now purchase first rights and nonexclusive reprint rights. This means we retain the right to reprint purchased material in other Meridian publications. Authors and photographers retain the option or the right to resell material to other reprint markets."

Tips: Needs "good action shots."

SPORTSMAN'S HUNTING, 1115 Broadway, New York NY 10010. (212)807-7100. Also publishes *Sportmen Bowhunting*, *Complete Deer Hunting Annual*, *Hunter's Deer Hunting Annual*, *Action Hunting*, *Guns and Hunting*. Editor-in-Chief: Lamar Underwood. Magazine published twice/year in early and late fall. Circ. 100,000. Emphasizes hunting for hunters. Free sample copy. Free photographer's guidelines with SASE.

Photo Needs: Uses up to 50 photos/issue; all supplied by freelance photographers. Needs "photos to accompany nostalgic, how-to, where-to and personal experience stories on hunting. Also use photo features with an establishing text." Photos purchased with or without accompanying ms. Model release required when recognizable face is included; captions required.
Making Contact & Terms: Query with list of stock photo subjects or send by mail for consideration 8x10 b&w glossy prints, any size transparencies or b&w contact sheet. SASE. Reports in 3 weeks. Pays $500/color cover; $75/b&w or $125/color inside. Pays on acceptance. Credit line given. Buys one-time rights.

SPUR, 1 West Washington St., Box 85, Middleburg VA 22117. (703)687-6314. Managing Editor: Kerry E. Phelps. Bimonthly magazine. Emphasizes Thoroughbred horses. Readers are "owners, breeders and trainers of Thoroughbreds, jockeys, equine vets, stable hands, and lovers of horses: both sexes, all ages, all income levels, foreign and domestic." Circ. 10,000 + . Sample copy $3.50. Photo guidelines free with SASE.
Photo Needs: Uses about 45-55 photos/issue; all supplied by freelance photographers. Needs photos of "horses—Thoroughbreds only—and sometimes jockeys in action (racing) or still shots for cover." Special needs include "covers—colorful, original approaches." Captions preferred.
Making Contact & Terms: Query with samples. Send 2¼x2¼ transparencies or slides by mail for consideration. Provide resume, business card, brochure, flyer or tearsheets to be kept on file for possible future assignments. SASE. Reports in 3 weeks. Pays $75 and up/color cover photo, $15/b&w inside photo, and $35/color inside photo. Pays on publication. Credit line given.

STAR, 660 White Plains Rd., Tarrytown NY 10591. (914)332-5000. Editor: Leslie Hinton. Photo Editor: Alistair Duncan. Weekly. Emphasizes news, human interest and celebrity stories. Circ. 4,500,000. Sample copy and photo guidelines free with SASE.
Photo Needs: Uses 100-125 photos/issue; 75% supplied by freelance photographers. Reviews photos with or without accompanying ms. Model release preferred; captions required.
Making Contact & Terms: Query with samples and with list of stock photo subjects, send 8x10 b&w prints, 35mm, 2¼x2¼ transparencies by mail for consideration. SASE. Reports in 2 weeks. Pays on publication. Credit line sometimes given. Simultaneous submissions and previously published work OK.

THE STATE, 417 N. Boylan Ave., Box 2169, Raleigh NC 27602. (919)833-5729. Editor: W.B. Wright. Monthly magazine. Circ. 21,000. Regional publication, privately owned, emphasizing travel, history, nostalgia, folklore, humor, all subjects regional to North Carolina and the South, for residents of, and others interested in, North Carolina.
Subject Needs: Photos on travel, history and personalities in North Carolina. Captions required.
Specs: Uses 5x7 and 8x10 glossy b&w prints; also glossy color prints. Uses b&w and color cover, vertical preferred.
Accompanying Mss: Photos purchased with or without accompanying ms.
Payment/Terms: Pays $5-10/b&w print and $10-50/cover. Credit line given. Pays on acceptance.
Making Contact: Send material by mail for consideration. SASE. Reporting time depends on "involvement with other projects at time received." Sample copy $1.

STEREO REVIEW, 1515 Broadway, New York NY 10036. (212)719-6000. Editor-in-Chief: William Livingstone. Art Director: Sue Llewellyn. Monthly. Circ. 575,000. Emphasizes stereo equipment and classical and popular music. Readers are music enthusiasts.
Photo Needs: Uses 30 photos/issue, supplied by freelance photographers and stock. "We use photos by photographers who do outstanding pictures at concerts; mostly in New York although we will look at work from the West Coast and country music areas." Needs photos of music celebrities performing. Also several products shots per issue, of the highest quality.
Making Contact & Terms: Query with list of stock photo subjects. Uses 35mm slides and b&w contact sheets. SASE. Reports in 1 week. Pays $100-750/b&w photo; $200-1,000/color photo. Credit line given. Payment on acceptance. Buys one-time rights. Simultaneous and previously published work OK if indicated.

STERLING'S MAGAZINES, 355 Lexington Ave., New York NY 10017. (212)391-1400, ext. 47. Photo Editor: Roger Glazer. Monthly magazine. Circ. 200,000. For people of all ages interested in TV and movie stars. Needs photos of TV, and movie stars. Buys "thousands" annually. "Will return b&w and color photos after publication." SASE. Send contact sheet for consideration.
B&W: Uses 8x10 glossy prints. Pays $30.
Color: Uses 35mm and 2¼x2¼ transparencies. Pays $75 minimum.
Cover: See requirements for color. Pays $75 minimum.

Tips: Only celebrity photos. "We deal with celebrities only—no need for model releases. Familiarize yourself with the types of photos we use in the magazine."

STING, Alpha Publications, Inc., 1079 De Kalb Pike, Center Square PA 19422. (215)277-6342. Photo Editor: Francis Laping. Bimonthly. Emphasizes humor and satire. Estab. 1984. Sample copy $3.
Photo Needs: Uses 5-10 photos/issue; all supplied by freelance photographers. Needs *political*, social and humor of any subject.
Making Contact & Terms: Query with samples, send 5x7, 8x10 glossy b&w prints by mail for consideration. SASE. Reports in 2 weeks. Payment depends on photo. Pays on publication. Credit line given. Buys one-time rights. Simultaneous submissions and previously published work OK.

STOCK CAR RACING MAGAZINE, 5 Bullseye Rd., Box 715, Ipswich MA 01938. (617)356-7030. Editor: Dick Berggren. Monthly magazine. Circ. 180,000. Emphasizes NASCAR GN racing and modified racing. Read by fans, owners and drivers of race cars and those with racing businesses. Photos purchased with or without accompanying ms and on assignment. Buys 50-70 photos/issue. Credit line given. Pays on publication. Buys one-time rights. Send material by mail for consideration. SASE. Reports in 1 week. Free photo guidelines.
Subject Needs: Documentary, head shot, photo essay/photo feature, product shot, personality, crash pictures, special effects/experimental and sport. No photos unrelated to stock car racing. Model release required unless subject is a racer who has signed a release at the track; captions required.
B&W: Uses 8x10 glossy prints. Pays $20/photo.
Color: Uses 35mm or 2¼x2¼ transparencies. Pays $35-250/photo.
Cover: Uses Kodachrome transparencies. Pays $35-250/photo.
Tips: "Send the pictures. We will buy anything that relates to racing if it's interesting, if we have the first shot at it, and it's well printed and exposed. Eighty percent of our rejections are for technical reasons—poorly focused, badly printed, too much dust, picture cracked, etc. We get far fewer cover submissions than we would like. We look for full bleed cover verticals where we can drop type into the picture and fit our logo too."

STRAIGHT, 8121 Hamilton Ave., Cincinnati OH 45231. (513)931-4050. Editor: Dawn Brettschneider Korth. Readers are ages 13 through 19, mostly Christian; a conservative audience. Weekly. Circ. 100,000.
Photo Needs: Uses about 4 photos/issue; all supplied by freelance photographers. Needs photos of teenagers, ages 13 through 19, involved in various activities such as sports, study, church, part-time jobs, school activities, classroom situations. Outside nature shots, groups of teens having good times together are also needed. "Try to avoid the sullen, apathetic look—vital, fresh, thoughtful, outgoing teens are what we need. Any photographer who submits a set of quality b&w glossies for our consideration, whose subjects are teens in various activities and poses, has a good chance of selling to us. This is a difficult age group to photograph without looking stilted or unnatural. We want to purport a clean, healthy, happy look. No smoking, drinking or immodest clothing. We especially need masculine-looking guys, and minority subjects. Submit photos coinciding with the seasons (i.e., winter scenes in December through February, spring scenes in March through May, etc.) Model release and captions not required, but noting the age of the model is often helpful.
Making Contact & Terms: Send 5x7 or 8x10 b&w photos by mail for consideration. Enclose sufficient packing and postage for return of photos. Reports in 4-6 weeks. Pays on acceptance $20-25/b&w photo. Credit line given. Buys one-time rights. Simultaneous submissions and previously published work OK. Sample copy and photo guidelines for SASE.
Tips: "Our publication is almost square in shape. Therefore, 5x7 or 8x10 prints that are cropped closely will not fit our proportions. Any photo should have enough 'margin' around the subject that it may be cropped square. This is a simple point, but absolutely necessary."

SUCCESS MAGAZINE, 342 Madison Ave., New York NY 10173. (212)503-0700. Contact: Art Director or Picture Editor. Monthly magazine. Circ. 350,000. Emphasizes business and entrepreneurs, self-improvement and goal-attainment for men and women. Buys 30 photos/year. Pays ASMP rates. Credit line given. Buys one-time rights or all rights. Query with samples which may be kept on file for future reference for assignments and stock list.
Subject Needs: Business, human interest, celebrity/personality and still life. Model release preferred; captions required.
B&W: Uses 8x10 prints.
Color: Uses transparencies.
Cover: Uses transparencies.
Tips: "We are always looking for new photographers, especially those who are located in places other than the major metropolitan areas, the midwest, south and southwest."

***SUNDAY SCHOOL COUNSELOR**, 1445 Boonville Ave., Springfield MO 65802. (417)862-2781. Editor: Sylvia Lee. Readers are local church school teachers and administrators. Monthly. Circ. 40,000.
Photo Needs: Uses about 5 photos/issue; 3-4 supplied by freelance photographers. Needs photos of people, "babies to senior adults." Model release required; captions not required.
Making Contact & Terms: Submit portfolio by mail for review (5x7 or 8x10 b&w and color photos; 35mm, 2¼x2¼ or 4x5 color transparencies). SASE. Reports in 2 weeks. Pays on acceptance $10-15/ b&w photo; $25-70/color transparency. Credit line given. Buys one-time rights. Simultaneous and previously published submissions OK. Free sample copy and photo guidelines.

***SUPERFIT**, 33 E. Minor St., Emmaus PA 18049. (215)967-5171. Editor: James McCullagh. Photo Editor: Sally Shenk Ullman. Quarterly magazine. Emphasizes sports. Readers are elite or serious athletes. Circ. 190,000. Estab. 1985. Sample copy $2. Photo guidelines free with SASE.
Photo Needs: Uses 50 photos/issue; 50% supplied by freelance photographers. Needs photos of fitness, recreational and professional sports, fit bodies and workouts. Model release required; captions preferred.
Making Contact & Terms: Query with samples. Send b&w and color prints, and transparencies by mail for consideration. SASE. Reports in 2 weeks. Pays $200-400/color cover photo; varies/inside photo; $150/color page. Pays on publication. Credit line given. Buys one-time rights and all rights. Simultaneous submissions OK.
Tips: Prefers "samples of work that is applicable to our subject or work that represents a specific photographic technique."

Peter Brouillet, senior staff photographer for Surfing Magazine, *shot this photo for the publication. He says the photo conveys "crisp, clear, hard-core surfing action." No actual assignments are given without a good, solid foundation in capturing surfing action, no matter how proficiently the photographer deals with other subjects, he explains. "Surfing photographers almost have to live the life to capture the best action."*

SURFING MAGAZINE/BODYBOARDING MAGAZINE, Box 3010, San Clemente CA 92672. (714)492-7873. Editor: David Gilovich. Photo Editor: Larry Moore. Monthly. Circ. 86,400. Emphasizes "surfing and bodyboarding action and related aspects of beach lifestyle. Travel to new surfing areas covered as well. Average age of readers is 18 with 92% being male. Nearly all drawn to publication due to high quality action packed photographs." Free photo guidelines with SASE. Sample copy $3.50.
Photo Needs: Uses about 80 photos/issue; 50%+ supplied by freelance photographers. Needs "intight front-lit surfing and bodyboarding action photos as well as travel-related scenics. Beach lifestyle photos always in demand."
Making Contact & Terms: Send by mail for consideration 35mm or 2¼x2¼ transparencies; b&w contact sheet and negatives. SASE. Reports in 2-4 weeks. Pays $500/color cover photo; $30-125/color inside photo; $20-70/b&w inside photo; $500/color poster photo. Pays on publication. Credit line given. Buys one-time rights.
Tips: Prefers to see "well-exposed, sharp images showing both the ability to capture peak action as well as beach scenes depicting the surfing and bodyboarding lifestyle. Color, lighting composition and proper film usage are important. Ask for our photo guidelines prior to making any film/camera/lens choices."

TAMPA BAY METROMAGAZINE, Suite 210, 405 Reo St., Tampa FL 33609. (813)877-6627. Editor: Terry Christian Hunter. Creative Director: Frank Jiannetti. Monthly. Circ. 25,000. City magazine for the Tampa Bay area. Readers are "upscale, professional, live in the Tampa Bay area." Sample copy $2.
Photo Needs: Uses about 25 photos/issue; all supplied by freelance photographers. Needs "photojournalism, fashion, food, cover; all are on assignment. Photos purchased with accompanying ms only. Model release and captions required. Pays $25-200/b&w photo per assignment, $25-600/color, cover negotiable.
Making Contact & Terms: Arrange a personal interview to show portfolio; query with resume of credits or with samples; or submit portfolio for review. SASE. Reports in 1 month. Pays by the job. Pays on publication. Credit line given. Negotiates rights purchased.
Tips: Prefers to see "an assortment of studio and journalistic work, color and b&w. Compile a thorough portfolio, be prepared to work hard."

TEEN POWER, Scripture Press, Box 632, Glen Ellyn IL 60138. (312)665-6000. Weekly magazine. "Illustrates biblical principles and faith in the everyday lives of teens." Readers are young teens, ages 12-16. Free sample copy and photo guidelines with SASE.
Photo Needs: Uses about 2-3 photos/issue; all supplied by freelance photographers. Needs photos of teens in school, home and church settings.
Making Contact & Terms: Send b&w prints by mail for consideration. Provide resume, business card, brochure, flyer or tearsheets to be kept on file for possible future assignments. SASE. Pays on acceptance. Credit line given. Buys one-time rights.

TEENS TODAY, 6401 The Paseo, Kansas City MO 64131. (816)333-7000, ext. 214. Editorial Accountant: Rosemary Postel. Editor: Gary Sivewright. Weekly magazine. Circ. 60,000. Read by junior- and senior-high-school/age persons. Photos purchased with or without accompanying ms and on assignment. Buys 150 photos/year; 3 photos/issue. Credit line given. Pays on acceptance. Buys one-time rights. Simultaneous submissions and previously published work OK.
Subject Needs: Needs shots of high-school age young people. "Many photographers submit straight-on shots. I'm looking for something that says 'this is different; take a look.' Junior and senior highs (grade 7-12) must be the subjects, although other age groups may be included." Shots of driving, talking, eating, walking, sports, singles, couples, groups, etc.
B&W: Uses 8x10 glossy prints. Pays $15-25/photo.
Accompanying Mss: Pays 3½¢ minimum/word first rights, 3¢/word for second rights. Free writer's guidelines with SASE.
Making Contact: Send material by mail for consideration. "Send photo submissions to our central distribution center to Rosemary Postel and they will be circulated through other editorial offices." SASE. Reports in 6-8 weeks. Free sample copy; photo guidelines free only with SASE.
Tips: "Make sure your work has good contrast and is dealing with the teen-age group. We buy many photos and so are always looking for a new good one to go with an article or story."

TENNIS MAGAZINE, 5520 Park Ave., Trumbull CT 06611. (203)373-7000. Art Directors: Bobbe Stultz and Michael Brent. Monthly magazine. Circ. 500,000. Emphasizes instructional articles and features on tennis for young, affluent tennis players. Freelancers supply 60% of photos. Payment depends on space usage. Credit line given. Pays on acceptance. Buys first world rights or on agreement with publisher. Send material by mail for consideration. SASE. Reports in 2 weeks.
Subject Needs: "We'll look at all photos submitted relating to the game of tennis. We use color action shots of the top athletes in tennis. They are submitted by freelance photographers covering tournaments relating to current and future articles." Also uses studio setups and instructional photography.
B&W: Uses 5x7 glossy prints.
Color: Uses 35mm transparencies.

TENNIS WEEK, 8th Floor, 6 E. 39th St., New York NY 10016. (212)696-4884. Publisher: Eugene L. Scott. Managing Editor: Robin Rothhammer. Readers are "tennis fanatics." Weekly. Circ. 40,000. Sample copy $1.25.
Photo Needs: Uses about 16 photos/issue. Needs photos of "off-court color, beach scenes with pros, social scenes with players, etc." Emphasizes originality. No captions required; subject identification required.
Making Contact & Terms: Send by mail for consideration actual 8x10 or 5x7 b&w photos. SASE. Reports in 2 weeks. Pays on publication $10-15/b&w photo; $50 cover. Credit line given. Rights purchased on a work-for-hire basis.

TEXAS FISHERMAN MAGAZINE, 5314 Bingle Rd., Houston TX 77092. (713)688-8811. Editor: Larry Bozka. Publishes 9/year.Circ. 64,000. Emphasizes all aspects of fresh and saltwater fishing in

Texas, plus hunting, boating and camping when timely. Readers: 90% are married, with 47.4% earning over $35,000 yearly. Sample copy free with SASE.
Photo Needs: Use 25 photos/issue; 75% supplied by freelance photographers. Needs "action photos of fishermen catching fish, close-ups of fish with lures, 'how-to' rigging illustrations, some wildlife." Especially needs photos of Texas coastal fishing (saltwater). Captions required.
Making Contact & Terms: Query with samples; if submitting ms, include contact sheets. "Mug shots with ms." SASE. Reports in 1 month. Pays $150/color cover photo; $15-35/b&w inside photo. Limited use of 4-color inside. Pays $50-75. Pays on publication. Credit line given. Buys one-time rights.
Tips: Prefers to see "*action* shots—no photos of fishermen holding up fish but tasteful stringer shots OK. Concentrate on taking photos that tell something, such as how-to."

TEXAS GARDENER, Box 9005, Waco TX 76714. (817)772-1270. Editor/Publisher: Chris S. Corby. Bimonthly. Circ. 37,000. Emphasizes gardening. Readers are "65% male, home gardeners, 98% Texas residents." Sample copy $1.
Photo Needs: Uses 20-30 photos/issue; 90% supplied by freelance photographers. Needs "color photos of gardening activities in Texas." Special needs include "photo essays on specific gardening topics such as 'Weeds in the Garden.' Must be taken in Texas." Model release and captions required.
Making Contact & Terms: Query with samples. SASE. Reports in 3 weeks. Pays $100-200/color cover photo; $5-15/b&w inside photo, $10-200/color inside photo. Pays on acceptance. Credit line given. Buys all rights.
Tips: "Provide complete information on photos. For example, if you submit a photo of watermelons growing in a garden, we need to know what variety they are and when and where the picture was taken."

TEXAS HIGHWAYS, 125 11th St., Autsin TX 78701. (512)463-8581. Editor-in-Chief: Frank Lively. Photo Editor: Bill Reaves. Monthly. Circ. 375,000. "*Texas Highways* interprets scenic, recreational, historical, cultural and ethnic treasures of the state and preserves the best of Texas heritage. Its purpose is to educate and entertain, to encourage recreational travel to and within the state and tell the Texas story to readers around the world." Readers are "35 and over (majority); $24,000 to $60,000 per year salary bracket with a college education." Sample copy and photo guidelines free.
Photo Needs: Uses about 50 photos/issue; 50% supplied by freelance photographers. Needs "travel and scenic photos in Texas only." Special needs include "fall, winter, spring, and summer scenic shots and wildflower shots (Texas only)." Model release preferred; captions required.
Making Contact & Terms: Query with samples. Provide business card and tearsheets to be kept on file for possible future assignments. SASE. Reports in 1 month. Pays $80 for ½ page color inside photo and $160/full-page color photo, $300 for front cover photo; $300-750 and up for complete photo story. Pays on acceptance. Credit line given. Buys one-time rights. Simultaneous submissions OK.
Tips: "Know our magazine and format. We take only color originals, 35mm Kodachrome or Fujichrome or 4x5. No negatives. Don't forget to caption and name names. We publish only photographs of Texas. We accept only high quality professional level work, no snapshots."

***THIRD COAST MAGAZINE**, 1611 West Ave., Austin TX 78701. (512)472-2016. Editor: John Talinferro. Photo Editor: Janice Van Mechelen. Monthly magazine. Emphasizes city of Austin. Readers are from Austin. Circ. 16,000. Sample copy free with SASE.
Photo Needs: Uses 20-30 photos/issue; all supplied by freelance photographers. "We occasionally need generic photos for departments on music, books, humor, food, exercise, sports, art, seasonal contents page photos." Model release required.
Making Contact & Terms: Query with list of stock photo subjects. Reports in 2 weeks. Pay negotiated/job. Pays on publication. Credit line given. Buys one-time rights. Previously published work OK.

TIDEWATER VIRGINIAN MAGAZINE, Box 327, Norfolk VA 23501. (804)625-4233. Editor: Sally Hartman. Circ. 15,000. Emphasizes regional business in Hampton Ponds for upper management. Freelancers supply 70% of photos. Photos purchased with or without accompanying mss. Credit line given. Pays by assignment or on a per-photo basis, on publication. Buys one-time rights or all rights. Model release required. Send samples of work that can be published immediately. Prefers to see business-type shots (not arty) in a portfolio. SASE. Simultaneous submissions OK. Reports in 3 weeks. Sample copy $1.95.
Subject Needs: Fine art (if it's relevant to a gallery or museum we're writing about); area scenic; photo essay/photo feature (in connection with a local story); travel (for business people); and business, computers, manufacturing and retail sales. Do not send photos not appropriate for a business magazine. Captions required.
B&W: Uses 8x10 and 5x7 glossy prints. Pays $10-25/print.
Cover: Uses color covers only. Vertical format required. Pays $200 maximum/photo.
Accompanying Mss: Seeks articles on business—taxes, financial planning, stocks and bonds, etc. Pays $75-200 for text/photo package.

TIGER BEAT MAGAZINE, 1086 Teaneck Rd., Teaneck NJ 07666. (201)833-1800. Editor: Diane Umansky. Monthly magazine. Circ. 500,000. Emphasizes celebrities, fashion, beauty, how-to, for ages 15-19.
Subject Needs: Photos of young stars featured in magazine. Wants on a regular basis everything from candids to portraits, location shots, stills from TV and movies.
Payment/Terms: Pays $25 minimum/b&w print; $50-75 minimum/color transparency; and $75 minimum/cover. Pays on acceptance.
Making Contact: Query with tearsheets along fashion lines or call for appointment. SASE. Reports in 2-3 weeks.
Tips: Prefers to see variety of entertainers popular with young people. "Supply material as sharply focused as possible." Opportunity for photographers just starting out. "Be patient and polite."

TODAY'S CHRISTIAN PARENT, 8121 Hamilton Ave., Cincinnati OH 45231. (513)931-4050. Editor: Mildred Mast. Quarterly magazine. Circ. 20,000. For parents and grandparents. Needs "family scenes: family groups in activities; teenagers and children with parents/grandparents; adult groups; family devotions." Natural appearance, not an artificial, posed, "too-perfect" look. Wants no "way out" photos or shots depicting "freakish family styles." Buys 12-15 annually. Buys first serial rights. Query by mail; send shipments of photos by mail or UPS. SASE. Pays on acceptance. Reports in 4 weeks. Free sample copy and guidelines for 7x10 or larger SASE.
B&W: Send 8x10 glossy prints, clear with sharp contrast. Pays $15-25/photo depending on use.
Tips: "This is a magazine used by churches/Christian families, so the themes are often devotional or 'uplifting' in nature." Also, "photos will be circulated to other editors; number or code photos for easy identification. Send no more than 50 at a time."

TORSO INTERNATIONAL, Suite 210, 7715 Sunset Blvd., Los Angeles CA 90046. (213)850-5400. Publisher: Casey Klinger. Monthly magazine. Circ. 475,000. Sample copy $5 with SASE.
Photo Needs: Uses 48-60 photos/issue; all supplied by freelance photographers. Needs photos of nude males. Model release required.
Making Contact & Terms: Arrange a personal interview to show portfolio; send 35mm, 2¼x2¼, 4x5 and 8x10 transparencies by mail for consideration. SASE. Reports immediately. Pays $250-500/job. Pays on publication. Credit line given. Buys one-time rights.

TRACK AND FIELD NEWS, Box 296, Los Altos CA 94023. (415)948-8417. Feature/Photo Editor: Jon Hendershott. Monthly magazine. Circ. 35,000. Emphasizes national and world-class track and field competition and participants at those levels for athletes, coaches, administrators and fans. Buys 10-15 photos/issue. Credit line given. Captions required. Payment is made bimonthly. Query with samples or send material by mail for consideration. SASE. Reports in 1 week. Free photo guidelines.
Subject Needs: Wants on a regular basis photos of national-class athletes, men and women, preferably in action. "We are always looking for quality pictures of track and field action as well as offbeat and different feature photos. We always prefer to hear from a photographer before he/she covers a specific meet. We also welcome shots from road and cross-country races for both men and women. Any photos may eventually be used to illustrate news stories in *T&FN*, feature stories in *T&FN* or may be used in our other publications (books, technical journals, etc.). Any such editorial use will be paid for, regardless of whether or not material is used directly in *T&FN*. About all we don't want to see are pictures taken with someone's Instamatic or Polaroid. No shots of someone's child or grandparent running. Professional work only."
B&W: Uses 8x10 glossy prints; contact sheet preferred. Pays $7/photo, inside.
Color: Pays $45/photo.
Cover: Uses 35mm color transparencies. Pays $125/photo, color.
Tips: "No photographer is going to get rich via *T&FN*. We can offer a credit line, nominal payment and, in some cases, credentials to major track and field meets to enable on-the-field shooting. But we can offer the chance for competent photographers to shoot major competitions and competitors up close as well as the most highly regarded publication in the track world as a forum to display a photographer's talents."

TRADITION MAGAZINE, 106 Navajo, Council Bluffs IA 51501. (712)366-1136. Editor: Bob Everhart. Monthly magazine. Circ. 2,000. Emphasizes country and folk music. Photos purchased with accompanying ms. Buys 5-6 photos/year. Credit line given. Pays on acceptance. Buys one-time rights. Mail query with samples relevant to country/folk music. SASE. Simultaneous submissions OK. Reports in 1 month. Sample copy, 26¢ postage.
Subject Needs: Anything relevant to country and folk music only. Travel (relating only to festivals, etc., music); documentary (relative to old-time country music, folk music, etc.); celebrity/personality (anyone connected with traditional country music—definitely not interested in current Nashville trend). Model release preferred; captions required.

B&W: Uses 5x7 glossy prints. Pays $2 minimum/photo.
Cover: Uses b&w prints. Vertical format required. Pays $5 minimum/photo.
Accompanying Mss: Articles relating to country and folk music. Pays $2 minimum/ms. Writer's guidelines free with SASE.
Tips: "The magazine sponsors a photo contest with cash prizes for the best photos (b&w) from the annual old-time country music festival held at the Pottawattamie fairgrounds in Avoca, Iowa over Labor Day weekend. Photos must be submitted to *Tradition Magazine* prior to December 1 to be judged for the current year's contest."

TRAILER BOATS MAGAZINE, Poole Publications Inc., 16427 S. Avalon, Box 2307, Gardena CA 90248. (213)323-9040. Editor: Jim Youngs. Monthly magazine. Circ. 85,000. "Only magazine devoted exclusively to legally trailerable boats and related activities" for owners and prospective owners. Photos purchased with or without accompanying ms. Uses 15 photos/issue with ms. Pays per text/photo package or on a per-photo basis. Credit line given. Pays on publication. Buys all rights. Query or send photos or contact sheet by mail for consideration. SASE. Reports in 1 month. Sample copy $1.25.
Subject Needs: Celebrity/personality, documentary, photo essay/photo feature on legally trailerable boats or related activities (i.e. skiing, fishing, cruising, etc.), scenic (with ms), sport, spot news, how-to, human interest, humorous (monthly "Over-the-Transom" funny or weird shots in the boating world), travel (with ms) and wildlife. Photos must relate to trailer boat activities. Captions required. Needs funny photos for Over the Transom column. No long list of stock photos or subject matter not related to editorial content.
B&W: Uses 5x7 glossy prints. Pays $7.50-50/photo.
Color: Uses transparencies. Pays $15-100/photo.
Cover: Uses transparencies. Vertical format required. Pays $150/photo.
Accompanying Mss: Articles related to trailer boat activities. Pays 7-10¢/word and $7.50-50/photo. Free writer's guidelines.
Tips: "Shoot with imagination and a variety of angles. Don't be afraid to 'set-up' a photo that looks natural. Think in terms of complete feature stories; photos and manuscripts. It is rare any more that we publish freelance photos only, without accompanying manuscript; with one exception, 'Over the Transom'—a comical, weird or unusual boating shot."

TRAILER LIFE, 29901 Agoura Rd., Agoura CA 91301. (818)991-4980. Editor: Bill Estes. Monthly magazine. Circ. 315,000. Emphasizes the why, how and how-to of owning, using and maintaining a recreational vehicle for personal vacation or full-time travel. The editors are particularly interested in photos for the cover; an RV must be included. Payment ranges up to $300. Credit line given. Pays on acceptance. Buys first North American rights. Send material by mail for consideration or query with samples. SASE. Reports in 3 weeks. Send for editorial guidelines.
Subject Needs: Human interest, how-to, travel and personal experience.
B&W: Uses 8x10 glossy prints.
Color: Uses 35mm and 2¼x2¼ transparencies.
Accompanying Mss: Related to recreational vehicles and ancillary activities.

TRAILS-A-WAY, 9425 S. Greenville Rd., Greenville MI 48838. (616)754-9179. Publisher: Dave Higbie. Monthly tabloid. Emphasizes camping and recreational vehicle travel. Readers are "middle-aged, mid- to upper-income with RVs and a strong desire to travel." Circ. 53,000.
Photo Needs: Uses about 12-15 photos/issue; "maybe half" supplied by freelance photographers. Needs photos of "travel, camping, RVs, etc." Captions required.
Making Contact & Terms: Query with samples. Send 5x7, 8x10 glossy prints or 35mm, 2¼x2¼ transparencies by mail for consideration. SASE. Reports in 1 month. Pays $25-35/color cover photo and $10/b&w inside photo. Pays on publication. Credit line given if requested. Buys one-time rights. Simultaneous submissions and previously published work OK.

TRAVEL & LEISURE, 1120 Avenue of the Americas, New York NY 10036. (212)382-5600. Editor: Pamela Fiori. Art Director: Adrian Taylor. Picture Editor: William H. Black, Jr. Monthly magazine. Circ. 1,000,000. Emphasizes travel destinations, resorts, dining and entertainment. Credit line given. Pays on publication. Buys first World serial rights, plus promotional use. Previously published work OK. Free photo guidelines. SASE.
Subject Needs: Nature, still life, scenic, sport and travel. Model release and captions required.
B&W: Uses 8x10 semigloss prints. Pays $65 minimum/photo.
Color: Uses transparencies. Payment negotiated.
Cover: Uses 35mm, 2¼x2¼, 4x5 and 8x10 transparencies. Vertical format required. Pays $1,000/photo or payment negotiated.
Tips: Demonstrate prior experience or show published travel-oriented work. Have a sense of "place" in travel photos.

TRAVEL & STUDY ABROAD, 18 Hulst Rd., Box 344, Amherst MA 01002. Editor-in-Chief/Photo Editor: Clay Hubbs. Quarterly. Circ. 15,000. Emphasizes special interest travel. Readers are study abroad program participants and others who travel to learn (not tourists). Sample copy $2.50 plus 95¢ postage. Free photo guidelines for SASE.

Photo Needs: Uses about 10-12 photos/issue; all supplied by freelance photographers. Needs photos of people in foreign places to accompany travel, study or work abroad stories. Photos seldom purchased without accompanying ms. Special needs: study, travel and work features on all countries outside U.S. Captions required.

Making Contact & Terms: Query with samples. Does not return unsolicited material. Reports in 1 month. Provide business card and tearsheets to be kept on file for possible future assignments. Pays $10-25/b&w inside or cover photo. Pays on publication. Credit line given. Buys one-time rights. Simultaneous submissions and/or previously published work OK.

Tips: Prefers to see travel photos of people. B&w only.

TRAVEL/HOLIDAY, Travel Bldg., Floral Park NY 11001. (516)352-9700. Executive Editor: Scott Shane. Photo Researcher: Claire Murphy. Monthly magazine. Circ. 816,000. Emphasizes quality photography on travel destinations, both widely known and obscure. For people "with the time and money to actively travel. We want to see travel pieces, mostly destination-oriented." Wants no "posed shots or snapshots." Readers are experienced travelers who want to be shown the unusual parts of the world. Credit line given. Buys 30 photos/issue. Buys first North American serial rights. Do not send samples for consideration. Pays on acceptance. Reports in 6 weeks. SASE. Write for free photo guidelines.

Subject Needs: Quality photography of all areas of world—scenics, people, customs, arts, amusements, etc. "We prefer shots which have people in them whenever possible."

B&W: Send 8x10 glossy or semigloss prints. Captions required. Pays $25.

Color: Send transparencies 35mm and larger. Captions required. Pays $75/¼ page, $100/½ page, $125/¾ page, $150/full page, $200/2-page spread.

Cover: Send color transparencies. Captions required. Pays $400.

Tips: "Send us a list that catalogues by geographic area the transparencies that you have on stock. Include, if applicable, a listing of recent publications in which your work has appeared. When we are seeking photography on a specific subject entered on your stock list, we will contact you at that time."

***TRAVEL INEXPENSIVE**, Box 11303, San Francisco CA 94101. (415)282-9338. Editor: Jerry Snider. Photo Editor: Michael Langevia. Quarterly magazine. Emphasizes travel. Readers are yuppies. Circ. 10,000. Estab. 1986. Photo guidelines free with SASE.

Photo Needs: Uses 45 photos/issue; all supplied by freelance photographers. Needs photos of travel. Model release preferred.

Making Contact & Terms: Query with samples, send b&w and color prints, b&w and color contact sheet by mail for consideration. SASE. Reports in 3 months. "We pay only in copies." Pays on publication. Credit line given. Buys one-time rights.

Tips: Prefers to see travel essays.

***TREASURE**, 6280 Adobe Rd., 29 Palms CA 92277. (619)367-3531. Editor: Jim Williams. Photo Editor: Rhonda Lewis. Monthly magazine. "We cover all aspects of treasure hunting—including prospecting, archaeological digs, relic hunting, all applications of metal detectors, beach combing and so forth." Readers are searchers, taking as much delight in hunting as in finding their particular kind of "treasure." Circ. 40,000. Sample copy free with SASE. Photo guidelines free with SASE.

Photo Needs: Uses 35 photos/issue; 30 supplied by freelance photographers. "We need photos for how-to articles, of treasures that have actually been found, and of people involved in a search. What we would most like to see are photos of valuables that have actually been found and photos for how-to projects that would help readers." Model release preferred.

Making Contact & Terms: Send 35mm transparencies and b&w contact sheets by mail for consideration. SASE. Reports in 1 week. Pays $75/color cover photo; $3/b&w inside photo; $30/page; $30-50/text/photo package (page). Pays on publication. Credit line given. Buys all rights. Simultaneous submissions and previously published work OK.

Tips: "Photographers should study a copy of the magazine to understand the breadth of the subject matter and our needs. Since we report only what has actually been found or done, we avoid fabricated stories and photos, except for cover shots."

Market conditions are constantly changing! If this is 1988 or later, buy the newest edition of Photographer's Market *at your favorite bookstore or order directly from Writer's Digest Books.*

***TRIATHLON MAGAZINE**, 8461 Warner Dr., Culver City CA 90230. (818)798-5886. Art Director: Patti Benner. Monthly magazine. Emphasizes triathlons. Readers are athletic. Circ. 100,000.
Photo Needs: Uses 30 photos/issue; all supplied by freelance photographers. Needs triathlon race shots. Captions preferred.
Making Contact & Terms: Arrange a personal interview to show portfolio, send 5x7 or 8x10 b&w and color prints; transparencies; contact sheet by mail for consideration. SASE. Reports in 1 month. Pays on publication. Credit line given. Buys one-time rights.
Tips: Prefers to see swimming, biking, running and triathlon race/training.

***TRIVIA QUEST**, 566 Westchester Ave., Rye Brook NY 10573. Photo Editor: Warren Tabatch. Monthly gamebook featuring a variety of trivia questions. Circ. 125,000. Sample copy for SASE and $1; photo guidelines for SASE.
Photo Needs: Uses 5-10 b&w photos per issue, depicting a variety of trivia topics: TV/movie stars, sports action, politicians, famous places and landmarks, sports stars, famous musicians—just about anything that makes for a good trivia question.
Making Contact & Terms: Query with a list of stock photo subjects; send 8x10 glossy b&w prints by mail for consideration. SASE. Reports in 1 week. Pays $20-40 per b&w, on publication. Previously published submissions OK.
Tips: "See sample copy for idea of our needs."

TROPICAL FISH HOBBYIST MAGAZINE, 211 West Sylvania Ave., Neptune City NJ 07753. (201)988-8400. Editor: John R. Quinn. Assistant Editor: Raymond D. Hunziker, III. Monthly magazine. Emphasizes the tropical fish and aquarium hobby. Readers include "a wide variety of hobbyists, from beginners to advanced. The magazine is widely distributed throughout the English-speaking world; and sold through petshops as well." Circ. 55,000. Sample copy available; query for reduced price.
Photo Needs: Uses about 25-35 photos/issue; "most are submitted by authors. On a continuing basis, we need good, clear 35mm slides of tropical and temperate fresh and saltwater fishes. Separations are made and originals returned to photographer." Special needs include "South American freshwater fishes, African Cichlids, Invertebrates."
Making Contact & Terms: Query with samples and list of stock photo subjects. SASE. Reports in 3 weeks. Pays $10/b&w inside photo. Pays on acceptance. Credit line given. Buys all rights, but photographer may sell work again."
Tips: "We require sharp, clear slides of fishes and other aquatic animals that will reproduce well. The more colorful the better. Ours is a rather specialized (underwater) area of photography; study techniques."

TRUE WEST, Box 2107, Stillwater OK 74076. (405)743-3370. Editor: John Joerschke. Monthly. Circ. 100,000. Emphasizes "history of the Old West (1830 to about 1910)." Readers are "people who like to read the history of the West." Sample copy free with SASE.
Photo Needs: Uses about 100 or more photos/issue; almost all are supplied by freelance photographers. Needs "mostly Old West historical subjects, some travel, some scenic, (ghost towns, old mining camps, historical sites). We prefer photos with manuscript." Special needs include western wear; cowboys, rodeos, western events.
Making Contact & Terms: Query with samples—b&w only for inside; color for covers. SASE. Reports in 1 month. Pays $100-150/color cover photo; $10/b&w inside photo; "minimum of 3¢/word for copy." Pays on acceptance. Credit line given. Buys one-time rights.
Tips: Prefers to see "transparencies of existing artwork as well as scenics for cover photos. Inside photos need to tell story associated with the Old West. Most of our photos are used to illustrate stories and come with manuscripts; however, we will consider other work, scenics, historical sites, old houses. Even though we are Old West history, we do need current photos, both inside and for covers—so don't hesitate to contact us."

TURF AND SPORT DIGEST, 511-513 Oakland Ave., Baltimore MD 21212. (301)323-0300. Publisher/Editor: Allen L. Mitzel, Jr. Bimonthly magazine. Circ. 35-50,000. Emphasizes Thoroughbred racing coverage, personalities, events and handicapping methods for fans of Thoroughbred horse-racing. Photos purchased with or without accompanying mss. Credit line given. Pays on publication. Buys one-time rights. Send photos by mail for consideration. SASE. Reports in 1 month. Free sample copy.
Subject Needs: People, places and events, past and present, in Thoroughbred racing. Emphasis on unusual views and action photos. No mug shots of people. Captions required.
B&W: Uses 8x10 glossy prints or contact sheet. Pays $15/print.
Cover: Uses 35mm minimum color transparencies. Vertical format required. Pays $100/color transparency.

TURN-ONS, TURN-ON LETTERS, UNCENSORED LETTERS, OPTIONS, Box 470, Port Chester NY 10573. Photo Editor: Wayne Shuster. Monthly magazines. Emphasizes "sexually oriented situations. We emphasize good, clean sexual fun among liberal-minded adults." Readers are mostly male; age range 20-50. Circ. 120,000. Sample copy free with 9x10 SASE and $1 postage.
Photo Needs: Uses approximately 20-30 photos/issue. Needs a "variety of b&w photos depicting sexual situations. Also need color transparencies for cover; present in a way suitable for newsstand display." Model release required.
Making Contact & Terms: Query with samples and list of stock photo subjects. Send 8x10 glossy b&w prints or 35mm, 2¼x2¼, 4x5 transparencies by mail for consideration. SASE. Reports in 2 weeks. Pays $250/color cover photo and $10-20/b&w inside photo. Pays on publication. Buys one-time rights on covers, second rights OK for b&ws.
Tips: "Please examine copies of our publications before submitting work."

TV GUIDE, Radnor PA 19088. (215)293-8500. Editor, National Section: David Sendler. Art Director: Jerry Alten. Picture Editors: Cynthia Young (Los Angeles), Ileane Rudolph (New York). Emphasizes news, personalities and programs of TV for a general audience. Weekly. Circ. 17,000,000.
Photo Needs: Uses 20-25 photos/issue; many supplied by freelance photographers. Selection "through photo editors in our New York and Los Angeles bureaus. Most work on assignment. Interested in hearing from more photographers."
Making Contact & Terms: Call or write photo editors to arrange personal interview to show portfolio. Buys one-time rights. Credit line given. No simultaneous submissions or previously published work.

TWINS MAGAZINE, Box 12045, Overland Park KS 66212. (913)722-1090. Editor: Barbara Unell. Bimonthly. Emphasizes parenting twins, triplets, quadruplets, or more. Readers include the parents of multiples. Circ. 25,000. Estab. 1984. Sample copy $3.50 plus $1.50 postage and handling. Free photo guidelines with SASE.
Photo Needs: Uses about 10 photos/issue; all supplied by freelance photographers. Needs family related—children, adults, family life. Usually needs to have twins, triplets or more included as well. Reviews photos with or without accompanying ms. Model release and captions required.
Making Contact & Terms: Query with resume of credits and samples; provide resume, business card, brochure, flyer or tearsheets to be kept on file for possible future assignments. SASE. Reports in 4-6 weeks. Pays $100 minimum/job. Pays on publication. Credit line given. Buys all rights. Simultaneous submissions OK.

ULTRASPORT, 711 Boylston St., Boston MA 02116. (617)236-1885. Editor: Chris Bergonzi. Monthly magazine. Circ. 225,000. Estab. 1984. Emphasizes active sports for today's athletes. Sample copy free with SASE and $1.22 postage; photo guidelines free with SASE.
Photo Needs: Uses about 50 photos/issue; all supplied by freelance photographers. Needs photos of "people in sports, active sports, new sports, adventure sports." Captions preferred.
Making Contact & Terms: Query with resume of credits or samples; send 35mm transparencies by mail for consideration. SASE. Reports in 4 weeks. Pays $500/color cover photo; $250/color page; $400-500/job or day rates. Pays on acceptance. Buys variable rights. Previously published submissions OK.

UNITY, Unity Village MO 64065. Editor: Pamela Yearsley. Associate Editor: Shirley Brants. Monthly magazine. Circ. 430,000. Emphasizes spiritual, self-help, poetry and inspirational articles. Photos purchased with or without accompanying ms or on assignment. Uses 2-4 photos/issue. Buys 50 photos/year, 90% from freelancers. Credit line given. Pays on acceptance. Buys first North American serial rights. Send insured material by mail for consideration; no calls in person or by phone. SASE. Reports in 2-4 weeks. Free sample copy and photo guidelines.
Subject Needs: Wants on a regular basis 12 nature scenics for covers and 10-20 b&w scenics. Also human interest, nature, still life and wildlife. No photos with primary emphasis on people; animal photos used sparingly. Model release required; captions preferred.
B&W: Uses 5x7 or 8x10 semigloss prints. Pays $15-25/photo.
Cover: Uses 4x5 color transparencies. Vertical format required, occasional horizontal wraparound used. Pays $100-150/photo; $25/inside color photo.
Accompanying Mss: Pays $25-200/ms. Rarely buys mss with photos. Free writer's guidelines.
Tips: "Don't overwhelm us with hundreds of submissions at a time. We look for nature scenics, human interest, some still life and wildlife, some photos of people (although the primary interest of the photo is not on the person or persons). We are looking for photos with a lot of color and contrast."

***US AIR MAGAZINE**, 600 Third Ave., New York NY 10016. Editor: Richard Busch. Monthly magazine. Emphasizes general interest. Readers are upscale, emphasis on business travelers. Circ. 190,000. Sample copy $3. Photo guidelines free with SASE.
Photo Needs: Uses 25-30 photos/issue; all supplied by freelance photographers. Needs photos of trav-

el, sport, nature, science, arts, food, etc. Captions preferred.
Making Contact: Send color prints; 35mm, 2¼x2¼; 4x5, 8x10 transparencies by mail for consideration; submit portfolio for review; provide resume, business card, brochure, flyer or tearsheets to be kept on file for possible future assignments. SASE. Reports in 2-3 weeks. Pays $400/color cover photo, $150/b&w page; $250/color page. Pays on acceptance. Credit line given. Buys one-time rights. Simultaneous submissions OK.

VEGETARIAN TIMES, Box 570, Oak Park IL 60303. Editor: Paul Obis. Published 12 times annually. Circ. 100,000. Photos purchased mainly with accompanying ms. Buys 80 photos/year. Credit line given. Pays 30 days after acceptance. Rights vary. Send material by mail for consideration. SASE. Simultaneous submissions OK. Reports in 6 weeks. Sample copy $2.
Subject Needs: Celebrity/personality (if vegetarians), sport, spot news, how-to (cooking and building), humorous, food to accompany articles. Model release and captions preferred.
B&W: Uses 8x10 glossy prints. Pays $15 minimum/photo.
Cover: Pays $200 and up (color slide).

VENTURE, Box 150, Wheaton IL 60189. (312)665-0630. Managing Editor: Steven P. Neideck. Art Director: Lawrence Libby. Magazine published 6 times annually. Circ. 35,000. Sample copy $1.50. "We seek to provide entertaining, challenging, Christian reading for boys 10-15." Needs photos of boys in various situations: alone; with other boys; with their families or girlfriends; in school; with animals; involved in sports, hobbies or camping, etc. Buys 1-2 photos/issue. Buys first serial rights. Arrange a personal interview to show portfolio or send photos for consideration. Pays on publication. Reports in 6 weeks. SASE. Simultaneous submissions and previously published work OK. Photo guidelines available (SASE).
B&W: Send 8x10 glossy prints. Pays $35.
Cover: Send glossy b&w prints. Pays $50-75.

VERMONT LIFE, 61 Elm St., Montpelier VT 05602. (802)828-3241. Contact: Editor. Quarterly magazine. Circ. 130,000. Emphasizes life in Vermont: its people, traditions, way of life, farming, industry, and the physical beauty of the landscape for "Vermonters, ex-Vermonters and would-be Vermonters." Buys 30 photos/issue. Buys first serial rights. Query first. Credit line given. Pays day rate of $200. Pays on publication. Reports in 3 weeks. SASE. Simultaneous submissions OK. Sample copy $4; free photo guidelines.
Subject Needs: Wants on a regular basis scenic views of Vermont, seasonal (winter, spring, summer, autumn), submitted 6 months prior to the actual season; animal, documentary; human interest; humorous; nature; photo essay/photo feature; still life; travel and wildlife. No photos in poor taste, nature close-ups, cliches, photos of blood sports or photos of places other than Vermont.
Color: Send 35mm or 2¼x2¼ transparencies. Captions required. Pays $75.
Cover: Send 35mm or 2¼x2¼ color transparencies. Captions required. Pays $200.

VICTIMOLOGY: AN INTERNATIONAL JOURNAL, 2333 N. Vernon St. Arlington VA 22207. (703)528-8872. Editor: Emilio C. Viano. Quarterly journal. Circ. 2,500. "We are the only magazine specifically focusing on the victim, on the dynamics of victimization." For social scientists; criminologists; criminal justice professionals and practitioners; social workers; volunteer and professional groups engaged in crime prevention and in offering assistance to victims of rape, spouse abuse, child abuse, etc.; victims of accidents, neglect, natural disasters, and occupational and environmental hazards. Needs photos related to those themes. Buys 20-30 photos/annually. Buys all rights, but may reassign to photographer after publication. Submit model release with photo. Query with resume of credits or submit material by mail for consideration. Pays on publication. Reports in 6 weeks. SASE. Simultaneous submissions and previously published work OK. Sample copy $5; free editorial guidelines.
B&W: Send contact sheet or 8x10 glossy prints. Captions required. Pays $25-50 depending on subject matter.
Color: Send 35mm transparencies, contact sheet, or 5x7 or 8x10 glossy prints. "We will look at color photos only if part of an essay with text." Captions required. Pays $30 minimum. "Collages OK."
Cover: Send contact sheet or glossy prints for b&w; contact sheet, glossy prints, or 35mm transparencies for color. Captions required. Pays $200 minimum.
Tips: "Contact us so that we can tell what themes we are going to be covering. Send us pictures around a theme, with captions and, if possible, a commentary—some text, even if not extensive. We will look at any pictures that we might use to break the monotony of straight text, but we would prefer essays with some text. A very good idea would be for a photographer to look for a writer and to send in pictures accompanying text as a package. For instance, an interview with the staff of a Rape Crisis Center or Abused Spouses Center or Crisis Intervention Hotline or victims of a natural or industrial disaster accompanied by photos would be very well received. Other topics: accident prevention, earthquake moni-

Vermont Life *purchased this photo by Sandy Macys of Waitsfield, Vermont, for one-time use. It was used as a feature illustration in the "scenic section" that runs in each quarterly issue. Selections were made by the editor, managing editor and art director, and were submitted by Macys six months in advance of the season for which they were considered. Macys feels the photograph conveys the pleasant mood associated with skiing. "*Vermont Life *is one of the best magazines in Vermont," he explains. "It is a goal to be published regularly in this magazine."*

toring, emergency room services, forensic pathologists, etc. A good example of what we are looking for is the work of the Smiths on the victims of mercury poisoning in Japan. We will pay well for good photo essays."

VIDEOMANIA MAGAZINE, 115 Stanton St., Ripon WI 54971. (414)748-2245. Monthly tabloid. Emphasizes home video, plus the world of entertainment (Hollywood, movies, TV, etc.). Readers are predominantly male, average age: 30-40 "very into home video and entertainment." Circ. a few thousand. Sample copy $1.50.
Photo Needs: Uses 12-15 photos/issue; 50 supplied by freelance photographers. Needs basically, anything of interest to home video buffs/entertainment fans—video products, celebrities, convention photos, etc. Model release required.
Making Contact & Terms: Send b&w prints by mail for consideration. SASE. Reports in 1 week. Pays $2.50/b&w cover photo; $1.50/b&w inside photo. Pays on acceptance. Credit line given. Buys all rights, may reassign after publication.
Tips: "Aim for candid shots concerning celebrities; and sharp, clear photos with good contrast. Instead of trying to take the entire scene in, look for an interesting focal point."

***THE VIRGINIAN MAGAZINE**, Box 8, New Hope VA 24469. (703)885-0388. Editor: Jeffrey Wexler. Bimonthly magazine. Emphasizes the state of VA (leisure, travel, history, food, people, etc.). Readers are upscale, college-educated. Circ. 20,000. Sample copy $4. Photo guidelines free with SASE.
Photo Needs: Uses 100 photos/issue; 25% supplied by freelance photographers. Needs photos of scenics, wildlife, seasonal activities.
Making Contact & Terms: Send b&w and color prints or any size transparency (35mm preferred), by mail for consideration; provide resume, business card, brochure, flyer or tearsheets to be kept on file for possible future assignments; or drop off and pick up policy. "We are not liable for loss or damage of material." SASE. Reports in 1 month. Payment negotiated. Pays 30 days after publication. Credit line giv-

en. Buys one-time rights. Simultaneous submissions OK.
Tips: "Past issues will give photographers a clearer idea of what we need. The magazine aspires to quality of National Geographic photos and leans toward photos which stand by themselves or leans toward Norman Rockwell-type story pictures."

VIRTUE MAGAZINE, 548 Sisters Parkway, Box 850, Sisters OR 97759. (503)549-8261. Art Director: Ann Staatz. Magazine published 10 times/year. Emphasizes Christian growth, marriage, family, food, and fashion. Readers are women—mostly married, ages 25-45, Christian, family-oriented. Circ. 125,000. Sample copy $2.
Photo Needs: Uses about 25-30 photos/issue; 1-2 supplied by freelance photographers. "Most freelance photos are assigned." Needs photos of "people relating to each other and to their environment, scenics, wildlife, travel; mood shots which would be difficult for us to set up." Model release preferred.
Making Contact: Query with samples or "send xerox or printed copies to be kept on file." Reports in 1 month. Pays $100-200/color cover photo, $25-75/b&w inside photo, and $50-125/color inside photo. Transparencies only for color photos. Pays on publication. Credit line given. Buys one-time rights. Simultaneous submissions OK.
Tips: Prefers to see "sharp, excellent quality photos with a unique outlook, point-of-view or mood. Send only your best samples. Mediocre work won't get you assignments. Send samples of your work for review. It's best to include one or two things that can be kept on file to remind us of your style/favorite subject matter. Most freelance work we use is specifically assigned to fit an article's subject matter. We use 1-3 freelance photos per issue, specifically assigned. We use 1-4 photos purchased from stock per year."

VISTA, Box 2000, Marion IN 46952. (317)674-3301. Contact: Photo Editor. Weekly. Circ. 60,000. Religious magazine for adults. Sample copy and photo guidelines free with SASE.
Photo Needs: Uses about 4-5 photos/issue; 2-3 supplied by freelance photographers. Needs photos of "adults and people of all ages (singles, couples, families, church groups)." Special needs include "family photos, action shots, photos of human interest and interaction in true-to-life situations, (mood shots)."
Making Contact & Terms: Send 8x10 b&w glossy prints by mail for consideration. SASE. Reports in 2 weeks. Pays $25/b&w cover photo, $15/b&w inside photo; "different rates for reuse." Pays on acceptance. Credit line given. Buys one-time rights. Simultaneous submissions OK.
Tips: "Be sure to read guidelines. We need women in dresses and very little jewelry (if possible)."

WALKING TOURS OF SAN JUAN, First Federal Bldg., Suite 301, 1519 Ponce de Leon Ave., Santurce, Puerto Rico 00909. (809)722-1767. Editor/Publisher: Al Dinhofer. Published biannually: January and July. Circ. 22,000. Emphasizes "historical aspects of San Juan and tourist-related information." Readers are "visitors to Puerto Rico interested in cultural aspects of historical Old San Juan." Sample copy $2.50 plus postage.
Photo Needs: Uses about 50 photos/issue; 25 supplied by freelance photographers. Needs "unusual or interesting shots of San Juan; inquire first." Model release and captions required.
Making Contact & Terms: "Tell us in a brief letter what you have." Does not return unsolicited material without SASE. Reports in 1 month. Pays $100/b&w cover photo; $150/color cover photo; $15-50/b&w inside photo. Pays on acceptance. Credit line given. Buys first North American serial rights. Simultaneous submissions OK.

WASHINGTON, The Evergreen State Magazine, 901 Lenora Ave., Seattle WA 98121. (206)624-8400. Picture Editor: Carrie Seglin. Bimonthly magazine. "We're a regional publication covering the entire state of Washington." Readers are "anybody and everybody living in the state, who wants to live in the state, or who is going to visit the state." Circ. 70,000 (projected). Estab. 1984. Sample copy $3.10; photo guidelines for SASE.
Photo Needs: Uses approximately 50 photos/issue; 35 supplied by freelance photographers. Needs "any and all subjects, provided all subjects are in Washington state. No ringers, please." Model release and captions required. "Captions need not be elaborate; they must, however, identify the subject matter and provide names of persons."
Making Contact & Terms: Submit portfolio for review; provide resume, business card, brochure, flyer or tearsheets to be kept on file for possible future assignments. "Preference is to set up an appointment and come in." SASE. Reports in 2 months. Pays $325/color cover photo, $250/b&w cover photo; $125-275/color inside photo, $50-200/b&w inside photo; $200/color page, $125/b&w page. Pays on publication. Credit line given "either individually for single shots or by-lined for multiple." Buys one-time rights or inclusive of use for magazine promotion. Simultaneous and previously published submissions OK, "depending on the subject and where published."

WASHINGTON POST MAGAZINE, 1150 15th St., NW, Washington DC 20071. (202)334-7585. Design Director: Jann Alexander. Art Director: Brian Noyes. Weekly. Circ. 1,000,000. Emphasizes current events, prominent persons, cultural trends and the arts. Readers are all ages and all interests.
Photo Needs: Uses 30 photos/issue; some are supplied by freelance photographers. Needs photos to accompany articles of regional and national interest on anything from politics to outdoors. Photo essays of controversial and regional interest. Model release required.
Making Contact & Terms: Send samples; then call for appointment. Uses 8x10 or larger b&w prints; 35mm, 2¼x2¼, 4x5 or 8x10 slides. Color preferred. SASE. Reports in 2 weeks. Credit line given. Payment on publication.

WATERFOWLER'S WORLD, Box 38306, Germantown TN 38183. (901)767-7978. Editor: Cindy Dixon. Emphasizes duck and goose hunting for the serious duck and goose hunter. Geared towards the experienced waterfowler with emphasis on improvement of skills. Bimonthly. Circ. 35,000. Sample copy $2.50
Photo Needs: Buys 6 freelance photos/issue. Photos must relate to ducks and geese, action shots, dogs and decoys. Will purchase outstanding photos alone but usually buys photos with accompanying ms. Model release and caption required.
Making Contact & Terms: Send by mail for consideration actual 8x10 b&w glossies and 35mm color transparencies for inside; 35mm color transparencies for cover. SASE. Reports in 8 weeks. Pays on publication $25 minimum/color for cover; $10 b&w. Credit line given. Buys first serial rights.

***WATERFRONT MAGAZINE**, Box 1337, Newport Beach CA 92663. (714)646-3963. Managing Editor: Linda Yuskaitis. Art Director: Jeffrey Fleming. Monthly magazine. Emphasizes sports of recreational sail and power boating; sportfishing; coastal news of southern California. *Waterfront* readers are well-educated, predominantly boat owners, and have knowledge of sail and power boating beyond the fundamentals. Circ. 32,640. Sample copy free with SASE. Photo guidelines free with SASE.
Photo Needs: Uses 40 photos/issue; 25 supplied by freelance photographers. Frequently need boating action shots. On-the-water coverage of specific races. Scenics of southern California harbors, coastal landmarks also welcomed. Also photos of well-known boating personalities. Special needs: photo coverage of America's Cup match races in Fremantle, Australia in January 1987 and Australia coverage of Olympic yachting in Korea, 1988. Model release preferred; captions required.
Making Contact & Terms: Arrange a personal interview to show a portfolio; query with resume of credits, samples, and list of stock photo subjects; provide resume, business card, brochure, flyer or tearsheets to be kept on file for possible future assignments; send 5x7 or larger glossy b&w and color prints; 35mm, 2¼x2¼ transparencies by mail for consideration. Prefers query before personal meeting. SASE. Reports in 3 weeks. Pays $200/color cover photo; $20-75/inside color photo; $75-100/b&w page; job. Pays on publication. Credit line given. Buys first North American serial rights, sometimes second serial (reprint) rights. Previously published work OK.
Tips: Prefers to see good variety of shots—action, portrait, news and feature. Action shots important. Wants to see nice treatment of human subjects (Does it capture the drama? Is it sensitive? Good character profile?) Scenics also welcomed. Have some experience shooting boats—sail or power in action. Also, portfolio should be neat, and show widest variety of assignments possible. Review photographer's guidelines and be flexible and available for assignments. "We welcome the submission of color transparencies solely for consideration as cover photos. Scene must be in southern California location; vertical format; coastal theme."

***WATER SKI**, Box 2456, Winter Park FL 32790. (305)628-4802. Photo Editor: Doug DuKane. Publication of World Publications Inc. Monthly magazine. Emphasizes watersports—waterskiing. Readers are of all ages and all income groups. Circ. 80,000. Sample copy $2.50. Photo gudielines free.
Photo Needs: Uses 90 photos/issue; 20% supplied by freelance photographers. Needs photos of "waterskiing—recreational, tournament and outrageous." Model release and captions preferred.
Making Contact & Terms: Query with samples; send unsolicited photos by mail for consideration; provide resume, business card, brochure, flyer or tearsheets to be kept on file for possible future assignments. Send 35mm, 2¼x2¼ and 4x5 transparencies by mail for consideration. Kodachrome and slow Fuji is preferred. SASE. Reports in 3 weeks. Pays $20-100/b&w page; $30-300/color page. Pays 30 days after publication. Credit line given. Buys one-time rights unless otherwise agreed upon. Simultaneous submissions OK.
Tips: Needs razor sharp images. "The best guideline is the magazine itself. High action sequences are good, but the ability to include personality/recreational/type work helps round out the submissions. Get used to shooting on, in or under water. Most of our needs are found there. Photographers are mailed needs list-(from stock) each issue."

WATERWAY GUIDE, 850 3rd Ave., New York NY 10022. Editor: Queene Hooper. Annually. Circ. approximately 15,000/edition. "The *Waterway Guide* publishes 3 East Coast (Southern, Mid-Atlantic,

and Northern) editions and Great Lakes edition. It is a boaters cruising guide to each area. Each edition includes advice on navigation, places to anchor, cruising tips, marina and restaurant listings, shore attractions. Each edition is revised each year." Readers are "affluent, mostly middle-age, college educated, own average of 28' boat. (Compiled from a market research report)." Sample copy $16.95/edition.
Photo Needs: Uses one full color cover shot per edition; supplied by freelance photographer. "Each edition's cover shot must depict that particular region's typical pleasure boating experience. We try to express the regionality of each edition within the photo, showing perhaps a typical *Waterway Guide* reader at anchor or cruising, or a scene that one might experience while cruising that area. Colorful shots preferred. Note: We get too many moody, seascape, sunset/sunrise shots. Don't send yours unless it is truly exceptional." Model release required.
Making Contact & Terms: Provide resume, business card, brochure, flyer or tearsheets to be kept on file for possible future assignments. "Calls will be accepted for further description of photo needs. Since we need photos from all over the East Coast we realize a personal interview is usually impossible." Does not return unsolicited material. Pays approximately $250/color cover photo. Pays on publication. Credit line given on contents page. Buys rights for one-year use from date of publication.
Tips: "Considering the nature of our publication, don't send racing shots, windsurfer or daysailor shots, or aground boat shots. Those people don't use *Waterway Guide*. Send shots that encourage people to cruise the area."

WEIGHT WATCHERS, 360 Lexington Ave., New York NY 10017. (212)370-0644. Editor: Lee Haiken. Art Director: Alan Richardson. Monthly magazine. Circ. 825,000. For those interested in weight control, proper nutrition, inspiration and self-improvement. Photos purchased on assignment only. Buys approximately 12 photos/issue. Pays $300/single page; $500/spread; and $700/cover. Credit line given. Pays on acceptance. Buys first rights. Portfolio—drop-off policy only.
Subject Needs: All on assignment: food and tabletop still life, beauty, health and fitness subjects, occasionally fashion, personality portraiture. All photos contingent upon editorial needs.

WEST COAST REVIEW, c/o English Dept., Simon Fraser University, Burnaby, British Columbia, Canada V5A 1S6. (604)291-4287. Editor: Frederick Candelaria. Quarterly. Circ. 500. Emphasizes art photography. "General audience. Institutional subscriptions predominate." Sample copy $4.
Photo Needs: Uses about 6 photos/issue; all supplied by freelance photographers. "All good works will be considered." Model release required.
Making Contact & Terms: Query with samples; send any size b&w glossy prints by mail for consideration. SASE. Reports as soon as possible. Pays $25-200/photo package. Pays on acceptance. Credit line given in table of contents. Buys one-time rights.
Tips: "Have patience. And subscribe to the *Review*."

***WESTERN FLYER/SPORT FLYER**, Box 98786, Tacoma WA 98498-0786. (206)588-1743. Editor: Bruce Williams. *Western Flyer*-biweekly and *Sport Flyer*-monthly, tabloids. Emphasizes WF: general aviation; SF: recreational flying—ultralight soaring, skydiving, ballooning, homebuilt aircraft, etc. Readers are pilots, aircraft owners. Circ. WF: 20,000; SF: 10,000. Sample copy $2 each. Photo guidelines free with SASE.
Photo Needs: Uses 30-35 photos/issue in *Western Flyer*; 15-20 photos/issue in *Sport Flyer*, ½ supplied by freelance photographers. Needs photos of aviation scenes; good, detailed photos of aircraft, etc. Model release preferred; captions required.
Making Contact & Terms: Query with resume of credits; provide resume, business card, brochure, flyer or tearsheets to be kept on file for possible future assignments. SASE. Reports in 3 weeks. Pays $25/b&w cover photo; $50/color cover photo; $10-15/b&w photo; $25/inside color photo. Pays "1 month following publication." Credit line given. Buys one-time rights. Simultaneous submissions and previously published work OK. "Must be identified as such."

WESTERN HORSEMAN, 3850 N. Nevada Ave., Box 7980, Colorado Springs CO 80933. Editor: Randy Witte. Monthly magazine. Circ. 156,357. For active participants in horse activities, including pleasure riders, ranchers, breeders and riding club members. Buys first rights. Submit material by mail for consideration. "We buy mss and photos as a package. Payment for 1,500 words with b&w photos ranges from $100-225. Articles and photos must have a strong horse angle, slanted towards the western rider—rodeos, shows, ranching, stable plans, training."

WESTERN OUTDOORS, 3197-E Airport Loop, Costa Mesa CA 92626. Editor-in-Chief: Burt Twilegar. Monthly magazine. Circ. 151,001. Emphasizes hunting, fishing for 11 western states, Alaska and Canada. Needs cover photos of hunting and fishing in the Western states. Buys one-time rights "but will negotiate." Query or send photos for consideration. Most photos purchased with accompanying ms. Pays on acceptance for covers. Reports in 4 weeks. SASE. Sample copy $1.75. Free editorial guidelines; enclose SASE.

B&W: Pays $25-75/b&w photo; $50-200/color photo.
Color: Send 35mm Kodachrome II transparencies. Captions required. Pays $300+ for text/photo package.
Tips: "Submissions should be of interest to western fishermen or hunters, and should include a 1,120-1,500 word ms; a Trip Facts Box (where to stay, costs, special information); photos; captions; and a map of the area. Emphasis is on where-to-go. Submit seasonal material 6 months in advance. Make your photos tell the story and don't depend on captions to explain what is pictured. Avoid 'photographic cliches' such as 'dead fish with man,' dead pheasants draped over a shotgun, etc. Get action shots, live fish and game. We avoid the 'tame' animals of Yellowstone and other National parks. In fishing, we seek individual action or underwater shots. Get to know the magazine and its editors. Ask for the year's editorial schedule (available through advertising departments) and offer cover photos to match the theme of an issue. Send duplicated transparencies as samples, but be prepared to provide originals rights away."

WESTERN SPORTSMAN, Box 737, Regina, Saskatchewan, Canada S4P 3A8. (306)352-8384. Editor: Rick Bates. Bimonthly magazine. Circ. 28,000. Emphasizes fishing, hunting and outdoors activities in Alberta and Saskatchewan. Photos purchased with or without accompanying ms. Buys 30 freelance photos/year. Pays on acceptance. Send material by mail for consideration or query with a list of stock photo subjects. SASE. Reports in 3 weeks. Sample copy $3; free photo guidelines with SASE.
Subject Needs: Sport (fishing, hunting, camping); nature; travel; and wildlife. Captions required.
B&W: Uses 8x10 glossy prints. Pays $20-25/photo.
Color: Uses 35mm and 2¼x2¼ transparencies. Pays $75-100/photo for inside pages.
Cover: Uses 35mm and 2¼x2¼ transparencies. Vertical format preferred. Pays $175-250/photo.
Accompanying Mss: Fishing, hunting and camping. Pays $75-325/ms. Free writer's guidelines with SASE.

WESTWAYS, Box 2890, Terminal Annex, Los Angeles CA 90051. Emphasizes Western US and World travel, leisure time activities, people, history, culture and western events.
Making Contact & Terms: Query first with sample of photography enclosed. Pays $25/b&w photo; $50/color transparency; $350/day on assignment; $300-350 plus $50 per photo published for text/photo package.
Tips: "We like to get photos with every submitted manuscript. We take some photo essays (with brief text), but it must be unusual and of interest to our readers. All photos should be tack sharp originals for final reproduction and well captioned."

*****WHEELINGS**, Box 389, Franklin MA 02038. (617)528-6211. Editor: J.A. Kruza. Published 9 times/year, tabloid-size magazine. Emphasizes auto body shops, auto paint shops, auto dealers, auto paint manufacturers. Readers are auto industries with 8 or more employees. Circ. 14,000. Estab. 1985. Sample copy and photo guidelines free.
Photo Needs: Uses 75 photos/issue; usually 10-15 supplied by freelance photographers. "We need news-type photos relating to the industry." Captions required.
Making Contact & Terms: Query with samples. SASE. Reports in 2 weeks. Pays $35 first photo, $10 for each additonal photo; buys 3-5 photos in a series. Pays on acceptance. Credit line given. Prefers all rights; reassigns to photographer after use. Simultaneous submissions and previously published work OK.
Tips: "Do some work and get in touch with us."

WHERE MAGAZINE, 2nd Floor, 600 Third Ave., New York NY 10016. (212)687-4646. Editor: Michael Kelly Tucker. Monthly. Emphasizes points of interest, shopping, restaurants, theatre, museums, etc., in New York City (specifically Manhattan). Readers are visitors to New York staying in the city's leading hotels. Circ. 108,000/month. Sample copy available in hotels.
Photo Needs: Covers showing New York scenes. No manuscripts. Model release and captions preferred.
Making Contact & Terms: Arrange a personal interview to show portfolio. Does not return unsolicited material. Payment varies. Pays on publication. Credit line given. Rights purchased vary. Simultaneous submissions and previously published work OK.

WHOLISTIC LIVING NEWS, 3335 Adams Ave., San Diego CA 92116. (619)280-0317. Contact: Managing Editor. Bimonthly newspaper. Emphasizes "the health and fitness area plus environmental and human rights issues." Readers are "health-conscious, environmentally-aware people." Circ. 75,000. Sample copy $1.50. Photo guidelines free with SASE.
Photo Needs: Uses about 20 photos/issue; most are assigned. Subject needs "depend on the focus of each particular issue. Please query about topic." Model release and captions required.
Making Contact & Terms: Query with resume of credits. SASE. Reports in 1 month. Pays $50/color cover photo. Pays on acceptance. Credit line given. Simultaneous submissions OK.

***WIND RIDER**, Box 2456, Winter Park FL 32790. (305)628-4802. Photo Editor: Doug DuKane. Monthly magazine. Emphasizes boardsailing. Readers are all ages and all income groups. Circ. 40,000. Sample copy $2.50. Photo guidelines free with SASE.
Photo Needs: Uses 40 photos/issue; 50% supplied by freelance photographers. Needs photos of boardsailing, flat water, recreational travel destinations to sail. Model release and captions preferred.
Making Contact & Terms: Query with samples; send unsolicited photos by mail for consideration; provide resume, business card, brochure, flyer or tearsheets to be kept on file for possible future assignments. Send 35mm, 2¼x2¼ and 4x5 transparencies by mail for consideration. Kodachrome and slow Fuji preferred. SASE. Reports in 3 weeks. Pays $20-100/b&w page; $30-350/color page. Pays 30 days after publication. Credit line given. Buys one-time rights unless otherwise agreed on. Simultaneous submissions OK.
Tips: "We need to see razor sharp images. The best guideline is the magazine itself. Get used to shooting on, in or under water. Most of our needs are found there."

WINDSOR THIS MONTH, Box 1029, Station "A", Windsor, Ontario, Canada N9A 6P4. (519)966-7411. Monthly. Circ. 22,000. "*Windsor This Month* is mailed out in a system of controlled distribution to 19,000 households in the area. The average reader is a university graduate, middle income and active in leisure area."
Photo Needs: Uses 12 photos/issue; all are supplied by freelance photographers. Selects photographers by personal appointment with portfolio. Uses photos to specifically suit editorial content; specific seasonal material such as skiing and other lifestyle subjects. Provide resume and business card to be kept on file for possible future assignments. Model release and captions required.
Making Contact & Terms: Send material by mail for consideration and arrange personal interview to show portfolio. Uses 8x10 prints and 35mm slides. SASE. Reports in 2 weeks. Pays $100/color cover; $25/b&w inside; $35/color inside. Credit line given. Payment on publication. Simultaneous and previously published work OK provided work hasn't appeared in general area.
Tips: "*WTM* is a city lifestyle magazine; therefore most photos used pertain to the city and subjects about life in Windsor."

WINE TIDINGS, 5165 Sherbrooke St. W., Montreal, Quebec, Canada H4A 1T6. (514)481-5892. Editor: Barbara Leslie. Published 8 times/year. Circ. 27,000. Emphasizes "wine for Canadian wine lovers, 85% male, ages 25 to 65, high education and income levels." Sample copy free with SAE and International Reply Coupons.
Photo Needs: Uses about 15-20 photos/issue; most supplied by freelance photographers. Needs "wine scenes, grapes, vintners, pickers, vineyards, bottles, decanters, wine and food; from all wine producing countries of the world. Many fillers also required." Photos usually purchased with accompanying ms. Captions preferred.
Making Contact & Terms: Send any size b&w and color prints; 35mm or 2¼x2¼ transparencies (for cover) by mail for consideration. SAE and International Reply Coupons. Reports in 5-6 weeks. Pays $150/color cover photo; $10-25/b&w inside photo; $25-100/color used inside. Pays on publication. Credit line given. Buys "all rights for one year from date of publication." Previously published work accepted occasionally.
Tips: "Send sample b&w prints with interesting, informed captions."

WISCONSIN SPORTSMAN, Box 2266, Oshkosh WI 54903. (414)233-7470. Editor: Tom Petrie. Bimonthly magazine. Circ. 76,000. Emphasizes fishing, hunting and the outdoors of Wisconsin. Photos purchased with or without accompanying ms. Buys 100 photos/year. Pays $100-800 for text/photo package, and on a per-photo basis; some cases prices are negotiable. Credit line given. Pays on acceptance. Buys first rights. Send material by mail for consideration or query with list of stock photo subjects. SASE. Previously published work OK. Reports in 3 weeks.
Subject Needs: Animal (upper Midwest wildlife); photo essay/photo feature (mood, seasons, upper Midwest regions); scenic (upper Midwest with text); sport (fishing, hunting and vigorous nonteam oriented outdoor activities); how-to; nature; still life (hunting/fishing oriented); and travel. "Good fishing/hunting action scenes." Captions preferred.
B&W: Uses 8x10 glossy prints. Pays $25-250/photo.
Color: Uses transparencies. Pays $50-400/inside photo. Full color photo essays/rates negotiable.
Cover: Uses color transparencies. Vertical format preferred. Pays $250-300/photo.
Accompanying Mss: How-to oriented toward fishing, hunting and outdoor activities in the upper Midwest; where-to for these activities in Wisconsin; and wildlife biographies. *Wisconsin Sportsman* frequently buys in combination with its sister publications, *Minnesota Sportsman*, *Michigan Sportsman*, *Pennsylvania Outdoors* and *New York In The Field*.

WISCONSIN TRAILS, Box 5650, Madison WI 53705. (608)231-2444. Photo Editor: Nancy Mead. Bimonthly magazine. Circ. 30,000. For people interested in history, travel, recreation, personalities, the

arts, nature and Wisconsin in general. Needs seasonal scenics and photos relating to Wisconsin. Annual Calendar: uses horizontal format; scenic photographs. Pays $150. Wants no color or b&w snapshots, color negatives, cheesecake, shots of posed people, b&w negatives ("proofs or prints, please") or "photos of things clearly not found in Wisconsin." Buys 200 photos annually. Buys first serial rights or second serial (reprint) rights. Query with resume of credits, arrange a personal interview to show portfolio, submit portfolio or submit contact sheet or photos for consideration. Provide calling card and flyer to be kept on file for possible future assignments. Pays on publication. Reports in 3 weeks. SASE. Simultaneous submissions OK "only if we are informed in advance." Previously published work OK. Photo guidelines with SASE.

B&W: Send contact sheet or 5x7 or 8x10 glossy prints. "We greatly appreciate caption info." Pays $15-20. Most done on assignment.

Color: Send transparencies; "we use all sizes." Locations preferred. Pays $50-100.

Cover: Send 35mm, 2¼x2¼ or 4x5 color transparencies. Photos "should be strong seasonal scenics or people in action." Uses vertical format; top of photo should lend itself to insertion of logo. Locations preferred. Pays $100.

Tips: "Because we cover only Wisconsin and because most b&w photos illustrate articles (and are done by freelancers on assignment), it's difficult to break into *Wisconsin Trails* unless you live or travel in Wisconsin." Also, "be sure you specify how you want materials returned. Include postage for any special handling (insurance, certified, registered, etc.) you request."

WITH, Box 347, Newton KS 67114. (316)283-5100. Editor: Susan E. Janzen. Monthly magazine. Circ. 7,000. Emphasizes "Christian values in lifestyle, vocational decision making, conflict resolution for US and Canadian high school students." Photos purchased with or without accompanying ms and on assignment. Buys 120 photos/year; 10 photos/issue. Pays $20-35/b&w photo, 4¢/word for text/photo packages, or on a per-photo basis. Credit line given. Pays on acceptance. Buys one-time rights. Send material by mail for consideration or submit portfolio and resume for review. SASE. Simultaneous submissions and previously published work OK. Reports in 3 weeks. Sample copy $1.25; photo guidelines free with SASE.

Subject Needs: Documentary (related to concerns of high school youth "interacting with each other, with family and in school environment"); fine art; head shot; photo essay/photo feature; scenic; special effects & experimental; how-to; human interest; humorous; still life; and travel. Particularly interested in mood/candid shots of youths. Prefers candids over posed model photos. Less literal photos, more symbolism. Few religious shots, e.g. crosses, bibles, steeples, etc.

B&W: Uses 8x10 glossy prints. Pays $15-25/photo.

Cover: Uses b&w glossy prints. Pays $15-35/photo.

Accompanying Mss: Issues involving youth—school, peers, family, hobbies, sports, community involvement, sex, dating, drugs, self-identity, values, religion, etc. Pays 4¢/printed word. Writer's guidelines free with SASE.

Tips: "Freelancers are our lifeblood. We're interested in photo essays, but good ones are scarce. Candid shots of youth doing ordinary daily activities and mood shots are what we generally use. Photos dealing with social problems are also often needed. We rely greatly on freelancers, so we're interested in seeing work from a number of photographers. *With* is one of 2 periodicals published at this office, and we also publish Sunday school curriculum for all ages here, so there are many opportunities for photographers. Needs to relate to teenagers—either include them in photos or subjects they relate to; using a lot of 'nontraditional' roles. Use models who are average-looking, not obvious model-types. Teenagers have enough self esteem problems without seeing 'perfect' teens in photos."

WITTMAN PUB INC., COMPANY—MARYLAND FARMER, VIRGINIA FARMER & GEORGIA FARMER NEWSPAPER, ALABAMA FARMER, Box 3689, Baltimore MD 21214. (301)254-0273. Photo Editor: W.D. Wittman. Monthly tabloid. Emphasizes agriculture. Readers are agri-related. Circ. 60,000. Free sample copy with SASE.

Photo Needs: Uses 50-60 photos/issue; 50% supplied by freelance photographers. Reviews photos with accompanying ms only. Model release and captions required.

Making Contact & Terms: Provide resume, business card, brochure, flyer or tearsheets to be kept on file for possible future assignments. Pays on publication. Credit line given. Buys one-time rights.

WOMAN'S DAY MAGAZINE, CBS Publications, 1515 Broadway, New York NY 10036. (212)719-6480. Art Director: Brad Pallas. Magazine published 17 times/year. Circ. 8,000,000. Emphasizes homemaking, cooking, family life and personal goal achievement. "We are a service magazine offering ideas that are available to the reader or ones they can adapt. We cater to women of middle America and average families." Uses story-related photographs on assignment basis only. Pays $450/day against a possible page rate, or on a per-photo basis. Credit line given. Pays on acceptance. Buys one-time rights and first rights. Complete woman's service magazine subjects (food, fashion, beauty, decorating, crafts, family relationships, money, health, children, etc.).

WOMAN'S WORLD, 177 N. Dean St., Englewood NJ 07631. (201)569-0006. Editor-in-Chief: Dennis Neeld. Photo Editor: R. Lynn Goldberg. Weekly. Circ. 1,000,000. Emphasizes women's issues. Readers are women 25-60 nationwide of low to middle income. Sample copies available.
Photo Needs: Uses up to 100 photos/issue; all supplied by freelance photographers. Needs photos of travel, fashion, crafts and celebrity shots. "For our editorial pages we mainly look for very informative straightforward photos of women's careers, travel, people in everyday personal situations—couples arguing, etc., and medicine. Photographers should be sympathetic to the subject, and our straightforward approach to it." Photos purchased with or without accompanying ms. Model release and captions required.
Making Contact & Terms: Query with 8x10 b&w glossy prints or 35mm transparencies or provide basic background and how to contact. Prefers to see tearsheets of published work, or prints or slides of unpublished work, as samples. SASE. Reports in 1 month. Provide resume and tearsheets to be kept on file for possible future assignments. Pays $250/day plus expenses; $300/page for color and fashion. Pays on acceptance. Credit line given. Buys one-time rights.

WOMEN'S CIRCLE HOME COOKING, Box 198, Henniker NH 03242. Contact: Editor. Monthly magazine. Circ. 200,000. For "practical, down-to-earth people of all ages who enjoy cooking. Our readers collect and exchange recipes. They are neither food faddists nor gourmets, but practical men and women trying to serve attractive and nutritious meals." Buys 48 photos annually. Freelancers supply 80% of the photos. Credit line given. Pays on acceptance. Buys all rights; will release after publication. Send material. SASE. Reports in 1 month. Free sample copy with 9x12 envelope and 40¢ postage.
Subject Needs: Needs photos of food with accompanying recipes. Wants no photos of raw fruit or vegetables, posed shots with "contrived backgrounds" or scenic shots. Needs material for a special Christmas issue. Submit seasonal material 6 months in advance. "Good close-ups of beautifully prepared food are always welcome." Props (dishes, utensils, kitchens, etc.) should contain that "home cooking" flavor. Captions and recipes are required.
B&W: Uses 5x7 glossy prints. Pays $10-20.
Color: Uses 35mm or 2¼x2¼ transparencies. Pays $35 for inside covers.
Cover: Uses 4x5 color transparencies; vertical format required. "Image of food should appear in bottom ⅔ of shot. We prefer shots of prepared dishes rather than raw ingredients." Pays $50-75.
Tips: Would like more b/w for inside use. Looks for "professional/food pics that retain a 'home cooking' flavor—superb recipes appealing to a married woman who has children or grandchildren which use fresh, basic ingredients. No food fads, no sophisticated gourmet recipes, nor those that call for expensive, hard-to-find ingredients or equipment. Must submit recipe(s) of food item(s) in pic. Give me a shot of food that makes the mouth water."

WOMEN'S SPORTS MAGAZINE AND FITNESS, 310 Town & Country Village, Palo Alto CA 94301. (415)321-5102. Production Manager: Lynda Locke. Art Director: Dorothy Yule. Monthly. Circ. 250,000. Emphasizes "health, sports, fitness, with women's emphasis. Personality profiles." Readers are "active women, average age 27.7 years old." Sample copy $2.
Photo Needs: Uses about 40 photos/issue; 75% supplied by freelance photographers. Needs "action shots, portraits." Model release preferred.
Making Contact & Terms: Query with resume of credits; provide resume, business card, brochure, flyer or tearsheets to be kept on file for possible future assignments. SASE. Reports in 3 weeks. Payment varies. Pays on publication. Credit line given. Buys one-time rights.
Tips: "Send intelligent sounding queries."

WOODHEAT: THE WOODSTOVE DIRECTORY, Box 2008, Village West, Laconia NH 03247. (603)528-4285. Editor: Jason Perry. Annual magazine. Emphasizes wood heaters and fireplaces. Readers are buyers and owners of wood heaters; energy-minded homeowners. Circ. 175,000. Sample copy $6 (postage included).
Photo Needs: Uses about 40 photos/issue; 75% supplied by freelance photographers. Needs "installation shots of wood heaters, energy-efficient homes, other energy topics on assignment. We need plenty of 4-color photos; the theme is energy, particularly anything to do with wood heat." Written release and captions required.
Making Contact & Terms: Query with samples. Send any size glossy prints, 2¼x2¼ transparencies, color contact sheet by mail for consideration. Submit portfolio for review. Provide resume, business card, brochure, flyer or tearsheets to be kept on file for possible future assignments. Payment varies. Rights purchased "varies, depending on photographer and use."

THE WORKBASKET, 4251 Pennsylvania, Kansas City MO 64111. (816)531-5730. Editor: Roma Jean Rice. Monthly except June/July and November/December. Circ. 1,800,000. Emphasizes primarily needlework with some foods, crafts and gardening articles for homemakers. Photos purchased with accompanying ms. Pays on acceptance. Buys all rights. Send material by mail for consideration. SASE. Reports in 1 month.

Subject Needs: Wants on a regular basis gardening photos with ms and craft photos with directions. "No needlework photos. Must have model accompanying directions." Captions required on how-to photos.
B&W: Uses 8x10 glossy prints. Pays $10/photo.
Accompanying Mss: Seeks articles on gardening or plants and how-to articles. Pays 7¢/word. Free writer's guidelines with SASE.

WORKBENCH MAGAZINE, 4251 Pennsylvania Ave., Kansas City MO 64111. Editor: Jay W. Hedden. Associate Editor: A. Robert Gould. Bimonthly magazine. Circ. 850,000. Emphasizes do-it-yourself projects for the woodworker and home maintenance craftsman. Photos are purchased with accompanying ms. Pays $75-200/published page. Credit line given with ms. Pays on acceptance. Buys all rights, but may reassign to photographer after publication. Ask for writer's guidelines, then send material by mail for consideration. SASE. Reports in 4 weeks. Free sample copy and photo guidelines.
Subject Needs: How-to; needs step-by-step shots. "No shots that are not how-to." Model release required; captions preferred.
B&W: Uses 5x7 or 8x10 glossy prints. Pay is included in purchase price with ms.
Color: Uses 2¼x2¼ or 4x5 transparencies and 8x10 glossy prints. Pays $125 minimum/photo.
Cover: Uses 4x5 color transparencies. Vertical format required. Pays $150 minimum/photo.
Accompanying Mss: Seeks how-to mss. Pays $75-200/published page. Free writer's guidelines.
Tips: Prefers to see "sharp, clear photos; they must be accompanied by story with necessary working drawings. See copy of the magazine."

WORLD COIN NEWS, 700 E. State St., Iola WI 54990. (715)445-2214. Managing Editor: Kit Kiefer. Weekly. Circ. 10,000. Emphasizes "foreign (non-US) numismatics—coins, medals, tokens, exonumia." Readers are "affluent, average age 45, professional." Sample copy free.
Photo Needs: Uses about 40 photos/issue; 25% supplied by freelance photographers. Needs photos of "coins, medals, tokens, sculptors of coins, banks, landmarks for special issues (12 per year around the country), business. In any given year, *WCN* runs on the average 12 special issues dealing with major conventions in cities throughout the U.S. and two or three in major cities of the world. We need freelancers to submit landmark photos along with directories of things to do and see of an editorial nature. We can get canned photos from the tourist agencies; what we're looking for are artistic shots with character. We desire to make contact with freelance photographers in as many countries as possible for future assignments. Therefore, we would appreciate the standard resume, calling card and samples for our files for reference." Model release and captions required.
Making Contact & Terms: Query with samples. Provide resume, business card, brochure, flyer or tearsheets to be kept on file for possible future assignments. SASE. Reports in 1 month. Pays $5/b&w cover photo; $5/b&w inside photo; payments negotiable for page rate, per hour, per job, and for text/photo package. Pays on acceptance. Credit line given. Rights negotiable. Simultaneous submissions and previously published work OK.
Tips: "Contact your local coin dealers and get acquainted with the hobby interests."

WORLD ENCOUNTER, 2900 Queen Lane, Philadelphia PA 19129. (215)438-6360. Editor: James E. Solheim. Quarterly magazine. Circ. 14,000. A world mission publication of the Lutheran churches in North America. Emphasizes world concerns as they relate to Christian activity. Readers have a more than superficial interest in and knowledge of world mission and global concerns. Photos purchased with or without accompanying ms, and on assignment. Buys 25 photos/year. Pays $20-300/job; $45-130 for text/photo package; or on a per-photo basis. Credit line given. Pays on publication. Buys all rights; second serial rights; and one-time rights. Query with subject matter consistent with magazine's slant. SASE. Simultaneous submissions and previously published work OK. Reports in 3 weeks. Sample copy $1.
Subject Needs: Personality (occasionally needs "world-leader" shots, especially from Third World countries); documentary; photo essay/photo feature; scenic; spot news (of Christian concern); human interest (if related to a highlighted theme, i.e., world hunger, refugees, overseas cultures). Needs photos church/religion related. No tourist-type shots that lack social significance. Captions required.
B&W: Uses 8x10 glossy prints; contact sheet and negatives OK. Pays $25 minimum/photo.
Cover: Uses b&w glossy prints or color transparencies. Vertical format preferred. Pays $50 minimum/photo.
Accompanying Mss: Articles relating to world mission endeavors or that help promote global consciousness. Pays $100-200/ms. Writer's guidelines free with SASE.
Tips: Query to determine specific needs, which change from time to time. "Investigate the overseas involvement of the Lutheran churches."

YACHT RACING & CRUISING, 23 Leroy Ave., Box 1700, Darien CT 06820. (203)655-2531. Editor: John Burnham. Magazine published monthly. Circ. 50,000. Emphasizes sailboat racing and perform-

ance cruising for sailors. Buys 250 photos/year; 20-25 photos/issue. Credit line given. Pays on publication. Buys first North American serial rights. Send material by mail for consideration. Provide calling card, letter of inquiry and samples to be kept on file for possible future assignments. SASE. Reports in 1 month. Sample copy $2.50; free photo guidelines.

Subject Needs: Sailboat racing and cruising photos and how-to for improving the boat and sailor. "Include some sort of story or caption with photos." Captions required. Note magazine style carefully.
B&W: Uses 5x7 and 8x10 glossy prints. Pays $30/photo.
Cover: Uses 35mm and 2¼x2¼ color transparencies. Vertical and gatefold formats. Pays $50-250/photo.
Accompanying Mss: Report of race or cruise photographed or technical article on photo subject. Occasionally does photo features with minimal story line. Pays $100-150/published page. Free writer's guidelines; included on photo guidelines sheet.
Tips: "Instructional or descriptive value important. Magazine is for knowledgeable and performance-oriented sailors. Send examples of work and schedule of events you're planning to shoot." Looks for "sharp images, often difficult with long lens needed; proper exposure, too often dark or sailors faces black because they're in the shade. We're looking for technical ability and new angles all the time. Don't use Ektachrome. Query us by sending 20 sample slides. You must have reasonable knowledge of sailing."

YACHTING, 5 River Rd., Box 1200, Cos Cob CT 06807. Associate Editor: Deborah Meisels. Monthly magazine. Circ. 150,000. For yachtsmen interested in powerboats and sailboats. Needs action photos of pleasure boating—power and sail. Buys 100 photos minimum annually. Buys first North American serial rights. Send photos for consideration. Pays on acceptance. Reports in 6 weeks. SASE.
B&W: Send 5x7 or 8x10 glossy prints. Captions required. Pays $50 minimum.
Color: Send 35mm. Captions required. Pays $75 minimum.
Cover: Pays $500 minimum.

YANKEE PUBLISHING, INC., Dublin NH 03444. (603)563-8111. Managing Editor: John Pierce. Editor: Judson D. Hale. Photography Editor: Stephen O. Muskie. Monthly magazine. Circ. 1,000,000. Emphasizes the New England lifestyle of residents of the 6-state region for a national audience. Buys 50-70 photos/issue. Credit line given. Buys one-time rights. Query only. Provide calling card, samples and tearsheets to be kept on file for possible future assignments. SASE. Previously published work OK. Reports in 4-6 weeks. Free photo guidelines.
Subject Needs: "Outstanding photos are occasionally used as centerspreads; they should relate to surrounding subject matter in the magazine. Photo essays ('This New England') must have strong and specific New England theme, i.e., town/region, activity or vocation associated with the region, etc. All *Yankee* photography is done on assignment." No individual abstracts. Captions required.
B&W: Uses 8x10 glossy prints; contact sheet OK.
Color: Uses 35mm, 2¼x2¼ and 4x5 transparencies. Pays $150/printed page; $50-300/b&w and color photo; $150-300/day; $1,500/maximum package.
Tips: "Send in story ideas after studying *Yankee* closely. We look for pro-level quality. Shouldn't have to make excuses or apologies for *anything* in a portfolio. Be persistent. Study the magazine."

YELLOW SILK: Journal of Erotic Arts, Box 6374, Albany CA 94706. Editor: Lily Pond. Quarterly magazine. Circ. 8,500. Emphasizes literature, arts and erotica. Readers are well educated, creative, liberal. Sample copy $4.
Photo Needs: Uses about 12 photos "by one artist" per issue. "All photos are erotic, none are cheesecake or sexist. We define 'erotic' in its widest sense; trees and flowers can be as erotic as humans making love. They are fine arts." Model release preferred.
Making Contact & Terms: Query with samples; submit prints, transparencies, contact sheets or photocopies by mail for consideration; submit portfolio for review. SASE. Reports in 1 week-2 months. "Payment to be arranged." Pays on publication. Credit line given. Buys one-time rights; "use for promotional and/or other rights arranged."
Tips: "Get to know the publication you are submitting work to and enclose SASE in all correspondence."

***YOUNG AMBASSADOR**, Box 82808, Lincoln NE 68501. (402)474-4567. Managing Editor: Nancy Bayne. Monthly magazine. Circ. 82,000. Emphasizes Christian living for Christian young people, ages 12-16. Buys 5-10 photos/issue. Buys one-time-use rights. Send photos for consideration, or send contact sheet. Address to Photo Coordinator. Pays on acceptance. Reports in 2-4 weeks. SASE. Simultaneous submissions and previously published work OK. Free sample copy and photographer's guidelines.
Subject Needs: Photos of young people 13-16 years old in unposed, everyday activities. Scenic, sport, photo essay/photo feature, human interest, head shot, still life, humorous and special effects/experimental. Especially needs covers for next year.

B&W: Send contact sheet or 8x10 glossy prints. Pays $20-25 for most.
Color: Send color transparencies. Pays $50 maximum.
Front Cover: Send 35mm or larger format vertical color transparencies. Pays $75 maximum.
Tips: "Close-up shots featuring moody, excited or unusual expressions needed. Would like to see more shots featuring unusual and striking camera and darkroom techniques."

YOUR HEALTH & FITNESS, 3500 Western Ave., Highland Park IL 60035. (312)432-2700. Photo Editor: Barbara A. Bennett. Published bimonthly. Health magazine. Sample copy and photo guidelines free with 8x11 SASE.
Photo Needs: Uses vertical 35mm or larger color transparencies of family involved in indoor/outdoor activities (no portraits); b&w photos of adults, primarily health, fitness, safety or nutrition themes.
Making Contact & Terms: Send prints or transparencies by mail for consideration. SASE. Reports in 2-4 weeks. Buys one-time rights only. Payment negotiable. Pays on publication. Credit line given. Simultaneous and previously published submissions OK.

YOUR HEALTH & MEDICAL BULLETIN, 5401 NW Broken Sound Blvd., Boca Raton FL 33431. (800)233-7733, (305)997-7733. Editor: Susan Gregg. Photo Editor: Judy Browne. Weekly tabloid. Emphasizes healthy lifestyles: aerobics, sports, eating; celebrity fitness plans, plus medical advances and the latest technology. Readers include consumer audience; males and females from early 20's through 70's. Circ. 60,000. Sample copy 95¢. Call for photo guidelines.
Photo Needs: Uses 40-45 photos/issue; all supplied by freelance photographers. Needs photos depicting nutrition and diet, sports (runners, tennis, hiking, swimming, etc.), food curiosity, celebrity workout, pain and suffering, arthritis and bone disease, skin care and problems. Also any photos illustrating exciting technological or scientific breakthroughs. Model release required.
Making Contact & Terms: Provide resume, business card, brochure, flyer or tearsheets to be kept on file for possible future assignments, and call to query interest on a specific subject. SASE. Reports in 2 weeks. Pay depends on photo size and color. Pays on publication. Pays $25-75/b&w photo; $75-150/color photo. Buys one-time rights. Simultaneous submissions and previously published submissions OK.
Tips: "Pictures and subjects should be interesting; bright and consumer-health oriented. We are using more magazine-type mood photos, less hard medical pix. We are looking for different, interesting, unusual ways of illustrating the typical fitness, health nutrition story; e.g., an interesting concept for fatigue, insomnia, vitamins. Send prints or dupes to keep on file. Our first inclination is to use what's on hand. There is approx. 1 assignment per issue."

***YOUR HOME**, Meridian Publishing Inc., Box 10010, Ogden UT 84409. Editor: Marjorie H. Rice. *Your Home* articles are about fresh ideas in home decor, ranging from floor and wall coverings to home furnishings. Subject matter includes the latest in home construction (exteriors, interiors, building materials, design), the outdoors at home (landscaping, pools, patios, gardening), remodeling projects, home management, and home buying and selling. Length is 1,200 words. Manuscript should be accompanied by excellent color transparencies.
Specs: Uses 35mm and 2¼x2¼ transparencies.
Payment & Terms: Pays $35/photo used inside the magazine and $50/cover photo. A photo that appears on both the cover and inside is purchased for $50. Photo credits are given. Meridian buys first rights and nonexclusive reprint rights.
Making Contact: Send query with SASE. Rarely acceptable are duplicate transparencies (unless they are excellent, first-generation dupes) or color prints (unless they are top-quality glossies). Does not accept b&w photos, negatives or photocopied material. Transparencies must be submitted in plastic protectors, between cardboard sheets, and each one should be marked with the photographer's name and address. Prints should be well protected, packed back-to-back, fact-to-face, and should not be written on. All photos must be accompanied by a caption sheet describing the location and identifying the subject. Model release required. Materials that are not accepted for publication will be returned within six weeks. Slides and photos are returned in SASE provided by photographer. "Please advise us with your submission if your materials require special handling, and be sure to enclose payment to cover special mailing requirements, such as insurance."
Tips: "We do not accept telephone queries. Requests for writer's guidelines must include a business SASE, sample copy requests must include $1 per copy and a 9x12 SAE. Send request to the attention of the Editorial Assistant."

This somewhat "hidden" market has good salability potential if you study the publications and the type of information their editors supply to readers. There are probably as many trade journals as there are professions, and like many association and company publications, you won't necessarily find these on your local newsstand. Many of the trade journals listed in this section specify whether samples are available on request. There may be a nominal charge.

If you have experience in other professions as well as photography, you will want to read through the related listings. With research, you could present a photo story about some unique aspect of a doctor's, lawyer's or pilot's career. Since trade journals are written to cover a variety of "news" levels, photo/text packages could include profiles of an industry leader, new products or services, or updates on industry news. Some journals read by executive level personnel even include travel and leisure, as well as health topics.

Study the Subject Needs and Tips paragraphs to get a good feel for the angle each publication takes. Since some of the photography could be used in a promotional context, you will want to be attuned to any possible needs for model releases.

***ABA BANKING JOURNAL**, 345 Hudson St., New York NY 10014. (212)620-7256. Editor: William Streeter. Monthly magazine. Circ. 45,000. Emphasizes "how to manage a bank better. Bankers read it to find out how to keep up with changes in regulations, lending practices, investments, technology, marketing and what other bankers are doing to increase community standing." Photos purchased with accompanying ms or on assignment. Buys 12 photos/year. Pays $100 minimum/job, or $200/printed page for text/photo package. Credit line given if requested. Pays on acceptance. Buys one-time rights. Query with samples. SASE. Reports in 1 month.
Subject Needs: Personality ("We need candid photos of various bankers who are subjects of articles"), and occasionally photos of unusual bank displays. Also, photos of small-town bank buildings including their surroundings. Captions required.
B&W: Contact sheet preferred; uses 8x10 glossy prints "if prints are ordered."
Color: Uses 35mm transparencies and 2¼x2¼ transparencies.
Cover: Uses color transparencies. Square format required. Pays $100-500/photo.

THE ABSOLUTE SOUND, #2 Glen Ave., Sea Cliff NY 11579. (516)676-2830. Production Manager: Brian Gallant. Trade bimonthly magazine. Emphasizes the "high end as audio—component reviews and record reviews. Our audience consists of audiophiles and professionals in science-related fields. Circ. 20,000.
Photo Needs: Uses 10-20 freelance photos/issue; all supplied by freelancers. Needs photos of "people of trade shows, in recording industry, artists, audio components."
Making Contact & Terms: Query with samples; send unsolicited photos by mail for consideration; provide resume, business card, brochure, flyer or tearsheets to be kept on file for possible future assignments. Uses 4x5 b&w prints; b&w contact sheet; b&w negatives. SASE. Reports in 1 month. Payment on publication. Credit line always given. Buys one-time rights.

❝ *We use corporate portraits, pictures of data communications centers and photo illustrations. We like to see executives shot in an interesting manner both with and without computers, framed well, interesting graphic images.* **❞**

—Bonnie Meyer, Computer Decisions

ACRE AGE, Box 130, Ontario OR 97914. (503)889-5387. Editor: Tom Murphy. Monthly tabloid. Emphasizes agriculture in eastern Oregon and southern Idaho. Readers are farmers, ranchers, and agribusiness people in agriculture in eastern Oregon and southern Idaho. Circ. 42,000. Sample copy $1.25. Photo guidelines free with SASE.
Photo Needs: Uses about 15 photos/issue; about ⅓ supplied by freelance photographers. Needs photos of "anything to do with agriculture. We like to see manuscripts with pictures." Captions required.
Making Contact & Terms: Query with resume of credits and samples. SASE. Reports in 3 weeks. Pay negotiable. Pays on publication. Credit line given. Buys first North American serial rights. Simultaneous submissions and previously published work OK "if the other publication does not cover any part of our circulation area."

ADVERTISING TECHNIQUES, 10 E. 39th St., New York NY 10016. (212)889-6500. Art Director: Carla Block. Monthly magazine. Circ. 4,500. Emphasizes advertising campaigns for advertising executives.
Accompanying Mss: Photos purchased with an accompanying ms only. Buys 2-3 photos/issue. Must relate to the advertising field.
Payment/Terms: Pays $50/b&w photo. Pays on publication.
Making Contact: Query. SASE. Reports in 4 weeks.

AG REVIEW, Farm Resource Center, 16 Grove St., Putnam CT 06260. (203)928-7778. Monthly magazine. Circ. 46,800. For commercial dairy and beef cattle owners and field crop farmers. Needs Northeastern agriculture-oriented photos. No "common" scenic shots. "Always looking for action shots in the field." Buys simultaneous rights. Present model release on acceptance of photo. Send photos for consideration. Pays on publication. Reports in 3 weeks. SASE. Simultaneous submissions OK.
B&W: No b&w used.
Color: Color shots considered only for covers. Send 35mm or larger transparencies (2¼x2¼ preferred). Cover is either seasonal or compliments theme of issue. 1986 themes: Sept.-woodland management; Oct.-ag education; Nov.-building and construction; Dec.-new product parade; Jan. 87-taxes, insurance, estate planning; spring months 87-doing equipment, forage, manure handling, planting, harvesting, soils. Captions requested. Pays $50 minimum.

***AGRICHEMICAL AGE**, 731 Market St., San Francisco CA 94103-2011. (415)495-3340. Editor: Len Richardson. Photo Editor/Art Director: Larry Bruderer. Monthly magazine. Emphasizes agri-chemicals. Readers are national dealers, applicators and consultants. Circ. 40,000. Sample copy free with SASE.
Photo Needs: Uses 8 photos/issue; 1-2 supplied by freelance photographers. Wants vertical format for covers. Subjects include weeds, insects, and machinery. Model release required.
Making Contact & Terms: Send 35mm transparencies by mail for consideration; provide resume, business card, brochure, flyer or tearsheets to be kept on file for possible future assignments. SASE. Reports in 1 week. Pays $350/color cover photo; $75-150/color photo page. Pays on receipt of invoice. Credit line given. Buys one-time rights. Simultaneous submissions OK.

***AGRI FINANCE MAGAZINE**, 5520 W. Touhy Ave., Skokie IL 60077. (312)676-4060. Editor: David Pelzer. Photo Editor: Judy Krajewski. Monthly (except June and July) magazine. Emphasizes agricultural finance, banking, state-of-the art production practices, commodity marketing. Readers are farm managers, bankers, large-scale farmers. Circ. 17,000. Sample copy $3.
Photo Needs: Uses 10-15 photos/issue; 2-3 supplied by freelance photographers. Needs portrait shots of farmers or bankers or farm managers, production shots of agricultural practices. Model release required.
Making Contact & Terms: Query with samples and list of stock photo subjects; provide resume, business card, brochure, flyer or tearsheets to be kept on file for possible future assignments. SASE. Reports in 1 month. Pays $350-500/color cover photo, $25-50/hour. Pays on acceptance. Credit line given. Buys one-time rights. Simultaneous submissions and previously published work OK.
Tips: Prefers to see specific shots that focus directly on subject. Shots that will blow up well if needed. Shots that have good contrast, especially b&w. "Query us to let us know you're there. Provide examples of your style and subject range. Past experience with agricultural subjects is a plus. Once given an assignment, be prompt on turnaround time."

 The asterisk before a listing indicates that the listing is new in this edition. New markets are often the most receptive to freelance contributions.

AIPE FACILITIES MANAGEMENT OPERATIONS AND ENGINEERING, 3975 Erie Ave., Cincinnati OH 45208. (513)561-6000. Editor-in-Chief: Eileen T. Fritsch. Bimonthly. Circ. 8,000. Emphasizes technical and problem solving information related to facilities management. Readers are plant engineers (members in U.S. and Canada), many of whom are in charge of America's industrial plant operations or related services. Sample copy and photo guidelines for SASE.
Photo Needs: Uses 10 photos/issue. "Subjects must be of interest to our audience; i.e., plant engineers who look to the Journal for technical information and data." Captions required. Also needs photos for special publications and promotional materials.
Making Contact & Terms: Query with resume of photo credits. SASE. Reports in 2 weeks. Pay is negotiable. Credit line given. Payment on publication. Buys one-time rights.
Tips: "We use freelancers rarely, as we get a large amount of photos from our members' employers."

***AIR CONDITIONING, HEATING & REFRIGERATION NEWS**, Box 2600, Troy MI 48007. (313)362-3700. Editor: Gordon Duffy. Weekly newspaper. Emphasizes heating, air conditioning and refrigeration service, manufacturing, etc. Readers are industry servicemen, manufacturers, contractors, wholesalers. Sample copy free with SASE.
Photo Needs: Uses 40 photos/issue; 2-15 supplied by freelance photographers. Needs photos of action service and installation shots, some product shots.
Making Contact & Terms: Send b&w prints and b&w contact sheets by mail for consideration. SASE. Reports in 3 months. Pay negotiated. Pays on acceptance. Credit line given. Buys one-time rights. Simultaneous submissions OK if exclusive to trade.

ALASKA CONSTRUCTION & OIL, 109 W. Mercer St., Seattle WA 98119. (206)285-2050. Editor: Christine Laing. Monthly magazine. Circ. 9,500. Emphasizes news/features on petroleum, construction, timber and mining for management personnel in these industries in Alaska. Photos purchased with or without accompanying ms, or on assignment. Credit line given. Pays on publication. Buys one-time rights or first serial rights. Send material by mail for consideration. Provide brochure, calling card, letter of inquiry, resume and samples to be kept on file for possible future assignments. SASE. Previously published work OK. Reports in 3-4 weeks. Sample copy $2.
Subject Needs: Photos illustrating an Alaska project in the construction, petroleum, timber and mining fields. Strictly industrial—no scenic or wildlife. Captions required.
B&W: Uses 5x7 and 8x10 glossy prints. Pays $15-25/photo.
Cover: Uses 35mm, 2¼x2¼ color transparencies. Pays $100/photo.
Accompanying Mss: Semitechnical project coverage; i.e., how a construction project is being accomplished. Pays $75/page (30" per page).
Tips: "Two things are paramount—accuracy and writing to the right audience. Remember, this is a trade magazine, not consumer-oriented."

ALTERNATIVE ENERGY RETAILER, Box 2180, Waterbury CT 06722. (203)755-0158. Editor: John Florian. Monthly. Emphasizes energy products, including solid fuel burning appliances and solar. Readers are retailers of alternative energy products. Circ. 14,000. Sample copy and photo guidelines free with SASE.
Photo Needs: Uses about 10 photos/issue; 5 supplied by freelance photographers. "Most photos accompany mss relating to the story. General shots tend to be of the sun, woodburning, etc." Model release preferred; captions required.
Making Contact & Terms: Query with samples. SASE. Reports in 2 weeks. Pays $100/color cover photo; $25/b&w inside photo. Pays on publication. Credit line given. Buys one-time rights.

AMERICAN AGRICULTURIST, Box 370, Ithaca NY 14851. (607)273-3507. Editor: Gordon Conklin. Photo Editor: Andrew Dellava. Monthly. Emphasizes agriculture in the Northeast—specifically New York, New Jersey and New England. Circ. 72,000. Free photo guidelines with SASE.
Photo Needs: Uses one photo/issue supplied by freelance photographers. Needs photos of farm equipment, general farm scenes, animals. Geographic location: only New York, New Jersey and New England. Reviews photos with or without accompanying ms. Model release required.
Making Contact & Terms: Query with samples and list of stock photo subjects; send 8x10 vertical, glossy color prints, and 35mm transparencies by mail for consideration. SASE. Reports in 3 months. Pays $100/color cover photo and $75/inside color photo. Pays on acceptance. Credit line given. Buys one-time rights.

***AMERICAN AUTOMATIC MERCHANDISER**, 7500 Old Oak Blvd., Cleveland OH 44130. (216)243-8100. Editor: David R. Stone. Monthly magazine. Emphasizes vending machines, foodservice, coffee service. Readers are owners and managers of companies that operate vending machines, run in-plant cafeterias and provide office coffee service. Circ. 12,000. Sample copy free with SASE.

Photo Needs: Uses 50 photos/issue; 5 supplied by freelance photographers. Needs photos taken to illustrate articles on specific companies, by assignment. Captions preferred.
Making Contact & Terms: Provide resume, business card, brochure, flyer or tearsheets to be kept on file for possible future assignments. SASE. Pays $50-500/job. Pays on acceptance.
Tips: Freelancers used only for color photos. Prefer large format transparencies.

AMERICAN BEE JOURNAL, 51 S. 2nd St., Hamilton IL 62341. (217)847-3324. Editor: Joe M. Graham. Monthly trade magazine. Emphasizes beekeeping for hobby and professional beekeepers. Sample copy free with SASE.
Photos Needs: Uses about 100 photos/issue; 1-2 supplied by freelance photographers. Needs photos of beekeeping and related topics, beehive products, honey, cooking with honey. Special needs include color photos of seasonal beekeeping scenes. Model release and captions preferred.
Making Contact & Terms: Query with samples; send 5x7 or 8½x11 b&w and color prints by mail for consideration. SASE. Reports in 2 weeks. Pays $25/b&w or color cover photo; $5/b&w or color inside photo. Pays on publication. Credit line given. Buys all rights.

AMERICAN BOOKSELLER, Production Dept., Suite 1410, 122 E. 42nd St., New York NY 10168. (212)867-9060. Editor: Ginger Curwen. Photo Editor: Amy G. Bogert. Monthly magazine. Circ. 8,700. "*American Bookseller* is a journal for and about booksellers. People who own or manage bookstores read the magazine to learn trends in book selling, how to merchandise books, recommendations on stock, and laws affecting booksellers." Photos purchased with or without accompanying ms. Works with freelance photographers on assignment only basis. Provide resume, business card, tearsheets and samples to be kept on file for possible future assignments. Buys 75 photos/year. Pays $25 minimum/job, $70 minimum for text/photo package, or on a per-photo basis. Credit line given. Pays on acceptance. Buys one-time rights, but may negotiate for further use. Send material by mail for consideration; arrange personal interview to show portfolio; query with list of stock photo subjects; submit portfolio for review; query with samples. SASE. Previously published work OK. Reports in 2-3 weeks. Sample copy $3.
Subject Needs: Human interest (relating to reading, or buying and selling books); humorous; photo essay/photo feature (coverage of bookselling conventions, original book displays, or unusual methods of book merchandising); and spot news (of events or meetings relating to bookselling—e.g., author luncheons, autograph parties, etc.). Wants on a regular basis "photos of specific bookstores (to accompany a written profile of the place), of specific events (conventions, meetings, publicity events for books and sometimes just general photos of people reading)." Especially needs for next year a "photographer to take shots of the annual convention floor activities and other events."
Special Needs: Photos of people doing things, photos of business operations, and reportage. No photos of libraries, soft focus pictures of book readers, photos of bookstores with no customers. Model release preferred; captions required.
B&W: Uses 5x7 prints. Pays $25/inside photo.
Color: No color used inside.
Cover: Uses 35mm color transparencies. Vertical format preferred. Pays $600/photo.
Accompanying Mss: By assignment. Pay is negotiable. Pays $40-80 for text/photo package.

THE AMERICAN CHIROPRACTOR, 3401 Lake Ave., Ft. Wayne IN 46805. (219)423-1432. Executive Editor: Laura A. Allen. Emphasizes chiropractic. Readers are professional chiropractors. Circ. 25,000. Sample copy free with SASE.
Photo Needs: Uses 1 photo/issue. Needs photos of "health-related subjects. Dynamic action photos preferred."
Making Contact & Terms: Query with samples and list of stock photo subjects. Send unsolicited 4x5 or larger glossy color prints; 4x5 or 8x10 transparencies; and color negatives by mail for consideration. Unsolicited material returned with SASE. Pays $100-200/color cover photo. Pays on publication. Buys one-time rights. Simultaneous submissions OK.

AMERICAN CITY & COUNTY MAGAZINE, 6255 Barfield Rd., Atlanta GA 30328. (404)256-9800. Editor: Ken Anderberg. Monthly magazine. Emphasizes "activities/projects of local governments." Readers are city and county government officials and department heads; engineers. Circ. 60,000.
Photo Needs: Uses 4-6 photos/issue; all supplied by freelance photographers. Needs "pictures of city and county projects, activities—prefer depictive, artsy photos rather than equipment and facility shots." Special needs include "cover photos to illustrate major themes, (editorial calendar with themes listed is available)."
Making Contact & Terms: Query with samples. Send 5x7 or 8x10 glossy b&w prints; 35mm, 2¼x2¼, 4x5 transparencies for consideration. SASE. Reports in 2 weeks. Pays $300/cover photo; $25/b&w inside photo; $50-100/color inside photo. Paste-up. Credit line given. Buys all rights.

AMERICAN COIN-OP, 500 N. Dearborn, Chicago IL 60610. (312)337-7700. Editor: Ben Russell. Monthly magazine. Circ. 19,000. Emphasizes the coin laundry business for owners of coin-operated laundry and drycleaning stores. Photos purchased with or without accompanying ms. Buys 60-75 photos/year. Pays on publication. Buys first rights and reprint rights. Send material by mail for consideration, query with list of stock photo subjects, or query with samples. SASE. Previously published work OK if exclusive to the industry. Reports in 1 week. Free sample copy.
Subject Needs: How-to, human interest, humorous, photo essay/photo feature and spot news. "We don't want to see photos that don't relate to our field, out-of-focus or poorly composed pictures, or simple exterior store photos, unless the design is exceptional." Captions required.
B&W: Uses 5x7 or 8x10 prints. Pays $6 minimum/photo.
Cover: Uses b&w prints. Vertical format preferred, "but some horizontal can be used." Pays $6 minimum/photo.
Accompanying Mss: "We seek case studies of exceptional coin laundries that have attractive decor, unusual added services, colorful promotions, or innovative management." Pays 6¢/word. Free writer's guidelines.
Tips: "Send us some sharp human interest shots that take place in a coin laundry."

AMERICAN DEMOGRAPHICS, Box 68, Ithaca NY 14851. (607)273-6343. Editor: Cheryl Russell. Art Director: Michael Rider. Monthly. Circ. 16,000. Emphasizes "demographics—population trends." Readers are "business decision makers, advertising agencies, market researchers, newspapers, banks, professional demographers and business analysts."
Photo Needs: Uses 10 photos/issue, all supplied by freelance photographers. Needs b&w photos of "people (crowds, individuals), ethnic groups, neighborhoods; people working, playing, and moving to new locations; regional pictures, cities, single parent families, aging America, baby boom and travel trends. Photographers submit prints or photocopies that they feel fit the style and tone of *American Demographics*. We may buy the prints outright or may keep a file of photocopies for future use and order a print when the photo is needed. No animals, girlie photos, politicians kissing babies, posed cornball business shots or people sitting at a computer keyboard." Model release required.
Making Contact & Terms: Send by mail for consideration actual 8x10 b&w or photocopies; submit portfolio by mail for review. SASE. Pays on publication $35-100/b&w photo. Credit line given on "Table of Contents" page. Buys one-time rights. Simultaneous and previously published submissions OK. Sample copy $6.

***AMERICAN FARRIERS JOURNAL**, Box 700, Ayer MA 01432. Editor: Horst D. Dornbusch. 7/year magazine. Circ. 4,000 paid. Emphasizes horseshoeing and horse health for professional horseshoers. Photos purchased with or without accompanying ms. Buys 20-30 photos/year. Credit line given. Pays on publication. Buys all rights, but may reassign to photographer after publication. Query with printed samples. SASE.
Subject Needs: Documentary, how-to (of new procedures in shoeing), photo essay/photo feature (of shoeing contests, conventions, manufacturers, etc.), product shot and spot news. Captions required.
B&W: Uses 5x7 or 8x10 semigloss prints.
Cover: Uses 4-color transparencies. Vertical format. Artistic shots.
Accompanying Mss: Useful information for horseshoers.

AMERICAN FIRE JOURNAL, Suite 7, 9072 E. Artesia Blvd., Bellflower CA 90706. (213)866-1664. Managing Editor: Carol Carlsen. Monthly magazine. Circ. 6,000. Emphasizes fire protection and prevention. Buys 5 or more photos/issue. Credit line given. Pays on publication. Buys one-time rights. Query with samples to Brian Strasmann, art director. Provide resume, business card or letter of inquiry. SASE. Reports in 1 month. Free sample copy and photo guidelines.
Subject Needs: Documentary (emergency incidents, showing fire personnel at work); how-to (new techniques for fire service); and spot news (fire personnel at work). Captions required.
B&W: Uses semigloss prints. Pays $9/photo. Negotiable.
Cover: Uses 35mm color transparencies. Pays $30/photo. Covers must be verticals.
Accompanying Mss: Seeks short description of emergency incident and how it was handled by the agencies involved. Pays $1.50-2/inch. Free writer's guidelines.
Tips: "Don't be shy! Submit your work. I'm always looking for contributing photographers (especially if they are from outside the L.A. area). I'm looking for good shots of fire scene activity with captions. The action should have a clean composition with little smoke and prominent fire, and show good firefighting techniques, i.e., firefighters in full turnout, etc. It helps if photographers know something about firefighting so as to capture important aspects of fire scene. We like photos that illustrate the drama of firefighting—large flames, equipment and apparatus, fellow firefighters. I.D. everyone and everything. Write suggested captions. Give us as many shots as possible to choose from."

AMERICAN FRUIT GROWER/WESTERN FRUIT GROWER, 37841 Euclid Ave., Willoughby OH 44094. (216)942-2000. Editor: Gary Acuff. Monthly. Emphasizes "all aspects of *commercial* fruit production, including marketing, production practices, equipment, government regulations, etc. Magazine does *NOT* cover backyard or hobby orchards or gardens. Tree fruits, grapes, nuts, and small fruits are covered." Readers are *commercial* fruit growers across the U.S. who make their living by growing fruit. Circ. 55,000. Sample copy free with $1 SASE.
Photo Needs: Needs "photos showing production practices in *commercial* fruit operations, such as pruning, spraying, irrigating, harvesting, etc; overall shots of commercial orchards, vineyards, groves, etc; fruit closeups; roadside markets or pick-your-own operations. Any photo must be completely labelled as practice shown, and crop/variety. Currently have cover openings for the following themes: "irrigating; spraying; roadside marketing."
Making Contact & Terms: Query with list of stock photo subjects. Pays $150/color cover photo; $50-75/color inside photo. Pays on publication. Credit line given. Buys one-time rights.

AMERICAN JEWELRY MANUFACTURER, 825 7th Ave., New York NY 10019. (212)245-7555. Editor: Steffan Aletti. Monthly. Circ. 5,500. Emphasizes "jewelry manufacturing; techniques, processes, machinery." Readers are "jewelry manufacturers and craftsmen." Sample copy and photo guidelines free with SASE.
Photo Needs: Uses about 10-30 photos/issue; "very few" supplied by freelance photographers. Needs photos of "manufacturing or bench work processes." Model release preferred.
Making Contact & Terms: Query with list of stock photo subjects. Provide resume, business card, brochure, flyer or tearsheets to be kept on file for possible future assignments. SASE. Reports in 2 weeks. Pays $150/color cover photo; $15/b&w inside photo; $25/color inside photo. Pays on publication. Credit line given "if requested." Buys one-time rights. Simultaneous submissions and previously published work OK.
Tips: "Since editor is a professional photographer, we use little freelance material, generally only when we can't get someone to photograph something."

AMERICAN TRUCKER MAGAZINE, Box 6366, San Bernardino CA 92412. (714)889-1167. Editor: Steve Sturgess. Monthly. Emphasizes the "trucking industry—independent owner-operators, small fleet truck companies." Readers are independent truckers or those who work for small fleets. Circ. 80,000. Sample copy free with SASE.
Photo Needs: Uses approximately 25-40 photos/issue; 15-30 supplied by freelancers. Needs "shots of trucks in action, shots that show details of truck and/or truck-trailer combinations and also include driver when possible." Special needs include "photo stories of trucking life in work situations, truck stops, truck washes, etc." Written release and captions required.
Making Contact & Terms: Query with samples. Returns unsolicited material with SASE. Pays $200/color cover photo; $100/page, $20/individual color inside photo. Pays 30 days after publication. Credit line given. Buys First North American rights. Previously published work "if not in another trucking publication" OK.
Tips: "Have a knowledge of the trucking industry."

APPAREL INDUSTRY MAGAZINE, Suite 300, 180 Allen Rd. S., Atlanta GA 30328. (404)252-8831. Editor: Karen Schaffner. Art Director: Judy Doi. Monthly magazine. Circ. 18,773. Emphasizes management and production techniques for apparel manufacturing executives; coverage includes new equipment, government news, finance, marketing, management, training in the apparel industry. Works with freelance photographers on assignment only basis. Provide resume, brochure and business card to be kept on file for possible future assignments. Buys 3 photos/issue. Pays on publication. SASE. Reports on queries in 4-6 weeks.
Subject Needs: Cover photos depicting themes in magazines; feature photos to illustrate articles.

APPLIED RADIOLOGY, Brentwood Publishing Corporation, 1640 Fifth St., Santa Monica CA 90401. (213)395-0234. Editor: Joe Phillips. Photo Editor: Tom Medsger. Bimonthly. Emphasizes radiology in all aspects. Readers are radiologists and physicians.
Photo Needs: Uses about 2-3 photos/issue; all supplied by freelance photographers. Needs abstracts on the specific fields of radiology; CT scan, mobile units, magnetic resonance imaging for cover photos. Model release preferred.
Making Contact & Terms: Query with resume of credits or with list of stock photo subjects. Uses 8x10 color prints, 35mm or 2¼x2¼ transparencies. SASE. Reports in 2 weeks. Pays $400/color cover photo; $100/color inside photo. Pays on acceptance. Credit line given for cover photos. Buys all rights. "Photographer gets picture back to sell again. BPC reserves the right to use picture again in one of its publications."

ART DIRECTION, 10 E. 39th St., New York NY 10016. (212)889-6500. Monthly magazine. Circ. 12,000. Emphasis is on advertising design for art directors of ad agencies. Buys 5 photos/issue.
Accompanying Mss: Photos purchased with an accompanying mss only.
Payment/Terms: Pays $50/b&w photo. Pays on publication.
Making Contact: Works with freelance photographers on assignment only basis. Send query to Carla Block. Provide tearsheets to be kept on file for possible future assignments. SASE. Reports in 2 weeks.

***ARTnews**, 5 W. 37th St., New York NY 10018. (212)398-1690. Editor: Sylvia Hochfield. Photo Editor: Cynthia Eyring. Monthly magazine. Emphasizes art. Readers are artists and other art world people. Circ. 70,000. Sample copy $4.
Photo Needs: Uses 200 photos/issue; "few" supplied by freelance photographers. Needs art related photos. Captions required.
Making Contact & Terms: Query with samples or telephone. SASE. Reports in 1 month. Pay negotiated. Pays "immediately after publicaton." Credit line given. Buys one-time rights. Simultaneous submissions and previously published work OK.
Tips: Prefers to see art related photos, artists, painters, sculpturers, etc.

ASSEMBLY ENGINEERING, Hitchcock Bldg., Wheaton IL 60188. (312)462-2215. Editor: Donald E. Hegland. Photo Editor & Art Director: Norman R. Herlihy. Monthly. Emphasizes design and manufacturing technology where individual parts become useful products (the processes and equipment needed to assemble a finished product). Readers include corporate executives, managers, design engineers, manufacturing engineers, professionals. Circ. 79,000. Sample copy free with SASE.
Photo Needs: Uses about 30-40 photos/issue; few (so far) are supplied by freelance photographers. Needs high-tech photos of assembly systems, robots, conveyors, lasers, machine vision equipment, electronics, printed circuit boards, computers, software, fasteners, welders, etc. Special needs include any general shot where parts (components) become a whole (product)—conceptual in nature. Vertical format could be a series of shots. Model release required; captions preferred.
Making Contact & Terms: Query with samples or with list of stock photo subjects; send any size b&w or color print, transparencies, color contact sheet or b&w negatives by mail for consideration; submit portfolio for review; provide resume, business card, brochure, flyer or tearsheets to be kept on file for possible future assignments. SASE. Reports in 2 weeks. Pays $100-500 for text/photo package. Credit line given "only if requested." Buys all rights. Simultaneous submissions and previously published work OK.

***ATHLETIC JOURNAL**, 1719 Howard, Evanston IL 60202. (312)328-8545. Editor: Lisa Gordey. Monthly magazine. Emphasizes coaches telling other coaches their methods for winning. Readers are high school and college coaches. Circ. 40,000. Sample copy $1. Photo guidelines free with SASE.
Photo Needs: Uses 50 photos/issue; 40 supplied by freelance photographers. Needs photos of sports *Action* (not atmosphere). "We use action photos for virtually every sport." Special needs include clear, sharp, crisp color slides for cover—good to excellent sports action. Captions preferred.
Making Contact & Terms: Query with samples and list of stock photo subjects, send 5x7 glossy b&w prints; 35mm transparencies; b&w or color contact sheet by mail for consideration. SASE. Reports in 1 week. Pays $75/color cover photo; $20/b&w and color inside photo. Pays on publication. Credit line given. Buys one-time rights.
Tips: Be reliable and consistent! Also, be aware of deadlines and editor needs.

THE ATLANTIC SALMON JOURNAL, Suite 1030, 1435 St-Alexandre St., Montreal, Quebec, Canada H3A 2G4. (514)842-8059. Managing Editor: Joanne Eidinger. Quarterly magazine. Circ. 20,000. Readers are dedicated salmon fishermen interested in techniques, management of the species and new places to fish. Free sample copy.
Photo Needs: Good action shots of Atlantic salmon fishing and/or management. All material held on spec unless otherwise stated. Model release preferred; captions and credits required. Prefers 5x7 or 8x10 b&w prints, 35mm or 2¼x2¼ color slides. SAE and International Reply Coupon. Pays $30-75/b&w photo; $50-100/color photo; $150-350/color cover shot. Reports in 6-8 weeks. Credit line given. Payment upon publication (first-time rights only, negotiable). Previously published submissions acceptable, but not encouraged.

AUTOMATION IN HOUSING & MANUFACTURED HOME DEALER, Box 120, Carpinteria CA 93013. (805)684-7659. Editor and Publisher: Don Carlson. Monthly. Circ. 26,000. Emphasizes home and apartment construction. Readers are "factory and site builders and dealers of all types of homes, apartments and commercial buildings." Sample copy free with SASE.
Photo Needs: Uses about 40 photos/issue; 10-20% supplied by freelance photographers. Needs in-plant and job site construction photos. Photos purchased with accompanying ms only. Captions required.

Making Contact & Terms: "Call to discuss story and photo ideas." Send 35mm or 2¼x2¼ transparencies by mail for consideration. SASE. Reports in 2 weeks. Pays $300/text/photo package. Credit line given "if desired." Buys first time reproduction rights.

AVIATION EQUIPMENT MAINTENANCE, 7300 N. Cicero Ave., Lincolnwood IL 60646. (312)674-7300. Editor: Paul Berner. Monthly. Circ. 27,000. Emphasizes "aircraft and ground support equipment maintenance." Readers are "aviation mechanics and maintenance management." Sample copy $2.50.
Photo Needs: Uses about 50-60 photos/issue. Needs "hands-on maintenance shots depicting any and all maintenance procedures applicable to fixed and rotary wing aircraft." Photos purchased with accompanying ms only. Model release and captions required.
Making Contact & Terms: Query with samples. Send 35mm, 2¼x2¼ or 4x5 transparencies by mail for consideration. SASE. Reports in 1 month. Pays $250-300 for text/photo package. Pays on acceptance. Buys all rights.

***BEEF**, 1999 Shepard Rd., St. Paul MN 55116. (612)690-7374. Editor: Paul D. Andre. Monthly magazine. Emphasizes beef cattle production and feeding. Readers are feeders, ranchers and stocker operators. Circ. 125,000. Sample copy free with SASE. Photo guidelines free with SASE.
Photo Needs: Uses 35-40 photos/issue; "less than 1%" supplied by freelance photographers. Needs variety of cow-calf and feedlot scenes. Model release and captions required.
Making Contact & Terms: Send 8x10 glossy b&w prints and 35mm transparencies by mail for consideration. SASE. Reports in 1 month. Pays $25/b&w inside photo; $50/color inside photo. Pays on acceptance. Buys one-time rights.
Tips: "We buy few photos, since our staff provides most of those needed."

BEVERAGE WORLD, 150 Great Neck Rd., Great Neck NY 11021. (516)829-9210. Managing Editor: Jeanne Lukasick. Monthly. Circ. 30,000. Emphasizes the beverage industry. Readers are "bottlers, wholesalers, distributors of beer, soft drinks, wine and spirits." Sample copy $3.50.
Photo Needs: Uses 25-50 photos/issue; some supplied by freelance photographers. Needs photos of people, equipment and products—solicited only. Needs "freelancers in specific regions of the US for occasional assignments." Model release and captions required.
Making Contact & Terms: Query with samples. Provide resume, business card, brochure, flyer or tearsheets to be kept on file for possible future assignments. Pays $300/color cover photo. Pays on publication or per assignment contract. Rights purchased varies. Simultaneous submissions and previously published work OK, "as long as work is not in any competing publication."
Tips: Prefers to see "interesting angles on people, products. Provide affordable quality."

***BOATING PRODUCT NEWS**, 850 Third Ave., New York NY 10022. (212)715-2732. Editor: James Pavia. Monthly newspaper. Emphasizes marine industry. Readers are marina owners, distributors, marine manufacturers. Circ. 27,000. Sample copy free with SASE.
Photo Needs: Uses 20-25 photos/issue; 2-3 supplied by freelance photographers. Needs photos for background info—of marina, boatyards, etc.—also would consider human interest type shots supplied with caption. Reviews photos with accompanying ms only. Model release and captions preferred.
Making Contact & Terms: Query with resume of credits. Reports in 1 month. Pays $20/b&w cover and inside photo. Pays on publication. Credit line given. Buys one-time rights. Simultaneous submissions and previously published work OK.

BRAKE & FRONT END, 11 S. Forge St., Akron OH 44304. (216)535-6117. Editor: Jeffrey S. Davis. Monthly magazine. Circ. 30,000. Emphasizes automotives maintenance and repair. For automobile mechanics and repair shop owners. Needs "color photos for use on covers. Subjects vary with editorial theme, but basically they deal with automotive or truck parts and service." Wants no "overly commercial photos which emphasize brand names" and no mug shots of prominent people. May buy up to 6 covers annually. Credit line given. Buys first North American serial rights. Submit model release with photos. Send contact sheet for consideration. Reports "immediately." Pays on publication. SASE. Simultaneous submissions OK. Sample copy $1.
B&W: Uses 5x7 glossy prints; send contact sheet. Captions required. Pays $8.50 minimum.
Cover: Send contact sheet or transparencies. Study magazine, then query. Lead time for cover photos is 3 months before publication date. Pays $50 minimum.
Tips: Send for editorial schedules; enclose SASE.

BROADCAST TECHNOLOGY, Box 420, Bolton, Ontario L0P 1A0 Canada. (416)857-6076. Bimonthly magazine. Circ. 6,500. Emphasizes broadcast engineering.
Accompanying Mss: Photos purchased with accompanying ms only. Seeks material related to broadcasting/cable TV only, preferably technical aspects.

Payment & Terms: Payment is open. Pays on publication.
Making Contact: Send query to Doug Loney, editor. Reports in 1 month.

BUILDER, Suite 475, 655 15th St., NW, Washington DC 20005. (202)737-0717. Editor: Frank Anton. Managing Editor: Noreen Welle. Monthly. Circ. 185,000. Emphasizes homebuilding. Readers are builders, contractors, architects. Sample copy $3. Photo guidelines free with SASE.
Photo Needs: Uses about 60 photos/issue; 20 supplied by freelance photographers. Needs photos of architecture (interior and exterior). Model release required.
Making Contact & Terms: Query with samples. Send 8x10 b&w glossy prints or 4x5 transparencies by mail for consideration. SASE. Reports in 1 month. Pays $400-600/job. Pays on publication. Credit line given. Buys one-time rights. Previously published work OK.

***BUS AND TRUCK TRANSPORT**, 5th Floor, Maclean Hunter Bldg., 777 Bay St., Toronto, Ontario Canada M4E 2P3. (416)596-5932. Editor: David Thompson. Associate Editor/Photo Editor: Jim Pollock. Monthly magazine. Emphasizes trucking, transportation, roads, maintenance/technical issues, management skills. Readers are managers of trucking operations, both private companies and common carriers providing for-hire hauling services. Circ. 38,000. Sample copy free with SASE. Photo guidelines free with SASE.
Photo Needs: Uses 30 photos/issue; cover/inside treatments commissioned. Needs truck-related/issue-related photos. Special needs include high tech as applied to trucking; computer applications, etc. Model release required; captions preferred.
Making Contact & Terms: Arrange a personal interview to show portfolio; query with samples; provide resume, business card, brochure, flyer or tearsheets to be kept on file for possible future assignments. SASE. Reports in 3 weeks. Pays $375-450/color cover photo; $50-100/inside b&w photo; $100/inside color photo. Pays on acceptance. Credit line given. Rights negotiated with photographer.
Tips: Prefers to see published work, slides/prints of work.

BUSINESS ATLANTA, 6255 Barfield Rd., Atlanta GA 30328. (404)256-9800. Editor: Luann Nelson. Monthly. Emphasizes "general magazine-style coverage of business and business-related issues in the metro Atlanta area." Readers are "everybody in Atlanta who can buy a house or office building or Rolls Royce." Circ. 24,600. Sample copy $2.
Photo Needs: Uses about 40 photos/issue; 35-40 supplied by freelance photographers. Needs "good photos mostly of business-related subjects if keyed to local industry." Model release and captions required.
Making Contact & Terms: Arrange a personal interview to show portfolio. SASE. Reports in 1 month. Pays $50/b&w photo; $300/color cover photo; $75/color inside photo; $200 minimum/job; $50-500/package. Pays on publication. Credit line given. Buys one-time rights and reprint rights.
Tips: "Study the publication for the feel we strive for and don't bring us something either totally off the wall or, at the other extreme, assume that business means boring and bring us something duller than ditchwater. People in the business community are becoming more willing to do unusual things for a photo. We need the ability to work on location with subjects who have little time to spend with a photographer. Anybody can shoot a perfume bottle in a studio. Study *Business Atlanta* to see the types of work we use. Then show me something better."

BUSINESS FACILITIES, Box 2060, Red Bank NJ 07701. (201)842-7433. Editor: Eric Peterson. Monthly magazine. Emphasizes economic development, commercial and industrial real estate. Readers are top corporate executives, public and private development organizations. Circ. 35,000. Free sample copy.
Photo Needs: Uses about 20-30 photos/issue; 2-3 supplied by freelance photographers. Needs "news-oriented shots; current events; generally illustrative of real estate development. We always need photos of nationally-known political or business leaders." Captions required.
Making Contact & Terms: Query with list of stock photo subjects. SASE. Reports in 2 weeks. All rates negotiable. Pays on publication. Credit line given sometimes; all times for cover shots. Rights negotiable. Simultaneous submissions and previously published work OK.
Tips: "No telephone queries, please! Put it in writing."

BUSINESS SOFTWARE, 501 Galveston Dr., Redwood City CA 94063. (415)366-3600. Editor: James Fawcette. Art Director: Bruce Olson. Monthly. Emphasizes software. Readers are entrepreneurs and middle-management. Circ. 50,000. Sample copy $2.95.
Photo Needs: Uses 3-4 or more photos/issue; all supplied by freelance photographers. Needs table top shots, studio shots and location shots. Model release preferred.
Making Contact & Terms: Provide business card, brochure, flyer or tearsheets to be kept on file for possible future assignments. Does not return unsolicited material. Pays $75-300/b&w photo; $100-500/

color photo; $500-1,200/day; $75-1,000/color cover photo; $250-300/b&w page; $400-500/color page. Credit line given. Buys first North American serial rights. Previously published work OK.
Tips: "We look for on sight/location photography that captures the environment of where someone works. Mail a promotional piece for review."

BUSINESS VIEW OF SOUTHWEST FLORIDA, Box 1546, Naples FL 33939. (813)263-7525. Publisher: Eleanor Sommer. Monthly magazine. Emphasizes business for professional and business readers. Sample copy $2.
Photo Needs: Uses about 5-10 photos/issue; 75% supplied by freelance photographers. "Usually needs head shots for profiles, press releases, etc. Almost all would be of local/regional interest (southwest Florida)." Captions required.
Making Contact & Terms: Query with samples. SASE. Reports in 6 weeks. Payment negotiable depending on the assignment. Pays on publication. Credit line given in masthead. Simultaneous submissions OK.
Tips: Prefers to see "sharp, clear b&w portraits" in samples. "Be local and available."

***BUTTER FAT MAGAZINE**, Box 9100, Vancouver, British Columbia, Canada V6B 4G4. (604)420-6611. Managing Editor: T.W. Low. Editor: C.A. Paulson. Photo Editor: Hugh Legg. Published monthly. Circ. 3,500. Emphasizes dairy farming and marketing for dairy farmers in British Columbia; also emphasizes dairy consumers in British Columbia. Free sample copy.
Photo Needs: Uses 40 photos/issue; 2 are supplied by freelance photographers. Especially needs freelance photographers throughout the province to work on assignment only basis. Needs photos on personalities, locations and events. Captions required.
Making Contact & Terms: Arrange personal interview with editor to show portfolio. Provide tearsheets to be kept on file for possible future assignments. Pays $10/photo; $50-500 for text/photo package. Pay on color photos and job is negotiable. Credit line given. Payment on acceptance. Simultaneous submissions OK.

CALIFORNIA BUILDER & ENGINEER, Box 10070, Palo Alto CA 94303. (415)494-8822. Publisher: David W. Woods. Bimonthly magazine. Circ. 12,500. Emphasizes the heavy construction industry. For public works officials and contractors in California, Hawaii, western Nevada and western Arizona. Send photos for consideration. Pays on publication. Reports in 2 weeks. SASE.
Subject Needs: Head shot (personnel changes), photo essay/photo feature and product shot (construction equipment on the job).
B&W: Send 4x5 glossy prints. Captions required. Pays $10-15.
Cover: Cover shots should have an accompanying ms. Color transparencies only. Purchase covers rarely, but will consider. Pays $15-25/4x5 color or b&w photo.
Tips: Camera on the Job column uses single photos with detailed captions. Photographers "should be familiar with their subject—for example, knowing the difference between a track dozer and a wheel loader, types and model number of equipment, construction techniques, identity of contractor, etc. We are using very little freelance material."

***CALIFORNIA FARMER**, 731 Market St., San Francisco CA 94103-2011. (415)495-3340. Editor: Len Richardson. Photo Editor/Art Director: Larry Bruderer. Semimonthly magazine. Emphasizes agriculture. Readers are statewide agricultural professionals. Circ. 56,000. Sample copy free with SASE.
Photo Needs: Uses 8 photos/issue; 1-2 supplied by freelance photographers.
Making Contact & Terms: Send 35mm transparencies by mail for consideration; provide resume, business card, brochure, flyer or tearsheets to be kept on file for possible future assignments. SASE. Reports in 1 week. Pays $250/color cover photo; $75-150/color photo page. Pays on receipt of invoice. Credit line given. Buys one-time rights. Simultaneous submissions OK.

CANADA POULTRYMAN, Farm Papers Ltd., #105A-9547-152nd St., Surrey, British Columbia, Canada V3R 5Y5. (604)526-8525. Managing Editor: A. Greaves. Monthly. Circ. 12,000. Emphasizes poultry. Readers are poultry producers, agribusiness, government and service people. Free sample copy with SASE.
Photo Needs: Uses about 20 photos/issue; "varying number" are supplied by freelance photographers. Photos purchased with or without accompanying ms.
Making Contact & Terms: Send by mail for consideration b&w or color prints of any size; 35mm, 2¼x2¼, 4x5 or 8x10 slides; b&w or color contact sheet or b&w and color negatives; or submit portfolio for review. SASE. Reports in 1 month. Payment is negotiable. Pays on publication. Credit line given. Rights purchased are negotiated. Simultaneous submissions and previously published work OK.

CATECHIST, 2451 E. River Rd., Dayton OH 45439. Editor: Patricia Fischer. Monthly magazine published from July/August through April. Circ. 40,000. Emphasizes religious education for profes-

sional and volunteer religious education teachers working in Catholic schools. Buys 4-5 photos/issue. Not copyrighted. Send photos or contact sheet for consideration. Pays on publication. Reports in 2-3 months. SASE. Simultaneous submissions OK. Sample copy $2.

Subject Needs: Fine art, head shot, human interest (all generations and races), nature, scenic, still life and seasonal material (Christmas, Advent, Lent, Easter). Wants on a regular basis family photos (all economic classes and races).

B&W: Send contact sheet or 8x10 glossy, matte, semigloss or silk prints. Pays $25-35.

Cover: Send b&w glossy, matte, semigloss or silk prints. Using 4-color art on covers now.

***CENTAUR & CO.**, 5 Willowbrook Ct., Potomac MD 20854. (301)983-1152. Editor: W.D. Magnes. Photo Editor: Carl H. Wurzer. Bimonthly magazine. Readers are CEO's. Publishes Brushware (circ: 2,000) and Nursing Homes (circ. 4,100). Sample copy free with SASE. Photo guidelines free with SASE.

Photo Needs: Uses 10 photos/issue; cover shots supplied by freelancers. Needs photos for front covers.

Making Contact & Terms: Query with samples, query with list of stock photo subjects, send 4x5 color prints and 35mm transparencies by mail for consideration. SASE. Reports in 2 weeks. Pays $50/color cover photo; $25/color inside photo. Pays on acceptance. Credit line given. Buys one-time rights. Simultaneous submissions and previously published work OK.

Tips: Prefers to see good vertical shots for covers.

CERAMIC SCOPE, 3632 Ashworth N., Seattle WA 98103. (206)632-7222. Editor: Michael Scott. Monthly magazine. Circ. 8,500 + . Emphasizes business aspects of hobby ceramics for small-business people running "mom-pop shops." Needs photos of ceramic shop interiors, "with customers if possible." Also needs photos of shop arrangements and exteriors. Buys 6 photos/issue. Buys all rights. Query first. Works with freelance photographers on assignment only basis. Provide letter of inquiry and tearsheets to be kept on file for possible future assignments. Pays on acceptance. Reports in 2 weeks. SASE. Sample copy $1.

B&W: Send glossy 5x7 prints. Captions required. Pays $5-10.

CERAMICS MONTHLY, Box 12448, Columbus OH 43212. (614)488-8236. Contact: Editorial Department. Monthly. Emphasizes "handmade pottery/ceramic art—particularly contemporary American, but also international and historic." Readers are "potters, ceramic artists, teachers, professors of art, collectors of ceramics, craft institutions and libraries." Circ. 36,000. Sample copy $3. Photo guidelines free with SASE.

Photo Needs: Uses about 100 photos/issue. Needs "museum-quality shots of ceramics (pottery, sculpture, porcelain, stoneware, individual objects) shot on plain backgrounds; shots of potters in their studios; photos of ceramic processes." Photos purchased with accompanying ms only "except cover photos which *sometimes* do not have a text." Captions required.

Making Contact & Terms: Send 8x10 glossy b&w prints; 35mm (Kodachrome 25 only), 2¼x2¼, 4x5 or 8x10 transparencies by mail for consideration. SASE. Reports "as time permits." Pays $50/color cover photo; $10/b&w or $20/color inside photo. "News and exhibition coverage excluded from payment." Pays on publication. Buys magazine rights.

Tips: "Team up with a good potter to help with ceramic aesthetic decisions."

CHEMICAL BUSINESS, Suite 1505, 100 Church St., New York NY 10007-2694. (212)732-9820. Managing Editor: J.R. Warren. Monthly magazine. Emphasizes chemicals for 40,000 managers (all levels) in chemical industry—making, research, engineering. Sample copy free with SASE.

Photo Needs: Uses 1-2 photos/issue; none currently supplied by freelance photographers. "Trying now to establish photo feature; several approaches in mind." Special needs include "unusual color shots of chemical plants, products, packages, chemicals." Model release and captions required.

Making Contact & Terms: Query with samples. SASE. Reports in 1 week. "We try for fast response." Pays $300/b&w cover photo; $25-75/b&w inside photo. Pays on acceptance. Credit line given in back of book. Buys all rights.

Tips: Prefers to see "ability to obtain dramatic shots of plants and products" in samples. "Make sure you've got clear identification of subject when and where shot; offer choice of the same subject."

***CHILDREN'S BUSINESS MAGAZINE**, 55 5th Ave., New York NY 10003. Editor: John Birmingham. Art Director: Joy Makon. Monthly magazine (over-sized). Emphasizes children's apparel and merchandise. Readers are retailers. Circ. 20,000 + . Estab. 1985. Sample copy $2.

Photo Needs: Uses 75-100 photos/issue; photographs by assignment only. No stock photos. Assigns photos of children's fashion; product; portraits; studio and location. Special needs include good location and studio work—work well with kids.

Making Contact & Terms: Drop off or send portfolio for review, include business card, brochure, flyer or tearsheets to be kept on file for possible future assignments. Does not return unsolicited material. Pays on publication. Credit line given. Buys one-time rights.

THE CHRISTIAN MINISTRY, 407 S. Dearborn St., Chicago IL 60605. (312)427-5380. Editor: A.P. Klausler. Bimonthly magazine. Circ. 12,000. For the professional clergy, primarily liberal Protestant. Seeks religious photos. Buys 2-3/issue. Pays $15 minimum/b&w print. Pays on publication. Send material by mail for consideration. SASE. Reports in 1 week.

CHRONICLE GUIDANCE PUBLICATIONS, INC., Moravia NY 13118. (315)497-0330. Editor-in-Chief: Paul Downes. Photo Editor: Karen Macier. Monthly. Circ. 8,000-10,000. Emphasizes career education and occupational guidance materials (education). "Our main market is with junior high and high school libraries and guidance departments. Materials aimed at students using them to prepare for postsecondary education and deciding on occupational fields."
Photo Needs: Uses about 15-20 photos/issue; 8-10 are supplied by freelance photographers. "We like to show people engaged in actual performance of occupations, without showing sex stereotyping. Males in typical female jobs and vice versa are ideal." Photos purchased with or without accompanying ms. Model release required; captions preferred.
Making Contact & Terms: Query with samples or submit portfolio for review. Does not return unsolicited material. Reports in 1 month. Provide brochure, tearsheets and literature that shows samples of work to be kept on file for possible future assignments. Pays $50-100/b&w cover and inside photos. Pays on acceptance. Credit line given. Buys one-time rights. Simultaneous submissions and previously published work OK.
Tips: Prefers to see "b&w glossy photos showing people engaged in work situations—something different that really portrays the overall occupation. Preferably close-up and with tools of the occupation visible. Action shots—not obviously posed. Sharp detail and color contrasts."

CIM TECHNOLOGY, 1 SME Dr., Dearborn MI 48121. (313)271-1500. Assistant Managing Editor: Rita R. Schreiber. Quarterly magazine. Emphasizes computers in design and manufacturing. Readers are members of the Computer and Automotive Systems Association. Circ. 20,000. Free sample copy with SASE.
Photo Needs: Uses about 25-40 photos/issue; number supplied by freelance photographers "depends on need." Needs photos of "computers, computers in workplace and computer images." Special needs include "specific cover shots, working on ideas with editor and art director."
Making Contact & Terms: Send 5x7 b&w or color prints or transparencies by mail for consideration; provide resume, business card, brochure, flyer or tearsheets to be kept on file for possible future assignments. SASE. Reports in 2 weeks. Pays $175-300/color cover photo; $25/b&w inside photo, $50/color inside photo; maximum $200/job. Pays monthly. Buys one-time rights or all rights. Simultaneous and previously published submissions OK.

CIRCUIT RIDER, 201 8th Ave. S., Nashville TN 37202. (615)749-6488. Associate Editor: Bette Prestwood. Magazine published 10 times/year. Emphasizes "United Methodist religion, theology, and ministry." Readers are United Methodist clergy. Circ. 41,000. Photo guidelines free with SASE.
Photo Needs: Uses about 6-8 photos/issue; "most of them" supplied by freelancers. Needs photos of "clergy (especially women and minorities) involved in tasks of preaching, studying, serving communion, baptism, etc. Some nature shots or other symbolic imagery; some family shots and group shots." Model release required; captions preferred.
Making Contact & Terms: Query with list of stock photo subjects. Send 5x7 glossy b&w prints or b&w contact sheet by mail for consideration. Submit portfolio for review. SASE. Reports in 2 weeks. Pays $75/b&w cover photo and $25/b&w inside photo. Pays on publication. Credit line given. Buys one-time rights. Simultaneous submissions and previously published work OK.
Tips: Would like to see "shots with unusual angles, lighting, special photographic techniques (such as double exposures, etc.) in addition to good clear photos. The publication is specialized. Provide good photos of the subject matter listed. Minority groups especially American Hispanic, Asian, Native American and black."

CITY NEWS SERVICE, Box 39, Willow Springs MO 65793. Photo Editor: Richard Weatherington. Readers are businessmen, travelers and photographers. Semimonthly. Circ. 8,000. Photo guidelines for SASE.
Photo Needs: Uses 10-12 photos/issue; 80% of which are supplied by freelance photographers. Needs business photos relating to taxation, employment, management. Can make multiple sales through syndication with existing editorial packages.
Making Contact & Terms: Send by mail for consideration 8x10 b&w or color prints, or 35mm slides.

Provide letter of inquiry and samples (particularly featuring people) to be kept on file for possible future assignments. SASE. Reports in 2-4 weeks. Pays on publication $15-25/photo; prices double if used on cover. Credit line given. Buys first North American serial rights. Simultaneous submissions and previously published work OK.

Tips: "Send the best samples you have."

CLASSROOM COMPUTER LEARNING, 19 Davis Dr., Belmont CA 94002. (415)593-1696. Editor: Holly Brady. Art Director: Ellen Wright. 2451 River Rd., Dayton OH 45439. Monthly. Emphasizes computer in education. Readers are teachers and administrators, grades K-12. Sample copy $4.
Photo Needs: Uses about 7-10 photos/issue; 5 or more supplied by freelance photographers. Photo needs "depends on articles concerned. No general categories. Usually photos used to accompany edit in a conceptual manner, computer screen shots needed often." Model release preferred.
Making Contact & Terms: Arrange a personal interview to show portfolio; query with samples; provide resume, business card, brochure, flyer or tearsheets to be kept on file for possible future assignments. SASE. Reports in 3 weeks. Pays $600-1,000/color cover photo; $50-100/b&w inside photo; $200-400/color inside photo. Pays on acceptance. Credit line given. Buys one-time rights. Previously published work OK.

CLAVIER, 200 Northfield Rd., Northfield IL 60093. (312)446-5000. Editor: Barbara Kreader. Magazine published 10 times/year. Circ. 25,000. For piano and organ teachers. Credit line given. Pays on publication. Buys all rights. Send material by mail for consideration. SASE. Reports in 1 month. Sample copy $2.
Subject Needs: Human interest photos of keyboard instrument students and teachers. Special needs include synthesizer photos, senior citizens performing.
B&W: Uses glossy prints. Pays $10-25.
Color: Color: any format. Pays $50-125/photo.
Cover: Kodachrome. Uses color glossy prints or 35mm transparencies. Vertical format preferred. Pays $25-75/photo.
Tips: "We need sharp, well-defined photographs and we like color. Any children or adults should be engaged in a *piano*-related activity and should have a look of deep involvement rather than a posed portrait look."

COASTAL PLAINS FARMER, Suite 300, 3000 Highwoods Blvd., Raleigh NC 27625. (919)872-5040. Editor: Sid Reynolds. Monthly magazine. Emphasizes agriculture. Readers are Coastal Plains professional farmers. Circ. 96,000. Sample copy free with SASE and 37¢ postage. Photo guidelines free with SASE.
Photo Needs: Uses about 30 photos/issue; 1-2 by freelance photographers. Needs how-to photos. Special needs include "technically accurate photos." Model release and captions required.
Making Contact & Terms: Query with samples. SASE. Reports in 2 weeks. Pays $100-300/4 color b&w cover photo, $10-25/b&w inside photo, $25-150/color inside photo, $50-150/b&w, and $150-250/color. Pays on publication. Credit line given "sometimes." Buys first North American serial rights.

COLLEGE UNION MAGAZINE, 825 Old Country Rd., Box 1500, Westbury NY 11590. (516)334-3030. Managing Editor: Catherine Orobona. Emphasizes leisure time aspects of college life for "campus activity and service professionals." Published 6 times a year. Circ. 10,000.
Photo Needs: Uses 5 photos/year. Needs documentary (refurbishing a student union), photo essay/photo feature (operations, vending room, lobby, building, remodeling, lobby theater, ballroom), sport (if related to student leisure time activities), spot news (trends in campus life, related to student centers or unions), how-to (refurbish, decorate, install). Special needs include renovation/refurbishing of student unions. Photos bought with accompanying ms. Column needs: Pinpoint—trends in campus life. Model release and captions preferred.
Making Contact & Terms: Query. "Samples aren't really necessary—send actual photos to be considered. Once we've used them, we keep photographer's name on file." SASE. Reports in 3 weeks. Pays on publication $5/photo; $2/column inch for accompanying ms. Credit line given. Buys all rights. No simultaneous submissions or previously published work.
Tips: "Pay close attention to our needs and don't send photos of students playing Frisbee—send a photo that tells a story by itself!"

COLLISION, Box M, Franklin MA 02038. Editor: Jay Kruza. Magazine published every 5 weeks. Circ. 20,000. Emphasizes "technical tips and management guidelines" for auto body repairmen and dealership managers in eastern US. Needs photos of technical repair procedures, association meetings, etc. A regular column called "Stars and Cars" features a national personality with his/her car. Prefers 3 + b&w photos with captions as to why person likes this vehicle. If person has worked on it or customized

it, photo is worth more. Buys 100 photos/year; 12/issue. Buys all rights, but may reassign to photographer after publication. In created or set-up photos, which are not direct news, requires photocopy of model release with address and phone number of models for verification. Query with resume of credits and representational samples (not necessarily on subject) or send contact sheet for consideration. Pays on acceptance. Reports in 3 weeks. SASE. Simultaneous submissions OK. Sample copy $2; free photo guidelines.
B&W: Send glossy or matte contact sheet or 5x7 prints. Captions required. Pays $25 for first photo; $7 for each additional photo in the series; pays $25-50/photo for "Stars and Cars" column depending on content. Extra pay for accompanying mss., "even if just facts are supplied."
Tips: "Don't shoot one or two frames; do a sequence or series. It gives us choice, and we'll buy more photos. Often we reject single photo submissions. Capture how the work is done to solve the problem."

COMMERCIAL CARRIER JOURNAL, Chilton Way, Radnor PA 19089. (215)964-4513. Editor-In-Chief: Gerald F. Standley. Managing Editor: Parry Desmond. Monthly magazine. Circ. 78,000. Emphasizes truck fleet maintenance operations and management. Photos purchased with or without accompanying ms, or on assignment. Pays on a per-job or per-photo basis. Credit line given. Pays on acceptance. Buys all rights. Send material by mail for consideration. SASE. Reports in 3 weeks.
Subject Needs: Spot news (of truck accidents, Teamster activities, and highway scenes involving trucks). Model release required; *detailed* captions required.
B&W: Contact sheet and negatives OK.
Color: Uses prints and 35mm transparencies; contact sheet and negatives preferred.
Cover: Uses color transparencies; color contact sheet and negatives preferred. Uses vertical cover only. Pays $100 minimum/photo.
Accompanying Mss: Features on truck fleets and news features involving trucking companies.

***COMMUNICATIONS WEEK**, 600 Community Dr., Manhasset NY 11030. (516)365-4600. Editor: Alan Perlman. Managing Editor: Mike Azzara. Weekly newspaper with magazine supplement. Emphasizes communications (telecom, datacom). Readers are users and vendors of communications equipment and services. Circ. 65,000. Estab. 1984. Sample copy free with SASE.
Subject Needs: Uses 15 photos/issue; 50% supplied by freelancers. Needs photos mostly of people in the industry. Will review photos only on assignment. Photo captions required.
Making Contact & Terms: Query with samples. Does not return unsolicited material. Reports back as photographers needed. Pay negotiable. Pays on publication. Credit line given. Buys all rights.

COMPRESSED AIR MAGAZINE, 253 E. Washington Ave., Washington NJ 07882-2495. (201)689-4557. Editor: S.M. Parkhill. Monthly. Circ. 149,000. Emphasizes "industrial subjects, technology, energy." Readers hold middle to upper management positions in SIC. Sample copy free.
Photo Needs: Uses about 20 photos/issue; "very few" supplied by freelance photographers. Model release and captions preferred.
Making Contact & Terms: Provide resume, business card, brochure, flyer or tearsheets to be kept on file for possible future assignments. Does not return unsolicited material. Previously published work OK.
Tips: "Write for editorial calendar to see subjects that might be needed. We look for high quality color shots, and have increased use of 'symbolic' photos to supplement industrial shots."

COMPUTER DEALER, Box 1952, Dover NJ 07801. (201)361-9060. Art Director: John Angelini. Monthly. Emphasizes computers. Readers are retail computer dealers. Circ. 40,000. Sample copy free with SASE.
Photo Needs: Uses about 5-10 photos/issue; all supplied by freelance photographers. Needs still lifes for covers, and photos of people and showrooms. Model release required.
Making Contact & Terms: Arrange a personal interview to show portfolio. Pays $300-500/b&w and $400-600/color cover photo; $75-150/b&w and $200-300/color inside photo. Buys all rights.

COMPUTER DECISIONS, 10 Mulholland Dr., Hasbrouck Hts. NJ 07604. (201)393-6015. Art Director: Bonnie Meyer. Biweekly magazine. Circ. 175,000. Emphasizes management procedures, computer operation and equipment. For computer-involved management in industry, finance, academia, etc. Well educated, sophisticated, highly paid. Buys 10-20 photos/issue. Uses color photos for covers and to illustrate articles. Also, location assignments out of town.
Payment & Terms: Fee negotiable, based on ASMP recommendations. Pays on acceptance.
Making Contact: Query. Works with freelance photographers on assignment only basis. Provide resume and samples to be kept on file for possible future assignments. SASE. Reports in 1 week.
Tips: "We use corporate portraits, pictures of data communications centers and photo illustrations. We like to see executives shot in an interesting manner both with and without computers, framed well, inter-

esting graphic images. We look for good lighting and the ability to take a comparatively commonplace situation and make it look interesting. Send samples, tearsheets and a cover letter. Almost all of our work is assigned; only occasional use of stock pictures."

***COMPUTER GRAPHICS TODAY**, 2722 Merrilee Dr., Fairfax VA 22031. (703)698-9600. Editor: Bob Cramblitt. Publication of the ACGA Association. Monthly tabloid. Emphasizes computer graphics related visuals. Readers are computer graphics users and OEMs. Circ. 35,000. Estab. 1984. Sample copy $3.
Photo Needs: Uses about 20 photos/issue; all supplied by freelance photographers. Needs computer related photos.
Making Contact & Terms: Query with samples or send 35mm, 2¼x2¼, 4x5, or 8x10 transparencies by mail for consideration. Does not return unsolicited material. Reports in 2 weeks. Credit line given. Buys one-time rights. Simultaneous submissions and previously published work OK.

COMPUTERWORLD, 375 Cochituate Rd., Box 880, Framingham MA 01701. (617)879-0700. Executive Editor: Sharon Frederick. Weekly newspaper. Circ. 130,000. Emphasizes new developments, equipment and services in the computer industry. For management-level computer users, chiefly in the business community, but also in government and education.
Subject Needs: DP-related even if specific subject is primarily impact on people of a DP system. Captions required.
Specs: B&w prints.
Accompanying Mss: Photos purchased with accompanying ms only.
Payment & Terms: Pays $20-35/b&w print. Pays on publication. Credit line given. Buys one-time rights.
Making Contact: Submit portfolio, query with resume or list of stock photos. SASE. Reports in 3 weeks. Provide resume and brochure to be kept on file for possible future assignments. Sample copy and photo guidelines available.

CONTRACTORS GUIDE, 5520 Touhy Ave., Skokie IL 60077. (312)676-4060. Editor: Richard Toland. Monthly magazine. Emphasizes "roofing, siding, insulation, solar construction business, both manufacturing and contracting." Circ. 33,000. Sample copy free with SASE.
Photo Needs: Uses about 10 photos/issue; 0-1 supplied by freelance photographers. Needs "head shots, group photos, product shots and on-site construction shots." Reviews photos with accompanying ms only. Model release and captions preferred.
Making Contact & Terms: Provide resume, business card, brochure, flyer or tearsheets to be kept on file for possible future assignment. SASE. Reports in 1 week. Pays negotiable rate for color cover photo; $25/b&w inside photo, $30/color inside photo. Pays on publication. Credit line given. Buys all rights.

COOKING FOR PROFIT, Box 267, Fond du Lac WI 54935. (414)923-3700. Editor: Bill Dittruch. Monthly. Emphasizes foodservice operations. Readers are operations managers for foodservice, mainly independent restaurants. Circ. 25,000. Sample copy free with 8½x11 SAE and 40¢ postage.
Photo Needs: Uses about 18 photos/issue; 3 supplied by freelance photographers. "We need photos of particular restaurants on which we are doing profiles, mainly photos of kitchen operations and workers. We need photo sequences demonstrating kitchen techniques—preferably b&w with commentary." Model release and captions required.
Making Contact & Terms: Provide resume, business card, brochure, flyer or tearsheets to be kept on file for possible future assignments. SASE. Reports in 1 month. Pays $50-150/job; $250-300 for text/photo package. Pays on publication. Credit line given on index page. Buys one-time rights. Previously published submissions OK.
Tips: "Be *positively* sure that you know what the editor wants before shooting. Make sure he/she tells you exactly."

CRANBERRIES, Box 249, Cobalt CT 06414. (203)342-4730. Publisher/Editor: Bob Taylor. Monthly. Emphasizes cranberry growing, processing, marketing and research. Readers are "primarily cranberry growers but includes anybody associated with the field." Circ. 650. Sample copy free with SASE.
Photo Needs: Uses about 10 photos/issue; half supplied by freelance photographers. Needs "portraits of growers, harvesting, manufacturing—anything associated with cranberries." Captions required.
Making Contact & Terms: Send 4x5 or 8x10 b&w glossy prints by mail for consideration; "simply query about prospective jobs." SASE. Pays $15-25/b&w cover photo; $5-15/b&w inside photo; $35-100 for text/photo package. Pays on publication. Credit line given. Buys one-time rights. Simultaneous and previously published submissions OK.
Tips: "Learn about the field."

DAIRY HERD MANAGEMENT, Box 67, Minneapolis MN 55440. (612)931-0211. Editor: Sheila Vikla. Monthly magazine. Circ. 108,000. Emphasizes dairy management innovations, techniques and practices for dairymen. Photos purchased with accompanying ms, or on assignment. Pays $100-250 for text/photo package, or on a per-photo basis. Pays on acceptance. Buys one-time rights. Query with list of stock photo subjects. SASE. Reports in 2 weeks. Free photo guidelines.
Subject Needs: Animal (natural photos of cows in specific dairy settings), how-to and photo essay/photo feature. Wants on a regular basis photos showing new dairy management techniques. No scenics or dead colors. Model release and captions preferred.
B&W: Uses 5x7 glossy prints. Pays $5-25/photo.
Color: Uses 35mm or 2¼x2¼ transparencies. Pays $25-100/photo.
Cover: Uses 35mm or 2¼x2¼ color transparencies. Vertical format required. Pays $50-150/photo.
Accompanying Mss: Interesting and practical articles on dairy management innovations, techniques and practices. Pays $100-150/ms. Writer's guidelines included on photo guidelines sheet.

DAIRYMEN'S DIGEST, Box 5040, Arlington TX 76005-5040. (817)461-2674. Editor: Phil Porter. Monthly magazine. Circ. 9,500. Emphasizes dairy-related articles for dairy farmers: "solid, family type, patriotic, hardworking Americans." Needs photos of farm scenes, "especially dairy situations." Prefers South or Southwest setting. Buys 6 photos/year. Not copyrighted. Works with freelance photographers on assignment only basis. Send contact sheet or photos for consideration. Pays on acceptance. Reports in 2 weeks. SASE. Simultaneous submissions and previously published work OK. Free sample copy and photo guidelines.
B&W: Uses 5x7 glossy prints; send contact sheet. Pays $15-30.
Color: Send 8x10 glossy prints or transparencies. Pays $75 minimum.
Cover: Send glossy prints or color transparencies. Cover photos "must be beautiful or unusual farm or dairy scenes." Pays $75 minimum.
Tips: Photos submitted with accompanying ms "should help tell the story or illustrate a point or situation in the story."

DANCE TEACHER NOW, Suite 2, University Mall, 803 Russell Blvd., Davis CA 95616. (916)756-6222. Editor: Susan Wershing. Circ. 5,500. Readers are "professional dance teachers in dance companies, college dance departments, private studios, secondary schools, recreation departments, etc." Sample copy $2.25.
Photo Needs: By assignment, from your stock of dance photos, or accompanied by an article of a practical nature, only. Uses 10-12 photos/issue, all by freelance photographers. Uses mostly "dance teaching" shots and "talking head" shots. Model release required; identification required, but editor writes captions.
Making Contact & Terms: Send samples by mail for consideration for assignment. SASE. Reports in 1 month. Pays $75 minimum/job or $20/stock photo. Credit line given on page with photo. Buys all rights.

***DATAMATION MAGAZINE**, 12th Floor, 875 Third Ave., New York NY 10022. (212)605-9711. Art Director: Ken Surabian. Biweekly magazine. Emphasizes data processing for professionals—computers. Readers are the professionals in data processing. Circ. 165,000. Sample copy $3.
Photo Needs: Uses 5 photos/issue; all supplied by freelance photographers. Special needs include special effects. Model release required.
Making Contact & Terms: Arrange a personal interview to show portfolio; query with samples; submit portfolio for review; provide resume, business card, brochure, flyer or tearsheets to be kept on file for possible future assignments. Pays $1,000/b&w and color cover photo; $500/b&w and color page. Pays on acceptance. Credit line given. Buys one-time rights and international rights. Simultaneous submissions OK.
Tips: Prefers to see special effects and still life.

DEALERSCOPE, 115 2nd Ave., Waltham MA 02154. (617)890-5124. Associate Publisher/Editorial Director: James M. Barry. Monthly magazine. Emphasizes consumer electronics and major appliances for retailers, distributors and manufacturers. Sample copy with SASE and 54¢ postage.
Photo Needs: Uses about 20 photos/issue; 5 supplied by freelance photographers. Needs photos of people, products and events. Send all photos to 401 N. Broad St., Philadelphia PA 19108. (215)238-5300. Editor: Neil Spann.
Making Contact & Terms: Query with resume of credits. SASE. Reports in 2 weeks. Pays $500/color cover photo; $50/b&w inside photo, $75/color inside photo. Pays on acceptance. Credit line given. Buys one-time rights.

DENTAL ECONOMICS, Box 3408, Tulsa OK 74101. Editor: Dick Hale. Monthly magazine. Circ. 100,000. Emphasizes dental practice administration—how to handle staff, patients and bookkeeping

and how to handle personal finances for dentists. Photos purchased with or without accompanying ms, or on assignment. Buys 20 photos/year. Pays $50-150/job, $75-400 for text/photo package, or on a per-photo basis. Credit line given. Pays in 30 days. Buys all rights, but may reassign to photographer after publication. Send material by mail for consideration. SASE. Reports in 2-4 weeks. Free sample copy; photo guidelines for SASE.

Subject Needs: Celebrity/personality, head shot, how-to, photo essay/photo feature, special effects/experimental and travel. No consumer-oriented material.

B&W: Uses 8x10 glossy prints. Pays $5-15/photo.

Color: Uses 35mm or 2¼x2¼ transparencies. Pays $35-50/photo.

Cover: "No outsiders here. Art/painting."

Accompanying Mss: "We use an occasional 'lifestyle' article, and the rest of the mss relate to the business side of a practice: scheduling, collections, consultation, malpractice, peer review, closed panels, capitation, associates, group practice, office design, etc." Also uses profiles of dentists. Writer's guidelines for SASE.

Tips: "Write and think from the viewpoint of the dentist—not as a consumer or patient. If you know of a dentist with an unusual or very visual hobby, tell us about it. We'll help you write the article to accompany your photos. Query please."

***DENTIST**, Box 7573, Waco TX 76714. (817)776-9000. Editor: Mark Hartley. Bimonthly magazine; tabloid. Emphasizes dentistry. Readers are 140,000 dental professionals. Circ. 140,000. Estab. 1985. Sample copy free with SASE.

Photo Needs: Uses 20 photos/issue; 10 supplied by freelance photographers. "Usually we require photos of dentists in a specific setting, avoiding, at all costs, simple shots of dentist treating patients in chair." Special needs: almost any photo that uniquely reflects dentistry is salable. Captions preferred.

Making Contact & Terms: Send unsolicited photos by mail for consideration; provide resume, brochure, flyer or tearsheets to be kept on file for possible future assignments. Send color slides by mail for consideration. SASE. Reports in 3 weeks. Pays $100-150/color cover photo; $50/b&w inside photo; $100/color inside photo. Pays on acceptance. Credit line given.

Tips: "Let us know where you are in case we have an assignment. Otherwise, submit unusual portrayals of dentistry for our consideration."

DESIGN FOR PROFIT, 4175 S. Memorial, Box 45745, Tulsa OK 74145. (918)622-8415. Editor: Ron Fore. Photo Editor: Jolene Bennett. Quarterly. Circ. 17,000. Emphasizes floral design. Readers are "florist shop owners, managers, designers, floral service advertisers, (refrigeration, gift accessories)." Sample copy $5.

Photo Needs: Uses about 35-40 photos/issue; 2 supplied by freelance photographers. Needs photos of "events significant to floral industry (designs for prominent weddings), and how-to (series of shots describing innovative designs." Model release preferred; captions required.

Making Contact & Terms: Send color prints, 2¼x2¼ transparencies or color negatives by mail for consideration. SASE. Reports in 1 month. Pay "negotiable." Pays on acceptance. Credit line given. Buys all rights. Simultaneous submissions and previously published work OK.

Tips: "Be innovative, suggest new angles for articles that accompany photos, mss are not necessary—just the idea. Use photos involving Florafax members."

DIAGNOSIS, 680 Kinderkamack Rd., Oradell NJ 07649. (201)262-3030. Editor: Harry Atkins. Art Director: Susan J. Kuppler. Photo Editor: Grady Olley. Monthly. Emphasizes medical diagnosis. Readers are physicians. Circ. 84,000. Sample copy $5.

Photo Needs: Uses about 20 photos/issue; 4-5 supplied by freelance photographers. Needs mostly clinical photos, but some editorial (people). Special needs include photos of disease, photomicrography and afflicted people. Model release and captions required.

Making Contact & Terms: Submit portfolio to the attention of G. Olley for review; provide resume, business card, brochure, flyer or tearsheets to be kept on file for possible future assignments. SASE. Reports in 3 weeks. Pays $350-700/color cover photo; $100-350/b&w inside photo; $175-450/color inside photo; $250-400/color page; $125-400 plus expenses/job. Pays on acceptance. "Our terms and conditions are listed on the purchase order which is issued upon commissioning of job." Credit line given. Buys one-time world rights. Previously published work OK.

Tips: "Examples of photographer's capabilities with lighting, special effects, capturing personalities, composition, reasonable prices, concept. Don't overprice yourself, be aggressive not obnoxious; photographers are a dime a dozen, good photographers are always in demand."

THE DISPENSING OPTICIAN, 10341 Democracy Ln., Box 10110, Fairfax VA 22030. (703)691-8355. Editor: James H. McCormick. Emphasizes information relevant to dispensing of spectacles, contact lenses, low-vision aids and artificial eyes by opticians. Readers are retail dispensing opticians and contact lens fitters. Monthly. Circ. 10,800. Free sample copy "to photographer who has a story/feature

idea of interest to us"; otherwise sample copy $2.

Photo Needs: Uses 9-12 photos/issue. Selects freelancers based on location, specialty and cost (plus willingness to give us negatives without additional cost in about 2 years when their only probable continuing value is historical)." Needs photos of "the optician in his shop" and "fitting patients with eyewear." Model release required (unless straight news photo); captions required.

Making Contact & Terms: Send by mail for consideration actual 5x7 or 8x10 b&w prints; query with resume of photo credits; query with list of stock photo subjects; or send ideas. SASE. Reports in 2 weeks. Pays on acceptance $15-60/b&w photo; $75 minimum/color photo; $150-200 minimum/cover. "Small additional payment made if more copy than photo description specified by us." No credit line given. Buys first North American serial rights and/or industry rights for photos originated by photographer; all rights for photo work originated by magazine. Simultaneous submissions OK ("but only on an exclusive basis in optical industry"); previously published work rarely accepted.

Tips: "Keep your eyes open for unusually good window displays, promotions or other activities by *opticians—not* by our dispensing competitors, optometrists or ophthalmologists."

DISTRIBUTION MAGAZINE, Chilton Way, Radnor PA 19089. (215)964-4388. Editor-in-Chief: Joseph Barks. Monthly magazine. Emphasizes freight transportation (all modes), warehousing, export/import. Readers are managers for manufacturing, wholesale and retail companies responsible for movement of goods inbound and outbound. Circ. 70,000.

Photo Needs: Uses about 12 photos/issue; 1 supplied by freelance photographers. Needs photos of transportation scenes (trucks, trains, planes, ships, ports, etc.). Written release preferred.

Making Contact & Terms: Query with samples. Send 8x10 color prints, and 35mm transparencies by mail for consideration. SASE. Reports in 3 weeks. Pays $150-250/color cover photo and $50-100/color inside photo. Pays on publication. Credit line can be given if requested. Buys one-time rights. Previously published work OK.

Tips: "Let use know if traveling, particularly abroad—we're *always* in need of shots of foreign ports, airports (cargo only), trucks, etc."

DISTRIBUTOR, Box 745, Wheeling IL 60090. (312)537-6460. Editorial Director: Steve Read. Published 6 times/year. Emphasizes heating, air conditioning, ventilating and refrigeration. Readers are wholesalers. Circ. 10,000. Sample copy free with SASE and $1 postage.

Photo Needs: Uses about 12 photos/issue; 1-2 supplied by freelance photographers. Needs photos pertaining to the wholesaling of heating, air conditioning, ventilating and refrigeration. Special needs include cover photos of interior and exteriors of wholesaling businesses. Model release and captions required.

Making Contact & Terms: Query with list of stock photo subjects; "query on needs of publications." SASE. Reports in 2 weeks. Pays $100-250/color cover photo; $10/b&w and $25/color inside photo. Pays on publication. Credit line given. Buys one-time rights. Simultaneous and previously published submissions OK "if not within industry."

DOMESTIC ENGINEERING MAGAZINE, 135 Addison St., Elmhurst IL 60126. Editor: Stephen J. Shafer. Monthly magazine. Circ. 40,000. Emphasizes plumbing, heating, air conditioning and piping; also gives information on management marketing and merchandising. For contractors, executives and entrepreneurs. "For photos without stories, we could use a few very good shots of mechanical construction—piping, industrial air conditioning, etc.," but most photos purchased are with stories. Buys 5 photos/issue. Rights purchased are negotiable. Submit model release with photo. Send contact sheet for consideration. Pays on acceptance. Reports in 2 weeks. SASE. Simultaneous submissions and previously published work OK.

B&W: Uses 5x7 glossy prints; send contact sheet. Captions required. Pays $10-100.

Color: Uses 8x10 glossy prints or transparencies; send contact sheet. Captions required. Pays $10-100.

Cover: Uses glossy b&w prints, glossy color prints or color transparencies; send contact sheet. Captions required. Pays $50-125.

DR. DOBB'S JOURNAL, 501 Galveston Dr., Redwood City CA 94063. (415)366-3600. Editor: Michael Swaine. Photo Editor: Michael Hollister. Monthly. Emphasizes computer programming, langagues and software. Readers are computer programmers and engineers. Circ. 41,000. Sample copy $2.95.

Photo Needs: Uses about 1 photo/issue; 1 supplied by freelance photographer. Needs photos of computer subjects—technical special effects. Model release required.

Making Contact & Terms: Provide resume, business card, brochure, flyer or tearsheets to be kept on file for possible future assignments. Does not return unsolicited material. Pays $500-800/color cover photo. Credit line given. Buys first North American serial rights. Previously published work OK.

***THE DRAMA REVIEW**, 300 South Bldg., 6th Floor, 721 Broadway, New York NY 10003. (212)598-2597. Editor: Richard Schechner. Managing Editor: Ann Daly. Quarterly magazine. Circ. 11,000. Emphasizes new developments in contemporary avant-garde performance for professors, students and the general theatre- and dance-going public, as well as professional practitioners in the performing arts. Intercultural performance, interdisciplinary political performance, movement analysis, African performance, simulations. Photos purchased with accompanying mss. Buys 300 photos/year, 50/issue. Credit given in captions. Pays on publication. Buys one-time rights. Query with article ideas. SASE. Previously published work OK. Reports in 2 weeks. Photo guidelines free with SASE.
Subject Needs: Intercultural performance and avant-garde theatre. "No unsolicited photos! Photos are used only to document the subject matter of articles." Captions required.
B&W: Uses 5x7 or 8x10 glossy prints. Pays $10 minimum/photo.
Cover: Uses b&w glossy prints. Vertical, horizontal or square format preferred. Pays $10 minimum/photo.
Accompanying Mss: Seeks mss on new developments in avant-garde performance. Should coordinate with the theme of an issue. Pays $20 minimum/ms or 2¢/word. Writer's guidelines included on photo guidelines sheet.
Tips: "Freelancers might hook up with TDR authors to contribute to journal."

***DRUG TOPICS**, 680 Kinder Kamack Rd., Oradell NJ 07649. (201)262-3030. Editor: Valentine Cardinale. Biweekly magazine. Emphasizes retail pharmacy, drugstores. Readers are pharmacists, drugstore owners, managers, executives. Circ. 80,000. Sample copy free with SASE.
Photo Needs: Uses 10-15 photos/issue; 8-12 supplied by freelance photographers. Needs unique pictorial aspects of drugstore/pharmacy: displays, construction, events, signs, equipment, damage, interior or exterior. Model release preferred.
Making Contact & Terms: Send any size, glossy finish, b&w prints and 35mm transparencies by mail for consideration. SASE. Reports in 2 weeks. Pays $20/b&w inside photo; $50/color inside photo. Pays on acceptance. Credit line given "on contents page." Buys all rights.
Tips: Know the drugstore field or at least what is new about what you're photographing and deliver a well composed, well toned shot with some life in it.

EARNSHAW'S REVIEW, 11 Penn Plaza, 393 7th Ave., New York NY 10001. (212)563-2742. Art Director: Bette Cowles. Monthly. Emphasizes children's wear. Readers are buyers of children's apparel for specialty and department stores. Circ. 10,000.
Photo Needs: Uses about 30 photos/issue; 4-5 supplied by freelance photographers. Needs photos of children in various settings (holiday, swimming, springtime, active, back-to-school, birthday parties, etc.)." Model release required.
Making Contact & Terms: Arrange a personal interview to show portfolio; query with list of stock photo subjects. Pays $250/color cover photo. Pays on publication. Credit line given. Buys one-time rights. Simultaneous and previously published submissions OK.
Tips: "Do not mail any original work unless specifically requested."

EDUCATION WEEK, Suite 775, 1255 23rd St., Washington DC 20037. (202)466-5190. Editor-in-Chief: Ronald A. Wolk. Photo Editor: Jane Trimback. Weekly. Circ. 55,000. Emphasizes elementary and secondary education.
Photo Needs: Uses about 8 photos/issue; all supplied by freelance photographers. Model release preferred; captions required.
Making Contact & Terms: Query with samples. Provide resume and tearsheets to be kept on file for possible future assignments. Does not return unsolicited material. Reports in 2 weeks. Pays $50-250/job; $50-300 for text/photo package. Pays on acceptance. Credit line given. Buys all rights. Simultaneous submissions and previously published work OK.

ELECTRICAL APPARATUS, Barks Publications, Inc., 400 N. Michigan Ave., Chicago IL 60611. (312)321-9440. Associate Publisher: Elsie Dickson. Monthly magazine. Circ. 15,000. Emphasizes industrial electrical machinery maintenance and repair for the electrical aftermarket. Photos purchased with accompanying ms, or on assignment. Credit line given. Pays on publication. Buys all rights, but "exceptions to this are occasionally made." Query with resume of credits. SASE. Reports in 3 weeks. Sample copy $2.50.
Subject Needs: "Assigned materials only. We welcome innovative industrial photography, but most of our material is staff-prepared." Model release required when requested; captions preferred.
B&W: Contact sheet or contact sheet and negatives OK. Pays $10-50/photo.
Color: Query. Pays $25-100.

ELECTRONICS, 1221 Avenue of the Americas, New York NY 10020. (212)512-2430. Art Director: Fred J. Sklenar. Biweekly magazine. Emphasizes electronics business and technology. Circ. 105,000.

Photo Needs: Uses about 35-50 photos/issue; 10% supplied by freelance photographers. Needs "corporate, people, high-tech (electronics), some special effects, creative (to concept) and studio photography." Model release required; captions preferred.

Making Contact & Terms: Provide resume, business card, brochure, flyer or tearsheets to be kept on file for possible future assignments. SASE. Reports in 1 month. Pays $600-1,000 color cover photo; $75/b&w inside photo, $150/color inside photo and/or ASMP day rate. Pays on acceptance. Credit line given if requested. Buys all rights but "depends on terms and subject."

EMERGENCY, The Journal of Emergency Services, 6200 Yarrow Dr., Carlsbad CA 92008. (619)438-2511. Editor: F. Mckeen Thompson. Monthly magazine. Circ. 40,000. Emphasizes pre-hospital emergency medical and rescue services for paramedics, EMTs, fire fighters to keep them informed of latest developments in the emergency medical field. Photos purchased with or without accompanying ms. Buys 100 photos/year; 10 photos/issue. Pays for mss/photo package, or on a per-photo basis. Credit line given. Pays on acceptance. Buys all rights. Send material by mail for consideration, especially action shots of first responders in action. SASE.

Subject Needs: Documentary, photo essay/photo feature and spot news dealing with pre-hospital emergency medicine. Needs shots to accompany unillustrated articles submitted; year's calendar of themes forwarded on request. No "shots of accident sites after the fact, backs of the emergency personnel, bloody or gory shots." Captions required. Also needs color transparencies for "Emergency Action," a department dealing with emergency personnel in action.

B&W: Uses 5x7 or 8x10 glossy prints. Pays $10-25/photo.

Color: Uses 35mm or larger transparencies. Pays $10-25/photo.

Cover: Prefers 35mm; 2¼x2¼ transparencies OK. Vertical format preferred. Pays $100-150/photo.

Accompanying Mss: Instructional, descriptive or feature articles dealing with emergency medical services. Pays $100-300/ms.

Tips: Wants well-composed photos that say more than "an accident happened here." Looking for more color photos for articles. "We're interested in people, and our readers like to see their peers in action, demonstrating their skills. Ninety percent of all photography is accepted on speculation from freelance photographers."

***ENGINEERED SYSTEMS**, 7314 Hart St., Mentor OH 44060. (216)255-6264. Editor: Bob Schwed. Bimonthly magazine. Emphasizes heating, air conditioning and refrigeration service, manufacturing, etc. Readers are industry manufacturers, engineers, contracters, wholesalers. Sample copy $5.

Photo Needs: Uses 20 photos/issue; 2-15 supplied by freelance photographers. Needs photos of action and installation shots, people, some product shots.

Making Contact & Terms: Send unsolicited photos by mail for consideration. Send b&w prints, b&w contact sheets, color slides by mail for consideration. SASE. Reports in 3 months. Pay negotiated. Pays on acceptance. Credit line given. Buys one-time rights. Simultaneous submissions OK if exclusive to trade.

EUROPE MAGAZINE, 2100 M St. NW, #707, Washington DC 20037. (202)862-9500. Editor-in-Chief: Webster Martin. Magazine published 10 times/year. Circ. 50,000. Covers the European Common Market with "in-depth news articles on topics such as economics, trade, US-EC relations, industry, development and East-West relations." Readers are "businessmen, professionals, academic, government officials." Free sample copy.

Photo Needs: Uses about 20-30 photos/issue, 3-5 of which are supplied by freelance photographers (mostly stock houses). Needs photos of "current news coverage and sectors, such as economics, trade, small business, people, transport, politics, industry, agriculture, fishing, some culture, some travel. Each issue we have an overview article on one of the 12 countries in the Common Market. For this we need a broad spectrum of photos, particularly color, in all sectors. Otherwise, freelance photos may be chosen from unsolicited submissions if they fit our needs or blend into a specific issue. If a photographer queries and lets us know what he has on hand, we might ask him to submit a selection for a particular story. For example, if he has slides or b&w's on a certain European country, if we run a story on that country, we might ask him to submit slides on particular topics, such as industry, transport or small business." Model release and captions not required; identification necessary.

Making Contact & Terms: Send by mail for consideration actual 5x7 and 8x10 b&w or color photos, 35mm/2¼x2¼ color transparencies; query with resume of photo credits; or query with list of stock photo subjects. Initially, a list of countries/topics covered will be sufficient. SASE. Reports in 3-4 weeks. Pays on publication $75-150/b&w photo; $100 minimum/color transparency for inside, $400 for front cover; per job negotiable. Credit line given. Buys one-time rights. Simultaneous and previously published submissions OK.

Tips: "For certain articles, especially the Member State Reports, we are now using more freelance material than previously. Good photo and color quality, not too touristic a shot, agriculture or industry if possible."

THE EVENER, Box 7, Cedar Falls IA 50613. (319)277-3599. Managing Editor: Susan Salterberg. Quarterly magazine. Emphasizes "the draft horse, mule and oxen industries—with emphasis on draft horses." Published primarily for draft horse, mule and oxen enthusiasts, as well as for individuals interested in nostalgia, back-to-basics, ecology and rural life." Circ. 9,000. Sample copy for SASE and $1.07 postage; photo guidelines for SASE and 39¢ postage.
Photo Needs: Uses about 60 photos/issue; 25 supplied by freelance photographers usually with accompanying mss. "Draft horse, mule and oxen photos showing beauty and power of these animals are most welcome. Also want human interest shots with owner, driver or farmer working with the animal. Capture the animal and people in creative and engaging angles." Special needs include draft horses captured in action in an attractive, attention-getting manner. Model release and captions preferred.
Making Contact & Terms: Send 5x7 b&w prints (limit—10 prints/submission) or b&w contact sheets by mail for consideration. SASE. Reports in 3 months. Pays $5-40/color cover photo; $5-40/b&w inside photo. Pays on acceptance. Credit line given. "Prefer to buy first rights, but will make exceptions."
Tips: "Peruse our magazine before sending any materials. Know magazine audience well, and submit only photos that apply to the specific market. We demand a unique mixture of clear photos."

EXCAVATING CONTRACTOR, 1495 Maple Way, Troy MI 48084. (313)643-8655. Editor/Publisher: Andrew J. Cummins. Monthly. Circ. 28,500. Emphasizes earthmoving/small business management. Readers are owner/operator excavating contractors. Will send sample copy and photo guidelines.
Photo Needs: Uses 20 photos/issue; 2-3 are supplied by freelance photographers. "We'll use a freelance photographer, especially for covers, if it is better than we can obtain elsewhere. Usually receive photos from equipment manufacturers and their hired guns of a very high quality, but if a freelancer submits a quality photo, one that not only features an easily identifiable machine hard at work, but also some nice mountains or water in the background, then we will consider it. Prominent credit line given. Vertical shots are a must." Photos must be of small work sites since readers are small contracting businesses. Captions preferred.
Making Contacts & Terms: Send material by mail for consideration. Uses 5x7 and 8x10 b&w and color prints, 2¼x2¼ slides and contact sheets. SASE. Reports in 2 weeks. Pays $75/color cover; $25/color inside; $25-100 for text/photo package. Credit line given. Payment on publication. Buys all rights on a work-for-hire basis. Simultaneous and previously published work OK, but please tell when and where work was published.
Tips: "We are using photography more than ever."

EXTERIORS, (formerly *Roof Design*), 7500 Old Oak Blvd., Cleveland OH 44130. (216)243-8100, ext. 451. Editor: Mike Russo. Bimonthly magazine. Emphasizes "commercial roofing, wall and glazing." Readers are architects and specifiers. Circ. 20,000. Sample copy free with SASE.
Photo Needs: Uses about 18+ photos/issue; 0-1 supplied by freelance photographers. Needs aerial photos. Written release required.
Making Contact & Terms: Call to discuss needs. Payment varies; minimum $600. Payment is made on publication. Credit line given. Buys one-time rights. Previously published work OK.

FAMILY PLANNING PERSPECTIVES, 111 Fifth Ave., New York NY 10003. (212)254-5656. Editor: Richard Lincoln. Bimonthly. Circ. 15,000. Emphasizes family planning (population). Readers are family planning professionals, clinicians, demographers and sociologists. Free sample copy with 9x12 SASE.
Photo Needs: Uses about 0-3 photos/issue; 1 is supplied by freelance photographers. Needs photos of women and children of all ages; large and small families; women receiving services in family planning and abortion clinics; certain medical procedures—sterilizations, abortions, Pap smears, blood pressure tests, breast exams—in clinics and hospitals; teenagers (pregnant and nonpregnant); sex education classes; women receiving services from family planning workers in developing countries; family planning and abortion counseling in hospitals and clinics; hospital nurseries, infant intensive-care units; childbirth; and pregnant women and teens. Photos purchased without accompanying ms only. Model release required; captions preferred. "We write captions used in magazine, but prefer to have identifying information with photo."
Making Contact & Terms: Arrange a personal interview to show portfolio. SASE. Reports in 2 weeks. Provide brochure to be kept on file for possible future assignments. Pay negotiated. Pays on publication. Credit line given. Buys one-time rights. Previously published work OK.
Tips: Needs photos of "women receiving services in clinics or private MD's offices. Pictures of childbirth, pregnant women and families are readily available from stock agencies."

FARM & POWER EQUIPMENT, 10877 Watson Rd., St. Louis MO 63127. (314)821-7220. Editor: Rick Null. Monthly magazine. Circ. 14,500. Emphasizes farm/power equipment merchandising and management practices for retailers. Photos purchased with accompanying ms. Pays $50-300 for text/

photo package. Credit line given. Pays on acceptance. Buys one-time rights. "Query is absolutely essential." Query by telephone. SASE. Simultaneous submissions and previously published work OK. Reports in 2 weeks. Sample copy 50¢.

Subject Needs: Photos to illustrate articles on farm and power equipment related subjects. Captions required.

B&W: Uses 8x10 prints; contact sheet and negatives OK. Pay included in total purchase price with ms.

Accompanying Mss: Articles on dealership sales and parts departments, or service shop management. Pay included in total purchase price with photos. Writer's guidelines must be obtained prior to production and are available by phone.

FARM CHEMICALS, 37841 Euclid Ave., Willoughby OH 44094. (216)942-2000. Editorial Director: Charlotte Sine. Editor: Bill Tindall. Emphasizes application and marketing of fertilizers and protective chemicals for crops for those in the farm chemical industry. Monthly magazine. Circ. 32,000. Needs agricultural scenes. Buys 6-7 photos/year. Not copyrighted. Query first with resume of credits. Pays on acceptance. Reports in 3 weeks. SASE. Simultaneous submissions and previously published work OK. Free sample copy and photo guidelines.

B&W: Uses 8x10 glossy prints. Captions required.

Color: Uses 8x10 glossy prints or transparencies.

FARM INDUSTRY NEWS, Webb Co., 1999 Shepard Rd., St. Paul MN 55116. (612)690-7292. Editor: Joseph Degnan. Graphics Editor: Lynn Varpness. Published 10 times/year. Circ. 300,000. Emphasizes "agriculture product news; making farmers better buyers." Readers are "high volume farm operators." Sample copy free with SASE.

Photo Needs: Uses 4 or less photos/issue; freelancers supply "very few, usually cover shots." Needs photos of "large midwestern acreage farms, up-to-date farm equipment, livestock, crops, farmshows, farm electronics, haying and chemical application." Model release required; captions preferred.

Making Contact & Terms: Query with samples or with list of stock photo subjects; send 35mm, 2¼x2¼, 4x5 or 8x10 transparencies by mail for consideration. SASE. Reports in 1 month. Payment per color cover photo negotiated. Pays on publication. Buys first publication rights.

Tips: Prefers "2¼x2¼ or larger format cover and feature material transparencies of *up-to-date* large farm operations, crops, scenics and action photos of newer farm equipment in the field."

FARM JOURNAL, INC., 230 SW Washington Square, Philadelphia PA 19105. Associate Editor: Jim Patrico. Monthly magazine. Circ. 900,000. Emphasizes the business of agriculture: "Good farmers want to know what their peers are doing and how to make money marketing their products." Photos purchased with or without accompanying ms. Freelancers supply 60% of the photos. Pays by assignment or $125-350 for photos; more for covers. Credit line given. Pays on acceptance. Buys one-time rights, but this is negotiable. Model release required. Arrange a personal interview or send photos by mail. Provide calling card and samples to be kept on file for possible future assignments. SASE. Simultaneous submissions OK. Reports in 1 week/1 month. Free sample copy upon request.

Subject Needs: Photos having to do with the basics of raising, harvesting and marketing of all the farm commodities. People-oriented shots are encouraged. Also uses human interest and interview photos. All photos must relate to agriculture. Captions are required.

B&W: Uses 8x10 or 11x14 glossy or semigloss prints. Pays $25-100 depending on size used.

Color: Uses 35mm or 2¼x2¼ transparencies or prints. Pays $100-200 depending on size used.

Cover: Uses color transparencies, all sizes.

Tips: "Be original, take time to see with the camera. Be more selective, take more shots to submit. Take as many different angles of subject as possible. Use fill where needed."

***FARM STORE MERCHANDISING**, 2501 Wayzata Blvd., Minneapolis MN 55114. (612)374-5200. Editor: Margaret Kaeter. Monthly magazine. Emphasizes agribusiness. Readers are feed, grain, animal health, fertilizer and chemical dealers. Circ. 35,000. Sample copy free with SASE.

Photo Needs: Uses 20 photos/issue; 2 supplied by freelance photographers. Needs photos of custom application field shots and agribusiness sales shots. Model release preferred; captions required.

Making Contact & Terms: Query with list of stock photo subjects. SASE. Reports in 1 month. Pays $25/b&w inside photo; $50/inside color photo; $25-200/job; $100-300/text/photo package. Pays on acceptance. Credit line given. Buys one-time rights. Simultaneous submissions and previously published work OK.

***FARM SUPPLIER**, Mount Morris IL 61054. Managing Editor: Marcella Sadler. For retail farm supply dealers and managers throughout the US. Payment established by query with photographers.

Subject Needs: "We will now use both color and b&w photos that stand alone and tell a story about the farm dealership market. Our audience handles crop chemicals and fertilizer, custom application of

same, feed and grain and related store shelf items. Photos should tell a brief story about one of those items, with appropriate caption." Special emphasis issues—January/companion animal products/fertilize; February/swine feed, pre-plant herbicides, pre-emerge; March/livestock insecticides, post emerge herbicides, April/computers, crop insecticides; May/feed grain/mix, ag chem safety; June/merchandising/display, pest control/field scouting; July/feed/grain handling, equipment maintenance, August/dairy feed, nat'l cust. ap. show; September/animal health, conservaton tellage; October/livestock equipment, ground equipment; November/beef feed, 1987 crop outlook; December/product showcase, product showcase. Looking for practical application photos in all of these areas. Farm suppliers involved in all cases.

***FENCE INDUSTRY/ACCESS CONTROL**, 6255 Barfield Rd., Atlanta GA 30328. (404)256-9800. Editor: Bill Coker. Monthly magazine. Emphasizes fencing/access control devices. Readers are fence installers and access control dealers. Circ. 16,000. Sample copy free with SASE.
Photo Needs: Uses 20 photos/issue; 10 supplied by freelance photographers. Reviews photos with accompanying ms only. Special needs include security fencing and access control devices. Model release and captions required.
Making Contact & Terms: Query with samples. Send 5x7 glossy b&w prints by mail for consideration. SASE. Reports in 1 month. Pays $10/b&w inside photo. Pays on publication. Credit line given. Buys one-time rights.

FIRE CHIEF MAGAZINE, 40 East Huron St., Chicago IL 60611. (312)642-9862. Editor: William Randleman. Monthly magazine. Circ. 33,000. Emphasizes administrative problem solving for management in the fire protection field. For municipal, district and county fire chiefs. Needs cover photos of "big fires with fire departments in action and fire chiefs or other officers in action at a fire. Also, photos in connection with feature articles." Buys 12 photos/year. Credit line given. Buys all rights, but may re assign to photographer after publication. Send photos for consideration. Photos purchased with accompanying ms; cover photos purchased separately. Pays 2 weeks after publication. Reports in 1 month. SASE. Free sample copy and photo guidelines.
B&W: Send 5x7 or 8x10 glossy prints. Captions required. Pays $5 maximum.
Cover: Send 8x10 glossy b&w or color prints, 35mm or color transparencies. Captions required. Pays $50 minimum.

FIREHOUSE MAGAZINE, 33 Irving Place, New York NY 10003. (212)475-5400. Editor: John Peige. Art Director: Jon Nelson. Monthly. Circ. 100,000. Emphasizes "firefighting—notable fires, techniques, dramatic fires and rescues, etc." Readers are "paid and volunteer firefighters, 'buffs,' EMT's." Sample copy $3; photo guidelines free with SASE.
Photo Needs: Uses about 30 photos/issue; 20 supplied by freelance photographers. Needs photos in the above subject areas. Model release preferred.
Making Contact & Terms: Send 8x10 matte or glossy b&w or color prints; 35mm, 2¼x2¼, 4x5, 8x10 transparencies or b&w or color negatives with contact sheet by mail for consideration. "Photos must not be more than 30 days old." SASE. Reports in 1 month. Pays $200/color cover photo; $15-30/b&w inside photo; $30-45/color inside photo; $45/b&w full page and $75/color full page. Pays on publication. Credit line given. Buys one-time rights. Simultaneous submissions OK "only if withdrawn from other publications."

***THE FISH BOAT**, Box 2400, Convington LA 70434. (504)893-2930. Editor: Harry L. Peace. Monthly magazine. Emphasizes commercial fishing. Readers are commercial fishermen, individual boat owners, fleet operators and seafood processors. Circ. 18,500. Photo guidelines free with SASE.
Photo Needs: Uses 1 photo/issue; 1 supplied by freelance photographers. "Photos should be of cover quality and portray technical work of US commercial fisheries—fish boat at work, vessels being unloaded, fish being processed, etc. Should be vertical with room in top right for magazine logo." Captions required.
Making Contact & Terms: Send 3x5 color prints; 35mm, 2¼x2¼ transparencies by mail for consideration. SASE. Reports in 1 month. Pays/cover photo. Negotiated. Pays on acceptance. Credit line given. Buys one-time rights.

FLOORING, 7500 Old Oak Blvd., Cleveland OH 44130. (216)243-8100. Editor: Dan Alaimo. Monthly magazine. Emphasizes floor covering and other interior surfacing for floor covering retailers, contractors and distributors. Circ. 22,000.
Photo Needs: Uses about 25-30 photos/issue; "a few" supplied by freelance photographers. Needs photos "basically to illustrate various articles—mostly showroom shots." Model release and captions preferred.
Making Contact & Terms: Prefers query with samples. Provide resume, business card, brochure,

flyer or tearsheets to be kept on file for possible future assignments. SASE. Pay varies. Pays on acceptance. Buys all rights.

Tips: "We are finding a great need to expand our contacts among photographers across the country, especially those available for simple, local assignments (general assignments). Looking for people with demonstrated abilities with 35mm cameras; prefer photojournalists. Get on file. We may need someone in your area soon. Stock photos are rarely purchased."

David A. Silverman, senior editor of Functional Photography *bought one-time rights to Rochester, New York, photographer Ron Sauter's photo. Silverman had seen this photograph in the brochure for which it was originally shot. It was published on* Functional Photography's *July/August 1985 cover in color, and utilized some studio photography imagination on Sauter's part to produce the color reflections in the jar and tubes, and the star-light effects in the background.*

FUNCTIONAL PHOTOGRAPHY, 101 Crossways Park West, Woodbury NY 11797. (516)496-8000. Editor-in-Chief: David A. Silverman. Published every 2 months. Circ. 31,517. Emphasizes scientific imaging for scientists, engineers, R&D and medical personnel who use imaging to document and communicate their work. Free sample copy; photo guidelines with SASE.

Photo Needs: Uses 20 photos/issue; all are supplied by readers. "Photography is almost exclusively done by our readers. However, we also have a strong need for photos depicting image-making equipment (especially motion picture and video) in action. Almost all material is accompanied by ms." Needs photos submitted with ms illustrating documentation.

Making Contact & Terms: Send material by mail for consideration or query with article suggestions. Uses 5x7 and 8x10 b&w and color prints; 35mm, 2¼x2¼, 4x5 and 8x10 transparencies. SASE. Reports in 6-8 weeks. Pays $100/color cover and $50-300 for text/photo package. Credit line given. Payment on publication. Buys one-time rights. Simultaneous and previously published work OK if not in competitive publication.

***FUTURES MAGAZINE**, Suite 950, 250 S. Wacker Dr., Chicago IL 60606. (312)977-0999. Editor: Darrell Jobman. Photo Editor: Susan Abbott. Monthly magazine. Emphasizes futures and options trading. Readers are individual traders, institutional traders, brokerage firms, exchanges. Circ. 75,000. Sample copy $3.

Photo Needs: Uses 12-15 photos/issue; 80% supplied by freelance photographers. Needs mostly personality portraits of story sources, some mug shots, trading floor environment. Model release required; captions preferred.

Making Contact & Terms: Arrange a personal interview to show portfolio; query with list of stock photo subjects; provide resume, business card, brochure, flyer or tearsheets to be kept on file for possi-

ble future assignments. SASE. Reports in 2 weeks. Pays $150/½ day minimum. Pays on publication. Buys all rights.

Tips: All work is on an assignment basis. Be competitive on price, shoot good work without excessive film use.

GARDEN SUPPLY RETAILER, Box 67, Minneapolis MN 55428. (612)374-5200. Editor: Kay M. Olson. Monthly. Emphasizes "all aspects of retail garden centers—products, displays, customers, employees, power equipment, green goods, holiday goods, service and repair of lawn equipment." Readers are retailers and dealers of garden and lawn supplies. Circ. 40,190. Sample copy free with SASE and 75¢ postage.

Photo Needs: Uses about 10-20 photos/issue; "very few if any" supplied by freelance photographers. Needs "photos depicting business at a retail garden center. Prefer people with products rather than products alone." Special needs include "photographing plants in garden centers located in various areas of the country (especially outside the upper Midwest)."

Making Contact & Terms: Query with samples; list of stock photo subjects; send 35mm transparencies, b&w contact sheets by mail for consideration; provide resume, business card, brochure, flyer or tearsheets to be kept on file for possible future assignments. SASE. Tries to report in 3 weeks. Pays $25/b&w photo; $50/color photo; $100/cover photo. Pays on publication. Credit line given only "in certain cases." Buys all rights.

Tips: Prefers to see "photos illustrating retailing in a garden center, or of interest to the magazine's audience. Know the audience of the magazine and photograph what would be of interest to them. Strive for simplicity in form, using natural, spontaneous shots, people going about daily business."

GLASS NEWS, Box 7138, Pittsburgh PA 15213. Manager: Liz Scott. Monthly. Circ. 1,625. Emphasizes glass manufacturing. Readers are "glass manufacturers, suppliers, users." Sample copy for SASE (40¢ postage).

Photo Needs: Uses 2-3 photos/issue. Needs photos of "glass manufacturing details, glass items."

Making Contact & Terms: Send b&w prints or b&w contact sheet by mail for consideration. SASE. Reports in 1 month or "ASAP." Pays $25 + /b&w cover photo; $25 + /b&w inside photo. Pays on acceptance. Credit line given. Buys all rights.

GOLF SHOP OPERATIONS, 5520 Park Ave., Box 395, Trumbull CT 06611. (203)373-7000. Editor: Nick Romano. Magazine published 6 times a year. Circ. 14,000. Emphasizes "methods that would allow the golf professional to be a better businessman." For golf professionals and golf retailers employed at country clubs, public and municipal golf courses, golf specialty outlets. Most work done on assignment. Special needs: human interest shots, unusual golf shops or displays. Buys 15-20 shots/year. Buys one-time reproduction rights. Provide business card, flyer and tearsheets to be kept on file for possible future assignments. Send contact sheet for consideration. Reports in one month. Free sample copy and photo guidelines. Pays on acceptance.

B&W: Send contact sheet. Captions required. Pays $25-150 per shot. Color: Send slides or color transparencies. Captions required. Pays $100-250 per shot.

***GROUND WATER AGE**, 8 Stanley Circle, Latham NY 12110. (518)783-1281. Editor: Dave Macaulay. Monthly magazine. Circ. 31,800. Emphasizes management, marketing and technical information. For water well drilling contractors and water pump specialists. Needs picture stories and photos of pump installation. Buys 10-20 annually. Buys all rights, but may reassign to photographer after publication. Send photos for consideration. Pays on acceptance. Reports in 3 weeks. SASE. Simultaneous submissions and previously published work OK. Free sample copy and photo guidelines.

B&W: Send 5x7 matte prints. Captions required. Pays $5-15, "sometimes more."

Color: Send negatives, 8x10 matte prints or transparencies. Captions required. Pays $20-75.

Cover: Send color negatives, 8x10 color prints or color transparencies. Uses vertical format. Captions required. Pays $20-75.

HARDWARE AGE, Chilton Way, Radnor PA 19089. (215)964-4275. Editor-in-Chief: Terry Gallagher. Managing Editor: Richard Carter. Emphasizes retail and wholesale hardware. Readers are "hardware retailers and wholesalers of all types." Monthly. Circ. 71,000. Sample copy $1; photo guidelines for SASE.

Photo Needs: Uses about 20 photos/issue, very few of which are supplied by freelance photographers. Needs clean, well-lighted, well-cropped photos of in-store displays, signs, merchandising ideas, etc. Looking for "clear, in-focus documentary photography showing what successful retailers have done. Most of our articles are organized along product lines (hardware, housewares, lawn and garden, tools, plumbing, etc.) so that's the logical way to submit material. Not interested in displays from the manufacturer, but rather what the retailer has done himself. People in photos OK, but model release required."

Captions not required, "just specs of what store and where."
Making Contact & Terms: Send by mail for consideration actual 5x7 or 8x10 color prints; 35mm, 2¼x2¼ or 4x5 color transparencies; or color contact sheet. SASE. Reports ASAP. Pays on acceptance $20/color photo; $10/b&w photo; $100-200 for text/color photo package. No credit line. Buys first North American serial rights. No simultaneous or previously published submissions.

HIGH VOLUME PRINTING, Box 368, Northbrook IL 60065. (312)564-5940. Editor-in-Chief: Bill Esler. Bimonthly. Circ. 26,000. Emphasizes equipment, systems and supplies; large commercial printers: magazine and book printers. Readers are management and production personnel of high-volume printers and producers of books, magazines, periodicals. Sample copy $5; free photo guidelines with SASE.
Photo Needs: Uses about 30-35 photos/issue. Model release required; captions preferred.
Making Contact & Terms: Query with samples or with list of stock photo subjects; send b&w and color prints (any size or finish); 35mm, 2¼x2¼, 4x5 or 8x10 slides; b&w or color contact sheet or negatives by mail for consideration. SASE. Reports in 1 month. Pays $200 maximum/color cover photo; $50 maximum/b&w or color inside photo and $200 maximum for text/photo package. Pays on publication. Credit line given. Buys one-time rights with option for future use. Previously published work OK "if previous publication is indicated."

HOSPITAL PRACTICE, 10 Astor Place, New York NY 10003. (212)477-2727. Editorial Director: David W. Fisher. Design Director: Robert S. Herald. Publishes 18 issues/year. Circ. 190,000. "*Hospital Practice* is directed to a national audience of physicians and surgeons. Major review articles provide comprehensive information on new developments and problem areas in medicine and clinical research. Authors are nationally recognized experts in their fields." Photos purchased on assignment, "vary occasionally, as needed." Pays ASMP rates plus expenses for first reprint rights. Credit lines grouped in space available. Occasionally requires second serial (reprint rights). Arrange personal interview to show portfolio, submit portfolio for review, or query with samples. SASE. Reports in 2 weeks. Photo guidelines provided on assignment.
Subject Needs: Documentary (narrow field, color close-ups of surgical procedures); and photo essay/photo feature (assignments are made based on ms needs). "Documentary photographers must have experience with medical and/or surgical photography for editorial (not advertising) purposes. May have to travel to location on short notice with appropriate equipment." Model release and captions required if requested. No studio photos, animals, landscapes, portraits, moods.
B&W: Contact sheet and negatives OK.
Color: Prefers 2¼x2¼ Ektachrome transparencies.

INDUSTRIAL ENGINEERING, 25 Technology Park/Atlanta, Norcross GA 30092. (404)449-0460. Editor: Gene Cudworth. Monthly magazine. Circ. 50,000. Emphasizes developments and new products in the industry. For "productivity-minded engineers and managers" with a practical or academic engineering background. Needs photos "related to feature articles in the magazine." Number of photos bought yearly varies tremendously. Submit model release with photo. Query. Works with freelance photographers on assignment only basis. Provide calling card, brochure and flyer to be kept on file for possible future assignments. Photos "must have adequate descriptive material to explain the subject of industrial photos." SASE. Previously published work OK. All rights negotiable. Sample copy $4.
B&W: Uses 8x10 glossy prints. Captions required. Pays $5 minimum.
Color: Uses transparencies and good quality prints. Captions required. Pays $10 minimum.
Cover: Uses color transparencies. Query first. Captions required. Pays $15 minimum.

INDUSTRIAL LAUNDERER, Suite 613, 1730 M St., NW, Washington DC 20036. (202)296-6744. Editor: David Ritchey. Monthly magazine. Circ. 3,000. For decisionmakers in the industrial laundry industry. Publication of the Institute of Industrial Launderers. Needs photo essays on member plants. Copyrighted. Query first with resume of credits. Provide business card, brochure and flyer to be kept on file for possible future assignments. Pays $10-40/color photo. Submit invoice after publication for payment. SASE. Sample copy $1.
B&W: Send minimum 3x5 glossies; 4x6 preferred. Pays $5-20/inside photo. Payment is negotiable.
Tips: Needs photographers in various regions of the US to take photos for Plant of the Month department. "Ours is a business-oriented magazine—we don't want to see photos of unrelated or nonbusiness-oriented subjects."

INDUSTRIAL MACHINERY NEWS, 29516 Southfield Rd., Southfield MI 48076. (313)557-0100. Editor: Richard Perish. Monthly tabloid. Metalworking, plants and machinery. Readers are metalworking plant managers/engineers and purchasing personnel. Circ. 80,000. Sample available for $4.
Photo Needs: Uses 2-4 photos/issue. 1-2 supplied by freelance photographers. Needs "action photos

of metalworking machinery in use." Photos purchased with accompanying ms only. Written release and captions required.

Making Contact & Terms: Query with list of stock photo subjects; send b&w prints and b&w contact sheet for consideration. Provide resume, business card, brochure, flyer or tearsheets to be kept on file for possible future assignments. SASE. Reports in 2 weeks. Pays on acceptance or publication. Buys all rights. Previously published work OK.

***INDUSTRIAL PHOTOGRAPHY**, 50 West 23rd St., New York NY 10010. (212)645-1000. Editor: Lynn Roher. Monthly magazine. Circ. 54,000. "Our emphasis is on the industrial photographer who produces images (still, cine, video) for a company or organization (including industry, military, government, medical, scientific, educational, institutions, R&D facilities, etc.)."

Subject Needs: All mss and photos must relate to the needs of industrial photographers. Captions and releases required.

Specs: Uses 4x5, 5x7 or 8x10 glossy b&w and color prints or color transparencies; allows other kinds of photos.

Accompanying Mss: Photos purchased with accompanying ms. Seeks mss that offer technical or general information of value to industrial photographers, including applications, techniques, case histories of in-plant departments, etc.

Payment & Terms: Pays $100 minimum/mss, including all photos and other illustrations. Credit line given. Pays on publication. Buys first North American serial rights except photo with text.

Making Contact: Query with story/photo suggestion. Provide letter of inquiry and samples to be kept on file for possible future assignments. SASE. Reports in 1 month. Free sample copy and writer's/photo guidelines.

INDUSTRIAL SAFETY AND HYGIENE NEWS, 201 King of Prussia Rd., Radnor PA 19089 (215)964-4057. Editor: Dave Johnson. Monthly magazine. Circ. 57,000. Emphasizes industrial safety and health for safety and health management personnel in over 36,000 large industrial plants (primarily manufacturing). Free sample copy.

Photo Needs: Uses 150 photos/issue; 1-2 are supplied by freelance photographers. "Theme assignment made through conversations with editors. Usage depends on the dramatic impact conferred upon otherwise dull subjects; ie., new industrial products, applications of safety and health products in the actual industrial environment." Special needs include photos on fire protection, personal protection items, security devices, other industrial product areas, and health problems.

Making Contact & Terms: Send material by mail for consideration. Uses 5x7 b&w prints, 35mm and 2¼x2¼ transparencies and color negatives. Photographer should request editorial schedule and sample of publication. SASE. Reports in 2 weeks. Pays $50-250/job. Credit line given. Payment on publication. Buys all rights on a work-for-hire basis. Previously published work OK.

INDUSTRY WEEK, 1111 Chester Ave., Cleveland OH 44114. (216)696-7000. Art Director: Nick Dankovich. Biweekly magazine. Circ. 350,000. Emphasizes current events, and economic and business news. For managers throughout the manufacturing industry. Buys 3-4 photos/issue. Buys all rights or one-time use. Present model release on acceptance of photo. Query first with resume of credits. Credit line given. Pays on acceptance. Reports in 2 weeks. SASE. Simultaneous submissions OK. Sample copy $2.

Subject Needs: Still life and special effects and experimental. Must be industry-related. No "standard" industrial shots, fashion photos or product shots. Photos dealing with labor, people or human interest related to industry/business are "a top interest."

B&W: Uses prints. Pays $50-350.

Color: Uses 8x10 glossy or matte prints; or 35mm, 2¼x2¼ or 4x5 transparencies. Pays $50-600.

Cover: Uses glossy or matte color prints; or 35mm, 2¼x2¼ or 4x5 color transparencies. Pays $400-600; negotiable.

Tips: "Contact the art director as all freelance buys are on assignment." Wants photographers who are "able to work well in an interview situation and think editorially (concepts, etc.)."

INKBLOT, 1506 Bonita, Berkeley CA 94709. Editor: Theo Green. Quarterly. Emphasizes avant-garde and experimental. Circ. 2,000. Sample copy $3.

Photo Needs: Uses 6 photos/issue; all supplied by freelance photographers. Needs bizarre, experimental. Reviews photos with or without accompanying ms.

Making Contact & Terms: Send b&w prints by mail for consideration. SASE. Reports in 2-3 months. Pays $25/b&w photo, $25/color photo. Credit line given. Buys one-time rights. Simultaneous submissions and previously published work OK.

IN-PLANT PRINTER, Box 368, Northbrook IL 60065. (312)564-5940. Editor: Kraig Debus. Bimonthly. Circ. 35,000. Emphasizes "in-plant printing; print and graphic shops housed, supported, and serving

larger companies and organizations." Readers are management and production personnel of such shops. Sample copy $5; free photo guidelines with SASE.
Photo Needs: Uses about 30-35 photos/issue. Needs "working/shop photos, atmosphere, interesting equipment shots, how-to." Model release required; captions preferred.
Making Contact & Terms: Query with samples or with list of stock photo subjects; send b&w and color (any size or finish) prints; 35mm, 2¼x2¼, 4x5, 8x10 slides, b&w and color contact sheet or b&w and color negatives by mail for consideration. SASE. Reports in 1 month. Pays $200 maximum/b&w or color cover photo; $50 maximum/b&w or color inside photo and $200 maximum for text/photo package. Pays on publication. Credit line given. Buys one-time rights with option for future use. Previously published work OK "if previous publication is indicated."
Tips: "Good photos of a case study—such as a printshop, in our case—can lead us to doing a follow-up story by phone and paying more for photos."

INSTANT AND SMALL COMMERCIAL PRINTER, Building 11, 425 Huehl Rd., Northbrook IL 60062. (312)564-5940. Editor-in-Chief: Dan Witte. Bimonthly. Circ. 25,000. Emphasizes the "instant and retail printing industry." Readers are owners, operators, managers of instant and smaller commercial (less than 20 employees) print shops. Sample copy $3; photo guidelines free with SASE.
Photo Needs: Uses about 15-20 photos/issue. Needs "working/shop photos, atmosphere, interesting equipment shots, some how-to." Model release required; captions preferred.
Making Contact & Terms: Query with samples or with list of stock photo subjects or send b&w and color (any size or finish) prints; 35mm, 2¼x2¼, 4x5 or 8x10 slides; b&w and color contact sheet or b&w and color negatives by mail for consideration. SASE. Reports in 1 month. Pays $300 maximum/ b&w and color cover photo; $50 maximum/b&w and color inside photo and $200 maximum for text/ photo package. Pays on publication. Credit line given. Buys one-time rights with option for future use. Previously published work OK "if previous publication is indicated."

THE INSTRUMENTALIST, 200 Northfield Rd., Northfield IL 60093. (312)446-5000. Managing Editor: Anne Driscoll. Monthly magazine. Circ. 22,500. Emphasizes instrumental music education. Read by school band and orchestra directors. Buys 1-5 photos/issue, mostly color. Credit line given. Pays on publication. Buys all rights. Send material by mail for consideration. SASE. Reports in 2-4 weeks. Sample copy $2.
Subject Needs: Head shot and human interest. "All photos should deal with instrumental music in some way." Especially needs photos for Photo Essay section.
B&W: Uses 5x7 or 8x10 glossy prints. Pays $5 minimum/photo.
Cover: Uses color 35mm, 2¼x2¼ transparencies and glossy prints. Vertical format preferred. Pays $50-150 minimum/photo.
Tips: More vertical b&w and color photographs. Shots of musicians having fun. More relaxed subjects. More shots of instruments at different angles—seen from different perspectives. In color, looking for sharp, colorful slides of subject-matter. Fine-grain, interesting light usage.

INSULATION OUTLOOK, Suite 410, 1025 Vermont Ave. NW, Washington DC 20005. (202)783-6277. Editor: Dixie M. Lee. Monthly. Circ. 6,000. Emphasizes general business and commercial and industrial insulation for personnel in the commercial and industrial insulation industries. Sample copy $2.
Photo Needs: Uses photos of industrial and commercial construction projects across the USA. Uses photographers for everything from head shots to covers. Publication features 4-color process on feature material and cover; also provides advertising preparation and production services. Especially needs photos on commercial/industrial insulation projects.
Making Contact & Terms: Query with resume of photo credits or submit portfolio by mail for review. SASE. Reports in 1 week. Pay is negotiable. Credit line given. Payment on publication. Buys one-time rights. Simultaneous and previously published work OK.

INTERIOR DESIGN, 475 Park Ave. S., New York NY 10016. (212)576-4182. Editor-in-Chief: Stanley Abercrombie. Monthly. Circ. 50,000. Emphasizes interior design including buildings and furnishings for interior designers and architects. Sample copy $5.
Photo Needs: Uses over 200 photos/issue; most supplied by designers and architects. "Happy to receive color transparencies (must be 4x5) from experienced architectural and interior design photographers." Photos purchased "must have release from the client and the photographer giving permission to *Interior Design* to publish."
Making Contact & Terms: Send unsolicited photos by mail for consideration. Reports in 3 weeks. "Usually design firms or the subject of the photos will arrange and pay for photos, then provide them gratis to *Interior Design*." Pays on acceptance. Buys one-time rights.

INTERNATIONAL BUSINESS MONTHLY, Box 87339, Houston TX 77287. (713)641-0201. Publisher: T. George Pratt. Monthly magazine. Emphasizes international business for companies engaged in world trade. Circ. 130,000. Sample copy $5 plus postage. Photo guidelines available.
Photo Needs: Uses about 10 photos/issue; all supplied by freelance photographers. Needs photos of "trade shows, exhibitions, travel, international scenics." Photos purchased with accompanying ms only. Model release and captions required.
Making Contact & Terms: Query with resume of credits; send 4x5 or 8x10 prints by mail for consideration; submit portfolio for review; call to discuss current needs. SASE. Reports in 2 weeks. Pays $25-100/b&w photo; $50-200/color photo; $25-200/complete package. Pays on publication. Credit line given. Buys all rights. Simultaneous submissions OK.

INTERNATIONAL FAMILY PLANNING PERSPECTIVES, 111 Fifth Ave., New York NY 10003. (212)254-5656. Editor: Richard Lincoln. Quarterly. Circ. 21,000. Emphasizes family planning (population). Readers are family planning professionals, clinicians, demographers and sociologists. Free sample copy with SASE.
Photo Needs: Uses 0-3 photos/issue; 1 is supplied by freelance photographers. Needs photos of Third World women and children of all ages; large and small families; women receiving services in family planning and abortion clinics; certain medical procedures—sterilizations, abortions, Pap smears, blood pressure tests, breast exams—in clinics and hospitals; teenagers (pregnant and nonpregnant); sex education classes; women receiving services from family planning workers in developing countries; family planning and abortion counseling in hospitals and clinics; hospital nurseries, infant intensive-care units; childbirth and pregnant women. Photos purchased without accompanying ms only. Model release and captions preferred. "We write captions used in magazine, but prefer to have identifying information with photo."
Making Contact & Terms: Arrange a personal interview to show portfolio. SASE. Reports in 2 weeks. Provide resume and brochure to be kept on file for possible future assignments. Pay negotiable. Pays on publication. Credit line given. Buys one-time rights. Previously published work OK.

***INVESTMENT DECISIONS**, 11 Elm Place, Box 689, Rye NY 10580. (914)967-9100. Editor: Walter R. Nelson. Published 8 times per year, magazine. Emphasizes professional investing (*not* individual investors). Readers are investment and financial executives on Wall Street and in corporations and institutions. Circ. 41,000. Sample copy free with SASE.
Photo Needs: Uses various photos/issue. Needs mostly people—in working environment photos. Model release preferred.
Making Contact & Terms: Provide resume, business card, brochure, flyer or tearsheets to be kept on file for possible future assignments. SASE. Payment varies. Pays on publication. Credit line usually given. Rights negotiable. Simultaneous submissions and previously published work OK.

JOB CORPS IN ACTION MAGAZINE, Meridian Publishing, Inc., Box 10010, Ogden UT 84409. Editor: Caroll McKanna Halley. Bimonthly magazine. "Job Corps matters. There are 107 Job Corps centers throughout the United States; our national editorial material draws from them all." Readers are Job Corps students and staff, Job Corps alumni (20 years), Congress, U.S. Dept. of Labor, Forestry, public libraries, job screening and employment opportunities offices. Estab. 1984. Sample copy $1 with 9x12 SASE. Photo guidelines free with SASE.
Photo Needs: Uses about 16 photos/issue; "roughly half" supplied by freelance photographers. Needs "only material relating to and including Job Corps Students in Action being trained or on the job." Special needs include "Job Corps community relations activities." Model release and captions preferred; names of people in photos required.
Making Contact & Terms: Send 5x7 glossy color prints and 35mm (any size) transparencies by mail for consideration. "Query with a sample photo. No resume necessary—you're either a photographer or you're not." SASE. Reports in 1 month or less—usually much less." Pays $50/color cover photo and $35/color inside photo. Pays on acceptance. Credit line given. Buys first North American serial rights and reprint rights. Previously published work OK.
Tips: "We now purchase first rights and nonexclusive reprint rights. This means we retain the right to reprint purchased material in other Meridian publications. Authors and photographers retain the option or the right to resell material to other reprint markets."

JOBBER RETAILER MAGAZINE, 110 N. Miller Rd., Akron OH 44313. (216)867-4401. Editor: Greg Smith. Monthly. Circ. 36,000. Emphasizes "automotive aftermarket." Readers are "wholesalers, manufacturers, retail distributors of replacement parts."
Photo Needs: Uses about 3-20 photos/issue; often needs freelance photographers. Needs automotive feature shots; exterior and interior of auto parts stores. Model release and captions preferred.
Making Contact & Terms: Provide resume, business card, brochure, flyer or tearsheets to be kept on

file for possible future assignments. Does not return unsolicited material. Reporting time varies. Pays $100-500 for text/photo package. Pays on publication. Credit line given. Buys various rights—"generally all rights." Simultaneous submissions and previously published work OK.
Tips: "Let us know *who* and *where* you are."

THE JOURNAL, 33 Russell St., Toronto, Ontario M5S 2S1 Canada. (416)595-0053. Editor: Anne MacLennan. Production Editor: Terri Arnott. Monthly tabloid. Circ. 21,771. For professionals in the alcohol and drug abuse field: doctors, teachers, social workers, enforcement officials and government officials. Needs photos relating to alcohol and other drug abuse, and smoking. No posed shots. Buys 4-10 photos/issue. Not copyrighted. Submit model release with photo. Send photos or contact sheet for consideration. Pays on publication. Reports "ASAP." Free sample copy and photo guidelines.
B&W: Send 5x7 glossy prints. Captions required. Pays $20 minimum.
Cover: See requirements for b&w.
Tips: "We are looking for action shots, street scenes, people of all ages and occupations. Model releases are necessary. Shots should not appear to be posed."

***THE JOURNAL OF COAL QUALITY**, 417 TCCW, Western Kentucky University, Bowling Green KY 42101. (502)745-6244. Editor: Deborah Kuehn. Quarterly. Circ. 3,500. Estab. 1981. Emphasizes the quality of coal. Readers are "professionals in coal testing and coal analysis." Sample copy $7.
Photo Needs: Uses 2-10 photos/issue; 2 supplied by freelance photographers. Needs "specific coal-related photos." Photos purchased with accompanying ms only. Model release and captions required.
Making Contact & Terms: Query with list of stock photo subjects. SASE. Reports in 1 month. Payment "quoted on individual basis." Pays on publicaton. Credit lines for cover only. Buys first North American serial rights.

***JOURNAL OF EXTENSION**, 436 Lowell Hall, 610 Langdon St., Madison WI 53703. (608)262-1974. Editor: Colleen L. Schuh. Quarterly journal. A professional journal for adult educators. Readers are adult educators, extension personnel. Circ. 5,500. Sample copy free with SASE.
Photo Needs: Uses 1 cover photo/issue; supplied by freelance photographers. "Each issue we try to highlight the lead article, so the subject matter varies each time." Model release required.
Making Contact & Terms: Send 4x6 or 5x7 b&w prints by mail for consideration. Call to check on current needs. SASE. Reports in 1 month. Pays $75-125/b&w cover photo. Pays on acceptance. Credit line given. Buys one-time rights.

THE JOURNAL OF FAMILY PRACTICE, 25 Van Zant St., E. Norwalk CT 06855. (203)838-4400. Editor: John P. Geyman, M.D. Photo Editor: Jane Ekstrom. Monthly. Circ. 84,000. Emphasizes medicine. Readers are family practitioners. Sample cover and photo guidelines free with SASE.
Photo Needs: Uses 1 photo/issue; all supplied by freelance photographers. Needs nonmedical photos in a horizontal format.
Making Contact & Terms: Send 35mm transparencies by mail for consideration. SASE. Reports in 6 weeks. Pays $350/color cover. Pays on publication. Credit line given. Buys one-time rights.

JOURNAL OF PSYCHOACTIVE DRUGS, 409 Clayton St., San Francisco CA 94117. (415)626-2810. Editors: E. Leif Zerkin and Jeffrey H. Novey. Quarterly. Circ. 1,000. Emphasizes "psychoactive substances (both legal and illegal)." Readers are "professionals (primarily health) in the drug abuse field."
Photo Needs: Uses one photo/issue; supplied by freelance photographers. Needs "full-color abstract, surreal, avant-garde or computer graphics."
Making Contact & Terms: Query with samples. Send 4x6 color prints or 35mm or 2¼x2¼ transparencies by mail for consideration. SASE. Reports in 2 weeks. Pays $50/color cover photo. Pays on publication. Credit line given. Buys one-time rights. Simultaneous submissions and previously published work OK.

***JOURNAL OF PSYCHOSOCIAL NURSING**, 6900 Grove Rd., Thorofare NJ 08086. (609)848-1000. Editor: Dr. Shirley Smoyak. Photo Editor: John Carter. Monthly magazine. Emphasizes psychosocial nursing (psychiatric/mental health). Circ. 13,000.
Photo Needs: Uses 5 photos/issue; 3 supplied by freelance photographers. Needs photos of people—abstract. Model release required.
Making Contact & Terms: Query with samples; query with list of stock photo subjects; provide resume, business card, brochure, flyer or tearsheets to be kept on file for possible future assignments. SASE. Reports in 1 month. Pay varies. Pays on publication. Credit line given. Buys one-time rights. Previously published work OK.

LABORATORY MANAGEMENT, 50 West 23rd St., New York City NY 10010. (212)645-1000. Editor: Kenneth W. Lane. Monthly magazine. Readers are "physicians and scientists who are directors of

clinical medical laboratories." Circ. 54,000. Sample copy available with SASE.
Photo Needs: Uses 1 cover photograph/issue; supplied by freelance photographers. Needs "photomicrographs (35mm) of crystals, cells, other biological materials as taken through a microscope (in color). Photographs must be colorful, interesting and sharply defined."
Making Contact & Terms: Query with samples. Send 35mm transparencies by mail for consideration. SASE. Pays $35/color cover photo. Payment is on publication. Credit line given.
Tips: Photographers "should have some experience in photomicrography."

LAW & ORDER MAGAZINE, 1100 Skokie Blvd., Wilmette IL 60091. (312)256-8555. Editor: Bruce Cameron. Monthly. Circ. 25,000. Emphasizes law enforcement. Readers are "police/sheriff administrators and command officers." Sample copy $2. Photo guidelines free with SASE.
Photo Needs: Needs photos of police performing duties, training, operation of equipment. Model release preferred; captions required.
Making Contact & Terms: Send 5x7 glossy prints or transparencies by mail for consideration. Provide resume, business card, brochure, flyer or tearsheets to be kept on file for possible future assignments. SASE. Reports in 1 month. Pays $100/color cover photo; $10/b&w photo; $300 maximum for text/photo package. Pays on publication. Credit line given for cover/feature stories only. Buys all rights. Simultaneous submissions and previously published work OK.
Tips: "Need *action* shots."

***LIQUOR STORE MAGAZINE**, 352 Park Ave. S., New York NY 10010. (212)685-4848. Editor: Nicolas Furlotte. Nine times/year magazine. Emphasizes distilled spirits, wine and beer. Readers are national—retailers (liquor stores, supermarkets, etc.), wholesalers, distillers, vintners, brewers, ad agencies, media. Circ. 50,000. Sample copy free with SASE.
Photo Needs: Uses 30 photos/issue; 15 supplied by freelance photographers and photo house (stock). Needs photos of retailers, product shots, concept shots, profiles. Special needs include good retail environments; interesting store settings; special effect wine and beer photos. Model release and captions required.
Making Contact & Terms: Query with samples and list of stock photo subjects. SASE. Reports in 1 month. Pays $500/color cover photo; $50-500/job. Pays on publication. Credit line given. Buys onetime rights or all rights on commissioned photos. Simultaneous submissions OK.

LOG HOME AND ALTERNATIVE HOUSING BUILDER, 16 First Ave., Corry PA 16407-1894. (814)664-8624. Production Director: William Stright. Bimonthly. Circ. 11,000. Emphasizes "log, dome and earth-sheltered housing construction (all other types of alternatives are covered as well)." Readers are builders, dealers, manufacturers, product suppliers and potential builders and dealers for this industry. Free sample copy.
Photo Needs: Uses 10 photos/issue; few supplied by freelance photographers. Needs interiors and exteriors of alternative structures. Model release and captions required.
Making Contact & Terms: Query with samples and list of stock photo subjects. Provide resume, business card, brochure, flyer or tearsheets to be kept on file for possible future assignments. Reports within a month. Rates established on individual basis. Pays on publication. Credit given. Buys all rights.

MANUFACTURING ENGINEERING, One SME Dr., Dearborn MI 48121. (313)271-1500. Editor-in-Chief: Robin Bergstrom. Monthly magazine. Emphasizes high technology manufacturing. Readers are "members of the Society of Manufacturing Engineers and paid subscribers. Circ. 105,000. Sample copy free with $2 postage.
Photo Needs: Uses 60-75 photos/issue: 1% supplied by freelance photographers. Needs photos of "manufacturing equipment, tool show shots, high technology, people in businesses, tooling shots." Special needs include "specific cover shots, working on ideas with editor and art director." Send 5x7 b&w or color prints; or 4x5 transparencies by mail for consideration. Provide resume, business card, brochure, flyer or tearsheets to be kept on file for possible future assignments. SASE. Reports in 1 week. Pays $175-300/color cover photo; $25/b&w inside photo; $50/color inside photo. Pays $200/day maximum. Payment is made monthly. Buys one-time or all rights. Simultaneous and previously published work OK.

MD MAGAZINE, 3 E. 54th St., New York NY 10022. (212)355-5432. Picture Editor: Doris Brautigan. Monthly magazine. Circ. 160,000. Emphasizes the arts, science, medicine, history and travel; written with the readership (physicians) in mind. For medical doctors. Needs a wide variety of photos dealing with history, art, literature, medical history, pharmacology, activities of doctors and sports. Also interested in photo essays. Buys first serial rights. Arrange a personal interview to show portfolio. Single pictures require only captions. Picture stories require explanatory text but not finished ms. Pays on pub-

lication. Reports ASAP. SASE. Simultaneous submissions and previously published work OK.
B&W: Send 8x10 glossy prints. Captions required.
Color: Send transparencies. Captions required.
Tips: *MD* also publishes a Spanish edition and automatically pays half the original use fee for reuse.

MEDIA & METHODS, 1511 Walnut St., Philadelphia PA 19102. (215)563-3501. Associate Editor: Robin Morrison. Publishes 6/issues year. Emphasizes "media, technologies and methods of teaching secondary school students." Readers are secondary school librarians, teachers, administrators. Circ. 40,000. Sample copy free with SASE and $1.07 postage.
Photo Needs: Uses 10-15 photos/issue; 1-2 supplied by freelance photographers. Needs "photos of students and teachers, schools, equipment." Written release and captions preferred.
Making Contact & Terms: Arrange a personal interview to show portfolio. Provide resume, business card, brochure, flyer or tearsheets to be kept on file for possible future assignments. Pays $100/b&w cover photo; $200/color cover photo; $50/b&w inside photo; $75/color inside photo. Payment is made on publication. Credit line given. Buys First North American serial rights. Simultaneous and previously published work OK.

***MEDICAL ECONOMICS MAGAZINE**, 680 Kinderkamack Rd., Oradell NJ 07649. (201)262-3030. Editor: Don L. Berg. Photo Editor: (Ms.) Grady Olley. Biweekly magazine. Emphasizes financial aspects of running a medical practice. Readers are physicians, financial specialists. Circ. 182,000. Sample copy free with SASE.
Photo Needs: Uses 15-20 photos/issue; 5-10 supplied by freelance photographers. Needs head and shoulders shots (Fortune 500 type shots), Day-in-the-life-of shots, indoor and outdoor. Special needs include photos of doctors and their families, homes, and hobbies. Doctors interacting with/examining patients. Model release and captions required.
Making Contact & Terms: Provide resume, business card, flyer or tearsheets to be kept on file for possible future assignments, "send to Grady Olley, Art Administrator." SASE. Reports in 2 weeks. Pay negotiated. Pays on acceptance. Credit line given on contents page. Buys one-time rights. Previously published work OK.
Tips: Prefers to see medical and editorial photography, still lifes and location shots, photomicrography, computer-generated images. "Don't be too pushy. Don't overprice yourself. A good photographer makes a good living."

MEDICAL TIMES, 80 Shore Rd., Port Washington NY 11050. (516)883-6350. Executive Editor: Susan Carr Jenkins. Monthly. Circ. 100,000. Emphasizes medicine. Readers are "primary care physicians in private practice." Sample copy $5.
Photo Needs: Uses 1-2 photos/issue by freelance photographers. Needs "medically oriented photos on assignment only." Model release and captions required.
Making Contact & Terms: Query with samples or list of stock photo subjects. SASE. Reports in 1 month. Pays approximately $50 and up/b&w or color inside. Pays on acceptance. Credit line given. Rights purchased vary with price.
Tips: Prefers to see "photos of interest to physicians or which could be used to illustrate articles on medical subjects. Send in a typed query letter with samples and an indication of the fee expected."

***MEDICAL WORLD NEWS**, Suite 112, 7676 Woodway, Houston TX 77063. (713)780-2299. Editor: Annette Oestreicher. Photo Editor: Pat Cleary. Bimonthly magazine. Emphasizes medicine. Readers are family practitioners, G.P.'s, Internists, D.O.'s, cardio- and gastro-enterologists. Circ. 126,000. Sample copy free with SASE.
Photo Needs: Uses 30 photos/issue; 10 supplied by freelance photographers. Needs photos of medical, people, news items. Reviews photos with accompanying ms only. Model release and captions required.
Making Contact & Terms: Provide resume, business card, brochure, flyer or tearsheets to be kept on file for possible future assignments. SASE. Reports in 2 weeks. Pays $500/color cover photo; $65/inside b&w photo; $65/page. Pays on publication. Credit line given. Buys one-time rights.

MICHIGAN BUSINESS MAGAZINE, Suite 302, 30161 Southfield, Southfield MI 48076. (313)647-0111. Editor: Ron Garbinski. Monthly independent circulated to senior executives. Emphasizes Michigan business. Readers include top-level executives. Circ. 27,000. Estab. 1984. Free sample copy with SASE; call editor for photo guidelines.
Photo Needs: Uses variable number of photographs; most supplied by freelance photographers. Needs photos of business people, environmental; feature story presentation; mug shots, etc. Reviews photos with accompanying ms only. Special needs include photographers based around Michigan for freelance work on job basis. Model release preferred; captions required.

Making Contact & Terms: Arrange a personal interview to show portfolio, query with resume of credits and samples. SASE. Reports in 2 weeks. Pay individually negotiated. Pays on publication. Credit line given. Buys all rights.

MINI MAGAZINE, 85 Eastern Ave., Box 61, Gloucester MA 01930. (617)283-3438. Editor: Marlene Comet. Publishes 6 issues/year. Emphasizes computer software and hardware. Readers include IBM System 34/36/38 Decision Makers. Circ. 38,000. Sample copy $3.
Photo Needs: Uses 7-10 photos/issue; currently none supplied by freelance photographers. Needs computer (IBM 34/36/38), office scenes, computer terminals. Reviews photos with or without accompanying ms. Special needs include IBM photos. Model release required; captions preferred.
Making Contact & Terms: Query with samples and list of stock photo subjects. Reports in 2 weeks. Pays on publication. Buys all rights. Simultaneous submissions and previously published work OK.

MISSOURI RURALIST, Suite 600, 2103 Burlington, Columbia MO 65202. (314)474-9557. Editor-in-Chief: Larry S. Harper. Biweekly. Circ. 80,000. Emphasizes agriculture. Readers are rural Missourians. Sample copy $2.
Photo Needs: Uses about 25 photos/issue; "few" are supplied by freelance photographers. "Photos must be from rural Missouri." Photos purchased with accompanying ms only. Pays $60/photo and page. Captions required.

***MODERN OFFICE TECHNOLOGY**, 1111 Chester Ave., Cleveland OH 44114. (216)696-7000. Editor: Lura K. Romei. Monthly magazine. Emphasizes office automation, data processing. Readers are middle management and higher in companies of 100 or more employees. Circ. 156,500. Sample copy free with SASE.
Photo Needs: Uses 15 photos/issue; 5 supplied by freelance photographers. Needs office shots, office interiors, computers, concept shots of office automation, networking. Special photo needs: "any and all office shots are welcome." Captions required.
Making Contact & Terms: Provide resume, business card, brochure, flyer or tearsheets to be kept on file for possible future assignments. Reports in 3 weeks. Pays $500/color cover photo; $50/b&w and color inside photo. Pays on publication. Credit line given. Buys one-time rights.
Tips: Good arty, conceptual material about the office and office supplies is hard to find. Crack that and you're in business.

MOTORCYCLE DEALER NEWS, Box 19531, Irvine CA 92713. Editors: Fred Clements and Kathy St. Louis. Monthly magazine. Circ. 15,000. Emphasizes running a successful retail motorcycle business for retail motorcycle dealers. Photos are purchased with accompanying ms. Buys 5 photos/year. Pays $50-125 for text/photo package or on a per-photo basis. Credit line usually given. Pays on publication. Buys all rights, but may reassign to photographer after publication. Works mostly with freelance photographers on assignment only basis. Provide resume, brochure, calling card, flyer, letter of inquiry, tearsheets, samples, or whatever photographer feels would be the most representative to be kept on file. SASE. Simultaneous submissions (if subject is not motorcycles) and previously published work OK. Reports ASAP. Sample copy and photo guidelines available.
Subject Needs: Wants material related to motorcycle dealerships and marketing techniques only. Does not want consumer-interest pieces. No competition shots. Model release and captions required.
B&W: Uses 5x7 and 8x10 prints. Pays $10/photo.
Accompanying Mss: Seeks mss on interesting and profitable marketing or promotional techniques for motorcycles and accessories by dealers. Pays $35-100/ms. Writer's guidelines free on request.
Tips: "We are a business publication and not interested in races or most consumer activities."

NATIONAL BUS TRADER, Theater Rd., Rt. 3, Box 349 B, Delavan WI 53115-9566. (414)728-2691. Editor: Larry Plachno. Monthly. Circ. 4,500. "The Magazine of Bus Equipment for the United States and Canada—covers mainly integral design buses in the United States and Canada." Readers are bus owners, commercial bus operators, bus manufacturers, bus designers. Sample copy free with SASE and $1 postage.
Photo Needs: Uses about 30 photos/issue; 22 supplied by freelance photographers. Needs photos of "buses; interior, exterior, under construction, in service." Special needs include "photos for future feature articles and conventions our own staff does not attend."
Making Contact & Terms: "Query with specific lists of subject matter that can be provided and ask whether accompanying mss are available." SASE. Reports in 1 week. Pays $25/per b&w or color photo; $100-3,000/complete package. Pays on acceptance. Credit line given. Buys rights "depending on our need and photographer." Simultaneous submissions and previously published work OK.
Tips: "We don't need samples, merely a list of what freelancers can provide in the way of photos or ms. Write and let us know what you can offer and do. We often use freelance work. We also publish *Bus*

Tours Magazine—a bimonthly which uses many photos but not many from freelancers; *The Bus Equipment Guide*—infrequent, which uses many photos and *The Official Bus Industry Calendar*—annual full-color calendar of bus photos. We also publish historical railroad books and are looking for historical photos on midwest interurban lines and railroads. Due to publication of historical railroad books—we are purchasing many historical photos. In photos looks for: appropriate subject matter, appropriate to current or pending article or book. Send a list of what is available with specific photos, locations, bus/interurban company and fleet number."

NATIONAL COIN-OPERATORS REPORTER, 717 E. Chelten Ave., Philadelphia PA 19144. (215)843-9795. Editor: Hal Horning. Bimonthly newspaper. Readers are drycleaners/coin-op owners. Circ. 15,000.
Photo Needs: Uses about 50 photos/issue; "very few" supplied by freelance photographers. Needs "unusual cover type shots; photos of drycleaners or coin-op laundries." Captions preferred.
Making Contact & Terms: Query with list of stock photo subjects; send 5x7 b&w prints by mail for consideration; "query first before shooting." SASE. Reports in 1 week. Pays $25-50/b&w cover photo. Pays on publication. Credit line given. Buys one-time rights.
Tips: "Query first for description of magazine's needs."

NATIONAL FISHERMAN, 21 Elm St., Camden ME 04843. (207)236-4342. Contact: James W. Fullilove. Monthly magazine. Circ. 55,000. Emphasizes commercial fishing, boat building, marketing of fish, fishing techniques and fishing equipment. For amateur and professional boatbuilders, commercial fishermen, armchair sailors, bureaucrats and politicians. Buys 5-8 photo stories monthly; buys 4-color action cover photo monthly.
Subject Needs: Action shots of commercial fishing, work boats, traditional (nonpleasure) sailing fishboats. No recreational, caught-a-trout photos.
Payment & Terms: Pays $10-25/inside b&w print and $250/color cover transparency. Pays on publication.
Making Contact: Query. Reports in 4 weeks.
Tips: "We seldom use photos unless accompanied by feature stories or short articles—i.e., we don't run a picture for its own sake. Even those accepted for use in photo essays must tell a story—both in themselves and through accompanying cutline information. We need sharp black and white glossy photos— 5x7s are fine."

NATIONAL GUARD, 1 Massachusetts Ave. NW, Washington DC 20001. (202)789-0031. Editor-in-Chief: Lieutenant Colonel Reid K. Beveridge. Monthly. Circ. 69,000. Emphasizes news, policies, association activities and feature stories for officers of the Army and Air National Guard. Readers are National Guard officers. Free sample copy and photo guidelines with SASE.
Photo Needs: "Pictures in military situations which show ability to shoot good quality, dramatic action pictures as this is the type of photography we are most interested in." Uses 40 photos/issue; 6 are supplied by freelance photographers. "Normally, photography accompanies the freelance articles we purchase. Freelance photographers should query first and their photography should be of subjects not available through normal public affairs channels. We are most interested in hiring freelance work in the Midwest, South and West. We never use freelance work in the Washington area because members of our staff take those pictures. Subject matter should be relevant to information of the National Guard officer. Please submit SASE with all material."

***NATIONAL LAW JOURNAL**, Suite 900, 111 8th Ave., New York NY 10011. (212)741-8300. Art Editor: Cynthia Currie. Photo Editor: Chris Losee. Weekly tabloid. Emphasizes legal stories and law-related topics. Readers are lawyers, law librarians, professors. Circ. 34,000. Sample copy on request.
Photo Needs: Needs generic stock oriented to topics—mostly news topics and portrait photography. Model release required; captions preferred.
Making Contact & Terms: Arrange a personal interview to show portfolio; provide resume, business card, brochure, flyer or tearsheets to be kept on file for possible future assignments. SASE. Reports in 2 weeks. Pays $200 maximum/job. Pays on publication. Credit line given. Buys "stock: one-time rights; our assignment: all rights." Simultaneous submissions and previously published work OK.

NEW ORLEANS BUSINESS, 401 Whitney Ave., Box 354, Gretna LA 70054. (504)362-4310. Executive Editor: Lan Sluder. Weekly tabloid. Emphasizes "business, industry and the professions in New Orleans and in the state of Louisiana." Readers are executives and professionals making more than $75,000 a year. Circ. 20,000. Free sample copy and photo guidelines with SASE.
Photo Needs: Uses about 3 photos/issue; 1 supplied by freelance photographers. Needs photos of "various business subjects, especially good color transparencies of subjects of interest to New Orleans business people." Model release preferred; captions required.

Making Contact & Terms: Query with samples. SASE. Reports in 2 weeks. Pays $75/b&w cover photo, $75-125/color cover photo, $25/b&w inside photo and $50/color inside photo. Pays on publication. Credit line given. Buys first rights in Louisiana. Simultaneous submissions and previously published submissions OK.

Denver, Colorado, photographer, Joanne Asher, shot this photo on assignment for Nightclub & Bar. *"The magazine used the cover photo and inset picture along with a third photo inside to illustrate a story on historic taverns and restaurants still in operation, and how they helped to shape today's restaurant industry," she explains. In the photos, Asher wanted to show the history of the restaurant and the memorabilia, as well as to include people as per the assignment. She originally sent a black and white photo of the tavern, along with some background information. This generated the assignment that earned her $150 for one-time use of the three photos.*

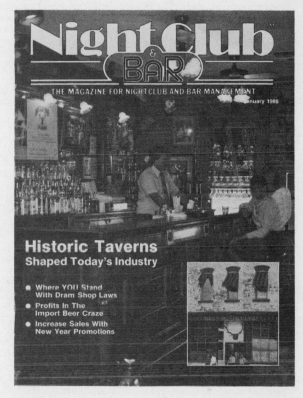

***NIGHT CLUB & BAR MAGAZINE**, 305 W. Jackson Ave., Oxford MS 38655. (601)234-0272. Editor: Beth Moore. Monthly magazine. Emphasizes bar and nightclub management personnel marketing, management, product information, industry news, features on bars/nightclubs. Circ. 20,000. Estab. 1985. Sample copy free with SASE. Photo guidelines free with SASE.
Photo Needs: Uses 35 photos/issue; one-third supplied by freelance photographers. Needs photos by freelancers to accompany feature articles on successful night clubs/bars, the owners, clientele, employees, surroundings. Model release required; captions preferred. "Need some information on people if shot is people-shot."
Making Contact & Terms: Query with list of stock photo subjects. SASE. Reports in 2 weeks. Pays $150/hour. Pays on publication. Credit line given. Buys one-time rights, "although would like to keep for future use—would then pay per photo used."
Tips: If you haven't done nightclub/bar work before—try before submitting anything. This lighting is hard to work with.

THE NORTHERN LOGGER & TIMBER PROCESSOR, Box 69, Old Forge NY 13420. Editor: Eric A. Johnson. Managing Editor: George F. Mitchell. Monthly magazine. Circ. 12,500. Emphasizes methods, machinery and manufacturing as related to forestry. For loggers, timberland managers, and processors of primary forest products in the territory from Maine to Minnesota and from Missouri to West Virginia. Photos purchased with accompanying ms. Buys 3-4 photos/issue. Credit line given. Pays on publication. Copyrighted. Query with resume of credits. SASE. Previously published work OK. Reports in 2 weeks. Free sample copy.
Subject Needs: Head shot, how-to, nature, photo essay/photo feature, product shot and wildlife; mostly b&w. Captions required. "The magazine carries illustrated stories on new methods and machinery for forest management, logging, timber processing, sawmilling and manufacture of other products of northern forests."

B&W: Uses 5x7 or 8x10 glossy prints. Pays $15-20/photo.
Color: Uses 35mm transparencies. Pays $35-40/photo.
Cover: Uses b&w glossy prints or 35mm color transparencies. Vertical format preferred. Pays $35-40/photo.
Accompanying Mss: Pays $100-250 for text/photo package.
Tips: "Send for a copy of our magazine and look it over before sending in photographs. We're open to new ideas, but naturally are most likely to buy the types of photos that we normally run. An interesting caption can mean as much as a good picture. Often it's an interdependent relationship."

NURSING MANAGEMENT, Suite 701, 600 S. Federal St., Chicago IL 60605. (312)341-1014. Production Manager: Andrew Miller. Monthly. Circ. 107,000 + . Emphasizes information on and techniques for nurse management. Readers are managerial level professional nurses.
Photo Needs: Uses 10 photos/issue; all are usually supplied by freelance photographers. Needs hospital oriented photos. Model release required.
Making Contact and Terms: Query with list of stock photo subjects. SASE. Reports in 1 month. Credit line given. Payment on publication.

OCCUPATIONAL HEALTH & SAFETY, Box 7573, Waco TX 76710. (817)776-9000. Associate Publisher: Darrell Denny. Published 12 times/year. Emphasizes the field of occupational health and safety. Readers are occupational physicians, occupational nurses, industrial hygienists, safety engineers, government and union officials. Circ. 92,000. Free sample copy.
Photo Needs: Uses about 30 photos/issue; 10 or more supplied by freelance photographers. Needs "vary according to editorial content," write for current editorial lineup. Model release and captions preferred.
Making Contact & Terms: Query with sample or list of stock photo subjects; send prints, transparencies and negatives by mail for consideration. SASE. Reports in 1 month. Payment negotiable, usually $25-100/slide. Pays on acceptance. Credit line given. Buys one-time rights or rights for reuse. Simultaneous and previously published submissions OK "only if not submitted to competing magazines."

OCEANUS, Woods Hole Oceanographic Institution, Woods Hole MA 02543. (617)548-1400. Editor: Paul R. Ryan. Quarterly. Circ. 15,000. Emphasizes "marine science and policy." Readers are "seriously interested in the sea. Nearly half our subscribers are in the education field." Sample copy free with SASE.
Photo Needs: Uses about 60 photos/issue; 25% supplied by freelance photographers. "Three issues per year are thematic, covering marine subjects." Captions required.
Making Contact & Terms: Query with resume of credits or with list of stock photo subjects; provide resume, business card, brochure, flyer or tearsheets to be kept on file for possible future assignments. Does not return unsolicited material. Reports in 1 month. Payments "to be negotiated based on size of photo used in magazine." Pays on publication. Credit line given. Buys one-time rights.
Tips: "The magazine uses only b&w photos. Color slides can be converted. Send us high contrast b&w photographs with strong narrative element (scientists at work, visible topographic, atmospheric alterations or events)."

OFFICE ADMINISTRATION & AUTOMATION, 1123 Broadway, New York NY 10010. (212)924-8989. Editor: Don Johnson. Monthly magazine. Circ. 54,000. Emphasizes office systems for "managers who have the responsibility of operating the office installation of any business." Buys 10 photos/year. Present model release on acceptance of photo. Works with freelance photographers on assignment basis only. Arrange a personal interview to show portfolio or send photos for consideration. Pays on publication. Reports in 4-6 weeks. SASE. Sample copy $3.50.
B&W: Uses 8x10 glossy prints; send contact sheet.
Color: Send 4x5 transparencies. Payment is "strictly negotiated."
Cover: See requirements for color. "The editor should be contacted for directions."
Tips: No photos of cluttered offices.

OFFICIAL COMDEX SHOW DAILY, 300 1st Ave., Needham MA 02194. (617)449-6600. Editor-in-Chief: Vic Farmer. Newspaper published 3-4 issues a show, 3 shows a year. Emphasizes COMDEX computer show coverage: Atlanta, Las Vegas and Los Angeles. Readers are show attendees.
Photo Needs: Uses about 10 photos/issue; half supplied by freelance photographers. Needs travel, scenic and entertainment photos. Model release and captions required.
Making Contact & Terms: Query with samples. SASE. Reports in 3 weeks. Pays $25/inside photo. Pays on publication. Credit line "sometimes" given. Buys one-time rights. Simultaneous submissions and previously published work OK.

OHIO BUSINESS, 1720 Euclid Ave., Cleveland OH 44115. (216)621-1644. Managing Editor: Michael Moore. Monthly magazine. Emphasizes "all types of business within Ohio." Readers are executives and business owners. Circ. 40,000. Sample copy $2.
Photo Needs: Uses 20-25 photos/issue; 0-3 supplied by freelance photographers. Needs photos of "people within articles and industrial processes." Captions preferred.
Making Contact & Terms: Provide resume, business card, brochure, flyer or tearsheets to be kept on file for possible future assignments. SASE. Reports in 2 weeks. Pays $150/color cover photo, $10 +/ b&w inside photo and $50 +/color inside photo. Pays on acceptance. Credit line given. Buys one-time rights. Simultaneous submissions and previously published work OK.
Tips: "Read the publication."

THE ONTARIO TECHNOLOGIST, Suite 253, 40 Orchard View Blvd., Toronto, Ontario, Canada M4R 2G1. (416)488-1175. Editor-in-Chief: Ruth M. Klein. Publication of the Ontario Association of Certified Engineering Technicians and Technologists. Bimonthly. Circ. 14,000. Emphasizes engineering technology. Sample copy free with SASE.
Photo Needs: Uses 10-12 photos/issue. Needs how-to photos—"building and installation of equipment; similar technical subjects." Prefers business card and brochure for files. Model release and captions preferred.
Making Contact & Terms: Send 5x7 b&w or color glossy prints for consideration. SASE. Reports in 1 month. Pays $25/b&w photo; $50/color photo. Pays on publication. Credit line given. Buys one-time rights. Previously published work OK.

***OPHTHALMOLOGY MANAGEMENT—OPTOMETRIC MANAGEMENT, CONTACT LENS FORUM, INSIGHT**, Five N. Greenwich Rd., Armonk NY 10504. (914)273-6666. Art Director: Barbara Gallois. Monthly magazines. Emphasizes eye care. Readers are optometrists, ophthalmologists, optical shots. Circ. 13,000-14,000 each.
Photo Needs: Uses 2 photos/issue; 50% supplied by freelance photographers. Needs photos of scenes doctors' offices, doctors, occasional graphic look, e.g., concerning optometry in the year 2000—used futuristic space scene. Special needs include a storm scene—dark clouds, ominous-looking sky, maybe some lighting. Model release and captions preferred.
Making Contact & Terms: Provide resume, business card, brochure, flyer or tearsheets to be kept on file for possible future assignments. Reports depending on need. Pays $500 maximum/color cover photo. Pays on acceptance. Credit line given. Previously published work OK.

OREGON BUSINESS MAGAZINE, Suite 404, 208 SW Stark, Portland OR 97204. (503)223-0304. Art Director: Richard Jester. Monthly. Circ. 23,000. Emphasizes business features. Readers are business executives. Sample copy free with SASE and 90¢ postage.
Photo Needs: Uses about 15 photos/issue; 5 supplied by freelance photographers. "Usually photos must tie to a story. Query any ideas." Model release and captions required.
Making Contact & Terms: Query first with idea. Reports in 1 week. Pays $20/b&w inside photo; $25/color inside photo with stories; $25 minumum/job. Pays on publication. Credit line given. Buys one-time rights. Simultaneous submissions and previously published work OK.
Tips: "Query first, also get hooked up with an Oregon writer. Must tie photos to an Oregon business story."

OUTDOOR AMERICA, Suite 1100, 1701 N. Ft. Myer Dr., Arlington VA 22209. (703)528-1818. Editor: Carol Dana. Published quarterly. Circ. 50,000. Emphasizes natural resource conservation and activities for sportsmen. Readers are members of the Izaak Walton League and all members of Congress. Sample copy $1.50; photo guidelines with SASE.
Photo Needs: Needs outdoor scenics or shots of fishermen or hunters for cover; occasionally buys pictures to accompany articles on conservation and outdoor recreation for inside. Captions (identification) required.
Making Contact & Terms: Query with resume of photo credits. Uses 35mm and 2¼x2¼ slides. SASE. Pays $200/color cover; $35-100/inside photo. Credit line given. Pays on publication. Buys one-time rights. Simultaneous and previously published work OK.

OWNER OPERATOR MAGAZINE, Chilton Co., Radnor PA 19089. (215)964-4264. Editor: Leon Witconis. Bimonthly magazine. Circ. 94,000. Emphasizes trucking business articles; selection, maintenance and safety of trucks, and new products and new developments in the industry. For independent truckers, age 18-60; most own and drive 1-3 trucks. Buys 5-6 photos/year. Buys all rights. Submit model release with photo. Submit story outline and plans for photos. Photos purchased with accompanying ms. Pays on publication. Reports in 6 weeks. SASE.
Subject Needs: Occupational photojournalism pieces; documentary; scenic; how-to (maintenance, re-

pairs); human interest and humorous (self-contained photo/caption or with short story); photo essay/photo feature; product shot (if unique); special effects/experimental (highway shots); and spot news.
B&W: Uses 8x10 semigloss prints. Captions required. Pay negotiable.
Color: Uses 8x10 glossy prints or transparencies. Captions required. Pay negotiable.
Cover: Uses 8x10 glossy prints or 2¼x2¼ transparencies. Prefers long vertical format. Pays $75-175.
Accompanying Mss: "We generally seek photojournalistic articles, such as features on log haulers, livestock haulers, steel haulers, etc. We also lean heavily on articles that help the small businessman, such as taxes, bookkeeping, etc. We would also entertain short news features of on-the-spot news coverage of trucker-sponsored blockades, strikes, human interest and safety."
Tips: "Photos of trucks simply because it's a truck don't sell. There has to be a point to the story or a reason for shooting the photo. Obviously we prefer photos showing trucks with people. Do not call us and ask what you can do. Select a story idea, submit an outline and type of photo coverage you have in mind."

P.O.B. (Point of Beginning), Box 810, Wayne MI 48184. (313)729-8400. Art/Production Director: Carol Boivin. Bimonthly magazine. Emphasizes the surveying and mapping profession. Circ. 65,500. Sample copy for 10x13 SASE and $1.75 postage.
Photo Needs: Uses about 25-30 photos/issue; approximately 10-15 supplied by freelance photographers. Needs "historical and current photos for articles of special interest to our audience." Model release and captions required.
Making Contact & Terms: Send 5x7 glossy b&w or color prints by mail for consideration. Provide resume, business card, brochure, flyer or tearsheets to be kept on file for possible future assignments. SASE. Reports in 1 month. Pays $5-25/b&w inside photo, $10-50/color inside photo and $150-450/text/photo package. Pays on publication. Credit line given. Buys all rights, first serial rights, or makes work-for-hire assignments.
Tips: Looks for sharp, in focus photos that can be dramatically enlarged if chosen for front cover. Front covers are always 4-color . . . Inside: 4-color; 4-color posterization would be interesting: black and white also. "Obtain a sample copy of the magazine and familiarize yourself with the types of photos we *are* using and see what would be of general interest to our readership who are professionals and technicians of the surveying and mapping community."

***PACIFIC BANKER**, 109 W. Mercer, Seattle WA 98119. (206)285-2050. Editor: Michele A. Dill. Monthly magazine. Emphasizes banking. Readers are banking executives in the Western states. Circ. 9,150. Sample copy $2.
Photo Needs: Uses 5 photos/issue; "most supplied by writers." Needs photo illustrations for abstract concepts and on banking issues. Special needs include photos on bank marketing, data processing and electronic banking, bank powers and services. Model release required; captions preferred or required.
Making Contact & Terms: Query with samples. Does not return unsolicited material. Reports back according to needs. Pays up to $100/b&w and color cover photo; $15-50/b&w inside photo. Pays on publication. Credit line "generally" given. Buys first North American serial rights. Previously published work OK "depends on where published."
Tips: Prefers to see clips that are business and banking related and that indicate ability to illustrate abstract concepts. Query with clips.

***PACIFIC COAST JOURNAL**, (formerly *The Quarter Horse of the Pacific Coast*), Box 254822, Gate 12, Cal Expo, Sacramento CA 95825. Editor: Jill L. Scopinich. Monthly magazine. Circ. 8,200. For West Coast quarter horse owners, breeders and trainers interested in performance, racing and showing of quarter horses. Buys all rights, first North American serial rights or one-time rights. Model release required. Send photos for consideration. Pays on publication. Reports in 1 month. SASE. Simultaneous submissions OK. Sample copy $2.
Subject Needs: Animal (racing or show quarter horses); celebrity/personality (quarter horse people on West Coast); how-to (in quarter horse industry, by qualified people only); human interest; humorous; photo essay/photo feature (quarter horse shows, etc. by experts on the West Coast); sport; and spot news.
B&W: Send 8x10 glossy prints. Captions required. Pays $10-50.

PACIFIC PURCHASOR, 819 S. Main St., Burbank CA 91506. (818)841-4712. Editor: Berd Johnson. Photo Editor: Jeanne Vlazny. Association publication for the purchasing managers. Monthly. Emphasizes purchasing and inventory management. Readers include professional buyers for corporations. Circ. 10,000. Sample copy $2.50.
Photo Needs: Uses 2-3 photos/issue; currently none supplied by freelance photographers. Reviews photos with accompanying ms only. Model release required; captions preferred.
Making Contact & Terms: Query with samples and list of stock photo subjects. SASE. Pays on publication. Credit line given. Buys one-time rights. Previously published work OK.

PACIFIC TRAVEL NEWS, 100 Grant Ave., San Francisco CA 94108. (415)781-8240. Managing Editor: James C. Gebbie. Monthly magazine. Circ. 25,000. Emphasizes information for the travel agent about the membership area of the Pacific Area Travel Association—Hawaii to Pakistan. Approximately 4 feature articles per issue on specific destinations, a destination supplement and a section of brief news items about all Pacific areas.
Subject Needs: Photo essay/photo feature, nature, sport, travel and wildlife, only as related to the Pacific. Prefers nature photos with people involved. "We try to avoid shots that look too obviously set up and commercial. We don't use anything outside the Hawaii-to-Pakistan area." Caption information needed.
Specs: Uses 8x10 glossy, matte or semigloss b&w prints and 35mm and 2¼x2¼ color transparencies. Format flexible.
Accompanying Mss: Photos purchased with or without accompanying ms. Seeks destination and news features describing attractions of an area as well as "nuts and bolts" of traveling there. Most ms are on assignment.
Payment & Terms: Pays $35/b&w print, $75 minimum/color transparency and $75-150/cover. Credit line given. Buys one-time rights. Simultaneous submissions (if not to a competing publication) and previously published work OK.
Making Contact: Send material by mail for consideration, query with resume of credits, send portfolio for review or list of Pacific areas covered in work with samples. SASE. Reports in 1 month. Sample copy available.
Tips: Very trade-oriented. Story should be specific, narrow focus on a topic.

THE PACKER, Box 2939, Shawnee Mission KS 66201. (913)451-2200. Editor: Bill O'Neill. Weekly newspaper. Circ. 16,000. Emphasizes news and features relating to all segments of the fresh fruit and vegetable industry. Covers crop information, transportation news, retailing ideas, warehouse information, market information, personality features, shipping information, etc. For shippers, fruit and vegetable growers, wholesalers, brokers and retailers. Photos purchased with or without accompanying ms, or on assignment. Buys 3-5 photos/issue. Pays $5-100/job, $35-150 for text/photo package or on a per-photo basis. Credit line given. Pays on publication. Buys all rights, but may reassign to photographer after publication. Query by phone. Previously published work OK. Reports in 1 week. Free sample copy.
Subject Needs: Celebrity/personality (if subject is participating in a produce industry function); human interest (e.g., a produce grower, shipper, truck broker, retailer—or a member of their family—with an unusual hobby); photo essay/photo feature (highlighting important conventions or special sections of the magazine); new product shot; scenic; and spot news (e.g., labor strikes by farm workers, new harvesting machinery, etc.). No large groups of 4 or more staring into the camera. Captions required. Supplements to *The Packer* using photos include The Grower, which discusses how large growers raise crops, new products, pesticide information, etc.; Produce and Flora Retailing, about merchandising techniques in supermarket produce departments and floral boutiques; Food Service, about the institutional use of produce in serving food; and Produce in Transit, about the transportation of fruits and vegetables.
B&W: Uses 5x7 or 8x10 glossy prints. Pays $5-25/photo.
Color: Uses 35mm, 2¼x2¼, 4x5 or 8x10 transparencies. Pays $35-75/photo.
Cover: Uses b&w glossy prints; or 2¼x2¼, 4x5 or 8x10 color transparencies. Vertical format preferred. Pays $40-80/photo.
Accompanying Mss: Copy dealing with fresh fruit and vegetables, from the planting and growing of the product all the way down the distribution line until it reaches the retail shelf. "We have little interest in roadside stands and small growing operations which sell their products locally. We're more interested in large growing-shipping operations."

PARTS PUPS, 2999 Circle 75 Pkwy., Atlanta GA 30339. Editor-in-Chief: Don Kite. Monthly. Circ. 270,000. Also publishes an annual publication; circulation 395,000. Emphasizes "fun and glamorous women." Readers are automotive repairmen. Free sample copy and photo guidelines.
Photo Needs: Uses about 4 photos/issue; all are supplied by freelance photographers. Needs "glamour-cheesecake-attractive females with a wholesome sex appeal. No harsh shadows, sloppy posing or cluttered backgrounds." Photos purchased with or without accompanying ms. Model release required.
Making Contact & Terms: Send by mail for consideration contact sheets; 35mm, 2¼x2¼ or 4x5 slides. SASE. Reports in 6-8 weeks. Provide tearsheets to be kept on file for possible future assignments. Pays $350/color cover photo; $100/b&w inside photo; $250/inside color nudes. Pays on acceptance. Credit line given. Buys one-time rights. Simultaneous submissions and previously published work OK.
Tips: Prefers to see "good craftsmanship and attention to details."

PEDIATRIC ANNALS, 6900 Grove Rd., Thorofare NJ 08086. (609)848-1000. Managing Editor: Donna Carpenter. Monthly journal. Emphasizes "the pediatrics profession." Readers are practicing pedia-

tricians. Circ. 36,000. Sample copy free with SASE.

Photo Needs: Uses 1-4 photos/issue; all supplied by freelance photographers. Needs photos of "children in a variety of moods and situations, some with adults." Written release required; captions preferred. Query with samples. Provide resume, business card, brochure, flyer or tearsheets to be kept on file for possible future assignments. Reports in 6 weeks. Pays $200/color cover photo; $25/inside photo; $50/color inside photo. Payment is on publication. Credit line given. Buys all rights. Simultaneous and previously published work OK.

PERINATOLOGY NEONATOLOGY, 1640 5th St., Santa Monica CA 90401. (213)395-0234. Editor: Esther Gross. Art Director: Tom Medsger. Bimonthly journal. Emphasizes problems of newborns. Readers include (MD) perinatologists, neonatologists, pediatricians.

Photo Needs: Uses 2-3 photos/issue; all supplied by freelance photographers. Needs photos of the monitoring of newborns, newborns in incubators, with doctors, nurses, etc. Model release and captions required.

Making Contact & Terms: Query with resume of credits, with list of stock photo subjects; provide resume, business card, brochure, flyer or tearsheets to be kept on file for possible future assignments. Uses 35mm transparencies. SASE. Reports in 2 weeks. Pays $400/color cover photo, $150/inside color photo. Pays on acceptance. Credit line given for covers only. Buys all rights; photo is returned to artist, but BPC reserves right to use it again in any of its publication.

PET BUSINESS, 7330 NW 66th St., Miami FL 33166. (305)591-1625. Editor: Robert Behme. Monthly magazine. Circ. 14,500. For pet industry retailers, groomers, breeders, manufacturers, wholesalers and importers. Buys 25 photos/year. Generally works with photographers on assignment basis. Model release required "when it's not a news photo." Submit portfolio or send contact sheet or photos for consideration. Provide resume and tearsheets to be kept on file for possible future assignments. Credit line given. Pays on acceptance. Reports in 3 weeks. SASE. Sample copy $1; free photo guidelines.

Subject Needs: Photos of retail stores; and commercial dog, cat, small animal, reptile and fish operations—breeding, shipping and selling. Pays $15/b&w inside; $35/color inside; $20-100/hour; $250 minimum/job; $150-1,500 for text/photo package.

B&W: Send contact sheet, 5x7 or 8x10 glossy or matte prints or negatives. Captions required; "rough data, at least."

Color: Send contact sheet or transparencies. Captions required.

Pet/Supplies/Marketing Magazine purchased this photo from Joan Balzarini of Walnut Creek, California, for one-time use as text illustration. She was paid $10 for its use. In addition, Bird Talk *paid another $10 for first rights. "For both* Bird Talk *and* Pets/Supplies/ Marketing *I submitted the photo on speculation," Balzarini explains. She recently has sold the photo to* Parrotworld *for cover use. "I was fortunate enough to capture this bird stretching its wings and through my photo hope to portray the beauty of a captive bird," Balzarini adds.*

PETS/SUPPLIES/MARKETING MAGAZINE, 1 E. 1st St., Duluth MN 55802. (218)723-9303. Editor: David D. Kowalski. Monthly magazine. Circ. 14,600. For pet retailers, owners and managers of pet store chains (3 or more stores), managers of pet departments, wholesalers (hardgoods and livestock), and manufacturers of pet goods. Needs pet and pet product merchandising idea photos; good fish photos—tropical fish, saltwater fish, invertebrates; bird photos—parakeets (budgies), cockatoos, cockatiels, parrots; cat photos (preferably purebred); dog photos (preferably purebred); and small animal photos—hamsters, gerbils, guinea pigs, snakes. Buys all rights. Send photos for consideration. Pays on publication only. Reports in 6-8 weeks. Sample copy $5. Photo guidelines free with SASE.
B&W: Send 5x7 glossy prints. Captions required. Pays $10 minimum.
Color: Send transparencies. Vertical format. Captions required. Pays $25 minimum.
Cover: Send 35mm color transparencies. Captions required. Pays $100 minimum.

PGA MAGAZINE, 100 Avenue of Champions, Palm Beach Gardens FL 33410. (305)626-3600. Editor/Advertising Director: W.A. Burbaum. Monthly. Circ. 38,000. Emphasizes golf for 14,000 club professionals and apprentices nationwide plus 13,000 amateur golfers. Free sample copy.
Photo Needs: Uses 20 photos/issue; 5 are supplied by freelance photographers. "Prefer local photographers who know our magazine needs." Interested in photos of world's greatest golf courses, major tournament action, golf course scenic, junior golfers. Model release and captions required.
Making Contact & Terms: Send material by mail for consideration, arrange personal interview to show portfolio and submit portfolio for review. Uses mostly color slides, very few color prints. SASE. Reports in 3 weeks. Pays $200-300/cover, $50-75/color photo inside. Credit line given. Payment on acceptance. Buys all time rights. Previously published work OK.
Tips: "Know golf and golf course architecture."

***PHOTOMETHODS**, 1 Park Ave., New York NY 10016. (212)685-8520. Editor-in-Chief: Leif Ericksenn. Senior Editor: Jack Nevbart. Monthly magazine. Circ. 53,000. Emphasizes photoinstrumentation, photography, photographic equipment, graphic arts and AV materials. For professional and inplant image-makers (still, film, video, photoinstrumentation, graphic arts); functional photographers; and those who use images in their work: research engineers, scientists, evidence photographers, technicians. Needs photos relating to applications of still photography, film, video and graphic reproduction. Especially needs for next year photos illustrating new techniques and applications in problem solving. Wants no calendar photos or photographs of children, pets, etc. Buys 12 covers annually. Buys one-time rights. Submit model release with photo. Query with resume of credits, samples or send photos for consideration. Credit line given. Pays on publication. Reports in 3 weeks. SASE. Free sample copy.
B&W: Uses 8x10 matte dried DWG prints; send contact sheet. Captions required.
Color: Send 8x10 prints or any size transparencies. Captions required.
Cover: Send 8x10 color prints or color transparencies. Photos "must either tie in with the theme of the inside feature, or be a photo that was made in the course of solving a problem, communicating, illustrating."
Tips: Publishes a special Progress Report issue in June outlining progress in the fields of still photography, film, video, processing and lighting. December is directory issue. Photo guidelines with SASE.

THE PHYSICIAN AND SPORTSMEDICINE, 4530 W. 77th St., Minneapolis MN 55435. (612)835-3222. Photo Editor: Marty Duda. Monthly journal. Emphasizes sports medicine. Readers are 85% physicians; 15% athletic trainers, coaches, athletes and general public. Circ. 120,000. Sample copy and photo guidelines available.
Photo Needs: Uses about 25 photos/issue; 20 supplied by freelance photographers. Needs "primarily generic sports shots—color slides preferred." Model release preferred.
Making Contact & Terms: Query with list of stock photo subjects; provide resume, business card, brochure, flyer or tearsheets to be kept on file for possible future assignments. Does not return unsolicited material. Reports in 1 month. Pays $250/color cover; $75/b&w half page, $100/color half page; $100/b&w page, $150/color page; $45 minimum or negotiates hourly rate; negotiates rate by the job. Pays on publication. Credit line given. Buys one-time rights unless otherwise specified. Simultaneous and previously published submissions OK.
Tips: "Be patient, submit shots that are specific to the subject defined, and submit technically sound (clear, sharp) photos. We generally use the clear, technically sound photos; we use very little artsy, creative images. Don't get discouraged. There is a lot of competition out there."

PIPELINE & GAS JOURNAL, Box 1589, Dallas TX 75221. (214)691-3911. Editor-in-Chief/Photo Editor: A. Dean Hale. Monthly. Circ. 28,500. Emphasizes oil and gas pipeline construction and energy transportation (oil, gas and coal slurry) by pipeline. For persons in the energy pipeline industry. Free sample copy.

Photo Needs: Uses about 40 photos/issue; up to 5 supplied by freelance photographers. Selection based on "knowledge of our industry. Should study sample issues. Location is important—should be close to pipeline construction projects. We would like to see samples of work and want a query with respect to potential assignments. We seldom purchase on speculation." Provide resume, calling card, letter of inquiry and samples to be kept on file for possible future assignments. Uses 35mm or larger b&w or color transparencies; 5x7 or larger prints. No 110 pictures. Send photos with ms. Articles purchased as text/photo package; "generally, construction progress series on a specific pipeline project." Model release required "if subject at all identifiable." Captions required.
Making Contact & Terms: Query with resume of photo credits. "Call or write." SASE. Reports in 2-3 weeks. Pays $50 minimum text/photo package. Credit line given if requested. Buys on a work-for-hire basis. No simultaneous submissions; no previously published work if "used in our field in a competitive publication."

PLANT MANAGEMENT & ENGINEERING, Maclean Hunter Building, 777 Bay St., Toronto, Ontario, Canada M5W 1A7. (416)596-5801. Editor: Ron Richardson. Monthly. Emphasizes manufacturing. Readers are plant managers and engineers. Circ. 25,000. Sample copy free with SASE and 67¢ Canadian postage.
Photo Needs: Uses about 6-8 photos/issue; 1-2 supplied by freelance photographers. Needs photos "to illustrate technical subjects featured in a particular issue—many 'concept' or 'theme' shots used on covers." Model release preferred; captions required.
Making Contact & Terms: Query with samples; provide resume, business card, brochure, flyer or tearsheets to be kept on file for possible future assignments. SASE. Reports in 1 month. Pays $150-300/color cover photo; $35-50/b&w and $50-200/color inside photo; $100-300/job; $120-600 for text/photo package. Pays on acceptance. Credit line given. Buys first North American serial rights.
Tips: Prefers to see "industrial experience, variety (i.e., photos in plants) in samples. Read the magazine. Remember we're Canadian."

***PLASTICS TECHNOLOGY**, 633 Third Ave., New York NY 10017. (212)986-4800. Editor: Matthew Naitove. Art Director: Anita Tai. Monthly magazine. Emphasizes plastics product manufacturing. Readers are engineers and managers in manufacturing plants using plastics. Circ. 41,000.
Photo Needs: Uses about 30-35 photos/issue; 1 supplied by freelance photographer. Needs manufacturing plant shots (mostly interiors) and machine close-ups, product still-lifes. Model release required; captions preferred.
Making Contact & Terms: Arrange a personal interview to show portfolio. SASE. Reports in 1 week. Pays $400-600/color cover photo; $100-200/b&w and color inside photo; $150-350/job. Pays on publication. Credit line given "mainly on covers." Buys one-time rights. Simultaneous and previously published work "if in non-competition medium" OK.

POLICE PRODUCT NEWS, 6200 Yarrow Dr., Carlsbad CA 92008. (714)438-3286. Editor: F. Keene Thompson. Monthly. Circ. 50,000. Emphasizes law enforcement. Readers are "line" or "beat" officers. Sample copy and contributor guidelines $5.
Photo Needs: Uses about 10-20 photos/issue; most are supplied by freelance photographers. "PPN has an ongoing need for both color and b&w photographs of law enforcement officers in action. We also run 1 photo each month depicting officers in unusual or humorous situations." Model release and captions required. "We like shots primarily in color, that can send a message: action, danger, humor, fatigue, etc."
Making Contact & Terms: Send by mail for consideration b&w prints, color transparencies or prints. SASE. Reports in 3-4 weeks. Pays on acceptance $10-25/b&w photo; $25-50/color transparency; $100-250/cover. Credit line given. Buys all rights. Simultaneous and previously published submissions OK.
Tips: "Break-in with a humorous or unusual photo for our '10-9' section."

POLICE TIMES/CHIEF OF POLICE, 1100 NE 125th St., North Miami FL 33161. (305)891-1700. Editor: Gerald S. Arenberg. Monthly magazines. Circ. 50,000 + . For law enforcement officers at all levels. Needs photos of police officers in action, CB volunteers working with the police and group shots of police department personnel. Wants no photos that promote products or other associations. Buys 30-60 photos/year. Buys all rights, but may reassign to photographer after publication. Send photos for consideration. Pays on acceptance. Reports in 3 weeks. SASE. Simultaneous submissions and previously published work OK. Sample copy $1; free photo guidelines. Model release and captions preferred. Credit line given if requested; editor's option.
B&W: Send 8x10 glossy prints. Pays $5-10 upwards.
Cover: Send 8x10 glossy color prints. Pays $25-50 upwards.
Tips: "We are open to new and unknowns in small communities where police are not given publicity."

***POLLED HEREFORD WORLD**, 4700 E. 63rd St., Kansas City MO 64130. (816)333-7731. Editor: Ed Bible. Monthly magazine. Circ. 13,500. Emphasizes Polled Hereford cattle for registered breeders, commercial cattle breeders and agribusinessmen in related fields.
Specs: Uses b&w prints and color transparencies and prints.
Payment & Terms: Pays $5/b&w print, $100/color transparency. Pays on publication.
Making Contact: Query. Reports in 2 weeks.

***PRIMARY CARE & CANCER**, 331 Willis Ave., Box 86, Williston Park NY 11595. (516)294-1880. Editor: James F. McCarthy. Monthly journal. Emphasizes cancer-diagnosis and treatment. Readers are physicians. Circ. 112,000.
Photo Needs: Uses 3 photos/issue; 1 supplied by freelance photographers. Needs gross pathology photos, photomicrographics, pictures of patients. Model release and captions required.
Making Contact & Terms: Query with samples. SASE. Reports in 1 month. Pays $400/color cover photo; $100-200/color inside photo. Pays on acceptance. Credit line given. Buys one-time rights and all rights. "No other use by medical journal for one year." Previously published work OK.

PRO SOUND NEWS, 2 Park Ave., New York NY 10016. (212)213-3444. Editor: Randolph P. Savicky. Senior Editor: Jeff Schwartz. Monthly tabloid. Emphasizes professional recording and sound and production industries. Readers are recording engineers, studio owners, and equipment manufacturers worldwide. Circ. 14,000. Sample copy free with SASE.
Photo Needs: Uses about 12 photos/issue; all supplied by freelance photographers. Needs photos of recording sessions, sound reinforcement for concert tours, permanent installations. Model release and captions required.
Making Contact & Terms: Query with samples; send 8x10 b&w glossy prints by mail for consideration. SASE. Reports in 2 weeks. Pays by the job or for text/photo package. Pays on publication. Credit line given. Buys one-time rights. Simultaneous and previously published submissions OK.

PROFESSIONAL AGENT, 400 N. Washington St., Alexandria VA 22314. (703)836-9340. Editor/Publisher: Janice J. Artandi. Monthly. Circ. 40,000. Emphasizes property/casualty insurance. Readers are independent insurance agents. Sample copy free with SASE.
Photo Needs: Uses about 20 photos/issue; 5 supplied by freelancers. Model release required; captions preferred.
Making Contact & Terms: Arrange a personal interview to show portfolio; query with list of stock photo subjects; provide resume, business card, brochure, flyer or tearsheets to be kept on file for possible future assignments. Prefers local photographers. Uses minimum 5x7 glossy b&w prints and 35mm and 2¼x2¼ transparencies. SASE. Reporting time varies. Pays $300/color cover photo. Pays on publication. Credit line given. Buys one-time rights or first North American serial rights, exclusive in the insurance industry.

***PROFESSIONAL BUILDER**, 1350 E. Touhy Ave., Des Plaines IL 60017-5080. (312)635-8800. Editor: Roy Diez. Art Director: William Patton. Monthly magazine. Emphasizes housing and light construction. Readers are builders of housing and light construction. Circ. 140,000.
Photo Needs: Uses 100 photos/issue; 10% supplied by freelance photographers. Needs photos of architectural interiors and exteriors of current, innovative projects throughout USA; 4x5 format preferred. "We make assignments based on specific editorial needs only. We do not accept unsolicited photography! We are always looking for good photographers throughout the USA." Model release required.
Making Contact & Terms: Provide resume, business card, brochure, flyer or tearsheets to be kept on file for possible future assignments. Does not return unsolicited material. Reports in 1 month. Pays on publication. Credit line given. Buys all rights.

PROFESSIONAL COMPUTING, Box 250, Hiland Mill, Camdon ME 04843. (207)236-4365. Editor: J.D. Hildebrand. Bimonthly magazine. Circ. 45,000. Estab. 1984. Emphasizes personal computers and Hewlett-Packard personal computers.
Photo Needs: Uses 10-20 photos/issue; all supplied by freelance photographers. Model release preferred. Needs "product shots and inventive photos of computers."
Making Contact & Terms: Provide resume, business card, brochure, flyer or tearsheets to be kept on file for possible future assignments. SASE. Reports in 1 month. Pays on acceptance. Payment guidelines on request. Credit line given. Buys one-time rights. Also publishes *PC Companion*, *VAR*, *Portable 100*, and *Epson World*. Send queries to above address.

THE PROFESSIONAL PHOTOGRAPHER, 1090 Executive Way, Des Plains IL 60018. (312)299-8161. Editor: Alfred DeBat. Art Director: Debbie Todd. Monthly. Emphasizes professional photography in the fields of portrait, commercial/advertising, and industrial. Readers include professional pho-

tographers and photographic services and educators. Approximately half the circulation is Professional Photographers of America members. Circ. 30,000 + . Sample copy $3.25; photo guidelines with SASE.
Photo Needs: Uses 25-30 photos/issue; all supplied by freelance photographers. "We only accept material as illustration that relate directly to photographic articles showing professional studio, location, commercial and portrait techniques. A majority are supplied by Professional Photographers of America members." Reviews photos with accompanying ms only. "We always need commercial/advertising and industrial success stories. How to sell your photography to major accounts, unusual professional photo assignments." Model release preferred; captions required.
Making Contact & Terms: Query with resume of credits. "We want a story query, or complete ms if writer feels subject fits our magazine. Photos will be part of ms package." Uses 8x10 glossy unmounted b&w/color prints, 35mm, 2¼x2¼, 4x5 and 8x10 transparencies. SASE. Reports in 8 weeks. PPA members submit material unpaid to promote their photo businesses and obtain recognition. Credit line given. Previously published work OK.

PROFESSIONAL SURVEYOR, Suite 410, 918 F Street NW, Washington DC 20004. (202)628-9696 (editorial office). Editor: W. Nick Harrison. Bimonthly. Circ. 55,000. Emphasizes surveying and related engineering professions. Readers are "all licensed surveyors in US and Canada, government engineers." Sample copy free with SASE.
Photo Needs: Uses about 5 photos/issue; "none at present" supplied by freelance photographers. Needs photos of "outdoors, surveying activities, some historical instruments." Photos purchased with accompanying ms only. Model release and captions required.
Making Contact & Terms: Provide resume, business card, brochure, flyer or tearsheets to be kept on file for possible future assignments. SASE. Reports in 1 month. "No fixed payment schedule." Pays on publication. Credit line given. Previously published work OK.
Tips: "Read magazine. Combine pictures with text, set up as photo story. Contact us. Work with us. We might be able to cover costs if something is good. We would like to use freelancers, but at present and for foreseeable future, we would only be able to 'reward' photographers with an appearance in the magazine."

PROGRESSIVE ARCHITECTURE, 600 Summer St., Box 1361, Stamford CT 06904. (203)348-7531. Editor: John Morris Dixon. Monthly magazine. Circ. 74,000. Emphasizes current information on building design and technology for professional architects. Photos purchased with or without accompanying ms, and on assignment. Pays $350/1-day assignment, $700/2-day assignment; $175/half-day assignment or on a per-photo basis. Credit line given. Pays on publication. Buys one-time rights. Send material by mail for consideration. SASE. Reports in 1 month. Sample copy $7; free photo guidelines.
Subject Needs: Architectural and interior design. Captions preferred.
B&W: Uses 8x10 glossy prints. Pays $25 minimum/photo.
Color: Uses 4x5 transparencies. Pays $50/photo.
Cover: Uses 4x5 transparencies. Vertical format preferred. Pays $50/photo.
Accompanying Mss: Interesting architectural or engineering developments/projects. Payment varies.

PSYCHIATRIC ANNALS, 6900 Grove Rd., Thorofare NJ 08086. (609)848-1000. Managing Editor: John C. Carter. Monthly journal. Emphasizes psychiatry. Readers are practicing psychiatrists. Circ. 30,000. Sample copy free with SASE.
Photo Needs: Uses 2-3 photos/issue; all supplied by freelance photographers. Needs photos of "adults and children in a variety of situations." Written release required; captions preferred.
Making Contact & Terms: Query with samples; provide resume, business card, brochure, flyer or tearsheets to be kept on file for possible future assignments. SASE. Reports in 3 weeks. Pays $250/color cover photo; $25/b&w inside photo; $50/color inside photo. Pays on publication. Credit line given. Buys all rights. Simultaneous submissions and previously published work OK.

THE RANGEFINDER, 1312 Lincoln Blvd., Box 1703, Santa Monica CA 90406. (213)451-8506. Editor-in-Chief: Arthur Stern. Monthly. Circ. 55,000. Emphasizes topics, developments and products of interest to professional photographers, including freelance and studio photographers. Sample copy $2.50; free photo guidelines with SASE.
Photo Needs: B&w and color photos are "contributed" by freelance photographers. The only purchased photos are with accompanying mss. "We use photos to accompany stories which are of interest to professional photographers. Photos are chosen for quality and degree of interest." Model release required; captions preferred.
Making Contact & Terms: Send material by mail for consideration or submit portfolio by mail for review. Uses 5x7 and 8x10 b&w and color prints; 35mm, 2¼x2¼, 4x5 and 8x10 color transparencies. SASE. Reports in 4 weeks. Credit line given.

Tips: "The best chance is when photos accompany a ms. There is seldom room in the magazine for pictorials alone."

REFEREE MAGAZINE, Box 161, Franksville WI 53126. (414)632-8855. Executive Editor: Barry Mano. Editor: Tom Hammill. Monthly magazine. Circ. 42,000. Emphasizes amateur level games for referees and umpires at the high school and college levels; also some pro. Readers are well educated, mostly 26- to 50-year-old males. Needs photos related to sports officiating/umpiring. No posed shots, shots without an official in them or general sports shots; but would consider "any studio set-up shots which might be related or of special interest to us." Buys 250 photos/year. Buys one-time and all rights (varies). Query with a resume of credits or send contact sheet or photos for consideration. Photos purchased with accompanying ms. Credit line given. Pays $75-175/job; $175-350 for text/photo package. Pays on acceptance and publication. Reports within 2 weeks. SASE for photo guidelines. Sample copy free on request.
B&W: Send contact sheet, 5x7 or 8x10 glossy prints. Captions preferred. Pays $15-25/photo.
Color: Send contact sheet, 5x7 glossy prints or 35mm transparencies. Captions preferred. Pays $25-35/photo.
Cover: Send color transparencies or 8½x12 glossy prints. Allow space at top for insertion of logo. Captions preferred. Pays $75-100/cover. Pays $175/day; $350/package.
Tips: Prefers photos which bring out the uniqueness of being a sports official. Need photos primarily of officials at the high school level in baseball, football, basketball, and softball in action. Other sports acceptable, but used less frequently. "When at sporting events, take a few shots with the officials in mind, even though you may be on assignment for another reason." Address all queries to Tom Hammill, Editor. "Don't be afraid to give it a try. We're receptive, always looking for new freelance contributors. We are constantly looking for offbeat pix of officials/umpires. Our needs in this area have increased."

***REFRIGERATION SERVICE AND CONTRACTING**, Box 2600, Troy MI 48007. (313)362-3700. Editor: Gordon Duffy. Publication of Refrigeration Service Engineers Society. Trade. Monthly magazine. Emphasizes heating, air conditioning and refrigeration service, manufacturing, etc. Readers are industry servicemen, manufacturers, contractors, wholesalers. Sample copy free with SASE.
Photo Needs: Uses 20 photos/issue; none currently supplied by freelancers. Needs photos of service and installation shots; some product shots.
Making Contact & Terms: Send unsolicited photos by mail for consideration. Send b&w prints, b&w contact sheet by mail for consideration. SASE. Reports in 3 months. Pay negotiated. Pays on acceptance. Credit line given. Buys one-time rights.

RESIDENT & STAFF PHYSICIAN, 80 Shore Rd., Port Washington NY 11050. (516)883-6350. Editor: Alfred Jay Bollet, M.D. Executive/Photo Editor: Anne Mattarella. Monthly. Circ. 100,000. Emphasizes clinical medicine. Readers are interns, residents, and the full-time hospital staff responsible for their training. Sample copy $8.
Photo Needs: Uses about 1 photo/issue; 2-4 per year supplied by freelance photographers. Needs "medical and mood shots; doctor-patient interaction." Model release required.
Making Contact & Terms: Query with samples or list of stock photo subjects or send 5x7 b&w glossy prints; 35mm, 2¼x2¼, 4x5, 8x10 transparencies or contact sheet by mail for consideration; provide resume, business card, brochure, flyer or tearsheets to be kept on file for possible future assignments. SASE. Reports in 3 weeks. Pays $300/color cover photo; b&w and color inside photo payment varies. Pays on acceptance. Credit line given. Buys all rights.

RESORT & HOTEL MANAGEMENT MAGAZINE, Box A, Del Mar CA 92014. (619)755-7431—editorial and administration; (619)436-8749—advertising. Art Director: Peggy Fletcher. Published semiquarterly. Emphasizes resort & hotel marketing and management. Readers are "executives of the finest resorts and hotels, convention center resorts and condomimium/timeshare resort communities in the US and abroad." Circ. 25,000. Sample copy with SASE and $5 postage.
Photo Needs: Uses about 10-20 photos/issue; "none at this time" supplied by freelance photographers. Model release required; captions preferred.
Making Contact & Terms: Query with samples or list of stock photo subjects; send 8x10 b&w or color prints; 35mm, 2¼x2¼, 4x5 or 8x10 transparencies; and b&w and color negatives by mail for consideration. SASE. Pays $350/color cover photo; $75/color inside photo; $75/100 color page; $50-200/job; $50/200 for text/photo package. Pays on publication. Credit line given. Buys all rights. Simultaneous and previously published submissions OK.
Tips: "Photos must be dramatic, unusual and should be resort or hotel specific."

RESOURCE RECYCLING, Box 10540, Portland OR 97210. (503)227-1319. Editor: Judy Roumpf. Published 7 times a year. Emphasizes "the recycling of waste materials (paper, metals, glass, etc.)"

Readers are "recycling company managers, local government officials, waste haulers, environmental group executives." Circ. 3,000. Sample copy free with $1.50 postage plus 9x12 SASE.
Photo Needs: Uses about 15-20 photos/issue; 6-8 supplied by freelance photographers. Needs "photos of recycling facilities, curbside recycling collections, secondary materials (bundles of newspapers, soft drink containers), etc." Model release and captions preferred.
Making Contact & Terms: Send glossy b&w prints and b&w contact sheet. SASE. Reports in 1 month. Payment "varies by experience and photo quality." Pays on publication. Credit line given. Buys first North American serial rights. Simultaneous submissions OK.
Tips: "Because *Resource Recycling* is a trade journal for the recycling industry, we are looking only for photos that relate to recycling issues."

RESTAURANT AND HOTEL DESIGN, 633 3rd Ave., New York NY 10017. (212)986-4800 ext. 355 or 338. Editor-in-Chief: Mary Jean Madigan. Publishes 10 issues/year. Circ. 40,000. Readers are architects, designers, restaurant and hotel executives.
Photo Needs: "We need high quality previously unpublished architectural photographs of restaurant/hotel/lounge and disco interiors and exteriors. No people, no food set-ups, please."
Making Contact & Terms: Send material by mail for consideration. Prefers to see a variety of interior and exterior shots (location work preferred over studio shots) in a portfolio. Uses 8x10 b&w prints and 4x5 color slides. SASE. Reports in 1 month. Pays per photo. Credit line given. Buys one-time rights.
Tips: "Virtually all our photographs are supplied by design firms, architects, or photographers on spec. We make very, very few assignments."

RETAILER & MARKETING NEWS, Box 191105, Dallas TX 75219. (214)871-2930. Editor-in-Chief: Michael J. Anderson. Monthly. Circ. 10,000. Readers are retail dealers and wholesalers in appliances, TV's, furniture, consumer electronics, records, air conditioning, housewares, hardware and all related businesses. Free sample copy.
Photo Needs: Uses 30-40 photos/issue; 5 supplied by freelance photographers. Needs photos of products in store displays and people in retail marketing situations. Captions required.
Making Contact & Terms: Send material by mail for consideration. Uses 5x7 and 8x10 b&w and color prints. SASE. Pay is negotiable. Credit line given. Payment on publication. Buys one-time rights. Simultaneous and previously published work OK.

RN MAGAZINE, 680 Kinderkamack Rd., Oradell NJ 07649. (201)262-3030. Editor-in-Chief: James A. Reynolds. Art Director: Andrea diBenedetto. Monthly. Circ. 275,000. Readers are registered nurses. Sample copy $3.
Photo Needs: Uses approximately 8-12 photos/issue. Photographers are used on assignment basis. "We select the photographers by previous work." Needs photos on clinical how-to and some symbolic theme photos. Model release and captions required.
Making Contact & Terms: Query with resume of photo credits and submit portfolio by mail for review. SASE. Reports in 2 weeks. Pay is negotiable. Credit line given. Payment on acceptance. Buys one-time reproduction rights; additional rights are renegotiated. Previously published work OK with qualifications.

ROBOTICS TODAY, 1 SME Dr., Dearborn MI 48121. (313)271-1500. Managing Editor: Bob Stauffer. Bimonthly magazine. Emphasizes automated manufacturing and robotics. Readers are members of Robotics International and paid subscriptions. Circ. 18,000. Sample copy free with SASE and $2 postage.
Photo Needs: Uses 40-70 photos/issue; number supplied by freelance photographers "depends on need." Needs photos of "automated manufacturing, robots." Special needs include "specific cover shots, working on ideas with editor and art director."
Making Contact & Terms: Send 5x7 b&w or color prints or 4x5 transparencies by mail for consideration. Provide resume, business card, brochure, flyer or tearsheets to be kept on file for possible future assignments. SASE. Reports in 2 weeks. Pays $175-300/color cover photo; $25/b&w inside photo; $50/color inside photo. Pays $200 maximum/job. Payment is made monthly. Buys one-time or all rights. Simultaneous submissions and previously published work OK.

ROOFER MAGAZINE, 10990 Metro Pkwy., Ft. Myers FL 33912. (813)275-7663. Editor: Mr. Shawn Holiday. Art Director: Kimberly Maness. Publishes 12 times/year. Circ. 17,000. Emphasizes the roofing industry and all facets of the roofing business. Readers are roofing contractors, manufacturers, architects, specifiers, consultants and distributors. "Current BPA Audit qualified subscribers total over 16,000 (100% of our subscription list)." Sample copy $2.50.
Photo Needs: Uses about 25 photos/issue; few are supplied by freelance photographers. Needs photos of unusual roofs for "Roof of . . ." section and photo essays of "the roofs of . . . " (various cities or re-

sort areas). Model release required; captions preferred.
Making Contact & Terms: Query with samples. Provide resume, brochure and tearsheets to be kept on file for possible future assignments. Does not return unsolicited material. Reports in 1 month. Pay negotiable. Pays on publication. Buys all rights.

***RV BUSINESS**, 29901 Agoura Rd., Agoura CA 91301. (818)991-4980. Editor: Michael Schneider. Monthly magazine. Emphasizes recreational vehicle industry. Readers are manufacturers, dealers and others related to the RV industry. Sample copy free with SASE.
Photo Needs: Uses 12 photos/issue; "about 99% are supplied by freelance writers of articles." Needs photos, all relative to article—some scenic, some how-to. Reviews photos with accompanying ms only. Model release and captions preferred.
Making Contact & Terms: Query with resume of credits and samples; provide resume, business card, brochure, flyer or tearsheets to be kept on file for possible future assignments. Does not return unsolicited material. Reports in 2 weeks. Pay varies. Pays on acceptance. Credit line given. Buys first North American serial rights.

***SALON TALK**, (formerly *International Designs*), 261 Madison Ave., New York NY 10016. Editor: Victoria Wurdinger. Bimonthly magazine for clients to read while in the salon, as well as for the professional stylist. "We profile creative hairstyles in the US and Europe, and show their work; also unusual phases of hairstyling (such as theater, opera, movies or TV). Anything relating to beautiful or dramatic hair is of interest to us. We are an American-based, European type styles publication with a high fashion, sophisticated audience."
Needs: In-depth personality profiles (interviews) with photos to back up story; and photos, captions and stories. "Photo packages (3-8) different high fashion hair styles for either men or women. Buys 20-30 photos annually. Buys all rights. Submit model release with photo. Submit portfolio, arrange a personal interview to show portfolio, or send contact sheet or photos for consideration. Photos purchased with accompanying ms. Pays on publication. Reports in 1 month. SASE.
B&W: Send contact sheet or 5x7 or 8x10 glossy prints. Captions required. Pay is included in total purchase price with ms.
Cover: Send 35mm or 4x5 color transparencies. Uses "fashion shots of well-groomed men or women; can be shot indoors or outdoors; can be head shot or full body. Hair must be professionally styled." Captions required. Covers published for credit only.
Tips: Prefers to buy text/photo package. No snapshots.

SANITARY MAINTENANCE, 2100 W. Florist, Box 694, Milwaukee WI 53201. (414)228-7701. Managing Editor: Don Mulligan. Monthly magazine. Circ. 13,000+. Emphasizes everyday encounters of the sanitary supply distributor or contract cleaner.
Subject Needs: Photo essay/photo feature (sanitary supply operations, candid). Captions required.
Specs: Uses glossy b&w prints and color slides preferred.
Accompanying Mss: Photos purchased with accompanying ms only. Query first. Seeks actual on the job type studies. Free writer's guidelines.
Payment & Terms: Pays $50-150 for text/photo package. Pays on publication. Buys all rights. Previously published work OK.
Making Contact: Query with samples. SASE. Reports in 1 month. Free sample copy and photo guidelines.

***SATELLITE ORBIT**, 9440 Fairview Ave., Box 53, Boise ID 83707. (208)322-2800. Editor: Rick Ardinger. Photo Editor: Brian Larkowski. Monthly magazine. Emphasizes satellite television industry. Readers are owners and dealers of home satellite television equipment. Circ. 300,000. Sample copy for shipping and handling.
Photo Needs: Uses 20-40 photos/issue; 60-70% supplied by freelance photographers. Needs assignment photos of people and places related to satellite television and assignment and stock images related to TV programming and satellite television.
Making Contact & Terms: Query with samples or list of stock photo subjects. SASE. Reports in 3 weeks. Pays $300-500/b&w cover photo; $400-1,000/color cover photo; $75-300/b&w inside photo; $100-750/color inside photo; negotiates page rate. Pays on acceptance. Credit line given. Buys first North American serial rights.
Tips: Prefers to see "examples of the photographer's best work—illustrating style and strong points. Follow-up great samples with personal contact (phone, etc.)."

THE SCIENCE TEACHER, National Science Teachers Association, 1742 Connecticut Ave. NW, Washington DC 20009. Managing Editor: Bry Pollack. Magazine published monthly from September through May. Circ. 22,000. For junior and senior high school level science teachers and administrators.

Uses photos each issue. Buys all rights, but flexible. Submit model release with photo. Send contact sheet or photos for consideration. Pays on publication. Reports in 3 months. SASE.

Subject Needs: Needs photos dealing with junior and senior high school students in science classrooms and laboratories, adolescents in school areas, computers in science classes, teachers interacting with other teachers.

B&W: Send contact sheet or 5x7 or larger glossy prints." Captions required. Pays $35 usually.

Color: Send transparencies. Captions required. Pays $100 for cover.

Cover: Prefers color slides or 3x5 transparencies. "We try to tie cover photos to an inside article, but we feature photos of high school kids, some face shots, occasional close ups of nature, especially animals. Captions required. Pays $100 minimum.

Tips: "Submit samples in portfolio. We are very interested in increasing the quality and number of photos used per issue."

SEAWAY REVIEW, 221 Water St., Boyne City MI 49712. Contact: Publisher. Quarterly magazine. Circ. 15,600. Maritime journal for "the Great Lakes/St. Lawrence maritime community, executives of companies that ship via the Great Lakes/Seaway, traffic managers, transportation executives, federal and state government officials and manufacturers of maritime equipment." Photos purchased with or without accompanying ms and on assignment. Buys 500 photos/year. Pays approximately $100 for text/photo package, less on a per-photo basis. Credit line given for covers only. Pays on acceptance. Send material by mail for consideration. Provide samples to be kept on file for possible future assignments. SASE. Previously published work OK. Reports in 3 weeks. Sample copy $5.

Subject Needs: Photos of Great Lakes shipping and ship views. "We also buy photos for files and for later usage." Special assignments around Great Lakes area. "No photos without ships, ports and cargos."

B&W: Uses 5x7 and 8x10 glossy prints; contact sheet OK. Pays $10-50/photo.

Color: Uses 8x10 glossy prints, and 35mm and 2¼x2¼ transparencies; contact sheet OK. Pays $10-50/photo.

Cover: Uses glossy color prints, 35mm and 2¼x2¼ transparencies. Vertical format only. Pays $100/photo.

Accompanying Ms: Seeks ms dealing with commercial transportation.

***SECURITY DEALER (SD)/SECURITY SYSTEMS ADMINISTRATION (SSA)**, 101 Crossways Park W., Woodbury NY 11797. (516)496-8000. Editor: Thomas Kapinos. Monthly magazines. Emphasizes security subjects. Readers are blue collar technician (*Security Dealer*), white collar manager (SSA). Circ. 220,000/44,000. Sample copy free with SASE.

Photo Needs: Uses 2-5 photos/issue; none supplied by freelance photographers. Needs photos of security-application-equipment. Model release preferred.

Making Contact & Terms: Send b&w and color prints by mail for consideration. SASE. Reports "immediately." Pays $100/color cover photo; $50/inside color photo. Pays 2 weeks after publication. Credit line given. Buys one-time rights in trade industry. Simultaneous submissions and previously published work OK.

SHUTTLE SPINDLE & DYEPOT, 65 LaSalle Rd., West Hartford CT 06107. (203)233-5124. Editor: Deborah Robson. Quarterly. Circ. 16,800. Emphasizes weaving and fiber arts. Readers are predominately weavers and craftspeople. Sample copy $4.75; photo guidelines free with SASE.

Photo Needs: Uses about 30-35 color photos and 40-45 b&w photos/issue. Needs photos of weaving, textiles and fabrics. "Writers often use professional photographers to document their works." Model release and captions required.

Making Contact & Terms: Query with samples. SASE. Reports in 6 weeks. Payment varies. Pays on publication. Credit line given. Buys first North American serial rights.

Tips: "We're looking for freelance photographers."

SINSEMILLA TIPS, 217 2nd St. SW, Box 2046, Corvalis OR 97339. (503)757-8477. Editor: Thomas Alexander. Quarterly. Circ. 10,000. Emphasizes "cultivation of marijuana in the United States." Readers are marijuana growers. Sample copy $5.

Photo Needs: Uses about 8-14 photos/issue; half supplied by freelance photographers. Needs "how-to, use of technological aids in cultivation, finished product (dried buds)." Model release required.

Making Contact & Terms: Query with samples. Send b&w or color prints; 4x5 transparencies, b&w or color contact sheets or b&w or color negatives. SASE. Reports in 3 weeks to 1 month or will keep material on file on request. Pays $50-75/color cover photo; $15-35/b&w inside photo, $20-50/color inside photo; $50-150 for text/photo package. Pays on publication. Credit line given if requested. Buys all rights. Simultaneous submissions and previously published work OK.

Tips: Prefers to see "any marijuana-related photo."

***SKIES AMERICA**, Suite 310, 9600 SW Oak, Portland OR 97223. (503)244-2299. Editor: Robert Patterson. Photo Editor: Orietta Patterson. Monthly, bimonthly magazine. "We publish 13 inflight magazines for regional airlines on topics ranging from business to leisure and travel." Readers are affluent; frequent fliers; business owners/executives. Circ. 160,000. Sample copy $3.
Photo Needs: Uses 20 photos/issue; 5 supplied by freelance photographers. Needs photos of cityscapes, travel. Captions preferred.
Making Contact & Terms: Query with resume of credits, and list of stock photo subjects. SASE. Reports in 1 month. Pays $300/text/photo package; separate photo payments negotiable. Pays on publication. Credit line given. Buys one-time rights. Simultaneous submissions and previously published work OK.

SKIING TRADE NEWS, 1 Park Ave., New York NY 10016. (212)725-3969. Managing Editor: Irwin Curtin. Tabloid published 7 times/year. Circ. 11,600. Emphasizes news, retailing and service articles for ski retailers. Photos purchased with accompanying ms or caption. Buys 2-6 photos/issue. Credit line given. Pays on publication. Buys one-time rights. Send material by mail for consideration. SASE. Reports in 1 month. Free sample copy.
Subject Needs: Celebrity/personality; photo essay/photo feature ("If it has to do with ski and skiwear retailing"); spot news; and humorous. Photos must be ski related. Model release and captions preferred.
B&W: Uses 5x7 glossy prints. Pays $25-35/photo.

SMALL FARMER'S JOURNAL, 3908 W. 1st., Box 2805, Eugene OR 97402. (503)683-6486. Editor/Publisher: Lynn Miller. Quarterly. Emphasizes "farming with horses, general small scale farming." Readers are "small farmers usually farming between 10 and 100 acres, some using horses, some not." Circ. 26,000. Sample copy $4.
Photo Needs: Uses about 100 photos/issue; 75% supplied by freelance writers/photographers. Needs "action shots and how-to shots, b&w only. Crops, livestock, horses in use and tools and their uses as well as farming how-to's." Model release required; captions preferred.
Making Contact & Terms: Query with samples; send up to 8x11 b&w prints by mail for consideration. SASE. Reports in 3 weeks. Pays $50/b&w cover photo; $10-35/b&w inside photo. Pays on publication. Buys one-time rights.

SOCIAL POLICY, 33 W. 42nd St., New York NY 10036. (212)840-7619. Managing Editor: Audrey Gartner. Quarterly. Emphasizes "social policy issues—how government and societal actions affect people's lives." Readers are academics, policymakers, lay readers. Circ. 3,500. Sample copy $2.
Photo Needs: Uses about 6 photos/issue; all supplied by freelance photographers. Needs photos of social consciousness and sensitivity. Model release preferred.
Making Contact & Terms: Arrange a personal interview to show portfolio; query with samples; provide resume, business card, brochure, flyer or tearsheets to be kept on file for possible future assignments. Send 8x10 b&w glossy prints; b&w contact sheets by mail for consideration. SASE. Reports in 2 weeks. Pays $75/b&w cover photo; $25/b&w inside photo. Pays on publication. Credit line given. Buys one-time rights. Simultaneous and previously published submissions OK.
Tips: Prefers to see "editorial content, clarity, sensitivity. Be familiar with social issues. We're always looking for relevant photos. Contact us."

SOONER LPG TIMES, Suite 114, 2910 N. Walnut, Oklahoma City OK 73105. (405)525-9386. Bimonthly magazine. Circ. 1,450. For dealers and suppliers of LP-gas and their employees. Pays on acceptance. SASE. Reports in 4 weeks.

***SOUNDINGS PUBLICATIONS, INC.**, Pratt St., Essex CT 06426. (203)767-0906. Editor: Arthur Henick. Monthly newspaper. Emphasizes boating, marine trades. Readers are boaters, tradesmen (marina). Circ. 100,000. Sample copy $1.95. Photo guidelines free.
Photo Needs: Uses 120-150 photos/issue; half are supplied by freelance photographers. Needs photos of boating; boating-related incidents, marine trade stories.
Making Contact & Terms: Query with samples or send 8x10 glossy b&w prints; 35mm transparencies; b&w contact sheets; b&w and color negatives by mail for consideration. SASE. Reports in 2 weeks "or ASAP." Pays $250/color cover photo; $15-25/b&w inside photo. Pays on publication. Credit line given. Buys one-time rights. Simultaneous submissions OK.
Tips: "Don't send tons of pix—be selective and quietly persistent."

SOUTHERN BEVERAGE JOURNAL, Box 561107, Miami FL 33256. (305)233-7230. Editor-in-Chief: Mary McMahon. Monthly. Circ. 20,000. Emphasizes beverage and alcoholic products. Readers are licensees, wholesalers and executives in the alcohol beverage industry. Free sample copy.
Photo Needs: Uses about 20 photos/issue. Needs photos of "local licensees (usually with a promotion

of some kind)." Captions required. Send b&w and color prints and any size transparency by mail for consideration. SASE. Reports in 1 week. Pays $10/b&w inside photo. Pays on acceptance. Credit line given "if they ask for it." Buys all rights. Simultaneous submissions and previously published work OK.

SOUTHERN MOTOR CARGO, Box 4169, Memphis TN 38104. Monthly magazine. Circ. 55,000. For trucking management and maintenance personnel of private, contract, and for-hire carriers in 16 southern states and Washington DC. Special issues include "ATA Convention," October; "Transportation Graduate Directory," January; "Mid-America Truck Show," February, "Southwest Truck Show," June.
Specs: Uses b&w prints.
Accompanying Mss: Photos purchased with or without accompanying ms.
Payment & Terms: Pays $25-50/b&w print. Pays on publication.
Making Contact: Send query to Tom Stone. SASE. Reports in 6 weeks.

SOUVENIRS & NOVELTIES MAGAZINE, Suite 226, 401 N. Broad St., Philadelphia PA 19108. (215)925-9744. Editor: Charles Tooley. Magazine, published 7 times annually. Circ. 20,000. Emphasizes new products, buying and selling, and other news of the industry. For managers and owners of resort and amusement park souvenir shops; museum and zoo souvenir shops and hotel gift shops. Buys 10-15 text/photo packages/year. Buys first serial rights or first North American serial rights. Photos purchased with accompanying ms; "the photos should illustrate an important point in the article or give an indication of how the shop looks." Credit line given. Pays on publication. Reports in 2 weeks. SASE. Simultaneous submissions and previously published work OK. Free sample copy.
B&W: Uses 8x10 glossy prints. Pays $20-40/photo.
Cover: See requirements for b&w. Captions "preferred." Pays $10.
Tips: Especially interested in articles which describe how a specific manager sells souvenirs to tourists.

SOYBEAN DIGEST, 777 Craig Rd., Box 27300, St. Louis MO 63141. (314)432-1600. Editor: Gregg Hillyer. Monthly magazine. Circ. 200,000. Emphasizes production and marketing of soybeans high acreage soybean growers. Photos purchased with or without accompanying ms and on assignment. Buys 75 photos/year. Pays $50-350 for text/photo package or on a per-photo basis. Credit line given. Pays on acceptance. Buys all rights, but may reassign after publication. Send material by mail for consideration; query with list of stock photo subjects, resume, card, brochure and samples. SASE. Reports in 3 weeks. Previously published work possibly OK. Sample copy $2.
Subject Needs: Soybean production and marketing photos of modified equipment. Captions preferred. No static, posed or outdated material.
B&W: Uses 5x7 or 8x10 prints. Pays $75-200/photo.
Color: Uses 35mm or 2¹/₄x2¹/₄ transparencies. Pays $150-300/photo.
Cover: Uses 35mm, 2¹/₄x2¹/₄, 4x5 and 8x10 transparencies. Vertical format preferred. Pays $200-350/photo.
Accompanying Mss: Grower techniques for soybean production and marketing. Pays $100-550/ms. Prefers photos with ms.

THE SPORTING GOODS DEALER, 1212 N. Lindbergh Blvd., St. Louis MO 63132. (314)997-7111. Editor: Steve Fechter. Monthly magazine. Circ. 27,600. Emphasizes news and merchandising ideas for sporting goods dealers. Photos purchased with or without accompanying ms or on assignment. Buys 20-50 photos/year. Credit line given occasionally. Pays on publication. Buys all rights. Send material by mail for consideration. Simultaneous submissions and previously published work OK if not published in a sporting goods publication. Sample copy $2 (refunded with first accepted photo). Free photo guidelines.
Subject Needs: Spot news relating to the merchandising of sporting goods. Outdoor (fishing, hunting, camping, water sports)—related photos (color preferred). Captions required.
B&W: Uses 5x7 glossy prints. Pays $3-6/photo.
Color: Uses transparencies, standard sizes. Pays $200-300 for full-page use.
Accompanying Mss: Seeks mss on the merchandising of sporting goods through trade channels. Pays 2¢/word. Free writer's guidelines.

***STAT MD**, 7628 Densmore Ave., Van Nuys CA 91406. (818)782-7328. Editor: Barbara Feiner. Monthly magazine. "Magazine supplement within existing publication." Emphasizes emergency medicine. Readers are emergency room physicians and nurses. Circ. 11,000. Estab. 1986. Sample copy $2.50.
Photo Needs: Uses 1 cover shot/issue; 50% supplied by freelance photographers. Needs *vertical only* shots of physicians at work in the emergency room; must convey sense of urgency. Model release and captions required.

Making Contact & Terms: Send 35mm, 2¼x2¼, 4x5 transparencies by mail for consideration. SASE. Reports in 1 month. Pays $100/color cover photo. Pays on publication. Credit line given. Buys one-time rights. Simultaneous submissions and previously published work OK.

Tips: "We're happy to look at unsolicited photos that fill the requirements listed under 'Photo Needs'."

STUDIO PHOTOGRAPHY, PTN Publishing Corp., 210 Crossways Park Dr., Woodbury NY 11797. (516)496-8000. Editor: Mark Zacharia. Monthly magazine. Circ. 65,000. Emphasizes the problems and solutions of the professional photographer. Photos purchased with accompanying ms only. Buys 70 photos/year. Pays $150-300 for text/photo package. Credit line always given. Pays on publication. Buys one-time rights. Query with SASE first. Reports in 3 weeks. Free sample copy and photo guidelines.

Subject Needs: Nude; human interest (children, men, women); still life; portraits; travel, nature, scenics and sports. Model release and captions required.

B&W: Uses 8x10 prints. Pays $50 minimum/photo.

Color: Uses 8x10 unmounted prints; 35mm, medium and large format transparencies.

Cover: Photo from article within that issue. Uses b&w and color prints and transparencies. Vertical format required.

Accompanying Mss: Business articles; anything related to photo studio owners. Interested in articles that will enhance the sales or techniques of wedding, portrait, school, commercial and freelance photographers. Pays $50 minimum/ms. Free writer's guidelines.

Tips: "Will only accept highest quality copy and photos. All mss typed, proofread and double-spaced before acceptance. Become familiar with the content of our magazine. If you don't write, pair up with someone who can. Transparencies and images should be top-notch—show us something that will really woo us. Explain a newer, easier or less expensive technique for accomplishing tasks in photography."

SUCCESSFUL FARMING, 1716 Locust St., Des Moines IA 50336. (515)284-2579. Editor: Richard Krumme. Monthly. Emphasizes farming and farm management. Circ. 620,000. Sample copy and photo guidelines free with SASE.

Photo Needs: Uses about 64 photos/issue; 55 supplied by freelance photographers. Needs photos of farm livestock, farm machinery, buildings, crops (corn, soybeans, wheat, mostly), farming activity, farm people. "We are always looking for good cover shots with unique situations-composition-lighting, etc., farm management oriented." Model release required.

Making Contact & Terms: Arrange a personal interview to show portfolio; query with samples and list of stock photo subjects; provide resume, business card, brochure, flyer or tearsheets to be kept on file for possible future assignments. Reports in 2 weeks. Pays $450-600/color covers (one time use); $100-250/color inside photo (one-time use); $630/day, plus mileage. Pays on acceptance. Credit line given. Buys all rights on per-day assignments, one-time use on stock photos. No simultaneous submissions or previously published work.

Tips: "We need technically good (lighting, focus, composition) photos. Photographer must remember that his/her pictures must be reproducible by color separation and printing process."

***SUCCESSFUL MEETINGS**, 633 Third Ave., New York NY 10017. Art Director: Don Salkaln. Monthly magazine. Emphasizes business group travel for all sorts of meetings. Readers are business and association executives who plan meetings, exhibits, conventions, incentive travel. Circ. 77,000. Sample copy $10.

Photo Needs: Uses 25 photos/issue. Needs photos of a few general travel—scenic and urban meeting groups, trade shows, conventions. Special needs include *good*, high-quality meeting—group shots. Model release preferred.

Making Contact & Terms: Arrange a personal interview to show portfolio; query with resume of credits and list of stock photo subjects. SASE. Reports in 2 weeks. Pays $500-750/color cover photo; $50-150/inside b&w photo; $50-250/inside color photo; $150-250/b&w page; $200-300/color page; $200-600/text/photo package. Pays on acceptance. Credit line given. Buys one-time rights. Simultaneous submissions and previously published work OK "only if you let us know."

Tips: Be fair, be professional, be persistent.

SUN/COAST ARCHITECT-BUILDER MAGAZINE, McKellar Publications, Inc., Suite 203, 410 West Arden Ave., Glendale CA 91203-1194. (818)241-0250. Monthly. Emphasizes architecture and building industry. Readers are architects, builders, developers, general contractors, specification writers, designers and remodelers in the Pacific, Mountain and Sunbelt states. Circ. 42,000 + .

Photo Needs: Number of photos used per issue varies. "Call to discuss needs before submittal. Editorial material is selected on the basis of the merits of the individual project; graphics to supplement the copy." Photos must be accompanied by ms. Model release and captions required.

Making Contact & Terms: "Call first to discuss story ideas." SASE. Reporting time varies. "No payments are made." Credit line given. Simultaneous and previously published submissions considered "depending on the story."

SYSTEMS/3X WORLD, (formerly *Small Systems World*), 950 Lee St., Des Plaines IL 60016. (312)296-0770. Executive Editor: Helena Smejda. Associate Editor: Ann Hedin. Monthly. Circ. 35,000. Emphasizes "small business computer management." Readers are "top data processing managers of IBM microcomputer sites."
Photo Needs: Uses 1-2 photos/issue; 1 supplied by freelance photographers. Needs "interesting how-tos, machine shots, conceptual cover shots. Model release and captions preferred.
Making Contact & Terms: Arrange a personal interview to show portfolio. Does not return unsolicited material. Reports in 2 weeks. Pays on publication. Credit line given. Buys all rights.
Tips: Looking for "good technical skills, creative shots."

***TANNING TRENDS**, 8888 Thorne Rd., Horton MI 49246. (517)563-2600. Editor: Monica Smiley. Monthly magazine. Emphasizes management of indoor tanning businesses. Readers are owners and managers of tanning salons and other businesses with tanning facilities on-site. Circ. 20,000. Estab. 1985. Sample copy "one free to qualified businesses."
Photo Needs: Uses 20-25 photos/issue; 10 supplied by freelance photographers. Needs photos of business operations of indoor tanning salon; young, fit, healthy people enjoying beach activities; all color photos. Captions preferred.
Making Contact & Terms: Query with list of stock photo subjects. SASE. Reports in 1 month. Payment varies. Pays on publication. Buys one-time rights. Previously published work OK.
Tips: "Tell us area of expertise, background as photographer, publication credits."

***TECHNICAL PHOTOGRAPHY**, 210 Crossways Park Dr., Woodbury NY 11797. (516)496-8000. Senior Editor: David A. Silverman. Monthly magazine. Emphasizes in-plant industrial, military and government image-production. Readers include individuals producing images—AV, video, motion picture, print—for use by non-photographic companies such as Ford, Kraft, Grumman, etc. Circ. 60,000. Sample copy $2. Photo and ms guidelines free with SASE.
Photo Needs: Uses 15 photos/issue, all supplied by freelance photographers. "Covers and inside articles written by photographers. Needs shots produced to fulfill a company need; to help our readers learn their craft." Model release and captions required.
Making Contact & Terms: Query with samples, send 4x5 or larger glossy b&w and color prints; 35mm, 2¼x2¼, 4x5, 8x10 transparencies by mail for consideration. SASE. Reports in 4-6 weeks. Pays $150/color cover photo, $75-250/text/photo package. Pays on publication. Credit line given. Buys one-time rights.
Tips: Prefers to see "materials related to our readership—industrial."

TELECOMMUNICATIONS, 610 Washington St., Dedham MA 02026. (617)769-9750. Executive Editor: Charles White. Monthly. Emphasizes "state-of-the-art voice and data communications equipment and services." Readers are "persons involved in communications management/engineering." Circ. 70,000. Sample copy with SASE and 40¢ postage.
Photo Needs: Uses about 6 photos/issue; varying number supplied by freelance photographers. Needs "applications-oriented photos of communciations systems/equipment." Model release and captions required.
Making Contact & Terms: Query with list of stock photo subjects; send b&w and color prints; 35mm transparencies by mail for consideration; provide resume, business card, brochure, flyer or tearsheets to be kept on file for possible future assignments. SASE. Reports in 1 week. Pays $250/color cover photo; $25/b&w and $50/color inside photo. Pays on publication. Credit line given. Buys all rights.

***TODAY'S OR NURSE**, 6900 Grove Rd., Thorofare NJ 08086. (601)848-1000. Managing Editor: Janice Bowermaster. Monthly. Emphasizes operating room and recovery room nursing practices. Readers are OR/Recovery Room RNs and supervisors. Circ. 36,000. Sample copy free with "large" SASE. Photo guidelines free with SASE.
Photo Needs: Uses about 10-15 photos/issue; "2% at present, may become more" supplied by freelance photographers. Needs "operative scenes, personnel, instruments, room set-up and surgery (anatomy). We print leads in color, b&w for intra-article shots." Model release and captions required.
Making Contact & Terms: Query with samples or list of stock photo subjects; send b&w or color glossy prints, 2¼x2¼, 4x5 transparencies; b&w contact sheets by mail for consideration. SASE. Reports in 2 weeks. Pays on publication. Credit line given. Buys all rights on cover photo; other rights "will be settled per photo." Simultaneous submissions OK.
Tips: Prefers to see "simplicity of theme, uncluttered appearance, room for logo across top quarter of photo. Send for the guidelines—we are very specific about subject matter appearance."

TOURIST ATTRACTIONS AND PARKS, Suite 226, 401 N. Broad St., Philadelphia PA 19108. (215)925-9744. Editor: Charles Tooley. Bimonthly. Circ. 22,000. Emphasizes theme parks, carnivals, concert arenas, amusement parks, zoos and tourist attractions for managers and owners. Needs photos

of new developments in amusement parks, such as new systems of promotion, handling crowds or drawing visitors. Buys 5-10 photos/year. Buys first North American serial rights. Send photos for consideration. Credit line given. Pays on publication. Reports in 2 weeks. SASE. Simultaneous submissions and previously published work OK. Free sample copy.
B&W: Send 8x10 glossy prints. Captions required. Pays $10-15.
Color: Send transparencies. Captions required. Pays $50.
Cover: See requirements for b&w and color. Pays $20-40.
Tips: Wants no nature shots; only professional quality photos of theme parks, attractions or amusement parks.

TOWING & RECOVERY TRADE NEWS, Box M, Franklin MA 02038. Editor: Jay Kruza. Bimonthly magazine. Circ. 15,000 tow truck operators. Needs photos of unusual accidents with tow trucks retrieving and recovering cars and trucks. Avoid gory or gruesome shots depicting burned bodies, numerous casualties, etc. Buys 50 photos/year, 8/issue showing how-to procedure. Buys all or reprint rights. Send photos for consideration. Pays on acceptance. Reports in 5 weeks. SASE. Simultaneous submissions OK. Sample copy $2; free photo guidelines.
B&W: Send glossy or matte contact sheet or 5x7 prints. Captions required. Pays $25 for first photo, $7 for each additional photo in the series.
Tips: "Most shots are 'grab' shots—a truck hanging off a bridge, recovery of a ferryboat in water, but the photographer should get sequence of recovery photos. Some interviews of owners of a fleet of tow trucks are sought as well as the 'celebrity' whose car became disabled."

TRADESWOMAN MAGAZINE, Box 40664, San Francisco CA 94140. (415)826-4732. Editors: Sandra Marilyn, Joss Eldredge. Quarterly. Emphasizes women in nontraditional blue collar trades work (carpenters, electricians, etc.). Readers are highly skilled specialized women in crafts jobs with trade unions, and self-employed women such as contractors. Women doing work which is currently considered nontraditional. Circ. 1,500. Sample copy $2.
Photo Needs: Uses about 10-15 photos/issue; one-third supplied by freelance photographers. Needs "photos of women doing nontraditional work—either job site photos or inshop photos. Occasionally we just use photos of tools." Special needs include cover quality photos—black and white only.
Making Contact & Terms: Send unsolicited photos by mail for consideration. Send high contrast b&w prints; b&w contact sheet. SASE. Reports in 1 month. Payment individually negotiated. Pays on acceptance. Credit line given. Rights negotiable. Simultaneous submissions and previously published work OK.
Tips: "We are looking for pictures of strong women whom we consider pioneers in their fields. Since we are a nonprofit and do not have a lot of money, we often offer write-ups about authors and photographers in addition to small payments."

***TRAFFIC MANAGEMENT**, 275 Washington St., Newton MA 01258. (617)964-3030. Editor: Frank Quinn. Photo Editor: Mark Fallon. Monthly magazine. Emphasizes transportation/distribution. Readers are logistics managers. Circ. 70,000.
Photo Needs: Uses 3 photos/issue; all supplied by freelance photographers. Needs manager's photo for cover, warehouse and equipment shots inside. Model release preferred; captions required.
Making Contact & Terms: Arrange a personal interview to show portfolio; query with samples; provide resume, business card, brochure, flyer or tearsheets to be kept on file for possible future assignments. Does not return unsolicited material. Reports "when I need a photographer in a specific state." Pays $50-300/text/photo package. Pays on publication. Buys one-time rights.
Tips: Prefers to see people and equipment shots. "Come in with a good price and good book (geared towards my specific needs)."

TRAINING MAGAZINE, 50 S. 9th St., Minneapolis MN 55402. (612)333-0471 or (1-800)328-4329. Editor: Jack Gordon. Managing Editor: Chris Lee. Monthly. Emphasizes training of employees by employers. Readers include trainers, managers and other educators of adults. Circ. 50,000. Free sample copy with SASE.
Photo Needs: Uses 5 photos/issue; cover supplied by freelance photographers. Needs people at work, e.g., working on a computer terminal, factory, etc.; people in or at training or classroom setting. Reviews photos with or without accompanying ms. Captions preferred.
Making Contact & Terms: Query with list of stock photo subjects; provide resume, business card, brochure, flyer or tearsheets to be kept on file for possible future assignments. SASE. Reports in 1 month. Pays on acceptance. Credit line given. Buys one-time rights. Simultaneous submissions OK.

TRAINING: THE MAGAZINE OF HUMAN RESOURCES DEVELOPMENT, Lakewood Building, 50 S. 9th St., Minneapolis MN 55402. Editor: Jack Gordon. Art Director: Jodi Scharff. Covers "job-relat-

ed training and education in business and industry, both theory and practice." Audience: "training directors, personnel managers, sales and data processing managers, general managers, etc." Monthly circ. 51,000. Sample copy $3 plus 9"x11" SASE.

Photo Needs: Uses about 10-15 photos/issue. "We accept vary few freelance submissions. Most work on assignment only. We do keep a contact file for future reference. We use b&w photos or color transparencies only."

Making Contact & Terms: Query with samples or with list of stock photo subjects. Call (612)333-0471 or write art director for appointment to show portfolio. Provide business card, brochure and flyer to be kept on file for possible future assignments. Samples returned only if requested and only by SASE. Payment negotiated. Pays on acceptance. Credit line given. Buys all rights. Previously published work OK.

TREE TRIMMERS LOG, Box 833, Ojai CA 93023. (805)646-3941. Editor: D. Keith. Newsletter published 10 times/year. Emphasizes tree trimming—horticulture. Readers include working tree trimmers, either one-man companies or very small. Tree trimming enterpreneurs. Circ. 400. Sample copy $1.

Photo Needs: Uses 2 photos/issue; "could be all supplied by freelance photographers." Needs unusual trees, trees with stories or history, claim to highest, widest, etc., tree trimmers with a slant or idea for work equipment in use (chain saws, etc.). Reviews photos with or without accompanying ms, but with some caption and facts. Captions required "at least what, who, why, where and when."

Making Contact & Terms: Send unsolicited photos by mail for consideration. Uses any PMT, b&w print, b&w contact sheet, b&w negative. SASE. Reports in 2 weeks. Pays $5/b&w inside photo, $20-25/text/photo package (250-word story). Pays on acceptance. Credit line given. Buys one-time rights. Simultaneous submissions and previously published work OK.

Tips: Prefers "action photos of trimmers (in the tree, getting ready to ascend). Will also need Arbor Day photos."

***T-SHIRT RETAILER AND SCREEN PRINTER**, 195 Main St., Metuchen NJ 00840. (201)494-2889. Editor: Marsha Parker Cox. Photo Editor: Deborah Slater. Monthly magazine. Emphasizes imprintable garment industry, T-shirt shops, screen printers. Circ. 27,000.

Photo Needs: Uses 40 photos/issue; 1-2 supplied by freelance photographers. Needs photographers around the country to shoot assignments—stores and printshops. Do not submit unsolicited photos. Send name, address and phone number only. Reviews photos with accompanying ms only. Model release and captions preferred.

Making Contact & Terms: Query with resume of credits; provide resume, business card, brochure, flyer or tearsheets to be kept on file for possible future assignments. Does not return unsolicited material. Reports "as needed." Pay negotiated.

Tips: Looks for good composition, close-ups on equipment, ability to handle wide range of shots. "Photos need to be exemplary if it involves a profile of a store or printer—the photos should speak for themselves. We rarely use freelancers, but if the opportunity arose, we would want assignments shots when needed."

U.S. NAVAL INSTITUTE PROCEEDINGS, U.S. Naval Institute, Annapolis MD 21402. (301)268-6110. Editor-in-Chief: Fred H. Rainbow. Monthly magazine. Circ. 100,000. Emphasizes matters of current interest in naval, maritime, and military affairs—including strategy, tactics, personnel, shipbuilding and equipment. For officers in the Navy, Marine Corps and Coast Guard; also for enlisted personnel of the sea services, members of other military services in this country and abroad, and civilians with an interest in naval and maritime affairs. Buys 15 photos/issue. Needs photos of Navy and merchant ships of all nations; military aircraft; personnel of the Navy, Marine Corps and Coast Guard; and maritime environment and situations. No poor quality photos. Buys one-time rights. Query first with resume of credits. Pays $200/color cover photo; $50 for article openers. Pays on publication. Reports in 2 weeks on pictorial feature queries; 6-8 weeks on other materials. SASE. Free sample copy. Color and b&w: Uses 8x10 glossy prints or slides. Captions required. Pays $25; pays $10 for official military photos submitted with articles. Pays $250-500 for naval/maritime pictorial features. "These features consist of copy, photos and photo captions. The package should be complete, and there should be a query first. In the case of the $25 shots, we like to maintain files on hand so they can be used with articles as the occasion requires."

VETERINARY ECONOMICS, 9073 Lenexa Dr., Lenexa KS 66215-3839. (913)492-4300. (800)255-6864. Art Director: Greg Kindred. Monthly magazine. Emphasizes "animals—domestic mostly; some wildlife. Our magazine is a practice management and finance magazine for veterinarians." Circ. 38,000. Sample copy for SASE and 97¢ postage.

Photo Needs: Uses 1-5 photos/issue, some supplied by freelance photographers. "Mostly domestic

animals—cats, dogs, horses, cattle, pigs, etc., in some kind of natural setting; cover photos specifically to cover feature slant (i.e., fees, salaries, investments)." Model release preferred. Some assignments assigned for editorial photography.

Making Contact & Terms: Query with list of stock photo subjects: provide flyer or tearsheets to be kept on file for possible future assignments. SASE. Reports in 2 weeks. Pays $400/color cover; negotiates rate for inside photos; maximum $400/color page. Pays on acceptance. Credit line given. Buys all rights. Simultaneous and photocopied submissions OK.

VIDEO SYSTEMS, Box 12901, Overland Park KS 66212. (913)888-4664. Publisher: Duane Hefner. Monthly magazine. Circ. 31,000. Emphasizes techniques for qualified persons engaged in various applications of professional video production who have operating responsibilities and purchasing authority for equipment and software in the video systems field. Needs photos of professional video people using professional video equipment. No posed shots, no setups (i.e., not real pictures). Buys 15-20 photos/year. Buys all rights, but may reassign to photographer after publication. Submit model release with photo. Query with resume of credits. Pays on acceptance. Reports in 1 month. SASE. Previously published work OK. Free sample copy and photo guidelines.

B&W: Uses 8x10 glossy prints. Captions required. Pays $10-25.

Color: Uses 35mm, 2¼x2¼ or 8x10 transparencies. Captions required. Pays $25-50.

Cover: Uses 35mm, 2¼x2¼ or 8x10 color transparencies. Vertical format. Allow space at top of photo for insertion of logo. Captions required. Pays $100.

VIDEOGRAPHY, 50 W. 23 St., New York NY 10010. (212)645-1000. Editor: John Rice. Monthly magazine. Circ. 22,000. Emphasizes technology, events and products in the video industry. For video professionals, TV producers, cable TV operators, "AV types," educators and video buffs. Needs photos of TV productions, movie and TV show stills, geographical and mood shots, and photos of people using video equipment. Uses 50 photos/year. Present model release on acceptance of photo. Query with resume of credits. Credit line given. Pays on publication. Reports in 4-6 weeks. SASE. Sample copy $3.

B&W: Send any size glossy prints. Captions required. Pays $5-10.

Color: Send transparencies. Captions required. Pays $5-10.

Cover: Send any size glossy b&w prints or 2¼x2¼ color transparencies. Captions required. Pays $10-50.

WALLCOVERINGS MAGAZINE, Suite 101, 15 Bank St., Stamford CT 06901. (203)357-0028. Editor/Publisher: Martin A. Johnson. Managing Editor: Peter J. Hisey. Monthly magazine. Circ. 16,000. Monthly trade journal of the flexible wallcoverings and window treatment industries. For manufacturers, wholesalers and retailers in the wallcovering, wallpaper and window treatment trade. Buys all rights. Submit model release with photo. Send contact sheet or photos for consideration. Pays on publication. SASE. Sample copy $2.

B&W: Send contact sheet, negatives, or 5x7 or 8x10 glossy prints. Captions required. Payment negotiated on individual basis.

WARD'S AUTO WORLD, 28 W. Adams St., Detroit MI 48226. (313)962-4433. Editor: David C. Smith. Monthly. Circ. 68,000. Emphasizes the automotive industry. Sample copy free with SASE.

Photo Needs: Uses about 40 photos/issue; 10-30% supplied by freelance photographers. Subject needs vary. "Most photos are assigned. We are a news magazine—the news dictates what we need." Model release preferred; captions required.

Making Contact & Terms: Arrange a personal interview to show portfolio or query with samples; provide resume, business card, brochure, flyer or tearsheets to be kept on file for possible future assignments. SASE. Reports in 2 weeks. Pays on publication. Credit line given. Buys all rights.

WATER WELL JOURNAL, 6375 Riverside Dr., Dublin OH 43017. (614)761-3222. Associate Editor: Gloria Swanson. Monthly. Circ. 28,000. Deals with construction of water wells and development of ground water resources. Readers are water well drilling contractors, managers, suppliers and scientists. Free sample copy.

Photo Needs: Uses 1-3 freelance photos/issue plus cover photos. Needs photos of installations and how-to illustrations. Captions required.

Making Contact & Terms: Contact with resume; inquire about rates. "We'll contact."

WEEDS TREES & TURF, 7500 Old Oak Blvd., Cleveland OH 44130. Editor: Jerry Roche. Monthly magazine. Circ. 45,000. Emphasizes professional landscape design, construction and maintenance. "We feature research, innovative and proven management techniques, and material and machinery used in the process." For "turf managers, parks; lawn care businessmen, superintendents of golf courses, airports, schools; landscape architects, landscape contractors and sod farmers." Photos purchased with ac-

companying ms and on assignment. Pays on publication. "Query as to applicability." SASE. Reports in 1 month.

Subject Needs: Turf or tree care in progress.

B&W: Uses 5x7 glossy prints. Pays $25 minimum/photo.

Color: Uses 8x10 glossy prints and transparencies; contact sheet and negatives OK. Pays $25-50/photo.

Cover: Uses color 35mm and 2¼x2¼ transparencies. Square format preferred. Pays $75-125/photo.

WESTERN AND ENGLISH FASHIONS, 2403 Champa St., Denver CO 80205. (303)296-1600. Publisher/Ad Director: Bob Harper. Editor: Lawrence Bell. Monthly. Circ. 14,000. A trade magazine serving the needs of today's sophisticated retailers of Western and English riding apparel, accessories and square dance fashion. Features editorials, business columns and display advertisements designed to keep retailers abreast of the latest in business and fashion developments. Free sample copy and photo guidelines.

Photo Needs: Uses 30 photos/issue; 5-10 are supplied by freelance photographers. "Most of our photos accompany mss; we do use photo essays about once every 2-3 months. Photographers should query with idea. Photo essays should show Western products or events (rodeo etc.)." Model release preferred; captions required.

Making Contact & Terms: Query with photo essay idea. "We will respond quickly; if interested we will ask to see sample of photographer's work." SASE. Reports in 2 weeks. Pays $10-25/inside b&w photo; $25-50/color cover; $150 maximum for text/photo package. Pays on publication. Credit line given. Buys one-time rights. Simultaneous and previously published work OK if they were not published by a competitive magazine.

WESTERN FOODSERVICE, Suite 711, 5455 Wilshire Blvd., Los Angeles CA 90036. (213)936-8123. Contact: Editor. Monthly magazine. Circ. 23,000. Emphasizes restaurateurs, legislation and business trends, news and issues affecting commercial and noncommercial foodservice operations in the western states for restaurant owners and operators. Works with freelance photographers on assignment only basis. Provide calling card and letter of inquiry. Buys 6-12 photos/year. Pays $25-200/job, or on a per-photo basis. Credit line given. Pays on publication. Buys all rights, but may reassign after publication. Sample copy $2.

Subject Needs: Celebrity/personality (restaurant chain executives, independent operators, foodservice operators in unusual situations, i.e., showing off prize car); documentary; head shot (restaurant owners, foodservice school directors, caterers, etc.); spot news; human interest; humorous; and still life (novel or innovative food service operations. Prefer owner or manager in scene, so the photo makes a statement about the person and place). No "standard stuff—ribbon cuttings, groundbreaking, etc." Wants the unusual or provocative angle. Western-based people and facilities only, including Alaska and Hawaii.

B&W: Uses 8x10 glossy prints. Pays $20-50/photo.

Color: Pays $50-200/photo.

Cover: Uses color transparencies. By assignment only.

Accompanying Mss: On assignment. Query. Pays $50-200/ms.

Tips: "I'm glad to review anyone's work. But, don't spend more than 20 minutes showing me your portfolio and don't show me work that doesn't pertain to the photos I buy, i.e., don't show me wedding shots or pictures of dogs at play. I need color photos shot on location."

WESTERN OUTFITTER, 5314 Bingle Rd., Houston TX 77092. (713)688-8811. Editor/Manager: Tad Mizwa. Monthly magazine. "Written for retailers of Western and English apparel, Western and English tack and horse supplies." Circ. 17,000. Sample copy free with SASE.

Photo Needs: Uses about 10-20 photos/issue; 0-10 supplied by freelance photographers. Needs "assigned photos illustrating merchandising techniques or showing a retailer and his store when we have an article on hand. All types of horse photos have potential use."

Making Contact & Terms: Query with samples. SASE. Reports in 1 month. Pays $25/b&w inside photo, $50/color inside photo; more for assigned photos. Pays on publication. Credit line given. Buys one-time rights.

WILSON LIBRARY BULLETIN, 950 University Ave., Bronx NY 10542. (212)588-8400. Editor: Milo Nelson. Monthly magazine. Circ. 28,000. Emphasizes the issues and the practice of librarianship. For professional librarians. Needs photos of library interiors, people reading in all kinds of libraries—school, public, university, community college, etc. No posed shots, dull scenics or dated work. Buys 10-15 photos/year. Buys first serial rights. Send photos for consideration. Provide business card and brochure to be kept on file for possible future assignments. Credit line given. Pays on acceptance or publication. Reports in 1 month. SASE.

B&W: Send 5x7 or 8x10 glossy prints. Pays $35-50/photo, inside.

Cover: Pays $300/color cover.
Accompanying mss: Pays $300 for text/photo package.

WINES & VINES,1800 Lincoln Ave., San Rafael CA 94901. Contact: Philip E. Hiaring. Monthly magazine. Circ. 5,000. Emphasizes winemaking in the US for everyone concerned with the wine industry, including winemakers, wine merchants, suppliers, consumers, etc. Wants color cover subjects on a regular basis.
Payment & Terms: Pays $10/b&w print; $50-100/color cover photo. Pays on publication.
Making Contact: Query or send material by mail for consideration. SASE. Reports in 5 weeks to 3 months. Provide business card to be kept on file for possible future assignments.

***WIRE TECH MAGAZINE**, 6521 Davis Industrial Pkwy., Solon OH 44139. (216)248-1125. Editor: Donald B. Dobbins. Bimonthly magazine. Emphasizes technology in the manufacture and use of bare and insulated wire, and cable and optical fiber cable. Readers are management, engineering management, production management. Circ. 12,000.
Photo Needs: Uses 20-30 photos/issue; presently none supplied by freelance photographers. Needs photos used to illustrate a particular article or editorial subject. Model release required; captions preferred.
Making Contact & Terms: Provide resume, business card, brochure, flyer or tearsheets to be kept on file for possible future assignments. Does not return unsolicited material. Reports in 2 weeks. Pays on acceptance. Rights purchased varies with use.

THE WISCONSIN RESTAURATEUR, 122 W. Washington Ave., Madison WI 53703. Editor: Jan La-Rue. Monthly magazine except November and December are combined. Circ. 3,600. Trade magazine for the Wisconsin Restaurant Association. Emphasizes the restaurant industry. Readers are "restaurateurs, hospitals, schools, institutions, cafeterias, food service students, chefs, etc." Photos purchased with or without accompanying ms. Buys 12 photos/year. Pays $15-50 for text/photo package, or on a per-photo basis. Credit line given. Pays on acceptance. Buys one-time rights. Send material by mail for consideration. SASE. Simultaneous submissions and previously published work OK. Reports in 2 weeks. Free sample copy; photo guidelines free with SASE. Provide xerox copies of previously submitted work.
Subject Needs: Animal; celebrity/personality; photo essay/photo feature; product shot; scenic; special effects/experimental; how-to; human interest; humorous; nature; still life; and wildlife. Wants on a regular basis unusual shots of normal restaurant activities or unusual themes. Photos should relate directly to food service industry or be conceived as potential cover shots. No restaurants outside Wisconsin; national trends OK. No nonmember material. Ask for membership list for specific restaurants. Model release required; captions preferred.
B&W: Uses 5x7 glossy prints. Pays $7.50-15/photo.
Cover: Uses b&w glossy prints. Vertical format required. Pays $10-25/photo.
Accompanying Mss: As related to the food service industry—how-to; unusual concepts; humorous and "a better way." No cynical or off-color material. Pays $15-50 for text/photo package. Writer's guidelines free with SASE.

***WOMEN ARTISTS NEWS**, Grand Central Station, Box 3304, New York NY 10163. (212)666-6990. Editor: Rena Hansen. Bimonthly. Circ. 5,000. Readers are people throughout US, Europe, Canada and Australia interested in the arts, primarily in the visual arts. Sample copy $3; free photo guidelines.
Photo Needs: Uses about 32 photos/issue; all supplied by freelance photographers. Needs photos of "women artists, artwork, and events such as conferences, openings, panels, etc. Done on assignment or submitted in conjunction with article. We assign topics to photographers whose work we are familiar with. In addition we welcome queries and occasional unsolicited material, as long as it is relevant to the art field. We are particularly interested in building a stable of photographers in all regions of the US who can cover events and other stories for us." Captions required.
Making Contact & Terms: Query with list of stock photo subjects. SASE. Uses b&w photos only. Reports in 2 weeks. Reimbursement for material and expenses only on acceptance of photos; no additional pay. Credit line given. Buys one-time rights.

WOODENBOAT, Naskeag Rd., Box 78, Brooklin ME 04616. Editor: Jonathan Wilson. Executive Editor: Billy R. Sims. Senior Editor: Peter H. Spectre. Managing Editor: Jennifer Buckley. Bimonthly magazine. Circ. 100,000. Emphasizes the building, repair and maintenance of wooden boats. Buys 50-75 photos/issue. Credit line given. Pays on publication. Buys first North American serial rights. Send contact sheet by mail for consideration. Queries with samples, suggestions and indication of photographer's interests relating to wooden boats are imperative. SASE. Previously published work OK. Reports in 6 weeks. Sample copy $3.50. Photo guidelines free with SASE.

Subject Needs: How-to and photo essay/photo feature (examples: boat under construction from start to finish or a how-to project related to wooden boat building). No "people shots, mood shots which provide little detail of a boat's construction features, scenic or flashy shots." Provide resume, brochure and tearsheets to be kept on file for possible future assignments. Model release preferred; captions required. "We *strongly* suggest freelancers thoroughly study sample copies of the magazine to become aware of our highly specialized needs."
B&W: Uses 8x10 glossy prints; contact sheet OK. Pays $15-75 minimum/photo.
Color: Uses 35mm transparencies. Pays $25-125 minimum/photo.
Cover: Uses color transparencies. Square format required. Pays $250/color photo.
Accompanying Mss: Seeks how-to, technical explanations of wooden boat construction, use, design, repair, restoration or maintenance. Boats under sail needed also. Pays $6/column inch. Negotiates pay for text/photo package. Writer's guidelines free with SASE.

WOOD 'N' ENERGY, Box 2008, Village West, Laconia NH 03247. (603)528-4285. Editor: Jason Perry. Monthly magazine. Emphasizes "wood heat and energy topics in general for manufacturers, retailers and distributors of wood stoves, fireplaces and other energy centers." Circ. 32,000. Sample copy $3.
Photo Needs: Uses about 30 photos/issue; 60% supplied by freelance photographers. Needs "shots of energy stores, retail displays, wood heat installations. Assignments available for interviews, conferences and out-of-state stories." Model release required; captions preferred.
Making Contact & Terms: Query with samples or list of stock photo subjects; send b&w or color glossy prints, 2¼x2¼ transparencies; b&w contact sheets by mail for consideration. SASE. Reports in 2 weeks. Payment varies. Pays on acceptance. Credit line given. Buys various rights. Simultaneous and photocopied submissions OK.
Tips: "Call and ask what we need. We're *always* on the lookout for material."

THE WORK BOAT, Box 2400, Covington LA 70434. (504)893-2930. Managing Editor: Chip Edgar. Monthly. Circ. 13,600. Emphasizes news of the work boat industry. Readers are executives of towboat, offshore supply, crew boat and dredging companies; naval architects; leasing companies; equipment companies and shipyards. Sample copy $3; photo guidelines for SASE.
Photo Needs: Uses about 35 photos/issue; a few of which are supplied by freelance photographers. "Covers are our basic interest. Photos must exhibit excellent color and composition. Subjects include working shots of towboats (river boats), tug boats (harbor and offshore), supply boats, crew boats, dredges and ferries. Only action shots; no static dockside scenes. Pictures should crop 8x11 for full bleed cover. Freelancers are used primarily for covers. Features sometimes require freelance help. We need to develop a file of freelancers along the coasts and rivers." Model release and captions required. No pleasure boats.
Making Contact & Terms: Send by mail for consideration actual 8x10 color prints or 35mm slides. "We will ask for negatives if we buy." Or query with resume of photo credits. Provide resume, calling card, samples (returned) and photocopies of tearsheets to be kept on file for possible future assignments. SASE. Reports in 2 weeks. Pays on acceptance $50-200/text/photo package. $50 minimum/cover. Credit line given on cover photos only. Buys one-time rights. Previously published work OK.

***WORLD DREDGING & MARINE CONSTRUCTION**, Box 17479, Irvine CA 92713-7479. (714)863-9390. Editor: Paul Mitchell. Monthly magazine. Emphasizes worldwide dredging, port improvement, and marine construction industry news, technology, issues. Readers are dredge owners/operators, marine engineers, port authorities, marine industry suppliers. Circ. 5,000. Sample copies $1.
Photo Needs: Uses 40 photos/issue; all supplied by freelance photographers. Needs good quality prints of worldwide marine construction projects, focusing mostly upon equipment, and details unique to that project. "We're always looking for *good quality* photos for front cover." Captions preferred.
Making Contact & Terms: Send unsolicited photos by mail for consideration. Send any size, glossy b&w and color prints. SASE. Reports in 1 month. "Payment depends on quality of material." Pays on publication. Credit line given. Buys one-time rights. Simultaneous submissions OK.
Tips: "We're a very unique, specialized market. Look at our back issues."

WORLD MINING EQUIPMENT, 27 Park St., London England EC2A 4JU. Editor: Keith R. Suttill. Monthly. Circ. 23,000. Emphasizes mine management, mining equipment and technology. Readers are "mine management worldwide." Sample copy free with SASE.
Photo Needs: Uses about 25-30 photos/issue; 75% supplied by freelance photographers. Needs photos illustrating articles. Photos purchased with accompanying ms only. Model release required "unless in public place"; captions preferred.
Making Contact & Terms: Send unsolicited photos and mss by mail for consideration; "can work with all formats—need color for cover." SASE "if requested." Reports in 2 weeks. Pays $200 + /color

cover photo; $100-200 + /b&w and color page. Pays on publication. Credit line on cover photos only. Buys one-time rights. Simultaneous submissions OK "only if submitted to noncompetitors."

WRITER'S DIGEST, 9933 Alliance Rd., Cincinnati OH 45242. (513)984-0717. Editor: William Brohaugh. Monthly magazine. Circ. 200,000. Emphasizes writing and publishing. For "writers and photojournalists of all description: professionals, beginners, students, moonlighters, bestselling authors, editors, etc. We occasionally feature articles on camera techniques to help the writer or budding photojournalist." Buys 30 photos/year. Buys first North American serial rights, one-time use only. Submit model release with photo. Query with resume of credits or send contact sheet for consideration. Photos purchased 5% on assignment; 95% with accompanying ms. Provide brochure and samples (print samples, not glossy photos) to be kept on file for possible future assignments. "We never run photos without text." Credit line given. Pays on acceptance. Reports in 4 weeks. SASE. Simultaneous submissions OK if editors are advised. Previously published work OK. Sample copy $2; guidelines free with SASE.
Subject Needs: Primarily celebrity/personality ("authors in the news—or small-town writers doing things of interest"); some how-to, human interest and product shots. All must be writer-related. "We most often use photos with profiles of writers; in fact, we won't buy the profile unless we can get usable photos. The story, however, is always our primary consideration, and we won't buy the pictures unless they can be specifically related to an article we have in the works. We sometimes use humorous shots in our Writing Life column."
B&W: Uses 8x10 glossy prints; send contact sheet. "Do *not* send negatives." Captions required. Pays $35-50.
Cover: "Freelance work is rarely used on the cover. Assignments are made through design director Steve Phillips."
Tips: "Shots should not *look* posed, even though they may be. Photos with a sense of place, as well as persona, preferred—with a mixture of tight and middle-distance shots of the subject. Study a few back issues. Avoid the stereotyped writer-at-typewriter shots; go for an array of settings. Move the subject around, and give us a choice. We're also interested in articles on how a writer earned extra money with photos, or how a photographer works with writers on projects, etc."

WRITER'S YEARBOOK, 9933 Alliance Rd., Cincinnati OH 45242. Editor: William Brohaugh. Annually. "We cover writing techniques, sales techniques, business topics and special opportunities for writers." Readers are freelance writers, working full-time or part-time, or trying to get started in writing. Sample copy $3.95; guidelines free with SASE.
Photo Needs: Uses about 10 photos/issue; some supplied by freelance photographers. "Almost all photos we use depict writers we are discussing in our articles. They should show the writer in familiar surroundings, at work, etc." Photos purchased with accompanying ms only. Model release preferred; captions required.
Making Contact & Terms: Query with article idea. SASE. Reports in 3 weeks. Pays $25 minimum/b&w inside photo. Pays on acceptance. Credit line given. Buys first North American serial rights, one-time use only. Previously published work OK.
Tips: "Our needs for *Writer's Yearbook* are similar to those for *Writer's Digest*. Check that listing for additional details."

***YOUNG FASHIONS MAGAZINE**, 370 Lexington Ave., New York NY 10017. (212)532-9290. Editor: Marc Richards. Photo Editor: David Whitten. Monthly magazine. Emphasizes children's fashions. Readers are retail store buyers for children's wear. Circ. 25,000. Estab. 1985.
Subject Needs: Uses 60 photos/issue; 30 supplied by freelance photographers. Needs photos of four color fashion shots with child models, photos of retail stores, personality profiles on manufacturing designers and retailers. Model release required.
Making Contact & Terms: Arrange a personal interview to show portfolio, submit portfolio for review. Does not return unsolicited material. Reports in 1 week. Pays $200-500/job. Pays on publication. Credit line given.
Tips: Must have experience in handling children.

Record Companies

To many photographers the idea of shooting on assignment for a record company probably conjures up images of New York- and Hollywood-style glitz. In reality, this exciting, interesting and creative market is very hard to break into. Many of the major record companies have on-staff photographers who handle their needs. The key to getting started in this field begins with covering local concerts and night club acts. By contacting local concert promoters, you may be able to obtain permission to shoot backstage.

Once your photos show you have mastered the problems of in-concert lighting variations and unusual photographic angles due to stage constraints, query some smaller local record companies. Keep building your portfolio—this is how the well known celebrity photographers got their start! Many of the listings in this section provide you with the subject matter each record company is most likely to purchase, as well as tips on styles and abilities sought from photographers interested in assignments. Many record companies are showing an increased interest in the photographer's ability to incorporate special effects into his photography.

Remember that in addition to album cover shots, record companies also have a need for good-quality black and white publicity photos to send to newspapers and magazines. If you have accumulated any photos (b&w or color) of performers you would like to market, you also will want to scan the Consumer Publications section for entertainment-oriented magazines and the Stock Photo Agencies for agencies who specialize in marketing celebrity photos.

Many of the record companies' pay scales are listed here, but others rely on negotiating via a per photo or per job basis. Be sure the fee is agreed upon in advance of any work performed. If you are sending material on speculation to companies, don't submit original work. Let the buyers know what photos you have and they can request specific shots. To succeed in this field, keep practicing using a variety of photographic styles under a variety of conditions—and be persistent. The creative and financial rewards make this an area well worth pursuing.

AIRWAVE INTERNATIONAL, #1502, 6430 Sunset, Hollywood CA 90028. (213)463-9500. President: Terrence Brown. Handles dance, pop, and black. Photographers used for portraits, in-concert shots, studio shots and special effects for album covers, inside album shots, publicity, brochures, posters, event/convention coverage and product advertising.
Specs: Uses 8x10 glossy b&w and color prints.
Making Contact: Arrange a personal interview to show portfolio or send unsolicited photos by mail for consideration. SASE. Reports in 1 month.
Payment & Terms: Pays $100-1,000/b&w photo, $200-2,000/color photo, $75/hour. Credit line given. Rights negotiable.
Tips: "We will respond to any material submitted."

***AMERICAN MUSIC CO., and CUCA RECORD & CASSETTE MANUFACTURING CO.**, Box 8604, Madison WI 53708. Vice President/Marketing: Daniel W. Miller. Handles mostly ethnic and old-time (polka, waltz, etc.). Photographers used for portraits, in-concert shots, studio shots and special effects for album covers.
Specs: Uses 8x10 or 5x7 b&w and color prints.
Making Contact: Send photos "that may be useful on album cover or back, especially as it may relate to ethnic and old-time music albums." Provide resume, business card, brochure, flyer, tearsheets and samples to be kept on file for possible future assignments. SASE. Reports within 6 months.
Payment & Terms: Pays $1-50/b&w photo and $2-50/color photo. Credit line given. Buys all rights.
Tips: "We suggest any interested photographers review their portfolios for pictures that they feel may interest us. Since we are a modest-sized record company, our need for pictures is infrequent, but we'd like to be aware of interested photographers."

AMERICAN MUSIC NETWORK INC., SCARAMOUCHE' RECORDS, Drawer 1967, Warner Robins GA 31099. (912)953-2800. President: Robert R. Kovach. Handles pop, easy listening, rhythm and blues and country records. Photographers used for portaits, live and studio shots and special effects for alubms, publicity, advertising and brochures. Buys 12 photos and gives 6 assignments/year. Works with freelance photographers on assignment basis only. Provide samples and tearsheets to be kept on file for possible future assignments. Pays $50-300/job. Credit line given. Buys one-time rights. Send material by mail for consideration. SASE. Reports in 2 months.
B&W: Uses 8x10 glossy prints.
Color: Uses 8x10 prints and transparencies.
Tips: Advice on how to best break into this firm: "Submit an excellent print, showing originality, with an offer we can't refuse. There is always the need for new people with new ideas."

***ANAMAZE RECORDS**, % Jacobson & Colfin, Suite 1103, 150 5th Ave., New York NY 10011. (212)691-5630. Attorney: Bruce Colfin. Handles rock. Photographers used for in-concert shots, studio shots, special effects, album covers, publicity, brochures, posters, event/convention coverage. Works with freelance photographers on an assignment basis only; gives 3 assignments/year.
Specs: Uses b&w and color prints.
Making Contact: Query with resume of credits; send unsolicited photos by mail for consideration; provide resume, business card, brochure, flyer or tearsheets to be kept on file for possible future assignments. SASE. Reports in 1 month.
Payment & Terms: Pay negotiable. Credit line given. Buys one-time rights.

APON RECORD COMPANY, INC., Steinway Station, Box 3082, Long Island NY 11103. (212)721-5599. President: Andre M. Poncic. Handles classical, folklore and international. Photographers used for portraits and studio shots for album covers and posters. Buys 50 + assignments/year. Provide borchure and samples to be kept on file for possible future assignments.
Specs: Uses b&w prints and 4x5 transparencies.
Making Contact: Send photos by mail for consideration. Does not return unsolicited material. Reports in 3 months.
Payment & Terms: Payment negotiable. Credit line given. Buys all rights.

***JUNE APPAL RECORDINGS**, 306 Madison, Box 743, Whitesburg KY 41858. (606)633-0108. Sales Manager: Diane Ratliff. Handles traditional mountain, appalachian mountain regional music. Photographers used for portraits, in-concert shots, studio shots, scenic, inside album shots, brochures.
Specs: Uses various b&w and color prints.
Making Contact: Provide resume, business card, brochure, flyer or tearsheets to be kept on file for possible future assignments. SASE. Reports in 1 month.
Payment & Terms: Pay negotiable. Credit line given. Buys all rights, but may reassign to photographer after use.
Tips: Wants to see what the photographer likes best. "Send a good selection of your best samples."

ART ATTACK RECORDS, INC./CARTE BLANCHE RECORDS, Fort Lowell Station, Box 31475, Tucson AZ 85751. (602)881-1212. President: William Cashman. Handles rock, pop, country, and jazz. Photographers used for portraits, in-concert shots, studio shots and special effects for album covers, inside album shots, publicity and brochures. Works with freelance photographers on assignment basis only; "gives 10-15 assignments/year."
Specs: "Depends on particular project."
Making Contact: Arrange a personal interview to show portfolio; provide resume, business card, brochure, flyer or tearsheets to be kept on file for possible future assignments. "We will contact only if interested."
Payment & Terms: Payment "negotiable." Credit line given.
Tips: Prefers to see "a definite and original style—unusual photographic techniques, special effects" in a portfolio. "Send us samples to refer to that we may keep on file."

AZRA RECORDS, Box 411, Maywood CA 90270. (213)560-4223. Contact: David Richards. Handles rock, heavy metal, novelty and seasonal. Photographers used for special effects and "anything unique and unusual" for picture records and shaped picture records. Works with photographers on assignment basis only; "all work is freelance-assigned."

 The asterisk before a listing indicates that the listing is new in this edition. New markets are often the most receptive to freelance contributions.

Specs: Uses 8x10 b&w or color glossy prints and 35mm transparencies.
Making Contact & Terms: Query with resume of credits or send "anything unique in photo effects" by mail for consideration. SASE. Reports in 2 weeks.
Payment & Terms: Payment "depends on use of photo, either outright pay or percentages." Credit line given. Buys one-time rights.

***BBW RECORDS**, Box 262, Livingston NJ 07039. (201)992-7300. Vice President: Dave Taylor. Estab. 1981. Handles jazz and big band. Photographers used for portraits, in-concert shots, studio shots, special effects for album covers, inside album shots, publicity, brochures. Works with freelance photographers on assignment basis only; gives 3 assignments/year.
Specs: Uses glossy b&w and color prints; 35mm, 2¼x2¼ transparencies.
Making Contact: Provide resume, business card, brochure, flyer or tearsheets to be kept on file for possible future assignments. Does not return unsolicited material. Reports in 1 month.
Payment & Terms: "We usually go out on bid." Credit line given. Buys all rights.
Tips: Prefers to see total professionalism, good clean pictures. Ingenuity. "Send us material and we will keep it on file and contact several photographers we feel would be right for a project and go out on bid."

MARK BLACKWOOD MUSIC GROUP, (formerly Voice Box Records), 5180 Park Ave., Memphis TN 38119. (901)761-5180. President: Mark Blackwood. General Manager: Leigh Chandler. Handles contemporary Christian music. Photographers used for in-concert shots, studio shots and special effects for album covers, publicity, brochures, posters, event/convention coverage and product advertising. Works with freelance photographers on assignment basis only; gives 10 assignments/year.
Specs: Uses 8x10 b&w or color glossy prints and 35mm transparencies.
Making Contact: Submit portfolio for review; provide resume, business card, brochure, flyer or tearsheets to be kept on file for possible future assignments. SASE. Reports in 3 weeks.
Payment & Terms: "A price is agreed upon depending on the project." Credit line given "for album covers and major projects." Buys one-time rights.
Tips: Prefers to see "commercial shots suitable for use as publicity shots and album covers as opposed to portraits; casual shots of people as opposed to scenery. Be sure to include with your resume and brochure a listing of work done before, project credits and complete price list. Depending on the project, record companies need different types of photographers so freelance photographers have a very good chance of working with record companies. Our record company and companies like ours are constantly using freelance photographers to take pictures for use in magazine advertisements, press releases, album covers, etc."

BLUE ISLAND ENTERTAINMENT, Box 171265, San Diego CA 92117-0975. President: Bob Gilbert. Handles rock and country. Photographers used for portraits and in-concert shots for inside album shots, publicity, brochures and posters. Buys 50 photos/year.
Specs: Uses 8x10 glossy b&w prints and 35mm transparencies.
Making Contact: Query with resume of credits; provide resume, business card, brochure, flyer, tearsheets or samples to be kept on file for possible future assignments. SASE. Reports in 1 month.
Payment & Terms: Pays $25-100/b&w photo and $30-150/color photo. Credit line given. Buys all rights.
Tips: "We will *not* look at portfolio until query/resume has been established. Your resume must sell you before we talk business. Shoot as many artists as possible—use film like it was sand through the hour glass. An artist is only on stage for several hours per show—make use of that time with a lot of photos. Record companies will only pay attention to a photographer who is determined to continue to knock on doors that remain shut. Sell yourself with hard work, good photos and a lot of talking to record companies and various rock (music) publications."

BOLIVIA RECORDS CO., 1219 Kerlin Ave., Box 1304. Brewton AL 36426. (205)867-2228. Contact: Manager. Handles soul, country and pop. Photographers used for portraits, in-concert/studio shots and special effects for album covers, inside album shots, publicity flyers, brochures, posters and event/convention coverage. Buys 400 photos and gives 40 assignments/year. Provide business card, brochure, flyer and samples to be kept on file for possible future assignments.
Specs: Uses 8x10 b&w/color prints.
Making Contact: Query with resume of credits or send indoor or outdoor shots of objects, scenery, people and places by mail for consideration. SASE. Reports in 1-3 weeks.
Payment & Terms: Pays by the photo or by the job. Buys all rights.

BOUQUET-ORCHID ENTERPRISES, Box 18284, Shreveport LA 71138. (318)686-7362. President: Bill Bohannon. Photographers used for live action and studio shots for publicity flyers and brochures. Works with freelance photographers on assignment only basis. Provide brochure and resume to be kept

on file for possible future assignments. SASE. Reports in 2 weeks.
Tips: "We are just beginning to use freelance photography in our organization. We are looking for material for future reference and future needs."

BOYD RECORDS, 2609 NW 36th St., Oklahoma City OK 73112. (405)942-0462. President: Bobby Boyd. Handles rock and country. Photographers used for portraits and album covers. Buys 12 freelance photos/year.
Specs: Uses 8x10 b&w prints.
Making Contact: Provide resume, business card, brochure, flyer or tearsheets to be kept on file for possible future assignments. Does not return unsolicited material.
Payment & Terms: Credit line given. Buys all rights.

BRENTWOOD RECORDS, INC., Box 1028, Brentwood TN 37027. (615)373-3950. President: Jim Van Hook. Handles gospel. Photographers used for in-concert shots, studio shots and special effects for album covers, inside album shots, publicity, brochures, posters and product advertising. Works with freelance photographers on assignment basis only; gives 10-20 assignments/year.
Specs: Uses color prints and 2¼x2¼ transparencies.
Making Contact: Provide resume, business card, brochure, flyer or tearsheets to be kept on file for possible future assignments. SASE. Reports in 1 month.
Payment & Terms: "Too many factors to print prices." Credit line given "most of the time." Buys "all rights and one-time rights, depending on our needs."
Tips: Prefers to see "warmth, inspiration, character; kids and seasonal shots (Christmas especially)."

***BRIGHT & MORNINGSTAR RECORDS**, Box 18a241, Los Angeles CA 90018. (213)512-7823. President: Stan Christopher. Uses freelance photographers for portraits, in-concert shots, special effects, inside album shots, publicity, product advertising. Works with freelance photographers on an assignment basis only; gives 7 assignments/year.
Specs: Uses 8x10 b&w and color prints.
Making Contact: Query with resume of credits. SASE. Reports in 2 weeks.
Payment & Terms: Pays $75-200/b&w photo; $150-500/color photo; $150-500/hour; $500-1,000/job. Credit line given. Buys one-time rights.

BROADWAY/HOLLYWOOD PRODUCTIONS, Box 10051, Beverly Hills CA 90213-3051. (813)761-2646. Producer: Doris Chu. Handles rock, country, pop, musicals, music videos and film. Photographers used for portraits, in-concert shots, studio shots, special effects for album covers, publicity, brochures, posters, event/convention coverage and product advertising. Works with freelance photographers on assignment basis only; gives 2-10 assignments/year.
Specs: Uses various sizes b&w and color prints, 35mm transparencies.
Making Contact: Arrange a personal interview to show portfolio; send unsolicited photos by mail for consideration; provide resume, business card, brochure, flyer or tearsheets to be kept on file for possible future assignments. SASE. Reports in 1 month.
Payment & Terms: Payment arranged individually. Credit line sometimes given. Buys all rights.
Tips: Looks for "good solid techniques, lighting, corporation."

***CAMEX INC.**, 489 5th Ave., New York NY 10017. (212)682-8400. President: Victor Benedetto. Handles rock, classical, country, S-T etc. Photographers used for portraits, in-concert shots, studio shots, special effects, album covers, inside album shots, publicity, brochures, posters, event/convention coverage, product advertising. Works with freelance photographers on an assignment basis only; gives "various" assignments/year.
Specs: Uses b&w and color prints (all sizes); 35mm, 2¼x2¼ transparencies.
Making Contact: Send unsolicited photos by mail for consideration, submit portfolio for review. Does not return unsolicited material. Reports in 1 month.
Payment & Terms: Pay negotiated. Buys one-time rights or all rights.

***CDE RECORDS**, Box 41551, Atlanta GA 30331. (404)344-7621. President: Charles Edwards. Handles soul, R&B, gospel and urban-contemporary. Photographers used for in-concert shots, studio shots, special effects, any creative photography for album covers, brochures. Works with freelance photographers on assignment basis only; gives various assignments/year.
Specs: Uses b&w or color prints.
Making Contact: Send any creative photograph that involves the music industry by mail for consideration. SASE. Reports ASAP.
Payment & Terms: Pay negotiated. Credit line given. Buys one-time rights.
Tips: "Freelancers are increasing with record companies. I predict a boom for the services of freelance photographers in upcoming years."

CLAY PIGEON INTERNATIONAL RECORDS, Box 20346, Chicago IL 60620. (312)778-8760. Contact: V. Beleska or Rudy Markus. Handles rock, pop, new wave and avant-garde. Photographers used for portraits, live action and studio shots, and special effects for albums, publicity flyers, brochures, posters, event/convention coverage and product advertising. Buys 100 photos and gives 10 assignments/year. Usually works with freelance photographers on assignment only basis. Provide resume, brochure and/or samples to be kept on file for possible future assignments.
B&W: Uses b&w.
Color: Uses color prints.
Making Contact: Query with resume and credits. Prefers to see a general idea of possibilites in a portfolio. SASE. Reports in 1 month. "We try to return unsolicited material but cannot guarantee it."
Payment & Terms: Negotiates payment per job. "We try to give credit lines." Purchase rights vary.
Tips: "Send something for our file so that we can keep you in mind as projects come up. Much of our shooting is in the Midwest but there are exceptions. We want innovative, yet viable work. You have a good chance with the smaller companies like ours, but please remember we have limited time and resources; thus, we can't tie them up interviewing prospective photographers or in screening applicants. Get our attention in a way that takes little time."

COMMAND RECORDS, (formerly Kent Washburn Productions), Box 1869, Hollywood CA 90078. (213)564-1008 or (213)466-3199. Contact: Kent Washburn. Handles R&B, gospel. Photographers used for album cover portraits, in-concert shots, studio shots, and special effects for album covers, inside album shots, publicity, brochures, posters. Works with freelance photographers on assignment basis only; gives 8 assignments/year.
Specs: Uses 8x10 color glossy prints and 2¼x2¼ transparencies.
Making Contact: Provide resume, business card, brochure, flyer or tearsheets to be kept on file for possible future assignments. SASE; "reply when needed."
Payment & Terms: Pays $200-1,400/job. Credit line given. Buys all rights.

CURTISS UNIVERSAL RECORD MASTERS, Box 4740, Nashville TN 37216. Manager: Susan D. Neal. Photographers used for live action shots and studio shots for album covers, inside album shots, posters, publicity flyers and product advertising. Buys 5 photos/year; gives 10 assignments/year. Works with freelance photographers on assignment only basis. Provide brochure, flyer and/or samples to be kept on file for possible future assignments. Negotiates payment. SASE. Reports in 3 weeks. Handles rock, soul, country, blues and rock-a-billy.
B&W: Uses 8x10 and 5x7.
Color: Uses 8x10 and 5x7.
Making Contact: Query with resume and credits; send material by mail for consideration; or submit portfolio for review. Prefers to see "everything photographer has to offer" in a portfolio. SASE. Reports in 3 weeks.
Payment & Terms: Negotiates payment per job and per photo. Credit line given. Buys one-time rights.

DANCE-A-THON RECORDS, 1957 Kilburn Dr., Atlanta GA 30324. Mailing address: Station K, Box 13584, Atlanta GA 30324. (404)872-6000. President: Alex Janoulis. Director, Creative Services: Patricia Johnson. Handles rock, country, jazz and middle-of-the-road. Photographers used for advertising and album photos. Gives 5 assignments/year. Pays $75-750/job. Credit line given. Buys all rights. Submit portfolio for review. Reports in 4 weeks.
B&W: Uses 8x8 and 8x10 prints. Pays $75-250.
Color: Uses 8x8 prints and 4x5 transparencies. Pays $100-350.
Tips: Send portfolio showing only what you are best at doing such as portraits, live action shots, special effects, etc. Only 3-4 shots maximum should be submitted. "Know your market—bizarre shots for heavy metal records, tranquil shots for gospel LP's, etc."

DAWN PRODUCTIONS LTD., Suite 1, 621 Park City Ctr., Lancaster PA 17601. President: Joey Welz. Freelance photographers supply 50% of photos. Uses photographers for in-concert and special effects for album covers. Submit photos by mail for consideration. Pays percentage of royalty on sales or LP. Rights vary; some photos purchased outright. Always gives photo credits.

***DELMARK RECORDS**, 4243 N. Lincoln, Chicago IL 60618. (312)528-8834. Art Director: Robert Koester. Handles jazz, gospel and blues records only. Photographers used for portraits, live action and studio shots and special effects for record album photos advertising illustrations and brochures. "We most frequently use 'found' work—photos already in existence of artists we record rather than assignments. We issued 2 LPs last year. Most had photos on covers." Buys 5-30 photos/year. Pays $25-100 b&w photo; $50-250/color photo; $25-250/job. Credit line given. Buys one-time rights and right to use

in ads and brochures. Arrange a personal interview to show portfolio. Prefers to see examples of creativity and technique and whatever artist feels best represents him in a portfolio. "It's best if the photographer is interested in jazz and blues. We prefer to work with local photographers." Provide resume, samples and tearsheets to be kept on file for possible future assignments. SASE. Reports in 1 week.
B&W: Prefers 11x14 prints. Payment depends on the sales potential of the album.
Color: Uses 2x2 or larger transparencies.
Tips: "We do prefer action shots and *room for copy in composition*. It is convenient for us to develop and establish long-standing relationships with a few good photographers rather than be constantly developing new sources."

***DESTINY RECORDING STUDIO**, 31 Nassau Ave., Wilmington MA 01887. Contact: Larry Feeney. Handles all types of records. Photographers used for portraits, in-concert shots, studio shots and special effects for album covers, publicity, brochures, posters and product advertising. Works with freelance photographers on assignment basis only; gives 4-6 assignments/year.
Making Contact: Provide resume, business card, brochure, flyer or tearsheets to be kept on file for possible future assignments. Does not return unsolicited material. Payment varies. Credit line sometimes given. Buys all rights, one-time rights, may reassign all rights to photographer after use.

DRG RECORDS INC., 157 W. 57th St., New York NY 10019. (212)582-3040. Managing Director: Rick Winter. Handles broadway cast soundtracks, jazz and middle-of-the-road records. Uses photographers for portraits and in-concert shots for album covers and inside album shots. Gives 4 assignments/year. Pays $150-500/job or on a per photo basis. Credit line given. Buys one-time rights. Arrange a personal interview to show portfolio. Does not return unsolicited work. Reports in 1 week.
B&W: Uses 11x14 prints. Pays $50-150/print.
Color: Uses prints; prefers transparencies. Pays $100-750/photo.
Tips: "Write us giving your interest in the record album printing market as it exists today and what you would do, design-wise, to change it."

***DYNAMITE RECORDS**, 5 Aldom Circle, W. Caldwell NJ 07006. (201)226-0035. Contact: Gidget Starr. Handles rock, country. Uses photographers for studio shots for publicity, posters.
Specs: Uses b&w prints and 8x10 transparencies.
Making Contact: Query with resume of credits and business card. Does not return unsolicited material. Reports in 1 month.
Payment & Terms: Credit line given. Buys all rights.

E.L.J. RECORDING CO., 1344 Waldron, St. Louis MO 63130. (314)863-3605. President: Edwin L. Johnson. Produces all types of records. Photographers used for musical shots and portraits for record album photos and posters. Freelance photographers supply 20% of photos, gives 8-12 assignments/year. Works with freelance photographers on assignment only basis. Provide samples to be kept on file for possible future assignments. Submit b&w and color samples of all types—scenics, people, etc.—by mail for consideration. SASE. Reports in 3 weeks. Pay and rights purchased by arrangement with each photographer.
Tips: "Send sample and prices."

EARTH RECORDS CO., Rt. 3, Box 57, Troy AL 36081. (205)566-7932. President: Eddie Toney. Handles all types of music. Photographers used for studio shots for album covers and product advertising. Works with freelance photographers on assignment basis only. Buys 5 photos/year.
Specs: Uses prints.
Making Contact: Arrange a personal interview to show portfolio or submit portfolio for review. SASE. Reports in 2 weeks.
Payment & Terms: Pays union rates/job. Credit line given. Buys one-time rights.

EPOCH UNIVERSAL PUBLICATIONS/NORTH AMERICAN LITURGY RESOURCES, 10802 N. 23rd Ave., Phoenix AZ 85029. (602)864-1980. Executive Vice President: David Serey. Publishes contemporary liturgical, inspirational records, music books and resource publications. Photographers used for covers and special effects for albums, posters and filler photos in music books. Buys 50-150 photos/year.
Specs: Uses 5x7 b&w/color glossy prints and 35mm, 2¼x2¼ transparencies.
Making Contact: Query with resume of credits or send inspirational shots, people shots, nature scenes. Urgently needs b&w photos of liturgical celebrations with congregation, musicians, celebrants. SASE. Reports in 1 month.
Payment & Terms: Pays $15-200 for stock pictures, depending on usage and rights. Credit line given. Buys one-time rights or all rights.

Tips: "Write David Serey, and enclose 4-5 samples for consideration. All work submitted is reviewed carefully. We like to keep photos on file, as filler photo needs pop up frequently and unexpectedly. The photographer who has work sitting in a file ready to use gets the space and the payment."

***FLEMING-BLUE ISLAND ENTERTAINMENT**, Box 171265, San Diego CA 92117. Manager: Bob Fleming. Handles rock and country & western. Photographers used for portraits, in-concert and studio shots for album covers, inside album shots, publicity flyers, brochures, posters, and event/convention coverage. Buys 100 photos and gives 50 assignments/year.
Specs: Uses 8x10 b&w and color glossy prints and 35mm, 2¼x2¼ and 4x5 transparencies.
Making Contact: Send "clear, crisp shots with SASE" by mail for consideration or submit portfolio for review. Reports in 3 weeks. Credit line given. Buys all rights.

***THE FLYING COWBOY JIMMY KISH**, Box 140316, Nashville TN 37214. (615)889-6675. Contact: Jimmy Kish. Handles country, western and gospel. Uses photographers for portraits, in-concert shots and studio-shots. SASE. Reports in 2 weeks.

GCS RECORDS, Suite 206, 1508 Harlem, Memphis TN 38114. (901)274-2726. Promotion Director: W.H. Blair. Handles R&B, blues, gospel, top forty. Photographers used for studio shots and special effects for inside album shots, publicity, brochures, posters, event/convention coverage and product advertising.
Specs: Gives 40 assignments/year. Buys 100 photos/year. Uses 8x10 b&w and color prints; 4x5 transparencies.
Making Contact: Arrange a personal interview to show portfolio; send unsolicited photos by mail for consideration; provide resume, business card, brochure, flyer or tearsheets to be kept on file for possible future assignment. Does not return unsolicited material. Reports in 1 month.
Payment & Terms: Credit line sometimes given. Buys all rights.

GMT PRODUCTIONS/RECORDS, Box 25141, Honolulu HI 96825. (808)533-3877, ext. 5088. President: Gil M. Tanaka. Handles all types of records. Photographers used for portraits, in-concert/studio shots and special effects for album covers, inside album shots, publicity flyers, brochures, posters, event/convention coverage and product advertising. Buys 10 photos and gives 12 assignments/year.
Specs: Uses 8x10 b&w/color glossy prints.
Making Contact: Send samples with specs listed above to be kept on file, query with resume of credits or submit portfolio for review. SASE. Reports in 3 weeks.
Payment & Terms: Payment negotiable. Credit line given. Buys all rights.

***GOLDEN RULE RECORD PRODUCTIONS INC.**, Box 11547 E. Station, Memphis TN 38111-0547. (901)525-5415. A&R: Style Wooten. Estab. 1981. Handles black gospel. Photographers used for album covers, inside album shots, publicity, brochures, posters, portraits. Works with freelance photographers on assignment basis only; gives 26 assignments/year.
Specs: Uses 8x10 glossy b&w prints.
Making Contact: Send unsolicited photos by mail for consideration; "pictures of groups you have taken." Reports in 1 month.
Payment & Terms: Payment varies, "depends on where the group is located." Credit line given. Buys all rights.

GRAMAVISION RECORDS, 260 West Broadway, New York NY 10013. (212)226-7057. Art Director: Dianna Calthorpe. Handles jazz. Photographers used for portraits, in-concert shots and special effects for album covers, inside album shots, publicity, posters, and event/convention coverage. Works with freelance photographers on assignment basis only; "gives 10 assignments/year."
Making Contact: Arrange a personal interview to show portfolio. Query with resume of credits. Provide resume, business card, brochure, flyer or tearsheets to be kept on file for possible future assignments. Reports in 6 weeks.
Payment & Terms: Payment negotiable.

GREENWORLD RECORDS, 20445 Gramercy Pl., Box 2896, Torrance CA 90509-2896. (213)533-8075. Handles rock (new wave, punk, heavy metal, progressive). Photographers used for in-concert shots, studio shots, and special effects for album covers, inside album shots, posters and product advertising. Buys 10 photos/year.
Specs: Uses any size or finish b&w or color prints.
Making Contact: Arrange a personal interview to show portfolio; send unsolicited photos of "anything interesting that would be appropriate for our use" by mail for consideration. SASE. Reporting time "varies—1 day to 1 month."

Close-up

Reginald Eskridge
Executive Director
GCS Records
Memphis, Tennessee

C. Kelly

Part of Reginald Eskridge's goal when starting GCS records was to expose the public to particular styles of music he felt were missing in the marketplace. In addition to producing a variety of radio advertisements, Eskridge has worked toward that goal by handling 40 artists who perform contemporary gospel, rhythm and blues, and soul music.

Eskridge formed this Memphis-based company in 1978 with knowledge accumulated from his college years as well as a specialized course in recording engineering, and internships served in music production and studio engineering. As executive director of GCS, he is well aware of competition in the record marketplace. Both Eskridge and his promotion manager, W.H. Blair, recognize the importance album covers play in the marketing role. "I tell the photographer his job is as important as the musician's. Records are so visual," Eskridge explains, "it (photography) is an important part of the product. Our album covers need to stand out in the record bin," he says. "They need to be eye catching and appealing, with vibrant colors. Many times if the performer isn't well known, the photograph will give an idea of what is contained on the record itself."

It is typical of record companies, Eskridge explains, to use the same photographers regularly. This is due to comfortable working relationships as well as the client's knowledge that the photographer has proven to be creative, and able to take a concept and run with it.

A photographer's samples, Eskridge says, should contain more than just creative subjects; they also should show attention to background visuals to further enhance that subject. And, photographers shooting for a record company will want to keep in mind where the album cover's graphics will be placed and make the photo work with that.

GCS uses 4x5 transparencies in order to obtain the desired sharpness for use on their 12x12 album covers. "Many times posters are made from these transparencies, so the larger the format, the better." About 30 percent of the subject shots are taken on location; the other 70 percent are composed in the studio, Eskridge says. During on-location shoots, photographers need to be aware of potentially distracting backgrounds, he emphasizes. "This is important to the cover shot."

In addition to album covers and posters, record companies like GCS also use photographers for recording artists' 8x10 black & white glossy publicity prints to release to magazines and newspapers. A large volume of GCS's market requests currently come from Canadian, European and Japanese publications, Eskridge says, where Temptations and Otis Redding-style soul music recorded at GCS is popular.

Freelancers interested in working with record companies should start with smaller, independent, local companies, he advises. "The beginner needs to accumulate samples of album cover work for his portfolio prior to soliciting larger companies." And the experience developed from working with these smaller, independent companies, will make them more likely to call you back for future jobs, as well, Eskridge adds.

Payment & Terms: Payment varies. Credit line given. Rights purchased varies.
Tips: "Record company budgets are being slashed. The prices charged (for photos) must reflect this but still keep quality high."

***HALPERN SOUNDS**, Box 1551, San Anselmo CA 94960-1551. (415)485-5755. President: Steven Halpern. Handles new age: relaxation, new acoustic jazz. Photographers used for special effects, nature shots, album covers. Works with freelance photographers on an assignment basis only.
Specs: Uses color prints; 2¼x2¼, 4x5 transparencies.
Making Contact: Send unsolicited photos by mail for consideration, submit portfolio for review. Wants to see innovative shots demonstrating new perspectives of natural beauty—i.e. rhythms of ripples of sand and surf (not "Hallmark" card quality). SASE. Reports in 1 month.
Payment & Terms: Pays $250-500/color photo. Credit line given. Buys one-time rights with rights to use photo in catalogs.

HAM-SEM RECORDS, 541 S. Spring St., Los Angeles CA 90013. (213)627-0557. President: William Campbell. Handles R&B and rock. Photographers used for portraits for brochures and product advertising. Buys 3-4 photos/year.
Specs: Uses 8x10 glossy b&w or color prints and 8x10 transparencies.
Making Contact: Provide resume, business card, brochure, flyer or tearsheets to be kept on file for possible future assignments. Reports in 1 month.
Payment & Terms: Payment negotiable. Credit line given if requested.

HARD HAT RECORDS & CASSETTES, 519 N. Halifax Ave., Daytona Beach FL 32018. (904)252-0381. President: Bobby Lee Cude. Handles country, pop, disco, gospel, MOR. Photographers used for portraits, in-concert shots, studio shots, special effects for album covers, publicity and posters. Works with freelance photographers on assignment basis only; gives varied assignments/year.
Specs: Uses 8x10 b&w glossy prints.
Making Contact: Provide resume, business card, brochure, flyer or tearsheets to be kept on file for possible future assignments. SASE. Does not return unsolicited material. Reports in 1 month.
Payment & Terms: Pays on a contract basis. Credit line sometimes given. Buys all rights.
Tips: "Submit credentials as well as work done for other record companies as a sample; also price, terms. Read *Billboard/MUSICIAN* magazines."

HEARTLAND RECORDS, 660 Douglas Ave., Altamonte Springs FL 32714. (305)788-2460. General Manager: David Brown. Handles contemporary Christian from rock to easy listening. Uses photographers for portraits, in-concert shots, studio shots, special effects for album covers, inside album shots and publicity.
Making Contact: Send unsolicited photos by mail for consideration; provide resume, business card, brochure, flyer or tearsheets to be kept on file for possible future assignments. Wants " 'artistic' shots, similar to those on Windham Hill Records." SASE. Reports in 1 month.
Payment & Terms: Payment negotiated individually. Credit line given. Rights purchased depends on the project.

HOMESTEAD RECORDS, 4926 W. Gunnison, Chicago IL 60630. President: Tom Petreli. Handles all types of records. Photographers used for portraits, in-concert shots, studio shots and special effects for album covers, inside album shots, publicity, brochures, posters and product advertising. Buys 25-40 photos/year.
Specs: Uses 8x10 b&w and color prints and 35mm and 4x5 transparencies.
Making Contact: Send unsolicited photos by mail for consideration. SASE. Reports in 1 month.
Payment & Terms: Pays $50-100/b&w photo; $125-2,000/color photo; $50-100/hour or $400-500/job. Credit line given. Buys all rights.

HULA RECORDS, INC., Box 2135, Honolulu HI 96805. (808)847-4608. President: Donald P. "Flip" McDiarmid III. Handles Hawaiian and traditional. Photographers used for portraits, in-concert shots, studio shots, special effects, and scenics for album covers, inside album shots, publicity, brochures, posters and product advertising. Works with freelance photographers on assignment basis only; gives 12 assignments/year.
Specs: Uses color prints and 35mm transparencies.
Making Contact: Arrange a personal interview to show portfolio; send scenic photos by mail for consideration; submit portfolio for review; provide resume, business card, brochure, flyer or tearsheets to be kept on file for possible future assignments. SASE. Reports in 2 weeks.
Payment & Terms: Pays $50 minimum/color photo. Credit line given. Buys one-time or all rights.

HYBRID RECORDS, Box 333, Evanston IL 60204. (312)274-9126. Art Director: Mike Rodgers. Handles all types of records. Photographers used for portraits, in-concert shots, studio shots and special effects for album covers, inside album shots, publicity, brochures, posters, event/convention coverage, product advertising and "other forms of creative merchandising." Number of photos bought/year varies.
Specs: Uses 8x10 matte or glossy color prints or 35mm transparencies.
Making Contact: Send "something that shows your best work, by mail for consideration—anything with women, i.e., flashy disco covers is nice," or submit portfolio for review. SASE. Reports ASAP.
Payment & Terms: Payment negotiable. Credit line given. Negotiates rights purchased.
Tips: Prefers to see "energy, flash and uniqueness" in photographer's portfolio. "Give us your best shot or don't bother."

J & J MUSICAL ENTERPRISES, Suite 1103, 150 Fifth Ave., New York NY 10011. (212)691-5630. General Manager: Jude St. George. Handles progressive. Uses photographers for in-concert shots, studio shots and special effects for inside album shots and publicity. Works with freelance photographers on an assignment basis only.
Specs: Uses 8x10 glossy b&w prints.
Making Contact: Provide resume, business card, brochure, flyer or tearsheets to be kept on file for possible future assignments. Does not return unsolicited material. Reports in 1 month.
Payment & Terms: Payment negotiated individually. Credit line given. Buys all rights.

JAY JAY RECORD CO./BONFIRE RECORDS, 35 NE 62nd St., Miami FL 33138. (305)758-0000. President: Walter Jay. Handles jazz, modern and polka. Photographers used for portraits for album covers, publicity, brochures and posters. Works with freelance photographers on assignment basis only.
Specs: Uses b&w and color glossy prints.
Making Contact: Submit portfolio for review. Does not return unsolicited material. Reports in 1 month.
Payment & Terms: "Photographer must give price." Credit line given.

***JODY RECORD CO.**, 2557 E. 1st St., Brooklyn NY 11223. (718)339-8047. A&R Director: Vince Vallis. Handles rock, jazz, country, pop. Photographers used for studio shots for album covers, posters. Works with freelance photographers on assignment only.
Specs: Uses b&w prints; 4x5 and 8x10 transparencies.
Making Contact: Send unsolicited photos by mail for consideration. Reports in 3 weeks.
Payment & Terms: Credit line given.

KENNING PRODUCTIONS, Box 1084, Newark DE 19711. (302)731-5558. President: Kenny Mullins. Handles rock, country, blues, bluegrass and folk. Photographers used for portraits, in-concert shots, studio shots and special effects for album covers, inside album shots, publicity, brochures, posters, event/convention coverage and product advertising. Works with freelance photographers on assignment basis only; gives 25-50 assignments/year.
Specs: Uses 8x10 b&w and color glossy prints and 35mm and 8x10 transparencies.
Making Contact: Provide resume, business card, brochure, flyer or tearsheets to be kept on file for possible future assignments. Does not return unsolicited material. Reports in 1 month-6 weeks.
Payment & Terms: Pays $50-100/b&w photo; $75-150/color photo. Credit line given. Buys all rights.

KIDERIAN RECORD PRODUCTS, 4926 W. Gunnison, Chicago IL 60630. (312)764-1144. President: Raymond Peck. Handles rock, classical, country. Photographers used for portraits, in-concert shots, studio shots and special effects for album covers, inside album shots, publicity, brochures, posters and product advertising. Buys 35-45 photos/year.
Specs: Uses b&w or color prints and 35mm or 8x10 transparencies.
Making Contact: Send unsolicited photos by mail for consideration. SASE. Reports in 1 month.
Payment & Terms: Pays $50-100/b&w photo. Credit line given. Buys all rights.

SID KLEINER ENTERPRISES, 3701 25th Ave. SW., Naples FL 33964. Director: Sid Kleiner. Freelance photographers supply 20% of photos. Uses subject matter relating to health, food, mental health, music, sex, human body, etc. Query with resume of credits or send samples. SASE. Pays $25/photo. Rights negotiable.

K-TEL INTERNATIONAL, INC., 15535 Medine Rd., Plymouth MN 55447. (612)932-4000. Creative Product Manager: Sherry Morales. Handles "a wide variation of musical selections." Photographers used for portraits, studio shots, special effects, and "imagery" for album covers, posters, product advertising, and P-O-P merchandise. Works with freelance photographers on assignment basis only; gives 1-10 assignments/year.

Specs: Uses 35mm, 2¼x2¼, 4x5 or 8x10 transparencies.

Making Contact: Send b&w and color prints and contact sheets by mail for consideration; provide resume, business card, brochure, flyer or tearsheets to be kept on file for possible future assignments. Does not return unsolicited material. Reporting time "depends on use and timing."

Payment & Terms: "All art is purchased via negotiation." Credit line given "when applicable." Buys all rights; "other situations can be reached for terms agreed upon."

Tips: Prefers to see "imagery and mood, both in scenery and people in samples. For our soft rock/love theme albums, we could use women in soft focus or ?? Our packages are mainly compilations of musical artists—we therefore are looking for imagery, both in scenery and people: 'mood photos', etc."

L.R.J. RECORDS, 1700 Plunkett Ct., Box 3, Belen NM 87002. (505)864-7441. President: Little Richie Johnson. Handles country and bilingual records. Photographers used for record album photos. Credit line given. Send material by mail for consideration.

LEGEND RECORDS & PROMOTIONS, 1102 Virginia St. SW, Lenoir NC 28645. (704)758-4170. President: Mike McCoy. Handles rock, old rock, blues, bluegrass, gospel, rockabilly, country/western. Uses photographers for studio shots, posters for music stores, for album covers, publicity, posters, product advertising and promotion kits. Works with freelance photographers on an assignment basis only; gives 9 assignments/year.

Specs: Uses 5x7 and 8x10 b&w and color prints.

Making Contact: Send unsolicited photos by mail for consideration or submit portfolio for review. Send photos of "work done on album covers of singers, etc." SASE. Reports in 2 weeks.

Payment & Terms: Pays $27-40/color photo; $25-35/hour for b&w photos. Credit line given. Buys all rights.

Tips: "Wants to see something new in photography. Be honest. Offer good rates and new ideals."

***LEGS RECORDS—A.J. PROMOTIONS**, 825 5th St., Menasha WI 54952. (414)725-4467. Executive President: Lori Lee Woods (artist). Manager: Jean M. Wilson. Handles rock, country, MOR, gospel. Photographers used for studio shots and special effects for publicity and posters. Works with freelance photographers on assignment basis only.

Specs: Uses 8x10 glossy b&w and color prints, and 35mm transprencies.

Making Contact: Submit portfolio for review; provide resume, business card, brochure, flyer or tearsheets to be kept on file for possible future assignments. Does not return unsolicited material. Reports in 3 weeks.

Payment & Terms: Credit line given. Buys all rights.

Tips: Prefers to see sexy but conservative, different, down to earth photos.

***LEMON SQUARE PRODUCTIONS**, Box 31819, Dallas TX 75231. (214)690-4155. Owner: Bart Barton. A&R Director: Mike Anthony. Handles country and gospel. Photographers used for portraits, live action shots and special effects for album covers, publicity flyers and posters. Works with freelance photographers on assignment only basis. Provide resume and samples to be kept on file for possible future assignments.

Color: Uses 8x10 prints.

Making Contact: Send material by mail for consideration or submit portfolio for review. Prefers to see creativity, abilities and thought in a portfolio. SASE. Reports in ASAP.

Payment & Terms: Negotiates payment per job. Credit line given. Buys all rights.

LIN'S LINES, Suite 1103, 150 Fifth Ave., New York NY 10011. (212)691-5630. President: Linda K. Jacobson. Estab. 1984. Handles all types of records. Uses photographers for portraits, in-concert shots, studio shots for album covers, inside album shots, publicity, brochures, posters and product advertising. Works with freelance photographers on an assignment basis only; gives 6 assignments/year.

Specs: Uses 8x10 prints; 35mm transparencies.

Making Contact: Query with resume of credits; provide resume, business card, brochure, flyer or tearsheets to be kept on file for possible future assignments. "Do not send unsolicited photos." SASE. Reports in 1 month.

Payment & Terms: Credit line given. Rights purchased varies.

Tips: Prefers unusual and exciting photographs. "Send *interesting* material."

***LOCONTO PRODUCTIONS & RECORDING STUDIOS**, 7766 NW 44 St., Sunrise FL 33321. (305)741-7766. Executive Vice President: Phyllis Loconto. Handles "all types" of records. Photographers used for portraits, studio shots, for album covers, inside album shots, publicity, brochures, posters, event/convention coverage, product advertising.

Specs: Varied.

Payment & Terms: Pays/job; negotiated. Credit line given. Buys all rights.
Tips: "I manage 'events' promotions—always interested in creative photography."

LUCIFER RECORDS, INC., Box 263, Brigantine NJ 08203. (609)266-2623. President: Ron Luciano. Photographers used for portraits, live action shots and studio shots for album covers, publicity flyers, brochures and posters. Freelancers supply 50% of photos. Provide brochure, calling card, flyer, resume and samples. Purchases photos for album covers and record sleeves. Submit portfolio for review. SASE. Reports in 2-6 weeks. Payment negotiable. Buys all rights.

LEE MAGID, Box 532, Malibu CA 90265. (213)858-7282. President: Lee Magid. Handles jazz, C&W, gospel, rock, blues, pop. Photographers used for portraits, in-concert shots, studio shots, and candid photos for album covers, publicity, brochures, posters and event/convention coverage. Works with freelance photographers on assignment basis only; gives about 10 assignments/year.
Specs: Uses 8x10 b&w or color buff or glossy prints and 2¼x2¼ transparencies.
Making Contact: Send print copies by mail for consideration. SASE. Reports in 2 weeks.
Payment & Terms: Credit line given. Buys all rights.

MARICAO RECORDS/HARD HAT RECORDS, 519 N. Halifax Ave., Daytona Beach FL 32018. (904)252-0381. President: Bobby Lee Cude. Handles country, MOR, pop, disco and gospel. Photographers used for portraits, in-concert shots, studio shots and special effects for album covers, inside album shots, publicity, brochures, posters, event/convention coverage and product advertising. Works with freelance photographers on assignment basis only; gives 12 assignments/year.
Specs: Uses b&w and color photos.
Making Contact: Submit portfolio for review; provide resume, business card, brochure, flyer, tearsheets or samples to be kept on file for possible future assignments. SASE. Reports in 2 weeks.
Payment & Terms: Pays "standard fees." Credit line sometimes given. Rights purchased negotiable.
Tips: "Submit sample photo with SASE along with introductory letter stating fees, etc. Read *Billboard/ Musician* and *Variety*."

MASTER-TRAK ENTERPRISES, Box 1345, Crowley LA 70526. (318)783-1601. General Manager: Mark Miller. Handles rock, soul, country & western, Cajun, Zydeco, blues. Photographers used for portraits, studio shots and special effects for album covers and publicity flyers. Buys 20-25 photos/year.
Specs: Uses b&w/color prints and 35mm, 2¼x2¼ and 4x5 transparencies.
Making Contact: Send samples with specs listed above by mail for consideration or submit portfolio for review. Does not return unsolicited material. Reports in 1 month.
Payment & Terms: Payment varies. Credit line given. Buys one-time rights.

MEADOWLARK VENTURES or CHRIS ROBERTS REPRESENTS, Box 7218, Missoula MT 59807. (406)728-2180. Owner/Art Director: Chris Roberts. Handles rock under the label Metal ARC records. Uses photographers for portraits, in-concert shots, studio shots and special effects for album covers, brochures, posters. "We are a photographers representative company." Buys 8-15 photos/year.
Specs: Uses 35mm and 4x5 transparencies.
Making Contact: Arrange a personal interview to show portfolio; send unsolicited photos by mail for consideration; submit portfolio for review; provide resume, business card, brochure, flyer or tearsheets to be kept on file for possible future assignments. SASE. Reports in 3 weeks.
Payment & Terms: Pays $10-50/b&w photos, $15-250/color photo. Credit line given. Buys one-time rights.

MEAN MOUNTAIN MUSIC, 926 W. Oklahoma Ave., Milwaukee WI 53215. (414)483-6500. Contact: M.J. Muskovitz. Handles rock, blues, R&B, rockabilly. Photographers used for portraits, in-concert shots and studio shots for album covers, publicity, brochures and product advertising. Works with freelance photographers on assignment basis only.
Specs: Buys 5x7 b&w prints and 35mm and 2¼x2¼ transparencies.
Making Contact & Terms: Send photos of "recording artists from the 1940s-1960s (examples: Gene Vincent, Buddy Holly, John Lee Hooker, Beatles, Johnny Burnette, etc.)" by mail for consideration. Does not return unsolicited material. Reports in 1 month.
Payment & Terms: Pays $5-50/b&w photo. Credit line given. Buys all rights.
Tips: "School not important. Experience and knowledge of past recording artists with samples of past work most important. Since we are in most cases looking for only photos from the 1940s thru the 1960s, the freelancer must have been active during this period of time."

MIRROR RECORDS, INC., KACK KLICK, INC., 645 Titus Ave., House of Guitars Building, Rochester NY 14617. (716)544-3500. Manager: Kim Simmons. Handles rock, blues and popular records. Photog-

raphers used for portraits, live and studio shots and special effects for album photos, advertising, publicity, posters, event/convention coverage and brochures. Buys 20 photos and gives 15 assignments/year. Pays per job. Credit line given. Buys all rights. Send material by mail for consideration or submit portfolio for review. Prefers to see photographer's control of light and color and photos with album covers in mind in a portfolio. SASE. Reports in 3 weeks.
B&W: Uses 5x7, 12½x12½ prints.
Color: Uses prints and transparencies.

***MOTOWN RECORD CORP.**, Graphics Dept., 16th Floor, 6255 Sunset Blvd., Los Angeles CA 90028. (213)468-3500. Art Director: Johnny Lee. Handles R&B, pop, very little rock. Photographers used for portraits, studio shots, special effects, on-location-type shots for album covers, inside album covers, publicity, posters. Works with freelance photographers on assignment basis only; gives 50-100 assignments/year.
Specs: Uses 2¼x2¼ and 4x5 transparencies.
Making Contact: Query with resume of credits; provide resume, business card, brochure, flyer or tearsheets to be kept on file for possible future assignments; or drop off policy. SASE. Reports in 2 weeks.
Payment & Terms: Pay negotiated. Credit line given. Buys one-time rights.
Tips: Prefers to see "anything you are good at doing."

MYSTIC OAK RECORDS, 1727 Elm St., Bethlehem PA 18017. (215)865-1083. Talent Coordinator: Bill Byron. Handles rock and classical, new wave and punk. Photographers used for portraits, in-concert shots, studio shots, and special effects for album covers, inside album shots, publicity, brochures and posters.
Specs: Uses 8x10 b&w or color glossy prints and 35mm transparencies.
Making Contact: Provide resume, business card, brochure, flyer or tearsheets to be kept on file for possible future assignments. Does not return unsolicited material. Reports in 3-6 weeks.
Payment & Terms: Payment varies according to distribution and artist. Credit line given. Rights purchased varies, usually one-time rights.
Tips: "Send resume and examples of previous work used in album content or record promotion. We use freelance photographers (or artists) on most projects because we find we get very creative results. Be extremely creative and do not be afraid of being new and trendsetting. We now also have 2 inhouse photographers, and are looking to add more."

NUCLEUS RECORDS, Box 111, Sea Bright NJ 07760. President: Robert Bowden. Handles rock, country. Photographers used for portraits, studio shots for publicity, posters and product advertising. Works with freelance photographers on assignment basis only.
Making Contact: Send still photos of people by mail for consideration. SASE. Reports in 3 weeks.
Payment & Terms: Pays $50-75/b&w photo; $75-100/color photo; $50 minimum/job. Credit line given. Buys all rights.

***ON TIME RECORDS, INC.**, Box 314, New York NY 10037. Director of Artist Development: Mr. D.N.A. Estab. 1980. Handles black, R&B, soul, pop, "hits of all kind!" Photographers used for portraits, in-concert shots, studio shots and special effects for album covers, inside album shots, publicity, posters. Sometimes works with freelance photographers on an assignment basis only; gives 12 assignments/year.
Specs: Uses 8x10 b&w and color prints; 8x10 transparencies.
Making Contact: Query with resume of credits; send unsolicited photos by mail for consideration; submit portfolio for review. Does not return unsolicited material. Reports in 1 month.
Payment & Terms: Credit line sometimes given. Buys all rights.

ORIGINAL CAST RECORDS; BROADWAY/HOLLYWOOD VIDEO PRODUCTIONS; BROADWAY/HOLLYWOOD FILM PRODUCTIONS, Box 10051, Beverly Hills CA 90213-3051. (818)761-2646. Executive Producer: Ms. Chu. Handles pop & rock, broadway musicals (original casts), C&W, AOR, operettas, etc. Photographers used for portraits, live and studio shots, and special effects for albums, publicity flyers, brochures, posters, event/convention coverage and product advertising. Buys 30 + photos and gives 15 assignments/year. Provides resume and samples to be kept on file for possible future assignments.
B&W: Uses 8x10 glossies.
Color: Uses prints and transparencies.
Making Contact: Arrange a personal interview to show portfolio or query with resume and credits. "Prefer interview with portfolio. Contact by phone and try another day if I am out." Prefers to see "clear, well-composed b&w and color photos. We also use slides for our video production work." Also interested in movie film in a portfolio. SASE. Reports in 1 month.

Payment & Terms: Pays $1-75 per job, $1-75 for b&w and minimum $1 for color. Credit line given. Buys one-time and all rights depending on need.
Tips: Currently working on film and TV production.

***ORINDA RECORDS**, Box 838, Orinda CA 94563. (415)254-7600. Executive Vice President: C.J. Black. Estab. 1984. Handles rock, classical, pop, jazz. Photographers used for portraits, studio shots and special effects for album covers and posters.
Specs: Uses 8x10 color prints and 35mm transparencies.
Making Contact: Submit portfolio for review; provide resume, business card, brochure, flyer or tearsheets to be kept on file for possible future assignments. Does not return unsolicited material. Reports in 3 weeks.
Payment & Terms: Credit line given. Buys all rights.
Tips: A cover must sell the product inside.

***PERPETUA RECORDS/REALTIME RECORDS**, 10391 Jefferson, Culver City CA 90232. (213)204-2854. President: Ken Kreisel. Handles classical and jazz. Photographers used for portraits, in-concert shots, studio shots, and special effects for album covers, inside album shots and posters. Buys 10 photos/year.
Specs: Uses 35mm 2¼x2¼ transparencies.
Making Contact: Provide resume, business card, brochure, flyer or tearsheets to be kept on file for possible future assignments. Does not return unsolicited material. Reports in 1 month or "as needed."
Payment & Terms: Pays $150-350/color photo. Credit line given. Buys all rights.

PETER PAN INDUSTRIES, 88 Frances, Newark NJ 07105. (201)344-4214. Art Director: John McKinzie. Handles all types of records and books. Photographers used for portraits, in-concert shots, studio shots, special effects and product photography for album covers, inside album shots, publicity, brochures, posters, event/convention coverage and product advertising. Works with freelance photographers on assignment basis only.
Specs: Uses b&w and color prints and 35mm, 2¼x2¼, 4x5 and 8x10 transparencies.
Making Contact: Arrange a personal interview to show portfolio. SASE.
Payment & Terms: Pays $40-45/b&w photo; $45-55/color photo.

PRAISE SOUND PRODUCTIONS LTD., (formerly Praise, Ind.), 7802 Express St., Burnaby, British Columbia V5J 4V6 Canada. (604)420-4227. Manager: Metro Yaroshuk. Handles gospel. Uses photographers for portraits, in-concert shots, studio shots for album covers and brochures. Buys 10 freelance photos/year.
Specs: Uses 8x10 prints.
Making Contact: Send unsolicited photos by mail for consideration. Likes to see modum senic shots.

THE PRESCRIPTION CO., 70 Murray Ave., Port Washington NY 10050. (516)767-1929. President: David F. Gasman. General Manager: Mitch Vidur. Handles rock, soul and country & western. Photographers used for portraits, in-concert/studio shots and special effects for album covers, inside album shots, publicity flyers, brochures, posters, event/convention coverage and product advertising. Works with freelance photographers on assignment only basis. "Record label currently not active but music production and publishing continue."
Specs: Uses b&w/color prints.
Making Contact: To arrange interview to show portfolio, "send us a flyer or some photos for our files." Does not return unsolicited material. "We want nothing submitted."
Payment & Terms: Payment negotiable. Rights purchased negotiable.
Tips: "Send us a flyer or some photos for our files. We're only a small company with sporadic needs. If interested we will set up an in-person meeting. There is always need for good photography in our business, but like most fields today, competition is growing stiffer. Art and technique are important, of course, but so is a professional demeanor when doing business."

PRIME CUTS RECORDS, 439 Tute Hill, Lyndonville VT 05851. (802)626-3317. President: Bruce James. Handles rock. Photographers used for in-concert shots, studio shots, and special effects for publicity, brochures, posters and product advertising. Gives 10 freelance assignments/year. Buys 4 photos/year.
Specs: Uses 4x5 color matte prints.
Making Contact: Provide resume, business card, brochure, flyer or tearsheets to be kept on file for possible future assignments. Does not return unsolicited material. Reports in 1 month.
Payment & Terms: Credit line given. Buys all rights.
Tips: Prefers to see "creative, exciting, colorful publicity photos."

PRO/CREATIVES, 25 W. Burda Pl., Spring Valley NY 10977. President: David Rapp. Handles pop and classical. Photographers used for record album photos, men's magazines, sports, advertising illustrations, posters and brochures. Buys all rights. Query with examples, resume of credits and business card. Reports in 1 month. SASE.

RANDALL PRODUCTIONS, Box 11960, Chicago IL 60611. (312)561-0027. President: Mary Freeman. Handles all types except classical music. Photographers used for in-concert shots, studio shots, and video for album covers, brochures, posters, and concert promotion/artist promotion. Works with freelance photographers on assignment basis only; gives 20 assignments/year.
Specs: Uses all sizes of b&w or color glossy prints and 35mm, 2¼x2¼, 4x5 or 8x10 transparencies.
Making Contact: Send surrealism, new concept, idealistic, or abstract material by mail for consideration; provide resume, business card, brochure, flyer or tearsheets to be kept on file for possible future assignments. "Call (312)561-0027 to receive application that will be kept on file until assignments arise." SASE if you wish to have material returned. Reports "when needs arise."
Payment & Terms: Pays $15-25/b&w photo; $25-40/color photo; $15-25/hour; $30-100/day; $30-150/job. Buys all rights "but will negotiate."
Tips: "Freelancers have just as much to contribute as any photographer, if not more. Because of the nature of the business, record companies tend to lean towards seeking unknowns, because their styles are usually, in our opinion, more unique."

RECORD COMPANY OF THE SOUTH, 5220 Essen Ln., Baton Rouge LA 70806. (504)766-3233. Art Director: Ed Lakin. Handles rock, R&B and white blues. Photographers used for portraits and special effects for album covers, inside album shots and product advertising. Buys 10 photos and gives 5 assignments/year. Works with freelance photographers on assignment only basis. Provide samples to be kept on file for possible future assignments.
Specs: Uses 8x10 b&w prints and 4x5 transparencies.
Making Contact: Send samples with specs listed above to be kept on file. Does not return unsolicited material. Reports in 2 weeks.
Payment & Terms: Pays $125-650/b&w photo; $250-1,000/color photo; $30-50/hour; $300-1,000/job. Credit line given. Rights purchased subject to agreement.
Tips: Prefers to see "Norman Seef photos at Ed Lakin prices. All of our acts are based in the Deep South. We find it more productive to work with photographers based in our area."

REDBUD RECORDS, A Division of CAE, Inc., 611 Empire Mill Rd., Bloomington IN 47401. (812)824-2400. General Manager: Rick Heinsohn. Handles folk, jazz and pop. Photographers used for portraits, in-concert shots, studio shots and special effects for album covers and brochures. Works with freelance photographers on assignment basis only; gives 2 assignments/year. Buys 5 photos/year.
Making Contact: Provide resume, business card, brochure, flyer or tearsheets to be kept on file for possible future assignments.
Payment & Terms: Payment depends on the job. Credit line given "sometimes." Buys all rights.

REVONAH RECORDS, Box 217, Ferndale NY 12734. (914)292-5956. Contact: Paul Gerry. Handles bluegrass, country and gospel. Photographers used for portraits and studio shots for album covers.
Specs: Uses 8x10 glossy b&w and color prints and 2¼x2¼ transparencies.
Making Contact: Arrange a personal interview to show portfolio or send unsolicited photos by mail for consideration; provide resume, business card, brochure, flyer, tearsheets or samples to be kept on file for possible future assignments. SASE. Reports in 1 month.
Payment: Pays $5-25/b&w photo and color photo. Credit line given. Buys all rights.
Tips: Prefers to see "a little of everything so as to judge the photographer's capability and feeling. Must look at work first—then perhaps a personal meeting."

RIPSAW RECORD CO., #805, 4545 Connecticut Ave. NW, Washington DC 20008. (202)362-2286. President: Jonathan Strong. Handles rockabilly. Photographers used for in-concert shots and studio shots for album covers, publicity, brochures and posters. Buys 0-5 photos/year.
Specs: "Depends on need."
Making Contact: Send "material we might use" by mail for consideration. SASE. Reporting time "depends on free time; we try to be considerate and return as promptly as possible."
Payment & Terms: Pays by the job. Credit line given. Buys all rights.

RMS TRIAD PRODUCTIONS, 6267 Potomac Circle, West Bloomfield MI 48033. (313)661-5167. Contact: Bob Szajner. Handles jazz. Photographers used for portraits, in-concert/studio shots and special effects for album covers and publicity flyers. Gives 3 assignments/year. Works with freelance photographers on assignment only basis. Provide samples to be kept on file for possible future assignments.
Specs: Uses 35mm and 2¼x2¼ transparencies.

Making Contact: Query then submit portfolio for review. Does not return unsolicited material. Reports in 3 weeks.
Payment & Terms: Negotiates payment by the job. Buys all rights.

ROB-LEE MUSIC, Box 1338, Merchantville NJ 08109. President: R.L. Russen. Handles rock, middle-of-the-road and rhythm & blues. Photographers used for portraits, live and studio shots and special effects for album covers, publicity flyers, brochures and posters. Buys 36 photos and gives 6 assignments/year. Works with freelance photographers on assignment only basis. Provide resume, calling card, brochure, flyer and/or samples to be kept on file for possible future assignments.
B&W: Uses 8x10 glossies.
Color: Uses 5x7 and 8x10 prints.
Making Contact: Send material by mail for consideration or submit portfolio for review. Prefers to see variety, style, technique and originality in a portfolio. SASE. Reports in 2 weeks.
Payment & Terms: Pays $50-300/b&w photo; $100-500/color photo; $25-100/hour or $300-1,000/job. Credit line given. Buys all rights.

ROCKWELL RECORDS, Box 1600, Haverhill MA 01831. (617)373-6011. President: Bill Macek. Produces top 40 and rock and roll records. Buys 8-12 photos and gives 8-12 assignments/year. Freelancers supply 100% of photos. Photographers used for live action shots, studio shots and special effects for album covers, inside album shots, publicity, brochures and posters. Photos used for jacket design and artist shots. Arrange a personal interview; submit b&w and color sample photos by mail for consideration; or submit portfolio for review. Provide brochure, calling card, flyer or resume to be kept on file for possible future assignments. SASE. Local photographers preferred, but will review work of photographers from anywhere. Payment varies.
Subject Needs: Interested in seeing all types of photos. "No restrictions. I may see something in a portfolio I really like and hadn't thought about using."

ROSE RECORDS COMPANY, INC., 922 Canterbury Rd., NE, Atlanta GA 30324. President: Mario W. Peralta. Handles MOR. Photographers used for in-concert shots, studio shots and special effects for album covers. Works with freelance photographers on assignment basis only.
Specs: Uses 8x10 color prints and 4x5 transparencies.
Making Contact: Send photos of "sexy girls (please, not nudes), beautiful landscapes and unusual and different types of photography" by mail for consideration or submit portfolio for review; provide resume, business card, brochure, flyer, tearsheets or samples to be kept on file for possible future assignments. Does not return unsolicited material. Reports in 1 month.
Payment & Terms: Pays $100 minimum/color photo; $50/hour. Credit line given. Buys all rights.

***RUSHWIN PRODUCTIONS**, Box K-1150, Buna TX 77612. (409)423-2521. Manager: James Gibson. Estab. 1985. Handles Christian; all styles. Photographers used for portraits, in-concert shots, studio shots, special effects for album covers, publicity, brochures, posters. Works with freelance photographers on assignment basis only; gives "various" assignments/year.
Specs: Uses 4x5 transparencies.
Making Contact: Send color print, matte finish photos by mail for consideration; provide resume, business card, brochure, flyer or tearsheets to be kept on file for possible future assignments. SASE. Reports in 1 month.
Payment & Terms: Pay varies/job. Credit line given. Buys all rights.

SHEPERD RECORDS, 2307 N. Washington Ave., Scranton PA 18509. (717)347-7395, 343-3031. Handles pop/rock. Photographers used for portraits, in-concert shots, studio shots and special effects for album covers, publicity and posters. Buys 15-25 photos/year.
Specs: Uses 8x10 b&w or color prints.
Making Contact: Query with resume of credits; send photos by mail for consideration. Does not return unsolicited material. Reports in 1 month.
Payment & Terms: Pays $25-100/b&w photo; $50-100/color photo. Credit line given. Buys one-time rights.

SP COMMUNICATIONS GROUP, INC./DOMINO RECORDS, Duck Creek Station Annex, Box 475184, Garland TX 75047. Vice President, Public Relations: Mr. Steve Lene. Handles adult contemporary, country, black, dance, jazz and international including major motion picture and national network television soundtracks and national television and radio jingles. Uses photographers for portraits, in-concert shots, studio shots, special effects, on location still shots of major feature films and national television and radio productions and commercials for album covers, inside album shots, publicity, brochures, posters, event/convention coverage and product advertising. Works with freelance photogra-

phers on an assignment basis only; "assignments vary according to number of projects we're working with."

Specs: Uses 8x10 glossy b&w or color prints.

Making Contact: Send unsolicited photos by mail for consideration. Needs "event/convention coverage shots; product advertising and marketing shots and tearsheets; sports portraits and sports events/convention coverage shots; and other entertainment personalities shots. Please identify subjects and personalities of photographs submitted." Does not return unsolicited material. Reports in 1 week.

Payment & Terms: Payment negotiated individually. Credit line given. "Usually rights purchased with photos are all rights but we have on occasion purchased the rights with photos as one-time rights. Rights are negotiable at times, but solely depend upon the nature of the project."

Tips: "All photographs submitted will also be reviewed for possible publication in our upcoming entertainment magazine publication, thus providing a continuous opportunity of national exposure in a national entertainment publication on a regular basis. Follow our company format outlined in Photographer's Market on material submitted. We are now accepting baseball related photos for our new publication 'Baseball Pioneer Journal.' Interested in older, original photographs as well as current players."

THE SPARROW CORPORATION, 9255 Deering Ave., Chatsworth CA 91311. (818)709-6900. Production Manager: Jean Hoefel. Handles rock, classical, worship, and children's albums. Uses photographers for portraits, studio shots for album covers, inside album shots, publicity, brochures, posters, event/convention coverage, product advertising, cassette inserts and mobiles. Works with freelance photographers on an assignment basis only; gives 10 assignments/year.

Specs: Uses 8x10 color prints; 2¼x2¼ transparencies.

Making Contact: Provide resume, business card, brochure, flyer or tearsheets to be kept on file for possible future assignments. SASE. Reports "if artist calls for feedback or when we decide to use the photos."

Payment & Terms: Pays $300-1,000/job. Credit line given. Buys all rights.

Tips: "Prefer to see people shots, close-up faces, nice graphic design and elements included. Send clean-cut samples with wholesome images. No nude models, etc. Be friendly, but not pushy or overbearing. Freelancers have very good chances. We are moving towards more detailed photo sets and designs that can carry a theme and using elements which can be used separately or together according to need. We have incorporated a new instrumental series and are always looking for mood shots."

SQN ENTERTAINMENT SOFTWARE CORP., 27 Dryden Lane, Providence RI 02904. (401)521-2010. Contact: Director of Creative Services. Handles classical and jazz. Photography used as cover images per classical/jazz records, cassettes, compact discs, children's audio/video product lines, shape-up health and fitness audio/video, under-sail video and *Entertainment Software* magazine. Photographers used for album covers. Works with freelance photographers on assignment basis only; gives 100 assignments/year.

Specs: Uses 35mm, 2¼x2¼ and 4x5 transparencies.

Making Contact: Call Creative Department (401)521-2010, or send unsolicited photos by mail for consideration; provide resume, business card, brochure, flyer or tearsheets to be kept on file for possible future assignments. Submissions should consist of "whatever the photographer considers to be most representative of the depth and breadth of his/her capabilities." SASE. Reports in 1 month.

Payment & Terms: All rates are negotiable. Credit line given. Buys exclusive album cover rights.

SONIC WAVE RECORDS, Box 256577, Chicago IL 60625. (312)764-1144. President: Tom Petreli. Handles new wave punk. Photographers used for in-concert shots, studio shots and special effects for album covers, inside album shots, publicity, brochures and posters. Works with freelance photographers on assignment basis only; gives 25-50 assignments/year.

Specs: Uses b&w and color prints, and 35mm and 8x10 transparencies.

Making Contact: Provide resume, business card, brochure, flyer or tearsheets to be kept on file for possible future assignments. SASE. Reports in 1 month.

Payment & Terms: Pays $50-100/b&w photo; $100-200/color photo; $25-50/hour; $125-300/job. Credit line given. Buys all rights.

***SOUNDS OF WINCHESTER**, Rt. 2, Box 116 H, Berkeley Springs WV 25411. Contact: Jim McCoy. Handles rock, gospel and country. Photographers used for portraits and studio shots for album covers, publicity flyers and brochures. Provide brochure to be kept on file for possible future assignments.

***STATUE RECORDS**, 11818 Felton Ave., Hawthorne CA 90250. (213)978-8830. A&R Director: Lincoln Damerst. Estab. 1982. Handles all forms of "rock" music and comedy. Uses photographers for special effects, album covers, in-concert shots, studio shots for inside album shots, publicity, event/convention coverage, product advertising. Works with freelance photographers on assignment basis only; gives 10-15 assignments/year.

Specs: Uses 8x10 glossy b&w prints; 35mm, 4x5, 8x10 transparencies.
Making Contact: Send unsolicited photos by mail for consideration; submit portfolio for review; provide resume, business card, brochure, flyer or tearsheets to be kept on file for possible future assignments. "Currently establishing 'Photographer File'." Wants to see something suitable for album covers. Unique and innovative. Photos of unique paintings considered. Does not return unsolicited material. Reports in 2-3 weeks.
Payment & Terms: "All rates and salaries are completely open to negotiation." Credit line given. Buys all rights "unless agreed upon otherwise in writing."
Tips: Prefers to see "documentary" event photos: concerts, parties, casual on location and studio posed. Unique innovative album cover-type shots of all types. "Be creative, this sells records. Don't forget computer graphics! Always include a business card and expected pay. Outlook looks good. We don't plan to have an 'inhouse' photographer so we will always use freelancers."

***TAKE HOME TUNES!**, Box 10051, Beverly Hills CA 90213-3051; and Box 1314, Englewood Cliffs NJ 07632. (818)761-2646. Production Assistant: Miya Fuji. Handles musicals, rock, pop. Uses photographers for portraits, in-concert shots, studio shots on album covers, inside album shots, publicity, brochures, posters, event/convention coverage, product advertising. Works with freelance photographers on an assignment basis only; gives 2 assignments/year.
Specs: Uses 8½x10 glossy b&w and color prints; 35mm transparencies.
Making Contact: Provide resume, business card, brochure, flyer or tearsheets to be kept on file for possible future assignments. Prefers to see best work—postcard size or larger. SASE. Reports in 1 month.
Payment & Terms: Credit line sometimes given. Buys all rights.

TEROCK RECORDS, Box 4740, Nashville TN 37216. Secretary: S.D. Neal. Handles rock, soul and country records. Uses photographers for in-concert and studio shots for album covers, inside album shots, publicity flyers, brochures, posters and product advertising. Pays per job. "Photographers have to set a price." Credit line given. Send material by mail for consideration. SASE. Reports in 3 weeks.

THIRD STORY RECORDS, INC., 5120 Walnut St., Philadelphia PA 19139. (215)386-5987. Promotion Coordinator: Alexandra Scott. Publishing Director: John O. Wicks. Handles rock, country, gospel. Photographers used for portraits and in-concert shots for album covers, publicity and product advertising. Works with freelance photographers on assignment basis only; gives 4-5 assignments/year.
Specs: Uses 8x10 b&w glossy prints.
Making Contact: Arrange a personal interview to show portfolio; send unsolicited photos by mail for consideration. Submissions should consist of professional quality, promotion shots for printed packages. Does not return unsolicited material. Reports in 2-3 weeks.
Payment & Terms: Credit line given. Buys all rights.
Tips: Prefers to see "pictures that look professional and make the subject look 'real' " in a portfolio. Photographer should provide "good prices, personality and good shots. I think the recording industry is a great market for photographers. We are a small company, so we don't require their services very often. But, with the video scene growing, everyone wants to 'see.' There are many uses for photography in the record field."

RIK TINORY PRODUCTIONS, Box 311, Cohasset MA 02025. (617)383-9494. Art Director: Claire Babcock. Handles rock, classical, country. Photographers used for portraits, in-concert shots, studio shots, and special effects for album covers, inside album shots, publicity, brochures, posters and event/convention coverage.
Specs: Uses 8x10 b&w prints and 2¼x2¼ transparencies.
Making Contact: Query first. Does not return unsolicited material.
Payment & Terms: Pays "flat fee—we must own negatives." Credit line given. Buys all rights plus negatives.
Tips: "Be good, fast and dependable."

TROD NOSSEL ARTISTS, 10 George St., Box 57, Wallingford CT 06492. (203)265-0010. Contact: Director of Promotion. Handles rock, soul, contemporary. Photographers used for portraits, in-concert shots, studio shots and special effects for album covers, publicity, posters and product advertising. Works with freelance photographers on assignment basis only; gives 1-10 assignments/year.
Specs: Uses 5x8 b&w and color prints, and 35mm and 2¼x2¼ transparencies.
Making Contact: Provide resume, business card, brochure, flyer, tearsheets or samples to be kept on file for possible future assignments. Reports in 1-3 weeks.
Payment & Terms: Credit line given. Buys all rights.
Tips: "Submit previous work and short resume—*with your goals and purposes* well defined."

TYSCOT RECORDS, 3532 N. Keystone Ave., Indianapolis IN 46218. (317)923-3343. President: Leonard Scott. Handles gospel. Uses photographers for portraits, in-concert shots, studio shots and special effects for album covers, inside album shots, publicity and posters. Works with freelance photographers on an assignment basis only; number of assignments/year varies.
Specs: Uses 8x10 prints.
Making Contact: Send unsolicited photos by mail for consideration or submit portfolio for review; provide resume, business card, flyer or tearsheets to be kept on file for possible future assignments. Does not return unsolicited material. Reports in 1 month.
Payment & Terms: Payment negotiated individually. Credit line given. Buys all rights.

***UPSWING PRODUCTIONS**, c/o Jacobson & Colfin, Suite 1103, 150 5th Ave., New York NY 10011. (212)691-5630. Vice President: Bruce Colfin. Handles rock, reggae, pop, country. Photographers used for in-concert shots, studio shots, special effects, album covers, publicity, brochures, posters, product advertising. Works with freelance photographers on an assignment basis only; gives 2-10 assignments/ year.
Specs: Uses b&w and color prints.
Making Contact: Query with resume of credits; provide resume, business card, brochure, flyer or tearsheets to be kept on file for possible future assignments. SASE. Reports in 2 weeks.
Payment & Terms: Pay negotiable. Credit line given. Buys one-time rights and all rights.

MIKE VACCARO MUSIC SERVICES/MUSIQUE CIRCLE RECORDS, Box 7991, Long Beach CA 90807. Contact: Mike Vaccaro. Handles classical. Photographers used for portraits, in-concert shots, studio shots, special effects for album covers, publicity, brochures, event/convention coverage and product advertising. Works with freelance photographers on assignment basis only; gives 2-3 assignments/year.
Making Contact: Arrange a personal interview to show portfolio; query with resume of credits; send unsolicited photos by mail for consideration or submit portfolio for review; provide resume, business card, brochure, flyer or tearsheets to be kept on file for possible future assignments. Does not return unsolicited material. Reports as needed.
Payment & Terms: Payment, credit line and rights purchased are negotiated.
Tips: "Flexibility in many styles and special effects" is advisable.

***VALHALLA RECORDS**, Suite 404, 299 Madison Ave., New York NY 10017. (212)687-3210. Vice President: Greg Thornwood. Handles rock only. Photographers used for in-concert shots, studio shots and special effects for album covers, inside album shots, publicity. Works with freelance photographers on assignment basis only; gives various assignments/year.
Specs: Uses b&w prints.
Making Contact: Query with resume of credits. SASE. Reports in 3 weeks.
Payment & Terms: Pay varies. Credit line given. Buys all rights.
Tips: Prefers a great feel for the rock idiom/medium.

***WANDON MUSIC COMPANY**, Box 1436 FDR Sta., New York NY 10150. (212)888-7838. Managing Director: Steven Trombetti. Estab. 1982. Handles MOR. Photographers used for portraits, in-concert shots, studio shots for album covers, publicity, brochures. Works with freelance photographers on assignment basis only; gives 6 assignments/year.
Specs: Uses 2¼x2¼ transparencies.
Making Contact: Provide resume, business card, brochure, flyer or tearsheets to be kept on file for possible future assignments. Does not return unsolicited material.
Payment & Terms: Credit line given on albums only. Buys all rights.

***WINDHAM HILL PRODUCTIONS, INC.**, 831 High St., Palo Alto CA 94301. (415)329-0647. Art Director: Anne Robinson. Handles mostly jazz oriented, acoustic music. Uses freelance photographers for portraits, art shots for covers, inside album shots, posters. Buys 20-30 freelance photos/year.
Specs: Uses 35mm, 2¼x2¼, 4x5, 8x10 transparencies. "Please send dupes, if we want more accurate version we will ask for original." Arrange a personal interview to show portfolio, submit portfolio for review. SASE. Reports in 1 month.
Payment & Terms: Payment varies. Credit line given. Buys one-time rights or all rights, "depends on the nature of the product."
Tips: "I am not looking for variations of shots we have already used. I am looking for unusual points of view, generally of natural subjects, without people, animals, etc. Become acquainted with our covers before submitting materials. Send materials that have personal significance. I am not merely looking for technically excellent work. I want work with heart."

Stock Photo Agencies

There comes a point in many professional photographers' lives when it becomes too difficult to maintain their photographic stock and still have time to continue shooting new stock on a regular basis. Stock photo agencies have emerged in answer to this problem. Such agencies catalog and stock the works of dozens or more photographers, as well as handle all marketing and sales arrangements on their behalf. Don't count on stock photo sales to pay all the bills however; there is no guarantee to how many of your photos will sell within a given time period. The photographer who supplements his stock photography with editorial or advertising photography is provided with a nice additional income, usually paid on a monthly or quarterly basis.

Many stock photo agencies prefer to limit their stable of photographers for two good reasons. It's easier to represent a handful of photographers, becoming well versed in the subject matter they shoot, so marketing their images to the appropriate buyers is more efficient. Second, a small clientele contributing large numbers of photographs on a regular basis increases the photographer's chance of making some good sales. Pay attention to the term "large numbers." Many stock agencies require that new photographers contribute upfront at least 1,000 images to their files, then keep building up that file on a regular basis with a few hundred additional photos. Most stock agencies handle color transparencies because that is what outside photo buyers frequently ask for, but a large percentage of agencies also deal, to a lesser degree, with black and white prints.

Be aware from the start that many stock photo agencies require a commission of 40 to 50 percent. If this seems excessive, consider that a stock agency already knows which markets are likely candidates for its photographers' work. The agency also can sell to more buyers at once than you would have the time to, and at a better price than you might be able to get. Before you start querying agencies, remember that magical number of 1,000 transparencies mentioned earlier. That number must be made up of the very best images you have available, otherwise no agency will be willing to invest its time in you.

While there are some large, well-established agencies in New York City, many newer and more specialized agencies are springing up all over the country. These specializations range from sports, celebrities and health-care material to travel destinations, animal and high-tech images. These agencies offer advantages to the freelancer in search of a stock agent: Their specialization makes it easier to find markets that would be interested in your work. Also, since they're newer they will be more receptive to queries from photographers, and they can offer more personalized service to the photographers they represent.

When you decide to query a stock photo agency, be sure to read the Making Contact instructions contained in each agency listing in this section. Most stock agencies prefer to be queried by mail. Include a list of the stock photo subjects you have on file. If the agency is interested, they may have you send a representative selection to them so they can review your work. If you are accepted, you can count on being expected to supply the agency with fresh photos on a regular basis. Stock photography has to be current in terms of subjects and style; they can't use material that's obviously dated. You also should be aware of the need for obtaining a model release as often as is possible, since in stock sales no one can guess whether the photo purchased will be for editorial or advertising use.

AFTERIMAGE, INC., Suite 250, 3807 Wilshire Blvd., Los Angeles CA 90010. (213)467-6033. Interested in all subjects, particularly color photos of model released contemporary people. Sells to advertising and editorial clients. Pays 50% commission. General price range: ASMP rates. Photographers must have a review. Send SASE for submission guidelines.
Tips: "Photographer needs at least 3,000 to 5,000 good quality originals of varied subject matters."

AIR PIXIES, Rt. 4, Box 330, Bedford NY 10506-9804. (212)486-9828. President: Ben Kocivar. Has 150,000 photos. Clients include advertising agencies, public relations firms, businesses, book publishers, magazine publishers, encyclopedia publishers, newspapers, postcard companies, calendar companies and greeting card companies. Buys photos outright; pays $50-1,000. Pays 50% commission. General price range: $100-1,000. Offers one-time rights or first rights. Model release and captions required. Photos solicited on assignment only. SASE. Reports in 2 weeks.
Subject Needs: Professional aerial photography, especially of major cities; also science, boats, cars.
B&W: Uses 8x10 prints.
Color: Uses prints.
Tips: "Our clients are requesting more color prints."

AMERICAN STOCK PHOTOS, 6842 Sunset Blvd., Hollywood CA 90028. (213)469-3908. Contact: Daryl O'Neil or Belle James. Has 2½ million b&w prints and 250,000 color transparencies. Clients include advertising agencies, public relations firms, businesses, AV firms, book publishers, magazine publishers, encyclopedia publishers, newspapers, postcard companies, calendar companies, greeting card companies, and churches and religious organizations. Does not buy outright; pays 40% commission/b&w, 50% commission/color. Offers one-time rights. Model release required; captions preferred. Send material by mail for consideration or "drop it off for review." SASE. Reports on queries in 1 day, on submitted materials in 2 weeks-30 days. Free photo guidelines with SASE; tip sheet distributed "irregularly—about twice a year" free to any photographer for SASE.
Subject Needs: "Everything—animals, scenics, points of interest around the world, people doing anything, festive occasions, sports of all types, camping, hiking. We have a few customers that buy shots of young couples in pleasant surroundings. No stiffly posed or badly lit shots."
B&W: Uses prints; contact sheet OK.
Color: Uses 35mm, 2¼x2¼ and 4x5 transparencies.
Tips: "Be patient on sales. Get releases; look through magazines and see what's popular; try and duplicate the background shots. B&w still a good seller—and not many doing it so market is open and begging for new work."

AMWEST PICTURE AGENCY, 1595 S. University, Denver CO 80210. (303)777-2770. President: Luke Macha. Has 150,000 photos. Clients include advertising agencies, public relations firms, businesses, book publishers, magazine publishers, encyclopedia publishers, postcard companies, calendar companies and poster companies. Does not buy outright; pays 50% commission. Offers one-time rights. Model release and captions required. Arrange a personal interview to show portfolio or send material by mail for consideration. SASE. Reports in 3 weeks. Free photo guidelines; tips sheet distributed periodically to established contributors.
Subject Needs: American West scenics, wildlife, nature, people in professions, scientific photography, recreational and sport activities, food, beverages, dining. In product photography, brands should not be identifiable.
B&W: Uses 8x10 glossy, dried matte double weight prints.
Color: Uses 35mm or larger transparencies.

ANIMALS ANIMALS/EARTH SCENES, (formerly Animals Enterprises), 17 Railroad Ave., Chatham NY 12037. (518)392-5500. Branch office: 9th Floor, 65 Bleeker St., New York NY 10012. (212)982-4442. President: Nancy Henderson. Has 600,000 photos. Clients include advertising agencies, public relations firms, businesses, AV firms, book publishers, magazine publishers, encyclopedia publishers, newspapers, post card companies, calendar companies and greeting card companies. Does not buy outright; pays 50% commission. Offers one-time rights; other uses negotiable. Model release required if used for advertising; captions required. Send material by mail for consideration. SASE. Reports in 1-2 months. Free photo guidelines with SASE. Tips sheet distributed regularly to established contributors.

 The asterisk before a listing indicates that the listing is new in this edition. New markets are often the most receptive to freelance contributions.

Amwest Picture Agency President Luke Macha is marketing this photo by Charles G. Summers, Jr. of Aurora, Colorado. To date the photograph has earned more than $7,000. It was used by the London Museum of Natural History and as a ²/₃ page spread in Stern Magazine *(West Germany). The photo, explains Summers, conveys "behavior and action" by portraying the baby cheetah on the back of the springbok. This photograph, entered in a contest by Macha, won Summers the prestigious Wildlife Photographer of the Year (1985) Award, which was presented in London.*

Subject Needs: "We specialize in nature photography with an emphasis on all animal life."
B&W: Uses 8x10 glossy or matte prints.
Color: Uses 35mm and some larger format transparencies.
Tips: "First, precdit your material. Second, know your subject. We need captions including Latin names, and they must be correct!"

***ANTHRO—PHOTO FILE**, 33 Hurlbut St., Cambridge MA 02138. (617)868-4784, 497-7227. President/Owner: Nancy S. Devore. Stock photo agency. Has approximately 10,000 color photos, 2,000 b&w photos. Clients include book/encyclopedia publishers, magazine publishers, newspapers.
Subject Needs: Anthropology and biology.
Specs: Uses 8x10 glossy b&w prints; 35mm, 2¼x2¼ transparencies.
Payment & Terms: Pays 60% commission on photos. General price range: ¼ page inside use—North-American rights b&w: $90/color; $135 and up from there. Sells one-time rights. No model release if documentary; captions required.
Making Contact: Query with samples. SASE.
Tips: Prefers to see behavioral photos.

APERTURE PHOTOBANK INC., 1530 Westlake Ave. N., Seattle WA 98109. (206)282-8116. Contact: Marty Loken or Gloria Grandaw. Has 400,000 photos of all subjects, with emphasis on the U.S. West Coast, western Canada and Alaska. Clients include advertising agencies, corporations, graphic designers, PR firms and publishers. Subject needs include recreation, high tech, travel, industries, wildlife, cities and towns, scenics, transportation—heavy emphasis on "people doing things" and photos that visually define a particular city, region or country (primarily attractions, travel destinations, industries, recreation possibilities). "We deal in color and strongly prefer Kodachrome originals in the 35mm format, and Ektachrome in larger formats. (Please do not send off-brand transparencies; they will not be accepted.)"

Specs: Uses 35mm, 2¼x2¼, 4x5, 5x7 and 8x10 color transparencies.

Payment & Terms: Does not buy outright; pays 50% commission "immediately upon receipt of payment from clients—not 3-6 months later. We follow ASMP rates. One-time use of color ranges from $175 to $1,500, generally—the lower figure being for a modest, local editorial usage; the higher figure being for a national consumer magazine ad." Offers one-time rights, first rights, rarely all rights. Model releases required when appropriate; captions always required (on wide edge of slide mounts).

Making Contact: Send submissions by mail, certified or registered, including return postage but not return envelope ("we prefer to use our own shipping materials"). Reports in 3 weeks. "Please submit photos that indicate the range of your photo coverage—both geographic and subject range—with all indication of the total number of photos available in different subject areas. Initial sampler should be fairly small—perhaps 100 photos—to be followed, upon invitation, by far larger submissions." Distributes newsletter, including want list, to photographers under contract.

Tips: "We are a small, responsive agency—an outgrowth of a regional stock photo library, AlaskaPhoto, that we launched in early 1979. We're looking for long-term relationships with top professional photographers, especially in the U.S. and Canada, and stock all imaginable subjects. (We do not stock many abstracts, nudes or fine-art images.) To make submissions, please assemble a portfolio of 100-200 transparencies in vinyl sheets, including an inventory of additional photos that could be submitted. We are selective, and only represent photographers who can place 2,000-10,000 images in our files. We also handle assignments for photographers under contract. Our standard contract is for a three-year period; no demands for exclusivity. Please do not send questionnaires."

ASSOCIATED PICTURE SERVICE, 394 Nash Circle, Mableton GA 30059. Has 25,000 photos. Clients include advertising agencies, AV firms, book publishers, magazine publishers, encyclopedia publishers and calendar companies. Does not buy outright; pays 50% commission. General price range: $500. Offers one-time rights. Model release required. Query with SASE. Reports in 2 weeks.

Subject Needs: Nature, historical points, city/suburbs, scenics.

Color: Uses 35mm transparencies only.

A-STOCK PHOTO FINDER (ASPF), Suite 30-F, 1030 N. State St., Chicago IL 60610. (312)645-0611. General Manager: Joanne Maenza. Has access to 1 million photos. Clients include primarily advertising agencies, but also public relations firms, businesses, AV firms, book publishers, magazine publishers, encyclopedia publishers, newspapers, postcard companies, calendar companies, greeting card companies, poster companies and others.

Specs: Uses 35mm, 2¼x2¼, 4x5, 8x10 and 11x14 etc., color transparencies and color contact sheets.

Payment & Terms: Pays 50% commission on leases. Commission payments made upon collection from clients. General price range: $75-2,000. Offers one-time rights or first rights. Copies of model releases required *at time of* submission; releasability status indicated on each transparency in *red* ink (R; NR). Cover letter with submission list and short, to-the-point captions required at time of submission.

Making Contact: Send samples and list of stock photo subjects. SASE. Complete kits with submission guidelines supplied on request. Tips sheets distributed regularly; also bimonthly newsletter.

Tips: "ASPF is known as 'Chicago's Image Marketplace—where the advertising professional calls for stock photographic art.' ASPF's standards are very high; the company is in pursuit of excellence. Please approach us only if you know you are excellent! This company's management is very strong, marketing-oriented, and agressive in the marketplace."

BERG & ASSOCIATES, Suite 203, 8334 Clairemont Mesa Blvd., San Diego CA 92111. (619)292-8257. Contact: Margaret C. Berg. Has 100,000 photos. Clients include advertising agencies, public relations and AV firms, businesses, textbooks/encyclopedia and magazine publishers, newspapers, post card, calendar and greeting card companies.

Subject Needs: Children, including ethnic and handicapped groups—all ages (playing, at school, sports, interacting); careers, business, industry; medical; sports and recreation; underwater; tourism; agriculture; families doing things together.

Specs: Uses color transparencies only; 35mm.

Payment & Terms: Pays 50% commission. Sells one-time rights, first rights or "special rights for specific time period." Model release and captions preferred.

Making Contact: Photo guidelines free with SASE. Query with list of stock photo subjects; and list geographical areas covered. Send photos by mail for consideration. SASE. Reports in 6 weeks. Tips sheet distributed periodically only "to those with photos in stock. *Don't* send photos before studying guidelines."

Tips: "For 35mm color, send 100 maximum. Kodachrome only. Package carefully. If you want photos returned by insured mail, include insurance cost. Remember most printed pages are vertical. We need photographers from other parts of the country. Especially looking for tourism, hi-tech, science, wildlife, city skylines, business, industry, manufacturing and service industries. Families, school scenes, sports and recreation always in high demand."

BERNSEN'S INTERNATIONAL PRESS SERVICE, LTD., 50 Fryer Court, San Ramon CA 94583. Contact: Simone Cryns-Lubell. Clients include public relations firms, book, magazine and encyclopedia publishers, newspapers and tabloids.
Subject Needs: "All general interest subjects: people, achievements, new inventions in all fields, bizarre topics for photo feature. All subjects need to be photographed in *action/people-orientation*.
Payment & Terms: Will either buy outright or handle on commission. Willing to buy rights for certain specified countries. Will buy second rights. Captions required.
Making Contact: By letter, listing types of subjects covered, preferably with some contact sheets or cuttings from published work. SASE. Reports in 2 to 3 weeks.
Tips: "We particularly need good picture stories of unusual sports and men's activities. Also good human interest stories such as 'the world's tallest woman', 'the child that can't cry', 'the woman who married three brothers', etc."

***BERNSEN'S INTERNATIONAL PRESS SERVICE LTD. (BIPS)**, 9 Paradise Close, Eastbourne, E. Sussex England BN20 8BT. Phone: (0323) 28760. Editor: E.L. Habets. International feature and stock picture agency founded 1945 with branch offices in USA, Germany, Italy, Holland, Belgium and Sweden. Clients include newspapers and magazines throughout the world. Stock library of more than 2,000,000 b&w and more than 600,000 color images.
Subject Needs: All general interest photo features suitable for sale on an international basis.
Specs: Uses b&w prints; 35mm transparencies.
Payment & Terms: Varies according to subject. General price range: $45/photo. Will also handle material on commission and handle second rights.
Making Contact: Query by letter in first instance, including contacts and/or cuttings. Reports within 30 days. Our leaflet "Guidelines for Photojournalists" free with two International Reply Coupons.

***BIOLOGICAL PHOTO SERVICE**, Box 490, Moss Beach CA 94038. (415)726-6244. Photo Agent: Carl W. May. Stock photo agency. Has 80,000 photos. Clients include advertising agencies, businesses, book/encyclopedia publishers, magazine publishers.
Subject Needs: All subjects in the life sciences, including agriculture, natural history and medicine. "Stock photographers must be scientists."
Specs: Uses 4x5-11x14, glossy, strong contrast b&w prints; 35mm, 2¼x2¼, 4x5, 8x10 transparencies. "Dupes acceptable but photographer should understand some clients will not consider them."
Payment & Terms: Pays 50% commission on b&w and color photos. General price range: $70-350, sometimes higher for advertising uses. Offers one-time rights. "Photographer is consulted during negotiations for buyouts, etc." Model release required for non-educational use; captions required.
Making Contact: Query with list of stock subjects and resume of scientific and photographic background. SASE. Reports in 2 weeks. Photo guidelines free with SASE. Tips sheet distributed intermittently to stock photographers only.
Tips: "When samples are requested, we look for proper exposure, maximum depth of field, adequate visual information and composition, and adequate technical and general information in captions. Requests fresh light and electron micrographs of traditional textbook subjects; applied biology such as bioengineering, agriculture, industrial microbiology, and medical research; biological careers. We avoid excessive overlap among our photographer/scientists."

BLACK STAR PUBLISHING CO., INC., 4th Floor, 450 Park Ave. S., New York NY 10016. (212)679-3288. President: Howard Chapnick. Has 2 million b&w and color photos of all subjects. Clients include magazines, advertising agencies, book publishers, encyclopedia publishers, corporations and poster companies. Does not buy outright; pays 50% commission. Offers first North American serial rights; "other rights can be procured on negotiated fees." Model release, if available, should be submitted with photos. Call to arrange an appointment, submit portfolio, or mail material for consideration. Reports in 2-3 weeks. SASE. Free photo guidelines.
B&W: Send 8x10 semigloss prints. Interested in all subjects. "Our tastes and needs are eclectic. We do not know from day to day what our clients will request. Submissions should be made on a trial and error basis. Our only demand is top quality."
Color: Send 35mm transparencies.
Tips: "We are interested in quality and content, not quantity. Comprehensive story material welcomed."

***D. DONNE BRYANT STOCK PHOTOGRAPHY**, Box 80155, Baton Rouge LA 70898. (504)769-1419. President: Douglas D. Bryant. Stock photo agency. Has 150,000 photos. Clients include advertising agencies, audiovisual firms, book/encyclopedia publishers, magazine publishers.
Subjects: The D. Donne Bryant Stock Photography Agency specializes in picture coverage of Latin America with emphasis on Mexico, Central America, South America and the Caribbean Basin. Eighty

percent of picture rentals are for editorial usage. Important subjects include agriculture, anthropology/ archeology, art, commerce and industry, crafts, education, festivals and ritual, geography, history, indigenous people and culture, museums, parks, religion, scenics, sports and recreation, subsistence, tourism, transportation, urban centers.

Specs: Uses 8x10 glossy b&w and 35mm, 2¼x2¼ and 4x5 color transparencies.

Payment & Terms: Pays 50% commission on b&w and color photos. General price range: $85-400. Offers one-time rights. Model release preferred; captions required.

Making Contact: Query with resume of credits and list of stock photo subjects. SASE. Reports in 1 month. Photo guidelines free with SASE. Tips sheet distributed every 6 months to agency photographers.

Tips: Prefers to see "developed picture stories related to one of the subject interests listed above. Would like to see more coverage of commerce and industry, as well as better coverage of the modern urban environment in Latin American countries. There is a decreasing interest in Latin America Indians and ruins and an increasing interest in the modern and dynamic urban Latin culture. A photographer interested in shooting Latin scenics will make sales through the DDB Stock Agency, but a photographer who is willing to photograph inside modern schools, factories, and hospitals will make far more."

CLICK/CHICAGO LTD., Suite 503, 213 West Institute Place, Chicago IL 60610. (312)787-7880. Photonet ID PHO 1113. Directors: Connie Geocaris, APA; Don Smetzer, ASMP. President: Barbara Smetzer, ASPP. Vice President: Brian Seed, APA. "*Click* has an extensive general file of both b&w and color pictures (all formats), with an especially large and current collection on Chicago and on international travel. Click is an agent in the USA for the photographs published in the Berlitz travel guides. Over 80 titles are currently in print. A quarterly newsletter is published in order to promote photographers travels and the work in their files. Photonet is also used to promote our photographers and their work. Clients include advertising agencies, major corporations, publishers of textbooks, encyclopedias, AV programs and filmstrips, trade books, magazines, newspapers, calendars, greeting cards. We actively seek assignments and sell stock photos, on an international basis using ASMP guidelines."

Subject Needs: Children, families, couples (with releases), agriculture, industry, new technology, pets, landmarks, national parks, European cities, transportation (planes, trains, trucks, ships), the sea and the seashore, and the midwestern USA-/all subjects including cities, agriculture, industry, geography and travel.

Payment & Terms: Works on 50% of stock sales and 25% of assignments.

***CNK ENTERTAINMENT**, Box 1642, Staten Island NY 10314. (718)356-9578. President: Chris Paladino. Stock photo agency. Has 5,000 photos. Clients include public-relations firms, magazine publishers, newspapers.

Subject Needs: Primarily live concert photos of music performers; also informal party, backstage, etc.

Specs: Uses 8x10 glossy or matte b&w and color prints; 35mm transparencies; b&w and color contact sheets.

Payment & Terms: Pays 50% commission on b&w and color photos. General price range: $10-500. Offers one-time rights or all rights. Captions preferred.

Making Contact: Arrange a personal interview to show portfolio, query with list of stock photo subjects, submit portfolio for review. SASE. Reports in 1 week. Photo guidelines free with SASE.

Tips: Prefers to see live photos of past or current performers—prefer to see some emotion. "We need people who shoot well in low and erratic light—but we're willing to look at what you have."

BRUCE COLEMAN, INC., 381 5th Ave., New York NY 10016. (212)683-5227. Telex 429 093. Contact: Stuart L. Craig, Jr. File consists of over 750,000 original color transparencies on all subjects including natural history, sports, people, travel, industrial, medical and scientific. Clients include major advertising agencies, public relations firms, corporations, magazine and book publishers, calendar companies, greeting card companies, AV firms, and jigsaw puzzle publishers. 350 photographers.

Subject Needs: "All subjects other than hot news."

Specs: Uses original color transparencies. "If sending 35mm, send only Kodachrome or Fujichrome professional transparencies."

Payment & Terms: Does not buy outright; pays 50% commission. Offers one-time rights. Model release preferred; captions required.

Making Contact: Write for details first. Large SASE. Reports in 4-6 weeks. Periodic "want list" distributed to contributing photographers.

Tips: "Edit your work very carefully. Include return postage with submission if you wish material returned. Photograph subject matter which interests you and do it better than anyone else. Don't try to copy other photographers because they're probably doing the work better! We need first rate original work. As the field becomes more competitive, there is more concentration on subject matter. Most photographers possess adequate technical skills, but a lack of imagination. Foreign markets are a major source for sales for our photographers."

Close-up

Brian Seed
Vice President
CLICK/Chicago Ltd.
Chicago, Illinois

Connie Geocaris

The photography profession has been a part of London-
born Brian Seed's world since he was 14 years old.
Through his first job, just after WWII, as an office boy/
photographer's assistant in the London office of Time Inc.,
he developed the skills that five years later put him in the
position of contract photographer for *Time*, *LIFE* and *SPORTS ILLUSTRATED*. Until
1979 when he came to America on a long-term assignment, Seed traveled the globe
shooting for such publications as *Fortune*, *US News and World Report*, *Esquire*, *London Ob-
server*, *New York Times*, and *Time-Life Books*.

When he established a family in the U.S., Seed decided to dedicate himself to more perma-
nently based photography work. With Don and Barbara Smetzer, he co-founded Chicago-
based Click in 1981. Click now incorporates Atoz Images and is in its sixth year. Seed esti-
mates Click's image files contain 800,000 predominantly color pictures which are sold both
nationally and internationally to diverse clients ranging from corporate, design, advertising
and AV firms, to special interest and general magazines, newspapers, book publishers, and
calendar, post card and poster companies.

Photographers interested in stock sales should heed one piece of advice—to edit their work
carefully before it is submitted. "The mistake," Seed explains, "comes with the attitude,
'well, those agency people are the experts. I'll send them everything.' At the agency end, the
editor is then drowning in material which is not up to the required standard. A carefully edited
selection of high-quality images will get into the files and be earning money quite quickly."

In addition to editing photos rigorously, Seed emphasizes, it is important to submit good
photo captions. These should be written or typed onto the photo mount, he says, not on sepa-
rate sheets. Good captions are essential, and they will help sell an image both to the agency
editor and to clients.

What sort of picture volume should stock photographers be generating? Seed requests an
initial selection of 200 photographs showing the range of a photographer's work. If this work
proves to be of interest, another 1,000 images should be available so that a meaningful file
can be set up at the agency. This isn't a hard and fast figure, Seed points out, because certain
specialized or technical subjects won't generate the same quantity of photos more general
topics would. The ideal photographer, according to Seed, is the person who would hypotheti-
cally say, " 'I'll start you off with a thousand photographs, then every three months send an-
other 200-300.' We can then see a file developing," Seed says, "that would generate income
for the photographer and ourselves." Seed compares submission of images to buying lottery
tickets; the more tickets one buys, the greater the chances of winning. "Quality is vitally im-
portant, of course," he says, "but numbers and variety of subject matter count as well."

When initially contacting an agency, be ready with information about your status as a pho-
tographer, the kind of equipment and the type of film that you use, the amount and type of im-
ages that currently comprise your file, and your commitment to the business of steadily
generating more stock images. "You need to establish upfront if you have something that will
be of interest to the agency concerned," Seed explains.

COMMUNITY FEATURES, Box 1062, Berkeley CA 94701. Contact: Photo Editor. Most clients are newspapers. Uses 250-280 prints/year. Pays $15-200 a photo or 50% commission. Offers various rights. Model release and captions preferred. Uses photo stories and captioned photo spreads. Send material by mail for consideration. Previously published work welcome. Work returned only if SASE is enclosed. Reports in 5-6 weeks. Photo guidelines available for $1.
Subject Needs: Human interest, family, parenting, seniors, education, ethnic communities, travel, consumer interest, nature, men and women filling nontraditional roles.
B&W: Uses 8x10 glossy prints.
Tips: "Photos must be storytelling shots, unusual content, well exposed and sharp with the full range of greys. Our nationwide newspaper distribution will help talented photographers build a substantial portfolio."

COMPU/PIX/RENTAL (C/P/R), Suite 119, 22231 Mulholland Hwy., Woodland Hills CA 91364. (213)888-9270. Photo Librarian: Sabine Wichert. Has 6,000,000+ photo files on computer. Clients include advertising agencies, public relations firms, businesses, AV firms, book publishers, magazine publishers, encyclopedia publishers, newspapers, post card companies, calendar companies, greeting card companies.
Subject Needs: General.
Specs: "We have no specifications in that we do not keep photos, but enter information about each photographer's collection in our PhotoBank (computerized). We refer clients to the photographer and they work out price and submission between them."
Payment & Terms: "Photographer deals with client and is paid directly. C/P/R receives 25% of photo rental fee." General price range: $75-2,000. Offers one-time rights; negotiable with photographer. Model release preferred.
Making Contact: Query with list of stock photo subjects. SASE. Reports in 2 weeks. Photo guidelines $1.

COMSTOCK, INC., (formerly PhotoFile International), 32 E. 31st St., New York NY 10016. (212)889-9700. President: Harry Scanlon. General Manager: Judy Yoshioka. Has 1,000,000 photos. Clients include advertising agencies, public relations and AV firms, businesses, book/encyclopedia and magazine publishers, newspapers and post cards, calendar and greeting card companies.
Subject Needs: Write for subject guidelines.
Specs: Uses 35mm (preferred), 2¼x2¼, 4x5 or 8x10 transparencies.
Payment & Terms: Pays 50% commission on color photos. General price range: $250-15,000. Model release and captions required.
Making Contact: Lynn Eskanazi, photography coordinator. Query with resume of credits or list of stock photo subjects. SASE. Reports in 3 weeks.
Tips: "We represent very few photographers all of whom are extremely productive, most of whom make their living from stock photography."

***CONTINENTAL NEWS SERVICE**, Suite 265, 341 W. Broadway, San Diego CA 92101. Director: Mr. Gary P. Salamone. News/features syndicate. "Photo purchases are a recent addition to our work. We just have assignments outstanding for photo submissions, to date." Clients include newspapers.
Subject Needs: "We seek photos on the news story of the day—broadly defined—but one with plainly national implications or generating nation-wide interest. We prefer photos of foreign persons or places, supporting news stories relating to some aspect of American foreign policy." Uses 3½x4½ glossy b&w prints. Process: screened or half-toned.
Payment & Terms: Buys photos outright; pays $1-3, (or more, in the director's discretion). "We buy photos with a view to the particular needs of our house publication. We are only secondarily interested in marketing photos to other media." Buys all rights. Model release and captions required.
Making Contact: Send unsolicited photos by mail for consideration. SASE. Reports in 1 month.
Tips: "The photographer should accompany his photo (photos) with a note specifying the date and place of shooting, mode of (foreign) travel, and travel schedule information, so that the continental news service can make appropriate representations about the photos we buy. We may ask to examine the photographer's portfolio later, but we must insist on the unsolicited photos being sent with a SASE to streamline our processing of mail. The sender is advised to keep all negatives, as we cannot be responsible for mail losses. We purchase topical photos for our house publication whether or not there is a market for the photos elsewhere."

CYR COLOR PHOTO AGENCY, Box 2148, Norwalk CT 06852. (203)838-8230. Contact: Judith A. Cyr. Has 125,000 transparencies. Clients include advertising agencies, businesses, book publishers, magazine publishers, encyclopedia publishers, calendar companies, greeting card companies, poster companies and record companies. Does not buy outright; pays 50% commission. General price range:

$150 minimum. Offers one-time rights, all rights, first rights or outright purchase; price depending upon rights and usage. Model release and captions preferred. Send material by mail for consideration. SASE. "Include postage for manner of return desired." Reports in 3 weeks. Distributes tips sheet periodically to active contributors; "usually when returning rejects."
Subject Needs: "As a stock agency, we are looking for all types. Photos must be well exposed and sharp, unless mood shots."
Color: Uses 35mm to 8x10 transparencies.
Tips: Each submission should be accompanied by an identification sheet listing subject matter, location, etc. for each photo included in the submission. Popular subjects recently include computer graphics, aerobics and any health fitness shots. Also office-of-the-future, with high-tech equipment. All photos should be properly numbered (with photographer's initials), and fully identified for subject matter, location, etc.

DESIGN PHOTOGRAPHERS INTERNATIONAL, INC., (DPI), 521 Madison Ave., New York NY 10022. (212)752-3930. President: Alfred W. Forsyth. Has approximately 1 million photos. Clients include advertising agencies, businesses, book publishers, magazine publishers, encyclopedia publishers, poster companies, postcard companies, calendar companies, greeting card companies, designers and printers. Does not buy photos outright; pays 50% commission on sale of existing stock shots. General price range for color: $135-7,000. Offers one-time rights; "outright purchase could be arranged for a fee." Model release and captions required on most subjects. "Accurate caption information a necessity. We suggest photographers first request printed information, which explains how we work with photographers, then sign our representation contract before we can interview them or look at their work. This saves their time and ours." SASE; "state insurance needed." Reports in 2 weeks-1 month. Free photo guidelines and monthly tips sheet distributed to photographers under contract.
Subject Needs: Human interest; natural history; industry; education; medicine; foreign lands; sports; agriculture; space; science; technology; ecology; energy related; leisure and recreation; transportation; U.S. cities, towns and villages; teenage activities; couples; families and landscapes. "In short, we're interested in everything." Especially needs photography from Pacific Area and Middle East Countries. Avoid brand name products or extreme styles of clothing, etc., that would date photos. "We also have a special natural history division." Ongoing need for pictures of family group activities and teenage activities; attractive all-American type family with boy and girl ages 6-12 years. Also family with teenage kids. Model releases are needed.
B&W: Uses 8x10 semigloss doubleweight prints; contact sheet OK for editing.
Color: Uses 35mm or larger original transparencies; "no dupes accepted."
Tips: "Master the fundamentals of exposure, composition and have a very strong graphic orientation. Study the work of top-notch successful photographers like Ken Biggs, Pete Turner or Jay Maisel." In portfolio, prefers to see "60-200 top quality cross-section of photographer's best work, on 20 slide clear plastic 35mm slide holders. Do not send loose slides or yellow boxes. Remember to include instructions for return, insurance needed and return postage to cover insurance and shipping."

DEVANEY STOCK PHOTOS, 51 E. 42nd St., New York NY 10017. (212)767-6900. President: William Hagerty. Has over 1 million photos on file. Does not buy outright. Pays 50% commission on color and 50% on b&w. Offers one-time rights. Model release preferred. Captions required. Query with list of stock photo subjects or send material by mail for consideration. SASE. Reports in 2 weeks. Free photo guidelines with SASE. Distributes monthly tips sheet free to any photographer.
Subject Needs: High technology; computers; computer chips; video games; modern offices; breaking a tape (winning); tiger-sitting down; industrial sites; close-up of eagle swooping; people; nursing homes; modern tractor trailer shots (dramatic); robot shots; automated production line; set-ups for holidays; exchange of money; teller-lobby shots; women doing housework; stress situations; modern supermarkets, drug, department and sports stores (can be empty); children at Christmas; large meetings (small, too); executives; hard hats; excited crowds; prizefighter on ropes; skylines; street scenes; major landmarks; weather; fires; fireworks; etc.—virtually all subjects. "Releases from individuals and homeowners are most always required if photos are used in advertisements."
B&W: Uses 8x10 glossy prints; contact sheet OK.
Color: Uses all sizes of transparencies.
Tips: "It is most important for a photographer to open a file of at least 1,000 color and b&w of a variety of subjects. We will coach."

LEO DE WYS INC., 1170 Broadway, New York NY 10001. (212)689-5580. Office Manager: Rana Youner. Has 350,000 photos. Clients include advertising agencies, public relations and AV firms, business, book, magazine and encyclopedia publishers, newspapers, calendar and greeting card companies, textile firms, travel agencies and poster companies.
Subject Needs: Sports (368 categories); recreation (222 categories); travel and destination (1,450 categories); and released people pictures.

Specs: Uses 8x10 b&w prints, 35mm, medium format color transparencies.

Payment & Terms: Price depends on quality and quantity. Usually pays 50% commission. General price range: $75-6,000. Offers to clients "any rights they want to have; pay is accordingly." Model release required; "depends on subject matter," captions preferred.

Making Contact: Query with samples "(about 20 pix) is the best way;" query with list of stock photo subjects or submit portfolio for review. SASE. Reporting time depends; often the same day. Photo guidelines free with SASE.

Tips: "Photos should show what the photographer is all about. They should show his technical competence—photos that are sharp, well composed, have impact, if color they should show color. Competition is terrific and only those photographers who take their work seriously survive in the top markets."

***FRANK DRIGGS COLLECTION**, 1235 E. 40 St., Brooklyn NY 11210. (718)338-2245. Owner: Frank Driggs. Stock photo agency. Has 100,000 photos and 20 films. Clients include advertising agencies, public-relations firms, audiovisual firms, businesses, book/encyclopedia publishers, magazine publishers, newspapers, motion picture.

Subject Needs: All aspects of music.

Payment & Terms: Buys photos/films outright. Pays 50% commission on b&w and color photos; 50% commission on film. General price range: $75-100/photo. Rights negotiated.

Making Contact: Query with samples and list of stock photo subjects. Solicits photos by assignment only. SASE. Reports in 1 month.

DRK PHOTO, 265 Verde Valley School Rd., Sedona AZ 86336. (602)284-9808; 284-9809. President: Daniel R. Krasemann. "We handle only the personal best of a select few photographers—not hundreds. This allows us to do a better job aggressively marketing the work of these photographers. We are not one of the biggest in volume of photographers but we are 'large' in quality." Clients include ad agencies; PR and AV firms; businesses; book, magazine, textbook and encyclopedia publishers; newspapers; post card, calendar and greeting card companies; branches of the government; and nearly every facet of the publishing industry, both domestic and foreign.

Subject Needs: "We handle only color material: transparencies. At present we are heavily oriented towards worldwide wildlife, natural history, wilderness places and parks. Subjects also on file are photos of people enjoying nature, leisure time activities, 'mood' photos, and some city life. In addition to high quality wildlife from around the world, we are interested in seeing more photos of suburban life, entertainment, historical places, vacation lands, tourist attractions, people doing things, marine photography, and all other types of photography from around the world. If you're not sure if we'd be interested, drop us a line. All transparencies on file are stored in polyethylene 'archival' storage sleeves to eliminate the possibility of any deterioration of material due to improper storage. Images are 'tracked' via computer. Whether in the file or out to a client we know exactly where each and every image is at all times."

Specs: Uses 35mm, 2¼x2¼ and 4x5 transparencies.

Payment & Terms: Pays 50% commission on color photos. General price range: $75—"many thousand." Sells one-time rights; "other rights negotiable between agency/photographer and client." Model release preferred; captions required.

Making Contact: "Photographers should query with a brief letter and SASE describing the photo subjects he/she has available. When submitting materials, sufficient return postage should accompany the submission. If more material is requested, DRK Photo will pay postage." SASE. Reports in 2-4 weeks.

Tips: Prefers to see "virtually any subject, from nature, wildlife and marinelife to outdoor recreation, sports, cities, pollution, children, scenics, travel, people at work, industry, aerials, historical buildings, etc., domestic and foreign. We look for a photographer who can initially supply many hundreds of photos and then continue supplying a stream of fresh material on a regular basis. We are always looking for new and established talent and happy to review portfolios. We are especially interested in seeing more marine photography and African, European and Far East wildlife."

DYNAMIC GRAPHICS INC., CLIPPER & PRINT MEDIA SERVICE, 6000 N. Forrest Park Dr., Peoria IL 61614. (309)688-8800. Photo Editor: Richard Swanson. Clients include ad agencies, printers, newspapers, companies, publishers, visual aid departments, TV stations, etc. Send tearsheets or folio of 8x10 b&w photos by mail for consideration; supply phone number where photographer may be reached during working hours. Reports in 2-4 weeks.

Subject Needs: Generic stock photos (all kinds). "Our needs are somewhat ambiguous and require that a large number of photos be submitted for consideration. We will send a 'photo needs list' and additional information if requested."

Specs: Uses 8x10 b&w prints; 35mm, 2¼ color and 4x5 color transparencies. Model release required.

Payment and Terms: Pays $35-40/b&w photo; $100/color photo. Pays on acceptance. Rights are specified in contract.

EARTH IMAGES, Box 10352, Bainbridge Island WA 98110. (206)842-7793. Director: Terry Domico. Has 80,000 photos and 3 films. Clients include advertising agencies, filmmakers, book publishers, businesses, magazine publishers, design firms, encyclopedia publishers and calendar companies.
Subject Needs: "We specialize in color photography which depicts life on planet Earth. We are looking for natural history, geography including peoples of the world, and documentary photography. Animals, insects, birds, fish, reptiles, science, ecology, scenics, landscapes, underwater, endangered species, foreign studies, especially photojournalism, people working, action recreation—worldwide."
Specs: Uses 35mm and larger slides, Kodachrome preferred. Some 16mm and 35mm motion picture film.
Payment & Terms: Pays 50% commission on photos. Usual price range: $100-650. Offers one-time rights. Captions required on slides.
Making Contact: Query with list of credits. Photo submission guidelines free with SASE. Reports in 2 weeks. Photographers represented by Earth Images have access to free computer net.
Tips: "We are seeking photographers who have particular talent and interests. We need to see at least 100 best images. We are looking for photographic excellence as this is a *very* competitive field. We are also interested in well done picture stories and exceptional film footage. Pictures of flowers, tiny ducks centered in the middle of the frame, 'miniature' moose, and fuzzy shots taken at the zoo just don't make it. Our focus is on quality, not quantity. We only want to see professional quality work."

EKM-NEPHENTHE, Box 217, El Rito NM 87530. (505)581-4460. Cable: Ekphot. Photone: Pho 1500. Additional Address: 7874 Tanglerod Ln., La Mesa CA 92041. Director: Robert V. Eckert. Has 100,000 photos. Clients include advertising agencies, public relations firms, businesses, AV firms, book publishers, magazine publishers, encyclopedia publishers and newspapers. Rarely buys photos outright. Pays 50% commission on photos. General price range: $75-2,500. Offers one-time rights. Captions preferred. Query with list of stock photo subjects. SASE. Reports in 1 month. Photo guidelines free on request.
Subject Needs: Subjects include "Folk Art (Americana); architecture; animals; beaches; business; cities; country; demonstrations and celebrations; ecology; education; emotions; agriculture; manufacturing; food, health, medicine and science research; law enforcement; leisure; occupations; nature; art; travel; people (our biggest category); performers; political; prisons; religion; signs; sports and recreation; transportation; weather; historical subjects for our newly formed historical section;" also earth sciences, biology, geology for newly developed area, etc. "We prefer b&w and color photos of prisons, education, people, technology, energy, robotics, housing, groups, medicine, science research, interaction, races (ethnic groups), people all ages and occupations (especially nontraditional ones, both male and female). Do not want to see sticky sweet pictures."
B&W: Uses 8x10 glossy, matte and semigloss contact sheets and prints.
Color: Uses any size color transparency.
Tips: "Photographers should have a long-term perspective toward stock photography. Realizing that stock is a slow business, the photographer must have a long-term outlook toward it. It can be very rewarding if you work hard at it, but it isn't for the person who wants to place his 100 best shots and wait for money to start rolling in. Try to provide unique, technically sound photos. Be objective about your work. Study the markets and current trends. Also work on projects that you feel strongly about, even if there is no apparent need (as to make strong images). Photograph a lot, you improve with practice. We are actively seeking new photographers. Edit carefully. We see too much technically and aesthetically bad work. We are not looking to have the most photographers in the world of photoagencies but we would not mind having the best. We try to work closely with our photographers, make them more than just a number with us."

FINE PRESS SYNDICATE, Box 112940, Miami FL 33111. Vice President: R. Allen. Has 49,000 photos and 100+ films. Clients include advertising agencies, public relations firms, businesses, AV firms, book publishers, magazine publishers, post card companies, calendar companies worldwide.
Subject Needs: Nudes; figure work, seminudes and erotic subjects.
Specs: Uses color glossy prints; 35mm, 2¼x2¼ transparencies; 16mm film; videocasettes: VHS and Beta.
Payment & Terms: Pays 50% commission on color photos and film. Price range "varies according to use and quality." Offers one-time rights.
Making Contact: Send unsolicited material by mail for consideration or submit portfolio for review. SASE. Reports in 2 weeks.
Tips: Prefers to see a "good selection of explicit work. Currently have European and Japanese magazine publishers paying high prices for very explicit nudes and 'X-rated' materials. Clients prefer 'American-looking' female subjects. Send as many samples as possible."

THE FLORIDA IMAGE FILE, 526-11 Ave. NE, St. Petersburg FL 33701. (813)894-8433. Contact: President. Has 40,000 photos. Clients include ad agencies; PR and AV firms; businesses; book and mag-

azine publishers; post card, calendar and greeting card companies; and billboards.

Subject Needs: "We are not only specializing in Florida and the Caribbean, but include all of North America, Europe, Middle East and South America as well. As such, all photos which suggest a theme associated with these geographic areas can be marketed. The best way to shoot for us is to make a list of impressions that remind you of Florida, then go out and shoot it."

Specs: Uses 35mm and 8x10 transparencies, Kodachrome preferred.

Payment & Terms: Pays 50% commission on color photos. General price range: $100-3,000. Offers one-time rights; "exceptions made for premium." Model release required; captions preferred.

Making Contact: Send unsolicited material by mail for consideration. SASE. Reports in 1 month. Photo guidelines free with SASE.

Tips: "Vacations and leisure are bywords to Florida developers and promoters. The key to Florida and the Caribbean is sunshine and smiling faces. People shooting for us should see the beauty around them as though it was their first time. It often is for many seeing their published work. Keep cars, telephone poles and lines out of frame. Go for happy action, sports, intimate beach shots, wildlife-nature."

***FOCUS PHOTO AGENCY**, 67A Portland St., Toronto, Ontario M5V 2M9 Canada. (416)598-1595. President: Pierre Bisaillon. Stock photo agency. Has 25,000 photos "and growing." Clients include advertising agencies, public-relations firms, audiovisual firms, book/encyclopedia publishers, magazine publishers, newspapers, post card companies, calendar companies, greeting card companies, poster companies.

Subject Needs: General. "We have a particular need for all kinds of people shots, travel, sports and wildlife."

Specs: Uses all formats of transparencies from 35mm to 8x10; 8x10 b&w prints.

Payment & Terms: Pays 50% commission. General price range: $100-3,000. Offers one-time rights or "all rights only with photographer's permission." Model release and captions are very important.

Making Contact: Query with resume of credits and list of stock photo subjects or submit portfolio. SASE. Reports in 3 weeks. Tips sheet distributed frequently to photographers on file.

Tips: "For submissions, place in slide pages, about 300 transparencies (less for larger formats) that clearly represent the type of work you shoot. Also, include a list of other photos you plan to submit if accepted. Please include SAE with International Reply Coupons. We report back in 3 weeks or less."

FOCUS WEST, 4112 Adams Ave., San Diego CA 92116. (619)280-3595. General Manager: Don Weiner. Has 100,000 photos. Clients include advertising agencies, public relations firms, businesses, book/encyclopedia and magazine publishers and newspapers.

Subject Needs: "We specialize in sports, recreation and leisure activities. We are interested in sports at any level: high school, college, pro, international."

Specs: Uses 35mm transparencies.

Payment & Terms: Pays 50% commission on color photos. General price range: "We prefer to charge ASMP-level rates." Sells one-time rights. Model release and captions preferred.

Making Contact: Query with samples. SASE. Reports in 2 weeks. Agency guidelines free with SASE. Tips sheet distributed periodically to photographers on file.

Tips: "We want a general sampling of the subjects the photographer considers as specialties; 60-80 slides are a good amount. We find a need for model-released recreational sports. There is a greater market for jogging, sailing, golf, windsurfing, etc., than some pro sports."

FOTO EXPRESSION (F.E.), A division of FOTO ex-PRESS-ion, Box 681, Station A, Downsview, Ontario, Canada M3M 3A9. (416)736-0119. Photo Editor: Mrs. Veronika Kubik. Selective archive of photo, film and audiovisual materials. Clients include Ad, PR and AV firms; TV stations, networks, film distributors, businesses; book, encyclopedia and trade magazine publishers; newspapers, news magazines; post card, calendar and greeting card companies.

Subject Needs: City views, aerial, travel, wildlife, nature-natural phenomena and disasters, underwater, aerospace, weapons, warfare, industry, research, computers, educational, religions, art, antique, abstract, models, sports. Worldwide news and features, personalities and celebrities.

Specs: Uses 8x10 b&w; 35mm and larger color transparencies; 16mm, 35mm film; VHS, Beta and commercial videotapes (AV).

Payment & Terms: Sometimes buys transparencies outright. "We pay non-exclusive contract—40% for b&w; 50% for color; 16mm, 35mm films and AV. On exclusive contract we pay 50% for b&w; 60% for color transparencies, film and AV." Offers one-time rights. Model release and captions required for photos.

Making Contact: Submit portfolio for review. The ideal portfolio for 8x10 b&w prints includes 10 prints; for color transparencies include 60 selections in plastic slide pages. With portfolio you must send SAE with return postage (out of Canada—either money-order or International Postal Coupon). Photo guidelines free with SAE and postage. Reports in 3 weeks. Tips sheet distributed twice a year only "on approved portfolio."

Tips: "We require photos, slides, motion picture films and AV that can fulfill the demand of our clientele." Quality and content therefore is essential. Photographers, cameramen, reporters, writers, correspondents and representatives are required world wide by FOTOPRESS (NEWS), a division of the FOTO ex-PRESS-ion in Toronto. Contact Mr. Milan J. Kubik, Director, International section.

***FOTOS INTERNATIONAL**, 4230 Ben Ave., Studio City CA 91604. (818)762-2181. Telex: 65-14-89. Cable: Fotosinter. Manager: Max B. Miller. New York Office: Suite 614, 130 W. 42nd St., New York NY 10036. (212)840-2026. Telex: 64-54-92. Has 4 million photos. Clients include advertising agencies, public relations firms, businesses, book publishers, magazine publishers, encyclopedia publishers, newspapers, calendar companies, TV and posters. Pays $5-250/photo. No pay on a commission basis. Offers one-time rights and first rights. Model release optional; captions required. Query with list of stock photo subjects. SASE. Reports in 1 month.
Subject Needs: "We are the World's Largest Entertainment Photo Agency. We specialize exclusively in motion picture, TV and popular music subjects. We want color only! The subjects can include scenes from productions, candid photos, concerts, etc., and must be accompanied by full caption information."
Color: Uses 35mm color transparencies only.

FPG INTERNATIONAL, 251 Park Ave. S., New York NY 10010. (212)777-4210. Manager, Photography Department: Rebecca Taylor. A full service agency with emphasis on advertising, calendar, travel and corporate clients. Pays a 50% commission. "We sell various rights as required by the client." Minimum submission requirement per year—500 original color transparencies, exceptions for large format, 100 b&w full-frame glossy prints. Material may be submitted by mail for consideration or a personal interview may be arranged. Photo guidelines and tip sheets provided for affiliated photographers. Model releases required and should be indicated on photograph.
Subject Needs: High-tech industry, model released human interest, foreign and domestic scenics in large formats, still life, animals, architectural interiors/exteriors with property releases and recreational sports.
Tips: "Submit regularly; we're interested in committed, high-caliber photographers only. Be selective—send only first-rate work. Our files are highly competitive."

FRANKLIN PHOTO AGENCY, 85 James Otis Ave., Centerville MA 02632. (617)428-4378. President: Nelson Groffman. Has 35,000 transparencies of scenics, animals, horticultural subjects, dogs, cats, fish, horses, antique and classic cars, and insects. Serves all types of clients. Does not buy outright; pays 50% commission. General price range: $100-300. Offers first serial rights and second serial rights. Present model release on acceptance of photo. Query first with resume of credits. Reports in 1 month. SASE.
Color: Uses 35mm, 2¼x2¼ and 4x5 transparencies.

FREELANCE VISUAL PRODUCTIONS, INC., Box 843, Philadelphia PA 19105. (215)342-1492. President: Leonard N. Friedman. Stock photo agency. Has 25,000 photos. Clients include advertising agencies, public relations firms, businesses, book publishers, magazine publishers, post card companies, calendar companies and greeting card companies, art decor markets, specialized paper products.
Subject Needs: Color and black and white prints (glossy) of: travel (cities, towns, beaches, resorts), nature, wildlife, landscapes, seascapes, still life (original concepts), classics (one of a kind) or very unusual.
Specs: Uses 4x5, 5x7, 8x10 glossy prints (samples) for file. "We also will consider contact sheets with list of subjects available."
Payment & Terms: Based on use and quality, general prices will range from $5-1,000. Offers all rights (unless otherwise agreed). Model release and captions required. "We also require proper property releases when required."
Making Contact: Query with samples and list of stock photo subjects; send unsolicited photos by mail for consideration. Reports in 3 weeks. Photo guidelines free with SASE.
Tips: "Our clients are publishers of specialized paper products which include: greeting card, calendar, poster, art decor markets which are geared towards a very special market. We are seeking visual artists who know more than just clicking shutters. Most of the work we market has been carefully planned and executed. Imagination and creativity are the ingredients we are looking for. If you are past experimenting and know what you are doing in the areas of the subjects we have requested, it is time to contact us."

***FROZEN IMAGES, INC.**, Suite 614, 400 First Ave. N., Minneapolis MN 55401. (612)339-3191. Director: Lonnie Schroeder. Stock photo agency. Has approximately 120,000 photos. Clients include advertising firms; public-relations firms, audiovisual firms, graphic designers, businesses, book/encyclopedia publishers, magazine publishers, newspapers and calendar companies.

Subject Needs: All subjects including abstracts, scenics, industry, agriculture, U.S and foreign cities, high-tech, businesses, sports, people and families.
Specs: Uses transparencies.
Payment & Terms: Pays 50% commission on color photos. General price range: "Use ASMP guidelines." Offers "generally one-time rights, special arrangements possible." Model release and captions required.
Making Contact: Query with resume of credits; query with list of stock photo subjects; call for procedures info. SASE. Reports in 1 month or ASAP (sometimes 6 weeks). Photo guidelines free with SASE. Tip sheet distributed quarterly to photographers in the collection.
Tips: Prefers to see strengths and scope of the photographer's work.

f/STOP PICTURES, INC., Box 359, Springfield VT 05156. (802)885-5261. President: John R. Wood. Stock photo agency. Has 100,000 photos. Clients include advertising agencies, public relations firms, businesses, book/encyclopedia publishers, magazine publishers, postcard companies, calendar companies, greeting card companies and poster publishers.
Subject Needs: Rural North American including everything from farms to small town life, wildlife and natural history, people doing things. "We specialize in New England, but we also need things from the rest of the country."
Specs: Uses 35mm, $2\frac{1}{4}$x$2\frac{1}{4}$, 4x5 and 8x10 transparencies.
Payment & Terms: Pays 50% commission. General price range: $150 and up. Sells only one-time rights. Model release and captions required.
Making Contact: Query with samples; submit portfolio for review. SASE. Reports in 3 weeks. Tips sheet distributed quarterly to photographers with whom they have contract.
Tips: "I want to see photos that show me the photographer knows how to use the camera. This means perfect technical quality (focus, exposure, etc.), as well as interesting subject matter and composition. Increase in requests for shots of people using computers and other high-tech equipment. I also get a lot of requests for photos of places, i.e. where people might go on vacation. Increasing business interest in down-home subjects, small-town values and scenics. Always need well-done and interesting photos of people doing things and relating to one another."

GAMMA/LIAISON, 150 E. 58th St., New York NY 10155. (212)888-7272. Director, Production Editor: Jennifer Coley. Has 5 million prints. Extensive stock files include hard news (reportage), travel features (expedition and adventure), human interest stories, movie stills, personalities/celebrities, corporate portraits, industrial images. Clients include newspapers and magazines, book publishers, audiovisual producers and encyclopedia publishers.
Specs: Uses b&w negatives or 8x10 glossy prints. Uses 35mm or $2\frac{1}{4}$x$2\frac{1}{4}$ transparencies.
Payment & Terms: Photographer and agency split expenses and revenues 50/50.
Making Contact: Submit portfolio with description of past experience and publication credits.
Tips: Involves a "rigorous trial period for first 6 months of association with photographer." Prefers previous involvement in publishing industry.

GLOBE PHOTOS, INC., 275 7th Ave., New York NY 10001. (212)689-1340. Contact: Ray Whelan. Has 10 million photos. Clients include advertising agencies, public relations firms, businesses, AV firms, book publishers, magazine publishers, encyclopedia publishers, newspapers, post card companies, calendar companies, and greeting card companies. Does not buy outright; pays 50% commission. Offers one-time rights. Model release preferred; captions required. Arrange a personal interview to show portfolio; query with samples; send material by mail for consideration; or submit portfolio for review. Prefers to see a representative cross-section of the photographer's work. SASE. Reports in 4 weeks. Photo guidelines free with SASE; tips sheet distributed at irregular intervals to established contributors.
Subject Needs: "Picture stories in color and/or b&w with short captions and text. Single shots or layouts on celebrities. Stock photos on any definable subject. Pretty girl cover-type color." No straight product shots.
B&W: Uses 8x10 glossy prints; contact sheet OK.
Color: Uses 35mm, $2\frac{1}{4}$x$2\frac{1}{4}$, 4x5, 8x10 transparencies.
Tips: "Find out what the markets need and produce as much as possible—regularly; but keep in mind quality is more important than quantity. It is important for the photographer to have good, technical skills as well as an imagination to shoot highly competitive stock photographs. There is a general increase in need of stock pictures, particularly photos of people doing things."

***GRAPHIC IMAGE PUBLICATIONS**, Box 6417, Alexandria VA 22306. (619)755-6558. Photo Editor: John Hunter. Stock photo agency. Has 10,000 photos; 50 films. Clients include advertising agencies, public-relations firms, audiovisual firms, magazine publishers, post card companies, calendar companies, greeting card companies.

Subject Needs: "Travel photography. Concentration is in Mexico cities and resorts. In depth files. Also handle industrial calendar type material—cheesecake women models for product representation calendars and posters. In depth file of various models, studio and location to fit client projects, needs. Glamour posters, calendars."

Specs: Uses 35 mm, 2¼x2¼, 4x5 transparencies; 16mm film; VHS videotape.

Payment & Terms: Buys slides outright. Payment negotiated. General price range: $75-500. Offers one-time rights. Model release required.

Making Contact: Query with samples, query with list of stock photo subjects. SASE. Reports in 1 month. Photo guidelines $1. Tip sheet distributed quarterly $1.

Tips: Prefers to see clean, well-composed work. New ideas and faces.

***GABRIEL D. HACKETT PHOTO ARCHIVES**, 116-40 Park Lane S., Kew Gardens NY 11418. (718)441-2574 or (212)265-6842. Contact: Gabriel D. Hackett. Picture library. Has 200,000-250,000 prints. Clients: book/encyclopedia publishers, magazine publishers, newspapers.

Subject Needs: Pix of *high historic interest*, American history, war action shots; 2 prints of each. Send postcard size glossy samples first, numbered and captioned, or 5x7 prints.

Specs: Uses b&w and color, 4x5 or 5x7 glossy prints; b&w and color contact sheets.

Payment & Terms: Pays 50% commission on b&w and color photos. General price range: ASMP rates, if possible. Offers one-time rights. Model release and photo captions required.

Making Contact: Send above mentioned exceptional pix only. Does not return unsolicited material.

HAVELIN ACTION PHOTO, #807, 7611 Maple Ave., Takoma Park MD 20912. (301)270-9592. Contact: Michael F. Havelin. Has 5,000 b&w and color photos. Clients include advertising agencies, public relation firms, audiovisuals firms, businesses, book/encyclopedia publishers, magazine publishers, newspapers, postcard companies, calendar companies and greeting card companies.

Subject Needs: "We specialize in underwater imagery, including salt and fresh water life (vertebrate and invertebrate), divers at work or play, dive sites, wrecks, etc. Also looking for photos of pollution and its effects, animals, insects, spiders, reptiles and amphibians, solar power and alternative energy sources. We also handle motorcycle road racing and industrial photo assignment work."

Specs: Uses 35mm, 2¼x2¼, 8x10 b&w prints and 4x5 transparencies.

Payment & Terms: Pays 50% commission on b&w and color. General price range: "highly variable." Sells one-time rights, but "sometimes negotiable with buyer." Model release sometimes necessary for recognizable people. Captions preferred.

Making Contact: Query with list of stock photo subjects. Send unsolicited photos by mail for consideration. SASE. Reports in 1 month. Photo guidelines free with SASE. Tips sheet distributed intermittently; free with SASE.

Tips: "We are always interested in well-exposed, informative images that have impact. Beauty is always a plus. Photo essays or images which tell a story on their own are also useful. A photographer who can research and write can sometimes pull assignment work. Photographers should not give up. Keep shooting and submitting. Don't expect to earn your living at this right away."

***HILLSTROM STOCK PHOTO**, 5483 N. Northwest Hwy., Box 31100, Chicago IL 60633. (312)775-4090. Owner: Ray F. Hillstrom, Jr. Stock photo agency. Has ½ million color transparencies; 10,000 b&w prints. Clients include advertising agencies, public-relations firms, audiovisual firms, businesses, book/encyclopedia publishers, magazine publishers, newspapers, calendar companies, greeting card companies, sales promotion agencies.

Specs: Uses color prints; 35mm, 2¼x2¼, 4x5 transparencies.

Payment & Terms: Pays 50% commission on b&w and color photos. Offers one-time rights or first rights. Model release preferred; captions required.

Making Contact: Send unsolicited photos by mail for consideration. SAE and check for postage for return of submitted material. Reports in 3 weeks. Photo guidelines free with SASE.

Tips: Prefers to see good professional images, proper exposure, mounted, name IDs on mount.

***THE HISTORIC NEW ORLEANS COLLECTION**, 533 Royal St., New Orleans LA 70130. (504)523-4662. Curators: Dode Platou, John Mahé, and John H. Lawrence. Has 85,000 photos on all aspects of Louisiana history, including architecture, culture, physical description, people and industry; also has over 100 16mm films on Mardi Gras celebrations and Louisiana industries and approximately 5,000 glass plates and lantern slides. Users include magazines, ad agencies, publishers of historical novels and textbooks, encyclopedias, AV firms, newspapers, businesses and TV stations, and scholars and historians, government agencies. No "purely abstract photographics or those which show no direct relationship to life, history, etc. in Louisiana." All items must be approved by an acquisition committee which meets once a month. Write or call to arrange an appointment to show work. Acknowledgement of receipt sent in 2 days. Decision in 1 month. SASE. "The Collection buys work from the artist with the right to

reproduce, and exhibit (i.e., non-exclusive license) the artist also retains simultaneous rights of exhibition and reproduction. We permit publication at our own discretion, all subject to director's and curator's approval. Please write or call before sending work for inspection. Package carefully. Some prints sent unsolicited have arrived in damaged condition."

B&W: Uses any size prints. Negatives considered when part of a large collection. No transparencies of any type are considered. Contemporary work should be unmounted.

Tips: Material must pertain to Louisiana. Only work on fibre base paper, processed for permanence is considered. "Have a portfolio of work done in New Orleans or Louisiana. Subjects should be of an informational or documentary nature, showing typical qualities of life and living in New Orleans or Louisiana. Note: significant holdings of work by: Clarence John Laughlin, Eugene Delcroix, Daniel S. Leyrer, Charles L. Frank, Stuart M. Lynn, Sam R. Sutton, Todd Webb, Michael A. Smith.

HOT SHOTS STOCK SHOTS, INC., 309 Lesmill Rd., Toronto, Ontario, Canada M3B 2V1. (416)441-3281. Submissions: Laurie Clark. "General file that is being constantly added to." Clients include ad agencies; AV firms; businesses; book, encyclopedia and magazine publishers; newspapers; postcard, calendar and greeting card companies.

Subject Needs: Animals, agriculture, scenics, industrial, people, human interest, business, action sports, recreation, beauty, abstract, religious, historic, symbolic.

Specs: Uses 35mm, 2¼x2¼, 4x5, 8x10 transparencies.

Payment & Terms: Pays 50% commission. General price range: $150-1,500. Offers one-time rights. Model release and captions required.

Making Contact: Send unsolicited transparencies by mail for consideration. SAE with International Reply Coupons. Reports in 1 week. Photo guidelines free with SAE and International Reply Coupons. Tips sheet distributed to member photographers "when necessary"; or free with SASE.

Tips: Prefers to see "creative, colorful, sharp, up-to-date, *clean* transparencies only (Kodachrome preferred)."

ILLUSTRATOR'S STOCK PHOTOS, Box 1470, Rockville MD 20850. (301)279-0045. Executive Editor: Jack Schneider. Also has offices in Washington DC (Consolidated Newspictures); and Los Angeles (Photographic Society International, contact Albert Molduay at (213)392-6537). Has 1,000,000 photos. Clients include advertising agencies, public relations and AV firms, businesses, book/encyclopedia and magazine publishers, newspapers, and postcard, calendar and greeting card companies.

Subject Needs: Political personalities, over the past 30 years; all generic subjects.

Specs: Uses 8x10 b&w prints; 35mm, 2¼x2¼, 4x5 and 8x10 transparencies; and b&w and color contact sheets.

Payment & Terms: Pays 50% commission on b&w and color photos. General price range: $75 minimum b&w inside editorial use; $125 minimum color inside editorial use. Offers one-time rights or negotiates. Model release and captions preferred.

Making Contact: Query with resume of credits or list of stock photo subjects. SASE. Reports in 3 weeks. Distributes quarterly tips sheet to "photographers we represent."

Tips: "Many requests we receive are for photos of lifestyles involving all age groups and sexes. Also environmental issues and, this year, labor and politics, photo essays with text, science, medicine, life and ideals."

THE IMAGE BANK, 111 5th Ave., New York NY 10003. (212)953-0303. President: Stanley Kanney. Has 3 million color photos. Clients include advertising agencies, public relations firms, major corporations, book publishers, magazine publishers, encyclopedia publishers, newspapers, post card companies, calendar companies, greeting card companies and government bureaus. Does not buy outright; pays 50% commission. Rights negotiated. Model release and captions required for advertising sales. Send material by mail for consideration, or submit portfolio for review.

Subject Needs: "Our needs cover every subject area. *The Image Bank* has over 4,000 subject categories—travel, scenics, sports, people, industry, occupations, animals, architecture and abstracts, to name just a few. We now have 40 offices worldwide. We especially need leisure-time photos and images of people doing *positive* things. The people can be in any age group, but must be attractive. Model releases are necessary."

Color: "We accept only color transparencies."

Tips: Put together about 300 representative color transparencies and submit to Editing Department, 111 5th Ave., New York NY 10003. Put all transparencies in clear vinyl pages. "Freelance photographers interested in working with *The Image Bank* should have a very large file of technically superb color transparencies that are highly applicable to advertising sales. Among other things, this means that close-up pictures of people should be released. The subject matter may vary widely, but should generally be of a positive nature. Although we have heretofore specialized in advertising sales, we are now building a large and superb editorial library. There has been an emphasis on the need for more sophisticated im-

ages. Very lucrative stock sales are being made by *Image Bank* throughout the world in areas where formerly only original assignments were considered." Also handles assignments for photographers under contract. Regional locations: *The Image Bank South*, Suite 800, Peachtree Center S. Tower, 225 Peachtree St., NE, Atlanta GA 30303. (404)223-0133. Contact: Lynn Brantley. *The Image Bank Chicago*, 510 N. Dearborn St., Chicago IL 60610. (312)329-1817. Contact: Michael Jungert. *The Image Bank Texas*, 1336 Conant St., Dallas TX 75207. (214)631-3808. Contact: Lynn Martin.

THE IMAGE BANK/WEST, 8228 Sunset Blvd., Los Angeles CA 90046. (213)656-9003. President: Stan Kanney. Maintains 1,000,000 photos in Los Angeles and 3,000,000 in New York. Serves advertising agencies; public relations firms; businesses; AV firms; book, magazine and encyclopedia publishers; newspapers; postcard, calendar and greeting card companies; and film/TV.
Specs: Uses 35mm color transparencies; "some larger formats."
Payment/Terms: Pays 50% commission for photos. Model release and captions required. Direct inquiries to *The Image Bank* in New York c/o Lenore Herson, see listing above.

***IMAGE BROKER**, 330 W. Spring, Box 1996, Columbus OH 43216. (614)461-6333. Manager: Pamela Willits. Stock photo agency. Has 20,000+ photos. Clients include advertising agencies, public-relations firms, businesses, book/encyclopedia publishers, magazine publishers.
Subject Needs: People in everyday situations, especially women, ethnics, elderly, children, occupations, office scenes, computers in use . . . Also travel photographs from anywhere in the world.
Specs: Uses 35mm, 2¼x2¼, 4x5 transparencies.
Payment & Terms: Pays 50% commission on b&w and color photo required. Model release and captions required.
Making Contact: Query with resume of credits, samples and list of stock photo subjects. SASE. Reports in 2 weeks. Photo guidelines free with SASE. "Tips sheet distributed monthly to our photographers."
Tips: Prefers to see strong coverage of one or more areas the photographer specializes in. "We need more than nature photographers, we need shooters who can interact with and photograph people in all situations."

***IMAGE ENTERPRISES**, Suite 364, 1433 Santa Monica, Santa Monica CA 90404. President: Keith A. Dunlop. Stock Photo Agency. Has 5,000 photos in files. Clients include advertising agencies, public-relations firms, businesses, book/encyclopedia publishers, magazine publishers, newspapers, post card companies, calendar companies and greeting card companies.
Subject Needs: All subjects/all formats. "We're new and growing and might be interested in anything you have in files."
Specs: Uses 8x10 b&w prints; 35mm, 2¼x2¼, 4x5 transparencies; b&w contact sheets.
Payment & Terms: Pays 40% commission on b&w photos; 50% commission on color pictures. General price range: $100-2,000. Offers one-time rights. Model release required; captions preferred.
Making Contact: Query first with stock subject list and business card or send $1.50 for submissions package that includes a photo guideline sheet and a current needs list. Do not send unsolicited material. Reports in 2 weeks.
Tips: "The only photographs that sell are ones that are technically perfect. All others are returned immediately upon receipt. Submissions that are professionally packaged are also more pleasing for us to receive. In short, pay attention to detail throughout your entire photographic process."

IMAGE FINDERS PHOTO AGENCY, INC., Suite 501, 134 Abbott St., Vancouver, British Columbia, Canada V6B 2K4. (604)688-9818. Contact: Miles Simons. Has 300,000 photos of all subjects. Clients include advertising agencies, public relations firms, businesses, AV firms, book publishers, magazine publishers, encyclopedia publishers, newspapers, postcard companies, calendar companies and greeting card companies. "We are mainly an advertising use photo agency. Ninety percent of our usage fees go toward advertising. Editorial material not required." Does not buy outright; pays 50% commission. General price range: $50-500, more for large ad campaigns. Offers one-time rights, all rights or first rights. For acceptance, model release and captions must be provided. Send material by registered mail for consideration (do not send in glass mounts); U.S. or other out-of-Canada photographers should contact first before mailing. Reports on queries in 2 weeks; submissions, 2-4 weeks. Photo guidelines free with SAE and International Reply Coupons. "(*Please no* US stamps—*stamps must be Canadian*)." Distributes semiannual tips sheet to established contributors.
Subject Needs: All subjects that can be used for promotional, advertising, public relations, editorial or decorative items: scenics; people; sports; industrial; commercial; wildlife; city and townscapes; agriculture; primary industry or tourist spots. Especially needs international shots of famous landmarks. Also people of all ages engaged in all kinds of activities, especially leisure and recreational type activities, (U.S.A. and foreign—must be generic.) "We advise photographers to check technical quality with a

loop before sending. We especially need photos on Canada, sports and recreation, couples in tropical beach settings, couples, events, families, children and teenagers, primary and secondary industries (especially oil and gas and mining)."
Color: Uses transparencies only.
Tips: "If traveling, take typical shots of scenics, cityscapes, points of interest, industry, agriculture and cultural activities. Try to retain seconds of assignment photography and rights to their further use. We prefer to represent photographers with large and varied stock collections and who are active in shooting stock photos. We are now at a stage of representing more photographers than we would like. Consequently material is being returned to those photographers who have failed to follow through with their initial commitment to shoot stock regularly. There are excellent opportunities for photographers with in-depth selections of people, sports and recreation, the work field and world landmarks and Canada. Shoot tight lifestyle pictures of people in all recreation and family activities, work situations and locations (city and country). Remember releases. This is one of our most requested areas. Write us for *detailed* instructions, suggestions and tips."

***IMAGE PHOTOS**, Main St., Stockbridge MA 01262. (413)298-5500. Director: Clemens Kalischer. Picture library. Has 300,000 photos. Clients include public-relations firms, book/encyclopedia publishers, magazine publishers.
Subject Needs: Editorial, documentary.
Payment & Terms: Pays 40% commission on b&w and color prints. General price range: $50-1,000. Offers first rights.
Making Contact: Query with list of stock photo subjects. SASE. Reports in 1 month.

***THE IMAGE WORKS**, Box 443, Woodstock NY 12498. (914)679-7172. Co-director: Alan Carey. Stock photo agency. Has 100,000 photos. Clients: advertising agencies, public-relations firms, audiovisual firms, book/encyclopedia publishers, magazine publishers.
Subject Needs: Social issues, documentary, social-psychology—no pretty landscapes please. Also— Latin America & Europe.
Specs: Uses 8x10 glossy b&w prints, 35mm transparencies.
Payment & Terms: Pays 50% commission on b&w and color photos. General price range: $90-600. Offers one-time rights. Model release preferred; captions required.
Making Contact: Query with list of stock photo subjects or submit portfolio for review. SASE. Reports in 3 weeks. Photo guidelines free with SASE. Tips sheet distributed every 2 months to photographers on file.

INDEX STOCK INTERNATIONAL INC., 126 Fifth Ave., New York NY 10011. (212)929-4644. Photo editors: Don Chiappinelli, Lynn Brewster. Has 500,000 tightly edited photos. Clients include ad agencies, corporate design firms, graphic design agencies, in-house agencies, direct mail production houses, magazine publishers, audiovisual firms, calendar companies and post card and greeting card companies.
Subject Needs: Business, industry, technology (science & research) and computers, people, family, mature adults, sports, US and general scenics, major cities and local color, foreign/travel, and animals.
Specs: 35mm, 2¼x2¼, 4x5 and 8x10 transparencies. "All 35mm must be Kodachrome."
Payment & Terms: Pays 50% commission on photos with exceptions of catalog photos. General price range: $125-5,000. Offers one-time rights plus some limited buy-outs and exclusives. Model/property releases and captions required.
Making Contact: Query with list of stock photo subjects. Responds in 2 weeks. Photo guidelines free. Tips sheet distributed 4-8 times yearly to photographers contracted to ISI.

***INTERNATIONAL PHOTO NEWS**, Box 2405, West Palm Beach FL 33402. (305)793-3424. Photo Editor: Jay Kravetz. News/feature syndicate. Has 20,000 photos. Clients include newspapers.
Subject Needs: Celebrities of politics, movies, music and television.
Specs: Uses 8x10 glossy b&w prints.
Payment & Terms: Pays 50% commission on b&w photos. General price range: $5. Offers one-time rights. Captions required.
Making Contact: Query with resume of credits. Solicits photos by assignment only. SASE. Reports in 1 week.
Tips: "We use celebrity photographs to coincide with our syndicated columns."

INTERNATIONAL STOCK PHOTOGRAPHY, LTD., 113 E. 31st St., New York NY 10016. (212)696-4666. Contact: Donna Macfie or Robert Brow. Has 400,000 photos. Clients include ad agencies, PR and AV firms, businesses, book, magazine and encyclopedia publishers; travel companies, poster, calendar and greeting card companies. Has overseas representation in Toronto, Tokyo, London, Milan, Dusseldorf, Amsterdam and Vienna.

Subject Needs: Domestic and foreign travel, leisure photos of families, couples and adults (model released); sports, industrials and still life, scenics (large format), animals.
Specs: Uses 8x10 b&w prints; 35mm, 2¼x2¼, 4x5 or 8x10 original transparencies.
Payment & Terms: Pays 50% commission on b&w or color photos. "We generally follow ASMP guidelines." Sells one-time, first or all rights or negotiates rights to clients. Photos from photographers on consignment. Model release preferred; captions required.
Making Contact: Query with samples or list of stock photo subjects or submit portfolio for review. Send unsolicited material by mail for consideration. SASE. Reports in 2-3 weeks. Photo guidelines free with SASE. Tips sheet distributed "every few months" to member photographers.
Tips: Prefers to see "an overview of what the photographer has to offer for stock—about 400 if 35mm size, in plastic sheets of 20 per page—or less if in larger format. To be put in some order of categories or places." Especially interested in "young and middle-aged couples (released), in active situations, sports, and new technologies. Think about presentation of work, captions, etc. from a buyer's point of view."

INTERPRESS OF LONDON AND NEW YORK, 400 Madison Ave., New York NY 10017. Editor: Jeffrey Blyth. Has 5,000 photos. Clients include magazine publishers and newspapers. Does not buy outright. Offers one-time rights. Send material by mail for consideration. SASE. Reports in 1 week.
Subject Needs: Offbeat news and feature stories of interest to European editors. Captions required.
B&W: Uses 8x10 prints.
Color: Uses 35mm transparencies.

JEROBOAM, INC., 120-D 27th St., San Francisco CA 94110. (415)824-8085. Contact: Ellen Bunning. Has 100,000 b&w photos, 50,000 color slides. Clients include text and trade books, magazine and encyclopedia publishers. Consignment only; does not buy outright; pays 50% commission. Offers one-time rights. Model release and captions required where appropriate. Call if in the Bay area; if not, query with samples, query with list of stock photo subjects, send material by mail for consideration or submit portfolio for review. "We look at portfolios the first Wednesday of every month." SASE. Reports in 2 weeks.
Subject Needs: "We want people interacting, relating photos, artistic/documentary/photojournalistic images, especially minorities and handicapped. Images must have excellent print quality—contextually interesting and exciting, and artistically stimulating." Need shots of school, family, career and other living situations. Child development, growth and therapy, medical situations. No nature or studio shots.
B&W: Uses 8x10 double weight glossy prints with a ¾" border.
Color: Uses 35mm transparencies.
Tips: "The Jeroboam photographers have shot professionally a minimum of 5 years, have experienced some success in marketing their talent and care about their craft excellence and their own creative vision. Jeroboam images are clear statements of single moments with graphic or emotional tension. New trends are toward more intimate, action shots."

***JOURNALISM SERVICES**, 118 E. Second St., Lockport IL 60441. (312)951-0269. President: John Patsch. Stock photo agency. Has 200,000 photos. Clients include advertising agencies, public-relations firms, businesses, book/encyclopedia publishers, magazine publishers, newspapers, post card companies, calendar companies, greeting card companies.
Subject Needs: Model released people, hi tech, travel, medical, factory, assembly lines, transportation, families, corporate. General coverage, released pictures for advertising, industry, corporate world travel, animals, scientific/technical, family life, agricultural, sports, medical.
Specs: Uses transparencies.
Payment & Terms: Pays 50% commission on color photos. General price range: $135-650. "ASMP rates are charged on all sales." Offers one-time rights. Model release and captions required.
Making Contact: Query with list of stock photo subjects. SASE. Reports in 3 weeks. Tips sheet distributed quarterly to photographers on file.
Tips: Prefers to see high quality color. "We look at the photographer's use of light and color as well as subject matter."

***JUST US PRODUCTIONS**, Box 8377, Santa Cruz CA 95061. (408)335-9171. Publishers: Brenda Shelton, Mark Marino. Stock photo agency. Has 300,000 photos. Clients include advertising agencies, audiovisual firms, magazine publishers, post card, calendar, and greeting card companies.
Subject Needs: "We specialize in photographic images of northern California but are occasionally interested in other subject matter."
Specs: Uses 35mm transparencies.
Payment &Terms: Pays 50% commission on color images. General price range: one-time use: $250-400/image. Offers one-time rights or first rights. Model release required.

Making Contact: Query with list of stock photo subjects; send unsolicited slides by mail for consideration. SASE. Reports in 3 weeks. Photo guidelines free with SASE. Tips sheet distributed free with SASE.
Tips: Prefers to see dynamic, colorful shots that will reproduce well.

JOAN KRAMER AND ASSOCIATES, INC., 5 N. Clover Dr., Great Neck NY 11021. (212)567-5545. President: Joan Kramer. Has 1 million b&w and color photos dealing with travel, cities, personalities, animals, flowers, scenics, sports and couples. Clients include advertising agencies, magazines, recording companies, photo researchers, book publishers, greeting card companies, promotional companies and AV producers. Does not buy outright; pays 50% commission. Offers all rights. Model release required. Query or call to arrange an appointment. SASE. Do not send photos before calling.
Subject Needs: "We use any and all subjects! Stock slides must be of professional quality."
B&W: Uses 8x10 glossy prints.
Color: Uses any size transparencies.

HAROLD M. LAMBERT STUDIOS, INC., Box 27310, Philadelphia PA 19150. (215)224-1400. Vice President: Raymond W. Lambert. Has 1.5 million b&w photos and 400,000 color transparencies of all subjects. Clients include advertising agencies, publishers and religious organizations. Buys photos outright—"rates depend on subject matter, picture quality and film size"; or pays 50% commission on color. Offers one-time rights. Present model release on acceptance of photo. Submit material by mail for consideration. Reports in 2 weeks. SASE. Free photo guidelines.
Subject Needs: Farm, family, industry, sports, scenics, travel and people activities. No flowers, zoo shots or nudes.
B&W: Send negatives or contact sheet. Photos should be submitted in blocks of 100.
Color: Send 35mm, 2¹/₄x2¹/₄ or 4x5 transparencies.
Tips: "We return unaccepted material, advise of material held for our file, and supply a contact record print with our photo number." Also, "we have 7 selling offices throughout the U.S. and Canada."

FREDERIC LEWIS, INC., Room 1003, 134 W. 29th St., New York NY 10001. (212)594-8816. President: David Perton. Has 1 million + color and b&w photos of all subjects. Clients include advertising agencies, TV, book, art and magazine publishers, record companies, major corporations and packaging designers. Does not buy outright; pays 40-50% commission. Offers all rights. Present model release on acceptance of photo. Call to arrange an appointment or submit portfolio. Request "want" list. SASE. Photo guidelines free with SASE; tips sheet free on request.
Color: Uses transparencies of all subjects. Especially looking for out-of-the-ordinary treatment of ordinary subjects: people, places, things and events.
B&W: Uses 8x10 glossy prints of all subjects.
Tips: "We will always look at a photographer's work, and will make the attempt to see you."

LIGHTWAVE, Suite 306-114, 1430 Massachusetts Ave., Cambridge MA 02138. (617)628-1052. Contact: Paul Light. Has 50,000 photos. Clients include ad agencies, book publishers, graphic designers and magazines.
Subject Needs: Candid photos of industrial workers, people using computers, research scientists, children in classroom situations, high technology workers, underwater photography and aerial photography.
Specs: Uses Kodachrome transparencies.
Making Contact: Mail Kodachromes in slide sheets for consideration. SASE.
Tips: "Photographers should have a photojournalistic or corporate photography background. The quantity of work you put on file is secondary to the quality. Work should be carefully edited before submission. Shoot constantly and watch what is being published. I go out of my way to give my photographers tips on what I am looking for as well as feedback as to why some of their work gets rejected. This is a very competitive field."

MAIN IMAGE PHOTOGRAPHICS, 285 S. Pearl St., Denver CO 80209. (303)698-2936/2937. Contact: Renee C. Arrington. "A full service picture agency offering clients over 20,000 current, original color images of a variety of subjects including the Rockies and the West, Denver cityscapes, people, skiing, and the history of photography." Clients include advertising agencies, public relations and AV firms, book/encyclopedia and magazine publishers and post card companies.
Subject Needs: People, family activities, recreation, sports, science, computer and medical technology.
Specs: Uses color transparencies.
Payment & Terms: Pays 50% commission. General price range: ASMP guidelines.
Making Contact: Query with resume of credits and samples. SASE. Reports in 3 weeks.

Tips: "We prefer to see at least 100 images. Send transparencies in plastic slide pages with return postage. If you are submitting images including people, please designate with the letters 'MR' when a model release is available. Model releases are almost always required in order to market people images. The more images that you shoot and can send to us, the more chances of making money. We are constantly updating our files and so do not like to keep old transparencies around that are not selling."

MEDICHROME, 271 Madison Ave., New York NY 10016. (212)679-8480. Manager: Anne Darden. Has 100,000 photos. Clients include publications firms, businesses, book/encyclopedia and magazine publishers, newspapers and pharmaceutical companies.
Subject Needs: Needs "everything that is considered medical or health-related, such as: stock photos of doctors with patients and general photos of that nature to very specific medical shots of diseases and surgical procedures; high-tech shots of the most modern diagnostic equipment; exercise and diet also."
Specs: Uses 8x10 b&w prints and 35mm, 2¼x2¼, 4x5 and 8x10 transparencies.
Payment & Terms: Pays 50% commission on b&w and color photos. General price range: "$125 for comp and AV; all magazine and other editorial, such as book, are ASMP prices with few exceptions. All brochures are based on size and print run. Ads are based on exposure and length of campaign." Offers one-time rights or first rights ("if possible and requested"); all rights ("rarely needed—very costly"). Model release preferred; captions required.
Making Contact: Query by "letter or phone call explaining how many photos you have and their subject matter." SASE. Reports in 2 weeks. Distributes tips sheet every 6 months to *Medichrome* photographers only.
Tips: Prefers to see "loose prints and slides in 20-up sheets. All printed samples welcome; no carousel, please. Lots of need for medical stock. Very specialized and unusual area of emphasis, very costly/difficult to shoot, therefore buyers are using more stock."

METRO ADVERTISING & MARKETING SERVICES, 33 W. 34th St., New York NY 10001. (800)223-1600. Contact: Stephen Tortorici. Clip art firm. Has 3,500 photos in files. Distributes to 4,200 daily and weekly paid and free circulation newspapers, schools and ad agencies and retail chains. Buys 100-200 freelance photos/year.
Subject Needs: Handles a wide variety of subject needs. Topics include family life, gardening, agriculture, fashion, industry, scenics, sports, country scenes, churches and snow photos, seasonal themes, country fairs, circuses and holiday themes.
Specs: Uses 5x7, 8x10 b&w prints; 35mm, 2¼x2¼, 4x5, 8x10 transparencies. (B&w photos preferred.)
Payment & Terms: Pays $25-400/photo. Rights negotiable. Model release required.
Making Contact: Send unsolicited photos by mail for consideration. Work will be returned for a SASE. Reports in 1 week.
Tips: Looks for clarity, design/layout and appropriateness of subject when reviewing samples. "We buy more than single shots from freelancers; we are noted for buying quantities of desired subject material and for quick payment upon purchase."

NATIONAL CATHOLIC NEWS SERVICE, 1312 Massachusetts Ave. NW, Washington DC 20005. (202)659-6720. Photo Editor: Bob Strawn. Wire service transmitting news and feature material to Catholic newspapers. Pays $25/photo also $75-200/job and $75-300 for text/photo package. Offers one-time rights. Captions required. Send material by mail for consideration. SASE. Reports in 2 weeks. Photo guidelines free with SASE.
Subject Needs: News or feature material related to the Catholic Church or Catholic people; head shots of Catholic newsmakers; close-up shots of news events, religious activities; timeless feature material (family life, human interest, humor, seasonal). Especially interested in photos depicting modern lifestyles, e.g., teens, poverty, active senior citizens, families in conflict, priests counseling couples, unusual ministries.
B&W: Uses 8x10 glossy prints.
Tips: "Submit 10-20 good quality prints with first letter covering a variety of subjects. Some should have relevance to a religious audience. Knowledge of Catholic experience and issues are helpful. All should have some caption information. We are mainly interested in people. No scenics, no churches, no flowers, no animals. As we use more than 1,000 photos a year, chances for frequent sales are very good. Send only your best, sell only one-time rights. I see a constant demand for family photos, and a special need for photos of teens. If photographer is not Catholic, he or she should read the diocesan newspaper. It will give ideas on the kinds of photos we use and be a source for potential subjects. Also get to know a local pastor."

NATIONAL NEWS BUREAU, 2019 Chancellor St., Philadelphia PA 19103. (215)569-0700. Photo Editor: Andy Edelman. Clients include book/encyclopedia and magazine publishers and newspapers. Distribute/syndicate to 1,100 publications.

Subject Needs: "All feature materials; fashion; celebrity."
Specs: Uses 8x10 b&w and color prints and b&w and color contact sheets.
Payment & Terms: Buys photos outright; pays $15-500. Offers all rights. Model release and captions required.
Making Contact: Query with samples; send photos by mail for consideration; submit portfolio for review. SASE. Reports in 2 weeks.
Tips: Needs photos of "new talent—particularly undiscovered female models."

***NAWROCKI STOCK PHOTO**, Suite 1630, 332 S. Michigan Ave., Chicago IL 60604. (312)427-8625. Director: William S. Nawrocki. Stock photo agency, picture library. Has over 250,000 photos and 150,000 historical photos. Clients include advertising agencies, public-relations firms, businesses, book/encyclopedia publishers, magazine publishers, newspapers, post card companies, calendar companies, greeting card companies.
Specs: Uses 8x10 matte or glossy b&w and color prints; 35mm, 2¼, 2¼x2¾, 4x5, 8x10 transparencies.
Payment & Terms: Buys only historical photos outright. Pays 50% commission on b&w and color photos. General price range: ASMP rates. Offers one-time rights, first rights, all rights, exclusive rights. Model release and captions required.
Making Contact: Arrange a personal interview to show portfolio, query with resume of credits, samples and list of stock photo subjects, submit portfolio for review. SASE. Reports ASAP. Photo guidelines free with SASE. Tips sheet distributed "very often to our photographers."
Tips: "A stock agency uses just about everything—model released material is important. Just about everything you can imagine will be asked for. Model releases are the most requested for ads/brochures."

***NEW JERSEY NEWS PHOTO**, Airport International Plaza, Rt. #1, Newark NJ 07114. (201)242-1111. Contact: Carole Trisler. Stock photo agency and picture library. Has 5 million photos. Clients include advertising agencies, public-relations firms, audiovisual firms, businesses, magazine publishers and newspapers.
Subject Needs: All subjects.
Specs: Uses b&w and color 8x10 glossy prints; 35mm, 2¼x2¼, 4x5 and 8x10 transparencies; b&w and color contact sheets; and b&w and color negatives.
Payment & Terms: General price range: $10/up. Offers one-time rights. Model release required.
Making Contact: Query with resume of credits. Solicits photos by assignment only. SASE. Reports in 1 week. Free photo guidelines with SASE.

***NEWS FLASH INTERNATIONAL, INC.**, Division of Observer Newspapers, 2262 Centre Ave., Bellmore NY 11710. (516)679-8888. Editor: Jackson B. Pokress. Has 25,000 photos. Clients include advertising agencies, public relations firm, business and newspapers. Pays $5 minimum/photo; also pays 40% commission/photos and films. Offers one-time rights or first rights. Model release and captions required. Query with samples, send material by mail for consideration or make a personal visit if in the area. SASE. Reports in 1 month. Free photo guidelines and tip sheet on request.
Subject Needs: "We handle news photos of all major league sports: football, baseball, basketball, boxing, wrestling, hockey. We are now handling women's sports in all phases including women in boxing, basketball, softball, etc." Some college and junior college sports. Wants emphasis on individual players with dramatic impact. "We are now covering the Washington DC scene. There is now an interest in political news photos."
Film: Super 8 and 16mm documentary and educational film on sports, business and news.
B&W: Uses 8x10 glossy prints; contact sheet OK.
Color: Uses transparencies.
Tips: "Exert constant efforts to make good photos—that newspapers call grabbers, make them different than other photos, look for new ideas. There is more use of color and large format chromes." Special emphasis on major league sports. "We cover Mets, Yankees, Jets, Giants, Islanders on daily basis. Rangers & Knicks on weekly basis."

***NORTHWEST PHOTOSTOCK**, 455 Rainier Blvd. N., Issaquah WA 98027. (206)392-8454. Owner: Bob Windom. Stock photo agency. Has 35,000 photos. Clients include advertising agencies, audiovisual firms, book/encyclopedia publishers, magazine publishers, post card companies, calendar companies, greeting card companies and graphic arts.
Subject Needs: Agriculture, airplanes, animals, bars, birds, boats, buildings, children, crowd scenes, faces, flowers, food, historical, landscapes, manufacturing, patterns, Seattle, sports, sunrise/sunset, transportation, work places.
Specs: Uses 35mm, 2¼x2¼ and 4x5 transparencies. Pays 50% commission on sales. General price range: $100-1,500. Sells one-time rights. Model release preferred; captions required.

Making Contact: Query with samples and list of stock photo subjects. SASE. Reports in 2 weeks. Photo guidelines free with SASE. Tips sheet distributed every two months to anyone.
Tips: "Requests for subject matter are getting broader. He or she needs to shoot as broad a subject range as possible."

OMEGA NEWS GROUP /USA, A.S. Rubel, Inc., 1200 Walnut St., Philadelphia PA 19107-5449. (215)985-9200. Managing Editor: A. Stephen Rubel. Stock photo and press agency servicing advertising agencies, public relations firms, businesses, book publishers, magazine publishers, encyclopedia publishers, newspapers, calendar and poster companies.
Subject Needs: "All major news, sports, features, society shots, shots of film sets, national and international personalities and celebrities in the news as well as international conflicts and wars."
Specs: Uses 35mm, 2¹/₁x2¹/₄ or 4x5 transparencies; 8x10 b&w glossy prints. Photos must be stamped with name only on mounts and back of prints; prints may be on single or double weight but unmounted.
Payment & Terms: Pays 50% commission. Price depends upon usage (cover, inside photo, etc.). Offers first North American serial rights; other rights can be procured on negotiated fees. Releasesrequired on most subjects; captions a must.
Making Contact: Submit material by mail for consideration. SASE. Send resume, including experience, present activities and interests, and range of equipment. Supply phone number where photographer may be reached during working hours. Photo guidelines and tip sheet with SASE.
Tips: Should have experience in news and/or commercial work on location. "We always welcome the opportunity to see new work. We are interested in quality and content, not quantity. Comprehensive story material welcomed."

OMNI-PHOTO COMMUNICATIONS, INC., 521 Madison Ave., New York NY 10022. (212)751-6530. President: Roberta Guerette. Has 10,000 photos. Clients include advertising agencies, public relations firms, businesses, AV firms, book publishers, magazine publishers, encyclopedia publishers, newspaper, post card companies, calendar companies, greeting card companies.
Subject Needs: "The file is a general stock file (color and b&w) with an emphasis on human interest."
Specs: Uses 8x10 b&w double weight semiglossy prints and transparencies.
Payment & Terms: Pays 50% commission on b&w and color photos. Price range "very much depends on the usage." Offers one-time rights. Model release and captions preferred.
Making Contact: Query with samples or with list of stock photo subjects. SASE. Reports in 1 month. Tips sheet distributed to signed photographers.
Tips: "I like to see a variety of work with emphasis on the subjects that particularly interest the photographer. Enough variation should be included to show how technique is handled as well as aesthetics."

***OUTLINE PRESS SYNDICATE INC.**, 1068 Second Ave., New York NY 10022. (212)319-1180. President: Jim Roehrig. Personality/Portrait. Has 250,000 photos. Clients include advertising agencies, public-relations firms, magazine publishers, newspapers, production/film co.
Subject Needs: Heavy emphasis on personalities, film, TV, political feature stories.
Payment & Terms: General price range: negotiable. Rights negotiable. Model release preferred; captions required.
Making Contact: Query with resume of credits. Deals with local freelancers by assignment only. Does not return unsolicited material. Reports in 3 weeks.
Tips: Prefers to see a photographer that can create situations out of nothing.

PANOGRAPHICS, Box 4191, Utica NY 13504. (315)797-9194. Contact: Larry Stepanowicz. Clients include advertising agencies, AV firms, book publishers and magazine publishers.
Subject Needs: Nature, biological, photomicrography, scientific; life in the US—people, places and things; graphic, poster-like images of all types including sports, children, models.
Specs: Uses 35mm, 2¹/₄x2¹/₄ slides.
Payment & Terms: Two year contract, or may duplicate selected material and return originals. Pays 50% commission on b&w and color photos. Offers one-time rights in most cases. Model release and captions preferred.
Making Contact: Query with samples or with list of stock photo subjects. SASE. Reports in 2 weeks. "Will give beginners a chance if work is of outstanding quality."
Tips: "Know your craft. Strive for quality. Build a large collection of photos over time."

PHOTO BANK, Suite 102, 313 E. Thomas Rd., Phoenix AZ 85012. (602)265-5591; also *Idaho Photo Bank*, Sun Valley Office, Box 3069, Ketchum ID 83340. (208)726-5731. General Manager: Don Petelle. Has 30,000 photos. Clients include businesses, advertising agencies, AV firms, magazine publishers, calendar companies, greeting card companies, poster companies and interior decorators.
Subject Needs: "We welcome all categories, especially people, lifestyles, business, investments, tots

"In this action ski shot," explains Photo Bank General Manager Don Petelle, "our photographer is Greg Loomis of Sun Valley, Idaho. Greg shoots a lot of his friends at sports. He gets a lot of action with snow flying to give a sense of speed and action excitement—qualities that art directors look for. Hot colors are also needed such as reds, yellows, bright greens and blues to make that picture pop." This photo was used for $175 in a resort brochure.

to aged, tots with animals, sports and activities, wildlife, world travel, scenics and food."

Specs: Uses 35mm to medium and large format color transparencies; 8x10 glossy b&w prints.

Payment & Terms: Standard 50-50 split. Sells one-time rights or first rights. Model release and captions required.

Making Contact: Query with SASE for a copy of contract agreements and information sheets. Send *all* submissions to Arizona address. Reports in 3 weeks.

Tips: "As there is a large portion of our business conducted in lifestyles such as tennis, golf, swimming, dining, skiing etc., your models should be appealing and healthful looking with nice teeth and smiles, making sure that they are attired properly. Color is very important. When shooting a scenic think of the effect of your subject matter e.g., cool and refreshing for a cascading brook waterfall or warm (comforting) and cosy for a picture of a fireplace, freezing and rough for the Swiss Alps, and so on. Send at least 100 of your best work with sufficient return postage and insurance fees. We are always in need of good color and action in sports and wildlife. Closely edit your work before sending. In order to make your photographs useful to the advertising market, make sure to obtain proper model releases from your lifestyle subjects. The Photo Bank is a member of the Picture Agency Council of America."

***PHOTOBANK**, Suite K, 17905 Skypark Circle, Irvine CA 92714. (714)250-4480. Photo Editor: Kristi Bressert. Stock photo agency. Has 175,000 transparencies. Clients include advertising agencies, public-relations firms, audiovisual firms, businesses, book/encyclopedia publishers, magazine publishers, newspapers, post card companies, calendar companies, greeting card companies, wall decor.

Subject Needs: Emphasis on couples (age 40-60 in high demand), lifestyle, medical, family and business. High tech shots are always needed.

Specs: Uses all formats: 35mm, 2¼, 4x5, 6x7, 8x10.

Payment & Terms: Pays 50% commission on b&w and color photos. General price range: 10% off

ASMP rates. Model release and captions desired.
Making Contact: Arrange a personal interview to show portfolio, or query with samples and list of stock photos. SASE. Reports in 1-3 weeks. Photo guidelines free with SASE.
Tips: Prefers to see "The 3 'C's: clarity, color, composition. Stock is a great way to generate income from slides collecting dust in your files."

PHOTO MEDIA, Div. Universal Media Inc., 3 Forest Glen Rd., New Paltz NY 12561. (914)255-8661. Photographer's queries to 3 Forest Glen Rd., New Paltz NY 12561. Contact: Jane Reynolds. Has 50,000 color transparencies only. Clients include advertising agencies, public relations firms, businesses, AV firms, book publishers, magazine publishers, calendar companies and greeting card companies. Does not buy outright; pays 50% commission. Offers one-time worldwide rights. Model release required; identify locations of geographical photos. Query with samples. SASE. Reports in 1 month. Photo guidelines free with SASE.
Subject Needs: Human interest, faces, couples, medical, crime, mood, special effect, nature, ecology, sports, industry, police, music, dance, personalities, leisure, vacation, retirement, arts, crafts. Wants "professional, clean transparencies, with good color saturation or subject matter, technically competent, imaginative and profound in its own way." No fashion or scenic 35mm.
Color: Uses transparencies only.
Tips: "Specialize in human interest, nature, medical, scientific or industrial photography and submit only specialized material."

PHOTO NETWORK, 1541J Parkway Loop, Tustin CA 92680. (714)259-1244. Owners: Mrs. Cathy Aron and Ms. Gerry McDonald. Stock photo agency. Pays 50% commission. General price range: $100-ranges upward. Has 300,000 photos. Works with ad agencies, AV producers—multimedia productions, textbook companies, graphic artists, public-relations firms, newspapers, businesses, calendar companies and greeting card companies. Model release and captions required. Query with list of stock photo subjects. SASE. Reports in 4 weeks.
Subject Needs: Needs shots of "personal" sports such as jogging, exercises, racquetball, tennis, golf, skiing. Also industrial shots, families, offices, animals and ethnic groups, California scenics and lifestyles.
Color: Uses 35mm, 2¼x2¼, 4x5 transparencies.

PHOTO RESEARCHERS, INC., 60 E. 56th St., New York NY 10022. (212)758-3420. President: Jane Kinne. Computer-controlled agency for hundreds of photographers including the National Audubon Society Collection. Clients include ad agencies and publishers of textbooks, encyclopedias, filmstrips, trade books, magazines, newspapers, calendars, greeting cards, posters, and annual reports in US and foreign markets. Rarely buys outright; works on 50% stock sales and 30% assignments. General price range: $75-7,500. Submit model release with photo. Query with description of work, type of equipment used and subject matter available; arrange a personal interview to show portfolio; or submit portfolio for review. Reports in 1 month maximum. SASE.
Subject Needs: All aspects of natural history and science; human nature (especially children and young adults 6-18 engaged in everyday activity); industry; "people doing what they do"; and pretty scenics to informational photos, particularly need model released people photos and property photos such as houses, cars and boats.
B&W: Uses 8x10 matte doubleweight prints.
Color: Uses any size transparencies.
Tips: "When a photographer is accepted, we analyze his portfolio and have consultations to give the photographer direction and leads for making sales of reproduction rights. We seek the photographer who is highly imaginative, or into a specialty, enthusiastic and dedicated to technical accuracy. Have at least 400 photos you deem worthy of reproduction, be adding to your files constantly and fully caption all material."

***PHOTO TRENDS**, Box 650, Freeport NY 11520. (516)379-1440. Owner: R. Eugene Keesee. Stock photo agency, news/feature syndicate. Has 500,000 photos. Clients include book/encyclopedia publishers, magazine publishers, newspapers, tabloids, international publishers.
Specs: Uses 8x10 glossy prints, b&w and color contact sheets.
Payment & Terms: Pays 50% commission on b&w and color photos. General price range: $30 to 1,200. Rights purchased negotiated. "Model releases increase possibilities of sales and income."
Making Contact: Send small sample: *XEROXES*. "Xeroxes will be returned with comments. We contact good photographers (by phone) who have exclusives on news events and celebrities."
Tips: Prefers to see contemporary Americana, with close-ups on people ("human interest") showing how Americans live today. "Most successful stock photo agencies do not 'need' photos from beginners, no matter how talented. But you want the best sales talent for your production, so what is your method

for enlisting their talent? I suggest you send xeroxes of your best pixs, with good, brief captions to those who sound most logical for YOU."

PHOTOPHILE, 2311 Kettner Blvd., San Diego CA 92101. (714)234-4431. Director: Linda L. Rill. Clients include advertising agencies, book publishers, magazine publishers, encyclopedia publishers and newspapers. Does not buy outright; pays 50% commission. Offers one-time rights or all rights. Captions required. Send material by mail for consideration. SASE.
Subject Needs: People: vocations and activities; sports and action shots; scenics of California, US and areas of interest around the world. Professional material only.
Color: Uses 35mm, 2¼x2¼ or 4x5 transparencies.
Tips: "Specialize."

PHOTOTAKE, 4523 Broadway, New York NY 10040. (212)942-8185. Director: Leila Levy. Stock photo agency; "also 'new wave' photo agency specializing in science and technology in stock and on assignment." Has 20,000 photos. Clients include advertising agencies, businesses, newspapers, public relations and AV firms, book/encyclopedia and magazine publishers, and post card, calendar and greeting card companies.
Subject Needs: General science and technology photographs, medical, high-tech, computer graphics, special effects for general purposes, health oriented photographs.
Specs: Uses 8x10 prints; 35mm, 2¼x2¼, 4x5 or 8x10 transparencies; contact sheets or negatives.
Payment & Terms: Pays 50% commission on b&w and color photos. Offers one-time or first rights (world rights in English language, etc.). Model release and captions required.
Making Contact: Arrange a personal interview to show portfolio; query with samples or with list of stock photo subjects; or submit portfolio for review. SASE. Reports in 1 month. Photo guidelines "given on the phone only." Tips sheet distributed monthly to "photographers that have contracted with us at least for a minimum of 40 photographs."
Tips: Prefers to see "at least 80 color photos on general photojournalism or studio photography and at least 5 tearsheets—this, to evaluate photographer for assignment. If photographer has enough in medical, science, general technology photos, send these also for stock consideration." Using more "illustration type of photography—for example 'Life After Death' requiring special effects. Topics we currently see as hot are: general health, computers, news on science. Photographers should always look for new ways of interpreting the words: 'technology' and 'science.' "

PHOTRI INC., Box 971, Alexandria VA 22313. (703)836-4439. President: Jack Novak. Has 400,000 b&w photos and color transparencies of all subjects. Clients include book and encyclopedia publishers, advertising agencies, record companies, calendar companies, and "various media for AV presentations." Seldom buys outright; pays 50% commission. General price range: "$50-unlimited." Offers all rights. Model release required if available and if photo is to be used for advertising purposes. Call to arrange an appointment or query with resume of credits. Reports in 2-4 weeks. SASE.
Subject Needs: Military, space, science, technology, romantic couples, people doing things, humor picture stories. Special needs include calendar and poster subjects. Has subagents in 10 foreign countries interested in photos of USA in general.
B&W: Uses 8x10 glossy prints.
Color: Uses all sizes of 35mm and larger transparencies.
Tips: "Respond to current needs with good quality photos. Take other than sciences, i.e., people and situations useful to illustrate processes and professions. Send photos on energy and environmental subjects. Also need any good creative 'computer graphics'."

THE PICTURE CUBE INC., Suite 1131, 89 Broad St., Boston MA 02110. (617)367-1532. President: Sheri Blaney. Has 200,000 photos. Clients include advertising agenices, public relations firms, business, AV firms, book publishers, magazine publishers, encyclopedia publishers, newspapers, post card companies, calendar companies, greeting card companies and TV.
Subject Needs: US and foreign coverage, contemporary images, agriculture, industry, energy, high technology, religion, family life, multicultural, animals, plants, transportation, work, leisure, travel, ethnicity, communications, people of all ages, psychology and sociology subjects.
Specs: Uses 8x10 prints and 35mm, 2¼x2¼, 4x5 and larger slides.
Payment & Terms: Pays 50% commission. General price range: $90 minimum/b&w; $135 minimum/color photo. Offers one-time rights. Model release preferred; captions required.
Making Contact: Arrange a personal interview to show portfolio. SASE. Reports in 1 month.
Tips: Serious freelance photographers "must supply a good amount (at least a thousand images per year, of high quality, sales-oriented subject matter) of material, in order to produce steady sales."

PICTURES INTERNATIONAL, Box 14051, Tulsa OK 74159. (918)664-1339. President: James W. Wray II. Has 50,000 photos. Clients include advertising agencies, public relations and AV firms;

businesses, book/encyclopedia and magazine publishers, newspapers, post card, calendar and greeting card companies.
Specs: Uses 8x10 b&w or color glossy prints; 35mm, 2¼x2¼, 4x5, 8x10 transparencies; b&w or color contact sheets; b&w or color negatives.
Payment & Terms: Pays 50% on b&w and color photos sold. Model release and captions required.
Making Contact: Arrange a personal interview to show portfolio; submit portfolio by mail for review. Photo guidelines and tips sheet on request. SASE.
Tips: "Ours is an agency supplying photos to a widely varied market. We will consider all types of photos as long as they are top quality."

PLANET EARTH PICTURES/SEAPHOT LTD, 4 Harcourt St., London England W1H ID5. 01-262-4427. Managing Director: Gillian Lythgoe. Has 80,000 photos. Clients include advertising agencies, public relations and AV firms, businesses, book/encyclopedia and magazine publishers, and post card and calendar companies.
Subject Needs: "Marine—surface and underwater photos covering all marine subjects, including water sports, marine natural history, seascapes, ships; natural history—all animals and plants; interrelationships and behavior; lanscapes, natural environments, the people and the animals and plants."
Specs: Uses any size transparencies.
Payment & Terms: Pays 50% commission on color photos. General price range: £30 (1 picture/1 AV showing), to over £1,000 for advertising use. Prices are all negotiated individually according to use. Offers one-time rights. Model release preferred; captions required.
Making Contact: Arrange a personal interview to show portfolio; send photos by mail for consideration. SASE. Reports ASAP. Distributes tips sheet every 6 months to photographers.
Tips: "We like photographers to have received our photographer's booklet that gives details about photos and captions. Trends change rapidly. There is a strong emphasis that photos taken in the wild are preferable to studio pictures."

***PORTFOLIO**, 4832 Park Rd., Box 168, Charlotte NC 28209. (704)553-9684. President: Janell Rice. Stock photo agency. Has over 5,000 photos. Clients include advertising agencies, public-relations firms, audiovisual firms, businesses, book/encyclopedia publishers, magazine publishers, post card companies, calendar companies, greeting card companies, galleries. "I am in the process of organizing a 'show case' exhibit for my contributing photographers."
Subject Needs: General subject matter.
Specs: Uses 8x10 glossy b&w prints; 35mm, 2¼x2¼, 4x5, 8x10 transparencies; b&w contact sheets.
Payment & Terms: Pays 50% commission on b&w and color photos. General price range: $200-500. Offers one-time rights. Model release preferred; captions required.
Making Contact: Arrange a personal interview to show portfolio; query with resume of credits, samples and list of stock photo subjects. SASE. Reports in 2 weeks. Photo guidelines free with SASE. Tips sheet distributed quarterly to anyone, free with SASE.
Tips: Prefers to see strong graphic images, no "cutesy" or obviously contrived shots.

PRO/STOCK, 11046 McCormick, North Hollywood CA 91601. (213)877-5694. President: Wayne Hallowell. Photo stock service. Clients: corporations, manufacturers, entertainment.
Needs: Works with 80-95 freelance photographers/year. Uses photographers for brochures, catalogs, posters, AV presentations, newsletters and annual reports. Subject matters covers "all areas." Also works with freelance filmmakers to produce movie titles and training films; "all types dependent on requirement or effects desired by projects."
Specs: Uses 8x10 b&w and color prints; 35mm, 4x5 and 8x10 transparencies.
First Contact & Terms: Arrange a personal interview to show portfolio or submit portfolio for review; provide resume, 2 business cards and samples to be kept on file for possible future assignments. SASE. Reports in 2 weeks. Pays ASMP rates per hour or job. Buys all rights or one-time rights. Model release and captions preferred. Credit line given "sometimes."

R.D.R. PRODUCTIONS, INC., 351 W. 54th St., New York NY 10019. (212)586-4432. President: Al Weiss. Photo Editor: Chuck Musse. Has 700,000 photos. Clients include advertising agencies, public relations firms, book publishers, magazine publishers, newspapers and calendar companies.
Subject Needs: Primarily editorial material: human interest, personalities, glamour and current news features.
Specs: Uses b&w and color glossy prints; 35mm and 2¼x2¼ color transparencies and b&w negatives.
Payment & Terms: "Occasionally" buys photos outright; price open. Pays 60% commission for photos. General price range varies from $35/b&w to $1,500 for color series. Average for b&w $75; average for single color $150. Offers one-time rights. Model release and captions required.
Making Contact: Query with samples or with list of stock photo subjects or send unsolicited material

by mail for consideration. SASE. Reports in 3 weeks. Tips sheet distributed "approximately quarterly to photographers we represent."

***RANGE FINDERS**, 275 Seventh Ave., New York NY 10001. (212)689-1340. President: Mary Beth Whelan. Clients: ad agencies, PR firms, businesses, AV firms, book/magazine publishers, encyclopedia publishers, newspapers, post card companies, calendar companies, greeting card companies.
Specs: Uses 8x10 glossy b&w prints; 35mm, 2¼x2¼, 4x5, 8x10 transparencies.
First Contact & Terms: Arrange a personal interview to show portfolio; submit portfolio by mail; query with samples. SASE. Reports in 3 weeks. Pays ASMP rates, range $125-7,500. Model release and captions required. Credit line given when possible.
Tips: "We are interested in quality and content, not quantity. We encourage communication between photographer and agency so we can better service each other's needs. Study the markets and current trends."

RELIGIOUS NEWS SERVICE PHOTOS, 104 W 56th St., New York NY 10019. (212)315-0870. Photo Editor: Kevin McLaughlin. Picture library. Maintains 250,000 photos. Serves church-related newspapers (Protestant, Catholic and Jewish).
Subject Needs: Works with 2-3 photographers/month. Uses photographers for weekly news ad feature photo service. Subjects include news and feature photos on religious subjects.
Specs: Uses 8x10 glossy b&w photos.
Payment & Terms: Query with samples. Works with freelancers by assignment or on spec; interested in stock photos. SASE. Reports in 1 month. Pays $25/photo. Pays on acceptance. Buys all rights. Captions required. Credit line given.
Tips: "Prefer photos dealng with topical religious issues, spirituality, prayer, religious architecture, etc. For breaking news with a regional or national slant, call or New York office. Avoid high-density, overly dark shots. Drugstore and other poor-quality material will be rejected."

CHRIS ROBERTS REPRESENTS, Box 7218, Missoula MT 59807. (406)728-2180. Owner: Chris Roberts. Stock photo and photographers/artists representation agency. Clients include advertising agencies, public relations firms, audiovisual firms, businesses, book/encyclopedia publishers, magazine publishers, post card companies, calendar companies and greeting card companies.
Subject Needs: Travel, western scenic, advertising, editorial, ethnic and wildlife.
Specs: Uses 35mm, 2¼x2¼, and 4x5 transparencies; b&w contact sheets.
Payment & Terms: Pays 50% commission on b&w and color photos. General price range: $50-1,500. Offers one-time rights or all rights. Model release preferred; captions required.
Making Contact: Arrange a personal interview to show portfolio; query with resume of credits, samples, or list of stock photo subjects; send unsolicited photos by mail for consideration; submit portfolio for review. Solicits photos by assignment only. Does not return unsolicited material. Reports in 3 weeks.

SHASHINKA PHOTO, Suite 2102, 501 5th Ave., New York NY 10017. Contact: Jane Hatta or A. Matano. Has over 100,000 photos in New York and Tokyo. Clients include AV firms, book publishers, magazine publishers, encyclopedia publishers and newspapers. Does not buy outright; pays 50% commission/35mm transparencies; 60% commission for larger format. Offers one-time rights. Model release and captions required. Send material by mail for consideration with SASE. No reply/return without SASE. Reports immediately.
Subject Needs: "We're strong on East Asian cultures because of our Tokyo office. We're also interested in material for a monthly children's picture book for schools (kindergarten through 3rd grade)." Uses very little b&w. Also needs wildlife, with theme or in sequence; natural, unposed photos of families having meals in their homes; photos of children 4-8 years old for specific shots. Especially needs photos for children's science monthly book on natural and physical sciences. Any series that tells or explains phenomena. Artistic nudes but no pornography.
Color: Prefers 2¼x2¼ and larger transparencies.
Tips: "Poor technical quality turns us off. Every Tom, Dick and Harry with a camera thinks he's a professional photographer, and it's wasting time for us both." Photographer should have professional technique; know lighting and composition.

SHOOTING STAR INTERNATIONAL PHOTO AGENCY, INC., Box 93368, Hollywood CA 90093. (213)876-2000 or 876-9000. President: Yoram Kahana. Clients include newspapers, magazines, book/ encyclopedia publishers, ad agencies, and anyone using celebrity and human interest photos.
Subject Needs: "We specialize in celebrity photos and photostories, with emphasis on at home photosessions, in-studio portraits and beauty shoots, special events and location filming. No run of the mill grab shots, paparazi, parties, etc. In order of importance and salability: Television, movies, music, arts

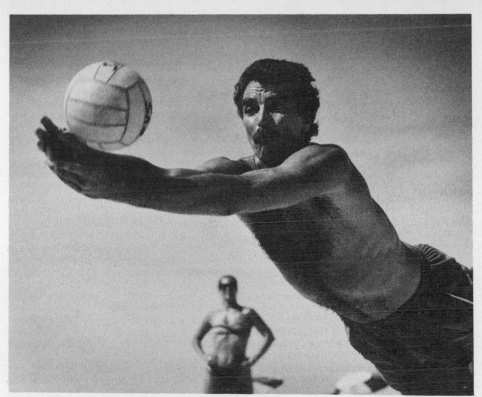

Tim Ryan, a Honolulu, Hawaii-based photographer, got this shot, and many others, of Tom Selleck on Waikiki Beach—and went to work marketing them. This one was sold to People magazine, Volleyball Monthly, *and a selection of magazines based in Europe. Due to the publicity the photos received, some were even purchased by Selleck. Earnings so far have totaled $1,575. Ryan has contracted with Shooting Star International Photo Agency to market his color images; he has received several hundred dollars from these sales. Gamma/Liaison is marketing his black and white images of Selleck. How else has Ryan benefitted from these photos being sold? ". . . what it did most of all was build my confidence. I had a shot that people wanted to see . . . I also felt confident about doing other things, and I began promoting myself. I made sure that* People *magazine knew I was available for other jobs if they needed something in Hawaii. And four months later they hired me for a day shoot—at $350!"*

and politics, etc. Human interest photos should be complete stories, timeless- unusual sports, upbeat medical, animal interest, curiosities, stunts and so on."

Specs: Color transparencies only (35mm preferred).

Payment: "We pay 60% bimonthly. General price range: From a few dollars per color in some third world countries to thousands of dollars for some covers in the USA and abroad." Must have captions, ID's and brief text.

Making Contact: Query with list of subjects, photocopies of tearsheets. SASE. Replies ASAP. Will send some additional info with SASE.

Tips: "We can resell your celebrity photos if you are a pro working with celebrities. e.g., a photographer working with a fitness magazine who shoots celebrities exercising, a fashion photographer who worked with celebrity models, another who did celebrity homes for an interior design magazine etc.; or you shoot celebrities outside of Hollywood such as a star's winter home in Tahoe, a star living in Arizona, etc. Shooting Star distributes directly and through sub agents to more than 30 countries—American TV is seen everywhere. We have more thorough coverage of TV actors than any other agency—we have done photosessions with more than 50 actors on Dallas, whole casts of other popular (and obscure) series. TV names outsell other celebrites 10 to 1, but we do cover all areas, especially if they have international appeal- e.g., golf, tennis, wrestling, but not baseball or horseracing. Human interest stories are

about 10% of our volume, but the good ones sell and resell; heartwarming, smile inducing, positive stories; animal trainers, medical miracles, heroic people and deeds—a one-armed surgeon, a water tower turned into home, custom dog houses, skiing on snow shovels, etc. The kind of photostories you see in *People*, the *National Enquirer*, *Life*—they have universal appeal.''

SHOSTAL ASSOCIATES, INC., 145 East 32nd St., New York, NY 10016. (212)686-8850. Has over 1 million photos. Contact: Joe Barnell or Dave Forbert. Clients include advertising agencies, public relations firms, businesses, AV firms, book publishers, magazine publishers, encyclopedia publishers, newspapers, calendars, greeting cards, industry, designers, interior decorators, etc. Does not buy outright; pays 50% commission. Offers one-time rights. Model releases and full captions on most subjects required. Arrange for personal interview to show portfolio for review.
Subject Needs: All subjects except news.
Color: Uses color transparencies only 35mm, 2¼x2¼, 4x5 and 8x10.
Tips: "Our markets are very demanding and will only use top quality professional photos. As the original all-color agency we made our reputation on large format originals. Today 35mm contemporary photos are also sought, but they must meet our high standards."

SICKLES PHOTO & REPORTING SERVICE, Box 98, Maplewood NJ 07040. (201)763-6355. Contact: Gus Sickles. Clients include advertising agencies, public relations firms, businesses, AV firms, editors, book publishers, magazine publishers, encyclopedia publishers, newspapers, post card companies and calendar companies. Primarily still photography assignments, and still photography and reporting assignments; motion picture assignments for footage and videotape assignments. Pays $50-500/photo assignment; $200-600/day for photography and reporting assignment plus expenses for processing, phone, mileage and mailing. Offers all rights. Model release and captions required. Query with resume of credits and experience. Photos purchased on assignment only. SASE. Reports "immediately."
Subject Needs: "We cover assignments relating to product applications and services in industry, agriculture and commerce, and human interest stories."
Film: Super 8 and 16mm documentary and ¼" and ½" videotape interviews. Gives assignments.
B&W: Need negatives, do not need prints.
Color: Uses transparencies and color negatives; do not need prints.
Tips: "Should have experience in news and/or commercial photography on location, and ability to get story with help of an outline prepared by us. Videotape capability and aerial photography experience of interest to us. Send resume, including experience, present activities and interests, and tell what cameras and lenses you are working with and your capability of getting stories with pictures. We need contacts with capable photographers and photojournalists and reporters in as many different locations across the USA and foreign countries as possible. We especially need contacts with photojournalists who can write or report in addition to covering photographic assignments for advertisers, public relations firms, advertising agencies and editors. We cover case history and story assignments. Many of our assignments result in trade paper articles, trade paper ads, publicity releases and sales promotion pieces, brochures, annual reports, etc. Just drop us a line about the type of work you are doing and your experience. We will respond and send a copy of our guidelines and suggestions."

***SIERRA NEVADA VIEWFINDER**, Box 920, Verdi NV 89439. President: Ted Roberson. Clients include advertising agencies, magazine publishers, book publishers, tourist boards, public relations firms, calendar companies, etc. SNV is a stock agency that focuses on images taken in the state of Nevada, the Reno-Tahoe region, and anywhere in the Sierra Nevada mountain range.
Subject Needs: "We need photos of rural Nevada, ranches, farms, people who make their life in the rural setting, Lake Tahoe activities with people actually doing them, seasonal mountain shots, hot ski photos at any Sierra resort or backcountry locale, camping, backpacking, casino action, Reno day and night life. Some scenics but they must be very, very good (David Muench quality please)."
Specs: Uses 35mm (Kodachrome preferred), medium and large format transparencies; 8x10 b&w prints. No color prints please!
Payment and Terms: Pays 50% commission. "We do not buy the photos outright, we sell one-time rights only." Model release and captions required.
Making Contact: Send a short letter of inquiry with a list of photo subjects. "We will send you the SNV guidelines for your initial submission." SASE (business size). Reports in 2 weeks.
Tips: "SNV is a new stock agency that is now looking for top quality photographers. We are very interested in new and upcoming talent and will look at all submissions closely. What we ask of you is clean, clear, perfectly exposed, sharp, story telling photography. Don't waste your time and my time with garbage that will never sell. Avoid cliche and overshot subject type photos. Imagination counts. Don't be afraid to take photos of people involved in some activity. People photos sell."

SINGER COMMUNICATIONS, INC., 3164 W. Tyler Ave., Anaheim CA 92801. (714)527-5650. Contact: Nat Carlton. Handles educational and theatre films for foreign TV. Clients include book publishers,

magazine publishers, newspapers, companies worldwide. Does not buy outright; pays 50% commission on photos; 25% on films. Rights offered depend on requirements and availability. "Do *not* send original transparencies. Send query first." SASE. Reports in 2 weeks. "Will advise of current needs for SASE."
Subject Needs: Interviews with celebrities. "Color transparencies for jacket covers of paperbacks and magazines." Especially needs westerns, mysteries, gothics, historical romance cover art.
Color: Uses 2¼x2¼ and 4x5 transparencies.
Tips: "The international market opens avenues for increased sales of material first sold in the North American area. We need transparencies for paperback jacket covers."

SOUTHERN STOCK PHOTOS, Suite 33, 3601 W. Commercial Blvd., Ft. Lauderdale FL 33309. (305)486-7117. Owner: Edward Slater. Manager: Jayne Lips. Photo Coordinator: Karin Devendorf. Clients include advertising agencies, public relations firms, businesses, book publishers, magazine publishers, encyclopedia publishers, calendar companies, mural and poster companies. Offers one-time rights or exclusive rights.
Subject Needs: Couples and single people in everyday situations such as dining, picnicking, biking, boating, swimming (pool and beach); jogging, exercising, walking, golf, tennis, romantic, etc. (Couples grouped as ages 25-35, 40-55, seniors); businessmen and women at work; family activities with parents and children together and separately; children playing organized group sports; color scenics and major cities (day and night, skylines) from US and foreign countries; underwater (especially divers); wildlife; boating and sailing, yachts; fishing (all kinds, especially action shots); sports (action shots) and their spectators, especially horse racing, jai-alai, dog tracks; sunsets; airports (interior and exterior); jets in air; industrial, and high-tech photography. "We specialize in Southern lifestyles." No posed, trite photos. "We especially need exceptional 4x5 chromes of scenics for calendar companies. General scenics will be returned unless they are of exceptional quality."
Specs: Uses color, 35mm, 2¼x2¼, 4x5, 8x10 transparencies. No color prints. Kodachrome & Fujichrome 35mm preferred over Ektachrome.
Payment & Terms: Does not normally buy outright; pays 50% commission. Model releases required and must be marked on the actual slide.
Making Contact: Send SASE for complete submission guidelines first. Reports in 3-4 weeks.
Tips: Photos are examined with 8x loupe. "Photographers, please use a loupe before we do. Serious professionals only."

***SPECTRUM PHOTOLIBRARY**, Box 440, Wyoming RI 02898. (401)539-8569. Stock photo agency. Has 100,000 plus photos. Clients include advertising agencies, public-relations firms, audiovisual firms, businesses, book/encyclopedia publishers, magazine publishers, post card companies, calendar companies, greeting card companies and travel companies, producing brochures for international travel/hotels/air/sea. "We also have a British based office."
Subject Needs: "We supply a wide range of subjects, for a wide range of clients. We need top quality, sharp, colorful transparencies/slides and b&w prints, including travel in any country worldwide, mood shots, people pictures and even abstracts, in addition to seasonal pictures for greeting cards, including table top."
Specs: Uses 35mm, 2¼x2¼, 4x5, 6x7, 8x10 transparencies; "best sales from 2¼ format and upwards." Black and white prints—8x10 (all subjects).
Payment & Terms: Pays 50% commission on sales the month after receipt of payment. General price range: $100 to unlimited. Rights negotiated. Model release and captions required.
Making Contact: Query with list of stock photo subjects. SASE. Reports in 2 weeks. Photo guidelines free with SASE. Tips sheet distributed monthly to contributing photographers.

***STAR FILE PHOTO AGENCY**, 1501 Broadway, New York NY 10036. (212)869-4901. Executive Researcher: Richard Collins. Celebrity Photo Agency. Has 1 million photos. Clients include advertising agencies, public-relations firms, businesses, book/encyclopedia publishers, magazine publishers, newspapers.
Subject Needs: Excellent photography of celebrities: movie stars, rock stars, television personalities, major sports stars, politicians, authors, etc.
Specs: Uses 8x10 b&w prints; 35mm, 2¼x2¼ transparencies; b&w contact sheets, b&w negatives.
Payment & Terms: Pays 50% commission on b&w and color photos. General price range: $100-5,000. Sells one-time rights. Model release and captions required.
Making Contact: Arrange a personal interview to show portfolio, query with samples and list of stock photo subjects. SASE. Reports in 1 month.
Tips: Prefers to see excellent color and b&w of major celebrities; exclusive situations preferred.

TOM STACK & ASSOCIATES, Suite #212, 3645 Jeannine Dr., Colorado Springs CO 80907. (303)570-1000. Contact: Jamie Stack. Has 750,000 photos. Member: Picture Agency Council of America. Clients include advertising agencies, public relations firms, businesses, AV firms, book pub-

This photograph of Julian Lennon has been sold by Star File Photo Agency, Inc. for use on magazine covers and for interior illustrations. The photo "is a new shot, has sold well and is an excellent example of the types of material we are looking for," explains agency owner, Virginia Lohle. "The photographer, Vinnie Zuffante, is a native New Yorker with many thousands of published photos to his credit, and is one of the hardest workers I have ever met. He started as a Lennon/ McCartney fan who took snapshots, and has evolved into a highly respected, well published photo veteran. This photo will sell repeatedly for years."

lishers, magazine publishers, encyclopedia publishers, post card companies, calendar companies and greeting card companies. Does not buy outright; pays 60% commission. General price range: $100-200/color; as high as $1,000. Offers one-time rights, all rights or first rights. Model release and captions preferred. Query with list of stock photo subjects or send at least 200 transparencies for consideration. SASE or mailer for photos. Reports in 2 weeks. Photo guidelines free with SASE. Monthly tips sheet $20/year; sample issue $2.

Subject Needs: Wildlife, endangered species, marine-life, landscapes, foreign geography, people and customs, children, sports, abstract, arty and moody shots, plants and flowers, photomicrography, scientific research, current events and political figures, Indians, etc. Especially needs women in "men's" occupations; whales; solar heating; up-to-date transparencies of foreign countries and people; smaller mammals such as weasels, moles, shrews, fisher, marten, etc.; extremely rare endangered wildlife; wildlife behavior photos; current sports; lightning and tornadoes; hurricane damage. Sharp images, dramatic and unusual angles and approach to composition, creative and original photography with impact. Especially needs photos on life science flora and fauna and photomicrography. No run-of-the-mill travel or vacation shots. Special needs include photos of energy-related topics—solar and wind generators, recycling, nuclear power and coal burning plants, waste disposal and landfills, oil and gas drilling, supertankers, electric cars, geo-thermal energy.

Color: Uses 35mm transparencies.

Tips: "Strive to be original, creative and take an unusual approach to the commonplace; do it in a different and fresh way." Have need for "more action and behavioral requests for wildlife. We are large enough to market worldwide and yet small enough to be personable. Don't get lost in the 'New York' crunch—try us. Use Kodachromes and Kodak processing. Competition is too fierce to go with anything less. Shoot quantity. We try harder to keep our photographers happy. We attempt to turn new submissions around within 2 weeks. We take on only the best, and so that we can continue to give more effective service, we have just doubled our office space and hired new personnel to keep our efficiency."

STOCK, BOSTON, INC., 36 Gloucester St., Boston MA 02115. General Manager: Martha Bates. Has 500,000 8x10 b&w prints and color transparencies. Clients include educational publishers, corporations, advertisers, and magazines.
Subject Needs: "As general as possible. Both high-tech and human interest—children, families, recreation, education, sports, government, science, energy, cities, both domestic and foreign."
Payment & Terms: Does not buy outright; pays 50% commission. General price range: "In accordance with ASMP and PACA guidelines. Minimums for editorial publication: $100/b&w, $145/color. Commercial use is higher." Offers one-time rights. Query first with resume of credits. SASE. Reports as soon as possible. Tips sheet distributed intermittently to established contributors.
Tips: Prefers to see "different types, not theme, showing the kind of work they like to do and generally do."

STOCK IMAGERY, 711 Kalamath, Denver CO 80204. (303)592-1091. Photo Researchers: Noel Sivertson and Gary Adams. Has 60,000 highly selected images. Clients include ad agencies; PR and AV firms; businesses; book, magazine and encyclopedia publishers; post card, calendar and greeting card companies; and in-house company publications.
Subject Needs: Stock Imagery's needs are on-going in virtually every category. "We need worldwide scenic and city shots. US city skylines, and lifestyles from around the world. We have a special ongoing need for people shots in everyday situations at home and in the workplace. No gimmicks . . . just good lighting, razor sharp focus and model releases."
Specs: 35mm Kodachrome (ASA 25 preferred), medium and large format transparencies. Seldom buys photos outright. Pays 50% commission on color photos. Offers one-time rights. Model releases and captions required.
Making Contact: Submit portfolio for review. Must enclose return postage for unsolicited material. Responds in 3-4 weeks. Quarterly newsletter sent to photographers on file.
Tips: "Call before submitting material so we can get to know each other. Ask for Noel or Garry. Send images in plastic pages. Stock Imagery requires 200 usable photos as a minimum before signing a contract."

***THE STOCK MARKET INC.**, #228, 93 Parliament St., Toronto, Ontario M5A 3Y7 Canada. (416)362-7767. President: Derek Trask. Stock photo agency. Has 200,000 photos. Clients include advertising agencies, public-relations firms, audiovisual firms, businesses, book/encyclopedia publishers, newspapers, post card and calendar companies and greeting card companies.
Subject Needs: All subjects.
Specs: Uses any size transparency.
Payment & Terms: Pays 50% commission on color photos. General price range: $125-10,000. Offers one-time rights. Model release and captions required.
Making Contact: Query with samples. Include return postage. SASE. Reports in 1 month. Free photo guidelines with SASE. Tips sheet distributed quarterly to photographers on file.
Tips: Prefers to see well edited, sharp, released images.

THE STOCK MARKET PHOTO AGENCY, 1181 Broadway, New York NY 10001. (212)684-7878. Director of Photography: Sally Lloyd. Has 400,000 photos. Clients include advertising agencies, public relations firms, businesses, AV firms, book publishers, magazine publishers, calendar companies, designers.
Subject Needs: "We are a general library; nature (scenics, birds, animals, flowers), sports, people, travel, industry and construction, transportation, food, agriculture."
Specs: Uses 35mm, 2¼x2¼, 4x5 and 8x10 transparencies.
Payment & Terms: Pays 50% commission on color photos. "We follow the 1982 ASMP business practices guide." Offers one-time rights. Model release preferred; captions required.
Making Contact: Arrange a personal interview to show portfolio (if possible) or submit portfolio for review. SASE. Reports in 2 weeks. Photo guidelines free with SASE. Tips sheet distributed every 3 months to members of TSM.
Tips: "Portfolio preferred; examples of photographer's style and general presentations or range of available material, preferably 200-300 strong images."

STOCK PILE, INC, 2404 N. Charles St., Baltimore MD 21218. (301)889-4243. Vice President: D.B. Cooper. Has over 25,000 photos "and growing every day." Clients include ad agencies, PR and AV firms, businesses, book and magazine publishers, newspapers, and slide show producers.
Subject Needs: "We are a general agency handling a broad variety of subjects. If it is salable we want to stock it."
Specs: Uses 8x10 b&w glossy prints and color 35mm or larger transparencies.
Payment & Terms: Pays 50% commission on b&w and color photos. Sells one-time rights. Model release preferred; captions required.

Making Contact: Arrange a personal interview to show portfolio or query with samples. SASE. Reports in 2 weeks. Photo guidelines free with SASE. Tips sheet distributed periodically. Minimum submission: 80-100 images.
Tips: "People is our largest selling subject."

***THE STOCK SHOP, INC.**, 271 Madison Ave., New York NY 10016. President: Barbara Gottlieb. Has 2,000,000 photos. Clients include advertising agencies, public relations firms, business, book publishers, magazine publishers.
Subject Needs: "Travel, industry, people (model released); all subjects—no exemptions."
Specs: Uses 35mm or larger slides.
Payment & Terms: Pays 50% commission for photos. General price range: $200-9,000. Offers one-time rights. Model release preferred; captions required.
Making Contact: Arrange a personal interview to show portfolio or query with samples or with list of stock photo subjects or submit portfolio for review. SASE. Reports in 3 weeks.

THE STOCKHOUSE, INC., 9261 Kirby, Houston TX 77054. (713)796-8400. Director of Sales and Marketing: Ken Krueger. Has 500,000 photos. Clients include publishers, advertising agencies, public relations firms, business, newspapers, calendar companies and decor prints.
Subject Needs: "Every possible category, including farming, transportation, wildlife, people, petroleum industry, construction, fine arts, nature, foreign countries, etc."
Specs: Uses 35mm, 2¼x2¼, 4x5 slides and original color transparencies.
Payment & Terms: Pays 50% commission on photos. General price range: $75-1,000. Offers one-time rights. Model release preferred; captions required.
Making Contact: Arrange a personal interview to show portfolio or send unsolicited material by mail for consideration. SASE. Reports in 1 month. Photo guidelines free with SASE. Tips sheet distributed every 6 months to photographers; free with SASE.
Tips: "While the calls we receive vary, we do a large volume of petroleum business (refineries, land and offshore rigs) as well as people shots. We have a great need for young couples and families involved in everyday activities, eating, picnicking, all types of sports activities, as well as good candids of happy children at play. We are rapidly expanding our decor print division and welcome exceptional nature shots, graphics and wildlife shots."

STOCKPHOTOS INC., 373 Park Avenue South, New York NY 10016. (212)686-1196. Director: Angelika Riskin. Editor: Craig Jordan. Has 1,000,000 photos. Clients include advertising agencies, corporate publishing, public relations firms, AV companies, book publishers, magazine and newspaper publishers, encyclopedia and textbook publishers, poster and greeting card companies, record cover and television companies, and private businesses.
Subject Needs: "We have no limitation on subject matter. Practically every possible picture subject is covered: people, glamour, nudes, industry and science, travel, scenics, sports and nature. Our most popular subjects are people (at work, at play, children, teenagers, women, men, couples, families, and the elderly), and industry (high-tech, computers, office scenes, communications, oil, steel, manufacturing, and transport). We are looking for creative photographers with innovative, dynamic styles and a willingness to take direction."
Specs: Buys photos outright or pays a 50% commission. Accepts original transparencies, all formats, with a special interest in large-format work, and high quality 8x10 prints (with negatives), primarily aimed at poster and calendar markets.
Payment & Terms: "We generally make sales ranging from $200-500 up to $5,000." Offers one-time rights or any rights desired by client. Model releases are necessary; transparencies should be captioned and the photographer's name stamped on the picture's mount or label.
Making Contact: Personal portfolio reviews are welcome, please call for an appointment. Portfolios and submissions may be sent by mail; please include a return envelope with postage.
Tips: "Portfolios should contain between 150 and 300 original transparencies that are representative of your photographic interests and that are appropriate to our markets. B&w portfolios should have between 30 and 60 prints. Portfolios will be promptly returned with an appraisal of your photographs and their marketability. We are always interested in working with energetic and creative photographers with exciting, colorful transparencies and b&w prints that we can market worldwide through 30 offices."

***STOCK WEST PHOTOGRAPHY, INC.**, 378 N. 26th St., Springfield OR 97477. President: Chris Mihulka. Clients include textbook publishers, magazines, calendar companies, greeting card companies, equipment manufacturers.
Subject Needs: "We specialize in wildlife and non-professional outdoor sports. If there is a recreational activity that takes place outdoors (hunting, fishing, sailing, climbing) we stock photos of it. We also stock outstanding scenics, flowers and still life shots for the calendar and greeting card market."

Specs: 35mm, 2¹/₄x2¹/₄ or 4x5 color transparencies.
Payment & Terms: Pays 60% commission. Negotiates rights.
Making Contact: Send for free photo guidelines or submit material by mail for consideration. Reports in 2 weeks. "When reviewing material, we like to see 40-60 shots that cover a wide range of subject matter."
Tips: "We are a new, small agency that still has a lot of space for the right people. We are, however, very selective as to technical quality. If your shots are not sharp, or are poorly exposed, we cannot use them. We would like to see more 2¹/₄x2¹/₄ and 4x5 shots."

STRAWBERRY MEDIA, 14/B Via Venezia, 80021 Afragola (NA) Italy. (081)869-3072 or 2072. Director: Michael H. Sedge. Clients include magazine publishers throughout Europe and the United States. Does not buy outright; pays 60% commission. General price range: $7 to newspapers to $500 for color in magazine. Offers one-time rights. Often holds photos for up to 3 years, upon agreement with photographer. Model releases and captions required where necessary. Query with samples. Prefers color slides—large amount. SASE; US postage accepted. Reports in 4 days after receipt.
Subject Needs: "Specializes in military subjects, sites in Europe, and sports for young people. We are looking for groups of photos that tell a story. Often our writers will originate an article to fit particular photos, if there are sale possibilities."
Color: Uses 35mm or larger.
Tips: "We deal a great amount with magazines for the US military stationed overseas. Try to keep this in mind for ideas and activity pictures. Upcoming projects include guidebooks on European cities, how to photograph pictures, and rock music stars."

SYGMA PHOTO NEWS, 225 W. 57th St., New York NY 10019. (212)765-1820. Director: Eliane Laffont. Has several million photos of both international news and domestic news and photos of celebrities. Clients include magazines, newspapers, textbooks, AV firms and most major film companies. Does not buy outright; pays 50% commission. SASE.
B&W: Negatives required. Especially wants photos of international news.
Color: Uses 35mm transparencies. Wants good specialty news, human interest, celebrities.

TANK INCORPORATED, Box 212, Shinjuku, Tokyo 160-91, Japan. (03)239-1431. President: Masayoshi Seki. Has 500,000 slides. Clients include advertising agencies, book publishers, magazine publishers, encyclopedia publishers and newspapers.
Subject Needs: "Women in various situations, families, special effect and abstract, nudes, scenic, sports, animal, celebrities, flowers, picture stories with texts, humorous photos, etc."
Specs: Uses 8x10 b&w prints; 35mm, 2¹/₄x2¹/₄ and 4x5 slides; b&w contact sheets.
Payment & Terms: Pays 60% commission on b&w and color photos. General price range: $70-1,000. Offers one-time rights. Captions required.
Making Contact: Query with samples; with list of stock photo subjects or send unsolicited material by mail for consideration. SASE. Reports in 1 month. Photo guidelines free with International Reply Coupons. Telex No. 26347 PHTPRESS; Fax: 03 230 3668.
Tips: "We need some pictures or subjects which strike viewers. Pop or rock musicians are very much in demand. If you want to make quick sales, give us some story ideas with sample pictures which show quality, and we will respond to you very quickly. Also, give us brief bio. Color transparencies with sample stories to accompany. No color print at all. Stock photography business requires patience. Try to find some other subjects than your competitors. Keep a fresh mind to see salable subjects."

TAURUS PHOTOS INC., 118 E. 28th St., New York NY 10016. (212)683-4025. Contact: Ben Michalski. Has 250,000 photos. Clients include advertising agencies, public relations firms, businesses, AV firms, book publishers, magazine publishers, encyclopedia publishers and newspapers.
Color: Uses transparencies.
B&W: Uses 8x10 prints.
Tips: "Looking for top-notch photographers. Photographers interested in being represented by Taurus should submit a portfolio of 100 transparencies and b&w prints for evaluation along with information about the type of material which they are able to shoot. An evaluation will be returned to you. A self-addressed stamped return envelope is necessary for this step. Beautiful photos of American life, e.g., family, industry, business or naturalist-type photos of nature are particularly welcome."

***TERRAPHOTOGRAPHICS/BPS**, Box 490, Moss Beach CA 94038. (415)726-6244. Photo Agent: Carl May. Stock photo agency. Has 15,000 photos on hand; 70,000 on short notice. Clients include advertising agencies, businesses, book/encyclopedia publishers, magazine publishers.
Subject Needs: All subjects in the Earth sciences: paleontology, volcanology, seismology, petrology, oceanography, climatology, mining, petroleum industry, civil engineering, meteorology, astronomy. Stock photographers must be scientists.

Specs: Uses 8x10 glossy b&w prints; 35mm, 2¼x2¼, 4x5, 8x10 transparencies.
Payment & Terms: Pays 50% commission on b&w and color photos. General price range: $70-350. Offers one-time rights. "Advertising rates negotiable." Model release and captions required for non-educational uses.
Making Contact: Query with list, and resume of scientific and photographic background. SASE. Reports in 2 weeks. Photo guidelines free with SASE. Tips sheet distributed intermittently only to stock photographers.
Tips: Prefers to see proper exposure, maximum depth of field, interesting composition, good technical and general information in caption. Natural disasters of all sorts, especially volcanic eruptions and earthquakes; scientists at work using modern equipment.

***THIRD COAST STOCK SOURCE**, Box 92397, Milwaukee WI 53202. (414)765-9442. Director: Paul Henning. Managing Editor: Mary Ann Platts. Research Manager: Renee Deljon. Has 75,000 photos. Clients include advertising agencies, public relations firms, audiovisual firms, businesses, book/encyclopedia publishers, magazine publishers, newspapers, calendar companies and greeting card companies. Recently bought company, Variations In Photography, which increased stock from 10,000 to 75,000 photos.
Subject Needs: Needs images specifically relating to the Third Coast region—Ohio, Minnesota, Wisconsin, Illinois, Iowa, Michigan, Indiana—people at work and play, scenics, animals. Also needs photos of other regions of the country.
Specs: Uses 8x10 glossy prints; and 35mm, 2¼x2¼, 4x5 and 8x10 transparencies (Kodachrome preferred).
Payment & Terms: Pays 50% commission. General price range: $200 + . Offers one-time rights. Model release preferred; captions required.
Making Contact: Arrange a personal interview to show portfolio; query with resume of credits, query with samples, query with list of stock photo subjects; submit portfolio for review. SASE. Reports in 1 month. Photo guidelines free with SASE. Tip sheet distributed 3-4 times/year to "photographers currently working with us."
Tips: "We are looking for technical expertise; outstanding dramatic and emotional appeal; photos representative of life in this region. We are extremely anxious to look at new work."

***THREE LIONS**, 145 E. 32nd St., New York NY 10016. Photo Editor: Ms. Pat Summers. Stock photo agency. Has 300,000 photos. Clients include advertising agencies, public-relations firms, audiovisual firms, businesses, book/encyclopedia publishers, magazine publishers, newspapers, post card companies, calendar companies, greeting card companies.
Subject Needs: All scenics, "people in photos must be released."
Specs: Uses all sizes transparencies.
Payment & Terms: Offers photos outright; pays $20-600. Pays 50% commission on color photos. General price range: $50-5,000. Offers one-time rights, first rights, or all rights. Model release and captions required.
Making Contact: Query with samples. Does not return unsolicited material. Reports in 3 weeks. Tips sheet distributed monthly to signed photographers.
Tips: Prefers to see simple photos that communicate quickly. The trend is for more creative stock photography and of highest technical quality.

UNIPHOTO PICTURE AGENCY, 1071 Wisconsin Ave. NW, Box 3678, Washington DC 20007. (202)333-0500. Vice President: Mike J. Pettypool. Agency Director: William Tucker. Has ½ million color transparencies and b&w prints. Clients include advertising agencies, design studios, corporations, associations, encyclopedia and book publishers and magazines. Does not buy outright; pays 50% commission. General price range: new ASMP guidelines; $150 minimum/b&w and $150/color for ¼ page and less than 5,000 circulation. Offers first serial or one-time rights. Present model release "when sale is confirmed by user." Call to arrange an appointment, submit material by mail for consideration, query with resume of credits, or submit portfolio. Prefers to see dynamic stock photos and corporate location assignments. Reports in 1 week. SASE.
Specs: Send 35mm, 2¼x2¼ or 8x10 color transparencies. Interested in all subjects. Query *first* for list of specific needs.
Tips: "We are a unique organization that combines traditional stock agency methods with high technology to sell photos. We have 6 researchers working. Microslides are a rendering of photo images on a 4x6 piece of film; 675 images are on each one. We are a full-service agency marketing stock photos and actively solicit assignments for our photographers. We sell directly from Washington to all types of clients and through stock photo agencies in other parts of the US. Available upon written request. *Uniphoto Picture Agency* also uses a computer data system that allows photographers to send in their data on their photo subjects for our data bank. We can then have photographers send their photos directly to clients.

We also utilize a computer trafficking program to trace slides that go out to clients. We recently introduced a *videodisc* (called the Photo Store) with our best slides for our clients—accessed by computer and is an electronic catalog depicting 104,000 images."

VALAN PHOTOS, 490 Dulwich Ave., St. Lambert, Montreal, Quebec, Canada J4P 2Z4. (514)465-2557. Manager: Valerie Wilkinson. Has 150,000 photos. Clients include advertising agencies, public relations firms, businesses, AV firms, book publishers, magazine publishers, encyclopedia publishers, newspapers, post card companies, calendar companies.
Subject Needs: Canadian scenics, international travel, agriculture, people, wildlife, pets, insects, photomicrography, underwater photography, sport fishing, hunting.
Specs: Uses 35mm or larger transparencies.
Payment & Terms: Will occasionally buy transparencies outright; pays $5-100. Pays 50% commission on stock transparencies. Price range: $50-1,500. Sells one-time rights. Model release preferred; captions required.
Making Contact: Query with list of stock photo subjects. SAE and International Reply Coupons. Reports in 1 month. Photo guidelines free with SAE and International Reply Coupons. Tips sheet distributed quarterly to established contributors.
Tips: "We are particularly looking for top quality wildlife photos. Primates, cats, marsupials and other animals found in Asia, Africa, Australia and South America. Query before sending samples. We represent many of Canada's leading Wildlife Photographers and we are anxious to make contact with International Wildlife Photographers of similar caliber."

***VANTAGE PHOTO DYNAMICS**, Dept. 10, 1607 Lima, San Luis Obispo CA 93401-6814. (805)546-9266. Owner: Wendell Dickinson. Stock photo agency. Clients include book/encyclopedia publishers, magazine publishers, denominational (religious) publishers.
Subject Needs: "We use human interest photos and transparencies of all ages, but we specialize in images of high school age students. We do not accept scenics without people in them, abstracts, cheesecake, nudes."
Specs: Uses 8x10 glossy b&w prints; 35mm, 2¼x2¼, 4x5 transparencies.
Payment & Terms: Pays 55% commission on b&w and color photos. General price range: $5-500. Offers one-time rights.
Making Contact: Send for photo guidelines. Reports in 1 month. Photo guidelines free with SASE.
Tips: "Send for free photo guidelines with SASE. Do not send material without first reading guidelines. We do not expect you to submit a zillion photos initially or even over the course of each year. What we request is a minimum of 40 top-quality transparencies or 50 outstanding b&w prints as your initial submission. Each year we require you to update your stock with a minimum of 80 transparencies or 100 b&w prints. We are not after huge quantity, just A-1 quality. Photo editors are always looking for images that say something. If you can show an emotion, concept, or trend, you will probably have an image which can sell many times over. Also, photos of minorities are always in demand. In short, we are looking for images of people the way they are, in their natural surroundings. We aggressively market your work if it follows this style."

***VIEW FINDER STOCK PHOTOGRAPHY**, 3rd Floor, 818 Liberty Ave., Pittsburgh PA 15222. (412)391-8720. Owner: David G. Kull. Stock photo agency. Has 160,000 photos. Clients include advertising agencies, public-relations firms, audiovisual firms, businesses, book/encyclopedia publishers, magazine publishers, post card companies.
Subject Needs: Released people in everyday situations (i.e., home, work, leisure), major city skyline buildings and events. Industrial, high tech, scenics from around the world.
Specs: Uses 35mm, 2¼x2¼, 4x5, 8x10 transparencies.
Payment & Terms: Pays 50% commission on b&w and color photos. General price range: $60-2,200. Offers one-time rights. Model release preferred; captions required.
Making Contact: Query with samples. SASE. Reports in 1 month. Photo guidelines free with SASE. Tips sheet distributed to anyone.
Tips: Prefers to see 35mm slides in 20 slide sheets, larger format in sleeves.

***VISIONS PHOTO INC.**, 9D, 105 Fifth Ave., New York NY 10003. (212)255-4047. President: Mark Greenberg. Stock photo agency, news/features syndicate. Has 275,000 photos. Clients include advertising agencies, public-relations firms, businesses, book/encyclopedia publishers, magazine publishers, newspapers.
Subject Needs: News related features and some news photos.
Specs: Uses 8x10 b&w prints; 35mm, transparencies; b&w and color contact sheets; b&w and color negatives.
Payment & Terms: Pays 60% commission. Sells one-time rights. Model release preferred; captions required.

Making Contact: "Letter of introduction." Does not want unsolicited material. Reports in 1 month.
Tips: Prefers to see strong feature-oriented material.

VISUALWORLD, Box 364, Evanston IL 60204. General Manager: Jim Kirk. Has 30,000 photos of all types with an emphasis on historical and scenic photos. Also emphasizes photos of children, students, Spain, Asia, Europe, biology, agricultural subjects and recreation. Clients include educational publishers, poster and post card companies and magazine publishers. Does not buy outright. General price range: $100/b&w single editorial use to $1,500/color national consumer magazine advertising. Offers first North American serial rights.

***WEST LIGHT**, Suite A, 1526 Pontius Ave., Los Angeles CA 90025. (213)477-0421. Director: Craig Aurness. Stock photo agency. Has over 1,000,000 photos. Clients include advertising agencies, public-relations firms, audiovisual firms, businesses, book/encyclopedia publishers, magazine publishers, newspapers, post card companies, calendar companies, greeting card companies, graphic designers.
Subject Needs: "*West Light* specializes in images used by ad agencies and designers. We have strong files on the western US, particularly California, high technology, people, agriculture, oil, mining, and general subjects like suns, roads, scenics."
Specs: Uses 35mm, 2¼x2¼, 4x5 transparencies.
Payment & Terms: Pays 50% commission on b&w and color photos; 40% on other agent sales overseas. General price range: minimum $200, "we use ASMP rates or higher." Offers first rights. Model release preferred; captions required.
Making Contact: Query with resume of credits. Deals with freelancers only. SASE. Reports in 1 month. Photo guidelines free with SASE. Tips sheet distributed 4 times/year only to contracted members.
Tips: "Don't call, don't send portfolio unless we ask. Write a letter with resume. We see stock getting better and better so we only want top professional photographers who shoot over 1,000 rolls of publishable film every year. We want only the best."

WEST STOCK, INC., Suite 600, 157 Yesler Way, Seattle WA 98104. (206)621-1611. President: Tim Heneghan. Project Director: Stephanie Webb. Has 350,000 photos. Clients include ad agencies, businesses, book, magazine and encyclopedia publishers, postcard, calendar and greeting card companies.
Subject Needs: "Our files are targeted to meet the photo needs of advertising, corporate communications and publishing. We use our understanding of the capabilities and strengths of our photographers' imagery to satisfy the photo tastes and styles of a diverse, changing photo marketplace."
Specs: Only original transparencies accepted, 35mm and larger.
Payment & Terms: Pays 50% commission on b&w or color photos. General price range: $100-3,500. Sells one-time rights. Model release and captions preferred.
Making Contact: Query with list of stock photo subjects. SASE. Reports in 2 weeks. Photo guidelines free with SASE. Tips sheet distributed quarterly to contract photographers.
Tips: Prefers to see "high quality, uncluttered, color transparencies (at least 1,000 available for contract signing), diverse subject matter ranging through leisure activity, travel shots, industrial imagery, as well as scenics. We take a long-term approach to the marketing of the imagery and the services of our organization. The photographer rewards are generally proportional to his/her participation. We need quality photography that is *current*. We look for photographers who are aware of the latest design trends, advertising styles and editorial requirements, demonstrating that awareness in their work."

WILDLIFE PHOTOBANK, 1530 Westlake Ave. N., Seattle WA 98109. (206)282-8116. Owners: Marty Loken and Gloria Grandaw. Stock photo agency. Has 100,000 photos. Clients: advertising agencies, magazine publishers, graphic design firms and corporations.
Subject Needs: "We carry photographs of all various forms of wildlife—mammals, birds, amphibians, fish, reptiles, insects—but need tight, graphic, expressive shots of bears, eagles, lions, monkeys, wolves, whales. Top-notch shots."
Specs: Uses b&w 8x10 prints and 35mm, 2¼x2¼ and 4x5 transparencies.
Payment & Terms: Pays 50% commission. Offers one-time rights. Captions required.
Making Contact: Query with list of wildlife subjects. SASE. Reports in 1-3 weeks. Photo guidelines free with SASE.
Tips: "We specialize in the sale of reproduction rights to corporate markets—ad agencies, graphic designers—and have launched an aggressive promotion campaign in that direction. We only need top-notch photos."

Services & Opportunities

Contests

Entering a photography contest can be an educational, and possibly ego-building, experience for a photographer. Though a contest won't advance your career in the same sense that selling a photo to a paying market would, it is a good chance to learn from a professional photographer/judge(s) what worked or didn't quite work in your photo(s).

The contests listed here, including still and motion picture categories, have prizes ranging from plaques, ribbons and medals to camera equipment and hundreds or even thousands of dollars. Through some of these contests may come the benefits of automatic publication for winning photographs, or a sale to an interested viewer who saw the photo on exhibit. The public exposure may serve as good PR for you, not to mention the information you can add to your résumé when you have received awards at a well respected competition.

When reviewing the listings in this section watch out for any phrase that reads, "Sponsor assumes all rights to entries." You should never have to give up rights to photos entered in competition any more than you would to a photo sold to an editorial or advertising market without adequate pay compensation. No contests assuming "all rights" have been included in these listings. In the meantime, enjoy the competition. At the very least, criticism from the judges will help you to produce better photos in the future. And for the winners, a mark of approval by a respected photographer/judge can be a psychologically uplifting experience.

***THE AMERICAN ASSOCIATION FOR THE ADVANCEMENT OF SCIENCE (AAAS) SCIENCE PHOTOGRAPHY CONTEST**, 1333 H St. NW, Washington DC 20005. (202)326-6700. Assistant Picture Editor: Craig Chapin. Sponsor: The American Association for the Advancement of Science. Annual event for still photos/prints held in Washington DC. Judging will be in late October or November. Average number of entrants/submissions: approximately 500. AAAS staff and family members ineligible. Student entrants must be enrolled in a primary or secondary school. Deadline: October 1. Maximum number of entries: 5. Entries prejudged by a panel of *Science 86* editors and art staff. Regular entry fee: $5 per entrant; student entry fee: $2 per entrant; refundable to those whose entries are not acceptable. Work may be offered for sale "but entries may not be published in any medium intended for the general public prior to judging." No sponsor commission. Sponsors assume one-time publication rights and rights to publish in foreign editions all winners and honorable mentions; right to exhibit, publish in desk diary any finalist (fee paid for latter); rights to use published/exhibited entries for promotional purposes. Awards cash prizes (first place winners-$1,000; student winners-$100; honorable mentions-$100); certificates for winners, honorable mentions and finalists. Accepts no larger than 8x10 prints. Transparencies not mounted in glass. May be black-and-white or color, print or transparency. Categories include science photography (includes biology, chemistry, geology, physics, astronomy, anthropology, technology, natural history, etc.) Write to: AAAS Science Photography Contest, 1333 H Street, NW, Washington DC 20005 or watch *Science 86* for details. "Include a self-addressed, stamped envelope for return of your photographs."

***ARTQUEST**, #124, 2265 Westwood Blvd., Los Angeles CA 90291. (213)399-9305. Executive Director: Jonette Slabey. Sponsor: ArtQuest Inc. Annual event for slides (35mm) held in Los Angeles CA.

"Exhibition dates vary each year." Average number of entrants/submissions: 150 in photo category. Requirements: Submit work on 35mm slides; open to all artists in North America. Deadline: November 20, 1986. Maximum number of entries: 10. Entry fee: $5/slide; not refundable. Work may be offered for sale; no sales commission. Sponsor assumes one-time publication/show rights, publication in the catalog. Total $5,400 cash awards, purchase awards, exhibition included in *video exhibit* (this year travels to 67 museums and galleries) published in ArtQuest'86 The Catalog. Accepts entries mounted, matted and ready to hang. Categories include fine-art documentary, experimental. For more information or entry forms phone (213)399-9305 or send SASE to: ArtQuest #124 P, 2265 Westwood Blvd., Los Angeles CA 90064.

***ATHENS INTERNATIONAL FILM FESTIVAL (1987)**, Box 388, Athens OH 45701. (614)594-6007. Director: Emily Calmer. Sponsor: Athens Center for Film and Video. Annual competition for film "usually held each spring, late April to early May for ten days in 1987 in Athens, Ohio." Average attendance: 11,000. Average number of entrants/submissions: over 200. "The film must be completed in the period between April 1985 and April 1987 and not have been entered in previous Athens International Film Festivals." Deadline: approximately mid February. "Entries are prescreened by a prescreening panel on a 1 to 5 scale; 1 = excellent, it will definitely be shown at the festival to 5 = Poor, will be returned to producer." The entry fee depends on the length of the film; not refundable. Work may be offered for sale; no sponsor commission. The Golden Athena Award will be presented to the winning entry in each of the major film categories. Prizes totaling $2,000 will also be awarded at the discretion of the judges and festival director. Film entries may be submitted on 35mm, 16mm (optical soundtracks only), and Super-8 (no separate soundtracks). All entry films must be technically fit for projection, have standard SMPTE leaders, and mounted on reels and be heads out. Cores are not acceptable. Categories include Feature Film: Fiction, Documentary; Short Story: Drama, Comedy; Animation: Imagist, Narrative; Experimental: Imagist, Structural; Documentary: Auto/Bio, Social/Political; Education: Informational, Instructional, 100 Ft. Film, Super-8, Young Media Artists. Write or call: Athens Center for Film and Video, Box 388, Athens OH 45701. (614)594-6007 for information/entry forms.

***BELL GALLERY PHOTOGRAPHIC COMPETITION**, #5, 169 Cohasset Rd., Chico CA 95926. (916)891-4951. Director/Owner: Michael Bell. Sponsor: Bell Gallery. Annual competition for still/prints, held Nov. 3 through Dec. 5 in Chico CA. Average attendance: estimated 475. Average number of entrants/submissions: 150. Deadline: October 17. All photographs must be ready to hang. Must be produced photographically. Entry fee: $5 per print; $2 surcharge for entries received Oct. 20-21; refundable. Work may be offered for sale; no sponsor commission. Sponsor assumes one-time publication/show rights. Awards: 1st place—$200; 2nd place—$50; 3rd place—$25. Accepts any size—must be ready to hang (on a nail). Historically, the 3 judges (different each year) prefer medium sized 8x10-16x20. The subject matter is *totally* open. A model release is required where it is legally required. Send SASE for official rules and entry form.

***BEST IN THE WEST**, Suite 302, 251 Post St., San Francisco CA 94108. (415)421-6867. Vice President: Janet Kennedy. Sponsor: American Advertising Federation. Annual competition for still photos and film held in January-February in 13 western states. Average attendance: 250. Average number of entrants/submissions: 2,600. Entries must be created in 13 western states. Deadline: mid-February. Entries prejudged by panels of judges selected by each Division Chairman. Entry fee: $70 single entry; $75 campaign; $80 complete campaign (in 1985); nonrefundable. Work not for sale. Awards trophy/certificate. Categories: Television, Consumer Magazine, Newspaper, Business Publications, Farms Publications, etc.—all advertising. Send in name to be placed on mailing list.

BEVERLY ART CENTER ART FAIR & FESTIVAL, 2153 W. 111th St., Chicago IL 60643. (312)445-3838. Chairman: Pat McGrail. Annual event for still photos and all fine art held in June in Chicago. Average attendance: 2,000-3,000. "Acceptance is based on quality of artwork only." Deadline: February 27. Maximum number of entries: 5 slides. Jury of three professional artists/critics/professors. "Jury fee is retained if not accepted. Entry fee is refundable. (Fees: jury-$5; entrance: $30.)" Works may be offered for sale. Sponsor assumes "no rights—object is for artists to sell." Awards $2,000 minimum and ribbons; including $400 Best of Show and eight $200 awards of excellence. Accepts photos. Call or write in December.
Tips: "Artists must include own set-ups, chairs, tables, etc. It is an outdoor art fair. Other media: painting, sculpture, graphics, fiber, ceramics, glass, jewelry. No trite subjects; good tonal quality; stress all formal aspects of the aesthetics of photography—good design, composition, imagery, etc. Try to submit professional slides for jurying purposes and work that is of an artistic, not mass-produced commercial nature. Offer a good variety of your work, so as to catch the attention of the sophisticated art fair attendee as well as that of the less sophisticated. Offer variety of prices also."

BIRKENHEAD INTERNATIONAL COLOUR SALON, 29 Fairview Rd., Oxton, Birkenhead, England. Contact: D.G. Cooper. Sponsor: Birkenhead Photographic Association. Annual event for 2x2 or 5x5 cm slides only held in June/July in Birkenhead. Average attendance: over 2,000. Deadline: May. Maximum number of entries: 4 in each of 2 classes. Entry fee: $4.50 or equivalent; not refundable. Work not for sale. Sponsor assumes one-time rights. Awards gold, silver and bronze medals (about 15 total); Honorary Mention Certificates to about 10% of accepted slides. Two categories: General Pictorial and Natural History. Looking for named, good modern work including contemporary. For information/entry forms: In US, write H&S Mass, 1864 61st St., Brooklyn NY 11204; in Great Britain or Europe, write to A.P. Williams, 5 Howards Ln., Thingwall, Birkenhead, England.
Tips: "Our competition provides a standard for comparison of your best work against currently accepted standards."

CANADIAN STUDENT FILM FESTIVAL, 1455 Blvd. de Maisonneuve Ouest, Room 109, Montreal, Quebec, Canada H3G 1M8. Director: Daniéle Cauchard. Sponsor: Conservatoire d'Art Cinematographique de Montreal. Annual festival for films held in Montreal. Average attendance: 500-700/day. Deadline: June 14. Entry fee: $10/entry; not refundable. Awards include "participating certificates, prizes for each category, Prix du Quebec ($500 cash) and the Norman McLaren ($1,000 cash)." Accepts 16mm and 35mm film. Four categories: animation, documentary, experimental and fiction. Write for information/entry forms.

THE CREATIVITY AWARDS SHOW, 10 E. 39th St., New York NY 10016. (212)889-6500. Show Director: Dan Barron. Sponsor: *Art Direction* magazine. Annual show for still photos and films held in September in New York City. Average attendance: 12,000. Entries must consist of advertising photography and TV commercials. Deadline: May. Entry fee: $8.50/photo; $17/TV commercial; not refundable. Work not for sale. Sponsor assumes one-time rights. Awards certificates of distinction and reproduction in an annual book. Write or call for information/entry forms.

ECLIPSE AWARDS, Thoroughbred Racing Associations, Suite 2W4, 3000 Marcus Ave., Lake Success NY 11042. (516)328-2660. Director of Service Bureau: Chris Scherf. Sponsor: Thoroughbred Racing Associations, Daily Racing Form and National Turf Writers Association. Annual event for photographers held in January or early February. Photographer must demonstrate excellence in the coverage of Thoroughbred racing; photo must be published in North American publication between January 1 and December 1. Maximum number of entries: 3. No entry fee. Awards Eclipse trophy, presented at annual Eclipse Awards dinner. Accepts b&w or color; 8x10 or same size as when published; glossy. No entry form; "cover letter including date and name of publication and tearsheet, plus 8x10 glossy must accompany entry."

8mm FILM FESTIVAL, Box 7571, Ann Arbor MI 48107. (313)769-7787. Director: Mark Scheier. Sponsor: Ann Arbor Film Co-op. Annual festival for films held in February in Ann Arbor. Average attendance: 200/show. Film entries can be shot in 8mm Video or Super 8mm. Deadline: January 20. Prejudging by screening committee. Entry fee: $10 for films less than 12 minutes, $15 for films 12-24 minutes and $20 for films over 24 minutes; not refundable. Work not for sale. Sponsor assumes one-time rights. Awards include over $2,500 in cash and prizes. Accepts Super 8 or 8mm film. Write for information/entry forms.

"EXPOSE YOURSELF" FILM FESTIVAL, Biograph Theatre, 2819 M St. NW, Washington DC 20007. (202)333-2696. General Manager: Jeffrey Hyde. Sponsor: Biograph Theatre Group. Film competition held about every year in Washington DC. Average attendance: 600-800. Entrants must be regional residents (DC, MD, VA) and work in 16mm film format. Deadline: 1 week prior to festival; dates vary. Maximum number of entries: "We choose from among the films entered—we do not run every one which is sent in." Sponsor assumes no rights; entertainment and competition only; "not necessarily a distribution or sales outlet." Cash prizes: $50/1st place; $25/2nd and 3rd place; $10/honorable mention. All winners receive 10 theater passes; all entrants receive tickets to attend the festival performances. Accepts 16mm film. May accept video in 1987. Call or write for more information. "Style and subject matter are at filmmaker's discretion; we avoid mere sensationalistic films, and look for those works which show a sense of growth in the medium; wit and taste." Call J. Hyde at (202)338-0707 or write to the theater.
Tips: "*Expose Yourself* is a competition and an entertainment. Its purpose is to spotlight the works of area filmmakers, and encourage development of their skills while affording them the opportunity to reach an audience they otherwise might not be exposed to. Keep it short. We program 2 hours of screen time and like to run as many films as possible in that time. Ours is a *film* (motion picture) event—still photos are *not* used."

F-8 CAMERA CLUB ANNUAL EXHIBIT, 430 E. Congress St., Sturgis MI 49091. (616)651-9919. Contest Chairman: Walt Kinsey, Jr. Sponsor: f-8 Camera Club. Annual event for still photos/prints. Competition held in November in Sturgis, Michigan. Average attendance: 20. Average number of entrants/submissions: 150. Entries must be mounted, suitable for hanging—no frames or glass. Deadline for receipt of entries: Oct. 15. "Mounting quality suitable for hanging. No nudes, suggestive scenes or graphic depictions of violence." Entry fees: $5 for 1st, 2nd; $4 for 3rd, 4th; $2 each additional. Work may be offered for sale. Receives 10% commission. Sponsor assumes one-time show rights. Awards best of show and first place. Write sponsor for more information.

***FALL-COLLEGE CONTEST/SPRING-SPRING CONTEST**, 614 Santa Barbara St., Santa Barbara CA 93101. (805)963-0439. Contact: Mary Middleton. Sponsor: Photographer Forum Magazine. Annual competition for still photos/prints held in Santa Barbara CA. Average number of entrants/submissions: 17,000+. Eligibility requirements include fall: college students; spring: open. Deadline: fall 11/30; spring 5/30. Entry fee: $2.75; nonrefundable. Work may be offered for sale. Sponsor assumes one-time publication/show rights. Awards $3,400 cash. Accepts 8x10 or smaller-unmounted. SASE. "Write us for more information and apply for entry coupon."

FOCUS (FILMS OF COLLEGE & UNIVERSITY STUDENTS), 1140 Avenue of the Americas, New York NY 10036. (212)575-0270. Director: Sam Katz. Sponsor: Nissan Motor Corp. in USA. Annual event for film: live action/narrative, animation/experimental, documentary, sound achievement, film editing, cinematography and screenwriting. Also: Women In Film Foundation Award and Renee Valente Producer Award. Competition held during the spring semester; awards made in early summer. Average entries: 700. Entries must have been produced by a student at a college, university, art institute or professional film school in the United States. Films and scripts must be made (written) on noncommercial basis. Deadline: late-April. Entries judged by screening committee made up of industry professionals as listed each year in the Official Rules Booklet. Entry fee: $15/film/scripts; films entered in any filmmaking categories may enter the sound, cinematography and/or Film Editing competition for no additional fee; fee nonrefundable. Films and scripts are returned. Sponsor assumes, two years from date of selection, rights for presentation without payment for noncommercial purposes only. Awards include cash prizes and Nissan automobiles. Schools of first place winners get film stock. Winners also flown to Los Angeles for 5 days. "All winning films screened each year at FOCUS Premiere and Award ceremony attended by Hollywood professionals." Films must be 16mm; silent or with optical sound; color or b&w. Write for information/entry forms.

GALLERY MAGAZINE, 800 2nd Ave., New York NY 10017. Contest Editor: Judy Linden. Monthly event for still photos. Entries must consist of photos of nonprofessional females. Maximum number of entries: 1 entry/model, several photos. No entry fee. Sponsor assumes first exclusive rights. Awards $1,000 plus cruise for two to monthly (model) winner; $100 to photographer who submitted photo. $500 for model (runner-up); free 1-year subscription to photographer. Annual awards: to model $25,000 in prizes; $500 to photographer. Accepts b&w or color photos of any size. "No negatives!" Wants "tastefully erotic females, 18 years old or older." Write for details.
Tips: "All photos must be accompanied by our entry blank, with the model's signature notarized. This is a must. Photos should be sharply focused and in good taste; and whenever possible out-of-doors. Study our Girl Next Door contest layout. If you think you can come up with a similar, but different layout, beautifully photographed, with a beautiful model (an amateur model that has not appeared in other men's magazines!), send it on speculation. The layout has to include some b&w photos of the model in a bikini (for publicity purposes). If the layout is accepted by us, we will pay the photographer $1,000 or more."

GOLDEN ISLES ARTS FESTIVAL #15, Box 673, Saint Simons Island GA 31522. (912)638-8770. Contact: Registration Chairman, Coastal Center for the Arts. Sponsor: Coastal Alliance for the Arts. Annual competition for still photos/prints; all fine art and craft held the second weekend in October in Saint Simons Island, Georgia. Average attendance: approximately 50,000. Average number of entrants/submissions: 175 from approximately 400-500 submissions. Deadline: August 1. Entries prejudged by Jury Committee by August 15th. Entry fee is $45 which must accompany each artist's entry for each space; refundable. "We highly encourage all work to be for sale." No sponsor commission; entrants are responsible for paying own sales tax. Cash Awards, plus Ribbon Awards at discretion of Judges. "We assume no rights. This is a limited space contest. Upon acceptance by jury, this entitles accepted participants to either a reserved panel, approximately 8x10' wide, or a reserved space approximately 100 square feet, minimum. All types of subject matter are encouraged. This is an outdoor festival, which ranks as one of the tops in the Southeast. Artists and craftmen from many different states vie for acceptance to this festival. Because of the time of year and size of festival, a very large audience attends yearly. We have always considered photography as an art form, and have promoted it in exhibits, etc. We have a

sales oriented audience, therefore feel if the photography is of good quality, it will be acquired. The audience knows it has been "juried" for quality. Make certain your slides are representative of your work, and are professionally made. (You wouldn't believe some of the slides that photographers, of all people, send us!)" Write or call for information/entry forms.

***INDUSTRIAL PHOTOGRAPHY ANNUAL COMPETITION**, 50 W. 23rd St., New York NY 10010. (212)725-2300. Contact: Editor. Sponsor: *Industrial Photography Magazine*. Annual competitions for still photos announced in September and judged in January in New York. "All industrial photographers—staff, commercial studio or freelance—may enter. Studio and freelancers must indicate the client for their submissions. "The 50 winning entries are published in our June issue, and the top winners will be exhibited at various industry events." Maximum number of entries: 5. Deadline: December 18. Entries prejudged. No entry fee. Sponsor assumes one-time rights. Awards certificates. Accepts b&w mounted prints only up to 8x10 image size, 11x14 mount size. Glossies preferred. Color transparencies, any format preferred, 35mm in 2x2 projection mounts, others should be mounted in cardboard holders no smaller than 5x7. Unmounted prints, image size up to 8x10. Categories: Portrait, Specialized Scientific Imaging, Architectural/Engineering Problem Shot and Glamorizing Industry. Call or write Industrial Photography for information/entry forms. "The June Annual issue is received by 54,000 industry people. Thousands of others will see the winners exhibited at various industry trade shows. In terms of exposure, the potential value of entering a competition such as ours is very high."

INTERNATIONAL DIAPORAMA FESTIVAL, Auwegemvaart 79, 2800 Mechelen, Belgium. President: J. Denis. Sponsor Koninklijke Mechelse Fokokring. Competition held every other year (even years) for slide sound sequences in Mechelen, Belgium. Average attendance: 3,000. Deadline: February 26. Maximum number of entries: 3. Prejudged by a preselection jury designed by the Koninklijke Mechelse Fotokring. Entry fee: $7; not refundable. Work not for sale. Awards "the medal of the King, other honourific prizes, and many prizes in materials." Slides mounted in 5x5 plus a sound tape. No limitations on subject matter. "No commercial sequences." Write for information/entry forms.

INTERNATIONAL EXHIBITION OF PHOTOGRAPHY, 1101 W. McKinley Ave., Box 2250, Pomona CA 91769. (213)623-3111. Coordinator: Aileen Robinson. Sponsor: Los Angeles County Fair. Annual exhibition for still photos and slides held in September in Pomona. Average attendance: 1,450,000. Maximum number of entries: 4 in each division. Prejudged by juried selection. Entry fee: 4 color and 4 monochrome prints, $3.50 each; 4 pictorial slides and 4 nature slides, $3.50 each; 4 stereo slides, $2.50; not refundable. Work not for sale. Sponsor assumes all rights unless otherwise requested. Awards PSA medals, ribbons, divisional trophies and participation ribbons. Accepts 16x20 maximum b&w or color photos; stereo, nature and pictorial color slides. No limitations on subject matter. Write for information.

INTERNATIONAL ADVERTISING FESTIVAL OF NEW YORK, 246 W. 38th St., New York NY 10018. (914)238-4481. Annual competition: June. Average attendance: 1,000. Entry fee: $65. Categories for print ads and campaign, posters, billboards, and other print advertising. Special category for commercial photography. Awards include Grand Award trophy bowls, Gold Medals, and certificates to finalists. "We don't assume any rights whatsoever, but the festival does not return entries."

ROBERT F. KENNEDY JOURNALISM AWARDS, 1031 31st St. NW, Washington DC 20007. (202)628-1300. Contact: Staff Director. For photojournalists. Purpose is to encourage coverage of the problems of the disadvantaged.
Requirements: Applicant may be professional or student. Deadline: January. Entries must have been published during the previous year. Send for entry blank and rules.
Awards/Grants: To professionals $1,000 prize for photojournalism and one $2,000 prize for best entry of all categories. Entries judged by professional journalists.

***MANILA INTERNATIONAL COLOR PRINT EXHIBITION**, Box 2748, Manila, Philippines. Contact: Exhibition Chairman. Sponsor: Multi-color Exhibitors Association, Inc. Competition held every other year for color slides (Autumn) in Manila. Average attendance: 400 + . Deadline: To be announced. Maximum number of entries: 4. Entry fee: Approximately $4; not refundable. Work may be offered for sale; through a personal transaction between the exhibitor and the interested party; commission and sponsor's rights to be arranged. Awards medals, ribbons, etc. Write for information.

***NEVADA CITY FILM FESTIVAL**, Box 1387, Nevada City CA 95959. Director: Ross Woodbury. Sponsor: Sierra Film Society. Annual competition for film held in "early spring" in Nevada City, California. Average attendance: 600. Average number of entrants/submissions: 50-80. "Films must be in Super-8 or 16mm, run less than 30 minutes, never have been commercially distributed and completed within 1½ years prior to festival. No restrictions on theme or content." Deadline: two weeks prior to fes-

tival. Entries are judged by a panel of veteran film critics and filmmakers. Entry fee: $5/film; none refused. Work may be offered for sale; no sponsor commission. Awards $150 for first prize; $100 for second prize; $50 for third prize and certificates of merit to all honorable mentions. Winning films are shown on public TV. All commercial rights assumed for 60 days following the festival. Write for complete specifications and information/entry forms.

NEW YORK STATE YOUTH MEDIA ARTS SHOWS, Bureau of Arts, Music and Humanities Education, The State Education Department, Room 681 EBA, Albany NY 12234. (518)474-5932. Sponsor: New York State Education Department. Annual competition for still photos, film, videotape, creative sound, computer arts and holography, held in 11 regional sites in New York. Average number of entrants/submissions: 800. Entrants must be high school students in New York state. Entries judged at state level by media artist/teachers of summer school. No entry fee. Work not for sale. Sponsor assumes the right to reproduce for educational distribution. Awards scholarships to school. Write for information/entry forms.

***1987 PHOTOGRAPHY ANNUAL**, 410 Sherman, Box 10300, Palo Alto CA 94303. (415)326-6040. Executive Editor: Jean A. Coyne. Sponsor: Communication Arts magazine. Annual competition for still photos/prints held in Palo Alto CA. Deadline: March 21, 1987; winners of competition will be published in August issue of CA. Average number of entrants/submissions: 5,540. Photography produced between March 22, 1986 and March 21, 1987 is eligible. Entry fee: $10 for a single entry, $20 for series (5 or less); not refundable. Work not for sale but "you may be contacted by people who saw your work in the Annual." Sponsor assumes one-time publication/show rights. Award of Excellence certificates. Accepts unmounted printed samples or photographs or plastic or paper mounted slides (no glass mounts). Categories include photography that was commissioned for advertising, design, editorial or any other area of communication arts. Also unpublished personal work. Contact: 1987 Photography Annual, Box 10300, Palo Alto CA 94303. "We would be pleased to add your name to the call for entries list. Please do not send any original slides. There are no return of entries. If the pieces are selected, we will request reproduction materials and those will be returned."

NORTHWEST INTERNATIONAL EXHIBITION OF PHOTOGRAPHY, Box 430, Puyallup WA 98371. (206)845-1771. Superintendent: Floramae D. Raught. Sponsor: Western Washington Fair and approved by Photographic Society of America. Annual event for still photos and slides held in September in Puyallup. Average attendance: 1,000,000. Photographers must make their own prints (except photojournalism and new small pictorial prints section). Deadline: August 13. Maximum number of entries: 4 photojournalism prints (maximum 8x10), 4-color prints, 4 b&w prints (maximum 16x20), 4 small prints (maximum 8x10, either b&w and/or color) and 4 slides. Cannot enter both large prints and small prints. Prejudged by panel of 3 judges. Entry fee: $3/medium—b&w prints, color prints, small prints and slides; not refundable. Work not for sale "but we refer prospective buyers to maker." Sponsor assumes right to use entries in catalog and publicity. Awards gold medal in each medium and ribbons for best in categories (8). Gives special awards for best of animals, children, design, action, humor, human interest, portrait and scenic subjects. Write for information.
Tips: "Mount prints attractively. Prints will be viewed by people who may be interested in buying."

***PHOTOGRAPHERS' FUND**, 59A Tinker St., Woodstock NY 12498. (914)679-9957. Assistant Director: Bil Jaeger. Sponsor: Catskill Center For Photography. Annual competition for still photos/prints, still imagery incorporating photo derived portions, held May each year in Woodstock NY. Average number of entrants/submissions: 120. Requirements for entrants: live in a twelve county area around Woodstock NY. Deadline: May 9. Maximum number of entries: send for info. Entries prejudged by a three member jury. Entry fee: $2.50; not refundable. Work not for sale. Rights assumed negotiable. Four cash awards of $750 each.
Tips: This a regrant program for committed artists using photography or photo-derived images.

PHOTOGRAPHY 86, (formerly Art Annual Photography 85), 410 Sherman Ave., Box 10300, Palo Alto CA 94303. (415)326-6040. Executive Editor: Jean A. Coyne. Sponsor: Communication Arts magazine. Annual event for still photos held in March in Palo Alto. Entries must consist of photos produced or published between March 22, 1985 and March 21, 1986. Deadline: March 21. Entry fee: $10/single entry, $20/series; not refundable. Work not for sale. "Submission gives *CA* the right to use the pieces for exhibition and publication purposes." Award of Excellence certificate given and the selections are published in the August issue. Prefers b&w and color photos of any size and "photography that is commissioned for publication, advertising or any other area of the communication arts." Write or call for entry forms.

***POLITICAL WOMAN MAGAZINE**, #254, 4521 Campus, Irvine CA 92715. Editor-in-Chief: Sally Marshall Corngold. Sponsor: *Political Woman Magazine*. Annual event for still photos/prints, slides,

(color and b&w), held November 1st each year—announced. Held nationally. Average number of entrants/submissions: 1,500-1,600. Deadline: January 15. Open to all. Entry fee: $4 for non-members per entry—$2 for members—membership $10 per year. Work may be offered for sale; "we offer a photobank for color slides." Sponsor commission: 25-50%. Sponsor assumes one-time publication/show rights, and photo bank if entrant desires. Awards "publishing and $200 grand prize, $100 first—$75 second—$50 third in each category black & white and color—plus addition to our photo bank." Accepts mounted slides and black & white and color prints. Entries should make political or social comment: humorous or serious—definitely not necessarily by/or about women. Write to above address for more information/entry forms. Magazine sample $3. Photo bank is optional upon request of photographer.

THE PRINT CLUB, 1614 Latimer St., Philadelphia PA 19103. (215)735-6090. Contact: Director. Sponsor: The Print Club. Annual national/international competition of prints and photos juried selections. Entrants must be members of The Print Club; membership is open to all interested. Sponsor assumes right to exhibit if selected and right to reproduce in show catalog if award-winning. Write for complete information.

PRO FOOTBALL HALL OF FAME PHOTO CONTEST, 2121 Harrison Ave. NW, Canton OH 44720. (216)456-8207. Vice President/Public Relations: Donald R. Smith. Sponsor: Canon USA, Inc. Annual event for still photos. Judging will be held in Canton in March for photos of the previous season. Must be professional photographers on assignment to cover NFL preseason, regular-season or postseason games. Deadline: February. Maximum number of entries: 12 b&w photos and 12 color slides. No entry fee. Sponsor assumes the right to use photos for publicity of the contest and Hall of Fame displays. Average attendance each year at the hall is 200,000. All other copyright benefits remain with entering photographer. Awards in each category: first place, $500 and plaque; second prize, $250 and plaque; third prize, $100 and plaque. Also: PHOTOGRAPH OF THE YEAR (from among four category winners): Additional $500 plus trip to Football's Greatest Weekend in Canton. Accepts b&w prints of any size, mounted on 14x20 boards, or 35mm color slides. Categories: B&w action, b&w feature, color action and color feature. Write or call the Pro Football Hall of Fame for information/entry forms.
Tips: "Follow the rules and regulations instructions that are distributed before each contest, particularly the tips on subject matter and the size specifications for entered material."

PSA YOUNG PHOTOGRAPHERS SHOWCASE, PSA Headquarters, 2005 Walnut St., Philadelphia PA 19103. (215)563-1663. Contact: Chairman. Sponsor: Photographic Society of America. Annual event for still photos held July 1. Average attendance: 200-1,500. Photographers must be 25 or younger. Deadline: July 1. Maximum number of entries: 4. Entries are prejudged by 3 qualified judges. Entry fee: "about $3; not refundable." Work not for sale. Photos used only to publicize winners. Awards cash prizes, certificates, ribbons and membership in PSA. Accepts 8x10 b&w or color photos on any subject. Contact Chairman at the above address for information.

***PULITZER PRIZES**, 702 Journalism, Columbia University, New York NY 10027. (212)280-3841 or 3842. Administrator: Robert C. Christopher. Sponsor: Pulitzer Prizes. Annual competition for still photos/prints held in New York City. Average number of entries: about 90 in two photo categories. Work must be published in a US daily or weekly newspaper during the calendar year. Tearsheets must be provided as proof of publication. 8x10 glossies are fine—maximum size is 20x24. Entry form must be included with exhibit as well as photo and bio of entrant and $20 handling fee per entry. Deadline: February 1. No more than twenty photos/exhibit. Work not for sale. "Rights belong to photographer; however, exhibits become property of Columbia University." Awards: Spot Photography—$1,000; Feature Photography—$1,000.

SANTA CRUZ VIDEO FESTIVAL, Box 1273, Santa Cruz CA 95061. Coordinator: Greg Becker. Sponsor: Open Channel. Annual competition for videotape held in Santa Cruz, California. Average attendance: 500-750. Average number of entrants/submissions: 75-100. "Oriented to independent and access videographers. Write to be put on mailing list. All tapes are cataloged and played by request at the Festival. Judging panel awards prizes. There is a $10 entry fee, plus return postage and a container to return the tape in." Entry fee not refundable. Work may be offered for sale; 10% sponsor commission. Varying theme from year to year.
Tips: "Keep the works short. Most work could easily be half as long."

***SPRINGFIELD INTERNATIONAL COLOR SLIDE EXHIBIT**, Box 255, Wilbraham MA 01095. Sponsor: Springfield Photographic Society. Annual event for still photos/prints (35mm and super slide transparency only) held, generally, the 4th weekend of January (Friday and Saturday) in Springfield, Mass. Average number of entrants/submissions: 600-800. Photo must have been made by entrant. Deadline: "Thursday prior to 4th weekend." Maximum number of entries: 4. Entry fee: $4 for US and $5 for for-

eign—(normal handling). Entry fee not refunded if entry is judged. Work may be offered for sale; no commission fee. Sponsor assumes one-time publication/show rights. Awards: medals for highest scoring, ribbons for any considered for medals. Accepts 2"x2", glass covered light paper mounts; glass covered heavy cardboard mounts not accepted. Request information after October 15, at above address.

***STC ANNUAL AUDIOVISUAL COMPETITION**, 332 Iowa Court, Ridgecrest CA 93555. (619)375-7514. Manager: S.M. (Marty) Shelton. Sponsor: Society for Technical Communication. Annual event for videotape, filmstrips, and slide/tape programs held mid-May each year in various locations. Average attendance: 1,200. Average number of entrants/submissions: 120. Entries must have been produced or released within 2 calendar years preceding the year of the competition in which they are entered; not have been entered in a previous STC Audiovisual Competition; be unclassified and released for public viewing. Deadline: January 25. The judging process is in two steps: preview judging, and final judging to select the *Best of Show* and the top entry in each category. Decision of the judges is final. *Entry Fees*: 1 to 20 minutes, STC members $50, nonmembers $60; 20.1 to 30 minutes, STC members $60, nonmembers $70; 30.1 to 40 minutes, STC members $65, nonmembers $75; 40.1 to 50 minutes, STC members $70, nonmembers $80; over 50.1 minutes, STC members $75, nonmembers $85. Entry fee not refundable. Awards: *Best of Show, Distinguished Technical Communication Award* (first place in category); *Award of Excellence; Award of Merit; Award of Achievement. Special Award:* The *Kodak Award for Photographic Excellence* will be presented to the one producer whose audiovisual show stands out for its markedly superior photography. Entries are limited to 35mm filmstrips, 35mm slide/tape shows, *two trays maximum*, having sound-on-tape cassette using automatic advance/dissolve cues 2nd VHS videotapes. "We strongly recommend use of the Kodak Ektagraphic Programmable Dissolve Control which is standard in this competition." Write to the above address for more information or entry forms.

***SUPERFEST 14**, Box 27573, Los Angeles CA 90034 (213)836-5726. Annual event for film, videotape, multi-media held throughout the West. Average attendance: "awards on TV." Average number of entrants/submissions: 110. Work must have been produced in just 18 months—must deal with persons with disabilities. Deadline: June. Entry fee. Entry fee nonrefundable. Work may be offered for sale; commission negotiable. Sponsor assumes limited publication/show rights and TV rights. Awards purchase, trophies, certificates, TV airing. Write to above address for more information/entry form.

TEN BEST OF THE WEST, Box 4034, Long Beach CA 90804. Executive Secretary: George Cushman. Annual competition in its 30th year for film and videotape held in October in the Western United States or Canada. Average attendance: 200. Average number of entrants/submissions: 60 + . Entrants must reside west of the Missouri River, or in one of the 3 western Provinces of Canada. Deadline: August 18. Entry fee: $5/ 1 or 2 entries; none refused. The maker retains all rights. Work may be offered for sale after the festival; no sponsor commission. Awards certificates. Accepts a limit of 30 minutes screening time/entry. Any subject is eligible. Write for information/entry forms.

***TEXPO FILM & VIDEO FESTIVAL**, 1519 W. Main, Houston TX 77006. (713)522-8592. Sponsor: S.W. Alternate Media Project. Annual invitational exhibition for film and videotape held in March in Houston. Average attendance: 500-750. Must be residents of Texas, New Mexico, Arizona, Oklahoma, Arkansas or Louisiana, Kansas, Missouri, or Nebraska. Entries selected by staff. Deadline: February 1. No entry fee—entrants should query staff by mail or phone. Honorarium. Accepts 16mm optical track or silent film; Super-8 mag-striped or silent film; ¾" U-matic and Beta 1 videotape. Categories: Film/Video Art, Documentary, Experimental, Fiction, Multi-Media Performance and Installation Pieces. Write or call for information/entry forms.

***37th INTERNATIONAL EXHIBITION OF PHOTOGRAPHY**, 2260 Jimmy Durante Blvd., Del Mar CA 92014-2216. (619)755-1161 ext. 14. Contact: Entry Supervisor. Sponsor: DEL MAR FAIR (22nd District Agricultural Association). Annual event for still photos/prints exhibitcd at the Del Mar Fair June 19 through July 6 (dates are similar every year) in Del Mar, CA. Average attendance: over 800,000 fair attendance in 1985. Average number of entrants/submissions: 2,000—USA & 39 foreign countries in 1985. Entrants: Open to anyone worldwide. Deadline: April. Maximum number of entries: 10. Entries prejudged by one panel of three jurists for black & white prints and one panel of three jurists for color prints. Each print is individually scored. "We are not able to hang more than about 300 prints in our gallery; therefore, we jury down by scores to that number." Entry fee: $4 for each print—maximum of 10 prints per exhibitor; not refundable. Work may be offered for sale; no sponsor commission. Sponsors assume one-time publication/show rights. "In each category B/W & Color we offer $200 for Best—1st $100, 2nd $75, 3rd $50, 4th $25, 5th $15, 6th $10. Management's Choice $50 & Rosette. Rosettes for best and ribbons for places. We also give an 'Accepted' ribbon with year and show on it." Accepts no minimum—maximum 16"x20"—must be mounted on 16"x20" mounting board (no cardboard, masonite, plywood or frames. Thickness must not exceed ⅛ in. This is because of the size of the grooves in

our display panels.)'' Write DEL MAR FAIR, INTERNATIONAL EXHIBITION OF PHOTOGRA-PHY, 2260 Jimmy Durante Blvd., Del Mar, CA 92014-2216, or call (619)755-1161-Ext. 14 for more information. Foreign entries may be sent unmounted. Prints must be camera work of entrant. Processing, printing and mounting may be done commercially at the option of the entrant. Mail entries will be returned by mail if sent in reuseable container. San Diego County entrants must pick up as indicated in rules.

THREE RIVERS ARTS FESTIVAL, #5 Gateway Center, Pittsburgh PA 15222. (412)261-7040. Executive Director: John Brice. Annual competition for still photos/prints, film and videotape held in June in Pittsburgh. Average attendance: 600,000. Average number of entrants/submissions: 370/941 for film/video and photography categories. Entrants must be 18 and over and must live, work or study in the following states: Pennsylvania, Ohio, West Virginia, Virginia, Maryland, Washington DC, New York, Delaware and New Jersey. Deadline: March 15. Maximum number of entries: 3. Entry fee: $15 for Juried Visual Arts: up to 3 works in each category may be submitted. All works must be for sale; 25% sponsor commission. Sponsor assumes one-time publication rights. Offers cash awards: (3)-$750-Festival Exhibition Award; (3)-$500-Festival Award; (3)-$250-Juror's Discretionary Award; $300-Leonard Schugar Award. Accepted photos are *not* restricted in style, content, color vs b&w, etc. All photos entered are juried; no prescreening. Please send name, address and two first-class stamps for information/entry forms.

***25TH ANNUAL NAVAL & MARITIME PHOTO CONTEST**, U.S. Naval Institute, Annapolis MD 21402. (301)268-6110, ext. 252. Director, Library/Photography: Mrs. Patty M. Maddocks. Sponsor: United States Naval Institute. Annual competition for still photos/prints and 35mm slides held in Annapolis MD. Average number of entrants/submissions: 920 entries for 1985. Deadline: December 31. Maximum number of entries: 5. Work may be offered for sale. Flat payment for works sold. Sponsor assumes one-time publication/show rights. Awards 15 prizes—$100 for winners, $50 for honorable mentions. Entries must be either b&w prints, color prints, or color transparencies. Minimum print size is 5x7; minimum transparency size is 35mm. No glass mounted transparencies. Full captions and the photographer's name and address must be on separate sheet of paper and attached to back of prints or printed on transparency mount. No staples. Accepts Naval and Maritime art only. Write for brochure. U.S. Naval Institute, Annapolis MD 21402. Attention: Patty M. Maddocks.

U.S. INDUSTRIAL FILM FESTIVAL, 841 N. Addison Ave., Elmhurst IL 60126. (312)834-7773. Chairman: J.W. Anderson. Executive Director: Patricia Meyer. Sponsor: The United States Festivals Association. Annual festival for film and video with awards presentation in May in Chicago, Illinois. Average entries: 1,100. Average attendance: 200. Open to work produced in previous 12 months only. Entry deadline: March 1. Entry fee varies by the type of entry; not refundable. Sponsor assumes no rights, "except one-time showing." Work not for sale. Awards include plaques and certificates. Accepts 16mm and 35mm filmstrips; ¾ video, video discs, 35mm slides and 16mm films. Write or call for information/entry forms.

U.S. TELEVISION & RADIO COMMERCIALS FESTIVAL, 841 N. Addison Ave., Elmhurst IL 60126. (312)834-7773. Chairman: J.W. Anderson. Executive Director: Patricia Meyer. Sponsor: The United States Festivals Association. Annual festival for film, ¾ videotape and radio commercials (reel to reel 7½" ips) with award presentation in January in Chicago, Illinois. Average entries: 3,500. Average attendance: 200. Open worldwide to work produced in previous 12 months only. Entry deadline: October 1. Entries prejudged by subcommittee panel. Entry fee varies by the type of entry; not refundable. Awards include "MOBIUS"℠statuettes and certificates. Accepts 16mm film and ¾ video and reel to reel audio casettes. Entries limited to TV and radio commercials. Assumes right to screen at awards, presentations and to retain winners for educational and publicity opportunies. "Entrant has option to limit our use." Call or write for information/entry forms.
Tips: "Make sure work is professional, creative and contemporary."

***WORKS ON PAPER**, 4701 San Leandso, Oakland CA 94601. (415)261-9148. Contact: Lawrence Fawcett. Sponsor: Third Floor Gallery. Annual competition for still photos/prints held in the summer in Oak, CA. Average attendance: 250. Average number of entrants/submissions: 125. Deadline: June 30. Maximum number of entries: 3. Entries prejudged. Entry fee: $3/15 slides; not refundable. Work may be offered for sale; 25% sponsor commission. Sponsor assumes one-time publication/show rights. Awards purchase, cash and exhibit. SASE for more information or entry forms.

This section of the book shouldn't be overlooked. As in any profession, the best photographers have become the best only through practice and learning from others techniques they could incorporate into their own work.

The workshops listed here cover black and white as well as color still photography, and video and film. As you read through the listings you will find classes that teach you how to improve a particular shooting technique, how to work with film to create special effects, to courses that instruct you in the business and marketing aspects of being a successful photographer.

When you find the workshop(s) that includes course subjects you're interested in, write to them for further information. In a marketplace as competitive as photography, learning new "techniques of the trade" can provide a needed creative edge.

AMPRO PHOTO WORKSHOPS, 636 E. Broadway, Vancouver, British Columbia, Canada V5T 1X6. (605)876-5501. President: Ralph Baker. Offers 12 different courses throughout the year in darkroom and camera techniques including studio lighting and portraiture, a working seminar where students can shoot. Class size depends on course, from 6-15. Length of sessions varies from 3-7 weeks. Cost ranges from \$85-150. "Creative Images is a course designed to help the photographer plan photos that are more effective." Write or phone for latest brochure. Private tutoring available. Darkroom facilities for b&w and color, mat cutting, mounting and studio rentals available. Now an approved educational institute.

ANDERSON RANCH ARTS CENTER, Box 5598, Snowmass Village CO 81615. (303)923-3181. Director: Bradley Miller. Offers workshops in photography, clay, wood, printing and painting. Photography: one week sessions for advanced and beginning photographers. Past faculty included: Ernst Haas, Frederick Sommer, Jay Maisel, Judy Dater, Mary Ellen Mark, Barbara Kasten, Ralph Gibson. Call or write for summer brochure. Housing available. Tuition: \$200-300.

APPALACHIAN PHOTOGRAPHIC WORKSHOPS INC., 242 Charlotte St., Asheville NC 28810. (704)258-9498. Director: Tim Barnwell. Offers basic programs in landscape and wildlife photography, studio and outdoor portraiture, glamour photography, lighting, darkroom technique, b&w and color printing and the zone system. Weekend and master classes, and evening courses are also offered. Workshops last up to four days and run year round; registration deadlines vary. Guest instructors include Ernst Haas, Nancy Brown, George Tice, Carson Graves, John Sexton, Fred Bodin, Ken Taylor, Sonja Bullaty and Angelo Lomeo, Robert Farber, Cole Weston, Steve Krongard, Ken Marcus, John Shaw, Galen Rowell, Rohn Engh, Alan McGee. Costs: \$45-365. Free catalogue upon request.

***BANFF CENTRE SCHOOL OF FINE ARTS**, Box 1020, Banff, Alberta, Canada TOL OCO. (403)762-6100. Though facilities are limited, there are a few positions available for photographers or visual artists with a primary interest in photography. The situation is based on independent production with many opportunities for critique and discussion with other artists, resident faculty and visiting artists. For information, contact the Registrar.

HOWARD BOND WEEKEND WORKSHOPS, 1095 Harold Circle, Ann Arbor MI 48103. (313)665-6597. Owner: Howard Bond. Offers two types of 2-day weekend workshops: Refinements in B&W Negative Making and Refinements in B&W Printing, each costing \$110. "The negative workshops clarify the Zone System and how to do the necessary calibration tests. About 1/3 of the time is spent on other topics relevant to exposing and developing negatives. The printing workshops are intended for people who already know how to make b&w prints. Primary emphasis is on strengthening a student's concept of the full scale fine print through critical examination and discussion of many prints by master photographers. Methods of achieving such prints are explained and demonstrated, often with student negatives. Particular attention is given to clarifying the situations in which various techniques are appropriate." Spring and fall in Ann Arbor, August in Denver. Class size: 11. Also offers 4-day b&w field

workshops in early summer at Lake Superior Provincial Park, Ontario. "These workshops stress practice in applying the zone system with several instructors available for individual help. Indoor sessions are in the evenings and as dictated by weather." Cost is $150. Write to apply.

***CALIFORNIA LANDSCAPE PHOTOGRAPHY**, Box 99, Weyers Cave VA 24486. (703)234-9261. Instructor: Glenn Showalter. Workshop emphasizes Edward Weston style large format camera. The workshop is held year round. Clases last one week. Class size: maximum 10. Location work primarily 4x5 view camera with 70mm and 35mm depending on students' equipment. Cost of workshop is $525; includes tuition, book, course materials for instruction but not photographic supplies or camera accessories. Location work is done with the student's own camera equipment. Some laboratory facilities available for limited use. Workshop is geared toward intermediate and advanced level photographers. Requires students submit one photograph not to be an original transparency but duplicate or a print. Personal liability waver required. Call or write for catalog. Instructor holds a Bachelor of Science degree in photographic arts and sciences from the Rochester Institute of Technology and Master of Science degree in instruction. Full-time academic appointments to three colleges and universities.

CATSKILL CENTER FOR PHOTOGRAPHY, 59 A Tinker St., Woodstock NY 12498. (914)679-9957. Director: Colleen Kenyon. Coordinator of *Woodstock Photography Workshops* summer program: Bil Jaeger. Summer weekend workshops are designed to be "varied, intensive experiences instructed by nationally known guest artists who will also present evening slide lectures." Average cost: $100. The year-round educational program consists of slide lectures, 2-day workshops, and a series of 8-week classes averaging $85 in cost. CCFP also houses 4 exhibition galleries, a darkroom and a library area. Call or write for detailed schedule.

***CHILMARK PHOTOGRAPHY WORKSHOP**, Chilmark MA 02535, (617)645 2854. Contact: Director. In its 14th year, offers the opportunity to photograph the wonders of Martha's Vineyard for students at all levels of experience from beginners to advanced. Students may design their own projects in specific areas as well as follow the general schedule for field trips, tech sessions, darkroom, critiques and staff presentations. Ratio of staff to student allows for one to-one instruction in addition to group activities. Sessions last 10 days each. Cost is $495 for one session, $850 for two. Fee includes b&w lab, $20 surcharge for color. Accommodations with breakfast and lunch daily (some other meals included in tuition fee) available for $395 for 10 days. (Tennis on premisis.) To apply, write or call Carol Lazar, 75 Central Park West, New York, NY 10023. (212)362-6739.

CUMBERLAND VALLEY PHOTOGRAPHIC WORKSHOPS, 3726 Central Ave., Nashville TN 37205. (615)269-6494. Director: John Netherton. "The major concerns are visual awareness and artistic quality. Technique is the foundation on which these concerns are based. It is a support, not a dominating factor, and will be emphasized only in so far as a means to this end: an aesthetically valid photograph." Offers workshops throughout the year including marketing photography, wildlife in the Everglades, scenics and macro in the Smoky Mountains, China, b&w rural in middle Tennessee, coastal photography at Ocracoke NC, nocturnal, basic photo classes, fashion, landscapes, large format, studio and location lighting, portrait, photographing people. Workshops last from 1 to 12 days. Class size 10 to 15. Costs $40 to $3,500. Write or call for brochure.

CUMMINGTON COMMUNITY OF THE ARTS, Cummington MA 01026. (413)634-2172. Director: Carol Morgan. Offers programs for writers, painters, visual artists, musicians, filmmakers and photographers. Exists "primarily to stimulate individual artistic growth and development while providing an atmosphere for communication and interdisciplinary cooperation among its residents." Occupancy during summer about 20 adults and 10 children; about 15 artists during nonsummer months. Year-round residencies. Minimum one-month stay, with two- and three-week stays possible on a space-available basis from November-March. Cost is $200-400. Cost for July and August is $200-500. Includes private room, work space and meals. Write to apply.
Tips: "Application deadline for September, October and November sessions is June 15; for December, January and February, September 15; for March, April and May, January 1; for June, July and August, March 15." A limited number of scholarships and loans are available to economically disadvantaged artists. April, May and October offer optional work-programs, in which a resident pays only $125 for room and board in exchange for 9 hours a week for the community.

THE DOUGLIS VISUAL WORKSHOPS, 212 S. Chester Rd., Swarthmore PA 19081. (215)544-7977. Director: Phil Douglis. "This workshop is not just in photography, but rather in visual thinking, particularly for word-oriented people such as editors of organizational publications. We also stress picture usage, particularly in employee publications, annual reports." Offers 29 workshops, year-round, entitled *Communicating with Pictures*, in 16 cities coast to coast. Class size. 15 maximum for 2½-day workshop. Cost is $645. Includes breaks and two luncheons. Write to director to apply.

***THE EYE PHOTOGRAPHY WORKSHOPS DBA EGYPTIAN EYE, ORIENTAL EYE, ETC.**, Box 215, Telluride CO 81435. (303)728-3463. President: Pam Conklin. Offers workshops in travel photography combined with sessions on basic skills and practical knowledge. Workshops held 2-3 times a year, each in a different foreign locale. Organized around a tour package. Length of classes vary from 10-14 days. Class size: 10. Instruction given in still b&w and color photography. Cost estimated at $175-200/day, includes air transportation, in-country transfers, tips, all lodging, most meals, ten workshop sessions and/or arranged photo shoots, photo permits where required, professional photographer group leader plus experienced tour guide(s). Also includes polaroid 35mm processing; occasional Ektachrome processing. "We travel light to occasionally remote locations." Workshop geared toward intermediate and advanced photographers. "We do ask for a written assessment of the participants' photography experience to assist the workshop leader in pre-planning." Call or write for catalog. "We try to make travel photography more successful by breaking away from the standard tour group on its typically tight schedule to allow time for set up and shoot, to go back and to go back at unusual hours for special shoots."

FILM IN THE CITIES/LIGHTWORKS, 2388 University Ave., St. Paul MN 55114. (612)646-6104. Director: James Dozier. Offers programs in b&w darkroom techniques, lighting, camera basics, zone system, still photography, motion picture studies, intermediate and advanced photography and concentrated summer workshops with leading photographers. Length of sessions vary from 1 4-hour session to 4 or more sessions; concentrated summer workshops of varying lengths, meet each day with assignments and critique sessions. College credit available. Costs range from $55-125 for short classes, $245-270 for summer workshops. Class fees include use of darkroom where appropriate, chemicals, other equipment, instruction, demonstration materials; workshop fees include instruction, private and class consultation with workshop leader, darkroom use and chemicals, breakfast, use of library, and field trips. Emphasis is always on personal growth in both ideas and skills. Write or call to apply. "We have no special forms. A letter telling about yourself and your interests is enough. Specify 'Still Photography' or 'Motion Picture' or both, to be sure you get the proper and full information." SASE.
Tips: Cheryl Younger is now the photography education director at Film in the Cities. "We will be offering more technically oriented workshops as well as one on assembling a portfolio."

FRIENDS OF PHOTOGRAPHY, Box 500, Carmel CA 93921. (408)624-6330. Workshop Coordinator: Julia Nelson-Gal. The Friends of Photography Workshop Program offers dynamic, short-term instruction to individuals of all levels of expertise. The workshop topics are diverse, ranging from black and white technical work to some of the most pressing issues in contemporary photography. All courses explore aesthetic and technical concerns as well as historical and critical aspects essential to a full understanding of the medium. Workshops last two to five days and give students the chance to meet with a distinguished creative faculty, a large number of highly motivated peers and a group of experienced workshop assistants. The programs consist of a combination of large lectures, small discussion groups, print critiques, darkroom demonstrations, studio demonstrations and field sessions. Tuition varies from $10 to $345. Write to be placed on the workshop brochure mailing list.

INTERNATIONAL CENTER OF PHOTOGRAPHY, 1130 5th Ave. at 94th St., New York NY 10128. (212)860-1776. Contact: Education Department. Offers programs in b&w photography, nonsilver printing processes, color photography, still life, photographing people, large format, studio, color printing, editorial concepts in photography, zone system, the freelance photographer, etc. Also offers advanced weekend workshops and 1- or 2-day weekend seminars for advanced professional photographers in a variety of technical and aesthetic subjects. There are 1,000-1,200 students at the center/semester. Class sizes range from 12 students in a darkroom course to 18 in seminars and 80 in lectures. The fall semester runs from October-December with registration beginning in September. The winter semester begins in February and runs through April with registration beginning in January. The spring session begins in late April and runs through June with registration beginning in April. An intensive summer session (July-August) offer a selection of courses, professional workshops and travel/study trips. Sessions last from 2 full weekends to 10 weeks. An interview with portfolio is required for all courses except introductory b&w photography weekend seminars and lecture series. ICP also offers a full-time studies program in both "photojournalism" and documentary photography and general studies in photography, which combines classroom study with independent study. Full-time programs are available for intermediate/advanced level students. In addition ICP in conjunction with New York University offers a Master of Arts Degree in Photography. The Master of Arts program combines the rich assortment of studies available through NYU and the highly specialized approach of the International Center of Photography. Write for the ICP Education Program Brochure for specific schedule of dates, times, costs, etc.
Tips: "It is recommended that wherever possible prospective students visit the Center. Where this is not possible, applicants can mail examples of their work to us along with a short statement of photographic background and interests. Work can be either prints or slides, and should have enclosed: (1) name of the course applied for, (2) a short statement of involvement with photography and reasons for wanting to

take the course, (3) instructions for returning or holding the portfolio, and return postage in case prints are to be returned. There are no restrictions in size, finish, etc."

***JOHN JEFFERSON PHOTO SAFARI WORKSHOPS—Aransas National Wildlife Refuge**, Box 12013, Austin TX 78711. (512)478-2248. Director: John Jefferson. Offers photo basics, composition, wildlife, outdoor portraiture, *practical field work*. Workshops held 1987: Feb. 13-15, Feb. 27-Mar. 1, Mar. 13-15. Length of classes are from Friday at 5:30—Sunday at noon. Class size: 20. Instruction given in still b&w photography (a little), and still color photography. Cost is $340/person, includes "two comfortable nights lodging at the Sand Dollar Resort, six seacoast meals, a land tour of the Aransas National Wildlife Refuge (winter home of the rare and endangered whooping cranes), a boat trip through the bays and rookery islands to photograph whooping cranes and other birds and the workshop itself. (Film and processing not included). Couples and former students receive a 10% discount. Plenty of room to shoot! Between the interior of the famous refuge and the area we cover by boat, the students will be able to test their skills on whitetail deer, javelina, whooping cranes, alligators, pelicans, roseate spoonbills, landscapes and about 40 other speices of wildlife." Workshops geared toward beginner and intermediate photographers. "We aim the workshops at beginners and intermediate amateurs, but the more advanced amateurs and professionals seem comfortable with even my presentation of the basics since it shows them how I apply them on a day to day operation. In the field, the more advanced can move at their own personal ISO and seek their own level. No requirements at this time, although we have contemplated it, and will require it for a professional level wildlife photography workshop we are planning." Write or call for more information.

***JOHN JEFFERSON PHOTO SAFARI WORKSHOPS—Y.O. Ranch**, Box 12013, Austin TX 78711. (512)478-2248. Director: John Jefferson. Offers photo basics, composition, wildlife, outdoor portraiture, *practical field work*. Workshops held *1986*: Apr. 4-6, May 23 25, June 6-8, Oct. 10-12, Oct. 31-Nov. 2; *1987*: Approx. same weekends. Length of classes are from Friday at 5:30 p.m. through Sunday noon. Class size: 20. Instruction given in still b&w photography (a little), and still color photography. Cost is $365/person, includes two nights lodging in quaint, 100 year old restored cabins (quite comfortable), six ranch style meals and the workshop (Film and processing *not* included.) 10% discount for couples or former students. "Plenty of room to shoot! The Y.O. Ranch is a 106 year old working Texas cattle ranch. There are 50,000 acres of hills, rocks, trees, windmills, longhorn cattle, cowboys, whitetail deer, and exotic game from four other continents. (We offer no darkroom nor indoor studio.)" Workshops geared toward beginner and intermediate photographers. "We aim the workshops at beginners and intermediate amateurs, but the more advanced amateurs and professionals seem comfortable with even my presentation of the basics since it shows them how I apply them on a day to day operation. In the field, the more advanced can move at their own personal ISO and seek their own level. No requirements at this time, although we have contemplated it, and will require it for a professional level wildlife photography workshop we are planning." Write or call for more information.

THE MacDOWELL COLONY, Peterborough NH 03458. (603)924-3886 or (212)966-4860. Resident Director: Christopher Barnes. Offers studio space to writers, composers, painters, sculptors, printmakers, photographers and filmmakers competitively, based on talent. Serves 31 artists in the summer; 20-25 in other seasons for stays of up to 2 months. Suggested fee is $15/day—"more if possible, less if necessary." Room, board and studio provided. Photography studio includes darkroom. Current application forms should be requested 8 months in advance of season desired, to meet deadlines. Write to Admissions Coordinator, The MacDowell Colony, Inc., 100 High St., Peterborough NH 03458.

***MACKINAC ISLAND WORKSHOPS**, Box 929, Flint MI 48501. Director: Gordon LaVere. Offers audiovisual, b&w fine art, commercial photography, computers in your business, understanding light and color in photography, studio portraits, wedding portraits, fundamentals of photography, educational/instructional TV. Workshops held June, July, August. Each course runs 10-12 hours over a three-day period. Class size about 20. Cost varies from $50-150/course, includes workshop only, no rooms or meals. No darkrooms. Workshop geared toward beginner through professional, depending on course. Write for catalog. Computer correspondence: CompuServe: 72376, 162; MCI: 291-3669.

JOHN SHAW & LARRY WEST NATURE PHOTOGRAPHY WORKSHOPS, 24 W. Barnes Rd., Mason MI 48854. Contact: Larry West or John Shaw. Offers 5 week-long sessions in Houghton Lake, Michigan, covering all aspects of nature photography. Subjects covered include: how to photograph various types of plants and animals; close-up photography; flash; equipment selection; bird photography; scenic photography; finding and identifying subjects; carrying equipment; using filters, long lenses and tripods; photography on trips and assignments; care of equipment in the field; stalking subjects; and marketing photos. Also offers Fall Color Workshop, a Great Smoky Mountains Workshop and Africa/Kenya Safari. Costs: $300 per person, or $450 including meals and lodging. Each workshop is limited to 20 students. Cost for the Africa/Kenya safari is approximately $3,300. Write for workshop information.

NORTHERN KENTUCKY UNIVERSITY SUMMER PHOTO WORKSHOP, Highland Heights KY 41076. (606)292-5423. Associate Professor of Art: Barry Andersen. Offers programs provided by a series of visiting photographers. Offers 1 course in "Applied Photography." Sessions limited to 15-20 fine art photographers. Sessions last 2 or 3 weeks. Cost is $150-300/session. Write to apply.

BOYD NORTON WILDERNESS PHOTOGRAPHY WORKSHOPS, Box 2605, Evergreen CO 80439. (303)674-3009. Director: Boyd Norton. Offers "intensive programs designed to aid in creative self-expression in nature photography. Strong emphasis is placed on critique of work during the several days of the workshop. We deal strongly with principles of composition, creative use of lenses and psychological elements of creativity." Has several programs in different locales: Kachemak Bay, Alaska (6 days); Shepp Ranch on Salmon River, Idaho (6 days); Snowy Range, Wyoming (7 days); St. Thomas and St. John, Virgin Islands (8 days). Also offers workshops in Maine, California, Colorado, Arizona, Utah and Ontario. "In Colorado we offer two advanced editorial workshops for aspiring pros and freelancers featuring the editor and picture editor of *Audubon* magazine. Some of our workshops also feature David Cavagnaro and Mary Ellen Schultz, both well-known and well-published photographers from California." In Alaska, holds 2 workshops in June; 2 workshops in Idaho in May; and in Wyoming—2 workshops in July, 2 in September; in Virgin Islands, 2 workshops in March. Class size is 10 in Alaska, 15 in Idaho, 10 in Virgin Islands and 16 in Wyoming. Cost is $1,500 in Alaska. Includes all meals, lodging, boat trip and Ektachrome processing. Cost is $895 in Idaho. Includes all meals, lodging, air charter and Ektachrome processing. Cost is $495 in Wyoming. Includes all meals, lodging and Ektachrome processing. Cost is $895 in Virgin Islands. Includes all meals, lodging (on 451 sailing boats) and scuba diving instruction. Housing is in comfortable cabins at the edge of wilderness. Uses semiautomated Ektachrome processing on-site for critique of work. Send for brochure. "Because of increasing popularity, we urge very early inquiry and reservations."

.*THE OGUNQUIT PHOTOGRAPHY SCHOOL, Box 568, Ogunquit ME 03907. (207)646-7055. Director: Stuart Nudelman. Offers programs in photographic sensitivity, marketing photos and photodocumentation, creative workshops with guest instructors and AV symposiums for educators. Traveling workshops to off-the-beaten-path areas include China, Monhegan Island, Nova Scotia and Kenya. New courses include seminars in instant photography, photo chemistry simplified, basic creative color workshop, advanced creative color workshop, basic color darkroom, photojournalism/documentary photography, graphic design and composition in photography. New programs introduced this year include the "Complete Portrait Workshop" and "Experimental Color Workshop." Guest instructors include Norman Rothschild, Peggy Sealfon, B.A. King, Isabel Lewando, Ed Meyers, Herb Schumacael and George Scurria. A seminar on "Marketing your Photographs" instituted in 1981 will be offered in the future with guest lecturers from the various markets. Summers only. Class size: 8-14. Programs last 1 and 2 weeks. Cost is $150-200 for 1-week seminars; $600-1,100 for traveling workshops, depending on duration and location. Includes breakfast and use of darkroom and library. Write to apply.

KAZIK PAZOVSKI SCHOOL AND WORKSHOP OF PHOTOGRAPHY, 2340 Laredo Ave., Cincinnati OH 45206. (513)281-0030. Director: Kazik Pazovski. Offers year-round programs in all phases of b&w photography. New offerings include portraiture in the studio and on location. Class size: 5-10. One course lasts approximately 3 months, 20-25 sessions. Cost is $75/course for continuing students, $85 for all others. Includes use of all studio and darkroom equipment and chemicals. Write or call the school. "All students are required to take a Photo-Quiz. Generally students with less than high school education may find even the beginners course too difficult to master. Basic knowledge of mathematics and chemistry is desired." Speical programs: photojournalism, nature, portraits on location etc.

PETERS VALLEY CRAFTSMEN, Star Route, Layton NJ 07851. (201)948-5200. Offers special summer workshops for all skill levels in specific techniques. Classes include field trips into the rural area of the beautiful Delaware River Valley National Park area, the figure in photography and darkroom classes. Sessions last from 1-7 days. Write for free brochure.

***PHOTO TOURS: ON LOCATION WITH LISL DENNIS; TRAVEL PHOTOGRAPHY TOURS**, Waters Travel Service, 888 17th St. NW, Washington DC 20006. (202)298-7100. President: Cynthia Newman. Tours are educational photo trips with on-location demonstrations and regular photo critiques. Tours go to England/Wales (Oct. 4-19, 1986); India (Nov. 4-23, 1986); Thailand/Burma (Jan. 12-31, 1987); Indonesia (June 28-July 19, 1987); Ireland (May 1-15, 1987); Provence (Oct. 10-25, 1987). Tours last 14-22 days. Maximum class size: 18. Instruction in still b&w photography and still color photography. Tours cost $2,985-4,350 and includes transportation, hotels, most meals, sightseeing, instruction and critiquing. Tours geared toward beginner through professional level photographers. Call or write Cynthia Newman for more information.

Close-up

Lewis Kemper
Co-founder
Sierra Photographic Workshops
El Portal, California

Sierra Photographic Workshops co-founder, Lewis Kemper, came to Yosemite on a photography trip . . . and never returned home. The reason? Through a stroke of good timing and, of course, good skills, Kemper was hired at the Ansel Adams Gallery to replace a photographer who had left. It was through this position that Kemper developed some of the teaching philosophies he now uses in his own workshops. This 1976 graduate of George Washington University holds a BA in Fine Arts Photography, and has experience in instruction through a position held on the East Coast, as well as through summer classes he taught while at the gallery. "Ansel Adams was a big influence on me," he says. "Probably the most important thing I learned from him was how to give, how to share with the students. With our students," he adds, referring to co-instructors William Neill and Jeff Nixon, "we will stay up all night if a question takes that much time." Some of their participants have commented on the amount of quality attention they received during the workshop, he says.

Students at the Sierra Workshops are taught "techniques to master the camera so they can express their feelings photographically. We handle beginners through advance-level photographers," Kemper explains, "because we feel each person can learn from the other." In addition to Neill (the other co-founder) and Nixon, guest instructors contribute to their workshops. Guests have included Philip Hyde, whose work has been featured in many Sierra Club books and calendars; Chris Rainier, former assistant to the late Ansel Adams; Eugene Fisher, whose work has been published in National Geographic Books, *Geo* and *Oceans*; and Cole Weston and Wanda Hammerbeck. Through such teachers, students can study color as well as black and white photographic techniques, learn about Zone System, and pick up valuable tips on how to effectively market their photographs.

Workshop locations vary as well as guest instructors. According to Kemper, four workshops are offered per year in Yosemite Valley, a spring or fall session is scheduled in Death Valley, and a class is held at a West Coast location such as Carmel or the Mendocino Coast in California.

The emphasis at the workshops is on individual attention. "There are always at least two instructors, sometimes three," Kemper explains, "who rotate around the group. Students have different instructors all throwing out their points of view. And, it's not hard to fire someone up to experiment with new techniques learned in class due to the high photographic potential of the landscapes."

Photographers of all levels can benefit from the workshop, Kemper says. "I think it can give beginners a real leap into their photographic experience because they're being influenced by more than one instructor. Our classes consist of three to five days of fairly intensive photography training," that allows for constant practice, he explains. More advanced photographers can "develop their own personal style and learn to see in a creative, photographic manner. We look for technical quality, and we ask the student to really see what he or she is trying to express." Skills acquired here combine development of technique and composition, he says.

***PHOTO WORKSHOP TOURS WITH D.E. COX**, 5856 Hartwell, Dearborn MI 48126. (313)581-0116. Organizer and leader: Dennis Cox. Offers individualized instruction according to each participant's interests. The goal of the workshop is for each participant to return home from the tour with professional quality travel images. Workshops held at least once per year with different destinations: China, Japan, and Kenya thus far, with additional ones planned. Length of classes are about three weeks. Class size: "Groups are from 10-16 participants." Instruction given in still b&w photography and still color photography. Cost varies "usually $3,000-3,500, all inclusive travel from US point of departure, except a few meals, the participant's personal and photo equipment, all films. Includes the cost of workshop instruction. No photography facilities available, except a Polachrome processor is provided. Sometimes local facilities are utilized, such as that of the China Photographers Association in Beijing." Workshops geared to "all levels (with non-photographers welcome too)." For more information, write the above address. "Photo Workshop Tours were originated to give the traveling photographer the benefit of tour group prices combined with much of the flexibility of individual travel. Logistical and itinerary details are taken care of so that the photographer can have maximum time and opportunity to photograph."

PROJECT ARTS CENTER, 141 Huron Ave., Cambridge MA 02138. (617)491-0187. Photo Director: Charles Leavitt. Offers programs in beginning and intermediate, b&w, color, portrait, darkroom techniques, studio lighting, nonsilver and advanced photography. Classes can be taken for college credit. Class size limited to 12. Length of classes is 5 or 10 weeks, 3 hours/week, in 4 sessions: fall, winter, spring and summer. Cost is $120 plus $30 lab fee. Includes 3 hours of instruction/week. Darkroom rental available. Also offers one and two day workshops taught by locally acclaimed photographers. Write or call to apply. SASE.

***SIERRA PHOTOGRAPHIC WORKSHOPS**, Box 33, El Portal CA 95318. (209)379-2828/2841. Contact: Sierra Photographic Workshops. Offers "personalized instruction in outdoor photography, technical knowledge useful to learning to develop a personal style, learning to convey ideas through photographs, marketing nature photography." Workshops held year round in various scenic areas of the west. "This year's classes include four in Yosemite National Park, one each in Death Valley, Point Reyes, Big Sur, Mendocino Coast." Length of classes vary from one to five days, with an average of 4 days. Class size: depends on number of instructors; low teacher/student ratio of about 1:5 is maintained. Instruction given in b&w and color photography. Cost varies from $40-400, includes tuition and in most cases lodging. "Since workshops are in various locations facilities change. Polaroid autoprocessing and demonstrations are always used." Workshops geared toward beginner through professional photographers. Call or write for information. "Be prepared for an intense period of photographic activity! The workshop runs non-stop from morning to late at night. Days include lectures, demonstrations, and plenty of time to photograph." Staff instructors are William Neill, Lewis Kemper, and Jeff Nixon. Guest instructors have included Cole Weston, Philip Hyde and Chris Rainier.

SOUTHEASTERN CENTER FOR THE PHOTOGRAPHIC ARTS, INC., (SCPA), 195 Cliff Valley Way, Atlanta GA 30329. (404)633-1990. Director: Neil Chaput de Saintonge. Professional career program: 15 month night program, 1 year day program. Adult education classes in camera, darkroom, nature, macro, travel, portraiture and audiovisual production. Workshops in Georgia and Appalachia. Visiting artist series. SCPA sponsors photography festivals in spring and fall. SCPA's gallery features the work of students and local and nationally known photographers. Call or write for a free catalog.

***TOUCH OF SUCCESS PHOTO SEMINARS**, Box 51532, Indianapolis IN 46251. (812)988-7865. Director: Bill Thomas. Offers "working with nature scenics, plants, wildlife, stalking, building rapport and communication, marketing and business management." Various classes held year-round; literature specifies schedule. Length of classes: 1 day, 1 week and 17 day adventure workshops. Class size: 15 for weeklong, 25-weekend, no limit on 1 day. Instruction is still color photography. Cost varies from $55-750. Weeklong and 17 day includes transporation, lodging and food, guide services, teaching. Workshop geared toward beginner through advanced. Call or write for catalog.

***TRAVEL PHOTOGRAPHY WORKSHOP**, Box 2847, Santa Fe NM 87504-2847. (505)982-4979. Founder/instructor: Lisl Dennis. Offers instruction on how to take better color travel photos. Workshops last one week beginning every Saturday in September every year. Maximum class size: 20. Instruction is given in still color photography. Cost is $795 including accommodations at La Posada, some meals, photo day trips, instruction and critiquing. "We have film processed." Workshops geared toward beginner through professional level photographers. Call or write for more information.

***THE VIRGINIA WORKSHOP**, Box 99, Weyers Cave VA 24486. (703)234-9261. Instructor: Glenn Showalter. Workshop emphasizes rural Virginia, its people, places, nature, commerce, etc. The workshop is held in late spring, summer and fall (through October). Classes last one week. Class size: 10. In-

struction given in still b&w photography, color photography and filmmaking. Cost of workshop is $375; includes tuition, book, course materials for instruction but not photographic supplies or camera accessories. Location work is done with the student's own camera equipment. Some laboratory facilities available for limited use. Workshop is geared toward intermediate and advance level photographers. Requires students submit one photograph not to be an original transparency but duplicate or a print. Personal liability waver required. Call or write for catalog. Instructor holds a Bachelor of Science degree in photographic arts and sciences from Rochester Institute of Technology and Master of Science degree in instruction. Full-time academic appointments to three colleges and universities.

***WILD HORIZONS, INC.**, 1836 E. Linden St./PM, Tucson AZ 85719. (602)795-0038; toll free (800)445-2010. President: Thomas A. Wiewandt. Offers field technique in nature/travel photography at vacation destinations selected for their outstanding natural beauty and wealth of photographic opportunities. "Scheduling is planned to give participants the best photographic opportunities at each destination selected. We focus on the American Southwest and places offering scenic and cultural diversity abroad." Length of trips varies from one to three weeks. Class size: 10 participants per instructor-guide. Instruction given in still b&w photography, (secondarily), and still color photography (primarily). Cost varies from $950-5,000/trip; includes transportation, food, lodging, special fees, and instruction. "Our trips are deluxe, all-inclusive vacation packages." Participants must bring their own film and equipment. All domestic tours include instructional slide programs designed by the instructors. "We keep our groups small to permit individualized instruction at all levels from beginners through advanced. If participants are interested in critique of their work, we request that they bring a selection of 20 of their best photographs. Call or write for catalog. "Our instructors are professional natural history photographers/naturalists, and we design our tours to help participants sharpen their photographic skills while learning about the plants, animals, landforms, and human cultures in places featured."

***YELLOWSTONE INSTITUTE**, Box 117, Yellowstone National Park WY 82190. (307)344-7381, ext. 2384. Director: Gene Ball. Offers nature photography; wildlife photography, filmmaking and video. Workshop held June, July, August, "We may add a winter course this year." Length of classes vary from 3-5 days. Class size: 15 (12 for backcountry classes). Instruction given in still b&w and color photography, videotaping and filmmaking. Cost varies from $105-280. "For courses at our field school, the fee covers tuition only. (Cabin fee is $6 per night extra.) For backcountry courses, the fee includes meals and camping gear. We operate as a field school out of a rather remote facility." Workshop geared toward beginner through advanced photographers. Call or write for 16-page course catalog, available free. The Institute offers a variety of field courses in the least traveled section of Yellowstone. Rustic cabins are available and there is a community kitchen where participants prepare their own meals giving enrollees options to economize.

ZONE VI WORKSHOP, c/o Fred Picker, Director, Putney VT 05346. (802)257-5161. Administrator: Lil Farber. "The Zone VI workshops are for the serious individual who wants to improve his technical and visual skills and probe the emotional and intellectual underpinnings of the medium. Long experience or a high degree of skill are not required. Strong motivation is the only requisite." Offers 2 7-day workshops covering negative exposure and development; (Zone System) printing theory and practice; equipment use and comparison; filters and tone control; field trips; and critiques. Summers only. Class size: 70; 8 instructors. Cost is $845 for everything—room, all meals, linen service, lab fee, chemicals; $625 for tuition and lab fees only; and $525 for room and board only for family members not attending. Write or call for brochure. "The program is usually filled by May."

Appendix

The Business of Freelancing

To become a commercially successful photographer, you need more than artistic skills. In order to compete in today's competitive market, the photographer must be a competent business person as well. This involves keeping accurate financial records; systematically filing prints and transparencies so they can easily be retrieved for market submissions; and practicing "business etiquette" techniques that include submitting attractive and informative resumes, cover letters and query letters to the market buyers.

Before setting up your freelancing practice, it would be wise to talk to other, more established photographers to learn some "do's and dont's." Such research will come in handy especially when considering what insurance policies to purchase, and how to set up financial records. If advice from friends or associates isn't helpful, don't hesitate to go to a professional. An accountant can help set up a recordkeeping system for those who aren't sure of the best method; a lawyer can counsel you about any contracts you may not understand. Good advice up front can prevent possible financial disaster later.

Financial recordkeeping

Tracking business expenses, payments and balances due can be quick and accurate with a good ledger. Browse around an office supply store to see what will most closely suit your needs. A ledger that allows for a job number space, date of assignment, client name, expenses incurred, sales taxes and payments due works well for many photographers. Be sure to retain all business receipts, invoices and cancelled checks; they are needed to support ledger entries during tax season. These supporting records can be filed in an envelope by month, an organizational trick that makes annual accounting to the IRS a less formidable affair.

You will also want to check into designing and printing some business forms. The service photographer working with clients will want a form that includes columns for estimation of services, assignment confirmation, delivery of photos and invoicing. Photographers dealing in stock images will only be concerned with delivery of photos and invoicing. Such forms can easily be reproduced by any quick printing service for a nominal fee. Use of such forms not only is an effective way to track your business affairs, but it presents to your clients or buyers the appearance of an organized professional. For any specific questions about business concerns, you can contact the Service Corps of Retired Executives Association (SCORE) at Suite 410, 1129 20th St. NW, Washington, D.C. 20416. This 12,000 member group of businessmen and women provide free management assistance to those starting a business, having problems with their business or expanding the business. The phone number is (202)653-6279.

Taxes

The small business person does get some assistance from our free enterprise system through tax deductions. It is to your advantage to contact the IRS periodically to request its

"Tax Guide of Small Business" publication; the toll-free information number is 1(800)424-1040.

Any photographer working out of a home office and/or darkroom can deduct a certain percentage of his house payment on that year's tax form. The work area must be used exclusively for business purposes, and on a regular basis. To figure the percentage of your residence used for business, divide the square footage of your work area(s) by the square footage of the house. Utilities also can be deducted, when used for work. Other areas to consider for deductions include the cost of office supplies, film, depreciation of cameras and related equipment, gas mileage (which is pertinent when driving to shoot stock photos as well as assignments), typewriters and telephone answering machines. Educational needs (e.g., workshops, lectures, professional organizations, trade periodicals) also can be deducted. Keep receipts or travel logs to substantiate these claims to the IRS.

Before deductions can be claimed, the IRS requires you to show "intent" that you are in business to make a profit. Such "intent" can be proven by having business stationery printed, opening a separate bank account under the business name, and asking the IRS for an employer's tax ID number, whether or not you intend to hire anyone. Deductions will be allowed by the IRS if profits are shown for two years out of a five-year period. It doesn't matter which two years the profit was reported.

As sole owner of an unincorporated business, you must report business income and expenses on Schedule C (Form 1040). If this is a new experience to you, the "Tax Guide of Small Business" booklet includes a sample Schedule C with explanations.

Insurance—business and personal

Insurance needs vary from photographer to photographer, and depend on whether the photographer is running a studio or freelancing from home. Even the freelancer working out of a home office needs to assess the value of his equipment because just a modest setup of photography and office equipment can easily represent thousands of dollars in investments, plus the hard-to-determine value of stock photos that could be stolen or damaged in a fire. (Photos should be stored in a fireproof file.) In addition to studio and equipment coverage, consider "business" car insurance if your auto is used regularly for business travels, as well as liability insurance if you have clients and/or models on the premises. According to the American Society of Magazine Photographers' (ASMP) "Professional Business Practices in Photography," coverage should be based on severity of loss over frequency of loss. This would mean that those on limited incomes would want to consider liability coverage before camera coverage, as an injury to a third party would be more catastrophic to the photographer's financial stability.

According to Jane R. Adler, marketing director of Professional Compensation Planners, Inc. (360 Lexington Ave., New York, NY 10017), a New York-based financial firm, self employed freelance photographers should evaluate their insurance needs from two levels, personal and business related. Since the full time freelancer doesn't get the benefits of company-sponsored life, health or disability insurance, he must take the financial responsibility off himself and place it in an insurance company. Health insurance should be considered due to the high costs of hospitalization the freelancer would otherwise have to pay out of his pocket, Adler explains. Also important is disability, she says, though some considerations have to be made here prior to choosing a particular policy. The first question, Adler cites, is how long you can carry yourself in the event of a long-term injury—30, 90, 180 days?—before disability would be needed. Most insurance companies pay about 60 percent of the disabled person's annual income, she says. The problem for the freelancer with a fluctuating annual income is what the insurance company should insure him for. Disability, emphasizes Adler, should be the primary concern of any self-employed photographer. Second, she suggests the freelancer save until he has three to four months of expenses liquid; such as cash value life insurance, money market accounts or savings accounts, that can be drawn from in an emergency. Such

savings should be in a form that would be accessible within two days, she advises. To build financial stability, Adler says 20 percent of income should go into savings programs, with the remaining 80 percent to be used for necessities.

How do you look for insurance? Find someone you feel comfortable with, Adler advises, look at their academic background, see how long they have been in business, and try to get some third-party referrals. She also advises thoroughly reading all policy clauses to be sure you are insured for the coverage you wish. Buy from a reputable broker/agent, she warns, and buy from a company licensed to do business in the state in which you live.

Filing prints and transparencies

Filing prints and transparencies is a process each photographer refines to suit his needs. According to Rohn Engh, author of *Sell & Re-Sell Your Photos*, Writer's Digest Books, the filing sytem can start with assigning subject categories to letters of the alphabet. For example, "A" could stand for farm animals, "B" for aviation, "C" for education, and so on. By assigning a transparency number to each slide, and filing it numerically under its appropriate subject letter, you have the beginning of an easy reference system. The key to finding topics easily, Engh explains, lies in setting up a good 3x5 cross-reference system. List the important subjects and categories, cross-refer them (i.e., slides of an aviation student and teacher could be cross referenced against "aviation" and "education") and file them alphabetically. When a request for a specific subject comes, an alphabetical search through the card system will provide quicker retrieval of the print or transparency. In addition to filing, is the consideration of the actual storage of your slides. Use three-ring binders that contain 20-slide capacity sleeves for 35mm transparencies. Just file the slides in the notebook by subject letter, then within the vinyl page by number.

Black and white prints work in a similar fashion, starting with a subject letter corresponding to a particular category. The next number, however, denotes how many rolls of film have been shot, and the last number represents the specific frame exposed. Using the subject categories above, A-20-28 would refer to the 28th frame shot on the 20th roll of film about farm animals. Black and white prints can be filed in a manila folder marked with the print number and a photo copy of that picture taken from the contact sheet. This helps to more readily identify the print in the folder, or if the folder is empty, serve as a reminder of what print(s) is out in the marketplace. Cross referencing via 3x5 cards is important here, too.

All slides and prints should be stamped immediately with the copyright symbol, 19_____ and your name. Don't fill in the last two numbers, Engh warns, to avoid dating your photo. This can be done on publication.

Another photo filing option is to develop a numerical coding system in which "1" stands for negatives, "2" for transparencies, "3" for prints, etc. Using the letter to represent the subject category, such as "N" for nature or "U" for urban, you would get 2-N-26, which would stand for the 26th nature slide. Here, again, a 3x5 card system would be helpful in keeping the picture's subject heading or caption information at your fingertips.

It is a good idea to keep track of what photos are out in the marketplace; and which have been sold, to whom, and for how much. This can be accomplished by maintaining separate "project" folders for longer-term sales that let you review the status of submissions easily, or it could be done by simply tracking in your payment ledger the date photo submissions are sent out, when they are returned and when payment is made. The photo's code can be entered in the ledger, thereby providing handy information about where a particular photo is at any given time.

Though this may sound like a job that could drive you to hire a secretary, don't worry. When your code system and files are set up, and a little time is spent to periodically update them, you will actually have more time to shoot new photos and market existing ones.

Cover letters/queries/resumes

The cover letter differs from the query letter in content—it is more general and can be a blanket sheet that is appropriate to send out with multiple submissions. The query letter proposes a specific idea or project. Both should explain how the work will benefit the buyer or readership. Have the query letter's goal firmly in mind before you begin writing it.

When mailing in your photo submissions, you should include a cover letter that contains an itemization of what photos are being submitted and caption information, what rights you are offering for sale with the pictures; and at multiple publishing houses, permission to show your photos to other editors. (Photo captions should explain who, what, where, why and how. Unless necessary, don't offer "when" because it will date your photo.) Your cover letter should be brief and concise, and should give the editor instructions on how to reach you should he have any questions. Keep a copy of each cover letter for your files—it will provide an efficient way to track which photos are out.

The query letter usually is limited to one page, and is the vehicle through which the photographer can propose a photo story idea or a photo/text package. Make the story idea sound exciting, yet maintain an overall business tone in the proposal. Such a letter may also provide information about the photographer's specialty, to help establish some credibility before requesting an assignment. When writing the query letter, you may either request the editor's (or buyer's) permission to shoot the assignment for his consideration, submit existing photos, or be considered for an upcoming assignment. If your query meets with approval, you may be asked to shoot on speculation. This means that if the material isn't used, you get no compensation. If however, you are hired on assignment, and for some reason the photos aren't used, then you should receive a "kill fee." A kill fee should be negotiated prior to accepting an assignment, and generally amounts to one-fourth to one-third of the agreed upon assignment fee.

In the initial query letter, it is important to establish a contact name, not just title, so a relationship more conducive to getting you a particular assignment may be developed.

If interested in assignment work, you may wish to submit a resume with your query letter. The resume should be attractive, and as complete as possible. Be sure to highlight past accomplishments beginning with photo experience (specify whether it's industrial, advertising or editorial). If you have any staff photo experience, include it, plus any photography-related education (including workshops attended), shows or exhibitions held, or awards and achievements earned in the photographic field. Professional memberships also are good to list.

Mailing photo submissions

Prior to actual packaging (we're starting from the inside out) be sure each print or transparency is stamped with your copyright notice, "Return to:" followed by your name and address, and an identifying number (see the section "Filing prints and transparencies"). The address and identifying number will be helpful to track down any misplaced prints the buyer may have separated from the other submissions.

Once each photo is identified, the next concern should be safe packaging. Slip your black and white photos (8x10 sizes are popular with most buyers) into an 8½x11 plastic jacket; transparencies should be inserted into protective vinyl pages. Some photographers even insert each individual slide into its own plastic envelope so that when it is removed from the vinyl page, it still is protected from potential damage. Never submit photos or transparencies mounted in glass—the glass can break.

It is important to include a return mailing label, postage and envelope with your submissions. This will ensure that the editor returns them to you, whether or not they are used. Photographers can now mail their submissions out in heavy-duty cardboard envelopes, which un-

like their manila counterparts, can be reused. Just send your return mailing label and postage in this case. Most office supply stores or stationery shops stock these cardboard envelopes. Presenting a professional appearance through proper packaging is important in a market where looking like an accomplished veteran rather than an amateur could determine whether the submission gets reviewed or set aside by a harried editor or art director.

Mail your submissions first class. The service is quicker and the handling tends to be less rough. If you're concerned about your photos getting lost, consider using certified mail. Though a certified package travels a bit slower than first class mail—it is logged in wherever it goes—it will be easier to trace in the event of a mishap. It is also a good policy to include a self-addressed, stamped post card along with your submissions so the editor can acknowledge that your photos did arrive safely. Be sure to specify on the post card what photos were included, so the editor or art director merely has to sign the card—it shouldn't be a time consuming process for him.

How can you safeguard against possible losses in the mail? Double check the address and zip code of the destination to which you're sending material. If a lengthy amount of time has passed, with no word from your markets, query regarding your photos' status. Possibly they're being held for final consideration!

Additional ways to safeguard against photo misplacements or losses vary with the format you're shooting. For black and white prints, always hold on to your negatives—only prints should be mailed out. If an editor likes your subject, but not the contrast or there is some other technical problem, offer to send a reprint. When submitting color transparencies on speculation, send a duplicate with an offer to send the original if the buying party is interested. Some labs can produce high quality dupes, and though this will cost a little extra, it's worth it for a slide you might consider to be valuable in terms of marketability. Another way to combat the problem of sending out original transparencies involves a little pre-planning. If you have the feeling a certain image could be marketable, shoot multiple images (if this is possible) at the time you shoot your "original." This way, you have multiple records of your salable image, and the loss of one "original" won't be quite so painful.

Copyright/rights

The Copyright Act of 1976 (effective January 1, 1978) guarantees photographers and other artists full control of the work they create. In order to ensure such control, certain procedures must be followed. First, the photo or transparency must contain a stamp or label with the copyright symbol, artist's name and year (for unpublished photos just use 19_____ and fill in the last two figures when appropriate). These rubber stamps can be ordered at an office supply or stationery store. Such a stamp informs the public that your work is protected, and that you are aware of these rights. (Copyright information can also be written on the photo, just be careful you don't damage the print by pressing too hard or "bleeding" ink through the paper.)

When submitting your work, you should specify as part of the purchase agreement that your copyright notice appear adjacent to your photo. Be aware that the publisher's copyright will protect your work within the body of the text, but some photographers still demand their own copyright symbol as a means to further protect their rights.

Absolute copyright protection can be obtained by registering your copyright with the Copyright Office of the Library of Congress, Washington, D.C. 20559. Ask for photography packet #107 to ensure getting the correct forms. Works can be registered individually, or as a group, for a single fee of $10 (fee will soon be $25) check before registering. Each work must bear a separate copyright notice, however. Photos can be registered before or after publication, though after publication this must be done within a five-year period.

The copyright is an artist's most fundamental right. A thorough understanding of rights and corresponding rates should be familiar to every photographer. No copyright should be given up easily or without the proper monetary compensation to reflect its "market value."

When a photographer sells rights to the buyer to use his photo, he does not have to—and

generally shouldn't—give up his copyright. Many editorial publications buy one-time rights, though there are variations to this. For the photographer, selling one-time rights to a photo allows him to "lease" it to other markets as well. Occasionally, a publication will want one-time rights with certain conditions attached. A sports magazine, for example, may buy a currently marketable shot of a baseball figure, and specify that they want first North American serial rights, so the photo doesn't run in a rival publication. There may even be a clause specifying the photo not be sold for 30 days to ensure a month's worth of exclusivity.

Some of the rights photographers generally are asked to sell include:

One-time rights purchased for one-time use only. Most stock photos are "rented" on a one-time basis.

First rights. This means essentially the same as one-time rights except that the buyer may pay a little more for the privilege of being the first to use the photo. He may use it only once unless other rights are negotiated.

Serial rights. The photographer has sold the right to use the photo in a periodical. It shouldn't be confused with using the photo in "installments." Most magazines will want to be sure the photo won't be running in a competing publication.

Second reprint rights. The owner of the copyright (most likely the photographer) sells the right to reprint an already published photo, or sells the rights to use an already published photo before anyone else. Sometimes reprint rights are sold to the buyer of the first rights if that buyer wants to use the photo twice.

All rights. The photographer sells the photo outright. This means the buyer can use the photo as often as he pleases without further reimbursement to the photographer. Try to avoid such a situation, or at least charge a price that reflects what you consider to be the "marketable" value of the picture. Some purchasers of all rights, will occasionally, on request, reassign rights to the photographer after the photo's use.

Exclusive rights. Exclusive rights guarantee the buyer's exclusive right to use the photo in his particular market or for a particular product. For instance, a men's magazine may purchase a photo with the stipulation that it not be sold to another men's magazine for a certain time period, e.g., a year. The photographer may, however, retain the right to sell the photo to other markets. Conditions should always be in writing to avoid any misunderstandings.

Generally, the more rights a buyer demands, the more the selling price should reflect the loss of marketability the photographer will realize. Advertising companies tend to pay more for photos purchased because the conditions call for purchase of all rights or photography is done on a work-for-hire basis. In the latter case, the photographer, working in the employ of the client, relinquishes all rights and negatives/transparencies to the buyer. The editorial market, by comparison, pays less but usually is buying limited rights to photography.

In general, get all conditions in writing to avoid misunderstandings, and be sure you understand the rights you're selling and the pay being offered for such rights.

Model releases

Any photographer shooting subjects should be aware of the importance of the model release. A signed model release gives the photographer the right to use, sell and publish that person's picture for editorial and advertising purposes with the assurance there won't be any legal reprisals. This does not mean the photograph can be used in such a way that it embarrasses or insults the subject. The law protects the subject from such an abuse over the photographer's right to publish.

Generally, the law states that photos used for editorial (i.e., public education purposes) are free from the need for a model release. This would include using a person's photo in a newspaper, textbook, filmstrip, encyclopedia or magazine. When used for advertising or trade purposes, the photographer should always have a model release. If photographing children, remember that the guardian also must sign for the child before the release is legally binding.

A Legal Guide for Photographers

by Timothy S. Jensen

Each professional photographer should be aware of the federal and state laws that affect him or her. These laws may restrict the allowable subjects for use in a photograph, but they also provide photographers with the ability to control ongoing use of the images they create, as well as determine the "bottom line" in many of the photographer's business dealings. Frequently asked questions about copyright law, and privacy and publicity rights are discussed here.

What is a copyright?

A copyright is a property right that laws in the U.S. and many other countries give to the creators of original work. In the U.S., there is only one source of copyright law—the federal Copyright Act of 1976, effective January 1, 1978. Since this is a federal law, it is uniform in all 50 states.

What kind of creative works does copyright protect?

Any kind of work—painting, photography, sculpture, etc.—which is both *original* and *fixed in tangible form*. To be "original," a work does not have to be unique, but it must have been created by the person claiming copyright, not a "finder," and it can't be an identical copy of another work. To be "fixed in tangible form," a work must actually have been created rather than simply conceived; the creator must actually take the photograph, carve the sculpture, or paint the painting.

What doesn't copyright protect?

The title of a photograph cannot be copyrighted, nor can its subject matter. You cannot prevent other photographers from taking the same subject unless they are trying to duplicate your own earlier photograph of that subject. Style is not protected by copyright, nor is a concept or idea for a photograph. Finally, copyright has nothing to do with ownership (e.g., the purchaser of a photograph from a gallery) or possession of the physical artwork (painting, photographic print, negative, etc.) embodying the copyrighted image. In connection with this, the fact that someone other than the photographer paid for or supplied the film is usually irrelevant to the issue of copyright ownership.

What rights does copyright give to the copyright owner?

There are three basic rights held exclusively by the copyright owner, who will retain these rights until he or she specifically transfers them to another party. First, the copyright owner has exclusive right to reproduce the work—in print or poster form, in a book or magazine, etc.—for distribution to the public. Second, the copyright owner has exclusive right to create derivative works based upon his or her original—works which change or add something to the original. Finally, the copyright owner has exclusive right to publicly display the work, at a gallery or museum, for example. This last exclusive right does not prevent, however, the owner of a copy of the work—photographic

Attorney **Timothy S. Jensen** *is presently New York Director of Legal Services for Volunteer Lawyers for the Arts, an organization which provides free legal assistance to artists and nonprofit arts organizations. He lectures extensively to professional arts organizations and teaches a clinic on art law at Columbia University's School of Law.*

print, painting, etc.—from publicly displaying that copy. Otherwise, no one may exercise the above rights without authorization from that copyright owner.

Who holds copyright on a photograph?

The photographer always holds copyright, unless one of the following four exceptions applies. First, if the photographer took the photograph in the regular course of his or her employment, the employer automatically holds copyright; no written agreement needs to be signed by the photographer. By the way, the "regular employment" need not be full-time; if the employer has the right to tell the photographer what to photograph, when to do so, and how to do so, this may be considered to be regular employment or "work for hire."

Second, if the photographer is specifically commissioned or hired as an independent contractor to take photographs, and that photographer signs an agreement specifically stating that his or her photography is "work for hire," the party hiring the photographer owns the copyright on the photographs. It is important to note that only certain types of commissioned work can be considered to be "work for hire" under the Copyright Act. In general, single photographs not intended for use as part of a larger work—a magazine, book or newspaper, for example—cannot be considered "work for hire" even if the photographer has signed a contract indicating that they are. In this case, the photographer would retain the copyright despite such an agreement.

Third, if the photographer signs an agreement stating that he or she transfers or gives to another party "all of his/her rights" in a photograph, or copyright in the photographs, the party to whom the copyright has been transferred owns the copyright. Note that such transfers of copyright, which must be in writing, can always be terminated by the original photographer or photographer's family 35-40 years after the transfer; the Copyright Office in Washington, D.C. can provide details on this.

Finally, if the photographer loses his or her copyright by failing to properly place a copyright notice on the work when it is published, or registering the work with the Copyright Office in Washington, D.C. (see "How do you reigister your copyright on a photograph?"), the work may go into the "public domain." This means that no one will hold any copyright on the photograph, and anyone may use it for any purpose whatsoever.

Can more than one person share a copyright on a single work?

Yes; if two or more artists (two photographers, a photographer and a painter, etc.) collaborate on a work, they may be considered to have "joint copyright" on that work—either may do anything or make any nonexclusive licensing arrangement he or she wishes with regard to that work, and the agreement or consent of the other joint copyright holder is not required. The only limitation on this is that any monies received from the exploitation of the work must be fairly divided and, in general, any licensing arrangement for the work covering territories outside of the U.S. requires the approval of all joint copyright holders. For a number of reasons, it is always a good idea to draw up a collaboration agreement among parties working together on a piece of art.

How does a photographer get copyright on a photograph?

A photographer automatically has copyright on every photograph he or she takes; no copyright notice is required, nor is registration with the Copyright Office required. In fact, if the photo is never published, i.e., copies of the photograph are never distributed to the public, and it is never reproduced in a magazine, book, newspaper, etc., nothing more ever need be done to preserve copyright.

What must a photographer do to protect copyright on a photograph that will be published?

All the photographer needs to do is place a proper copyright notice on the photograph whenever it appears. This notice consists of the symbol "©" or the word "Copyright" or the abbreviation "Copr.," the artist's name (legal or professional) or an abbreviation by which that name can be recognized, and the year of publication or year in which the photograph was taken (if the notice is being placed on the work before publication). This notice should appear on all copies of the work which are publicly distributed or displayed. The notice can appear anywhere on the work—on the frame of a slide, on the back of a print, etc.—as long as it is easy to locate or see. Note: the year or date can be omitted from notice on photographs reproduced on or in greeting cards, post cards, stationery, calendars, or other "useful" articles.

Where should the notice appear for photographs reproduced in a book or magazine?

The copyright notice in the name of the publisher of a book, magazine or newspaper usually appearing on the title page or masthead, will satisfy the notice requirement for all photographs in that magazine, book or newspaper. It does not mean that the publisher has copyright to all photographs in the book or magazine unless each photographer has transferred his or her copyright. One important exception is advertisements—advertisements in a magazine or newspaper require a separate copyright notice on the page on which they appear; this notice can be in the name of the advertiser.

What happens if notice is omitted when a work is published?

Failure to properly place notice on a work that is published will most likely result in the photographer's loss of copyright, and the photograph's movement into the "public domain," unless one of the following exceptions applies:

First, if the notice was omitted from only a relatively small number of copies distributed, the photographer will not lose copyright.

Second, if the absence of copyright notice was in violation of the photographer's written instructions requiring that such notice appear whenever the work is published, the photographer retains copyright.

Third, if within five years after publication without notice, the photograph is registered with the Copyright Office in Washington, D.C. and a "reasonable" effort is made to add notice to the copies already distributed without a notice (a letter to the publisher or distributor of the published work informing them of the absence of proper notice, with a request to add that notice to remaining copies, would probably suffice), the photographer can "save" his copyright. This exception is most important, because it allows a photographer to repair any inadvertent failure to place the notice. Note: although registration of an unpublished work with the Copyright Office prior to publication without notice may prevent loss of copyright, it would be wise to re-register the photograph in published form, and make the effort to add notice to remaining copies.

How do you register your copyright on a photograph?

By filling out a federal copyright registration application form and mailing it to the Copyright Office in Washington, D.C. For photographs, form "VA" is always used. These forms can be ordered by telephone, without any charge, by calling the Copyright

Office at 202-287-9100. If you run out of forms, order more—photostated copies are not accepted for filing. A fee, which is presently $10 and will shortly be $25, must accompany each registration form. With the completed form and fee, send two copies of the photograph in its published form if publication has already taken place, and one copy of the work if it is unpublished. The deposit for an unpublished photograph can be a transparency (at least 35mm, mounted if 3x3" or less) or a print (no less than 3x3", no more than 9x12"). The deposit must be in color if the original is in color.

Photographers can take advantage of "group registration" if they register their work before it is published. This allows registration of a whole series of photographs by the photographer on one registration form, for one fee. The only requirements are generally that the group bears some single title identifying the group as a whole ("Beach Photos of John Photographer," etc.), and that all photographs are taken by the same photographer. There is no limit on the number of photographs which can appear in a group registration. Again, this aspect of the Copyright Act can save a photographer a great deal of money in registration fees, since published photographs must be registered in their individually published form, one per application, and each with a registration fee.

If you have any questions about the registration requirements, you can call the Copyright Office at 202-287-8700.

Besides saving money, are there any other advantages to registering photographs before they are published?

Yes. Remember that as long as a proper copyright notice appears whenever a photograph is published, the copyright is preserved, and registration is not necessary, either before or after publication. However, registration prior to publication is of benefit.

First, if registration is made either before publication or within five years after publication, a presumption arises that the person indicated on the filed registration is indeed the copyright holder.

Second, you must register a photograph before you can initiate a copyright infringement action against someone who is misusing the image. Registration can sometimes take months for the Copyright Office to process, and although you can get an expedited, 24-hour filing for a high fee (telephone Copyright Office for details), it is far easier to complete this process before your work is exposed to risk after publication.

Third, if you register either before publication or within three months after publication, you have the option of suing an infringer for either your actual damages or "statutory damages." Actual damages would consist of what you normally would have received as a fee for the infringing use if you had consented to it, or the amount of profit made by the infringer from that use. "Statutory damages" are fixed damages set forth in the Copyright Act itself, ranging from $250 to $10,000 per infringement, and if the infringement is "willful," they can go as high as $50,000. Statutory damages are a helpful alternative in situations in which actual damages might be difficult to prove.

Fourth, if you are successful in an infringement action, you can recover, in addition to damages, "reasonable attorney's fees"; the infringing party will have to cover a substantial portion of your legal fees. This can make it easier for the photographer without a great deal of money to spend to find an attorney—the attorney will be able to look to the party being sued for his or her fees.

How long does copyright protection last?

The duration of copyright in a photograph taken January 1, 1978, or after, is the life of the photographer plus 50 years. It therefore doesn't make any difference whether the photograph is taken today or twenty years in the future; the term will still be life plus 50 years. If a corporation owns the copyright on a photograph, or the copyright is

"work for hire," the copyright term is either 75 years from first publication, or 100 years from creation, whichever expires first.

Are there any exceptions to the rule that one must have the copyright owner's permission to reproduce a copyright work, or prepare derivative works?

Yes. One exception relates to works which are considered to be "fair use" of the original copyrighted work—such use is allowed, even without permission from the original copyright holder, for purposes of "criticism, comment, news reporting, teaching, scholarship, or research." This would allow reproduction of a photograph in the context of a magazine review of a photography exhibit, for example. However, such uses are fair use only if they will not significantly affect the original copyright holder's ability to market his or her work. A related exception can apply to the use of copyrighted material for the purpose of satire or parody. If one wished to satirize a famous photograph by adding a mustache to the face of its feminine subject, for example, this might be considered a satiric use, not subject to suit for copyright infringement.

Both of the above are *limited* exceptions to the general rule that you must obtain permission for any use of a copyrighted work. Consult a lawyer with regard to any individual proposed use.

This is all so complicated—what are the basic rules to remember?

1.) Assume that you will need permission to use (for reference, reproduction, etc.), photographs published in the U.S. less than 75 years ago.

2.) Place proper copyright notice on every photograph you develop.

3.) If possible, register all of your photographs in groups before publication to reduce costs and maximize protection.

4.) When contracting for the reproduction of your photographs, always insist upon a written agreement specifying that a copyright notice will appear in any publication.

5.) If you believe that you've been infringed upon, contact a lawyer within three years.

6.) If you forget the other rules, remember that it is fairly difficult to lose the copyright on your photographs to the "public domain" or to another party by "accident."

Finally, remember that copyright is only a tool for you to use, and that it will not help you unless you use it.

What are privacy rights?

Privacy rights are those rights held by every individual, in varying degrees, to be free from interference. There are four general types of invasion of privacy (or violation of privacy rights):

First, "false light" invasion of privacy. If a published photograph suggests something both false and reasonably offensive about the subject of the photograph, the photographer may be liable. An example might be a photograph of a group of prostitutes in which a non-prostitute, because she is standing close to the group, appears to be part of the group.

Second, "private facts" invasion of privacy. If a published photograph shows a scene from the private life of the subject which is of no legitimate concern to the public, and

which would be highly offensive if publicized, the photographer may be liable. An example might be nude photographs of a couple making love.

Third, "intrusion" invasion of privacy. This applies to a photographer who intentionally trespasses upon the privacy of the subject; breaking and entering, secret surveillance, etc. Ron Galella was found to have violated this privacy right of Jacqueline Kennedy Onassis by the manner in which he pursued her for photographs.

Fourth, "commercial usage" invasion of privacy. With virtually no exception, a photographer may not use a person's image or photograph for a trade or commercial purpose (advertising, bubble-gum card, etc.) without written permission of that person. Note that this privacy right also applies to the use of a recognizable body part other than the face—an arm with a distinctive and recognizable tattoo, etc.

Does it make any difference if the subject of the photograph is a celebrity?

Not in connection with a "false light" or "commercial usage" invasion of privacy. However, with regard to a "private facts" invasion, it must be shown that the photograph in question depicts a scene of no legitimate concern to the public. Celebrities or "public figures" are considered to have chosen a higher profile than most private individuals, and may consequently have more of their daily lives and activities considered of public "concern." Similarly, the surreptitious surveillance and photographing of a known figure, otherwise subject to a suit for "intrusion" invasion of privacy, may be considered in the public interest. In general, if a photograph is somehow used to illustrate a news story in a newspaper, magazine, or television feature, the photographer is given more protection against privacy suits.

Do buildings, cars and animals have privacy rights?

Generally not. However, a photographer should never trespass onto private property without permission in order to take a photograph. If you anticipate trouble when shooting buildings, it might be wise to get the owner to sign a property release.

Must a person be living in order to claim a right of privacy?

Generally yes; the family of a deceased individual cannot claim invasion of privacy with regard to the use of photographs of the deceased.

What should be included in a standard release form?

Every release should include the date; the consideration given to the subject or model (often a token payment of "$1"); the limits of the release (or a description of intended use); parties other than the photographer who are granted rights by the release (the photographer's "assigns, licensees, legal representatives, etc."); the signature of the subject; and if the subject is a minor, the signature of a parent or guardian.

Acceptance (payment on). The buyer pays for certain rights to publish a picture at the time he accepts it, prior to its publication.

Agent. A person who calls upon potential buyers to present and sell existing work or obtain assignments for his client. A commission is usually charged. Such a person may also be called a *photographer's rep*.

Archival processing. A printing technique, included as part of the actual processing, intended to preserve the quality of prints or negatives by meeting stated levels of freedom from contaminants that can cause image fading and staining.

Bimonthly. Every two months.

Biweekly. Every two weeks.

Blurb. Written material appearing on a magazine's cover describing its contents.

Bracket. To make a number of different exposures of the same subject in the same lighting conditions.

Caption. The words printed with a photo (usually directly beneath it) describing the scene or action. Synonymous with *cutline*.

Commission. The fee (usually a percentage of the total price received for a picture) charged by a photo agency or agent for finding a buyer and attending to the details of billing, collecting, etc.

Credit line. The byline of a photographer or organization that appears below or beside published photos.

Cutline. See Caption.

Enlargement. A print that is larger than the negative. Also called blow-up.

Fee-plus basis. An arrangement whereby a photographer is given a certain fee for an assignment—plus reimbursement for travel costs, model fees, props and other related expenses incurred in filling the assignment.

Glossy. A smooth and shiny surface on photographic paper.

IRC. Abbreviation for International Reply Coupon. IRCs are used instead of stamps when submitting material to foreign buyers.

Jury. A group of persons who make judgments of photographic quality, as in some competitions.

Leasing. A term used in reference to the repeated selling of one-time rights to a photo; also known as *renting*.

Logo. The distinctive nameplate of a publication which appears on its cover.

Matte. A textured, dull, nonglossy surface on a photographic paper.

Model release. Written permission to use a person's photo in publications or for display.

Monograph. A book consisting solely of one photographer's work.

Page rate. An arrangement in which a photographer is paid at a standard rate per page. A page consists of both illustrations and text.

Point-of-purchase display. A display device or structure located in or at the retail outlet, which advertises the product and is intended to increase sales of the product. Abbreviated P-O-P.

Portfolio. A group of photographs assembled to demonstrate a photographer's talent and abilities, often presented to buyers.

Publication (payment on). The buyer does not pay for rights to publish a photo until it is actually published, as opposed to payment on acceptance.

Query. A letter of inquiry to an editor or potential buyer soliciting his interest in a possible photo assignment or photos that the photographer may already have.

Resume. A short written account of one's career, qualifications, and accomplishments.

Royalty. A percentage payment made to a photographer/filmmaker for each copy of his work sold.

SASE. Abbreviation for self-addressed stamped envelope. Most buyers require SASE if a photographer wishes unused photos returned to him, especially unsolicited materials.

Semigloss. A paper surface with a texture between glossy and matte, but closer to glossy.

Semimonthly. Twice a month.

Silk. A textured surface on photographic paper.

Simultaneous submissions. Submission of the same photo or group of photos to more than one potential buyer at the same time.

Speculation. The photographer takes photos on his own with no assurance that the buyer will either purchase them or reimburse his expenses in any way, as opposed to taking photos on assignment.

Stock photos. General subject photos, kept on file by a photographer or a photo agency, which can be sold any number of times on a one-time publication basis.

Stringer. A freelancer who works part-time for a newspaper, handling spot news and assignments in his area.

Table-top. Still-life photography; also the use of miniature props or models constructed to simulate reality.

Tabloid. A newspaper that is about half the page size of an ordinary newspaper, and which contains news in condensed form and many photos.

Tearsheet. An actual sample of a published work from a publication.

Transparency. A color film with positive image, also referred to as a slide.

Videotape. Magnetic recording material that accepts sound and picture signals for later use, as on a delayed broadcast.

Zone system. A system of exposure which allows the photographer to previsualize the print, based on a gray scale containing nine zones. Many workshops offer classes in zone system.

Other Books of Interest

General Writing Books
Beginning Writer's Answer Book, edited by Polking and Bloss $14.95
Getting the Words Right: How to Revise, Edit and Rewrite, by Theodore A. Rees Cheney $13.95
How to Get Started in Writing, by Peggy Teeters (paper) $8.95
How to Write a Book Proposal, by Michael Larsen $9.95
How to Write & Sell Your Personal Experiences, by Lois Duncan (paper) $9.95
How to Write & Sell (Your Sense of) Humor, by Gene Perret (paper) $9.95
How to Write While You Sleep, by Elizabeth Ross $12.95
Law & the Writer, edited by Polking & Meranus (paper) $10.95
Knowing Where to Look: The Ultimate Guide to Research, by Lois Horowitz $16.95
Pinckert's Practical Grammar, by Robert C. Pinckert $12.95
The 29 Most Common Writing Mistakes & How to Avoid Them, by Judy Delton $9.95
Writer's Block & How to Use It, by Victoria Nelson $12.95
Writer's Guide to Research, by Lois Horowitz $9.95
Writer's Market, edited by Becky Williams $21.95
Writer's Resource Guide, edited by Bernadine Clark $16.95
Magazine/News Writing
Basic Magazine Writing, by Barbara Kevles $16.95
How to Sell Every Magazine Article You Write, by Lisa Collier Cool $14.95
How to Write & Sell the 8 Easiest Article Types, by Helene Schellenberg Barnhart $14.95
Writing Nonfiction that Sells, by Samm Sinclair Baker $14.95
Fiction Writing
Creating Short Fiction, by Damon Knight (paper) $8.95
Fiction Writer's Market, edited by Jean Fredette $18.95
Handbook of Short Story Writing, by Dickson and Smythe (paper) $8.95
How to Write & Sell Your First Novel, by Oscar Collier with Frances Spatz Leighton $14.95
Storycrafting, by Paul Darcy Boles $14.95
Writing Romance Fiction—For Love and Money, by Helene Schellenberg Barnhart $14.95
Writing the Modern Mystery, by Barbara Norville $15.95
Writing the Novel: From Plot to Print, by Lawrence Block (paper) $8.95
Special Interest Writing Books
The Craft of Comedy Writing, by Sol Saks $14.95
How to Make Money Writing About Fitness & Health, by Celia & Thomas Scully $16.95
How to Make Money Writing Fillers, by Connie Emerson (paper) $8.95
How to Write the Story of Your Life, by Frank P. Thomas $12.95
How You Can Make $50,000 a Year as a Nature Photojournalist, by Bill Thomas (paper) $17.95
Mystery Writer's Handbook, by The Mystery Writers of America (paper) $8.95
Nonfiction for Children: How to Write It, How to Sell It, by Ellen E.M. Roberts $16.95
On Being a Poet, by Judson Jerome $14.95
The Poet's Handbook, by Judson Jerome (paper) $8.95
Poet's Market, by Judson Jerome $16.95
Travel Writer's Handbook, by Louise Zobel (paper) $9.95
TV Scriptwriter's Handbook, by Alfred Brenner (paper) $9.95
Writing for Children & Teenagers, by Lee Wyndham (paper) $9.95
The Writing Business
Complete Guide to Self-Publishing, by Tom & Marilyn Ross $19.95
Editing for Print, by Geoffrey Rogers $14.95
How to Bulletproof Your Manuscript, by Bruce Henderson $9.95
How to Get Your Book Published, by Herbert W. Bell $15.95
How to Understand and Negotiate a Book Contract or Magazine Agreement, by Richard Balkin $11.95
Literary Agents: How to Get & Work with the Right One for You, by Michael Larsen $9.95
Professional Etiquette for Writers, by William Brohaugh $9.95

To order directly from the publisher, include $2.00 postage and handling for 1 book and 50¢ for each additional book. Allow 30 days for delivery.
Writer's Digest Books, Dept. B, 9933 Alliance Rd., Cincinnati OH 45242
Prices subject to change without notice.

The Process of Submitting Photographs_____

Study Photographer's Market *listings*

Send for sample of publication/photo guidelines (if applicable)

Prepare cover letter and appropriate samples, tearsheets or stock photo lists

Stamp back of each print or slide mount with name, address and copyright notice

Properly package photos in heavy cardboard mailer or between cardboard sheets (transparencies should be inserted into sleeves prior to packaging)